CULTURE AND VALUES

A Survey of the Humanities

ALTERNATE VOLUME FIFTH EDITION

CULTURE AND VALUES

A Survey of the Humanities

LAWRENCE S. CUNNINGHAM

John A. O'Brien Professor of Theology University of Notre Dame

JOHN J. REICH

Syracuse University Florence, Italy

ALTERNATE VOLUME FIFTH EDITION

WADSWORTH

THOMSON LEARNING

Australia • Canada • Mexico • Singapore • Spain
United Kingdom • United States

THOMSON LEARNING

Publisher:

Earl McPeek

Editor:

John Swanson

 $Development\ Editor:$

Stacey Sims

Marketing Manager:

Steve Drummond

Project Editor: Production Manager: Rebecca Dodson

Print/Media Buyer:

Serena Sipho

Permissions Editor: Text Designer: Elaine Curda Shirley Webster Brian Salisbury

Art Editor:

Brian Salisbury

COPYRIGHT (c) 2002 Thomson Learning, Inc. Thomson LearningTM is a trademark used herein under license.

ALL RIGHTS RESERVED. No part of this work covered by the copyright hereon may be reproduced or used in any form or by any means—graphic, electronic, or mechanical, including but not limited to photocopying, recording, taping, Web distribution, information networks, or information storage and retrieval systems—without the written permission of the publisher.

Printed in the United States of America 5 6 7 05 04

For more information about our products, contact us at: Thomson Learning Academic Resource Center 1-800-423-0563

For permission to use material from this text, contact us by:

Library of Congress Cataloging-in-Publication Data 2001091450

ISBN 0-15-508532-8

Photo Researcher:

Cheri Throop

Copy Editor:

Maxine Barber,

Roberta J. Landi

Cover Designer:

Brian Salisbury

Cover Image:

Jan Vermeer, The Letter, 1666.

Rijksmuseum, Amsterdam.

Cover Printer:

Lehigh Press, Inc.

Compositor:

Progressive

Printer: R.R. D

R.R. Donnelley, Willard

Asia

Thomson Learning 60 Albert Street, #15-01 Albert Complex Singapore 189969

Australia

Nelson Thomson Learning 102 Dodds Street South Melbourne, Victoria 3205 Australia

Canada

Nelson Thomson Learning 1120 Birchmount Road Toronto, Ontario M1K 5G4 Canada

Europe/Middle East/Africa

Thomson Learning Berkshire House 168-173 High Holborn London WC1 V7AA United Kingdom

Latin America

Thomson Learning Seneca, 53 Colonia Polanco 11560 Mexico D.F. Mexico

Spain

Paraninfo Thomson Learning Calle/Magallanes, 25 28015 Madrid, Spain

T is now over twenty years since we finished the manuscript which would become this textbook. In the various additions, updatings, and rewriting that constitute the various editions of *Culture and Values*, we have not repented of our earliest convictions about what this book should represent. We repeat here what we said in the first edition, namely, that our desire is to present, in a chronological fashion, the most crucial landmarks of Western culture with clarity and, in such a way, that students might react to this tradition and its major accomplishments with the same enthusiasm as we experienced when we first encountered them and began to teach about them.

We believe that our own backgrounds have enhanced our appreciation for what we discuss in these pages. Lawrence Cunningham has degrees in philosophy, theology, literature, and humanities, while John Reich is a trained classicist, musician, and field archaeologist. Both of us have lived and lectured for extended periods in Europe. There is very little Western art or architecture discussed in this book which we have not seen firsthand.

In developing the new editions of *Culture and Values*, we have been the beneficiaries of the suggestions and criticisms of classroom teachers who have used the book. We have also consulted closely with the editorial team in meetings at Harcourt's Fort Worth office. Our own experiences as teachers both here and abroad have also made us sensitive to new needs and refinements as we rework this book.

In this new edition we have made a number of changes: updated and pruned the suggested readings; brought the final chapter up-to-date; and made additions to the Glossary. Furthermore, we have expanded some of the discussions, art representations, and readings to reflect the ever growing retrieval of women's voices in the history of Western culture. We are also very pleased that the editorial team has obtained some newer art reproductions, redrawn the timelines, and generally used the latest in technology to make the book so attractive. The biggest improvements to this edition are several new chapters which take into account the Islamic, African, and Asian cultures, which more than ever impinge on the ideas of the West. We have added these chapters in response to the many teachers who have noted the increasingly multicultural character of the world in which we live.

While it is true that the newer and ever expanding information technologies as well as the emergence of a global socio-political economy may render the notion of a purely occidental culture somewhat skewed (think, for example, of the globalization of popular music), we have generally stayed within the traditional parameters of the West, although we now feel it necessary to put that Western context into a larger, more global, framework. This fifth edition, which comes in the beginning of the new millenium, seems the appropriate time to start such an expanded vision.

One of the more vexatious issues with which we have had to deal is what to leave out. Our aim is to provide some representative examples from each period, hoping that instructors would use their own predilections to fill out where we have been negligent. In that sense, to borrow the Zen concept, we are fingers pointing the way—attend to the direction and not to the finger. We refine that direction using input from instructors making those decisions and would like to acknowledge the reviewers of the fifth edition:

Debra Barrett-Graves, College of Santa Fe; Margaret Brill, Corning Community College; Michael Call, Brigham Young University; Rich Campbell, Riverland College; Ransom P. Cross, The University of Texas—El Paso; Kimberly Felos, St. Petersburg Junior College; Jenette Flow, Pasco—Hernando Community College; Bruce W. Hozeski, Ball State University; David Hutto, Georgia Perimeter College; Steven P. Johnson, Brigham Young University; Terrence Lewis, Calencia Community College; Fay C. McMillan, Northeast State Technical Community College; Sarah C. Neitzel, University of Texas—Pan American; Carol Nicklaus, Amarillo College; Lilian Taylor, College of Santa Fe; Elizabeth D. Van Loo, Troy State University—Dothan; Michael Walensky, Diablo Valley College; Gary Zacharias, Palomar College.

Finally, we would like to express our gratitude to those who have helped us in preparing this fifth edition. We would especially like to acknowledge the work of Scott Douglass of Chattanooga State Technical Community College, who served as our technology consultant on the new edition, providing assistance on the Web sites and captions for the cues, in development of the *Culture and Values* Web site, and in creation of online course materials for the book. Special thanks also go to John R. Swanson, acquisitions editor; Stacey Sims, developmental editor; Rebecca Dodson, project editor; Serena Manning, production manager; Brian Salisbury, art director; and Shirley Webster, picture and rights editor.

LSC JJR

FEATURES

The fifth edition of *Culture and Values* maintains many of the features that have made the book so successful.

Enhanced Illustrations. As in prior editions, the text is beautifully illustrated with over five hundred images, most of them in color. This new edition includes over ninety new images, including a photo of King Tutankhamen's golden death mask and another of the restored Last Supper with its unfamiliarly bright color. Many of the images previously reproduced in the book have been replaced with higher quality photos that provide either a better view of the original artwork or a truer match to the original's color and overall appearance. A number of the line drawings have also been redrawn for better accuracy of representation and better consistency with similar drawings found in the book.

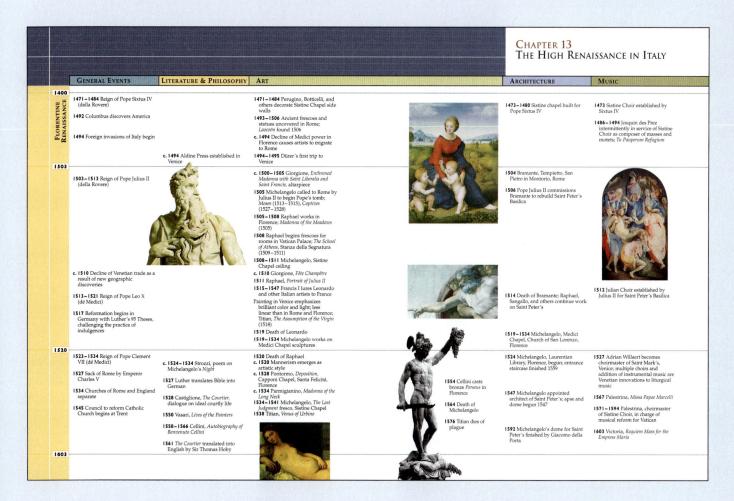

Timelines. Each chapter begins with an illustrated, two-page timeline that organizes the major events and works for each era and, where appropriate, for each major category of works discussed in the chapter (i.e., general events, literature

and philosophy, art, architecture, and music). The timelines provide an instant visual reference that allows students to see the development of each type of art over the time period presented.

47 CHAPTER 17 The Romantic Era

VALUES

One of the consequences of the rise of the cities and growing political consciousness was the development of nationalism: the identification of individuals with a of nationalism: the identification of individuals with a nation-state, with its own culture and history. In the past, the units of which people felt a part were either smaller—a local region—or larger—a religious orga-nization or a social class. In many cases, the nations with which people began to identify were either bro-ken up into separate small states, as in the case of the future Germany and Italy or formed part of a larger state: Hungary, Austria, and Serbia were all under the relia of the Largery Environment with Austria dominative rule of the Hapsburg Empire, with Austria dominating

the rest.

The period from 1848 to 1914 was one in which the struggle for national independence marked political and social life and left a strong impact on Buropean culture. The arts, in fact, became one of the chief ways in which nationalists sought to stimulate a sense of peels awareness of their national roots. One of the basic factors that distinuished the Humaniana or the Czechs over land to the control of the second of the control of the second of the s

guage, they had been ruled for centuries by a bewildering array of outside powers. In Sicily alone, Arabs, French, Spaniards, and English were only some of the occupiers who had succeeded one another. The architects of Italian unity used the existence of a common language, which went back to the poet Dante, to forge a sense of national identity.

The arts also played their part. Nationalist composers used folktunes, sometimes real and sometimes invented, to underscore a sense of national consciousment.

ness. In the visual arts, painters illustrated historical ness. In the visual arts, painters illustrated historical events and sculptors portrayed particult leaders. While the newly formed nations aimed to create an independent national culture, the great powers reinforced their own identities. Russian composers turned away from Western models to underline their Slavic roots, while in Britain the artists and writers of the Victorian Age depicted the glories (and, in some cases, the horrors) of their nation.

The consequences of the rise of national conscious-

The consequences of the rise of national conscious the Czechs , and paown lanown lanown laningerian of the twentied curry, and are still with
us today. The age of world war was inaugurated by
ungarian
ingerian of the countries created in the first half.
Among the casualties are the former Czechoslovakia
and Yugoslavia. The struggle of minorities to win their
operated.
same lanoperated.
same lanoperated

46 CHAPTER 10 High Middle Ages: The Search for Synthesis CONTEMPORARY VOICES

A Medieval Parent and a Student

I have recently discovered that you live dissolutely and I have recently discovered that you live dissolutely and solutifully, preferring license to restraint and play to work and strumming a guitar while the others are at their studies, whence it happens that you have read but one volume of law while more industrious companions have read several. I have decided to exhort you herewith to repent utterly of your dissolute and careless ways that you may no longer be called a waster and that your shame may be turned to good repute.

We occupy a good and comely dwelling, next door but one from the schools and marketplace, so that we can go to school each day without wetting our feet. We

have good companions in the house with us, well advanced in their studies, and of excellent habits—an advantage which we appreciate for, as the palamist says "with an upright man thou will show thyself upright." Wherefore, lest production should case for lack of material, we beg your paternity to send us by the bearer money for the purchase of parchment, ink, a desk, and the other things which we need, in sufficient amount that we may suffer no want on your account (God forbidl) but finish our studies and return home with honor. The bearer will also take charge of the shoes and stockings which you will send us, and any news at all. stockings which you will send us, and any news at all.

By our standards, student life in the thirteenth century was harsh. Food and lodging were primitive, heat-ing scarce, artificial lighting nonexistent, and income sporadic. The daily schedule was rigorous, made more so by the shortage of books and writing material. An "ideal" student's day, as sketched out in a late medieval pamphlet for student use, now seems rather grim:

A Student's Day at the University of Paris 4:00 A.M.

5:00-6:00 Arts lectures 6:00 8:00-10:00 Mass and breakfast Lectures Disputations before the noon meal "Repetitions"—study of morning lec-tures with tutors 11:00-12:00 1:00-3:00 P.M. 3:00-5:00 Cursory lectures (generalized lectures on special topics) or disputa-

tions Supper Study and repetitions Bed 6:00 7:00-9:00 9:00

The masters' lectures consisted of detailed commen taries on certain books the master intended to cover in a given term. Since books were expensive, emphasis was put on note taking and copying so that the student might build up his own collection of books. Examinations were oral, before a panel of masters. Students were also expected to participate in formal debates (called disputa-tions) as part of their training.

Geoffrey Chaucer provides us an unforgettable, albeit idealized, portrait of the medieval student (the clerk or cleric-many of the students were members of the minor clerical orders of the church) in his Prologue to the Canterbury Tales:

A clerk from Oxford was with us also, Who di turned to getting knowledge, long ago. As meager was his horse as is a rake, Nor he himself too fat, I'll undertake. But he looked hollow and went soberly. Right threadbare was his overcoat; for he Had got him yet no churchly benefice, Nor was so worldly as to gain office. For he would rather have at his bed's head Some twenty books, all bound in black and red, Of Aristotle and his philosophy. Than rich robes, fiddle, or gay psaltery. Yet, and for all he was philosopher, He had but little gold within his coffer; He had but little gold within his coffer; but all that he might borrow from a friend On books and learning he would swiftly spend, And then he'd pary right bussly for the souls Of those who gave him wherewithal for schools. Of study took be utmost care and heed. Not one word spoke he more than was his need; And that was said in fullest reverence And short and quick and full of high good sense. Pregnant of moral vitrue was his speech. And gladly would he learn and gladly teach.

Chaucer's portrait of the lean, pious, poor, zealous student was highly idealized to create a type. We proba-bly get a far more realistic picture of what students were actually doing and thinking about from the considerable amount of popular poetry that comes from the student culture of the medieval period. This poetry depicts a stu-dent life we are all familiar with: a poetry of wine, women, song, sharp satires at the expense of pompous

England, ect with Scenery ense of

t aimed son and is is the ing with ed by renothing results. have an has no painting

paint-

Lake George [17.31] by Martin J. Heade (1819–1904), one of the leading luminists, seems almost to foreshadow the Surrealist art of the twentieth century.

The two great American painters of the latter nineteenth century—Winslow Homer (1836–1910) and Thomas Eakins (1844–1916)—both used the luminist approach to realism as a basis for their own very individual styles. In the case of Homer, the realism of his early paintings was in large measure the result of his work as a documentary artist, recording the events of the Civil War. His style underwent a notable change as he became exposed to contemporary French Impressionist painting (discussed in Chapter 18). His mysterious Eagle Head [17.32] is certainly far more than a naturalistic depiction of three women and a dog on a beach. By the way in which he has positioned the figures, Homer suggests

Boxes. Two types of boxes run throughout the book. "Contemporary Voices" boxes, taken from letters, journals, and narratives of the time period under discussion, provide students with insight into the concerns of individuals responding to the major events and ideas of the era firsthand. "Values" boxes make

explicit the underlying issues or concerns unifying the works of a given era, examining their root causes and their ultimate impact on the type of art produced. New Global Coverage. Many instructors using Culture and Values have expressed an interest in seeing more global coverage of the humanities. Under their guidance and review, three new chapters covering Asian and African cultures have been added to the book, and the treatment of Islamic culture has been expanded to a full chapter. In each case, the presentation focuses on the unique achievements and traditions of these cultures and their place within the broader human story.

SUPPLEMENTS*

Culture and Values Listening CD. This all-new CD features selections and excerpts from some of the major musical works discussed in the text. An icon of a lyre appears throughout the textbook to indicate the musical works represented on the CD. A full listing of the contents of the CD is provided on the textbook Web site. The Listening CD can be value-added to Culture and Values at a substantial discount to the student.

Culture and Values Online. Completely revised for the fifth edition and fully integrated with the textbook, the Web site for Culture and Values includes links to sites on major artists, writers, thinkers, and composers, and other resources related to the introduction to the humanities course. Included are chapter-by-chapter links to the sites referenced in the textbook's cues and end-of-chapter

^{*}Adoption requirements may apply, so see your representative for details.

Web resources and to other sites directly related to the material in the text. The site also provides the timelines and the Glossary from the textbook, an audio pronunciation guide, and a selection of self-assessment tools. A variety of instructor's resources is also available, including a syllabus generator, online course management tools, and an electronic instructor's manual.

Course Management Tools (WebCT and Blackboard). For the first time ever, a text-specific online course prepared by Scott Douglass is also available for adoption with Culture and Values. Among the many features are chapter-by-chapter learning modules, assignments, discussion questions, Web links and activities, and self-tests. Also available for Blackboard.

Humanities Hits on the Web. This brief guide by Scott Douglass of Chattanooga State Technical Community College provides an overview on accessing

and exploring the wealth of resources available to students of the humanities on the World Wide Web. It includes information on major search engines, e-mail, list serves and newsgroups, information on documenting Internet resources, as well as an annotated list of Web sites specifically for the humanities.

Great Artists CD-ROM. This CD-ROM focuses on the works of eight major

artists—William Blake, El Greco, Leonardo da Vinci, Pablo Picasso, Rembrandt, Vincent van Gogh, J.H.M. W. Turner, and Jean-Antoine Watteau. Students explore forty famous paintings and discover the influences that inspired the artists. They examine each painting by date, type, and content, and find out exactly how they were created. The CD-ROM includes one thousand full-color images, twenty minutes of running video, biographies of the artists, five hundred thousand words of descriptive text, and one hundred music excerpts and video clips. It also provides an examination of the artists' materials and methods, the ability to compare and contrast sections of different paintings, and insight into composition and techniques through video sequences and timelines. *Great Artists*

can be value-added to Culture and Values at a substantial discount to the student.

Humanities Video and CD-ROM Library. This extensive library of videos and CD-ROMs contains selections covering every era, a significant number of major artists, and a variety of media including architecture and photography. Videos and CD-ROMs are available featuring civilizations from around the globe including the Americas, Africa, and Asia.

Instructor's Manual and Test Bank

The Instructor's Manual, prepared by Roberta Vandermast, contains a variety of features for each chapter including suggestions for classroom discussion, assignments for students, and audiovisual resources. The Test Bank provides fill-in-the-blank, matching, short-answer, essay, and multiple-choice questions for each chapter. A computerized version of the Test Bank is available on CD for both Windows and Mac users.

Study Guide

For the first time a study guide, prepared by Ira Holmes, is available for purchase with *Culture and Values*. It provides a section of self-review activities and a self-quiz for each chapter of the book. Additional resources at the end of the book include information on researching and writing about the humanities, suggestions for a museum visit, and a set of study cards that can be used for preparing exams.

Slide Package I: 100 Artworks

Each of the one hundred slides in this all-new package has been carefully selected to provide the highest quality and closest match available to the view of the image provided in the textbook. So that previous adopters of the textbook may enjoy even more comprehensive slide coverage, the fifth edition slide set is composed of all-new images and does not reproduce images provided in the previous edition set.

Slide Package II: Maps and Diagrams

This smaller slide set contains twenty-five slides of maps and diagrams taken directly from the textbook.

Digital Images from Saskia

Enter the digital age with a set of high quality digital images from the leading provider of fine art images, Saskia, Ltd. The entire one hundred-slide collection is delivered on CD-ROM for your department's use. Build classroom presentations, use on your Web site, or build study collections for your students.

TABLE OF CONTENTS—SPECIAL FEATURES ALTERNATE VOLUME

Maps

- 1 The Ancient World 5
- 2 Ancient Greece 34
- 3 The Hellenistic World 79
- The Roman World 90

- 5 The Spread of Buddhism 127 Shang Control of Ancient China 131
- 6 Israel at the Time of Jesus 148 Christian Communities 148
- 7 The Byzantine World 168 Justinians' Empire 176
- 8 The Islamic World 187
- 9 The Carolingian World 202
- 10 The Île of France 229
- 11 The Black Death 254
- 12 Italy 304
- 14 Religious Divisions in Europe c. 1600 343
- 15 Overseas Possessions at the End of the 17th Century 376
- 16 Eighteenth-Century Europe 417
- 17 Europe in 1848 450
- 19 Asia 524
 The Mughal Empire in India 524
 The Ming Empire 528
- 20 The African Environment 546 Africa 553
- 21 Europe after World War I 569

Values Boxes

- 1 Mortality 14
- 2 Destiny 37
- 3 Civic Pride 60
- 4 Empire 101
- 6 Revelation 146
- 7 Autocracy 169
- 8 Values 195
- 9 Feudalism 217
- 10 Dialectics 238
- 11 Natural Disaster and Human Response 255
- 12 Intellectual Synthesis 297
- 13 Patronage 325
- 14 Reform 345
- 15 Scientific Truth 404
- 16 Revolution 439
- 17 Nationalism 478
- 18 Colonialism 509
- 21 Disillusionment 567
- 22 Liberation 606

Contemporary Voices Boxes

- Love, Marriage, and Divorce in Ancient Egypt 18
- 2 Daily Life in the World of Homer 39
- 3 Kerdo the Cobbler 80
- 4 A Dinner Party in Imperial Rome 97
- 5 War and Religion in the Age of Ashoka 126
- 6 Vibia Perpetua 149
- 7 Procopius of Caesarea 163
- 8 Contemporary Voices 194
- 9 An Abbot, an Irish Scholar, and Charlemagne's Biographer 205
- 10 A Medieval Parent and a Student 240

11	John Ball 259
12	Fra Savonarola 282
13	Donna Vittoria and Michelangelo 317
14	Katherine Zell 342
15	Giambattista Passeri 397
16	Horace Walpole 433
17	Isabella Bird Meets a Mountain Man 474
18	Gustav Mahler 510
19	The Emperor of China Studies Western
	Mathematics 533
20	An Arab and a European Visit Africa 551
21	Virginia Woolf 570
22	Ceorgia O'Keeffe 596

VOLUME I	VOLUME II
Chapter 1 The Beginnings of Civilization 1	Chapter 12 The Early Renaissance 279
Chapter 2 Early Greece 31	Chapter 13 The High Renaissance in Italy 311
CHAPTER 3 CLASSICAL GREECE AND THE HELLENISTIC	Chapter 14 The Renaissance in the North 337
Period 55 Chapter 4 The Bonney Legency 87	Chapter 15 The Baroque World 371
THE ROMAN LEGACY 87 CHAPTER 5 ANCIENT CIVILIZATIONS OF INDIA AND	Chapter 16 The Eighteenth Century: From Rococo to Revolution 413
CHINA 121 CHAPTER 6 JERUSALEM AND EARLY CHRISTIANITY 141	Chapter 17 The Romantic Era 445
CHAPTER 7 BYZANTIUM 159	Chapter 18 Toward the Modern Era: 1870–1914 487
CHAPTER 8 ISLAM 183 CHAPTER 9	Chapter 19 India, China, and Japan: From the Medieval to the Modern World 521
CHARLEMAGNE AND THE RISE OF MEDIEVAL CULTURE 199 CHAPTER 10	Chapter 20 The Peoples and Cultures of Africa 543
HIGH MIDDLE AGES: THE SEARCH FOR SYNTHESIS 223	CHAPTER 21 Between the World Wars 559
CHAPTER 11 THE FOURTEENTH CENTURY: A TIME OF TRANSITION 251	CHAPTER 22 THE CONTEMPORARY CONTOUR 587

GLOSSARY 626 INDEX 634 PHOTO CREDITS 666 LITERARY CREDITS 672

Early Greek Literature and Philosophy

The First Philosophers: The Presocratics

52

53

Herodotus: The First Greek Historian

52

53

Pronunciation Guide

Further Reading 53 Online Chapter Links

Lyric Poetry

Summary

Exercises

49

50 51

CLASSICAL GREECE AND THE HELLENISTIC PERIOD 55
The Classical Ideal 57
VALUES: Civic Pride 60
Drama and Philosophy in Classical Greece The Drama Festivals of Dionysus 60 The Athenian Tragic Dramatists 62 Aristophanes and Greek Comedy 64 Philosophy in the Late Classical Period 65
Greek Music in the Classical Period 67
Fifth Century B.C. 68 Architecture in the Fifth Century B.C. 69
The Visual Arts in the Fourth Century B.C. 76
The Hellenistic Period 78
CONTEMPORARY VOICES: Kerdo the Cobbler 80
Summary 83 Pronunciation Guide 84 Exercises 84 Further Reading 84 Online Chapter Links 85 CHAPTER 4 THE ROMAN LEGACY 87
The Importance of Rome 89
The Etruscans and Their Art 91
Republican Rome (509–31 B.C.) 92 Literary Developments During the Republic 95 Roman Philosophy and Law 96
CONTEMPORARY VOICES: A Dinner Party in Imperial Rome 97 Republican Art and Architecture 98
Imperial Rome (31 B.C. – A.D. 476) 99 Augustan Literature: Vergil 100
Values: Empire 101 Augustan Sculpture 102 The Evidence of Pompeii 105 Roman Imperial Architecture 109 Rome as the Object of Satire 112
The End of the Roman Empire 113 Late Roman Art and Architecture 115
Summary 116 Propunciation Guide 117

CHAPTER 3

Exercises 118 Further Reading 118	CONTEMPORARY VOICES: Procopius of Caesarea 163
Online Chapter Links 118	The Ascendancy of Byzantium 163 Church of Hagia Sophia: Monument
CHAPTER 5	and Symbol 164
ANCIENT CIVILIZATIONS OF INDIA AND CHINA 121	Ravenna 166 Art and Architecture 166
Indian Civilization 123 The Indus Valley Civilization 123	VALUES: <i>Autocracy</i> 169 Saint Catherine's Monastery at Mount Sinai 175
The Aryans 123	The Persistence of Byzantine Culture 178
Buddha 125 The Emperor Ashoka 126	Summary 180 Pronunciation Guide 180
CONTEMPORARY VOICES: War and Religion in the Age of Ashoka 126	Exercises 180 Further Reading 181
Hindu and Buddhist Art 127	Online Chapter Links 181
The Gupta Empire and Its Aftermath 128	
Gupta Literature and Science 129 The Collapse of Gupta Rule 130	CHAPTER 8 ISLAM 183
The Origins of Civilization in China 131	ISLAM 183
The Chou Dynasty 131 Confucianism and Taoism 132	Muhammad and the Birth of Islam 185 The Qur'an 186
The Unification of China: The Ch'in, Han, and T'ang Dynasties 133 The Arts in Classical China 134	Calligraphy 187 Islamic Architecture 188 Sufism 193
Summary 136	CONTEMPORARY VOICES 194
Pronunciation Guide 138	The Culture of Islam and the West 194
Exercises 138	Values 195
Further Reading 138 Online Chapter Links 139	Summary 196 Pronunciation Guide 196
	Exercises 197
CHAPTER 6	Further Reading 197
JERUSALEM AND EARLY Christianity 141	Online Chapter Links 197
Judaism and Early Christianity 143 The Hebrew Bible and Its Message 144	Chapter 9
Values: Revelation 146	CHARLEMAGNE AND THE RISE
The Beginnings of Christianity 147	OF MEDIEVAL CULTURE 199
CONTEMPORARY VOICES: Vibia Perpetua 149 Constantine and Early Christian Architecture 152	Charlemagne as Ruler and Diplomat 201
Early Christian Music 154	Learning in the Time of Charlemagne 203
Summary 155 Pronunciation Guide 156	Benedictine Monasticism 204 The Rule of Saint Benedict 204
Exercises 156 Further Reading 156	CONTEMPORARY VOICES: An Abbot, an Irish Scholar, and Charlemagne's Biographer 205
Online Chapter Links 156	Women and the Monastic Life 206
•	Monasticism and Gregorian Chant 206
Chapter 7	Liturgical Music and the Rise of Drama 208
BYZANTIUM 159	The Liturgical Trope 208 The Quem Quæritis Trope 208
The Decline of Rome 161 Literature and Philosophy 161	The Morality Play: Everyman 209 Nonliturgical Drama 209

The Legend of Charlemagne: Song of	CONTEMPORARY VOICES: John Ball 259
Roland 210	Art in Italy 259
The Visual Arts 211	The Italo-Byzantine Background 260
The Illuminated Book 211	Giotto's Break with the Past 263 Painting in Siena 266
Charlemagne's Palace at Aachen 213	Art in Northern Europe 266
The Carolingian Monastery 216 The Romanesque Style 216	•
VALUES: Feudalism 217	Late Gothic Architecture 270
	Music: Ars Nova 272
Summary 220 Pronunciation Guide 221	Summary 276
Exercises 221	Pronunciation Guide 276 Exercises 276
Further Reading 221	Further Reading 277
Online Chapter Links 221	Online Chapter Links 277
Chapter 10	VOLUME II
HIGH MIDDLE AGES: THE SEARCH FOR SYNTHESIS 223	Chapter 12
	THE EARLY RENAISSANCE 279
The Significance of Paris 225	
The Gothic Style 225	Toward the Renaissance 281
Suger's Building Program for Saint Denis 225 The Mysticism of Light 229	The First Phase: Masaccio, Ghiberti, and Brunelleschi 281
The Many Meanings of the Gothic Cathedral 230 Music: The School of Notre Dame 236	CONTEMPORARY VOICES: Fra Savonarola 282
Scholasticism 237	The Medici Era 288
The Rise of the Universities 237	Cosimo de' Medici 289
Values: Dialectics 238	Piero de' Medici 293 Lorenzo the Magnificent 294
CONTEMPORARY VOICES: A Medieval Parent and a	The Song of Bacchus 295
Student 240	Values: Intellectual Synthesis 297
Francis of Assisi 241	The Character of Renaissance Humanism 302
Thomas Aquinas 242	Pico della Mirandola 303
Dante's Divine Comedy 245	Printing Technology and the Spread of
Summary 248	Humanism 303
Pronunciation Guide 248	Women and the Renaissance 305
Exercises 248	Two Styles of Humanism 305
Further Reading 249 Online Chapter Links 249	Machiavelli 305 Erasmus 306
Offine Chapter Black	Music in the Fifteenth Century 307
Chapter 11	Guillaume Dufay 307
THE FOURTEENTH CENTURY:	Music in Medici Florence 307
A TIME OF TRANSITION 251	Summary 308
Calamity, Decay, and Violence 253	Pronunciation Guide 308
The Black Death 253	Exercises 308
The Great Schism 253	Further Reading 309
VALUES: Natural Disaster and Human	Online Chapter Links 309
Response 255	Chapter 13
The Hundred Years' War 255	THE HIGH RENAISSANCE
Literature in Italy, England, and France 255	IN ITALY 311
Petrarch 256	Popes and Patronage 313
Petrarch's Sonnet 15 257 Chaucer 257	Raphael 313
Christine de Pisan 258	Michelangelo 316

CONTEMPORARY VOICES: Donna Vittoria and Michelangelo 317 The New Saint Peter's 320	CHAPTER 15 THE BAROQUE WORLD 371
The High Renaissance in Venice 323	The Counter-Reformation Spirit 373
Giorgione 324 Titian 324 VALUES: Patronage 325 Tintoretto 326	The Visual Arts in the Baroque Period 375 Painting in Rome: Caravaggio and the Carracci 375 Roman Baroque Sculpture and Architecture: Bernini
Mannerism 327	and Borromini 380
Sofonisba Anguissola 329	Baroque Art in France and Spain 383
Music in the Sixteenth Century 330	Baroque Art in Northern Europe 391
Music at the Papal Court 330 Venetian Music 331 Contrasting Renaissance Voices 332 Castiglione 332 Cellini 333	CONTEMPORARY VOICES: Giambattista Passeri 397 Baroque Music 398 The Birth of Opera 398 Baroque Instrumental and Vocal Music: Johann Sebastian Bach 400
Summary 333 Pronunciation Guide 334 Exercises 334	Philosophy and Science in the Baroque Period 402 Galileo 402
Further Reading 334 Online Chapter Links 334	VALUES: Scientific Truth 404 Descartes 404 Hobbes and Locke 405
CHAPTER 14 THE RENAISSANCE IN THE NORTH 337 The Referentian 240	French Baroque Comedy and Tragedy 406 The Novel in Spain: Cervantes 407 The English Metaphysical Poets 407 Milton's Heroic Vision 408
The Reformation 340 CONTEMPORARY VOICES: Katherine Zell 342 Causes of the Reformation 342 Renaissance Humanism and the Reformation 344 VALUES: Reform 345 Cultural Significance of the Reformation 345	Summary 409 Pronunciation Guide 410 Exercises 411 Further Reading 411 Online Chapter Links 411
Intellectual Developments 347 Montaigne's Essays 347 The Growth of Science 348 The Visual Arts in Northern Europe 349	CHAPTER 16 THE EIGHTEENTH CENTURY: FROM ROCOCO TO REVOLUTION 413
Painting in Germany: Dürer, Grünewald, Altdorfer 349	Age of Diversity 415
Painting in the Netherlands: Bosch and Bruegel 354	The Visual Arts in the Eighteenth Century The Rococo Style 417
Art and Architecture in France 357	Neo-Classical Art 422 Classical Music 426
Art in Elizabethan England 359	The Classical Symphony 428
Music of the Northern Renaissance Music in France and Germany 362 Elizabethan Music 362	CONTEMPORARY VOICES: Horace Walpole 433 Literature in the Eighteenth Century 433 Intellectual Developments 433
English Literature: Shakespeare 364	Intellectual Developments 433 The Late Eighteenth Century:
Summary 367 Pronunciation Guide 368 Exercises 368	Time of Revolution 438 VALUES: Revolution 439
Further Reading 368 Online Chapter Links 368	Summary 441 Pronunciation Guide 442

Exercises 442 Further Reading 442 Online Chapter Links 443	New Subjects for Literature 515 Psychological Insights in the Novel 515 Responses to a Changing Society: The Role of Women 516
CHAPTER 17 THE ROMANTIC ERA 445 The Concerns of Romanticism 447	Summary 517 Pronunciation Guide 518 Exercises 518
	Further Reading 519
	Online Chapter Links 519
Music in the Romantic Era 452 Beethoven 452	Chapter 19
Instrumental Music after Beethoven 454 The Age of the Virtuosos 455 Musical Nationalism 456 Opera in Italy: Verdi 456 Opera in Germany: Wagner 458	INDIA, CHINA, AND JAPAN: FROM THE MEDIEVAL TO THE MODERN WORLD 521
Romantic Art 460 Painting at the Turn of the Century: Goya 460	India: From Mughal Conquest to British Rule 523
Painting and Architecture in France: Romantics and Realists 462 Painting in Germany and England 467	The Mughal Empire 523 Mughal Art 525 The End of Mughal Rule and the Arrival of the British 526
Literature in the Nineteenth Century 470	The Rise of Nationalism 526
Goethe 470 Romantic Poetry 472 The Novel 473	Chinese Culture under Imperial Rule The Arts under the Ming Dynasty 527
CONTEMPORARY VOICES: Isabella Bird Meets a Mountain Man 474	The Qing Dynasty: China and the Western Powers 531
The Romantic Era in America 475 American Literature 476	Contemporary Voices: The Emperor of China Studies Western Mathematics 533
American Painting 477 VALUES: Nationalism 478	The Art and Culture of Japan 533 Early Japanese History and Culture 533 The Period of Feudal Rule 536
Summary 481 Pronunciation Guide 483	The Edo Period 536
Exercises 483	Modern Japan: The Meiji 538
Further Reading 483	Summary 538
Online Chapter Links 484	Pronunciation Guide 540 Exercises 540
Chapter 18	Further Reading 541
TOWARD THE MODERN ERA: 1870–1914 487	Online Chapter Links 541
The Growing Unrest 489	Chapter 20
New Movements in the Visual Arts Impressionism 493 Park Impressionism 501	THE PEOPLES AND CULTURES OF AFRICA 543
Post-Impressionism 501 Fauvism and Expressionism 504	Religion and Society in Early Africa 545
New Styles in Music 507 Orchestral Music at the Turn of the Nineteenth	Three Early African Kingdoms: Ghana, Benin, and Zimbabwe 545
Century 508	African Literature 548
VALUES: Colonialism 509	Traditional African Art in the
CONTEMPORARY VOICES: Gustav Mahler 510	Modern Period 550
Impressionism in Music 512 The Search for a New Musical Language 513	Contemporary Voices: An Arab and a European Visit Africa 551

Online Chapter Links

584

The Impact of African Culture on the West 553 CHAPTER 22 Summary 555 THE CONTEMPORARY **Pronunciation Guide** 556 **CONTOUR** 587 **Exercises** 556 Toward a Global Culture **Further Reading** 589 556 **Online Chapter Links** 556 Existentialism 590 **Painting Since 1945** 591 CHAPTER 21 Abstract Expressionism 592 BETWEEN THE CONTEMPORARY VOICES: Georgia O'Keeffe 596 WORLD WARS 559 The Return to Representation **Contemporary Sculpture** 602 The Great War (World War I) and VALUES: Liberation 606 Its Significance 561 Architecture 608 Literary Modernism 561 T. S. Eliot and James Joyce 562 Some Trends in Contemporary Literature 617 562 Franz Kafka A Note on the Postmodern Virginia Woolf 562 **Music Since 1945** The Revolution in Art: Cubism 563 Avant-Garde Developments 620 VALUES: Disillusionment 567 The New Minimalists Traditional Approaches to Modern Music 622 Freud, the Unconscious, and Surrealism 567 Popular (Pop) Music 622 CONTEMPORARY VOICES: Virginia Woolf 570 **Summary** 624 The Age of Jazz 573 **Pronunciation Guide** 624 George Gershwin 574 **Exercises** 624 **Duke Ellington** 574 **Further Reading** 625 The Harlem Renaissance 575 **Online Chapter Links** 625 **Ballet: Collaboration in Art** 575 Art as Escape: Dada Art as Protest: Guernica GLOSSARY 627 Art as Propaganda: Film 578 **Photography** 580 **INDEX** 635 Art as Prophecy: From Futurism to Brave New World 581 PHOTO CREDITS 666 Summary 583 **Pronunciation Guide** 583 LITERARY CREDITS 672 **Exercises** 583 **Further Reading** 584

ONE way to see the arts as a whole is to consider a widespread mutual experience: a church or synagogue service or the worship in a Buddhist monastery. Such a gathering is a celebration of written literature done, at least in part, in music in an architectural setting decorated to reflect the religious sensibilities of the community. A church service makes use of visual arts, literature, and music. While the service acts as an integrator of the arts, considered separately, each art has its own peculiar characteristics that give it shape. The same integration may be seen, of course, in an opera or in a music video.

Music is primarily a temporal art, which is to say that there is music when there is someone to play the instruments and sing the songs. When the performance is over, the music stops.

The visual *arts* and *architecture* are spatial arts that have permanence. When a religious service is over, people may still come into the building to admire its architecture or marvel at its paintings or sculptures or look at the decorative details of the building.

Literature has a permanent quality in that it is recorded in books, although some literature is meant not to be read but to be heard. Shakespeare did not write plays for people to read, but for audiences to see and hear performed. Books nonetheless have permanence in the sense that they can be read not only in a specific context, but also at one's pleasure. Thus, to continue the religious-service example, one can read the psalms for their poetry or for devotion apart from their communal use in worship.

What we have said about the religious service applies equally to anything from a rock concert to grand opera: artworks can be seen as an integrated whole. Likewise, we can consider these arts separately. After all, people paint paintings, compose music, or write poetry to be enjoyed as discrete experiences. At other times, of course, two arts may be joined when there was no original intention to do so, as when a composer sets a poem to music or an artist finds inspiration in a literary text or, to use a more complex example, when a ballet is inspired by a literary text and is danced against the background or sets created by an artist to enhance both the dance and the text that inspired it.

However we view the arts, either separately or as integrated, one thing is clear: they are the product of human invention and human genius. When we speak of *culture*, we are not talking about something strange or "highbrow"; we are talking about something that derives from human invention. A jungle is a product of nature, but a garden is a product of culture: human ingenuity has modified the vegetative world.

In this book we discuss some of the works of human culture that have endured over the centuries. We often refer to these works as *masterpieces*, but what does the term mean? The issue is complicated because tastes and attitudes change over the centuries. Two hundred years ago the medieval cathedral was not appreciated; it was called Gothic because it was considered barbarian. Today we call such a building a masterpiece. Very roughly we can say that a masterpiece of art is any work that carries with it a surplus of meaning.

Having "surplus of meaning" means that a certain work not only reflects technical and imaginative skill, but also that its very existence sums up the best of a certain age, which spills over as a source of inspiration for further ages. As one reads through the history of the Western humanistic achievement it is clear that certain products of human genius are looked to by subsequent generations as a source of inspiration; they have a surplus of meaning. Thus the Roman achievement in architecture with the dome of the Pantheon both symbolized their skill in architecture and became a reference point for every major dome built in the West since. The dome of the Pantheon finds echoes in 6th-century Constantinople (Hagia Sophia); in 15th-century Florence (the Duomo); in 16th-century Rome (St. Peter's); and in 18thcentury Washington D.C. (the Capitol building).

The notion of surplus of meaning provides us with a clue as to how to study the humanistc tradition and its achievements. Admittedly simplifying, we can say that such a study has two steps that we have tried to synthesize into a whole in this book:

The Work in Itself. At this level we are asking the question of fact and raising the issue of observation: What is the work and how is it achieved? This question includes not only the basic information about, say, what kind of visual art this is (sculpture, painting, mosaic) or what its formal elements are (Is it geometric in style? bright in color? very linear? and so on), but also questions of its function: Is this work an homage to politics? for a private patron? for a church? We look at artworks, then, to ask questions about both their form and their function.

This is an important point. We may look at a painting or sculpture in a museum with great pleasure, but that pleasure would be all the more enhanced were we to see that work in its proper setting rather than as an object on display. To ask about form and function, in short, is to ask equally about context. When reading certain literary works (such as the *Iliad* or the *Song of Roland*) we should read them aloud since, in their original form, they were written to be recited, not read silently on a page.

The Work in Relation to History. The human achievements of our common past tell us much about earlier cultures both in their differences and in their similarities. A study of the tragic plays that have survived from ancient Athens gives us a glimpse into Athenians' problems, preoccupations, and aspirations as filtered through the words of Sophocles or Euripides. From such a study we learn both about the culture of Athens and something about how the human spirit has faced the perennial issues of justice, loyalty, and duty. In that sense we are in dialogue with our ancestors across the ages. In the study of ancient culture we see the roots of our own.

To carry out such a project requires willingness really to look at art and closely read literature with an eye equally to the aspect of form/function and to the past and the present. Music, however, requires a special treatment because it is the most abstract of arts (How do we speak about that which is meant not to be seen but to be heard?) and the most temporal. For that reason a somewhat more extended guide to music follows.

How to Look at Art

Anyone who thumbs through a standard history of art can be overwhelmed by the complexity of what is discussed. We find everything from paintings on the walls of caves and huge sculptures carved into the faces of mountains to tiny pieces of jewelry or miniature paintings. All of these are art because they were made by the human hand in an attempt to express human ideas and/or emotions. Our response to such objects depends a good deal on our own education and cultural biases. We may find some modern art ugly or stupid or bewildering. We may think of all art as highbrow or elitist despite the fact that we like certain movies (film is an art) enough to see them over and over. At first glance, art from the East may seem odd simply because we do not have the reference points with which we can judge the art good or bad.

Our lives are so bound up with art that we often fail to recognize how much we are shaped by it. We are bombarded with examples of graphic art (television commercials, magazine ads, CD jackets, displays in stores) every day; we use art to make statements about who we are and what we value in the way we decorate our rooms and in the style of our clothing. In all of these ways we manipulate artistic symbols to make statements about what we believe in, what we stand for, and how we want others to see us. The many sites on the Web bombard us with visual clues which attempt to make us stop and find out what is being offered or argued.

The history of art is nothing more than the record of how people have used their minds and imaginations to symbolize who they are and what they value. If a certain age spends enormous amounts of money to build and decorate churches (as in 12th-century France) and another spends the same kind of money on palaces (like 18th-century France), we learn about what each age values the most.

The very complexity of human art makes it difficult to interpret. That difficulty increases when we are looking at art from a much different culture and/or a far different age. We may admire the massiveness of Egyptian architecture, but find it hard to appreciate why such energies were used for the cult of the dead. When confronted with the art of another age (or even our own art, for that matter), a number of questions we can ask of ourselves and of the art may lead us to greater understanding.

For What Was This Piece of Art Made? This is essentially a question of context. Most of the religious paintings in our museums were originally meant to be seen in churches in very specific settings. To imagine them in their original setting helps us to understand that they had a devotional purpose that is lost when they are seen on a museum wall. To ask about the original setting, then, helps us to ask further whether the painting is in fact devotional or meant as a teaching tool or to serve some other purpose.

Setting is crucial. A frescoed wall on a public building is meant to be seen by many people, while a fresco on the wall of an aristocratic home is meant for a much smaller, more elite class of viewer. The calligraphy decorating an Islamic mosque tells us much about the importance of the sacred writings of Islam. A sculpture designed for a wall niche is going to have a shape different from one designed to be seen by walking around it. Similarly, art made under official sponsorship of an authoritarian government must be read in a far different manner than art produced by underground artists who have no standing with the government. Finally, art may be purely decorative or it may have a didactic purpose, but (and here is a paradox) purely decorative art may teach us while didactic art may end up being purely decorative.

What, If Anything, Does This Piece of Art Hope to Communicate? This question is one of intellectual or emotional context. Funeral sculpture may reflect the grief of the survivors, or a desire to commemorate the achievements of the deceased, or to affirm what the survivors believe about life after death, or a combination of these purposes. If we think of art as a variety of speech we can then inquire of any artwork: What is it saying?

An artist may strive for an ideal ("I want to paint the most beautiful woman in the world," or "I wish my painting to be taken for reality itself," or "I wish to move people to love or hate or sorrow by my sculpture") or to illustrate the power of an idea or (as in the case with most primitive art) to "capture" the power of the spirit world for religious and/or magical purposes.

An artist may well produce a work simply to demonstrate inventiveness or to expand the boundaries of what art means. The story is told of Pablo Picasso's reply to a

woman who said that her ten-year-old child could paint better than he. Picasso replied, "Congratulations, Madame. Your child is a genius." We know that before he was a teenager Picasso could draw and paint with photographic accuracy. He said that during his long life he tried to learn how to paint with the fresh eye and spontaneous simplicity of a child.

How Was This Piece of Art Made? This question inquires into both the materials and the skills the artist employs to turn materials into art. Throughout this book we will speak of different artistic techniques, like bronze casting or etching or panel painting; here we make a more general point. To learn to appreciate the craft of the artist is a first step toward enjoying art for its worth as art—to developing an "eye" for art. This requires looking at the object as a crafted object. Thus, for example, a close examination of Michelangelo's Pietà shows the pure smooth beauty of marble, while his Slaves demonstrates the roughness of stone and the sculptor's effort to carve meaning from hard material. We might stand back to admire a painting as a whole, but then to look closely at one portion of it teaches us the subtle manipulation of color and line that creates the overall effect.

What Is the Composition of This Artwork? This question addresses how the artist "composes" the work. Much Renaissance painting uses a pyramidal construction so that the most important figure is at the apex of the pyramid and lesser figures form the base. Some paintings presume something happening outside the picture itself (such as an unseen source of light); a cubist painting tries to render simultaneous views of an object. At other times, an artist may enhance the composition by the manipulation of color with a movement from light to dark or a stark contrast between dark and light, as in the chiaroscuro of Baroque painting. In all of these cases the artists intend to do something more than merely "depict" a scene; they appeal to our imaginative and intellectual powers as we enter into the picture or engage the sculpture or look at their film.

Composition, obviously, is not restricted to painting. Filmmakers compose with close-ups or tracking shots just as sculptors carve for frontal or side views of an object. Since all of these techniques are designed to make us see in a particular manner, only by thinking about composition do we begin to reflect on what the artist has done. If we do not think about composition, we tend to take an artwork at "face value" and, as a consequence, are not training our "eye." Much contemporary imaging is done by the power of mixing done on the computer.

What Elements Should We Notice about a Work of Art? The answer to this question is a summary of what we have stated above. Without pretending to exclusivity, we should judge art on the basis of the following three aspects:

Formal elements. What kind of artwork is it? What materials are employed? What is its composition in terms of

structure? In terms of pure form, how does this particular work look when compared to a similar work of the same or another artist?

Symbolic elements. What is this artwork attempting to "say"? Is its purpose didactic, propagandistic, to give pleasure, or what? How well do the formal elements contribute to the symbolic statement being attempted in the work of art?

Social elements. What is the context of this work of art? Who is paying for it and why? Whose purposes does it serve? At this level, many different philosophies come into play. A Marxist critic might judge a work in terms of its sense of class or economic aspects, while a feminist might inquire whether it affirms women or acts as an agent of subjugation and/or exploitation.

It is possible to restrict oneself to formal criticism of an artwork (Is this well done in terms of craft and composition?), but such an approach does not do full justice to what the artist is trying to do. Conversely, to judge every work purely in terms of social theory excludes the notion of an artistic work and, as a consequence, reduces art to politics or philosophy. For a fuller appreciation of art, then, all of the elements mentioned above need to come into play.

How to Listen to Music

The sections of this book devoted to music are designed for readers who have no special training in musical theory and practice. Response to significant works of music, after all, should require no more specialized knowledge than the ability to respond to *Oedipus Rex*, say, or a Byzantine mosaic. Indeed, many millions of people buy recorded music in one form or another, or enjoy listening to it on the radio without the slightest knowledge of how the music is constructed or performed.

The gap between the simple pleasure of the listener and the complex skills of composer and performer often prevents the development of a more serious grasp of music history and its relation to the other arts. The aim of this section is to help bridge that gap without trying to provide too much technical information. After a brief survey of music's role in Western culture, we shall look at the "language" used to discuss musical works—both specific terminology, such as *sharp* and *flat*, and more general concepts, such as line and color.

Music in Western Culture

The origins of music are unknown, and neither the excavations of ancient instruments and depictions of performers nor the evidence from modern primitive societies gives any impression of its early stages. Presumably, like the early cave paintings, music served some kind of magical or ritual purpose. This is borne out

by the fact that music still forms a vital part of most religious ceremonies today, from the hymns sung in Christian churches or the solo singing of the cantor in an Orthodox Jewish synagogue to the elaborate musical rituals performed in Buddhist or Shinto temples in Japan. The Old Testament makes many references to the power of music, most notably in the famous story of the battle of Jericho, and it is clear that by historical times music played an important role in Jewish life, both sacred and secular.

By the time of the Greeks, the first major Western culture to develop, music had become as much a science as an art. It retained its importance for religious rituals; in fact, according to Greek mythology the gods themselves invented it. At the same time the theoretical relationships between the various musical pitches attracted the attention of philosophers such as Pythagoras (c. 550 B.C.), who described the underlying unity of the universe as the "harmony of the spheres." Later 4th-century-B.C. thinkers like Plato and Aristotle emphasized music's power to affect human feeling and behavior. Thus for the Greeks, music represented a religious, intellectual, and moral force. Once again, music is still used in our own world to affect people's feelings, whether it be the stirring sound of a march, a solemn funeral dirge, or the eroticism of much modern "pop" music (of which Plato would thoroughly have disapproved).

Virtually all of the music—and art, for that matter to have survived from the Middle Ages is religious. Popular secular music certainly existed, but since no real system of notation was invented before the 11th century, it has disappeared without a trace. The ceremonies of both the Western and the Eastern (Byzantine) church centered around the chanting of a single musical line, a kind of music that is called monophonic (from the Greek "single voice"). Around the time musical notation was devised, composers began to become interested in the possibilities of notes sounding simultaneously-what we would think of as harmony. Music involving several separate lines sounding together (as in a modern string quartet or a jazz group) became popular only in the 14th century. This gradual introduction of polyphony ("many voices") is perhaps the single most important development in the history of music, since composers began to think not only horizontally (that is, melodically), but also vertically, or harmonically. In the process the possibilities of musical expression were immeasurably enriched.

The Experience of Listening

"What music expresses is eternal, infinite, and ideal. It does *not* express the passion, love, or longing of this or that individual in this or that situation, but passion, love, or longing in itself; and this it presents in that unlimited variety of motivations which is the exclusive and particular characteristic of music, foreign and inexpressible in

any other language" (Richard Wagner). With these words, one of the greatest of all composers described the power of music to express universal emotions. Yet for those unaccustomed to serious listening, it is precisely this breadth of experience with which it is difficult to identify. We can understand a joyful or tragic situation. Joy and tragedy themselves, though, are more difficult to comprehend.

There are a number of ways by which the experience of listening can become more rewarding and more enjoyable. Not all of them will work for everyone, but over the course of time they have proved helpful for many newcomers to the satisfactions of music.

1. *Before listening* to the piece you have selected, ask yourself some questions:

What is the historical context of the music? For whom was it composed—for a general or for an elite audience?

Did the composer have a specific assignment? If the work was intended for performance in church, for example, it should sound very different from a set of dances. Sometimes the location of the performance affected the sound of the music: composers of masses to be sung in Gothic cathedrals used the buildings' acoustical properties to emphasize the resonant qualities of their works.

With what forces was the music to be performed? Do they correspond to those intended by the composer? Performers of medieval music, in particular, often have to reconstruct much that is missing or uncertain. Even in the case of later traditions, the original sounds can sometimes be only approximated. The superstars of the 18thcentury world of opera were the castrati, male singers who had been castrated in their youth and whose soprano voices had therefore never broken; contemporaries described the sounds they produced as incomparably brilliant and flexible. The custom, which seems to us so barbaric, was abandoned in the 19th century, and even the most fanatic musicologist must settle for a substitute today. The case is an extreme one, but it points to the moral that even with the best of intentions, modern performers cannot always reproduce the original sounds.

Does the work have a text? If so, read it through before you listen to the music; it is easiest to concentrate on one thing at a time. In the case of a translation, does the version you are using capture the spirit of the original? Translators sometimes take a simple, popular lyric and make it sound archaic and obscure in order to convey the sense of "old" music. If the words do not make much sense to you, they would probably seem equally incomprehensible to the composer. Music, of all the arts, is concerned with direct communication.

Is the piece divided into sections? If so, why? Is their relationship determined by purely musical considerations—the structure of the piece—or by external factors, the words of a song, for example, or the parts of a Mass?

Finally, given all the above, what do you expect the music to sound like? Your preliminary thinking should have prepared you for the kind of musical experience in store for you. If it has not, go back and reconsider some of the points above.

2. While you are listening to the music:

Concentrate as completely as you can. It is virtually impossible to gain much from music written in an unfamiliar idiom unless you give it your full attention. Read written information before you begin to listen, as you ask yourself the questions above, not *while* the music is playing. If there is a text, keep an eye on it but do not let it distract you from the music.

Concentrating is not always easy, particularly if you are mainly used to listening to music as a background, but there are some ways in which you can help your own concentration. To avoid visual distraction, fix your eyes on some detail near you—a mark on the wall, a design in someone's dress, the cover of a book. At first this will seem artificial, but after a while your attention should be taken by the music. If you feel your concentration fading, do *not* pick up a magazine or gaze around; consciously force your attention back to the music and try to analyze what you are hearing. Does it correspond to your expectations? How is the composer trying to achieve an effect? By variety of instrumental color? Are any of the ideas, or tunes, repeated?

Unlike literature or the visual arts, music occurs in the dimension of time. When you are reading, you can turn backward to check a reference or remind yourself of a character's identity. In looking at a painting, you can move from a detail to an overall view as often as you want. In music, the speed of your attention is controlled by the composer. Once you lose the thread of the discourse, you cannot regain it by going back; you must try to pick up again and follow the music as it continues—and that requires your renewed attention.

On the other hand, in these times of easy access to recordings, the same pieces can be listened to repeatedly. Even the most experienced musicians cannot grasp some works fully without several hearings. Indeed, one of the features that distinguishes "art" music from more "popular" works is its capacity to yield increasing rewards. On a first hearing, therefore, try to grasp the general mood and structure and note features to listen for the next time you hear the piece. Do not be discouraged if the idiom seems strange or remote, and be prepared to become familiar with a few works from each period you are studying.

As you become accustomed to serious listening, you will notice certain patterns used by composers to give form to their works. They vary according to the styles of the day, and throughout this book there are descriptions of each period's musical characteristics. In responding to the general feeling the music expresses, therefore, you should try to note the specific features that identify the time of its composition.

After you have heard the piece, ask yourself these questions:

Which characteristics of the music indicated the period of its composition? Were they due to the forces employed (voices and/or instruments)?

How was the piece constructed? Did the composer make use of repetition? Was there a change of mood and, if so, did the original mood return at the end?

What kind of melody was used? Was it continuous or did it divide into a series of shorter phrases?

If a text was involved, how did the music relate to the words? Were they audible? Did the composer intend them to be? If not, why not?

Were there aspects of the music that reminded you of the literature and visual arts of the same period? In what kind of buildings can you imagine it being performed? What does the music tell you about the society for which it was written?

Finally, ask yourself the most difficult question of all: What did the music express? Richard Wagner described the meaning of music as "foreign and inexpressible in any other language." There is no dictionary of musical meaning, and listeners must interpret for themselves what they hear. We all understand the general significance of words like *contentment* or *despair*, but music can distinguish between a million shades of each.

Concepts in Music

There is a natural tendency in talking about the arts to use terms from one art form in describing another. Thus most people would know what to expect from a "colorful" story or a painting in "quiet" shades of blue. This metaphorical use of language helps describe characteristics that are otherwise often very difficult to isolate, but some care is required to remain within the general bounds of comprehension.

Line. In music, line generally means the progression in time of a series of notes: the melody. A melody in music is a succession of tones related to one another to form a complete musical thought. Melodies vary in length and in shape and may be made up of several smaller parts. They may move quickly or slowly, smoothly or with strongly accented (stressed) notes. Some melodies are carefully balanced and proportional, others are irregular and asymmetrical. A melodic line dictates the basic character of a piece of music, just as lines do in a painting or the plot line does for a story or play.

Texture. The degree to which a piece of music has a thick or thin *texture* depends on the number of voices and/or instruments involved. Thus the monophonic music of the Middle Ages, with its single voice, has the thinnest texture possible. At the opposite extreme is a 19th-century opera, where half a dozen soloists, chorus, and a large orchestra were sometimes combined. Needless to say, thickness and thinness of texture are neither

good nor bad in themselves, merely simple terms of description.

Composers control the shifting texture of their works in several ways. The number of lines heard simultaneously can be increased or reduced—a full orchestral climax followed by a single flute, for example. The most important factor in the texture of the sound, however, is the number of combined independent melodic lines; this playing (or singing) together of two or more separate melodies is called *counterpoint*. Another factor influencing musical texture is the vertical arrangement of the notes: six notes played close together low in the scale will sound thicker than six notes more widely distributed.

Color. The color, or timbre, of a piece of music is determined by the instruments or voices employed. Gregorian chant is monochrome, having only one line. The modern symphony orchestra has a vast range to draw upon, from the bright sound of the oboe or the trumpet to the dark, mellow sound of the cello or French horn. Different instruments used in Japanese or Chinese music will result in a quite distinct but very different timbre. Some composers have been more interested than others in exploiting the range of color instrumental combinations can produce; not surprisingly, Romantic music provides some of the most colorful examples.

Medium. The *medium* is the method of performance. Pieces can be written for solo piano, string quartet, symphony orchestra, or any other combination the composer chooses. A prime factor will be the importance of color in the work. Another is the length and seriousness of the musical material. It is difficult, although not impossible, for a piece written for solo violin to sustain the listener's interest for half an hour. Still another is the practicality of performance. Pieces using large or unusual combinations of instruments stand less chance of being frequently programmed. In the 19th century composers often chose a medium that allowed performance in the home, thus creating a vast piano literature.

Form. Form is the outward, visible (or hearable) shape of a work as opposed to its substance (medium) or color. This structure can be created in a number of ways. Baroque composers worked according to the principle of unity in variety. In most Baroque movements the principal melodic idea continually recurs in the music, and the general texture remains consistent. The formal basis of much classical music is contrast, where two or more melodies of differing character (hard and soft, or brilliant and sentimental) are first laid out separately, then developed and combined, then separated again. The Romantics often pushed the notion of contrasts to extremes, although retaining the basic motions of classical form. Certain types of work dictate their own form. A composer writing a requiem mass is clearly less free to experiment with formal variation than one writing a piece for symphony orchestra. The words of a song strongly suggest the structure of the music, even if they do not impose it. Indeed, so pronounced was the Baroque sense of unity that the sung arias in Baroque operas inevitably conclude with a repetition of the words and music of the beginning, even if the character's mood or emotion has changed.

Thus music, like the other arts, involves the general concepts described above. A firm grasp of them is essential to an understanding of how the various arts have changed and developed over the centuries and how the changes are reflected in similarities—or differences—between art forms. The concept of the humanities implies that the arts did not grow and change in isolation from one another or from around the world. As this book shows, they are integrated both among themselves and with the general developments of Western thought and history.

HOW TO READ LITERATURE

"Reading literature" conjures up visions of someone sitting in an armchair with glasses on and nose buried in a thick volume—say, Tolstoy's *War and Peace*. The plain truth is that a fair amount of the literature found in this book was never meant to be read that way at all. Once that fact is recognized, reading becomes an exercise in which different methods can serve as a great aid for both pleasure and understanding. That becomes clear when we consider various literary forms and ask ourselves how their authors originally meant them to be encountered. Let us consider some of the forms that will be studied in this volume to make the point more specifically:

Dramatic Literature. This is the most obvious genre of literature that calls for something more than reading the text quietly. Plays—ancient, medieval, Elizabethean, or modern—are meant to be acted, with living voices interpreting what the playwright wrote in the script. What seems to be strange and stilted language as we first encounter Shakespeare becomes powerful and beautiful when we hear his words spoken by someone who knows and loves language.

A further point: Until relatively recent times most dramas were played on stages nearly bare of scenery and, obviously, extremely limited in terms of lighting, theatrical devices, and the like. As a consequence, earlier texts contain a great deal of description that in the modern theater (and, even more, in a film) can be supplied by current technology. Where Shakespeare has a character say "But look, the morn in russet mangle clad/Walks o'er the dew of yon high eastward hill," a modern writer might simply instruct the lighting manager to make the sun come up.

Dramatic literature must be approached with a sense of its oral aspect as well as an awareness that the language reflects the intention of the author to have the words acted out. Dramatic language is meant to be *heard* and *seen*

Epic. Like drama, epics have a strong oral background. It is commonplace to note that before Homer's Iliad took its present form, it was memorized and recited by a professional class of bards. Similarly, the Song of Roland was probably heard by many people and read by relatively few in the formative decades of its composition. Even epics that are more consciously literary echo the oral background of the epic; Vergil begins his elegant Aeneid with the words "Arms and the man I sing" not "Of Arms and the man I write." The Islamic scriptures—the Koran—is most effectively recited.

The practical conclusion to be drawn from this is that these long poetic tales take on a greater power when they are read aloud with sensitivity to their cadence.

Poetry. Under this general heading we have a very complicated subject. To approach poetry with intelligence, we need to inquire about the kind of poetry with which we are dealing. The lyrics of songs are poems, but they are better heard sung than read in a book. On the other hand, certain kinds of poems are so arranged on a page that not to see them in print is to miss a good deal of their power or charm. Furthermore, some poems are meant for the individual reader, while others are public pieces meant for the group. There is, for example, a vast difference between a love sonnet and a biblical psalm. Both are examples of poetry, but the former expresses a private emotion while the latter most likely gets its full energy from use in worship: we can imagine a congregation singing a psalm, but not the same congregation reciting one of Petrarch's sonnets to Laura.

In poetry, then, context is all. Our appreciation of a poem is enhanced once we have discovered where the poem belongs: with music? on a page? with an aristocratic circle of intellectuals? as part of a national or ethnic or religious heritage? as propaganda or protest or to express deep emotions?

At base, however, poetry is the refined use of language. The poet is the maker of words. Our greatest appreciation of a poem comes when we say to ourselves that this could not be said better. An authentic poem cannot be edited or paraphrased or glossed. Poetic language, even in long poems, is economical. One can understand that by simple experiment: take one of Dante's portraits in the *Divine Comedy* and try to do a better job of description in fewer words. The genius of Dante (or Chaucer in the *Prologue* to *The Canterbury Tales*) is his ability to sketch out a fully formed person in a few stanzas.

Prose. God created humans, the writer Elie Wiesel once remarked, because he loves a good story. Narrative is as old as human history. The stories that stand behind the *Decameron* and *The Canterbury Tales* have been shown to have existed not only for centuries, but in widely different cultural milieus. Stories are told to draw out moral examples or to instruct or warn, but, by and large, stories are told because we enjoy hearing them. We read novels in order to enter into a new world and suspend the workaday world we live in, just as we watch films for the same purpose. The difference between a story and a film is that one can linger over a story, but in a film there is no "second look."

Some prose obviously is not fictional. It can be autobiographical like Augustine's *Confessions* or it may be a philosophical essay like Jean-Paul Sartre's attempt to explain what he means by existentialism. How do we approach that kind of writing? First, with a willingness to listen to what is being said. Second, with a readiness to judge: Does this passage ring true? What objections might I make to it? and so on. Third, with an openness that says, in effect, there is something to be learned here.

A final point has to do with attitude. We live in an age in which much of what we know comes to us in very brief "sound bites" via television, and much of what we read comes to us in the disposable form of newspapers and magazines and inexpensive paperbacks. To readreally to read—requires that we discipline ourselves to cultivate a more leisurely approach to that art. There is merit in speed-reading the morning sports page; there is no merit in doing the same with a poem or a short story. It may take time to learn to slow down and read at a leisurely pace (leisure is the basis of culture, says Aristotle), but if we learn to do so we have taught ourselves a skill that will enrich us throughout our lives. A good thought exercise is to ask whether reading from a computer screen is a different exercise than reading from a book.

CULTURE AND VALUES

A Survey of the Humanities

ALTERNATE VOLUME FIFTH EDITION

PREHISTORY

MESOPOTAMIA

2,000,000 B.C.

PALEOLITHIC PERIOD (OLD STONE AGE)

c. 100,000 First ritual burying of dead

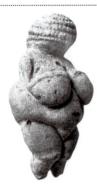

- c. 28,000 23,000 Venus of Willendorf; worship of female creative power
- c. 15,000 10,000 Cave art at Lascaux and Altamira

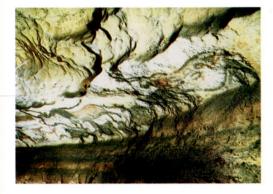

Hunting predominates

Stone weapons

Domestication of animals; cultivation of food

Villages formed

First wars

c. 5000 Beginnings of civilization; pottery

First large-scale architecture; bronze tools

NEOLITHIC PERIOD 3500-2350 Sumerian Period: Development of pictographic writing; construction of first ziggurats; cult of mother goddess

c. 3000 Lady of Warka

c. 2700 Reign of Gilgamesh

c. 2600-2400 Ram in a Thicket, from Royal Cemetery at Ur

2350-2150 Akkadian Period: Rule of Sargon and descendants; ended by invasion of Gutians from Iran

c. 2200 *Head of an Akkadian Ruler,* probably Sargon; Victory Stele of Naram-Sin

2150-1900 Neo-Sumerian Period

2100-2000 Construction of ziggurat at Ur

c. 2100 Gudea, governor of Lagash

c. 2000 Earliest version of The Epic of Gilgamesh

1900-1600 Babylonian Period

1792-1750 The Law Code of Hammurabi

c. 1780 Stele of Hammurabi

1600-1150 Kassite Period

1150-612 Assyrian Period

883-859 Reign of Assurnasirpal II; palace at Nimrud

668-626 Reign of Assurbanipal; palace at Nineveh

612 Fall of Nineveh

559–529 Reign of Cyrus the Great; expansion of Persian Empire

NEOLITHIC PERIOD (LATE STONE AGE)

8000

3000

Most dates are approximate

8000

B.C.

3000

BRONZE AGE

1000

IRON AGE

600

CHAPTER 1 THE BEGINNINGS OF CIVILIZATION

EGYPT

AEGEAN WORLD

3200-2700 Predynastic Period

c. 3100 Development of hieroglyphic writing

c. 6000 Introduction of new agricultural techniques from the East

c. 2650 Imhotep constructs first pyramid for King Zoser at Saqqara

2650-2514 Great Pyramids and Sphinx built at Giza

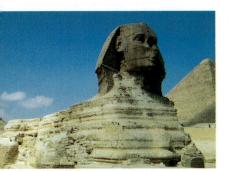

c. 2470 *Seated Scribe,* from Saqqara

2250-1990 First Intermediate Period

1990–1790 Middle Kingdom: art reflects new uncertainty

c. 1900 "Song of the Harper"

c. 1878–1841 Reign of Sesostris III; Portrait: *Sesostris III*

1790-1570 Second Intermediate Period

1570-1185 New Kingdom

c. 1370 Portrait: Nefertiti; Akhenaton, "Hymn to Aton"

1361 – 1352 Reign of Tutankhamen; return to conservatism

1298–1232 Reign of Ramses II; colossal buildings constructed at Luxor, Karnak, Abu Simbel

1185-500 Late Period: Egypt's power declines; artists revert to Old Kingdom styles

671 – 663 Assyrian occupation of Egypt

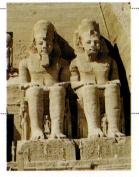

2800–2000 Early Minoan Period on Crete; growth of Cycladic culture

c. 2500 Cycladic idol

c. 1700 Knossos Palace destroyed by earthquake and rebuilt on grander scale; Wasp Pendant, from Mallia

1600 - 1400 Late Minoan Period on Crete

c. 1600 First Mycenaean palace constructed; Royal Grave Circle at Mycenae

c. 1600 Snake Goddess, from Knossos

c. 1550 Gold death mask, from Mycenae

1500 Frescoes from House Delta, Thera

1400 Fall of Knossos and decline of Minoan civilization

I400 – I 200 Mycenaean empire flourishes

1250 Mycenaean war against Troy

1100 Final collapse of Mycenaean power

1100-1000 Dark Age

1000-750 Heroic Age

c. 900 - 700 Evolution of Homeric epics Iliad and Odyssey

750-600 Age of Colonization

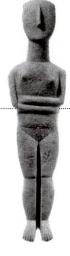

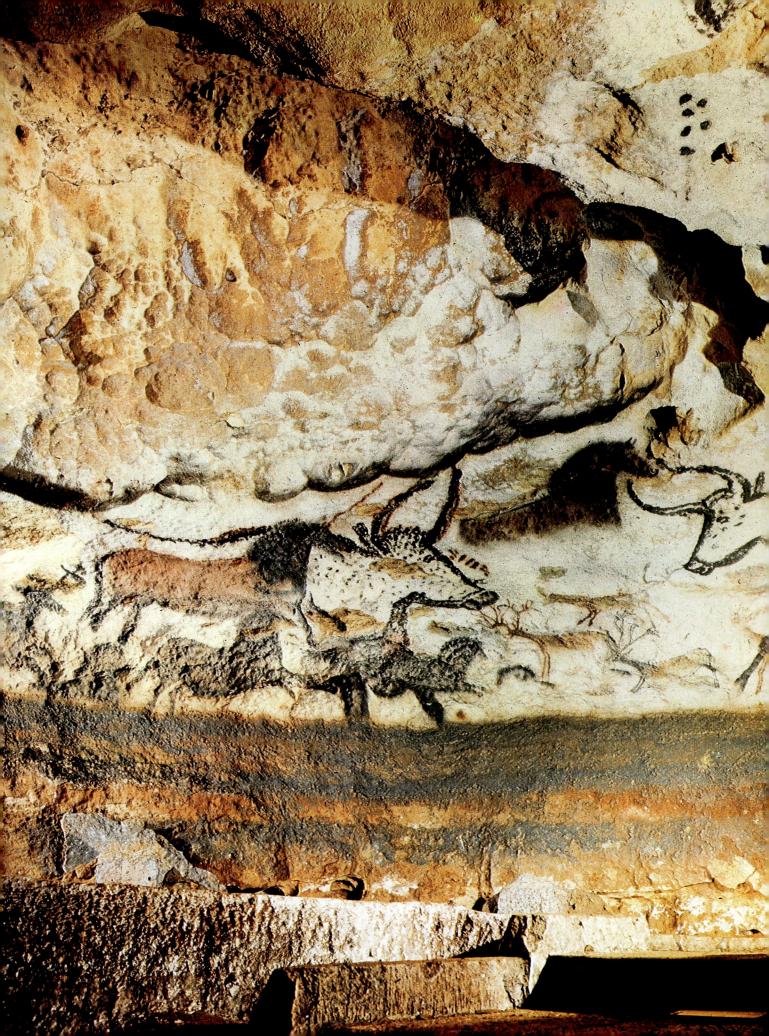

CHAPTER 1

THE BEGINNINGS OF CIVILIZATION

round 5000 B.C. humans began to lay the bases for the growth of civilization. After millennia of hunting and gathering, the development of agriculture made possible for the first time the formation of settled communities. Civilization is so broad a term that it is not easy to define simply. Nonetheless, societies which qualify for the label "civilized" generally possess at least the majority, if not all, of the following characteristics:

- 1. some form of urban life involving the construction of permanent settlements—cities, in short;
- a system of government which regulates political relations;
- the development of distinct social classes, distinguished from one another by two related factors, wealth and occupation;
- 4. tools and specialized skills for the production of goods, leading to the rise of manufacturing and trade;
- 5. some form of written communication, making it possible to share and preserve information; and
- a shared system of religious belief, whose officials or priests often play a significant role in community affairs.

It is important to realize, at the beginning of our survey of Western civilization, that the term "civilized," when used in this anthropological sense, implies no value judgment as to the merits of a particular society. So-called "primitive" peoples are capable of producing valuable and lasting works of art, and of living full and satisfying lives, while, as the twentieth century demonstrated, some of the most "civilized" societies in history can be responsible for causing indescribable human suffering. Furthermore, at that century's end, advanced industrial civilization seemed increasingly in danger of destroying the environment, and making the world uninhabitable for any form of life, human or animal. The pages that follow chronicle the high achievements of Western civilization, but the grim background against which many of these appeared should never be forgotten. As the eighteenth-century philosopher Giambattista Vico observed, "advanced" civilizations can be barbaric in ways far more terrible than preliterate peoples.

The basic advances that made possible the growth of Western civilization were first achieved by the earlier civilizations of the ancient Middle East. These ancient peoples were the first who systematically produced food, mined and processed metals, organized themselves into cities, and devised legal and moral codes of behavior, together with systems of government and religion. In all these areas they had a profound influence on later peoples. At the same time they produced a major artistic tradition which, quite apart from its high intrinsic interest, was to have a number of effects on the development of Western art.

To discover the origins of Western civilization, we must therefore look at cultures that at first seem remote in both time and place. Yet these peoples produced the achievements described in this chapter—achievements that form the background to the history of our own culture.

THE EARLIEST PEOPLE AND THEIR ART

Even the earliest civilizations appeared relatively late in human history, at the beginning of the period known as the Neolithic or Late Stone Age (c. 8000 B.C.). The process of human evolution is long and confusing, and many aspects of it remain uncertain. The earliest form of hominid, Ramapithecus, is known from fossil fragments dating from eight to eleven million years ago, but our first direct ancestors, homo erectus, probably appeared between a million and half a million years ago in the Paleolithic period or Old Stone Age. For most of the succeeding millennia, people were dominated by the physical forces of geography and climate, able to keep themselves alive only by a persistent search for food and shelter. Those who chose the wrong places or the wrong methods did not survive, whereas others were preserved by their instincts or good fortune.

Primitive conditions hardly encouraged the growth of civilization, yet there is some evidence of a kind of intellectual development. Archaeological evidence has shown that about one hundred thousand years ago the ancestors of Homo sapiens belonging to the type known as Neanderthal people were the first to bury their dead carefully and place funerary offerings in the graves—the earliest indication of the existence of religious beliefs.

Toward the end of the Paleolithic period, around 15,000 B.C., there was a major breakthrough. The human desire for self-expression resulted in the invention of visual art. The cave paintings of Lascaux and Altamira and statuettes like the Venus of Willendorf are among the earliest products of the human creative urge. Although the art of this remote age would be valuable for its historical significance alone, many of the paintings and statues stand as masterpieces in their own right.

The lines are concentrated but immensely expressive. In some cases, artists used the surface on which they were painting to create an added sense of realism: a bulge on a cave wall suggested the hump of a bull [1.1]. The combination of naturalistic observation and abstraction can only be described as sophisticated, and since their discovery in the twentieth century the paintings have served as a powerful inspiration to modern eyes.

The choice of subjects tells us something about the worldview of Paleolithic people. The earliest cave paintings show animals and hunting, which played a vital part in providing food and clothing. More significant, perhaps, is the fact that all the oldest known statuettes of human figures represent women, who are shown with their sexual characteristics emphasized or enlarged [1.2]. The Paleolithic world perhaps viewed woman's practical role—the source of birth and life—as symbolic of a more profound feminine force that underlay the masculine world of the hunt. Worship of female creative power was also to play an important part in the religion of the ancient Middle East and of Bronze Age Greece. Even though the Greeks of a later period emphasized other aspects of human power, reverence for a mother goddess—or Earth Mother—was to live on.

The Neolithic period (c. 8000 B.C.) represents in all aspects a major break with the past. After a million years of hunting, ways to domesticate animals and cultivate food were discovered. People began to gather together in villages where they could lead a settled existence. The development of improved farming techniques made it possible for a community to accumulate stores of grain and thereby become less dependent for their survival on a good harvest each year. But these stores provided a motive for raids by neighboring communities. Thus war, for the first time in human history, became profitable.

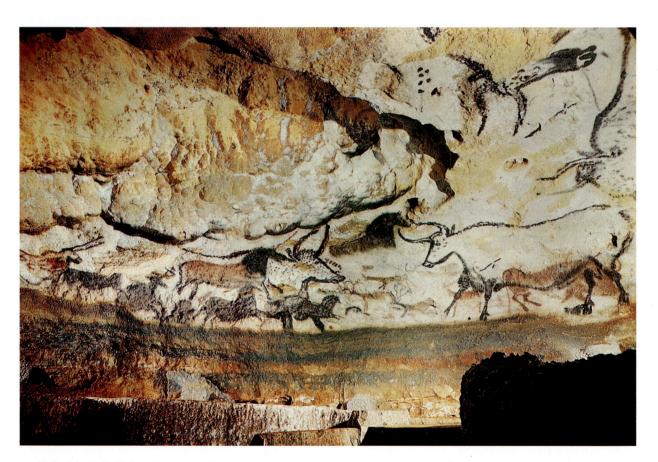

1.1 Hall of the Bulls (left wall), Lascaux (Dordogne), France, c. 15,000–13,000 B.C. Largest bull approx. 11'6" long. Paintings like these were not intended to be decorations, since they are not in the inhabited parts of the caves, but in the dark inner recesses. They probably had magical significance for their creators, who may have believed that gaining control of an animal in a painting would help to defeat it in the hunt.

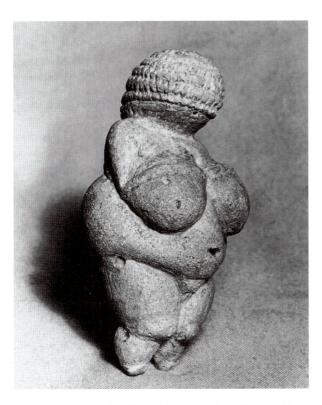

1.2 Venus of Willendorf (Austria), c. 28,000–23,000 B.C. Limestone, approx. $4^{1}/_{4}^{n}$ (11 cm) high. Naturhistorisches Museum, Vienna. This tiny statuette is one of a series of female figurines from the Upper Paleolithic period that are known as Venus figures. The statuette, which has no facial features, is evidently a fertility symbol.

Other more constructive changes followed at a rapid pace. Pottery was invented around 5000 B.C. and not long afterward metal began to replace stone as the principal material for tools and weapons. The first metal used was copper, but it was soon discovered that an alloy of copper and tin would produce a far stronger metal: bronze. The use of bronze became widespread, giving its name to the Bronze Age, which lasted from around 3000 B.C. to the introduction of iron around 1000 B.C.

At the beginning of the Bronze Age, large-scale architecture began to appear. The fortified settlements that had been established in Egypt and Mesopotamia were now able to develop those aspects of existence that entitle them to be called the first true civilizations.

http://touregypt.net/egyptantiquities/

Search this site. . . .

Egypt and Mesopotamia have much in common. Their climates are similar and both are dominated by great rivers, Egypt by the Nile and Mesopotamia by the Tigris and Euphrates (see map). Yet each was to develop its own distinct culture and make its own contribution to the history of civilization. Mesopotamia is discussed first in the following account, but both areas developed over the same general time span.

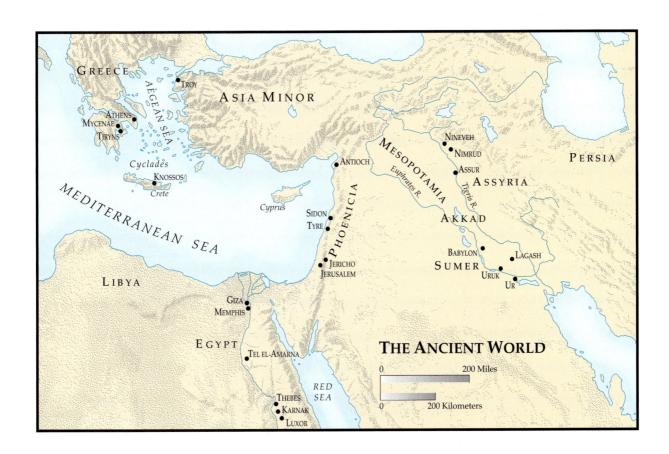

The Cultures of Mesopotamia

The unity so characteristic of ancient Egyptian culture has no parallel in the history of ancient Mesopotamia. A succession of different peoples, each with their own language, religion, and customs, produced a wide variety of achievements. This makes it far more difficult to generalize about Mesopotamian culture than about ancient Egyptian. The picture is further complicated by the presence of a series of related peoples on the periphery of the Mesopotamian territory. The Hittites, the Syrians, and the peoples of early Iran all had periods of prosperity and artistic greatness, although in general they were overshadowed by the more powerful nations of Mesopotamia and Egypt. A description of their achievements would be beyond the scope of this book.

Sumer

The history of Mesopotamia can be divided into two major periods: the Sumerian (c. 3500–2350 B.C.) and the Semitic (c. 2350–612 B.C., when Nineveh fell). The Sumerians and Semitic peoples differed in their racial origins and languages; the term "Semitic" is derived from the name of Shem, one of the sons of Noah, and is generally used to refer to people speaking a Semitic language. In the ancient world, these included the Akkadians, Babylonians, Assyrians, and Phoenicians. The most common association of *Semitic* is with the Jewish people, whose traditional language, Hebrew, falls into the same group; they also originated in the region of Mesopotamia (for a discussion of the early history of the Jews, see Chapter 6). Arabic and certain other Mediterranean languages—including Maltese—are also Semitic.

The earliest Sumerian communities were agricultural settlements on the land between the Tigris and Euphrates rivers, an area known as the Fertile Crescent. Unlike Upper Egypt, the land here is flat; dikes and canals were therefore needed to prevent flooding during the rainy season and to provide water during the rest of the year. When the early settlers found that they had to undertake these large-scale construction projects in order to improve their agriculture, they began to merge their small villages to form towns.

By far the most important event of this stage in the development of Sumerian culture was the invention of the first system of writing, known as cuneiform [1.3]. The earliest form of writing was developed at Uruk (now Warka), one of the first Mesopotamian settlements, around the middle of the fourth millennium B.C. It consisted of a series of simplified picture signs (pictographs) that represented the objects they described and, in addition, related ideas. Thus a leg could mean either a leg itself or the concept of walking. The signs were drawn on soft clay tablets which were then baked hard. These pictorial signs evolved into a series of wedge-shaped marks that were pressed in clay with a split reed. The cunei-

form system (*cuneus* is the Latin word for "wedge") had the advantage of being quick and economical, and the inscribed clay tablets were easy to store. The ability to write made it possible to trade and to keep records on a wider scale, and with the increasing economic strength this more highly organized society brought, a number of powerful cities began to develop.

The central focus of life in these larger communities was the temple, the dwelling place of the particular god who watched over the town. Religion, in fact, played a central part in all aspects of Sumerian culture. The gods themselves were manifest in natural phenomena, sky and earth, sun and moon, lightning and storm. The chief religious holidays were closely linked to the passage of the seasons. The most important annual event was the New Year, the crucial moment when the blazing heat of the previous summer and the cold of winter gave way to the possibility of a fertile spring. The fertility of the earth was symbolized by the Great Mother and the sterility of the winter by the death of her partner, Tammuz. Each year his disappearance was mourned at the beginning of the New Year festival. When his resurrection was celebrated at the end of the festival, hope for the season to come was expressed by the renewal of the sacred marriage of god and goddess.

As in the Paleolithic period, the importance of female creative power is reflected in Sumerian art. Among its finest achievements is the so-called *Lady of Warka* [1.4], a female head from the city of Uruk. It is not clear whether the head is of a divine or mortal figure. The face shows an altogether exceptional nobility and sensitivity.

The governing power in cities like Uruk was in the hands of the priests, who controlled and administered both religious and economic affairs. The ruler himself served as the representative on Earth of the god of the city but, unlike the pharaoh, was never thought of as divine and never became the center of a cult. His purpose was to watch over his people's interests by building better temples and digging more canals rather than acquiring personal wealth or power. Over the centuries, rulers began to detach themselves increasingly from the control of the priests, but the immense prestige of the temples assured the religious leaders a lasting power.

The most famous of all Sumerian rulers was Gilgamesh, who ruled at Uruk about 2700 B.C. Around his name grew up a series of legends that developed into one of the first great masterpieces of poetic expression. The Epic of Gilgamesh begins with the adventures of Gilgamesh and his warrior friend Enkidu. Gilgamesh himself is courted by the queen of heaven, the goddess Ishtar. He rejects her advances and later kills a bull sent against him as a punishment. In revenge, the gods kill Enkidu; his death marks the turning point of the poem's mood. With the awareness of death's reality even for the bravest, Gilgamesh now sets out to seek the meaning of life. Toward the end of his journey he meets Utnapishtim,

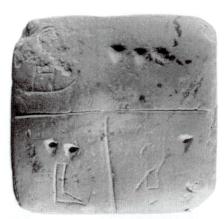

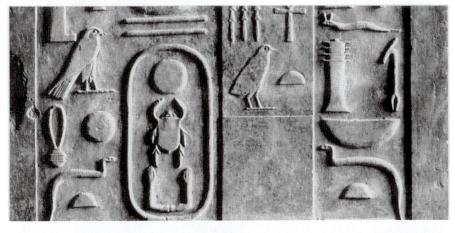

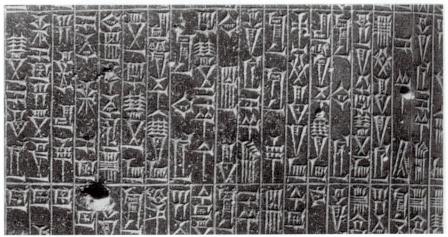

the only person to whom the gods have given everlasting life; from him Gilgamesh seeks the secrets of immortality. Utnapishtim, in the course of their conversation, tells him the story of the flood as it was known in Babylonia. By the end of the epic, Gilgamesh fails to achieve immortality and returns home to die.

Originally composed in Sumerian (c. 2000 B.C.), the epic was eventually written down on clay tablets in their own languages by Babylonians, Hittites, and others. The poem was widely known. The story of the flood, re-

corded in tablet eleven, bears a striking resemblance to that of the biblical story in Genesis; both accounts have parallel accounts of the building of boats, the coming of torrential rain, and the sending out of birds. The tone is very different, however. The God of the Hebrews acts out of moral disapproval, while the divinities in the epic were disturbed in their sleep by noisy mortals. The Epic of Gilgamesh is a profoundly pessimistic work. Unlike the ancient Egyptians, the Mesopotamians saw life as a continual struggle whose only alternative was the bleak

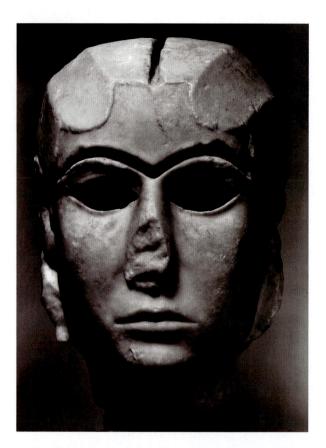

1.4 Female head (Inanna?), from Uruk, c. 3500-3000 B.C. Marble, height $7^7/_8$ " (20 cm). Iraq Museum, Baghdad. Originally, the hair was probably gold leaf and the eyes and eyebrows were colored inlays.

darkness of death. Dying Egyptians, if they were righteous, could expect a happy existence in the next life, but for the Mesopotamian there was only the dim prospect of eternal gloom. The story of Gilgamesh rises to a supreme level in the section that describes the last stages of his journey. Then the epic touches on universal questions: Is all human achievement futile in the face of death? Is there a purpose to human existence? If so, how can it be discovered? The quest of Gilgamesh is the basic human search. Only at the end of Gilgamesh's journey do we sense that the purpose of the journey may have been the journey itself and that what was important was to have asked the questions. Weary as he was on his return he was wiser than when he left, and in leaving us an account of his experiences, "engraved on a stone," he communicates them to us, a dramatic and moving illustration of the power of the written word.

Akkadian and Babylonian Culture

In the years from 2350 to 2150 B.C. the whole of Mesopotamia fell under the control of the Semitic king Sargon and his descendants. The art of this Akkadian period (named for Sargon's capital city, Akkad) shows a contin-

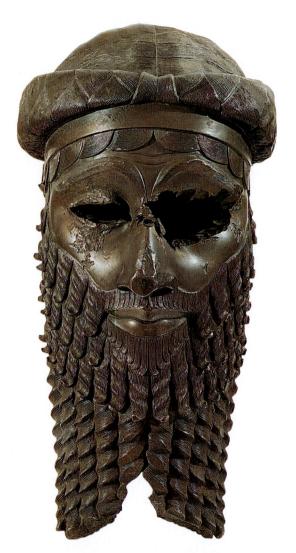

1.5 Head of an Akkadian ruler (King Sargon?), from Nineveh, c. 2200 B.C. Bronze, height $14^{1}/_{4}^{\prime\prime}$ (37 cm). Iraq Museum, Baghdad. Originally, the eyes were probably precious stones.

uation of the trends of the Sumerian Age, although total submission to the gods is replaced by a more positive attitude to human achievement. A bronze head from Nineveh [1.5], perhaps a portrait of Sargon himself, expresses a pride and self-confidence that recur in other works of the period like the famous Stele of Naram-Sin (stele: stone slab), showing a later Akkadian king standing on the bodies of his enemies [1.6].

When Akkadian rule was brought to an abrupt and violent end by the invasion of the Gutians from Iran, the cities of Mesopotamia reverted to earlier ways. As in the early Sumerian period, the chief buildings constructed were large brick platforms with superimposed terraces, known as *ziggurats*. These clearly had religious significance; the one built at Ur around 2100 B.C. [1.7] had huge staircases that led to a shrine at the top. The same return

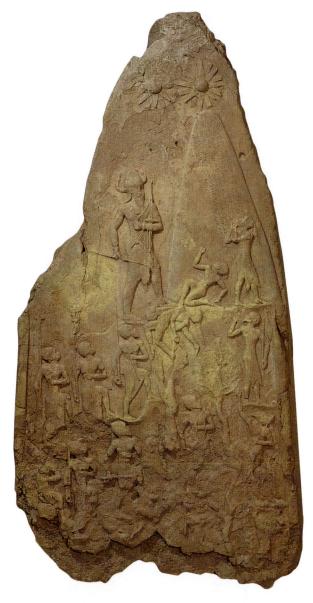

1.6 *Victory Stele of Naram-Sin,* from Susa, Iran, Akkadian c. 2200 B.C. Pink sandstone, approx. 6'7" high. Musée du Louvre, Paris. The king, wearing a horned crown, stands beneath symbols of the gods. The diagonal composition is well suited to the triangular shape of the stele.

to traditional beliefs is illustrated by the religious inscriptions on the bases of the many surviving statues of Gudea, the governor of the city of Lagash around 2100 B.C., as well as by his humble attitude [1.8].

http://www-lib.haifa.ac.il/www/art/ur.html

Ziggurat at Ur

By around 1800 B.C., Mesopotamia had once again been unified, this time under the Babylonians. Their

most famous king, Hammurabi, was the author of a law code that was one of the earliest attempts to achieve social justice by legislation—a major development in the growth of civilization. The laws were carved on a stele, with Hammurabi himself shown at the top in the presence of the sun god Shamash [1.9]. Many of the law code's provisions deal with the relationship between husbands, wives, and other family members, as the following shows.

from The Law Code of Hammurabi

131. If a man accuse his wife and she have not been taken in lying with another man, she shall take an oath in the name of god and she shall return to her house.

142. If a woman hate her husband and say, "Thou shalt not have me," her past shall be inquired into for any deficiency of hers; and if she have been careful and be without past sin and her husband have been going out and greatly belittling her, that woman has no blame. She shall take her dowry and go to her father's house.

145. If a man take a wife and she do not present him with children, and he set his face to take a concubine, that man may take a concubine and bring her into his house. That concubine shall not take precedence of his wife.

162. If a man take a wife and she bear him children and that woman die, her father may not lay claim to her dowry. Her dowry belongs to her children.

The Assyrians

By 1550 B.C. Babylon had been taken over by the Kassites, a formerly nomadic people who had occupied Babylonia and settled there, but they too would fall in turn under the domination of the Assyrians, who evolved the last great culture of ancient Mesopotamia. The peak of Assyrian power was between 1000 and 612 B.C., the time when Greek civilization was developing, as described in Chapter 2. But Assyrian achievements are the culmination of the culture of ancient Mesopotamia.

A huge palace constructed at Nimrud during the reign of Assurnasirpal II (883–859 B.C.) was decorated with an elaborately carved series of relief slabs. The subjects are often religious, but a number of slabs that show the king on hunting expeditions have a vigor and freedom that are unusual in Mesopotamian art. The palaces of later Assyrian kings were decorated with similar reliefs. At Nineveh, the palace of Assurbanipal (668–626 B.C.) was filled with scenes of war appropriate to an age of increasing turmoil. The representations of dead and dying soldiers on the battlefields are generally conventional, if highly elaborate. But again the hunting scenes are different—they show a genuine and moving identification with the suffering animals [1.10].

With the fall of Nineveh in 612 B.C. Assyrian domination ended. The Assyrian Empire fell into the hands of two tribes, first the Medes and then the Persians; the great age of Mesopotamia was over. The Persians, like

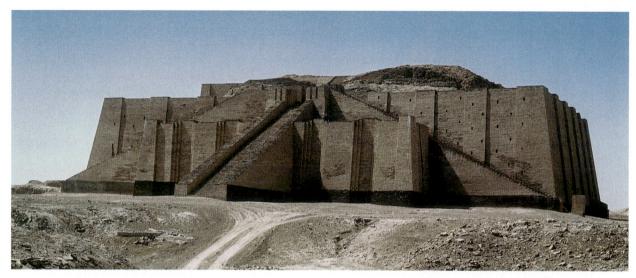

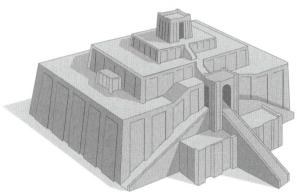

1.7 Ziggurat at Ur, Neo-Sumerian, c. 2100–2000 B.C. Mudbrick faced with baked brick laid in bitumen. This drawing shows the probable original appearance. The photograph shows the *ziggurat* now, partially restored. The Akkadian word *ziggurat* means "pinnacle" or "mountaintop"—a place where the gods were thought to reveal themselves. These plains dwellers made artificial mountains surrounded by shrines.

the Medes whom they subsequently conquered and absorbed, were originally a nomadic warrior people. In the century following their victory over the Assyrians, they continued to expand; by the death of the Persian ruler Cyrus the Great (c. 590–529 B.C.), their empire stretched from the Mediterranean to the Indus River. After an unsuccessful attempt to conquer Greece (see Chapter 2), the Persians were finally themselves conquered by Alexander the Great around 330 B.C.

Lacking the unifying elements provided in Egypt by the pharaoh and a national religion, the peoples of Mesopotamia perhaps never equaled Egyptian achievements in the arts. However, they formed ordered societies within independent city—states that anticipated the city—states of the Greeks. They also evolved a comparatively enlightened view of human relationships, as shown by *The Law Code of Hammurabi*.

Ancient Egypt

One major determinant in the development of ancient Egyptian culture was geography. In total area, ancient Egypt was only a little larger than the state of Maryland. At the delta of the Nile was Lower Egypt, broad and flat, within easy reach of neighboring parts of the Mediterranean. Upper Egypt, more isolated from foreign

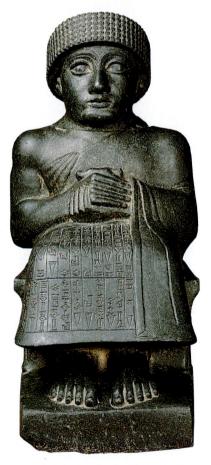

1.8 Seated Statue of Gudea, from Telloh, c. 2100 B.C. Diorite, approx. $17^{1}/_{4}$ " high. The Metropolitan Museum of Art, Harris Brisbane Dick Fund, 1959.

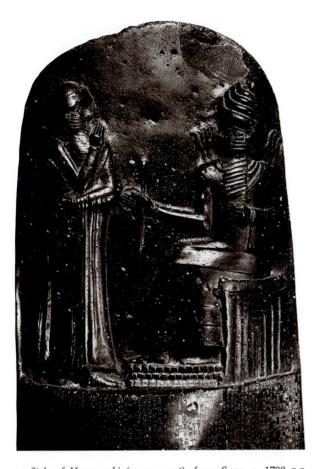

1.9 Stele of Hammurabi (upper part), from Susa, c. 1780 B.C. Basalt, entire stele height 7'3³/₄" (2.25 m) high. Musée du Louvre, Paris. The sun god is dictating the law to the king, who is listening reverently. They are shown on a mountain, indicated by the irregular ridges beneath the god's feet. Below is *The Law Code of Hammurabi*, carved in cuneiform.

contacts, consisted of a long narrow strip of fertile soil, hemmed in by high cliffs and desert, running on either side of the Nile for most of its 1250 miles (2000 kilometers).

Since rainfall was very sparse along the Nile, agriculture depended on the yearly flooding of the river. The immensely long span of Egyptian history was divided into thirty-one dynasties by an Egyptian priest, Manetho, who wrote a *History of Egyptian Greek* around 280 B.C. Modern scholars still follow his system, putting the dynasties into four groups and calling the period that preceded them the Predynastic. The four main divisions, with their approximate dates, are: the Old Kingdom, c. 2700 B.C.; the Middle Kingdom, c. 1990 B.C.; the New Kingdom, c. 1570 B.C.; and the Late Period, c. 1185 B.C. until Egypt was absorbed into the Persian Empire around 500 B.C. The periods were separated from one another by intermediate times of disturbances and confusion.

During the final centuries of the Late Period, Egypt was invaded by the Nubians of the upper Nile, a black people whom the Egyptians called Cush. Overrunning first Upper Egypt in 750 B.C. and then Lower Egypt around 720 B.C., they and their successors, the Nobatae, helped to preserve Egyptian culture through the periods of foreign rule. The role played by these black peoples in the formation of the Western cultural tradition, in particular their influence on the Greeks, has recently become the focus of much scholarly discussion.

Despite its long history, the most striking feature of Egyptian culture is its unity and consistency. Nothing is in stronger contrast to the process of dynamic change

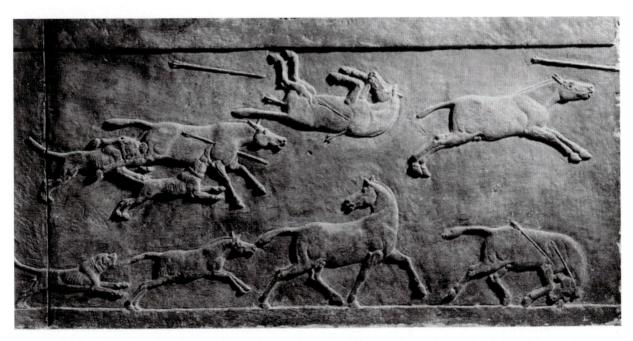

1.10 Detail, relief from the Palace of Assurbanipal at Nineveh, 668–626 B.C. Gypsum slab carved in low relief, height 19" (50 cm). British Museum, London (reproduced by courtesy of the Trustees). Wild asses are being hunted by mastiffs. The mare below turns in her flight to look back for her foal.

initiated by the Greeks and still characteristic of our own culture than the relative absence of change of Egyptian art, religion, language, and political structure over thousands of years. Naturally, even the Egyptians were subject to outside influences, and events at home and abroad affected their worldview. It is possible to trace a mood of increasing pessimism from the vital, life-affirming spirit of the Old Kingdom to the New Kingdom vision of death as an escape from the grim realities of life. Nevertheless, the Egyptians maintained a strong resistance to change. Their art, in particular, remained conservative and rooted in the past.

In a land where regional independence already existed in the natural separation of Upper from Lower Egypt, national unity was maintained by a strong central government firmly controlled by a single ruler, the pharaoh. He was regarded as a living god, the equal of any other deity. He had absolute power, although the execution of his orders depended on a large official bureaucracy whose influence tended to increase in time.

Beneath the pharaoh were the priests, who saw as their responsibility the preservation of traditional religious beliefs. One of the most fundamental of these was the concept of divine kingship involving the pharaoh himself, a belief that reflected the Egyptian view of creation. The first great god of Egyptian religion, the sun god Aton-Ra, had created the world by imposing order on the primeval chaos of the universe; in the same way, the pharaoh ordered and controlled the visible world.

The most striking aspect of Egyptian religious thought, however, is its obsession with immortality and the possibilities of life after death. All Egyptians, not only the ruling class, were offered the hope of survival in the next world as a reward for a good life in a form that was thought of in literal, physical terms. Elaborate funeral rituals at which the dead would be judged and passed as worthy to move on to the afterlife began to develop. The funeral rites, together with their meaning, were described in a series of sacred texts known collectively as the *Book of the Dead*. The god who presided over these ceremonies was Osiris [1.11]. The worship of Osiris, his wife Isis, and their son, the falcon god Horus, which came in time to symbolize a sense of spiritual afterlife, as opposed to simple material survival, represented the mystical side of Egyptian religion. Osiris himself, according to the myth, had been killed and then reborn; he owed his resurrection to the intervention of Isis, the dominant mother goddess of Egyptian religion, protectress of the living and dead. The worship of Isis became one of the most important and durable of Egyptian cults—a temple to her was found among the ruins of Roman Pompeii-while the return to life of Osiris provided a divine parallel to the annual rebirth of the land caused by the flooding Nile.

At the same time the Egyptians worshiped a host of other deities, subdeities, and nature spirits whose names

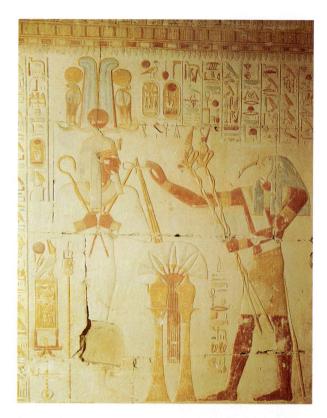

1.11 Painted relief from the funerary temple of Sethos I at Abydos. c. 1300 B.C. Sethos in the guise of the god Osiris, standing at left, is conversing with Thoth, the ibis-headed god of writing.

were often confused and sometimes interchangeable. These gods, responsible for all aspects of existence, inspired mythology and ritual that affected the daily life of every Egyptian. They included Hathor, the goddess of beauty and love, often represented as a cow; Bes, the god of war; and Hapi, the god of the Nile. A number of animals, like the jackal and the cat, also had special sacred significance (Table 1.1).

Traditional Egyptian religion involved, then, a bewildering confusion of figures whose rights and privileges were jealously guarded by their priests. One of the ways to worship them was to give them visible form in works of art—a principal function of Egyptian artists. In addition to producing images of deities, artists were required to provide temples and shrines where they could be honored. Even the buildings that commemorated the names and deeds of real people served religious purposes.

Thus the same central authority that controlled religion affected the development of the arts. The pharaoh's court laid down the standards applied throughout Egypt. Individual artists had little opportunity to exercise their own ingenuity by deviating from them.

The Old and Middle Kingdoms

The huge scale of many Egyptian works of art is at least in part the result of the easy availability of stone, the

TABLE 1.1	Principal	Egyptian	Deities

Aton-Ra	Sun God	Creator of Heaven and Earth
Osiris	King of the	Judge of the Dead
	Underworld	
Isis	Sister and Wife	Mourner of the Dead
	of Osiris	
Horus	Son of Isis and Osiris	God of the Morning
		Sun
Chensu	Moon God	Human-headed with
		crescent moon
Ptah	Father of the Gods	Created humans
Thoth	Ibis (bird) God	The Scribe of the
		Gods
Set	Brother of Osiris	Personification of
		Evil
Anubis	Jackal God	God of the Dead
Hapi	God of the Nile	Fertility God
Hathor	Cow Goddess	Sky Goddess
Seker	Hawk God	God of the Night Sun

most frequently used material from the early Old Kingdom to the Late Period. In Dynasty III, the architect Imhotep used stone to construct the earliest pyramid as a tomb for his master, the pharaoh Zoser. This began the tradition of building massive funerary monuments that would serve to guarantee immortality for their occupants. At the same time, the practice of mummification developed. The body was embalmed to maintain its physical form, since Egyptian religious belief held that preservation of the body was necessary for the survival of the soul. Imhotep himself, the first architect known to history, was in later ages regarded as the epitome of wisdom and was deified.

The great age of the pyramid came in Dynasty IV with the construction of the three colossal pyramids at Giza for the pharaohs Cheops, Chefren, and Mycerinus. In size and abstract simplicity, these structures show Egyptian skill in design and engineering on a massive scale—an achievement probably made possible by slave labor, although some scholars believe that the building of the great monuments was essentially the work of farmers during the off season. In any case, the pyramids and almost all other Egyptian works of art perpetuate the memories of members of the upper classes, and bear witness to a lifestyle which would not have been possible without slaves. We still know little about the slaves or the poor Egyptians who were farm laborers. Many of the slaves were captured prisoners, who were forced to labor in the government quarries and on the estates of the temples. Over time, the descendants of slaves could enlist in the army; as professional soldiers they could take their place in Egyptian society.

http://www.pbs.org/wgbh/nova/pyramid/explore/

The Great Pyramids at Giza

The construction of the pyramids was an elaborate and complex affair. Stone quarried on the spot formed the core of each structure, but the fine limestone blocks originally used for facing, now eroded away, came from across the Nile. These were quarried in the dry season; then when the floods came they were ferried across the river, cut into shape, and dragged into place. At the center of each pyramid was a chamber in which was placed the mummified body of the pharaoh, surrounded by the treasures that were to follow him into the next life. The pharaohs planned these massive constructions as their resting places for eternity and as monuments that would perpetuate their names. Their success was partial. Four and a half thousand years later, their names are remembered—their pyramids, still dominating the flat landscape, symbolize the enduring character of ancient Egypt. As shelters for their occupants and their treasures, however, the pyramids were vulnerable. The very size of the pyramids drew attention to the riches hidden within them, and robbers were quick to tunnel through and plunder them, sometimes only shortly after the burial chamber had been sealed.

Chefren, who commissioned the second of the three pyramids at Giza, was also responsible for perhaps the most famous of all Egyptian images, the colossal Sphinx [1.12], a guardian for his tomb. The aloof tranquility of the human face, perhaps a portrait of the pharaoh, set on a lion's body, made an especially strong impression fifteen hundred years later on the Classical Greeks, who saw it as a divine symbol of the mysterious and enigmatic. Greek art makes frequent use of the sphinx as a motif, and it also appears in Greek mythology, most typically in the story of how Oedipus solved its riddle and thereby saved the Greek city of Thebes from disaster.

http://www.pbs.org/wgbh/nova/pyramid/explore/sphinx.html

The Sphinx at Giza

The appearance of Chefren himself is preserved for us in a number of statues that are typical of Old Kingdom art [1.13]. The sculptor's approach to anatomy and drapery is realistic, and details are shown with great precision. But the features of the pharaoh are idealized; it is a portrait not of an individual but of the concept of divine power, power symbolized by the falcon god Horus perched behind the pharaoh's head. The calmness, even indifference, of the expression is particularly striking.

The art of the Old Kingdom reflects a mood of confidence and certainty that was brought to an abrupt end around 2200 B.C. by a period of violent disturbance.

VALUES

Mortality

The first humans to preserve the bodies of their dead were the Neanderthal people. They buried them in shallow graves, and left offerings with them, suggesting that they envisioned a future life, in which the dead person would use the objects placed with them. Virtually all subsequent cultures either inhumed (buried intact) the bodies of the dead, or cremated them, placing the ashes in a container.

The notion of a life beyond the grave became central to the development of religious systems, although it took a wide variety of different forms. For the Egyptians, death brought judgment, and for those who passed the test survival in the next world. The burial ritual sought to provide the dead person with the means to continue a life which was similar to that of this world. The body was preserved by the process of mummification, and food, servants (in the form of small statuettes known as shawabtis), and other necessities were placed in the tomb.

http://touregypt.net/historicalessays/mummyessay.htm

Mummification

The Mesopotamian view of the world of the dead was far less comforting: a place of gloom and shadows. Nonetheless, the tombs of the illustrious dead contained treasures and, in the Royal Cemetery at Ur, the bodies of scores of human attendants sacrificed to accompany their dead rulers.

For many cultures, the treatment of a corpse was a major factor in the future life of the dead person. To leave a body unburied was regarded by the Greeks as the most terrible of punishments, since the victim could not complete the journey to the next world. In Sophocles' play *Antigone*, the heroine buries the body of her brother even though Creon, the king of Thebes, has decreed that he should be left unburied as punishment for his betrayal of his city.

The range of funeral practices over the past ten thousand years or so is vast, but most at least imply a belief in some form of survival—physical or spiritual—after death.

Divisions between the regions began to strengthen the power of local governors. By the time of the Middle Kingdom, it was no longer possible for pharaoh, priests, or nobles to face the future with complete trust in divine providence. Middle Kingdom art reflects this new uncertainty in two ways: On the one hand, the Old Kingdom came to represent a kind of Golden Age; artists tried to recapture its lofty serenity in their own works. At the same time, the more troubled spirit of the new period is reflected in the massive weight and somber expressions of some of the official portraits. The furrowed brow and grim look of Sesostris III convey the impression that to be a Middle Kingdom pharaoh was hardly a very relaxing occupation [1.14].

The New Kingdom

Despite increasing contacts with foreign cultures, New Kingdom artists continued basically to work within age-old traditions. Like virtually all artists in the ancient world they depicted the idea of what they wanted to show rather than its actual appearance; an eye in a profile carving, for example, would be depicted as if seen from the front. This approach is often called "concep-

tual," as opposed to the "descriptive" style the Greeks were to develop. In Dynasty XVIII, however, there was a remarkable change. The pharaoh Amenhotep IV, who ruled from 1379 to 1362 B.C., single-handedly attempted a total reform of Egyptian religious and political life. He replaced the numberless deities of traditional religion with a single one, the sun god Aton, and changed his own name to Akhenaton, or "the servant of Aton." The most complete expression of his devotion to Aton survives in the form of a hymn to the god, which movingly expresses his sincerity: "Thou appearest beautifully on the horizon of Heaven, thou living Aton, the beginning of life! When thou art risen on the eastern horizon, thou hast filled every land with thy beauty. . . . " In order to make these revolutionary moves more effective and to escape the influence of the priests at the royal court of Thebes, he transferred the capital to a new location, known today as Tel el-Amarna.

Here a new kind of art developed. The weight and idealism of the traditional conceptual style gave way to a new lightness and naturalism. For the first time physical characteristics are depicted in detail, and scenes are relaxed and even humorous. A stone relief showing the royal couple and three of their children sitting quietly

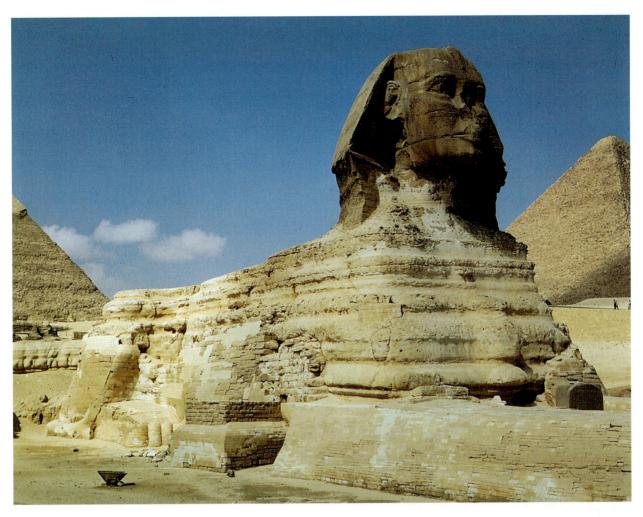

1.12 Great Sphinx (with Pyramid of Chefren in the background at left), Gizeh, Dynasty IV, c. 2575–2525 B.C. Sandstone, approx. 65′ (19.83 m) high, 240′ (73.2 m) long. The lion's body symbolizes immortality. The pharaohs were often buried in lion skins.

under the rays of the sun disc is an astonishing departure from the dignified style of the preceding thousand years [1.15]. Queen Nefertiti herself is the subject of perhaps the most famous of all Egyptian portraits [1.16], a sculpture that shows none of the exaggeration to which Amarna art is sometimes prone, but a grace and elegance very different from earlier official portraits.

All these artistic changes were, of course, the result of Akhenaton's sweeping and revolutionary religious reforms. They did not last long. Akhenaton's belief in a single god who ruled the universe was threatening to the priests, who had a vested interest in preserving the old polytheistic traditions. Not surprisingly, Akhenaton's successors branded him a heretic and fanatic and cut out his name from all the monuments that survived him.

The reaction against Akhenaton's religious policy and the Amarna style was almost immediate. His successor, Tutankhamen, however, is remembered not for leading the opposition-or indeed for any event in his short life. He owes his fame to the treasures found intact in his undisturbed tomb. These sumptuous gold objects, enriched with ivory and precious stones, still show something of the liveliness of Amarna art, but a return to conservatism is beginning; in fact by Dynasty XIX and XX, Akhenaton had been completely forgotten. In any case, it is not so much for what they reveal about the trends in art that the treasures of Tutankhamen are significant. The discovery of the tomb is important for a different reason. Our knowledge of the cultures of the ancient world is constantly being revised by the work of archaeologists; many of their finds are minor, but some are major and spectacular. In the case of excavations such as the tomb of Tutankhamen the process of uncovering the past sometimes becomes as exciting and significant as what is discovered. The long search conducted by Howard Carter in the Valley of the Kings that

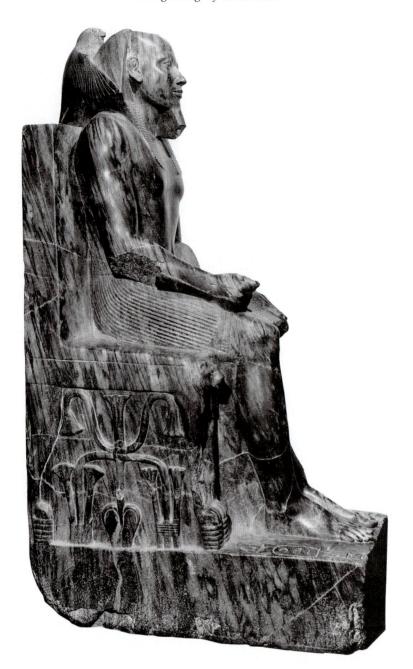

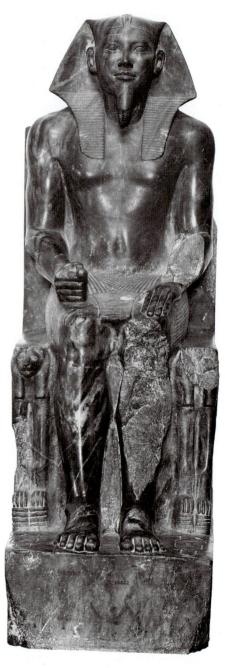

1.13 *Chefren* (right side and front), from Gizeh, Dynasty IV, c. 2575–2525 B.C. Dark green diorite, approx. 5'6" high. Egyptian Museum, Cairo.

http://www.powerup.com.au/~ancient/tutl.htm

Tutankhamen

http://www.powerup.com.au/~ancient/kv.htm

Valley of the Kings

culminated in the opening of the inner chamber of the sealed tomb of Tutankhamen on February 17, 1923, and the discovery of the intact sarcophagus of the king has become part of history [1.17, 1.18].

The excavations of Knossos and Mycenae, discussed later in this chapter, and the discovery of Pompeii (Chapter 4) are also major turning points in the growth of our knowledge of the past. But sensational finds like these are exceptions. Understanding the cultural achievements of past civilizations involves a slow and painstaking series of minor discoveries, each of which adds to the knowledge that thus must be constantly revised and reinterpreted.

By the close of the New Kingdom the taste for monumental building had returned. The temples constructed during the reign of Ramses II (1298–1232 B.C.) at Luxor,

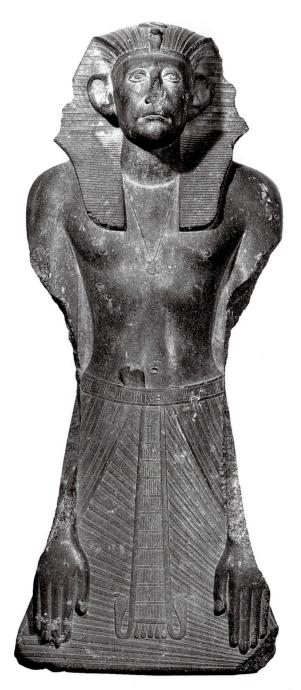

1.14 Sesostris III, c. 1878–1841 B.C. Black granite, height $4'10^{1}/_{2}''$ (1.5 m). Egyptian Museum, Cairo.

Karnak, and Abu Simbel are probably the most colossal of all Egyptian constructions [1.19]. Within a century, however, internal dissensions and foreign events had produced a sharp decline in Egypt's power. Throughout the Late Period, artists reverted again to the styles of earlier periods. Tombs were once again constructed in the shape of pyramids, as they had been in the Old Kingdom, and sculptors tried to recapture the realism and sense of volume of Old and Middle Kingdom art. Even direct contacts with the Assyrians, Persians, and Greeks—during the period between the Assyrian occupation of 671–633 B.C. and Alexander's conquest of

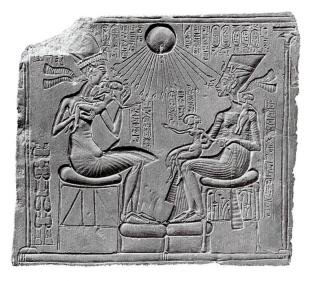

1.15 Akhenaton, Nefertiti, and Three of Their Children, Amarna, c. 1370–1350 B.C. Limestone relief, height 17" (43 cm). Egyptian Museum, State Museums, Berlin. The naturalism of this relief, verging on sentimentality, is typical of late-Amarna art.

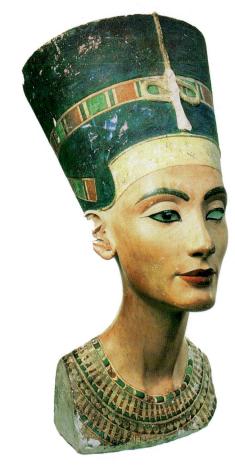

1.16 Queen Nefertiti, Tell el-Amarna, Dynasty XVIII, c. 1355–1335 B.C. Painted limestone, approx. 20" high. Ägyptisches Museum, Berlin. Though the portrait is not exaggerated, it is idealized.

CONTEMPORARY VOICES

Love, Marriage, and Divorce in Ancient Egypt

A Young Man's Love Song:

Seven days from yesterday I have not seen my beloved,

And sickness has crept over me,
And I am become heavy in my limbs
And am unmindful of mine own body.
If the master-physicians come to me,
My heart has no comfort of their remedies,
And the magicians, no resource is in them,
My malady is not diagnosed.
Better for me is my beloved than any remedies,
More important is she for me than the entire compendium of medicine.

My salutation is when she enters from without. When I see her, then am I well; Opens she her eye, my limbs are young again; Speaks she, and I am strong; And when I embrace her, she banishes evil, And it passes from me for seven days.

Quoted in Leonard Cottrell, Life Under the Pharaohs (New York: Holt, Rinehart and Winston, 1960), p. 84.

A Young Girl's Song to Her Beloved:

Oh, flower of henna!
My heart stands still in thy presence.
I have made mine eyes brilliant for thee with kohl.
When I behold thee, I fly to thee, oh my Beloved!
Oh, Lord of my heart, sweet is this hour. An hour passed with thee is worth an hour of eternity!
Oh, flower of marjoram!

Fain would I be to thee as the garden in which I have planted flowers and sweet-smelling shrubs! the garden watered by pleasant runlets, and refreshed by the north breeze!

Here let us walk, oh my Beloved, hand in hand, our hearts filled with joy! Better than food, better than drink, is it to behold

thee.
To behold thee, and to behold thee again!

10

Quoted in Amelia B. Edwards, Pharaohs, Fellahs, and Explorers (New York: Harper, 1891), p. 225.

A Father's Advice to His Son:

Double the food which thou givest thy mother, carry her as she carried thee. She had a heavy load in thee, but she did not leave it to me. After thou wert borne she was still burdened with thee; her breast was in thy mouth for three years, and though thy filth was disgusting, her heart was not disgusted. When thou takest a wife, remember how thy mother gave birth to thee, and her raising thee as well; do not let thy wife blame thee, nor cause that she raise her hands to the god.

Quoted in Barbara Mertz, Temples, Tombs and Hieroglyphics (New York: Coward-McCann, 1964), p. 333.

How a Wife Can Obtain a Divorce:

If she shall stand up in the congregation and shall say, "I divorce my husband," the price of divorce shall be on her head; she shall return to the scales and weigh for the husband five shekels, and all which I have delivered into her hand she shall give back, and she shall go away whithersoever she will.

Quoted in Leonard Cottrell, Life Under the Pharaohs (New York: Holt, Rinehart and Winston, 1960), p. 94.

Egypt in 331 B.C.—produced little effect on late Egyptian art. To the end of their history, the Egyptians remained faithful to their three-thousand-year-old tradition. Probably no other culture in human history has ever demonstrated so strong a conservatism and determination to preserve its separate traditions.

Aegean Culture in the Bronze Age

Neither the Egyptians of the Old Kingdom nor the Sumerians appear to have demonstrated any interest in their contemporaries living to the west of them, and with good reason. In Greece and the islands of the Aegean Sea, although the arrival of immigrants from farther east in the early Neolithic period (c. 6000 B.C.) had brought new agricultural techniques, life in general continued there for the next three thousand years almost completely untouched by the rise of organized cultures elsewhere.

Yet, beginning in the early Bronze Age, there developed in the area around the Aegean Sea a level of civilization as brilliant and sophisticated as any other in Europe or western Asia. (The same period saw the appearance of a similarly urban culture in the Indus Valley

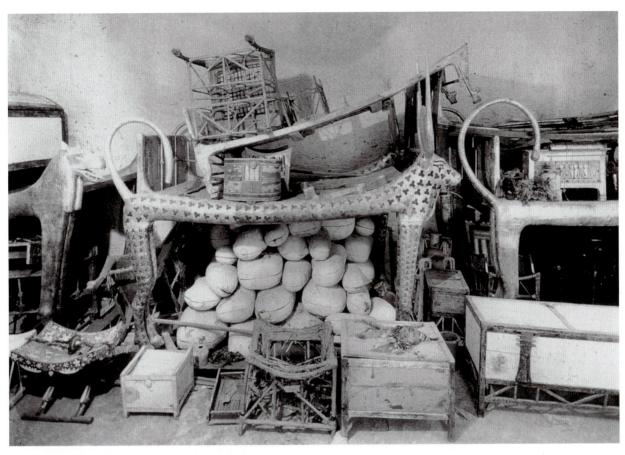

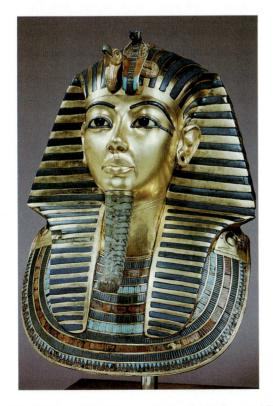

1.18 Death Mask of Tutanhkamen, Thebes, Egypt. Dynasty XVIII, ca. 1323 B.C. Gold with inlay of semiprecious stones, $1'9^{1}/_{4}''$ high. Egyptian Museum, Cairo.

1.17 The first view of the treasures of Tutankhamen. Egyptian, Dynasty XVIII. Thebes: Valley of the Kings. Antechamber: west side. This is what Howard Carter saw when he opened the doorway of the antechamber of the tomb of Tutankhamen on November 26, 1922. The objects include three gilt couches in the form of animals and, at the right in back, the pharaoh's golden throne. The tomb itself was opened three months later.

on the Indian subcontinent.) Then around 1100 B.C., after almost two thousand years of existence, this Bronze Age Aegean civilization disappeared as dramatically as it had arisen. The rediscovery in the twentieth century of these peoples—the Minoans of Crete and the Mycenaeans of mainland Greece—is perhaps the most splendid achievement in the history of archaeology in the Mediterranean—and one that has opened up vast new perspectives in the study of the later Greeks.

What connection is there between Greek culture and the magnificent civilization of the Bronze Age? Did much of later Greek religion, thought, and art have its origins in this earlier period, even though the Greeks themselves seemed to know nothing about it? Or was the culture of the Minoans and Mycenaeans an isolated phenomenon, destroyed utterly near the end of the Bronze Age, lost until it was found again in the twentieth century? The Aegean culture is important not only for the possible light it throws on later times. Its existence also shows

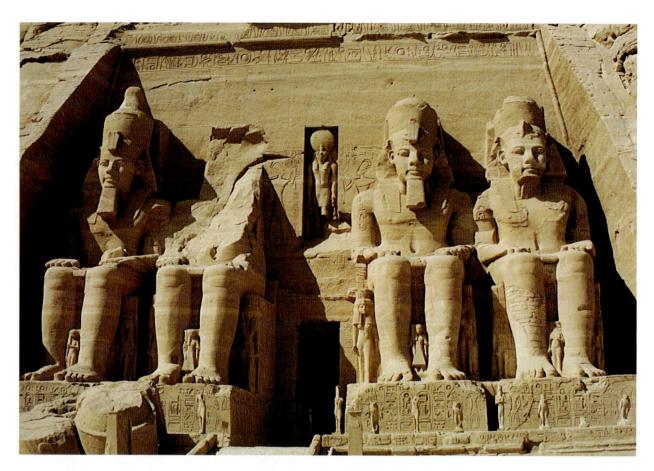

1.19 Temple of Ramses II, Abu Simbel (now relocated), Dynasty XIX, c. 1275–1225 B.C. Colossi approx. 65' high. These four huge statues, erected in commemoration of Ramses' military victories, are all of the pharaoh himself. Between and near the feet are small statues of Ramses' mother, wife, and children. Below are statues of the pharaoh as the god Osiris and the falcon god Horus, to whom the temple was dedicated.

that the ancient world could reach beyond the monumentality and earnestness of the Egyptians and Mesopotamians, that it could attain a way of life that valued grace, beauty, and comfort—a life that could truly be called civilized.

Cycladic Art

During most of the Bronze Age the major centers of Aegean culture were on Crete or the mainland, but in the early phase there were settlements on a group of islands of the central Aegean, the Cyclades. Little is known about these Cycladic people. They used bronze tools. They also produced pottery which, though less finely made than that produced elsewhere in the Aegean at the time, sometimes shows remarkable imagination and even humor [1.20]. The chief claim to fame of Cycladic art—a considerable one—lies in the marble statues, or idols, that were produced in large quantities and in

many cases buried with the dead. The statues range in height from a few inches to almost life-size; the average is about a foot (30.5 centimeters) high. Most of the figures are female; the most common type shows a naked woman standing or, more probably, lying, with her arms folded and head tilted back [1.21]. The face is indicated only by a central ridge for the nose. The simplicity of the form and the fine working of the marble—stone of superb quality—often produce an effect of great beauty.

The purpose of the Cycladic idols remains uncertain. The fact that most of them have been found in graves suggests that they had a religious function in the funeral ritual. The overwhelming preponderance of female figures seems to indicate that they were in some way connected with the cult of the mother goddess, which was common in Mesopotamia and which dominated Aegean Bronze Age religion. Whether the figures actually represent goddesses remains uncertain.

We now know that the period of the production of the Cycladic idols was one of increasing development on Crete. Yet for the classical Greeks of the fifth century B.C. Crete was chiefly famous as the home of the legendary King Minos, who ruled at Knossos. Here, according to myth, was a Labyrinth that housed the Minotaur, a monstrous creature, half man and half bull, the product of the union of Minos' wife Pasiphae with a bull. Minos exacted from Athens a regular tribute of seven boys and seven girls who were sent to be devoured by the Mino-

1.20 Cycladic vase in the shape of a hedgehog drinking from a bowl. Syros, c. 2500–2200 B.C. Painted clay, height $4^1/_4$ " (11 cm). National Archaeological Museum, Athens.

taur. According to the myths, after this had been going on for some time, the Athenian hero Theseus volunteered to stop the grisly tribute. He went to Knossos with the new group of intended victims and, with the help of the king's daughter Ariadne (who had fallen in love with him) killed the Minotaur in its lair in the middle of the Labyrinth. He then escaped with Ariadne and the Athenian boys and girls. Theseus later abandoned Ariadne on the island of Naxos, but the god Dionysus discovered her there and comforted her. The story had many more details, and other myths describe other events. The important point is that the later Greeks had a mythological picture of Knossos as a prosperous and thriving community ruled by a powerful and ruthless king from his palace. Knossos was not the only center mentioned in Greek stories of Crete. In the *Odyssey* Homer even refers to "Crete of a hundred cities."

These were, however, legends. By the time of Classical Greece no evidence whatsoever for the existence of the Palace of Minos or the other cities could be seen. It is not surprising that the Greeks themselves showed no inclination to try to find any hidden traces. Archaeology, after all, is a relatively modern pursuit, and there is little indication of any serious enthusiasm in classical antiquity for the material remains of the past. Later ages continued to accept the Greeks' own judgment. For many centuries the story of Minos and the Labyrinth was thought to be a good tale with no foundation in fact.

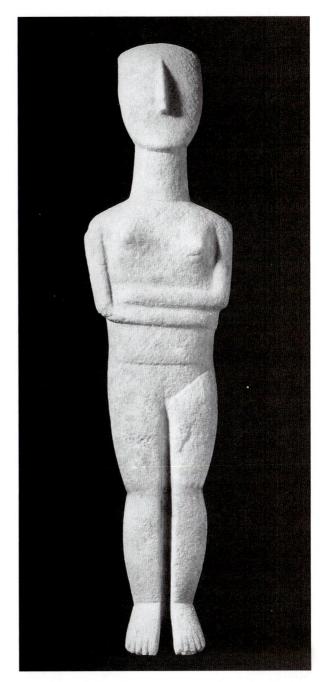

1.21 Cycladic idol, c. 2500 B.C. Marble, height $19^{1}/_4$ " (50 cm). British Museum, London (reproduced by courtesy of the Trustees).

The Excavation of Knossos

By the end of the nineteenth century, however, things had changed. Heinrich Schliemann had proven that the stories of the war against Troy and the Mycenaeans who had waged it were far from mere legends. Was it possible that the mythical palace of King Minos at Knossos also really existed? In 1894 the English archaeologist Arthur Evans first went to Crete to see if he could discover

something of its history in the Bronze Age. At Knossos he found evidence of ancient remains, some of them already uncovered by amateur enthusiasts. He returned in 1899 and again in 1900, this time with a permit to excavate. On March 23, 1900, serious work began at Knossos, and within days it became apparent that the finds represented a civilization even older than that of the Mycenaeans. The quantity was staggering: pottery, frescoes, inscribed tablets, and, on April 13, a room with elaborate paintings and a raised seat with high back—the throne room of King Minos. Evans' discoveries at Knossos (and finds later made elsewhere on Crete by other archaeologists) did much to confirm legendary accounts of Cretan prosperity and power. Yet these discoveries did far more than merely give a true historical background to the myth of the Minotaur. Evans had in fact found an entire civilization, which he called Minoan after the legendary king. Evans himself is said to have once remarked modestly, "Any success as an archaeologist I owe to two things: very short sight, so I look at everything closely, and being slow on the uptake, so I never leap to conclusions." Actually, the magnitude of his achievement can scarcely be exaggerated. All study of the Minoans has been strongly influenced by his initial classification of the finds, especially the pottery. Evans divided the history of the Bronze Age in Crete into three main periods—Early Minoan, Middle Minoan, and Late Minoan-and further subdivided each of these into three. The precise dates of each period can be disputed, but all the excavations of the years following Evans have confirmed his initial description of the main sequence of events.

Life and Art in the Minoan Palaces

The Early Minoan period was one of increasing growth. Small towns began to appear in the south and east of Crete, and the first contacts were established with Egypt and Mesopotamia. Around 2000 B.C., however, came the first major development in Minoan civilization, marking the beginning of the Middle Minoan period. The earlier scattered towns were abandoned and large urban centers evolved. These are generally called palaces, although their function was far more than just to provide homes for ruling families.

The best known of these centers is Knossos (other important ones have been excavated at Phaistos, Mallia, and Zakro) [1.22]. The main palace building, constructed around an open rectangular courtyard, contained rooms for banquets, public receptions, religious ceremonies, and administrative work. In addition, there were living quarters for the royal family and working areas for slaves and craftsmen [1.23, 1.24]. Around the palace were the private houses of the aristocrats and chief religious leaders. The technical sophistication of these great centers was remarkable. There were elaborate drainage systems, and the palaces were designed and constructed to remain cool in summer and be heated easily in winter.

Few aspects of the Minoan achievement are more impressive than the development of an architectural style appropriate for these great structures. Unlike the carefully, almost obsessively planned Egyptian building complexes, Minoan palaces seem at first disorganized in plan. In practice, however, the division between the various functions of a palace-official, residential, religious—was achieved by a careful division of space. In the construction of the buildings themselves, rough stonework was hidden behind plaster and frescoes. Minoan columns tapered downward; their narrowest point was at their base, unlike Greek columns, which widen to their base, or Egyptian columns, most of which retain the same width from top to bottom. Minoan architects used these columns to provide impressive entrances, and to construct "light-wells" (vertical shafts running down through the buildings to carry light to the lower stories).

Middle Minoan art shows great liveliness and color. The brilliantly painted pottery, superb jewelry such as the famous Wasp Pendant from Mallia [1.25], and the many exquisitely carved seal stones all attest to the Minoans' love of beauty and artistic skill. Unlike their contemporaries in Egypt and Mesopotamia, the Minoans showed little interest in monumental art. Their greatest works are on a small, even miniature, scale. At the same time, they invented a writing system of hieroglyphic signs that was used in the archives of the palace for administrative purposes.

http://www.tourism.egnet.net/cafe/tor_trn.htm Hieroglyphics

Toward the end of the Middle Minoan period (c. 1700 B.C.) the palaces were destroyed, probably by an earthquake, then rebuilt on an even grander scale. There was further reconstruction about a century later, perhaps because of another earthquake. These palaces of the Late Minoan period represent the high point of Minoan culture. The wall paintings of this period are among the greatest treasures of all. Their spontaneity and freedom create a mood very different from Egyptian and Mesopotamian art, and they show a love of nature expressed with brilliant colors and vivid observation. Most of the best examples of these later paintings are from Knossos, but some particularly enchanting scenes have been found in the recent excavation of a Minoan colony on the island of Thera [1.26].

Although the rulers of the palaces seem to have been male, the central figure of Minoan religion was a mother goddess who was connected with fertility. She seems to have taken on different forms, or rather the function of female divinity was divided among several separate deities. Sometimes when she is shown flanked by animals, as the Mistress of the Beasts, she seems to be the ancestor of the Greek goddess Artemis. Other depictions show goddesses of vegetation. The most famous Minoan figurine is the so-called *Snake Goddess* [1.27].

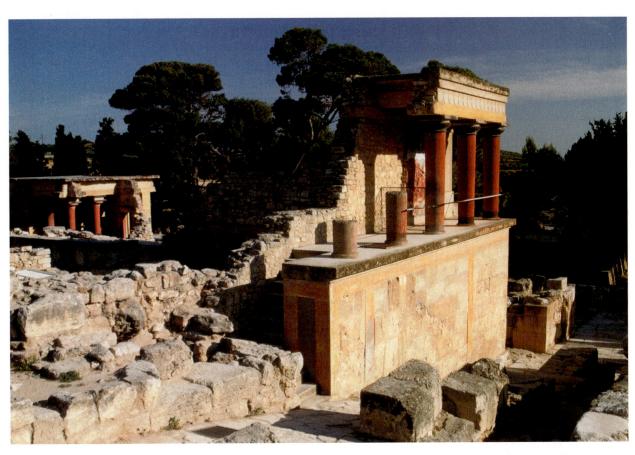

1.22 Palace of Minos at Knossos, c. 1600–1400 B.C. Exterior view.

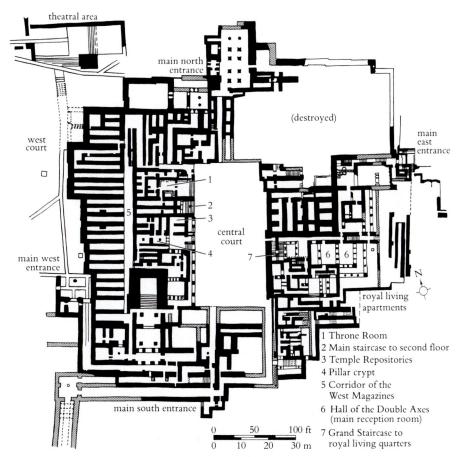

1.23 Plan of the Palace of Minos at Knossos. c. 1600–1400 B.C. Each Cretan palace had a central court oriented north—south, state apartments to the west, and royal living apartments to the east.

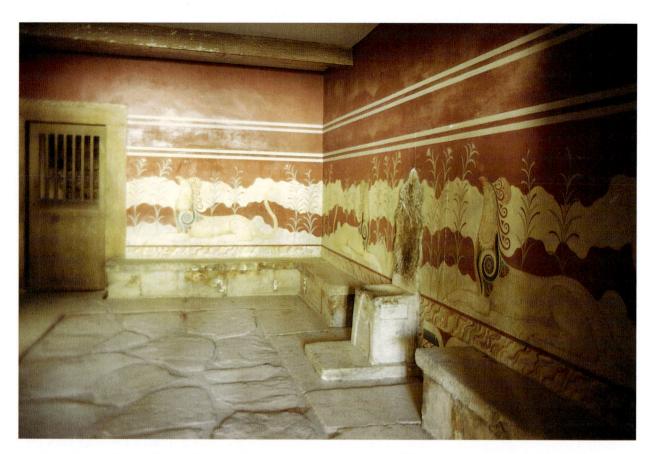

1.24 Throne Room, Palace of Minos at Knossos. The room was reconstructed about 1450 B.C., shortly before the final destruction of the palace. The frescoes around the throne show sacred flowers and griffins—mythological beasts with lion bodies and bird heads.

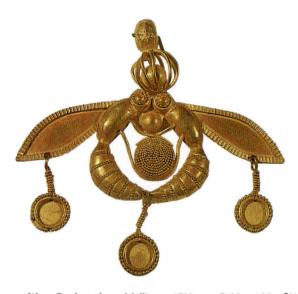

1.25 Wasp Pendant, from Mallia, c. 1700 B.C. Gold, width $1^7 \/ s$ " (5 cm). Archaeological Museum, Heraklion. This enlarged view shows the exquisite craftsmanship, using the techniques of granulation and wire-working. Two wasps (or perhaps hornets) are curved around a honeycomb.

Throughout the last great age of the palaces, the influence of Minoan artistic styles began to spread to the mainland. But Minoan political and military power was on the wane, and Knossos seems to have been invaded and occupied by mainlanders around 1450 B.C. Shortly afterward, both at Knossos and elsewhere, there is evidence of widespread destruction.

By 1400 B.C., Minoan culture had come to an abrupt end. The causes are mysterious and have been much argued; we shall probably never know exactly what happened. The eruption of a volcano on Thera a century earlier, about 1500 B.C., may have played some part in changing the balance of power in the Aegean. In any case, there is no doubt that throughout the last period of the palaces a new power was growing, the Mycenaeans. These people may well have played a part in the destruction of Knossos.

Schliemann and the Discovery of Mycenae

The Mycenaeans, the people of mainland Greece in the Bronze Age, are named after the largest of their settlements, Mycenae. Most of the Mycenaean centers were in the southern part of Greece known as the Peloponnesus,

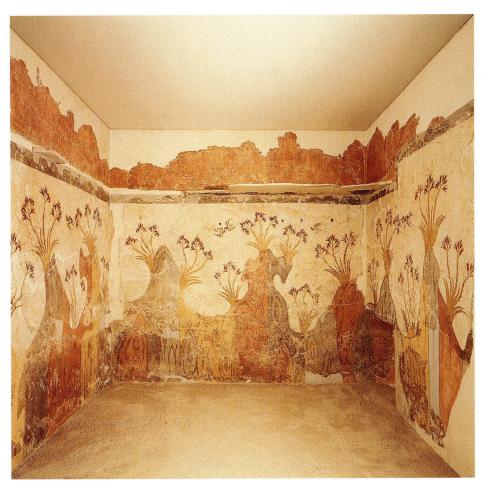

1.26 Room with frescoes: Landscape with swallows (Spring Fresco), from Room Delta 2, Akrotiri, Thera, c. 1650 B.C. Fresco, approx. 7'6" high. National Archaeological Museum, Athens. A springtime scene—bright flowers and soaring birds—covers three sides of a small room.

although there were also some settlements farther north, of which the two most important were Athens and Thebes. Like the Minoans, the Mycenaeans were familiar from Greek myths long before their material remains were excavated. They were famous in legend mainly for launching an expedition against Troy, across the Aegean Sea. The Trojan War (c. 1250 B.C.) and its aftermath provided the material for many later Greek works, most notably the *Iliad* and the *Odyssey*, the two great epic poems of Homer, but for a long time it was believed that the war and even the very existence of Troy were myths.

Heinrich Schliemann dedicated his life and work to proving that the legends were founded on reality. Born in Germany in 1822, Schliemann was introduced to the Homeric poems as a child by his father and was overwhelmed by their incomparable vividness. He became determined to discover Homer's Troy and prove the poet right. Excavation has always been expensive, and Schliemann therefore decided to make his fortune in business, retire early, and devote his profits to the pursuit of his goal. By 1863, this remarkable man had accumulated a considerable amount of money from trading in, among other things, tea and was ready to devote himself to his second career. After a period of study and travel, in 1870

he finally began excavations on the site where he had decided the remains of Homer's Troy lay buried beneath the Roman city of Ilium. By 1873 he had found not only walls and the gate of the city but quantities of gold, silver, and bronze objects.

Inspired by the success of his Trojan campaign, Schliemann moved on to the second part of his task: to discover the Mycenaeans who had made war on Troy. In 1876 he began to excavate within the walls of Mycenae itself, and there he almost immediately came upon the Royal Grave Circle with its stupendous quantities of gold treasures [1.28]. Homer had described Mycenae as "rich in gold," and Schliemann was always convinced that the royal family whose graves he had unearthed was that of Agamemnon, leader of the Mycenaean expedition against Troy. We now know that the finds date to an even earlier period, and later excavations both at Mycenae and at other mainland sites have provided a much more exact picture of Mycenaean history. This does not diminish Schliemann's achievement. However unscientific his methods, he had proved the existence of a civilization in Bronze Age Greece that surpassed in splendor even the legends; he had opened a new era in the study of the past.

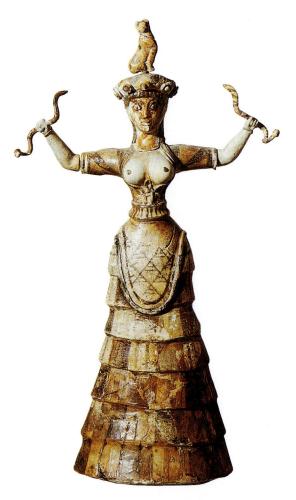

1.27 Snake Goddess, from the Temple Repository, the palace at Knossos, c. 1600 B.C. Faïence, approx. $13^{1}/_{2}^{\prime\prime}$ high. Archaeological Museum, Heraklion. The bare breasts are typical for Minoan court ladies, but the apron indicates a religious function. The figure probably represents a priestess serving the goddess, not the goddess herself.

Mycenaean Art and Architecture

Like the Minoans, the Mycenaeans centered their life around great palace complexes. In Mycenae itself, the palace probably was first built around 1600 B.C., and the graves found by Schliemann date to shortly thereafter. Until the fall of Knossos in 1400 B.C., the Mycenaeans were strongly under the influence of Minoan culture, but with the end of Minoan power they became the natural leaders in the Aegean area. From 1400 to 1200 B.C., Mycenaean traders traveled throughout the Mediterranean, from Egypt and the Near East as far west as Italy. The Mycenaean empire grew in power and prosperity.

Toward the end of this period (around 1250 B.C.), the successful expedition was launched against Troy, perhaps for reasons of trade rivalry. A short time later (around 1200 B.C.), the Mycenaean empire itself fell, its major centers destroyed and most of them abandoned. Invasion by enemies, internal strife, and natural causes

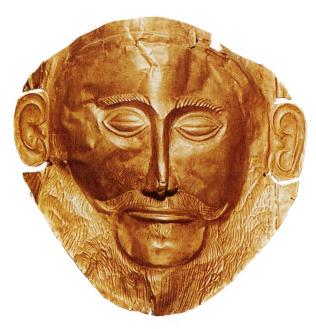

1.28 Funerary mask, from Grave Circle A, Shaft Grave V, Mycenae, c. 1600-1500 B.C. Beaten gold, height $10^{1}/s''$ (26 cm). National Archaeological Museum, Athens. This death mask is actually a portrait of a Mycenaean ruler of three centuries earlier than Agamemnon.

have all been suggested, but the fall of the Mycenaeans still remains mysterious.

Their collapse is made even more incomprehensible by the massive fortifications that protected most of the palaces. At Mycenae itself, the walls are 15 feet (4.6 meters) thick and probably were 50 feet (15.3 meters) high. As in the case of other Mycenaean centers, the actual location was chosen for its defensibility [1.29]. The somber character of these fortress—palaces is reflected in the general tone of Mycenaean civilization.

Unlike the relaxed culture of the Minoans, Mycenaean culture as reflected in its art was preoccupied with death and war. It is no coincidence that many of the richest finds have come from tombs. Like the Minoans, the Mycenaeans decorated their palaces with frescoes, although the Mycenaean paintings are more solemn and dignified than their Minoan counterparts.

The disaster of 1200 B.C. brought a violent end to the Mycenaeans' political and economic domination of the Mediterranean, but their culture lingered on for another one hundred years. A few of the palaces were inhabited again, and some Mycenaeans fled eastward, where they settled on the islands of Rhodes and Cyprus. By 1100 B.C., however, renewed violence had extinguished the last traces of Bronze Age culture in Greece. A century later, after a period our lack of information forces us to call the Dark Age, the story of Western culture truly begins with the dawning of the Iron Age.

Before leaving the rich achievements of the Bronze Age world, both in Greece and farther afield, it is worth

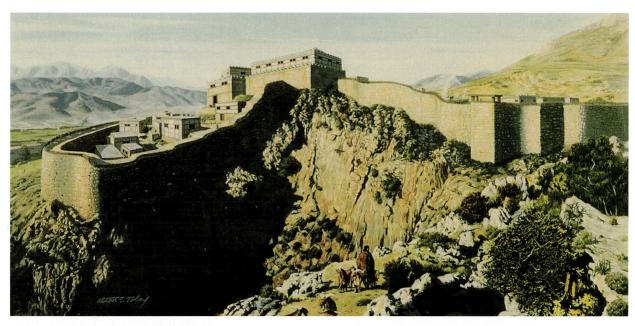

1.29 Reconstruction of the Citadel of Mycenae as it would have looked around 1300 B.C. The very thick walls are visible. The palace has a commanding position at the summit.

asking how much survived to be handed down to our own civilization. For the Greeks themselves, the Iron Age brought a new beginning in most material respects. At the same time, however, there are links with the earlier era in less tangible areas. In particular, although Greek religion never placed as strong an emphasis on worship of the mother goddess as did the Bronze Age, she remained a potent force in traditional beliefs. Behind the official reverence for Zeus, father of the gods and mortals, there lay a profound respect for goddesses like Hera, patroness of the family; Artemis, Mistress of the Beasts and goddess of childbirth; and Demeter, the goddess of fertility and agriculture. The continued worship of these goddesses, which was to last under different guises for centuries, represents a reverence for female creative power that is one of the oldest legacies from the period before our culture began—we saw it as far back as the Paleolithic period—and perhaps one of the most significant.

Regarding Egypt and Mesopotamia, their impact on later culture remains the subject of debate. In the course of their growth and development, the Greeks were brought into contact with the black Cushite culture of Egypt, and Greek art and architecture were decisively influenced by it. Although the Greeks retained their artistic independence, the style they developed under the inspiration of Eastern models, including those of Mesopotamia, has conditioned the entire history of Western art. The cultures of ancient Egypt and the Middle East had very little firsthand influence on the formation of our civilization, partly because Greek culture had a vitality that was by this time lacking in the older peoples

and at least partly because of historical accident. Egypt and Assyria, powerful though they were, fell to the Persians, while Greece managed not only to survive but even to inflict an ignominious defeat on its Persian invaders. Yet even if ancient Egypt and Mesopotamia lie outside the mainstream of our cultural tradition, they continue to exert a powerful influence on the Western imagination, as the Tutankhamen exhibitions and their accompanying "Tut mania" showed in the 1970s. In part, their fascination lies in their exoticism and in the excitement of their rediscovery in our own day. The pharaoh who can curse his excavator from beyond the grave is certainly a dramatic, if fictional, representative of his age. At the same time, the artistic achievements of those distant times need no historical justification. Created in a world very remote from our own, they serve as a reminder of the innate human urge to give expression to the eternal problems of existence.

SUMMARY

The Beginnings of Civilization The early civilizations of the ancient Middle East laid the basis for the development of Western culture. In Egypt and Mesopotamia, in the period around 3000 B.C., the simple farming communities of the earlier Neolithic (New Stone) Age were replaced by cities, the product of agricultural discoveries that provided the food supply for relatively large numbers of people to live together.

Many of the characteristics of urban life developed during the following centuries: large-scale buildings, trade and commerce, systems of government and religion. The people of the Mesopotamian city of Uruk invented the earliest known writing system in the world.

Ancient Egypt Egyptian society was dominated by a strong central monarchy, with the pharaoh (the Egyptian

king) presiding over a large bureaucracy that administered the affairs of state. Egyptian religious life was controlled by the priests, who sought to maintain old traditions, and Egyptian art generally reflected the policy of state control. Periods of political uncertainty were reflected in contemporary art. The confidence and stability of Old Kingdom sculpture, for example, disappeared in the unsettled conditions of the Middle Kingdom.

In the reign of the New Kingdom pharaoh Amenhotep IV, better known as Akhenaton (1379–1362 B.C.), there was a change: The numberless deities of Egyptian religion were replaced by a single sun god, and Egyptian art became naturalistic for the first time in its history. Akhenaton's successors, however, restored the traditional system of deities and the artistic conventions of former times.

The chief characteristic of Egyptian religious thought was the belief in survival after death for those who had led a good life. Elaborate funeral rituals were devised, in which the god Osiris, Judge of the Dead, was invoked. From early in Egyptian history monumental tombs were constructed for the ruling classes, the most famous of which are the Great Pyramids at Giza.

The People of Mesopotamia Mesopotamian culture lacked the unity of Egyptian life: A series of different peoples had their own languages, religions, and customs. The Sumerians, the earliest, lived in cities dominated by great temples built on artificial platforms. The temple priests administered both religious and economic affairs, sharing their duties with local civic rulers. Unlike the Egyptian pharaohs who were thought of as gods, Sumerian rulers never became the focus of a cult. They represented their city's god and served the interests of their people by overseeing government projects. Among the earliest of Sumerian kings was Gilgamesh, whose legendary deeds are described in the epic poem that bears his name. Mesopotamia was ruled by the Akkadians, a Semitic people, from 2350 to 2150 B.C. Their kingdom was invaded and destroyed, and in a brief period of Neo-Sumerian revival the principal religious monument at Ur, the Ziggurat, was built. Around 1800 B.C. Mesopotamia was reunified by the Babylonians, whose most famous king, Hammurabi, was the author of an important law code.

The last people to rule Mesopotamia were the Assyrians, the peak of whose power occurred between 1000 B.C. and 612 B.C., the year in which their capital Nineveh was sacked by the Persians. Successive royal palaces, first at Nimrud and then at Nineveh, were decorated with massive stone relief carvings that showed aspects of life at court (royal processions, hunting scenes) with considerable realism.

The Cultures of Bronze Age Greece The first urban culture in the West, known as Minoan, developed on the Mediterranean island of Crete. Around 2000 B.C. large towns were constructed; these served as centers for the

ruling families and the chief religious leaders. The largest Minoan community, Knossos, was destroyed several times by earthquakes and each time was rebuilt on a grander scale. Like the other Minoan palaces, Knossos was decorated with vivid wall paintings depicting religious ceremonies and scenes from daily life. Many examples have been found of the elaborate jewelry worn by figures in the paintings; one of the richest is the gold Wasp Pendant from Mallia.

Around 1400 B.C., Knossos was abandoned for reasons that remain mysterious, and power passed to mainland Greece, where a people called the Mycenaeans had appeared by 1600 B.C. Most of our information about the Mycenaeans comes from their tombs. The earliest ones, at Mycenae itself, were dug into the ground within a circular enclosure; vast quantities of gold treasure—including death masks, jewelry, and weapons—were buried with the bodies of the dead. The Mycenaeans traded widely in the Mediterranean area, and around 1250 B.C. they sacked the city of Troy, an economic rival. Shortly after, however, their own cities were destroyed. Within a century Mycenaean culture had vanished, although it was to exert important influence upon later Greek civilization.

Pronunciation Guide

Akhenaton: Ak-en-AH-tun
Akkadian: Ak-AY-di-un
Amarna: Am-AR-nuh
Assurbanipal: As-er-BAN-i-pal
Assurnasirpal: A-ser-na-SEER-pal

Chefren: KEF-ren Cheops: KEE-ops **Cuneiform:** CUE-ni-form Cyclades: SIK-la-dees **Euphrates:** You-FRAY-tees Gilgamesh: GIL-gum-esh Hammurabi: Ham-oo-RA-bee Hieroglyph: HIGH-ro-glif **Knossos: KNO-sos** Lascaux: Lasc-OWE Mallia: MAH-lia

Mesopotamia: Mes-o-pot-AIM-i-a

Minos:MY-nosMycenae:My-SEEN-eeNefertiti:Nef-er-TEE-TEE

Phaistos: FES-tos
Pharaoh: FARE-owe
Schliemann: SHLEE-man
Stele: STAY-lay
Sumerian: Soo-MEE-ri-an
Tutankhamen: Tu-tan-KA-mun
Uruk: Oo-ROOK

Willendorf: Zakro:

Ziggurat:

VIL-en-dorf ZAK-roe ZIG-oo-rat

EXERCISES

- Compare the religious beliefs of the Egyptians and the Mesopotamians. What do their differences tell us about the cultures involved?
- 2. How did the development of Egyptian society affect their art? What were the principal subjects depicted by Egyptian artists?
- 3. What evidence is there for the role of women in the cultures discussed in this chapter?
- 4. What information do the excavations at the Palace of Knossos provide about Minoan daily life?
- 5. If you could return in time to visit one of the peoples described in the chapter, which would you choose?

FURTHER READING

- Aldred, C. (1987). *The Egyptians*. London: Thames and Hudson. A short but comprehensive account of Egyptian culture by one of the leading Egyptologists of the century.
- Binford, L. R. (1988). *In pursuit of the past*. New York: Thames and Hudson. An absorbing introduction to prehistoric archaeology; written for general readers.
- Frankfort, H. (1996). The art and architecture of the ancient Orient (5th ed.). New Haven: Yale University Press. The best single-volume guide to its subject. Technical in places but written with immense breadth of knowledge; fully illustrated.
- Hood, S. (1978). The arts in prehistoric Greece. Baltimore: Penguin. An introduction to Minoan and Mycenaean art. The author, who has himself dug both in Crete and at Mycenae, includes evidence from the excavations new at the time of its publication.
- Lerner, G. (1986). The creation of patriarchy. New York: Oxford University Press. A study of gender and politics in the ancient world.
- Malek, Jaromir. (1999). *Egyptian art*. London: Phaidon. Well illustrated and current.
- Nissen, H. J. (1988). The early history of the ancient Near East 9000–2000 B.C. Chicago: University of Chicago Press. A survey of Mesopotamian history and culture that takes into account excavations up to its publication date.
- Roux, G. (1980). Ancient Iraq (2nd ed.). Baltimore: Penguin. A history of the ancient Near East from the Paleolithic period to Roman times.
- Smith, W. S. (1981). *The art and architecture of ancient Egypt* (2nd ed., revised by W. K. Simpson). Baltimore: Penguin. A thorough survey of all aspects of Egyptian art, with numerous photographs and diagrams.
- Trigger, B. B. G., et al. (1983). Ancient Egypt: A social history. Cambridge: Cambridge University Press. A collection of essays on various aspects of ancient Egyptian life.

- Warren, P. (1989). *The Aegean civilizations* (2nd ed.). Oxford: Elsevier-Phaidon. A good general account of Bronze Age Aegean culture, especially well illustrated. The author includes an interesting account of his own excavations in Crete.
- Willetts, R. F. (1977). *The civilization of ancient Crete*. London: Methuen. Deals with the Minoans and their successors on Crete and concludes with a section on Crete in the twentieth century.

ONLINE CHAPTER LINKS

Convert any English word to hieroglyphics at http://www.tourism.egnet.net/cafe/tor_trn.htm

An extensive listing of Egyptian rulers is available at

http://www.touregypt.net/kings.htm

To investigate recent excavations at the Great Pyramids and the Sphinz at Giza, visit the *Pyramids*: *The Inside Story* at

http://www.pbs.org/wgbh/nova/pyramid/

Links to a large number of Internet resources related to the pyramids are available at http://guardians.net/egypt/pyramids.htm

Links to a large number of Internet resources related to the Sphinx are available at http://www.guardians.net/egypt/sphinx/

Links to a large number of Internet resources related to Egyptian mummies are available at http://guardians.net/egypt/mummies.htm

Links to a large number of Internet resources related to the hieroglyphs are available at http://guardians.net/egypt/hiero.htm

The Ancient Egypt site at http://www.geocities.com/amenhotep.geo/lets visitors explore more than 3,000 years of Ancient Egyptian history and also offers categorized links to other Internet sites related to this

Visit these Web sites for extensive information about the mummification process, plus a key to hieroglyphs, a timeline, and links to other related Web sites.

Mummies of the World at

subject.

http://www.pbs.org/wgbh/nova/peru/mummies/index.html

Visit Mummies of Ancient Egypt at www.si.umich.edu/CHICO/mummy

Funerary Beliefs Connected with Mummification at http://touregypt.net/historicalessays/mummyessay.htm

		GENERAL EVENTS	LITERATURE & PHILOSOPHY	Art
	3000			
Щ	MYCENAEAN 99	c. 1184 Fall of Troy		
BRONZE AG	DARK AGE	1100 Collapse of Mycenaean Empire	,	
	Heroic Age	 1000 Development of Iron Age culture at Athens 800-700 Greeks begin colonizing in East and Italy 776 First Olympic Games c. 775 First Greek colony in Italy founded at Pithekoussai 	c. 900 – 700 Evolution of Homeric epics <i>Iliad</i> and <i>Odyssey</i>8th cent. Hesiod, <i>Works and Days</i> and <i>Theogony</i>	 1000-900 Protogeometric pottery decoration: bold circular shapes similar to Mycenaean motifs 900-700 Geometric pottery decoration: linear designs of zigzags, triangles, diamonds, meanders
	AGE OF COLONIZATION	750–600 Greeks found colonies throughout Mediterranean, from Egypt to Black Sea	 c. 700 Greeks adapt Phoenician alphabet for their own language c. 650 Archilochus, earliest Greek lyric poet, active 	 8th cent. Geometric pottery incorporates stylized human figure in painted design; Dipylon amphora c. 650 Large freestanding sculpture evolves late 7th cent. Orientalizing styles in vase painting; Corinthian aryballos c. 600 New York Kouros; Athenians develop narrative style in blackfigure vase painting; increased naturalism in Greek art
IRON AGE	AR	 c. 590 Solon reforms Athenian constitution 546 Rule of Pisistratus begins growth of Athenian power; Persian Empire expands to take over Greek colonies in Asia Minor 510 Restoration of democracy at Athens 490 Start of the Persian Wars; forces of King Darius defeated at Marathon 	 early 6th cent. Sappho, Poems 6th cent. Development of Presocratic schools of philosophy: Materialists, Pythagoreans, Dualists, Atomists c. 540-480 Heraclitus of Ephesus teaches his theory of "impermanence" late 6th cent. Playwriting competition begins after 525 First official version of Homeric epics written 	 c. 550 Calf-Bearer c. 530 Anavysos Kouros; Peplos Kore c. 525 Exekias, The Suicide of Ajax, amphora late 6th cent. Red-figure style of vase painting introduced; Euphronios Vase, krater c. 490 Kritios Boy; turning point between Archaic and Classical periods
	CLASSICAL PERIOD	 480 Xerxes leads a second expedition against Greece; wins battle of Thermopylae and sacks Athens; Greeks defeat Persians decisively at Salamis 479 Greek victories at Plataea and Mycale end Persian Wars 	c. 475 Parmenides writes on his theory of knowledgec. 440 Herodotus begins <i>History of the Persian Wars</i>	

323

Most dates are approximate

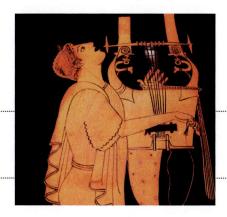

Early music primarily vocal with instrumental accompaniment; use of flute and simple lyre popular

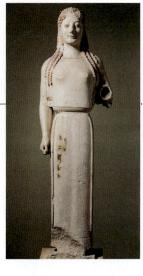

c. 600 Form of Doric temple fully established, derived from early wooden structures; Temple of Hera at Olympia

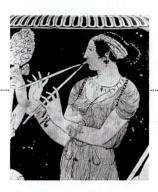

- **7th cent.** Development of aulos (double flute), used to accompany songs
- **c. 675** Terpander of Lesbos introduces cithara

 c. 550 Pythagoras discovers numerical relationship of music harmonies and our modern musical scale

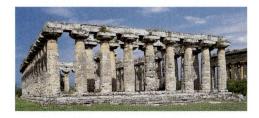

c. 540 Temple of Apollo at Corinth

c. 550 Basilica at Paestum

c. 500 Temple of Aphaia, Aegina

5th cent. First widespread use of Ionic order

late 5th cent. Earliest surviving fragment of Greek music

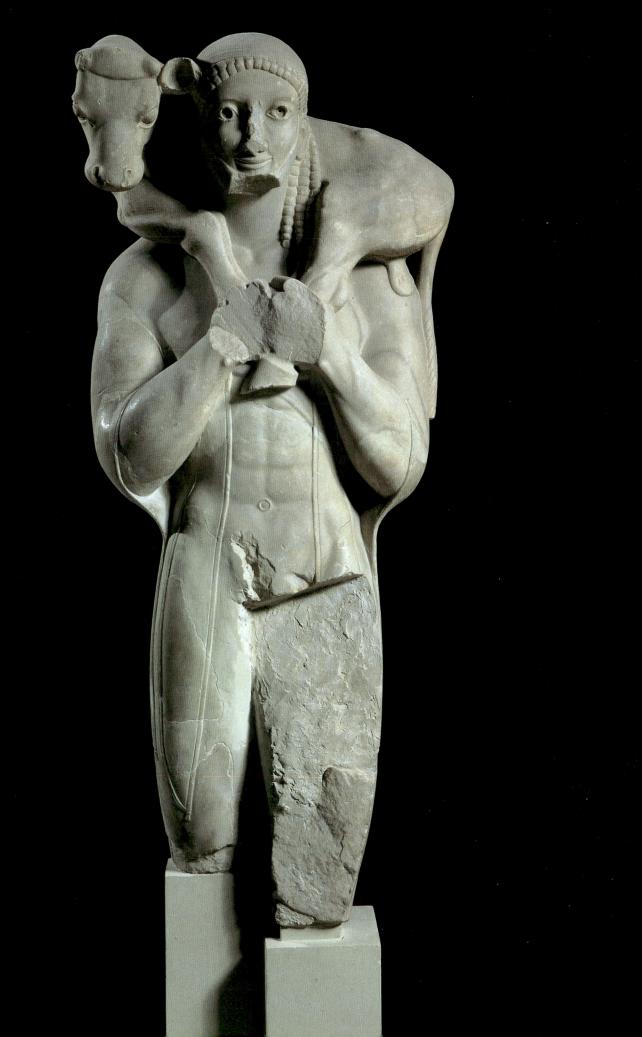

CHAPTER 2 EARLY GREECE

ne of the major turning points of history is the period around 1000 B.C., the change from the Bronze Age to the Iron Age throughout the Mediterranean area. In the following centuries a culture developed in a small corner of southeastern Europe—Greece—which was to form the foundation of Western civilization. By the fifth century B.C. this culture had produced one of the greatest eras of human achievement.

In certain basic ways, of course, there was some continuity between the Bronze Age and the Iron Age. For example, Athens, which in the fifth century B.C. became the intellectual center of Classical Greece, had been a Mycenaean city long before the Iron Age began. In most significant respects, however, the Iron Age Greeks had to discover for themselves almost all the cultural skills associated with civilization—the visual arts, architecture, literature, philosophy, even the art of writing. The Mycenaeans had known how to write and build and create art. However, their abrupt and violent end around 1100 B.C. was followed by a century of disturbance and confusion that cut off the Bronze Age from the new world of the Iron Age. To follow the first attempts of these Iron Age people to develop an artistic style, organize their societies, and question the nature of the universe is to witness the birth of Western culture.

The history of early Greece falls naturally into three periods, each marked by its own distinctive artistic achievement. During the first three hundred years or so of the Iron Age, development was slow and the Greeks had only limited contact with other Mediterranean peoples. During this period the first great works of literature were created: the epic poems known as the *Iliad* and the *Odyssey*. Because these works treat heroic themes, the early Iron Age in Greece is sometimes known as the Heroic Age. The visual art of the period used a style known as Geometric.

http://www.velocity.net/~jutman/homersgreece.htm

Homer's Greece

By the beginning of the eighth century B.C. Greek travelers and merchants had already begun to explore the

lands to the east and west. In the next one hundred fifty years (c. 750–600 B.C.), called the Age of Colonization, many new ideas and artistic styles were brought to Greece. These foreign influences were finally absorbed in the third era of early Greece known as the Archaic period (c. 600–480 B.C.). This period, the culmination of the first five hundred years of Greek history, paved the way for the Classical period (discussed in Chapter 3). The Greeks' relationship to the world around them took a decisive turn at the very end of the Archaic period with their victory over the Persians in the wars that lasted from 490 to 479 B.C. The events of the Persian Wars thus end this chapter.

HOMER AND THE HEROIC AGE

During the Mycenaean period most of Greece had been united under a single influence. When the Mycenaeans fell, however, Greece split up into a series of independent regions that corresponded to the geographically separated areas created by the mountain ranges and high hills that crisscross the terrain. Within each of these geographically discrete areas there developed an urban center that controlled the surrounding countryside. Thus Athens became the dominating force in the geographical region known as Attica; Thebes controlled Boeotia; Sparta controlled Laconia; and so on (see map, "Ancient Greece"). A central urban community of this kind was called by the Greeks of a later period a *polis*, a term generally translated as "city-state."

The polis served as focal point for all political, religious, social, and artistic activities within its region. Its citizens felt toward their own individual city a loyalty that was far stronger than any generalized sense of community with their fellow Greeks over the mountains. Each of the leading cities developed its own artistic style, which led to fierce competition and in time to bitter and destructive rivalries. The polis was therefore both the glory and the ruin of Greek civilization, producing on the one hand an unequaled concentration of intellectual and cultural development, and on the other a tendency to internal squabbling at the least provocation.

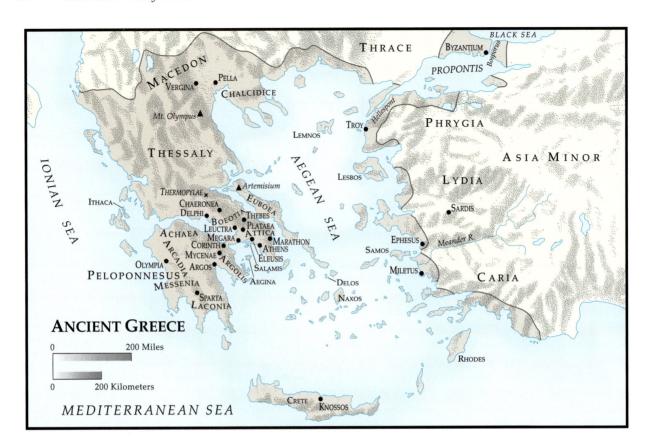

The fragmentation of social and cultural life had a marked effect on the development of Greek mythology and religion. Religion played an important part in Greek life, as Greek art and literature demonstrate, but it was highly different in nature from the other systems of belief that influenced our culture, Judaism and Christianity. For one thing, Greek mythology offers no central body of information or teaching corresponding to the Old Testament or New Testament. Often there are varying versions of the same basic story; even when these versions do not actually contradict one another, they are difficult to reconcile. For another thing, the very characters of the Greek gods and goddesses often seem confused and selfcontradictory. For example, Zeus, president of the Immortals and father of gods and humans, generally represented the concept of an objective moral code to which both gods and mortals were expected to conform; Zeus imposed justice and supervised the punishment of wrongdoers [2.1]. Yet this same majestic ruler was also involved in many love affairs and seductions, in the course of which his behavior was often undignified and even comical. How could the Greeks have believed in a champion of morality whose own moral standards were so lax?

The answer lies in the fact that Greek myth and religion of later times consist of a mass of folktales, primitive customs, and traditional rituals that grew up during the Heroic Age and were never developed into a single unified system. Individual cities had their own mytho-

logical traditions, some of them going back to the Bronze Age, others gradually developing under the influence of neighboring peoples. Poets and artists felt free to choose the versions that appealed to their own tastes or helped them to express their ideas. Later Greeks, it is true, tried to organize all these conflicting beliefs into something resembling order. Father Zeus ruled from Mount Olympus, where he was surrounded by the other principal Olympian deities. His wife Hera was the goddess of marriage and the protectress of the family. His daughter Athena symbolized intelligence and understanding. Aphrodite was the goddess of love, Ares, her lover, the god of war, and so on. But the range and variety of the Greek imagination defied this kind of categorization. The Greeks loved a good story, and so tales that did not fit the ordered scheme continued to circulate.

http://www.goddess-athena.org

Shrine to Athena

These contradictions were, of course, perfectly apparent to the Greeks themselves, but they used their religion to illuminate their own lives, rather than to give them divine guidance. One of the clearest examples is the contrast that Greek poets drew between the powers of Apollo and Dionysus, two of the most important of their gods. Apollo represented logic and order, the power of

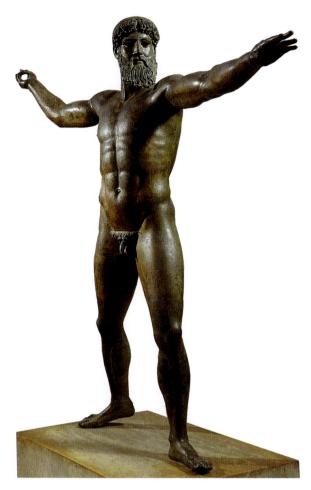

2.1 Zeus (Poseidon?), c. 465 B.C. Bronze, height 6'10" (2.08 m). National Archaeological Museum, Athens. Whether this striding god is Zeus or Poseidon, god of the sea, the combination of majestic dignity and physical strength reflects the Greeks' view of their gods as superior beings with definitely human attributes. This statue, found in the sea off Cape Artemisium, comes from the end of the period covered in this chapter; it may have been intended to commemorate the Greek victory over the Persians.

the mind; Dionysus was the god of the emotions, whose influence, if excessive, could lead to violence and disorder. By worshiping both these forces, the Greeks were acknowledging an obvious dual existence in human nature and trying to strike a prudent balance.

The Greek deities served many purposes, therefore, but these purposes were very different from those of the other Western religions. No Greek god, not even Zeus, represents supreme good. At the other end of the moral scale, there is no Greek figure of supreme evil corresponding to the Christian concept of Satan. The Greeks turned to their deities for explanations of both natural phenomena and psychological characteristics they recognized in themselves. At the same time they used their gods and goddesses as yet another way of enhancing the glory of their individual city—states, as in the case of the cult of Athena at Athens. Problems of human morality required human, rather than divine, solutions. The

Greeks turned to art and literature, rather than prayer, as a means of trying to discover them (Table 2.1).

At the beginning of Greek history stand two epic poems, which even the quarrelsome Greeks themselves saw as national—indeed universal—in their significance. The *lliad* and the *Odyssey* have, from that early time, been held in the highest esteem. Homer, their accepted author, is generally regarded as not only the first figure in the Western literary tradition but also one of the greatest. Yet even though Homer's genius is beyond doubt, little else about him is clear. In fact, the many problems and theories connected with the Homeric epics and their creator are generally summed up under the label "the Homeric Question."

The ancient Greeks themselves were not sure who had composed the *lliad* and the *Odyssey*, when and where the author had lived, or even if one person was responsible for both of them. In general, tradition ascribed the epics to a blind poet called Homer; almost every city worthy of the name claimed to be his birthplace. Theories about when he had lived ranged from the time of the Trojan War, around 1250 B.C., to 500 years later.

The problem of who Homer was, and even whether he existed at all, continues to vex scholars to this day. In any case, most experts would probably now agree that the creation of the *Iliad* and the *Odyssey* was a highly complex affair. Each of the epics consists basically of a number of shorter folktales that were combined, gradually evolving over a century or more into the works as we now know them.

These epic poems were almost certainly composed and preserved at a time before the introduction of writing in Greece by individuals who passed them down by word of mouth. Professional bards—storytellers—probably learned a host of ready-made components: traditional tales, stock incidents, and a whole catalog of repeated phrases and descriptions. In the absence of any written text the works remained fluid, and individual

TABLE 2.1 Principal Greek Deities

Zeus	Father of Gods and Men
Hera	Wife of Zeus, Queen of Heaven
Poseidon	Brother of Zeus, God of the Sea
Hephaestus	Son of Zeus and Hera, God of Fire
Ares	God of War
Apollo	God of Prophecy, Intellect, Music, and
	Medicine
Artemis	Goddess of Chastity and the Moon
Demeter	Earth Mother, Goddess of Fertility
Aphrodite	Goddess of Beauty, Love, and Marriage
Athena	Goddess of Wisdom
Hermes	Messenger of the Gods, God of
	Cleverness
Dionysus	God of Wine and the Emotions

reciters would bring their own contributions. On the other hand, both the Homeric epics show a marked unity of style and structure.

The first crystallization of these popular stories had probably occurred by around 800 B.C., but the poems were still not in their final form for more than a century. The first written official version of each epic was probably not made before the late sixth century B.C. The edition of the poems used by modern scholars was made by a scribe working at Alexandria in the second century B.C.

Where, then, in this long development must we place Homer? He may perhaps have been the man who first began to combine the separate tales into a single whole; or perhaps he was the man who, sometime after 800 B.C., imposed an artistic unity on the mass of remembered folk stories he had inherited. The differences between the Iliad and the Odyssey have suggested to a number of commentators that a different "Homer" may have been responsible for the creation or development of each work, but here we enter the realm of speculation. Perhaps after all it would be best to follow the ancient Greeks themselves, contenting ourselves with the belief that at some stage in the evolution of the poems they were filtered through the imagination of the first great genius of the Western literary tradition, without being too specific about which stage it was.

Both works show evidence of their long evolution by word of mouth. All the chief characters are given standardized descriptive adjectives as "epithets" that are repeated whenever they appear: Achilles is "swift-footed" and Odysseus "cunning." Phrases, lines, and entire sections are often repeated. There are also minor inconsistencies in the plots.

Further, the heroic world of warfare is made more accessible to the poem's audience by the use of elaborate similes that compare aspects of the story to everyday life in the early Iron Age—the massing of the Greek forces, for example, is likened to a swarm of flies buzzing around pails of milk.

Although the two poems are clearly of a single tradition, they are very different in spirit. The *Iliad* is somber, taut, direct. The concentration of its theme makes it easier to understand, and certainly easier to explain, than the more digressive and lighthearted *Odyssey*. But the *Odyssey* is certainly not a lesser work; if anything, its range and breadth of humanity are even greater, and its design more elaborate.

The action of the *Iliad* takes place during the final year of the Greeks' siege of Troy, or Ilium. Its subject is only indirectly concerned with the Trojan War, however, and the poem ends before the episode of the wooden horse and the fall of the city. Its principal theme is stated in the opening lines of Book I, which establish the tragic mood of the work. Here the poet invokes the goddess of poetic inspiration: "Sing, goddess, of the anger of Peleus' son Achilles, which disastrously inflicted countless sufferings

on the Greeks, sending the strong souls of many heroes to Hades and leaving their bodies to be devoured by dogs and all birds. . . ."

The subject of the *Iliad*, then, is the anger of Achilles and its consequences. Its message is a direct one: We must be prepared to answer for the results of our own actions and realize that when we act wrongly we will cause suffering both for ourselves and, perhaps more important, for those we love. Although the setting of the Iliad is heroic, even mythic, the theme of human responsibility is universal. This relevance to our own experience is underlined by the realism in the scenes of battles and death, which are characteristic of epic literature's interest in heroic warfare. The story of Achilles' disastrous mistake is told in a basically simple and direct narrative. It begins with a quarrel between Agamemnon, commander-inchief of the Greek forces; and Achilles, his powerful ally, who resents Agamemnon's overbearing assertion of authority. After a public argument, Achilles decides to punish Agamemnon by withdrawing his military support and retiring to his tent, in the hope that without his aid the Greeks will be unable to overcome the Trojans. In the battles that follow he is proved correct; the Trojans inflict a series of defeats on the Greeks, killing many of their leading warriors.

Agamemnon eventually (Book IX) admits that he behaved too highhandedly and offers Achilles, through intermediaries, not only a handsome apology but a generous financial inducement to return to the fighting and save the Greek cause. Achilles, however, rejects this attempt to make amends and stubbornly nurses his anger as the fighting resumes and Greek casualties mount. Then his dearest friend Patroclus is killed by the Trojan leader Hector, son of their king (Book XVI). Only now does Achilles return to battle, his former anger against Agamemnon now turned against the Trojans in general and Hector in particular.

After killing Hector in single combat (Book XXII), Achilles abuses Hector's corpse in order to relieve his own sense of guilt at having permitted Patroclus' death. Finally, Priam, the old king of Troy, steals into the Greek camp by night to beg for the return of his son's body (Book XXIV). In this encounter with Priam, Achilles at last recognizes and accepts the tragic nature of life and the inevitability of death. His anger melts and he hands over the body of his dead enemy. The *Iliad* ends with the funeral rites of Hector, "tamer of horses."

As is clear even from this brief summary, there is a direct relationship between human actions and their consequences. The gods appear in the *Iliad* and frequently play a part in the action, but at no time can divine intervention save Achilles from paying the price for his unreasonable anger. Furthermore, Achilles' crime is committed not against a divine code of ethics but against human standards of behavior. All his companions, including Patroclus, realize that he is behaving unreasonably.

VALUES

Destiny

Like most peoples since them, the Greeks had conflicting ideas on how much of human life was preordained by some force in the universe, which they called Fate, or Destiny. In one passage, Homer speaks of the three Fates, or Moirai, goddesses who govern the thread of life for each individual person. Lachesis assigns each person's lot at birth, Clotho spins the thread of life, and Atropos—her name means "she who cannot be turned—cuts the thread at the moment of death.

Neither Homer himself or later Greeks seemed very clear on how the Fates related to the other gods. One author, Hesiod, describes them as the daughters of Zeus and Themis (Righteousness), while Plato calls them the daughters of Ananke (Necessity). Sometimes Fate is a force with unlimited power over all humans and deities, and Zeus performs its commands; on other occasions Zeus can change the course of Destiny, and even humans sometimes succeed in reversing their fate.

The Greeks also acknowledged another force operating in their lives, that of pure random chance, which

they symbolized by the goddess Tyche, or Fortune. Tyche can award lavish benefits, but she does so at random. Her symbols—wings, a wheel, a revolving ball—convey her variability. With the general decline of traditional religious beliefs in later Greek history, Tyche became revered as one of the most powerful forces in the universe.

Although the Romans adopted the Greek Moirai in the form of the Parcae, they paid far more attention to the notion of luck, worshiped as Fortuna. In art, Fortuna was represented like Tyche, but the Roman goddess appeared in a wide variety of forms: Fortuna liberum (of children), Fortuna redux (assuring a safe return from a journey), Fortuna privata (of family life), and many more. In the early second century A.D., the Roman emperor Trajan founded a special temple in honor of Fortuna as the all-pervading power of the world.

From its earliest beginnings, therefore, the Greek view of morality is in strong contrast to the Judeo-Christian tradition. At the center of the Homeric universe is not God but human beings, who are at least partly in control of their own destiny. If they cannot choose the time when they die, they can at least choose how they live. The standards by which human life will be judged are those established by one's fellow humans. In the Iliad the gods serve as divine "umpires." They watch the action and comment on it and at times enforce the rules, but they do not affect the course of history. Humans do not always, however, fully realize the consequences of their behavior. In fact, they often prefer to believe that things happen "according to the will of the gods" rather than because of their own actions. Yet the gods themselves claim no such power. In a remarkable passage at the beginning of Book I of the *Odyssey* we see the world for a moment through the eyes of Zeus as he sits at dinner on Mount Olympus: "How foolish men are! How unjustly they blame the gods! It is their lot to suffer, but because of their own folly they bring upon themselves sufferings over and above what is fated for them. And then they blame the gods." These are hardly words we can imagine coming from the God of the Old Testament.

The principal theme of the *Odyssey* is the return home of the Greek hero Odysseus from the war against Troy. Odysseus' journey, which takes ten years, is filled with adventures involving one-eyed giants, monsters of various kinds, a seductive enchantress, a romantic young girl, a floating island, a trip to the underworld, and many

other fairytale elements. Into this main narrative is woven a description of the wanderings of Odysseus' son, Telemachus, who, searching for his missing father, visits many of the other Greek leaders who have returned safely from Troy.

In the last half of the poem Odysseus finally returns home in disguise. Without revealing his identity to his ever-faithful wife Penelope, he kills the suitors who have been pestering her for ten years to declare her husband dead and remarry. Homer keeps us waiting almost to the very end for the grand recognition scene between husband and wife. All ends happily, with Penelope, Odysseus, and his aged father Laertes peacefully reunited.

It is worth examining the Homeric world at some length, because the *Iliad* and the *Odyssey* formed the basis of education and culture throughout the Greek and Roman world; children learned the two poems by heart at school. Ideas changed and developed, but reverence for Homer remained constant.

ART AND SOCIETY IN EARLY GREECE

Geometric Art

Our impressions of the first three hundred years of Greek art (1000–700 B.C.) are based largely on painted pottery, hardly a major art form even in later times, for

little else has survived. Of architecture there is almost no trace. Although small bronze and ivory statuettes and relief plaques were being made from the ninth century B.C. on, the earliest surviving large stone sculptures date to the mid-seventh century B.C.

Painted vases are therefore our major source of information about artistic developments. It comes as something of a surprise to find that Homer's contemporaries decorated their pots with abstract geometric designs, with no attempt at the qualities most typical of their literature: vividness and realism. This style has given its name to the two subdivisions of the period, the Protogeometric (1000–900 B.C.) and the Geometric (900–700 B.C.).

For the first hundred years, artists decorated their vases with simple, bold designs consisting mainly of concentric circles and semicircles [2.2]. In some ways this period represents a transition from the end of the Mycenaean age, but the memory of Mycenaean motifs soon gave way to a new style. If Protogeometric pottery seems a long way from Greek art of later centuries, it does show qualities of clarity and order that reappear later, although in a very different context.

2.2 Protogeometric amphora, c. 950 B.C. Height $21^{3}/_{4}$ " (56 cm). Kerameikos Museum, Athens. Photo DAI Athens, Ker 7750. The circles and semicircles typical of this style were drawn with a compass.

In the Geometric pottery of the following two centuries (900–700 B.C.) the use of abstract design continued, but the emphasis changed. Circles and semicircles were replaced by linear designs, zigzags, triangles, diamonds, and above all the *meander* (a maze pattern). There is something strangely obsessive about many of these vessels—a sense of artists searching for a subject, meanwhile working out over and over the implications of mathematical formulas. Once again we seem a long way from the achievements of later Greek artists, with their emphasis on realism, yet precise mathematical relationships lie behind the design of much of the greatest Greek art.

By the eighth century B.C., artists had begun to find their way toward the principal subject of later Greek art: the human form. Thus human and animal figures begin to appear among the meanders and zigzags. This is a moment of such importance in the history of Western art that we should not take it for granted. We have been so conditioned by the art of the ancient Greeks that from the late Geometric period until our own time Western art has been primarily concerned with the depiction of human beings. Landscapes are a popular subject, it is true, and in contemporary times, art has again become abstract. Yet most paintings and sculptures deal with the human form, treated in a more or less realistic way. This realism may seem so obvious as to be hardly worth stating, but it must be remembered that the art of peoples who were not influenced by the Greeks is very different. Islamic art, for example, deals almost exclusively in abstract design. Indian sculptors depicted their gods and heroes in human form, but they certainly did not treat them realistically. The Hindu god Shiva, for example, is often shown with many arms. It is a tribute to the Greeks' overwhelming influence on our culture that, from the Roman period to the beginning of the twenty-first century, artists have accepted the Greeks' decision to make the realistic treatment of the human form the central focus of art, whether the forms were those of mortal people or divine gods and goddesses.

The Greeks themselves did not achieve this naturalism overnight. The first depictions of human beings, which appear on Geometric vases shortly after 800 B.C., are highly stylized. They are painted in silhouette, and a single figure often combines front and side views, the head and legs being shown in profile while the upper half of the body is seen from the front. A number of the vases decorated with stick figures of this kind are of immense size. One of them, the *Dipylon Amphora*, is almost 5 feet (1.24 meters) tall [2.3]. These vases were set up over tombs to serve as grave markers; they had holes in their bases so that offerings poured into them could seep down to the dead below. The scenes on them frequently show the funeral ceremony. Others show processions of warriors, both on foot and in chariots.

CONTEMPORARY VOICES

Daily Life in the World of Homer

From the description of scenes on the shield of Achilles:

Next he showed two beautiful cities full of people. In one of them weddings and banquets were afoot. They were bringing the brides through the streets from their homes, to the loud music of the wedding-hymn and the light of blazing torches. Youths accompanied by flute and lyre were whirling in the dance, and the women had come to the doors of their houses to enjoy the show. But the men had flocked to the meeting-place, where a case had come up between two litigants, about the payment of compensation for a man who had been killed. The defendant claimed the right to pay in full and was announcing his intention to the people; but the other contested his claim and refused all compensation.

Both parties insisted that the issue should be settled by a referee; and both were cheered by their supporters in the crowd, whom the heralds were attempting to silence. The Elders sat on the sacred bench, a semicircle of polished stone; and each, as he received the speaker's rod from the clear-voiced heralds, came forward in his turn to give his judgment, staff in hand. Two talents of gold were displayed in the center: They were the fee for the Elder whose exposition of the law should prove the best.

Homer, Iliad, trans. E. V. Rieu (Baltimore: Penguin, 1950), Book XVII, p. 349.

THE AGE OF COLONIZATION

Throughout the period of Homer and Geometric art, individual city-states were ruled by small groups of aristocrats who concentrated wealth and power in their own hands. Presumably, it is their graves that were marked with great amphoras like the *Dipylon* vase. By the eighth century B.C., however, two centuries of peace had allowed the individual city-states to become quite prosperous. The ruling classes became increasingly concerned with the image of their city-states. They began to function as patrons of the arts as well as military leaders. Great international festivals began to develop at Olympia, Delphi, and other sacred sites, at which athletes and poets—representing their city—would compete against one another.

During the seventh century, as trade with both fellow Greeks and other Near Eastern peoples increased, economic success became a crucial factor in the growth of a *polis*; individual cities began to mint their own coins shortly before 600 B.C. Yet political power remained in the hands of a small hereditary aristocracy, leaving a growing urban population increasingly frustrated. Both the accumulation of wealth and the problem of overpopulation produced a single result: colonization.

Throughout the eighth and seventh centuries B.C., enterprising Greeks went abroad either to make their fortunes or to increase them. To the west, Italy and Sicily were colonized and Greek cities established there. Some of these, like Syracuse in Sicily or Sybaris in southern Italy, became even richer and more powerful than the mother cities from which the colonizers had come. Unfortunately if inevitably, the settlers took with them not only the culture of their polis but also their intercity

2.3 *Dipylon Amphora*, c. 750 B.C. Height 4'11" (1.24 m). National Archaeological Museum, Athens. This immense vase originally was a grave marker. The main band, between the handles, shows the lying-in-state of the dead man on whose grave the vase stood; on both sides of the bier are mourners tearing their hair in grief. Note the two bands of animals, deer and running goats, in the upper part of the vase.

rivalries, often with disastrous results. To the south and east, cities were also established in Egypt and on the Black Sea.

The most significant wave of colonization was that which moved eastward to the coast of Asia Minor, in some cases back to territory that had been inhabited by the Mycenaeans centuries earlier. From here the colonizers established trade contacts with peoples in the ancient Near East, including the Phoenicians and the Persians. Within Greece itself the effect on art and life of this expansion to the east was immense. After almost three hundred years of cultural isolation, in a land cut off from its neighbors by mountains and sea, the Greeks were brought face to face with the immensely rich and sophisticated cultures of the ancient Near East. Oriental ideas and artistic styles were seen by the colonizers and carried home by the traders. A growing quantity of Eastern artifacts, ivories, jewelry, and metalwork was sent back to the mother cities and even to the Greek cities of Italy. So great was the impact of Near Eastern art on the Greeks from the late eighth century to around 600 B.C. that this period and its style are generally known by the name Orientalizing.

THE VISUAL ARTS AT CORINTH AND ATHENS

Different Greek cities reacted to Oriental influences in different ways, although all were strongly influenced. In particular, the growing hostility between the two richest city—states—Athens and Corinth—which two centuries later led to the Peloponnesian War and the fall of Athens, seems already symbolized in the strong differences between their Orientalizing pottery. The Corinthian artists developed a miniature style that made use of a wide variety of Eastern motifs—sphinxes, winged human figures, floral designs—all of which were arranged in bands covering almost the entire surface of the vase. White, yellow, and purple were often used to highlight details, producing a bold and striking effect. After the monotony of Geometric pottery the variety of subject and range of color come as a welcome change.

The small size of the pots made them ideal for export. Corinthian vases have in fact been discovered not only throughout Greece but also in Italy, Egypt, and the Near East. Clearly, any self-respecting woman of the seventh century B.C. wanted an elegant little Corinthian flask [2.4] for her perfume, oil, or makeup. The vases are well made, the figures lively, and the style instantly recognizable as Corinthian—an important factor for commercial success. Corinth's notable political and economic strength throughout the seventh and early sixth centuries B.C. was, in fact, built on the sale of these little pots and their contents.

2.4 Aryballos, Middle Corinthian, c. 625 B.C. State Museums, Berlin. The black-figure techniques and the very Eastern-looking panther are characteristic of the Orientalizing style. Also characteristic are the flowerlike decorations, which are blobs of paint scored with lines. The musculature and features of the panther are also the result of scoring.

In Athens, potters were slower to discard the effects of the Geometric period and less able to develop an all-purpose style like the Corinthian. The vases remain large and the attempts to depict humans and animals are often clumsy. The achievements of later Athenian art are

2.5 Attic Black-figure krater (the "François Vase") by Clitias and Ergotimos, c. 575 B.C. Archaeological Museum, Florence.

nonetheless clearly foreshadowed in the vitality of the figures and the constant desire of the artists to illustrate events from mythology [2.5] or daily life rather than simply to decorate a surface in the Corinthian manner.

By 600 B.C., the narrative style had become established at Athens. As the Athenians began to take over an increasing share of the market for painted vases and their contents, Corinth's position declined, and the trade rivalry that later had devastating results began to develop.

THE BEGINNINGS OF GREEK SCULPTURE

The influence of Near Eastern and Egyptian models on Greek sculpture and architecture is more consistent and easier to trace than that of pottery. The first Greek settlers in Egypt were given land around the mid-seventh century B.C. by the Egyptian pharaoh Psammetichos I. It is surely no coincidence that the earliest Greek stone sculptures, which date from about the same period, markedly resemble Egyptian cult statues and were placed in similarly grandiose temples. (The earliest surviving temple, that of Hera at Olympia, dates at least in part to this period.) These stone figures consist of a small number of subjects repeated over and over. The most popular were the standing female, or kore, clad in drapery [2.6]; and the standing male, or kouros, always shown nude [2.7]. This nudity already marks a break with the Egyptian tradition in which figures wore loincloths and foreshadows the heroic male nudity of Classical Greek art. The stance of the kouros figures, however, was firmly based on Egyptian models. One foot (usually the left) is forward, the arms are by the sides, and the hands are clenched. The elaborate wiglike hair is also Egyptian in inspiration.

By 600 B.C., only a few years after the first appearance of these statues, Greek art had reached a critical stage. After the slow and cautious progress of the Geometric period, the entire character of painting and sculpture had changed and, within the century following 700 B.C., Greek artists had abandoned abstract design for increasing realism. At this point in their development the Greek spirit of independence and inquiry asserted itself. Instead of following their Eastern counterparts and repeating the same models and conventions for centuries, Greek painters and sculptors allowed their curiosity to lead them in a new direction, one that changed the history of art. The early stone figures and painted silhouettes had represented human beings, but only in a schematic, stylized form. Beginning in the Archaic period artists used their work to try to answer such questions as: What do human beings really look like? How do perspective and foreshortening work? What in fact is the true nature of appearance? For the first time in history

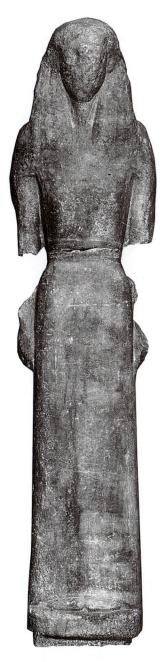

2.6 Kore from Delos, dedicated by Nikandre, c. 650 B.C. Marble, National Archaeological Museum, Athens. Photo DAI Athens, Hege 1100. Unlike the kouros, the figure is completely clothed, although both have the same rigid stance, arms by sides, and wiglike hair.

artists began to reproduce the human form in a way true to nature rather than merely to echo the achievements of their predecessors.

Sculpture and Painting in the Archaic Period

It is tempting to view the works of art and literature of the Archaic period (600–480 B.C.) as steps on the road that leads to the artistic and intellectual achievement in

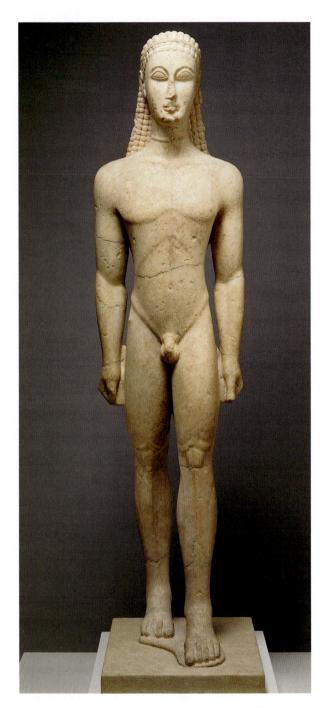

2.7 *Kouros*, from Attica, c. 600 B.C. Marble, height $6'1^{1}/_{2}''$ (1.87 m). The Metropolitan Museum of Art, Fletcher Fund, 1932.

the Classical Age of the fifth and fourth centuries B.C. rather than to appreciate them for their own qualities. This would be to underestimate seriously the vitality of one of the most creative periods in the development of our culture. In some ways, in fact, the spirit of adventure, of striving toward new forms and new ideas, makes the Archaic achievement more exciting, if less perfected, than that of the Classical period. It is better to travel hopefully than to arrive, as Robert Louis Stevenson put it.

The change in Archaic art is a reflection of similar social developments. The hereditary aristocrats were beginning to lose their commanding status. At Athens, Solon (c. 639-559 B.C.), the legislator and poet, reformed the legal system in 594 B.C., and divided the citizens into four classes; members of all four could take part in the debates of the Assembly and sit in the law courts. In place of the old aristocratic clans, a new class of rich merchant traders, who had made their fortunes in the economic expansion, began to dominate, winning power by playing on the discontent of the oppressed lower classes. These new rulers were called "tyrants," although the word had none of the unfavorable implications it now has. Many of them were in fact patrons of the arts. The most famous of them all was Pisistratus, who ruled Athens from 546 until 528 B.C. Clearly, revolutions like those that brought him and his fellow tyrants to power were likely to produce revolutionary changes in the arts.

In sculpture there was an astounding progress from the formalized *kouroi* of the early Archaic period, with their flat planes and rigid stances, to the fully rounded figures of the late sixth century, toward the end of the period. Statues like the *Anavysos Kouros* [2.8] show a careful study of the human anatomy. The conventions remain the same, but the statues have a new life and vigor.

Although most of the male figures are shown in the traditional stance, there are a few important exceptions. The finest is perhaps the famous *Calf-Bearer* [2.9] from the Athenian Acropolis (the hill that dominated the center of ancient Athens). The essential unity between man and beast is conveyed simply but with great feeling by the diagonals formed by the man's hands and the calf's legs and by the alignment of the two heads.

The finest female figures of the period also come from the Acropolis. The Persians broke them when they sacked Athens in 480 B.C., and then the Athenians buried them when they returned to their city the next year after defeating the Persians. Rediscovered by modern excavators, the statues are among the most impressive of Archaic masterpieces. They show a gradual but sure development from the earliest *korai* (the plural form of *kore*) to the richness and variety of the work of the late sixth century B.C. [2.10].

In addition to these freestanding figures, two other kinds of sculpture now appeared: large-scale statues made to decorate temples and carved stone slabs. In both cases sculptors used the technique of *relief* carving: Figures do not stand freely, visible from all angles, but are carved into a block of stone, part of which is left as background. In *high relief* the figures project from the background so much as to seem almost three-dimensional. In *low relief* the carving preserves the flat surface of the stone. Temple sculpture or, as it is often called, architectural sculpture, was frequently in high relief, as in the depiction of the decapitation of Medusa from Selinus [2.11]. Individual carved stone slabs are generally in low relief. Most that have survived were used as grave mark-

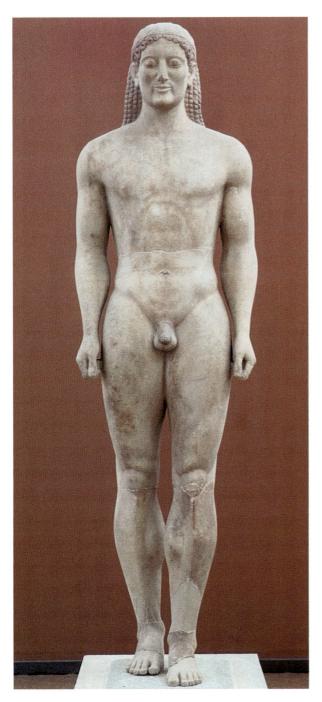

2.8 Kouros from Anavysos, c. 530 B.C. Marble, height 6'4'' (1.93 m) high. National Archaeological Museum, Athens. Note the realism of the muscles and the new sense of power. According to the inscription on the base, this was the funerary monument to a young man, Kroisos, who had died heroically in battle.

ers. The workmanship is often of a remarkable subtlety, as on the grave stele, or gravestone, of Aristion [2.12].

The range of Archaic sculpture is great, and the best pieces communicate something of the excitement of their makers in solving new problems. Almost all of them, however, have in common one feature that often disturbs the modern viewer: the famous "archaic smile." This facial expression, which to our eyes may seem more like a

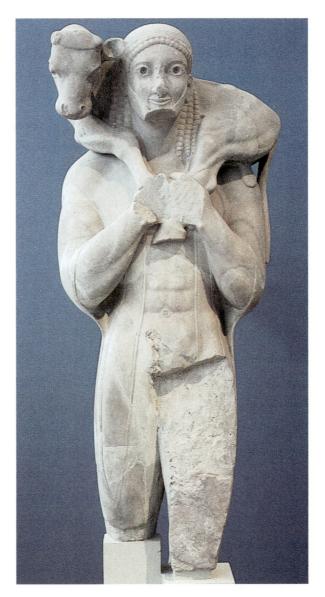

2.9 Calf-Bearer, c. 550 B.C. Marble, height 5'6" (1.65 m). Acropolis Museum, Athens. The archaic smile is softened in this figure. Realism appears in the displacement of the man's hair by the animal's legs and in the expression of the calf.

grimace, has been explained in a number of ways. Some believe that it is merely the result of technical inexperience on the part of the sculptors. Others see it as a reflection of the Archaic Greeks' sense of certainty and optimism in facing a world that they seemed increasingly able to control. Whatever its cause, by the end of the sixth century B.C., and with the increasing threat posed by the Persians, the archaic smile had begun to fade. It was replaced by the more somber expression of works like the Kritios Boy [2.13]. This statue marks a literal "turning point" between the late Archaic world and the early Classical period. For the first time in ancient art the figure is no longer looking or walking straight ahead. The head and the upper part of the body turn slightly; as they do so, the weight shifts from one leg to the other and the hips move. Having solved the problem of

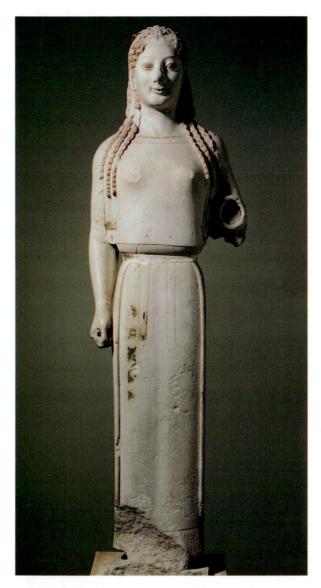

2.10 *Peplos Kore,* from the Acropolis, Athens, c. 530 B.C. Marble, approx. 4' (1.21 m) high. Acropolis Museum, Athens. The statue is identified by the woolen *peplos* (mantle) the woman is wearing over her dress. The missing left arm was extended. The Greeks painted important parts of their stone statues; traces of paint show here.

representing a standing figure in a realistic way, the sculptor has tackled a new and even more complex problem—showing a figure in motion. The consequences of this accomplishment were explored to the full in the Classical period.

By the mid-sixth century B.C. the art of vase painting had also made great progress. Works like those of Exekias, perhaps the greatest of black-figure painters, combine superb draftsmanship and immense power of expression [2.14]. For so restricted a medium, vase painting shows a surprising range. If Exekias' style is serious, somber, sometimes even grim, the style of his contemporary, the Amasis painter, is relaxed, humorous, and charming.

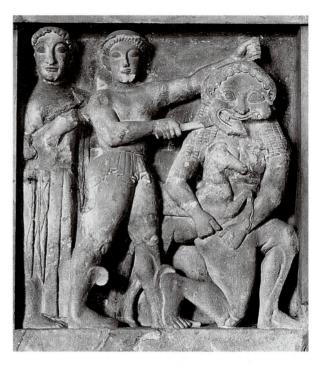

2.11 Metope showing the decapitation of Medusa, Selinus, c. 540 B.C. Archaeological Museum, Palermo. Medusa was a gorgon whose look turned anyone to stone. Perseus is cutting off Medusa's head with the encouragement of Athena, who stands at left. The gorgon's son Pegasus, the winged horse, leaps up at her side. Medusa is shown in the conventional pose indicating rapid motion.

The end of the sixth century B.C. marks a major development in vase painting with the introduction of the new *red-figure style*. This showed the figures in the red color of the clay, with details filled in using a brush. The increased subtlety made possible by this style was used to develop new techniques of foreshortening, perspective, and three-dimensionality.

Although some artists continued to produce black-figure works, by the end of the Archaic period, around 525 B.C., almost all had turned to the new style. The last Archaic vase painters are among the greatest red-figure artists. Works like the *Euphronios Vase* [2.15] have a solidity and monumentality that altogether transcend the usual limitations of the medium.

Architecture: The Doric and Ionic Orders

http://www.cmhpf.org/kids/dictionary/ClassicalOrders.html

Orders of Architecture

In architecture, the Archaic period was marked by the construction of a number of major temples in the Doric

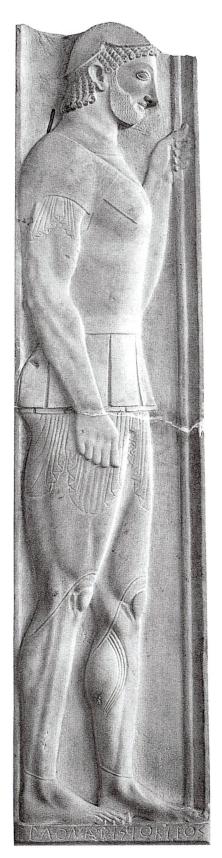

2.12 Aristokles, *Stele of Aristion*, c. 510 B.C. Height without base 8' (2.44 m). National Archaeological Museum, Athens. The leather jacket contrasts with the soft folds of the undershirt.

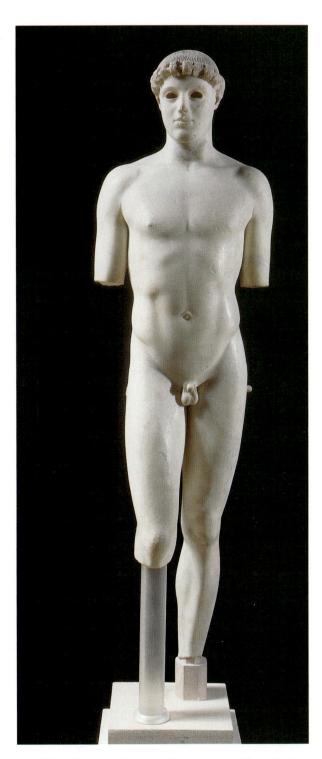

2.13 Kritios Boy, from the Acropolis, Athens, c. 490 B.C. Marble, height 34" (86 cm). Acropolis Museum, Athens. The archaic smile has been superseded by a more natural expression.

style or order. As in the case of sculpture, Egyptian models played an important part in the early development of the Greek style. The first architect in history whose name has come down to us was the Egyptian Imhotep. The earliest Egyptian buildings made use of bundles of

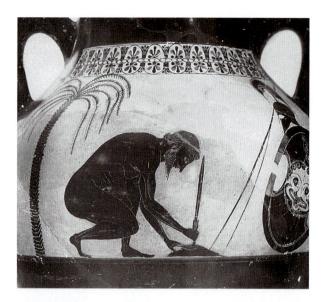

2.14 Exekias, *The Suicide of Ajax*, c. 525 B.C. Black-figure vase, height $21^{1}/_{4}^{w}$ (54 cm). Musée des Beaux-Arts, Boulogne. Ajax buries his sword in the ground so that he can throw himself on to it. The pathos of the warrior's last moments is emphasized by the empty space around him, the weeping tree, and his now useless shield and helmet.

papyrus to form posts; from these there soon developed the stone post-and-lintel constructions characteristic of Egyptian architecture. Buildings in this style probably inspired the first Greek temples.

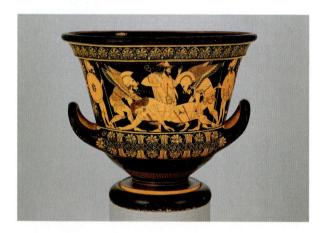

2.15 Euphronios, painter, Euxitheos, potter, red-figure calyx krater, side A, Sarpedon carried by Thanatos and Hypnos, c. 515 B.C. Terra cotta, height of vase 18" (46 cm), diameter 21³/₄" (55 cm). Metropolitan Museum of Art, bequest of Joseph H. Durkee, gift of Darius Ogden Mills, and gift of C. Ruxton Love, by exchange, 1972 (1972.11.10). This masterpiece of red-figure vase painting, generally known as the *Euphronios Vase*, shows the moment when Sarpedon falls in battle during the Trojan War. As his body stiffens in agony, his wounds streaming blood, the twin gods Death (on the right) and Sleep come to his aid. The god Hermes, who leads the souls of the dead to Hades, stands sympathetically behind.

The Doric order seems to have been firmly established by 600 B.C., although none of the earlier examples of the evolving style have survived. Important Doric temples include the Temple of Hera at Olympia, the Temple of Apollo at Corinth, and the earliest of the three Doric temples at Paestum, often called the Basilica (meeting hall), but now known to have been dedicated to the goddess Hera [2.16]. The Ionic style of temple architecture, which was widely used in Classical Greece, did not become fully established until later. In the Archaic period, Ionic buildings were constructed at such sites as Samos and Ephesus, but most Ionic temples date to the fifth century B.C. and later. For the sake of convenience, both the Doric and Ionic orders [2.17] are described here. A later order, the Corinthian, is principally of interest for its popularity with Roman architects and is discussed in that context in Chapter 4.

The Doric order is the simpler and the grander of the two. Some of its characteristics seem directly derived from construction methods used in earlier wooden buildings, and its dignity is perhaps in part related to the length of its history. Doric columns have no base but rise directly from the floor of a building. They taper toward the top and have twenty flutes, or vertical grooves. The capital, which forms the head of each column, consists of two sections, a spreading convex disc (the echinus) and, above, a square block (the abacus). The upper part of the temple, or entablature, is divided into three sections. The lowest, the architrave, is a plain band of rectangular blocks, above which is the frieze, consisting of alternating triglyphs and metopes. The triglyphs are divided by grooves into three vertical bands. The metope panels are sometimes plain, sometimes decorated with sculpture or painting. The building is crowned by a cornice, or projecting upper part, consisting of a horizontal section and two slanting sections meeting at a peak. The long extended triangle thus formed is the pediment, often filled with sculptural decoration.

In contrast, the Ionic order is more graceful and more elaborate in architectural details. Ionic columns rise from a tiered base and have twenty-four flutes. These flutes do not meet at a sharp angle as Doric flutes do but are separated by narrow vertical bands. The capitals consist of a pair of spirals, or *volutes*. The architrave is not flat as in the Doric order but composed of three projecting bands. In place of the Doric triglyphs and metopes is a continuous band often decorated with a running frieze of sculpture.

The two orders produced different effects. The Doric order suggested simple dignity; the absence of decorative detail drew attention to the weight and massiveness of the Doric temple itself. Ionic temples, on the other hand, conveyed a sense of lightness and delicacy by means of ornate decorations and fanciful carving. The surface of an Ionic temple is as important as its structural design.

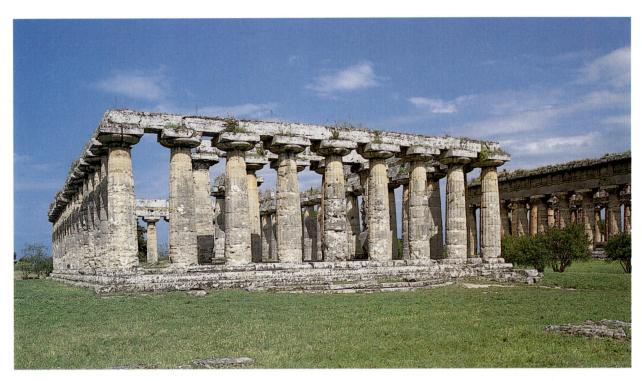

2.16 Basilica at Paestum, c. 550 B.C. This temple to Hera is one of the earliest surviving Greek temples. The bulging columns and spreading capitals are typical of Doric architecture in the period. To the right is the Temple of Neptune.

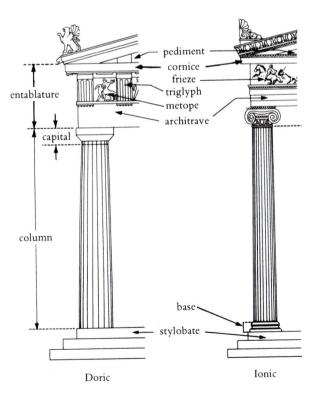

2.17 The Doric and Ionic orders.

Music and Dance in Early Greece

In comparison to the visual arts, the history of Greek music is highly problematic. The very small quantity of evidence is as confusing as it is helpful. Although the frequent references to musical performance make it clear that music played a vital role in all aspects of Greek life, less than a dozen fragments of actual Greek music have survived; the earliest of these dates from the late fifth century B.C. Unfortunately, the problem of understanding the system of notation makes authentic performance of these fragments impossible.

Our inability to recreate even the examples we have is particularly frustrating because from the earliest times music was renowned for its emotional and spiritual power. For the Greeks, music was of divine origin; the gods themselves had invented musical instruments: Hermes or Apollo the lyre, Athena the flute, and so on. Many of the earliest myths told of the powerful effect of music. Orpheus could move trees and rocks and tame wild beasts by his song; the lyre playing of Amphion brought stones to life. Nor was music making reserved for professional performers or women, as so often in later centuries. When, in Book IX of the Iliad, Agamemnon's ambassadors arrive at the tent of Achilles they find the great hero playing a lyre, "clear-sounding, splendid and carefully wrought," and entertaining himself by singing "of men's fame." How one would like to have heard that song!

The Greek belief that music could profoundly affect human behavior meant that it played an important part

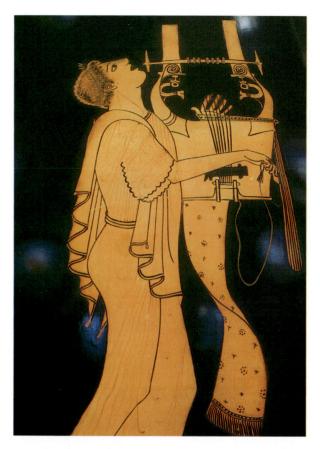

2.18 Berlin painter, detail of red-figure amphora, Nola, c. 490 B.C. Terra cotta, height of vase $16^3/8^{"}$ (42 cm). Metropolitan Museum of Art, New York (Fletcher Fund, 1956). This vase gives a good idea of the Greeks' enthusiasm for music in general and the cithara in particular. The young musician is singing to his own accompaniment.

in both public and private life and was especially important in a religious context. Greek musical theory was later summarized by the two great philosophers of the fourth century B.C., Plato and Aristotle, both of whom discuss the doctrine of *ethos* and give music an important place in their writings. An understanding of doctrines of musical theory was also considered fundamental to a good general education.

Greek music was composed using a series of distinct modes, or scale types, each of which had its own name (see Chap. 3, "Greek Music in the Classical Period"). According to the doctrine of ethos, the characteristic of each mode was so powerful that it gave music written in it the ability to affect human behavior in a specific way. Thus, the *Dorian* mode expressed firm, powerful, even warlike feelings; whereas the *Phrygian* mode produced passionate, sensual emotions. This identification of specific note patterns with individual human reactions seems to reach back to the dawn of Greek music history. The legendary founder of Greek music was Olympus, who was believed by the Greeks to have come from Asia Minor; it is surely

no coincidence that two of the modes—the Phrygian and the Lydian—bear names of places in Asia Minor.

The first figure in music about whose existence we can be relatively certain was Terpander, who came from the island of Lesbos. Around 675 B.C., he used the *cithara*, an elaborate seven-string lyre, to accompany vocal music on ceremonial occasions. The simple lyre, relatively small and easy to hold, had a sounding box made of a whole tortoise shell and sides formed of goat horns or curved pieces of wood. On the other hand, the cithara had a much larger sounding box made of wood, metal, or even ivory, and broad, hollow sides, to give greater resonance to the sound. The player had to stand while performing on it; the instrument had straps to support it, leaving the player's hands free [2.18].

Another musical instrument developed about this time was the *aulos*, a double-reed instrument [2.19] similar to the modern oboe, which according to the traditional account had first been brought into Greece by Olympus. Like the cithara and lyre, the aulos was generally used by singers to accompany their songs.

The little evidence we have suggests that early Greek music was primarily vocal—the instruments were used

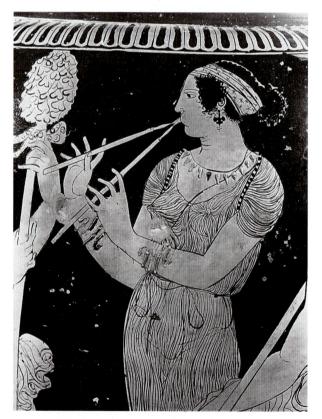

2.19 Karneia painter, detail of red-figure krater, Ceglie del Campo, c. 410 B.C. Terra cotta. Museo Nazionale, Taranto. A young woman plays the aulos for the god Dionysus. The flowing lines of the dress accentuate her figure. The necklace and bracelets are in low relief.

mainly to accompany the singers. The breakthrough into purely instrumental music seems to have come at the beginning of the Archaic period. We know that in 586 B.C. Sacadas of Argos composed a work to be played on the aulos for the Pythian Games at Delphi—a piece that remained well known and popular for centuries. Also, its character confirms the Greek love of narrative, for it described in music Apollo's fight with the dragon that the Pythian Games commemorated. The information is tantalizing indeed, since this first piece of "program music," the remote ancestor of Richard Strauss' *Till Eulenspiegel* and *Don Quixote*, must have been highly effective for its appeal to have lasted so long.

We know little more of the music of the Archaic period than these odd facts. The lyrics of some of the songs have survived, including some of the choral odes performed in honor of various gods. Apollo and his sister Artemis were thanked for delivery from misfortune by the singing of a paean, or solemn invocation to the gods; whereas the dithyramb, or choral hymn to Dionysus, was sung in his honor at public ceremonies. Also closely tied to music was dance, which played a significant part as well in the development of drama. Our knowledge of Greek dance is limited to visual evidence. For example, we have from as early as the late Geometric period actual depictions of dances in progress [2.20]. On the other hand, in the Classical period the function of dance remained religious and social, and was rarely described in writing, whereas a vast literature on music theory developed, with philosophical implications that became explicit in the writings of Plato and Aristotle; through this literature some information on early music has been preserved.

What we do know about dancing and individual dances suggests that here, as in music and visual arts, telling a story was important. One famous dance was

2.20 Geometric bowl showing dancing, c. 740 B.C. Diameter $6^{1}/_{4}^{"}$ (16 cm). National Archaeological Museum, Athens. The dancers include both women and men, three playing lyres.

called the *geranos*, from the word for "crane." The dancers apparently made movements like those of the bird, but the steps of the dance had a more specific meaning. According to tradition, it was first performed by Theseus outside the Labyrinth with the boys and girls he had saved by killing the Minotaur. The intricate patterns of the dance were supposed to represent the Labyrinth itself. Having accomplished two dangerous feats—killing the Minotaur and finding his way out of the Labyrinth—Theseus stayed around long enough to lead a complicated performance. Dancing was obviously of great importance to the Greeks.

EARLY GREEK LITERATURE AND PHILOSOPHY

Our knowledge of literary developments between the time of Homer and the Archaic period is very limited. An exception is Hesiod, who probably lived shortly before 700 B.C. He is the author of a poetic account of the origins of the world called the *Theogony* and a rather more down-to-earth long poem, the *Works and Days*, which mainly concerned the disadvantages in being a poor, oppressed (and depressed) farmer in Boeotia, where the climate is "severe in winter, stuffy in summer, good at no time of year." In the Archaic period, however, the same burst of creative energy that revolutionized the visual arts produced a wave of new poets. The medium they chose was lyric verse.

Lyric Poetry

The emergence of lyric poetry was, like developments in the other arts, a sign of the times. The heroic verse of Homer was intended for the ruling class of an aristocratic society, which had the leisure and the inclination to hear of the great and not so great deeds of great men and who were interested in the problems of mighty leaders like Agamemnon and Achilles. Lyric verse is concerned above all else with the poet's own feelings, emotions, and opinions. The writers of the sixth century B.C. do not hesitate to tell us how they themselves feel about life, death, love, drinking too much wine, or anything else that crosses their minds. Heroes and the glories of battle are no longer the ideal.

Above all other Greek lyric poets, Sappho has captured the hearts and minds of the following ages. She is the first woman to leave a literary record that reflects her own personal experiences. Her poems have survived only in fragmentary form, and the details of her life remain confused and much disputed. We must be grateful, then, for what we have and not try to overinterpret it.

Sappho was born around 612 B.C. on the island of Lesbos, where she spent most of her life. She seems to have

been able to combine the roles of wife and mother with those of poet and teacher; within her own lifetime she was widely respected for her works and surrounded by a group of younger women who presumably came to Lesbos to finish their education, in much the same way that Americans used to go to Paris for a final cultural polish.

The affection between Sappho and her pupils was deep and sincere and is constantly reflected in her poems. The nature of this affection has been debated for centuries. The plain fact is that apart from her poetry we know almost nothing about Sappho herself. Even her appearance is debatable; she is described by one ancient authority as "beautiful day" and by another as short, dark, and ugly. Her fellow poet Alcaeus calls her "violethaired, pure, and honey-smiling." Thus, those who read Sappho must decide for themselves what the passion of the poems expresses, for passionate they certainly are. Perhaps Sappho's greatest quality lies in her ability to probe the depths of her own responses and by describing them to understand them. Just as contemporary sculptors and painters sought to understand the workings of their own bodies by depicting them, so Sappho revealed both to herself and to us the workings of her emotions.

The First Philosophers: The Presocratics

The century that saw the expression of the intimate self-revelations of lyric poetry was marked by the development of rational philosophy, which challenged the traditional religious ideas of Homer and Hesiod and scoffed at gods who took human form. If horses and cows had hands and could draw, they would draw gods looking like horses and cows, wrote Xenophanes of Colophon in the second half of the sixth century B.C.

The word *philosophy* literally means "love of wisdom," but in the Western tradition it usually refers to inquiries into the nature and ultimate significance of the human experience. Ever since the Archaic period philosophers have spent some two and a half millennia debating the question: "What is philosophy?" Some of its branches are logic (the study of the structure of valid arguments); metaphysics (investigation into the nature of ultimate reality); epistemology (theory of knowledge); ethics (moral philosophy); aesthetics (the philosophy of the arts and, more generally, taste); and political philosophy.

For the first time in history, the philosophers of the Archaic period turned away from religious teachings; they used the power of human reason to try to discover how the world came into being and how it works, and to understand the place of humans in it. A wide variety of schools of thought developed, which is collectively described by the somewhat confusing label *Presocratics*. The label is accurate in that they all lived and died before the time of Socrates (469–399 B.C.), who, together with his pupil Plato (c. 427–347 B.C.), are the greatest names in Greek philosophy. On the other hand, these sixth-century

philosophers had little in common with one another except the time in which they lived. Thus it is important to remember that the term Presocratic does not describe any single philosophical system. Indeed, many of the so-called Presocratic philosophers, with their studies into the origins of the world and the workings of nature, were examining questions that we would consider scientific rather than philosophical. The various schools were united principally by their use of logic and theoretical reasoning to solve practical questions about the world and human existence.

The earliest school to develop was that of the *Materialists*, who sought to explain all phenomena in terms of one or more elements. Thales of Miletus (c. 585 B.C.), for example, thought that water alone underlay the changing world of nature. However absurd Thales' theory was, his notion that the world had evolved naturally, rather than as a result of divine creation, was revolutionary. He also began the Greek tradition of free discussion of ideas in the marketplace and other public areas. Intellectual exchange was no longer limited to an educated elite or a priestly class. In this way, as with his rejection of traditional religion, Thales and his successors created a fundamental breakaway from the traditional values of Homeric society.

Later, Empedocles of Acragas (c. 495 B.C.) introduced four elements—fire, earth, air, water. The varying combinations (through love) and separations (through strife and war) of these elements in a cyclical pattern explained how creatures as well as nations were born, grew, decayed, and died. Anaxagoras of Clazomenae (c. 500 B.C.) postulated an infinite number of small particles, which, however small they might be, always contained not only a dominant substance (for example, bone or water) but also stray bits of other substances in lesser quantities. Unity in nature, he claimed, came from the force of Reason.

The Presocratic philosopher who had the greatest influence on later times was Pythagoras of Samos (c. 550 B.C.). He left his home city for political reasons and settled in southern Italy, where he founded a school of his own. He required his followers to lead pure and devout lives, uniting together to uphold morals and chastity, as well as order and harmony, for the common good. These apparently noble principles did nothing to win him favor from the people among whom he had settled; according to one account he and three hundred of his followers were murdered.

http://www-groups.dcs.st-and.ac.uk/~history/Mathematicians/Pythagoras.html

Pythagoras

It is difficult to know which of the principles of *Pythagoreanism* can be directly attributed to Pythagoras himself and which were later added by his disciples. His

chief religious doctrines seem to have been belief in the transmigration of souls and the kinship of all living things; teachings that led to the development of a religious cult that bore his name. In science, his chief contribution was in mathematics. He discovered the numerical relationship of musical harmonies. Our modern musical scale, consisting of an *octave* (a span of eight tones) divided into its constituent parts, derives ultimately from his researches. Inspired by this discovery, Pythagoras went on to claim that mathematical relationships represented the underlying principle of the universe and of morality, the so-called harmony of the spheres. He is chiefly remembered today for a much less cosmic discovery, the geometrical theorem that bears his name.

In contrast to Pythagoras' belief in universal harmony, the *Dualists* claimed that there existed two separate universes: the world around us, subject to constant change; and another ideal world, perfect and unchanging, which could be realized only through the intellect. The chief proponent of this school was Heraclitus of Ephesus (c. 500 B.C.) whose cryptic pronouncements won him the label "the Obscure." He summed up the unpredictable, and therefore unknowable, quality of Nature in the well-known saying, "It is not possible to step twice into the same river." Unlike his predecessors who had tried to understand the fundamental nature of matter, Heraclitus thus drew attention instead to the process whereby matter changed.

Parmenides of Elea (c. 510 B.C.), on the other hand, went so far as to claim that true reality can only be apprehended by reason and is all-perfect and unchanging, without time or motion. Our mistaken impressions come from our senses, which are flawed and subject to error. As a result, the world which we perceive through them, including the processes of time and change, is a sham and a delusion. His younger pupil, Zeno (c. 490 B.C.), presented a number of difficult paradoxes in support of their doctrines. These paradoxes were later discussed by Plato and Aristotle.

The last and perhaps the greatest school of Presocratic philosophy was that of the *Atomists*, led by Leucippus and Democritus (c. 460 B.C.), who believed that the ultimate, unchangeable reality consisted of atoms (small "indivisible" particles not obvious to the naked eye) and the void (nothingness). Atomism survived into Roman times in the later philosophy of Epicureanism and into the nineteenth century in the early Atomic Theory of John Dalton. Even in the recent past, the great physicist Werner Heisenberg (1901–1976), who astonished the world of science with his discoveries in quantum mechanics, derived his initial inspiration from the Greek Atomists.

The various schools of Presocratic philosophers are often complex and difficult to understand. This is due to the kinds of questions they addressed, but also to the fragmentary nature of the texts in which their ideas have survived. Further, unlike all subsequent philosophers, they had no predecessors on whom to base their ideas or methods. Yet, through the cryptic phrases and often mysterious arguments, there shines a love of knowledge and a passionate search for answers to questions that still perplex humanity. And in their emphasis on the human rather than the divine they prefigure many of the most important stages in the development of the Western tradition, from Classical Athens to the Renaissance to the eighteenth-century Age of Reason. In the words of Protagoras (c. 485–415 B.C.), "Man is the measure of all things, of the existence of those that exist, and of the nonexistence of those that do not."

Herodotus: The First Greek Historian

At the beginning of the fifth century B.C. the Greeks had to face the greatest threat in their history. Their success in meeting the challenge precipitated a decisive break with the world of Archaic culture.

In 499 B.C., the Greek cities of Asia Minor, with Athenian support, rebelled against their Persian rulers. The Persian king Darius, succeeded in checking this revolt; he then resolved to lead a punitive expedition against the mainland Greek cities that had sent help to the eastern cities. In 490 B.C. he led a massive army to Greece; to everyone's surprise, the Persians were defeated by the Athenians at the Battle of Marathon. After Darius' death in 486 B.C., his son Xerxes launched an even more grandiose expedition in 480 B.C. Xerxes defeated the Spartans at Thermopylae and then attacked and sacked Athens itself. While the city was falling, the Athenians took to their ships, obeying an oracle that enjoined them to "trust to their wooden walls." Eventually they inflicted a crushing defeat on the Persian navy at nearby Salamis. In 479 B.C., after being conquered on land and sea, at Plataea and Mycale, the Persians returned home, completely beaten.

http://www.dcaccess.com/~postapuk/marathon.html

Battle of Marathon

The great historian Herodotus (484–420 B.C.) has left us, in his nine books of *History of the Persian Wars*, a detailed account of the closing years of the Archaic period. He also, however, has two other claims on our attention. He is the first writer in the Western tradition to devote himself to historical writing rather than epic or lyric poetry, a fact that has earned him the title Father of History. At the same time, he is one of the greatest storytellers, always sustaining the reader's interest in both the mainline of his narrative and the frequent and entertaining digressions. One of these, the tale of Rhampsinitus and the thief, has been described as the first detective story in Western literature.

Herodotus was not a scientific historian in our terms—he had definite weaknesses. He never really understood the finer points of military strategy. He almost always interpreted events in terms of personalities, showing little interest in underlying political or economic causes. His strengths, however, were many. Although his subject involved conflict between Greeks and foreigners, he remained remarkably impartial and free from national prejudice. His natural curiosity about the world around him and about his fellow human beings was buttressed by acute powers of observation. Above all, he recorded as much information as possible, even when versions conflicted. He also tried to provide a reasonable evaluation of the reliability of his sources so later readers could form their own opinions.

Herodotus' analysis of the Greek victory was based on a serious philosophical, indeed theological, belief—that the Persians were defeated because they were morally in the wrong. Their moral fault was *hubris* (excessive ambition); thus the Greeks' victory was at the same time an example of right over might and a demonstration that the gods themselves would guarantee the triumph of justice. In Book VII, Xerxes' uncle, Artabanus, warns him in 480 B.C. not to invade Greece: "You know, my lord, that amongst living creatures it is the great ones that Zeus smites with his thunder, out of envy of their pride. It is God's way to bring the lofty low. For He tolerates pride in none but Himself."

Modern readers, however, less influenced by Herodotus' religious beliefs, will be more inclined to draw a political message from the Persian defeat. The Greeks were successful at least partly because for once they had managed to unite in the face of a common enemy. Their victories inaugurated the greatest period in Greek history, the Classical Age.

SUMMARY

The Dawn of Greek Culture Shortly after 1000 B.C., Greek civilization began to develop. From the beginning, the Greek world was divided into separate city-states among which fierce rivalries would grow. For the first two centuries the Greeks had little contact with other peoples but, around 800 B.C., Greek travelers and merchants began to explore throughout the Mediterranean. The visual arts during these early centuries are principally represented by pottery decorated with geometric designs. The period also saw the creation of two of the greatest masterpieces of Western literature: the *Iliad* and the *Odyssey*.

The Age of Colonization During the Age of Colonization (c. 750–600 B.C.) the Greeks came in contact with a wide range of foreign peoples. The ancient Near East, in particular, played a large part in influencing the development of Greek art and architecture. The decoration of pottery became Orientalizing in style, while large free-

standing sculpture based on Egyptian models began to evolve. Important Greek colonies began to develop in southern Italy and Sicily.

The Archaic Period The period from 600 B.C. to 480 B.C., known as the Archaic Age, was marked by political and cultural change. A new literary form, lyric poetry, became popular; one of its leading practitioners was the poetess Sappho. The so-called Presocratics began to develop a wide range of philosophical schools. Sculpture and vase painting both became increasingly naturalistic. The aristocratic rulers of earlier times were supplanted by "tyrants," rich merchant traders who depended on the support of the lower classes. In Athens, Solon's reform of the constitution introduced a form of democracy, which was overthrown by the tyrant Pisistratus in 546 B.C.

The Persian Wars Democratic government was restored at Athens in 510 B.C., and shortly thereafter the Greeks became embroiled with the mighty Persian empire to their east. In 499 B.C., the Greek cities of western Asia, established more than a century earlier, rebelled against their Persian rulers; the Athenians sent help. The Persians crushed the revolt and, in 490 B.C., the Persian king Darius led an expedition against the Greeks to punish them for their interference. Against all odds, the Persians were defeated at the Battle of Marathon. Darius, humiliated, was forced to withdraw, but ten years later Xerxes, his son, mounted an even more grandiose campaign to restore Persian honor. In 480 B.C. he invaded Greece, defeated Spartan troops at Thermopylae, and sacked Athens. The Athenians took to their ships, however, and destroyed the Persian navy at the Battle of

The following year combined Greek forces defeated Xerxes' army on land, and the Persians returned home in defeat. Faced by the greatest threat in their history, the Greeks had managed to present a united front. Their victories set the scene for the Classical Age of Greek culture. A detailed account of the Greeks' success can be found in the *History of the Persian Wars* written by Herodotus, the first Greek historian and the earliest significant prose writer in Western literature.

Pronunciation Guide

Achilles: A-KILL-ees Agamemnon: A-ga-MEM-non Amphora: AM-fo-ra Aphrodite: Af-ro-DIE-tee Boeotia: Bee-OWE-sha Darius: Dar-I-us Dionysus: Di-on-EES-us Dithyramb: DITH-ee-ram **Euphronius:** You-FRO-ni-us Hera: HERE-a Herodotus: Her-ODD-ot-us

Kore: KO-ray
Laconia: La-CONE-ee-a
Metope: MET-owe-pe
Paestum: PES-tum

Peloponnesian: Pel-op-on-EASE-i-an **Phoenician:** Fun-EESH-i-an

Priam: PRY-am
Sappho: SAF-owe
Thales: THAY-lees
Thermopylae: Ther-MOP-u-lee

Triglyph: TRIG-lif Xerxes: ZER-ksees

EXERCISES

- 1. What are the main features of the Homeric worldview? What effect do they have on the style of the Homeric epics?
- 2. Describe the development of Greek sculpture from the mid-seventh century to the end of the Archaic period.
- 3. What evidence has survived as to the nature of Greek music? What does it tell us about the Greeks' attitude to music?
- 4. Discuss the principal schools of Presocratic philosophy.
- 5. What are the chief differences between the Doric and Ionic orders of architecture?

FURTHER READING

- Biers, William. (1996). *The archaeology of Greece: An introduction* (2nd ed.). Ithaca, NY: Cornell University Press. A good overall picture of the present state of our knowledge of the material remains of ancient Greece.
- Boardman, J. (1982). *The Greek overseas*. New York: Penguin Books. A vivid and informative account of the development and effects of Greek colonization.
- Bury, J. B., & R. Meiggs. (1975). A history of Greece to the death of Alexander the Great (4th ed.). New York: St. Martin's. The best single-volume history of ancient Greece.
- Cook, R. M. (1976). *Greek art*. Baltimore: Penguin. The best single-volume survey of all the visual arts in Greece, this book places them in their historical context.
- Fullerton, Mark D. (2000). *Greek art.* New York: Cambridge University Press. Perhaps the best recent survey of the range of Greek art.
- Hooker, J. T. (1980). *The ancient Spartans*. London: Methuen. A detailed study of a still relatively neglected subject; collects and interprets discoveries up to the time of its publication.
- Luce, J. V. (1975). Homer and the heroic age. New York: Harper & Row. A masterful account of the historical background of the Homeric epics, although the author's view that Homer's world reflects chiefly that of the Mycenaeans is by no means universally shared.
- Schups, K. (1979). Economic rights of women in ancient Greece. Edinburgh: Edinburgh University Press. By using modern research techniques to analyze a wide range of material, this book significantly enlarges our view of Greek society.

- Snodgrass, A. (1980). *Archaic Greece*. Berkeley: University of California Press. An important survey of the historical and archaeological evidence for a rich and complex period.
- Stansbury-O'Donnell. (1999). *Pictorial narratives in ancient Greek art*. New York: Cambridge University Press. This book examines one of the most characteristic and revolutionary aspects of Greek art, its ability to tell a story.
- Stewart, A. (1997). Art, desire and the body in ancient Greece. New York: Cambridge University Press. A fascinating study of Greek attitudes toward life, and their transformation into art.
- Vermeule, E. (1981). Aspects of death in early Greek art and poetry. Berkeley: University of California Press. In a sensitively written study, the author uses the visual arts and poetry to deal with themes that are, by their nature, difficult to pin down.

ONLINE CHAPTER LINKS

The Ancient Greek World at

http://www.museum.upenn.edu/Greek_World/Index.html

covers such topics as daily life, the economy, and religion and death.

The Shrine of the Goddess Athena at

www.goddess-athena.org

provides extensive information about the patroness of Athens, including a museum with countless exhibits, an atlas, a timeline, and numerous links to related Internet resources.

The Ancient Olympic Games are examined at http://www.perseus.tufts.edu/Olympics

which features a tour of ancient Olympia as well as interesting stories about the athletes.

Biographical information about Sappho is available at

http://www.sappho.com/poetry/historical/sappho.html which also provides excerpts from her works as well as a bibliography.

Euesperides: An Ancient Greek Colony in North Africa at

http://www.ashmol.ox.ac.uk/ash/departments/antiquities/euesperides/

reports about the archaeological research sponsored by Oxford University's Ashmolean Museum.

View the Cast Gallery at Oxford Univeristy's Ashmolean Museum at

http://www.ashmol.ox.ac.uk/ash/departments/cast-gallery/

where Greek works are represented among this outstanding collection of casts derived from sculptures found in museums around the world.

	480			between Archaic and Classical Periods
	400	478 Formation of Delian League; beginning of Athenian empire		480–323 First naturalistic sculpture and painting appear
		461 Pericles comes to prominence at Athens		c. 460 Sculptures at Temple of Zeus, Olympia
SICAL LENIOD	450	454 Treasury of Delian League moved to Athens	458 Aeschylus, <i>Oresteia</i> trilogy wins first prize in drama festival of Dionysus	
	GOLDEN AGE	443 – 429 Pericles in full control of Athens	440 Sophocles, Antigone	c. 450 Myron, Discus Thrower
		431 Peloponnesian War begins	c. 429 Sophocles, <i>Oedipus the King</i>	c. 440 Polykleitos,
		429 Pericles dies of plague that devastates Athens	c. 421 Euripides, The Suppliant Women	Doryphoros, treatise The Canon
		421 Peace of Nicias	c. 420 – c. 399 Thucydides, History of Peloponnesian War	432 Phidias completes Parthenon
		413 Renewed outbreak of Peloponnesian War	414 Aristophanes, The Birds	sculptures
		reiopoimesian war	411 Aristophanes, <i>Lysistrata</i>	relief sculpture and white-ground vase painting; lekythos, Warrior Seated at
7	404	404 Fall of Athons and vistoms of	200 Till and annual and Company	His Tomb
	CLASSICAL PERIOD	404 Fall of Athens and victory of Sparta	399 Trial and execution of Socrates	200 C D 1
		404–403 Rule of Thirty Tyrants	before 387 Plato, Republic	c. 350 Scopas, Pothos
		387 King's Peace signed	387 Plato founds Academy	c. 350 Frescoes, Royal Cemetery at Vergina
	CAL	371–362 Ascendancy of Thebes	c. 385 Xenophon chronicles teachings of Socrates	240 Provided as Hamman with
	LATE CLASSION	359–336 Philip II, king of Macedon		c. 340 Praxiteles, Hermes with Infant Dionysus
		338 Macedonians defeat Greeks at Battle of Chaeronaea	c. 347–c. 399 Aristotle, Politics, Metaphysics	
		336–323 Alexander the Great, king of Macedon	335 Aristotle founds Lyceum	
	323	331 City of Alexandria founded		c. 330 Lysippus, Apoxyomenos
	O	323–281 Wars of Alexander's successors		
CIVI	101	262 Pergamum becomes independent kingdom		323–146 Development of realistic portraiture

LITERATURE & PHILOSOPHY

ART

c. 490 Kritios Boy; turning point

c. 150 Laocoön; mosaic, House of

Masks, Delos

GENERAL EVENTS

197-156 Eumenes II, king of

146 Romans sack Corinth; Greece

becomes Roman province

Pergamum

146

500 B.C. ARCHITECTURE

Music

470–456 Libon of Elis, Temple of Zeus at Olympia

c. 500–425 Music serves as accompaniment in dramatic performances

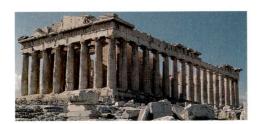

449 Pericles commissions work on Acropolis

447–438 Ictinus and Callicrates, Parthenon

437-431 Mnesikles, Propylaea

c. 427–424 Callicrates, Temple of Athena Nike

421-406 Erechtheum

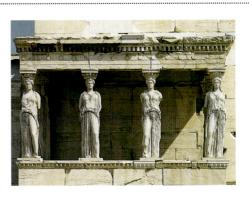

c. 400 Music dominates dramatic performances

4th cent. Instrumental music becomes popular

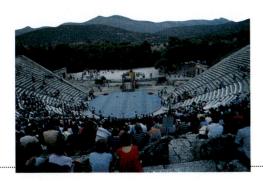

356 Temple of Artemis at Ephesus destroyed by fire and rebuilt

c. 350 Theater at Epidaurus

323 – I46 *Tholos* and other new building forms appear

279 Lighthouse at Alexandria

c. 180 – 160 Eumenes II, Pergamum Altar of Zeus

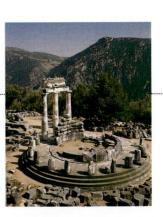

late 2nd cent. Earliest surviving Greek music

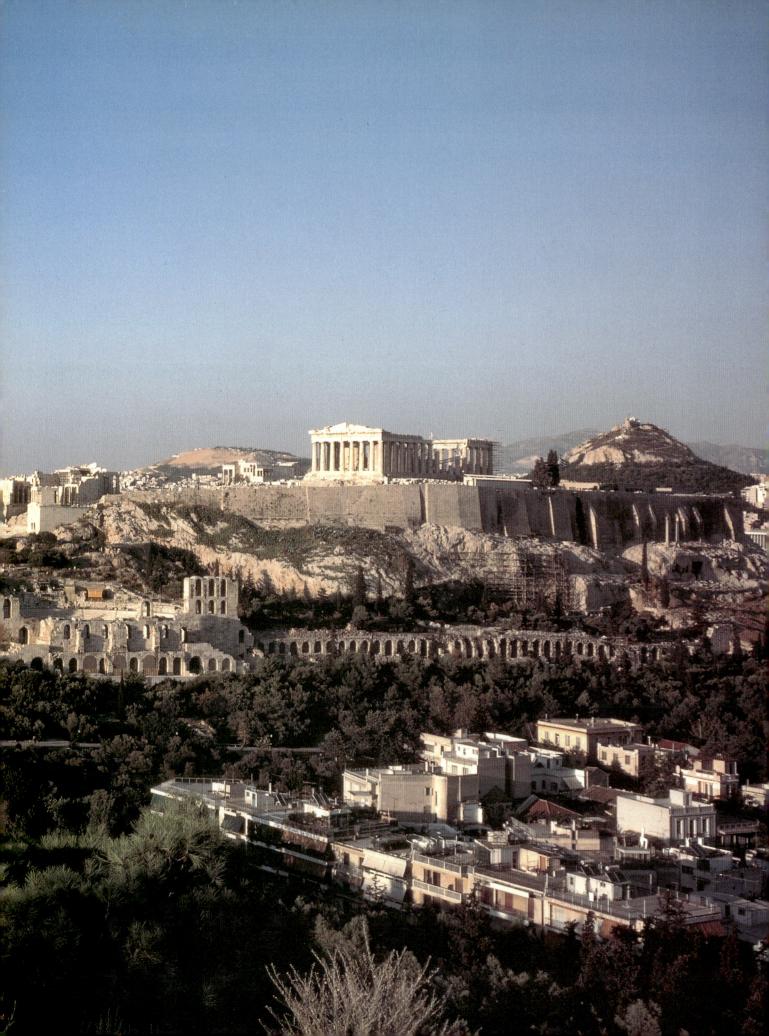

CHAPTER 3

CLASSICAL GREECE AND THE HELLENISTIC PERIOD

he victories in the Persian Wars produced a new spirit of optimism and unity in Greece. Divine forces, it appeared, had guaranteed the triumph of right over wrong. There seemed to be no limit to the possibilities of human development. The achievements of the Classical period, which lasted from 479 B.C. to the death of Alexander the Great in 323 B.C., do much to justify the Greeks' proud self-confidence. They certainly represent a level of civilization that has rarely, if ever, been reached since—a level that has been a continuing inspiration to our culture.

http://www.pbs.org/mpt/alexander/

Alexander the Great

Classical civilization reached its high point in Athens during the last half of the fifth century B.C., a time of unparalleled richness in artistic and intellectual achievement that is often called the Golden Age of Greece. To some extent, the importance of the great figures who dominated this period lies in the fact that they were the first in their fields. There are, in fact, few areas of human thought in which the fifth-century Greeks were not pioneers. In subjects as diverse as drama and historiography, town planning and medicine, painting and sculpture, mathematics and government, they laid the foundations for later achievements. Even more astonishing, often they were not merely the first in their fields but also among the greatest of all time. Greek tragedies, for example, are still read and performed today because they give experiences that are as intense emotionally and intellectually as anything in the Western dramatic tradition.

In the Late Classical period (404 to 323 B.C.), artists and writers continued to explore ideas and styles first outlined in the century before, though in different ways. Greek cultural life was no longer dominated by Athens; a single center no longer governed artistic developments.

This fourth-century period was therefore one of greater variety, with individual artists following their own personal visions. The greatest of all Late Classical contributions to modern cultural tradition was in the field of philosophy. The works of Plato and Aristotle became the basis of Western thought for the next two thousand years.

http://library.thinkquest.org/18775/aristotle/bioar.htm

Aristotle

Even after the death of Alexander the Great and the end of the Classical Age, the Hellenistic period that followed was characterized by an artistic vitality that ultimately drew its inspiration from Classical achievements. Only when Greece was conquered by the Romans in the late second century B.C. did Greek culture cease to have an independent existence.

THE CLASSICAL IDEAL

Although the Roman conquest of Greece ended the glories of the Classical Age, in a way it also perpetuated them by contributing to the melding of Greek culture into the Western humanistic tradition. It was not the Greeks themselves but their conquerors who spread Greek ideas throughout the ancient world and thus down in time to the present. These conquerors were first the Macedonians and then, above all, the Romans, possessors of practical skills that they used to construct a world sufficiently at peace for ideas to have a place in it. The Greeks did not live in such tranquility; we must always remember that the Athenians of the Golden Age existed not in an environment of calm contemplation but in a world of tension and violence

Their tragic inability to put into practice their own noble ideals and live in peace with other Greeks—the

darker side of their genius-proved fatal to their independence; it led to war with the rest of Greece in 431 B.C. and to the fall of Athens in 404 B.C. In this context, the Greek search for order takes on an added significance. It was the belief that the quest for reason and order could succeed that gave a unifying ideal to the immense and varied output of the Classical Age. The central principle of this Classical Ideal was that existence can be ordered and controlled, that human ability can triumph over the apparent chaos of the natural world and create a balanced society. In order to achieve this equilibrium, individual human beings should try to stay within what seem to be reasonable limits, for those who do not are guilty of hubris—the same hubris of which the Persian leader Xerxes was guilty and for which he paid the price. The aim of life should be a perfect balance: everything in due proportion and nothing in excess. "Nothing too much" was one of the most famous Greek proverbs.

The emphasis that the Classical Greeks placed on order affected their spiritual attitudes. Individuals can achieve order, they believed, by understanding why people act as they do and, above all, by understanding the motives for their own actions. Thus confidence in the power of both human reason and human self-knowledge was as important as belief in the gods. The greatest of all Greek temples of the Classical Age, the Parthenon, which crowned the Athenian Acropolis [3.1], was planned not so much to honor the goddess Athena as to glorify Athens and thus human achievement. Even in their darkest days, the Classical Greeks never lost sight of the

3.1 The Acropolis, Athens, from the northwest. The Parthenon, temple to Athena, is at the highest point. Below it spreads the monumental gateway, the Propylaea. At far left is the Erechtheum.

magnitude of human capability and, perhaps even more important, human potential—a vision that has returned over the centuries to inspire later generations and has certainly not lost its relevance in our own times.

The political and cultural center of Greece during the first half of the Classical period was Athens. Here, by the end of the Persian Wars in 479 B.C., the Athenians had emerged as the most powerful people in the Greek world. For one thing, their role in the defeat of the Persians had been a decisive one. For another, their democratic system of government, first established in the late sixth century B.C., was proving to be both effective and stable. All male Athenian citizens were not only entitled but were required to participate in the running of the state, either as members of the General Assembly, the *ecclesia*, with its directing council, the *boulé*, or by holding individual magistracies. They were also eligible to serve on juries.

Under Athenian leadership in the years following the wars, a defensive organization of Greek city-states was formed to guard against any future outside attack. The money collected from the participating members was kept in a treasury on the island of Delos, sacred to Apollo and politically neutral. This organization became known as the Delian League.

Within a short time a number of other important city-states, including Thebes, Sparta, and Athens' old trade rival Corinth, began to suspect that the league was serving not so much to protect all of Greece as to strengthen Athenian power. They believed the Athenians were turning an association of free and independent states into an empire of subject peoples. Their suspicions were confirmed when (in 454 B.C.) the funds of the league were transferred from Delos to Athens and some of the money was used to pay for Athenian building projects, including the Parthenon. The spirit of Greek unity was starting to dissolve; the Greek world was

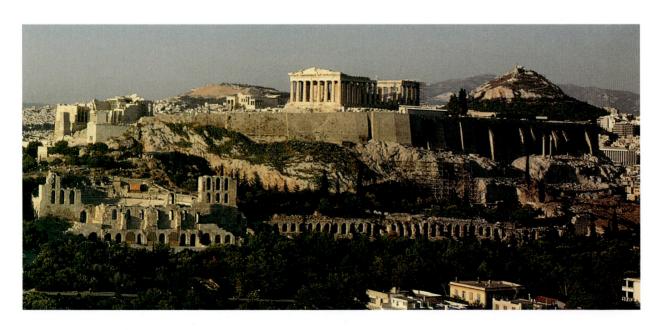

beginning to divide into two opposing sides: on the one hand, Athens and her allies (the cities that remained in the league) and on the other, the rest of Greece. Conflict was inevitable. The Spartans were finally persuaded to lead an alliance against Athens to check her "imperialistic designs." This war, called the Peloponnesian War after the homeland of the Spartans and their supporters, began in 431 B.C. and dragged on until 404 B.C.

Our understanding of the Peloponnesian War and its significance owes much to the account by the great historian Thucydides, who himself lived through its calamitous events. Born around 460 B.C., Thucydides played an active part in Athenian politics in the years before the war. In 424 B.C., he was elected general and put in charge of defending the city of Amphipolis in northern Greece. When the city fell to Spartan troops, Thucydides was condemned in his absence and sentenced to exile. He did not return to Athens until 404 B.C.

http://classics.mit.edu/Thucydides/pelopwar.html

Thucydides

Thucydides intended his History of the Peloponnesian War to describe the entire course of the war up to 404 B.C., but he died before completing it; the narrative breaks off at the end of 411 B.C. The work is extremely valuable for its detailed description of events, for, although its author was an Athenian, he managed to be both accurate and impartial. At the same time, however, Thucydides tried to write more than simply an account of a local war. The history was an attempt to analyze human motives and reactions so that future generations would understand how and why the conflict occurred and, in turn, understand themselves. The work was not meant to entertain by providing digressions and anecdotes but to search out the truth and use it to demonstrate universal principles of human behavior. This emphasis on reason makes Thucydides' work typical of the Classical period.

The hero of Thucydides' account of the years immediately preceding the war is Pericles, the leader whose name symbolizes the achievements of the Athenian Golden Age [3.2]. An aristocrat by birth, Pericles began his political career in the aftermath of the transfer of the Delian League's funds to Athens. By 443 B.C., he had unofficially assumed the leadership of the Athenian democracy, although he continued democratically to run for reelection every year. Under his guidance the few remaining years of peace were devoted to making visible the glory of Athens by constructing on the Acropolis—the majestic buildings that still, though in ruins, evoke the grandeur of Periclean Athens (Table 3.1).

Had Pericles continued to lead Athens during the war itself, the final outcome might have been different, but in

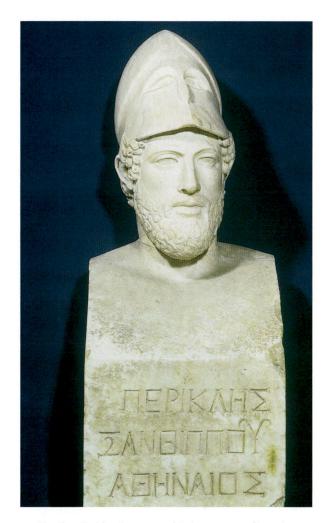

3.2 Kresilas, *Pericles*. Roman marble herm copy after a bronze original of c. 429 B.C. Approx. 72" high. Vatican Museums, Rome. Pericles is wearing a helmet, pushed up over his forehead because his official rank, while leader of Athens, was that of general.

TABLE 3.1 Athens in the Age of Pericles (ruled 443–429 B.C.)

TABLE 3.1 Athens in the Age of Pericles (ruled 443–429 B.C.)			
Area of the city	7 square miles		
Population of the city	100,000-125,000		
Population of the	200,000-250,000		
region (Attica)			
Political institution	General Assembly, Council of		
	500, Ten Generals		
Economy	Maritime trade; Crafts (textiles,		
	pottery); Farming (olives,		
	grapes, wheat)		
Cultural life	History (Thucydides); Drama		
	(Aeschylus, Sophocles, Euripi-		
	des, Aristophanes); Philosophy		
	(Socrates); Architecture (Ictinus,		
	Callicrates, Mnesicles); Sculp-		
	ture (Phidias)		
Principal buildings	Parthenon, Propylea (the		
	Erechtheum, the other major		
	building on the Athenian Acrop		

lifetime)

olis, was not begun in Pericles

VALUES

Civic Pride

Aristotle's comment that "Man is a creature who lives in a city," sometimes translated as "Man is a political animal," summarizes the Greeks' attitude to their *polis* (city). The focus of political, religious, and cultural life, and most other aspects as well—sport, entertainment, justice—the *polis* came to represent the central force in the life of each individual citizen.

The Greeks saw the importance of their city-states as the fundamental difference between their culture and that of the "barbarians," since it enabled them to participate in their community's affairs as responsible individuals. This participation was limited to adult male citizens; female citizens played little significant role in public life, and slaves and resident foreigners were completely excluded.

If the *polis* was responsible for many of the highest achievements of Greek culture, the notion of civic pride produced in the end a series of destructive rivalries that

ended Greek independence. The unity forged in the threat of the Persian invasions soon collapsed in the build-up to the Peloponnesian War. Even in the face of the campaigns of Philip of Macedon, the Greek cities continued to feud among themselves, unable to form a common front in the face of the danger of conquest.

The notion of the individual city as the focus of political and cultural life returned in the Italian Renaissance. Renaissance Florence and Siena, Milan, Venice and Verona, saw themselves as separate city—states, with their own styles of art and society. Even a small community such as Urbino became an independent political and artistic unit, modeled consciously on the city—states of Classical Greece. As in Greek times, civic pride led to strife between rivals, and left the Italians helpless in the face of invasions by French forces, or those of the Holy Roman Emperor.

430 B.C. the city was ravaged by disease, perhaps bubonic plague, and in 429 B.C. Pericles died. No successor could be found who was capable of winning the respect and support of the majority of his fellow citizens. The war continued indecisively until 421 B.C., when an uneasy peace was signed. Shortly thereafter the Athenians made an ill-advised attempt to replenish their treasury by organizing an unprovoked attack on the wealthy Greek cities of Sicily. The expedition proved a total disaster; thousands of Athenians were killed or taken prisoner. When the war began again (411 B.C.), the Athenian forces were fatally weakened.

The end came in 404 B.C. After a siege that left many people dying in the streets, Athens surrendered unconditionally to the Spartans and their allies.

Drama and Philosophy in Classical Greece

The Drama Festivals of Dionysus

The tumultuous years of the fifth century B.C., passing from the spirit of euphoria that followed the ending of the Persian Wars to the mood of doubt and self-questioning of 404 B.C., may seem unlikely to have produced the kind of intellectual concentration characteristic of Classical Greek drama. Yet it was, in fact, in the plays written specifically for performance in the theater of

Dionysus at Athens in these years that Classical literature reached its most elevated heights. The tragedies of the three great masters—Aeschylus, Sophocles, and Euripides—not only illustrate the development of contemporary thought but also contain some of the most memorable scenes in the history of the theater.

http://www.watson.org/rivendell/dramagreekaeschylus.html

Aeschylus

Tragic drama was not itself an invention of the fifth century B.C. It had evolved over the preceding century from choral hymns sung in honor of the god Dionysus, and the religious character of its origins was still present in its fully developed form. The plays that have survived from the Classical period at Athens were all written for performance at one of the two annual festivals sacred to Dionysus before an audience consisting of the entire population of the city. (Like the Egyptian god, Osiris, Dionysus died and was reborn, and the festivals held in his honor may be related to earlier ceremonies developed in Egypt.) To go to the theater was to take part in a religious ritual; the theaters themselves were regarded as sacred ground [3.3].

Each of the authors of the works given annually normally submitted four plays to be performed consecutively on a single day—three tragedies, or a "trilogy," and a more lighthearted play called a *satyr* play (a satyr

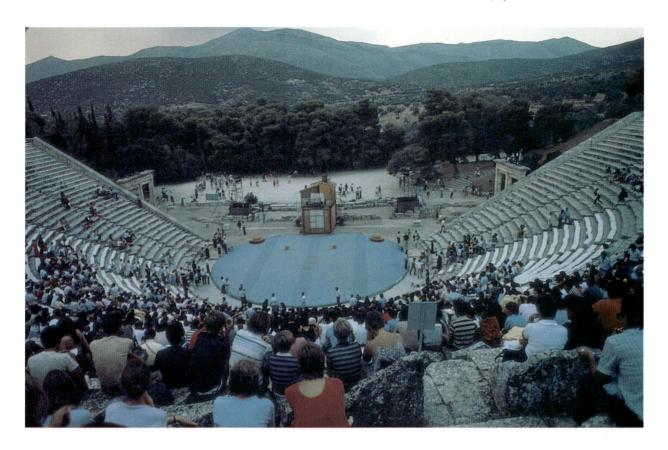

3.3 Polykleitos, Theater, Epidaurus, c. 350 B.C. Diameter 373' (113.69 m), orchestra 66' (20.12 m) across.

was a mythological figure: a man with an animal's ears and tail). The trilogies sometimes narrated parts of a single story, although often the three works were based on different stories with a common theme. At the end of each festival the plays were judged and a prize awarded to the winning author.

The dramas were religious not only in time and place but also in nature. The plots, generally drawn from mythology, often dealt with the relationship between the human and the divine. To achieve an appropriate seriousness, the style of performance was lofty and dignified. The actors, who in a sense served as priests of Dionysus, wore masks, elaborate costumes, and raised shoes.

The chorus, whose sacred dithyrambic hymn had been the original starting point in the development of tragedy, retained an important function throughout the fifth century B.C. In some plays (generally the earlier ones) the chorus forms a group centrally involved in the action, as in Aeschylus' *Suppliants* and *Eumenides*. More often, as in Sophocles' *Oedipus the King* or *Antigone*, the chorus represents the point of view of the spectator, rather than that of the characters participating directly in the events on stage; in these plays the chorus reduces to

more human terms the intense emotions of the principals and comments on them. Even in the time of Euripides, when dramatic confrontation became more important than extended poetic or philosophical expression, the chorus still retained one important function: that of punctuating the action and dividing it into separate episodes by singing lyric odes the subject of which was sometimes only indirectly related to the action of the play.

These aspects of Classical tragedy are a reminder that the surviving texts of the plays represent only a small part of the total experience of the original performances. The words—or at least some of them—have survived; but the music to which the words were sung and which accompanied much of the action, the elaborate choreography to which the chorus moved, indeed the whole grandiose spectacle performed out-of-doors in theaters located in sites of extreme natural beauty before an audience of thousands—all of this can only be recaptured in the imagination. It is perhaps relevant to remember that when, almost two thousand years later, around A.D. 1600, a small group of Florentine intellectuals decided to revive the art of Classical drama, they succeeded instead in inventing opera. Similarly, in the nineteenth century, the German composer Richard Wagner was inspired by Greek tragedy to devise his concept of a Gesamtkunstwerk (literally "total work of art"), a work of art that combined all the arts into one; he illustrated this concept by writing his dramatic operas.

The Athenian Tragic Dramatists

Even if some elements of the surviving Greek dramas are lost, we do have the words. The differing worldviews of the authors of these works vividly illustrate the changing fate of fifth-century-B.C. Athens. The earliest of the playwrights, Aeschylus (525–456 B.C.), died before the lofty aspirations of the early years of the Classical period could be shaken by contemporary events. His work shows a deep awareness of human weakness and the dangers of power (he had himself fought at the Battle of Marathon in 490 B.C.), but he retains an enduring belief that in the end right will triumph. In Aeschylus' plays, the process of being able to recognize what is right is painful. One must suffer to learn one's errors; yet the process is inevitable, controlled by a divine force of justice personified under the name of Zeus.

The essential optimism of Aeschylus' philosophy must be kept in mind because the actual course of the events he describes is often violent and bloody. Perhaps his most impressive plays are the three that form the *Oresteia* trilogy. This trilogy, the only complete one that has survived, won first prize in the festival of 458 B.C. at Athens. The subject of the trilogy is nothing less than the growth of civilization, represented by the gradual transition from a primitive law of *vendetta* ("blood for blood") to the rational society of civilized human beings.

The first of the three plays, the Agamemnon, presents the first of these systems in operation. King Agamemnon returns to his homeland, Argos, after leading the Greeks to victory at Troy. Ten years earlier, on the way to Troy, he had been forced to choose either to abandon the campaign because of unfavorable tides or to obtain an easy passage by sacrificing his daughter Iphigenia. (The situation may seem contrived, but it clearly symbolizes a conflict between public and personal responsibilities.) After considerable hesitation and self-doubt he had chosen to sacrifice his daughter. On his return home at the end of the Trojan War, he pays the price for her death by being murdered by his wife Clytemnestra and her lover Aegisthus [3.4]. Her ostensible motive is vengeance for Iphigenia's death, but an equally powerful, if less noble, one is her desire to replace Agamemnon both as husband and king by her lover Aegisthus. Thus, Aeschylus shows us that even the "law of the jungle" is not always as simple as it may seem, while at the same time the punishment of one crime creates in its turn another crime to be punished. If Agamemnon's murder of his daughter merits vengeance, then so does Clytemnestra's sacrifice of her husband. Violence breeds violence.

The second play, *The Libation Bearers*, shows us the effects of the operation of this principle on Agamemnon and Clytemnestra's son, Orestes. After spending years in exile, Orestes returns to Argos to avenge his father's death by killing his mother. Although a further murder can accomplish nothing except the transfer of blood guilt

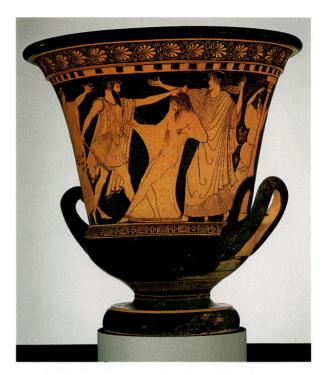

3.4 Attic Red Figured Calyx Krater, The Dokimasia Painter, about 460 B.C. Side A: The Murder of Agamemnon by Aegisthus. Clay, height: 0.51 m, diam: 0.51 m. Museum of Fine Arts, Boston. Aegisthus strikes the blow in this version of the story, with Clytemnestra standing behind him grasping an axe. Agamemnon, murdered as he was about to take a bath, is wearing only a light robe.

to Orestes himself, the primitive law of vendetta requires him to act. With the encouragement of his sister Electra, he kills Clytemnestra. His punishment follows immediately. He is driven mad by the Furies, the implacable goddesses of vengeance, who hound him from his home.

The Furies themselves give their name to the third play, in which they are tactfully called *The Eumenides* ("the kindly ones"). In his resolution of the tragedy of Orestes and his family, Aeschylus makes it clear that violence can only be brought to an end by the power of reason and persuasion. After a period of tormented wandering, Orestes comes finally to Athens where he stands trial for the murder of his mother before a jury of Athenians, presided over by Athena herself. The Furies insist on his condemnation on the principle of blood for blood, but Orestes is defended by Apollo, the god of reason, and finally acquitted by his fellow human beings. Thus, the long series of murders is brought to an end, and the apparently inevitable violence and despair of the earlier plays is finally dispelled by the power of persuasion and human reason, which-admittedly with the help of Athena and Apollo—have managed to bring civilization and order out of primeval chaos.

Despite all the horror of the earlier plays, therefore, the *Oresteia* ends on a positive note. Aeschylus affirms his belief that progress can be achieved by reason and order. This gradual transition from darkness to light is handled throughout the three plays with unfailing skill. Aeschylus matches the grandeur of his conception with majestic language. His rugged style makes him sometimes difficult to understand, but all the verbal effects are used to dramatic purpose. The piling up of images and complexity of expression produce an emotional tension that has never been surpassed.

The life of Sophocles (496–406 B.C.) spanned both the glories and the disasters of the fifth century B.C. Of the three great tragic poets, Sophocles was the most prosperous and successful; he was a personal friend of Pericles. He is said to have written 123 plays, but only seven have survived, all of which date from the end of his career. They all express a much less positive vision of life than that of Aeschylus. His philosophy is not easy to extract from his work, since he is more concerned with exploring and developing the individual characters in his dramas than with expounding a point of view; in general, Sophocles seems to combine an awareness of the tragic consequences of individual mistakes with a belief in the collective ability and dignity of the human race.

The consequences of human error are vividly depicted in his play *Antigone*, first performed around 440 B.C. Thebes has been attacked by forces under the leader-

3.5 The ancient theater at Delphi, 1951. The columns in the background are the ruins of the Temple of Apollo.

ship of Polynices; the attack is beaten off and Polynices killed. In the aftermath Creon, king of Thebes, declares the dead warrior a traitor and forbids anyone to bury him on pain of death. Antigone, Polynices' sister, disobeys, claiming that her religious and family obligations override those to the state. Creon angrily condemns her to death. He subsequently relents, but too late: Antigone, his son (betrothed to Antigone), and his wife have all committed suicide. Creon's stubbornness and bad judgment thus result in tragedy for him as well as for Antigone.

Paradoxically, however, the choice between good and evil is never clear or easy and is sometimes impossible. More than any of his contemporaries, Sophocles emphasizes how much lies outside our own control, in the hands of destiny or the gods. His insistence that we respect and revere the forces that we cannot see or understand makes him the most traditionally religious of the tragedians. These ambiguities appear in his best-known play, Oedipus the King, which has stood ever since Classical times as a symbol of Greek tragic drama [3.5]. A century after it was first performed (c. 429 B.C.), Aristotle used it as his model when, in the Poetics, he discussed the nature of tragedy. Its unities of time, place, and action, the inexorable drive of the story with its inevitable yet profoundly tragic conclusion, the beauty of its poetry all have made *Oedipus the King* a true classic, in all senses. Its impact has lasted down to the present; it had a notable effect on the ideas of Sigmund Freud. Yet in spite of the

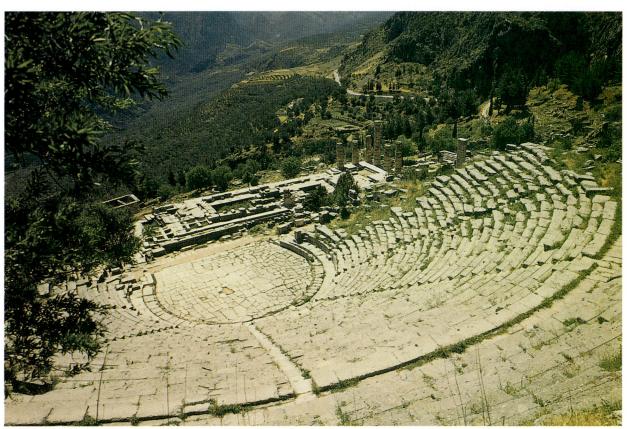

universal admiration the play has excited, its message is far from clear.

The story concerns Oedipus, doomed even before his birth to kill his father and marry his mother, his attempts to avoid fate, and his final discovery that he has failed. If the play seems, in part, to be saying that we cannot avoid our destiny, it leaves unanswered the question of whether or not we deserve that destiny. Certainly Oedipus does not choose deliberately to kill his father and marry his mother, even though unknowingly everything he does leads to this end. Then why does he deserve to suffer for his actions?

One of the traditional answers to this question can be found in Aristotle's analysis of tragedy in the Poetics. Referring particularly to Oedipus, Aristotle makes the point that the downfall of a tragic figure is generally the result of a flaw (the Greek word is hamartia) in his character. Thus Oedipus' pride and stubbornness in insisting on discovering who he is and the anger he shows in the process bring about the final disastrous revelation. In this way the flaws, or weaknesses, in his character overcome his good points and destroy him. As a description of Oedipus' behavior, this explanation is convincing enough, but it fails to provide a satisfactory account of the original causes of his condition. Perhaps the message of the play is, in fact, that there are some aspects of existence beyond our understanding, aspects that operate by principles outside our range of experience. If this is so, and many literary critics would deny it, Sophocles seems to be describing the final helplessness of humanity in the face of forces that we cannot control and warning against too great a belief in self-reliance.

The significance for the Athenians themselves of Oedipus' fall from greatness emerges in full force in the work of Euripides (c. 484–406 B.C.). Although only slightly younger than Sophocles, Euripides expresses all the weariness and disillusion of the war-torn years at the end of the fifth century B.C. Of all the tragedians, Euripides is perhaps the closest to our own time, with his concern for realism and his determination to expose social, political, and religious injustices.

Although Euripides admits the existence of irrational forces in the universe that can be personified in the forms of gods and goddesses, he certainly does not regard them as worthy of respect and worship. This skepticism won him the charge of impiety. His plays show characters frequently pushed to the limits of endurance; their reactions show a new concern for psychological truth. In particular, Euripides exhibits a profound sympathy and understanding for the problems of women who live in a society dominated by men. Characters like Medea and Phaedra challenged many of the basic premises of contemporary Athenian society.

Euripides' deepest hatred is reserved for war and its senseless misery. Like the other dramatists he draws the subject matter of his plays from traditional myths, but the lines delivered by the actors must have sounded in their hearers' ears with a terrible relevance. *The Suppliant Women* was probably written in 421 B.C., when ten years of indecisive fighting had produced nothing but an uneasy truce. Its subject is the recovery by Theseus, ruler of Athens, of the bodies of seven chiefs killed fighting at Thebes in order to return them to their families for burial. He yields to their mothers—the women of the title—who beg him to recover the corpses. The audience would have little need to be reminded of the grief of wives and mothers or of the kind of political processes that produced years of futile fighting.

If Aeschylus' belief in human progress is more noble, Euripides is certainly more realistic. Although unpopular in his own time, he later became the most widely read of the three tragedians. As a result, more of his plays have been preserved (nineteen in all), works with a wide range of emotional expression. They extend from romantic comedies like *Helen* and *Iphigenia in Taurus* to the profoundly disturbing *Bacchae*, his last completed play, in which Euripides the rationalist explores the inadequacy of reason as the sole approach to life. In this acknowledgment of the power of emotion to overwhelm the order and balance so typical of the Classical ideal, he is most clearly speaking for his time.

Aristophanes and Greek Comedy

Euripides was not, of course, the only Athenian to realize the futility of war. The plays of Aristophanes (c. 450–385 B.C.), the greatest comic poet of fifth-century-B.C. Athens, deal with the same theme. His work combines political satire with a strong vein of fantasy.

In *The Birds*, produced in 414 B.C., two Athenians decide to leave home and find a better place to live. They join forces with the birds and build a new city in midair called Cloudcuckooland, which cuts off contact between gods and humans by blocking the path of the smoke rising from sacrifices. The gods are forced to come to terms with the new city and Zeus hands over his scepter of authority to the birds.

This is simple escapism, but *Lysistrata*, written a few years later (411 B.C.), deals with the problem of how to prevent war in a more practical fashion. In the course of the play, the main protagonist, Lysistrata, persuades her fellow women of Athens to refuse to make love with their husbands until peace is negotiated. At the same time her followers seize the Acropolis. The men, teased and frustrated, finally give in and envoys are summoned from Sparta. The play ends with the Athenians and Spartans dancing together for joy at the new peace.

With the end of the Peloponnesian War (404 B.C.) and the fall of Athenian democracy, both art and political life were to be affected by an atmosphere of considerable confusion. Though Athens had been removed as the dominating force in Greece, there was no successor among her rivals. The vacuum was not filled until the mid-fourth century with the appearance on the scene of

Philip of Macedon. Earlier, a disastrous series of skirmishes between Sparta, Thebes, Athens, Corinth, and Argos had been temporarily suspended by the intervention of the great King of the Persians himself, and the so-called King's Peace was signed in 387 B.C. But after a brief respite, the Thebans decisively defeated the Spartan forces at Leuctra in 371 B.C. and remained for a few years the leading force in Greek political life.

With the accession of Philip in Macedon (359 B.C.), however, the balance of power in Greece began to change. The hitherto backward northern kingdom of Macedon began to exert a new unifying influence, despite opposition in Thebes and in Athens, where the great Athenian orator Demosthenes led the resistance. In 338 B.C., at the Battle of Chaeronaea (see map, "Ancient Greece," Chap. 2), Philip defeated Athenian and Theban forces and unified all the cities of Greece, with the exception of Sparta, in an alliance known as the League of Corinth.

Even before his assassination in 336 B.C., Philip had developed schemes for enlarging his empire by attacking Persia. His son and successor, Alexander, carried them out. He spent the ten years from 333 B.C. until his own death in 323 B.C. in an amazing series of campaigns across Asia, destroying the Persian Empire and reaching as far as India. The effects of the breakup of this new Macedonian empire after the death of Alexander were to be felt throughout the Hellenistic period that followed.

Philosophy in the Late Classical Period

The intellectual and cultural spirit of the new century was foreshadowed in its very first year in an event at Athens. In 399 B.C., the philosopher Socrates was charged with impiety and corruption of the young, found guilty, and executed. Yet the ideas that Socrates represented—concern with the fate of the individual and the questioning of traditional values—could not be killed so easily. They had already begun to spread at the end of the fifth century B.C. and came to dominate the culture of the fourth century B.C.

Socrates is one of the most important figures in Greek history. He is also one of the most difficult to understand clearly. Much of the philosophy of the Greeks and of later ages and cultures has been inspired by his life and teachings. Yet Socrates himself wrote nothing; most of what we know of him comes from the works of his disciple, Plato. Socrates was born around 469 B.C., the son of a sculptor and a midwife; in later life he claimed to have followed his mother's profession in being a "midwife to ideas." He seems first to have been interested in natural science, but soon turned to the problems of human behavior and morality. Unlike the *sophists* (the professional philosophers of the day), he neither took money for teaching, nor did he ever found a school. Instead he went around Athens, to both public places like the markets and the gymnasia and private gatherings, talking and arguing, testing traditional ideas by subjecting them to a barrage of questions—as he put it, "following the argument wherever it led."

Socrates gradually gained a circle of enthusiastic followers, drawn mainly from the young. At the same time he acquired many enemies, disturbed by both his challenge to established morality and the uncompromising persistence with which he interrogated those who upheld it. Socrates was no respecter of the pride or dignity of others, and his search for the truth inevitably exposed the ignorance of his opponents. Among Socrates' supporters were a number who had taken part in an unpopular and tyrannical political coup at Athens immediately following the Peloponnesian War. The rule of the socalled Thirty Tyrants lasted only from 404 to 403 B.C.; it ended with the death or expulsion of its leading figures. The return of democracy gave Socrates' enemies a chance to take advantage of the hostility felt toward those who had "collaborated" with the tyrants; thus, in 399 B.C., he was put on trial. It seems probable that to some degree the proceedings were intended for show and that those who voted for the death sentence never seriously thought it would be carried out. Socrates was urged by his friends to escape from prison, and the authorities themselves offered him every opportunity. However, the strength of his own morality and his reverence for the laws of his city prohibited him from doing so. After a final discussion with his friends, he was put to death by the administration of a draught of hemlock.

Many of Socrates' disciples tried to preserve his memory by writing accounts of his life and teachings. The works of only two have survived. One of these is the Greek historian Xenophon, whose *Apology, Symposium*, and *Memorabilia* are interesting, if superficial. The other is Plato, who, together with his pupil Aristotle, stands at the forefront of the whole intellectual tradition of Western civilization.

The Dialogues of Plato claim to record the teachings of Socrates. Indeed, in almost all of them Socrates himself appears, arguing with his opponents and presenting his own ideas. How much of Plato's picture of Socrates is historical truth and how much is Plato's invention, however, is debatable. The Socratic problem has been almost as much discussed as the identity of Homer. In general, modern opinion supports the view that in the early Dialogues Plato tried to preserve something of his master's views and methods, while in the later ones he used Socrates as the spokesman for his own ideas. There can certainly be no doubt that Plato was deeply impressed by Socrates' life and death. Born in 428 B.C., he was drawn by other members of his aristocratic family into the Socratic circle. Plato was present at the trial of Socrates, whose speech in his own defense Plato records in the Apology, one of three works that describe Socrates' last days. In the Crito, set in prison, Socrates explains why he refuses to escape. The Phaedo gives an account of his last day spent discussing with his friends the immortality of the soul and his death.

After Socrates' death, Plato left Athens, horrified at the society that had sanctioned the execution, and spent a number of years traveling. He returned in 387 B.C. and founded the Academy, the first permanent institution in Western civilization devoted to education and research, and thus the forerunner of all our universities. Its curriculum concentrated on mathematics, law, and political theory. Its purpose was to produce experts for the service of the state. Some twenty years later, in 368 B.C., Plato was invited to Sicily to put his political theories into practice by turning Syracuse into a model kingdom and its young ruler, Dionysius II, into a philosopher king. Predictably, the attempt was a dismal failure and, by 366 B.C., he was back in Athens. Apart from a second visit to Syracuse in 362 B.C., equally unsuccessful, Plato seems to have spent the rest of his life in Athens, teaching and writing. He died there in 347 B.C.

Much of Plato's work deals with political theory and the construction of an ideal society. The belief in an ideal is, in fact, characteristic of most of his thinking. It is most clearly expressed in his Theory of Forms, according to which in a higher dimension of existence there are perfect forms of which all the phenomena we perceive in the world around us represent pale reflections. There can be no doubt that Plato's vision of an ideal society is far too authoritarian for most tastes, involving among other restrictions the careful breeding of children, the censorship of music and poetry, and the abolition of private property. In fairness to Plato, however, it must be remembered that his works are intended not as a set of instructions to be followed literally but as a challenge to think seriously about how our lives should be organized. Furthermore, the disadvantages of democratic government had become all too clear during the last years of the fifth century B.C. If Plato's attempt to redress the balance seems to veer excessively in the other direction, it may in part have been inspired by the continuing chaos of fourthcentury Greek politics.

Plato's most gifted pupil, Aristotle (384–322 B.C.), continued to develop his master's doctrines, at first whole-heartedly and later critically, for at least twenty years. In 335 B.C., Aristotle founded a school in competition with Plato's Academy, the Lyceum, severing fundamental ties with Plato from then on. Aristotle in effect introduced a rival philosophy—one that has attracted thinking minds ever since. Indeed, in the nineteenth century, the English poet Samuel Taylor Coleridge was to comment, with much truth, that one was born either a "Platonist" or an "Aristotelian."

The Lyceum seems to have been organized with typical Aristotelian efficiency. In the morning Aristotle himself lectured to the full-time students, many of whom came from other parts of Greece to attend his courses and work on the projects he was directing. In the afternoon the students pursued their research in the library, museum, and map collection attached to the Lyceum,

while Aristotle gave more general lectures to the public. His custom of strolling along the Lyceum's circular walkways, immersed in profound contemplation or discourse, gained his school the name *Peripatetic* (the "walking" school).

As a philosopher Aristotle was the greatest systematizer. He wrote on every topic of serious study of the time. Many of his classifications have remained valid to this day, although some of the disciplines, such as psychology and physics, have severed their ties with philosophy and have become important sciences in their own right. The most complex of Aristotle's works is probably the *Metaphysics*, in which he deals with his chief dispute with Plato, which concerned the Theory of Forms. Plato had postulated a higher dimension of existence for the ideal forms and thereby created a split between the apparent reality that we perceive and the genuine reality that we can only know by philosophical contemplation. Moreover, knowledge of these forms depended on a theory of "remembering" them from previous existences.

Aristotle, on the other hand, claimed that the forms were actually present in the objects we see around us, thereby eliminating the split between the two realities. Elsewhere in the *Metaphysics* Aristotle discusses the nature of God, whom he describes as "thought thinking of itself" and "the Unmoved Mover." The nature of the physical world ruled over by this supreme being is further explored in the *Physics*, which is concerned with the elements that compose the universe and the laws by which they operate.

Other important works by Aristotle include the Rhetoric, which prescribes the ideal model of oratory; and the *Poetics*, which does the same for poetry and includes the famous definition of tragedy mentioned earlier. Briefly, Aristotle's formula for tragedy is as follows: The tragic hero, who must be noble, through some undetected "tragic flaw" in character meets with a bad end involving the reversal of fortune and sometimes death. The audience, through various emotional and intellectual relations with this tragic figure, undergoes a "cleansing" or "purgation" of the soul, called *catharsis*. Critics of this analysis sometimes complain that Aristotle was trying to read his own very subjective formulas into the Greek tragedies of the time. This is not entirely justified, since Aristotle was probably writing for future tragedians, prescribing what ought to be rather than what was.

Aristotle's influence on later ages was vast, although not continuous. Philip of Macedon employed him to tutor young Alexander, but the effect on the young conqueror was probably minimal. Thereafter his works were lost and not recovered until the first century B.C., when they were used by the Roman statesman and thinker Cicero (106–43 B.C.). During the Middle Ages, they were translated into Latin and Arabic and became a philosophical basis for Christian theology. Saint Thomas Aquinas' synthesis of Aristotelian philosophy and Chris-

tian doctrine still remains the official philosophical position of the Roman Catholic Church. In philosophy, theology, and scientific and intellectual thought as a whole, many of the distinctions first applied by Aristotle were rediscovered in the early Renaissance and are still valid today. Indeed, no survey such as this can begin to do justice to one described by Dante as "the master of those who know." In the more than two thousand years since his death only Leonardo da Vinci has come near to equaling his creative range.

Greek Music in the Classical Period

Both Plato and Aristotle found a place for music in their ideal states; their comments on it provide some information on the status of Greek music in the Classical period. Throughout the fifth century B.C., music played an important part in dramatic performances but was generally subordinated to the poetry. By the end of the Peloponnesian War, however, the musical aspect of tragedy had begun to predominate. It is interesting to note that Euripides was criticized by his contemporaries for the lack of form and symmetry and the overemotionalism of his music, not of his verse. With its release from the function of mere accompaniment, instrumental music became especially popular in the fourth century B.C.

The belief in the doctrine of ethos whereby music had the power to influence human behavior, meant that the study of music played a vital part in the education and lifestyle of Classical Greeks. In Plato's view, participation in musical activities molded the character for better or worse—thus the ban on certain kinds of music, those with the "wrong" ethos, in his ideal Republic. At the same time, the musical scale—with its various ratios of pitches—reflected the proportions of the cosmos; music thereby provided a link between the real world and the abstract world of forms. For Aristotle, music held a more practical, less mystical, value in the attainment of virtue. As a mathematician he believed that the numerical relationships, which linked the various pitches, could be used by a musician to compose works which imitated the highest state of reason, and thus virtue. Further, just as individuals could create works with a virtuous, moral ethos, so too the state would be served by "ethical" music.

For all its importance in Greek life and thought, however, the actual sound of Greek music and the principles whereby it was composed are not easy to reconstruct or understand. The numerical relationship of notes to one another established by Pythagoras was used to divide the basic unit of an octave (series of eight notes) into smaller intervals named after their positions in relation to the lowest note in the octave. The interval known as a *fourth*, for example, represents the space between the lowest note and the fourth note up the octave. The intervals were then combined to form a series of scales, or *modes*. Each was given a name and was associated with a particular emotional range. Thus the Dorian mode was serious and warlike, the Phrygian exciting and emotional, and the Mixolydian plaintive and pathetic.

The unit with which Greek music was constructed was the *tetrachord*, a group of four notes of which the two outer ones are a perfect fourth apart and the inner ones variably spaced. The combination of two tetrachords formed a mode. The Dorian mode, for example, consisted of the following two tetrachords:

The Lydian mode was composed of two different tetrachords:

The origin of the modes and their relationship to one another is uncertain; it was disputed even in ancient times. The situation has not been made easier by the fact that medieval church music adopted the same system of mathematical construction and even some of the same names, but applied them to different modes. The word harmony is Greek in origin; literally it means a "joining together," and in a musical context the Greeks used it to describe various kinds of scales. There is nevertheless no evidence that Greek music contained any element of harmony in a more modern sense—that is, of groups of notes (chords) sounded simultaneously. Throughout the fifth century B.C., musical rhythm was tied to that of the words or dance steps the music accompanied. Special instruments such as cymbals and tambourines were used to mark the rhythmical patterns, and Greek writers on music often discussed specific problems presented to composers in terms of the Greek language and its accent system.

Although few traces have survived, a system of musical notation was used to write down compositions; the Greeks probably borrowed it, like their alphabet, from the Phoenicians. Originally used for lyre music, it used symbols to mark the position of fingers on the lyre strings, rather like modern guitar notation (tablature). The system was then adapted for vocal music and for nonstringed instruments such as the *aulos*. The oldest of the few examples to survive dates to around 250 B.C.

THE VISUAL ARTS IN CLASSICAL GREECE

Sculpture and Vase Painting in the Fifth Century B.C.

Like the writers and thinkers of their time, artists of the mid-fifth century B.C. were concerned with ideas of balance and order. Very early Classical works like the *Kritios Boy* [2.13] revealed a new interest in realism, and the sculptors who came later began to explore the exciting possibilities of representing the human body in motion. Among the most famous fifth-century sculptors working at Athens was Myron. Although none of his sculptures have survived, there are a number of later copies of one of his most famous pieces, the *Discus Thrower* [3.6]. The original, made around 450 B.C., is typical of its age in combining realistic treatment of an action with an idealized portrayal of the athlete himself.

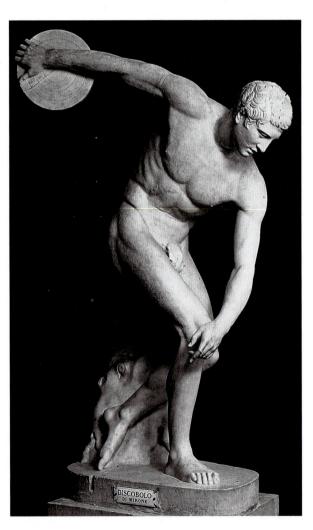

3.6 Myron, *Discobolos (Discus Thrower)*, Roman copy after bronze original of c. 450 B.C. Marble, life-size. Museo Nationale Romano, Rome, Italy.

While striving for naturalism, artists like Myron tried also to create a new standard of human beauty by controlling the human form according to principles of proportion, symmetry, and balance. Among the finest examples of mid-fifth-century-B.C. sculpture are two bronze statues found off the coast of southeast Italy in the 1980s [3.7]. Known as the Riace Bronzes, they were probably the work of a master sculptor on the Greek mainland. They represent warriors, although their precise subject, together with the reason for their presence in Italian waters, remains a mystery. Around 440 B.C., one of the greatest of Classical sculptors, Polykleitos of Argos, devised a mathematical formula for representing the perfect male body, an ideal canon of proportion, and wrote a book about it. The idea behind The Canon was that ideal beauty consisted of a precise relationship between the various parts of the body. Polykleitos' book must have set forth the details of his system of proportion. To illustrate his theory, he also produced a bronze statue of a young man holding a spear, the Doruphoros. Both book and original statue are lost; only later copies of the Doryphoros survive [3.8].

We do not therefore know exactly what Polykleitos' system was. Nevertheless, we have some indication in the writings of a later philosopher, Chrysippus (c. 280–207 B.C.), who wrote that "beauty consists of the proportion of the parts; of finger to finger; of all the fingers to the palm and the wrist; of those to the forearm; of the forearm to the upper arm; and of all these parts to one another, as set forth in *The Canon* of Polykleitos." Even if the exact relationships are lost, what was important about Polykleitos' ideal—and what made it so characteristic of the Classical vision as a whole—was that it depended on precisely ordered and balanced interrelationships of the various parts of the human body. Furthermore, the ideal beauty this created was not produced by nature, but by the power of the human intellect.

In the late fifth century B.C., as the Greeks became embroiled in the Peloponnesian War, sculpture and vase painting were characterized by a growing concern with the individual rather than a generalized ideal. Artists began to depict the emotional responses of ordinary people to life and death instead of approaching these responses indirectly through the use of myths.

Thus death and mourning became increasingly common subjects. Among the most touching works to survive from the period are a number of oil flasks used for funerary offerings [3.9]. They are painted with mourning or graveside scenes on a white rather than red background. The figures are depicted with quiet and calm dignity but with considerable feeling. This personal rather than public response to death is also found on the gravemarkers of the very end of the fifth century B.C., which show a grief that is perhaps resigned but still intense [3.10].

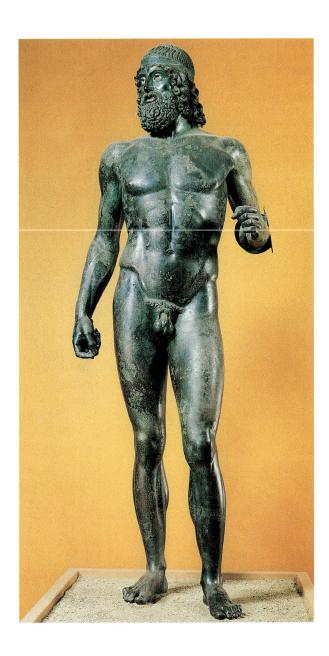

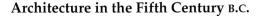

In architecture, as in sculpture, designers were concerned with proportion and the interrelationship of the various parts that constitute a complete structure. Nowhere is this more apparent than in the Temple of Zeus at Olympia [3.11], the first great artistic achievement of the years following the Persian Wars, begun in 470 B.C. and finished by 456 B.C. By the time of its completion it was also the largest Doric temple on mainland Greece; it was clearly intended to illustrate the new Classical preoccupation with proportion. The distance from the center of one column to the center of the next was the unit of measurement for the whole temple. Thus the height of each column is equal to two units, and the combined length of a triglyph and a metope equals half a unit. The theme of

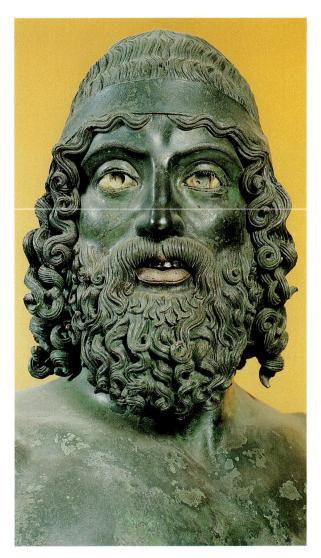

3.7 Warrior (front and detail of head), from the sea off Riace (Italy), c. 460-450 B.C. Bronze with glass, bone, silver, and copper inlay, height 6'6'' (2 m). Archaeological Museum, Reggio Calabria, Italy.

order, implicit in the architecture of the temple, became explicit in the sculpture that decorated it. At the center of the west pediment, standing calmly amidst a fight raging between Lapiths and Centaurs, was the figure of Apollo, the god of reason, exerting his authority by a single confident gesture [3.12].

http://ce.eng.usf.edu/pharos/wonders/zeus.html

The Statue of Zeus at Olympia

Like the works of Aeschylus, the sculptures from Olympia express a conviction that justice will triumph and that the gods will enforce it. The art of the second half of the fifth century B.C., however, is more concerned with human achievement than with divine will.

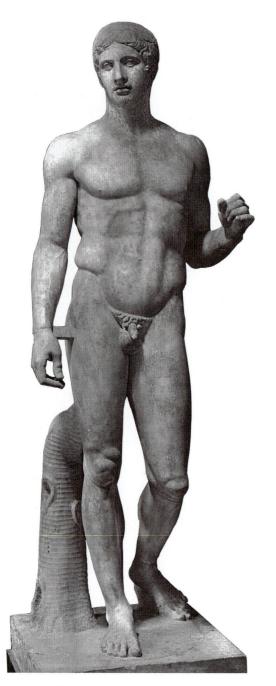

3.8 Polykleitos, *Doryphoros* (*Spear-bearer*). Roman marble copy after a bronze original of c. 450–440 B.C. Marble, height: 6'11". Museo Nazionale, Naples, Italy.

Pericles' building program for the Acropolis, or citadel of Athens, represents the supreme expression in visual terms of Classical ideals [3.13]. This greatest of all Classical artistic achievements has a special grandeur and poignancy. The splendor of its conception and execution has survived the vicissitudes of time; the great temple to Athena, the Parthenon, remains to this day an incomparable symbol of the Golden Age of Greece. Yet it was built during years of growing division and hostility

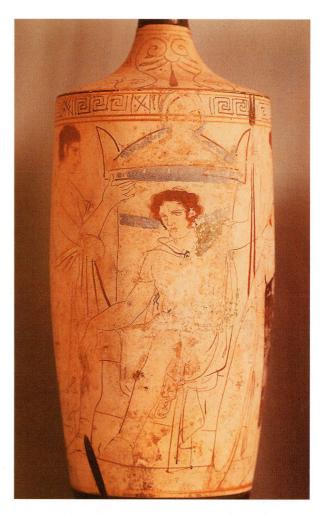

3.9 Reed Painter, *Warrior Seated at His Tomb*, late fifth century B.C. White-ground lekythos, height 18⁷/₈" (48 cm). National Archaeological Museum, Athens. A youth is at one side. On the other side is a young woman who holds the warrior's shield and helmet.

in the Greek world—the last sculpture was barely in place before the outbreak of the Peloponnesian War in 431 B.C. Pericles died in 429 B.C., but fighting and building both dragged on. The Erechtheum, the final temple to be completed, was not finished until 406 B.C., two years before the end of the war and the fall of Athens. Pericles had intended the entire program to perpetuate the memory of Athens' glorious achievements, but instead it is a reminder of the gulf between Classical high ideals and the realities of political existence in fifthcentury-B.C. Greece.

http://cal044202.student.utwente.nl/~marsares/acro/

The Acropolis

Even the funding of the Parthenon symbolizes this gap, since it was paid for at least in part from the trea-

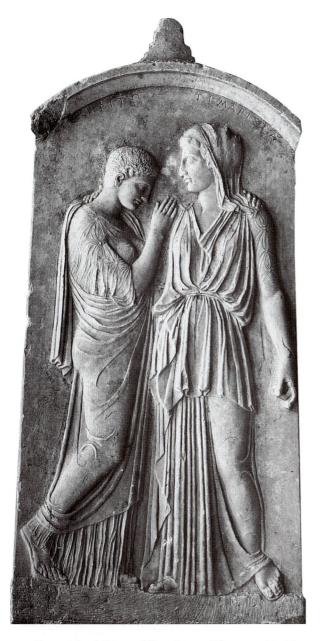

3.10 Grave stele of Crito and Timarista, c. 420 B.C., marble, Museum, Rhodes.

sury of the Delian League. The transfer of the League's funds to Athens in 454 B.C. clearly indicated Pericles' imperialist intentions, as did the use to which he put them. In this way the supreme monument of Periclean Athens was built with money originally intended for a pan–Hellenic League. It is even more ironic that Athens' further high-handed behavior created a spirit of ill feeling and distrust throughout the Greek world that led inevitably to the outbreak of the Peloponnesian War—a war that effectively destroyed the Athenian glory the Parthenon had been intended to symbolize.

The great outcrop of rock that forms the Acropolis was an obvious choice by Pericles for the Parthenon and

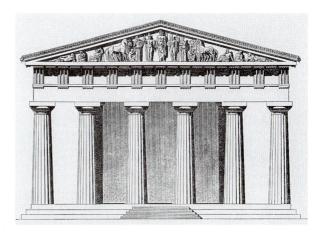

3.11 Reconstruction drawing of east facade, Temple of Zeus, Olympia, c. 470–456 B.C. The pediment shows Zeus between two contestants prior to a chariot race.

the other buildings planned with it. The site, which towers above the rest of the city, had served as a center for Athenian life from Mycenaean times, when a fortress was built on it. Throughout the Archaic period a series of temples had been constructed there, the last of which was destroyed by the Persians in 480 B.C. Work on the Acropolis was begun in 449 B.C. under the direction of Phidias, the greatest sculptor of his day and a personal friend of Pericles. The Parthenon [3.14] was the first building to be constructed (the name of the temple comes from the Greek parthenos ["virgin"]; that is, the goddess Athena). It was built between 447 and 438 B.C.; its sculptural decoration was complete by 432 B.C. Even larger than the Temple of Zeus at Olympia, the building combines the Doric order of its columns (seventeen on the sides and eight on the ends) with some Ionic features, including a continuous running frieze inside the outer colonnade, at the top of the temple wall and inner colonnades. The design incorporates a number of refinements intended to prevent any sense of monotony or heaviness and gives the building an air of richness and grace. Like earlier Doric columns, those of the Parthenon are thickest at the point one-third from the base and then taper to the top, a device called *entasis*. In addition, all the columns tilt slightly toward each other (it has been calculated that they would all meet if extended upward for two miles, or 3.2 kilometers). The columns at the corners are thicker and closer together than the others and the entablature leans outwards. The seemingly flat floor is not flat at all but convex. All these refinements are, of course, extremely subtle and barely visible to the naked eye. The perfection of their execution, requiring incredible precision of mathematical calculation, is the highest possible tribute to the Classical search for order.

The sculptural decoration of the Parthenon occupied three parts of the building and made use of three

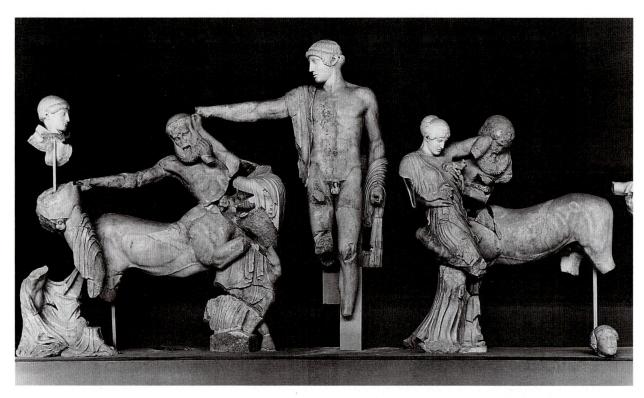

3.12 Apollo intervenes in the battle between the Lapiths and Centaurs, from the west pediment of the Temple of Zeus, Olympia, c. 470-456 B.C., Museum, Olympia.

3.13 Model reconstruction of the Acropolis. Royal Ontario Museum, Toronto. Most of the smaller buildings no longer exist, leaving an unobstructed view of the Parthenon that was not possible in ancient times.

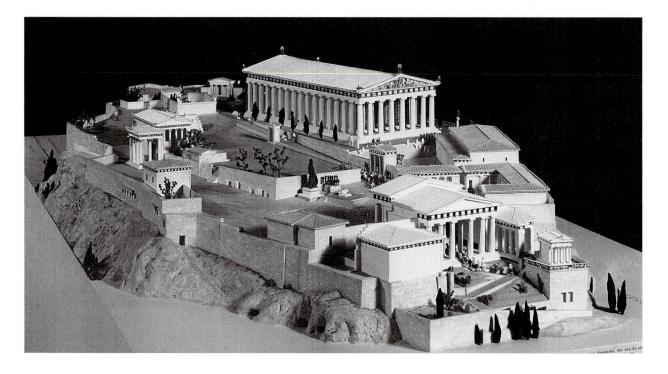

different techniques of carving. The figures in the pediments are freestanding; the frieze is carved in low relief; the metopes are in high relief (see next page). The Ionic frieze, 520 feet (158.6 meters) long, is carved in low relief;

it depicts a procession that took place every four years on the occasion of the Great Panathenaic Festival. It shows Athenians walking and riding to the Acropolis in a ceremony during which an ancient wooden statue of Athena

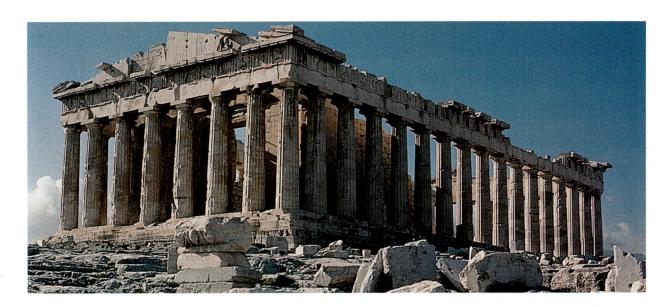

was presented with a new robe. The variety of movement, gesture, and rhythm achieved in the relatively limited technique of low relief makes the frieze among the greatest treasures of Greek art [3.15]. At the beginning of the nineteenth century, most of the frieze, together with other Parthenon sculptures, was removed from the building by the British ambassador to Constantinople, Lord Elgin; these are now in the British Museum. (All the sculptures from the Parthenon that are in the British Museum are generally known as the Elgin Marbles.)

Equally impressive are the surviving figures from the east and west pediments, which are freestanding. They show, respectively, the birth of Athena and her contest with Poseidon, god of the sea, to decide which of them should be patron deity of the city. They are badly damaged; even so, statues like the group of three goddesses [3.16], from the east pediment, show a combination of idealism and naturalism that has never been surpassed. The anatomy of the figures and the drapery, which in some cases covers them, are both treated realistically, even in places where the details of the workmanship would have been barely visible to the spectator below. The realism is combined, however, with a characteristically Classical preoccupation with proportion and balance; the result is sculptures that achieve an almost perfect blend of the two elements of the Classical style: ideal beauty represented in realistic terms. In contrast to the frieze, the technique employed on the metopes is high relief, so high, in fact, that some of the figures seem almost completely detached from their background. These metopes, which illustrate a number of mythological battles, represent a lower level of achievement, although some are more successful than others at reconciling scenes of violence and Classical idealism. The most impressive ones show episodes from the battle between Lapiths and Centaurs [3.17], the same story we saw on the west pediment at Olympia.

3.14 Ictinus and Callicrates, the Parthenon, Athens. 447–432 B.C. Height of columns 34' (10.36 m). Below is a plan of the temple.

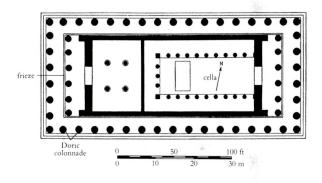

http://www.diaspora-net.org/marbles/story.htm

The Elgin Marbles

The monumental entrance to the Acropolis, the Propylaea [3.18], was begun in 437 B.C. and finished on the eve of the outbreak of war, although probably only by a modification of the architect Mnesikles' original plan. An unusual feature of its design is that both Doric and Ionic columns are used, the Doric ones visible from the front and the back and the Ionic ones lining the passageway through the outer porch.

The other major building on the Acropolis is the Erechtheum, an Ionic temple of complex design, which was begun in 421 B.C. but not completed until 406 B.C. The chief technical problem facing the architect, whose identity is unknown, was the uneven ground level of the site. The problem was solved by creating a building with entrances on different levels. The nature of the building itself produced other design problems. The Erechtheum had to commemorate a whole series of elaborate religious events and honor a number of different deities.

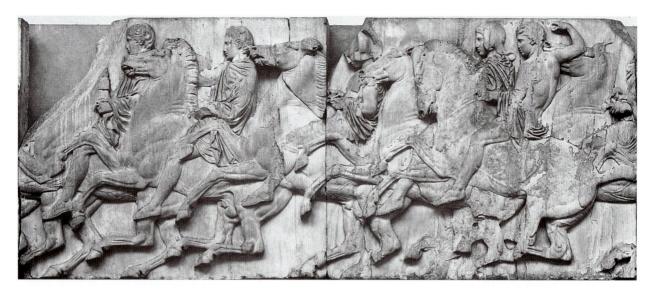

3.15 Equestrian group, detail of Parthenon frieze (north face), c. 442-432 B.C. Pentelic marble, height $41^3/8$ " (106 cm). British Museum, London (reproduced by courtesy of the Trustees). The composition is elaborate but clear. The riders, with their calm, typically Classical expressions, are shown in various positions. Note especially the last figure on the right.

One of its four chambers housed the ancient wooden statue of Athena that was at the center of the Great Panathenaic Festival shown on the Parthenon frieze. Elsewhere in the temple were altars to Poseidon and Erechtheus, an early Athenian king; to the legendary Athenian hero Butes; and to Hephaistos, the god of the forge. Furthermore, the design had to incorporate the marks in the ground made by Poseidon's trident during the competition with Athena, as shown on the west pediment of the Parthenon, and the site of the grave of another early and probably legendary Athenian king, Cecrops. The result of all this was a building whose com-

plex plan is still not fully understood. In fact, the exact identification of the inner chambers remains in doubt.

The decoration of the temple is both elaborate and delicate, almost fragile. Its best-known feature is the South Porch, where the roof rests not on columns but on the famous *caryatids*, statues of young women [3.19]. These graceful figures, which stand gravely upright with one knee slightly bent as if to sustain the weight of the roof, represent the most complete attempt until then to conceal the structural functions of a column behind its form. In many respects innovations such as these make the Erechtheum as representative of the mood of the late

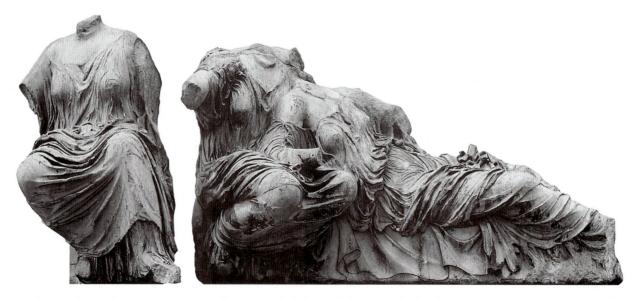

3.16 Three Goddesses from Parthenon east pediment, c. 438–432 B.C. Marble, over life-size. British Museum, London (reproduced by courtesy of the Trustees). The robes show the sculptor's technical virtuosity in carving drapery.

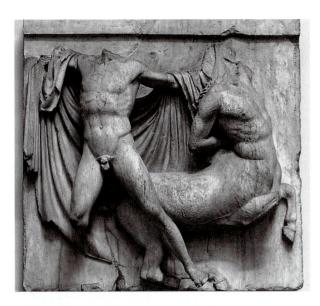

3.17 Lapith and Centaur, metope from Parthenon (south face) c. 448-442 B.C. Pentelic marble, height $4'4^1/_4$ " (1.34 m). British Museum, London (reproduced by courtesy of the Trustees). The assailed Lapith has dropped to one knee.

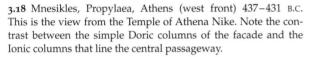

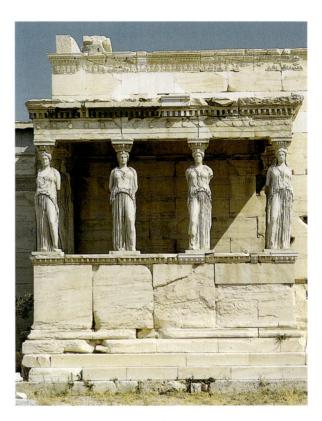

3.19 *Porch of the Maidens,* Erechtheum, Athens, $421-406\,$ B.C. Height of the caryatids 7'9'' ($2.36\,$ m).

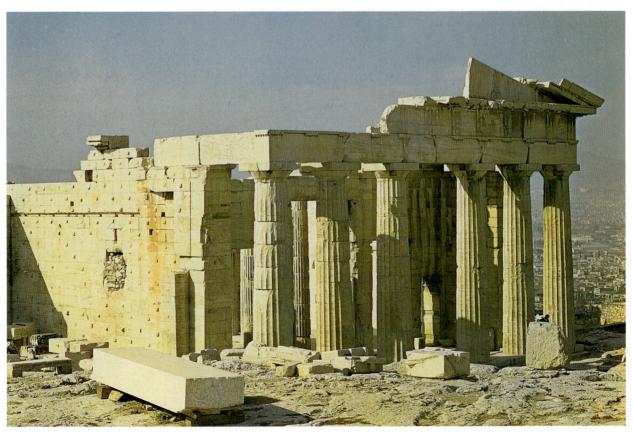

fifth century B.C. as the confident Parthenon is of the mood of a generation earlier. The apparent lack of a coherent overall plan and the blurring of traditional distinctions between architecture and sculpture, structure and decoration, seem to question traditional architectural values in a way that parallels the doubts of Euripides and his contemporaries.

THE VISUAL ARTS IN THE FOURTH CENTURY B.C.

As in the case of literature and philosophy, the confusion of Greek political life in the years following the defeat of Athens (404 B.C.) affected the development of the visual arts. In general, the idealism and heroic characters of High Classical art were replaced with a growing interest in realism and emotion. Our knowledge of the visual arts in the fourth century B.C. is, however, far from complete. Greek fresco painting of the period has been entirely lost, although recent discoveries in northern Greece at the Royal Cemetery of Vergina suggest that some of it may yet be found again [3.20]. In sculpture, fortunately, Roman copies of lost original statues enable us to form a

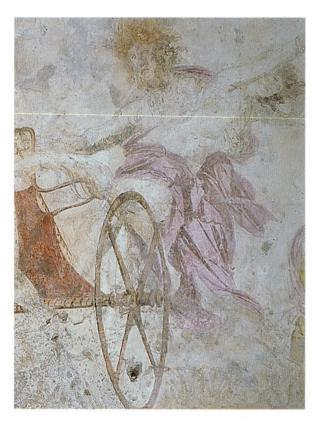

3.20 Pluto Seizing Persephone, detail of wall painting from Royal Tomb I, Vergina, mid-fourth century B.C. This unique example of Late Classical monumental painting was discovered by the Greek archaeologist Manolis Andronikos in 1977. It shows a remarkable fluency and freedom of technique.

fairly good estimation of the main developments. It is clear that Plato's interest in the fate of the individual soul finds its parallel in the sculptural treatment of the human form. Facial expressions become more emotional, often characterized by a mood of dreamy tenderness. Technical skill in depicting drapery and the anatomy beneath are put to the service of a new virtuosity. The three sculptors who dominated the art of the fourth century B.C. are Praxiteles, Scopas, and Lysippus.

The influence of Praxiteles on his contemporaries was immense. His particular brand of gentle melancholy is

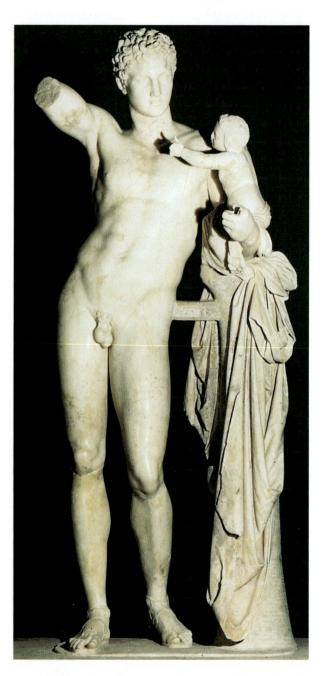

3.21 Praxiteles. *Hermes with Infant Dionysus*, c. 340 B.C. Marble, height 7'1" (2.16 m). Museum, Olympia. Hermes' missing right arm held a bunch of grapes just out of the baby's reach.

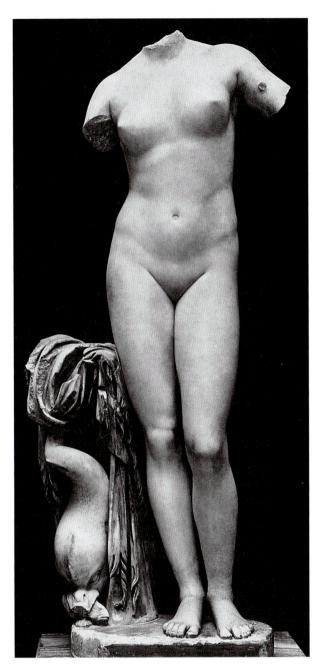

3.22 Praxiteles, *Aphrodite of Cyrene*. Roman copy of c. 100 B.C. Marble, height 5′ (1.52 m). National Museum, Rome. This copy was found by chance in the Roman baths at Cyrene, North Africa. The status is also called *Venus Anadyomene*, the Roman name for Aphrodite and a Greek word meaning "rising up from the sea," often used in referring to Aphrodite because she was supposed to have arisen from the sea at her birth. The porpoise is a reminder of the goddess' marine associations.

well illustrated by the *Hermes* at Olympia [3.21] that is generally attributed to him. Equally important is his famous statue of Aphrodite nude [3.22], of which some fifty copies have survived. This represents the discovery of the female body as an object of beauty in itself; it was also one of the first attempts in Western art to introduce

the element of sensuality into the portrayal of the female form. The art of Scopas was more dramatic, with an emphasis on emotion and intensity. Roman copies of his statue of *Pothos* (or *Desire*) [3.23], allow comparison of this yearning figure with Praxiteles' more relaxed *Hermes*. The impact of Lysippus was as much on succeeding periods as on his own time. One of his chief claims to fame was as the official portraitist of Alexander the Great. Lysippus' very individual characteristics—a new, more attenuated system of proportion, greater concern for realism, and the large scale of many of his work— had a profound effect later on Hellenistic art [3.24].

In architecture, as in the arts generally, the Late Classical period was one of innovation. The great sanctuaries at Olympia and Delphi were expanded and new cities were laid out at Rhodes, Cnidus, and Priene, using Classical principles of town planning. The fourth century B.C.

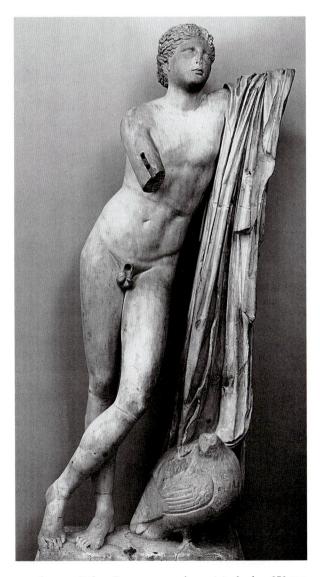

3.23 Scopas, *Pothos*. Roman copy after original of c. 350 B.C. Marble. Palazzo dei Conservatori, Rome.

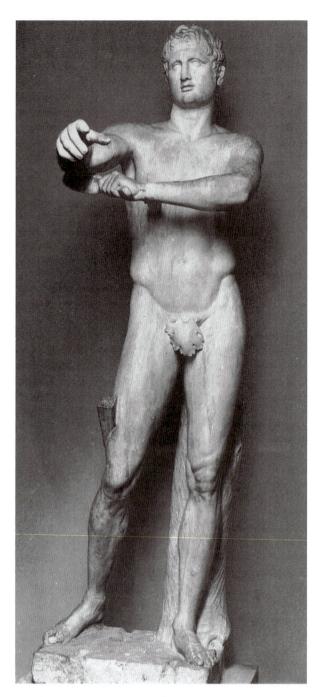

3.24 Lysippus, *Apoxyomenos (The Scraper)*. Roman copy after bronze original of c. 330 B.C. Marble, height 6'9" (2.06 m). Vatican Museums, Rome. The young athlete is cleaning off sweat and dirt with a tool called a *strigil*.

was also notable for the invention of building forms new to Greek architecture, including the *tholos*, ("circular building") [3.25]. The most grandiose work of the century was probably the Temple of Artemis at Ephesus, destroyed by fire in 356 B.C. and rebuilt on the same massive scale as before. Although the Greeks of the fourth century B.C. lacked the certainty and self-confidence of their predecessors, their culture shows no lack of ideas

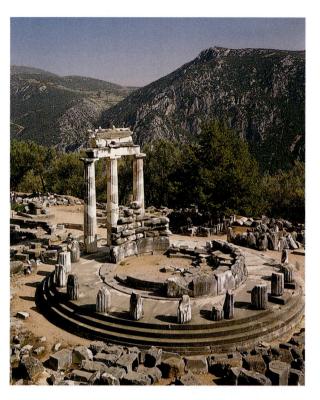

3.25 Theodoros of Phokaia, Tholos of the Sanctuary of Athena Pronaia, Delphi, c. 390 B.C. Marble and limestone; diameter of cella $28'2^{5}/8''$ (8.6 m). This is one of the first circular designs in Greek architecture. Originally, twenty Doric columns encircled the temple and ten Corinthian columns were set against the wall of the cella within.

or inspiration. Furthermore, even before Alexander's death the Macedonian Empire had spread Greek culture throughout the Mediterranean world. If Athens itself had lost any real political or commercial importance, the ideas of its great innovators began to affect an evergrowing number of people.

When Alexander died in the summer of 323 B.C., the division of his empire into separate independent kingdoms spread Greek culture even more widely. The kingdoms of the Seleucids in Syria and the Ptolemies in Egypt are the true successors to Periclean Athens. Even as far away as India sculptors and town planners were influenced by ideas developed by Athenians of the fifth and fourth centuries B.C. In due course, the cultural achievement of Classical Greece was absorbed and reborn in Rome, as Chapter 4 will show. Meanwhile, in the period known as the Hellenistic Age, which lasted from the death of Alexander to the Roman conquest of Greece in 146 B.C., that achievement took a new turn.

THE HELLENISTIC PERIOD

Alexander's generals' inability to agree on a single successor after his death made the division of the Macedon-

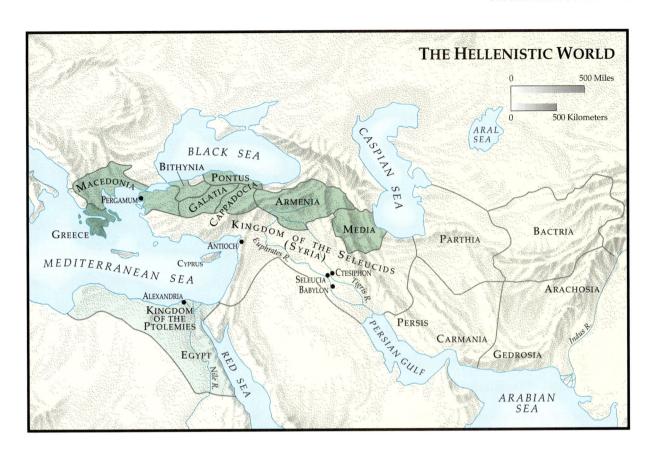

ian Empire inevitable. The four most important kingdoms that split off, Syria (the kingdom of the Seleucids), Egypt, Pergamum, and Macedonia itself (see map, above), were soon at loggerheads and remained so until they were finally conquered by Rome. Each of these, however, in its own way continued the spread of Greek culture, as the name of the period implies (it is derived from the verb "to Hellenize," or to spread Greek influence).

The greatest of all centers of Greek learning was in the Egyptian city of Alexandria, where King Ptolemy, Alexander's former personal staff officer and bodyguard, planned a large institute for scholarship known as the Temple of the Muses, or the Museum. The Library at the Museum contained everything of importance ever written in Greek, up to seven hundred thousand separate works, according to contemporary authorities. Its destruction by fire when Julius Caesar besieged the city in 47 B.C. must surely be one of the great intellectual disasters in the history of Western culture.

In Asia Minor and farther east in Syria the Hellenistic rulers of the new kingdoms fostered Greek art and literature as one means of holding foreign influences at bay. Libraries were built at Pergamum and the Syrian capital of Antioch, and philosophers from Greece were encouraged to visit the new centers of learning and lecture there. In this way Greek ideas not only retained their hold but began to make an impression on more remote

peoples even farther east. The first Buddhist monumental sculpture, called *Gandharan* after the Indian province of Gandhara where it developed, made use of Greek styles and techniques. There is even a classic Buddhist religious work called *The Questions of King Milinda* in which a local Greek ruler, probably called Menandros, is described exchanging ideas with a Buddhist sage, ending with the ruler's conversion to Buddhism—one example of the failure of Greek ideas to convince those exposed to them.

Yet, however much literature and philosophy could do to maintain the importance of Greek culture, it was primarily to the visual arts that Hellenistic rulers turned. In so doing they inaugurated the last great period of Greek art. The most powerful influence on the period immediately following Alexander's death was the memory of his life. The daring and immensity of his conquests, his own heroic personality, the new world he had sought to create—all these conspired to produce a spirit of adventure and experiment. Artists of the Hellenistic period sought not so much to equal or surpass their Classical predecessors in the familiar forms as to discover new subjects and invent new techniques. The development of realistic portraiture dates to this period [3.26], as does the construction of buildings like the Lighthouse at Alexandria [3.27], in its day the tallest tower ever built and one of the Seven Wonders of the World.

CONTEMPORARY VOICES

Kerdo the Cobbler

Step lively: open that drawer of sandals.

Look first at this, Metro; this sole, is it not adjusted like the most perfect of soles? Look, you also, women, at the heel-piece; see how it is held down and how well it is joined to the straps; yet, no part is better than another: all are perfect. And the color!—may the Goddess give you every joy of life!—you could find nothing to equal it. The color! neither saffron nor wax glow like this! Three minæ, for the leather, went to Kandas from Kerdo, who made these. And this other color! it was no cheaper. I swear, by all that is sacred and venerable, women, in truth held and maintained, with no more falsehood than a pair of scales—and, if not, may Kerdo know life and pleasure no more!—this almost drove me bankrupt! For enormous gains no longer satisfy the leathersellers. They do the least of the work, but our works of art depend on them and the cobbler suffers the most terrible misery and distress, night and day. I am glued to my stool even at night, worn out with work, sleepless until the noises of the dawn. And I have not told all: I support thirteen workmen, women, because my own children will not work. Even if Zeus begged them in tears, they would only chant: "What do you bring? What do you bring?" They sit around in comfort somewhere else, warming their legs, like little birds. But, as the saying goes, it is not talk, but money, which pays the bills. If this pair does not please you, Metro, you can see more and still more, until you are sure that Kerdo has not been talking nonsense.

Pistos, bring all those shoes from the shelves.

You must go back satisfied to your houses, women. Here are novelties of every sort: of Sykione and Ambrakia, laced slippers, hemp sandals, Ionian sandals, night slippers, high heels, Argian sandals, red ones:—name the ones you like best. (How dogs—and women—devour the substance of the cobbler!)

A WOMAN: And how much do you ask for that pair you have been parading so well? But do not thunder too loud and frighten us away!

Kerdo: Value them yourself, and fix their price, if you like; one who leaves it to you will not deceive you. If you wish, woman, a good cobbler's work, you will set a price—yes, by these gray temples where the fox has made his lair which will provide bread for those who handle the tools. (O Hermes! if nothing comes into our net now, I don't know when our saucepan will get another chance as good!)

Herondas, trans. George Howe and Gustave Adolphus Harrer, *Greek literature in translation* (New York: Harper, 1924), p. 542. Herondas was a Greek poet of the third century B.C. whose mimes, from one of which this passage comes, were probably written for public performance.

http://ce.eng.usf.edu/pharos/wonders/pharos.html

Lighthouse at Pharos

The all-pervading spirit of the Classical Age had been order. Now artists began to discover the delights of freedom. Classical art was calm and restrained, but Hellenistic art was emotional and expressive. Classical artists sought clarity and balance even in showing scenes of violence, but Hellenistic artists allowed themselves to depict riotous confusion involving strong contrasts of light and shade and the appearance of perpetual motion. It is not surprising that the term baroque, originally used to describe the extravagant European art of the seventeenth century A.D., is often applied to the art of the Hellenistic period. The artists responsible for these innovations created their works for a new kind of patron. Most of the great works of the Classical period had been produced for the state, with the result that the principal themes and inspirations were religious and political.

With the disintegration of the Macedonian Empire and the establishment of prosperous kingdoms at Pergamum, Antioch, and elsewhere, there developed a group of powerful rulers and wealthy businessmen who commissioned works either to provide lavish decoration for their cities or to adorn their private palaces and villas. Artists were no longer responsible to humanity and to the gods, but to whoever paid for the work. Their patrons encouraged them to develop new techniques and surpass the achievements of rivals. At the same time, the change in the artist's social role produced a change in the function of the work. Whereas in the Classical period architects had devoted themselves to the construction of temples and religious sanctuaries, the Hellenistic Age is notable for its marketplaces and theaters, as well as for scientific and technical buildings like the Tower of the Winds at Athens and the Lighthouse at Alexandria [3.27]. Among the rich cities of Hellenistic Asia, none was wealthier than Pergamum, ruled by a dynasty of kings known as the Attalids. Pergamum was founded in the early third century B.C. and reached the high point of its

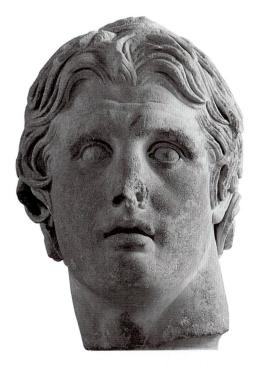

3.26 Alexander the Great, Pergamum, c. 160 B.C. Marble. Archaeological Museum, Istanbul. Note the emotional fire of the eyes and mouth, emphasized by the set of the head.

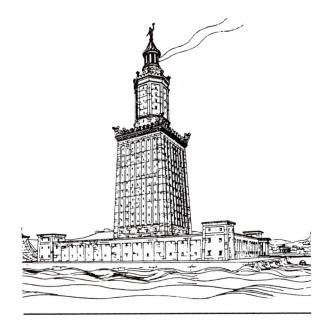

3.27 Reconstruction of the Lighthouse on Pharos, north of Alexandria harbor, 279 B.C. Original height 440′ (134.2 m). The beam of light from the lantern atop was intensified by a system of reflectors. The name of the island, Pharos, became, and still is, another word for *lighthouse* or *beacon*.

greatness in the reign of Eumenes II (197–159 B.C.). The layout of the chief buildings in the city represents a rejection of the Classical concepts of order and balance. Unlike the Periclean buildings on the Athenian Acropolis, the buildings in Pergamum were placed independently of one another with a new and dramatic use of space. The theater itself, set on a steep slope, seemed to be falling headlong down the hillside [3.28].

The chief religious shrine of Pergamum was the immense Altar of Zeus erected by Eumenes II (c. 180 B.C.) to commemorate the victories of his father, Attalus I, over the Gauls. Its base is decorated with a colossal frieze

3.28 Reconstruction model of Upper City, State Museums, Berlin, Germany. The steeply sloping theater is at left; the Altar to Zeus is in the center foreground.

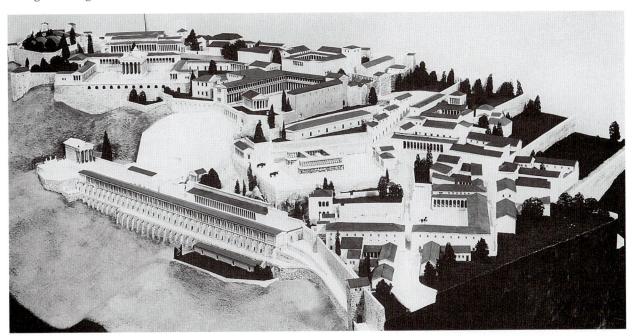

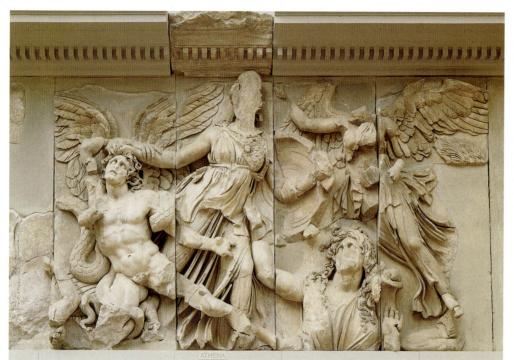

3.29 Athena Slaying the Giant. Detail of Altar to Zeus frieze, Pergamum, c. 180 B.C. Marble, height 7'6" (2.29 m). State Museums, Berlin, Germany. Athena is grasping the giant Alcyoneus by the hair, source of his strength, to lift him off the ground. His mother, Ge, the earth goddess, looks on despairingly from below.

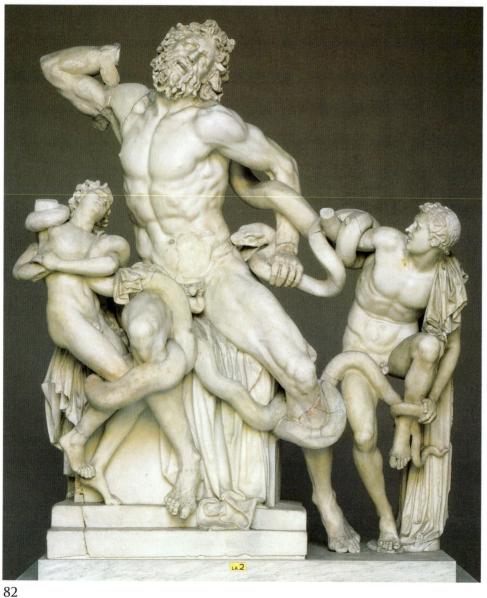

3.30 Agesander, Athenodorus, and Polydorus of Rhodes, Laocoön Group, early first century A.D. Marble, height $7'10^{1}/_{2}"$ (2.44 m). Vatican Museums, Rome. This statue was unearthed in 1506 in the ruins of Nero's Golden House. Note the similarity between Laocoön's head and the head of the giant Alcyoneus on the Pergamum frieze.

depicting the battle of the gods and giants. The triumphant figure of Zeus stands presumably as a symbol for the victorious king of Pergamum. The drama and violence of the battle find perfect expression in the tangled, writhing bodies, which leap out of the frieze in high relief, and in the intensity of the gestures and facial expressions [3.29]. The immense emotional impact of the scenes may prevent us from appreciating the remarkable skill of the artists, some of whom were brought from Athens to work on the project. However, the movement of the figures is far from random and the surface of the stone has been carefully worked to reproduce the texture of hair, skin, fabric, metal, and so on.

The Altar of Zeus represents the most complete illustration of the principles and practice of Hellenistic art. It is, of course, a work on a grand, even grandiose, scale, intended to impress a wide public. But many of its characteristics occur in freestanding pieces of sculpture like the *Laocoön* [3.30]. This famous work shows the Trojan priest Laocoön, punished by the gods for his attempt to warn his people against bringing into their city the wooden horse left by the Greeks. To silence the priest, Apollo sends two sea serpents to strangle him and his sons. The large piece is superbly composed, with the three figures bound together by the sinuous curves of the serpents; they pull away from one another under the agony of the creature's coils.

By the end of the Hellenistic period both artists and public seemed a little weary of so much richness and elaboration, and returned to some of the principles of Classical art. Simultaneously, the gradual conquest of the Hellenistic kingdoms by Rome and their absorption into the Roman Empire produced a new synthesis in which the achievements of Classical and Hellenistic Greece fused with the native Italian culture and passed on to later ages.

SUMMARY

The Classical Age The period covered in this chapter falls into three parts. The first, the years from 479 B.C. to 404 B.C., saw the growth of Athenian power and the consequent mistrust on the part of the rest of the Greek world of Athens' intentions. The same period was marked by major cultural developments at Athens. Sculptors such as Myron and Phidias created the High Classical blend of realism and idealism. Tragic drama, in which music played an important role, reached its highest achievement in the works of Aeschylus, Sophocles, and Euripides. In 449 B.C., work was begun on the buildings on the Athenian Acropolis planned by Pericles, Athens' ambitious leader. The Parthenon and the Propylaea were completed in an atmosphere made increasingly tense by the deteriorating relations between Athens and the other leading Greek states, particularly Corinth and Sparta.

The Peloponnesian War In 431 B.C., the Peloponnesian War erupted, with Athens and her few remaining allies on one side, and the remaining Greek world on the other. In 429 B.C. Pericles died from a plague that ravaged the city. In the absence of firm leadership the war dragged on and, during a period of truce, the Athenians launched a disastrous campaign against the Greek cities of Sicily. When hostilities resumed, the Athenians were fatally weakened and, in 404 B.C., they surrendered to the Spartans and their allies.

Classical Art and Literature The years of fighting profoundly affected cultural developments at Athens. Both the sculpture and the vase painting of the late fifth century B.C. show a new and somber interest in funerary subjects. In the theater, the later plays of Euripides depicted the horrors of war, while the comedies of Aristophanes mocked the political leaders responsible for the turmoil. Thucydides wrote his History of the Peloponnesian War to try to analyze the motives and reactions of the participants. Socrates began to question his fellow Athenians about their moral and religious beliefs in a similar spirit of inquiry.

The Late Classical Period The second period, from 404 B.C. to 323 B.C., was marked by considerable upheaval. Athens was no longer the dominating force in the Greek world, but there was no successor among her rivals. First Sparta and then Thebes achieved an uneasy control of Greek political life. With the collapse of the optimism of the High Classical period the Late Classical Age was marked by a new concern with the individual. The dreamy melancholy of Praxiteles' statues is in strong contrast to the idealism of a century earlier, while his figure of Aphrodite naked was one of the first examples in the Western tradition of sensuous female nudity. The most complete demonstration of the new interest in the fate of the individual can be found in the works of Plato, Socrates' disciple, who spent much of his life studying the relationship between individuals and the state. Aristotle, Plato's younger contemporary, also wrote on political theory as well as on a host of other topics.

The Rise of Macedon In 359 B.C., the northern kingdom of Macedon passed under the rule of Philip II and began to play an increasing part in Greek affairs. Despite Athenian resistance, led by the orator Demosthenes, Philip succeeded in uniting the cities of Greece in an alliance known as the League of Corinth; the only important city to remain independent was Sparta.

When Philip was assassinated in 336 B.C., he was succeeded by his son Alexander, who set out to expand the Macedonian Empire. After defeating the Persians, he set out in an amazing series of campaigns across Asia that brought him to the borders of India. Only the revolt of his weary troops prevented him from going farther. In 323 B.C., in the course of the long journey home, Alexander died of fever.

The Hellenistic World The period from 323 to 146 B.C., marked by the spread of Greek culture throughout

the parts of Asia conquered by Alexander, is known as the Hellenistic Age. In the confusion following his death, four kingdoms emerged: Syria, Egypt, Pergamum, and Macedon itself. Prosperous and aggressive and frequently at war with one another, they combined Greek intellectual ideas and artistic styles with native Eastern ones.

The chief characteristics of Hellenistic art were virtuosity and drama. Works such as the Altar of Zeus at Pergamum were commissioned by Hellenistic rulers to glorify their reigns. Artists were encouraged to develop elaborate new techniques and employ them in complex and dramatic ways. The principal buildings of the age were public works like markets and theaters or scientific constructions such as the Lighthouse at Alexandria.

The Roman Conquest of Greece The inability of the Hellenistic kingdoms to present a united front caused them to fall—one by one—victim to a new force in the eastern Mediterranean: Rome. By the end of the third century B.C., the Romans had secured their position in the western Mediterranean and begun an expansion into Asia that was to bring all the Hellenistic kingdoms under their control.

In 146 B.C., Roman troops captured the city of Corinth, center of the League of Corinth founded by Philip and symbol of Greek independence. Greece was made into a Roman province, and its subsequent history followed that of the Roman Empire. If Greece was under Roman political control, however, Greek art and culture dominated much of Roman cultural life and were passed on by the Romans into the Western tradition.

Pronunciation Guide

Aegisthus: Ee-GISTH-us Aeschylus:

ESK-ill-us

Antigone:

Ant-IG-owe-nee

Aristophanes:

A-rist-OFF-an-ease

Caryatid: Catharsis: Ca-ree-AT-id Cath-ARE-sis

Chaeronaea: Clytemnestra: Kai-ron-EE-a Klit-em-NESS-tra

Demosthenes:

Dem-OSTH-en-ease

Doryphoros: Elgin:

Dor-IF-or-us EL-ghin **ENT-ass-iss**

Entasis: Erechtheum:

Er-EK-thee-um

Eumenides: Euripides:

You-MEN-id-ease You-RIP-id-ease

Ictinus:

Ic-TINE-us

Laocoön: Mnesikles: La-OK-owe-on

Oedipus:

MNEE-sik-lees ED-ip-us

Panathenaic:

Pan-ath-e-NAY-ic

Parthenon:

PARTH-en-on PE-rik-lees

Pericles: Phaedo:

FEE-doe

Phidias:

FID-i-ass Po-lic-LIE-tus

Polykleitos: Propylaea: Ptolemy:

Pro-pie-LEE-a PTOL-em-ee

Satyr: Scopas: SAY-tr

Seleucids:

SKOWE-pass Sell-YOU-sids

Thucydides:

Thyou-SID-id-ease

EXERCISES

- 1. Explain the chief differences between the three principal Greek tragic dramatists. Illustrate with episodes in partic-
- 2. Discuss the contributions of Plato and Aristotle to the development of philosophy.
- 3. Describe Greek musical theory in the fifth and fourth centuries B.C.
- 4. How was sculpture used to decorate the buildings on the Athenian Acropolis? What is the significance of the myths it illustrates?
- What are the features of a work of art that indicate it is Hellenistic? How does the Hellenistic style contrast with that of the Classical period?

FURTHER READING

Barnes, J. (1982). Aristotle. Oxford: Oxford University Press. In a mere eighty pages this remarkable book provides an excellent general introduction to Aristotle's vast range of works.

Boardman, J. (1987). Greek sculpture: The classical period. New York: Thames and Hudson.

Boardman, J. (1995). Greek sculpture: The late classical period and sculpture in colonies and overseas. New York: Thames and Hudson. This and the above-listed book provide authoritative guides to the Greek sculpture produced during the period covered by this chapter.

Boardman, J., J. Griffin, & O. Murray. (1988). Greece and the Hellenistic world. New York: Oxford University Press. An excellent collection of essays on aspects of Greek history

and culture.

Bosworth, A. B. (1988). Conquest and empire. New York: Cambridge University Press. The rise of Macedon, and the careers of Philip and Alexander.

Finley, M. I. (Ed.). (1981). The legacy of Greece: A new appraisal. Oxford: Oxford University Press. A collection of essays by authors who discuss Greek achievements in various fields-philosophy, art, literature, among others-and evaluate their relevance to the late twentieth century.

Garlan, Y. (1988). Slavery in ancient Greece. Ithaca, NY: Cornell University Press. An account of slavery in the Greek

Hammond, N. G. L. (1981). Alexander the Great: King, commander, and statesman. London: Methuen. Alexander is still a controversial figure. The author of this scholarly study, clearly an admirer, provides a vivid account of Alexander's life.

Keuls, E. C. (1985). The reign of the phallus: Sexual politics in ancient Athens. New York: Harper & Row. A thoughtprovoking discussion of the role of gender in Athenian life.

Lesky, A. (1983). *Greek tragic poetry* (3rd ed.; trans. M. Dillon). New Haven: Yale University Press. The latest version of one of the standard works on Greek tragedy, analyzing it as literature rather than as theater.

Morford, M. P. O., & P. J. Lenardon. (1977). Classical mythology. New York: Longman. A useful reference source for the many myths found in Greek art and literature, this book also discusses Greek religion and the Greeks' views of the afterlife.

Pollitt, J. J. (1986). *Art in the Hellenistic Age*. New York: Cambridge University Press. A thorough survey of Hellenistic

art, with good illustrations.

Walbank, F. W. (1982). The Hellenistic world. Cambridge: Harvard University Press. This book describes the various Hellenistic kingdoms and evaluates their cultural achievements; includes a good section on Hellenistic science and technology.

Wycherley, R. E. (1978). *The stones of Athens*. Princeton, NJ: Princeton University Press. An authoritative description of the monuments of Classical Athens that includes an individual description as well as a bibliography for each important building.

ONLINE CHAPTER LINKS

An extensive investigation of the Parthenon is available at

http://homer.reed.edu/Parthenon.html

In the Footsteps of Alexander the Great at

http://www.pbs.org/mpt/alexander/

a companion site to the PBS documentary, follows the journey of Alexander and his army as they swept across Africa.

This Hellenistic Greek Sculpture

http://harpy.uccs.edu/greek/hellsculpt.html

Web site affords images of actual sculptures from this era and others.

View the Cast Gallery at Oxford University's Ashmolean Museum at

http://www.ashmol.ox.ac.uk/ash/departments/cast-gallery/

where Greek works are represented among this outstanding collection of casts derived from sculptures found in museums around the world.

509

3 1

ROMAN REPUBLIC

RECONSTRUCTION AND DECLINE

476

753 B.C. Founding of Rome (traditional date)

c. 700 Development of Etruscan culture

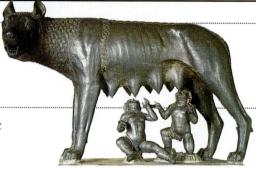

509 Expulsion of Etruscan kings and foundation of Roman Republic

450 Promulgation of the *Twelve Tables* of laws

c. 390 Sack of Rome by Gauls

287 Hortensian Law reinforces plebeian power

264–241 First Punic War: Roman conquest of Sicily, Sardinia, Corsica

218-201 Second Punic War: Roman conquest of Spain

146 Destruction of Carthage: Africa becomes Roman province; sack of Corinth: Greece becomes Roman province

c. 200 – 160 B.C. Ennius, Annals, epic poem; Plautus, Mostellaria, Roman comedy; Terence, Roman comedies

2nd cent. Epicureanism and Stoicism imported to Rome

c. 65–43 Lucretius, *On the Nature of Things*, Epicurean poem; Cicero,

Commentaries, on Gallic wars

c. 27 B.C.-A.D. 14 Horace, Odes and

Ars Poetica; Vergil, Aeneid, Georgics, Eclogues; Ovid, Metamorphoses,

mythological tales; Livy, Annals of

orations and philosophical essays; Catullus, lyric poems; Caesar,

90-88 Social War

82-81 Sulla dictator at Rome

60 First Triumvirate: Pompey, Caesar, Crassus

58-56 Caesar conquers Gaul

48 Battle of Pharsalus: war of Caesar and Pompey ends in death of Pompey; Caesar meets Cleopatra in Egypt

46-44 Caesar rules Rome as dictator until assassinated

43 Second Triumvirate: Antony, Lepidus, Octavian

31 Battle of Actium won by Octavian

30 Death of Antony and Cleopatra

27-14 Octavian under name of Augustus rules as first Roman emperor

c. 6 Birth of Jesus; crucified c. A.D. 30

A.D. 14-68 Julio-Claudian emperors: Tiberius, Caligula, Claudius, Nero

69-96 Flavian emperors: Vespasian, Titus, Domitian

70 Capture of Jerusalem by Titus; destruction of Solomon's Temple

79 Destruction of Pompeii and Herculaneum

96-138 Adoptive emperors: Nerva, Trajan, Hadrian, et al.

138-192 Antonine emperors: Antoninus Pius, Marcus Aurelius, et al.

c. A.D. 100–150 Tacitus, History; Juvenal, Satires; Pliny the Younger, Letters; Suetonius, Lives of the Caesars; Epictetus, Enchiridion, on Stoicism

c. 166–179 Marcus Aurelius, *Meditations*, on Stoicism

the Roman People

193–235 Severan emperors: Septimius Severus, Caracalla, et al.

212 Edict of Caracalla

284-305 Reign of Diocletian; return of civil order

301 Edict of Diocletian, fixing wages and prices

307–337 Reign of Constantine; sole emperor after 324

330 Founding of Constantinople

392 Paganism officially suppressed; Christianity made state religion

409-455 Vandals and Visigoths invade Italy, Spain, Gaul, Africa

476 Romulus Augustulus forced to abdicate as last Western Roman emperor

CHAPTER 4 THE ROMAN LEGACY

ART

ARCHITECTURE

Music

c. 650–500 B.c. Influence of Greek and Orientalizing styles on Etruscan art

late 6th cent. Etruscan Apollo of Veii

c. 616 – 509 B.C. Etruscans drain marshes, build temples, construct roads Extension of Greek trumpet into Roman tuba, used in games, processions, battles

c. 2nd cent. B.c. Greek music becomes popular at Rome

Ist cent. Realistic portraiture;
Portrait of Cicero

c. 30 B.C.—A.D. 30 Villa of Mysteries frescoes, Pompeii 1st cent. Discovery of concrete

c. 82 Sulla commissions Sanctuary of Fortuna Primagenia, Praeneste

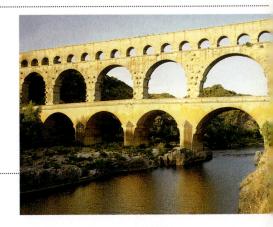

c. 20 *View of a Garden,* fresco from Augustus' villa, Prima Porta

13-9 Ara pacis

Use of arch, vault, dome, principles of stress/counterstress

Ist cent. A.D. Pont du Gard, Nîmes; atrium-style houses at Pompeii

c. A.D. 14 Augustus of Prima Porta

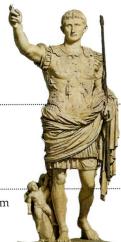

c. 126 Pantheon, Rome

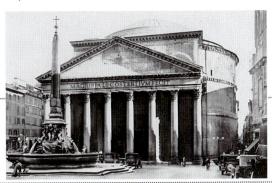

Decline of realism

324–330 Colossal head from Basilica of Constantine, Rome

300-305 Diocletian's palace, Split

306–315 Basilica of Constantine, Rome

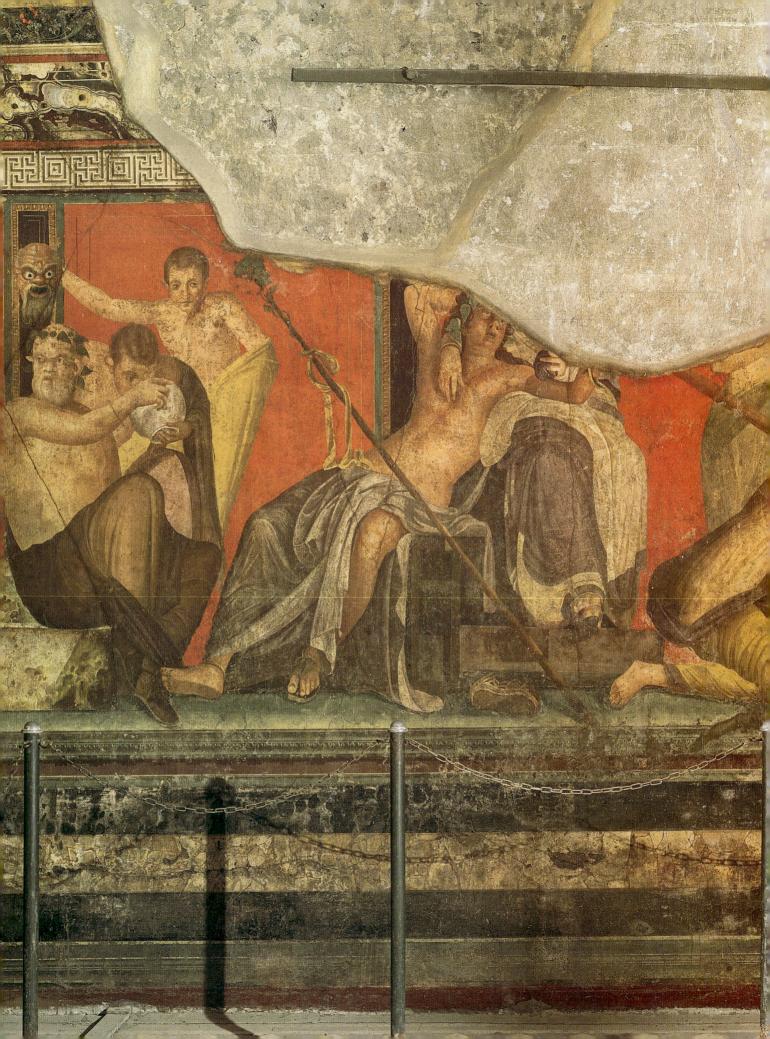

CHAPTER 4 THE ROMAN LEGACY

THE IMPORTANCE OF ROME

If the origins of our intellectual heritage go back to the Greeks and, less directly, to the peoples of Egypt and the Near East, the contribution of Rome to the wider spreading of Western civilization was tremendous. In fields like language, law, politics, religion, and art Roman culture continues to affect our lives. The road network of modern Europe is based on one planned and built by the Romans some two thousand years ago; the alphabet we use is the Roman alphabet; and the division of the year into twelve months of unequal length is a modified form of the calendar introduced by Julius Caesar in 45 B.C. Even after the fall of the Roman Empire the city of Rome stood for centuries as the symbol of civilization itself; later empires deliberately shaped themselves on the Roman model.

http://virgil.org/caesar/

Julius Caesar

The enormous impact of Rome on our culture is partly the result of the industrious and determined character of the Romans themselves, who very early in their history saw themselves as the divinely appointed rulers of the world. In the course of fulfilling their mission they spread Roman culture from the north of England to Africa, from Spain to India (see map, "The Roman World"). This Romanization of the entire known world permitted the Romans to disseminate ideas drawn from other peoples. It was through the Romans that Greek art and literature were handed down and incorporated into the Western tradition, not from the Greeks themselves. The rapid spread of Christianity in the fourth century A.D. was a result of the decision by the Roman emperors to adopt it as the official religion of the Roman Empire. In these and in other respects, the legacy that Rome was to pass on to Western civilization had been inherited from its predecessors.

The Romans themselves were in fact surprisingly modest about their own cultural achievements, believing that their strengths lay in good government and military prowess rather than in artistic and intellectual attainments. It was their view that Rome should get on with the job of ruling the world and leave luxuries like sculpture and astronomy to others.

It is easy but unfair to accept the Romans' estimate of themselves as uncreative without questioning it. True, in some fields the Roman contribution was not very impressive. What little we know about Roman music, for example, suggests that its loss is hardly a serious one. It was intended mainly for performance at religious events like weddings and funerals, and as a background for social occasions. Musicians were often brought into aristocratic homes to provide after-dinner entertainment at a party, and individual performers, frequently women, would play before small groups in a domestic setting. Small bands of traveling musicians, playing on pipes and such percussion instruments as cymbals and tabourines, provided background music for the acrobats and jugglers who performed in public squares and during gladiatorial contests [4.1].

Nonetheless, for the Romans music certainly had none of the intellectual and philosophical significance it bore for the Greeks, and when Roman writers mention musical performances it is often to complain about the noise. The only serious development in Roman music was the extension of the Greek trumpet into a longer and louder bronze instrument known as the *tuba*, which was used on public occasions like games and processions and in battle, when an especially powerful type some 4 feet (1.2 m) long gave the signals for attack and retreat. The sound was not pleasant.

In general, Roman music lovers contented themselves with Greek music played on Greek instruments. Although serious music began to grow in popularity with the spread of Greek culture, it always remained an aristocratic rather than a popular taste. Emperor Nero's love of music, coupled with his insistence on giving public concerts on the lyre, may have even hastened his downfall.

In areas other than music, the Roman achievement is considerable. There is no doubt that Roman art and literature rarely show the originality of their Greek

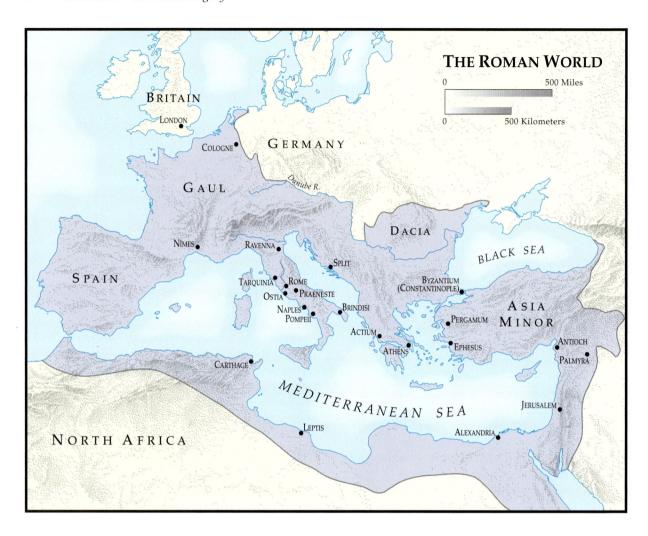

predecessors, but originality is neither the only artistic virtue, nor is its absence always a defect. The Roman genius, in fact, lay precisely in absorbing and assimilating influences from outside and going on to create from them something typically Roman. The lyric poetry of first-century-B.C. writers like Catullus was inspired by

the works of Sappho, Alcaeus, and other Greek poets of the sixth century B.C., but nothing could be more Roman

4.1 Mosaic, from villa near Zliten, North Africa, c. A.D. 70. Gladiatorial contest with orchestra of hydraulic organ, trumpet, and horn players. Museum of Antiquities, Tripoli.

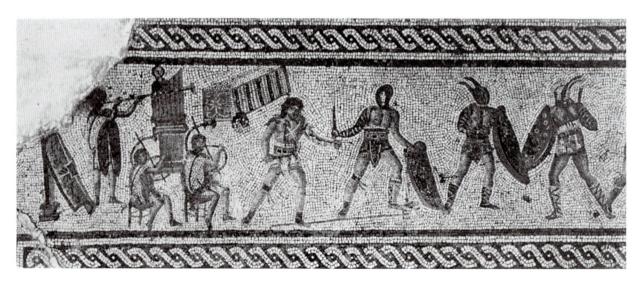

in spirit than Catullus' poems. In architecture, the Romans achieved a style that is one of the most impressive of all our legacies from the ancient world.

It is useful to emphasize the very real value of Roman art and literature because there has been a tendency since the nineteenth century to exalt the Greek cultural achievement at the expense of the Roman. All agree on the superior quality of Roman roads, sewers, and aqueducts; Roman sculpture or drama has in general been less highly rated, mainly because of comparisons to that of the Greeks. Any study of Roman culture inevitably involves examining the influences that went to make it up, and it is always necessary to remember the Roman ability to absorb and combine outside ideas and create something fresh from them.

Rome's history was a long one, beginning with the foundation of the city in the eighth century B.C. For the first two and a half centuries of its existence it was ruled by kings. The rest of the vast span of Roman history is divided into two long periods: Republican Rome (509–31 B.C.), during which time democratic government was first developed and then allowed to collapse; and Imperial Rome (31 B.C.–A.D. 476), during when the Roman world was ruled, at least in theory, by one man—the emperor. The date A.D. 476 marks the deposition of the last Roman emperor in the West; it forms a convenient, if artificial, terminus to the Imperial period.

Shortly after the foundation of the Republic, the Romans began their conquest of neighboring peoples, first in Italy, then throughout Europe, Asia, and North Africa. As their territory grew, Roman civilization developed along with it, assimilating the cultures of the peoples who fell under Roman domination. But long before the Romans conquered Greece or anywhere else, they were themselves conquered by the Etruscans, and the story of Rome's rise to power truly begins with the impact on Roman life made by Etruscan rule there.

http://www.comune.bologna.it/bologna/Musei/Archeologico/etruschi/en/7_e.htm

Etruscans

THE ETRUSCANS AND THEIR ART

The late eighth century B.C. was a time of great activity in Italy. The Greeks had reached the south coast and Sicily. In the valley of the Tiber, farmers and herdsmen of a group of tribes known as the Latins (origin of the name of the language spoken by the Romans) were establishing small village settlements, one of which was to become the future imperial city of Rome. The most flourishing area at the time, however, was to the north

of Rome, where in central Italy a new culture—the Etruscan—was appearing.

The Etruscans are among the most intriguing of ancient peoples, and ever since early Roman times scholars have argued about who they were, where they came from, and what language they spoke. Even today, in spite of the discoveries of modern archaeologists, we still know little about the origins of the Etruscans and their language has yet to be deciphered. By 700 B.C., they had established themselves in the part of Italy named for them, Tuscany; but it is not clear whether they arrived from abroad or whether their culture was a more developed form of an earlier Italian one. The ancient Greeks and Romans believed that the Etruscans had come to Italy from the East, perhaps from Lydia, an ancient kingdom in Asia Minor. Indeed, many aspects of their life and much of their art have pronounced Eastern characteristics. In other ways, however, the Etruscans have much in common with their predecessors in central Italy. Even so, no other culture related to the Etruscans' has ever been found. Whatever their origins, they were to have a major effect on Italian life, and on the growth of Rome and its culture [4.2].

From the very beginning of their history the Etruscans showed an outstanding sophistication and technological ability. The sumptuous gold treasures buried in their tombs are evidence both of their material prosperity and of their superb craftsmanship. The commercial contacts of the Etruscans extended over most of the western Mediterranean and, in Italy itself, Etruscan cities like Cerveteri and Tarquinia developed rich artistic traditions. Etruscan art has its own special character, a kind of elemental force almost primitive in spirit, although the

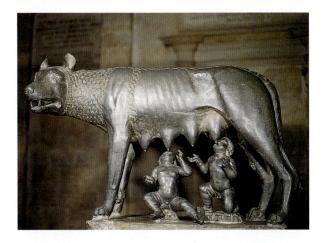

4.2 Capitoline She-Wolf, c. 500–480 B.C. Bronze, height 31", length 4'4" (1.32 m). Palazzo dei Conservatori, Rome. Although this statue or one very like it became the mascot of Rome, it was probably made by Etruscan craftsmen. The twins Romulus and Remus, legendary founders of the city, were added during the Renaissance.

craftsmanship and techniques are highly sophisticated. Unlike the Greeks, the Etruscans were less interested in intellectual problems of proportion or understanding how the human body works than in producing an immediate impact upon the viewer. The famous statue of Apollo found in 1916 at Veii [4.3] is unquestionably related to Greek models, but the tension of the god's pose and the sinister quality of his smile produce an effect of great power in a typically Etruscan way. Other Etruscan

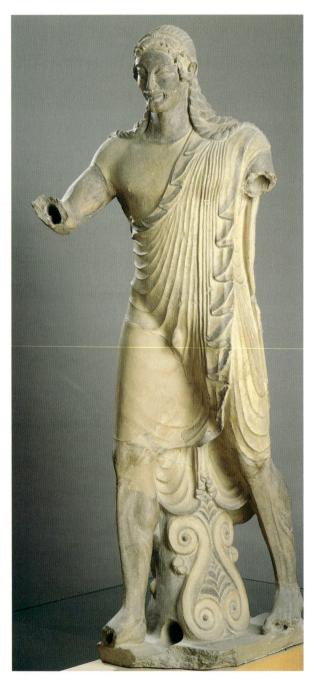

4.3 *Apollo of Veii*, from the roof of the Portonaccio Temple, Veii, Etruscan, c. 510–500 B.C. Painted terra cotta, height 5'11" (1.78 m). Museo Nazionale di Villa Giulia, Rome.

art is more relaxed, showing a love of nature rarely found in Greek art. The paintings in the Tomb of Hunting and Fishing at Tarquinia [4.4] convey a marvelous sense of light and air, the hazy blue background evoking the sensations of sea and spray.

This gifted people was bound to exert a strong influence on the development of civilization in Italy; Etruscan occupation of Rome (616-510 B.C.) marks a turning point in Roman history. According to later tradition, the city of Rome had been founded in 753 B.C. and was ruled in its earliest days by kings (in actual fact, Rome was probably not much more than a small country town for most of this period). The later Romans' own grandiose picture of the early days of their city was intended to glamorize its origins, but only with the arrival of the Etruscans did anything like an urban center begin to develop. Etruscan engineers drained a large marshy area, previously uninhabitable, which became the community's center, the future Roman forum. They built temples and shrines and constructed roads. Among other innovations, the Etruscans introduced a number of things we are accustomed to think of as typically Roman, including public games like chariot racing and even the toga, the most characteristic form of Roman dress.

Most important, however, was the fact that under Etruscan domination the Romans found themselves for the first time in contact with the larger world. Instead of being simple villagers living in a small community governed by tribal chiefs, they became part of a large cultural unit with links throughout Italy and abroad. Within a hundred years Rome had learned the lessons of Etruscan technology and culture, driven the Etruscans back to their own territory, and begun her unrelenting climb to power.

The rise of Rome signaled the decline of the Etruscans throughout Italy. In the centuries following their expulsion from Rome in 510 B.C., their cities were conquered and their territory taken over by the Romans. In the first century B.C., they automatically received the right of Roman citizenship and became absorbed into the Roman Empire. The gradual collapse of their world is mirrored in later Etruscan art. The wall paintings in the tombs become increasingly gloomy, suggesting that for an Etruscan of the third century B.C. the misfortunes of this life were followed by the tortures of the next. The old couple from Volterra whose anxious faces are so vividly depicted on the lid of their sarcophagus [4.5] give us some idea of the troubled spirit of the final days of Etruscan culture.

REPUBLICAN ROME (509-31 B.C.)

With the expulsion of the Etruscans the Romans began their climb to power, free now to rule themselves. Instead of choosing a new king, Rome constituted itself a

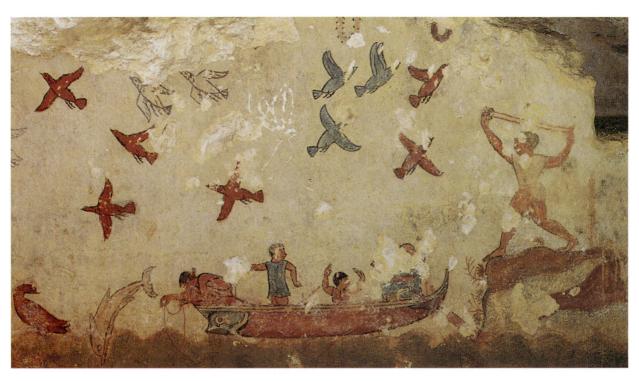

4.4 Wall painting from the Tomb of Hunting and Fishing, Tarquinia, c. 520 B.C., Fresco. Men, fish, and birds are all rendered naturalistically, with acute observation. Note the bird perched on the waves to the left of the diving fish and the hunter at right.

Republic, governed by the people somewhat along the lines of the Greek city-states, although less democratically. Two chief magistrates or consuls were elected for a one-year term by all the male citizens, but the principal assembly, the Senate, drew most of its members from Roman aristocratic families. From the very beginning, therefore, power was concentrated in the hands of the upper class (the *patricians*), although the lower class (the *plebeians*) was permitted to form its own assembly.

The leaders elected by the plebeian assembly, the *tribunes*, represented the plebeians' interests and protected them against state officials who treated them unjustly. The meeting place for both the Senate and the assemblies of the people was the *forum*, the large open space at the foot of the Palatine and Capitoline hills that had been drained and made habitable by the Etruscans [4.6].

From the founding of the Roman Republic to its bloody end in the civil wars following the murder of

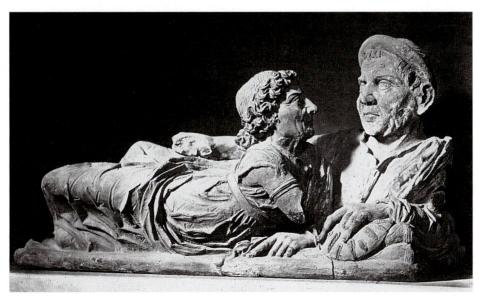

4.5 Lid of funerary urn showing the dead couple whose ashes it contains. Etruscan, first century B.C., terra cotta, length 18" (47 cm). Museo Guarnacci, Volterra, Italy.

4.6 The Roman forum — center of the political, economic, and religious life of the Roman world as it appears today.

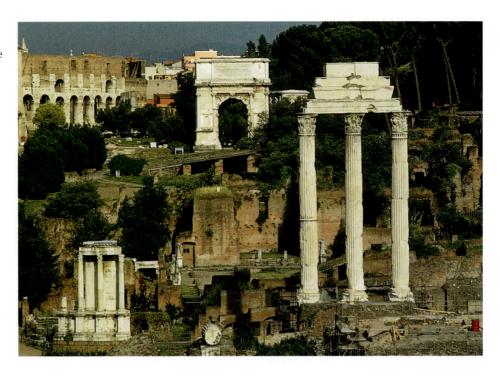

Julius Caesar (44 B.C.), its history was dominated by agitation for political equality. Yet the first major confrontation—the conflict between patricians and plebeians—never seriously endangered political stability in Rome or military campaigns abroad. Both sides showed a flexibility and spirit of compromise that produced a gradual growth in plebeian power while avoiding any split disastrous enough to interrupt Rome's growing domination of the Italian peninsula. The final plebeian victory came in 287 B.C. with the passage of the Hortensian Law, which made the decisions of the plebeian assembly binding on the entire Senate and Roman people. By then most of Italy had already fallen under Roman control.

Increasing power brought new problems. In the third and second centuries B.C., Rome began to build its empire abroad. The first major target of Roman aggression was the city of Carthage, founded by the Phoenicians around 800 B.C., and by the third century the independent ruler of territories in North Africa, Spain, and Sicily. In the Punic Wars (called after the Roman name for the Phoenicians, *Poeni*), the Romans decisively defeated the Carthaginians and confiscated their territories. By the first century B.C., the entire Hellenistic world had been conquered. From Spain to the Middle East stretched a vast territory consisting of subject provinces, protectorates, and nominally free kingdoms, all of which depended on Roman goodwill and administrative efficiency.

Unfortunately, the Romans had been too busy acquiring their empire to think very hard about how to rule it; the results were frequently chaotic. Provincial adminis-

tration was incompetent and often corrupt. The long series of wars had hardened the Roman character, leading to insensitivity and, frequently, brutality in the treatment of conquered peoples. This situation was not helped by increasing political instability at home. The old balance of power struck between the patricians and plebeians was being increasingly disturbed by the rise of a middle class, the equites, many of whom were plebeians who had made their fortunes in the wars. Against this background were fought bitter struggles that eventually caused the collapse of the Republic.

By the first century B.C., it was apparent that the political system that had been devised for a thriving but small city five hundred years earlier was hopelessly inadequate for a vast empire. Discontent among Rome's Italian allies led to open revolt. Although the Romans were victorious in the Social War of 90–88 B.C., the cost in lives and economic stability was tremendous. The ineffectuality of the Senate and the frustration of the Roman people led to a series of struggles among the leading statesmen for supreme power. The popular leader Marius briefly held power but was replaced by his aristocratic rival, Roman general Sulla, who ruled as dictator for a brief and violent period beginning in 82 B.C., only suddenly to resign three years later, in 79 B.C. There followed a longdrawn-out series of political skirmishes between Pompey, the self-appointed defender of the Senate, and Julius Caesar, culminating in Caesar's withdrawal to Gaul and subsequent return to Rome in 49 B.C. After a short but bitter conflict, Caesar defeated Pompey in 48 B.C. at the

Battle of Pharsalus and returned to Rome as dictator, only to be assassinated himself in 44 B.C. The civil wars that followed brought the Republic to its unlamented end.

The years of almost uninterrupted violence had a profound effect upon the Roman character, and the relief felt when a new era dawned under the first emperor, Augustus, can only be fully appreciated in this light.

Literary Developments During the Republic

The Romans put most of their energy into political and military affairs, leaving little time for art or literature. By the third century B.C., when most of the Mediterranean was under their control and they could afford to relax, they were overwhelmed intellectually and artistically by the Greeks. Conquest of the Hellenistic kingdoms of the East and of Greece itself brought the Romans into contact with Hellenistic Greek culture (see Chap. 3, "The Hellenistic Period"). Thus, from the third century B.C., most Roman works of art followed Greek models in form and content. Roman plays were based on Greek originals, Roman temples imitated Greek buildings, and Roman sculpture and painting depicted episodes from Greek mythology.

Greek influence extends to the works of Ennius (239–169 B.C.), known to later Romans as the father of Roman poetry. Almost all of his works are lost, but from later accounts Ennius' tragedies appear to have been adapted from Greek models. His major work was the *Annals*, an epic chronicle of the history of Rome, in which for the first time a Greek metrical scheme was used to write Latin verse.

The two comic playwrights—Plautus (c. 254-184 B.C.) and Terence (c. 185-159 B.C.)—are the first Roman writers whose works have survived in quantity. Their plays are adaptations of Greek comedies; whereas the Greek originals are comic satires, the Roman versions turn human foibles into pure comedy. Plautus, the more boisterous of the two, is fond of comic songs and farcical intrigues. Terence's style is more refined and his characters show greater realism. It says something about the taste of the Roman public that Plautus was by far the more successful. In later times, however, Terence's sophisticated style was much admired. His plays were studied and imitated both during the Middle Ages and more recently. Both authors were fond of extremely elaborate plots involving mistaken identities, identical twins, and general confusion, with everything sorted out in the

In general, however, when educated Romans of the late Republic stopped to think about something other than politics, it was likely to be love. Roman lyric poetry, often on a romantic theme, is one of the most rewarding

genres of Latin literature. The first great Roman lyric poet, Catullus (c. 80-54 B.C.), is one of the best-loved of all Roman authors. Instead of philosophical or historical themes, he returned to a traditional subject from Sappho's time—personal experience—and charted the course of his own love affair with a woman whom he calls Lesbia. Among his works are twenty-five short poems describing the course of that relationship, which range from the ecstasy of its early stages to the disillusionment and despair of the final breakup. The clarity of his style is the perfect counterpart to the direct expression of his emotions. These poems, personal though they are, are not simply an outpouring of feelings. Catullus makes his own experiences universal. However trivial one man's unhappy love affair may seem in the context of the grim world of the late Republic, Lesbia's inconstancy has achieved a timelessness unequaled by many more serious events.

Two of the principal figures who dominated those events also made important contributions to Republican literature. Julius Caesar (100–44 B.C.) is perhaps the most famous Roman of them all. Brilliant politician, skilled general, expert administrator and organizer, he was also able to write the history of his own military campaigns in his *Commentaries*, in a simple but gripping style. In the four years during which he ruled Rome he did much to repair the damage of the previous decades. Caesar's assassination on March 15, 44 B.C., at the hands of a band of devoted republicans, served only to prolong Rome's agony for another thirteen years—as well as to provide Shakespeare with the plot for one of his best-known plays: *Julius Caesar*.

Perhaps the most endearing figure of the late Republic was Marcus Tullius Cicero (106-43 B.C.), who first made his reputation as a lawyer. He is certainly the figure of this period about whom we know the most, for he took part in a number of important legal cases and embarked on a political career. In 63 B.C., he served as consul. A few years later, the severity with which he had put down a plot against the government during his consulship earned him a short period in exile as the result of the scheming of a rival political faction. Cicero returned in triumph, however, and in the struggle between Pompey and Caesar supported Pompey. Although Caesar seems to have forgiven him, Cicero never really trusted Caesar, despite his admiration for the dictator's abilities. His mixed feelings are well expressed in a letter to his friend Atticus after he had invited Caesar, by then the ruler of the Roman world, to dinner:

http://classics.mit.edu/Plutarch/cicero.html

Cicero

Quite a guest, although I have no regrets and everything went very well indeed. . . . He was taking medicine for his digestion, so he ate and drank without worrying and seemed perfectly at ease. It was a lavish dinner, excellently served and in addition well prepared and seasoned with good conversation, very agreeable, you know. What can I say? We were human beings together. But he's not the kind of guest to whom you'd say "it's been fun, come again on the way back." Once is enough! We talked about nothing serious, a lot about literature: he seemed to enjoy it and have a good time. So now you know about how I entertained him—or rather had him billeted on me. It was a nuisance, as I said, but not unpleasant.

From letters like these we can derive an incomparably vivid picture of Cicero and his world. Almost nine hundred were published, most of which after his death. If they often reveal Cicero's weaknesses—his vanity, his inability to make a decision, his stubbornness—they confirm his humanity and sensitivity. For his contemporaries and for later ages his chief fame was nevertheless as an orator. Although the cases and causes that prompted his speeches have ceased to have any but historical interest, the power of a Ciceronian oration can still thrill the responsive reader, especially when it is read aloud.

Roman Philosophy and Law

The Romans produced little in the way of original philosophical writing. Their practical nature made them suspicious of professional philosophers and unable to appreciate the rather subtle delights involved in arguing both sides of a complex moral or ethical question. In consequence most of the great Roman philosophical writers devoted their energies to expounding Greek philosophy to a Roman audience. The two principal schools of philosophy to make an impact at Rome—*Epicureanism* and *Stoicism*—were both imported from Greece.

Epicureanism never really gained many followers, in spite of the efforts of the poet Lucretius (99–55 B.C.), who described its doctrines in his brilliant poem *On the Nature of Things* (*De Rerum Natura*). A remarkable synthesis of poetry and philosophy, this work alone is probably responsible for whatever admiration the Romans could muster for a system of thought so different from their own traditional virtues of simplicity and seriousness. According to Epicurus (341–271 B.C.), the founder of the school (Epicureanism), the correct goal and principle of human actions is pleasure. Although Epicureanism stresses moderation and prudence in the pursuit of pleasure, the Romans insisted on thinking of the philosophy as a typically Greek enthusiasm for self-indulgence and debauchery.

Lucretius tried to correct this impression by emphasizing the profoundly intellectual and rational aspects of Epicureanism. Its principal teaching was that the gods, if

they exist, play no part in human affairs or in the phenomena of nature; we can therefore live our lives free from superstitious fear of the unknown and the threat of divine retribution. The Epicurean theory of matter explains the world in purely physical terms. It describes the universe as made up of two elements: small particles of matter, or atoms, and empty space. The atoms are completely solid, possessing the qualities of size, shape, and mass, and can be neither split nor destroyed. Their joining together to form complex structures is entirely caused by their random swerving in space, without interference from the gods. As a result, human life can be lived in complete freedom; we can face the challenges of existence and even natural disasters like earthquakes or plagues with complete serenity, since their occurrence is random and outside our control. According to Epicurus, at death the atoms that make up our body separate and body, mind, and soul are lost. Since no part of us is in any way immortal, we should have no fear of death, which offers no threat of punishment in a future world but rather brings only the complete ending of any sensation.

Epicureanism's rejection of a divine force in the world and its campaign against superstition probably appealed to the Romans as little as its claim that the best life was one of pleasure and calm composure. The hardheaded practical moralizing of the Roman mentality found far more appeal in the other school of philosophy imported into Rome from Greece, Stoicism. The Stoics taught that the world was governed by Reason and that Divine Providence watched over the virtuous, never allowing them to suffer evil. The key to becoming virtuous lay in willing or desiring only that which was under one's own control. Thus riches, power, or even physical health—all subject to the whims of Fortune—were excluded as objects of desire. For the Stoic, all that counted was that which was subject to the individual's will.

Although Stoicism had already won a following at Rome by the first century B.C. and was discussed by Cicero in his philosophical writings, its chief literary exponents came slightly later. Seneca (8 B.C.-A.D. 65) wrote a number of essays on Stoic morality. He had an opportunity, and the necessity, to practice the moral fortitude about which he wrote when his former pupil, the emperor Nero, ordered him to commit suicide, since the taking of one's own life was fully sanctioned by Stoic philosophers. Perhaps the most impressive of all Stoic writers is Epictetus (c. A.D. 50-134), a former slave who established a school of philosophy in Rome and then in Greece. In his Enchiridion (Handbook) he recommends an absolute trust in Divine Providence to be maintained through every misfortune. For Epictetus, the philosopher represented the spokesman of Providence itself "taking the human race for his children."

Epictetus' teachings exerted a profound influence on the last great Stoic, emperor Marcus Aurelius (A.D.

Contemporary Voices

A Dinner Party in Imperial Rome

At the end of this course Trimalchio left the table to relieve himself, and so finding ourselves free from the constraint of his overbearing presence, we began to indulge in a little friendly conversation. Accordingly Dama began first, after calling for a cup of wine. "A day! what is a day?" he exclaimed, "before you can turn round, it's night again! So really you can't do better than go straight from bed to board. Fine cold weather we've been having; why! even my bath has hardly warmed me. But truly hot liquor is a good clothier. I've been drinking bumpers, and I'm downright fuddled. The wine has got into my head."

Seleucus then struck into the talk: "I don't bathe every day," he said; "your systematic bather's a mere fuller. Water's got teeth, and melts the heart away, a little every day; but there! when I've fortified my belly with a cup of mulled wine, I say 'Go hang!' to the cold. Indeed I couldn't bathe today, for I've been to a funeral. A fine fellow he was too, good old Chrysanthus, but he's given up the ghost now. He was calling me just this moment, only just this moment; I could fancy my-

self talking to him now. Alas! alas! what are we but blown bladders on two legs? We're not worth as much as flies; they are some use, but we're no better than bubbles."

"He wasn't careful enough in his diet?"

"I tell you, for five whole days not one drop of water—or one crumb of bread—passed his lips. Nevertheless he has joined the majority. The doctors killed him, or rather his day was come; the very best of doctors is only a satisfaction to the mind.

Anyhow he was handsomely buried, on his own best bed, with good blankets. The wailing was first class—he did a trifle manumission before he died; though no doubt his wife's tears were a bit forced. A pity he always treated her so well. But woman! woman's of the kite kind. No man ought ever to do 'em a good turn; just as well pitch it in the well at once. Old love's an eating sore!"

From Petronius, The Satyricon, trans. attributed to Oscar Wilde (privately printed, 1928), p. 81.

121–180), who was constantly plagued with the dilemma of being a Stoic and an emperor at the same time. Delicate in health, sentimental, inclined to be disillusioned by the weaknesses of others, Marcus Aurelius struggled hard to maintain the balance between his public duty and his personal convictions. While on military duty he composed his *Meditations*, which are less a philosophical treatise than an account of his own attempt to live the life of a Stoic. As many of his observations make clear, this was no easy task: "Tell yourself every morning 'Today I shall meet the officious, the ungrateful, the bullying, the treacherous, the envious, the selfish. All of them behave like this because they do not know the difference between good and bad.'"

Yet, even though Stoicism continued to attract a number of Roman intellectuals, the great majority of Romans remained immune to the appeal of the philosophical life. In the first century B.C. and later, the very superstition both Stoicism and Epicureanism sought to combat remained deeply ingrained in the Roman character. Festivals in honor of traditional deities were celebrated until long after the advent of Christianity (Table 4.1). Rituals that tried to read the future by the traditional examination of animals' entrails and other time-honored methods continued to be popular. If the Romans had paused more often to meditate on the nature of existence, they would probably have had less time to civilize the world.

Among the most lasting achievements of Julius Caesar's dictatorship and of Roman culture in general was

the creation of a single unified code of civil law: the Ius Civile. The science of law is one of the few original creations of Roman literature. The earliest legal code of the Republic was the so-called Law of the Twelve Tables of 451-450 B.C. By the time of Caesar, however, most of this law had become either irrelevant or outdated and had been replaced by a mass of later legislation, much of it contradictory and confusing. Caesar's Ius Civile, produced with the help of eminent legal experts of the day, served as the model for later times, receiving its final form in A.D. 533, when it was collected, edited, and published by Byzantine Emperor Justinian (A.D. 527-565). Justinian's Corpus Iuris Civilis remained in use in many parts of Europe for centuries, and profoundly influenced the development of modern legal systems. Today, millions of people live in countries whose legal systems

TABLE 4.1 Principal Roman Deities and Their Greek Equivalents

-			
ROMAN	Greek	ROMAN	GREEK
Jupiter	Zeus	Diana	Artemis
Juno	Hera	Ceres	Demeter
Neptune	Poseidon	Venus	Aphrodite
Vulcan	Hephaestus	Minerva	Athena
Mars	Ares	Mercury	Hermes
Apollo	Apollo	Bacchus	Dionysus
=			

derive from that of ancient Rome; one eminent British judge has observed of Roman law that "there is not a problem of jurisprudence which it does not touch: there is scarcely a corner of political science on which its light has not fallen." According to the great Roman lawyer Ulpian (died A.D. 228), "Law is the art of the good and the fair." The Romans developed this art over the centuries during which they built up their empire of widely differing peoples. Roman law was international, adapting Roman notions of law and order to local conditions, and changing and developing in the process. Many of the jurists responsible for establishing legal principles had practical administrative experience from serving in the provinces. Legal experts were in great demand at Rome; the state encouraged public service, and problems of home and provincial government frequently occupied the best minds of the day. Many of these jurists acquired widespread reputations for wisdom and integrity. Emperor Augustus gave to some of them the right to issue "authoritative opinions," while a century or so later Emperor Hadrian formed a judicial council to guide him in matters of law. Their general aim was to equate human law with that of Nature by developing an objective system of natural justice. By using this, the emperor could fulfill his duty to serve his subjects as benefactor, and bring all peoples together under a single government.

http://iuscivile.com/>

lus Civile

Thus, over the centuries, the Romans built up a body of legal opinion that was comprehensive, concerned with absolute and eternal values, and valid for all times and places; at its heart lay the principle of "equity"—equality for all. By the time Justinian produced his codification, he was able to draw on a thousand years of practical wisdom.

Republican Art and Architecture

In the visual arts as in literature, the late Republic shows the translation of Greek styles into new Roman forms. The political scene was dominated by individuals like Cicero and Caesar; their individualism was captured in portrait busts that were both realistic and psychologically revealing. To some extent these realistic sculptures are based on such Etruscan models as the heads of the old couple on the Volterra sarcophagus (see Figure 4.5) rather than on Hellenistic portraits, which idealized their subjects. However, the subtlety and understanding shown in portraits like those of Cicero and Caesar represent a typical Roman combination and amplification of others' styles. In many respects, indeed, Roman portraiture represents Roman art at its most creative and sensitive. It certainly opened up new expressive possibilities,

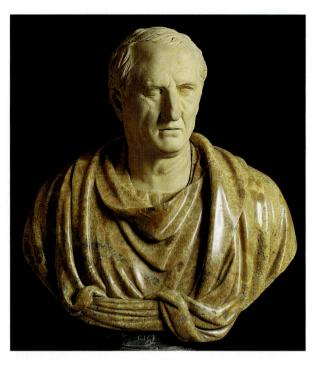

4.7 *Bust of Cicero*, Roman, first century B.C. Uffizi, Florence, Italy. This portrait of one of the leading figures of the late Republic suggests the ability of Roman sculptors of the period to capture both likeness and character. Cicero is portrayed as thoughtful and preoccupied.

4.8 Reconstruction drawing of the Sanctuary of Fortuna Primigenia, Palestrina. This vast complex, constructed by Sulla after his destruction of the city in 82 B.C., is a series of six immense terraces crowned by a semicircular structure in front of which stood an altar.

as artists discovered how to use physical appearance to convey something about character. Many of the best Roman portraits serve as revealing psychological documents, expressing, for example, Cicero's self-satisfaction as well as his humanity [4.7]. Realistic details like the lines at the corners of the eyes and mouth, the hollows in the cheeks, or the set of the lips are used to express both outer appearance and inner character. The new skill, as it developed, could of course be put to propaganda use, and statesmen and politicians soon learned that they could project their chosen self-image through their portraits.

The powerful political figures of the period also used the medium of architecture to express their authority. The huge sanctuary constructed by Sulla at Praeneste (modern Palestrina) around 82 B.C. [4.8] has all the qualities of symmetry and grandeur we associate with later Roman imperial architecture, although it took its inspiration from massive Hellenistic building programs such as that at Pergamum. Caesar himself cleared a large area in the center of Rome for the construction of a forum, to be named after him. In time, it was dwarfed by later monumental fora, but it had initiated the construction of public buildings for personal display and glory.

IMPERIAL ROME (31 B.C.-A.D. 476)

With the assassination of Julius Caesar, a brief respite from civil war was followed by further turmoil. Caesar's lieutenant, Mark Antony, led the campaign to avenge his death and punish the conspirators. He was joined in this by Caesar's young great-nephew, Octavius, who had been named by Caesar as his heir and who had recently arrived in Rome from the provinces. It soon became apparent that Antony and Octavius (or Octavian, to use the name he then adopted) were unlikely to coexist very happily. After the final defeat of the conspirators (42 B.C.) a temporary peace was obtained by putting Octavian in charge of the western provinces and sending Antony to the East. A final confrontation could not be long delayed, and Antony's fatal involvement with Cleopatra alienated much of his support in Rome. The end came in 31 B.C. at the Battle of Actium. The forces of Antony, reinforced by those of Cleopatra, were routed, and the couple committed suicide. Octavian was left as sole ruler of the Roman world, a world that was now in ruins. His victory marked the end of the Roman Republic.

When Octavian took supreme control after the Battle of Actium, Rome had been continuously involved in both civil and external wars for the better part of a century. The political and cultural institutions of Roman life were beyond repair, the economy was wrecked, and large areas of Italy were in complete turmoil. By the time of Octavian's death (A.D. 14), Rome had achieved a peace and prosperity unequaled in its history—before or after.

The art and literature created during his reign represents the peak of the Roman cultural achievement. To the Romans of his own time it seemed that a new Golden Age had dawned, and for centuries afterward his memory was revered. As the first Roman emperor, Octavian inaugurated the second great period in Roman history—the empire, which lasted technically from 27 B.C., when he assumed the title Augustus, until A.D. 476, when the last Roman emperor was overthrown. In many ways, however, the period began with the Battle of Actium and continued in the subsequent western and Byzantine empires (Table 4.2).

http://virgil.org/augustus/

Caesar Augustus

Augustus' cultural achievement was stupendous, but it could only have been accomplished in a world at peace. In order to achieve this, it was necessary to build a new political order. A republican system of government suitable for a small state had long since proved woefully inadequate for a vast and multi-ethnic empire. Augustus tactfully, if misleadingly, claimed that he "replaced the State in the hands of the Senate and Roman people." He in fact did the reverse: While maintaining the appearance of a reborn republic, Augustus took all effective power into the hands of himself and his imperial staff.

From the time of Augustus, the emperor and his bureaucracy controlled virtually all decisions. A huge civil service developed, with various career paths. A typical

TABLE 4.2 The Principal Roman Emperors

Augustus Tiberius Gaius (Caligula) Claudius Nero Year of the	27 B.C. – A.D. 14 14–37 37–41 41–54 54–68	Julio-Claudians
Four Emperors Vespasian Titus Domitian Nerva Trajan Hadrian Antoninus Pius Marcus Aurelius Commodus Septimius Severus Alexander Severus Decius Diocletian Constantine	69 69-79 79-81 81-96 96-98 98-117 117-138 138-161 161-180 180-193 193-211 222-235 249-251 284-305 306-337	Flavians Adoptive Emperors Antonines

middle-class Roman might begin with a period of military service, move on to a post as fiscal agent in one of the provinces, then serve in a governmental department back in Rome, and end up as a senior official in the imperial postal service or the police.

Augustus also began the reform of the army, which the central government had been unable to control during the last chaotic decades of the Republic. Its principal function now became to guard the frontiers. It was made up of some 250,000 Roman citizens, and about the same number of local recruits. The commanders of these half a million soldiers looked directly to the emperor as their general-in-chief. The troops did far more than fight. They served as engineers, building roads and bridges. They sowed crops and harvested them. They surveyed the countryside and helped to police it. In the process, they won widespread respect and gratitude from Rome's provincial subjects.

Protected by the army, and administered by the civil service, the Empire expanded economically. With freedom of travel and trade, goods circulated with no tariffs or customs duties; traders only had to pay harbor dues. From the time of Augustus, the Roman road system carried increasing numbers of travelers—traders, officials, students, wandering philosophers, the couriers of banks and shipping agencies—between the great urban centers. Cities like Alexandria or Antioch were self-governing to some degree, with municipal charters giving them constitutions based on the Roman model.

Not all later emperors were as diligent or successful as Augustus. Caligula, Nero, and some others have become notorious as monsters of depravity. Yet the imperial system which Augustus founded was to last for almost five hundred years.

Augustan Literature: Vergil

http://www.idmon.freeserve.co.uk/zmyth3a.htm

Vergil

Augustus himself played an active part in supporting and encouraging the writers and artists of his day; many of their works echo the chief themes of Augustan politics: the return of peace, the importance of the land and agriculture, the putting aside of ostentation and luxury in favor of a simple life, and above all the belief in Rome's destiny as world ruler. Some of the greatest works of Roman sculpture commemorate Augustus and his deeds; Horace and Vergil sing his praises in their poems. It is sometimes said that much of this art was propaganda, organized by the emperor to present the most favorable picture possible of his reign. Even the greatest works of the time do relate in some way or other to the

Augustan worldview, and it is difficult to imagine a poet whose philosophy differed radically from that of the emperor being able to give voice to it. But we have no reason to doubt the sincerity of the gratitude felt toward Augustus or the strength of what seems to have been an almost universal feeling that at last a new era had dawned. In any case, from the time of Augustus art at Rome became in large measure official. Most of Roman architecture and sculpture of the period was public, commissioned by the state, and served state purposes.

The greater the artist, the more subtle the response to the Augustan vision. Vergil, the greatest of all Roman poets, whose full name was Publius Vergilius Maro (70-19 B.C.), devoted the last ten years of his life to the composition of an epic poem intended to honor Rome and, by implication, Augustus. The result was the Aeneid, one of the great poems of the world, not completely finished at the poet's death. For much of the Middle Ages, Vergil himself was held in the highest reverence. A succession of great poets have regarded him as their master: Dante, Tasso, and Milton, among others. Probably no work of literature in the entire tradition of Western culture has been more loved and revered than the Aeneid—described by T. S. Eliot as the classic of Western society—vet its significance is complex and by no means universally agreed upon.

http://ablemedia.com/ctcweb/netshots/vergil.htm

The Aeneid

The Aeneid was not Vergil's first poem. The earliest authentic works that have survived are ten short pastoral poems known as the Eclogues (sometimes called the Bucolics) which deal with the joys and sorrows of the country and the shepherds and herdsmen who live there. Vergil was the son of a farmer; his deep love of the land emerges also in his next work, the four books of the Georgics (29 B.C.). Their most obvious purpose is to serve as a practical guide to farming; they offer helpful advice on such subjects as cattle breeding and beekeeping as well as a deep conviction that the strength of Italy lies in its agricultural richness. In a great passage in Book II of the Georgics, Vergil hails the "ancient earth, great mother of crops and men." He does not disguise the hardships of the farmer's life, the poverty, hard work, and frequent disappointments, but still feels that only life in the country brings true peace and contentment [4.9].

The spirit of the *Georgics* clearly matched Augustus' plans for an agricultural revival. Indeed, it was probably the emperor himself who commissioned Vergil to write an epic poem that would be to Roman literature what the

VALUES

Empire

The Romans were certainly not the first people to extend their power by external conquests: from the time of ancient Egypt, ambitious rulers had sought control over weaker states. Neither was the Roman Empire the first multi-ethnic one. For the Greeks, Persian agression was the one threat sufficiently strong to drive them to unite, but for many of the peoples who formed part of the Persian Empire, their conquerors' rule was benign—not least for the Jews.

Yet no power before Rome—or since, for that matter—succeeded in ruling so vast and varied an empire for so long. In order to maintain its unity, the Romans had to devise a system of provincial government that guaranteed central control, while allowing for local differences. In the process, they developed many aspects of daily life, which foreshadow the modern world: systems of highways, a postal service, efficient food and water distribution.

At the same time, the spread of Roman culture became an end in itself. Even in the remotest Roman cities in Europe, Asia and North Africa, Roman theaters for the performance of Roman plays, Roman baths, a Roman forum with a temple to Jupiter of the Capitoline at

its north end, and Roman schools all reinforced the sense of a dominant imperial power, symbolized in the person of the emperor.

Many later peoples aimed to repeat the Romans' achievements. Constantine built his new capital, which became the center of the Byzantine Empire, as a "New Rome" in the East. The title which Augustus, the first emperor, assumed—Pater Patriae (Father of his native land)—was imitated by many rulers, among them Cosimo de Medici of Renaissance Florence. In ninteenthcentury England, the Victorian Age owes its name to the symbolic importance of Queen Victoria, whose crowning glory was to become "Empress of India," while the use of cultural unity to underpin political stability soon became a feature of the growth of the United States. Indeed, many of the political characteristics of the young Republic were borrowed by the Founding Fathers from Rome: The U.S. Senate and Congress are based on the Roman Senate and Assembly of the People, while the separation of federal and state government reflects the Romans' distinction between central and provincial rule.

Iliad and *Odyssey* were for Greek literature: a national epic. The task was immense. Vergil had to find a subject that would do appropriate honor to Rome and its past as well as commemorate the achievements of Augustus.

The *Aeneid* is not a perfect poem (on his deathbed Vergil ordered his friends to destroy it), but in some ways it surpasses even the high expectations Augustus must have had for it. Vergil succeeded in providing Rome with

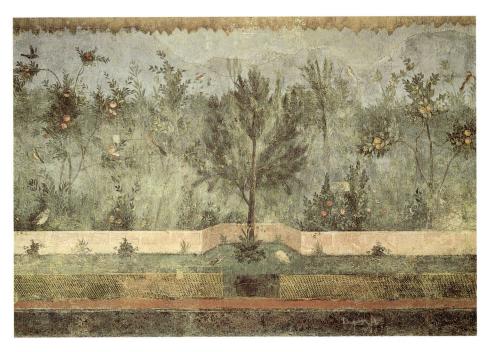

4.9 View of the garden from the villa of Livia and Augustus, at Prima Porta, c. 20 B.C. Fresco, detail, Museo di Palazzo Massimo, Rome. The peaceful scene, with its abundance of fruit and flowers, reflects the interest in country life expressed in Vergil's *Eclogues* and *Georgics*.

its national epic and stands as a worthy successor to Homer. At the same time, he created a profoundly moving study of the nature of human destiny and personal responsibility.

The Aeneid is divided into twelve books. Its hero is a Trojan prince, Aeneas, who flees from the ruins of burning Troy and sails west to Italy to found a new city, the predecessor of Rome. Vergil's choice was significant: Aeneas' Trojan birth establishes connections with the world of Homer; his arrival in Italy involves the origins of Rome; and the theme of a fresh beginning born, as it were, out of the ashes of the past corresponds perfectly to the Augustan mood of revival. We first meet Aeneas and his followers in the middle of his journey from Troy to Italy, caught in a storm that casts them upon the coast of North Africa. They make their way to the city of Carthage, where they are given shelter by the Carthaginian ruler, Queen Dido. At a dinner in his honor Aeneas describes the fall of Troy (Book II) and his wanderings from Troy to Carthage (Book III), in the course of which his father Anchises had died.

In Book IV, perhaps the best known, the action resumes where it had broken off at the end of Book I. The tragic love that develops between Dido and Aeneas tempts Aeneas to stay in Carthage and thereby abandon his mission to found a new home in Italy. Mercury, the divine messenger of the gods, is sent to remind Aeneas of his responsibilities. He leaves after an agonizing encounter with Dido, and the distraught queen kills herself.

Book V brings the Trojans to Italy. In Book VI, Aeneas journeys to the underworld to hear from the spirit of his father the destiny of Rome. This tremendous episode provides the turning point of the poem. Before it we see Aeneas, and he sees himself, as a man prone to human weaknesses and subject to personal feelings. After Anchises' revelations, Aeneas' humanity is replaced by a sense of mission and the weary, suffering Trojan exile becomes transformed into a "man of destiny."

In Books VII and VIII, the Trojans arrive at the river Tiber and Aeneas visits the future site of Rome while the Italian peoples prepare to resist the Trojan invaders. The last four books describe in detail the war between the Trojans and the Latins, in the course of which there are losses on both sides. The *Aeneid* ends with the death of the great Italian warrior Turnus and the final victory of Aeneas.

It is tempting to see Aeneas as the archetype of Augustus; certainly Vergil must have intended for us to draw some parallels. Other historical analogies can also be found: Dido and Cleopatra, for example, have much in common. The *Aeneid* is, however, far more than an allegorical retelling of the events leading up to the foundation of the Empire. Put briefly, Aeneas undertakes a responsibility for which initially he has no real enthusiasm

and which costs him and others considerable suffering. It would have been much easier for him to have stayed in Carthage, or settled somewhere else along his way, rather than push forward under difficult circumstances into a foreign land where he and his followers were not welcome.

Once he has accepted his mission, however, Aeneas fulfills it conscientiously and in the process learns to sublimate his own personal desires to a common good. If this is indeed a portrait of Augustus, it represents a far more complex view of his character than we might expect. And Vergil goes further. If greatness can only be acquired by sacrificing human individuals, is it worth the price? Is the future glory of Rome a sufficient excuse for the cruel and unmanly treatment of Dido? Readers will provide their own answers. Vergil's might have been that the sacrifices were probably worth it, but barely. Much, of course, depends on individual views on the nature and purpose of existence, and for Vergil there is no doubt that life is essentially tragic. The prevailing mood of the poem is one of melancholy regret for the sadness of human lives and the inevitability of human suffering.

Augustan Sculpture

Many of the characteristics of Vergil's poetry can also be found in contemporary sculpture. In a relief from one of the most important works of the period, the Ara Pacis (Altar of Peace), Aeneas himself performs a sacrifice on his arrival in Italy before a small shrine that contains two sacred images brought from Troy [4.10]. More significantly, the Ara Pacis depicts the abundance of nature that could flourish again in the peace of the Augustan Age. The altar, begun on Augustus' return to Rome in 13 B.C. after a visit to the provinces, was dedicated on January 30, 9 B.C., at a ceremony that is shown in the surrounding reliefs [4.11]. The procession making its way to the sacrifice is divided into two parts. On the south side Augustus leads the way, accompanied by priests and followed by the members of his family; the north side shows senators and other dignitaries. The lower part of the walls is decorated with a rich band of fruit and floral motifs, luxuriantly intertwined, amid which swans are placed. The actual entrance to the altar is flanked by two reliefs—on the right, the one showing Aeneas; and on the left, Romulus and Remus.

The *Ara Pacis* is perhaps the single most comprehensive statement of how Augustus wanted his contemporaries and future generations to view his reign. The altar is dedicated neither to Jupiter or Mars nor to Augustus himself but to the spirit of Peace. Augustus is shown as the first among equals rather than supreme ruler; although he leads the procession, he is marked by no special richness of dress. The presence of Augustus' family indicates that he intends his successor to be drawn from

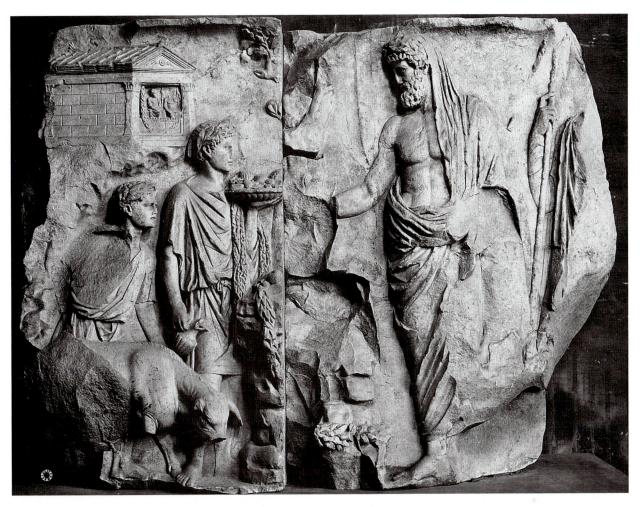

4.10 Aeneas sacrificing, from the *Ara Pacis*, Rome 13–9 B.C. Marble. Aeneas is depicted in the manner of a Classical Greek god; the landscape and elaborate relief detail are typical of late Hellenistic art.

among them, and that they have a special role to play in public affairs. The reliefs of Aeneas and of Romulus and Remus relate the entire ceremony to Rome's glorious past. Further scenes at the back showing the Earth Mother and the goddess of war emphasize the abundance of the land and the need for vigilance. The rich vegetation of the lower band is a constant reminder of the rewards of agriculture that can be enjoyed once more in the peace to which the whole altar is dedicated.

Amazingly enough, this detailed political and social message is expressed without pretentiousness and with superb workmanship. The style is deliberately and self-consciously "classical," based on works like the Parthenon frieze. To depict the New Golden Age of Augustus, his artists have chosen the artistic language of the Golden Age of Athens, although with a Roman accent. The figures in the procession, for instance, are portrayed far more realistically than those in the sculpture of fifthcentury-B.C. Athens.

The elaborate message illustrated by the Ara Pacis can also be seen in the best-preserved statue of the emperor himself, the Augustus of Prima Porta, so-called after the spot where an imperial villa containing the sculpture was excavated [4.12]. The statue probably dates from about the time of the emperor's death; the face is in the full vigor of life, calm and determined. The stance is one of quiet authority. The ornately carved breastplate recalls one of the chief events of Augustus' reign. In 20 B.C., he defeated the Parthians, an eastern tribe, and recaptured from them the Roman standards that had been lost in battle in 53 B.C. On that former occasion Rome had suffered one of the greatest military defeats in its history, and Augustus' victory played an important part in restoring national pride. The breastplate shows a bearded Parthian handing back the eagle-crowned standard to a Roman soldier. The cupid on a dolphin at Augustus' feet serves two purposes. The symbol of the goddess Venus, it connects Augustus and his family with Aeneas (whose mother was Venus) and thereby with the origins of Rome. At the same time it looks to the future by representing Augustus' grandson Gaius, who was born the year of the victory over the Parthians and was at one time considered a possible successor to his grandfather.

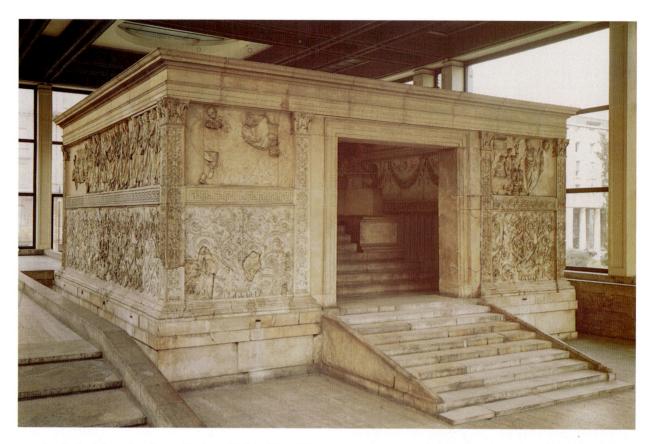

4.11 Ara Pacis of Augustus, Rome, 13–9 B.C. Marble, $36' \times 33'$ (11×10 m). The central doorway, through which the altar itself is just visible, is flanked by reliefs showing Romulus and Remus and Aeneas. On the right side is the procession led by Augustus. The altar originally stood on the ancient Via Flaminia. Fragments were discovered in the sixteenth century; the remaining pieces were located in 1937 and 1938, and the structure was reconstructed near the mausoleum of Augustus.

4.12 Augustus of Prima Porta, portrait of Augustus as general, from Prima Porta. Marble, height 6'8" (2.03 m). Vatican Museums, Rome.

The choice of his successor was the one problem that Augustus never managed to resolve to his own satisfaction. The death of other candidates forced him to fall back reluctantly on his unpopular stepson Tiberius—the succession was a problem that was to recur throughout the long history of the Empire, since no really effective mechanism was ever devised for guaranteeing a peaceful transfer of power. (As early as the reign of Claudius [A.D. 41–54], the right to choose a new emperor was seized by the army.) In every other respect the Augustan age was one of high attainment. In the visual arts, Augustan artists set the styles that dominated succeeding generations, while writers like the poets Vergil, Horace, Ovid, and Propertius, and the historian Livy established a Golden Age of Latin literature.

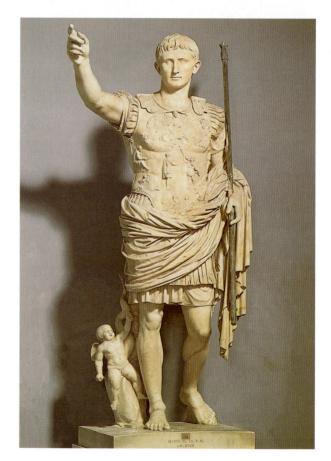

Curiously enough, perhaps the only person to have any real doubts about the Augustan achievement may have been Augustus himself. The Roman writer and gossip Suetonius (A.D. c. 69–c. 140) tells us that as the emperor lay dying he ordered a slave to bring a mirror so that he could comb his hair. He looked at himself, then turned to some friends standing by and asked, "Tell me, have I played my part in the comedy of life well enough?"

The Evidence of Pompeii

http://jefferson.village.virginia.edu/pompeii/

Pompeii

The first and second centuries A.D. are probably the best-documented times in the whole of classical antiquity. From the main literary sources and the wealth of art and architecture that has survived, it is possible to reconstruct a detailed picture of life in imperial Rome. Even more complete is our knowledge of a prosperous but unimportant little town some 150 miles (240 km) south of Rome that owes its worldwide fame to the circum-

stances of its destruction [4.13]. On August 24 in the year A.D. 79, the volcano Vesuvius above the Gulf of Naples erupted and a number of small towns were buried, the nearer ones under flowing lava and those some distance away under pumice and ash. By far the most famous is Pompeii, situated some ten miles (16 km) southeast of the erupting peak. Excavation first began there more than two hundred years ago. The finds preserved by the volcanic debris give us a rich and vivid impression of the way of life in a provincial town of the early Empire—from the temples in which the Pompeians worshiped and the baths in which they cleansed themselves to their food on the fatal day [4.14 a & b, 4.15].

An eyewitness report about the eruption comes from two letters written by the Roman politician and literary figure Pliny the Younger (A.D. 62–before 114)—so-called to distinguish him from his uncle, Pliny the Elder (A.D. 23–79). The two were in fact together at Misenum on the Bay of Naples on the day of the eruption. Pliny's uncle was much interested in natural phenomena (his chief work was a *Natural History* in thirty-seven volumes); to investigate for himself the nature of the explosion he made his way toward Vesuvius, where he was suffocated to death by the fumes. The younger Pliny stayed behind with his mother and in a letter to the historian Tacitus

4.13 Aerial view of excavated portion of Pompeii as it appears today. The long, open rectangular space in the lower center is the forum. The total area is 166 acres (67.23 ha). Although excavations at Pompeii have been in progress for more than two hundred years, some two-fifths of the city is still buried.

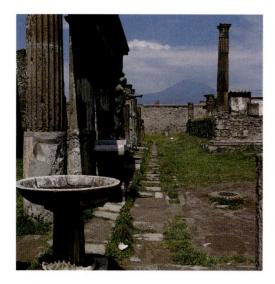

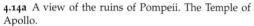

4.14b Casts of people trapped in volcanic pumice during the eruption of Mount Vesuvius at Pompeii, A.D. 79.

a little while later described the events of the next few hours.

Pliny the Younger

Letter to Tacitus on the Eruption of Vesuvius

You say that the letter I wrote at your request about the death of my uncle makes you want to hear about the terrors, and dangers as well, which I endured, having been left behind at Misenum—I had started on that topic but broken off.

"Though my mind shudders to remember, I shall begin." After my uncle departed I spent the rest of the day

on my studies; it was for that purpose I had stayed. Then I took a bath, ate dinner, and went to bed; but my sleep was restless and brief. For a number of days before this there had been a quivering of the ground, not so fearful because it was common in Campania. On that night, however, it became so violent that everything seemed not so much to move as to be overturned.

My mother came rushing into my bedroom; I was just getting up, intending in my turn to arouse her if she were asleep. We sat down in the rather narrow courtyard of the house lying between the sea and the buildings. I don't know whether I should call it iron nerves or folly—I was only seventeen: I called for a book of Titus Livy

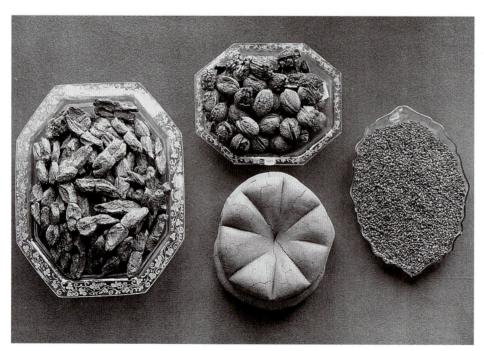

4.15 Carbonized dates, walnuts, sunflower seeds, and bread from Pompeii, August 24, A.D. 79. Museo Nazionale, Naples, Italy.

and as if at ease I read it and even copied some passages, as I had been doing. Then one of my uncle's friends, who had recently come from Spain to visit him, when he saw my mother and me sitting there, and me actually reading a book, rebuked her apathy and my unconcern. But I was as intent on my book as ever.

It was now the first hour of day, but the light was still faint and doubtful. The adjacent buildings now began to collapse, and there was great, indeed inevitable, danger of being involved in the ruins; for though the place was open, it was narrow. Then at last we decided to leave the town. The dismayed crowd came after us; it preferred following someone else's decision rather than its own; in panic that is practically the same as wisdom. So as we went off we were crowded and shoved along by a huge mob of followers. When we got out beyond the buildings we halted. We saw many strange fearful sights there. For the carriages we had ordered brought for us, though on perfectly level ground, kept rolling back and forth; even when the wheels were checked with stones they would not stand still. Moreover the sea appeared to be sucked back and to be repelled by the vibration of the earth; the shoreline was much farther out than usual, and many specimens of marine life were caught on the dry sands. On the other side a black and frightful cloud, rent by twisting and quivering paths of fire, gaped open in huge patterns of flames; it was like sheet lightning, but far worse. Then indeed that friend from Spain whom I have mentioned spoke to us more sharply and insistently: "If your brother and uncle still lives, he wants you to be saved; if he has died, his wish was that you should survive him; so why do you delay to make your escape?" We replied that we would not allow ourselves to think of our own safety while still uncertain of his. Without waiting any longer he rushed off and left the danger behind at top speed.

Soon thereafter the cloud I have described began to descend to the earth and to cover the sea; it had encircled Capri and hidden it from view, and had blotted out the promontory of Misenum. Then my mother began to plead, urge, and order me to make my escape as best I could, for I could, being young; she, weighed down with years and weakness, would die happy if she had not been the cause of death to me. I replied that I would not find safety except in her company; then I took her hand and made her walk faster. She obeyed with difficulty and scolded herself for slowing me. Now ashes, though thin as yet, began to fall. I looked back; a dense fog was looming up behind us; it poured over the ground like a river as it followed. "Let us turn aside," said I, "lest, if we should fall on the road, we should be trampled in the darkness by the throng of those going our way." We barely had time to consider the thought, when night was upon us, not such a night as when there is no moon or there are clouds, but such as in a closed place with the lights put out. One could hear the wailing of women, the crying of children, the shouting of men; they called each other, some their parents, others their children, still others their mates, and sought to recognize each other by their voices. Some lamented their own fate, others the

fate of their loved ones. There were even those who in fear of death prayed for death. Many raised their hands to the gods; more held that there were nowhere gods any more and that this was that eternal and final night of the universe. Nor were those lacking who exaggerated real dangers with feigned and lying terrors. Men appeared who reported that part of Misenum was buried in ruins, and part of it in flames; it was false, but found credulous listeners.

It lightened a little; this seemed to us not daylight but a sign of approaching fire. But the fire stopped some distance away; darkness came on again, again ashes, thick and heavy. We got up repeatedly to shake these off; otherwise we would have been buried and crushed by the weight. I might boast that not a groan, not a cowardly word, escaped from my lips in the midst of such dangers, were it not that I believed I was perishing along with everything else, and everything else along with me; a wretched and yet a real consolation for having to die. At last the fog dissipated into smoke or mist, and then vanished; soon there was real daylight; the sun even shone, though wanly, as when there is an eclipse. Our still trembling eyes found everything changed, buried in deep ashes as if in snow. We returned to Misenum and attended to our physical needs as best we could; then we spent a night in suspense between hope and fear. Fear was the stronger, for the trembling of the earth continued, and many, crazed by their sufferings, were mocking their own woes and others' by awful predictions. But as for us, though we had suffered dangers and anticipated others, we had not even then any thought of going away until we should have word of my uncle.

You will read this account, far from worthy of history, without any intention of incorporating it; and you must blame yourself, since you insisted on having it, if it shall seem not even worthy of a letter.

With a few exceptions, like the frescoes in the Villa of the Mysteries [4.16], the works of art unearthed at Pompeii are not masterpieces. Their importance lies precisely in the fact that they show us how the ordinary Pompeian lived, worked, and played [4.17]. The general picture is very impressive. Cool, comfortable houses were decorated with charming frescoes and mosaics and included quiet gardens, remote from the noise of busy streets and watered by fountains. The household silver and other domestic ornaments found in the ruins of houses were often of very high quality. Although the population of Pompeii was only twenty thousand, there were no fewer than three sets of public baths, a theater, a concert hall, an amphitheater large enough to seat the entire population, and a more-than-adequate number of brothels. The forum was closed to traffic, and the major public buildings ranged around it include a splendid basilica or large hall that served as both stock exchange and law courts. Life must have been extremely comfortable at Pompeii, even though it was by no means the most prosperous of the towns buried by Vesuvius. Although only a small

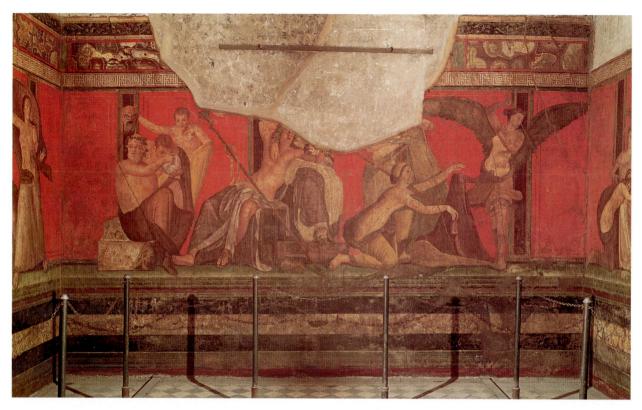

4.16 Wall paintings from the Villa of the Mysteries, Pompeii, c. 60 B.C. Frescoes. Probably no ancient work of art has been more argued about than these paintings. They seem to relate to the cult of the Greek god Dionysus and the importance of the cult for girls approaching marriage, but many of the details are difficult to interpret. There is no argument, however, about the high quality of the paintings.

4.17 Atrium of the House of the Silver Wedding, Pompeii, first century A.D. The open plan of substantial houses such as this helped keep the interior cool in summer; the adjoining rooms were closed off by folding doors in winter.

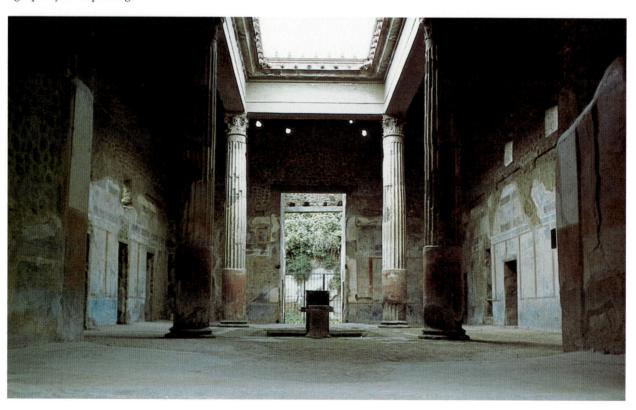

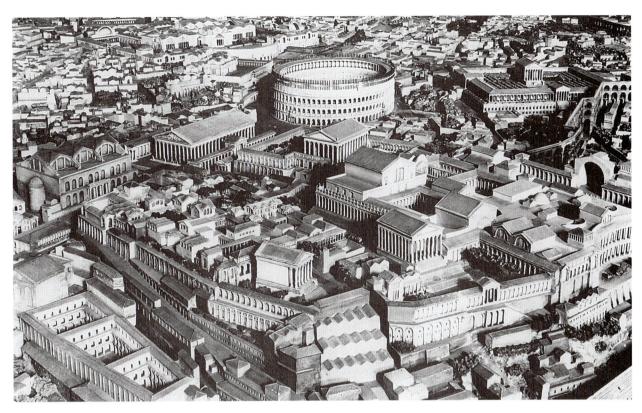

part of Herculaneum has been excavated, some mansions found there far surpass the houses of Pompeii. In the past few years work has begun at Oplontis, where a superbly decorated villa has already come to light.

Apart from its historic importance, the excavation of Pompeii in the eighteenth and nineteenth centuries had a profound effect on contemporary writers and artists. Johann Wolfgang von Goethe visited the site in 1787 and wrote of the buried city that "of all the disasters there have been in this world, few have provided so much delight to posterity." Johann Winckelmann (1717-1768), sometimes called the father of archaeology and art history, used material from the excavations in his History of Ancient Art. Artists like Ingres, David, and Canova were influenced by Pompeian paintings and sculptures; on a more popular level a style of Wedgwood china was based on Pompeian motifs. Countless poets and novelists of the nineteenth century either set episodes in the excavations at Pompeii or tried to imagine what life there was like in Roman times.

Roman Imperial Architecture

All the charm and comfort of Pompeii pale before the grandeur of imperial Rome itself, where both public buildings and private houses were constructed in numbers and on a scale that still remains impressive [4.18]. The Roman achievement in both architecture and engineering had a lasting effect on the development of later architectural styles. In particular their use of the arch, probably borrowed from the Etruscans, was widely

4.18 Model of ancient Rome as it was in about A.D. 320. Museo della Civiltà Romana, Rome. In the right center is the emperor's palace on the Palatine Hill, with the Colosseum above and the mammoth Basilica of Constantine at the upper left.

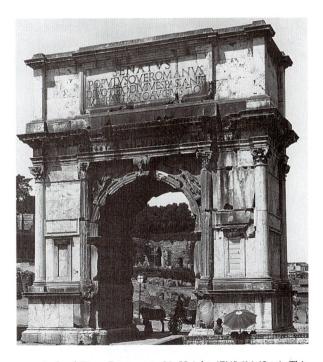

4.19 Arch of Titus, Rome, A.D. 81. Height 47'4'' (14.43 m). This structure commemorates the Roman capture of Jerusalem in A.D. 70.

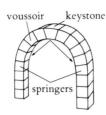

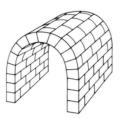

4.20 *Top:* Simple arch composed of wedge-shaped blocks (*voussoirs*) and keystone; the curve of the arch rises from the springers on either side. *Center:* Tunnel (barrel vault) composed of a series of arches. *Bottom:* Dome composed of a series of arches intersecting each other around a central axis.

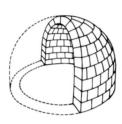

4.21 Pantheon, Rome. c. A.D. **126**. Height of portico 59' (17.98 m).

imitated, and pseudo-Roman triumphal arches have sprung up in such unlikely places as the Champs Elysées in Paris and Washington Square in New York. The original triumphal arches commemorated military victories [4.19]; each was a permanent version of the temporary wooden arch erected to celebrate the return to the capital of a victorious general.

Equally important was the use of internal arches and vaults [4.20] to provide roofs for structures of increasing size and complexity. Greek and Republican Roman temples had been relatively small, partly because of the difficulties involved in roofing over a large space without supports. With the invention of concrete in the first century B.C. and growing understanding of the principles of stress and counterstress, Roman architects were able to experiment with elaborate new forms, many of which—like the barrel vault and the dome—were to pass into the Western architectural tradition.

The Greeks rarely built arches, but the Etruscans used them as early as the fifth century B.C., and the Romans may well have borrowed the arch from them. From the second century B.C. on, stone arches were used regularly for bridges and aqueducts. Vaults of small size were often used for domestic buildings, and by the time of Augustus, architects had begun to construct larger-scale barrel vaults, semicylindrical in shape, two or more of

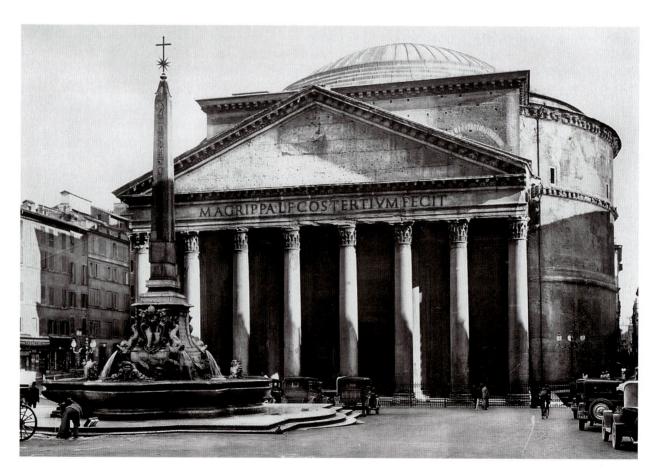

which could intersect to roof a large area. The dome, which is really a hemispherical vault, became increasingly popular with the building of the vast public baths of Imperial Rome. Using both bricks and concrete, architects could combine vaults, barrel vaults, and domes to construct very elaborate buildings capable of holding thousands of people at a time. The inside and outside surfaces of the buildings were then covered with a marble facing to conceal the elaborate internal support structures.

Much of the work of these architects was destroyed during the Barbarian invasions of the fifth and sixth centuries A.D. and more was wrecked in the Renaissance by builders removing bricks or marble. By great good fortune one of the most superb of all imperial structures has been preserved almost intact. The Pantheon [4.21] was built around A.D. 126, during the reign of Hadrian (117–138) to a design by the emperor himself. An austere and majestic exterior portico is supported on granite columns with Corinthian capitals [4.22]. It leads into the central rotunda, an astonishing construction approxi-

mately 142 feet (43.3 m) high and wide in which a huge concrete dome rests on a wall interrupted by a series of niches. The building's only light source is a huge *oculus* (*eye*) at the top of the dome, an opening 30' (9.2 m) across. The proportions of the building are very carefully calculated and contribute to its air of balance. The height of the dome from the ground, for example, is exactly equal to its width.

http://www.architectour.com/3.htm#portico

Pantheon

The Pantheon was dwarfed by the huge complex of buildings that made up the imperial fora. Completed by the beginning of the second century A.D., they formed a vast architectural design unsurpassed in antiquity and barely equaled since [4.23]. Elsewhere in the city, baths, theaters, temples, racetracks, and libraries catered to the

4.22 Corinthian capital. This elaborate bell-shaped design, decorated with acanthus leaves, first became commonly used in Hellenistic times. It was especially popular with Roman architects who generally preferred it to both the Doric and Ionic styles.

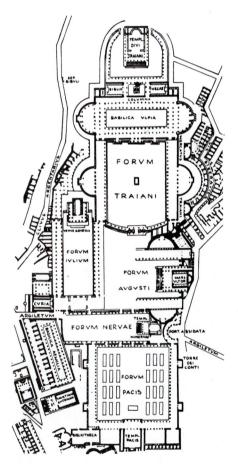

4.23 Plan of the imperial fora, Rome. Unlike the Republican forum, which served as a public meeting place, these huge complexes were constructed as monuments to the emperors who commissioned them.

needs and fancies of a huge urban population. In many of these structures builders continued to experiment with new techniques of construction, and architectural principles developed in Rome were applied throughout the Roman Empire. From Spain to the Middle East, theaters, amphitheaters, and other public buildings were erected according to the same basic designs, leaving a permanent record of construction methods for later generations.

Urban life on such a scale required a constant supply of one of the basic human necessities: water. Their system of aqueducts is one of the most impressive of the Romans' engineering achievements. A vast network of pipes brought millions of gallons of water a day into Rome, distributing it to public fountains and baths and to the private villas of the wealthy. At the same time, a system of covered street drains was built, eliminating the open sewers that had been usual before Roman times. These open drains were to return during the medieval period, when many of the Roman engineering skills were lost.

With the passage of time, most of the aqueducts that supplied ancient Rome have been demolished or have collapsed. Elsewhere in the Roman Empire, however, examples have survived that give some idea of Roman engineering skill. The famous Pont du Gard [4.24], which

can still be seen in southern France, was probably first constructed during the reign of Augustus. It carried the aqueduct that supplied the Roman city of Nîmes with water—a hundred gallons (387.5 lit) a day—for each inhabitant and was made of uncemented stone. The largest blocks weigh two tons (1.8 MT).

Even with the provision of such facilities, Imperial Rome suffered from overcrowding. The average Roman lived in an apartment block, of which there were some 45,000. Most of these have long since disappeared, although their appearance can be reconstructed from examples excavated at Ostia, Rome's port [4.25]. The height of the apartment blocks was controlled by law to prevent the construction of unsafe buildings, but it was not unheard of for a building to collapse and fire was a constant danger. No doubt the grandeur of the public buildings in Rome was intended at least in part to distract the poorer Romans from thoughts of their humble private residences.

Rome as the Object of Satire

Life in this huge metropolis had many of the problems of big-city living today: noise, traffic jams, dirty streets, and overcrowding were all constant sources of complaint. A particularly bitter protest comes from the Roman satirist

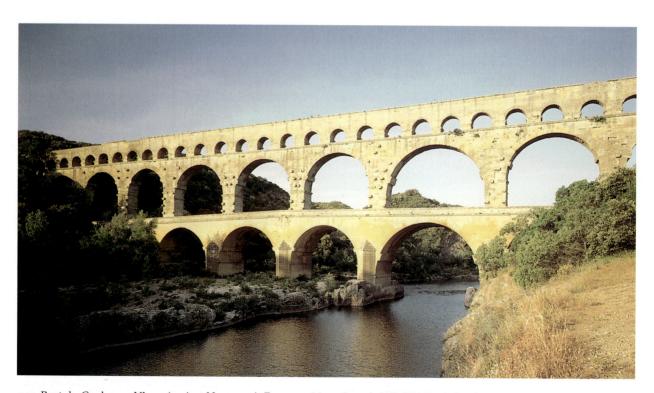

4.24 Pont du Gard, near Nîmes (ancient Nemausus), France, c. 16 B.C. Length 902' (274.93 m), height 161' (49.07 m). Note the careful positioning of the three rows of arches along the top of which ran the water channel. The whole aqueduct was 25 miles (40 km) long. This section carried the water over the river Gard.

4.25 Reconstruction drawing of the garden façade of the Insula dei Dipinti, an apartment block in Ostia, the seaport of ancient Rome.

Juvenal (A.D. c. 60–c. 130). Born in the provinces, he came to Rome, where he served as a magistrate and irritated the then current emperor, Domitian—not a difficult task. After a period of exile, probably in Egypt, he returned to Rome and lived in considerable poverty. Toward the end of his life, however, his circumstances improved. His sixteen *Satires* make it perfectly clear that Juvenal liked neither Rome nor Romans. He tells us that he writes out of fierce outrage at the corruption and decadence of his day, the depraved aristocracy, the general greed and meanness. "At such a time who could not write satire?" His fiercest loathing is reserved for foreigners, although in the sixth satire he launches a particularly virulent attack against women in one of the archetypal documents of misogyny.

Juvenal himself does not emerge as a very pleasant character and his obsessive hatred frequently verges on the psychopathic. As a satirical poet, though, he is among the greatest in Western literature, and strongly influenced many of his successors, including Jonathan Swift. Few other writers can make better or more powerful use of biting sarcasm, irony, and outright invective.

THE END OF THE ROMAN EMPIRE

Few historical subjects have been as much discussed as the fall of the Roman Empire. It is not even possible to agree on when it fell, let alone why. The traditional date—A.D. 476—marks the deposition of the last Roman emperor, Romulus Augustulus. By that time, however, the political unity of the empire had already disintegrated. Perhaps the beginning of the end was A.D. 330, when Emperor Constantine moved the capital from Rome to a new city on the Bosporus, Constantinople, although in another sense the transfer represented a new development as much as a conclusion. It might even be possible to argue that Constantine's successors in the East, the Byzantine emperors, were the successors of Augustus and that there is a continuous tradition from the beginning of the Empire in 31 B.C. to the fall of Constantinople in A.D. 1453.

Fascinating though the question may be, in a sense it is theoretical rather than practical. The Roman Empire did not fall overnight. Many of the causes for its long decline are obvious though not always easy to order in importance. One crucial factor was the growing power and changing character of the army. The larger it became, the more necessary it was to recruit troops from the more distant provinces—Germans, Illyrians, and others, the very people the army was supposed to be holding in check. Most of these soldiers had never been anywhere

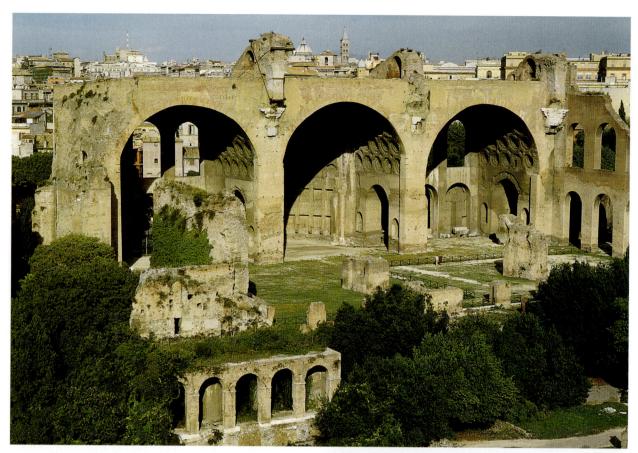

4.26 Basilica of Constantine, the last great imperial building in Rome. Begun in A.D. 306 by Maxentius, it was finished by Constantine after A.D. 315. Only the northern side is still standing; the central nave and south aisle collapsed during antiquity.

4.27 Head of the colossal statue of Constantine that stood in the Basilica of Constantine, Rome, A.D. 324–330. Marble, height 8'6" (2.59 m). Palazzo dei Conservatori, Rome. The massive and majestic simplicity of this portrait is very different from the detailed observation of earlier, much smaller Roman portraits like that of Cicero (Figure 4.7), illustrating the new belief in the emperor as God's regent on earth.

near Rome. They felt no loyalty to the empire, no reason to defend Roman interests. A succession of emperors had to buy their support by raising their pay and promising gifts of lands. At the same time, the army came to play an increasingly prominent part in the choice of a new emperor and, since the army itself was largely non-Roman, so were many of the emperors chosen. Rulers of the third and fourth centuries included Africans, Thracians, a Syrian, and an Arab—men unlikely to feel any strong reason to place the interests of Rome over those of themselves and their own men.

Throughout this late period the empire was increasingly threatened from outside. To the west, barbarian tribes like the Huns, the Goths, and the Alemanni began

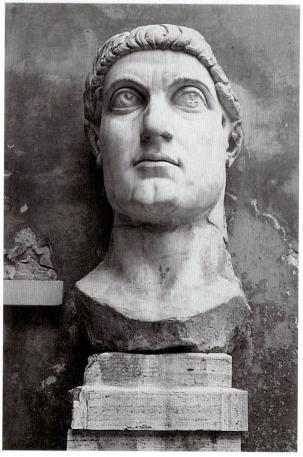

to penetrate farther and farther into its defenses and even to sack Rome itself. Meanwhile, in the east, Roman armies were continually involved in resisting the growing power of the Persians. In many parts of the empire it became clear that Rome could provide no help against invaders, and some of the provinces set themselves up as independent states with their own armies.

Problems like these inevitably had a devastating effect on the economy. Taxes increased and the value of money depreciated. The constant threat of invasion or civil war made trade impossible. What funds there were went for the support of the army, and the general standard of living suffered a steady decline. The eastern provinces, the old Hellenistic kingdoms, suffered rather less than the rest of the empire, since they were protected in part by the wealth accumulated over the centuries and by their long tradition of civilization. As a result, Italy sank to the level of a province rather than remaining the center of the imperial administration.

Total collapse was prevented by the efforts of two emperors: Diocletian, who ruled from A.D. 284 to 305; and Constantine, who ruled from 306 to 337. Both men were masterly organizers who realized that the only way to save the empire was to impose the most stringent controls on every aspect of life—social, administrative, and economic. In A.D. 301, the Edict of Diocletian was passed, establishing fixed maximums for the sale of goods and for wages. A vast bureaucracy was set up to collect taxes and administer the provinces. The emperor himself be-

came once again the focal point of the empire, but to protect himself from the dangers of coups and assassinations, he never appeared in public. As a result, an elaborate court with complex rituals developed, and the emperor's claim to semidivine status invested him with a new religious authority.

Late Roman Art and Architecture

Even if the emperor did not show himself to his subjects, he could impress them in other ways, and the reigns of Diocletian and Constantine marked the last great age of Roman architecture. The immense Basilica of Constantine [4.26], with its central nave rising to a height of 100 feet (30.5 meters), is now in ruins, but in its day this assembly hall must have been a powerful reminder of the emperor's authority. It also contained a 30-foot (9.2 m) statue of the emperor himself [4.27]. The palace Diocletian had built for him at Split, on the Adriatic coast, is constructed on the plan of a military camp, with enormous central avenues dividing it into four quarters [4.28]. The decoration makes use of eastern motifs, and the entire design is far from the Classical style of earlier times.

http://www.dalmacija.net/split/split_4.htm

Diocletian's Palace

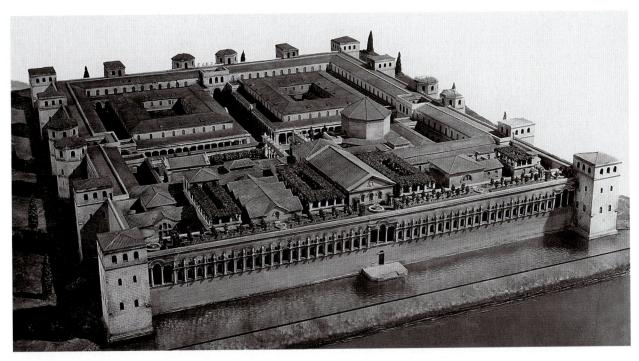

4.28 Reconstruction model of the Palace of Diocletian at Split, Croatia, A.D. 300–305. Museo della Civiltà Romana, Rome. Note the octagonal dome of the emperor's mausoleum.

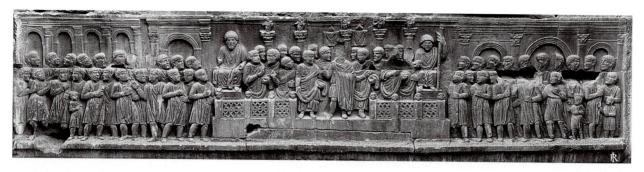

4.29 Constantine Receiving Homage from the Senate, frieze on the Arch of Constantine, Rome, A.D. 315. Marble relief, $3'4'' \times 17'6''$ (1.02 \times 5.33 m). On both sides of the emperor (seated in the center) his officials distribute money to the crowd below. The simplified style, in which most of the puppetlike figures are shown frontally, foreshadows Byzantine and medieval art and is certainly very different from the style of earlier reliefs (Figures 4.10, 4.11).

In sculpture, too, Classical forms and styles were increasingly abandoned. Realistic portraiture and naturalistic drapery were neglected, and sculptors no longer tried to express depth or reality in their relief carving. The lack of perspective and precision in their work foreshadows the art of the early Middle Ages [4.29]. The general abandonment of Classical ideas these artistic changes indicate went along with a waning of interest in Stoicism and Epicureanism and a new enthusiasm for Eastern religious cults. Traditional Roman religion had always been organized by the state, and from the time of the late Republic some Romans had sought a more personal religious satisfaction in the worship of Eastern deities. During the last stages of the empire, strong cults developed around the Phrygian goddess Cybele, the Egyptian Isis, and the sun god Mithras.

The appearance and eventual triumph of Christianity is outside the scope of this account, but its emergence as the official religion of the empire played a final and decisive part in bringing to an end the Classical era. Pagan art, pagan literature, and pagan culture as a whole represented forces and ideals Christianity strongly rejected, and the art of the early Christians is fundamentally different in its inspiration. Yet even the fathers of the early church, implacable opponents of paganism, could not fail to be moved by the end of so great a cultural tradition.

The memory of Rome's greatness lived on through the succeeding ages of turmoil and achievement and the Classical spirit survived, to be reborn triumphantly in the Renaissance.

SUMMARY

The Monarchy The vast extent of ancient Roman history—more than twelve hundred years—can be conveniently divided into three chief periods: the Monarchy

(753–510 B.C.); the Republic (509–31 B.C.); and the Empire (31 B.C.–A.D. 476). The city was founded in the mideighth century, around the time the Greeks were setting up colonies in southern Italy and Sicily. Rome's first inhabitants were Latins, an Italian people native to central Italy, after whom the Roman language is named. Traditional accounts of the city's origins claimed that its first rulers were a series of seven kings. The first four were Latin, but in 616 B.C. Rome fell under Etruscan control.

Rome Under the Etruscans The Etruscans had developed in the region of central Italy to the north of Rome, although their origins are uncertain; they may have migrated to Italy from western Asia. Etruscan art was strongly influenced by Greek and Orientalizing styles. Among the most striking works to survive are the tomb paintings at Tarquinia, one of the principal Etruscan cities, and the sculpture from the temple of Apollo at Veii. Although many Etruscan inscriptions can be deciphered, no Etruscan literature has been discovered. For the century during which they ruled Rome, the Etruscans expanded its trade contacts and introduced important technological innovations. In 510 B.C., the Romans drove out the last Etruscan king.

The Beginnings of the Roman Republic In 509 B.C., the Roman Republic was declared. The political system of the new state evolved from the need to achieve a balance of political power between the two classes of citizens: the aristocratics (patricians) and the people (plebeians). There gradually developed two political institutions, the Senate and the assembly of the people, while plebeians eventually won the right to run for election to virtually all offices of state. The growth of internal political stability was accompanied by the spread of Roman power throughout Italy. Among those to fall under Roman domination were the Etruscans, their former rulers. Little in the way of art or literature has survived from this early period, and most of what was produced seems to have been inspired by Etruscan or, more generally, Greek models.

Roman Expansion in the Mediterranean In 264 B.C. there began a series of wars (the Punic wars) between Rome and her chief rival in the western Mediterranean, Carthage. By 201 B.C., the Romans had proved victorious, and Roman colonies were established in Spain and North Africa. Throughout the following century Roman power spread eastward. In 146 B.C., Greece was absorbed into the Roman Empire, and the Hellenistic kingdom of Pergamum was bequeathed to Rome by its last king, Attalus III, on his death in 133 B.C. The second century B.C. also saw the beginnings of the development of an independent Roman culture, although Greek influence remained strong. The Roman poet Ennius composed his epic, the Annals, while Plautus and Terence wrote comedies based on Greek originals. Greek music became popular in Rome, and the two chief schools of Greek philosophy, Stoicism and Epicureanism, began to attract Roman adherents.

The Collapse of the Republic With such vast territorial expansion, strains began to appear in Roman political and social life. The growth of a middle class, the equites, disturbed the old equilibrium, and the last century of the Republic (133 B.C. to 31 B.C.) was beset by continual crisis. A succession of powerful figures—Marius, Sulla, Pompey, Caesar—struggled to assume control of the state. The last of these proved victorious in 48 B.C. only to be assassinated four years later. Amid bitter fighting between Mark Antony, Caesar's lieutenant, and Octavius, the late dictator's nephew and heir, the Republic collapsed.

The political confusion of the Republic's last century was accompanied by important cultural developments. Among the major literary figures of the age were the Epicurean poet Lucretius, the lyric poet Catullus, and the orator and politician Cicero. Caesar himself combined his political and military career with the writing of accounts of his campaigns. In the visual arts realistic portrait sculpture became common, while the invention of concrete was to have enormous consequences, both for Roman building and for the history of all later architecture in the West. Sulla's great Sanctuary at Praeneste inaugurated the tradition of large-scale public building projects that became common during the empire.

The Augustan Age In 31 B.C., Octavius defeated the combined forces of Antony and Cleopatra to emerge as sole ruler of the Roman world; in 27 B.C., under the name Augustus, he became its first emperor. The Augustan Age marked the high point of Roman art and literature, and many of its finest achievements were produced to celebrate the Augustan revolution. Vergil was commissioned to write a Roman national epic: The result was the Aeneid. Augustus himself was portrayed in numerous statues and portraits, including the Augustus of Prima Porta, and in the reliefs on the Ara Pacis. Important public works included the Pont du Gard near Nîmes, France.

Life, Art, and Literature in the Early Empire From the time of Augustus until A.D. 476, the empire was ruled by a series of emperors who were increasingly dependent on an elaborate state bureaucracy. Augustus and his first four successors were from a single family, but with time emperors either seized power for themselves or were imposed by the army. The empire continued to expand until the reign of Hadrian (A.D. 117-138), who fixed its borders to achieve stability abroad. Some idea of the character of provincial daily life in the Empire can be gained from the excavations at Pompeii and the other cities around the Bay of Naples, which were destroyed by an eruption of the volcano Vesuvius in A.D. 79. Writers of the early empire include the historian Tacitus and the satirist Juvenal. Among the most impressive works of architecture of the period is the Pantheon, designed by Hadrian himself, which makes bold use of concrete.

The Roman Empire in Decline The third century was marked by continual struggles for imperial power. Only Emperor Diocletian (A.D. 284–305) managed to restore order by massive administrative and economic reform. After Diocletian's retirement to his palace at Split, one of his successors, Constantine (A.D. 307–337), transferred the imperial capital from Rome to the new city of Constantinople in A.D. 330, and the western part of the empire began its final decline. During this last period, Roman art became less realistic as Classical forms and styles were abandoned in favor of simpler, more massive effects. Finally Rome itself was shaken by barbarian assaults, and the last western emperor was forced to abdicate in A.D. 476.

Pronunciation Guide

Ee-NEE-id Aeneid: **Anchises:** Ank-ICE-ease ARE-a-PAH-kiss Ara Pacis: SEAR-ease Ceres: Cher-VET-er-ee Cerveteri: Cicero: SISS-er-owe KIB-e-lee Cybele: Dido: DIE-doe

Diocletian: Die-owe-KLEE-shan Epictetus: Ep-ic-TEE-tus

Epicureanism: Ep-ik-you-REE-an-ism

Etruscans: Et-RUSK-ans

Gaius: GUY-us
Ius Civile: YUS-kiv-EE-lay

Lydia: LID-i-a
Pantheon: PAN-thi-on
Plautus: PLAW-tus
Plebeians: Pleb-EE-ans
Pliny: PLIN-ee

Praeneste:

Pry-NEST-ee

Stoicism:

STOW-i-sism TASS-it-us

Tacitus: Tarquinia:

Veii:

Tar-OUIN-i-a VAY-ee

Winckelmann:

VIN-kel-man

EXERCISES

- 1. What are the chief features of Etruscan culture and religion? What light do they cast on the problem of the Etruscans' origins?
- 2. "Roman art and culture are late and debased forms of Hellenistic art." Discuss.
- 3. In what ways does the Aeneid fulfill its aim to provide the Romans with a national epic?
- 4. Compare the Aeneid in this respect to the Greek epics, the Iliad and Odyssey, discussed in Chapter 2.
- 5. Describe in detail Augustus' use of the visual arts as instruments of propaganda. Are there comparable examples of the arts used for political purposes in recent times?
- 6. What do the discoveries at Rome and Pompeii tell us about daily life in the Roman Empire? In what significant respects did it differ from life today?

FURTHER READING

- Anderson, James C. (1997). Roman architecture and society. Baltimore: Johns Hopkins University Press. An excellent introduction to the influence of social factors in the development of Roman architectural forms.
- Boardman, J., J. Griffin, & O. Murray. (1988). The Roman world. New York: Oxford University Press. An excellent collection of essays on a wide range of aspects of Roman history and culture.
- Brendel, O. J. (1995). Etruscan art (2nd ed.). New Haven: Yale University Press. The most up-to-date survey of Etruscan painting and sculpture; numerous illustrations.
- Claridge, Amanda. (1998). Rome: An Oxford archaeological guide. New York. The best recent archaeological guide to the Imperial capital.
- Crawford, M. (1982). The Roman republic. Cambridge: Harvard University Press. An excellent survey of Republican history and culture; particularly good on coinage.
- D'Ambra, Eve. (1998). Roman art. New York: Cambridge University Press. Perhaps the best recent single-volume survey of a vast body of material.
- Dixon, S. (1988). The Roman mother. Norman: University of Oklahoma Press. An absorbing study of the legal and social status of Roman mothers.
- Elsner, Jas. (1998). Imperial Rome and Christian triumph. New York: Oxford University Press. Very good on the later years of the empire and the transition to Christianity.
- Garnsey, P., & R. Saller. (1987). The Roman Empire: Economy, society, and culture. Berkeley: University of California Press. A wide-ranging examination of the many aspects of Roman civilization, with special attention paid to Roman influences on other Mediterranean cultures.
- Graves, Robert. (1977). I, Claudius and Claudius the God. Baltimore: Penguin. These two historical novels, originally

- published in 1934, are re-creations of the Roman world that are both scholarly and thoroughly absorbing. Highly recommended.
- Kleiner, Diana E. E., & Susan B. Matheson (eds.). (1996). I Claudia. Women in ancient Rome. New Haven: Yale University Art Gallery.
- Kleiner, Diana E. E., & Susan B. Matheson (eds.). (2000). I Claudia II: Women in Roman art and society. New Haven: Yale University Art Gallery. These two well-illustrated catalogues reveal a wealth of new information on the role of women in Roman society and culture. Highly recommended.
- Pallottino, M. (1975). The Etruscans. Baltimore: Penguin. A revised version of the standard work by the most eminent Etruscologist of our time, covering all aspects of Etruscan culture. Especially good on the language.
- Richardson, Lawrence, Jr. (1988). Pompeii: An architectural history. Baltimore: Johns Hopkins University Press. A masterly introduction to the variety of Roman architectural forms represented at Pompeii.
- Spivey, Nigel. (1997). Etruscan art. New York: Thames and Hudson. An interesting and up-to-date analysis of all aspects of Etruscan art.
- West, D., & A. J. Woodman. (1984). Poetry and politics in the age of Augustus. New York: Cambridge University Press. A study of the effects of Augustus' cultural program.
- Zanker, Paul. (1998). Pompeii: Public and private life. Cambridge: Harvard University Press. This recent survey incorporates much new material.

ONLINE CHAPTER LINKS

Etruscan artifacts are found at http://www.comune.bologna.it/bologna/Musei/ Archaeologico/etruschi/en/7_e.htm

An Annotated Guide to Internet Resources related to Julius Caesar is available at

http://virgil.org/caesar/

which provides links to primary sources, background information, a collection of images, and modern commentary.

An Annotated Guide to Internet Resources related to Caesar Augustus is available at

http://virgil.org/augustus/

which provides links to primary sources, background information, a collection of images, and modern commentary.

The Vergil Project at

http://vergil.classics.upenn.edu

provides resources for students, teachers, and readers of Vergil.

The Cicero of Homepage at

http://www.utexas.edu/depts/classics/documents/ Cic.html

offers a biography, a timeline, a bibliography, and links to texts.

The Pompeii Forum Project at http://jefferson.village.virginia.edu/pompeii offers an extensive archive of photographs that chronicle excavations among the ruins of ancient

Pompeii.

Roman Law Resources at

http://iuscivile.com

provides links to a variety of Internet resources related to *Ius Civile*.

This General Interest Resource page http://acad.depauw.edu/romarch/genr.html of the ROMARCH site provides an extensive annotated list of links to Internet sites related to Roman Studies.

View the Cast Gallery at Oxford University's Ashmolean Museum at

http://www.ashmol.ox.ac.uk/ash/departments/cast-gallery/

where Roman works are represented among this outstanding collection of casts derived from sculptures found in museums around the world.

	1				
		GENERAL EVENTS	LITERATURE & PHILOSOPH	Y ART & ARCHITECTURE	
200			India		
	INDUS VALLEY CIVILIZATION	300–1700 в.с.е. Sites occupied at Harappa and Mohenjo-daro	Development of written language based on picture signs	Stone and ceramic remains Public buildings of fired brick Communal drainage system	
		I700–500 в.с.е. Aryan Invasion	First evidence of the Sanskrit language Vedic tradition evolves	Bronze work	
1200	B.C.E.		I 000 B.C.E. The <i>Vedas</i> committed to writing		
500	B.C.E.	 326 B.C.E. Invasion of Alexander the Great Life of Siddartha Gautama, who becomes known as the Buddha (c. 563–483) 261 B.C.E. Emperor Ashoka unifies India, making Buddhism the official state religion 	Upanishads develop Mahabharata, including the Baghavad-Gita, is written	Large scale sculpture and architecture begins to appear	
200	A.D.				
		320–500 A.D. Founding of the Gupta Empire Indian development of "Arabic" numerals	Kalidasa, Sakuntala; Sudraka, The Little Clay Cart	Temples of Khajuraho	
	A.D.	Use of decimal and zero developed 480–500 A.D. Invasion of the White Huns			
	-,,,,				
700	A.D.				

900 A.D.

CHAPTER 5 ANCIENT CIVILIZATIONS OF INDIA AND CHINA

GENERAL EVENTS

LITERATURE & PHILOSOPHY

ART & ARCHITECTURE

CHINA

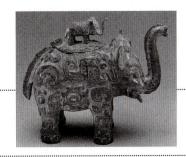

Bronze works

1600-1100 в.с.е. Shang Dynasty

System of writing based on picture signs evolves

IIOO-221 B.C.E. Chou Dynasty

Lao-Tzu (c. 570 B.C.)

Life of Confucius (c. 551–479 B.C.)

403–221 B.C.E. Period of the Warring States

221 – 210 B.C.E. Ch'in Dynasty (c. 221 B.C. – 210 B.C.)

Shih Huang-ti ("First Emperor") conquers all rivals in China

202 B.C.-A.D. **220** Han Dynasty

Kao-tsu, the first Han Emperor restores a degree of order after Shih Hung-ti's death Five Classics and the Classic of Songs circulate

403 – 221 B.C.E. *Tao te ching* written c. 3rd century B.C.

Buddhist writings, *Mahayana* and *Hinayana*, circulate

The Great Wall; the First Emperor connects existing structures to create the Great Wall and prepares an elaborate tomb

618-906 A.D. T'ang Dynasty

Beginning of China's Golden Age

Li Po, best-known Chinese poet (701–762)

Monumental shrines to Buddha reflect the influence of similar Indian works

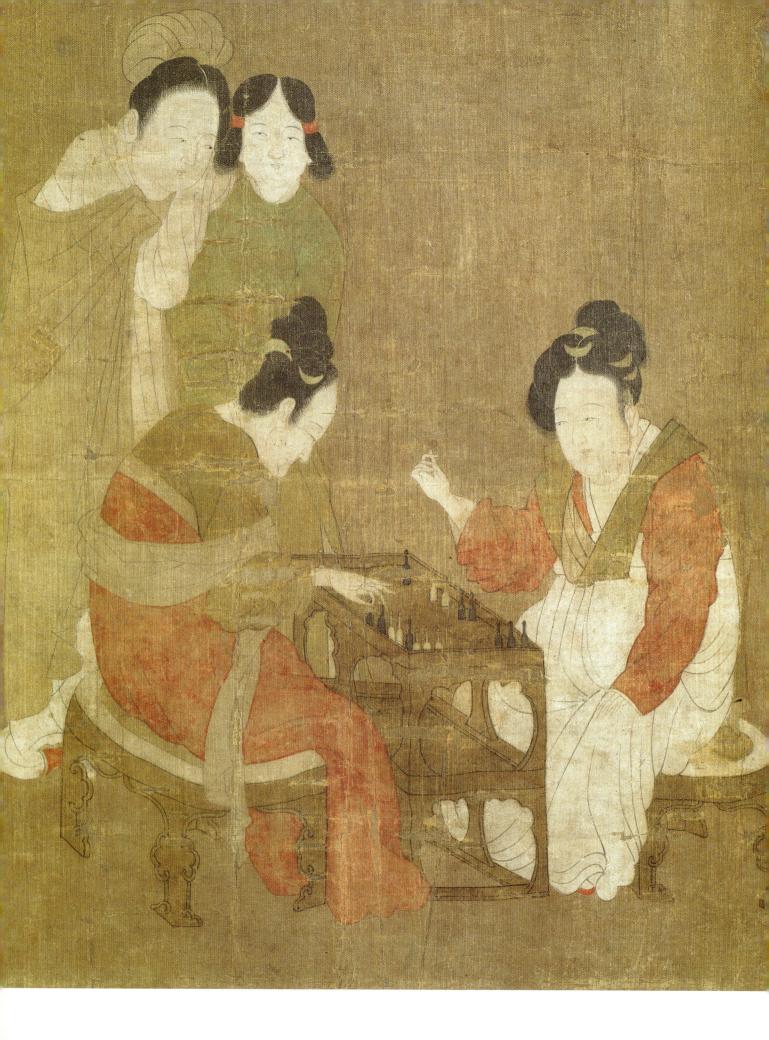

CHAPTER 5

ANCIENT CIVILIZATIONS OF INDIA AND CHINA

INDIAN CIVILIZATION

The Indus Valley Civilization

n what is present-day Pakistan there once existed, three thousand years before the common era (B.C.E.), a culture that had two large centers at Harappa and Mohenjo-daro. What we know of these people can be told only by a reading of the archaeological evidence and that evidence, is only imperfectly understood. They possessed a written language based on picture signs, but that language has yet to be deciphered. At Mohenjodaro, scholars have uncovered a vast assembly hall, a large bath, and other public buildings all made from fired brick. Despite such urban centers, the Indus Valley dwellers were an agriculture-based society. It is believed that they were the first people to cultivate cotton.

http://www.harappa.com/walk/index.html

Harappa

http://www.harappa.com/har/moen0.html

Mohenjo-daro

From their seal stones and other art works recovered from excavations they seem to have had an intense interest (possibly religious) in the figure of the bull, but no direct link between their bull cult and that of the Minoans—who had a similar cult—has been established. Although there is much evidence of a highly developed religious life (based mainly on stone and ce-

ramic remains) there is no clear evidence as to what that religion entailed [5.1]. Other archaeological evidence suggests that there was some centralization in their culture since they used standard weights and measures for trading purposes, and had communal drainage systems as well as ways of distributing goods (mainly pottery).

Around 1700 B.C. the Indus Valley culture, as this complex civilization is known, began to go into decline as the area was struck by series of floods and through the exhaustion of the soil as well as the overuse of the woodlands. To these ecological disasters, apparent in the archaeological record, was added a new threat: a series of invasions from the Northwest by a people called the *Aryans*. The decline of the older Indus Valley culture was so complete that archaeologists have failed to find any significant art works from the period of decline until the later emergence of Buddhist culture.

THE ARYANS

The Aryan people settled in the Indus Valley by around 1500 B.C., but who they were and where they came from is not at all clear. Some scholars point to the Russian steppes, but the picture of their migration into the subcontinent of India is not completely understood. The material evidence mapping the spread of the Aryan peoples is at best spotty. What we do know (mainly by reading back into their history from texts written at a later time) is that they spoke the language we call *Sanskrit*. That language is thought to be the source of Indo-European language groups and as such is the ancestor of Latin and the other Romance languages. A few examples might help to see how words evolved as Sanskrit words developed in Latin and then were borrowed as English words.

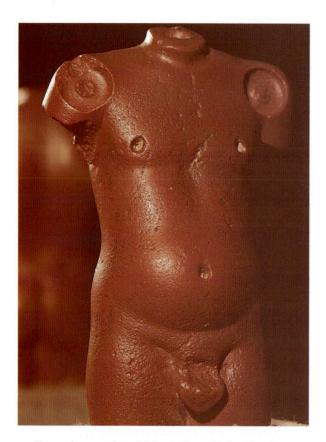

5.1 Torso of a man from Mohenjo-daro, third millennium B.C. Red stone. National Museum, New Delhi.

riage, table exclusion (who could eat with whom), laws of ritual purity, and so on.

Aryan culture mixed agricultural and pastoral culture with cattle, serving as a medium of trade, functioning almost like a currency. The horse was also known, but served mainly as an instrument of the warrior caste where the use of the chariot was common. Horses were so important for the warriors that some of the earliest hymns speak of rare but highly important horse rituals including horse sacrifices. While settled agriculture was common enough it was not considered as prestigious as cattle raising. The Aryan people also possessed high technical skills with evidence indicating that they had a keen sense of technology for bronze work. The early Aryans did not found great city centers; they were more tribal in their structure but aggressive in their growth. Over the centuries they would migrate from their strongholds in the Northwest of the subcontinent into the southern reaches of India. The great epic poems of India like the Ramayana and the Mahabharata, written centuries after the events they purport to describe, reflect the warring period when the Aryans subdued the Indus Valley dwellers. These epics—with their complex story lines of gods, heroes, and battles—are central to Indian culture; their dramatization on Indian television has proved to be one of the most popular shows among all classes of people in India.

http://www.alkhemy.com/sanskrit/

Sanskrit

yoga (yoke for an animal; later: discipline) — jugum
(Latin: yoke) — yoke (English)
Agni (God of fire) — ignis (Latin: fire) — ignition
(English)

The Aryans brought with them a culture that made a class distinction between the *nobility* and the commonality (common people). Over a long period of time, this distinction developed into a *caste system* which divided all of society into the castes of the priesthood, the warriors, the laborers, and the serfs. The development of the caste system in India underwent many changes over the millennia so that today the caste system recognizes the priests, warriors and rulers, merchants, and laborers with a subgroup simply known as *outcasts* (the unclean ones). Within the large groupings there are many subcastes. The caste system was one of the shaping social forces in India reinforced by many laws concerning mar-

http://www.joglosemar.co.id/mahabharata.html

Mahabharata

Most characteristic of Aryan culture was its elaborate religious system that placed enormous emphasis on ritual sacrifice to the pantheon of gods. The fact that the priests had the highest place in the caste system was due to their responsibility in the carrying out of the religious ceremonies in honor of the gods. Highly complex in its detail, the rituals had to be carried out exactly according to tradition in order for the ceremonies to attain their goal, for example, the fertility of the soil, the arrival of the rains, and so on. These ceremonies and their companions—hymns and gestures—were passed from one generation of hereditary priests to the next in a fixed oral form. It was only around the year 1000 B.C. that these texts were committed to writing in a slow compilation which is now know as the Vedas, with the best known of these compilations called the Rig Veda. The Vedas represent the oldest strain of Indian religious literature and are still chanted by Hindus at all important moments in Indian religious life: at birth, naming ceremonies, rites of

passage to adulthood, in sickness, and at death. They also form the core text of Hindu temple worship. The *Vedas*, in fact, represent one of the oldest bodies of religious writings known to humanity.

http://home.earthlink.net/~tolp/rigveda.htm

Rig Veda

Shortly after the composition of the *Rig Veda* a new kind of literature came into being. The sages of India were interested in the large questions of what we would call philosophical issues, for example: What caused the cosmos to be? How did human beings arise? Why is human life short? Why do people suffer? What is the deep meaning behind the priestly rituals and sacrifices? The responses to those and similar questions are treated in a series of classical Indian texts known as the *Upanishads* (meaning a "session"; i.e., from a learned person). We possess over one hundred upanishadic texts which vary in length and sophistication. Some deal with the allegorical meaning of ritual, while others are more philosophical in nature.

The fundamental worldview of the *Upanishads* may be stated briefly. The ultimate reality is an impersonal reality called *Brahman*. Everything else is a manifestation of this underlying reality. Each individual person has within the self *Brahman*, which, in a person, is called *Atman*. The secret of life is to come to the knowledge that *Brahman* is the ultimate reality (i.e., one's inner self is part of this fundamental reality) and everything else is, in a certain fashion, permeable and "unreal." This fundamental assertion is summed up in a classical Sanskrit expression *Tat tvam asi:* "you (the individual) are that (the eternal essence or Brahman)."

Indian religion, later called the Hindu religion (derived from an Arabic word meaning "those who live in the Indus Valley"), combined, then, a highly ritualized worship of the gods of the pantheon (many believe these gods are merely faces or names for the ultimate reality) with a strong speculative tradition that tries to grasp the ultimate meaning of the cosmos and those who live in it. Indian religion, in short, is both a religion of the priest and the temple as well as the religion of solitary meditation and study. Most Indian homes to this day will have a small altar for a god or goddess in order for the family to show respect and worship (called puja) in the home. The fundamental aim of Indian religion, however, is to find the path that leads one to the correct knowledge of ultimate reality which, when known, leads one to be liberated from the illusory world of empirical reality and be absorbed into the one true reality, Brahman.

Broadly speaking, three paths have been proposed for attaining such knowledge. These paths are: (1) The path

http://www.hinduism.co.za/

Hinduism

or discipline (i.e., yoga) of asceticism (fasting, nonpossession, bodily discipline, etc.) by which one lives so that the material world becomes accidental and that person becomes enlightened. This is the hardest path of all which, if at all undertaken, usually comes after one has had a normal life as a householder. (2) The path or discipline of *karma* in which one does one's duty according to one's caste obligations (e.g., priests should sacrifice; warriors fight, etc.) and not out of greed or ambition—motives that cloud the mind. (3) The path of devotion in which all people refer all of their deeds as an act of devotion (*bhakti*) to the gods or to the one god to whom a person has a special devotion. By doing everything out of devotion one does not fall into the trap of greed or self-centeredness.

Buddha

http://www.sivanandad/shq.org/saints/buddha.htm

Buddha

It is into this highly complex world of the Indian subcontinent that the person who came to be called Buddha (meaning "the enlightened one"; it is a title not a personal name) was born. Because biographies of Buddha were written several centuries after his death, his story is somewhat clouded by myths. The main lines, however, seem to be reasonably clear. His given name was Siddhartha and his family name was Gautama. He was born around 563 B.C. into the family of a king who belonged to the warrior caste in the foothills of the Himalayas in what is present-day Nepal. Raised in luxury, he married young and fathered a son. When he was not yet thirty he traveled outside his palatial quarters and saw enough suffering (beggars, a corpse, a sick person and a wandering, begging ascetic) to wonder about the inescapability of suffering and death. Leaving his family, he took up a wandering life as an ascetic practitioner of meditation and self-denial. According to Buddhist tradition, he visited learned men, undertook meditation, and practiced fasting and self-deprivation. At age thirty-five, frustrated by his lack of insight, he decided to sit under the shade of a tree until he intuited the truth about existence. At the climax of this long vigil he received the illumination that caused him to be called the Enlightened One (Buddha). He left his spot and went to the Deer Park at Sarnath

CONTEMPORARY VOICES

War and Religion in the Age of Ashoka

Ashoka's intrinsic tolerance emerges in this extract from his Rock Edict XII:

His Sacred and Gracious Majesty does reverence to men of all sects, whether ascetics or householders, by gifts and various forms of reverence. His Sacred Majesty, however, cares not so much for gifts or external reverence as that there should be a growth of the essence of matter in all sects. The root of this is restraint of speech; to wit, a man must not do reverence to his own sect by disparaging that of another man without reason. Concord, therefore, is meritorious; to wit, hearkening, and hearkening willingly to the law of piety as accepted by other people. For it is the desire of his Sa-

cred Majesty that adherents of all sects should hear much teaching and hold sound doctrine.

In his Rock Edict XIII, the king describes his attitude to war:

This pious edict has been written in order that my sons and grandsons, who may be, should not regard it as their duty to conquer a new conquest. If, perchance, they become engaged in a new conquest by arms, they should take pleasure in patience and gentleness, and regard the only true conquest the conquest won by piety. That avails for both this world and the next.

near what is present-day Benares (Varanasi) to teach his new doctrine. It was there that he preached his famous first sermon outlining the "Middle Way" between extreme asceticism and self-indulgence. Buddha's doctrine has been called the "Fourfold Noble Path":

http://www.buddhanet.net/wings4nt.htm

Fourfold Noble Path

- 1. existence itself is suffering;
- 2. suffering comes from craving and attachment;
- 3. there exists a cessation of suffering, which is called *nirvana*; and
- 4. there is a path to nirvana, which is eightfold.

The eightfold path can be summarized as a "way of life," which derives from the following: right views, right resolve, right speech, right action, right livelihood, right effort, right mindfulness, and right concentration. When these eight basic dispositions are lived correctly, one then might escape the never-ending cycle of rebirth and find nirvana. The specific character of this eightfold disposition would emphasize ethical living, awareness of who one is and what one does; nonviolence (ahimsa); temperance in dealing with material realities; erasure of impulses to greed, acquisition, sensual living, and so on. This kind of life leads a person to understand the passing reality in which people are enmeshed and thus find liberation.

http://www.buddhanet.net/wings_h.htm

Eightfold Path

Like its parent religion, Buddhism preaches liberation through knowledge. The typical figures that represent Buddha makes the point forcefully: Buddha sits in a meditative position with eyes half closed and a half smile on his face because he has discovered within himself the ultimate truth, which has enlightened him. Buddha does not look up to the heavens to a god or kneel in worship. Truth comes from within.

The Emperor Ashoka

When Buddha died in 483 B.C., his religious tradition was just one of many that circulated within India even though it had its own growth and the accumulation of a religious tradition based on Buddha's teaching. That situation was to change through the efforts of perhaps the greatest emperor of ancient India: Ashoka. He was a superb and ruthless ruler who unified all of India (including such faraway places as Afghanistan and Baluchistan) around 261 B.C. However, Ashoka was appalled by the suffering and bloodshed he had caused in this enterprise. Out of remorse, he converted from traditional Brahmanism to Buddhism and, out of his Buddhist conviction, began to preach the doctrine of nonviolence in his empire. Although tolerant of all religious traditions, he established Buddhism as the religion of the state. He mitigated the harsh laws of the empire, regulated the slaughter of animals, founded and sustained Buddhist

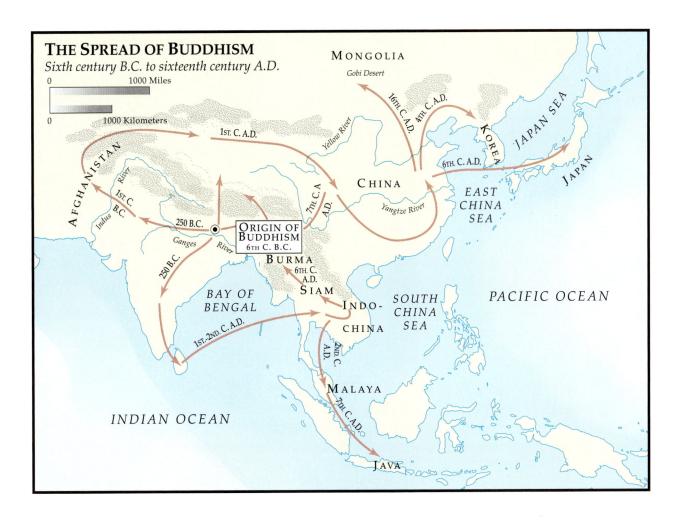

monasteries (called *sanghas*) and erected many *stupas*—those characteristic towers which one finds in Buddhists lands. They may serve as reliquaries for Buddha or a repository of Buddhists texts but symbolically they represent the enlightenment of the Buddha. In addition, Ashoka erected pillars and towers with his decrees carved on them, some of which exist to this day. Finally, Ashoka is credited with calling a vast Buddhist convocation to fix the canon of sacred books for Buddhism; that is, the authoritative list of writings that are the measure (canon) of Buddhist belief and practice.

Perhaps the most important thing that Ashoka did was to send Buddhist monks as missionaries to all parts of India and to other countries to share Buddhist wisdom. There is evidence that his missionaries went as far as Syria, Egypt, and Greece. One of his most important missions was the sending of a blood relative (perhaps a son or a brother) to Ceylon (present-day Sri Lanka) where the Buddhist doctrine took root and then spread to other parts of Southeast Asia (see map). Although Buddhism—like all of the major religions of the world—has a variety of forms and quite different cultural expressions, at its core is the code enshrined in the Buddha's

"Four Noble Truths." It is one of the small ironies of history that Ashoka, the emperor of all of India, spread Buddhism all over the East, while in his native India, Buddhism would shrink in time to a small minority—which is the situation at present.

HINDU AND BUDDHIST ART

There is little evidence for artistic production in the period following the disappearance of the Indus Valley people. Only with the reign of Ashoka does a tradition of large-scale sculpture and architecture begin to appear, probably influenced by developments to the west, in Persia. Thus, the earliest monumental Indian sculpture, a column crowned with lions [5.2], which comes from one of his palaces, resembles similar column decorations found at Persepolis, the capital of Persia.

Both Hindu and Buddhist art are overwhelmingly religious in spirit. The great statues and sculptural reliefs that decorate the temples are narrative, telling the stories of the Hindu deities and the life of Buddha to their worshipers. The difference between the two styles of art

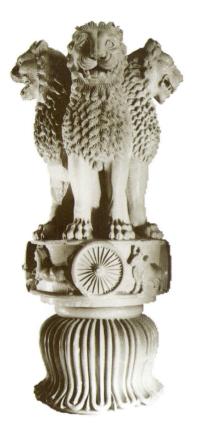

5.2 Lion capital, from a column erected by King Ashoka, 242–232 B.C. Height 7' (2.1 m).

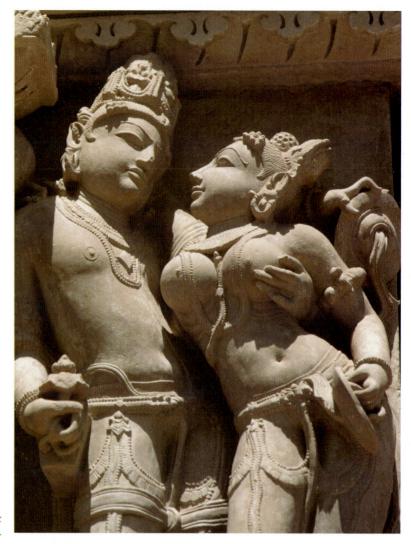

5.3 Detail from sculptured frieze showing erotic scene on a temple at Khajuraho, northern India.

reflects the differing characteristics of the two faiths. Much of Hindu art is openly erotic, reflecting the belief of pious Hindus that sexual union represents union with their gods [5.3]. Other works illustrate the Hindu sense of the unity of all forms of life. Thus, Vishnu—the supreme Hindu spirit—appears in a series of *avataras*, or incarnations, which include that of a boar, a fish, or a dwarf [5.4]. Over time, scenes from the *Mahabharata* and other great Hindu epics combined the elements of eroticism and naturalism. Figure 5.5 shows Krishna, the hero of the *Mahabharata*'s central section, the *Baghavad-Gita*, in a pleasant landscape where the birds in the trees are painted in detail [5.5].

By contrast, Buddhist art emphasizes the spiritual, even austere nature of Buddhist doctrines. Buddha and his many saints, the *Bodhisattvas*, are shown as calm, often transcendent images, inviting prayer and meditation [5.6]. Sometimes the Buddhist command to renounce all worldly pleasures becomes even more powerfully expressed, as in the image of the Fasting Buddha [5.7].

THE GUPTA EMPIRE AND ITS AFTERMATH

In the years following the death of Ashoka, his empire began to fall apart, and a series of invaders from the north established small kingdoms in the Indus and Ganges valleys. These northerners never penetrated the southern regions, where numbers of small independent states flourished economically by trading with Southeast Asia and, to the west, with the expanding commercial power of the Roman Empire.

Only in A.D. 320 did Chandra Gupta I lay the foundations of a new large-scale kingdom, known as the *Gupta Empire*, which reached its zenith under his grandson, Chandra Gupta II (ruled A.D. c. 380–c. 415). Known as "The Sun of Power," Chandra Gupta's reign was famous for its cultural achievements, economic stability, and religious tolerance. As a Buddhist monk noted, "The people vie with each other in the practice of benevolence and

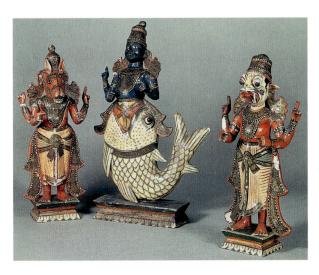

5.4 Wooden figure representing the *avatar* (incarnation) of the god Vishnu as the boar Varaha. Other incarnations include the fish (Matsya) and the dwarf (Vamena).

righteousness." In spite of this general tolerance, however, the Gupta period saw the rapid decline of Buddhism in India and a return to the traditions of Hinduism.

http://www.itihaas.com/ancient/gupta-end.html#skand

Gupta Empire

Gupta Literature and Science

Literary skills assumed vast importance at the Gupta court, where poets competed with one another to win fame. The language they used was ancient Sanskrit, that of the old Hindu Vedas, which served as the literary language of the period; it was no longer spoken by the general population. The most famous of all Indian Classical writers was Kalidasa (active c. 400), who wrote plays,

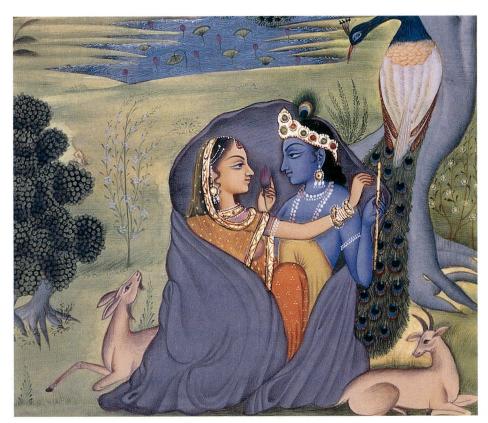

5.5 Krishna and the Maiden in a Garden. Painted illustration of a scene from the Mahabharata. Krishna is easily recognizable by the blue color of his skin.

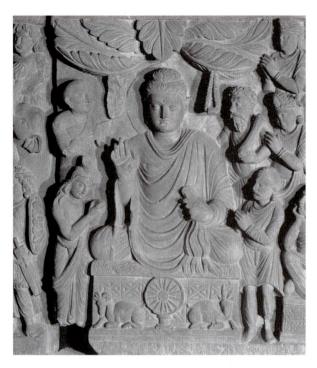

5.6 Buddha surrounded by devotees, second century A.D. Stone. Smithsonian Institution, Freer Gallery of Art, Washington, D.C.

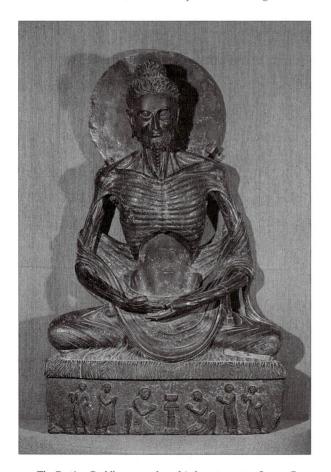

5.7 The Fasting Buddha, second or third century A.D. Stone. Central Museum, Lahore, Pakistan.

epics, and lyric poetry. His best-known work was the play *Sakuntala*, which describes the happy marriage of the beautiful Sakuntala to King Dusyanta, its collapse as a result of a curse pronounced by an irascible holy man, and the couple's eventual triumphant reunion. By contrast to the Classical dramas of the Greek tradition, with their analysis of profound moral dilemmas, Kalidasa's play has the spirit of a fairytale with a happy ending.

http://www.sibal.com/sandeep/texts/shakuntala.html

Sakuntala

The work of another author of the same period, Sudraka, is more realistic. Among the characters in his play *The Little Clay Cart* are a nobleman, a penniless Brahmin, a prostitute, and a thief, who at one point offers a vivid description of his technique of housebreaking.

Under the Guptas, many important scientific discoveries were made possible by the foundation of large universities. The most important, at Nalanda, had some five thousand students who came from various parts of Asia. Among the subjects taught were mechanics, medicine, and mathematics. In this latter field, Indian scholars continued to make important advances. The system of socalled Arabic numerals, which only became widespread in Western Europe in the Renaissance (A.D. fifteenth and sixteenth centuries), had first been invented in India in the late third century B.C. By the time of the Gupta Empire, Indian mathematicians were using a form of decimal, and it may have been at this time that the concept of the zero was first employed. Among their work in algebra were quadratic equations and the use of the square root of two.

The Collapse of Gupta Rule

The decline of the Gupta Empire, which began with the death of Chandra Gupta II, became headlong with a series of invasions around A.D. 480–500 by the White Huns, a people related to the Huns and other Central Asian tribes. Around the same time, other related tribes moved westward from Central Asia and sacked Rome in A.D. 476, thereby effectively ending the Roman Empire. The White Huns never managed to establish a secure power base in India, however, and over the following centuries innumerable local princely states fought both among themselves and against foreign invaders. In part, the difficulty in constructing a central government and a lasting peace was due to the powerful Hindu priestly

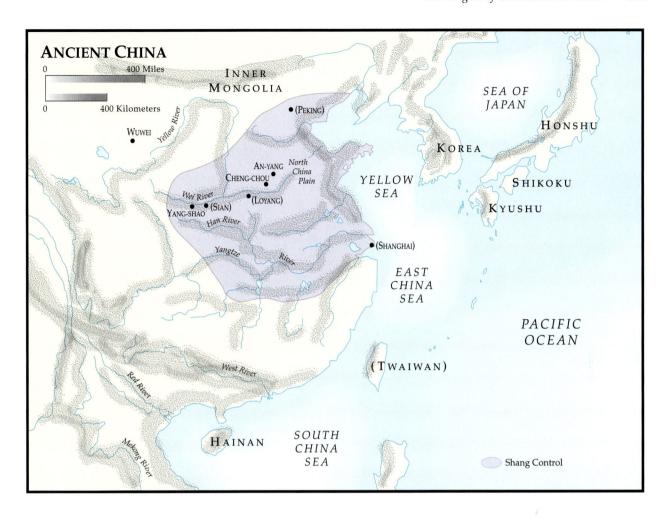

class, who were unwilling to surrender conflicting religious interests to an overall secular, political settlement. When a new united Indian Empire did begin to develop in the fifteenth and sixteenth centuries, its rulers were Muslim, not Hindu.

http://www.silk-road.com/artl/heph.shtml

White Huns

THE ORIGINS OF CIVILIZATION IN CHINA

Although some of the earliest traces in history of human habitation settlements come from Northern China, urban life seems to have developed in China somewhat later than in Mesopotamia or Egypt. The earliest period for which we have secure evidence is that of the *Shang Dynasty* (c. 1600–1100 B.C.) (see map). Under Shang rulers, the Chinese began to work bronze, and many magnifi-

cent bronze sacrificial vessels—in a wide variety of shapes—demonstrate their creators' technical skill and artistic imagination [5.8]. Trade and commerce began to develop and, at the same time, the Chinese devised a system of writing, based—like the Egyptian hieroglyphs—on picture signs representing sounds or ideas.

The Chou Dynasty

Around 1100 B.C., a new dynasty replaced the Shang, known as the *Chou Dynasty* (c. 1100–c. 221 B.C.). The Chou rulers did not provide strong central government, but served as the coordinators of a series of separate kingdoms, each with its own local lord. The relationship of these local rulers with the Chou emperors was often unstable. In times of trouble they could supply the Chou with military aid, but frequently feuded with both the central authority and each other. Over time, Chou influence began to diminish, and the last period of their dynasty is known as the Period of the Warring States (403–221 B.C.). It was during these centuries of increasing crisis that the foundations of Chinese thought and culture were laid.

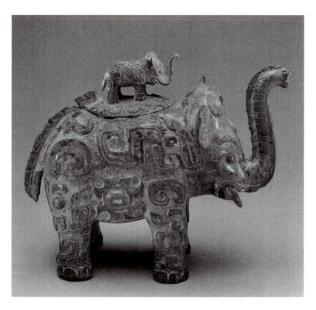

5.8 Ceremonial vessel in the form of an elephant, c. 1200 B.C. Bronze. Smithsonian Institution, Freer Gallery of Art, Washington D.C.

Confucianism and Taoism

The two chief schools of Chinese philosophy were founded by *Confucius* (c. 551–479 B.C.) and Lao-tzu (active c. 570 B.C.). Born in humble circumstances in central China at a time when local wars were raging, Confucius' chief aim was to restore the peace of earlier times by en-

5.9 *Portrait of Confucius*. c. third century B.C. This image of Confucius is stylized rather than realistic.

couraging the wise and virtuous to enter government service. A state run by a wise ruling class, he believed, would produce similar characteristics in its people. To achieve this he traveled throughout China in search of pupils [5.9].

http://www.confucius.org/ebio.htm

Confucius

According to the central dogma of Confucianism, the morally superior person should possess five inner virtues, and acquire another two external ones. The five with which each virtuous person is born are righteousness, inner integrity, love of humanity, altruism, and loyalty. Those with these natural gifts should also acquire culture (education) and a sense of decorum, or ritual. If individuals with these qualities served their rulers in government, they would be loyal and unconcerned with material rewards, yet fearlessly critical of their masters.

Traditional religion played no part in Confucius' teachings. He refused to speculate about the gods, or the possibility of life after death; he is said to have commented "Not yet understanding life, how can we understand death?" Confucius was a revolutionary figure in that he defended the rights of the people and believed that the state existed for the benefit of the people, rather than the reverse. At the same time, however, he strongly endorsed strict authority and discipline, both within the state and the individual family—devotion to parents, worship of ancestors, respect for elders, and loyalty to rulers were all crucial to the Confucian system. In the centuries following his death, many totalitarian regimes in China abused the innate conservatism of Confucius' teaching, using it to justify their assaults on the freedom of individuals.

If the central principle of Confucianism is the possibility of creating a new, virtuous social order, Taoism emphasized the limitations of human perceptions, and encouraged withdrawal and passivity. Its central concept is that of "the Way" (tao). According to this, one should follow one's own nature, not distinguishing between good and bad, but accepting both as part of "the Way." The traditional founder of this school of philosophy, Laotzu, an obscure, even legendary figure, is said to have lived around the time of Confucius. Many modern scholars, however, believe that the book that sets out Laotzu's teachings, The Classic of the Way and Its Power (Tao te ching) was written two or more centuries after the death of Confucius, at some point in the third century B.C.

http://www.easternreligions.com/tframe.html

Taoism

The followers of Taoism often expressed their ideas in obscure and frequently contradictory language. Their overriding concept is perhaps best illustrated by one of the central images of Taoist art: water. As it flows, water gives way to the rocks in its path, yet over time "the soft yield of water cleaves the obstinate stone." Humans should, in the same way, avoid participating in society or culture or seeking actively to change them. Far from sharing Confucius' mission to reform the world, the Taoists preached passivity and resignation. Worst of all was war, for "every victory celebration is a funeral rite."

Both Confucianism and Taoism can be seen as reactions—albeit opposing ones—to the increasingly chaotic struggles of the later Chou period. They were to remain powerful sources of inspiration over the succeeding centuries, and the tension between them played a large part in the evolution of Chinese civilization.

THE UNIFICATION OF CHINA: THE CH'IN, HAN, AND T'ANG DYNASTIES

In the struggle for power in the last years of the Chou period, one state emerged victorious. In 221 B.C., the king of

the state of Ch'in succeeded in conquering all his rivals and ruling them by means of a centralized government, thereby establishing the *Ch'in Dynasty*. He took the name of Shih Huang-ti ("First Emperor") and was remembered by later generations for the brutality of his conquests as much as for the brilliant organizational skill with which he organized his new empire.

He ordered the building of a magnificent capital city, Hsien-yang (near modern Sian), and instructed the leading noble families from the former independent kingdoms to move there, where they would be under his direct control, and thus unable to lead revolts. No private citizen was allowed to possess weapons, and it was left to the imperial army to maintain order. The emperor divided his territory into thirty-six provinces, imposed a single writing system, and unified weights and measures throughout them. In order to check criticism, he ordered the destruction of all philosophical writings, the so-called "Burning of the Books"—including, of course, the works of Confucius—an action that his successors bitterly condemned.

To defend his empire from outside invaders, Shih Huang-ti connected a series of preexisting defensive walls to make the *Great Wall*, some fourteen hundred miles long (about two thousand two hundred km) [5.10]. Peasants and prisoners of war were forced into construction gangs.

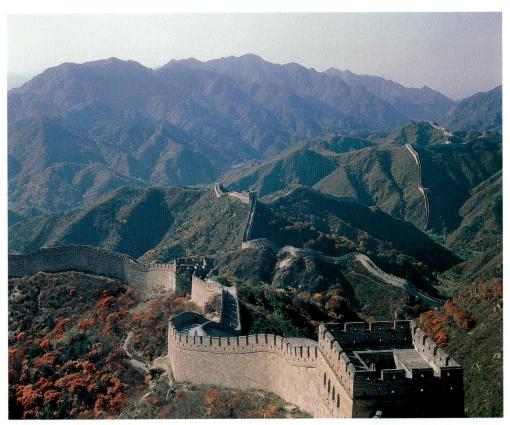

5.10 The Great Wall of China. Height 15–30' (4.3–8.6 m), width 12–20' (3.5–6.2 m). The Wall runs for 1400 miles (approx. 2200 km), and has been repaired and rebuilt many times since its first construction in the late third century B.C.

In the extreme climates of north and south, it was said that each single stone cost the life of one of the workers. The Great Wall has remained continuously visible to this day; indeed, it is one of the few human constructions on earth which can be seen from the moon. The emperor's other great building project, the massive tomb he designed for himself, barely survived his death, and was only rediscovered in 1974. Ever since, archaeologists have been exploring its riches [5.11].

http://www.walkthewall.com/greatwall/

Great Wall

Shih Huang-ti believed that he was creating an empire to last forever, but his ruthless methods ensured that his rule barely survived his death. One contemporary described him as "a monster who had the heart of a tiger and a wolf. He killed men as though he thought he could never finish, he punished men as though he were afraid he would never get round to them all." When Shih Huang-ti died in 210 B.C., the empire plunged into chaos as nobles and peasants alike ran riot.

By 202 B.C., a new dynasty had established itself—the *Han Dynasty*—which was to rule China for the next four centuries. The first Han emperor, Kao-tsu (256–195 B.C.), returned a degree of power to the local rulers, but maintained the Ch'in system of provinces, with governors appointed by the central authority. In order to strengthen the imperial administration, Kao-tsu and his

successors created an elaborate central bureaucracy. To reinforce their authority, the early Han emperors lifted the ban on philosophical works, and encouraged scholars to reconstruct the writings of Confucius and others either from the few surviving texts or from memory. With the emperor's encouragement, many of these reconstructions emphasized the need for loyalty to the emperor and a central bureaucracy, and omitted Confucius' emphasis on constructive criticism by virtuous observers.

By the second century A.D., the central government gradually lost its control over the provinces. The great aristocratic families began to take control, as successive emperors became paralyzed by internal feuding and plotting. In the ensuing civil war, the last Han emperor finally abdicated in A.D. 220, only to plunge China into another extended period of confusion. Finally, in the early seventh century, the *T'ang Dynasty* (A.D. 618–906) managed to reunite China. The political and economic stability they created made possible a period of cultural achievement known as China's "Golden Age."

The Arts in Classical China

With the notable exception of the period of Ch'in rule, literature played an important part in Chinese culture. As early as the Chou period, standard texts, known as the *Five Classics*, circulated widely—Confucius may have been partly responsible for editing them. They included history, political documents such as speeches, and descriptions of ceremonies. The *Classic of Songs* contained

5.11 Excavation of the life-size pottery figures of soldiers and horses found near the tomb of Shih Huang-ti. Sian, China. The tomb dates to the late third century B.C.

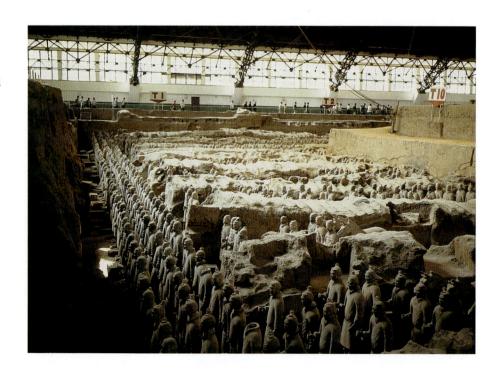

more than three hundred poems dealing with private life (love, the family) and public affairs. Because the Chinese language makes use of pitch and stress (inflections; the meanings of words and/or phrases change according to the way they are pronounced), poetry became especially popular, and any educated Chinese person was expected to memorize and recite Classical verse.

Later generations drew inspiration from these Classical texts, developing their themes and expressing new ideas based on familiar concepts. The introduction of Buddhism into China during the Han Dynasty provided a new subject for philosophical writing; during the years of chaos following the fall of the Han rulers, Buddhist texts provided consolation for the suffering by offering eventual release from pain. The two main strains of Buddhism were Mahayana, the "Great Vehicle"; and Hinayana, the "Lesser Vehicle." The first of these was less ascetic and more worldly than the second, and thus appealed more to those influenced by Confucianism. It also met with more favor in the eyes of the ruling class although, when the Buddhist monasteries began to grow in wealth and influence, the central authorities started to limit the number of monasteries permitted and set limits on the ordination of monks and priests. For this reason, Buddhist writings never acquired the status that religious texts have in the Christian world.

During the T'ang Dynasty a new literary form developed: the short story. Unlike the works inspired by Classical models, these tales often provide a vivid picture of contemporary life. The best known of all Chinese poets, Li Po (A.D. 701–762), lived in the early years of T'ang rule. Appointed court poet in 742, after a couple of years his unruly temperament and wild behavior (many of his poems describe his addiction to wine) drove him to a life of wandering. Inspired by Taoism, Li Po preferred simple

5.12 Perforated pendant in the form of a dragon. Green jade, $5 \times 2^{1}/2^{"}$ (18.5 \times 9 cm). China, Late Chou (Warring States) period (403–221). Musee des Arts Asiatiques-Guimet, Paris.

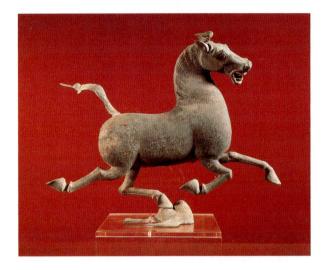

5.13 Prancing Horse, Han Dynasty, second century A.D. Ceramic.

language and ignored the rules of the Classical style. Impressing his contemporaries as much by his charisma and personal appearance as by his writings, he could produce poems of all kinds and lengths, and his unconventional lifestyle provided him with unlimited subject matter. Many of his best-loved poems describe scenes from nature, often involving rivers or waterfalls—images central to Taoist thought.

http://www.columbia.edu/itc/eacp/asiasite/topics/index.html?topic=LiBo+subtopic=Intro

Li Po

The visual arts continued to use traditional styles while introducing new ones. A jade pendant from the end of the Chou Dynasty [5.12] depicting a dragon is reminiscent of the Shang bronzes of centuries earlier, while a bronze horse from a little later shows much greater realism [5.13]. Other works offer a more direct impression of daily life, whether in the form of a pottery tile illustrating hunters and peasants [5.14] or a painting of T'ang ladies playing a board game [5.15]. With the coming of Buddhism, Chinese devotees began to construct shrines and decorate them with monumental carvings. Many of these show the influence of similar relief sculptures in India, particularly in the treatment of drapery [5.16].

In all the art of the Classical period great emphasis went into craftsmanship. From the smallest carved jade or ivory to the huge stone statues, precision and clarity of design were the mark of the supreme artist. One of the effects of this emphasis on beauty of line was that writing itself became an art; examples of fine handwriting—calligraphy—were as prized as a work made of precious material [5.17].

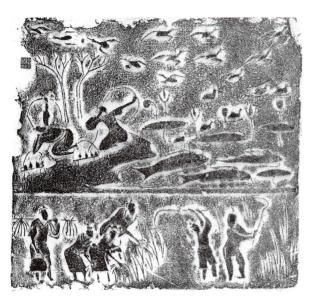

5.14 Scene of Hunting and Threshing, rubbing from a tomb tile from Cha'ang-tu, Szechuan, China. Han Dynasty, second century A.D.

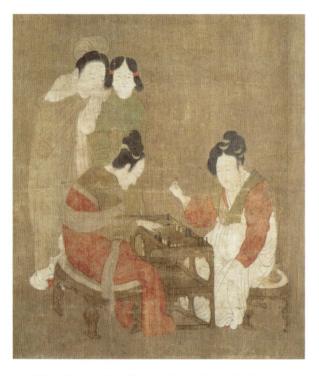

5.15 T'ang Court Ladies Playing a Board Game. Attributed to Chou Fang (c. A.D. 800). Smithsonian Institution, Freer Gallery of Art, Washington, D.C.

SUMMARY

The Indus Valley People The earliest culture to develop in the subcontinent of India appeared in the Indus Valley around 3000 B.C. Its people supported themselves by

farming, growing grain and rice, and cotton. The two main centers were Harappa and Mohenjo-daro, which became large urban settlements with imposing public buildings and elaborate drainage systems. They mass-produced pottery and invented a hieroglyphic script (still undeciphered) which they carved on seal-stones. Around 1700 B.C., their civilization went into decline, in part as the result of the arrival of a new people, the Aryans.

The Aryans The founders of the culture we think of as Indian were the Aryans, a people whose origin is uncertain, and who brought to India two of its most vital aspects: religion—Hinduism, and language—Sanskrit. The Hindu religion, as it developed, acquired a mass of deities and legends, but its basis remained, and remains to this day, the sacred texts of the Vedas, which were first written down around 1000 B.C. Over time, Hinduism evolved into a complex philosophical vision of life, which aims to distinguish between the illusions of everyday life and the ultimate reality. One way to achieve this reality is by yoga, a renunciation of worldly pleasures. Another is by fulfilling the requirements of one's caste, or destiny, and living according to one's duty (karma). Aryan society was divided into castes (social classes) of which the priestly caste was the highest.

Buddha At the end of the sixth century B.C., the figure known to posterity as Buddha inspired a new approach to life that emphasized the more austere aspects of Hinduism. Buddhism claimed that human suffering came from indulgence in superficial pleasures. Whereas Hinduism taught that life consisted of an endless series of deaths and reincarnations, according to the Buddha this cycle could be broken by renouncing all worldly ambitions and satisfactions. In this way it was possible to achieve nirvana, the ultimate freedom and release from the ego. The truth came not from external ritual or ceremony, but as a result of personal internal meditation. Thus, while Hinduism encouraged its followers to enjoy the pleasures of life permitted to them by their caste, Buddhism viewed life pessimistically and emphasized the rejection of the world in favor of spiritual redemption.

King Ashoka The spread of Buddhism owed much to Ashoka, the third-century-B.C. Indian ruler, who abandoned his early military campaigns, supposedly horrified at the human suffering they caused, gave up traditional Hindu beliefs, and converted to Buddhism. Under his rule, Buddhism became the predominant religion in India, although, like Buddha himself, Ashoka encouraged religious tolerance.

Ashoka's reign strengthened the influence of Buddhism in two important ways: He established a standard edition of Buddhist texts—the *Canon*—and encouraged Buddhist missionaries to spread the master's teachings outside India. As a result, Buddhism became widespread throughout southeast Asia, most notably in China.

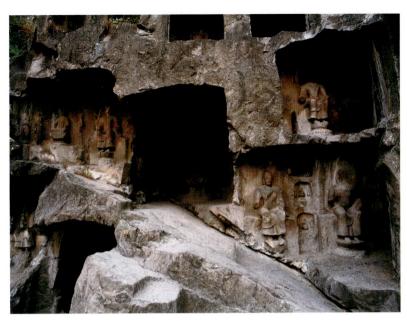

5.16 Lung-men Caves, Loyang, China. The Buddhist rock carvings were begun in the sixth century A.D., and greatly extended around 690, when Loyang became the new T'ang capital.

Hindu and Buddhist Art Most Indian art of the period of Ashoka and his successors was religious in inspiration. Hindu artists depicted their gods, in their various incarnations, as representative of all aspects of life, and Hindu myths often stressed sensual elements: Sexual union served as a symbol of union with the divine. By contrast, Buddhist art aimed to inspire spiritual meditation and a rejection of worldly values.

The Gupta Empire After the collapse of Ashoka's empire, India split into a series of local states, until it became united again in A.D. 320 under the rule of Gupta emperors. Hinduism regained its position as the dominating religion in India, and art, literature, and science flourished. The Gupta court became a center of learning and culture, and commerce developed with China and other parts of southeast Asia. Shortly before A.D. 500, the invasion of the White Huns from Central Asia caused the collapse of Gupta power, however, and India once again fragmented into separate local kingdoms. Only with the arrival of Muslim rule—almost a thousand years later—did India reunite under a central authority.

Early China: The Shang Dynasty The first organized urban society in China came under the rule of the Shang Dynasty (c. 1600–1100 B.C.). Trade and commerce began to develop, a system of writing was invented, and crafts-

men achieved a high standard of workmanship in bronze.

The Chou Dynasty (c. 1100–221 B.C.) The Chou rulers, who replaced the Shang Dynasty around 1100 B.C., served as the coordinators of a series of regional kingdoms rather than as a central governing authority. In a system that somewhat resembles the feudal system of Medieval Europe, the Chou ruler relied on the support and military resources of the nobles who ruled the local kingdoms. Over time this support fluctuated eventually collapsed: the end of Chou rule is known as the "Period of the Warring States" (403–221 B.C.).

Confucianism and Taoism The two schools of philosophy that have influenced Chinese culture for much of the past two thousand five hundred years developed around 500 B.C., toward the end of the Chou Dynasty. Confucianism, an essentially optimistic system of belief, argued that those who were naturally virtuous should, while behaving with loyalty and respect, help to govern their country by maintaining their independence and criticizing their rulers if necessary: The government served its citizens, rather than the reverse. Taoism, by contrast, taught that humans should withdraw from culture and society, devoting themselves to meditation and, like water, adapt themselves to natural forces.

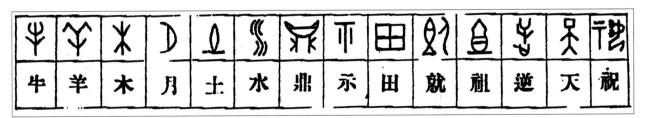

5.17 Rubbing from a stone inscription of the Han Dynasty. The carving of each character separately, rather than continuously, is known as the "Official Style."

The Ch'in, Han, and T'ang Dynasties The disorder of the latter part of Chou rule led finally to the brief Ch'in Dynasty (221–202 B.C.). Shih Huang-ti, the Ch'in leader, forcibly united the warring kingdoms, removed from power the regional noble rulers, and created a centralized state with an imperial army, unified a writing system, and standardized weights and measures. By a policy known as "the Burning of the Books" he eliminated philosophical writings he viewed as dangerous (including Confucian texts). So cruel was his reign that it barely survived his own death in 210 B.C.

The succeeding dynasty, that of the Han emperors (202 B.C.—A.D. 221), sought to establish a compromise between central government and local independence. During the first two centuries of their reign, China prospered, the arts flourished, and the philosophical teachings banned under the Ch'in returned to circulation. As their authority began to wane, however, under challenge by the regional states, China once again fell into chaos. Order was only restored under the T'ang Dynasty (A.D. 618–906), which saw an artistic and cultural revival often known as China's Golden Age.

The Arts in Classical China Under the Han and T'ang dynasties China enjoyed a cultural revival. A standard body of literature, the Five Classics, circulated widely. Among the new subjects to inspire writers, painters, and sculptors was Buddhism, which spread throughout China following its introduction in the first century A.D. The most important poet of the T'ang Dynasty—and one of the best-loved of all China's writers—was Li Po.

Pronunciation Guide

Aryans: AIR-i-ans
Ashoka: A-SHOW-ka
Avatar: AV-a-TAR

Baghavad-Gita: BAG-a-vad-GEE-ta **Bodhisattvas:** BODY-SAT-vas

Chou: Ch-owe
Confucius: Con-FEW-shus
Gautama: GORE-ta-ma
Harappa: Har-AP-a
Hinayana: Hin-a-YA-na
Li Po: LEE POE

Mahabharata: MA-hab-HAR-a-ta Mahayana: MA-ha-YA-na

Mohenjo-daro: Mo-HENJ-owe-DAR-owe

Persepolis: Per-SEP-o-lis
Ramayana: RAM-a-YA-na
Sakuntala: Sak-UN-ta-la
Taoism: TOW-ism
Upanishad: Up-AN-i-shad
Vedas: VAY-das

EXERCISES

- 1. The early civilization of the Indus Valley had many of the marks of a sophisticated culture, including a writing system. This is still, however, undeciphered. If scholars one day decipher it, what new information about the Indus Valley people could they hope to learn? Are there any other ancient cultures whose writing we have but cannot understand?
- 2. What are the chief features of Buddhism? How do they differ from traditional Hindu beliefs, and why did they induce many Indians to convert?
- 3. Both Buddhism and Hinduism have many followers today. What gives these religions their continuing appeal? More particularly, why does Buddhism continue to attract increasing numbers in the United States and other Western countries?
- 4. Indian art and literature was based in large measure on the great epic poems, the *Mahabharata* and the *Ramayana*. What are the characteristics of their heroes? Illustrate them by describing two or three episodes.
- 5. Buddhism never acquired the same importance in China that Hinduism has always had in India. What effect has this had on the history of the two countries, both in ancient times and today?
- 6. What light do Chinese painting and sculpture of the Han and T'ang dynasties cast on daily life in those times?

FURTHER READING

Allchin, Bridget, & Raymond Allchin. (1968). The birth of Indian civilization. Harmondsworth, UK: Penguin. This survey includes material on the Indus Valley people, and the first centuries of Aryan development.

Basham, A. L. (1967). *The wonder that was India*. New York: Sidgwick and Jackson. One of the standard introductions to ancient India, a little dated by more recent discoveries, but still very readable.

Buchanan, K., et al. (1981). *China: The land and people.* New York: Crown. A useful collection of essays on various aspects of Chinese life and culture.

Hook, B. (Ed.). (1982). The Cambridge encyclopedia of China. Cambridge: Cambridge University Press. A massive work, invaluable for its entries on the whole range of Chinese studies.

Humfries, Christmas. (1987). *The wisdom of Buddhism*. Atlantic Heights, NJ: Humanities Press. An excellent reader, which includes Buddhist texts and writings about Buddhism from the earliest times to the present.

Ling, Trevor. (1973). *The Buddha*. New York: Scribner's. A lucid account of Buddhism and the physical, economic and social conditions under which it developed, with a good chapter on "The Ashokan Buddhist State."

Mandelbaum, David G. (1970). Society in India. Berkeley: University of California Press. A two-volume examination of life in India during the Classical period.

O'Flaherty, Wendy D. (1975). *Hindu myths*. Harmondsworth, UK: Penguin. A useful brief guide to a highly complex subject.

Rawson, Jessica. (1980). *Ancient China*. London: British Museum Publications. A handy guide to Chinese art and archaeology, which takes the story from the earliest period to the end of the Han Dynasty.

Sen, K. M. (1961). Hinduism. Harmondsworth, UK: Penguin. One of the best standard introductions to the many aspects of Hinduism, including its role in the modern world.

Wolpert, Stanley. (1989). A new history of India (3rd ed.). New York, Oxford: Oxford University Press. This third edition of the best single-volume book on Indian history begins with an introductory section on "The Ecological Setting," and then takes the story from the Indus Valley period to modern India.

ONLINE CHAPTER LINKS

A virtual tour of Harappa is available at http://www.harappa.com/walk/index.html

This Mohenjo-daro site at

http://www.harappa.com/har/moen0.html

provides a virtual tour, a photo gallery, insights about life at Mohenjo-daro, plus much more.

Information concerning the rise and fall of the Indus civilization is found at

http://www.harappa.com/script/maha15.html

For extensive information about Sanskrit documents, visit

http://sanskrit.gde.to/

where links to many additional related Internet resources—including Sanskrit dictionaries—are available.

Extensive information about Gotama (Buddha), his teachings, and historical places related to him is found at

http://www.vri.dhamma.org/publications/buddha.html

Among the sites providing valuable information related to Buddhism are

http://www.fundamentalbuddhism.com/ http://www.easternreligions.com/bframe.html http://www.internets.com/buddha.htm Hindu Resources Online at

http://www.hindu.org/

http://www.hindunet.org

provide numerous links to a wide variety of information—including art, music, and culture; dharma and philosophy; travel and pilgrimage; and ancient sciences (e.g., yoga).

Links to Hindu art are available at http://www.hindunet.org/hindu_pictures/

For information about *Ramayana*, one of the great epics of India, visit this site

http://www.askasia.org/frclasrm/lessplan/

and click on lesson plan 1000054.htm, where links provide an English translation of the text accompanied by illustrations.

Among the sites providing valuable information related to Confucius are

http://www.confucius.org/main01.htm#e

http://www.easternreligions.com/cframe.html

which offer links to biographies, translations in several languages, and graphics representing several writings in their original characters.

Among the sites providing valuable information related to Taoism are

http://www.easternreligions.com/tframe.html

http://www.taorestore.org/intro.html

http://www.tao.org/

http://www.dmoz.org/Society/

Religion_and_Spirituality/Taoism/

http://www.chebucto.ns.ca/Philosophy/Taichi/ other.html#taoist

Walk along the Great Wall of China at this intriguing site

http://www.walkthewall.com/greatwall/

Read about the construction of the Great Wall at http://www.crystalinks.com/chinawall.html

View radar images of the Great Wall as seen from space at

http://www.discovery.com/stories/history/greatwall/satphoto.html

		GENERAL EVENTS	LITERATURE & PHILOSOPHY		
	3000				
AGE	BEFORE 9	1800 – 1600 Age of the Hebrew Patriarchs: Abraham, Isaac, Jacob			
		1600 Israelite tribes in Egypt			
		1280 Exodus of Israelites from Egypt under leadership of Moses			
E /	1260				
7	IOD OF JUDGES	1260 Israelites begin to penetrate land of Canaan			
40					
PERIOD CTHE JUDG					
B	1040				
	1000	1040–1000 Reign of Saul, first king of Israel			
	AGE OF THE MONARCHY	1000–961 Reign of King David	c. 1000 Formation of the Scriptures in written form		
		961–922 Reign of Solomon; use of iron-tipped plow and iron war chariots; height of ancient Israel's cultural power: achievements form basis of Judaic,	c. 950 Book of Psalms		
		Christian, and Islamic religions	10th-9th cent. Book of Kings		
922			0		
	THE RESIDENCE OF THE PARTY OF THE PARTY.	922 Civil war after death of Solomon; split of Northern Kingdom (Israel) and Southern Kingdom (Judah); classical prophetic period begins	9th 4th cont Old Testament heals		
	AGE OF THE TWO KINGDOMS	Southern Kingdom (Judah); classical prophetic period begins 8th-6th cent. Old Testament books of Isaiah, Jeremiah, and Ezekiel 721 Northern Kingdom destroyed by Assyria			
	OF ING	Northern Kingdom destroyed by Assyria			
	AGE VO K				
	Tw				
RON AGE	587	587 Southern Kingdom defeated; Jews driven into captivity in Babylonia	after 5th cent. Book of Job		
	AGE OF EXILE, RETURN, AND OCCUPATIONS	539 Cyrus the Persian permits Jews to return to Jerusalem	arter 3th cent. book of job		
		516 Dedication of Second Temple in Jerusalem			
		332 Conquest of Jerusalem by Alexander the Great	end of 2nd cent. Apocryphal Book of Judith		
		2nd cent. Cult of Mithra in Rome	Juditi		
R	E OF	2.1.2 Cents Cut of Manual It None			
	AG				
	63	63 Conquest of Jerusalem by Romans under Pompey			
	Q	37 B.C. – A.D. 4 Reign of Herod the Great under Roman tutelage			
В.С	RIO	c. 6 B.C. Birth of Jesus			
A.D	ROMAN PERIOD	c. A.D. 30 Death of Jesus; beginnings of Christianity in Palestine	c. A.D. 70 "Sermon on the		
	MAL	45–49 First missionary journeys of Saint Paul	Mount" in Gospel of Saint Matthew, New Testament		
	Rol	66–70 Jewish rebellions against Romans	c. A.D. 150 Justin Martyr,		
			Apology		

c. 70 Titus destroys Jerusalem and razes the Temple; Jews sent into exile

Dates before the 10th cent. $\ensuremath{\text{B.c.}}$ are approximate and remain controversial

A.D. 324

CHAPTER 6 Jerusalem and Early CHRISTIANITY

ART

ARCHITECTURE

Music

Music often accompanied the Psalms; musical instruments in use: drums, reed instruments, lyre, harp, horns

c. 961 - c. 922 Building of Temple of Solomon; city of Megiddo rebuilt by Solomon

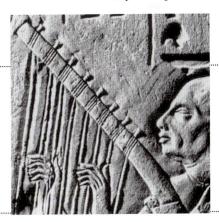

Depiction of divinity in art prohibited in Jewish religion

734 Oxen from bronze "sea" given to King of Assyria by King Achaz

- 587 Solomon's Temple destroyed by Babylonians
- c. 536-515 Second Temple of Solomon constructed

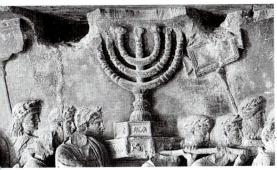

- 19 Herod the Great begins rebuilding Third Temple of Solomon
- A.D. 70 Herod's Temple destroyed by the armies of Titus under Emperor Vespasian
- c.81 Arch of Titus, Rome, commemorates victory of Roman army in Jerusalem
- c. A.D. 230 240 Synagogue and House Church at Dura Europos

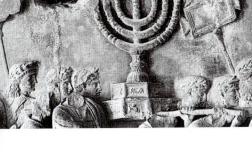

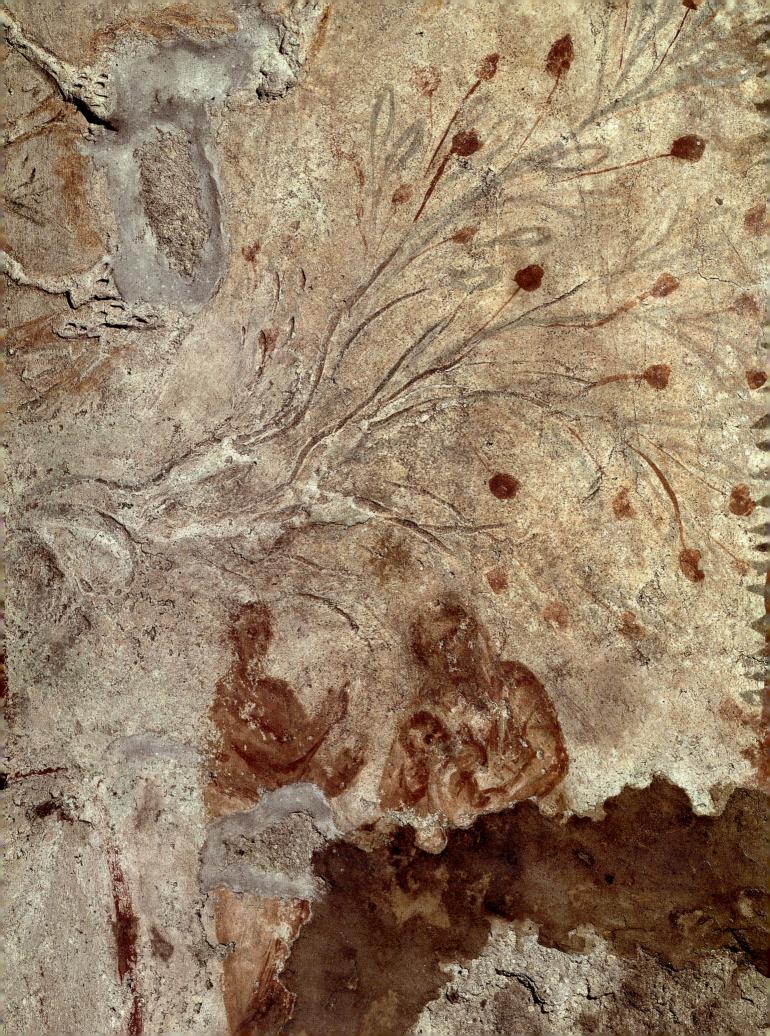

CHAPTER 6

JERUSALEM AND EARLY CHRISTIANITY

Judaism and Early Christianity

ne of the interesting ironies of history is the fact that, more than three thousand years ago in the Middle East, a small tribe-turned-nation became one of the central sources for the development of Western civilization. The fact is incontestable: The marriage of the biblical tradition and Graeco-Roman culture has produced, for better or worse, the West as we know it today.

The irony is all the more telling because these ancient biblical people did not give the world great art, significant music, philosophy, or science. Their language did not have a word for *science*. Their religion discouraged the plastic arts. We have the texts of their hymns, canticles, and psalms, but we can only speculate how they were sung and how they were accompanied instrumentally. What these people did give us was a book; more precisely, a collection of many different books we now call the Bible.

http://www.iclnet.org/pub/resources/ christian-history.html#canon

Early Church Documents

These people called themselves the Children of Israel or Israelites; at a later time they became known as the Jews (from the area around Jerusalem known as Judaea). In the Bible they are called Hebrews (most often by their neighbors), the name now most commonly used to describe these biblical people.

The history of the Hebrew people is long and complex, but the stages of their growth can be outlined as follows:

■ The Period of the Patriarchs. According to the Bible, the Hebrew people had their origin in Abraham, the father (patriarch) of a tribe who took his people from ancient Mesopotamia to the land of Canaan on the east coast of the Mediterranean about 2000 B.C. After settling in this land, divided

into twelve tribal areas, they eventually went to Egypt at the behest of Joseph, who had risen to high office in Egypt after his enslavement there.

- The Period of the Exodus. The Egyptians eventually enslaved the Hebrews (perhaps around 1750 B.C.), but they were led out of Egypt under the leadership of Moses. This "going out" (exodus) is one of the central themes of the Bible; this great event also gives its name to one of the books of the Bible.
- The Period of the Conquest. The biblical books of Joshua and Judges relate the struggles of the Hebrews to conquer the land of Canaan as they fought against the native peoples of that area and the competing "Sea People" (the Philistines) who came down from the north.
- The United Monarchy. The high point of the Hebrew political power came with the consolidation of Canaan and the rise of a monarchy. There were three kings: Saul, David, and Solomon. An ambitious flurry of building during the reign of Solomon (c. 961–922 B.C.) culminated in the construction of the great temple in Jerusalem [6.1].
- Solomon a rift over the succession resulted in the separation of the Northern Kingdom and the Southern Kingdom, the center of which was Jerusalem. Both were vulnerable to pressure from the surrounding great powers. The Northern Kingdom was destroyed by the Assyrians in the eighth century B.C. and its inhabitants (the so-called Lost Tribes of Israel) were swept away by death or exile. In 587 B.C., the Babylonians conquered the Southern Kingdom, destroyed Solomon's temple in Jerusalem, and carried the Hebrew people into an exile known to history as the Babylonian Captivity.
- The Return. The Hebrews returned from exile about 520 B.C. to rebuild their shattered temple and to resume their religious life. Their subsequent history was marked by a series of foreign (Greek, Egyptian, and Syrian) rulers, one brief period of political independence (c. 165 B.C.), and, finally, rule by Rome after the conquest of 63 B.C. In A.D. 70, after a Jewish revolt, the Romans destroyed Jerusalem

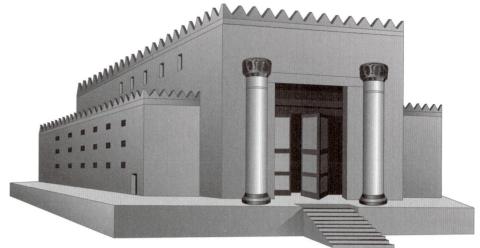

6.1 Reconstruction drawing of Solomon's Temple. The description in the Bible of this destroyed temple was an inspiration for sacred architecture well into the Middle Ages. The two bronze columns in front may have represented the columns of fire and smoke that guided the Israelites while they were in the desert.

and razed the rebuilt temple [6.2]. One small band of Jewish rebels that held off the Romans for two years at a mountain fortress called Masada was defeated in A.D. 73. Except for pockets of Jews who lived there over the centuries, not until 1948, when the state of Israel was established, would Jews hold political power in their ancestral home.

http://www.pbs.org/wgbh/pages/frontline/shows/religion/portrait/Masada.html

Masada

The Hebrew Bible and Its Message

The English word *bible* comes from the Greek name for the ancient city of Byblos, from which the papyrus reed used to make books was exported. As already noted, the Bible is a collection of books that took its present shape over a long period of time.

The ancient Hebrews divided the books of their Bible into three large groupings: the Law, the Prophets, and the Writings. The Law referred specifically to the first five books of the Bible, called the *Torah* (from the Hebrew word for "instruction" or "teaching"). The Prophets con-

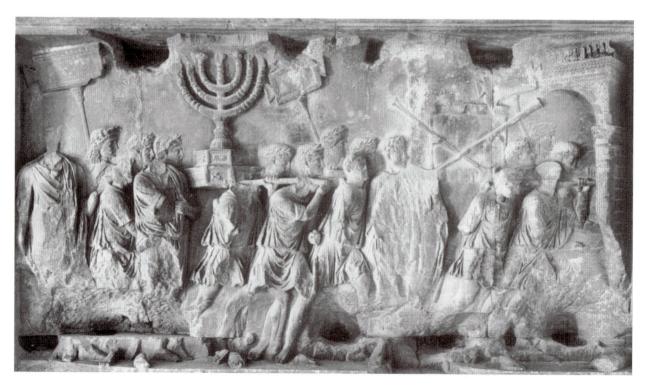

6.2 The Spoils of Jerusalem, from the Arch of Titus, Rome, c. A.D. 81, passageway relief. The seven-branched candelabrum (a menorah) is carried as part of the booty after the Romans sacked the city of Jerusalem.

sists of writings attributed to the great moral teachers of the Hebrews who were called prophets because they spoke with the authority of God (*prophet* derives from a Greek word for "one who speaks for another"). The Writings contain the wisdom literature of the Bible, prose or poetry (like the Book of Psalms) or a mixture of the two, as in the Book of Job.

The list of books contained in the modern Bible was not established until A.D. 90, when an assembly of rabbis drew up such a list or *canon* even though its main outline had been known for centuries. The Christians in turn accepted this canon and added the twenty-seven books that make up what we know as the Christian Scriptures of the New Testament. (Roman Catholics and Orthodox Christians also accept as canonical some books of the Old Testament that are not in the Hebrew canon but are found in an ancient Greek version of the Hebrew Scriptures known as the *Septuagint*, a version of the Bible widely used in the ancient world.)

http://www.newadvent.org/cathen/13722a.htm

Septuagint

One fundamental issue about the Bible must be emphasized: Both ancient Israel, subsequent Jewish history, and the Christian world have made the Bible *the* central document not only for worship and the rule of faith but also as moral guide and anchor for ethical and religious stability. The Bible, directly and indirectly, has shaped our law, literature, language, ethics, and social outlook. It permeates our culture. To cite one single example: At Solomon's temple the people sang hymns of praise (psalms) to God just as they are sung in Jewish synagogues today. Those same psalms were sung by Jesus and his followers in their time just as they are sung and recited in Christian churches in every part of the world. That ancient formulation is, in a deep sense, part of our common religious culture.

The Bible is not a philosophical treatise; it is a sacred book. It is, nonetheless, a book that contains ideas; those ideas have had an enormous impact on the way we think and the way we look at the world. Some of the basic motifs of the Bible have been so influential in our culture that they should be considered in some detail. We will examine three such motifs that run like strands throughout the Hebrew Scriptures.

1. Biblical monotheism. A central conviction of biblical religion is that there is one God, that this God is good, and (most crucially) that this God is involved in the arena of human history. This God is conceived of as a person and not as some impersonal force in the world of nature. Monotheism (the belief in one god) can thus be distinguished both from henotheism (the belief that there may be other gods, although only one is singled

out for worship) and *polytheism* (the belief that there are many gods).

The opening pages of the Bible set out a creation story (see Genesis 1:1-2:4a) that, properly understood, provides us with a rather complete vision of what the Bible believes about God. The creation story of Genesis makes three basic assertions about God. First, God exists before the world and called it into existence by the simple act of utterance. God, unlike the gods and goddesses of the Hebrews' ancient neighbors, is not born out of the chaos that existed before the world. God is not to be confused with the world, neither did God have to struggle with the forces of chaos to create. Second, God pronounces each part of creation and creation as a whole as "good." Thus, the Book of Genesis does not present the material universe as evil or, as certain Eastern religions teach, an illusory world that conceals the true nature of reality. Finally, God creates human beings as the apex and crown of creation. The material world is a gift from God and human beings are obliged to care for it and be grateful for it. A basic motif of biblical prayer is gratitude to God for the gift of creation.

Biblical monotheism must not be thought of as a theory that simply sees God as the starting point or originator of all things after the fashion of a craftsperson who makes a chair and then forgets about it. The precise character of biblical monotheism is its conviction that God creates and sustains the world in general and chose a particular people to be both vehicle and sign of divine presence in the world. The precise character of that relationship can be found in the biblical notion of covenant.

Covenant is the crucial concept for setting out the relationship between God and the Hebrew people. The covenant can be summed up in the simple biblical phrase "I will be your God; you will be my people." In Hebrew history, the Bible insists, God has always been faithful to that covenant which was made with the people of Israel while the people must learn and relearn how to be faithful to it. Scholars have pointed out that the biblical covenant may be based on the language of ancient marriage covenants (e.g., "I will be your husband; you will be my wife"); if that is true, it gives us an even deeper understanding of the term: The relationship of God and Israel is as close as the relationship of husband and wife.

This strong portrait of a single, deeply involved God who is beyond image or portrayal has had a profound impact on the shape of the Judeo-Christian worldview. The notion of covenant religion not only gave form to Hebrew religion; the idea of a renewed covenant became the central claim of Christianity. (Remember that another word for covenant is *testament*; hence the popular Old/New Testament split Christianity insists upon.) The idea has even spilled over from synagogues and churches into our national civil religion, where we affirm

VALUES

Revelation

One deep theme that runs through the Bible is the concept of revelation. *Revelation* means a disclosure or "making plain" (literally: "pulling back the veils"). The Bible has the strong conviction that God reveals Himself in the act of creation but, more important, through the process of human history. The Old Testament makes clear the Hebrew conviction that God actually chose a people, exercised His care for them (providence), prompted prophets to speak, and inspired persons to write. Christians accepted this divine intervention and expanded it with the conviction that God's final revelation to humanity came in the person of Jesus of Nazareth.

A number of consequences derive from the doctrine of revelation. First is the idea that God gives shape to

history and that it is through history that God is most deeply revealed. Second, biblical religion conceived of God not as a distant figure separated from people but One who guided, encouraged, and finally shaped the destiny of a particular people (the Jews) and eventually the whole human race. The concept of revelation is intimately connected to the idea of *covenant*, which we discuss in the text.

It should be also noted that Islam, in continuity with biblical religion, also focuses on the idea of revelation. Islam teaches respect for the Hebrew patriarchs, prophets, and the person of Jesus but insists that Muhammed receives the final unveiling of God's purposes for the human race.

- a belief in "One nation under God" and "In God we trust"—both sentiments rooted in the idea of a covenant.
- 2. Ethics. The Bible is not primarily an ethical treatise; it is a theological one even though it does set out a moral code of behavior both for individuals and society. The Bible has a large number of rules for worship and ritual but its fundamental ethical worldview lies in the idea that humans are created in "the image and likeness of God" (Genesis 1:26). The more detailed formulation of that link between God and individual and social relationships is contained in the Ten Commandments, which the Bible depicts as being given by God to Moses after the latter brings the people out of the bondage of Egypt and before they reach the Promised Land (see Exodus 20). These commandments, consisting of both prohibitions (against murder, theft, idolatry, etc.) and positive commands (for worship, honoring of parents, etc.), are part of the larger ethical commands of all civilizations. The peculiarly monotheistic parts of the code appear in the first cluster, with the positive command to worship God alone and the prohibition of graven images and their worship.

Ancient Israel's ethics take on a more specific character in the writings of the prophets. The prophet (Hebrew nabi) speaks with God's authority. In Hebrew religion the prophet was not primarily concerned with the future (prophet and seer are thus not the same thing) even though the prophets do speak of a coming of peace and justice in the age of the Messiah (the Hebrew word meaning "anointed one"). The main prophetic task was to call people back to the observance of the covenant and to warn them about the ways in which they failed that covenant. The great eighth-century prophets who flour-

ished in both the north and the south after the period of the monarchy left a great literature. They insisted that worship of God, for example, in the worship of the temple, was insufficient if that worship did not come from the heart and include love and compassion for others. The prophets were radical critics of social injustice and defenders of the poor. They linked worship with a deep concern for ethics. They envisioned God as a God of all people and insisted on the connection between worship of God and righteous living.

http://www.newadvent.org/cathen/10212c.htm

Messiah

Prophets were not a hereditary caste in ancient Israel, as were the priests. Prophets were "called" to preach. In many instances they even resisted that call and expressed reluctance to undertake the prophetic task. The fact that they had an unpopular message explains both why many of them suffered a violent end and why some were reluctant to undertake the task of preaching.

The prophetic element in religion was one of Israel's most enduring contributions to the religious sensibility of the world. The idea that certain people are called directly by God to preach peace and justice in the context of religious faith would continue beyond the biblical period in Judaism and Christianity. It is not accidental, to cite one modern example, that the great civil rights leader Martin Luther King, Jr. (1929–1968), often cited the biblical prophets as exemplars for his own struggle in behalf of African Americans. That King died a violent death in 1968 is an all-too-ready example of how disquieting the prophetic message can be.

3. Models and types. Until modern times relatively few Jews or Christians actually read the Bible on an individual basis. Literacy was rare, books expensive, and leisure at a premium. Bibles were read to people most frequently in public gatherings of worship in synagogues or churches. The one time that the New Testament reports Jesus as reading is from a copy of the prophet Isaiah kept in a synagogue (Luke 4:16ff.). The biblical stories were read over the centuries in a familial setting (as at the Jewish Passover) or in formal worship on the Sabbath. The basic point, however, is that for more than three thousand years the stories and (equally important) the persons in these stories have been etched in the Western imagination. The faith of Abraham, the guidance of Moses, the wisdom of Solomon, the sufferings of Job, and the fidelity of Ruth have become proverbial in our culture.

These events and stories from the Bible are models of instruction and illumination; they have taken on a meaning far beyond their original significance. The events described in the Book of Exodus, for example, are often invoked to justify a desire for freedom from oppression and slavery. It is not accidental that Benjamin Franklin suggested depicting the crossing of the Reed Sea (not the Red Sea as is often said) by the Children of Israel as the centerpiece of the Great Seal of the United States. Long before Franklin's day, the Pilgrims saw themselves as the new Children of Israel who had fled the oppression of Europe (read: Egypt) to find freedom in the land "flowing with milk and honey" that was America. At a later period in history, slaves in this country saw themselves as the oppressed Israelites in bondage. The desire of African Americans for freedom was couched in the language of the Bible as they sang "Go down, Moses. . . . Tell old Pharaoh: Let my people go!"

No humanities student can ignore the impact of the biblical tradition on our common culture. Our literature echoes it; our art is saturated in it; our social institutions are shaped by it. Writers in the Middle Ages said that all knowledge came from God in the form of two great books: the book of nature and the book called the Bible. We have enlarged that understanding today but, nonetheless, have absorbed much of the Hebrew Scriptures into the very texture of our culture.

The Beginnings of Christianity

The fundamental fact with which to study the life of Jesus is to remember that he was a Jew, born during the reign of Roman Emperor Augustus in the Romanoccupied land of Judaea. What we know about Him, apart from a few glancing references in pagan and Jewish literature, comes from the four Gospels (*gospel* derives from the Anglo-Saxon word meaning "good news") attributed to Matthew, Mark, Luke, and John. These Gospels began to appear more than a generation after the

death of Jesus, which probably occurred in A.D. 30. The Gospels are religious documents, not biographies, but they contain historical data about Jesus as well as theological reflections about the meaning of His life and the significance of His deeds.

http://www.newadvent.org/cathen/06655b.htm

The Gospels

Jesus must also be understood in the light of the Jewish prophetical tradition discussed above. He preached the coming of God's kingdom, which would be a reign of justice and mercy. Israel's enemies would be overcome. Until that kingdom arrived, Jesus insisted on a life of repentance; an abandonment of earthly concerns; love of God and neighbor; compassion for the poor, downcast, and marginalized; and set forth His own life as an example. His identification with the poor and powerless antagonized his enemies—who included the leaders of His own religion and the governing authorities of the ruling Romans. Perhaps the most characteristic expression of the teachings of Jesus is to be found in His parables and in the moral code He expressed in what is variously called the Beatitudes or the Sermon on the Mount.

All of the teachings of Jesus reflect a profound grasp of the piety and wisdom of the Jewish traditions, but the Gospels make a further claim for Jesus, depicting Him as the *Christ* (a Greek translation of the Hebrew *Messiah*, "anointed one")—the Savior promised by the ancient biblical prophets who would bring about God's kingdom. His tragic death by crucifixion (a punishment so degrading that it could not be inflicted on Roman citizens) would seem to have ended the public career of Jesus. The early Christian church, however, insisted that Jesus overcame death by rising from the tomb three days after His death. This belief in the resurrection became a centerpiece of Christian faith and preaching and the basis upon which early Christianity proclaimed Jesus as the Christ.

Christianity Spreads

The slow growth of the Christian movement was given an early boost by the conversion of a Jewish zealot, Saul of Tarsus, around the year A.D. 35 near Damascus, Syria. Paul (his postconversion name) won a crucial battle in the early Christian church, insisting that non-Jewish converts to the movement would not have to adhere to all Jewish religious customs, especially male circumcision. Paul's victory was to change Christianity from a religious movement within Judaism to a religious tradition that could embrace the non-Jewish world of the Roman Empire. One dramatic example of Paul's approach to this pagan world was a public sermon he gave in the city of Athens in which he used the language of Greek culture to speak to the Athenians with the message of the Christian movement (see Acts 17:16–34).

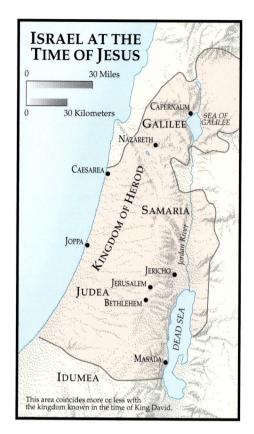

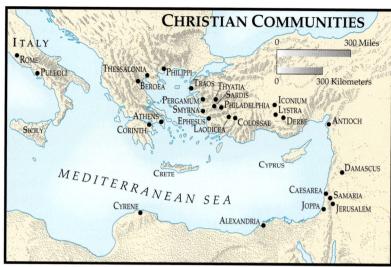

Paul was a tireless missionary. He made at least three long journeys through the cities on the northern shore of the Mediterranean (and may once have gotten as far as Spain). On his final journey he reached Rome itself, where he met his death at the hands of a Roman executioner around the year A.D. 62. In many of the cities he visited he left small communities of believers. Some of his letters (to the Romans, Galatians, Corinthians, and so on) are addressed to believers in these places and pro-

By the end of the first century, communities of Christian believers existed in most of the cities of the vast Roman Empire. Their numbers were sufficient enough that, by A.D. 64, Emperor Nero could make Christians scapegoats for a fire that destroyed the city of Rome (probably set by the emperor's own agents). The Roman writer Tacitus provides a vivid description of the terrible tortures meted out against the Christians:

vide details of his theological and pastoral concerns.

Nero charged, and viciously punished, people called Christians who were despised on account of their wicked practices. The founder of the sect, Christus, was executed by the procurator Pontius Pilate during the reign of Tiberius. The evil superstition was suppressed for a time but soon broke out afresh not only in Judea where it started but also in Rome where every filthy outrage arrives and prospers. First, those who confessed were seized and then, on their witness, a huge number was convicted, less for arson than for their hatred of the human race.

 TABLE 6.1 Books of the Old and New Testaments

Old	New
Genesis	The Gospels:
Exodus	Matthew
Leviticus	Mark
Numbers	Luke
Deuteronomy	John
Joshua	The Acts of the Apostles
Judges	The Letters of Paul:
Ruth	Romans
I and II Samuel	I Corinthians
I and II Kings	II Corinthians
I and II Chronicles	Galatians
Ezra	Ephesians
Nehemiah	Philippians
Esther	Colossians
Job	I Thessalonians
Psalms	II Thessalonians
Proverbs	I Timothy
Ecclesiastes	II Timothy
Song of Solomon	Titus
Isaiah	Philemon
Jeremiah	Hebrews
Lamentations	<i>The Letters of:</i>
Ezekiel	James
Daniel	I Peter
Hosea	II Peter
Joel	I John
Amos	II John
Obadiah	III John
Jonah	Jude
Micah	The Book of Revelation
Nahum	(also called <i>The Apocalypse</i>)
Habakkuk	
Zephaniah	

Haggai

Zechariah

Malachi

CONTEMPORARY VOICES

Vibia Perpetua

Another day, while we were dining at noonday, we were summoned away to a hearing at the forum. At once, rumors swept the neighborhoods and a huge crowd assembled. We mounted the tribune. The others, when questioned, confessed. Then it was my turn. My father arrived with my infant son and pulled me down saying, "Sacrifice! Have mercy on your child!" The governor Hilarianus, who held judicial power in place of the proconsul Minucius Timianus, chimed in: "Pity your father's old age! Have mercy on your infant child! Perform the imperial rituals for the well-being of the emperor." And I answered, "I will not perform it." Hilarianus: "You are a Christian?" And I answered, "I am a Christian." And as my father still stood by trying to change my mind, Hilarianus ordered him expelled from his sight; he was struck with a rod. I wept for my father's misfortune as if I had been hit myself; I grieved for his old age.

Then the governor read out the sentence: condemned to the beasts of the arena.

Cheerfully, we returned to prison.

Since my child was an infant and accustomed to breastfeeding in prison, I sent the deacon Pomponius to my father imploring that my child be returned to me. But my father refused to give the child up. Somehow, through the will of God, the child no longer required the breast nor did my breasts become sore. I was neither tortured with grief over the child nor with pain in my breasts.

Excerpt from the narrative of Vibia Perpetua, who was martyred in Carthage in A.D. 203, when she was twenty-two years old. The last line of her narrative, written the day before her death, says simply, "If anyone wishes to write of my outcome, let him do so."

In their death they were mocked. Some were sewn in animal skins and worried to death by dogs; others were crucified or burned so that, when daylight was over, they could serve as torches in the evening. Nero provided his own gardens for this show and made it into a circus. He mingled with the crowd dressed as a charioteer or posed in his chariot. As a result, the sufferers guilty and worthy of punishment although they were, did arouse the pity of the mob who saw their suffering resulted from the viciousness of one man and not because of some need for the common good.

[Annals XV]

Two questions arise at this point: Why were the Christians successful in spreading their religion? Why did they become the object of persecution at the hands of the Romans?

http://www.catacombe.roma.it/persecuzioni.html

Persecution of the Christians

A number of social factors aided the growth of Christianity: There was peace in the Roman Empire; a good system of safe roads made travel easy; there was a common language in the empire (a form of common Greek called *koine*: the language of the New Testament); and Christianity was first preached in a network of Jewish centers. Scholars have also offered some religious reasons: the growing interest of pagans in monotheism; the strong Christian emphasis on salvation and freedom from sin; the Christian custom of offering mutual aid and

charity for its members; and its relative freedom from class distinctions. Paul wrote that in this faith there was "neither Jew nor Gentile; male nor female; slave nor free person."

This new religion met a good deal of resistance. The first martyrs died before the movement spread outside Jerusalem because of the resistance of the Jewish establishment. Very quickly, too, the Christians earned the enmity of the Romans. Even before Nero's persecution in A.D. 64, the Christians had been expelled from the city of Rome by Emperor Claudius. From those early days until the third century there were sporadic outbreaks of persecutions. In A.D. 250, under Emperor Decius, there was an empire-wide persecution, with two others coming in 257 (under Emperor Valerian) and under Emperor Diocletian in 303. Finally, in A.D. 312, Emperor Constantine issued a decree in Milan allowing Christianity toleration as a religion.

What was the basis for this long history of persecution?

The reasons are complex. Ordinarily, Rome had little interest in the religious beliefs of its subjects so long as these beliefs did not threaten public order. The Christian communities seemed secretive; they had their own network of communication in the empire; they kept away from active life in the political realm; most telling of all, they refused to pay homage to the state gods and goddesses. A common charge made against them was that they were atheists: They denied the existence of the Roman gods. Romans conceived of their society as bound together in a seamless web of *pietás*, a virtue that

meant a combination of love and reverential fear. The Romans felt that one should express *pietás* to the parents of a family, the family should express that *pietás* toward the state, and the state in turn owed *pietás* to the gods. That brought everything into harmony, and the state would flourish. The Christian refusal to express *pietás* to the gods seemed to the Romans to strike at the heart of civic order. The Christians, in short, were traitors to the state.

Christian writers of the second century tried to answer these charges by insisting that the Christians wished to be good citizens and, in fact, could be. These writers (called *apologists*) wrote about the moral code of Christianity, about their beliefs and the reasons they could not worship the Roman deities. Their radical monotheism, inherited from Judaism, forbade such worship. Furthermore, they protested their roles as ready scapegoats for every ill—real and imagined—in society. The acid-tongued North African Christian writer Tertullian (c. 160–225) provided a sharp statement concerning the Christian grievance about such treatment: "If the Tiber floods its banks or the Nile doesn't flood; if the heavens stand still or the earth shakes, if there is hunger or drought, quickly the cry goes up, 'Christians to the lions!'"

One of the most important of the early Christian apologists was Justin Martyr. Born around A.D. 100 in Palestine, he converted to Christianity and taught, first, at Ephesus, and later in Rome. While in Rome he wrote two lengthy apologies to the emperors asking for toleration and attempting, at the same time, to explain the Christian religion. These early writings are extremely important since they provide a window on early Christian life and Christian attitudes toward both Roman and Jewish culture. Justin's writings did not, however, receive the audience for which he had hoped. In A.D. 165 he was scourged and beheaded in Rome under the anti-Christian laws.

http://www.newadvent.org/cathen/08580c.htm

Justin Martyr biography

Early Christian Art

Little significant Christian art or architecture dates from before the fourth century because of the illegal status of the Christian church and the clandestine life it was forced to lead. We do have art from the cemeteries of Rome and some other cities that were maintained by the Christian communities. These cemeteries (known as catacombs from the name of one of them, the coemeterium ad catacumbas) were the burial places of thousands of Christians. Contrary to romantic notions, these underground galleries, hewn from the soft rock known as tufa, were never hiding places for Christians during the times of

persecution, neither were they secret places for worship. Such ideas derive not from fact but from nineteenth-century novels. Similarly, only a minuscule number of the tombs contained the bodies of martyrs; none do today, since the martyrs were reburied inside the walls of the city of Rome in the early Middle Ages.

These underground cemeteries are important, however, because they provide us some visual evidence about early Christian beliefs and customs. This artistic material falls into the following categories.

Frescoes (Wall Paintings Done on Wet Plaster)

Frescoes are found frequently in the catacombs. Most depict biblical subjects that reflect the Christian hope of salvation and eternal life. Thus, for example, common themes like the story of Jonah or the raising of Lazarus from the dead allude to the Christian belief that everyone would be raised at the end of time. Another common motif is the communion meal of Jesus at the Last Supper as an anticipation of the heavenly banquet that awaited all believers in the next life [6.3]. These frescoes herald the beginnings of artistic themes that would continue down through the centuries. In the catacombs of Priscilla in Rome, for example, we find the first known depiction of the Virgin and Child, a subject that would in time become commonplace [6.4].

Glass and Sculpture

Although sculpture is quite rare before the fourth century, a statue of Christ as Good Shepherd [6.5], unbearded and with clearly classical borrowings, may be dated from this period. The figure repeats a common theme in the catacomb fresco art of the period. More common are the glass disks with gold paper cutouts pressed in them that are found in both Jewish and Christian catacombs as a decorative motif on individual tomb slots. After the period of Constantine, carved sarcophagi also became both common and elaborate [6.6, 6.7].

Inscriptions

Each tomb was covered by a slab of marble that was cemented in place. On those slabs would be carved the name and death date of the buried person. Quite frequently, there was also a decorative symbol such as an anchor (for hope) or a dove with an olive branch (peace). One of the most common symbols was a fish. The Greek letters that spell out the word *fish* were considered an anagram for the phrase "Jesus Christ, Son of God and Savior" so that the fish symbol became a shorthand way of making that brief confession of faith [6.8].

http://www.newadvent.org/cathen/06083a.htm

Symbolism of the Fish (Ichthys)

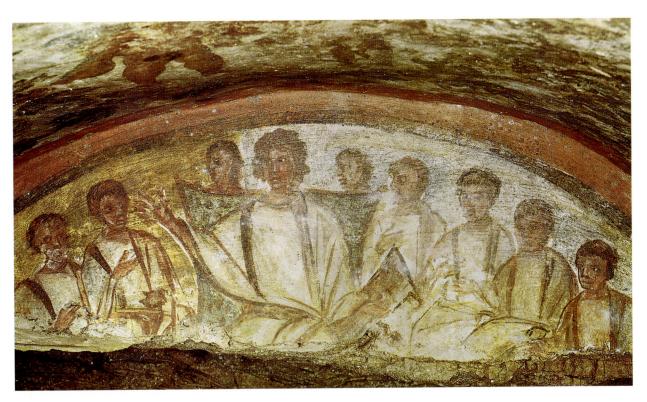

6.3 Christ Teaching the Apostles, Catacomb of Domitilla, Rome, c. A.D. 300. Wall painting. $1'3'' \times 4'3''$ (.38 \times 1.3 m). The beardless Christ and the use of the Roman toga are characteristic. Partially destroyed; the original setting was meant to depict a eucharistic banquet.

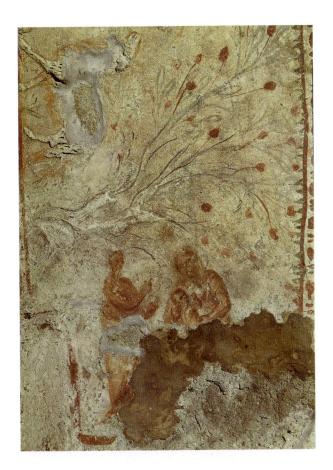

6.4 *Virgin and Child,* Cemetery of Priscilla, c. A.D. 250. Wall painting. The figure to the left has been identified as a prophetic figure, perhaps the prophet Isaiah.

Dura-Europos

Despite the persecutions of the Christians and the hostility of the Romans to the Jews, the religions managed to coexist and, to a certain extent, to thrive in the Roman Empire. One small indication of this fact can be seen in the spectacular archaeological finds made in the 1930s at a small town in present-day Syria called Dura-Europos. This small Roman garrison town, destroyed by Persian armies in A.D. 256, was covered by desert sands for nearly seventeen hundred years. The scholars who excavated it found a street that ran roughly north and south along the city wall (they called it Wall Street) and contained a Christian house church with some intact frescoes, a temple to a Semitic god called Aphlad, a temple to the god Zeus (Roman Jupiter), a meeting place for the worshipers of the cult of Mithra, and a Jewish synagogue with more than twenty well-preserved fresco paintings of scenes from the Hebrew Scriptures [6.9].

The Dura-Europos discoveries revealed both the mingling of many religious cultures and demonstrated that the usual Jewish resistance to the visual arts was not total. Further, the evidence of a building for Christian worship

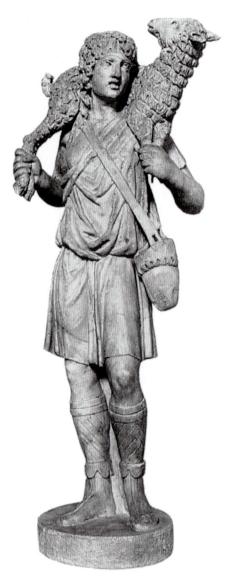

6.5 Good Shepherd, c. A.D. 300. Marble. Height 39" (99 cm). Vatican Museums, Rome. This depiction of Christ is very common in early Christian art, although sculptural examples are rather rare.

(part of a papyrus of the four Gospels harmonized into one whole was found at the site) in place sixty years before Constantine's Edict of Toleration and in use during a time when there were empire-wide persecutions of Christians is a significant discovery. Scholars see in the art of Dura-Europos the mingling of both Eastern and Roman styles that might be the source for the art that would emerge more fully in the Byzantine world. Most significantly, the finds at Dura-Europos demonstrate how complex the religious situation of the time really was and how the neat generalizations of historians do not always correspond to the complicated realities of actual life.

Constantine and Early Christian Architecture

Two of the most famous churches in Christendom are associated with the reign of Emperor Constantine (A.D. 306-337). The present Saint Peter's Basilica in the Vatican rests on the remains of a basilica built by Constantine and dedicated in A.D. 326. We do not have a fully articulated plan of that church, but its main outlines are clear. The faithful would enter into a courtyard called an atrium around which was a colonnaded arcade and from there through a vestibule into the church proper. The basilica, modeled after secular counterparts in Rome, featured a long central nave with two parallel side aisles. The nave was intersected at one end by a transept, the roof of which was pitched with wooden trusses and supported by the outer walls and the columned interiors. High up on the walls above the arches and below the roof was the so-called clerestory (windows that provided most of the interior illumination). This basilica-type church [6.10, 6.11] became a model from which many of the features of later church architecture evolved.

6.6 *Jonah Sarcophagus*, fourth century. Museo Pio Cristiano, the Vatican, Rome. Limestone. Besides the Jonah cycle there are other biblical scenes: at the top left, the raising of Lazarus; to the right of the sail at top, Moses striking the rock; at the far top right, a shepherd with a sheep.

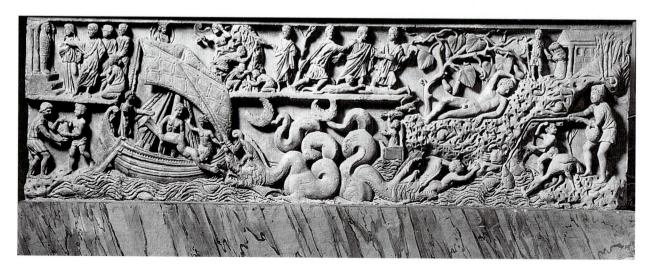

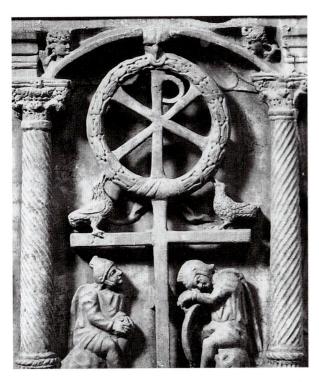

6.7 *Chi-Rho Monogram,* ninth century A.D. Detail of the sarcophagus of Saint Theodorus. Ravenna. The Vatican Museum, Rome. The first letters of Christ's name in Greek are in the center of the Roman military standard. The figure represents the Risen Christ; note the sleeping guards at the tomb under the arm of the cross.

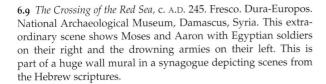

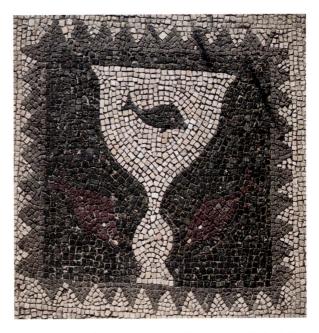

6.8 Fish and Chalice, third century. Floor mosaic. Ostia Antica (Rome). This mosaic and other evidence led scholars to believe that a house excavated in the Roman port city of Ostia was a house church with a baptistery. The fish was a common symbol of Christ. This is one of the earliest uses of the symbol.

http://www.greatbuildings.com/buildings/ St Peters of Rome.html

Old St. Peter's Basilica

The other famous church built in the Constantinian period is the Church of the Holy Sepulchre in Jerusalem [6.12]. This church was also built in the basilica style, its atrium in front of the basilica hall, but with a significant

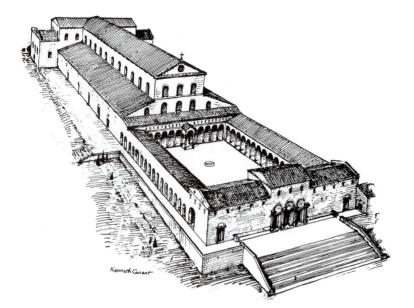

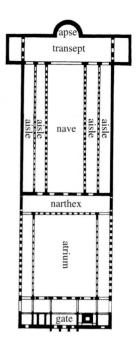

6.10 Old Saint Peter's Basilica, Rome, c. A.D. 333. Length of grand axis 835' (254.5 m), width of transept 295' (86.87 m). Reconstruction study by Kenneth J. Conant. Note the open atrium area and the basilica-style church behind it. The church was demolished in the sixteenth century when the new basilica was constructed.

6.11 Floorplan of Old Saint Peter's Basilica.

addition: Behind the basilica was a domed structure that covered—it was believed—the rocky place where the body of Christ had been buried for three days. The domelike structure was utilized in Christian architecture as an adaptation of existing domed structures in pagan Rome, most notably the Pantheon and some of the vast baths.

http://christusrex.org/www1/ofm/TSspmain.html

Church of the Holy Sepulchre

Early Christian Music

If the visual arts of early Christianity turned to Graeco-Roman models for inspiration, the music of the early church drew on Jewish sources. The tradition of singing (or, rather, chanting) sacred texts at religious services

was an ancient Jewish custom that appears to go back to Mesopotamian sources. What little we know of Jewish music, in fact, suggests that it was influenced strongly by the various peoples with whom the Jews came into contact. The lyre used by Jewish musicians was a common Mesopotamian instrument, whereas the harp for which King David was famous came to the Jews from Assyria by way of Egypt [6.13].

By early Christian times Jewish religious services consisted of a standardized series of prayers and scriptural readings organized in a fashion such as to create a cycle that fit the Jewish calendar. Many of these readings were taken over by early Christian congregations, particularly those where the number of converted Jews was high. In chanting the Psalms, the style of execution often depended on how well they were known by the congregation. Where the Jewish component of the congregation was strong the congregation would join in the chant.

6.12 Church of the Holy Sepulchre, Jerusalem, as it appeared c. A.D. 345. Reconstruction by Kenneth J. Conant. In this drawing, both the domed area, which covered the burial place of Christ, and the detached basilica in front of it can be seen. In the present church there is no separation between the domed area and the basilica.

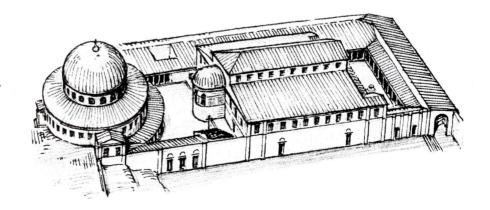

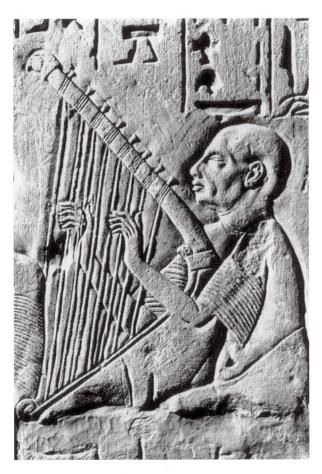

6.13 The Blind Harper of Leiden, detail from the tomb of Paatenemmheb, Saqqara, c. 1340–1330 B.C. Limestone basalt relief, height 11 1/2" (29 cm). Rijksmuseum van Oudheden, Leiden, Netherlands. It is quite possible that the lyre depicted here is similar to those mentioned in the book of Psalms.

Increasingly, however, the singing was left to trained choruses with the other congregants joining in only for the standard response of "Amen" or "Alleluia." As the music fell more into the hands of professionals, it became increasingly complex.

This professionalization proved unpopular with church authorities who feared that the choirs were concerned more with performance than with worship. In A.D. 361, a provincial council of the Christian church in Laodicea ordered that there should be only one paid performer (*cantor*) for each congregation. In Rome, the authorities discouraged poetic elaboration on the liturgical texts, a practice common among the Jews and the Christians of the East.

Part of the early Christian suspicion of music, in the West at least, was a reaction against the Greek doctrine of ethos in music, which claimed that music could have a profound effect on human behavior. That music might induce moods of passion or violence or might even be an agreeable sensation in itself was not likely to appeal to a church that required the ethos of its music to express religious truth alone. For this reason instrumental music

was rejected as unsuitable for the Christian liturgy. Such instrumentation was, in the minds of many Christians, too reminiscent of pagan customs.

By the fourth century, then, the standard form of music in Christian churches was either *responsorial* singing, with a cantor intoning lines from the Psalms and the congregation responding with a simple repeated refrain, or *antiphonal* singing, with parts of the congregation (or the cantor and the congregation) alternating verses of a psalm in a simple chant tone. By the beginning of the fifth century, there is evidence of nonscriptural hymns being composed. Apart from some rare fragments, we have no illustration of music texts with notation before the ninth century.

SUMMARY

This chapter traces a very long history from the beginnings of the biblical tradition to the emergence of Christianity as a state religion in the Roman Empire, a history so complex that one hesitates to generalize about its shape and significance. Nonetheless, certain points deserve to be highlighted both because they are instructive in their own right and because of their continuing impact on the shape of Western culture.

First, the biblical tradition reflects the emergence of monotheism (a belief in one God) as a leading idea in Western culture. Judaism held the ideal of the uniqueness of God against the polytheistic cultures of Babylonia, Assyria, and Egypt. That idea carried over into Christianity and became a point of conflict with Roman culture. The Roman charge that Christians were atheists meant not that they denied the existence of God but that they rejected the Roman gods.

Second, the entire biblical tradition had a very strong ethical emphasis. The prophets never ceased to argue that the external practice of religion was worthless unless there was a "pure heart." Jesus preached essentially the same thing in his famous criticisms of those who would pray publicly but secretly, in his words, "devour the substance of widows."

This ethic was rooted in the biblical notion of *prophetism*—the belief that people could be called by God to denounce injustice in the face of hostility either from their own religious establishment or from equally hostile civil governments. Such prophetic protest, inspired by the biblical message, was always a factor in subsequent Judaism and Christianity.

Both Judaism and Christianity insisted on a personal God who was actively involved with the world of humanity to the degree that there was a *covenant* between God and people and that the world was created and sustained by God as a gift for humans. This was a powerful doctrine that flew in the face of the ancient belief in impersonal fate controlling the destiny of people or a pessimism about the goodness or reliability of the world as we have it and live in it.

The biblical belief in the providence of God would have an enormous impact on later Western culture in everything from shaping its philosophy of history (that history moves in a linear fashion and has a direction to it) to an optimism about the human capacity to understand the world and make its secrets known for the benefit of people. Western culture never accepted, at least as a majority opinion, that the physical world itself was sacred or an illusion; rather it was a gift to be explored and at times exploited.

Finally, the Jewish and Christian tradition produced a work of literature: the Bible. The significance of that production can best be understood in the subsequent chapters of this book. It will soon become clear that a good deal of what the humanistic tradition of art, literature, and music produced until well into the modern period is unintelligible if not seen as an ongoing attempt to interpret that text in various artistic media according to the needs of the age.

Pronunciation Guide

catacombs: Constantine: CAT-ah-combs

covenant:

CON-stan-tine KUV-e-nent

Decius:

DAY-see-us Die-oh-KLE-shun

Diocletian: **Dura-Europos:**

Dew-rah You-ROPE-us

Exodus:

X-oh-dus

Laodicea:

Lay-oh-de-SEE-ah

Messiah: Mithraism:

Mess-EYE-ah MYTH-rah-is-im

pietá:

Pea-eh-TA

Torah: tufa:

TOE-rah TOO-fa

EXERCISES

- 1. Hebrew religion begins in a patriarchal culture (a tribe headed by a "father") and much of its language derives from that fact. What are the common titles for God that reflect that masculine dominance? Do some feminists have a case in their criticism of the overly patriarchal nature of biblical religion?
- 2. Biblical religion insists that God has no name and cannot be depicted in art. What do you believe were the reasons behind that attitude (almost unique in the ancient world) and what were its cultural consequences?
- 3. The biblical covenant is summed up in "I will be your God; you will be my people." Can you suggest a short phrase to sum up a marriage covenant? a covenant between citizens and the state? What are the essential characteristics of a covenant?
- 4. Reread the Ten Commandments. Which of them make sense only to religious believers? Which have general ap-

- plications? Could you suggest other commandments for inclusion in a modern version?
- 5. How would you characterize Jesus as a cultural type: teacher? philosopher? prophet? hero? martyr? other? Ex-
- 6. It is said that the Beatitudes are at the heart of the teaching of Jesus. Paraphrase those Beatitudes in contemporary language. Which of them sound strangest to
- 7. Do you see any lessons about religious tolerance today from the history of the persecution of the Christians in the Roman Empire?
- 8. Constantine extended the aid of the state to Christians. What are the benefits of state support for religion? the problems?
- 9. In his famous praise of the virtue of love (I Cor. 13), Paul the Apostle says that love outlives both faith and hope. What kind of love is he talking about? How does love outlive both hope and faith?

FURTHER READING

- Achtemeier, P. (Ed.). (1996). Rev. ed. Harper's Bible dictionary (Rev. ed.). San Francisco: Harper. Excellent one-volume reference work.
- Finegan, J. (1992). The archeology of the New Testament (Rev. ed.). Princeton, NJ: Princeton University Press. Excellent survey of Palestinian archeology and its relation to the Christian scriptures.
- Freedman, D. N. (Ed.). (1992). The Anchor Bible dictionary (6 vols.). Garden City, NY: Doubleday. Standard reference work.
- Frend, W. H. C. The rise of Christianity. Philadelphia: Fortress, 1983. Comprehensive history of early Christianity.
- Jeffrey, D. L. (Ed.). (1992). A dictionary of biblical tradition in English literature. Grand Rapids, MI: Eerdmans. Useful compendium of biblical themes in English literature.
- May, H. (Ed.). (1974). Oxford Bible atlas. New York: Oxford University Press. Invaluable for biblical geography.
- Mays, J. L. (Ed.). (1996). Harper's Bible commentary. San Francisco: Harper. Handy commentary on entire Bible.
- Pelikan, J. (1985). Jesus through the centuries: His place in the history of culture. (2nd ed.) New Haven, CT: Yale University Press. Excellent study of interpretations of Jesus in Western culture.
- Pritchard, J. B. (1969). Ancient Near Eastern texts relating to the Old Testament. Princeton, NJ: Princeton University Press. Indispensable collections of texts and images from the Near East that illuminate the study of the Bible.

ONLINE CHAPTER LINKS

Masada: Desert Fortress Overlooking the Dead Sea at

http://www.us-israel.org/jsource/Archaeology/ Masada1.html

provides a historical account with graphics and links to related information.

Photographs, maps, and biblical references are among the evidence offered at *The Location of the First and Second Temples in Jerusalem* at

http://www.templemount.org/theories.html

Internet Jewish History Sourcebook at http://www.fordham.edu.halsall/jewish/

jewishsbook/html provides an extensive list of links to related Web sites.

The Christian Catacombs of Rome at http://www.catacombe.roma.it/welcome.html provides a wide array of photographs and extensive information about the Catacombs of St. Callix-

tus, the spirituality of the catacombs, and the Christians of the persecutions.

For accounts about the formation of the biblical scriptures, consult the *Guide to Early Church Documents* at

http://www.iclnet.org/pub/resources/christian-history.html

Return to Dura Europos at

http://pages.cthome.net/hirsch/dura.htm provides an account of the archaeological excavations at this ancient synagogue in Syria.

		GENERAL EVENTS	LITERATURE & PHILOSOPHY
	A.D.		
STIAN ERA	64	250 Persecution of Christians under Decius	c. 67 Apostle Paul, bearer of Christian message throughout Mediterranean, martyred at Rome
	PERIOD OF ERSECUTION	286 Diocletian divides Roman Empire into East and West parts ruled by himself and Maximian	
	PERIOD ERSECUT	305 Abdication of Diocletian and Maximian; Constantius and Galerius rule as joint emperors	
	313	307–327 Reign of Constantine	
EARLY CHRISTIAN ERA	515	313 Edict of Milan, giving Christians freedom of religion	
	PERIOD OF RECOGNITION	324 Constantine convenes Council of Nicaea	c. 350 <i>Codex Sinaiticus,</i> earliest extant Greek codex of New Testament
		330 Constantine dedicates new capital of Roman Empire on site of Byzantium, naming it Constantinople	c. 374–404 Saint John Chrysostom active as writer and preacher
		337 Constantine is baptized a Christian on his deathbed	
	395	383 Ostrogoths accept Christianity	c. 386 Saint Jerome translates Bible into Latin
	373	395 Division of Roman Empire begun by Diocletian becomes total separation	397 Augustine of Hippo, Confessions
	ζE	4th-5th cent. Decline of Western Roman Empire	410 404 4 11 6771 771
		410 Visigoths sack Rome	412–426 Augustine of Hippo, <i>The City of God</i>
	EMPIRE	455 Vandals sack Rome	
	OF EN	476 Romulus Augustulus forced to abdicate as last Western Roman emperor; Ostrogoths rule Italy	
		493–526 Theodoric the Ostrogoth reigns in Italy	
	GROWTH	527–565 Reign of Justinian as Eastern Roman emperor in Constantinople	c. 522 – 524 Boethius, The Consolation of Philosophy, allegorical treatise; translation of Aristotle's writings
Z.		532 Nika revolt; civil disorders in Constantinople	524 Execution of Boethius by
Ш		c. 533 Justinian codifies Roman Law	Theodoric the Ostrogoth
IN.	565	540 Belisarius conquers Ostrogoths in Italy for Justinian; Ravenna comes under Byzantine rule	c. 562 Procopius, History of the Wars, The Buildings, Secret History
F	RIAL NE	570 Muhammad born; dies 632	
\bar{\bar{\bar{\bar{\bar{\bar{\bar{		730–843 Iconoclastic controversy: ban on religious imagery	c. 620 Qur'an develops
BYZANTINE	Tel	800 Pope Leo III crowns first Western Roman emperor (Charlemagne) at Rome since 5th cent.	
	900	988–989 Russians accept Christianity	
	NE	1054 Eastern and Western Church formally split	
	SECOND GROWTH	Lastern and Western Church formany spin	
	1100	1204 Crusaders sack Constantinople on way to Holy Land	
	FINAL	1453 Constantinople falls to Ottoman Turks, ending Byzantine Empire; Church of Hagia Sophia becomes a mosque	
	1453		
	. 433		

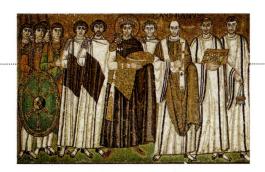

- c. 390 Obelisk of Theodosius erected in Hippodrome at Constantinople
- c. 415 Theodosius II moves gilded horses and chariot from Rome to Hippodrome
- c. 425 Mosaics at Mausoleum of Galla Placidia, Ravenna

- c. 450 Dome mosaic in Orthodox Baptistery, Ravenna
- 6th cent. Art tied to theological doctrine and liturgical practice of Orthodox Church
- c. 546-556 Ivory throne of Archbishop Maximian, given by Justinian for San Vitale
- c. 550 Mosaics at Sant' Apollinare Nuovo and San Vitale, Ravenna; Metamorphosis of Christ, apse mosaic from Katholikon, Monastery of Saint Catherine, Mount Sinai

- c. 324 Constantine has stadium in Constantinople enlarged to form Hippodrome
- c. 326 Holy Sepulchre, Jerusalem
- c. 333 Old Saint Peter's Basilica, Vatican

Use of basilica plan and central plan with dome

- c. 450 Mausoleum of Galla Placidia, Neonian and Arian
- c. 493 526 Sant' Apollinare Nuovo, Ravenna

Baptisteries, Ravenna

- c. 530-548 San Vitale, Ravenna
- 526 Theodoric's Tomb, Ravenna
- 527 Hagia Eirene, Constantinople, begun
- 532-537 Anthemius of Tralles and Isidore of Miletus rebuild Hagia Sophia, Constantinople, combining basilica plan and central plan with dome
- c. 533 549 Sant' Apollinare in Classe
- c. 550 Stephanos, Monastery of Saint Catherine, Mount Sinai

386 Saint Ambrose of Milan begins use of vernacular hymns in church

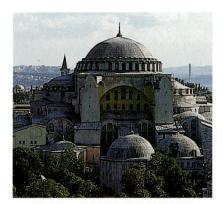

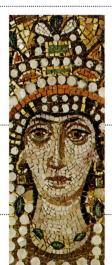

730-843 Ban on religious imagery; most earlier pictographic art destroyed

Renewal of icon tradition

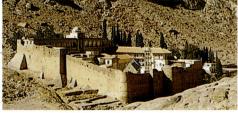

1063 Saint Mark's, Venice, begun

Greek liturgy; musical modifications decline

12th cent. Mosaics at Palermo, of the Virgin, near Vladimir, c. 1410 Rublev active as painter of icons in Moscow

c. 1166 Church of the Intercession Russia; "onion dome" adapted from central dome

7th cent. Golden Age of Byzantine hymnody

Ith cent. Codification of

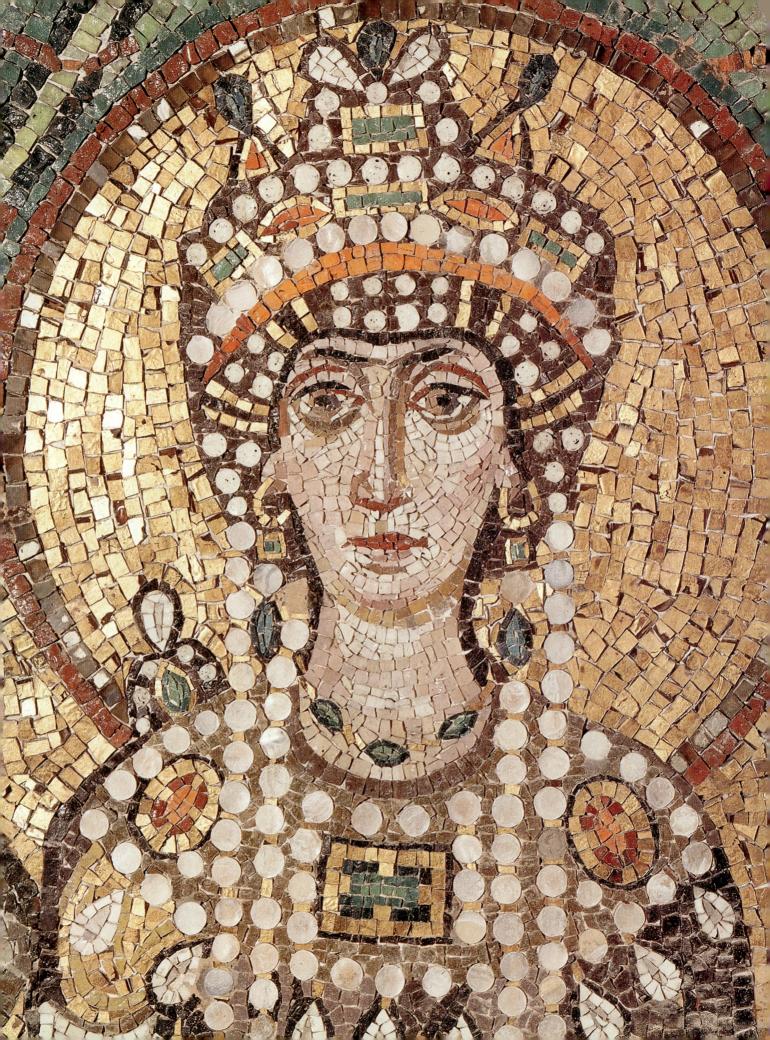

CHAPTER 7 BYZANTIUM

THE DECLINE OF ROME

By the early fourth century, the Roman Empire already had severe economic, political, and social problems. In 330, Emperor Constantine dedicated a Greek trading town on the Bosporus as his eastern capital, changing its name from Byzantium to Constantinople. It was to be a "new" Rome. Constantinople had some obvious advantages for a major city: It straddled the most prominent land route between Asia and Europe.

http://w4u.eexi.gr/~ippotis/consten.html

Constantinople

It had a deepwater port with natural shelter. It guarded the passage between the Mediterranean and the Black Sea. The surrounding countryside was rich in forests and water. The neighboring areas of both Europe (Thrace) and Asia (Bithynia) were rich agricultural areas that could supply the city's food needs.

Because of the tumultuous conditions in Rome, the emperors spent less time there. By the beginning of the fifth century (in A.D. 402), Emperor Honorius moved the capital of the Western empire to the northern Italian city of Ravenna on the Adriatic coast. Seventy-four years later, in A.D. 476, the last Roman emperor in the West would die there. Goths would occupy the city; they in turn were defeated by the imperial forces from Constantinople.

In the waning decades of the fourth and fifth centuries, Christianity continued to grow and expand in influence. During that period, in far different places, two writers would live who saw the decline of the West: Augustine in Roman North Africa and Boethius in the city of Ravenna. Their writings were to have an enormous impact on the culture of Europe. Each deserves consideration.

Literature and Philosophy

Augustine of Hippo

http://www.newadvent.org/cathen/02084a.htm

St. Augustine of Hippo

The greatest writer of the Christian Latin West, Augustine of Hippo, was a witness to the decline of Roman power. Born in 354 in North Africa (then part of the Roman provinces), Augustine received a thorough Classical education in Africa and in Rome. He was converted to Christianity in Milan and soon afterward returned to his native country, where he was named Bishop of Hippo in 390. When the Visigoths sacked Rome in 410, the pagan world was aghast and many blamed the rise of Christianity for this event. Partially as a response to this charge, Augustine wrote The City of God in an attempt to demonstrate that history had a direction willed by God and that "in the end" all would be made right as the city of man gave way to the city of God. Augustine's work, packed with reflections on scripture, philosophy, and pagan wisdom, is often cited as one of the most influential philosophies of history written in the Western world.

Indeed, it is difficult to overestimate the intellectual impact of Augustine of Hippo on the subsequent cultural history of the West. His influence within Christianity is without parallel. Until Thomas Aquinas in the thirteenth century, all Christian theologians in the West started from explicitly Augustinian premises. Even Thomas did not shake off his debt to Augustine, although he replaced Augustine's strong Platonic orientation with a more empirical Aristotelian one. Augustine emphasized the absolute majesty of God, the immutability of God's will, and the flawed state of the human condition (notions derived from Saint Paul). These tenets received a powerful reformulation in the Protestant Reformation by Martin Luther (who as a Catholic friar had lived under the rule of Saint Augustine) and by John Calvin, a profound student of Augustine's theological writings.

Augustine also made a notable impact beyond theology. The City of God, begun about 412, was an attempt to formulate a coherent and all-embracing philosophy of history, the first such attempt in the West. For Augustine, history moves on a straight line in a direction from its origin in God until it ends, again in God, at the consummation of history in the Last Judgment. Augustine rejected the older pagan notion that history repeats itself in endless cycles. His reading of the Bible convinced him that humanity had an origin, played out its story, and would terminate. The city of man would be judged and the city of God would be saved. Subsequent philosophers of history have secularized this view but, with very few exceptions (Vico, a seventeenth-century Italian philosopher, was one), have maintained the outlines of Augustine's framework to some extent. "A bright future," "an atomic wasteland of the future," and "classless society" are all statements about the end of history, all statements that echo, however dimly, the worldview of Augustine.

Augustine also invented the genre of self-reflective writing in the West. "I would know myself that I might know Thee," Augustine writes of God in the Confessions. Before Augustine's time, memoirs related a life in terms of social, political, or military affairs (as did, for example, Caesar's Gallic Wars), but Augustine's intimate selfscrutiny and inquiry into the significance of life were new in Western culture. There would be no other work like the Confessions until Petrarch, an indefatigable student of Augustine, wrote his Letter to Posterity in the mid-fourteenth century. The Renaissance writers, an extremely self-conscious generation, were devoted students of Augustine's stately Latin prose; even the great later autobiographies of our inherited culture—those of Gibbon, Mill, Newman—are literary and spiritual descendants of Augustine.

Augustine's *Confessions* is a compelling analysis of his spiritual and intellectual development from his youth until the time of his conversion to Christianity and readiness to return to his native Africa. The title must be understood in a triple sense—a confession of sin, an act of faith in God, and a confession of praise—so it is appropriate that Augustine began his book as a prayer directed to God.

Although strongly autobiographical, the *Confessions* is actually a long meditation by Augustine on the hidden grace of God as his life is shaped toward its appointed end. Augustine "confesses" to God (and the reader) how his early drive for fame as a teacher of rhetoric, his flirtation with the Manichean sect and its belief in gods of evil and good, his liaison with a woman that resulted in the birth of a son, and his restless movement from North Africa to Rome and Milan were all part of a seamless web of circumstance that made up an individual life. Interspersed in the narrative line of his early life are Augustine's reflections on the most basic philosophical and

theological questions of the day, always linked to his own experience.

If the *Confessions* can be said to be the beginning of autobiography, beyond that historic importance it is classic and singular in its balance of immense learning, searching speculation, and intense self-scrutiny. It is a work concerned first of all with meaning at the deepest philosophical level, and its full power is evident only to the reader who will take the time to enter Augustine's line of argument.

Boethius

http://www.fordham.edu/halsall/basis/procop-anec.html

Justinian

In the twilight period in Ravenna, between the death of the last Roman emperor and the arrival of Justinian's troops, an important figure who bridged the gap between Classical paganism and Christianity lived and died. Anicius Manlius Severinus Boethius was a highly educated Roman who entered the service of the Goth king Theodoric in 522. Imprisoned for reasons that are not clear, Boethius wrote a treatise called The Consolation of Philosophy while awaiting execution. Cast as a dialogue between Lady Philosophy and the author on the philosophical and religious basis for human freedom, the work blends the spirit of the Book of Job with Roman stoicism. Attempting to console him for his sad state of disgrace and imprisonment, Lady Philosophy demands that the author avoid self-pity, that he face his troubles with serenity and hope. Insisting that a provident God overcomes all evil, Philosophy insists that blind fate has no control over humanity. She explains that human freedom exists along with an all-knowing God and that good will triumph. Although Christian themes permeate the work, there is no explicit mention of Christian doctrine. What one does sense is the recasting of Roman thought into Christian patterns. In a way, The Consolation of Philosophy is one of the last works of the late Roman period. It reflects the elegance of Roman expression, the burgeoning hope of Christianity, and the terrible sadness that must have afflicted any sensitive Roman living in this period.

The Consolation of Philosophy was one of the most widely read and influential works of the Middle Ages (Chaucer made an English translation of it from an already-existing French version). Its message of hope and faith was quoted liberally by every major medieval thinker from Thomas Aquinas to Dante Alighieri.

Boethius sets out a basic problem and provides an answer that would become normative Christian thought for subsequent centuries. In *The Consolation*, Boethius

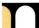

CONTEMPORARY VOICES

Procopius of Caesarea

The whole ceiling is overlaid with pure gold . . . yet the light reflecting from the stones [of the mosaics] prevails, shining out of rivalry with the gold. There are two colonnades, one on each side, not separated in any way from the church itself. . . . They have vaulted ceilings and are decorated with gold. One of these is designated for men-worshipers and the other for women but they have nothing to distinguish them nor do they differ in any way. Their very equality serves to beautify the church and their similarity to adorn it.

Who can recount the beauty of the columns and the stones with which the church is decorated? One might imagine that he had come upon a meadow with its flowers in full bloom. For he would surely marvel at the purple of some, the green tint of others, and at those from which the white flashes, and again, at those which Nature, like some painter, varies with contrasting colors.

And whenever anyone enters this church to pray . . . his mind is lifted up toward God and is exalted, feeling that He cannot be very far away, but must especially love to dwell in this place which He has favored. And this does not happen only to one who sees the church for the first time, but the same experience comes to him on each successive occasion, as though the sight were new each time. Of this spectacle no one ever has a surfeit, but when present in the church people rejoice in what they see, and when they depart they take enormous delight in talking about it.

Procopius of Caesarea, The Buildings, Book 1.1. Procopius was in the service of Emperor Justinian. His Secret History was a bitterly critical portrait of the emperor and the empress.

asks how one can reconcile human freedom with the notion of an all-knowing God. Put another way: If God knows what we do before we do it, how can we be said to be free agents who must accept responsibility for personal acts? The answer, Boethius insists through Lady Philosophy, is to look at the problem from the point of view of God, not from the human vantage point. God lives in eternity. Eternity does not mean a "long time" with a past and a future. Eternity means "no time": God lives in an eternal moment that for Him is a "now." In that sense God, does not "foresee" the future. There is no future for God. God sees everything in one simple moment that is only past, present, and future from the human point of view. Boethius says that God does not exercise praevidentia (seeing things before they happen) but providence (seeing all things in the simultaneity of their happening). Thus God, in a single eternal, ineffable moment, grasps all activity, which exists for us as a long sequence of events. More specifically, in that moment, God sees our choices, the events that follow from them, and the ultimate consequences of those choices.

The consolation of Boethius, as Lady Philosophy explains it, rests in the fact that people do act with freedom, that they are not in the hands of an indifferent fate, and that the ultimate meaning of life rests with the allseeing presence of a God, not a blind force. Lady Philosophy sums up her discussion with Boethius by offering him this "consolation." It is her assurance that his life, even while awaiting execution in a prison cell, was not the product of a blind fate or an uncaring force in the universe.

The language of Boethius, with its discussion of time, eternity, free will, and the nature of God, echoes the great philosophical tradition of Plato and Aristotle (Boethius had translated the latter's works) as well as the stoicism of Cicero and the theological reflections of Augustine. It is a fitting end to the intellectual tradition of the late Roman Empire in the West.

THE ASCENDANCY OF BYZANTIUM

The city of Constantinople became the center of imperial life in the early fifth century and reached its highest expression of power in the early sixth century with the ascension to the throne of Justinian (527). His stated intention was to restore the empire to a state of grandeur. In this project he was aided by his wife Theodora. A former dancer and prostitute, Theodora was a toughminded and capable woman who added strength and resolve to the grandiose plans of the emperor. She was Justinian's equal, and perhaps more.

The reign of Justinian and Theodora was impressive, if profligate, by any standard. The emperor encouraged Persian monks residing in China to bring back silkworms for the introduction of the silk industry into the West. Because the silk industry of China was a fiercely guarded monopoly, the monks accomplished this rather dangerous mission by smuggling silkworm eggs out of the country in hollow tubes and, within a decade, the silk industry in the Western world rivaled that of China.

Justinian also revised and codified Roman law, a gigantic undertaking of scholarship and research. Roman law had evolved over a thousand-year period and, by Justinian's time, was a vast jumble of disorganized and often contradictory decisions, decrees, statutes, opinions, and legal codes. Under the aegis of the emperor, a legal scholar named Tribonian produced order out of this chaos. First a Code that summarized all imperial decrees from the time of Hadrian (in the second century) to the time of Justinian was published. The Code was followed by the Pandects ("digest"), which synthesized a vast quantity of legal opinion and scholarship from the past. Finally came the Institutes, a legal collection broken down into four categories by which the laws concerning persons, things, actions, and personal wrongs (in other words, criminal law) were set forth. The body of this legal revision became the basis for the law courts of the empire and, in later centuries, the basis for the use of Roman law in the West.

Justinian and Theodora were fiercely partisan Christians who took a keen interest in theology and ecclesiastical governance. Justinian's fanatical devotion prompted him to shut down the last surviving Platonic academy in the world on the grounds that its paganism was inimical to the true religion. His own personal life—despite evidences of cruelty and capriciousness—was austere and abstemious, influenced by the presence of so many monks in the city of Constantinople. His generosity to the church was great, with his largess shown most clearly in openhanded patronage of church building. Hagia Sophia, his most famous project, has become legendary for the beauty and opulence of its decoration.

http://www.princeton.edu/~asce/const_95/ayasofya.html

Hagia Sophia

Church of Hagia Sophia: Monument and Symbol

Hagia Sophia (Greek for "Holy Wisdom") was the principal church of Constantinople. It had been destroyed twice, once by fire and—during Justinian's reign—during the terrible civil disorders of the Nika revolt in 532 that devastated most of the European side of the city. Soon afterward, Justinian decided to rebuild the church using the plans of two architects: Anthemius of Tralles and Isidore of Miletus. Work began in 532 and the new edifice was solemnly dedicated five years later in the presence of Justinian and Theodora.

The Church of Hagia Sophia was a stunning architectural achievement that combined the longitudinal shape of the Roman basilica with a domed central plan. Two centuries earlier Constantine had used both the dome

and basilica shapes in the Church of the Holy Sepulcher in Jerusalem, as we have seen, but he had not joined them into a unity. In still earlier domed buildings in the Roman world, such as the Pantheon and Santa Costanza, the dome rested on a circular drum. This gave the dome solidity but limited its height and expansiveness. Anthemius and Isidore solved this problem by the use of pendentives [7.1], triangular masonry devices that carried the weight of the dome on massive piers rather than straight down to the drum. In the Church of Hagia Sophia the central dome was abutted by two half-domes so that a person looking down at the building from above might see a nave in the form of an oval instead of a quadrangle [7.2].

The church—184 feet (55.2 m) high, 41 feet (12.3 m) higher than the Pantheon—retained a hint of the old basilica style as a result of the columned side aisles and the gallery for female worshipers in the triforium space above the arches of the aisles, but the overwhelming visual impression came from the massive dome. Since the pendentives reduced the weight of the dome, the area between drum and dome could be pierced by forty windows that made the dome seem to hang in space. Light streamed into the church from the windows and refracted off the rich mosaics and colored marbles that covered the interior [7.3].

Light, in fact, was a key theoretical element behind the entire conception of Hagia Sophia. Light is the

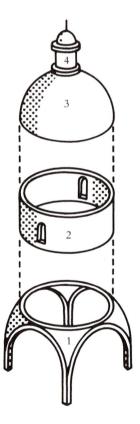

7.1 Dome construction: 1. Pendentive; 2. Drum;

3. Cupola; 4. Lantern.

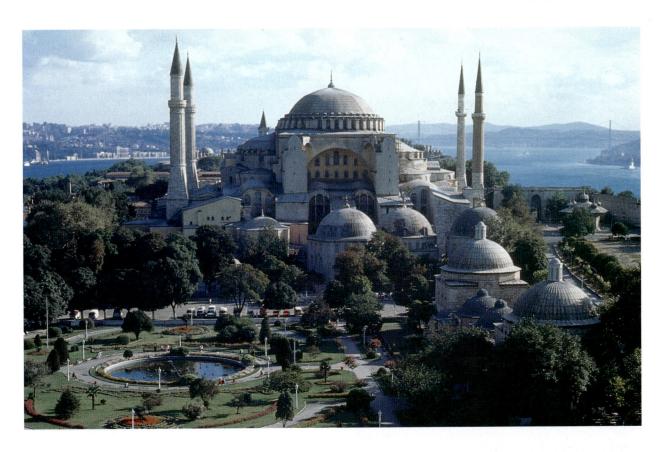

7.2 Anthemius of Tralles and Isidore of Miletus. Church of Hagia Sophia, Constantinople (Istanbul). Exterior view from the southeast. The towers, of Turkish origin, are a later addition.

symbol of divine wisdom in the philosophy of Plato and in the New Testament. A common metaphor in pagan and biblical wisdom had the sun and its rays represent the eternity of God and His illumination of mortals. The suffusion of light was an element in the Hagia Sophia that went far beyond the functional need to illuminate the interior of the church. Light refracting in the church created a spiritual ambiance analogous to that of heaven, where the faithful would be bathed in the actual light of God.

The sequence of the various parts of the worship service at Constantinople—the *liturgy*—was developed from the inspiration of Saint John Chrysostom (345–407), patriarch of the city in the century before Justinian. The official liturgy of Byzantine Christianity is still the Divine Liturgy of Saint John Chrysostom, modified and added to over the centuries. In that liturgy, the worshiping community visualized itself as standing in the forecourt of heaven when it worshiped in the church. Amid the swirling incense, the glittering light, and the stately chants of the clergy and people comes a sense of participation with the household of heaven standing before God. A fragment from the liturgy—added during the reign of Justinian's successor Justin II (565–578)—

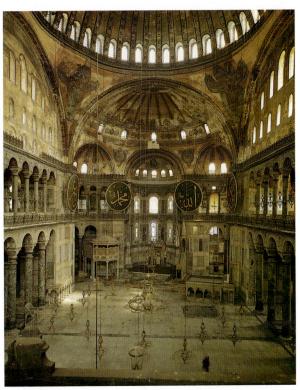

7.3 Anthemius of Tralles and Isidore of Miletus. Church of Hagia Sophia, Constantinople (Istanbul). An interior view, looking toward the apse, shows how the windows between drum and dome give an impression of floating lightness that continues down to the floor.

underscores the point dramatically. Note the characteristic cry of Wisdom! and the description of the congregation as mystically present in heaven:

PRIEST

Wisdom! That ever being guarded by Thy power, we may give glory to Thee, Father, Son, and Holy Spirit, now and forevermore.

CONGREGATION Amen. Let us here who represent the mystic Cherubim in singing the thrice holy hymn to the life-giving Trinity now lay aside every earthly care so that we may welcome the King of the universe who comes escorted by invisible armies of angels. Alleluia, Alleluia, Alleluia,

Hagia Sophia was enriched by subsequent emperors, and after repairs were made to the dome (in 989), new mosaics were added to the church. After the fall of Constantinople (1453), the Turks turned the church into a mosque; the mosaics were whitewashed or plastered over since the Qur'an (also called Koran) prohibited the use of images. When the mosque was converted to a museum by the modern Turkish state, some of the mosaics were uncovered, so today we can get some sense of the splendor of the original interior.

Other monuments bear the mark of Justinian's creative efforts. His Church of the Holy Apostles, built on the site of an earlier church of the same name destroyed by an earthquake, did not survive the fall of the city in 1453 but did serve as a model for the Church of Saint Mark in Venice. Near the Church of Hagia Sophia is the Church of Hagia Eirene ("Holy Peace"), now a mosque, whose architecture also shows the combination of basilica and dome. The church, dedicated to the martyr saints Sergius and Bacchus and begun in 527, was a preliminary study for the later Hagia Sophia. In all, Justinian built more than twenty-five churches and convents in Constantinople. His program of secular architecture included an impressive water conduit system that still exists.

Ravenna

Art and Architecture

http://www.akros.it/comuneravenna/gallapluk.htm

Mausoleum of Galla Placidia

Ravenna is a repository of monuments that reflect its late Roman, barbarian Gothic, and Byzantine history. The Mausoleum ("burial chapel") of Galla Placidia (who reigned as regent from 430 to 450) was built at the end of the Roman period of Ravenna's history [7.4]. Once thought to be the tomb of the empress (hence its name), it is more likely a votive chapel to Saint Lawrence origi-

7.4 The so-called Mausoleum of Galla Placidia, Ravenna. Early fifth century. This building has sunk more than a meter (approx. 4') into the marshy soil, thus making it rather squat in appearance.

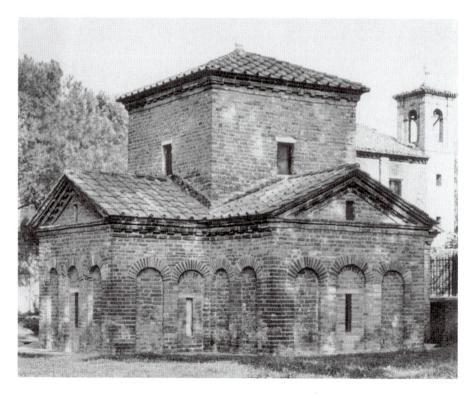

nally attached to the nearby Church of the Holy Cross. The huge sarcophagi in the building are probably medieval. This small chapel in the shape of a cross, very plain on the outside, shows the architectural tendency to combine the basilica-style nave with the structure of a dome (it even uses a modified pendentive form) used later in monumental structures like Hagia Sophia.

The importance of Galla Placidia rests in the complete and breathtakingly beautiful mosaics that decorate the walls and ceiling. The north niche, just above the entrance, has a lunette (small arched space) mosaic depicting Christ as the Good Shepherd [7.5]. Clothed in royal purple and with a gold staff in his hand, the figure of Christ has a courtly, almost languid elegance that refines the more rustic depictions of the Good Shepherd theme in earlier Roman Christian art. The vaulting of both the apse (the altar end of the church) and the dome is covered with a deep blue mosaic interspersed with stylized sunbursts and stars in gold. This "Persian rug" motif symbolized the heavens, the dwelling place of God. Since the tesserae (the small cubes that make up the mosaic) are not set fully flush in the wall, the surfaces of the mosaic are irregular. These surfaces thus refract and break up the

7.5 Christ as the Good Shepherd. Mosaic from the entrance wall of the Mausoleum of Galla Placidia, Ravenna, fifth century. The Persian rug motif can be seen in the vault. Note the beardless Christ dressed in a Roman toga.

light in the chapel, especially from flickering lamps and candles. (The translucent alabaster windows now in the chapel were installed in the twentieth century.)

Opposite the lunette of the Good Shepherd is another lunette that depicts the deacon martyr of the Roman Church, Saint Lawrence, who stands next to the gridiron that was the instrument of his death. Beyond the gridiron is an open cabinet containing codices of the four gospels [7.6]. The spaces above these mosaics are filled with figures of the apostles. Between these are symbols of the search for religious understanding: deer, doves, fountains. In the arches, more spectacular and often overlooked, are the abstract interlocking designs with their brightness and *trompe l'œil* ("trick-the-eye") quality.

The two baptisteries of Ravenna represent a major religious division of the time between the Orthodox Christians, who accepted the divinity of Christ, and the Arian Christians, who did not. The Neonian Baptistery, built by Orthodox Christians in the early fifth century next to the ancient cathedral of the city, is octagonal, as were most baptisteries, because of their derivation from Roman bathhouses. The ceiling mosaic, directly over the baptismal pool, is particularly striking. The lower register of the mosaic, above the windows, shows floral designs based on common Roman decorative motifs. Just above is a circle of empty thrones interspersed with altars with biblical codices open on them [7.7]. In the band above are

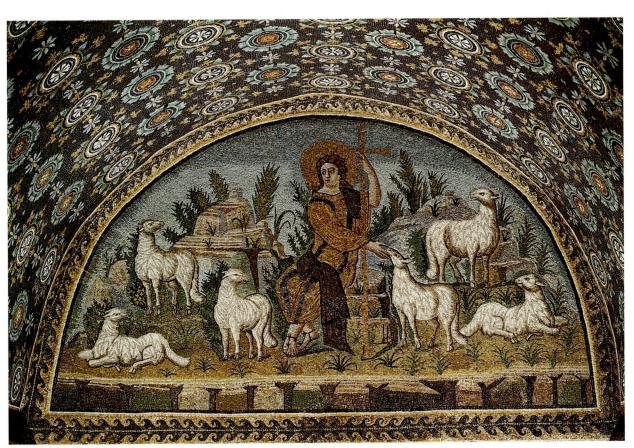

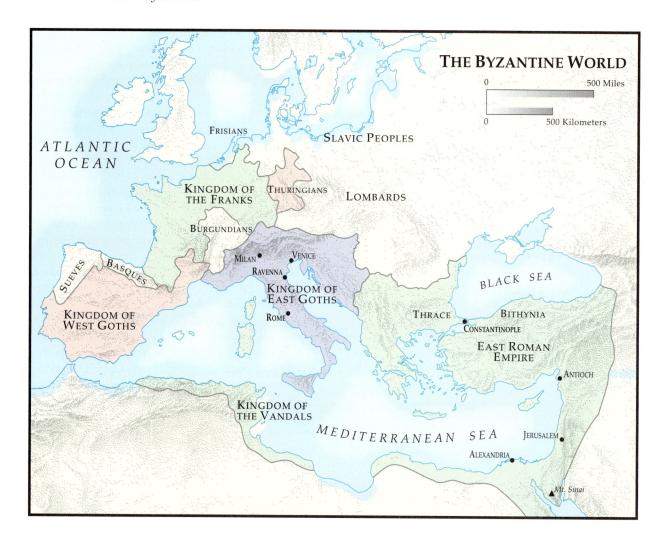

7.6 The Martyrdom of Saint Lawrence, from the Mausoleum of Galla Placidia, Ravenna, fifth century. Mosaic. The window, a modern one, is made of alabaster. Saint Lawrence, with the gridiron on which legend said he was roasted, is at the lower right.

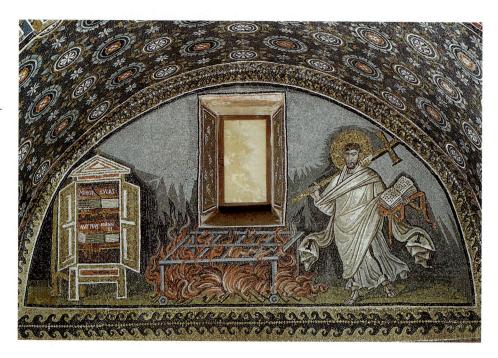

VALUES

Autocracy

The Byzantine Empire was characterized by its acceptance of the belief that the emperor was God's representative on earth who was the sole ruler of the empire and from whom all of the social and political goods for the empire flowed. This view of the political order is called *autocracy* which means, in essence, that the imperial power is unlimited and whatever power others may have (e.g., in the military or in the state bureaucracy), that power flows from the unlimited power of the emperor who has it by divine right. In this view, the emperor is both the highest civil and religious leader of the empire.

In the actual political order, emperors were overthrown or manipulated by political intrigue, but officially autocracy was accepted as the divinely ordered nature of things.

Symbolic reinforcement of the autocratic power of the emperor (visually represented in the Ravenna mosaics of Justinian and Theodora) came through a variety of symbolic means. The emperor alone dressed in the purple and gold once reserved for the semidivine pagan emperors. He lived in a palace with a rigid protocol of ceremony. When participating in the public worship of the church (the *liturgy*) he was given a special place and special recognition within that liturgy. Public insignia and other artifacts like coins recognized his authority as coming from God. It was a commonplace in the literature of the time to see the emperor as the regent of God on earth with his role compared to the sun which brings light and warmth to his subjects.

Many autocracies (from the Egyptian pharaohs to the French kings just before the Revolution) claimed such a relationship to the divine. The Byzantine Empire not only built itself on this idea but also maintained an intimate bond between the human and the divine in the person of the emperor. This concept would last almost a millennium in Constantinople and be replicated in Russia with the tsar until modern times.

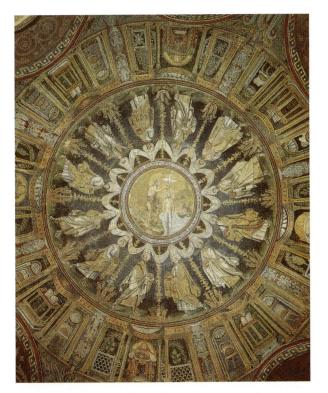

7-7 Ceiling mosaic of the Orthodox Baptistery, Ravenna, mid-fifth century.

the apostles, who seem to be walking in a stately procession around the circle of the dome. In the central disc is a mosaic of the baptism of Christ by John the Baptist in the river Jordan. The spirit of the river is depicted as Neptune.

http://www.akros.it/comuneravenna/neonfruk.htm

The Neone Baptistery

The mosaic ensemble in the ceiling was designed to reflect the beliefs of the participants in the ceremonies below. The circling apostles reminded the candidates for baptism that the church was founded on the apostles; the convert's baptism was a promise that one day he or she would dwell with the apostles in heaven. Finally, the codices on the altars taught of the sources of their belief, whereas the empty thrones promised the new Christians a place in the heavenly Jerusalem. The art, then, was not merely decorative but, in the words of a modern Orthodox thinker, "theology in color."

The Arian Baptistery, built by the Goths toward the end of the fifth century, is far more severely decorated. Again the traditional scene of Christ's baptism is in the central disc of the ceiling mosaic. Here the figure of the river Jordan has lobsterlike claws sprouting from his head—a curiously pagan marine touch. The Twelve Apostles in the lower register are divided into two groups: one led by Peter and the other by Paul. These

two groups converge at a throne bearing a jeweled cross (the crucifix with the body of Christ on the cross is very uncommon in this period) that represents in a single symbol the passion and the resurrection of Christ.

http://www.akros.it/comuneravenna/arianifruk.htm

The Arian Baptistery

Theodoric, the emperor of the Goths who had executed Boethius and reigned from 493 to 526, was buried in a massive mausoleum that may still be seen on the outskirts of Ravenna [7.8]. The most famous extant monument of Theodoric's reign aside from his mausoleum is the Church of Sant' Apollinare Nuovo, originally called the Church of the Redeemer, the palace church of Theodoric. This church is constructed in the severe basilica style: a wide nave with two side aisles partitioned off from the nave by double columns of marble. The apse decorations have been destroyed, but the walls of the basilica, richly ornamented with mosaics, can be seen. The mosaics, however, are of two different dates and reflect in one building both the Roman and Byzantine styles of art. On each side of the aisles, in the spaces just above the aisle arches, are processions of male and female saints, each procession facing toward the apse and main altar [7.9]. They move to an enthroned Christ on

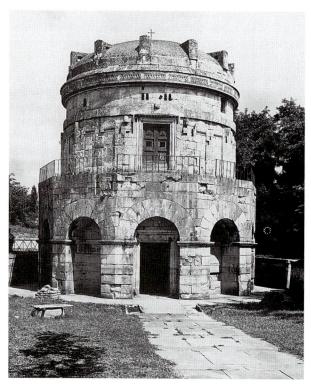

7.8 Tomb of Theodoric, Ravenna, early sixth century. The cap of the mausoleum is a huge stone that measures $36' \times 10'$ (11×3 m). The great porphyry tomb inside the mausoleum was pillaged in the early Middle Ages.

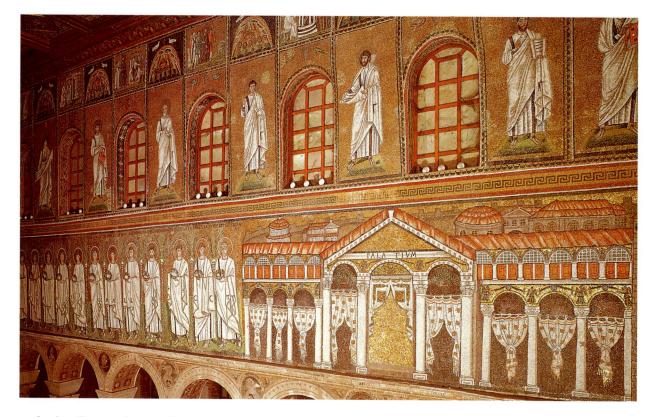

7.9 South wall mosaic, Sant' Apollinare Nuovo, Ravenna, early sixth century. The procession of male saints is in the lower register. The prophets and apostles are placed between the windows. Scenes from the Gospels are in the upper register. Detail appears in Figure 7.11.

one side and toward a Madonna and Child on the other. These mosaics were added to the church when the building passed from the Goths into Byzantine hands in the reign of Justinian. The depiction of Theodoric's palace [7.10] still in fact shows evidence of Orthodox censorship. In the arched spaces one can still see traces of halos of now-excised Arian saints (or perhaps members of Theodoric's court). On several columns of the mosaic can be seen the hands of figures that have now been replaced by decorative twisted draperies. The next register above has a line of prophetic figures. At the level of the clerestory windows are scenes from the New Testament—the miracles of Christ on one side [7.11-7.13] and scenes from his passion on the other. These mosaics are very different in style from the procession of sainted martyrs on the lower level. The Gospel sequence is more Roman in inspiration: severe and simple. Certain themes of earlier Roman Christian iconography are evident. The procession of saints, most likely erected by artists from a Constantinople studio, is much more lush, reverent, and static in tone. The Orientalizing element is especially noteworthy in the depiction of the Three Magi (with their Phrygian caps) who offer gifts to the Christ Child.

The Church of San Vitale most clearly testifies to the presence of Justinian in Ravenna [7.14]. Dedicated by Bishop Maximian in 547, it had been begun by Bishop Ec-

clesius in 526, the year Justinian came to the throne, while the Goths still ruled Ravenna. The church is octagonal, with only the barest hint of basilica length. How different it is may be seen by comparing it to Sant' Apollinare in Classe (the ancient seaport of Ravenna), built at roughly the same time [7.15]. The octagon has another octagon within it. This interior octagon, supported by columned arches and containing a second-story women's gallery, is the structural basis for the dome. The dome is supported on the octagonal walls by small vaults called *squinches* that cut across the angles of each part of the octagon.

http://www.akros.it/comuneravenna/vitalefruk.htm

Basilica of San Vitale

The most arresting characteristic of San Vitale, apart from its intricate and not fully understood architectural design, is its stunning program of mosaics. In the apse is a great mosaic of Christ the Pantocrator, the one who sustains all things in his hands [7.16]. Christ is portrayed as a beardless young man, clothed in royal purple. He holds in his left hand a book with seven seals (a reference to the Book of Revelation) and offers the crown of martyrdom to Saint Vitalis with his right. Flanked by the two archangels, Christ is offered a model of the church by

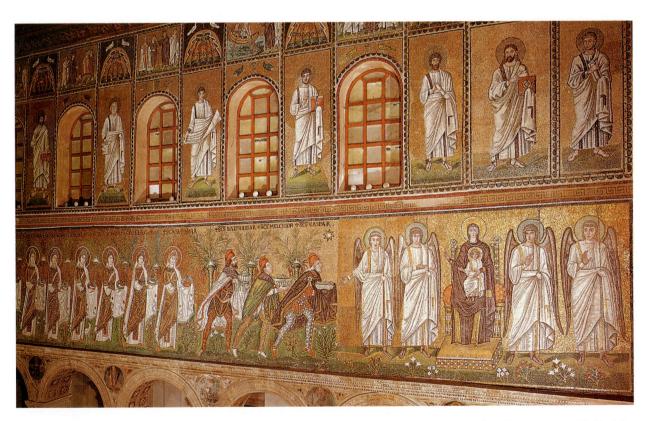

7.10 North wall mosaic, Sant' Apollinare Nuovo, Ravenna, early sixth century. Note the procession of female saints oriented behind the Three Magi, who all approach the enthroned Madonna. Details appear in Figure 7.12 and Figure 7.13.

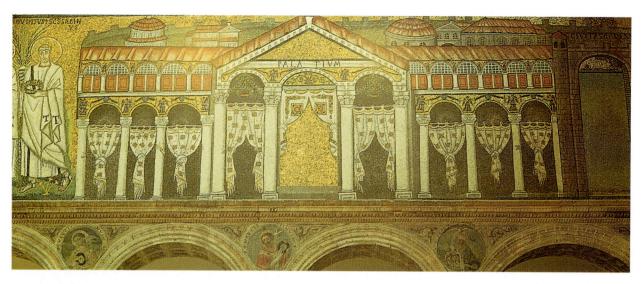

7.11 Theodoric's palace. Detail of south wall mosaic, Sant' Apollinare Nuovo, Ravenna.

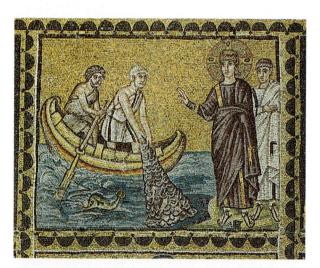

7.12 Jesus calls the apostles Peter and Andrew. North wall upper-register mosaic, Sant' Apollinare Nuovo, Ravenna. Note the Christ figure in the royal purple toga and his beardless appearance.

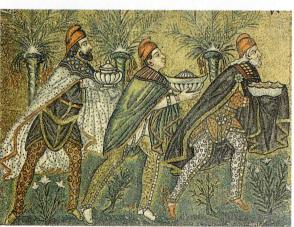

7.13 The Magi bearing gifts. Detail of north wall mosaic, Sant' Apollinare Nuovo, Ravenna. Christian legend had already named these figures Balthasar, Melchior, and Caspar, which can be seen inscribed on the mosaic. Bishop Apollinaris was a second-century apologist for Christianity who defended his faith in a treatise addressed to Emperor Marcus Aurelius.

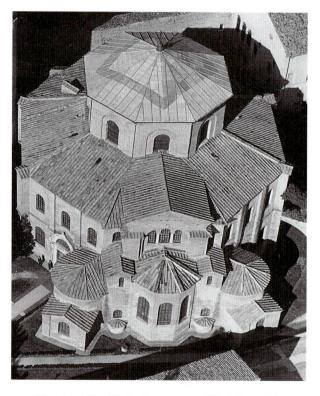

7.14 Church of San Vitale, Ravenna, c. 530–548. Aerial view. This complex building, the inspiration for Charlemagne's church at Aachen, gives little exterior evidence that it is done in the basilica style.

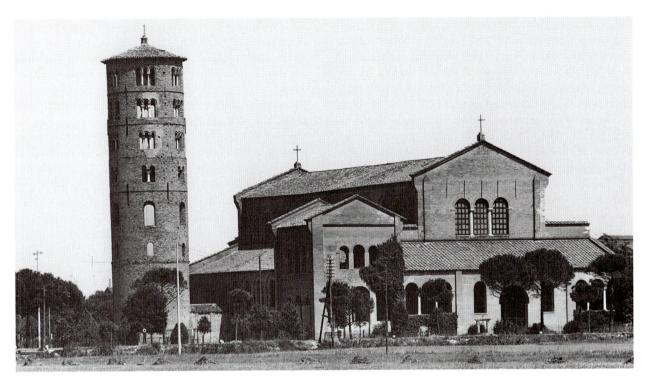

7.15 Sant' Apollinare in Classe, Ravenna, Italy, c. 533–549. The tower is a medieval addition. The clear outlines of the basilica style, with its side aisles, can be clearly seen in the photograph.

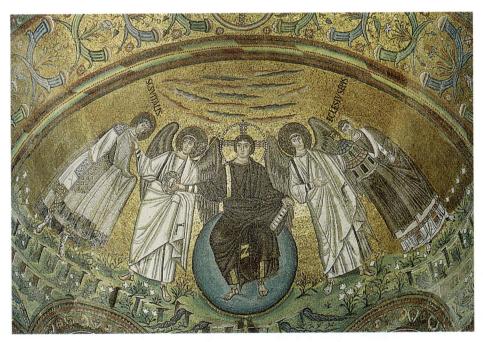

7.16 Christ enthroned, with Saint Vitalis and Bishop Ecclesius. Ceiling mosaic, San Vitale, Ravenna, c. 530. The bishop holds a model of the church at the extreme right while Christ hands the crown of martyrdom to the saint on the left.

Bishop Ecclesius, who laid its foundations. Above the figures are symbolic representations of the four rivers of paradise.

Mosaics to the left and right of the apse mosaic represent the royal couple as regents of Christ on earth. On the left wall of the sanctuary is a mosaic depicting Justin-

ian and his attendants [7.17]. It is no mere accident or exercise of simple piety that the soldiers carry a shield with *chi* and *rho* (the first Greek letters in the name of Christ) or that there are twelve attendants or that the figure of the emperor divides clergy and laity. The emperor considered himself the regent of Christ, an attitude summed

up in the iconographic, or symbolic, program: Justinian represents Christ on earth and his power balances both church and state. The only figure identified in the mosaic is Bishop (later Archbishop) Maximian flanked by his clergy, who include a deacon with a jeweled gospel and a subdeacon with a chained incense pot.

Opposite the emperor's retinue, Empress Theodora and her attendants look across at the imperial group [7.18–7.19]. Theodora holds a chalice to complement the paten ("bread basket") held by the emperor. At the hem of Theodora's gown is a small scene of the Magi bringing gifts to the Christ Child. Scholars disagree whether the two mosaics represent the royal couple bringing the eucharistic gifts for the celebration of the liturgy or the donation of the sacred vessels for the church. It was customary for rulers to give such gifts to the more important churches of their realm. The fact that the empress seems to be leaving her palace (two male functionaries of the court are ushering her out) makes the latter interpretation the more probable one. The women at Theodora's left are striking; those to the extreme left are stereotyped, but the two closest to the empress appear more individualized, leading some art historians to suggest that they are idealized portraits of two of Theodora's closest friends: the wife and daughter of the conqueror of Ravenna, Belisarius.

The royal generosity extended not only to the building and decoration of the Church of San Vitale. An ivory throne, now preserved in the episcopal museum of Ravenna, was a gift from the emperor to Bishop Maximian, the ecclesiastical ruler of Ravenna when San Vitale was dedicated [7.20]. A close stylistic analysis of the carving on the throne has led scholars to see the work of at least four different artists on the panels, all probably from Constantinople. The front of the throne bears portraits of John the Baptist and the four evangelists, while the back has scenes from the New Testament with sides showing episodes from the Old Testament of the life of Joseph. The purely decorative elements of trailing vines and animals show the style of a different hand, probably Syrian. The bishop's throne (cathedra in Latin; a cathedral is a church where a bishop presides) bears a small monogram: "Maximian, Bishop."

The entire ensemble of San Vitale, with its pierced capitals typical of the Byzantine style, its elaborate mosaic portraits of saints and prophets, its lunette mosaics of Old Testament prefigurements of the Eucharist, and monumental mosaic scenes, is a living testimony to the

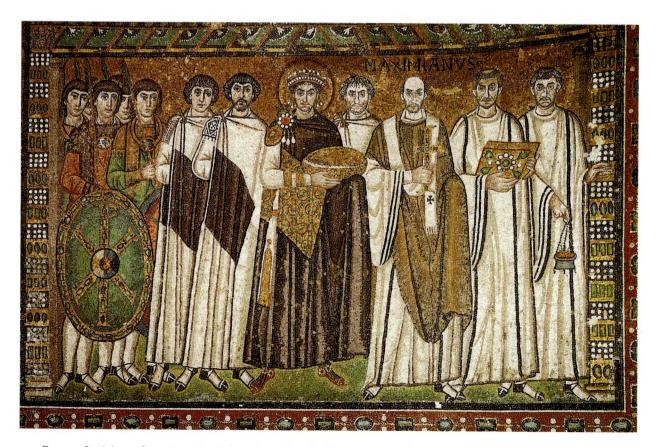

7.17 Emperor Justinian and courtiers. Mosaic from the north wall of the apse, San Vitale, c. 547. The church authorities stand at the emperor's left; the civil authorities at the right.

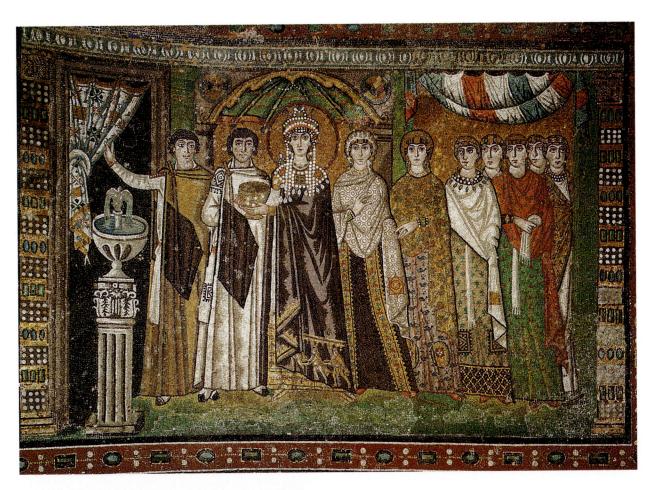

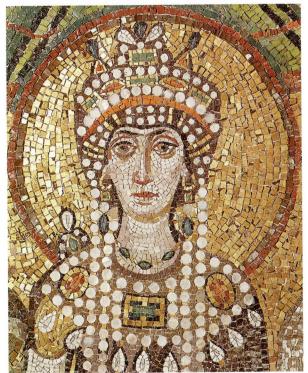

7.19 Empress Theodora. Detail of Figure 7.18, San Vitale, Ravenna, c. 547. Note the irregular placement of the tesserae in this mosaic.

7.18 Empress Theodora and retinue. Mosaic from the south wall of the apse, San Vitale, Ravenna, c. 547. Note the Three Magi on the hem of the empress' gown.

rich fusion of imperial, Christian, and Middle Eastern cultural impulses. San Vitale is a microcosm of the sociopolitical vision of Byzantium fused with the religious worldview of early Christianity.

Saint Catherine's Monastery at Mount Sinai

Justinian is remembered not only in Constantinople and Ravenna but also in the Near East, where he founded a monastery that is still in use some fifteen hundred years later—a living link back to the Byzantine world.

In her *Peregrinatio*, that wonderfully tireless traveler of the fourth century, Etheria, describes a visit to the forbidding desert of the Sinai to pray at the site where God appeared to Moses in a burning bush (that, Etheria assures us, "is still alive to this day and throws out shoots") and to climb the mountain where the Law was given to Moses. She says that there was a church at the spot of the burning bush with some hermits living nearby to tend it and see to the needs of pilgrim visitors. More than a century later, Emperor Justinian built a

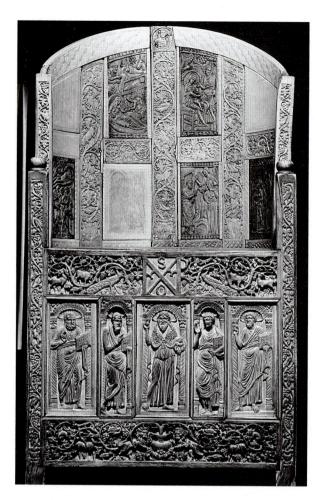

monastery fortress at the foot of Mount Sinai and some pilgrimage chapels on the slopes of the mountain [7.21]. An Arabic inscription over one of the gates tells the story:

The pious king Justinian, of the Greek Church, in the expectation of divine assistance and in the hope of divine promises, built the monastery of Mount Sinai and the Church of the Colloquy [a church over the spot where Moses spoke to God in the burning bush] to his eternal memory and that of his wife, Theodora, so that all the earth and all its inhabitants should become the heritage of God; for the Lord is the best of masters. The building was finished in the thirtieth year of his reign and he gave the monastery a superior named Dukhas. This took place in the 6021st year after Adam, the 527th year [by the calendar] of the era of Christ the Savior.

Because of the number of factors—most important its extreme isolation and the very dry weather—the monastery is an immense repository of ancient Byzantine art and culture. It preserves some of Justinian's architecture and also some of the oldest icons in Christianity. The monastery is also famous as the site of the rediscovery of the earliest Greek codex of the New Testament hitherto

7.20 Bishop's *cathedra* ("throne") of Maximian, c. 546–556. Ivory panels on wood frame. Height 4'11" (1.5 m), width 1'11⁵/₈" (.6 m). Archepiscopal Museum, Ravenna. Maximian is portrayed with his name in the Justinian mosaic (see Figure 7.17).

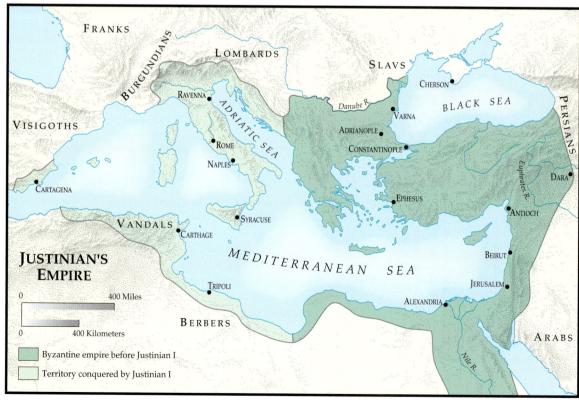

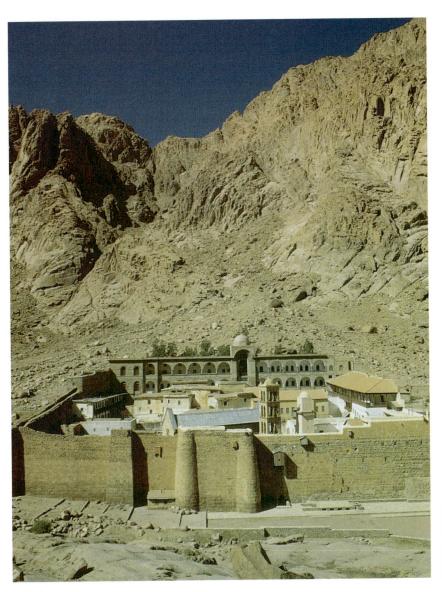

7.21 Fortress monastery of Saint Catherine in the Sinai Desert, sixth century. The church (called the *Katholikon*) from Justinian's time can be seen in the lower center of the walled enclosure, flanked by a bell tower.

found. Called the *Codex Sinaiticus*, it was discovered in the monastery by the German scholar Konstantin von Tischendorf in the nineteenth century. The codex, from the middle of the fourth century, was given by the monks to the Tsar of Russia. In 1933, the Soviet government sold it to the British Museum for £100,000, where it remains today, a precious document.

The monastery is surrounded by heavy, fortified walls, the main part of which date from before Justinian's time. Within those walls are some modern buildings, including a fireproof structure that houses the monastery's library and icon collections. The monastic church, the *Katholikon*, dates from the time of Justinian, as recently discovered inscriptions carved into the wooden trusses in the ceiling of the church prove. Even the name of the architect, Stephanos, was uncovered. This church thus is unique: signed sixth-century ecclesiastical architecture.

One of the more spectacular holdings of the monastery is its vast collections of religious icons. Because of the iconoclastic controversies of the eighth and ninth centuries in the Byzantine Empire, almost no pictorial art remains from the period prior to the eighth century. Sinai survived the purges of the iconoclasts that engulfed the rest of the Byzantine world because of its extreme isolation. At Sinai, a range of icons (the Greek word *icon* means "image") that date from Justinian's time to the modern period can be seen. In a real sense, the icons of the monastery of Saint Catherine show the entire evolution of icon painting.

In the Byzantine Christian tradition, icon refers to a painting of a religious figure or a religious scene that is used in the public worship (the liturgy) of the church. Icons are not primarily decorative and they are didactic only in a secondary sense: For the Orthodox Christian faithful, the icon is a window into the world of the

sacred. Just as Jesus Christ was in the flesh but imaged God in eternity, so the icon is a "thing," but it permits a glimpse into the timeless world of religious mystery. One stands before the icon and speaks through its image to the reality beyond it. This explains why the figures in an icon are usually portrayed full-front with no shadow or sense of three-dimensionality. The figures "speak" directly and frontally to the viewer against a hieratic background of gold.

This iconic style becomes clear by an examination of an icon of Christ that may well have been sent to his new monastery by Justinian himself [7.22]. The icon is done using the *encaustic* method of painting (a technique common in the Roman world for funerary portraits): painting with molten wax that has been colored by pigments. Christ, looking directly at the viewer, is robed in royal purple; in his left hand he holds a jeweled codex and with his right hand he blesses the viewer.

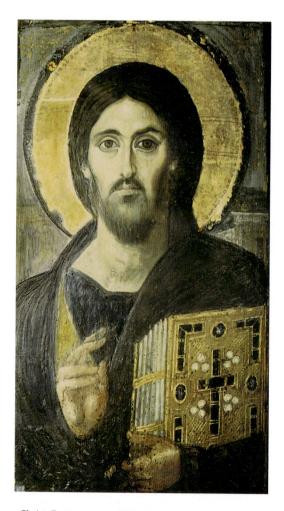

7.22 Christ Pantocrater, c. 500-530. Encaustic on wood panel. $32'' \times 27''$ (84×46 cm). Monastery of Saint Catherine, Mount Sinai. The book is a complex symbol of the Bible, Christ as the Word of God, and the record of human secrets that will be opened on the Last Day.

This icon is an example from a large number found at Sinai that can be dated from before the tenth century. The entire corpus represents a continuous tradition of Byzantine art and piety. Mount Sinai is unique in its great tradition of historical continuity. Despite the rise of Islam, the harshness of the atmosphere, the vicissitudes of history, and the changing culture of the modern world, the monastery fortress at Sinai is living testimony to a style of life and a religiosity with an unbroken history to the time of Justinian's building program.

THE PERSISTENCE OF BYZANTINE CULTURE

It is simplistic to describe Byzantine art as unchanging—it underwent regional, intellectual, social, and iconographic changes—but a person who visits a modern Greek or Russian Orthodox church is struck more by the similarities than by the dissimilarities with the art of early medieval Constantinople. Furthermore, the immediately recognizable Byzantine style can be found in the history of art in areas as geographically diverse as Sicily in southern Italy and the far-eastern reaches of Russia. What explains this basic persistence of style and outlook?

First of all, until it fell to the Turks in 1453, Constantinople exerted an extraordinary cultural influence over the rest of the Eastern Christian world. Russian emissaries sent to Constantinople in the late tenth century to inquire about religion brought back to Russia both favorable reports about Byzantine Christianity and a taste for the Byzantine style of religious art. It was the impact of services in Hagia Sophia that most impressed the delegates of Prince Vladimir, the first Christian ruler in Russia. Although art in Christian Russia was to develop its own regional variations, it was still closely tied to the art of Constantinople; Russian "onion-dome" churches, for example, are native adaptations of the central-dome churches of Byzantium.

Russia, in fact, accepted Christianity about one hundred fifty years after the ban on icons was lifted in Constantinople in 843. By this time the second "golden age" of Byzantine art was well under way. By the eleventh century, Byzantine artists were not only working in Russia but had also established schools of icon painting in such centers as Kiev. By the end of the century, these schools had passed into the hands of Russian monks, but their stylistic roots remained the artistic ideas of Byzantium. Even after the Mongol invasions of Russia in 1240, Russian religious art continued to have close ties to the Greek world, although less with Constantinople than with the monastic centers of Mount Athos and Salonica in Greece.

Byzantine influence was also very strong in Italy. We have already seen the influence of Justinian's court on

Ravenna. Although northern Italy fell to Lombard rule in the eighth century, Byzantine influence continued in the south of Italy for the next five hundred years. During the iconoclastic controversy in the East many Greek artisans went into exile in Italy, where their work is still to be seen. Even while the Kingdom of Sicily was under Norman rule in the twelfth century, Byzantine artisans were still active, as the great mosaics of Monreale, Cefalù, and Palermo testify. In northern Italy, especially in Venice, the trade routes to the East and the effects of the Crusades permitted a strong presence of Byzantine art, as the mosaics of the Church of Saint Mark (as well as Byzantine art looted when the crusaders entered Constantinople in 1204) and the cathedral on the nearby island of Torcello attest. We shall see in later chapters the impact of this artistic presence on panel painting in Italy. Until the revolutionary changes by Cimabue and Giotto at the end of the thirteenth century, the pervasive influence of this style was so great that Italian painting up to that time is often characterized as Italo-Byzantine.

There is another reason that Byzantine aesthetics seem so changeless over the centuries. From the time of Justinian (and even more so after controversies of the eighth and ninth centuries) Byzantine art was intimately tied to the theology and liturgical practices of the Orthodox Church. The use of icons, for example, is not merely a pious practice but a deep-rooted part of the faith. Each year the Orthodox Church celebrated a feast commemorating the triumph of the Icon party called the Feast of the Triumph of Orthodoxy.

Art, then, is tied to theological doctrine and liturgical practice. Because of the innate conservatism of the theological tradition, innovation either in theology or in art was discouraged. The ideal of the artist was not to try something new but to infuse his work with a spirit of deep spirituality and unwavering reverence. This art, while extremely conservative, was never stagnant. The artists strove for fidelity to the past as their aesthetic criterion. As art historian André Grabar has noted, "Their role can be compared to that of musical performers in our day, who do not feel that their importance is diminished by the fact that they limit their talent to the interpretation of other people's work, since each interpretation contains original nuances."

This attitude of theological conservatism and aesthetic stability helps explain why, for example, the art of icon painting is considered a holy occupation in the Eastern Orthodox church. Today, when a new Orthodox church is built the congregation may commission from a monk or icon painter the necessary icons for the interior of the church. The expeditions of scholars who went to Saint Catherine's monastery to study the treasures there recall the sadness they felt at the funeral of a monk, Father Demetrios, in 1958. The last icon painter in the monastery, he marked the end of a tradition that stretched back nearly fifteen hundred years.

Travelers to Mount Athos in Greece can visit (with some difficulty) the small monastic communities (sketes) on the south of the peninsula, where monastic icon painters still work at their art. In our century there has been a renaissance of the appreciation of this style of painting. In Greece there has been a modern attempt to purge icon painting of Western influences (especially those of the Renaissance and the Baroque periods) in order to recover a more authentic link with the great Byzantine tradition of the past. In Russia there has been a surge of interest in the treasures of past religious art. This has resulted in careful conservation of the icons in Russia, exhibits of the art in the museums of Russia and abroad, and an intense scholarly study of this heritage as well as a revival of interest in the Orthodox Church itself.

Byzantine culture was not confined to artistic concerns. We have already seen that Justinian made an important contribution to legal studies. Constantinople also had a literary, philosophical, and theological culture. Although Justinian closed the pagan academies, later Byzantine emperors encouraged humanistic and theological studies. Even though the links between Constantinople and the West were strained over the centuries, those links did remain intact. At first a good deal of Greek learning came into the West (after having been lost in the early Middle Ages) through the agency of Arabic sources. The philosophical writings of Aristotle became available to Westerners in the late twelfth and early thirteenth centuries in the form of Latin translations or Arabic translations of the Greek: Aristotle came to the University of Paris from the Muslim centers of learning in Spain and northern Africa. Not until the fifteenth century did Greek become a widely known language in the West; in the fourteenth century Petrarch and Boccaccio had a difficult time finding anyone to teach them the language. By the fifteenth century this had changed. One factor contributing to the Renaissance love for the classics was the presence in Italy of Greek-speaking scholars from Constantinople.

The importance of this reinfusion of Greek culture can be seen easily enough by looking at the great libraries of fifteenth-century Italy. Of the nearly four thousand books in the Vatican library listed in a catalogue of 1484, a thousand were in Greek, most of which were from Constantinople. The core of the great library of Saint Mark's in Venice was Cardinal Bessarion's collection of Greek books, brought from the East when he went to the Council of Ferrara-Florence to discuss the union of the Greek and Latin churches in 1438. Bessarion brought with him, in addition to his books, a noted Platonic scholar, Genistos Plethon, who lectured on Platonic philosophy for the delighted Florentines. This event prompted Cosimo de' Medici to subsidize the collection, translation, and study of Plato's philosophy under the direction of Marsilio Ficino. Ficino's Platonic Academy, supported by Medici money, became a rallying point for the study of philosophical ideas.

The fall of Constantinople to the Turks in 1453 brought a flood of émigré Greek scholars to the West, in particular to Italy. The presence of these scholars enhanced the already considerable interest in Greek studies. Greek refugee scholars soon held chairs at the various studia ("schools") of the leading Italian cities. These scholars taught language, edited texts, wrote commentaries, and fostered an interest not only in Greek pagan learning but also in the literature of the Greek Fathers of the church. By the end of the fifteenth century, the famous Aldine press in Venice was publishing a whole series of Greek classics to meet the great demand for such works. This new source of learning and scholarship spread rapidly throughout Western Europe so that by the early sixteenth century the study of Greek was an ordinary but central part of both humanistic and theological education.

The cultural worldview of Justinian's Constantinople is preserved directly in the conservative traditionalism of Orthodox religious art and indirectly by Constantinople's gift of Greek learning to Europe during the Renaissance. The great social and political power of the Byzantine Empire ended in the fifteenth century although it had been in decline since the end of the twelfth century. Only the great monuments remain to remind us of a splendid and opulent culture now gone but once active and vigorous for nearly a thousand years.

SUMMARY

This chapter traces briefly the slow waning of Roman power in the West by focusing on two late Roman writers who are both Christians: Boethius, who wrote in provincial Ravenna, and Augustine, who lived in Roman North Africa.

As the wheel of fortune turned downward for Rome, Byzantium began its ascent as the center of culture. Our focus was on the great builder and patron of Byzantine culture, Emperor Justinian and his consort, Theodora. The central feature of their reign is its blending of their political power with the Christian Church so that church and state became a seamless whole. Christianity, which had been a despised and persecuted sect, now became the official religion of the state.

Byzantine Christianity had a readily recognizable look to it, a look most apparent in its art and architecture. It was an art that was otherworldly, formal, and profoundly sacred. A contemporary Orthodox theologian has said that the proper attitude of a Byzantine worshiper is *gazing*. The mosaics and icons of this tradition were meant to be seen as windows through which the devout might view the eternal mysteries of religion. No conscious attempt was made to be innovative in this art.

The emphasis was always on deepening the experience of sacred mystery.

The influence of this art was far-reaching. Italo—Byzantine styles of art persisted in the West up to the beginnings of the Italian Renaissance. These same styles entered Russia at the end of the tenth century and still persist. Today, students can visit Greek or Russian churches and see these art forms alive as part of traditional Christian Orthodox worship and practice.

Because Byzantium (centered in the city of Constantinople) was Greek-speaking, the culture of ancient Greece was kept alive in that center until the middle of the fifteenth century, when the city fell to the Ottoman Turks. The removal of much of that culture to the West was a strong influence on the development of the Renaissance, as we shall see in subsequent chapters.

PRONUNCIATION GUIDE

Anthemius: An-THEE-me-us
Boethius: Bow-E-thee-us
Chrysostom, John: CHRIS-o-stam, Jon
Galla Placidia: Gala Plah-SID-e-ah
Hagia Sophia: Ha-GE-ah So-FEE-ah

Honorius: Ho-NOR-e-us Justinian: Jus-TIN-e-an Maximian: Max-IM-e-an Ravenna: Rah-VEN-ah

Sant' Apollinare: Sahnt Ah-pole-een-ARE-eh

San Vitale: Sahn Vee-TAHL-eh
Theodora: Thee-ah-DOOR-ah
Theodoric: Thee-AH-door-ick
Tribonian: Tree-BONE-e-an

EXERCISES

- Augustine understood the word confessions to mean both an admission of sin and a statement of belief. Why is that term so useful and correct for an autobiography? Do most modern autobiographies constitute a confession in Augustine's sense of the term?
- 2. In The City of God Augustine defines peace as "the tranquillity of order." What does he mean? Is that definition a good one?
- 3. The outstanding art of the Byzantine period is the mosaic. What made mosaic such a desirable art form for the period? What do you see as its limitations?
- 4. Take a long look at the Ravenna mosaics of Justinian and Theodora and their court. Taken as a whole, what political and social values show through in the composition of the scenes?
- 5. Look carefully at the various depictions of Christ found in Byzantine mosaics and icons. Which religious values are underscored in those depictions? Which values are neglected?
- 6. Define the word *icon* and be sure you understand its function in Orthodox Christianity. Is there anything comparable in contemporary art in terms of function?

7. Byzantine art prided itself on not changing its style but on preserving and perfecting it. Is there something to be said for continuity rather than change in artistic styles? What are the more apparent objections to such a philosophy?

FURTHER READING

Beckwith, John. (1961). *The art of Constantinople*. New York: Phaidon. A reliable survey with good illustrations.

Brown, Peter. (1967; 2nd edition, 1999). Augustine of Hippo. Berkeley: University of California Press. A brilliant biography.

Cormack, Robin. (1986). Writing in gold: Byzantine society and its icons. New York: Oxford University Press. Good cultural study.

Kazhdan, Alexander (Ed.). (1991). The Oxford dictionary of Byzantium (3 vols.). New York: Oxford University Press. Standard reference work.

Mango, Cyril. (1986). *Art of the Byzantine Empire:* 312–1453. Toronto: University of Toronto Press. A survey by a noted scholar.

Rodley, Lyn. (1994). *Byzantine art and architecture: An introduction.* New York: Cambridge University Press. An upto-date survey.

Simson, Otto von. (1948). *The sacred fortress*. Chicago: University of Chicago Press. A classic work.

Ware, Timothy. (1969). *The orthodox church*. Baltimore: Penguin. Excellent introduction to Orthodox faith and practice.

ONLINE CHAPTER LINKS

Byzantine Studies on the Internet at

http://www.fordham.edu/halsall/byzantium/ provides an extensive list of links to related Web sites.

For introductory information about Byzantine art as well as links to sites related to representative artists, consult *Artcyclopedia* at

http://www.artcyclopedia.com/history/byzantine.html

Experience a virtual tour of the churches and monuments of Ravenna at

http://www.akros.it/comuneravenna/artefruk.htm

	GENERAL EVENTS	LITERATURE & PHILOSOPHY	Art
500	570–632 Life of Muhammad 622 Muhammad flees to Mecca; this year now marks the beginning of the Muslim calendar		1
600	610–733 Spread of Islam to Arabia, Egypt, Syria, Iraq, and parts of northern Africa 638 Muslims capture Jerusalem	Circa 530–850 Development of Kufic script Qur'an develops and with it the tradition of Hadith or religious commentary Development of Shar'a, the Islamic legal code 651 Publication of Qur'an	
700	 700 Islam spreads to all of northern Africa and to southern Spain 732 Charles Martel holds off Muslim northern expansion at Tours 794 First paper factory established in Baghdad 		730–843 Muslim belief that God's divinity defies representation leads to a blend of intricate geometric design and sacred script in Muslim art and architecture
		 801 Death of Rabia, Sufi saint and poet 833 House of Wisdom established in Baghdad, drawing scholars from all over the Muslim world, translating and preserving many Greek texts 780-850 Al-Khwarizmi, inventor of algebra, develops use of zero as a number 	
1100	1099 Crusading Christians capture Jerusalem	(980–1037) Avicenna, philosopher- scientist	
1200		(1126–1198) Averröes (1135–1204) Maimonides, great Jewish thinker, physician, Talmudist	
1400	1258 Mongols sack Baghdad 1281 Ottoman Empire founded	1207–1273 Life of Rumi, perhaps the best-known Sufi mystic-poet	
1500	 1453 Constantinople falls to Ottoman Turks, ending Byzantine Empire; Church of Hagia Sophia becomes a mosque 1492 Muslims driven from Spain in the "Reconquista" 		
1600	1526–1858 Mughal Reign in India	(
1700			
1800			

CHAPTER 8 ISLAM

ARCHITECTURE

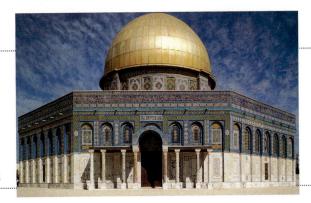

687–692 Dome of the Rock

706–715 Great Mosque of Damascus built by Al Walid

Circa 790 Great Mosque of Córdoba begun

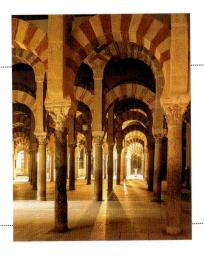

Circa 980 Al-Hakam enhances existing structure

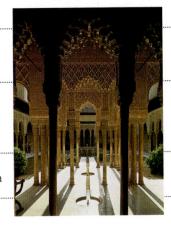

1200 - 1300 The Alhambra

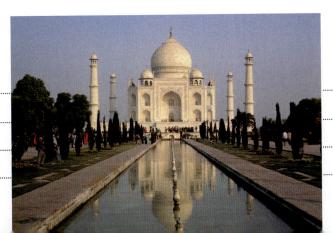

I 532 Cathedral begun inside the Great Mosque of Córdoba

1632-1647 Taj Mahal

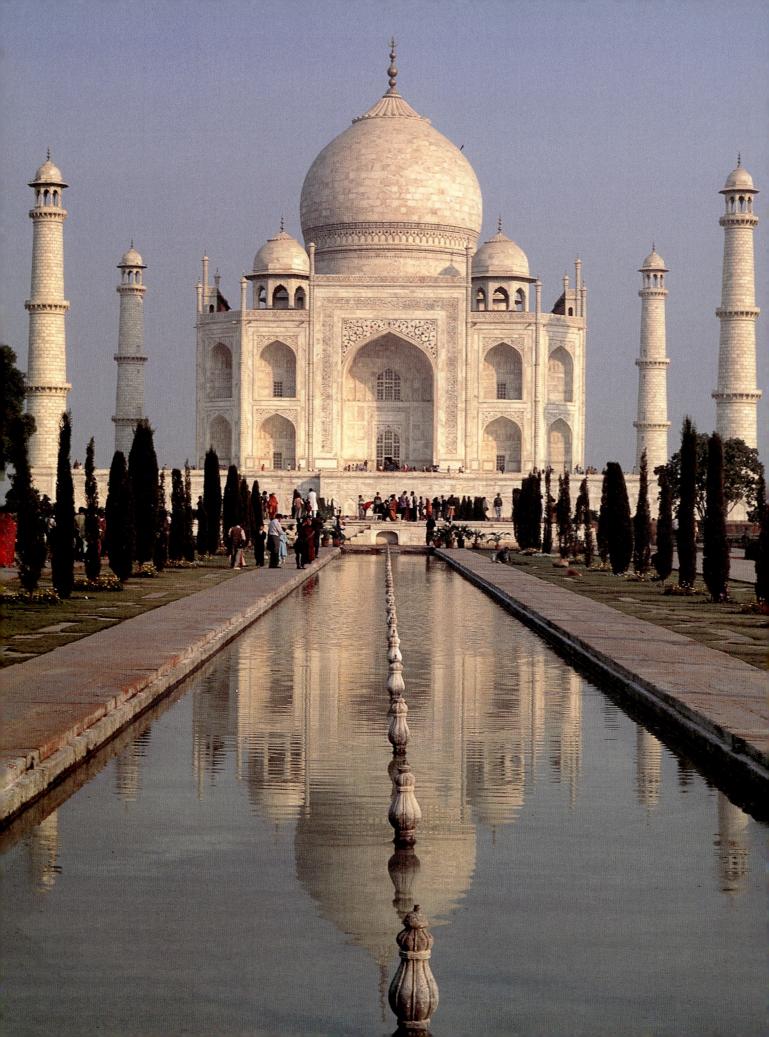

CHAPTER 8 ISLAM

MUHAMMAD AND THE BIRTH OF ISLAM

http://www.webstories.co.nz/focus/deserts/hittmai2.htm

Muhammad

uhammad, the founder of Islam, was born in 570 in the Arabian city of Mecca. Orphaned as a child and reared in poverty, while still young he married a rich widow who would bear him a daughter, Fatima. Fatima would later marry the first Imam (authoritative religious leader) of the Shiites. As an ancestor of all followers of Islam, Fatima is highly venerated by all Muslims as a model of piety and purity. Muhammad's deep religious nature led him to ponder the reasons for his good fortune and he began to retreat into caves in the neighboring mountains to meditate. At about the age of forty, he began receiving revelations from God through the agency of the angel Gabriel. When he began to speak publicly about his ideas of religious reform, Muhammad soon encountered severe opposition from the citizens of Mecca who had little patience with his sermons against the city's prevalent idolatry and his insistence on the worship of one God. The antagonism was so adamant that he had to flee the city in 622, a year the Muslims now mark as the beginning of their calendar: the hegira.

In Medina, his city of refuge, Muhammad soon attracted a community of supporters. He achieved such success in this endeavor that he was able, less than ten years later, to return to Mecca and make its once pagan shrine called the Qa´aba (Arabic for "cube") the focal point of his new religion. It did not take him long to consolidate his hold over that city.

By the time Muhammad reached Mecca the rough outlines of the basis for his religion were already in place. The fundamental principle of the faith was a bedrock monotheism (the word *Islam* means "submission [to God]"). This belief was a conscious rejection of the Christian doctrine of the Trinity of persons in God. The prophet began to articulate the so-called five pillars of Islam:

http://www.islamzine.com/pillars/

Five Pillars

- 1. The recitation of the Muslim act of faith that there is one God and that Muhammad is God's messenger.
- 2. The obligation to pray five times a day in a direction that points to the Qa´aba in Mecca. Soon there was added the obligation to participate in Friday prayers as a community and hear a sermon.
- 3. To donate a portion of the surplus of one's wealth to charity.
- 4. To fast during the holy month of Ramadan—a total abstinence of all food and drink from sunrise to sunset.
- 5. To make a pilgrimage to Mecca (called the *Haj*) at least once in a lifetime.

That latter obligation was performed by Muhammad himself around the purified and restored Qa'aba in 632, which was the same year he died in the arms of his wife. The pilgrimage to Mecca today draws millions of faithful to Mecca [8.1].

In addition to these core practices there are other characteristic practices of Islam: like Jews, Muslims do not eat pork products. Unlike Judaism and Christianity, Islam forbids the consumption of alcoholic beverages. Muslim males are circumcised. Polygamy is permitted under Islamic law but not practiced universally. The taking of interest on loans or lending for interest (usury) is forbidden by Islamic law. Over the course of time a

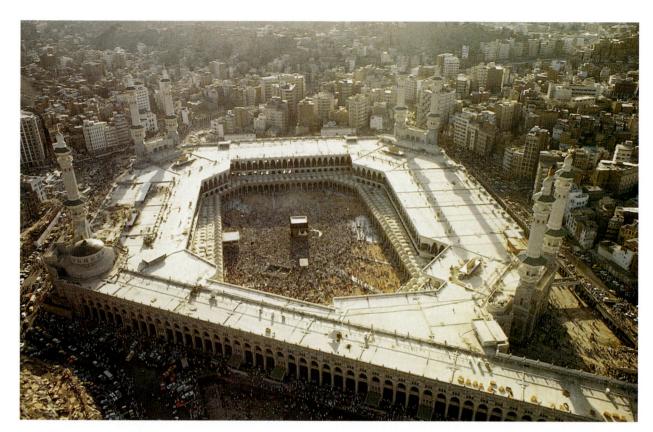

8.1 The Sanctuary at Mecca. This is the central focus of the Islamic pilgrimage in Mecca. Pious pilgrims circle the draped black stone (*Qa'aba*) upon which, it is believed, one can see the footprints of Abraham. The left and front of the *Qa'aba* is the tomb of Ishmael, from whom Muslims trace their descent.

cycle of feast days and observances developed (e.g., the birthday of the Prophet).

The very simplicity of the original Islamic teaching its emphasis on submission to the will of the one God, its insistence on daily prayer, its appeal for charity, and a demand for some asceticism in life—all help to explain the phenomenal and rapid spread of this new religion coming out of the deserts of Arabia. In less than ten years after the death of the Prophet, Islam had spread to all of Arabia, Egypt, Syria, Iraq, and parts of North Africa. A generation after the Prophet's death, the first Muslim attack (unsuccessful) on Constantinople was launched; within two generations Muslims constituted a forceful majority in the holy city of Jerusalem. By the eighth century, Islam had spread to all of North Africa (modernday Libya, Morocco, Tunisia, and Algeria) and had crossed the Mediterranean near Gibraltar to create a kingdom in Southern Spain.

The Qur'an

Evidently, many of the revelations received by the Prophet during his life at both Mecca and Medina were

maintained orally, but soon after his death followers began to write down the revelations as they had received them from him. Within a generation, a serious attempt was made to collate the various oral revelations with a view of producing a uniform edition of the revelations received both at Medina and Mecca. The net result of these long editorial efforts resulted in a central sacred text of Islam called the *Qur'an* (sometimes spelled *Koran*; the word is Arabic for "recitation").

http://www.islamzine.com/quran/introq.html

Qur'an

The Qur'an is roughly as long as the Christian New Testament. The book is divided into one hundred fourteen chapters (called $s\hat{u}rahs$). There is an opening chapter in the form of a short prayer invoking the name of God followed by one hundred thirteen chapters arranged in terms of their length, with chapter two being the longest and the final chapter only a line or two long. Muslims have devised ways of dividing these chapters; for example, into thirty parts of near equal length so that one could complete reciting the entire book during the thirty days of the sacred month of Ramadan, which is a time of intense devotion accompanying the annual fast.

The language of the *Qur'an* is Arabic. Like all Semitic languages (e.g., Hebrew and Syriac) the text is written and read from right to left. Since Muslims believe that

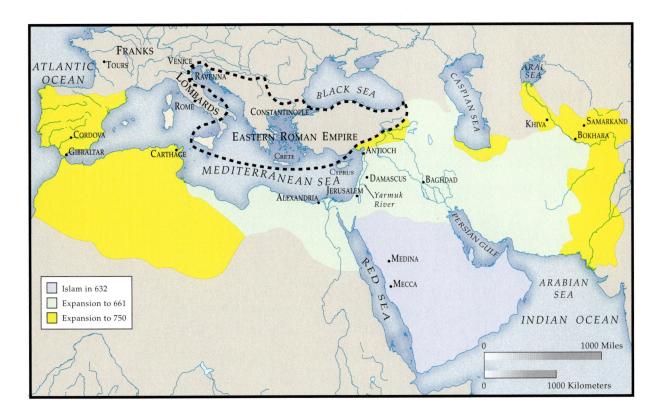

the Qur'an came as a result of divine dictation, it cannot be translated into other languages. While many vernacular versions of the Qur'an exist, they are considered to be paraphrases or glosses. The result of this conviction is that no matter where Muslims live they will hear the Qur'an recited only in Arabic. Although Arabs (contrary to popular belief) make up a relatively small proportion of the total Muslim population of the world (the largest Muslim population resides in Indonesia), the Qur'an serves as a source of unification for all Muslims. Reverence for the Qur'an, further, means that it is literally God's word to people and as such is held in the highest reverence. Committing the entire Qur'an to memory is a sign of devotion and the capacity to chant it aloud is a much-admired gift since the beauty and care of such recitation is deemed an act of religious piety in its own right. Today, public competitions of recitations of the Qur'an are a regular feature on radio and television in Muslim countries. In cities having a Muslim majority it is not uncommon to find radio stations that feature a reading of the *Qur'an* twenty-four hours a day.

The *Qur'an* is the central text of Islam, but there is also another authoritative tradition which has shaped Islamic religion and culture. Authoritative commentators on the *Qur'an* and the explication of certain oral traditions about the Prophet and the early Islamic community constitute a body of literature called *Hadith*. From this living stream of sacred text and tradition Islamic sages and jurists have developed a complex legal code called

Shari'a ("law"). When Muslim countries are described as adopting Islamic law for its governance, it is *Shari'a* that is being referred to. Like all legal codes *Shari'a* is both traditional and conservative yet adaptable to the needs and circumstances of time.

http://www.usc.edu/dept/MSA/fundamentals/hadithsunnah/scienceofhadith/atit.html

Hadith

Calligraphy

Calligraphy comes from two Greek words that mean "beautiful writing." It was only natural that such skills would be developed in order to render adequate honor to the written text of the *Qur´an*. The evolution of Arabic script is a long and highly complex study in its own right but certain standard forms of writing were developed. One of the most characteristic form of this writing, although it also admits of many variations, is called *Kufic* [8.2].

http://www.islamic-awareness.org/Quran/Text/Mss/kufic.html

Kufic script

Such calligraphic skills were brought to bear not only on the text of *Qur'an* itself but also as a decorative

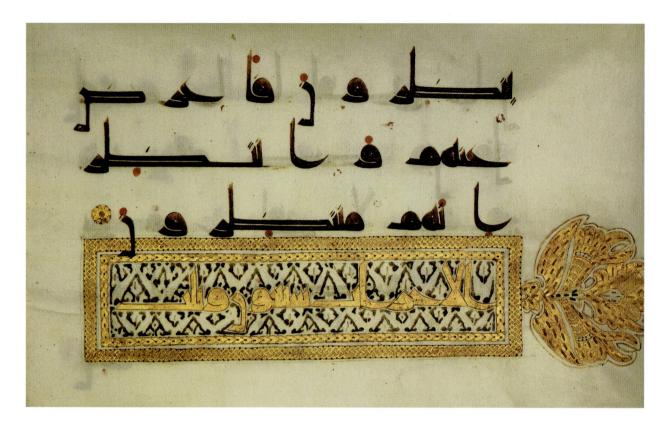

8.2 Page from the *Qur'an*, eighth century(?), $8'' \times 13''$ (21.6 \times 32.5 cm). Museum of Islamic Art, Berlin. The highly stylized calligraphy is known as *Kufic* script; it is one of the earliest and most beautiful of Arabic calligraphy styles.

feature of public buildings—especially the great halls erected for assemblies of the faithful for Friday prayers and the sermons preached at the end of those prayers. These buildings are called *mosques* (from the Arabic word *masjid*, meaning "a place for ritual prostration"). Perhaps nothing is so familiar to people then pious Muslim men kneeling in prayer, touching their heads to the ground, in the great mosques of the world. This act of prostration can be "read" as a gesture touching the heart of the religion: to prostrate is to show "submission" to God (in Arabic, *Allah*).

The exterior and interior decoration of the great classical mosques are always done in an art form that emphasizes the abstract and the geometric because Muslims believe that one cannot depict divinity since Allah is beyond all imagining. It is therefore commonplace to see an intricate blend of abstract geometric designs entwined with exquisitely rendered sacred texts from the *Qur'an*. Some of the decoration found on the exterior of mosques, like that found decorating the great seventeenth-century Friday Mosque of Ishfahan in Iran uses blue tiling to set forth intricate patterns of arabesques and highly stylized bands of calligraphic renderings of lines from the *Qur'an* [8.3].

Although Islamic decoration is usually abstract it is not exclusively so. Some mosques do in fact have representational scenes in the interior. These usually depict nonhuman images of plants and flowers executed mainly in mosaic—especially when the skills of Byzantine mosaic artists were available to do such work. One does not find in such art narrative scenes since very little of the *Qur'an* has a narrative quality.

Islamic Architecture

Islam has a fifteen-hundred-year history. Its communities are found in every part of the world. In that long history it has built its buildings suitable to the circumstances in which it finds itself even though the basic needs of the mosque remain fairly constant: a large covered space for the faithful to pray especially when the community gathers for Friday prayers. Typically, the gathering area is covered with rugs; except for the steps leading up to a minbar (the "pulpit"), there is no furniture in a mosque. A niche in the wall called a michrab indicates the direction of Mecca so that the faithful at prayer are accurately oriented East. In traditional Friday mosques, there is also usually some type of fountain so that the devout may ritually cleanse their hands, feet, and mouth before prayer. Adjacent to the mosque is a tower or minaret so that the Muezzin may call the faithful to prayer five times a day. Visitors to Muslim countries soon become accustomed to the Muezzin's predawn call, "Wake up! Wake up! It is better to pray than to sleep. . . ."

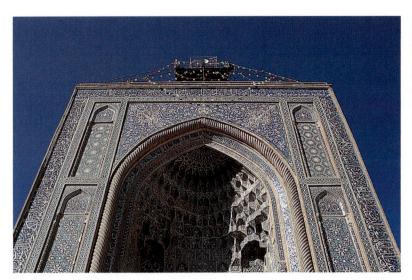

8.3 The Portal of the Ishafan Mosque (1611–1666). Notice the Islamic script that decorates both long piers of the portal (entrance) as well as the script that is on the lintel below the coffered ceiling. The interplay of calligraphy and abstract design is typical of mosque decoration in various periods.

While primarily designed to shelter the faithful at prayer, the mosque serves a larger community function in Islam. It is a community gathering center; it is a place where scholars meet to study and debate; courtroom proceedings could be held there; leisurely conversations could be held in its courtyards and people could escape the heat of the sun in its covered areas. As scholars have noted, the mosque is to Islamic countries what the Roman forum or the precincts of the medieval cathedral or the town square were to other cultures: a gathering place for the community to express itself as community.

The simple requirements for the mosque leaves much for the ingenuity and genius of the individual architect to develop. As a result, the history of Islamic architecture provides extraordinary examples of art.

The Dome of the Rock in Jerusalem is the earliest and one of the most spectacular achievements of Islamic architecture [8.4] built toward the end of the seventh century by Caliph Abd al Malik in Damascus on the Temple Mount in Jerusalem. The Temple Mount is an elevated space that was once the site of the Jewish temple destroyed by the Romans in A.D. 70. The Dome of the Rock is an octagonal building capped by a golden dome which sits upon a heavy drum supported by four immense piers and twelve columns. The interior is decorated lavishly with mosaics as was the outside of the building until, in the late Middle Ages, the mosaics were replaced by tiles. The building owes a clear debt to Roman and Byzantine architecture, but its Qur'anic verses on the inside make it clear that it was to serve an Islamic function.

What was that function? Was its original purpose to be a mosque? a masoleum? It may well have been erected to serve as a counterpoint to the Church of the Holy Sepulcher in Jerusalem acting as a rebuff in stone to Christianity, making the artistic argument (as the Qur'an itself does) that Islam is a worthy successor both to Judaism and to Christianity. Built around a still-visible rock outcropping, it is not totally clear what the original purpose of the building was. Scholars still do not agree on the building's original purpose (some have even argued that it was built as a rival to the Qa'aba in Mecca), but all are unanimous that it is a splendid example of Islamic architecture. A ninth-century story speaks of it commemorating the spot of the night journey of the Prophet from Jerusalem to heaven, whereas other traditions speak of it as being the place where Abraham (regarded by Muslims as the first great prophet) sacrificed his son (whom the Muslims believe was Ishmael) or the place where Adam died and was buried. Apart from the tiling of the exterior in more modern times, the building stands pretty much as it did when first built two generations after Muhammad's death.

The great Mosque of Damascus, built by Abd al Malik's son, al Walid (died 715), on the site of what had been a Roman temple turned into a Byzantine church, used the massive walls surrounding the church complex as the walls of the mosque itself [8.5]. The building within the walls had its façade facing the inside of the walls (mosques tend to be inward looking). The interior prayer hall had three spaces each separated by heavy columns. Like the Dome of the Rock the interior was decorated lavishly with the lower walls paneled in marble and the upper registers decorated (by Byzantine craftsmen) with mosaics including a depiction of heaven resplendent with palaces and flowing waters [8.6]. The caliph's palace (now gone) was next to the mosque so that the ruler could pass easily from his home to the mosque.

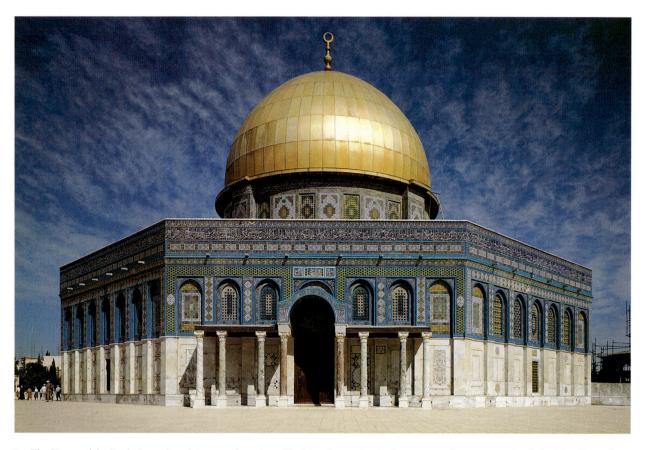

8.4 The Dome of the Rock, Jerusalem, late seventh century. The blue decoration in the upper registers are made of tile. The tile work replaces earlier mosaic work that probably was done by Byzantine craftsmen who were acknowledged experts in that art.

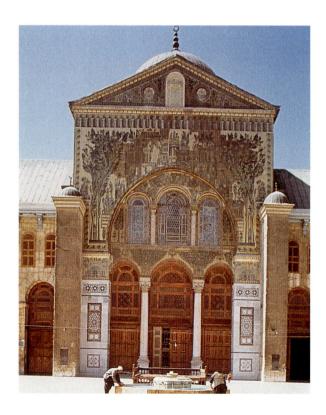

8.5 Courtyard of the Great Mosque of Damascus (c. 715). Worshippers at Friday prayers would gather in the courtyard as a spillover from the building itself. The mosque is built over a former Christian church; details of the earlier church (façade, laterals, and dome) may be detected in the architecture of the mosque itself.

http://www.greatbuildings.com/buildings/ Great_Mosque_of_Damascus.html

Great Mosque of Damascus

One final mosque showing the relationship of Islamic architecture and Byzantine decoration is the great mosque in Córdoba (Spain). Muslims arrived in Spain in the eighth century and made Córdoba their capital. Construction began on a mosque in the late eighth century with additions both to the courtyard and the prayer hall itself executed in the ninth and tenth century. In the late tenth century, Al-Hakam, the ruler of the city, decided to enhance his mosque to make it a rival of the great mosque in Damascus. The interior of the mosque seems to be a vast tangle of columns supporting Roman arches [8.7]. To enhance the interior, Al-Hakam sent emissaries to the emperor in Constantinople with a request for

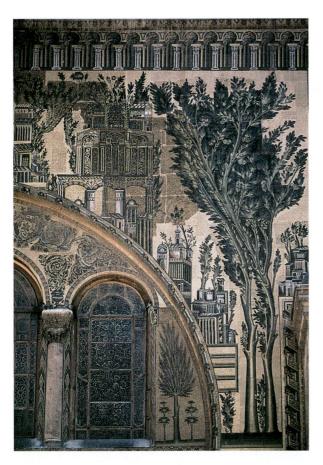

8.6 Mosaic Decoration in the Damascus Mosque, early eighth century. Even though trees and houses are easily detectable in the mosaic, the absence of any human figure is striking. This absence reflects early Islamic resistance to depicting the human figure.

workmen. Contemporary sources state that the emperor complied not only with workmen but also sent roughly seventeen tons of tesserae. The master mosaic artist, who enjoyed the hospitality of the caliph, decorated the interior of the mosque lavishly finishing his work, according to an inscription, in 965 [8.8]. The mosque managed to survive the destruction of Islamic building when the Christians drove the Muslims out of Spain in 1492—the period known as the *Reconquista*. Within the confines of the mosque, an undistinguished cathedral was begun in 1532 and much of its original interior still remains today.

One other notable Islamic building in Spain that escaped the destruction of Muslim architecture during the Reconquista was the palace complex in Granada known as the Alhambra. Its beauty was so renowned that an inscription of a poet's line on one of its exterior towers urging donations for the blind beggars of the city bears witness:

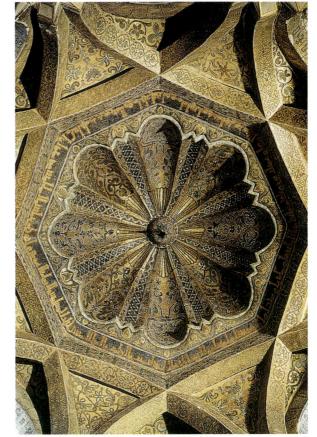

8.7 Central Dome of the Mosque of Córdoba, mid-tenth century. The decoration of the mosque, done a century after its building, is elaborate. Contemporary records show that the ruler of Córdoba imported 30,000 mosaic tessarae and workmen from Constantinople to do the work.

Give him alms, good woman, For in life there is nothing like the heartache Of being blind in Granada.

The exterior of the Alhambra, with its complex of towers and walls, provides no hint of the beauty of its interior. Built largely in the thirteenth and fourteenth centuries, the Alhambra actually consists of two adjacent palaces: the Palace of the Myrtles (so-called because of the myrtle plants in the gardens) and the Palace of the Lions [8.9]. Both palaces have central courtyards with covered walkways or porches. The Palace of the Myrtles was evidently used for public occasions; the Palace of the Lions was designed as a private home. The interiors were decorated lavishly with colored tiles and intricate woodwork. The most cunning aspect of this complex is the use of water, which runs through small interior streams springing up into fountains. The quiet murmur of the water is evident in all parts of the palaces so that one gains a sense of both interior space connected to the outside by the sound of water. The mid-fourteenth century Court of the Lions is perhaps the most representative

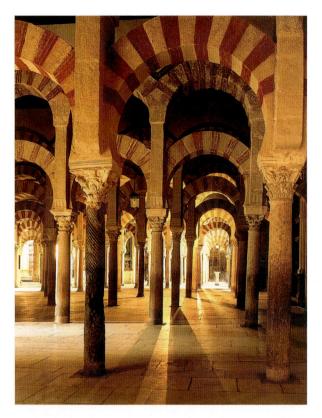

8.8 Maqsura screen of the Córdoba Mosque. The elaborate stone work columns cordoned off the space called the *maqsura*, which was the place where the ruler and his elite company would worship in the mosque.

example of the opulence within the Alhambra: slender columns; careful wooden ceiling work; molded plaster decoration; delicate tracery providing a frame for the fountain in the center held up by lions; and the water trough running to a simple circular bubbling fountain set in the tiled floor.

No discussion of Islamic architecture would be complete without reference to one of the most fabled buildings in all the world: India's Taj Mahal. From the eleventh century on, Muslim raiders arrived at the Indian subcontinent in large numbers. The high point of Muslim culture in India developed under the reign of a series of emperors known as the *Mughals*. Their long reign lasted from 1526 to 1858. India still prides itself in the many architectural, artistic, and literary works produced under these rulers.

http://www.islamicart.com/library/empires/india/taj_mahal.html

Taj Mahal

The great Emperor Shah Jahan (died 1666) had a wife named Mumtaz Mahal (the "palace favorite") who died (1632) giving birth to their fourteenth child. Overwhelmed by grief, the emperor began a vast building complex a year later to house her body and to honor her memory. Scholars debate the complex's completion (as early as 1647; as late as 1652), but everyone agrees that it is one of the great masterpieces of world architecture and design. The building is now quite emblematic of India; it has been used in advertisements to attract tourists to the country.

Set on the banks of the river Jumna at the outskirts of the city of Agra, the central building is crowned with a great dome set on an octagonal building which houses four pavilions. The central building, which is the empress's tomb, is framed by four slender minarets [8.10]. The building, made from highly polished white marble (unlike the traditional red sandstone favored by the Mughal architects), gives the complex a shimmering quality. The exterior decorations of the building are restrained with little attempt to add any color beyond the whiteness of the polished marble.

The complex of minarets and the domed tomb are placed in a large garden setting which has reflecting pools, providing a coolness for the gardens while reflecting the whiteness of the Taj Mahal. The complex seen as a whole is inspired by the description of paradise found in the *Qur'an*. The righteous will find a paradise which is

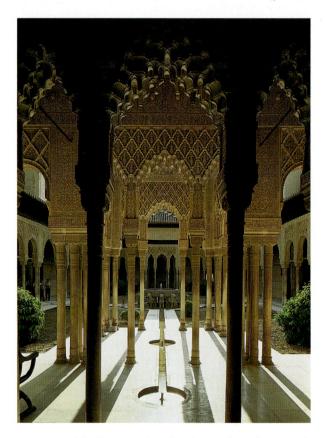

8.9 Court of the Lions in the Alhambra in Granada (c. 1391). This final great piece of Islamic architecture is characterized by the slender delicacy of its interior. Note the waterway and fountains at the level of the floor.

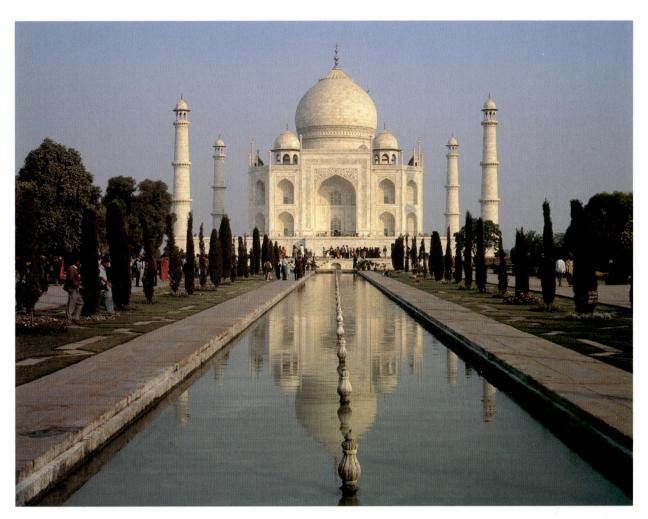

8.10 Taj Mahal, Agra, India (1631–1647).

depicted as a lush garden, abundant in water, and shimmering in the light of Allah.

Sufism

Like all of the world's religions, Islam has various traditions within it. About 85 percent of all Muslims belong to what is called the *Sunni* ("well trod") tradition. A significant minority (the majority in Iran) are members of the *Shi'a* (meaning "party" or "tradition") branch of Islam. Within those two large branches are various minor branches and traditions. From the perspective of Muslim literature, one of the most influential of these traditions is *Sufism.* The name *Sufi* most likely derives from the Arabic word for unbleached wool—the simple clothing many Sufis adopted.

Sufism is a word that describes a very ancient and highly complex movement of communities or small groups of teachers of immense religious authority called sheyks and their disciples that emphasized practices and disciplines that would lead a person to come to some di-

rect experience of God in this life. In other words, Sufism represents the mystical dimension of Islam. Like most mystical movements in a religious tradition, Sufism was sometimes embraced with enthusiasm by religious and civil authorities, while at other periods they and their practices were looked at with suspicion or downright hostility. In its earliest manifestations, Sufi mystics tended to live a life of retirement in poverty, preaching to people about piety and repentance.

While there are many forms of Sufism in Islamic history, it has been a significant thread in Muslim life to the present. Sufi *tariqas* ("communities") are to be found in various Muslim lands with a significant presence in North Africa and Egypt. Westerners have expressed a keen interest in Sufi practices with most large bookstores stocking translations of Sufi texts.

Two representative Sufi writers might provide us with some sense of the range of Sufi thought and expression.

The Sufi woman Saint Rabia, known as the flute player (died 801), regarded a highly developed sense of the love of God as the key to union with God. Kidnapped and sold into slavery as a child, after receiving a grant of freedom from her master she became convinced that she was one of God's chosen ones. Rabia expressed

CONTEMPORARY VOICES

Lastly, I turned to the way of the mystics. I knew that in their path there has to be both knowledge and activity and that the object of the latter is to purify the self from vices and faults of character. Knowledge was easier for me than activity so I began by reading their books . . . Then I realized that what is most distinctive of them can be attained only by personal experience, ecstasy, and change of character. I saw clearly that the mystics

were people of personal experience not of words, and that I had gone as far as possible by way of study and intellectual application, so that only personal experience and walking in the mystic way was left. . . .

Al-Ghazali (1058–1111) reflecting on his discovery of the Sufi path during his lifetime of philosophical study and research. Some see his quest for truth to be like that of the Christian writer, Saint Augustine of Hippo.

her convictions in a series of aphorisms, poems, and meditations. Her intuition about love derived from her conviction that the *Qur'an* is filled with verses speaking about the concern that Allah has for His people and the corresponding love that we should have for Allah. Like many mystics (and others concerned with the issue of love), Rabia enunciated her sayings most frequently in the form of poetry. Her focus on the love of God was highly central so she taught that when one loved God centrally in one's life, such a focus would exclude any fear of damnation as well as any hope for paradise. Love would be its own concern. "The best thing in the whole world," she once wrote, "is to possess nothing in this world or the next world except Allah."

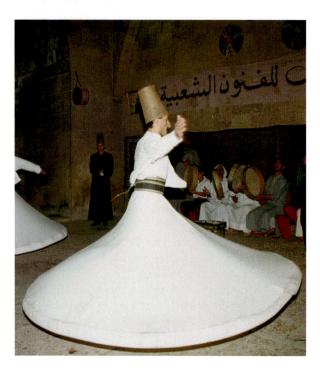

8.11 Dancing Dervishes. Many Sufi Orders practice dancing to the accompaniment of musical instruments. The practice, not universally admired by Muslims, may represent the souls of the just whirling toward paradise.

Perhaps the most famous of the Sufi mystic poets was the thirteenth-century writer known as Rumi (1207–1273). Born in what is now Afghanistan, Rumi moved with his family to what is present-day Turkey. A prolific writer of religious verse in a form that used rhyming couplets developed by earlier Sufis, Rumi, writing in the Persian language, composed more than three thousand poems while also leaving behind seventy long discourses on mystical experience. His poetic corpus is extensive and so powerfully expressed that some have called his body of work the "Qur'an" in Persian. He was most admired for his capacity to take almost any observable ordinary thing and turn his observance of it into a poem of religious praise.

One feature of Rumi's poetry was his practice of reciting his poems while dancing in a formal but ecstatic fashion. Rumi believed that the combination of recitation and movement would focus the devotee's total attention on Allah. Rumi founded a community of these ecstatic dancers (*dervishes*), whose practitioners continue ecstatic dancing to this day [8.11].

THE CULTURE OF ISLAM AND THE WEST

One of the high points of Islamic culture in its earlier history was centered in the city of Baghdad (present-day Iraq) under the Abbasid Dynasty, which flourished in the eighth and ninth centuries. It was there that papermaking was learned from a Chinese prisoner who had learned the process in China, where papermaking had long been commonplace. Baghdad opened its first papermaking factory in 794. It would be some centuries before this process would pass to the West. Caliph Al-Mamun built a library and study center, completed in 833, which was known as the *Bait al-hikma* (the "House of Wisdom"). It was to that center that scholars flocked from all over the Muslim world.

A crucial part of the scholarly labors at the House of Wisdom was the translation of texts into Arabic. It is to this center that we owe the preservation of the works of

VALUES

Islam, considered as a culture, is a highly complex reality that contains various religious, philosophical, artistic, and theoretical currents. One thing, however, that is fundamental in Islam is its unbending teaching about the oneness of God; the Islamic statement of faith begins: "There is but One God, Allah. . . . " To grasp this belief in radical monotheism is to understand a whole variety of issues connected to Islam which have been touched on in our brief survey. The word Islam means "submission" to God. Since God is almighty his divinity is hidden from humanity; as a consequence Allah may not be depicted in artistic form. Because the revelation of Allah is final and definitive, Islam sees the reality of God beyond the revelation of the God of the Jewish Scriptures and is explicitly resistant to the trinitarian faith of Christianity. Jesus is honored as a prophet, but the idea of Jesus as divine is denied in the pages of the *Qur'an*. The *Qur'an* insists that the revelation to Muhammad brought the pure monotheism of Moses back to its original meaning. Whether God's power is such that it controls all human activity has been a subject of discussion among Islamic thinkers since the early medieval period who divide into the "free will" and "predestination" schools relative to human activity.

The fundamental monotheism of Islam also helps to explain why Islam has a tradition of missionary expansion. The omnipotent will of God is for all humanity to submit to God; if people are not aware of that fact they are not living according to the will of God. Hence, the devout are encouraged to teach people this fundamental truth.

Aristotle that were translated into Arabic by a team of Greek-speaking Christians who were in the center's employ. It is estimated that every text of Aristotle we know today (except *Politics*) was translated in the House of Wisdom. Additionally, these scholars translated a number of Platonic texts, the medical texts of Galen, and many treatises of the Neo-Platonic authors. When scholars (like Saint Thomas Aquinas) read Aristotle in Paris in the thirteenth century, they did so in Latin versions translated from Arabic manuscripts—the work of the scholars of Baghdad.

The greatest single scholar at the House of Wisdom was the polymath researcher Al-Khwarizmi (780–850), who made revolutionary discoveries. He led three expeditions to India and Byzantium in order to gather manuscripts and meet other scholars. As a consequence, Al-Khwarizmi had at his disposal much learning from both Indian and Byzantine (Greek) sources. He invented algebra (the word *algebra* derives from the title of one of his books). Medieval Europeans who knew his writings in Latin gave us another important mathematical term, which is a corruption of his name: *algorithm*.

http://www-groups.dcs.st-and.ac.uk/~history/ Mathematicians/Al-Khwarizmi.html

Al-Khwarizmi

The most important contribution made by Al-Khwarizmi was his adaptation of Hindu notations for numbers that used nine symbols and a placeholder. This simplified numerical system replaced the clumsy Greek and Latin notational system as any person who has tried to multiply CLXII by LIV instead of 162×54 will testify. The Hindu placeholder called *sunya* in Sanskrit and *cifra*

("cipher") in Arabic came to be called *zero* in the West, was now regarded not merely as a placeholder, but as a number. One further advance, made in the next century by an otherwise obscure Syrian Muslim named Al-Uqlidisi, was the development of decimal fractions which then permitted, for example, the computation of a solar year at 365.242199 days.

Although these profound mathematical advances developed very rapidly in the Islamic world, their development in the West would be slow. It would take nearly one hundred fifty years before these ideas entered the Christian West via translations in those places that had the closest connection to the Muslim world, namely, Sicily (not a distant voyage from North Africa) and especially through that part of Spain which was Muslim.

Mathematics, however, was not the only area where Islamic scholarship advanced. The Egyptian scientist Al-Hazen (died 1038) did crucial work in optics and on the theory of the grinding and making of lenses. Three other scholars in the Muslim world who had had contact with Greek medicine and other sources shaped the future of medicine. Rhazes (died 932), head of the hospital in Baghdad, excelled in clinical observation, giving the world for the first time a clear description of smallpox and measles, demonstrating that they were two quite distinct diseases. It was from the observations of Rhazes that other scientists began to understand the nature of infection and the spread of infectious diseases. In the following two centuries, influential writers like Avicenna (died 1037) and Averröes (died 1198), in addition to their important work in philosophy, wrote influential treatises in medicine. The important Jewish thinker Moses Maimonides (died 1204) was trained first as a physician. He stressed the need for personal hygiene as a way of avoiding disease (a concept uncommon in his day) and had done influential work on the nature of poisons. Maimonides was so renowned as a physician that he was called from his native Spain to serve as personal doctor to the sultan of Baghdad, Saladin. The high reputation of Jewish doctors trained in Arabic medicine was such that the popes consulted Jewish physicians who lived in the Jewish quarter across from the Vatican right through the Renaissance period.

The Islamic world in the centuries between the culture of the Abassid Dynasty in Baghdad and the flourishing culture of North Africa and Muslim Spain also gave Europe a number of goods through trade that were legendary for their quality. The swordmakers of both Damascus (Syria) and Toledo (Spain) were legendary for their quality. The woven silk of Damascus still lingers in our word *damask*. Among the earlier gifts of the Muslim world is coffee. The plants, native to tropical Africa, became a common hot beverage when Muslim traders in Ethiopia began to pulverize the beans to brew the drink. So popular was the result that in a very short time one could find in Mecca, Damascus, and even in Constantinople, an institution popular to this day: the coffeehouse.

Despite the antagonism between the Christian West and the Islamic world there was a common exchange of ideas and goods between the two worlds. The results were widespread. The West learned how to make windmills from the Muslims. Many words entered the vocabulary of the West from Arabic sources. These include agricultural words (orange, lemon, sugar, saffron, syrup, alcohol); words that reflected Islamic geographical researches into navigation and mapmaking (zenith and nadir) as well as now common words like sherbet (via Persian from the Arabic sherbah—"drink").

Finally, as emphasized in other chapters, Muslim scholars provided not only a great body of Greek philosophical writing but a vast commentary on it in the High Middle Ages. When Al-Ghazali (died 1111) attacked Greek philosophy in a book called *The Incoherence of the Philosophers*, he was answered by Averröes who wrote a treatise showing how Islam could be reconciled with Greek philosophy. Averröes called his book *The Incoherence of Incoherence*. A century after his death, Dante would salute Averröes in his *Divine Comedy* by calling him "He of the Great Commentary," even though Dante regarded Muhammad and Islam with fearful disdain.

SUMMARY

Muhammad always thought of the new revelation he had received from God as a new religion which could unify the whole human race under one God and bring with it amity among nations. Islam regards itself as the final perfection of God's revelation first announced to the Jews and later to the Christians. For that reason, Muhammad's religion was an unapologetic missionary faith. Within two hundred years Islam had spread from the desert

world of Arabia throughout present-day Middle East and along the southern coast of the Mediterranean Sea and the Iberian peninsula of present-day Southern Spain; much of this dispersion came via military conquest.

Islam's rise coincided with a period of stagnation in what was the Christian West. The old Roman Empire was in a state of decline, having been hammered by successive waves of Barbarian invasions. The Byzantine Empire with its capital at Constantinople controlled only the city itself and its adjacent territories. It was an essentially inward looking, conservative, and noninnovative culture. Islam, by contrast, was a vigorous young religious culture and at its apex—when the Abassids ruled from its center in Baghdad and later in Damascus and Córdoba—was innovative and forward-looking.

While Islamic incursions were halted in the West in the generations before Charlemagne, and Muslims would not take possession of Constantinople until the fifteenth century, there were constant exchanges between the two cultures even though they warred against each other with ferocity (i.e., the Crusades). This hostility shows up clearly in the West. The Muslims, in Christian eyes, were simply the "Infidel" and their wickedness is a theme in *The Song of Roland*, where their beliefs and their practices were criticized and twisted into parody. The Christian Crusades had the express aim to wrest the Christian holy places from these "Infidels." It should not surprise us that Dante comes to describe the walls of the city of hell as crenellated walls with domes of "fiery mosques."

The antagonism between the Christian West and the world of Islam has a long and bitter history. It is an antagonism that reflects itself today in the stereotyping of Muslims as backward, fundamentalist terrorists out to ruin the world. The irony is, of course, that we read such things on paper—an innovation that the House of Wisdom in Baghdad gave to the West in the medieval period. The real truth is that Islam is a highly complex and deeply rich culture in which religion is so central that it cannot be disentangled from political and social culture. Islam has a long tradition of learning and the arts with a worldview that attempts to explain the place of people in the social order under the watchful eye of an all-powerful God who is adored under the name of Allah.

Pronunciation Guide

Al-Ghazali: All Ga-zall-e Al-Khwarizmi: All-Kwa-riz-me Averröes: ah-ver-oh-es Hadith: Hah-dith Hegira: Hay-jeer-ah Michrab: Mick-rab Qa'aba: Caw-ah-bah Qur'an: Coor-awn Rhazes: Rah-zes Sura: Soo-rah

Taj Mahal: Tarigas: Taj Maw-hall Tar-e-kas

EXERCISES

- Contrast the interior space of a mosque and a Christian basilica. What similarities can be noted? differences?
- Is the Muslim concept of Allah compatible with the biblical view of God? Explain why or why not.
- Look at a map to see where the closest points of contact were in the eighth century between Islamic countries and the Christian West.
- 4. How does the Muslim gesture of kneeling and profoundly bowing at prayer symbolize their basic belief in God? Be attentive in future chapters to the attitude of the Christian West to the rise of Islam.

FURTHER READING

Bloom, J., & S. Blair. (1998). *Islamic arts*. London: Phaidon. Excellent survey.

Esposito, J. (1998). *Islam: The straight path* (5th ed.). New York: Oxford University Press. A standard work.

Irwin, R. (1997). *Islamic art in context: Art, architecture and the literary world.* New York: Harry Abrams. Very good interdisciplinary text.

Lewis, B. (Ed.). (1976). *The world of Islam.* London: Thames & Hudson. Authoritative work.

Schimmel, A. (1976). Mystical dimensions of Islam. Chapel Hill: University of North Carolina. A standard study.

ONLINE CHAPTER LINKS

Internet Islamic Historic Sourcebook at

http://www.fordham.edu/halsall/islam/islamsbook.html provides an extensive list of links related to Web sites.

For information about Islam, consult

http://www.sim.org/islam

which offers a guide to understanding Muslim religion, history, and culture.

Extensive information about the *Qur'an* is available at these Web sites:

Holy Qur'an Resources on the Internet at

http://www.quran.org.uk/

The Noble Qur'an at

http://www.usc.edu/dept/MSA/quran/

Islamzine.com at

http://www.islamzine.com/quran/

Audio readings from the *Qur'an* are available at http://www.islaam.com/audio/quran/

Extensive information related to the hajj is available through a large number of links found at http://www.ummah.net/hajj/

Extensive information related to the hadith is available through a large number of links found at http://islamicity.com/mosque/sunnah/

To view an online collection of Islamic ceramics at Oxford University's Ashmolean Museum, visit http://www.ashmol.ox.ac.uk/ash/departments/

Among the sites providing valuable information related to the Taj Mahal are

http://www.taj-mahal.net/topEng/index.htm http://www.liveindia.com/tajmahal/index.html http://users.erols.com/zenithco/tajmahal.html http://www.angelfire.com/in/myindia/tajmahal.html 768

EARLY MIDDLE AGES

II65 Charlemagne canonized at Cathedral of Aachen

I187 Sultan Saladin conquers Jerusalem

I202 – I204 Fourth Crusade; sack of Constantinople by crusaders

1270 Eighth Crusade

1291 Fall of Acre, last Christian stronghold in Holy Land

711 Muslims invade Spain

714–741 Charles Martel, grandfather of Charlemagne, reigns as first ruler of Frankish kingdom

732 Charles Martel defeats Muslims at Battle of Poitiers

741 – 768 Reign of Pepin the Short, father of Charlemagne

735 Death of Venerable Bede, author of *Ecclesiastical History of the English People* and other religious writings

768 Charlemagne ascends Frankish throne

772–778 Charlemagne's military campaigns against Muslim Emirates

778 Battle of Roncesvalles

c. 790 Charlemagne settles his court at Aachen (Aix-la-Chapelle)

800 Charlemagne crowned Holy Roman emperor at Rome by Pope Leo III

814 Death of Charlemagne

910 Founding of monastery at Cluny

987–996 Reign of Hugh Capet in France ends Carolingian line of succession

after 780 Carolingian minuscule form of lettering developed

781 Charlemagne opens palace school, importing such scholars as Theodulf of Orléans and Alcuin of York

785 Alcuin, Sacramentary

after 814 Carolingian monasteries adopt *Rule* of Saint Benedict of Nursia (480–547?)

821 Einhard, Vita Caroli (Life of Charlemagne)

after 950 Hroswitha's Thais

IIth cent. Pilgrimages become very popular

1066 Norman invasion of England by William the Conqueror

1096–1099 First Crusade; capture of Jerusalem by Christians

c. 1098 Song of Roland, chanson de geste inspired by Battle of Roncesvalles, written down after 300 yrs. of oral tradition

12th cent. Development of liturgical drama

c. 1125 Saint Bernard of Clairvaux denounces extravagances of Romanesque decoration

14th – 15th cent. Play cycles performed outside the church; *Everyman* (15th cent.), morality play

THI

1400

CHAPTER 9 CHARLEMAGNE AND THE RISE OF MEDIEVAL CULTURE

Music ARCHITECTURE ART

8th-9th cent. Irish Book of

Illuminated manuscripts

c. 775 Centula Evangeliary

and carved ivories

prevalent

and

Dagulf

Psalter

Monastic complexes become important centers in rural life

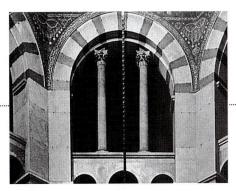

c. 795 Palace and chapel of Charlemagne at Aachen

c. 820 Plan for Abbey of Saint Gall, the "ideal" monastery

c. 800 Monasteries become centers for encouragement of sacred music; theoretical study of music at Charlemagne's palace school

9th cent. Use of semidramatic trope in liturgical music; Quem Quaeritis trope introduced into Easter Mass

c. 810 Gregorian plain chant (cantus planus) obligatory in Charlemagne's churches

822 Earliest documented church organ

IIth-I2th cent. Gregorian

chant codified

800–810 Gospel Book of Charlemagne

early 9th cent. Crucifixion Ivory, done at palace school of Charlemagne

c. 820-840 Utrecht Psalter

II20-II32 Sculptures at Abbey Church of La Madeleine, Vézelay

c. I I 40 Portal sculptures at Priory Church, Saint-Gilles-du-Gard

candelabra commissioned

by Frederick Barbarossa for canonization of Charlemagne

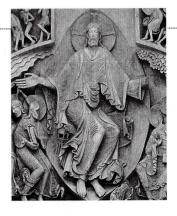

Use of massive walls and piers, rounded arches, and minimal windows

c. 1071-1112 Pilgrimage church at Santiago de Compostela, Spain

c. 1080-1120 Church of Saint Sernin, Toulouse, pilgrimage center

1088-1130 Great Third Church at Cluny

1096-1120 Abbey Church of La Madeleine, Vézelay

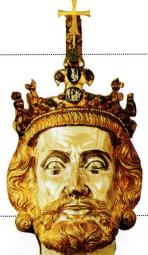

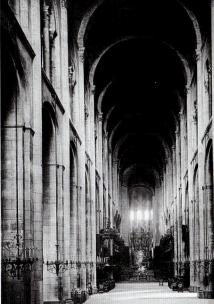

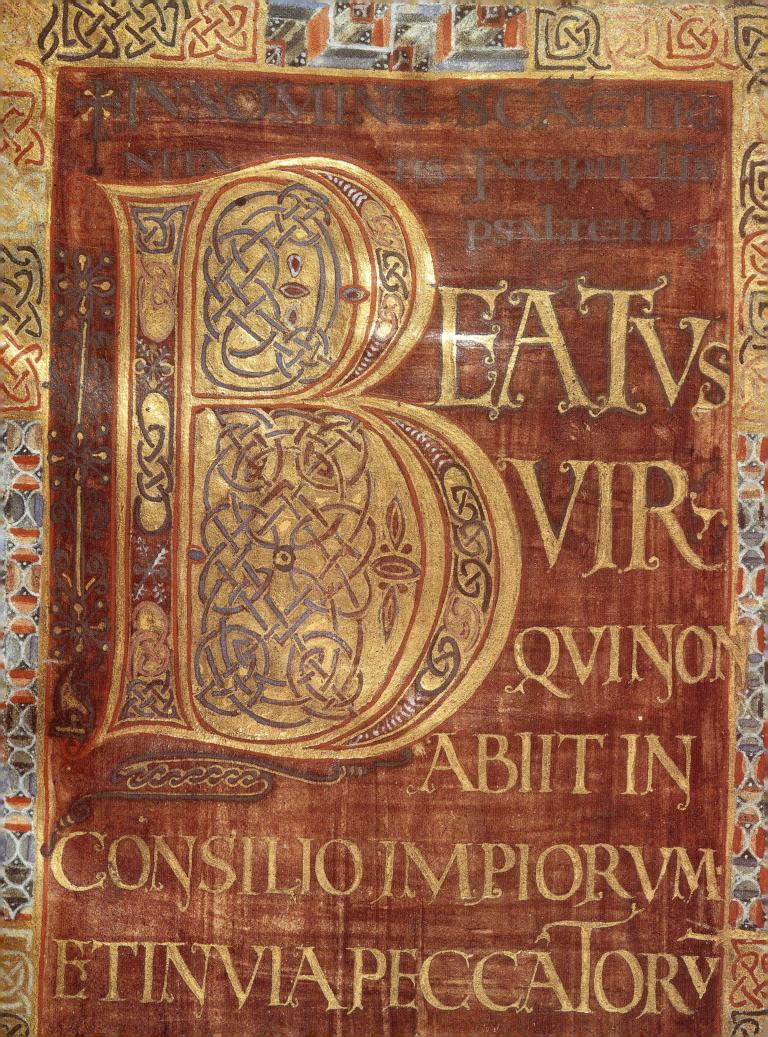

CHAPTER 9

CHARLEMAGNE AND THE RISE OF MEDIEVAL CULTURE

CHARLEMAGNE AS RULER AND DIPLOMAT

http://www.bulfinch.org/legends/welcome.html

Charlemagne

harles the Great (742?-814)—known to subsequent history as Charlemagne—was crowned emperor of the Roman Empire in Saint Peter's Basilica in Rome on Christmas Day A.D. 800 by Pope Leo III, in the first imperial coronation in the West since the late sixth century. The papal coronation was rebellion in the eyes of the Byzantine court, and the emperor in Constantinople considered Charlemagne a usurper, but this act marked the revival of the Roman Empire in the West.

Charlemagne was an able administrator of lands brought under his subjugation. He modified and adapted the classic Roman administrative machinery to fit the needs of his own kingdom. Charlemagne's rule was essentially feudal-structured in a hierarchical fashion, with lesser rulers bound by acts of fealty to higher ones. Lesser rulers were generally large landowners who derived their right to own and rule their land from their tie to the emperor. Charlemagne also maintained a number of vassal dependents at his court who acted as counselors at home and as legates to execute and oversee the imperial will abroad. From his palace the emperor regularly issued legal decrees modeled on old Imperial Rome decrees [9.1]. These decrees were detailed sets of instructions that touched on a wide variety of secular and religious issues. Those that have survived give us some sense of what life was like in the very early medieval period. The legates of the emperor carried the decrees to the various regions of the empire and reported back on their acceptance and implementation. This burgeoning bureaucratic system required a class of civil servants with a reasonable level of literacy, an important factor in the cultivation of letters that was so much a part of the so-called Carolingian Renaissance.

The popular view of the early Middle Ages—often referred to as the Dark Ages-is that of a period of isolated and ignorant peoples with little contact outside the confines of their own immediate surroundings, and at times that was indeed the general condition of life. Nonetheless, it is important to note that in the late eighth and early ninth centuries Charlemagne not only ruled over an immense kingdom (all of modern-day France, Germany, the Low Countries, and Italy as far south as Calabria) but also had extensive diplomatic contact outside that kingdom. Charlemagne maintained regular, if somewhat testy, diplomatic relations with the emperor in Constantinople (at one point he tried to negotiate a marriage between himself and Byzantine Empress Irene in order to consolidate the two empires). Envoys from Constantinople were received regularly in his palace at Aachen, and Charlemagne learned Greek well enough to understand the envoys speaking their native tongue.

Charlemagne's relationship with the rulers of Islamic kingdoms is interesting. Islam had spread all along the southern Mediterranean coast in the preceding century. Arabs were in complete command of all the Middle East, North Africa, and most of the Iberian peninsula. Charlemagne's grandfather Charles Martel (Charles the Hammer) had defeated the Muslims decisively at the Battle of Poitiers in 732, thus halting an Islamic challenge from Spain to the rest of Europe. Charlemagne himself had fought the Muslims of the Córdoba caliphate on the Franco–Spanish borders; the Battle of Roncesvalles (778) was the historical basis for the later epic poem the *Song of Roland*.

http://www.fordham.edu/halsall/source/roland-ext.html

Song of Roland

Despite his warlike relationship with Muslims in the West, Charlemagne had close diplomatic ties with the great Harun al-Rashid, the caliph of Baghdad. In 787, Charlemagne sent an embassy to the caliph to beg

9.1 Charlemagne's seal, ninth century. Archives Nationales, Paris. This Roman gem with the head of a philosopher or an emperor was used on official documents by Charlemagne, impressed on wax. The inscription reads *Christ protect Charles King of the Franks*.

protection for the holy places of the Christians in Muslim-held Palestine. The caliph (of *A Thousand and One Nights* fame) received and welcomed the Frankish legates and their gifts (mainly bolts of the much-prized Frisian cloth) and sent an elephant back to the emperor

as a gesture of friendship. This gift arrived at Aachen and lived there for a few years before succumbing to the harsh winter climate. Charlemagne's negotiations were successful. From a pair of Palestinian monks he received the keys to the church of the Holy Sepulchre and other major Christian shrines, an important symbolic act that made the emperor the official guardian of the holiest shrines in Christendom.

Charlemagne's reign was also conspicuous for its economic developments. He stabilized the currency system of his kingdom. The silver *denier* struck at the royal mint in Frankfurt after 804 became the standard coin of the time; its presence in archaeological finds from Russia to England testifies to its widespread use and the faith traders had in it.

Trade and commerce were vigorous. Charlemagne welcomed Jewish immigrants to his kingdom to provide a merchant class for commerce. There were annual trade fairs at Saint Denis near Paris, at which English merchants could buy foodstuffs, honey, and wine from the Carolingian estates. A similar fair was held each year at Pavia, an important town of the old Lombard kingdom of northern Italy. Port cities such as Marseilles provided mercantile contracts with the Muslims of Spain and North Africa. Jewish merchants operated as middlemen in France for markets throughout the Near East. The chief of Charlemagne's mission to Harun al-Rashid's court was a Jew named Isaac who had the linguistic ability and geographic background to make the trip to Baghdad and back—with an elephant—at a time when travel

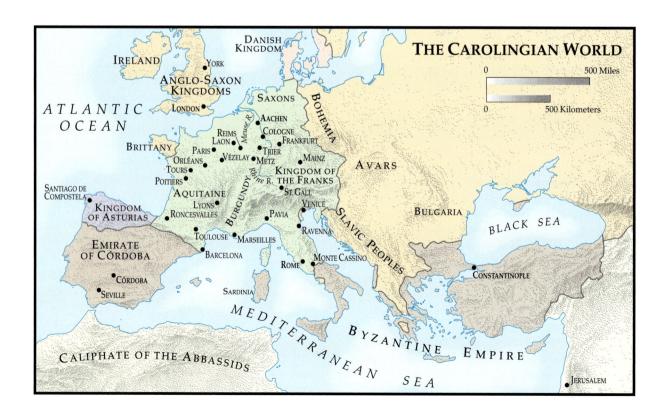

was a risky enterprise. Rivers such as the Rhine and the Moselle were utilized as important trade routes. One of the most sought-after articles from the Frankish kingdom was the iron broadsword produced at forges in and around the city of Cologne and sold to Arabs in the Middle East through Jewish merchants at the port cities. Vivid testimony to their value can be read in the repeated embargoes (imposed under penalty of death) decreed by Charlemagne against their export to the land of the Vikings, who too often put them to effective use against their Frankish manufacturers in coastal raids on North Sea towns and trading posts.

LEARNING IN THE TIME OF CHARLEMAGNE

At Aachen, Charlemagne opened his famous "palace school"—an institution that was a prime factor in initiating what has been called the Carolingian Renaissance. Literacy in Western Europe before the time of Charlemagne was rather spotty; it existed, but hardly thrived, in certain monastic centers that kept alive the old tradition of humanistic learning taken from ancient Rome. Original scholarship was rare, although monastic copyists did keep alive the tradition of literary conservation. Charlemagne himself could not write.

The scholars and teachers Charlemagne brought to Aachen provide some clues as to the various locales in which early medieval learning had survived. Peter of Pisa and Paul the Deacon (from Lombardy) came to teach grammar and rhetoric at his school since they had had contact with the surviving liberal arts curriculum in Italy. Theodulf of Orleans was a theologian and poet. He had studied in the surviving Christian kingdom of Spain and was an heir to the encyclopedic tradition of Isadore of Seville and his followers. Finally and importantly, Charlemagne brought an Anglo-Saxon, Alcuin of York, to Aachen after meeting him in Italy in 781. Alcuin had been trained in the English intellectual tradition of the Venerable Bede (died 735), the most prominent intellectual of his day, a monk who had welded together the study of humane letters and biblical scholarship. These scholar-teachers were hired by Charlemagne for several purposes.

http://justus.anglican.org/resources/bio/169.html

Venerable Bede

First, Charlemagne wished to establish a system of education for the young of his kingdom. The primary purpose of these schools was to develop literacy; Alcuin of York developed a curriculum for them. He insisted

that humane learning should consist of those studies which developed logic and science. It was from this distinction that later medieval pedagogues developed the two courses of studies for all schooling prior to the university: the *trivium* (grammar, rhetoric, and dialectic) and the *quadrivium* (arithmetic, geometry, music, and astronomy). These subjects remained at the heart of the school curriculum from the medieval period until modern times. (The now much-neglected "classical education" has its roots in this basic plan of learning.)

Few books were available and writing was done on slates or waxed tablets because parchment was expensive. In grammar, some of the texts of the Latin grammarian Priscian might be studied and then applied to passages from Latin prose writers. In rhetoric, the work of Cicero was studied, or Quintilian's Institutio Oratoria, if available. For dialectic, some of the work of Aristotle might be read in the Latin translation of Boethius. In arithmetic, multiplication and division were learned and perhaps there was some practice on the abacus, since the Latin numerals were clumsy to compute with pen and paper. Arithmetic also included some practice in chronology as students were taught to compute the variable dates of Easter. They would finish with a study of the allegorical meaning of numbers. Geometry was based on the study of Euclid. Astronomy was derived from the Roman writer Pliny, with some attention to Bede's work. Music was the theoretical study of scale, proportion, the harmony of the universe, and the "music of the spheres." Music at this period was distinguished from cantus, which was the practical knowledge of chants and hymns for church use. In general, all study was based largely on rote mastery of the texts.

Beyond the foundation of schools, Charlemagne needed scholars to reform existing texts and to halt their terrible corruption, especially those used in church worship. Literary revival was closely connected with liturgical revival. Part of Charlemagne's educational reform envisioned people who would read aloud and sing in church from decent, reliable texts. Literacy was conceived a necessary prerequisite for worship.

It was mainly Alcuin of York who worked at the task of revising the liturgical books. Alcuin published a book of Old and New Testament passages in Latin for public reading during Mass. He sent for books from Rome in order to publish a *sacramentary*, a book of prayers and rites for the administration of the sacraments of the church. Alcuin's sacramentary was made obligatory for the churches of the Frankish kingdom in 785. Charlemagne made the Roman chant (called *Gregorian* after Pope Gregory the Great, who was said to have initiated such chants in the end of the sixth century) obligatory in all the churches of his realm. Alcuin also attempted to correct scribal errors in the Vulgate Bible (the Latin version of Saint Jerome) by a comparative reading of manuscripts—a gigantic task he never completed.

http://www.solesmes.com/anglais/ang_solesmes.html

Gregorian Chant

Beyond the practical need for literacy there was a further aim of education in this period. It was generally believed that all learning would lead to a better grasp of revealed truth—the Bible. The study of profane letters (by and large the literature of Rome) was a necessary first step toward the full study of the Bible. The study of grammar would set out the rules of writing, while dialectic would help distinguish true from false propositions. Models for such study were sought in the works of Cicero, Statius, Ovid, Lucan, and Vergil. These principles of correct writing and argumentation could then be applied to the study of the Bible in order to get closer to its truth. The pursuit of analysis, definition, and verbal clarity are the roots from which the scholastic form of philosophy would spring in the High Middle Ages. Scholasticism, which dominated European intellectual life until the eve of the Renaissance, had its first beginnings in the educational methodology established by Alcuin and his companions.

These educational enterprises were not centered exclusively at the palace school at Aachen. Under Charlemagne's direction, Alcuin developed a system of schools throughout the Frankish Empire-schools centered in both monasteries and towns. Attempts were also made to attach them to parish churches in the rural areas. The monastic school at Metz became a center for singing and liturgical study; schools at Lyons, Orleans, Mainz, Tours, and Laon had centers for teaching children rudimentary literary skills and offered some opportunity for further study in the liberal arts and the study of scripture. The establishment of these schools was accomplished by a steady stream of decrees and capitularies emanating from the Aachen palace. A circular letter, written most likely by Alcuin, called On the Cultivation of Learning, encouraged monks to study the Bible and to teach the young to do the same. A decree of 798 insisted that prelates and country clergy alike start schools for children.

This program of renewal in educational matters was an ideal set forth at a time when education was at a low ebb in Europe. Charlemagne tried to reverse that trend and in so doing encouraged real hope for an educated class in his time. His efforts were not entirely successful; many of his reforms came to naught in following generations when Europe slipped back into violence and ignorance.

Most of those who were educated were young men although there is some evidence of learning among the aristocratic women of Charlemagne's court. The only book written by a Frankish woman in his time was a sort

of manual for Christian living written by Dhouda for her own son. We do, however, know that there had to be a certain level of literacy for nuns and there is also some evidence that illuminated manuscripts that have come to us were done by women in such convents.

BENEDICTINE MONASTICISM

Monasticism—from the Greek *monos* ("alone")—was an integral part of Christianity from the third century on. Monasticism came into the West from the great Eastern tradition of asceticism (self-denial) and eremitism (the solitary life). Its development in the West was very complex, and we cannot speak of any one form of monasticism as predominant before the time of Charlemagne.

Celtic monasticism in Ireland was characterized both by austere living and by a rather lively intellectual tradition. Monasticism in Italy was far more simple and rude. Some of the monasteries on the continent were lax, and Europe was full of wandering monks. No rule of life predominated in the sixth and seventh centuries. Monastic lifestyles varied not only from country to country but also from monastery to monastery.

The Rule of Saint Benedict

One strain of European monasticism derived from a rule of life written in Italy by Benedict of Nursia (480-547?) in the early sixth century. Although it borrowed from earlier monastic rules and was applied only to a small proportion of monasteries for a century after its publication, the Rule of Saint Benedict eventually became the Magna Carta of monasticism in the West. Charlemagne had Alcuin of York bring the rule to his kingdom and impose it on the monasteries of the Frankish kingdom to reform them and impose on them some sense of regular observance. In fact, the earliest copy of the Rule of Saint Benedict we possess today (a ninth-century manuscript preserved in the Swiss monastery of Saint Gall) is a copy of a copy Charlemagne had made in 814 from Saint Benedict's autographed copy then preserved at the abbey of Monte Cassino in Italy (now lost).

http://www.osb.org/gen/bendct.html

St. Benedict

The Rule of Saint Benedict consists of a prologue and seventy-three chapters (some only a few sentences long), which set out the ideal of monastic life. Monks (the

CONTEMPORARY VOICES

An Abbot, an Irish Scholar, and Charlemagne's Biographer

Even as the sailor, fatigued with his labors, rejoices when he sights the familiar shore toward which he has long aspired, so does the scribe rejoice who sees the long-desired end of the book which has so overcome him with weariness. The man who does not know how to write makes light of the scribes' pains, but those who have done it know how hard is this work.

A ninth-century monk-copyist describing labor in the scriptorium

I love, better than all glory, to sit in diligent study over my little book. Pangur Ben has no envy of me, for he finds a mouse in his snares while only a difficult argument falls into mine. He bumps against the wall and I against the rigors of science. . . . He rejoices when he has a mouse in his paw as I rejoice when I have understood a difficult question. . . . Each of us loves our art.

An Irish scholar and his cat

He paid the greatest attention to the liberal arts. He had great respect for men who taught them, bestowing high honors on them. When he was learning the rules of grammar he received tuition from Peter the Deacon of Pisa who, by then, was an old man. For all other subjects he was taught by Alcuin, surnamed Albinus, a man of the Saxon race who came from Britain and was the most learned man anywhere to be found. Under him, the emperor spent much time and effort in studying rhetoric, dialectic, and especially astrology. He applied himself to mathematics and traced the course of the stars with great attention and care. He also tried to learn to write. With this end in view he used to keep writing tablets and notebooks under the pillows of his bed, so that he could try his hand at forming letters during his leisure moments; but, although he tried very hard, he had begun late in life and he made very little progress.

Einhard in his biography of Charlemagne

brethren) were to live a family life in community under the direction of a freely elected father (the abbot) for the purpose of being schooled in religious perfection. They were to possess nothing of their own (poverty); they were to live in one monastery and not wander (stability); their life was to be one of obedience to the abbot; and they were to remain unmarried (chastity). Their daily life was to be a balance of common prayer, work, and study. Their prayer life centered around duly appointed hours of liturgical praise of God that were to mark the intervals of the day. Called the "Divine Office," this consisted of the public recitation of psalms, hymns, and prayers with readings from the Holy Scriptures. The offices were interspersed throughout the day and were central to the monks' lives. The periods of public liturgical prayer themselves set off the times for reading, study, and the manual labor that was performed for the good of the community and its sustenance. The lifestyle of Benedictine monasticism can be summed up in its motto: "Pray and work." The rule was observed by both men and women.

The daily life of the monk was determined by sunrise and sunset (as it was for most people in those days). Here is a typical day—called the horarium—in an early medieval monastery. The italicized words designate the names for the liturgical hours of the day:

Horarium Monasticum

2:00 A.M. Rise

2:10-3:30 Nocturns (later called Matins; the longest office of the day)

3:30-5:00 Private reading and study

5:00-5:45 Lauds (the second office; also called "morning prayer")

5:45–8:15 Private reading and *Prime* (the first of the short offices of the day); at times, there was communal Mass at this time and, in some places, a light breakfast, depending on the season

8:15-2:30 Work punctuated by short offices of *Tierce*, Sext, and None (literally the third, sixth, and ninth hours)

2:30-3:15 Dinner

3:15-4:15 Reading and private religious exercises

4:15-4:45 *Vespers*—break—*Compline* (night prayers)

5:15-6:00 To bed for the night

This daily regimen changed on feast days (less work and more prayer) and during the summer (earlier rising, work later in the day when the sun was down a bit, more food, and so on). While the schedule now seems harsh, it would not have surprised a person of the time. Benedict would have found it absurd for people to sleep while the sun was shining and then stay up under the glare of artificial light. When we look at the horarium closely we see a day in which prayer and reading get four hours each, while there are about six hours of work. The rest of the day was devoted to personal chores, eating, and the like.

The triumph of the Benedictine monastic style of life (the early Middle Ages has been called the Benedictine centuries by some historians) is to be found in its sensible balance between the extreme asceticism of Eastern monastic practices and the unstructured life of Western monasticism before the Benedictine reforms. There was an even balance of prayer, manual labor, and intellectual life.

Women and the Monastic Life

While we tend to think of monasticism as a masculine enterprise, it should be remembered that the vowed religious life was open to both men and women. The entire early history of Christianity records a flourishing monastic life for women. In the late Roman period, groups of religious women flourished all over the Roman Empire. Saint Benedict's own sister, Scholastica (died c. 543), was head of a monastery not far from her brother's establishment at Monte Cassino. Her contemporary, Brigid of Ireland (died c. 525), was such a powerful figure in the Irish church that legends grew up about her prowess as a miracle worker and teacher. Her reputation as a saint was such that churches dedicated to her dotted Ireland, England, and places on the continent where Irish monasticism took root. In England, in the seventh century, Hilda, abbess of Whitby (614-680), not only ruled over a prominent monastery which was a center of learning (many Anglo-Saxon bishops were educated there) but she also held a famous episcopal gathering (synod) to determine church policy. Hilda also encouraged lay learning. It was she who fostered the talents of the cowherd poet Caedmon who produced vernacular poetry concerned with Christian themes.

http://www.osb.org/gen/scholast.html

Scholastica

Since monasticism presumed a certain degree of literacy, it was possible for women to exercise their talents in a way that was not possible within the confines of the more restricted life of the court or the family. The Benedictine tradition produced great figures like that of Hildegard of Bingen (1098–1179) who wrote treatises on prayer, philosophy, medicine, and devotion. She was also a painter, illustrator, musician, critic, and a preacher.

Among her most important works are included a vast visionary work called *Scivias* (*The Way to Knowledge*); the medical treatises *Physica* and *Causae et Curae* (*Causes and*

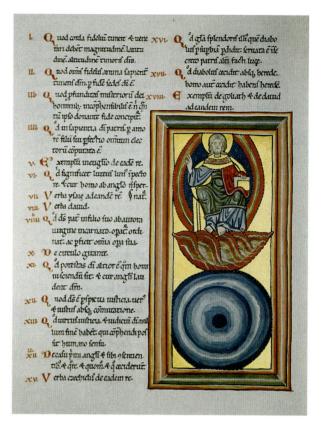

9.2 Hildegard of Bingen, The 1st Vision of Book 3 (Tafel 19) from the *Scivias*, Benediktinerinnenabtei St. Hildegard, Rüdesheim am Rhein, Germany.

Cures); as well as a song sequence called the *Symphonia* and a morality play set in music called the *Ordo Virtutum*; music from these latter works has been performed recently and recorded with a wonderful contemporary response. Hildegard commissioned illustrations for her *Scivias* but, alas, the originals were destroyed during the bombing of Dresden in the World War II and we now know them only in copies [9.2].

From this great tradition of monastic women we possess a number of edifying lives written by the contemporaries of these women which laud their decision to give up marriage in order to serve God. These lives of the saints were extremely popular since they served as exemplars of holy living. They were read publicly in churches (hence they were called *legends*—things read aloud) and for private devotion.

Monasticism and Gregorian Chant

The main occupation of the monk was the *Opus Dei* (work of God)—the liturgical common prayer of the monasteric horarium; life centered around the monastic

church where the monks gathered seven times a day for prayer. The centrality of the liturgy also explains why copying, correcting, and illuminating manuscripts was such an important part of monastic life. Texts were needed for religious services as well as for spiritual reading. The monks were encouraged to study the scriptures as a lifelong occupation. For monks this study was *lectio divina* (divine reading) and was central to their development as a monk. This monastic imperative encouraged the study of the Bible and such ancillary disciplines (grammar, criticism, and the like) as necessary for the study of scripture. From the seventh century on, monastic scriptoria were busily engaged in copying a wealth of material, both sacred and profane.

The monasteries were also centers for the development of sacred music. We have already seen that Charlemagne was interested in church music. His biographer Einhard tells us that the emperor "made careful reforms in the way in which the psalms were chanted and the lessons read. He was himself an expert at both of these exercises but he never read the lesson in public and he would sing only with the rest of the congregation and then in a low voice." Charlemagne's keen interest in music explains why certain monasteries of his reign—notably those at Metz and Trier—became centers for church music.

Charlemagne brought monks from Rome to stabilize and reform church music in his kingdom as part of his overall plan of liturgical renovation. In the earlier period of Christianity's growth quite diverse traditions of ecclesiastical music developed in various parts of the West. Roman music represented one tradition—later called Gregorian chant after Pope Gregory the Great (540-604), who was believed to have codified the music in the late sixth century. Milan had its own musical tradition, known as Ambrosian music—in honor of Saint Ambrose, who had been a noted hymn writer, as Saint Augustine attests in the Confessions. There was a peculiar regional style of music in Spain known as Mozarabic chant, while the Franks also had their own peculiar style of chant. All of these styles derive from earlier models of music that have their roots in Hebrew, Greco-Roman, and Byzantine styles. Lack of documentation permits only an educated reconstruction of this early music and its original development.

For an example of Gregorian Chant, play "Passer invenit sibi domum" on the Listening CD.

Gregorian chant, as we know it today, was not codified until the eleventh and twelfth centuries, so it is rather difficult to reconstruct precisely the music of Charlemagne's court. It was probably a mixture of Roman and Frankish styles of singing. It was *monophonic* (one or many voices sang a single melodic line) and more

often than not lacked musical accompaniment in the monastic churches. Most scholars believe that the majority of music consisted of simple chants for the recitation of the psalms at the Divine Office; more elaborate forms were used for the hymns of the office and the Mass chants. The music was simply called *cantus planus* ("plainsong or plainchant").

In its more elementary form the chant consisted of a single note for each syllable of a word. The basic symbols used to notate Gregorian chant were called *neums*. Using the Gregorian notational system with its four-line staff and the opening line of Psalm 109, *Dixit Dominus Domino Meo, sede a dextris meis* (The Lord said to my Lord: sit on my right hand), a line of syllabic chant would look like this:

Even in the earliest form of chants, a cadence was created by emphasizing the final word of a phrase with the addition of one or two extra notes, as above. Later, more notes were added to the final words or syllables for elaboration and variation. For example:

The simplicity of syllabic chant should not be regarded as useful only for the monotonous chanting of psalm verses. Very simple yet hauntingly melodic Gregorian compositions still exist that do not use elaborate cadences but rely on simple syllabic notes. A fine example is the Gregorian melody for the Lord's Prayer, reproduced here in modern notation. No rests are indicated in the musical text; the singer should simply breathe on a skipped note (it is presumed that not all would skip the same note) so that the music flows without pause. Ordinarily, these chants would be sung *a capella* (without musical accompaniment).

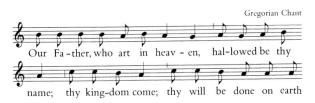

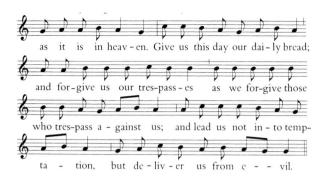

Certain phrases, especially words of acclamation (like *Alleluia*) or the word at the end of a line, were elaborated beyond the few notes provided in syllabic chant. This extensive elaboration of a final syllable (or any syllable) by a chain of intricate notes was called a *melisma*. An example of melismatic chant may be noted in the elaboration of the final *-ia* of the Easter *Alleluia* sung at the Easter Mass:

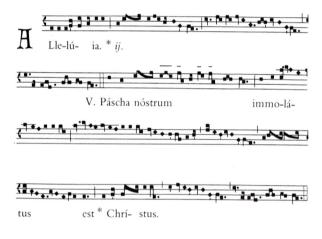

LITURGICAL MUSIC AND THE RISE OF DRAMA

The Liturgical Trope

One development connected with melismatic chant which evolved in the Carolingian period was the *trope*. Since books were scarce, monks memorized a great deal of liturgical chant. As an aid to memorization and to also provide some variety in the chant, words would be added to the long melismas. These words, tropes, would be verbal elaborations of the content of the text. Thus, for example, if there was a melismatic *Kyrie Eleison* (the Greek "Lord, have mercy on us" retained in the Latin Mass) with an elaboration of notes for the syllables *ri-e* of Kyrie, it became customary to add words such as *sanctus* (holy), *dominus* (lord), and the like, which were sung to the tune of the melisma. The use of tropes grew rapidly

and became standard in liturgical music until they were removed from the liturgy at the time of the Counter-Reformation in the sixteenth century.

Scholars have pointed to the introduction of tropes into liturgical music as the origin of drama in the Western world. There had of course been drama in the Classical and Byzantine worlds, but drama in Europe developed from the liturgy of the medieval church after it had largely been lost (or suppressed) in the very early Middle Ages.

A ninth-century manuscript (preserved at the monastery of Saint Gall) preserves an early trope that was added to the music of the Easter entrance hymn (the *Introit*) for Mass. It is in the form of a short dialogue and seems to have been sung by either two different singers or two choirs. It is called the *Quem Quæritis* trope from its opening lines:

The Quem Quæritis Trope

De Resurrectione Domini	Of the Lord's Resurrection
Int[errogatio]: Quem quæritis in sepulchro, {o} Christicolæ?	Question [of the angels]: Whom seek ye in the sepulcher, O followers of Christ?
R[esponsio]: Jesum Nazarenum crucifixum, o cælicolæ.	Answer [of the Marys]: Jesus of Nazareth, which was cruci- fied, O celestial ones.
[Angeli:] Non est hic; surrexit, sicut, prædixerat.	[The angels:] He is not here; he is risen, just as he foretold.
Ite, nuntiate quia surrexit de sepulchro.	Go, announce that he is risen from the sepulchre.

Very shortly after the introduction of this trope into the Easter Mass the short interrogation began to be acted, not at Mass but at the end of the night services preceding Easter dawn. The dialogue of the *Quem Quæritis* was not greatly enlarged but the directions for its singing were elaborated into the form of a short play. By the eleventh and twelfth centuries, the dialogue was elaborated beyond the words of the Bible and more persons were added. By the twelfth century, the stories took on greater complexity.

It was a logical step to remove these plays from the church and perform them in the public square. By the fourteenth century, sizable cycles of plays were performed in conjunction with various feast days and underwritten by the craft or merchants' guilds. Some of these cycles acted out the major stories of the Bible, from Adam to the Last Judgment. The repertory also began to

include plays about the lives of the saints and allegorical plays about the combats of virtue and vice, such as the fifteenth-century work *Everyman*. These plays were a staple of public life well into the sixteenth century. William Shakespeare, for example, may well have seen such plays in his youth.

http://www.fordham.edu/halsall/basis/everyman.html

Everyman

THE MORALITY PLAY: EVERYMAN

Everyman is a fifteenth-century play that may well be a translation from a much earlier Dutch play. The subject is no longer a redoing of a biblical theme but rather the personification of abstractions representing a theme dear to the medieval heart: the struggle for the soul. The unprepared reader of Everyman will note the heavy-handed allegorizing and moralizing (complete with a "Doctor" who makes a final appearance to point up the moral of the play) with some sense of estrangement, but with a closer reading, students will also note the stark dignity of the play, the earnestness with which it is constructed, and the economy of its structure. Written in rather spare rhyming couplets, Everyman is a good example of the transitional play that forms a link between the earlier liturgical drama and the more secular drama that was to come at the end of the English medieval period.

The plot of Everyman is simplicity itself; it is quickly summarized by the messenger who opens the play. Everyman must face God in final judgment after death. None of the aids and friends of this life will support Everyman, as the speeches of the allegorical figures of Fellowship and others make clear. The strengths for Everyman come from the aiding virtues of Confession, Good Deeds, and Knowledge. The story, however, is not the central core of this play; the themes that run through the entire play are what should engage our attention. First is the common medieval notion of life itself as a pilgrimage, a notion that comes up again and again. It is embedded not only in the medieval penchant for pilgrimage but the use of that term (as one sees, for example, in Chaucer) as a metaphor. Second, the notion of the inevitability of death as the defining action of human life is omnipresent in medieval culture. Everyman has an extremely intense memento mori ("Keep death before your eyes!") motif. Finally, medieval theology places great emphasis on the will of the human being in the attainment of salvation. It is not faith (this virtue is presumed) that will save Everyman; his or her willingness to learn (Knowledge), act (Good Deeds), and convert (Confession) will make the difference between salvation and damnation.

The Messenger says that *Everyman* is "By figure a moral play." It is meant not merely to instruct on the content of religion (as does a mystery play) but to instruct for the purposes of moral conversion. The earlier mystery plays usually point out a moral at the end of the performance. The morality play uses its resources to moralize throughout the play.

The one lingering element from the liturgy in a play like *Everyman* is its pageant quality: The dramatic force of the presentation is enhanced by the solemn wearing of gowns, the stately pace of the speeches, and the seriousness of the message. The play depends less on props and place. Morality plays did not evolve directly out of liturgical drama (they may owe something to the study of earlier plays based on the classics studied in schools) but the liturgical overtones are not totally absent.

Nonliturgical Drama

At the end of the early Middle Ages we also have evidence of plays that were not dependent upon liturgical worship. Thus, a German nun-poet named Hroswitha (or Roswitha; the name is spelled variously), who lived at the aristocratic court of Gandersheim and died around the year 1000, has left us both a collection of legends written in Latin and six plays modeled on the work of the Roman dramatist Terence. What is interesting about this well-educated woman is the broad range of her learning and her mastery of classical Latin in an age that did not put a high premium on the education of females. Scholars also point out that her prose legend called *Theophilus* is the first known instance in German literature of the Faust theme—the selling of one's soul to the devil for material gain and public glory.

Hroswitha's plays were probably meant to be read aloud by a small circle of literate people, but there is some internal evidence that they may also have been acted out in some rudimentary fashion. They are heavily moralistic (typically involving a religious conversion or steadfastness in faith during a time of persecution) and very didactic. In the play The Conversion of the Harlot Thaïs, for example, the holy man Pafnutius begins with a long conversation with his disciples on a liberal education and the rules of musical proportion and harmony. Such a discussion would seem a wild digression to us today, but for her audience it would be a way not only of learning about the liberal arts but a reminder that their study inevitably leads to a consideration of God. That her plays do not have a finished dramatic quality underscores the fact that she was the first dramatist writing in Germany (as well as Germany's first female poet). Her model was the ancient drama of Rome as far as style was concerned, but her intention was to use that style to educate and convert. She was a direct heir of the humane learning that developed in the Carolingian and Ottonian periods.

THE LEGEND OF CHARLEMAGNE: SONG OF ROLAND

Charlemagne's kingdom did not long survive intact after the death of the emperor. By the tenth century, the Frankish kingdom was fractured and Europe reduced to a state worthy of the name "Dark Ages." Anarchy, famine, ignorance, war, and factionalism were constants in tenth-century Europe; Charlemagne's era was looked back to as a long-vanished Golden Age. By the twelfth century, Charlemagne's reputation was such that he was canonized (in Aachen on December 29, 1165) by Emperor Frederick Barbarossa. Charlemagne's cult was immensely popular throughout France—especially at the royal abbey of Saint Denis in Paris, which made many claims of earlier links with the legendary emperor.

A fifteenth-century oil painting in Aachen depicts an idealized Charlemagne as saint, wearing the crown of the Holy Roman Emperor and carrying a model of the church he had built at Aachen. Frederick Barbarossa commemorated the canonization by commissioning a great wrought-bronze candelabrum to hang in the Aachen cathedral. He also ordered a gold reliquary (now in the Louvre in Paris) to house the bones of one of his saintly predecessor's arms [9.3]; another reliquary, in the form of a portrait bust that contains fragments of Charlemagne's skull, is in the cathedral treasury at Aachen.

The memory of Charlemagne and his epoch was kept more vividly alive, however, in cycles of epic poems and in tales and memoirs developed, embroidered, and disseminated by poets and singers throughout Europe from shortly after Charlemagne's time until the late Middle Ages. These are the famous *chansons de geste* ("songs of deeds") or, as some were called, *chansons d'histoire* ("songs of history"). Of these songs, the oldest extant—as well as the best and most famous—is the *Song of Roland*.

The Song of Roland was written sometime late in the eleventh century, but behind it lay some three hundred years of oral tradition and earlier poems celebrating a battle between Charlemagne's army and a Muslim force at the Spanish border. Charlemagne did indeed campaign against the emirate of Spain in 777 and 778 without conclusive result. In August 778, Charlemagne's rear guard was ambushed by the Basques while making its way through the Pyrenees after the invasion of Spain. The real extent of that battle (later placed, on not too much evidence, at the town of Roncesvalles) is unclear. Some experts maintain that it was a minor skirmish, remembered in the area in local legends later told and retold (and considerably embroidered in the process) by monks of the monasteries and sanctuaries on the pilgrimage routes to the great shrine of Saint James at Santiago de Compostela in Spain. Other historians insist that the battle was a horrendous bloodbath for the army of Charlemagne and that the tale was carried back to the

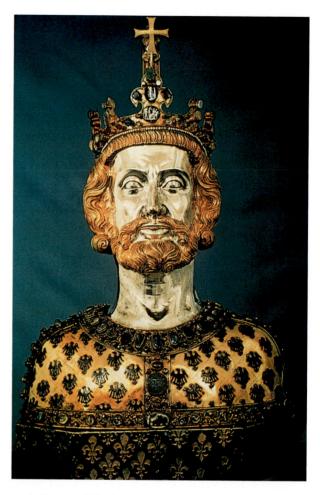

9.3 Reliquary of Charlemagne, Bust of Charlemagne after 1349; crown before 1349. Cathedral Treasury, Aachen, Germany. Reliquaries of this type are containers for some relic of the person depicted by the statue, in this case the crown of Charlemagne's skull.

Frankish cities; the legend was transformed as it was repeated by the descendants of the few survivors.

http://www.humnet.ucla.edu/santiago/iagohome.html

El Camino de Santiago

In any event, by the eleventh century the tale was widely known in Europe. Excerpts from the *Song of Roland* were sung to inspire the Norman army before the Battle of Hastings in 1066, and in 1096 Pope Urban II cited it in an appeal to French patriotism when he attempted to raise armies for a crusade to free the Holy Land. Medieval translations of the poem into German, Norse, and Italo–French attest to its widespread popularity outside the French-speaking area.

The *Song of Roland* is an epic poem; its unknown writer or writers had little interest in historical accuracy or geographic niceties. Its subject matter is the glory of the military campaign, the chivalric nature of the true

knight, the constant possibility of human deviousness, and the clash of good and evil. The poem, although set in the eighth century, reflects the military values and chivalric code of the eleventh century.

The story is simple: Muslims attack the retreating rear portion of Charlemagne's army (through an act of betrayal) while it is under the command of Roland, a favorite nephew of the emperor. Roland's army is defeated, but not before he sounds his ivory horn to alert the emperor to the peril. The emperor in turn raises a huge army from throughout Christendom while the Muslims also raise a great force. An epic battle follows; Charlemagne, with divine aid, is victorious.

The *Song of Roland* is some four thousand lines long; it is divided into stanzas, and each line contains ten syllables. It is impossible to reproduce the rhyme in English, since each stanza ends with an assonance, so the poem is best read in blank verse translation—although that sacrifices the recitative quality of the original.

This poem was meant to be heard, not read. It was recited by wandering minstrels—jongleurs—to largely illiterate audiences. This fact explains the verse style, the immediacy of the adjectives describing the characters and the situations, and the somewhat repetitive language. The still-unexplained AOI at the end of many stanzas may have something to do with the expected reaction of the jongleur as he uttered that particular sound to give emphasis to a stanza. (Some sense of the immediacy of the original may be gained by a reader today who declaims some of these stanzas with gestures and appropriate pauses.)

Certain details of the poem merit particular attention. A portion of the poem recounts Charlemagne's arrival on the scene and his victory over the Saracens who are beleaguering the forces commanded by Roland. Most striking is the mixture of military and religious ideals, not an uncommon motif in the medieval period. This mixture is reflected not only in the imagery and in the plot (Charlemagne's prayer keeps the sun from setting in order to allow time for victory, an echo of the biblical siege of Jericho by Joshua) but also in the bellicose Archbishop Turpin. Christian valor is contrasted with Saracen wickedness and treachery; the anti-Muslim bias of the poem is clear. The Muslim Saracens are pagans and idolaters—an odd way to describe the rigidly monotheistic followers of Islam. The Song of Roland, like much of the epic tradition from which it springs, is nevertheless devoted to the martial virtues of courage and strength, the comradeship of the battlefield, and the power of great men as well as the venality of evil ones.

The Song of Roland was immensely popular in its own time. It spawned a number of other compositions like the Pseudo Turpin and the Song of Aspremont in order to continue the story or elaborate portions of it. At a much later time in Italy the story was redone in the telling of the exploits of Orlando (Roland). To this day, children in Sicily visit the traditional puppet shows in which the exploits

of brave Roland and his mates are acted out with great clatter and verve. Spectators at those shows witness stories that go back to the beginnings of the medieval period.

THE VISUAL ARTS

The Illuminated Book

Given Charlemagne's preoccupation with literary culture, it should not be surprising that a great deal of artistic effort was expended on the production and illumination of manuscripts. Carolingian manuscripts were made of parchment (treated animal skins, mainly from cows and sheep) since papyrus was unavailable and the process of papermaking was unknown during this period. For very fine books, the parchment was dyed purple and the letters were painted on with silver and gold pigments.

While a good deal of decoration of Carolingian manuscripts shows the influence of Irish models, the illustrations often show other influences. This is strikingly apparent in the illustrations of the *Gospel Book of Charlemagne* (800–810), where it is clear that the artists were conscious of the Roman style [9.4]. The page showing the four evangelists with their symbolic emblems is strikingly classical: The four evangelists are toga-clad like ancient Roman consuls. There is some evidence that the artists attempted some experiments in three-dimensionality. The wooded background in the receding part of the upper two illustrations tends to bring the evangelists forward and thus diminish the flatness we associate with both Byzantine and Celtic illustrations.

The Utrecht Psalter (so-called because its present home is the University of Utrecht in Holland) has been called the masterpiece of the Carolingian Renaissance. Executed at Rheims sometime around 820 to 840, it contains the whole psalter with wonderfully free and playful pen drawings around the text of the psalms. The figures are free from any hieratic stiffness; they are mobile and show a nervous energy. The illustration for Psalm 150, for example, has a scene at the bottom of the page showing various figures "praising God with horn and cymbals" [9.5]. There are two other interesting aspects of the same illustration. One is that the figures are in the act of praising Christ, who stands at the apex of the illustration with the symbols of his resurrection (the stafflike cross in his hand). Although the psalms speak of the praise of God, for the medieval Christian the "hidden" or true meaning of the scriptures was that they speak in a prefigurative way of Christ. Thus the psalmist who praises God is a "shadow" of the church that praises Christ. A second thing to note in this illustration is the bottom-center scene of an organ with two men working the bellows to supply the air.

The style of the *Utrecht Psalter* has much in common with early Christian illustration. The lavish purple and

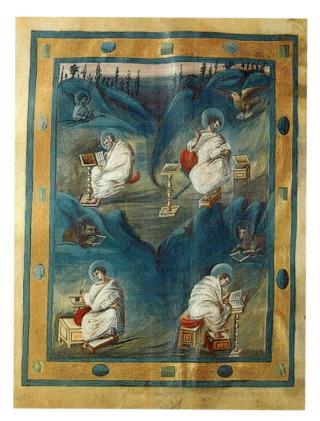

9.4 The four evangelists and their symbols, from the *Gospel Book of Charlemagne*, Palace School of Charlemagne, Aachen, early ninth century. Manuscript illustration. Cathedral Treasury, Aachen.

silver manuscripts show a conscious imitation of Byzantine taste. We have also noted the influence of Celtic illustration. Carolingian manuscript art thus had a certain international flavor, and the various styles and borrowings offer ample testimony to the cosmopolitan character of Charlemagne's culture. This universality diminished in the next century; not until the period of the so-called

International Style in the fourteenth century would such a broad eclecticism again be seen in Europe.

One other art form that developed from the Carolingian love for the book is ivory carving. This technique was not unique to Charlemagne's time; it was known in the ancient world and highly valued in Byzantium. The ivories that have survived from Charlemagne's time were used for book covers. One beautiful example of the ivory carver's art is a crucifixion panel made at the palace workshop at Aachen sometime in the early ninth century [9.6]. Note the crowded scenes that surround the crucifixion event. Reading clockwise from the bottom left, one sees the Last Supper, the betraval in the garden, and, at the top, a soldier piercing Jesus' side. As a balance at the top right another soldier offers Iesus a vinegar-soaked sponge on a lance. Below that scene is one of the women at the tomb and, at the bottom, the incredulity of Thomas. Framing these scenes above are the ascension of Christ on the left and the Pentecost on the right, the two scenes separated by a stylized sun and moon. The entire ivory is framed with geometric and abstract floral designs. The composition indicates that the carver had seen some examples of early Christian carving, whereas the beardless Christ and the flow of the drapery indicate familiarity with Byzantine art.

One surviving Carolingian manuscript that allows us to see both illumination and ivorywork is the *Dagulf Psalter*, made as a gift for Pope Hadrian I, who reigned from 772 to 795. The psalms are not illustrated like the ones in the *Utrecht Psalter*; instead, the illustrator begins a tradition that will be fairly normal for future psalters: He enlarges and illuminates the initial letter of the first, fifty-first, and hundred-first psalms. The *B* of the first word of Psalm 1, *Beatus vir qui* ("Blessed is the man who"), is enlarged and decorated in the swelling style of Celtic illumination; the same patterns are echoed on the page margin [9.7].

9.5 Psalm 150, from the Utrecht Psalter, from Hautvilliers, France, (near Reims) c. 820–840, 12 7/8" × 10" (33 × 26 cm). University Library, Utrecht, Netherlands. This page is typical of the quick nervous style of the unknown illustrator who did similar symbolic drawings for the entire psalter of 150 psalms.

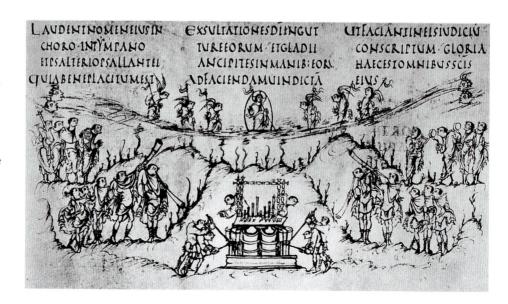

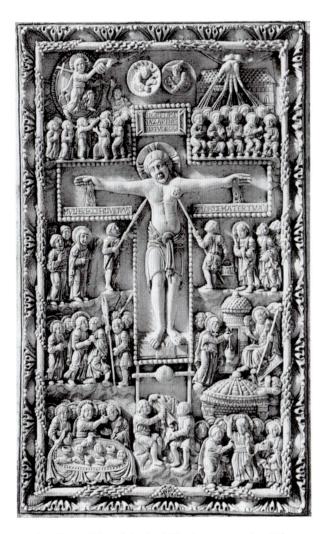

9.6 Crucifixion. Palace School of Charlemagne, early ninth century. Ivory $9.7/8'' \times 6.1/2''$ (25 \times 16 cm). Cathedral Treasury of Saint Just, Narbonne. Such ivories were often used as covers for Gospel books and other liturgical works and were frequently produced as gifts for special occasions.

The ivory covers of the psalter have been preserved and are now in the Louvre [9.8]. Rather than the usual crowded scenes of most of these covers, the ivories from the *Dagulf Psalter* are composed of two scenes on each of the panels; the scenes make references to both the psalter and the papal connection. The top-left panel shows David and his court; in the scene below, David is shown singing one of his psalms to the accompaniment of his lyre. The top-right panel depicts Saint Jerome receiving a letter from Pope Damasus instructing him to correct the psalter; the scene below depicts Jerome in the act of working on the psalter while a grateful clergy looks on.

One other advance in manuscript production during the Carolingian period was in the area of fine handwriting or, as it is more technically known, calligraphy. Handwriting before the Carolingian period was cluttered, unformed, and cramped. It was very difficult to read because of its erratic flourishes and lack of symme-

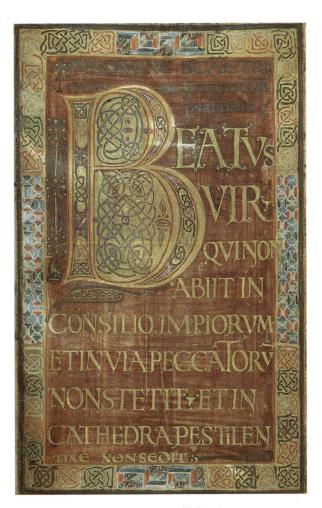

9.7 Beginning of Psalm 1 from the *Dagulf Psalter*, late eighth century. Manuscript illustration, $7\ 1/2'' \times 4\ 5/8''\ (19 \times 12\ cm)$. Austrian National Library. This psalter may well have been produced by a woman's hand at a convent.

try. After 780, scribes in Carolingian scriptoria began to develop a precise and rounded form of lettering that became known as the Carolingian *minuscule*, as opposed to the *majuscule* or capital letter. This form of lettering was so crisp and legible that it soon became a standard form of manuscript writing. Even in the fifteenth century, the Florentine humanists preferred the minuscule calligraphy for their manuscripts. When printing became popular in the early sixteenth century, printers soon designed type fonts to conform to Carolingian minuscule. It superseded Gothic type in popularity and is the ancestor of modern standard lettering systems.

Charlemagne's Palace at Aachen

Beyond his immediate commercial, military, and political goals, Charlemagne had an overwhelming desire to

9.8 Cover panels for the *Dagulf Psalter*, late eighth century. Ivory. $6\,1/8'' \times 3\,1/8'' \,(17\times 8\,\text{cm})$. Louvre, Paris. Jerome correcting the psalter (lower right panel) reflects common work in the monasteries of the Carolingian period.

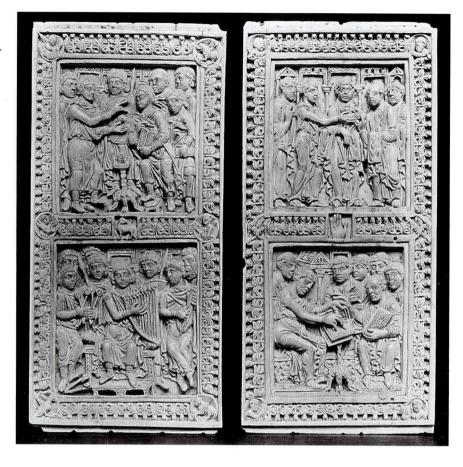

model his kingdom on that of ancient Rome. His coronation in Rome symbolized the fusion of the ancient imperial ideal with the notion of Christian destiny. It was not accidental that Charlemagne's favorite book—he had it read to him frequently at meals—was Augustine's *The City of God.* One highly visible way of making this ideal concrete was to build a capital.

At Aachen (in French it is called Aix-la-Chapelle) Charlemagne built his palace and royal chapel [9.9]. Except for the chapel (incorporated into the present cathedral), all the buildings of Charlemagne's palace have been destroyed and the Aachen city hall (itself built in the fourteenth century) covers the palace site. The palace proper was a long one-story building; its main room was the large royal hall, which measured roughly $140' \times 60'$ (42.7 × 18.3 m). So richly decorated that even the fastidious and sophisticated Byzantine legates were favorably impressed, the room had as its focal point at the western end the emperor's throne. In front of the palace was an open courtyard around which were outbuildings and apartments for the imperial retinue. Around the year 800, the courtyard held a great bronze statue of Theodoric, once king of the Ravenna Ostrogoths, that Charlemagne had brought back from Ravenna to adorn his palace.

The royal hall was joined to Charlemagne's chapel by a long wooden gallery. This royal chapel was probably

built around 795. With sixteen exterior walls, the chapel was a central-plan church based on an octagon [9.10]; its model undoubtedly was the Church of San Vitale in Ravenna, which Charlemagne had visited and admired. The octagon formed the main nave of the church, which was surrounded by cloisters; the building itself was twostoried. At the eastern end of the chapel was an altar dedicated to the Savior, with a chapel dedicated to the Virgin directly below it. The central space was crowned with an octagonal cupola, the lower part of which was pierced by windows—the main source of light in the church. The outside of the church was austere; the inside was richly ornamented with marbles brought to Aachen from Ravenna and Rome. The interior of the cupola was decorated with a rich mosaic depicting Christ and the twenty-four elders of the Apocalypse (now destroyed; the present mosaics in the chapel are modern copies) while the other planes of the interior were covered with frescoes (now also destroyed). The railing of the upper gallery was made from bronze screens that are still in place, wrought in geometrical forms.

The chapel included two objects that emphasized its royal status: the most important relic of the kingdom, Saint Martin of Tours' cape, and a throne. Charlemagne's throne was on the second floor, opposite the Savior chapel. From this vantage point, the emperor could observe the liturgical services being conducted in the

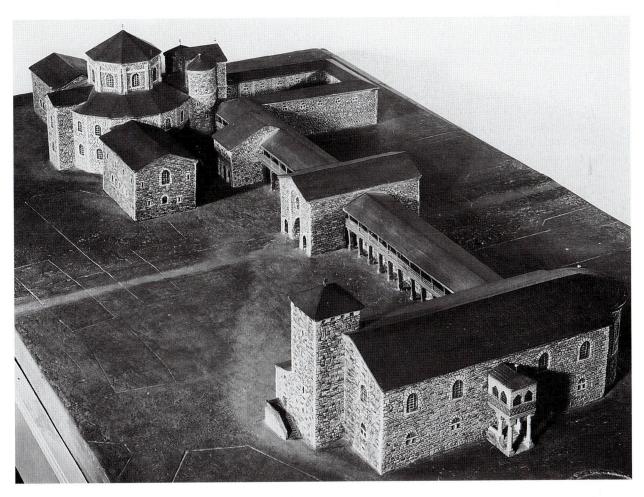

9.9 Model reconstruction of Charlemagne's palace at Aachen. Romisch-Germanisches Zentral Museum, Mainz. The royal hall with its long gallery is in the foreground. The octagonal royal chapel in the background should be compared to San Vitale in Ravenna.

Savior chapel and at the same time view the Virgin chapel with its rich collection of relics.

Charlemagne's throne, with its curved back and armrests, was mounted by six stone steps. This arrangement was obviously taken from King Solomon's throne as described in the Bible (I Kings 10: 18–19). Charlemagne was to be thought of as the "new Solomon" who, like his ancient prototype, was an ambitious builder, a sagacious lawgiver, and the symbol of national unity. That this analogy was not an idle fancy is proved by a letter to the emperor from Alcuin, Charlemagne's friend and tutor, in anticipation of his return to Aachen: "May I soon be allowed to come with palms, accompanied with children singing psalms, to meet your triumphant glory, and to see once more your beloved face in the Jerusalem of our most dear fatherland, wherein is the temple set up to God by this most wise Solomon."

9.10 Interior of the Palatine Chapel of Charlemagne, Aachen. This view, toward the east, shows the emperor's tribune in the second story. The ceiling mosaics and the lower-level inscriptions are modern.

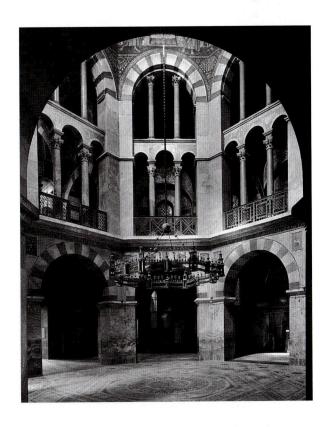

The Carolingian Monastery

In the period between Saint Benedict and Charlemagne, the Benedictine monastery underwent a complex evolution. Originally the monasteries were made up of small communities with fewer than fifteen members who led a life of prayer and work in a rather simple setting. With the decline of city, life and the disorders brought on by the repeated invasions of the Barbarians after the fifth century, the monastery became increasingly a center of life for rural populations. Monasteries not only kept learning alive and worship intact but were also called upon to serve as shelters for the traveler, rudimentary hospitals for the sick, places of refuge in time of invasion, granaries for the farmer, centers of law for both religious and civil courts, and places that could provide agricultural services such as milling and brewing.

This expansion of services, making the monastery into what has been called a "miniature civic center," inevitably changed the physical character of the monastery compound itself. By Charlemagne's time the monastery was an intricate complex of buildings suitable for the many tasks it was called upon to perform [Table 9.1]. One vivid example of the complexity of the Carolingian monastery can be gained by a study of a plan for an ideal monastery developed about 820 at the Benedictine abbey of Saint Gall in present-day Switzerland [9.11].

In the Saint Gall plan the monastic church dominated the area. Set off with its two round towers, it was a basilica-style church with numerous entrances for the use of the monks. To the south of the church was a rectangular garden space surrounded by a covered walkway (the cloister) from which radiated the monk's dormitory, dining hall (refectory), and kitchens. To the north of the church were a copying room (scriptorium), a separate house for the abbot, a school for youths and young novices, and a guest house. To the extreme south of the church were ranged workshops, barns, and other utilitarian outbuildings. To the east beyond the church were an infirmary and a separate house for aspirant monks (the novitiate), gardens, poultry houses, and the community cemetery.

The Romanesque Style

The plan of Saint Gall was never realized in stone, but the Benedictines did participate in ambitious architectural works after the Carolingian period. In the eleventh century, after a long period of desolation and warfare, Europe began to stir with new life. Pilgrimages became very popular as travel became safe. Pilgrimage routes in particular to sites in Spain, England, and Italy—crisscrossed Europe. Crusades were mounted to free the holy places of the Middle East from the Muslims so that pilgrims could journey in peace to the most desired goal of the pilgrim: Jerusalem. During this period monks built and maintained pilgrimage churches and hostels on the major routes of the pilgrims.

TABLE 9.1 The Major Parts of the Monastery	
The Monastic Church	Site of the major religious ser-
The Chapter House	vices. Ordinary meeting room of the monastic community; the name
The Children	comes from the custom of reading a chapter of the Rule of Saint Benedict aloud each day to the community.
The Cloister	Technically, the enclosed part of the monastery; more commonly, the enclosed garden and walk- way in the interior of the
The Scriptorium	monastery. Library and copying area of the monastery.
The Refectory	Monks' dining hall.
The Novitiate	Quarters for aspirant monks not
The Dormitory The Infirmary	yet vowed in the community. Sleeping area for the monks. For sick, retired, and elderly
The Guest House	monks. For visitors, retreatants, and travelers.
The Outbuildings	Buildings for the farms and crafts of the monastery. Small

buildings far from the main

monks were called granges.

monastery that housed farmer

The building style of this period (roughly from 1000 to 1200) is called Romanesque because the architecture was larger and more Roman-looking than the work done in the earlier medieval centuries. The two most striking characteristics of this architecture were the use of heavy stone arches and generous exterior decoration, mainly sculpture. The Romanesque style had two obvious advantages. First was that the use of heavy stone and masonry walls permitted larger and more spacious interiors. Second, the heavy walls could support stone arches (mainly the Roman barrel arch), at least in France and Spain, which in turn permitted fireproof stone and masonry roofs. Long experience had shown that basilicastyle churches, with their wooden trusses and wooden roofs, were notoriously susceptible to destruction by fire.

Romanesque architecture sprouted all over Europe, and while it showed great regional variation, its main lines are distinct. The Benedictine pilgrimage Church of Saint Sernin in Toulouse was designed to accommodate the large number of pilgrims as they made their way to the famous shrine of Santiago de Compostela in Spain. A glimpse at the floor plan [9.12] and the interior [9.13] shows clearly that the generous interior space was articulated in a manner such that large numbers of persons besides the monastic community could move freely through the building. For example, the floor plan allows

VALUES

Feudalism

The social organization of late Carolingian society was based on *feudalism*; a form of government that had its primary focus on the holding of land. Theoretically, the monarch held all land with nobles, who swore allegiance to the monarch, possessing land as a gift from the monarch. Under the nobles were persons, again pledging allegiance to their noble superiors, who held a smaller piece of land (e.g., a manor). The agricultural peasants (serfs) had the use of the land in exchange for fees and for cultivating a certain percentage for the lord above them. The clergy, also, had the legal right to certain tithes on the production of goods and services. This highly stratified system also impacted the system of warfare. Each knight (a small landholder) pledged loyalty to a higher noble who in turn pledged loyalty to

the crown. Armies could be raised when, for instance, a monarch would call up the nobles pledged to him and they in turn would call up the knights who had sworn loyalty to them.

Feudal society existed only so long as a country remained rural and without large towns. Italy, with its long history of town life, never had as strong a feudal society as did the Frankish lands of what is today France and Germany. Feudalism was a highly static, hierarchical, and basically agricultural way of organizing life. It would undergo vast changes with the slow emergence of city life and the increased mobility brought on by vigorous trade and such military movements as the Crusades.

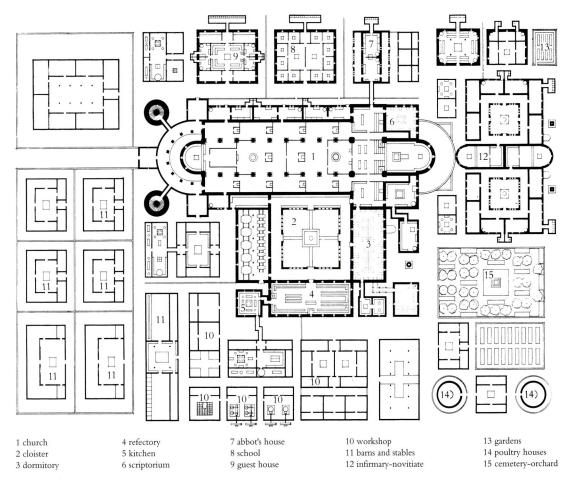

9.11 Plan for an ideal monastery, c. 820. Reconstruction by Walter Horn and Ernest Born from the manuscript in the library of the Monastery of Saint Gall in Switzerland. The original plan, 3'8'' (1.12 m) across, was drawn to scale on vellum. The monastery site would have been $480' \times 640'$ (146×195 m), and would have housed 120 monks and 170 serfs. It was a plan for future monasteries and exerted, over the centuries, considerable influence on monastery construction.

for an aisle parallel to the nave to go completely around the church. In that fashion the monastic choir, which extended out into the nave, was circumvented by the faithful—who could make a complete circle of the church without disturbing the monks.

Exterior church decoration was almost unknown in the Carolingian period, but during the Romanesque period there was a veritable explosion of exterior sculpture. The lack of interior light (precluded by the thick solid walls needed for roof vaulting) in a sense drove the artist outside. A favorite area of decoration was the *portal* or doorway, since the crowds would pass through the doors to enter the church and receive edifying instruction in the process. The artist might decorate a door jamb [9.14], a capital [9.15], or the central supporting post of a portal, the *trumeau* [9.16].

The fullest iconographic program of the Romanesque sculptor can usually be found in the half-moon-shaped space called the *tympanum* over the portal; Romanesque churches in France offer many splendid examples of this elaborated art. The sculptural program over the inner west door of the Benedictine abbey Church of Sainte

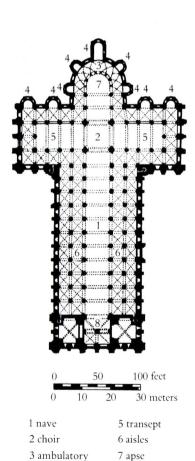

9.12 Floor plan of the Church of Saint Sernin, Toulouse. Note the ample aisles for easy passage of pilgrim groups around the entire church. The radiating chapels around the ambulatory permitted many priests to celebrate Mass simultaneously.

8 narthex

4 chapels

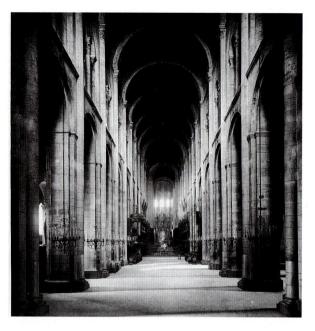

9.13 Nave of the Church of Saint Sernin, Toulouse, c. 1080–1120. The massive ceiling vaults are called *barrel* or *tunnel* vaults. The heavy stonework required heavy walls to support the weight of the vaults. The galleries, with their own vaults, also helped to support the cutstone ceiling vaults.

Madeleine at Vézelay is representative of the elaborated art in stone [9.17].

http://www.pitt.edu/~medart/menufrance/vezelay/vezintro.html

Church of St. Madeleine

The Vézelay tympanum depicts Christ, ascending into heaven, giving his church the mission to preach the gospel to the entire world. Christ, in the center almond shape called the *mandorla*, sends the power of the Holy Spirit into the apostles who cluster on either side and just below with copies of the Gospel in their hands. Below the apostles the lintel stone depicts the peoples of the world, including fanciful races known to the sculptor only through the legendary travel books and encyclopedias that circulated in Europe. The theme of the exotic peoples to be healed by the Gospel is repeated in the eight arching compartments above the central scene, which depict strange peoples, lepers, cripples, and others who need to hear the Gospel.

The outer arches, or *archivolts*, depict the signs of the zodiac and the symbolic seasons of the year, a reminder that the Gospel depicted in the central scene is to be preached "in season and out"; these symbolic medallions are interspersed with mythical and fantastic beasts. The outer archivolts are purely decorative, derived perhaps

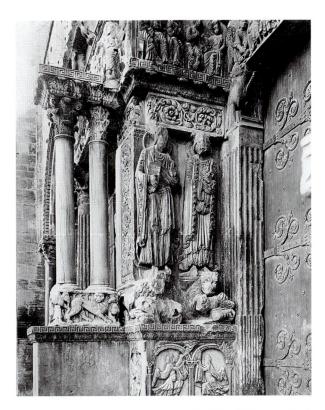

9.14 North jamb on the central portal, Saint Gilles du Gard, France, c. 1140. Notice the echoes of classical column capitals and low-relief carving on the jambs.

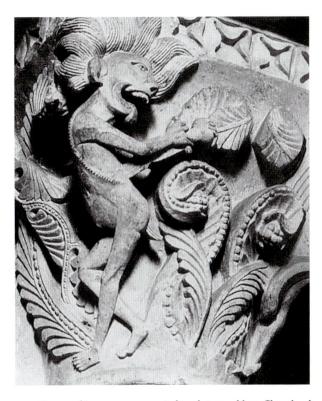

9.15 *Demon of Luxury,* nave capital sculpture, abbey Church of La Madeleine, Vézelay, c. 1130. This kind of extravagant figure would later be criticized by monastic reformers of the twelfth century.

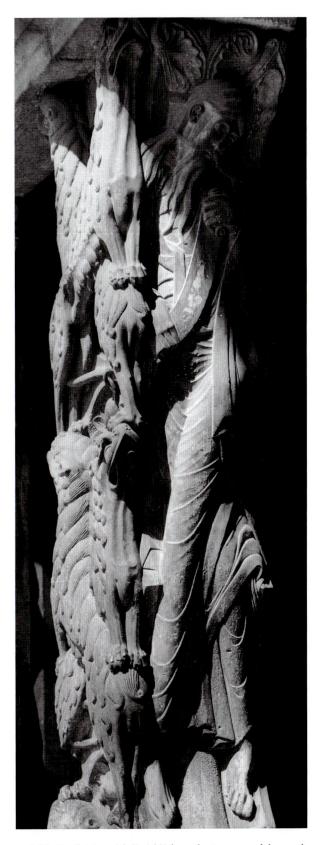

9.16 The Prophet Jeremiah (Isaiah?) from the trumeau of the south portal of St. Pierre, Moissac, France, early twelfth century. Lifesize. The serpentine figure of the prophet leans toward the church as he holds the scroll of his biblical book. The lions probably reflect the influence of Islamic art from Spain.

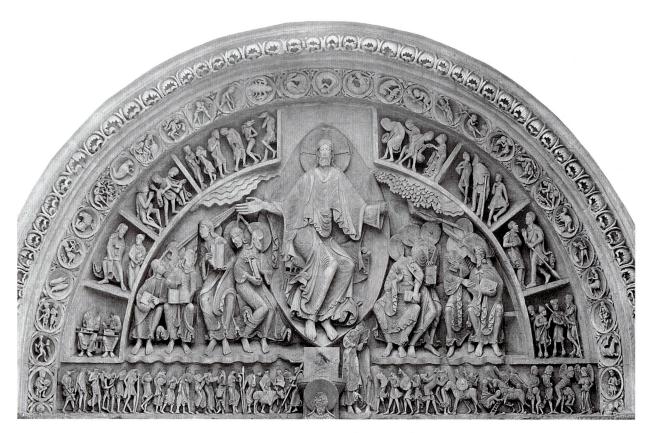

9.17 Pentecost, tympanum, abbey Church of La Madeleine, Vézelay, c. 1120–1132. The lower band of figures reflects all of the peoples of the earth called to salvation by the central figure of Christ.

from Islamic sources known to the artists through the Muslim architecture of Spain.

Romanesque style was a European phenomenon—its variant forms in Italy, Germany, and England give ample testimony—and a summing-up of much of European culture between the end of the Carolingian period and the rise of city life and the Gothic style in the late twelfth century. The roots of the Romanesque were in the Benedictine tradition of service, scholarship, and solidity. Churches like Vézelay also manifest the period's concern with travel, expansion, and the attendant knowledge that comes from such mobility. When reaction came against the more extravagant forms of Romanesque decoration it came from Bernard of Clairvaux (1090–1153), who was primarily a monastic reformer. Bernard was horrified by the fantastic nature of Romanesque sculpture since he felt so many "and so marvelous are the varieties of diverse shapes that we are more tempted to read in the marbles than in the Book and to spend our whole day wondering at these things rather than meditating on the Law of God." Even Bernard's strictures testify to the close relationship between the Benedictines and the Romanesque (especially the French Romanesque), which is another reason the period after Charlemagne and before the primacy of the city can be called simply the Benedictine Age.

SUMMARY

Our attention in this chapter shifted from Byzantium to the West and, more specifically, to the rise of the kingdom of the Franks under Charlemagne. The so-called Carolingian Renaissance rekindled the life of culture after the dark period following the fall of the last Roman emperor in the West in the late fifth century and the rise of the so-called Barbarian tribes.

Charlemagne's reign saw the standardization of monasticism, worship, music, and education in the church. Those reforms would give general shape to Western Catholicism that in some ways endured into the modern period. Equally important was Charlemagne's assumption of the title of Holy Roman Emperor. This act would establish a political office that would exist in Europe until the end of World War I in the twentieth century. It also became a cause for friction between Rome and Constantinople because the Byzantine emperors saw Charlemagne's act as an intrusion on their legitimate claim to be the successors of the old Roman Empire.

The Carolingian world was essentially rural and feudal. Society was based on a rather rigid hierarchy with the emperor at the top, the nobles and higher clergy below him, and the vast sea of peasants bound to the land at the bottom. There was little in the way of city life on any scale. The outpost of rural Europe was the miniature town known as the monastery or the stronghold of the nobles. The rise of the city and increased social mobility would eventually destroy the largely agricultural and feudal society as the High Middle Ages emerged in the eleventh century.

Finally there was Charlemagne as a mythic figure who eventually would be drawn larger than life in the *Song of Roland*. The growth of such myths always occurs because they have some deep desires behind them. In the case of Charlemagne, the desire was to describe the ideal warrior who could perform two very fundamental tasks for Europe: vanquish the Islamic powers that threatened Christian Europe and provide a model for a unified empire (the Holy Roman Empire) that would be both a perfect feudal society and one strong enough to accomplish the first task of destroying Islam. Not without reason was the *Song of Roland* a central poem for the first crusaders who turned their faces to the East.

Pronunciation Guide

Aachen: Ah-ken

Aix-la-Chapelle: Aches-la-Sha-PELL

Alcuin: AL-quin
Dagulf: Dah-gulf

Harun al-Rashid: Haw-RUNE all-Rah-sheed

horarium: hoar-ARE-e-um

Hroswitha: Haw-ros-WITH-ah *or* Ross-WITH-ah

psalter: SALT-er

Quem Quæritis: kwem QUAY-re-tus

Roland: ROLL-on
Roncesvalles: Ron-sa-vals
trope: TROP
Utrecht: YOU-trek(t)
Vézelay: Vayz-e-LAY

EXERCISES

- 1. The "seven liberal arts" are divided into the trivium and the quadrivium. How much of the trivium lingers in primary education today? What has been added to those "trivial" subjects?
- 2. Two subjects studied in the quadrivium were music and astronomy. Those subjects were quite different from what we understand them to be today. How were they understood and how do we understand them?
- 3. One feature of the Carolingian period was the central place of monasticism. Why was monasticism exceptionally suited to a time when there was little urban life?
- 4. Many scholars have argued that monasticism is the living out of a utopian ideal. How is monasticism a "utopian" behavior and to what degree is it also a form of countercultural living?
- 5. Why is plainchant (Gregorian chant) ideally suited for congregational singing, especially for the unaccompanied voice?
- Contrast the place of books in early medieval culture and in our own beyond the obvious issue of our better production technologies.

- 7. Drama evolved out of worship in the early medieval period just as Greek tragedy evolved out of worship in its time. Speculate on why there should be this connection between worship and drama.
- 8. Byzantine churches tended to lavish their decorative efforts on the insides of churches while Romanesque churches tended to decorate the outsides, more especially the façades. Suggest reasons for this widely observable fact.

FURTHER READING

Brault, Gerald. (1978). *The song of Roland* (2 vols.). University Park: University of Pennsylvania Press. Excellent bilingual edition with comprehensive notes.

Bullough, Donald. (1996). *The age of Charlemagne*. New York: Putnam. Well written and lavishly illustrated.

Dronke, Peter. (1984). Women writers of the Middle Ages. New York: Cambridge University Press. An authoritative study.

McNamara, Joann. (1992). Sainted women of the Dark Ages. Durham, NC: Duke University Press. Excellent sourcebook for the period.

Price, Lorna. (1982). The plan of St. Gall in brief. Berkeley: University of California. An inexpensive version of the two-volume study. Well illustrated and readable text.

Riché, Pierre. (1978). *Daily life in the age of Charlemagne*. Philadelphia: University of Pennsylvania. Fascinating reading by the great Carolingian scholar of this age.

ONLINE CHAPTER LINKS

For information about the Order of St. Benedict, visit

http://www.osb.org/gen/rule.html

The Medieval Art and Architecture Web site at

http://info.pitt.edu/~medart/

provides access to a wide variety of architectural wonders in Europe—including those at St. Denis and Vézelay.

To hear Gregorian Chant, visit the Solesmes Abbey at

http://www.solesmes.com/anglais/ang_solesmes.html

For information about the pilgrimage to El Camino de Santiago visit

http://www.humnet.ucla.edu/santiago/iagohome.html which provides maps, historical accounts, and links to related sites.

A complete text of *Everyman* is available at http://www.fordham.edu/halsall/basis/everyman.html

The Romanesque style of architecture is examined

http://www.geocities.com/Athens/Parthenon/8063/romanesque.html

		GENERAL EVENTS	LITERATURE & PHILOSOPHY	Art
	768			
		987 Paris made center of feudal kingdom of Hugh Capet		
EARLY MIDDLE AGES	ROMANESQUE 0001	IIth cent. Capetian kings consolidate power and expand French kingdom I096–1099 First Crusade; capture of Jerusalem by Christians	 12th cent. Golden Age of University of Paris under scholastic masters 1113 Abelard begins teaching in Paris; meets Heloise 1121 Abelard, Sic et Non; birth of Scholasticism 	I 2th cent. <i>Notre Dame de Belle</i> <i>Verrière,</i> stained glass window at Chartres
EARLY A	EARLY GOTHIC PERIOD	 1141 Saint Bernard of Clairvaux leads condemnation of Abelard at Council of Sens c. 1150 Universities of Paris and Bologna founded c. 1163 Oxford University founded 1180 Philip Augustus assumes throne of France; promotes Paris as capital 	 after 1150 Recovery of lost texts by Aristotle and others via Arabic translations c. 1190 Maimonides, <i>Guide for the Perplexed</i> 	c. 1145–1170 Tympanum of right door, Royal Portal, Chartres
	1194	1202–1204 Fourth Crusade;		1200 Ch. 1
HIGH MIDDLE AGES		crusaders sack Constantinople on way to Holy Land c. 1209 Cambridge University founded 1215 Magna Carta, limiting powers of king, signed in England c. 1220 Growth begins of mendicant friars: Franciscans, Dominicans 1258 Robert de Sorbon founds Paris hospice for scholars, forerunner of Sorbonne 1270 Eighth Crusade; death of Saint	 13th cent. Era of secular poems; Goliardic verse c. 1224–1226 Saint Francis of Assisi, "Canticle of Brother Sun" c. 1267–1273 Aquinas, Summa Theologica 	 c. 1200 Charlemagne window at Chartres c. 1215 Christ Blessing, trumeau, south porch, Chartres c. 1215-c. 1250 Guild windows at Chartres
H		Louis of France		

bury Tales

1300 Dante exiled from Florence

c. 1303-1321 Dante, Divine Comedy

c. 1385-1400 Chaucer, The Canter-

MATURE GOTHIC PERI

c. 1271 – 1293 Marco Polo travels to

1348–1367 Universities based on Paris model founded in Prague, Vi-

1291 Fall of Acre, last Christian

stronghold in Holy Land

enna, Cracow, Pecs

China and India

CHAPTER 10 HIGH MIDDLE AGES: THE SEARCH FOR SYNTHESIS

ARCHITECTURE

Music

10th cent. Organum develops

IIth cent. Guido of Arezzo invents musical notation used today

c. I I 30 Halt of construction at Great Third Abbey Church of Cluny

12th cent. Notre Dame School of Paris is center of music study and composition

1140 Abbot Suger begins rebuilding Abbey Church of Saint Denis; Gothic style evolves: use of pointed arch, flying buttress, window tracery

12th–13th cent. French troubadours and trouvères flourish

c. 1163–1250 Cathedral of Notre Dame, Paris

1160 Léonin of Paris, Magnus Liber Organi

 c. 1180 Philip Augustus commissions Louvre as royal residence and treasury

II81 Pérotin "the Great," director of Notre Dame School of Paris

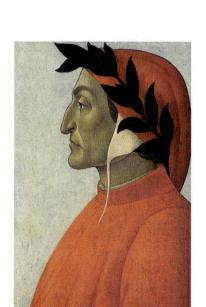

1220-1269 Cathedral of Amiens

c. 1235 Honnecourt, notebook

1243 – 1248 Sainte Chapelle, Paris

1247-1568 Cathedral of Beauvais; Cathedral of Strasbourg **13th cent.** German minnesingers flourish

c. 1250 Polyphonic motets are principal form of composition

1399–1439 Spire of Strasbourg cathedral erected

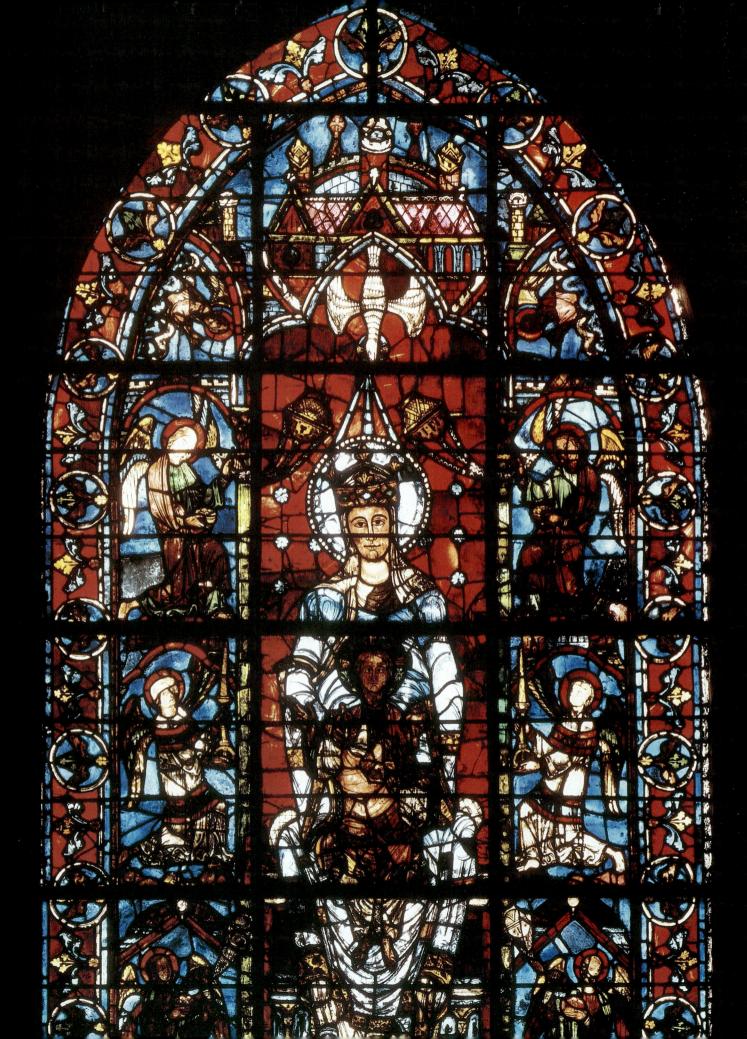

CHAPTER 10

HIGH MIDDLE AGES: THE SEARCH FOR SYNTHESIS

THE SIGNIFICANCE OF PARIS

rom about 1150 to 1300, Paris could well claim to be the center of Western civilization. Beyond its position as a royal seat, it was a strong mercantile center. Its annual trade fair was famous. In addition, Paris gave birth to Gothic architecture, the philosophical and theological traditions known as scholasticism, and the educational community that in time became known as the university. These three creations have their own distinct history but sprang from a common intellectual impulse: the desire to articulate all knowledge in a systematic manner.

The culture of the Middle Ages derives from the twin sources of all Western high culture: (1) the humane learning inherited from the culture of Greece and Rome and (2) the accepted faith of the West, which has its origin in the worldview of the Judeo–Christian scriptures and religious worldview.

The flowering of a distinct expression of culture in and around medieval Paris was made possible by a large number of factors. There was a renewed interest in learning, fueled largely by the discovery of hitherto lost texts from the Classical world—especially the writings of Aristotle—which came to the West via the Muslim world. The often ill-fated Crusades begun in the eleventh century to recover the Holy Land and the increasing vogue for pilgrimages created a certain cosmopolitanism that in turn weakened the static feudal society. Religious reforms initiated by new religious orders like that of the Cistercians in the twelfth century and the begging friars in the thirteenth breathed new life into the church.

Beyond these more generalized currents one can also point to individuals of genius who were crucial in the humanistic renaissance of the time. The University of Paris is inextricably linked with the name of Peter Abelard just as scholasticism is associated with the name of Thomas Aquinas. The Gothic style, unlike most art movements, can be pinpointed to a specific time at a par-

ticular place and with a single individual. Gothic architecture began near Paris at the Abbey of Saint Denis in the first half of the twelfth century under the sponsorship of the head of the abbey, Abbot Suger (1080–1151).

http://justus.anglican.org/resources/bio/142.html

Peter Abelard

http://www.newadvent.org/cathen/14326a.htm

Abbot Suger

THE GOTHIC STYLE

Suger's Building Program for Saint Denis

The Benedictine Abbey of Saint Denis, over which Abbot Suger presided from 1122 until his death nearly twentynine years later, was the focal point for French patriotism. The abbey church—built in Carolingian times—housed the relics of Saint Denis, a fifth-century martyr who had evangelized the area of Paris before his martyrdom. The crypt of the church served as burial place for Frankish kings and nobles from before the reign of Charlemagne, although it lacked the tomb of Charlemagne himself. One concrete link between the Abbey of Saint Denis and Charlemagne came through a series of literary works. The fictitious Pélerinage de Charlemagne claimed that the relics of the Passion housed at the abbey had been brought there personally by Charlemagne when he returned from a pilgrimage-crusade to the Holy Land. Another work, the Pseudo-Turpin, has Charlemagne returning to the Abbey of Saint Denis after his Spanish campaign and proclaiming all France to be under the protection and tutelage of the saint. These two legends were widely believed in the Middle Ages; there is fair evidence that Suger himself accepted their authenticity. The main themes of the legends—pilgrimages, crusades, and the mythical presence of Charlemagne—created a story about the abbey that made it a major Christian shrine as well as one worthy of the royal city of Paris.

Pilgrims and visitors came to Paris to visit Saint Denis either because of the fame of the abbey's relics or because of the annual *Lendit* (the trade fair held near the precincts of the abbey). Accordingly, in 1124 Suger decided to build a new church to accommodate those who flocked to the popular pilgrimage center. This rebuilding program took the better part of fifteen years and never saw completion. Suger mentions as models two sacred buildings that by his time already had archetypal significance for Christianity. He wanted his church to be as lavish and brilliant as Hagia Sophia in Constantinople, which he knew only by reputation, and as loyal to the will of God as the Temple of Solomon as it was described in the Bible.

The first phase of Suger's project was basically a demolition and repair job; he had to tear down the more deteriorated parts of the old church and replace them. He reconstructed the western façade of the church and added two towers. In order better to handle the pilgrimage crowds and the increasingly elaborate processions called for in the medieval liturgy, the entrance was given three portals. The *narthex*, the part of the church one enters first (before the nave), was rebuilt and the old nave was to be extended by about 40 feet (12.2 m). In about 1140, Suger abruptly ceased work on the narthex to commence work at the opposite end—the choir, the area of the church where the monks sang the office. By his own reckoning, he spent three years and three months at this new construction. The finished choir made a revolutionary change in architecture in the West.

Suger's choir was surrounded by a double *ambulatory*, an aisle around the apse and behind the high altar. The outer ambulatory had seven radiating chapels to accommodate the increasing number of monks who were priests and thus said Mass on a daily basis. Two tall windows pierced the walls of each chapel so that there was little external masonry wall in relation to the amount of space covered by windows. The chapels were shallow enough to permit the light from the windows to fall on the inner ambulatory [10.1].

Although Suger's nave was never completed, there is some evidence that it would have had characteristics similar to that of the choir: crossed rib vaults with an abundance of stained-glass windows to permit the flooding of light into the church. We can get some idea of what that nave might have looked like by looking at churches directly inspired by Saint Denis: the cathedrals of Senlis and Noyons [10.2] (their bishops were both at the consecration of Saint Denis in 1144), begun respec-

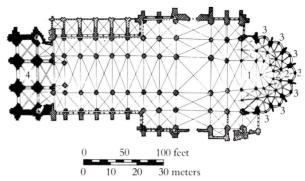

1. choir 2. ambulatory 3. radiating chapels 4. narthex

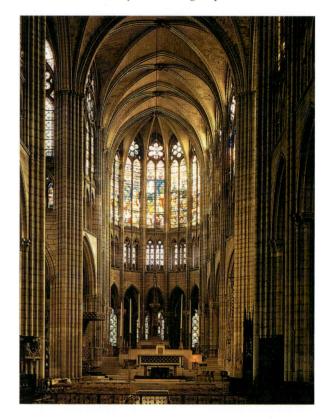

10.1 Plan of the Abbey Church of Saint Denis, built around 1140, and photograph of the ambulatory. Parts of the existing church shaded black in the plan are those rebuilt by Abbot Suger. The photograph shows how use of the ribbed vault and pointed arches gives scope for the passage of light through the lancet windows.

$\label{lem:http://vrcoll.fa.pitt.edu/medart/menufrance/sdenis/windows/} Twelfthc \textbf{W} indows.html$

Abbey of St. Denis

tively in 1153 and 1157, as well as the Cathedral of Notre Dame in Paris, the first stone of which was laid in 1163. This quick emulation of the style of Saint Denis blossomed by the end of the century into a veritable explosion of cathedral building in the cities and towns radiat-

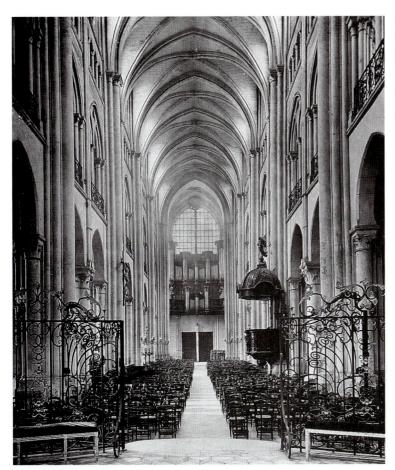

10.2 Interior of Noyons Cathedral. The nave was finished between 1285 and 1330. A fine example of the older style of Gothic architecture. The walls have four rather than the typical three levels: the nave arcade at floor level; a triforium; the clerestory with its windows. The rather thick walls of the triforium level would give way in other Gothic churches to thinner walls and more pointed

ing out from Paris, the so-called Île de France. The Gothic impulse so touched other countries as well that, by the end of the thirteenth century, there were fine examples of Gothic architecture in England, Germany, and Italy.

The term Gothic merits a word of explanation. It was used first in the seventeenth century as a pejorative term meaning "barbarous" or "rude" to distinguish buildings that did not follow the Classical models of Greece and Rome, a use still current in the mid-eighteenth century. It was only as a result of the reappraisal of the medieval period in the late nineteenth century that the word lost its negative meaning.

It is tempting to say that the common characteristic of these cathedrals was the desire for verticality. We tend to identify the Gothic style with the pointed arch, pinnacles and columns, and increasingly higher walls buttressed from the outside by flying arches to accommodate the weight of a pitched roof and the sheer size of the ascending walls [10.3]. It is a truism that medieval builders seemed to engage in contests to build higher and higher almost as a matter of civic pride: Chartres (begun in 1194) reached a height of 122 feet (37.2 m); almost as a response, the builders of Amiens (begun 1220) stretched that height to 140 feet (42.7 m), while Beauvais (begun 1247) pushed verticality almost to the limit with a height

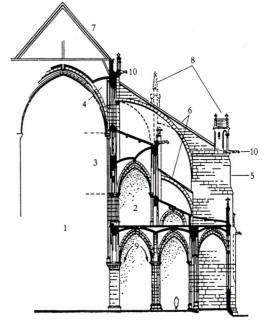

1. nave arcade

5. buttress

9. pointed arch 10. gargoyle

2. triforium 3. clerestory

6. flying buttress

4. vault

7. pitched roof 8. pinnacle

10.3 Transverse half-sectional drawing of the Cathedral of Notre Dame in Paris. Height approx. 140' (42.7 m). The tiny figure at the lower right gives some sense of scale.

of 157 feet (47.9 m) from the cathedral pavement to the roof arch; indeed, Beauvais had a serious collapse of the roof when the building was barely completed.

http://www.chartres-csm.org/us.html

Chartres Cathedral

That verticality typified Gothic architecture is indisputable, yet Romanesque architects only a generation before Suger had attempted the same verticality, as is evident in such churches as the proposed third abbey church of Cluny or the pilgrimage church at Santiago de Compostela in Spain. What prevented the Romanesque architect from attaining greater verticality was not lack of

desire but insufficient technical means. The pointed arch was known in Romanesque architecture but not fully understood. It distributed weight more thoroughly in a downward direction and lessened the need for the massive interior piers of the typical Romanesque church. The size of the piers was further reduced by using buttresses outside the building to prop the interior piers and absorb some of the downward thrust. Furthermore, the downward thrust of the exterior buttresses themselves could be increased by the addition of heavy decorative devices such as spires.

The net result of these technical innovations was to lessen the thickness, weight, and mass of the walls of the Gothic cathedral. This reduction provided an opportunity for greater height with less bulk to absorb the weight of the vaulted roof. Such a reduction made the walls more available as framing devices for the windows

10.4 Interior of the upper chapel of La Sainte Chapelle, Paris, 1243–1248. Built to house relics of Christ's Passion, this is an exquisite example of Gothic luminosity. Restored heavily, the overall effect is nonetheless maintained of skeletal architecture used as a frame for windows.

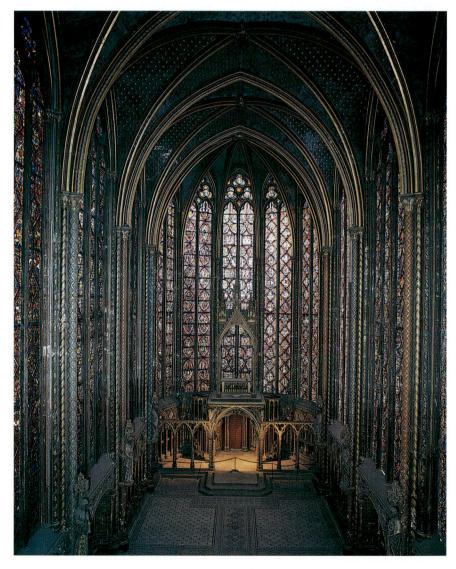

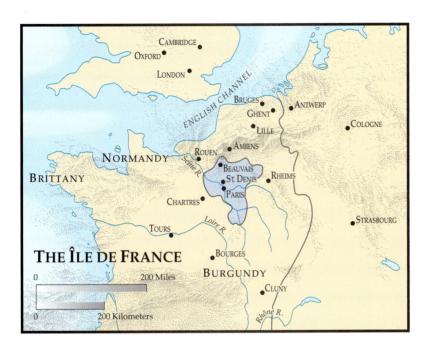

that are so characteristic of the period. It has been said, perhaps with some exaggeration, that walls in Gothic cathedrals were replaced by masonry scaffolding for windows [10.4]. In any case, the basic characteristic of Gothic architecture is not verticality but luminosity. The Gothic may be described as transparent—diaphanous—architecture.

The Mysticism of Light

Abbot Suger wrote two short booklets about his stewardship of the abbey and his ideas about the building and decorating program he initiated for the abbey church extremely important sources for our understanding of the thought that stood behind the actual work of the builder and artist. Underlying Suger's description of the abbey's art treasures and architectural improvements was a theory or (perhaps better) a theology of beauty. Suger was heavily indebted to his reading of certain mystical treatises written by Dionysius the Areopagite (whom Suger and many of his contemporaries assumed was the Saint Denis for whom the abbey was named), a fifth-century Syrian monk whose works on mystical theology were strongly influenced by Neo-Platonic philosophers as well as by Christian doctrine. In the doctrine of the Pseudo-Dionysius (as later generations have called him), every created thing partakes, however imperfectly, of the essence of God. There is an ascending hierarchy of existence that ranges from inert mineral matter to the purity of light, which is God. The Pseudo-Dionysius described all of creation under the category of light: Every created thing is a small light that illumines the mind a

bit. Ultimately, as light becomes more pure (as one ascends the hierarchy) one gets closer to pure light, which is God.

The high point of this light mysticism is expressed in the stained-glass window. Suger himself believed that when he finished his nave with its glass windows (never completed in fact) to complement his already finished choir, he would have a total structure that would make a single statement: "Bright is that which is brightly coupled with the bright, and bright is the noble edifice which is pervaded by the new light [lux nova]." The lux nova is an allusion to the biblical description of God as the God of light. Suger did not invent stained glass but he fully exploited its possibilities both by encouraging an architecture that could put it to its most advantageous employment and at the same time providing a theory to justify and enhance its use.

$\label{lem:http://www.stainedglass.org/main_pages/association_pages/history \textbf{SG}.html$

Stained Glass

No discussion of light and glass in this period can overlook the famous windows of the Cathedral of Chartres, a small but important commercial town south of Paris. When the cathedral was rebuilt after a disastrous fire in 1194 (which destroyed everything except the west façade of the church), the new building gave wide scope to the glazier's art.

When the walls were rebuilt, more than one hundred seventy-three windows were installed covering an area

of about two thousand square yards (1672 sq. m) of surface. It is important to note that, except for some fine details like facial contours, the glass is not painted. The glaziers produced the colors (the blues and reds of Chartres are famous and the tones were never again reproduced exactly) by adding metallic salts to molten glass. Individual pieces were fitted together like a jigsaw puzzle and fixed by leading the pieces together. Individual pieces were rarely larger than 8 feet (2.4 m) square, but 30 feet (9.2 m) sections could be bonded together safely in the leading process. The sections were set into stone frames (mullions) and reinforced in place by the use of iron retaining rods. Windows as large as 60 feet (18.3 m) high could be created in this fashion.

It would be useful at this point to compare the aesthetics of the stained-glass window to the mosaics discussed in Chapter 7. There was a strong element of light mysticism in the art of Byzantine mosaic decoration, derived from some of the same sources later utilized by Abbot Suger: Neo-Platonism and the allegorical reading of the Bible. The actual perception of light in the two art forms, however, was radically different. The mosaic refracted light off an opaque surface. The "sacred" aura of the light in a Byzantine church comes from the oddly mysterious breaking up of light as it strikes the irregular surface of the mosaic tesserae. The stained-glass window was the medium through which the light was seen directly, even if it was subtly muted into diverse colors and combinations of colors.

You can only "read" the meaning of the window by looking at it from the inside with an exterior light source—the sun—illuminating it. (*Read* is not a rhetorical verb in this context. It was a commonplace of the period to refer to the stained-glass windows as the "Bible of the Poor" since the illiterate could "read" the biblical stories in their illustrated form in the cathedral.) It was a more perfectly Platonic analogy of God's relationship to the world and its creatures. The viewer sees an object (the illustrated window) but "through it" is conscious of a distant unseen source (the sun—God) that illumines it and gives it its intelligibility.

A close examination of one window at Chartres will illustrate the complexity of this idea. The *Notre Dame de Belle Verrière* ("Our Lady of the Beautiful Window") [10.5], one of the most famous works in the cathedral, is a twelfth-century work saved from the rubble of the fire of 1194 and reinstalled in the south choir. The window, with its characteristic pointed arch frame, depicts the Virgin enthroned with the Christ Child surrounded by worshiping angels bearing candles and censers (incense vessels). Directly above her is the dove that represents the Holy Spirit and at the very top a stylized church building representing the cathedral built in her honor.

To a simple viewer, the window honored the Virgin to whom one prayed in time of need and to whom the church was dedicated. A person of some theological sophistication would further recognize the particular scene of the Virgin enthroned as the symbol of Mary as the Seat of Wisdom, a very ancient motif in religious art. The window also has a conceptual link with the exterior sculptural program. In the tympanum of the portal is an enthroned Madonna and Christ Child with two censerbearing angels. This scene is surrounded by sculptured arches, called *archivolts*, in which there are symbolic representations of the Seven Liberal Arts [10.6], which together constitute a shorthand version of the window.

The Blessed Virgin depicted as the Seat of Wisdom would be an especially attractive motif for the town of Chartres. The cathedral school was a flourishing center of literary and philosophical studies—studies that emphasized that human learning became wisdom only when it led to the source of wisdom: God. The fact that Mary was depicted here in glass would also call to mind an oft-repeated *exemplum* ("moral example") used in medieval preaching and theology: Christ was born of a virgin. He passed through her body as light passes through a window, completely intact without changing the glass. The Christ/light–Mary/glass analogy is an apt and deepened metaphor to be seen in the Belle Verrière of Chartres.

That kind of interpretation can be applied profitably to many aspects of Gothic art and architecture. Builders and theologians worked together closely while a cathedral was under construction. Church authorities felt it a primary duty not only to build a place suitable for divine worship but also to utilize every opportunity to teach and edify participating worshipers. The famous Gothic gargoyles [10.7] are a good example of this blend of functionality and didacticism. These carved beasts served the practical purpose of funneling rainwater off the roofs while, in their extended and jutting positions on the roofs and buttresses, signifying that evil flees the sacred precincts of the church. At a far more ambitious level, the whole decorative scheme of a cathedral was an attempt to tell an integrated story about the history of salvation—a story alluded to in both profane and divine learning. The modern visitor may be overwhelmed by what appears a chaotic jumble of sculptures depicting biblical scenes, allegorical figures, symbols of the labors of the month, signs of the Zodiac, representatives of pagan learning, and panoramic views of Last Judgments; for the medieval viewer the variegated scenes represented a patterned whole. The decoration of the cathedral was, as it were, the common vocabulary of sermons, folk wisdom, and school learning fleshed out in stone.

The Many Meanings of the Gothic Cathedral

Some theological and philosophical background is crucial for an appreciation of the significance of the Gothic cathedral, but it is a serious oversimplification to view the cathedral only in the light of its intellectual milieu.

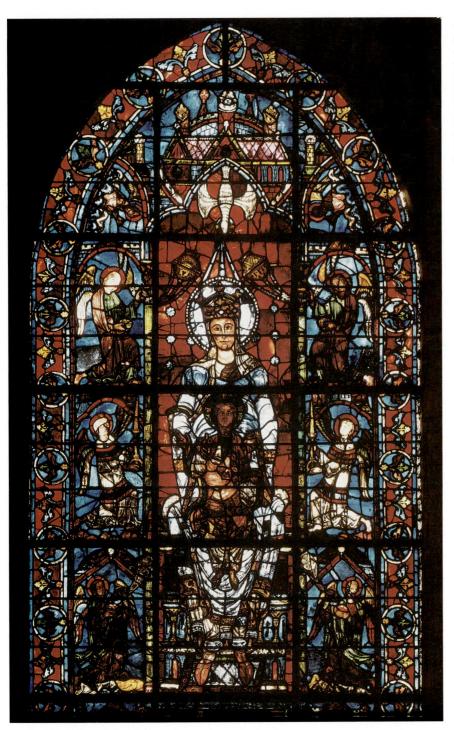

10.5 Notre Dame de Belle Verrière, Chartres Cathedral. Stained-glass window, early thirteenth century. The heavy vertical and horizontal lines are iron reinforcing rods to hold the window in place. The thinner lines are the leading. Details such as the Virgin's eyes, nose, and mouth are painted in. The red is a distinctive characteristic of the Chartres stained-glass workshops.

The cathedral was, after all, the preeminent building in the episcopal towns of the Île de France, as a view of any of the towns shows. The cathedral overwhelms the town either by crowning a hilly site, as at Laon, or rising up above the town plain, as at Amiens. The cathedrals were *town* buildings (Saint Denis, a monastic church, is a conspicuous exception) and one might well inquire into their functional place in the life of the town. It is simplistic to think that their presence in the town reflected a credulous faith on the part of the populace or the egoma-

nia of the civil and religious builders. In fact, the cathedral served vital social and economic functions in medieval society.

A modern analogy illustrates the social function of architecture and building. Many small towns in America, especially those in rural areas of the South and the Northeast, center their civic and commercial life around a town square. The courthouse symbolically emanates social control (justice); social structures (births, weddings, and deaths are registered there); power (the

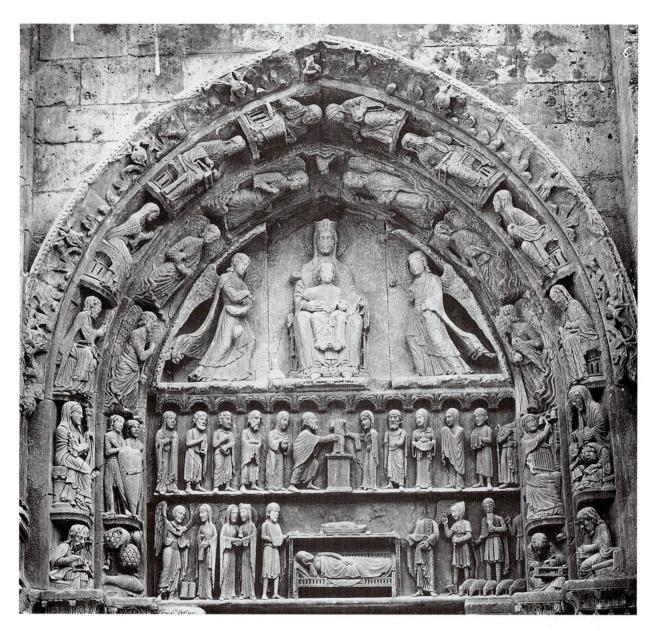

10.6 Scenes from the life of the Virgin Mary. Tympanum of the right door of the royal portal west façade, Chartres Cathedral. Done between 1145 and 1170, the central panel shows the Virgin and Child as an almost mirror image of the *Belle Verrière* (Figure 10.5). The arch has adoring angels while the outer arch (the archivolt) depicts the Seven Liberal Arts. At the lower left is Aristotle dipping his pen in ink with the female figure of Dialectic above him. Under the central figure of the Virgin are scenes from the life of Mary and the young Christ. At the lower left one can see the scene of the Annunciation.

sheriff, commissioners or aldermen, and the mayor are housed there); and—to a degree—culture, with its adjacent park and military or civic monuments to the founders and war dead. The better stores, the "uptown" churches, and the other appurtenances of respectability—banks, lawyers' and physicians' offices—cluster about the square. (The urbanization and suburbanization of

America has steadily destroyed this basic symmetry, replacing it with a far more diffuse city or suburban pattern where the concept of "center" is less easily identified.) The cathedral square of the typical European or Latin American town is the ancestor of the courthouse square. The difference is that the medieval cathedral exercised a degree of social control and integration more comprehensive than that of the courthouse.

The cathedral and its power were a serious force that shaped both individual and social life in the town. The individual was baptized in, made a communicant of, married in, and buried from, the cathedral. Schooling was obtained from the cathedral school and social services (hospitals, poor relief, orphanages, and so on) directed by the decisions of the cathedral staff (the *chapter*). The daily and yearly round of life was regulated by the horarium of the cathedral. People rose and ate and went to bed in rhythm with the tolling of the cathedral bell

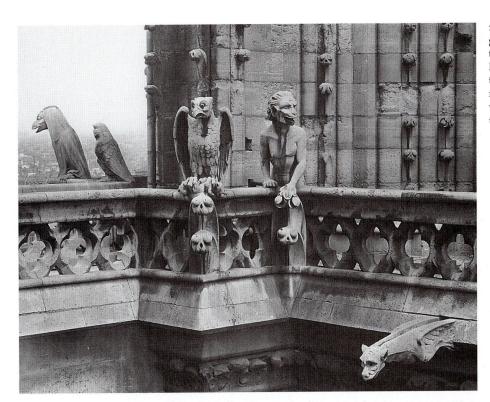

10.7 Grotesques and a gargoyle waterspout on a tower terrace of the Cathedral of Notre Dame, Paris. Many of these figures are modern representations of originals that were badly damaged during the French Revolution.

just as they worked or played in line with the feast days of the liturgical calendar of the church year. Citizens could sue and be sued in the church courts, and those same courts dispensed justice on a par with the civil courts; the scenes of the Last Judgment over the central portals of medieval cathedrals referred to more than divine justice.

Far more significant than the social interaction of town and cathedral was the economic impact of the cathedral on the town. The building of a cathedral was an extremely expensive enterprise. When the people of Chartres decided to rebuild their cathedral in 1194, the bishop pledged all of the diocesan revenues for three years (three to five million dollars!) simply to initiate the project [10.8]. It should be remembered that a town like Chartres was very small in the late twelfth century, with no more than ten to fifteen thousand residents in the town proper. Some economic historians have attempted to show that the combination of civic pride and religious enthusiasm that motivated the town to build a cathedral was economically ruinous in the long run. The majority of scholars, however, insist that it was precisely economic gain that was the significant factor in construction. This was surely the case with Chartres.

From the late ninth century, Chartres had been a major pilgrimage site. The cathedral possessed a relic of the Virgin (the tunic she wore when Jesus was born) given in 877 by Charles the Bald, the great-grandson of Charlemagne. Relics were very popular throughout the Middle Ages and this particular one was especially important to the pilgrims of the time. The relic had not been destroyed

by the fire of 1194, a sure sign in the eyes of the populace that the Virgin wished the church rebuilt. Furthermore, the four great feasts of the Blessed Virgin in the liturgical year (the Purification of Mary on February 2, the Annunciation on March 25, the Assumption on August 15, and the Nativity of the Virgin on September 8) were celebrated in Chartres in conjunction with large trade fairs that drew merchants and customers from all over Europe.

These fairs were held in the shadow of the cathedral and their conduct was protected by legislation issued by the cathedral chapter. Regulations from the chapter, for example, stated that the prized textiles of the area were to be sold near the north portal while the purveyors of fuel, vegetables, fruit, and wine were to be located by the south portal. There were also sellers of images, medals, and other religious objects (forerunners of the modern souvenir) to the pilgrims who came both for the fair and for reasons of devotion. The church, then, was as much a magnet for outsiders as it was a symbol for the townspeople.

The patrons who donated the windows of Chartres Cathedral also give some indication of the economics of the place. It was only natural that some of the large windows—like a rose window—would be the gift of a royal family or that a tall, pointed *lancet* window like those in the choir would be given by the nobility or the higher clergy. A large number of the windows, however, were donated by the members of the various craft and commercial guilds in the town; their "signature frames" can be found at the bottoms of the windows. The fact

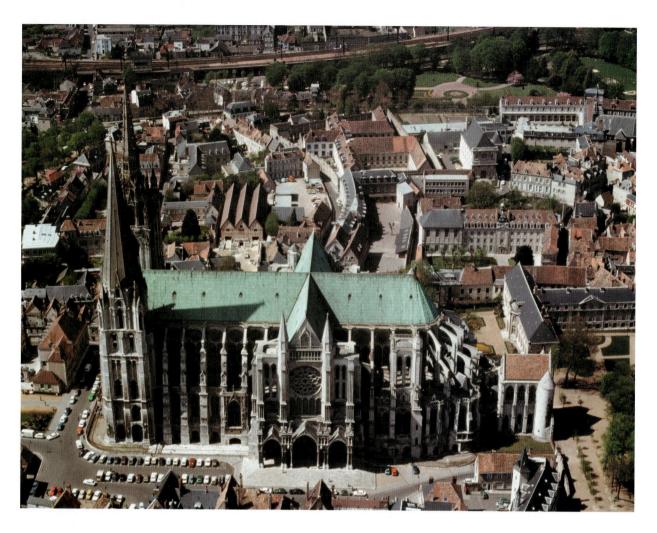

 ${f 10.8}$ Chartres Cathedral as rebuilt after 1194. Aerial view from the southeast.

that the five large windows in honor of the Virgin in the *chevet*, the east end of the cathedral, were donated by merchants—principally the bakers, butchers, and vintners—indicates the significant power of the guilds [10.9].

The guild, a fraternal society of craftsmen or merchants, was a cross between a modern-day union and a fraternal organization like the Elks or the Knights of Columbus. Members of the guilds put themselves under the patronage of a saint, promised to perform certain charitable works, and acted as a mutual-aid society. Many of the economic guilds appear to have developed out of earlier, more purely religious confraternities. One had to belong to a guild to work at any level beyond day labor. The guild accepted and instructed apprentices; certified master craftsmen; regulated prices, wages, working conditions; and maintained funds for the care of older members and the burial of their dead. The guilds were a crucial part of town life and would remain so well into the modern period. And, as we shall see, the univer-

sity developed from the guild idea in the twelfth century.

The motivation for the building of a medieval catedral, then, came from the theological vision, religious devotion, civic pride, and socioeconomic interest. The actual construction depended on a large number of people. The cathedral chapter decided to construct a building, raised the money, and hired the master builder-architect. He in turn was responsible for hiring the various master craftsmen, designing the building, and creating the decorative scheme from ideas generated and approved by the theologians or church officials of the chapter. A great workshop was set up near the proposed site, with each master (mason, stonecutter, glazier) hiring his crew, obtaining his material, and setting up work quarters. Manual and occasional labor was recruited from the local population, but the construction crews were usually migratory groups who traveled from job to job.

The names of a number of master builders, including the builder of Chartres, have been lost, but others have survived in funerary inscriptions, commemorative plaques, and building records. Notes intended for students of buildings written by Villard de Honnecourt (about 1235), an architect from northern France, preserved in a unique copy at the Bibliothèque Nationale in

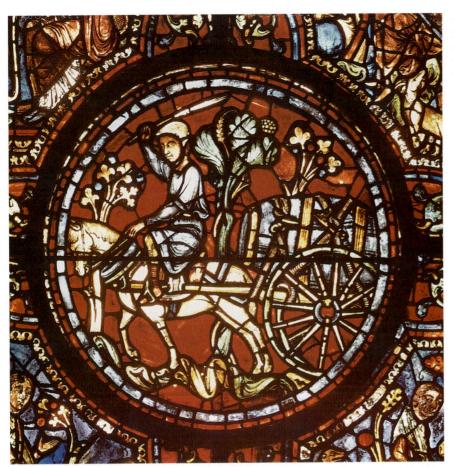

10.9 Vintner's window, glass roundel, c. 1215. Detail from the window of Saint Lubin, Cathedral, Chartres, France. This panel from a window donated by the winemakers of the area shows a wine merchant transporting vats.

Paris, provide us a rare glimpse into the skills of a medieval cathedral builder. Villard says in his book that he could teach a willing apprentice a wide range of skills ranging from carpentry and masonry to the more demanding skills of practical geometry [10.10] and plan drafting. The notebook also has random sketches and ideas jotted down for his own personal use; they include religious figures to serve as models for stonecarvers; animals and buildings that caught his eye; a perpetual motion machine (which didn't work); the first example of clockwork in the West; and a self-operating saw for cutting huge timbers for buttressing and roofing, among others. He visited Rheims and made sketches of the cathedral. He tells of traveling as far as Hungary to get work. While not as complete and wide-ranging as the Renaissance notebooks of Leonardo da Vinci (with which they have often been compared), Villard's notebook reveals a highly skilled, persistently inquisitive, and very inventive man.

A look through Villard's notebook forcefully reminds us that because our tendency is to emphasize the religious and social significance of a cathedral (as that is what first strikes us about it), we easily overlook the basic fact that a cathedral is a stunning technological achievement. A prime example of the technological vir-

tuosity of such buildings is the elegant spire of Strasbourg Cathedral. Finished in 1439, the spire is 466 feet (142.1 m) high from pavement to tip—as high as a forty-story building. This stone structure remained the tallest in Europe until the mid-1960s, when the London Post Office Tower was completed.

The Gothic cathedral is an almost perfect artifact for the study of the humanistic enterprise since it may be approached from so many angles and at so many levels. It was first an architectural and technological achievement. Its ensemble of walls, windows, sculpture, and decoration demonstrated a peculiar way of combining human knowledge and religious faith that provides a basic aesthetic experience to the viewer. It had a fundamental economic and social significance for the community in which it was located. Finally, it was, for those who entered it in faith, a transcendental religious experience of passing from the profane to the sacred world. Henry Adams, in his wonderfully eccentric book Mont-Saint-Michel and Chartres, says that only a person coming to Chartres as a pilgrim could understand the building. The pilgrim is a central metaphor for the period whether one speaks of the actual pilgrim on the road to Santiago de Compostela or Canterbury or life itself as a pilgrimage toward God. Pilgrims to Chartres or the other cathedrals

10.10 Villard de Honnecourt. Page on "practical geometry" from his Album, c. 1275. Pen and ink. Bibliothèque Nationale, Paris. *Top row:* Measuring the diameter of a partially visible column; finding the middle of a circle; cutting the mold of an arch; arching a vault with an outer covering; making an apse with twelve windows; cutting the spring stone of an arch. *Second row:* Bringing together two stones; cutting a voussoir for a round building; cutting an oblique voussoir. *Third row:* Bridging a stream with timbers; laying out a cloister without plumb line or level; measuring the width of a river without crossing it; measuring the width of a distant window. *Bottom row:* Cutting a regular voussoir.

were pilgrims in both senses: They traveled to visit a real monument and, at the same time, hoped to find rest and salvation through the act [10.11]. It is no wonder Abbot Suger should have called Saint Denis the "Gate of Heaven": That is exactly what it was meant to be.

Music: The School of Notre Dame

It should not be surprising that in an age of artistic and architectural development such as the Gothic the austere music of the early church should also undergo change. From the time Charlemagne introduced Gregorian chant into the church life of the Frankish kingdom there had

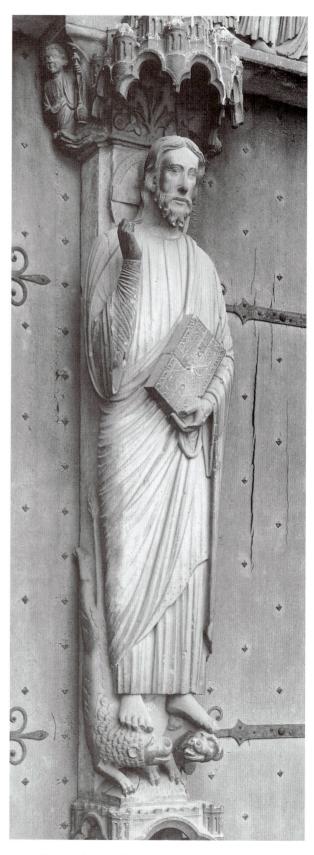

10.11 Christ in the act of blessing, c. 1215. Figure on trumeau of main portal, Chartres Cathedral. This statue symbolically blesses all pilgrims who pass through the door, the "Gate of Heaven."

been further developments of that musical form. In the eleventh century, Guido di Arezzo had worked out a system of musical notation that provided the basis for the development of the musical notation used today. Church musicians from the tenth century on also experimented with a single melodic line of plainchant by adding parallel voices at different musical intervals above the line of chant. This first step toward polyphony, a musical term for "many voices," is called organum. Outside the church, the knightly classes also composed and performed secular music. Some of the melodies of the troubadours and trouvères have survived, giving us an idea of secular music in the twelfth and thirteenth centuries. The German minnesingers (minne means "love") of the thirteenth century used traditional church modes and melodies to create secular and sacred songs.

The school of Notre Dame in Paris was the center of systematic musical study and composition in the twelfth century. Léonin's *Magnus Liber Organi* (c. 1160) is an important source for our knowledge of music in the period of the Gothic cathedral. Léonin's book was a collection of organum compositions for use during the liturgical services throughout the church year. Léonin's work was carried on by the other great composer of the century, Pérotin, who assumed the directorship of the music school of Notre Dame sometime around 1181.

For a selection from *Magnus Liber Organi*, see the Listening CD.

In Pérotin's music, the Notre Dame organum utilized the basic melodic line of the traditional chant (the *cantus firmus*) while a second melodic line (the *duplum*), a third (*triplum*), and in some cases a fourth (*quadruplum*) voice were added above the melody. These added lines mirrored the rhythmic flow of the cantus firmus. It was soon learned, however, that pleasing and intricate compositions could be created by having the duplum and triplum move in opposition to the cantus firmus. This *counterpoint* (from *contrapunctum*, "against the note") meant, at its most basic level, that a descending series of notes in the cantus firmus would have an ascending series of notes in the melodic lines above it.

One development in the Gothic period deriving from the polyphony of organum was the motet. The *motet* usually had three voices (in some cases, four). The tenor—from the Latin *tenere* ("to hold"), another term for *cantus firmus*—maintained the traditional line, usually derived from an older ecclesiastical chant. Since some of the manuscripts from the period show no words for this tenor position, it has been thought that for many motets the tenor line was the musical accompaniment. Above the tenor were two voices who sang interweaving melodies. In the early thirteenth century, these melodies were invariably in Latin and exclusively religious in content. In the late thirteenth century, it was not uncommon to sing

the duplum in Latin and the triplum in French. Indeed, the two upper voices could be singing quite distinct songs: a hymn in Latin with a love lyric in French with a tenor voice (or instrument) maintaining an elaborated melody based on the melismas of Gregorian chant.

This increasingly sophisticated music, built on a monastic basis but with a new freedom of its own, is indicative of many of the intellectual currents of the period. It is a technically complex music rooted in the distant past but open to daring innovation, a blend of the traditional and the vernacular—all held together in a complicated balance of competing elements. Gothic music was an aural expression of the dynamism inherent in the medieval Gothic cathedral.

SCHOLASTICISM

The Rise of the Universities

A number of contemporary institutions have their roots in the Middle Ages. Trial by jury is one, constitutional monarchy another. By far the best-known and most widely diffused cultural institution that dates from the Middle Ages is the university. In fact, some of the most prestigious centers of European learning today stand where they were founded eight hundred years ago: Oxford and Cambridge in England; the University of Paris in France; the University of Bologna in Italy. There is also a remarkable continuity between the organization and purposes of the medieval university and our own, except that we have coeducation. The medieval student would be puzzled, to be sure, by the idea of football games, coeducation, degrees in business or agriculture, and wellmanicured campuses, were he to visit an American university. Such a student would find himself at home with the idea of a liberal arts curriculum, the degrees from the baccalaureate through the master's to the doctorate, and the high cost of textbooks. At a less serious level, he would be well acquainted with drinking parties, fraternities, and friction between town and gown (the phrase itself has a medieval ring). The literature that has come down to us from the period is full of complaints about poor housing, high rents, terrible food, and lack of jobs after graduation. Letters from the Middle Ages between students and parents have an almost uncanny contemporaneity about them except for the fact that women did not study in the medieval universities.

European universities developed in the late twelfth and early thirteenth centuries along with the emergence of city life. In the earlier medieval period, schools were most often associated with the monasteries, which were perforce situated in rural areas. As cities grew in importance, schools also developed at urban monasteries or, increasingly, under the aegis of bishops whose cathedrals were in the towns. The episcopal or cathedral school was

VALUES

Dialectics

In ancient Greece the word dialectics originally meant the "art of conversation." By the fifth century B.C.E., dialectics took on the meaning of techniques used to come to logical conclusions based on a rigorous style of reasoning. Plato singled out dialectic in The Republic as a mark of the philosopher–king, whereas Aristotle saw it containing the "path to the principles of all inquiries."

The rediscovery of *dialectic* (which was the common medieval term for "logic") coincided with the rise of the university. The study of theology and philosophy were increasingly cast into terms that could be expressed in logic modes like that of the deductive syllogism. University professors of theology, for example, had three duties: to explain the text of scripture; to preach; and to dispute"—that is, to set out Christian doctrines in some logical form. What was true of these

Christian scholars was also true of both contemporary Islamic and Jewish thinkers who had inherited the same tradition of Aristotle's logic. Modern scholars have pointed out that this form of dialectical reasoning, with its focus on resolving problems, had ramifications for both literature and architecture.

The greatest weakness of this emphasis was the temptation to turn the logical process into an end in itself: forgetting the search for truth in a desire to dazzle people with the sheer technique of logic. Dante would open Canto XI of the *Paradiso* with a critique of such mental pyrotechnics as he complained of those who were useless in their "reasoning" (literally: their "syllogisms") that make the wings of the mind bend "in downward flight."

a direct offshoot of the increasing importance of towns and the increasing power of bishops, the spiritual leaders of town life. In Italy, where town life had been relatively strong throughout the early Middle Ages and where feudalism never took hold, there was also a tradition of schools controlled by the laity. The center of medical studies in Salerno and the law faculty of Bologna had been in secular hands since the tenth century.

A number of factors help to explain the rapid rise of formal education institutions in the twelfth century. First, the increasing complexity of urban life created a demand for an educated class who could join the ranks of administrators and bureaucrats. Urban schools were not simply interested in providing basic literacy. They were designed to produce an educated class who could give support to the socioeconomic structures of society. Those who completed the arts curriculum of a twelfth-century cathedral school (like the one at Chartres) could find ready employment in either the civil or the ecclesiastical bureaucracy as lawyers, clerks, or administrators.

There were also intellectual and cultural reasons for the rise of the universities. In the period from 1150 to 1250 came a wholesale discovery and publication of texts from the ancient world. Principal among these were lost books by Aristotle that came to the West through Muslim sources in Spain. Aristotle's writings covered a vast range of subjects ranging from meteorology and physics to logic and philosophy. Further, with a closer relationship between Christian and Arabic scholars, a large amount of scientific and mathematical material was coming into Europe [10.12]. There was also a renaissance of legal studies centered primarily at Bologna, the one intellectual center that could nearly rival Paris. Finally, there

was a new tool being refined by such scholars as Peter Abelard and Peter Lombard: dialectics. Theologians and philosophers began to apply the principles of logic to the study of philosophy and theology. Abelard's book *Sic et Non* (1121) combined conflicting opinions concerning theological matters with contradictory passages from the Bible and the Church Fathers and then attempted to mediate and reconcile the apparent divergences. This method was later refined and stylized into the method that was to become *scholasticism*, so-called because it was the philosophical method of the schools, the communities of scholars at the nascent universities.

http://www.fordham.edu/halsall/source/1120abelard.html

Abelard's Sic et Non

The most famous and representative university to emerge in the Middle Ages was the University of Paris. The eminence of Paris rested mainly on the fame of the teachers who came there to instruct. At this state of educational development, the teacher really was the school. Students in the twelfth century flocked from all over Europe to frequent the lectures of teachers like William of Champeaux (1070-1121) and, later, his formal student and vehement critic, Peter Abelard (1079-1142). Besides these famous individual teachers Paris also had some established centers of learning that enjoyed a vast reputation. There was a school attached to the Cathedral of Notre Dame, a theological center associated with the canons of the Church of Saint Victor, and a school of arts maintained at the ancient monastery of Sainte Geneviève.

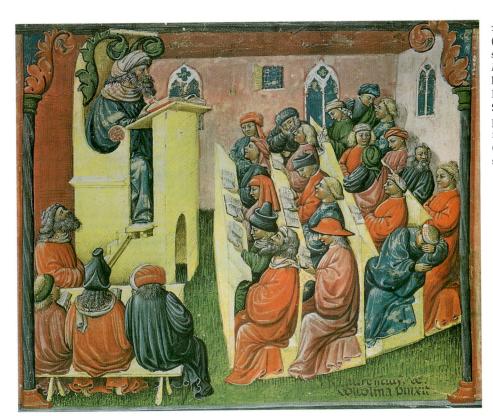

10.12 Laurencius de Voltolina (School of Bologna). A university lecture from *Lecture of Henricus de Alemania*, second half of fourteenth century. Manuscript illumination. State Museums, Berlin. The professor expounds his text from the professorial chair (*cathedra*). Note the sleeping student at the lower right.

Although it is difficult to assign precise dates, it is safe to say that the university at Paris developed in the final quarter of the twelfth and early part of the thirteenth centuries. Its development began with the *magistri* ("masters"; "teachers") of the city forming a corporation after the manner of the guilds. At this time the word *universitas* simply meant a guild or corporation. The masters formed the universitas in Paris in order to exercise some "quality control" over the teaching profession and the students entrusted to their care. At Bologna, the reverse was true. The students formed the universitas in order to hire the teachers with the best qualifications and according to the most advantageous financial terms.

The universitas soon acquired a certain status in law with a corporate right to borrow money, to sue (and be sued), and to issue official documents. As a legal body it could issue stipulations for the conduct of both masters and students. When a student completed the course of studies and passed examinations, the universitas would grant him a teaching certificate that enabled him to enter the ranks of the masters: he was a master of arts (our modern degree has its origin in that designation). After graduation, a student could go on to specialized training in law, theology, or medicine. The completion of this specialized training entitled one to be called doctor (from the Latin doctus, "learned") in his particular field. The modern notion that a professional person (doctor, lawyer, and the like) should be university-trained is an idea derived directly from medieval university usage.

Since the Carolingian period—indeed, earlier—the core of education was the arts curriculum. In the late twelfth century in Paris the arts began to be looked on as a prelude to the study of theology. This inevitably caused a degree of tension between the arts faculty and the theology masters. In 1210 this tension resulted in a split, with the masters and students of arts moving their faculty to the Left Bank of the Seine, where they settled in the area intersected by the rue du Fouarre ("Straw Street"—so named because the students sat on straw during lectures). That part of the Left Bank has traditionally been a student haunt. The name Latin Quarter reminds us of the old language that was once the only tongue used at the university.

By the end of the twelfth century, Paris was the intellectual center of Europe. Students came from all over Europe to study there. We do not have reliable statistics about their number, but an estimate of five to eight thousand students would not be far from the mark for the early thirteenth century. The students were organized into *nationes* by their place of national origin. By 1294, there were four recognized *nationes* in Paris: the French, the Picard, the Norman, and the Anglo-German. Student support came from families, pious benefactors, church stipends, or civic grants to underwrite an education. Certain generous patrons provided funds for hospices for scholars, the most famous of which was that underwritten by Robert de Sorbon in 1258 for graduate students in theology; his hospice was the forerunner of the Sorbonne in Paris.

CONTEMPORARY VOICES

A Medieval Parent and a Student

I have recently discovered that you live dissolutely and slothfully, preferring license to restraint and play to work and strumming a guitar while the others are at their studies, whence it happens that you have read but one volume of law while more industrious companions have read several. I have decided to exhort you herewith to repent utterly of your dissolute and careless ways that you may no longer be called a waster and that your shame may be turned to good repute.

[Parent to a son at the university in Orleans, fourteenth century]

We occupy a good and comely dwelling, next door but one from the schools and marketplace, so that we can go to school each day without wetting our feet. We have good companions in the house with us, well advanced in their studies, and of excellent habits—an advantage which we appreciate for, as the psalmist says "with an upright man thou wilt show thyself upright." Wherefore, lest production should cease for lack of material, we beg your paternity to send us by the bearer money for the purchase of parchment, ink, a desk, and the other things which we need, in sufficient amount that we may suffer no want on your account (God forbid!) but finish our studies and return home with honor. The bearer will also take charge of the shoes and stockings which you will send us, and any news at all.

[Scholar to his father, Orleans, fourteenth century]

By our standards, student life in the thirteenth century was harsh. Food and lodging were primitive, heating scarce, artificial lighting nonexistent, and income sporadic. The daily schedule was rigorous, made more so by the shortage of books and writing material. An "ideal" student's day, as sketched out in a late medieval pamphlet for student use, now seems rather grim:

A Student's Day at the University of Paris

4:00 A.M.	Rise
5:00-6:00	Arts lectures
6:00	Mass and breakfast
8:00-10:00	Lectures
11:00-12:00	Disputations before the noon meal
1:00-3:00 P.M.	"Repetitions"—study of morning lec-
	tures with tutors
3:00-5:00	Cursory lectures (generalized lec-
	tures on special topics) or disputa-
	tions
6:00	Supper
7:00-9:00	Study and repetitions
9:00	Bed

The masters' lectures consisted of detailed commentaries on certain books the master intended to cover in a given term. Since books were expensive, emphasis was put on note taking and copying so that the student might build up his own collection of books. Examinations were oral, before a panel of masters. Students were also expected to participate in formal debates (called disputations) as part of their training.

Geoffrey Chaucer provides us an unforgettable, albeit idealized, portrait of the medieval student (the clerk or cleric—many of the students were members of the minor clerical orders of the church) in his Prologue to the *Canterbury Tales:*

A clerk from Oxford was with us also, Who'd turned to getting knowledge, long ago. As meagre was his horse as is a rake, Nor he himself too fat, I'll undertake, But he looked hollow and went soberly. Right threadbare was his overcoat; for he Had got him yet no churchly benefice, Nor was so worldly as to gain office. For he would rather have at his bed's head Some twenty books, all bound in black and red, Of Aristotle and his philosophy Than rich robes, fiddle, or gay psaltery. Yet, and for all he was philosopher, He had but little gold within his coffer; But all that he might borrow from a friend On books and learning he would swiftly spend, And then he'd pray right busily for the souls Of those who gave him wherewithal for schools. Of study took he utmost care and heed. Not one word spoke he more than was his need; And that was said in fullest reverence And short and quick and full of high good sense. Pregnant of moral virtue was his speech: And gladly would he learn and gladly teach.

Chaucer's portrait of the lean, pious, poor, zealous student was highly idealized to create a type. We probably get a far more realistic picture of what students were actually doing and thinking about from the considerable amount of popular poetry that comes from the student culture of the medieval period. This poetry depicts a student life we are all familiar with: a poetry of wine, women, song, sharp satires at the expense of pompous

professors or poor accommodations, and the occasional episodes of cruelty that most individuals are capable of only when banded into groups.

The student subculture had also invented a mythical Saint Golias, who was the patron saint of wandering scholars. Verses (called Goliardic verse) were written in honor of the "saint." The poems that have come down to us are a far cry from the sober commentaries on Aristotle's *Metaphysics* that we usually associate with the medieval scholar.

One of the more interesting collections of these medieval lyrics was discovered in a Bavarian monastery in the early nineteenth century. The songs in this collection were written in Latin, Old French, and German and seem to date from the late twelfth and thirteenth centuries. Their subject range was wide but, given the nature of such songs, predictable. There were drinking songs, laments over the loss of love or the trials of fate, hymns in honor of nature, salutes to the end of winter and the coming of spring, and cheerfully obscene songs of exuberant sexuality. The lyrics reveal a shift of emotions ranging from the happiness of love to the despair of disappointment just as the allusions range from classical learning to medieval piety. One famous song, for example, praises the beautiful powerful virgin in language that echoes the piety of the church. The last line reveals, however, that the poem salutes not Mary but generous Venus.

In 1935 and 1936, German composer Carl Orff set a number of these poems to music under the title *Carmina Burana*. His brilliant, lively blending of heavy percussion, snatches of ecclesiastical chant, strong choral voices, and vibrant rhythms have made this work a modern concert favorite. The listener gets a good sense of the vibrancy of these medieval lyrics by the use of the modern setting. Since the precise character of student music has not come down to us, Orff's new setting of these lyrics is a fine beginning for learning about the musicality of this popular poetry from the medieval university.

Did women study at the university? By and large they did not. Medieval customs sheltered women in a manner we find hard to imagine. Women were educated either privately (Heloise was tutored by her uncle in Paris when she met Abelard) or within the cloister of the convent. Furthermore, most of university life was tied to the church. The masters were clerics (except at Bologna) and most students depended on ecclesiastical benefices ("pensions") to support them. There are exceptions to this rule. There seem to have been women in universities in both Italy and Germany, but they were the exception. At Salerno, famous for its faculty of medicine, there may have been women physicians who were attached to the faculty. We do know that by the fourteenth century the university was licensing women physicians. There is also a tradition that Bologna had a woman professor of law who, according to the story, was so beautiful that she lectured from behind a screen so as not to dazzle her students! It is well to remember that the universities were very conservative and traditional institutions. It was not until this century, for example, that provisions were made for women's colleges at Oxford that enjoyed the full privileges of university life. The discrimination against women at the university level was something, for example, that moved the bitter complaints of the English novelist, Virginia Woolf, as late as the 1920s.

Francis of Assisi

http://www.newadvent.org/cathen/06221a.htm

St. Francis of Assisi

In Italy, at the end of the twelfth century, a young man would be born who would reshape medieval religious and cultural life. Giovanni Bernadone, born in 1181 in the Umbrian hill town of Assisi, was renamed "Francesco" ("Little Frenchman") by his merchant father. Francis grew up the son of wealthy parents as a popular, somewhat spendthrift, and undisciplined youth. He joined the volunteer militia as a youth to do battle against the neighboring city of Perugia only to be captured and put into solitary confinement until a ransom could be found.

That incident seems to have marked a turning point in his life. He dropped out of society and began to lead a life of prayer and self-denial. Eventually he came to the conclusion that the life of perfect freedom demanded a life of total poverty. He gave away all of his goods and began a life of itinerant preaching that took him as far away as the Middle East. His simple lifestyle attracted followers who wished to live in imitation of his life. By 1218, there were over three thousand "Little Brothers" (as he called them) who owed their religious allegiance to him. Francis died in 1226 when the movement he started was already a powerful religious order in the church [10.13].

If we know Francis of Assisi today, it is because of garden shop statues of him with a bird on his shoulder. That he preached to the birds is a fact [10.14], but to think of him only as a medieval Doctor Doolittle speaking to animals is to trivialize a man who altered medieval culture profoundly. First, his notion of a mendicant ("begging") brotherhood that would be mobile and capable of preaching in the newly emerging cities of Europe was a worthy substitute for the more rural, land-bound monasteries of the past. Second, Francis believed that the Gospels could be followed literally and this led him to identify closely with the humanity of Christ. It is said that in 1224, he had so meditated on the Passion of Christ that his own body bore the crucifixion marks of Christ (stigmata). This emphasis on Christ's humanity would have a powerful impact in making religious art more

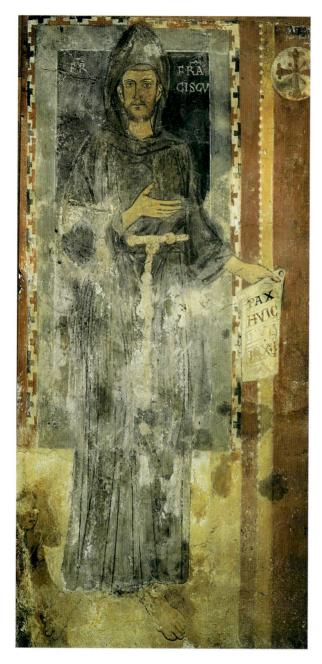

10.13 Saint Francis of Assisi. Fresco. Santo Specchio. This may be the earliest portrait of Saint Francis; some scholars believe that it was executed during the saint's lifetime.

realistic and vivid. Finally, Francis' attitude toward religious faith was powerfully affirmative. He praised the goodness of God's creation; he loved the created world; he preached concern for the poorest of the poor; he felt that all creation was a gift and that everything in creation praised God in its own way. Some scholars have argued that the impact of the Franciscan vision on the imagination of European culture was a remote cause of the Renaissance preoccupation with the natural world and the close observation of nature.

The early part of the thirteenth century, in fact, saw that rise of two complementary impulses that would energize late medieval culture: the intellectualism of the schools epitomized in someone like Thomas Aquinas (discussed below) and the affective and emotional religion of a Francis of Assisi. Those two impulses were best synthesized in the masterpiece that summed up high medieval culture: the *Commedia* of Dante Alighieri.

http://www.iath.virginia.edu/dante/

Dante

Thomas Aquinas

The Golden Age of the University of Paris was the thirteenth century, since in that period Paris could lay fair claim to being the intellectual center of the Western world. It is a mark of the international character of medieval university life that some of its most distinguished professors did not come from France: Albert the Great (a German), Alexander of Hales (English), Bonaventure and Thomas Aquinas (Italian).

Thomas Aquinas (1225?-1274) was the most famous and influential of the Parisian masters of the thirteenth century [10.15]. His intellectual influence went far beyond the lecture halls of Paris and is felt to the present. Born of noble parentage in southern Italy, Thomas Aquinas joined the Preaching Friars of Saint Dominic (the Dominicans) in 1243. From 1245 to 1248, he studied with Albert the Great at both Paris and Cologne. He was made a magister of theology in 1258 after completing his doctoral studies. During this same period (roughly 1256 to 1259) Thomas Aquinas lectured on theology in Paris. From 1259 to 1268, he was back in Italy where he lectured and wrote at Orvieto (the papal court for a time), Rome, and Naples. From 1268 to 1272, he again held a chair of theology, when he returned to Naples to teach there. He died two years later on his way to a church council at Lyons in France.

Thomas Aquinas' life ended before he was fifty, but in that span he produced a vast corpus of writings (they fill forty folio volumes) on theology, philosophy, and biblical studies. It is a mark of his mobility that his masterpiece—the Summa Theologica—was composed at Rome, Viterbo, Paris, and Naples, although it was unfinished at his death. While his writings touched on a wide variety of subjects, at root Thomas Aguinas was interested in and made a lifetime study of a very basic problem: How does one harmonize those things that are part of human learning (reason) with those supernatural truths revealed by God in the Bible and through the teaching of the church (revelation)? Aquinas' approach was to steer a middle path through two diametrically opposed opinions, both of which had avid supporters in the Middle Ages: the position of fideism, which held that religious faith as an absolute is indifferent to the efforts of human reason (credo quia absurdum est, "I believe because it is absurd") and rationalism, which insists that everything, rev-

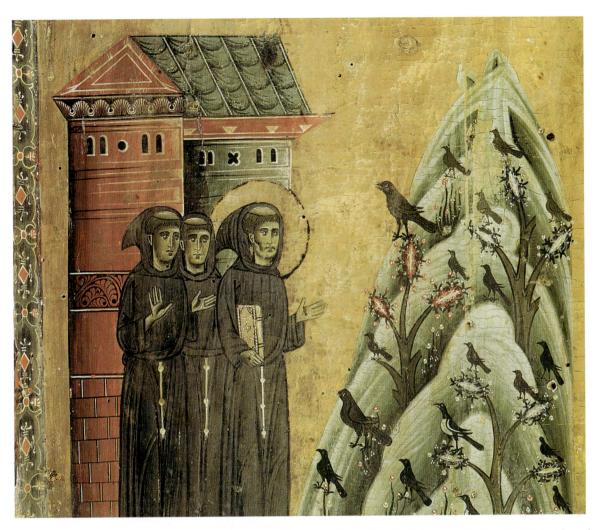

10.14 Saint Francis Preaching to the Birds. Detail of Berlingheri Altarpiece. Pescia. This detail from an altarpiece depicts incidents from the saint's life taken from early legends written about him.

elation included, must meet the test of rational human scrutiny. Aquinas wanted to demonstrate what the Gothic cathedral illustrated: that the liberal arts, the things and seasons of the world, and the mysteries revealed by God could be brought into some kind of intellectual harmony based on a single criterion of truth.

http://www.ccel.org/a/aquinas/summa/home.html

Thomas Aquinas' Summa Theologica

For Aquinas, reason finds truth when it sees evidence of truth. The mind judges something true when it has observed a sufficient number of facts to compel it to make that judgment. The mind gives assent to truth on the basis of evidence. Aquinas was convinced that there was a sufficient amount of observable evidence in the world to conclude the existence of God. He proposed five arguments in support of such a position. Still he recognized that such argumentation only yields a very limited un-

derstanding of God. Aquinas did not believe that the naked use of reason could ever discover or prove the mysteries about God revealed in the Bible: that God became a man in Jesus Christ or that there was a Trinity of persons in God. God had to tell us that. Our assent to it is not based on evidence, but on the authority of God who reveals it to us. If we could prove the mysteries of faith, there would have been no need for revelation and no need of faith.

Thus for Aquinas there is an organic relationship between reason and revelation. Philosophy perfects the human capacity to know and revelation perfects one beyond self by offering salvation and eternal life. Aquinas stated this relationship between reason and revelation at the very beginning of his great work of theology, the *Summa Theologica*.

When we read Aquinas today we get some sense of his stark and rigorous attempt to think things through. For one thing, he offers no stylistic adornment to relieve his philosophical and rational discourse. For another, he makes clear that philosophical reasoning is difficult; it is

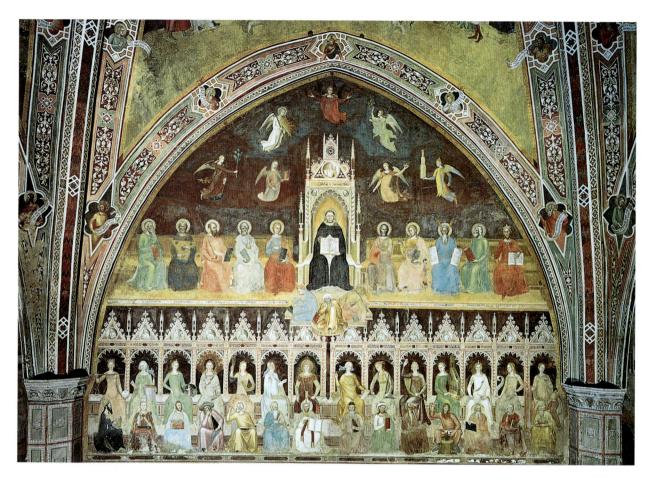

10.15 Andrea di Buonaiuto. *The Triumph of St. Thomas Aquinas*, c. 1365. Fresco. Santa Maria Novella, Florence. The saint is enthroned between figures of the Old and New Testaments with the personification of the Virtues, Sciences, and Liberal Arts below. This Florentine church had a school of studies attended by Dante Alighieri in his youth.

not a pastime for the incompetent or the intellectually lazy. Yet Aquinas was not a mere machine for logic. He had the temperament of a mystic. Some months before he died he simply put down his pen; when his secretary asked him why he had stopped writing, Aquinas simply said that in prayer and quiet he had had a vision and that what he had written "seemed as straw." Aquinas was a rare combination of intellectual and mystic.

The philosophical tradition Aquinas used in his writing was that of the Greek philosopher Aristotle. He first knew Aristotle's work in Latin translations based on Arabic texts done by Muslim scholars in the south of Spain and North Africa. Later Aquinas was able to use texts translated directly out of Greek by a Flemish friar and sometime companion, William of Moerbeke. Aquinas' use of Aristotle was certainly not a novelty in the Middle Ages. Such Arabic scholars as Avicenna (980–1036) and Averröes of Córdova (1126–1198) commented on Aristotle's philosophy and its relationship to the faith of Islam. Jewish thinkers like the famous Moses Maimonides

(born in Córdova in 1135, died in Egypt in 1204) made similar attempts to bridge Greek thought and their own religious faith. Maimonides wrote his famous *Guide for the Perplexed* to demonstrate the essential compatibility of the Hebrew scriptures with the thought of Aristotle. Maimonides was determined that essentials of the biblical message not be compromised, but he likewise felt that in nonessentials there was room for human reflection. In this task of distinguishing the place of intellect and faith Maimonides anticipated the work of Thomas Aquinas by two generations.

Two other characteristics of the thought of Aquinas should be noted. First, his worldview was strongly hierarchical. Everything has its place in the universe, and that place is determined in relation to God. A rock is good because it is (to Aquinas existence was a gift), but an animal is more nearly perfect because it has life and thus shares more divine attributes. In turn, men and women are better still because they possess mind and will. Angels are closer yet to God because they, like God, are pure spirit.

This hierarchical worldview explains other characteristics of Aquinas' thought in particular and medieval thought in general: It is wide-ranging, it is encyclopedic, and in interrelating everything it is synthetic. Everything fits and has its place, meaning, and truth. That a person would speak on psychology, physics, politics, theology, and philosophy with equal authority would strike us as

presumptuous, just as any building decorated with symbols from the classics, astrology, the Bible, and scenes from everyday life would now be considered a hodge-podge. Such was not the case in the thirteenth century, since it was assumed that everything ultimately pointed to God.

DANTE'S DIVINE COMEDY

In any discussion of the culture of the High Middle Ages two descriptive adjectives come immediately to mind: hierarchical and synthetic. It is a commonplace, for example, to compare the Gothic cathedral and the systematic treatises on philosophy and theology like the Summa Theologica of Saint Thomas Aquinas. On close inspection such comparisons may be facile, but they point to the following truths about this period that are relatively secure: Both the Gothic cathedral and the theology of Aquinas, for example, started from the tangible and sensual ("Nothing comes to the mind except through the senses" is a basic axiom for Aquinas) in order to mount in a hierarchical manner to the light that is God. Again, both writer and architect felt it possible to be universal in their desire to synthesize all human knowledge as prelude and pointer to the full revelation of God. Finally, they both constructed their edifices by the juxtaposition of tensions and syntheses.

If the Gothic cathedral and the Summa Theologica represent two masterpieces of the hierarchical and synthetic religious humanism of the Middle Ages, the Divine Comedy of Dante Alighieri (1265-1321) represents the same masterly achievement in literature. Dante [10.16] was a Florentine. He was nonetheless deeply influenced by the intellectual currents that emanated from the Paris of his time. As a comfortably fixed young man he devoted himself to a rigorous program of philosophical and theological study in order to enhance his already burgeoning literary talent. His published work gives evidence of a profound culture and a deep love for study. He wrote on the origin and development of language (De Vulgari Eloquentia), political theory (De Monarchia), and generalized knowledge (Convivio) as well as his own poetic aspirations (Vita Nuova). His masterpiece is the Divine Comedy.

Dante was exiled from Florence for political reasons in 1300. In his bitter wanderings in the north of Italy he worked on—and finally brought to conclusion—a long poem to which he gave a bitingly ironical title: *The Comedy of Dante Alighieri, A Florentine by Birth but Not in Behavior.* Dante called his poem a comedy since, as he noted, it had a happy ending and was written in the popular language of the people. The adjective *divine* was added later; some say by Boccaccio, who in the next generation lectured on the poem in Florence and wrote one of the first biographies of the great poet.

The *Divine Comedy* relates a symbolic journey that the poet begins on Good Friday, 1300, through hell, purga-

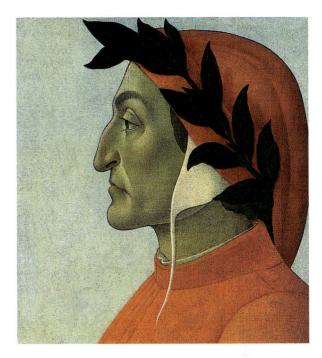

10.16 Sandro Botticelli, *Dante*, c. 1480–1485. Oil on canvas, $24^{1}/_{2}^{"} \times 18^{1}/_{2}^{"}$ (54 × 47 cm). Collection Dr. Martin Bodmer, Cologny/Geneva. Like most portraits of Dante, Botticelli's depicts him wearing the traditional laurel wreath of the poet.

tory, and heaven [Table 10.1]. In the first two parts of his journey, Dante is guided by the ancient Roman poet Vergil, whose *Aeneid* was such an inspiration to him and from which he borrowed (especially from Book VI, which tells of Aeneas' own journey to the Underworld). From the border at the top of the Mount of Purgatory to the pinnacle of heaven where Dante glimpses the "still point of light" that is God, Dante's guide is Beatrice, a young woman Dante had loved passionately if platonically in his youth [10.17].

Every significant commentator on the Comedy has noted its careful organization. The poem is made up of one hundred cantos. The first canto of the Inferno serves as an introduction to the whole poem. There are then thirty-three cantos for each of the three major sections (Inferno, Purgatorio, and Paradiso). The entire poem is written in a rhyme scheme called terza rima (aba, bcb, cdc, and so on) that is almost impossible to duplicate in English because of the shortage of rhyming words in our language. The number three and its multiples, symbols of the Trinity, occur over and over. The Inferno is divided into nine regions plus a vestibule, and the same number is found in the Purgatorio. Dante's Paradiso is constituted by the nine heavens of the Ptolemaic system plus the Empyrean, the highest heaven. This scheme mirrors the whole poem of ninety-nine cantos plus one. The sinners in the Inferno are arranged according to whether they sinned by incontinence, violence, or fraud (a division Dante derived from Aristotle's Ethics), while the yearning souls of purgatory are divided in three ways according to how they acted or failed to act in relation to love.

TABLE 10.1 The Structure of Dante's Comedy

Hell

The Anteroom of the Neutrals

Circle 1: The Virtuous Pagans (Limbo)

Circle 2: The Lascivious

Circle 3: The Gluttonous

Circle 4: The Greedy and the Wasteful

Circle 5: The Wrathful

Circle 6: The Heretics

Circle 7: The Violent against Others, Self, God/Nature/ and Art

Circle 8: The Fraudulent (subdivided into ten classes, each of which dwells in a separate ditch)

Circle 9: The Lake of the Treacherous against kindred, country, guests, lords and benefactors. Satan is imprisoned at the center of this frozen lake.

Purgatory

Ante-Purgatory: The Excommunicated/The Lazy/The Unabsolved/Negligent Rulers

The Terraces of the Mount of Purgatory

- 1. The Proud
- 2. The Envious
- 3. The Wrathful
- 4. The Slothful
- 5. The Avaricious
- 6. The Gluttonous
- 7. The Lascivious

The Earthly Paradise

Paradise

- 1. The Moon: The Faithful who were inconstant
- 2. Mercury: Service marred by ambition
- 3. Venus: Love marred by lust
- 4. The Sun: Wisdom; the theologians
- 5. Mars: Courage; the just warriors
- 6. Jupiter: Justice; the great rulers
- 7. Saturn: Temperance; the contemplatives and mystics
- 8. The Fixed Stars: The Church Triumphant
- 9. The Primum Mobile: The Order of Angels
- 10. The Empyrean Heavens: Angels, Saints, the Virgin, and the Holy Trinity

The saved souls in the *Paradiso* are divided into the lay folk, the active, and the contemplative. Nearest the throne of God, but reflected in the circles of heaven, are the nine categories of angels.

Dante's interest in the symbolic goes beyond his elaborate manipulation of numbers. In the *Inferno* sinners suffer punishments that have symbolic value; their sufferings both punish and instruct. The gluttonous live on heaps of garbage under driving storms of cold rain, while the flatterers are immersed in pools of sewage and the sexually perverse walk burning stretches of sand in an environment as sterile as their attempts at love. Conversely, in the *Paradiso*, the blessed dwell in the circles

most symbolic of their virtue. The theologians are in the circle of the sun since they provided such enlightenment to the world, and the holy warriors dwell in the sphere of Mars.

We can better appreciate the density and complexity of Dante's symbolism by looking at a single example. Our common image of Satan is that of a sly tempter (in popular art he is often in formal dress whispering blandishments in a willing ear with just a whiff of sulphur about him) after the manner of Milton's proud, perversely tragic, heroic Satan in *Paradise Lost*. For Dante, Satan is a huge, stupid beast, frozen in a lake of ice in the pit of hell. He beats six batlike wings (a demonic leftover from his angelic existence; see Isaiah 6:1–5) in an ineffectual attempt to escape the frozen pond that is watered by the four rivers of hell. He is grotesquely three-headed (a parody of the Trinity) and his slavering mouths remorselessly chew the bodies of three infamous traitors from sacred and secular history (Judas, Cassius, and Brutus).

Why does Dante portray Satan so grotesquely? It is clear that Dante borrowed some of the picture of Satan from Byzantine mosaics with which he would have been familiar in the baptistery of Florence [10.18]. Beyond that, the whole complex of Satan is heavily weighted with symbolic significance. Satan lies in frozen darkness at a point in the universe farthest from the warmth and light of God. He is the fallen angel of light (Lucifer means "light-bearer"), now encased in a pit in the center of the earth excavated by the force of his own fall from heaven. Satan is immobile in contrast to God who is the mover of all things in the universe. He is totally inarticulate and stupid because he represents, par excellence, all of the souls of hell who have lost what Dante calls "the good of intellect." Satan, and all the souls in hell, will remain totally unfulfilled as created rational beings because they are cut off from the final source of rational understanding and fulfillment: God. Intellectual estrangement from God is for Dante, as it was for Thomas Aquinas, the essence of damnation. This estrangement is most evident in the case of Satan, who symbolizes in his very being the loss of rationality and all that derives from that fact.

Dante, following a line of thought already developed by Suger and Aquinas, conceived the human journey as a slow ascent to the purity of God by means of the created things of this world. To settle for less than God was, in essence, to fail to return to the natural source of life, God. This explains why light is such a crucial motif in the *Divine Comedy* as it had been in the theories of Abbot Suger. Neither light nor the sources of light (the sun) is ever mentioned in the *Inferno*. The overwhelming visual impression of the *Inferno* is darkness—a darkness that begins when Dante is lost in the "dark wood" of Canto I and continues until he climbs from hell and sees above his head the stars (the word *stars* ends each of the three major parts of the poem) of the Southern Hemisphere. In the ascent of the mountain of purgatory, daylight and

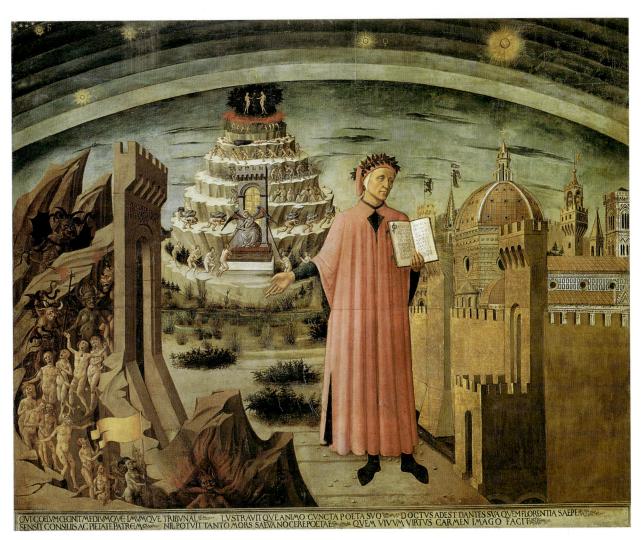

10.17 Domenico di Michelino. *Dante and His Poem*, 1465. Fresco. Florence Cathedral. Dante, with an open copy of the *Comedy*, points to Hell with his right hand. The Mount of Purgatory with its seven terraces is behind him. Florence's cathedral (with its newly finished dome) represents Paradise on the poet's left.

sunset are controlling motifs to symbolize the reception and rejection of divine light. In the *Paradiso*, the blessed are bathed in the reflected light that comes from God. At the climax of the *Paradiso*, the poet has a momentary glimpse of God as a point of light and rather obscurely understands that God, the source of all intelligibility, is the power that also moves the "sun and the other stars."

Within the broad reaches of Dante's philosophical and theological preoccupations the poet still has the concentrated power to sketch unforgettable portraits: the doomed lovers Paolo and Francesca—each of the tercets that tell their story starts with the word *amore* ("love"); the haughty political leader Farinata degli Umberti; the pitiable suicide Pier delle Vigne; or the caricatures of gluttons like Ciacco the Hog. Damned, penitent, or saved, the characters are by turns both symbols and persons. Saint Peter represents the church in the *Paradiso* but

also explodes with ferociously human anger at its abuses. Brunetto Latini in the *Inferno* with "his brownbaked features" is a condemned sodomite but still anxious that posterity at least remember his literary accomplishments.

It has been said that a mastery of the Divine Comedy would be a mastery of all that was significant about the intellectual culture of the Middle Ages. It is certainly true that the poem, encyclopedic and complex as it is, would provide a primer for any reader interested in the science, political theory, philosophy, literary criticism, and theology of the thirteenth century as well as a detailed acquaintance with the burning questions of Dante's time. The very comprehensiveness of the poem has often been its major obstacle for the modern reader. Beyond that hurdle is the strangeness of the Dantean world, so at variance with our own: earth-centered, manageably small, sure of its ideas of right and wrong, orthodox in its theology, prescientific in its outlook, Aristotelian in its philosophy. For all that, Dante is not only to be read for his store of medieval lore; he is, as T. S. Eliot once wrote, the most universal of poets. He had a deeply sympathetic appreciation of human aspiration, love and hate, the destiny of humanity, and the meaning of nature and history.

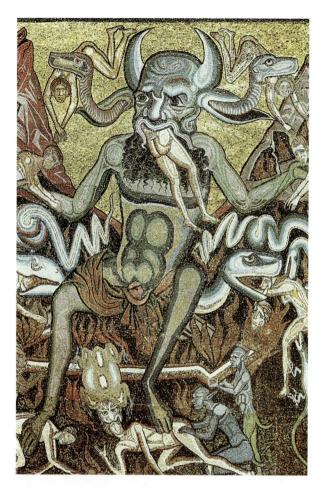

10.18 *Hell.* Detail of mosaic in vault of baptistery of Florence Cathedral, thirteenth century. As a young man Dante would have seen this mosaic, which adorned the baptistery ("My beautiful San Giovanni," he calls it in his poem) of his native city.

SUMMARY

The High Middle Ages saw the growth of a number of institutions that stood in sharp contrast to those of the Carolingian period. Foremost was the rise of the city. Urbanization brought with it a lessening of the importance of monastic life as a cultural center and the emergence of the influence of the bishop and the cathedral school. The increased need for a "knowledge class" triggered an expansion in education that would eventually lead to the university of scholars. Urbanization also warred against the old feudal values; it fostered trade and commerce; it made possible the growth of what we today call a "middle class" who stood on the social ladder between the rural peasant/city worker and the landed royalty or hereditary aristocracy.

The twelfth and thirteenth centuries were times of intense intellectual ferment and advance. New sources of knowledge came through Arabic sources either as original contributions (e.g., in medicine and science) or in the form of lost works of the Classical past (e.g., the writings of Aristotle) to fuel the work of scholars. Advances in

technology as "spinoffs" from the ambitious plans of both Romanesque and Gothic architects had their impact. The increase of a money economy over a barter economy aided the growth of artistic and musical culture.

One conspicuous characteristic of medieval culture was its belief that everything knowable could be expressed in a manageable and rational whole. Whether it appeared in stone (Chartres) or technical prose (Thomas Aquinas) or in poetry (Dante), the medieval mind saw hierarchy, order, intelligibility, and, above all, God in all of observable creation. This hierarchy expressed itself in its emphasis on advancing steps of understanding. The sculptural program of Chartres, for example, is a revelation of the Old Testament figures who point us to their proper fulfillment in the New. In the theology of Aquinas we move from the plane of natural reason to a fuller truth taught by revelation. In Dante we progress from an awareness of our sinful nature to an intuition into the nature of God. In all of these cases the emphasis is on harmony and gradation and a final purpose of all knowledge, which is to become aware of God. In that sense, at least, much of medieval culture could be said to be oriented in an otherworldly manner.

PRONUNCIATION GUIDE

Abelard: AB-eh-lard
Alighieri (Dante): Al-e-GARY
Aquinas: Ah-KWI-nas
Averröes: Av-ER-row-es
Avicenna: Av-e-CHENA

CAR-me-nah Bur-RAN-ah

Chartres: CHART-reh

Divina Commedia: Dee-VEE-nah Com-EH-dee-ah Gwido di Arezzo: GWE-dough deh Ah-RET-so

Léonin:LEE-oh-ninMaimonides:My-MON-id-ezePérotin:PEAR-oh-tin

Pseudo-Dionysius: SUE-dough-Die-oh-NY-sius

Suger: SUE-jay

Universitas: U-nee-VER-see-tas
Villard de Honnecourt: VEE-yar deh HO-nee-cor

EXERCISES

- Is it possible to think of a building or complex of buildings serving as an organizing metaphor for a contemporary city in the way a cathedral served in the Middle Ages?
- 2. What positive and/or negative outcomes do you see deriving from the medieval cult of the Virgin?
- Compare the use and role of light in the atmosphere of Hagia Sophia and the Cathedral of Chartres.
- Describe some of the technological problems medieval builders had to solve in an age with limited power sources, no tempered metals, no computers or slide rules for calculations, and so on.
- The medieval university was organized around the body of scholars who made up the faculty. To what degree

- does that model hold up today? What is the organizing principle of the modern college or university?
- 6. A good deal of medieval education utilized dialectics. What does that word mean? Where do dialectics, broadly understood, find their usefulness today?
- 7. Thomas Aquinas had no doubt that all knowledge was both interrelated and capable of being synthesized into a whole. Everything from science and philosophy to theology would fit into that synthesis. Would that view find many supporters today? If not, why not?

8. If you were to organize a contemporary hell for the great villains of our day, would you use Dante's classification or would you construct another schema? On what basis

would it be organized?

9. Dante looks back to Vergil as the model for his great work of poetry. If we were to write a work today to celebrate our culture and destiny, would we feel the need to invoke a past model to do so? If so, who might it be? If not, why not?

FURTHER READING

Adams, Henry. (1959). *Mont-Saint-Michel and Chartres*. Garden City: Doubleday. A brilliant albeit eccentric work on the culture of the Gothic world. While its scholarship has been superseded in this century, it is still an aesthetic classic.

Bony, Jean. (1983). French Gothic architecture of the 12th and 13th centuries. Berkeley: University of California Press.

Authoritative and lavishly illustrated.

Cunningham, Lawrence S. (1981). *Saint Francis of Assisi*. San Francisco: Harper & Row. Readable essays on the saint and his culture with profuse illustrations.

Ferruolo, Stephen. (1985). *The origins of the university*. Stanford, CA: Stanford University Press. A scholarly focus on the schools of Paris from 1100 to 1215.

Gilson, Étienne. (1966). *Reason and revelation in the Middle Ages*. New York: Scribner's. A brief but excellent survey of the intellectual milieu of the period by one of the foremost authorities of our century.

Gimpel, Jean. (1977). The medieval machine: The Industrial Revolution of the Middle Ages. New York: Penguin. A wonderful introduction to technology in medieval times.

Golding, William. (1964). The spire. New York: Harcourt. A brilliant fictional evocation of medieval cathedral building.

Holmes, Urban T. (1966). *Daily living in the twelfth century*. Madison: University of Wisconsin. An extremely readable account of ordinary life in medieval London and Paris drawn from documentary evidence.

Knowles, David. (1962). *The evolution of medieval thought.* New York: Vintage. A classic study of medieval thought from Augustine to the eve of the Reformation.

Macauley, David. (1973). *Cathedral: The story of its construction*. Boston: Houghton, Mifflin. A book for young and old readers on the construction of a cathedral, with penand-ink drawings by the author. A fascinating and lovely work that is simple but richly informative.

McInerny, Ralph M. (1990). A first glance at St. Thomas Aquinas. Notre Dame: University of Notre Dame Press. A readable introduction to the thought of Thomas Aquinas.

Panofsky, Erwin. (1946). Abbot Suger. Princeton, NJ: Princeton University Press. A translation of Suger's booklets on

Saint Denis with an important introduction and full notes. Indispensable for the period.

Singleton, Charles. (1972). *The* Divine Comedy *of Dante Alighieri* (6 vols.). Princeton, NJ: Princeton University Press. With a commentary in English by the foremost authority on Dante in America. There are separate volumes of the poem in English with companion volumes of commentary. Excellent and indispensable.

Wilson, Christopher. (1993). The gothic cathedral. New York:

Thames and Hudson.

ONLINE CHAPTER LINKS

Gothic architecture is examined at http://www.geocities.com/Athens/Parthenon/8063/ gothic.html

For introductory information about Gothic art as well as links to sites related to representative artists, consult *Artcyclopedia* at

http://www.artcyclopedia.com/history/gothic.html

The Medieval Art and Architecture Web site at

http://info.pitt.edu/~medart/

provides access to a wide variety of architectural wonders in Europe—including those at St. Denis, Chartres, and Amiens.

For a virtual tour of Chartres Cathedral, visit http://info.pitt.edu/~medart/menufrance/chartres/ charmain.html

where the floor plan, glass work, and sculptures are examined in detail.

The St. Francis of Assisi Web site at

http://www.americancatholic.org/Features/Francis/ features a brief biography of the patron saint of animals and ecology and his association with blessing animals.

For information about the Franciscan Order in America, visit

http://www.pressroom.com/~franciscan/

Dante Alighieri on the Web at

http://www.greatdante.net/index.html

provides a wide range of information about the author, downloads of some of his complete texts including the *Divine Comedy*, and links to related Internet sites.

For a catalog of useful links to Internet resources, consult *Medieval Music Links* at

http://classicalmus.hispeed.com/medieval.html

Karadar Classical Music at

http://www.karadar.it/Dictionary/Default.htm provides an alphabetical listing of musicians with brief biographies and a list of works (some of which are available on MIDI files).

		GENERAL EVENTS	LITERATURE & PHILOSOPHY	Art
		GENERAL EVENTS	ETTERATORE & TIMEOSOTHI	ARI
	1200			13th cent. Dependence on Byzantine models in Italian painting
		1299 Ottoman Turk dynasty founded		c. 1240–1302 Cimabue, Madonna Enthroned; Crucifixion
		1300 Pope Boniface VIII proclaims first Jubilee Year ("Holy Year")		c. 1300 New naturalism in Italian painting appears with work of Giotto
<u>111</u>		1303 Philip the Fair of France humiliates Pope Boniface VIII	c. 1303-1321 Dante, Divine Comedy	1305–1306 Giotto, Arena Chapel frescoes
NA				c. 1308–1311 Duccio, Maestà altarpiece, Siena
DLE AGES/PROTO-RENAISSANC	1309	1309 "Babylonian Captivity" of the papacy at Avignon begins		c. 1310 G. Pisano completes Pisa Cathedral pulpit; Giotto, Madonna Enthroned
Z	APAC	1326 Earliest known use of cannon		1333 Martini, The Annunciation
-RI	OF THE PAPACY	1337–1453 "Hundred Years' War" between France and England		1337–1339 A. Lorenzetti, Allegory of Good Government fresco, Siena
TO.	OF T	1346–1378 Reign of Charles IV, Holy Roman emperor		c. 1347–1360 Prague, as residence of Charles IV, becomes major art
RO	TTY"	1346 English defeat French at Crécy		center
/P	APTIV	1348 Bubonic plague depopulates Europe	1348 – 1352 Boccaccio, <i>Decameron</i> , collection of tales	c. 1350–1360 Unknown Bohemian Master, <i>Death of the Virgin</i>
FES	NN C.	1356 English defeat French at Poitiers	after 1350 Petrarch compiles <i>Canzoniere</i> , collection of poems	c. 1363 Court of dukes of Burgundy
A	BABYLONIAN CAPTIVITY"	1358 Revolt of lower classes (<i>Jacquerie</i>) in France	c. 1370 Saint Catherine of Siena urges end of "Babylonian Captivity"	at Dijon becomes important center of International Style
DLI	'BAB)	1363–1404 Reign of Philip the Bold, duke of Burgundy	1373 Petrarch, Letter to Posterity, autobiography	
ID	1377	1376 Popes return to Rome from Avignon		
ATE M		1377–1399 Reign of Richard II in England	c. 1377 Wycliff active in English church reform; translates Bible into English	c. 1377–1413 Wilton Diptych
1	SM	1378 "Great Schism" begins	21.51.01.	
Γ	SCH	1381 Peasant riots ("Wat Tyler Rebellion") in England	c. 1385 – 1400 Chaucer, <i>The Canter-bury Tales</i> , collection of tales	
	Тне Great	1399–1413 Reign of Henry IV in England	c. after 1389 Christine de Pisan, <i>The</i>	1395 – 1399 Broederlam, Presentation
	Гне G	1413 English defeat French at Agincourt	Book of the City of Ladies	in the Temple and Flight into Egypt 1395–1406 Sluter, The Well of Moses
	1417	1417 Council of Constance ends "Great Schism" with election of Pope Martin V		1413–1416 Limbourg Brothers, illustrations for <i>Très Riches Heures du Duc de Berry</i>

CHAPTER 11 THE FOURTEENTH CENTURY: A TIME OF TRANSITION

ARCHITECTURE

Music

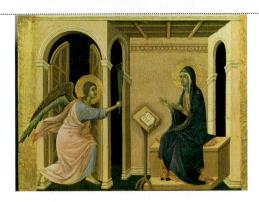

1288-1309 Palazzo Pubblico, Siena

1295 Santa Croce, Florence, begun

1296 Florence Cathedral (Duomo) begun

1298 Palazzo Vecchio, Florence, begun

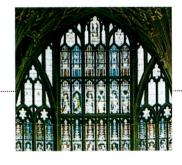

1332–1357 Gloucester Cathedral choir ("Perpendicular" style)

1325 Vitry, Ars Nova Musicae, treatise describing new system of musical notation

after 1337 Machaut, *Messe de Notre Dame*, polyphonic setting of the Ordinary of the Mass

 c. 1350 Landini famous in Florence as performer and composer of madrigals and ballads

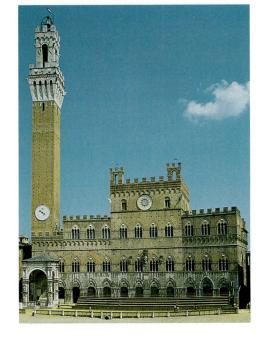

c. 1345 – 1438 Doge's Palace, Venice

1386 Duomo of Milan begun

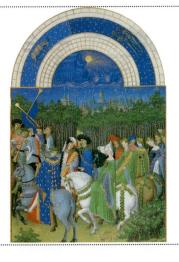

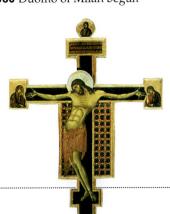

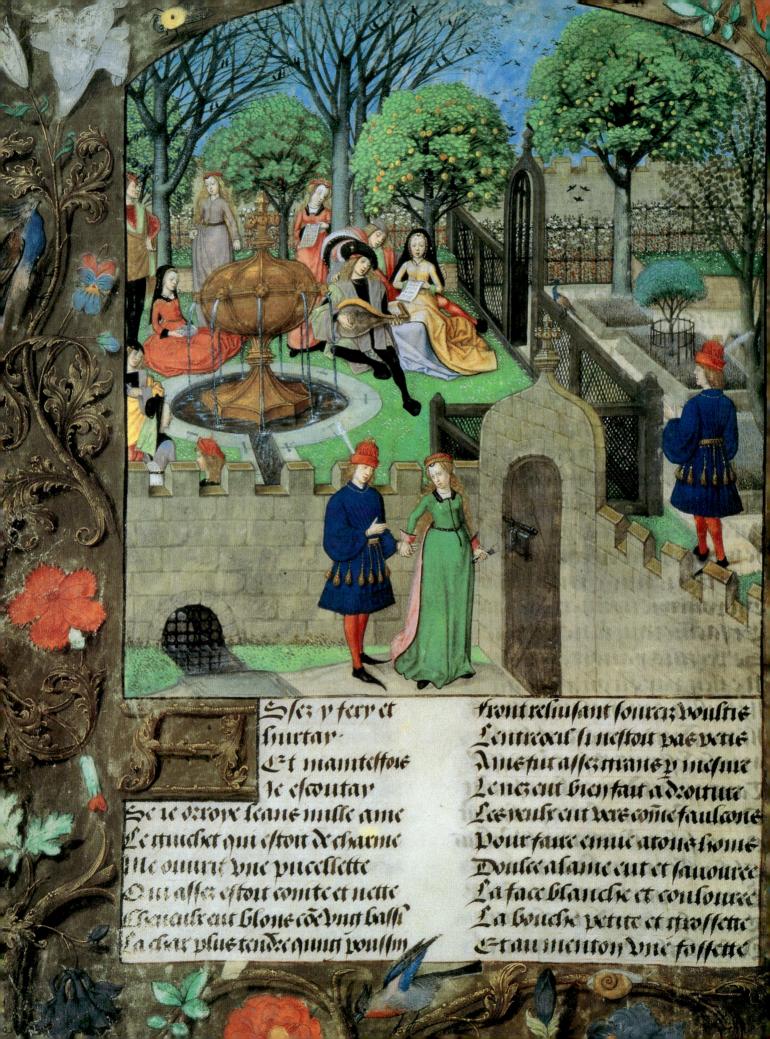

CHAPTER 11

THE FOURTEENTH CENTURY: A TIME OF TRANSITION

CALAMITY, DECAY, AND VIOLENCE

he fourteenth century (often called the *Trecento*, Italian for "three hundred") is usually described by historians as the age that marks the end of the medieval period and the beginning of the Renaissance in Western Europe. If we accept this rather neat description of the period we should expect to see strong elements of the medieval sensibility as well as some stirrings of the "new birth" (Renaissance) of culture that was the hallmark of fifteenth-century European life. We must, however, be cautious about expecting the break between "medieval" and "Renaissance" to be clean and dramatic. History does not usually work with the precision employed by the historians. Neither should we expect to see cultural history moving upward in a straight line toward greater modernity or greater perfection. In fact, the fourteenth century was a period of unparalleled natural calamity, institutional decay, and cruel violence.

The Black Death

http://www.discovery.com/stories/history/blackdeath/ blackdeath.html

The Black Death

Midway through the century, in 1348, bubonic plague swept through Europe in a virulent epidemic that killed untold numbers of people and upset trade, culture, and daily life in ways difficult for us to imagine. It has been estimated that some cities in Italy lost as many as two-thirds of their population in that year.

One prominent figure who lived through that devastation was the Italian writer Giovanni Boccaccio (1313–1375). His great collection of stories, the *Decameron*, has a plague setting. A group of young men and

women flee Florence to avoid the plague; during their ten days' sojourn in the country (*Decameron* is Greek for "ten days") they amuse each other by telling stories. Each of the ten young people tells a story on each of the ten days. The resulting one hundred stories constitute a brilliant collection of folktales, *fabliaux* ("ribald fables"), *exempla* ("moral stories"), and romances Boccaccio culled from the oral and written traditions of Europe. Because of their romantic elements, earthiness, and somewhat shocking bawdiness the *Decameron* has often been called the "Human Comedy" to contrast it with the lofty moral tone of Dante's epic work of an earlier generation.

However delightful and pleasing these stories are to read, they stand in sharp contrast to the horrific picture Boccaccio draws of the plague in his introduction to the *Decameron*. Boccaccio's account has the ring of authenticity. He had been an eyewitness to the events he describes. His vivid prose gives some small sense of what the plague must have been like for a people who possessed only the most rudimentary knowledge of medicine and no knowledge at all about the source of illness and disease.

The Great Schism

http://www.newadvent.org/cathen/13539a.htm

Great Schism

Nature was not the only scourge to affect the stability of Europe. The medieval Christian church, that most powerful and permanent large institution in medieval life, underwent convulsive changes in the fourteenth century—changes that were distant warning signals of the Reformation at the beginning of the sixteenth century.

A quick look at some dates indicates clearly the nature of these changes. In 1300, Pope Boniface VIII celebrated the great jubilee year at Rome that brought

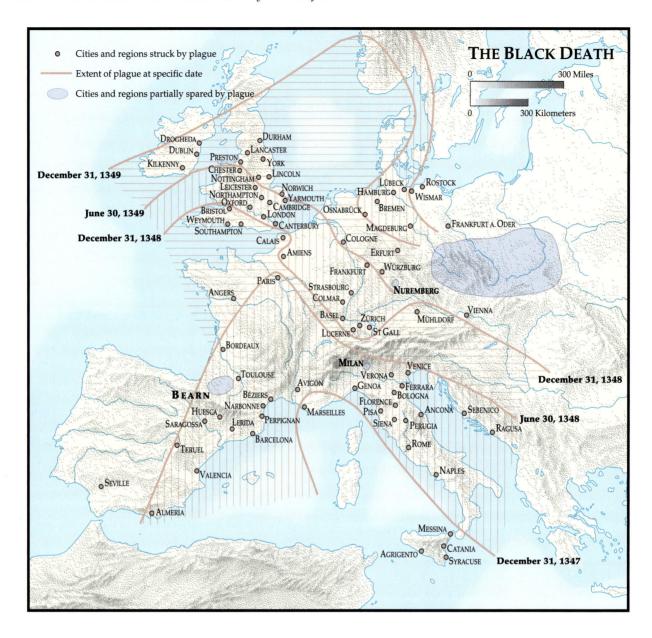

pilgrims and visitors from all over the Christian West to pay homage to the papacy and the church it represented and headed. This event was one of the final symbolic moments of papal supremacy over European life and culture. Within the next three years, Philip the Fair of France imprisoned and abused the same pope at the papal palace of Anagni. The pope died as a result of his humiliating encounters with royal power; even Dante's implacable hatred of Boniface could not restrain his outrage at the humiliation of the office of the pope. By 1309, the papacy, under severe pressure from the French, had been removed to Avignon in Southern France, where it was to remain for nearly seventy years. In 1378, the papacy was further weakened by the Great Schism, which saw European Christianity divided into hostile camps, each of

whom pledged allegiance to a rival claimant to the papacy. Not until 1417 was this breach in church unity healed; a church council had to depose three papal pretenders to accomplish the reunification of the church.

The general disarray of the church in this period spawned ever more insistent demands for church reforms. Popular literature (as both Boccaccio and, in England, Geoffrey Chaucer, clearly demonstrate) unmercifully satirized the decadence of the church. Great saints like the mystic Catherine of Siena (1347–1380) wrote impassioned letters to the popes at Avignon in their "Babylonian Captivity" demanding that they return to Rome free from the political ties of the French monarchy. In England, John Wyclif's cries against the immorality of the higher clergy and the corruption of the church fueled

VALUES

Natural Disaster and Human Response

All of the chapters in this book single out a particular value expressed in the culture of the period under discussion. In this chapter, however, we raise another kind of issue affecting human values: How do people respond to catastrophic events in their lives? One historian has called the Plague Years of 1347–1351 the "greatest natural disaster ever to have struck Europe." Although firm figures are hard to come by, it is safely assumed that Europe lost 30 percent of its population in that period, with mortality rates in some areas as high as 60 percent.

Boccaccio, in the *Decameron*, said that the Florentines responded either with an orgy of entertainment, on the presumption that on the morrow they might all be dead; or by turning to religion for solace; while many, like the ten young people of the *Decameron*, fled to what they thought would be an area of safety.

We have abundant documentation to show that other (not surprising) reactions were common. One was to find a scapegoat upon whom blame for the plague could be laid. The most conspicuous fourteenth-century scapegoat was the Jewish population, who became the object of expulsion orders, riots, and massacres by unruly mobs with the compliance of the authorities.

Another common reaction was the outbreak of religious mania. During the plague years, itinerant bands of men and women marched through villages and towns, scourging themselves, crying out for penance, and describing the plague as God's judgment. These flagellants (as they were called) came mainly from the lay ranks who were infected with a hysteria over a catastrophe they could not understand.

With the slow passing of the plague, its long-range effects began to take hold: famine caused by the shortage of manpower in agriculture, and the breakdown of social authority which, within a generation, would result in the uprisings of the lower classes in places as different as Florence, France, and England.

The most poignant of the Plague Chronicles was one written by an Irish friar in 1349 who says that he left some unused parchment attached to his story in case anyone "of Adam's race" would survive to continue his story. Another hand wrote in that blank space: "Here it seems that the author died."

indignation at all levels. The famous Peasant Revolt of 1381 was greatly aided by the activism of people aroused by the ideas of Wyclif and his followers.

The 1381 revolt in England was only the last in a series of lower-class revolutions that occurred in the four-teenth century. The frequency and magnitude of these revolts (like that of the French peasants beginning in 1356) highlight the profound dissatisfactions with the church and the nobility in the period. It is not accidental that the story of Robin Hood, with its theme of violence toward the wealthy and care for the poor, began in the four-teenth century.

The Hundred Years' War

The terrible violence of the fourteenth century was caused not only by the alienation of the peasants but also by the Hundred Years' War between France and England. While the famous battles of the period—Poitiers, Crécy, Agincourt—now seem romantic and distant, it is undeniable that they brought unrelieved misery to France for long periods. Between battles, roaming bands of mercenaries pillaged the landscape to make up for their lack of pay. The various battles were terrible in themselves. One example must suffice. According to Jean Froissart's *Chronicles*, the English King Edward III sent a

group of his men to examine the battlefield after the Battle of Crécy (1346), in which the English longbowmen slaughtered the more traditionally armed French and mercenary armies: "They passed the whole day upon the field and made a careful report of all they saw. According to their report it appeared that eighty banners, the bodies of eleven princes, twelve hundred knights, and thirty thousand common men were found dead on the field." It is no wonder that Barbara Tuchman's splendid history of life in fourteenth-century France, *A Distant Mirror* (1978), should have been subtitled "The Calamitous Fourteenth Century."

http://www.fordham.edu/halsall/source/froissart1.html

Hundred Years' War

LITERATURE IN ITALY, ENGLAND, AND FRANCE

Amid the natural and institutional disasters of the fourteenth century there were signs of intense human creativity in all the arts, especially in literature. In Italy, Dante's literary eminence was secure at the time of his death (1321) and the reputation of Italian letters was further enhanced by two other outstanding Tuscan writers: the poet Francesco Petrarch and Giovanni Boccaccio, famed for the *Decameron*. In England, one of the greatest authors in the history of English letters was active: Geoffrey Chaucer. His life spanned the second half of the fourteenth century; he died, almost symbolically, in 1400.

Petrarch

http://www.newadvent.org/cathen/11778a.htm

Petrarch

It is appropriate to begin a discussion of fourteenthcentury culture with Petrarch. His life spanned the better part of the century (1304–1374) and in that life we can see the conflict between the medieval and early Renaissance ideals being played out.

Petrarch (Petrarca in Italian) was born in Arezzo, a small town in Tuscany, south of Florence. As a young man, in obedience to parental wishes, he studied law for a year in France and for three years at the law faculty in Bologna. He abandoned his legal studies immediately after the death of his father to pursue a literary career. To support himself he accepted some minor church offices but was never ordained to the priesthood.

Petrarch made his home at Avignon (and later at a much more isolated spot near that papal city, Vaucluse), but for the greater part of his life he wandered from place to place. He could never settle down; his restlessness prevented him from accepting lucrative positions that would have made him a permanent resident of any one place. He received invitations to serve as secretary to various popes in Avignon and, through the intercession of his close friend Boccaccio, was offered a professorship in Florence. He accepted none of these positions.

Petrarch was insatiably curious. He fed his love for the ancient classics by searching out and copying ancient manuscripts that had remained hidden and unread in the various monasteries of Europe. It is said that at his death he had one of the finest private libraries in Europe. He wrote volumes of poetry and prose, carried on a vast correspondence, advised the rulers of the age, took a keen interest in horticulture, and kept a wide circle of literary and artistic friends. We know that at his death he possessed pictures by both Simone Martini and Giotto, two of the most influential artists of the time. In 1348, Petrarch was crowned poet laureate of Rome, the first artist so honored since the ancient days of Rome.

One true mark of the Renaissance sensibility was a keen interest in the self and an increased thirst for personal glory and fame. Petrarch surely is a fourteenthcentury harbinger of that spirit. Dante's Divine Comedy is totally oriented to the next life; the apex of Dante's vision is that of the soul rapt in the vision of God in eternity. Petrarch, profoundly religious, never denied that such a vision was the ultimate goal of life. At the same time, his work exhibits a tension between that goal and his thirst for earthly success and fame. In his famous prose work Secretum (My Secret), written in 1343, the artist imagines himself in conversation with Saint Augustine. In a dialogue extraordinary for its sense of self-confession and self-scrutiny, Petrarch discusses his moral and intellectual failings, his besetting sins, and his tendency to fall into fits of depression. He agrees with his great hero Augustine that he should be less concerned with his intellectual labors and the fame that derives from them and more with salvation and the spiritual perfection of his life. However, Petrarch's argument has a note of ambivalence: "I will be true to myself as far as it is possible. I will pull myself together and collect my scattered wits, and make a great endeavor to possess my soul in patience. But even while we speak, a crowd of important affairs, though only of this world, is waiting for my attention."

The inspiration for the Secretum was Augustine's Confessions, a book Petrarch loved so much that he carried it with him everywhere. It may well have been the model for Petrarch's Letter to Posterity, one of the few examples of autobiography we possess after the time of Augustine. That Petrarch would have written an autobiography is testimony to his strong interest in himself as a person. The Letter was probably composed in 1373, a year before his death. Petrarch reviews his life up until 1351, where the text breaks off abruptly. The unfinished work is clear testimony to Petrarch's thirst for learning, fame, and selfawareness. At the same time, it is noteworthy for omitting any mention of the Black Death of 1348, which carried off the woman he loved. The letter is an important primary document of the sensibility of the fourteenthcentury "proto-Renaissance."

Petrarch regarded as his most important works the Latin writings over which he labored with devotion and in conscious imitation of his most admired classical masters: Ovid, Cicero, and Vergil. Today, however, only a literary specialist or an antiquarian is likely to read his long epic poem in Latin called Africa (written in imitation of Vergil's Aeneid), or his prose work in praise of the past masters of the world (De Viris Illustris), or his meditations on the benefits of the contemplative life (De Vita Solitaria). What has assured the literary reputation of Petrarch is his incomparable vernacular poetry, which he considered somewhat trifling but collected carefully into his Canzoniere (Songbook). The Canzoniere contains more than three hundred sonnets and forty-nine canzoni ("songs") written in Italian during the span of his adult career.

The subject of a great deal of Petrarch's poetry is his love for Laura, a woman with whom he fell immediately in love in 1327 after seeing her at church in Avignon. Laura died in the plague of 1348. The poems in her honor are divided into those written during her lifetime and those mourning her untimely death. Petrarch poured out his love for Laura in over three hundred sonnets (fourteen-line poems) he typically broke into an octave and a sestet. Although they were never actually lovers (Petrarch says in the Secretum that this was due more to her honor than to his; Laura was a married woman), his Laura was no mere literary abstraction. She was a flesh-and-blood woman whom Petrarch genuinely loved. One of the characteristics of his poetry, in fact, is the palpable reality of Laura as a person; she never becomes (as Beatrice does for Dante) a symbol without earthly reality.

The interest in Petrarch's sonnets did not end with his death. Petrarchism, by which is meant the Petrarchan form of the sonnet and particularly the poet's attitude to his subject matter—praise of a woman as the perfection of human beauty and the object of the highest expression of love—was introduced into other parts of Europe before the century was over. In England, Petrarch's sonnets were first imitated in form and subject by Sir Thomas Wyatt in the early sixteenth century. Although the Elizabethan poets eventually developed their own English form of the sonnet, the English Renaissance tradition of poetry owes a particularly large debt to Petrarch, as the poetry of Sir Philip Sidney (1554-1586), Edmund Spenser (1552-1599), and William Shakespeare (1564-1616) shows. Their sonnet sequences follow the example of Petrarch in linking together a series of sonnets in such a way as to indicate a development in the relationship of the poet to his love.

Petrarch's Sonnet 15

Backwards at every weary step and slow
These limbs I turn which with great pain I bear;
Then take I comfort from the fragrant air
That breathes from thee, and sighing onward go.
But when I think how joy is turned to woe,
Remembering my short life and whence I fare,
I stay my feet for anguish and despair,
And cast my tearful eyes on earth below.
At times amid the storm of misery
This doubt assails me: how frail limbs and poor
Can severed from their spirit hope to live.
Then answers Love: Hast thou no memory
How I to lovers this great guerdon give,
Free from all human bondage to endure?
(John Addington Symonds, trans.)

Chaucer

http://icg.fas.harvard.edu/~chaucer/

Chaucer

While it is possible to see the beginning of the Renaissance spirit in Petrarch and other Italian writers of the fourteenth century, the greatest English writer of the century, Geoffrey Chaucer (1340–1400), still reflects the culture of his immediate past. The new spirit of individualism discernible in Petrarch is missing in Chaucer. He is still very much a medieval man. Only in the later part of the fifteenth century, largely under the influence of Italian models, can we speak of the Renaissance in England. This underscores the valuable lesson about history that movements do not necessarily happen immediately and everywhere.

Scholars have been able to reconstruct Chaucer's life with only partial success. We know that his family had been fairly prosperous wine merchants and vintners and that he entered royal service early in his life, eventually becoming a squire to King Edward III. After 1373, he undertook various diplomatic tasks for the king, including at least two trips to Italy to negotiate commercial contracts. During these Italian journeys Chaucer came into contact with the writings of Dante, Petrarch, and Boccaccio. There has been some speculation that he actually met Petrarch, but the evidence is tenuous. Toward the end of his life Chaucer served as the customs agent for the port of London on the river Thames. He was thus never a leisured "man of letters"; his writing had to be done amid the hectic round of public affairs that engaged his attention as a highly placed civil servant.

Like many other successful writers of the late medieval period, Chaucer could claim a widespread acquaintance with the learning and culture of his time. This was still an age when it was possible to read most of the available books. Chaucer spoke and wrote French fluently, and his poems show the influence of many French allegories and "dream visions." That he also knew Italian literature is clear from his borrowings from Dante and Petrarch and from his use of stories and tales in Boccaccio's Decameron (although it is not clear that he knew that work directly). Chaucer also had a deep knowledge of Latin literature, both classical and ecclesiastical. Furthermore, his literary output was not limited to the composition of original works of poetry. He made a translation from Latin (with an eye on an earlier French version) of Boethius' Consolation of Philosophy as well as a translation from French of the thirteenth-century allegorical erotic fantasy Romance of the Rose. He also composed a short treatise on the astrolabe and its relationship to the

study of astronomy and astrology (two disciplines not clearly distinguished at that time).

The impressive range of Chaucer's learning pales in comparison to his most memorable and noteworthy talents: his profound feeling for the role of the English language as a vehicle for literature; his efforts to extend the range of the language (the richness of Chaucer's vocabulary was not exceeded until Shakespeare); and his incomparable skill in the art of human observation. Chaucer's characters are so finely realized that they have become standard types in English literature: his pardoner is an unforgettable villain, his knight the essence of courtesy, his wife of Bath a paradigm of rollicking bawdiness.

These characters, and others, are from Chaucer's masterpiece, *The Canterbury Tales*, begun sometime after 1385. To unify this vast work, a collection of miscellaneous tales, Chaucer used a typical literary device: a narrative frame, in this case a journey during which people tell each other tales. As noted, Boccaccio had used a similar device in the *Decameron*.

http://www.cta.dmu.ac.uk/projects/ctp/

Canterbury Tales

Chaucer's plan was to have a group of thirty pilgrims travel from London to the shrine of Saint Thomas à Becket at Canterbury and back. After a general introduction, each pilgrim would tell two tales on the way and two on the return trip in order to pass the long hours of travel more pleasantly. Between tales they might engage in perfunctory conversation or prologues of their own to cement the tales further into a unified whole.

Chaucer never finished this ambitious project; he died before half of it was complete. The version we possess has a General Prologue in which the narrator, Geoffrey Chaucer, describes the individual pilgrims, his meeting with them at the Tabard Inn in London, and the start of the journey. Only twenty-three of the thirty pilgrims tell their tales (none tells two tales) and the group has not yet reached Canterbury. There is even some internal evidence that the material we possess was not meant for publication in its present form.

Although *The Canterbury Tales* is only a draft of what was intended to be Chaucer's masterwork, it is of incomparable literary and social value. A close reading of the General Prologue, for instance—with its representative, although limited, cross section of medieval society (no person lower in rank than a plowman or higher in rank than a knight appears)—affords an effortless entry into the complex world of late medieval England. With quick, deft strokes Chaucer not only creates verbal portraits of people who at the same time seem both typical and uniquely real but also introduces us to a world of slowly

dying knightly values; a world filled with such contrasts as clerical foibles, the desire for knowledge, the ribald taste of the lower social classes, and an appetite for philosophical conversation.

After the General Prologue, the various members of the pilgrim company begin to introduce themselves and proceed to tell their tales. Between the tales they engage in small talk or indulge in lengthy prologues of their own. In the tales that he completed, we see that Chaucer drew on the vast treasury of literature—both written and oral—that was the common patrimony of medieval culture. The Knight's Tale is a courtly romance; the miller and reeve tell stories that spring from the ribald *fabliaux* tradition of the time; the pardoner tells an *exemplum* such as any medieval preacher might employ; the prioress draws from the legends of the saints; the nun's priest uses an animal fable, while the parson characteristically enough provides a somewhat tedious example of a medieval prose sermon.

At places, as in the prologue to the tale of the Wife of Bath, we get from Chaucer a long meditation on some of the problems of the age. The Wife of Bath introduces her tale, for instance, with a discourse explaining why the persistent tradition against women (misogyny) is unjust and contrary to authentic Christian theology. She also makes a passionate plea for seeing sexual relations as a good given by God. This may strike us as unnecessary but in an age that prized the unmarried state (e.g., for monks, nuns, priests, etc.) it was a necessary corrective.

Christine de Pisan

http://www.netsrq.com/~dbois/pisan.html

Christine de Pisan

Christine de Pisan (1365–1428?) is an extraordinary figure in late medieval literature if for no other reason than her pioneering role as one of Europe's first women professional writers to make her living with the power of her pen.

Born in Venice, Christine accompanied her father Thomas de Pizzano to the French court of Charles V when still a small child. Thomas was the king's physician, astrologer, and close adviser. He evidently gave his daughter a thorough education: She was able to write in both Italian and French and probably knew Latin well enough to read it. At fifteen she married Eugene of Castel, a young nobleman from Picardy. That same year (1380) the king died and the family fell on hard times with the loss of royal patronage. Five years later her father and her husband were both dead, leaving Christine the sole support of her mother, niece, and three young

CONTEMPORARY VOICES

John Ball

Good people: things cannot go right in England and never will, until goods are held in common and there are no more villeins ["peasants"] and gentle-folk. . . . In what way are those whom we call lords greater masters than ourselves? How have they deserved it? If we all spring from a common mother and father, Adam and Eve, how can they claim or prove that they are lords more than us except by making us produce and grow the wealth which they spend?

They are clad in velvet and camlet lined with squirrel and ermine, while we go dressed in coarse cloth.

They have the wines, the spices, and the good bread; we have the rye, the husks, and the straw and we drink

They have shelters and ease in their fine manors and we have hardship and toil, the winds and the rains in the fields.

And from us must come, from our labor, the things which keep them in luxury.

We are called serfs and beaten if we are slow in service to them, yet we have no sovereign lord we can complain to; none to hear us and do us justice.

Let us go to the king—he is young—and show him how we are oppressed and tell him how we want things changed or else we will change them ourselves. If we go in good earnest and all together, very many people who are called serfs and are held in subjection will follow us to get their freedom.

When the king hears us he will remedy the evil, willingly or otherwise!

[Sermon of the priest John Ball, a leader in the English Peasant Revolt of 1381, recorded in The Chronicles of Froissart.]

children. To maintain this large family, Christine hit on an almost unheard of solution for a woman of the time: She turned to writing and the patronage such writing could bring to earn a living.

Between 1399 and 1415, Christine composed fifteen books, which, as one of her translators has noted, is a staggering record in an age that had neither typewriters nor word processors. In 1399, she entered a famous literary debate about the Romance of the Rose. The Romance, a long and rather tedious poem, had been written in the preceding century and was immensely popular (Chaucer did an incomplete English translation of it). In 1275, Jean de Meung had written an addition to it that was violently critical of women. Christine attacked this misogynistic addition in a treatise called A Letter to the God of Love. In 1404, she wrote her final word on this debate in a long work titled The Book of the City of Ladies.

http://digital.library.upenn.edu/women/pisan/Christine.html

Christine de Pisan's The Book of the City of Ladies

The Book of the City of Ladies is indebted in its structure to Augustine's The City of God, and for its sources, a Latin treatise by Boccaccio titled De Claris Mulieribus. Through use of stories of famous women (clarae mulieres), Christine demonstrates that they possessed virtues precisely opposite to those vices imputed to women by Jean de Meung.

The following year (1405) Christine wrote *The Treasure* of the City of Ladies, a book of etiquette and advice to help women survive in society. What is extraordinarily interesting about this book (one of the few available in English translation) is its final section, in which Christine pens advice for every class of women-from young brides and wives of shopkeepers to prostitutes and peasant women.

Around 1418, Christine retired to a convent in which her daughter was a nun, where she continued to write. Besides a treatise on arms and chivalry and a lament about the horrors of civil war, she also composed prayers and seven allegorical psalms. Of more enduring interest was The Book of Peace, a handbook of instruction for the Dauphin who was to become Charles VII and a short hymn in honor of the great Joan of Arc. Whether Christine lived to see the bitter end of Joan is uncertain, but her hymn is one of the few extant works written while Joan was alive.

Immensely popular in her own time (the Duc de Berry owned copies of every book she wrote), her reputation waned in the course of time, to be revived only in the last decade or so as scholars have tried to do justice to the forgotten heroines of our common history.

ART IN ITALY

Giorgio Vasari's Lives of the Artists (1550), the earliest account of the rebirth of Italian art in the Renaissance, treats first of all the great Florentine painter Giotto da Bondone (1266 or 1267-1337). In his Life of Giotto Vasari pays tribute to Giotto's work and also gives him credit for setting painting once again on the right path, from which it had strayed.

http://easyweb.easynet.co.uk/giorgio.vasari/lives.htm

Vasari's Lives of the Artists

Later generations have accepted Vasari's assessment and have seen Giotto as a revolutionary figure not for the fourteenth century alone but for the entire history of European art, marking a major break with the art of the Middle Ages. Like all revolutionary figures, Giotto was more intimately linked with his past than his contemporaries and immediate successors realized, and to understand the magnitude of his achievements we must first see something of their context.

The Italo-Byzantine Background

Throughout the later Middle Ages art in Italy showed little of the richness and inventiveness of the great centers of northern Europe. Not only in France, where the University of Paris formed the intellectual capital of the Western world, but also in England and Germany, construction of the great Gothic cathedrals provided opportunities for artists to refine and develop their techniques. Sculptured decorations like *The Death of the Virgin* from Strasbourg Cathedral [11.1] are stylistically far more advanced than contemporary work in Italy. One of the reasons for this is that northern Gothic artists were begin-

ning to return for inspiration not to their immediate predecessors but to Classical art, with its realistic portrayal of the body and drapery. In Italy, however, artists were still rooted in the Byzantine tradition. Italian churches were generally decorated not with lifelike sculptural groups like the one from Strasbourg, but with solemn and stylized frescoes and mosaics, a style called Italo-Byzantine.

There are notable exceptions to the generally conservative character of Italian art in the thirteenth century. Nicola Pisano (1220/1225-1284?) and his son Giovanni (1245/1250-1314) have been described as the creators of modern sculpture. Nicola's first major work was a marble pulpit for the baptistery in Pisa completed in 1260, clearly influenced by the Roman sarcophagi the sculptor could see around him in Pisa. By crowding in his figures and filling the scene with lively detail Nicola recaptured much of the vitality and realism of late Roman art while retaining the expressive qualities of Gothic sculpture. The work of his son Giovanni was less influenced by Classical models than by his contemporaries in northern Europe—so much so that some scholars believe he must have spent some time in France. In his pulpit for the cathedral at Pisa, finished in 1310, the figures are more elegant and less crowded than those of his father, and show an intensity of feeling typical of northern late Gothic art [11.2, 11.3]. Both of these great sculptors foreshadowed major characteristics in the art of the Renaissance, Nicola by his emphasis on Classical models and Giovanni by the naturalism and emotionalism of his figures and by his use of space.

11.1 The Death of the Virgin, tympanum of the south transept portal, Strasbourg Cathedral, c. 1220. The expressive faces and elaborate drapery shows the influence of Classical sculpture.

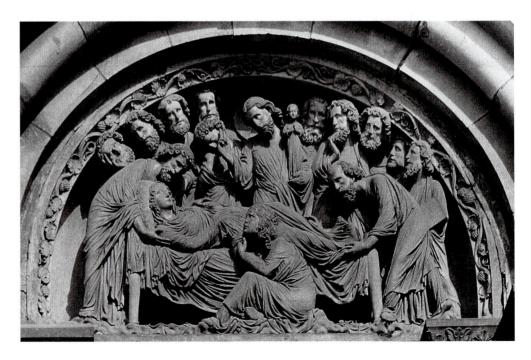

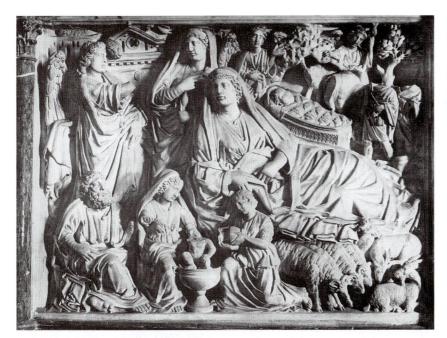

11.2 Nicola Pisano, *Annunciation and Nativity*, detail of pulpit, Baptistery, Pisa, 1259–1260. Marble. By crowding his figures together Nicola was able to combine the scene of the Nativity with the Annunciation and the shepherds in the fields.

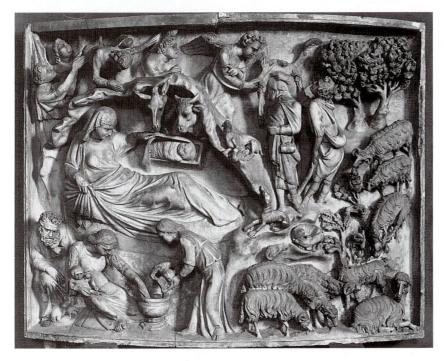

11.3 Giovanni Pisano, Nativity and Annunciation to the Shepherds, 1302–1310. Detail of pulpit. Marble. Cathedral, Pisa. The slender figures and sense of space create an effect very different from that of the work of the artist's father.

http://www.kfki.hu/~arthp/bio/p/pisano/giovanni/biograph.html

Pisano Family Bio

While some Italian sculptors were responding to influences from outside, painting in Italy remained firmly grounded in the Byzantine tradition. Byzantine art was originally derived from Classical art. Although its static and solemn characteristics seem a long way away from Greek or Roman styles, Byzantine painters and mosaicists inherited the late Hellenistic and Roman artists' ability to give their figures a three-dimensional quality and to represent foreshortening. With these techniques available to him, Giotto was better able to break away from the stereotypical forms of Italo-Byzantine art and bring to painting the same naturalism and emotional power that appear in Giovanni Pisano's sculptures.

Giotto's predecessor as the leading painter in Florence, and perhaps also his teacher, was Cimabue (1240?-1302?). Not enough of his work has survived for us to have a clear impression of how much Giotto owed to Cimabue's influence, but the crucifix Cimabue painted for the Church of San Domenico in Arezzo shows a remarkable realism and sophistication in the depiction of Christ's body [11.4]. Cimabue shows a genuine if incomplete understanding of the anatomy of the figure and, more important, uses it to enhance the emotional impact of his painting by emphasizing the sense of strain and weight. At the same time the draped loincloth is not merely painted as a decorative design but as naturalistically soft folds through which the limbs beneath are visible. If in other works, like the immense Santa Trinità Madonna [11.5], Cimabue is more directly in the Italo-Byzantine tradition, here at least he seems directly to prefigure the impact of Giotto's art.

http://www.kfki.hu/~arthp/bio/c/cimabue/biograph.html

Cimabue

The works of Cimabue's contemporary Duccio di Buoninsegna (1255/60-1318/19) are more directly Byzantine in inspiration, but here too the new spirit of

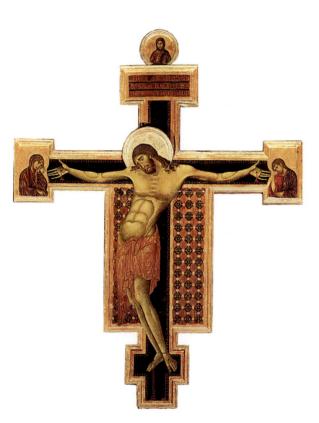

11.4 Cimabue. Crucifixion, c. 1240–1302. Church of San Domenico, Arezzo.

the times can be felt [Table 11.1]. His greatest achievement was the huge Maestà, painted between 1308 and 1311, for the high altar of Siena Cathedral in his native city. The majestic Madonna who gives the work its name faced the congregation [11.6], while both the front and back of the altarpiece were covered with small compartments filled with scenes from the lives of Christ and the Virgin. The episodes themselves are familiar from earlier painters, but the range of emotional expression is new and astonishing, as Duccio reveals to us not only the physical appearance of each of his subjects but their emotional states as well. In a number of the scenes the action takes place within an architectural setting that conveys a greater sense of space than we find in any earlier paintings, including those from the ancient world [11.7].

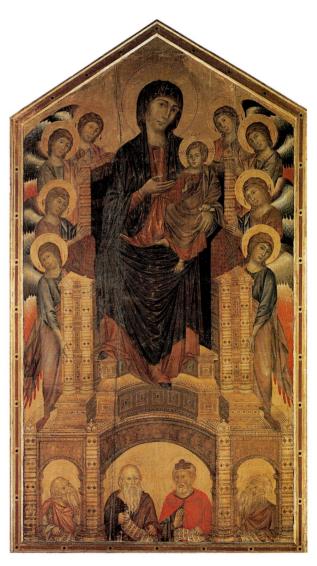

11.5 Cimabue. *Madonna Enthroned*, 1270–1285. Tempera on panel, $12'6'' \times 7'4''$ (3.81 \times 2.24 m). Galleria degli Uffizi, Florence. Although much of the detail is Byzantine in inspiration, the scale of this painting has no Byzantine counterpart.

TABLE 11.1 *Siena in the Age of Duccio* (1255/1260–1318/1319)

Population 20,000

Political Institutions Council of the Nine, rotating Con-

sistory (Magistracy)

Economy Banking, wool manufacture, jew-

elry, and goldwork

Cultural Life Painting (Duccio, Martini); Sculp-

ture (della Quercia); *Laudi*, or sacred songs (Bianco da Siena); Theology (Saint Catherine)

Principal Buildings Cathedral, Palazzo Pubblico

(Town Hall)

Divine Protectress The Virgin Mary, Queen of Siena

Giotto's Break with the Past

Great as Duccio's contribution was to the development of painting, it was achieved without any decisive break with the tradition in which he worked. Even if we can now see the roots of some of Giotto's achievements in the works of Cimabue, the boldness of his vision, and the certainty with which he communicates it to us, represent one of the supreme achievements of Western art.

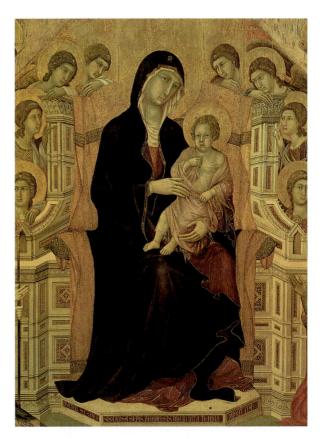

11.6 Duccio. Madonna Enthroned. Detail of front panel of Maestà Altar, c. 1308–1311. Tempera on panel. Height $6'10^{1}/_{2}''$ (2.1 m). Cathedral Museum, Siena. Note the greater gentleness of the faces and the softer, flowing robe of the Virgin here than in Cimabue's painting (Figure 11.5).

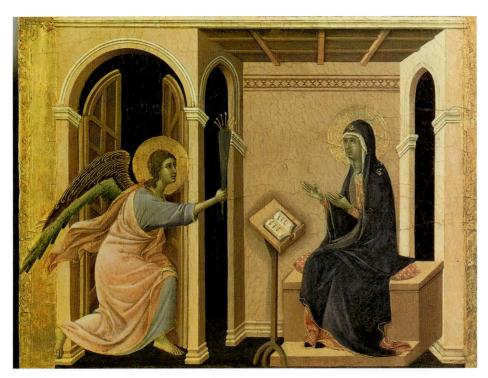

11.7 Duccio. *The Annunciation of the Death of the Virgin,* c. 1308–1311. Tempera on panel. From the *Maestà* Altar. Cathedral Museum, Siena. One of the episodes from the *Maestà* altarpiece, this scene demonstrates Duccio's ability to create a convincing architectural space around his figures.

264

Giotto's preeminent characteristic was his realism. The Byzantine style had aimed for a rich, glowing surface, with elaborate linear designs. Now for the first time figures were painted with a sense of depth, their volume represented by a careful use of light and dark, so that they took on the same strength and presence as works of sculpture. Instead of being confronted with an image, spectators saw the living and breathing figures before them. In his great altarpiece, Madonna Enthroned, painted in 1310, Giotto brings us into the presence of the Virgin herself [11.8]. We see the majestic solidity of her form, an impression enhanced by the realistic throne on which she sits. This is achieved not only by the three-dimensional modeling of the figures but also by the sense of space that surrounds the Virgin and child and separates them from the worshiping angels.

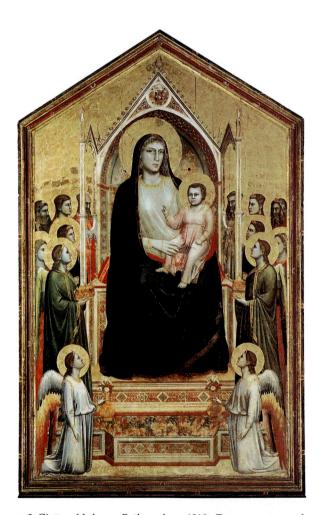

11.8 Giotto. *Madonna Enthroned*, c. 1310. Tempera on wood, $10'8'' \times 6'8''$ (3.25 \times 2.03 m). Galleria degli Uffizi, Florence. Although contemporary with Duccio's Madonna from the *Maestà* altarpiece, Giotto's painting has a much greater sense of weight and volume.

But Giotto's greatness lay not so much in his ability to create realistic images—to "imitate Nature," as his contemporaries called it—as in using these images for dramatic effect. Rather than confining himself to single subjects in individual panel paintings, like that of the Madonna enthroned, he preferred to work on a more complex and monumental scale. His chief claim to fame is the great cycle of frescoes that fills the walls of the Arena Chapel in Padua. In these panels illustrating the lives of the Virgin and of Christ, Giotto used the new naturalistic style he had developed to express an almost inexhaustible range of emotions and dramatic situations. In the scene depicting the meeting of Joachim and Anna, the parents of the Virgin, the couple's deep affection is communicated to us with simplicity and humanity [11.9]. The quiet restraint of this episode is in strong contrast to the cosmic drama of the lamentation over the dead body of Christ [11.10]. Angels wheel overhead, screaming in grief, while below Mary supports her dead son and stares fiercely into his face. Around her are the other mourners, each a fully characterized individual. If the disciple John is the most passionate in the expression of his sorrow, as he flings his arms out, no less moving are the silent hunched figures in the foreground.

The Franciscans also engaged the talents of Giotto to pay honor to their patron, Francis of Assisi. While there is no scholarly consensus that Giotto painted the great cycle on the life of Francis once attributed to him in the upper basilica at Assisi (most scholars now attribute those works to an unknown artist called the "Master of the St. Francis Cycle"), there is no doubt that in the second decade of the fourteenth century he did the fresco cycle in the Bardi Chapel in the Church of Santa Croce in Florence.

http://www.kfki.hu/~arthp/bio/g/giotto/biograph.html

Giotto

Giotto interpreted the deeds of Francis based on the life of the saint written by Saint Bonaventure (died 1274) who had been a contemporary of Thomas Aquinas. The narratives are not as simple as they first seem. The scene depicting Francis renouncing all of his earthly goods [11.11] shows a dramatic confrontation set before the palace of the local bishop. On the left is Pietro Bernadone holding the clothes of the saint who had stripped himself nude as a sign of renunciation. To the viewer's right is Bishop Guido, covering the nakedness of the saint with his episcopal cape (symbolizing his entry into the life of the church) while Francis assumes an attitude of prayer. Bonaventure's *Life* says that on that occasion Francis said, "Once I was called the son of Pietro Bernadone; now I say 'Our Father, who art in heaven'." Giotto frames

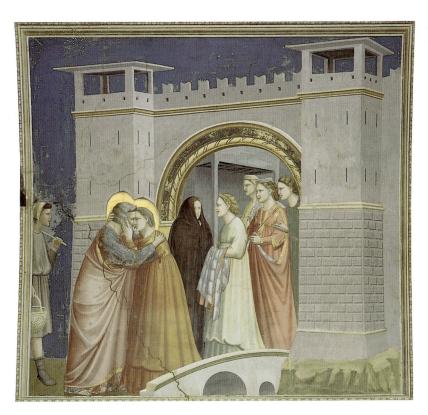

11.9 Giotto. *The Meeting of Joachim and Anna,* c. 1305. Fresco. Arena Chapel, Padua.

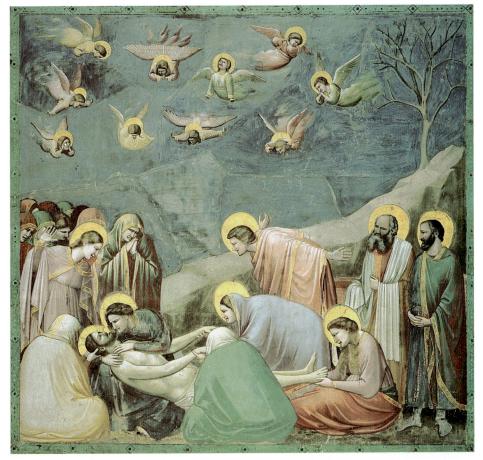

11.10 Giotto. The Lamentation over the Dead Christ, 1305. Fresco, $7'7'' \times 7'9''$ (2.31 \times 2.36 m). Arena Chapel, Padua, Italy.

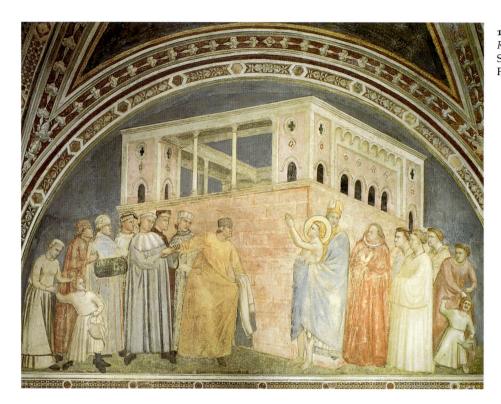

11.11 Giotto. Saint Francis Renounces His Worldly Goods. Santa Croce, Bardi Chapel in Florence, Scala.

this dramatic scene with children placed at opposite ends of the line of figures, reacting to the confrontation of father and son.

Painting in Siena

Giotto's appeal was direct and immediate, and at Florence his pupils and followers continued to work under his influence for most of the remainder of the fourteenth century, content to explore the implications of the master's ideas rather than devise new styles. As a result, the scene of the most interesting new developments in the generation after Giotto was Siena, where Duccio's influence (although considerable) was much less overpowering. Among Duccio's pupils was Simone Martini (c. 1285-1344), a close friend of Petrarch, who worked for a time at Naples for the French king Robert of Anjou and spent the last years of his life at the papal court of Avignon. In Martini's work we find the first signs of the last great development of Gothic art, the so-called International Style. The elegant courts of France and the French kingdoms of Italy had developed a taste for magnificent colors, fashionable costumes, and rich designs. Although Martini's Sienese background preserved him from the more extreme effects, his Annunciation has an insubstantial grace and sophistication that are in strong contrast to the solid realism of Giotto [11.12]. The resplendent robe and mantle of the angel Gabriel and the deep-blue dress of the Virgin, edged in gold, produce an

impression of great splendor, while their willowy figures approach the ideal of courtly elegance.

If Simone Martini was willing to sacrifice naturalism to surface brilliance, two of his contemporaries in Siena were more interested in applying Giotto's discoveries to their own work. Pietro Lorenzetti was born around 1280, his brother Ambrogio around 1285; both probably died in 1348, the year of the Black Death. The younger brother's best-known work is a huge fresco that decorates an entire wall in Siena's city hall, the Palazzo Pubblico; it was painted between 1338 and 1339 and illustrates the effects of good government on the city of Siena and the surrounding countryside [11.13]. The streets and buildings, filled with scenes of daily life, are painted with elaborate perspective. Richly dressed merchants with their wives, craftsmen at work, and graceful girls who dance in the street preserve for us a vivid picture of a lifestyle that was to be abruptly ended by the Black Death. The scenes in the country, on the other hand, show a world that survives even today in rural Tuscany: peasants at work on farms and in orchards and vineyards [11.14].

ART IN NORTHERN EUROPE

By the middle of the fourteenth century the gulf between artists in Italy and those north of the Alps had been

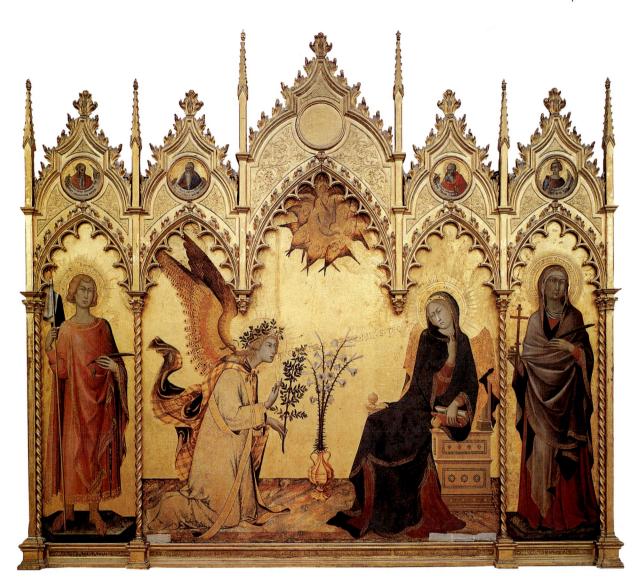

11.12 Simone Martini. *The Annunciation*, 1333. Tempera on wood, approx. $10'1'' \times 8'8^{1}/2''$ (3.05 × 2.54 m). (Frame reconstructed in the nineteenth century.) Galleria degli Uffizi, Florence. The courtly elegance of the figures is in strong contrast to the massive realism of Giotto's Madonna (Figure 11.8).

reduced considerably. Painters like Simone Martini who carried the latest developments in Sienese art to France, were in turn influenced by styles they found there, and subsequently brought them back to Italy. The growing tendency toward a unity of artistic language throughout Western Europe was further increased by political developments. When, for example, in 1347 the city of Prague became the residence of Emperor Charles IV, it became a major art center rivaling even Paris in importance. Around 1360, an unknown Bohemian master working there painted a panel showing the death of the Virgin that combines the rich colors and careful architecture of Sienese painting with the strong emotional impact of

northern Gothic art [11.15]. By the end of the century it was no longer possible to identify an artist's origins from the work. The Wilton Diptych was painted in England sometime after 1377 [11.16]. One of the two panels shows the young King Richard II accompanied by his patron saints, while on the other the Virgin and child appear before the praying king, accompanied by eleven angels. They probably commemorate Richard's coronation in 1377, since he was eleven years old at the time. The wonderfully delicate yet rich colors and the careful use of shading have no parallel in English art of the period. The artist seems to have been familiar with the work of painters like Duccio and Simone Martini, but the elegance of the paintings and technique are neither simply Italian nor French. The painter of the Wilton Diptych was working in a style that can only be called International.

One of the first great centers of the International Style was the court of the Duke of Burgundy at Dijon, where sculptors like the Dutchman Claus Sluter and painters like the Flemish Melchior Broederlam served Duke

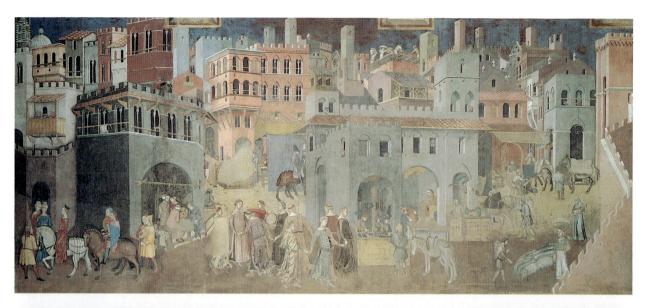

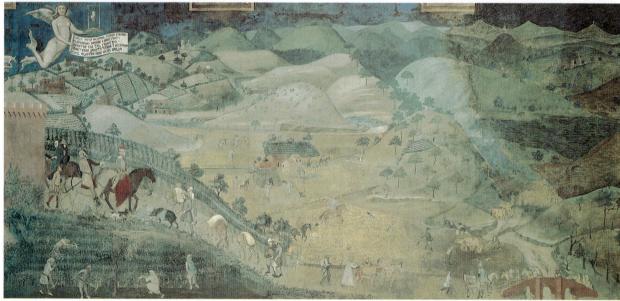

11.13 Top: Ambrogio Lorenzetti. Peaceful City. Detail from the fresco Allegory of Good Government: The Effects of Good Government in the City and the Country, 1337–1339. Sala della Pace, Palazzo Pubblico, Siena. Note the skillful use of perspective.

11.14 Bottom: Ambrogio Lorenzetti. Peaceful Country, detail from the fresco Allegory of Good Government: The Effects of Good Government in the City and the Country, 1337–1339. Sala della Pace, Palazzo Pubblico, Siena.

Philip the Bold, who ruled there from 1364 to 1404, and his brother John, Duc de Berry. Sluter (active about 1380–1406) was commissioned to provide sculpture for a monastery, the Chartreuse de Champmol, founded near Dijon by Duke Philip. His most impressive work there is the so-called *Well of Moses*, designed for the monastery's cloister [11.17]. Not really a well at all, it consists of an elaborate base surrounded by statues of Moses and five other Old Testament prophets on which originally stood a crucifixion, now missing. At first glance, the style of the figures is reminiscent of earlier Gothic statues, like those

at Strasbourg; but a more careful look shows a host of carefully depicted details. In the figure of Moses the textures of the heavy drapery, the soft beard, and the wrinkled face are differentiated skillfully, and the expression has the vividness of a portrait. Equally realistic is the sense of weight and mass of the body beneath the drapery.

http://www.kfki.hu/~arthp/html/s/sluter/moses/index.html

Sluter's Well of Moses

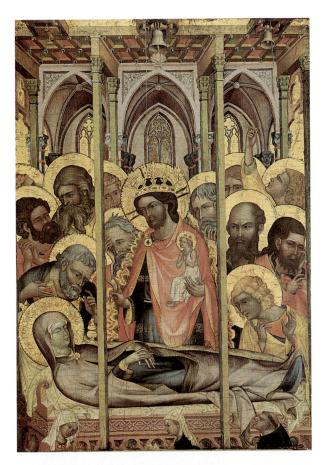

But for the most attractive details in all of late Gothic art we must turn to the Très Riches Heures du Duc de Berry, an illustrated prayerbook commissioned by Philip the Bold's brother and completed in 1416. It was painted by the Limbourg brothers-Pol, Hennequin, and Herman. They were Flemish in origin, may have spent some time in Italy, and finally settled in France. Twelve illuminated pages are included in the book; these illustrate the twelve months of the year. These paintings are filled with an almost inexhaustible range of details that combine to depict the changing seasons of the year with poetry and humanity. On the page representing February the farmworkers warming themselves inside the cottage, and the sheep huddling together outside, attract our attention immediately, but the whole scene is filled with marvelously painted details, from the steamy breath of the girl on the far right, stumbling back through the snow toward a warm fireside, to the snow-laden roofs of the frozen village in the far distance [11.18]. In May we move

11.15 Unknown Bohemian Master, second quarter, fourteenth century. Death of the Virgin. Tempera on panel, $39^3/8'' \times 28'' (100 \times 70 \text{ cm})$. Museum of Fine Arts, Boston (William Francis Warden Fund; Seth K. Sweetser Fund, The Henry C. and Martha B. Angell Collection, Juliana Cheney Edwards Collection, Gift of Martin Brimmer, and Gift of the Reverend and Mrs. Frederick Frottingham, by exchange).

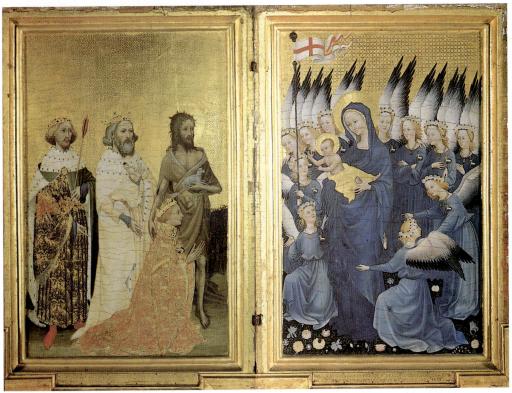

11.16 French School. *Richard II Presented to the Virgin and Child by His Patron Saints (Wilton Diptych)*, c. 1395. Oak panels, each $18'' \times 11^{1}/2''$ (46 × 29 cm). National Gallery, London (reproduced by courtesy of the Trustees).

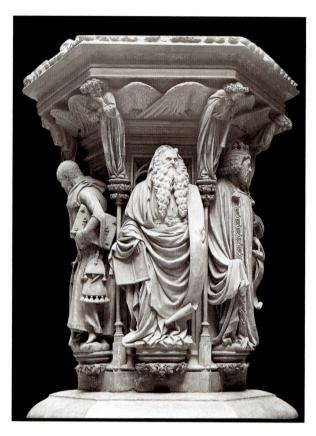

11.17 Claus Sluter. *The Well of Moses*, 1395–1406. Marble. Height of figures about 6' (1.83 m). Chartreuse de Champmol, Dijon. The horns represent rays of light (a usage based on a Bible mistranslation).

from the world of peasants to that of the aristocracy as a gorgeously dressed procession of lords and ladies rides out in the midst of the fresh greenery of springtime with the roof and turrets of a great castle in the background [11.19]. The sense of idleness and the delightful conceits of chivalry seem to evoke the world of Chaucer, while stylistically the sense of perspective and elegance of the figures is still another reminder of the influence of Sienese art.

http://www.ibiblio.org/wm/rh/glo/limburg.html

Limbourg Brothers

LATE GOTHIC ARCHITECTURE

As in the case of painting and sculpture, the generally unified style of northern Gothic architecture never really crossed the Alps into Italy. Although some of the most important Italian buildings of the fourteenth century are generally labeled Gothic, their style is very different from that of their northern counterparts. Two of the century's

greatest churches illustrate this, both begun in Florence at the end of the thirteenth century—Santa Croce around 1295 and the cathedral (better known by the Italian word for cathedral, *duomo*) in 1296. Neither has buttresses and in both most of the wall surface is solid rather than pierced with the typical Gothic windows. The duomo's most outstanding feature does not even date to the fourteenth century: Its magnificent dome was built by the great early Renaissance architect Filippo Brunelleschi between 1420 and 1436 [11.20].

More self-consciously Gothic is the duomo in Milan, begun in 1386, which perhaps makes one feel relieved that Italian architects in general avoided the chief features of northern Gothic style. The immensely elaborate façade, bristling with spires, and the crowded piers of the sides seem to be stuck on rather than integrated into the design. The presence of Classical elements in the dec-

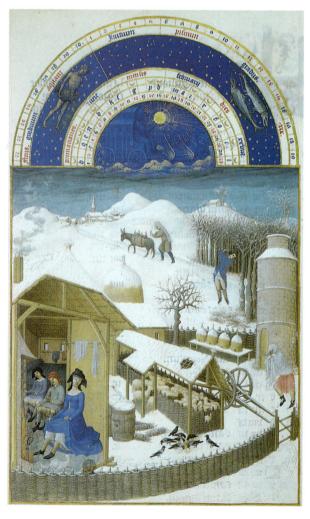

11.18 Limbourg Brothers. February page from the *Très Riches Heures du Duc de Berry*, 1416. Manuscript illumination, approx. $8^{1}/_{2}^{"} \times 5^{3}/_{8}^{"}$ (22 × 14 cm). Musée Condé, Chantilly, France. The chart above the painting represents the signs of the zodiac for the month of February.

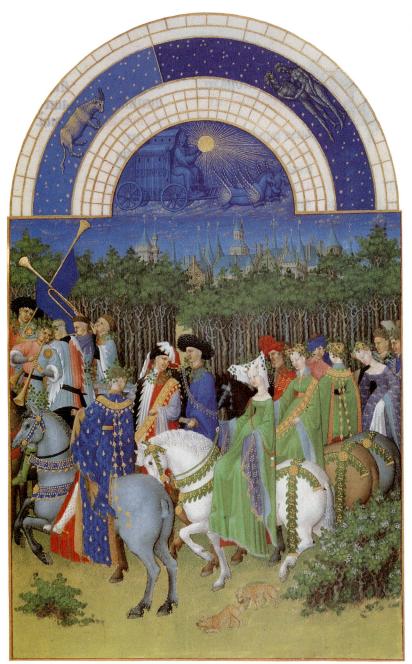

11.19 Limbourg Brothers. May page from the *Très Riches Heures du Duc de Berry*, 1413–1416. Manuscript illumination, approx. $8^{1}/_{2}^{"} \times 5^{3}/_{8}^{"}$ (22 \times 14 cm). Musée Condé, Chantilly, France. The hunters blow their horns, but the courtiers are more interested in the ladies.

orations is a reminder that by the time the Milan Duomo was completed the Renaissance had dawned [11.21].

Far more attractive are the secular public buildings of the age. The town halls of Florence and Siena, the Palazzo Vecchio (begun 1298) and the Palazzo Pubblico (begun 1288), convey the sense of strong government and civic pride that characterized life in these cities during the Trecento [11.22]. The towers served the double purpose of providing a lookout over the city and surrounding countryside while they expressed the determination of the city rulers to resist attack. The most beautiful of all government centers is probably the Doge's Palace in Venice, a city where more than anywhere else

Gothic architecture took on an almost magical quality of lightness and delicacy. The Doge's Palace (begun about 1345) is composed of a heavy upper story that seems to float on two arcades, the lower a short and sturdy colonnade and the upper composed of tall, slender columns. The effect is enhanced by the way in which the entire building seems suspended in space between sky and sea [11.23].

http://www.doge.it/smarco/pali.htm

Doge's Palace, Venice

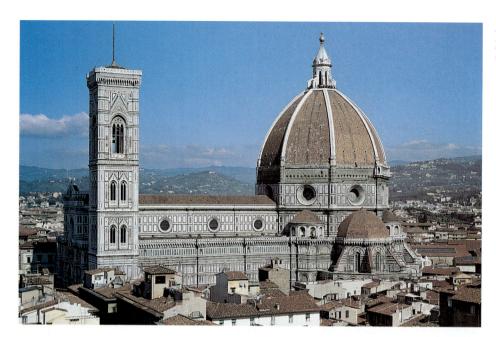

11.20 Florence Cathedral, Italy, 1296–1436 (view from the south).

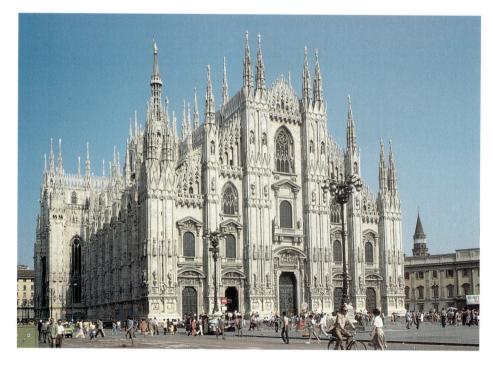

11.21 Duomo, Milan. Begun 1386. The Classical moldings over the windows and doorways of the façade area are a reminder that the duomo was not completed until the Renaissance.

For a final look at late Gothic architecture at its most typical we must turn to England, where the style of this period is generally known as Perpendicular. The choir of Gloucester Cathedral, built between 1332 and 1357, illustrates the reason for the label [11.24]. The vertical line is emphasized, and our eyes are carried up to the roof, where a complex web of ribs decorate the vault. Unlike the ribs in earlier buildings, these serve no structural purpose but have become purely decorative. Their delicacy seems an apt reflection in stone of the graceful precision of the *Wilton Diptych* and the *Très Riches Heures*.

http://web.ukonline.co.uk/flight/gloster.html

Gloucester Cathedral

MUSIC: ARS NOVA

While Giotto was laying the foundations for a new naturalistic style of painting, and writers like Petrarch and Chaucer were breathing fresh life into literary forms,

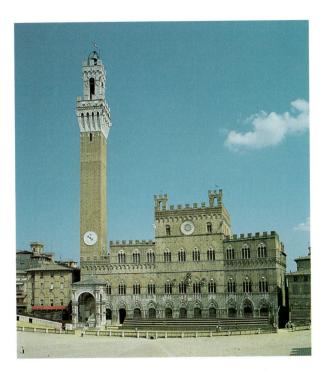

11.22 Palazzo Pubblico, Siena, Italy, 1288–1309. The slits around the base of the gallery at the top of the tower were used for firing through on attackers below.

11.23 Doge's Palace, Venice, 1345–1438. Unlike the heavily fortified Palazzo Pubblico at Siena, this palace of the rulers of Venice, with its light, open arches, reflects the stability and security of the Venetian Republic.

composers in France and Italy were changing the style of music. To some extent this was the result of social changes. Musicians had begun to break away from their traditional role as servants of the church and to establish themselves as independent creative figures; most of the music that survives from the fourteenth century is secular. Much of it was written for singers and instrumentalists to perform at home for their own pleasure [11.25], or for the entertainment of aristocratic audiences like those depicted in the *Très Riches Heures*. The texts composers set to music were increasingly varied: ballads, love songs, even descriptions of contemporary events, in contrast to the religious settings of the preceding century.

As the number of persons who enjoyed listening to music and performing it began to grow, so did the range of musical expression. The term generally used to describe the sophisticated musical style of the fourteenth century is ars nova, derived from the title of a treatise written by the French composer Philippe de Vitry (1291–1361) around 1325. The work was written in Latin and called Ars Nova Musicae (The New Art of Music). Although it is really concerned with only one aspect of composition and describes a new system of rhythmic notation, ars nova has taken on a wider use and is applied to the new musical style that began to develop in France in the early fourteenth century and soon spread to Italy.

Its chief characteristic is a much greater richness and complexity of sound than before. This was partly achieved by the use of richer harmonies; thirds and sixths were increasingly employed and the austere

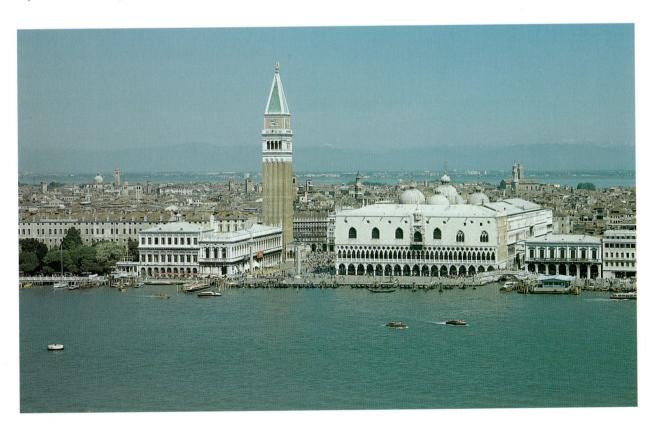

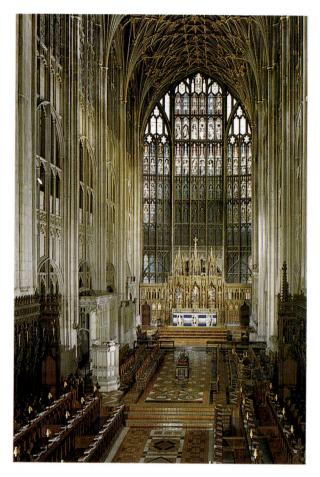

11.24 Choir, Gloucester Cathedral, 1332–1357. The strong vertical lines show why the style of such buildings is called Perpendicular.

sounds of parallel fifths, unisons, and octaves were generally avoided. Elaborate rhythmic devices were also introduced, including the method of construction called *isorhythm* (from the Greek word *isos*, which means "equal"). Isorhythm consisted of allotting to one of the voices in a polyphonic composition a repeated single melody. The voice was also assigned a repeating rhythmical pattern. Since the rhythmical pattern was of a different length from the melody, different notes would be stressed on each repetition. The purpose of this device was twofold: It created a richness and variety of texture, and imparted an element of unity to the piece.

The most famous French composer of this period was Guillaume de Machaut (1304?–1377), whose career spanned the worlds of traditional music and of the *Ars Nova*. He was trained as a priest and took holy orders, but much of his time was spent traveling throughout Europe in the service of the kings of Bohemia, Navarre, and France. Toward the end of his life he retired to Rheims, where he spent his last years as a canon. His most famous composition, and the most famous piece of music from the fourteenth century, is the *Messe de Notre Dame*. A four-part setting of the Ordinary of the Mass, it is remarkable chiefly for the way in which Machaut gives

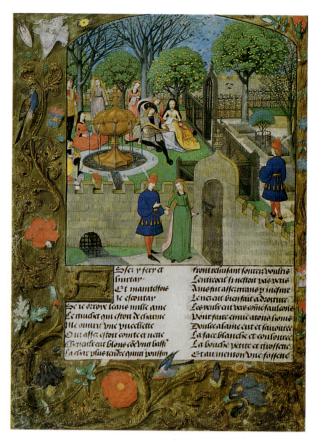

11.25 A knight playing and singing to a lady, manuscript illumination of *Romance of the Rose*. Flemish, $14'' \times 10''$ (36×25 cm). British Library, London. The romantic interlude is enhanced by the idyllic surroundings: a walled garden with a fountain playing.

unity to the five sections that make up the work by creating a similarity of mood and even using a single musical motif that recurs throughout:

http://www.medieval.org/emfaq/composers/machaut.html

Guillaume de Machaut

http://www.newadvent.org/cathen/10001a.htm

Ordinary of the Mass

Machaut's *Messe de Notre Dame* is the first great example of the entire Ordinary of the Mass set to polyphonic music by a single composer. The Ordinary of the Mass refers to those parts of the Roman Catholic liturgy that do not change from day to day in contrast to the Propers (the readings from the Gospel or Epistles), which do change daily. The parts of the Ordinary are:

- 1. The *Kyrie Eleison:* the repeated Greek phrases that mean "Lord have mercy on us!" and "Christ have mercy on us!"
- 2. The *Gloria:* a hymn of praise sung at all masses except funerals and masses during Lent and Advent.
- 3. The *Credo*: the Profession of Faith sung after the Gospel.
- 4. The *Sanctus* and *Benedictus*: a short hymn based on the angelic praise found in Isaiah 6, sung at the beginning of the eucharistic prayer.
- 5. The *Agnus Dei*: the prayer that begins "Lamb of God," sung before Communion.

For a selection from *Messe de Notre Dame,* see the Listening CD.

Machaut's Messe de Notre Dame, then, stands at the head of a long tradition of musical composition in which composers use the Ordinary of the Mass to express in their own cultural idiom the timeless words of the liturgy. Machaut's Mass, in that sense, is the ancestor of the Renaissance compositions of Palestrina in the sixteenth century, the Baroque masses of Johann Sebastian Bach in the eighteenth century, and the frenetically eclectic modern Mass of Leonard Bernstein.

Machaut also contributed to another great musical tradition, that of secular song. With the increasing use of polyphony, composers began to turn their attention to the old troubadour songs and write new settings that combined several different voices. Machaut's polyphonic secular songs took a number of forms. His *ballades* were written for two or three voices, the top voice carrying the melody while the others provided the accompaniment. These lower voices were probably sometimes played on instruments rather than sung. As in the ballades of earlier times the poems consisted of three stanzas, each of seven or eight lines, the last one or two lines being identical in all the stanzas to provide a refrain.

Many of these secular songs, both by Machaut and by other composers, deal with amorous topics, and are often addressed to the singer's beloved. The themes are predictable—the sorrow of parting, as in Machaut's *Au départir de vous*, reproaches for infidelity, protestations of love, and so on—but the freshness of the melodies and Machaut's constant inventiveness prevent them from seeming artificial.

The other important composer of the fourteenth century was the Italian Francesco Landini (1325–1397), who lived and worked in Florence. Blinded in his youth by smallpox, he was famous in his day as a virtuoso performer on the organ, lute, and flute. Among his surviving works are a number of *madrigals*, a form of word setting involving two or three verses set to the same music and separated by a refrain set to different music. In addition, he wrote a large number of *ballate* ("ballads") including many for solo voice and two accompanying in-

struments. The vocal lines are often elaborate, and Landini makes use of rich, sonorous harmonies. But in the case of these and other works of the period, there is no specification of the instruments intended, or, indeed, of the general performance style Landini would have expected [11.26]. We know from contemporary accounts that in some cases performers would have changed the written notes by sharpening or flattening them, following the convention of the day. This practice of making sounds other than those on the page was called musica ficta ("fictitious music"), but no systematic description of the rules followed has been handed down to us. As a result, modern editors and performers often have only their own historical research and instincts to guide them. Although the Ars Nova of the fourteenth century marks a major development in the history of music, our knowledge of it is far from complete.

The fourteenth century was a time of stark contrast between the horrors of natural and social disasters and the flowering of artistic and cultural movements that were the harbingers of the fifteenth-century Renaissance in Italy.

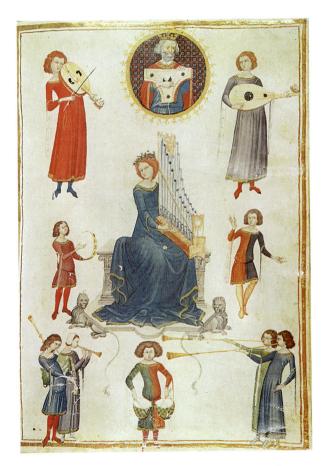

11.26 Music and musicians. Manuscript illumination illustrating a treatise, *De Musica*, fourteenth century. Biblioteca Nazionale, Naples. Some of the instruments of the time are shown. The goddess Music is at the center, playing a small organ. Grouped around her are musicians with stringed instruments, percussion, and wind instruments. The inset shows David, founder of church music, plucking a psaltery.

Chaucer, as noted, died in 1400, the year that may be taken as the close of the medieval period. By that time, some of the prime figures of the Italian Renaissance—Donatello, Fra Angelico, and Ghiberti—were already in their teens. The great outburst of cultural activity that was to mark Florence in the fifteenth century was near, even though it would not make a definite impact on England until the end of the century. The calamitous fourteenth century was a costly seedbed for rebirth and human renewal.

SUMMARY

The Transition from Medieval Culture to the Renaissance The fourteenth century marks the painful transition from the medieval period to the world of the Renaissance. Its beginning saw the construction of several major buildings in Italy, including Florence's duomo and Siena's Palazzo Pubblico, seat of city government. Music flourished throughout the century, especially in France, where Machaut was the leading composer of his day. In the years shortly after 1300, the new naturalistic style of Giotto revolutionized the art of painting, whereas the works of the Pisano family proved equally important for the history of sculpture. Yet the age was fraught with disaster and racked by war: the Hundred Years' War between France and England (1337-1453) was barely under way when in 1348 Europe was devastated by bubonic plague—the Black Death. Among the works of literature to reflect the effects of the terrible plague is Boccaccio's Decameron.

The Papacy in Avignon: Petrarch As the century began, the church appeared to be at the height of its influence. In 1300, Pope Boniface VIII proclaimed the first holy year, and pilgrims flocked to Rome. Yet within a few years the French had forced the transfer of the papacy to Avignon in Southern France. Among those who accompanied the papal court was the poet Petrarch, many of whose sonnets deal with his love for Laura, killed by the Black Death. The Babylonian Captivity lasted from 1309 to 1376, and the pope's return to Rome was embittered by the Great Schism, which saw the Western powers locked in a struggle to impose rival claimants.

The International Style One of the artistic consequences of the papal move from Rome was that Italian styles were carried north of the Alps. The resulting blend of Italian and Northern elements is called the International Style, which quickly spread throughout Europe; two of its main centers were at Prague and at Dijon. The more cosmopolitan spirit of the age is also illustrated by the career of the greatest English writer of the time, Chaucer, who traveled to Italy and to France and may have actually met Petrarch.

Social Protests In an age of such foment the pressure for reform intensified. In England, John Wyclif's charges

of church corruption heightened dissatisfaction among the lower classes, leading to the peasant riots of 1381. Similar popular protests against both the church and the aristocracy occurred in France in 1356, while in 1378 the poor woolen workers of Florence revolted against the city authorities. These manifestations of general discontent brought no immediate radical changes in government, but they did prepare the way for the social mobility of the Renaissance.

The Hundred Years' War The greatest struggle of the century, the Hundred Years' War, was supposedly fought over the right of succession to the French throne. In fact, its underlying cause was the commercial rivalry between France and England and the attempts of both countries to gain control of the wool-manufacturing region of Flanders. The war's early stages were marked by a series of English victories, culminating in the Battle of Poitiers (1356). By 1380, the French had reversed the tide, and the last years of the century saw inconclusive skirmishes, with both sides resigned to a stalemate.

Thus, a century in which political, economic, and religious strife and revolutionary artistic developments were accompanied by the disaster of plague produced deep changes in the fabric of European society and made possible the renewal of the Renaissance.

PRONUNCIATION GUIDE

Arezzo: a-RET-so Avignon: AV-een-yon **Boccaccio: Bo-KACH-owe** Chaucer: CHAW-ser Cimabue: Chim-a-BOO-ay Crécy: CRAY-see Duccio: DO-chee-owe duomo: DWO-mo Froissart: FRWAS-are Giotto: IOT-toe

Guillaume Machaut: Ghee-OHM Mash-OWE

Lorenzetti: Lo-ren-ZETT-i Maestà: Ma-ey-STAH

Palazzo Vecchio: Pa-LAT-so VEK-ee-owe

Petrarch: PET-rark
Pisano: Pee-ZAN-owe
Poitiers: PWAH-tee-ay
Santa Croce: SAN-ta CROW-chay

schism: SISM

Trecento: Tray-CHEN-toe Vasari: Vaz-ARE-ee

EXERCISES

Compare the literary achievements of Boccaccio and Petrarch. What light do they throw on the history of their times?

- How does Chaucer characterize the participants in *The Canterbury Tales?* Select two and describe their chief features.
- Describe Giotto's contribution to the history of painting and compare him to his predecessors.
- 4. What are the principal characteristics of Northern European art in the fourteenth century? How does it differ from Italian art?
- How did musical styles change in the fourteenth century? Discuss the contribution of Guillaume Machaut.

FURTHER READING

- Allmand, C. T. (1988). *The Hundred Years' War: England and France at war c.* 1300–c. 1450. New York: Cambridge University Press. A concise introduction to the major conflict of the fourteenth century.
- Bynum, C. W. (1987). Holy feast and holy fast: The religious significance of food to medieval women. Berkeley: University of California Press. An engrossing study of medieval links between food and spirituality in women's lives.
- Duby, G. (Ed.). (1988). A history of private Life, volume II: Revelations of the medieval world. Cambridge, MA: Harvard University Press. Essays on various aspects of life in medieval times, showing the developing concepts of privacy and the individual.
- Gottfried, R. S. (1983). The Black Death: Natural and human disaster in medieval Europe. New York: Free Press. An important cultural study of the plague and its impact on late medieval culture.
- Howard, D. (1977). *The idea of* Canterbury Tales. Berkeley: University of California Press. An important study of the structure of Chaucer's greatest work.
- Kane, G. (1984). Chaucer. New York: Oxford University Press. A brief, well-written study; part of the "Past Masters" series.
- Martindale, A. (1966). *The complete paintings of Giotto.* New York: Abrams. After a brief introduction, the book offers a fully illustrated catalogue of Giotto's paintings with some excellent detail photographs.
- Meiss, M. (1964). Painting in Florence and Siena after the Black Death. New York: Harper & Row. A brilliant work of scholarship that treats "The arts, religion and society in the mid-Fourteenth Century."
- Pope-Hennessy, J. (1972). *Italian Gothic sculpture*. London: Phaidon. An excellent illustrated survey. The comprehensive bibliography is especially valuable.
- Stubblebine, J. (Ed.). (1969). The Arena Chapel frescoes. New York: Norton. An illustrated collection of essays on Giotto's frescoes.
- Tuchman, B. (1978). A distant mirror: The calamitous fourteenth century. New York: Knopf. A brilliant work by one of our best popular writers on history. The book focuses almost exclusively on France and as a result lacks some balance. A joy to read and very revealing nevertheless.
- White, J. (1966). Art and architecture in Italy 1250–1400. Baltimore, MD: Pelican. A useful single-volume survey, comprehensive yet detailed. Highly recommended.
- Wilkins, E. H. (1961). *Life of Petrarch*. Chicago: University of Chicago Press. An exemplary biography valuable for its

discussion of Italy in the fourteenth century and Petrarch's relationship with such figures as Boccaccio, Giotto, Simone Martini, and Chaucer.

ONLINE CHAPTER LINKS

The Decameron Web at

http://www.brown.edu/Departments/Italian_Studies/dweb/dweb.shtml

provides valuable information about Boccacio's *Decameron*, the author, a beautiful image collection, historical background, links to related Internet sites, useful maps, and a bibliography.

The Canterbury Tales Project at

http://www.cta.dmu.ac.uk/projects/ctp/

provides a summary of textual research and links to related sites.

The City of Women at

http://library.thinkquest.org/12834/index.html

highlights the roles of medieval women, including selected individuals who were authors; the site includes links to other sites of interest.

An extensive Giotto biography and links to numerous related sites, including many of his best-known works of art, are found at

http://www.christusrex.org/www1/francis/

Many of Giotto's best known and most beautiful frescoes are available at

http://www.kfki.hu/~arthp/html/g/giotto/padova/index.html (the Arena Chapel, Padua)

http://www.kfki.hu/~arthp/html/g/giotto/s_croce/bardi/index.html (the Bardi Chapel, Florence)

Beautiful graphics and informative text related to the Limbourg Brothers and *Les Très Riches Heures du Duc de Berry* are available at

http://christusrex.org/www2/berry/index.html

For introductory information about Gothic art as well as links to sites related to representative artists, consult *Artcyclopedia*

http://www.artcyclopedia.com/history/gothic.html

For a catalog of useful links to Internet resources, consult *Medieval Music Links*

http://classicalmus.hispeed.com/medieval.html

Karadar Classical Music at

http://www.karadar.it/Dictionary/Default.htm provides an alphabetical listing of musicians with brief biographies and a list of works (some of which are available on MIDI files). FLORENTINE RENAISSANCE

1503

15th cent. Florence center of European banking system; renaissance in exploration outside Europe begins

1417 Council of Constance ends

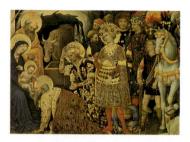

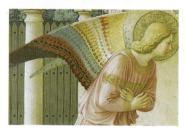

"Great Schism"

1432 Florentines defeat Sienese at San Romano

- 1434 Cosimo de' Medici becomes de facto ruler of Florence
- 1439-1442 Ecumenical Council of Florence deals with proposed union of Greek and Roman churches
- 1453 Fall of Constantinople to Turks; scholarly refugees bring Greek manuscripts to Italy
- 1464 Piero de' Medici takes power in Florence after death of Cosimo
- 1469 Lorenzo de' Medici rules city after death of Piero
- 1478 Pazzi conspiracy against the Medici fails
- 1489 Savonarola begins sermons against Florentine immorality
- 1492 Death of Lorenzo de' Medici
- 1494 Medici faction in exile: Savonarola becomes de facto ruler of Florence; Charles VIII of France invades Italy, beginning foreign invasions
- 1498 Savonarola burned at stake by order of Pope

1512 Medici power restored in

Florence; Machiavelli exiled

- 1446-1450 Gutenberg invents movable printing type
- 1456 Gutenberg Bible printed at Mainz
- 1462 Cosimo de' Medici founds Platonic Academy in Florence, headed by Marsilio Ficino
- 1465 First Italian printing press, at
- 1470 1499 Laura Cetera's humanist writings
- 1470-1527 Height of humanist learning
- 1475 Recuyell of the Historyes of Troye, printed by William Caxton, first book published in English
- c. 1476-1477 Lorenzo de' Medici begins Comento ad Alcuni Sonetti
- 1482 Ficino, Theologia Platonica
- 1486 Pico della Mirandola, Oration on the Dignity of Man
- 1490 Lorenzo de' Medici, The Song of Bacchus
- 1491 Lorenzo de' Medici, Laudi
- c. 1494 Aldus Manutius establishes Aldine Press in Venice
- 1496 Burning of books inspired by Savonarola
- 1502 Erasmus, Enchiridion militis Christiani
- 1506 Erasmus travels to Italy
- **1509** Erasmus, The Praise of Folly
- 1513 Machiavelli, The Prince
- 1516 Erasmus, Greek New Testament

- 1401 Competition for North Doors of Florence Baptistery won by Ghiberti's Sacrifice of Isaac
- 1403 Ghiberti begins Baptistery doors; Brunelleschi, Donatello study Roman
- c. 1416-1417 Donatello, Saint George 1423 Fabriano, Adoration of the Magi, International Style altarpiece
- 1425 Masaccio begins frescoes for Brancacci Chapel, Santa Maria del Carmine, Florence; Expulsion of Adam and Eve from Eden (c. 1425)
- c. 1425-c. 1452 Masaccio, The Tribute Money (c. 1427); Ghiberti sculpts panels for East Doors of Florence Baptistery; The Story of Jacob and Esau (1435)
- Use of linear perspective to create threedimensional space; naturalistic rendering of figures; return to classical ideals of beauty and proportion: Masaccio, The Holy Trinity, Santa Maria Novella, Florence (c. 1428)
- c. 1428-1432 Donatello, David, first free-standing nude since antiquity
- 1445 1450 Fra Angelico, Annunciation, fresco for Convent of San Marco, Florence
- c. 1455 Donatello, Saint Mary Magdalene; Uccello, Battle of San Romano
- 1459-1463 Gozzoli, The Journey of the
- c. 1467-1483 Leonardo works in Florence
- 1475 The Medici commission Botticelli's Adoration of the Magi for Santa Maria Novella
- 1478-c. 1482 Botticelli, La Primavera, The Birth of Venus, Pallas and the Centaur

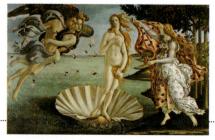

- 1498-1499 Michelangelo, Pietá late 15th-early 16th cent. Leonardo, Notebooks
- c. 1495 1498 Leonardo, The Last Supper
- c. 1496 Botticelli burns some of his work in response to Savonarola's sermons
- c. 1503 1505 Leonardo, Mona Lisa
- 1506 Ancient Laocoön sculpture discovered

1520

1417 – 1420 Brunelleschi designs and begins construction of Florence Cathedral dome (completed 1436)

1419–1426 Brunelleschi, Foundling Hospital

Use of classical order and proportion to achieve rational harmony of elements; Brunelleschi, Pazzi Chapel, Santa Croce, Florence (1430–1433)

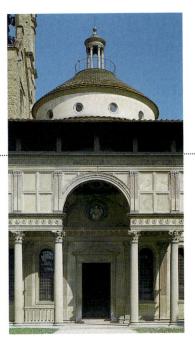

1434 Jan Van Eyck, Giovanni Arnolfini and His Bride

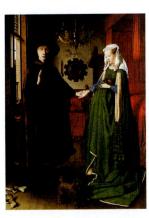

c. 1489 Michelangelo begins studies in Lorenzo's sculpture garden; *Madonna of the Stairs* (1489–1492)

1437–1452 Michelozzo, Convent of San Marco, Florence

1444–1459 Michelozzo, Palazzo Medici-Riccardi, Florence

1479 – 1492 Heinrich Isaac, court composer to Medici family and organist and choirmaster at Florence Cathedral, sets Lorenzo's poems to music

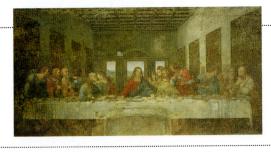

1501-1504 Michelangelo, David

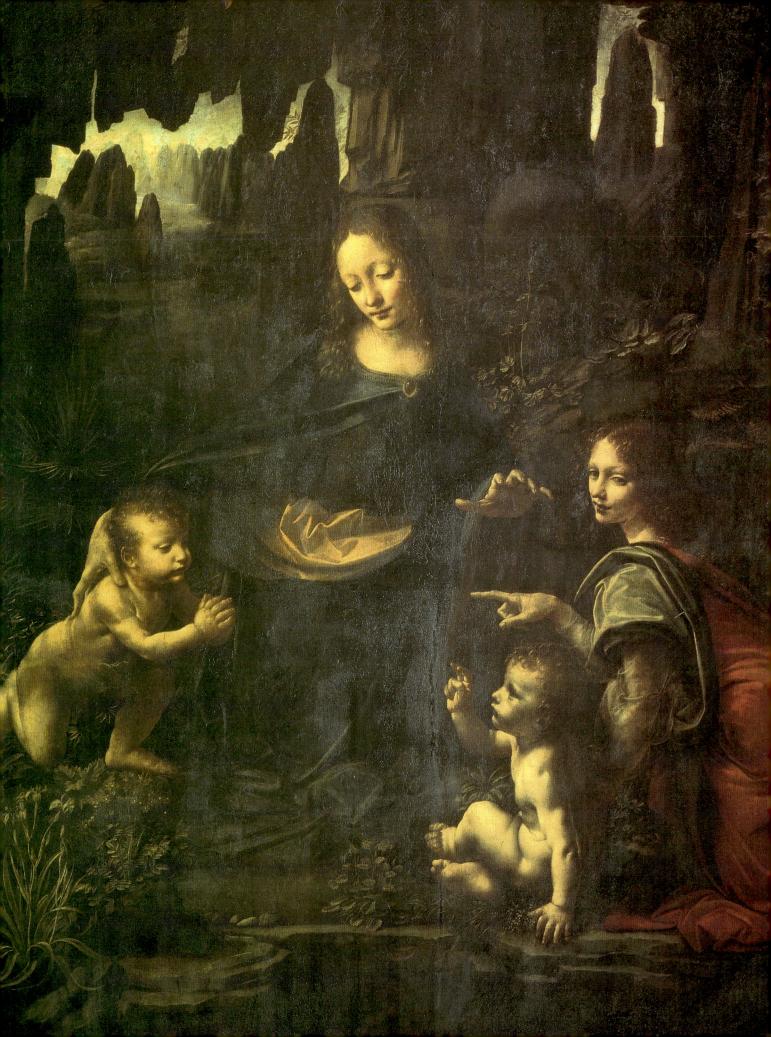

CHAPTER 12 THE EARLY RENAISSANCE

TOWARD THE RENAISSANCE

he fourteenth century was a period of great social strife and turmoil as well as a time in which new stirrings were abroad in Europe. It was the century of Dante, Petrarch, Boccaccio, and Chaucer. The entrenched scholastic approach to learning was being tempered by renewed interest in Classical literature. The long-cherished Byzantine art style was being challenged by the new realism of such Italian artists as Cimabue and Giotto in Florence, Simone Martini, and the Lorenzetti brothers, among others. Renewed interest in the world of nature was fueled by the enormous impact of Saint Francis of Assisi (1181–1226), who taught Europeans to see God in the beauty of the world and its creatures.

Europe was slowly recovering from the fearful plague-stricken years around 1348, a rebirth aided by a new growth in economics and trade. Wealth was being created by an emerging class whose claim to eminence was based less on noble blood than on ability to make money.

In the fifteenth century, the center of this new vitality was Florence in Italy. No city its size has in its day exerted more influence on culture at large than this focus of banking and commerce. From roughly the 1420s until the end of the century a collaborative effort of thinkers, artists, and wealthy patrons enriched the city, in the process making it a magnet for all Europe. To that city and its cultural development we now turn.

THE FIRST PHASE: MASACCIO, GHIBERTI, AND BRUNELLESCHI

http://www.mega.it/eng/egui/pers/fibru.htm

Filippo Brunelleschi

At the beginning of the fifteenth century, Florence had every reason to be a proud city. It stood on the main road connecting Rome with the north. Its language—known at the time as the Tuscan dialect or the Tuscan idiom—was the strongest and most developed of the Italian dialects; its linguistic power had been demonstrated more than a century earlier by Dante Alighieri and his literary successors, Petrarch and Boccaccio. The twelve great *Arti* ("trade guilds") of Florence were commercially important for the city; in addition, representatives of the seven senior guilds formed the body of magistrates that ruled the city from the fortresslike town hall, the Palazzo Vecchio. This "representative" government, limited though it was to the prosperous guilds, preserved Florence from the rise of the terrible city tyrants who plagued so many other Italian cities.

Florence had been one of the centers of the wool trade since the late Middle Ages. In the fifteenth century it was also the center of the European banking system. In fact, our modern banks (the word bank is from the Italian banco, which means "counter" or "table"—the place where money is exchanged) and their systems of handling money are based largely on practices developed by the Florentines. They devised advanced accounting methods, letters of credit, and a system of checks; they were the first to emphasize the importance of a stable monetary system. The gold florin minted in Florence was the standard coin in European commerce for centuries.

Great Florentine banking families made and lost fortunes in trading and banking. These families—the Strozzi, Bardi, Tornabuoni, Pazzi, and Medici—were justly famous in their own time. They, in turn, were justly proud of their wealth and their city. A visitor to Florence today walks on streets named for these families and past palaces built for them. They combined a steady sense of business conservatism with an adventuresome pursuit of wealth and fame. No great Florentine banker would have thought it odd that one of this group began his will with the words "In the name of God and profit. Amen."

CONTEMPORARY VOICES

Fra Savonarola

Creatures are beautiful insofar as they share in and approach the beauty of the soul. Take two women of like bodily beauty, and if one is holy and the other is evil, you will notice that the holy one is more loved by everyone than the evil one, so all eyes will rest on her. The same is true of men. A holy man, however deformed bodily, pleases everyone because, no matter how ugly he may be, his holiness shows itself and makes everything he does gracious.

Think how beautiful the Virgin was, who was so holy. She shines forth in all she does. Saint Thomas [Aquinas] says that no one who saw her ever looked on her with evil desire, so evident was her sanctity.

But now think of the saints as they are painted in the churches of the city. Young men go about saying "This is the Magdalen and that is Saint John," and only because the paintings in the church are modeled on them. This is a terrible thing because the things of God are undervalued.

You fill the churches with your own vanity.

Do you think that the Virgin Mary went about dressed as she is shown in paintings? I tell you she went about dressed like a poor person with simplicity and her face so covered that it was hardly seen. The same is true of Saint Elizabeth.

You would do well to destroy pictures so unsuitably conceived. You make the Virgin Mary look like a whore. How the worship of God is mocked!

From a sermon of Fra Savonarola to a congregation in the Cathedral of Florence.

http://es.rice.edu/ES/humsoc/Galileo/People/medici.html

House of Medici

For all their renown and wealth, it was not the bankers who really gave Florence its lasting fame. By some mysterious stroke of good fortune, Florence and its immediate surroundings produced, in the fifteenth cen-

12.1 Gentile da Fabriano. *Adoration of the Magi*, 1423. Altarpiece from Santa Trinita, Florence. Tempera on wood, approx. 9'11" × 9'3" (3.02 × 2.81 m). Galleria degli Uffizi, Florence. This painting reflects the flat two-dimensional quality of most Byzantine and medieval painting. Note the very crowded composition.

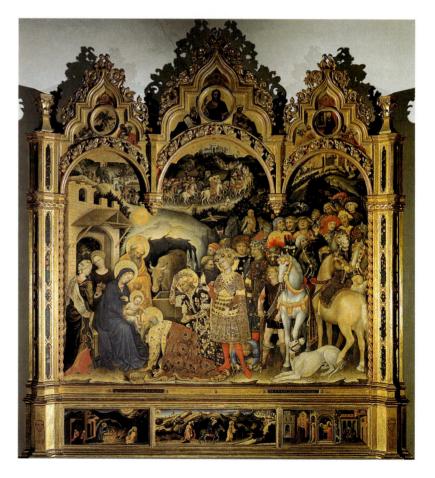

TABLE 12.1 Major Social Events of the Fifteenth Century

- 1439—Council of Florence attempts to reconcile Catholic and Orthodox churches
- 1453—End of the Hundred Years' War
- 1453—Constantinople (Byzantium) falls to the Turks
- 1469—Spain united under Ferdinand and Isabella
- 1485—Henry VII begins reign as first Tudor King of England
- 1486—First European voyage around Cape of Good Hope
- 1492—Columbus discovers America
- 1492 Last Islamic city in Spain (Granada) falls to Ferdinand and Isabella
- 1494—Spain and Portugal divide spheres of influence in the New World
- 1497—Vasco da Gama begins first voyage to India
- 1498—Savonarola executed in Florence

tury, a group of artists who revolutionized Western art to such an extent that later historians refer to the period as a time of *renaissance* ("rebirth") in the arts.

The character of this revolutionary change in art is not easy to define, but we can evolve a partial definition by comparing two early fifteenth-century Florentine paintings. Sometime before 1423 a wealthy Florentine banker, Palla Strozzi, commissioned Gentile da Fabriano (c. 1385-1427) to paint an altarpiece for the Florentine Church of Santa Trinitá. The Adoration of the Magi [12.1], completed in 1423, is ornately framed in the style of Gothic art, with evidence of influences from the miniature painting of Northern Europe and from the older painting tradition of Italy itself. The altarpiece is in the style called "International" because it spread far beyond the area of its origins in France. This style reflects the old-fashioned tendency to fill up the spaces of the canvas, to employ the brightest colors on the palette, to use gold lavishly for halos and in the framing, and to ignore any strict proportion between the characters and the space they occupy. Gentile's altarpiece is, in fact, a strikingly beautiful painting that testifies to the lush possibilities of the conservative International Gothic style.

Only about five years later Tommaso Guidi (1401–1428), known as Masaccio, the precocious genius of Florentine painting, painted a fresco for the Dominican Church of Santa Maria Novella in Florence, *The Holy Trinity* [12.2], that is strikingly different from the kind of painting by Gentile. The most apparent difference is in the utilization of space. In *The Holy Trinity* the central figures of God the Father, the Holy Spirit, and the crucified Christ seem to stand in the foreground of deep three-dimensional space created by the illusionistically painted architectural framing of the Trinity. The character of the architecture is Roman, its barrel vaulting and coffering sus-

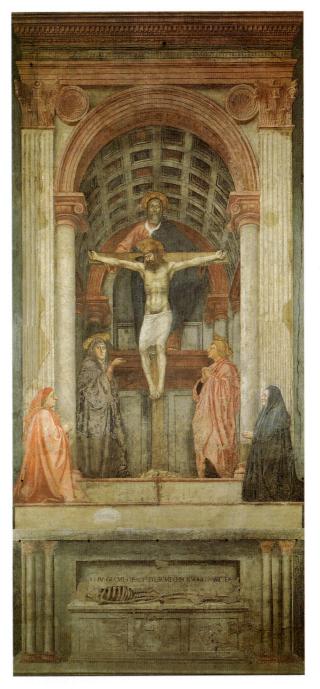

12.2 Masaccio. *The Holy Trinity*, c. 1428. Fresco, $21'10^{1}/2'' \times 10'5''$ (6.66 \times 3.19 m). Santa Maria Novella, Florence. The donors of the panel kneel at bottom left and right. The Trinity, with the Holy Spirit symbolized as a dove, is set in a Classical Roman architectural frame.

tained by Corinthian columns and pilasters. At the sides, and slightly lower, Mary looks out at the viewer, while Saint John looks at Mary. At the edge of the scene, members of the donor family kneel in profile. The entire scene has an intense geometrical clarity based on the pyramid, with God as the apex of the triangle formed with the line of donors and saints at the ends of the baseline.

http://www.kfki.hu/~arthp/html/m/masaccio/trinity/

Masaccio's Holy Trinity

In this single fresco appear many of the characteristics of Florentine Renaissance painting that mark it off from earlier painting styles: clarity of line, a concern for mathematically precise perspective, close observation of "real people," concern for psychological states, and an uncluttered arrangement that rejects the earlier tendency in painting to produce crowded scenes to fill up all the available space.

Masaccio's earlier frescoes in the Brancacci Chapel of the Church of Santa Maria del Carmine in Florence also show his revolutionizing style. His 1427 fresco called The Tribute Money [12.3] reflects his concern with realistic depiction of human beings. The central scene portrays Christ telling Peter that he can find the tax money for the temple in the mouth of a fish; at the left Peter recovers the coin of tribute; at the right he makes the tribute payment (Matthew 17:24-27). The clusters of figures surrounding Christ reflect a faithfulness to observed humanity that must have been startling to Masaccio's contemporaries who had never seen anything quite like it. The figures are in a space made believable by the receding lines of the buildings to the right. The fresco of the Expulsion of Adam and Eve from Eden [12.4] in the same chapel shows not only realism in the figures, but also a profound sense of human emotions: the shame and dismay of the first human beings as they are driven from the Garden of Paradise.

The revolutionary character of Masaccio's work was recognized in his own time. His influence on any number of Florentine painters who worked later in the century is clear. Two generations after Masaccio's death the young Michelangelo often crossed the river Arno to sketch the frescoes in the Brancacci chapel. In the next century, Giorgio Vasari (1511–1574) in his *Lives of the Artists* would judge Masaccio's influence as basic and crucial: "The superb Masaccio . . . adopted a new manner for his heads, his draperies, buildings, and nudes, his colors, and foreshortening. He thus brought into existence the modern style which, beginning during his period, has been employed by all of our artists down to the present day."

The innovative character of fifteenth-century art was not limited to painting. Significant changes were occurring in sculpture and architecture as well. A famous competition was announced in 1401 for the right to decorate the doors of the Florence Baptistery, dedicated to Saint John the Baptist and a focal point of Florentine life. The baptistery is an ancient octagonal Romanesque building which, in the fifteenth century, had such a reputation for antiquity that some thought it had originally been a Roman temple. Vasari tells us that an eminent group of artists including Lorenzo Ghiberti (1378–1455) and Filippo Brunelleschi (1377–1466) were among the competitors. Ghiberti won.

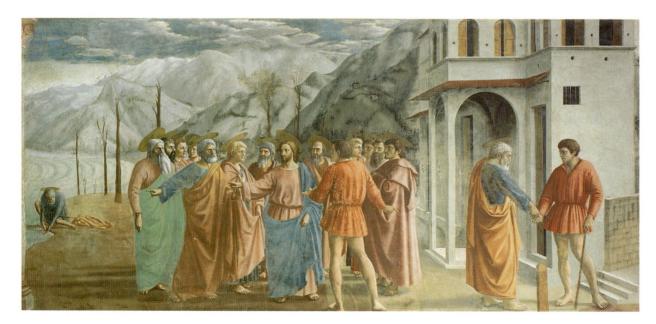

12.3 Masaccio. *The Tribute Money*, c. 1427. Fresco. $8'1'' \times 19'7''$ (2.54 \times 5.9 m). Brancacci Chapel, Santa Maria del Carmine, Florence. Three moments of the story are seen simultaneously. *Center:* Jesus instructs Peter to find the coin of tribute. *Left:* Peter finds it in the mouth of a fish. *Right:* Peter pays the tribute money. The story is in Matthew 17:24–27.

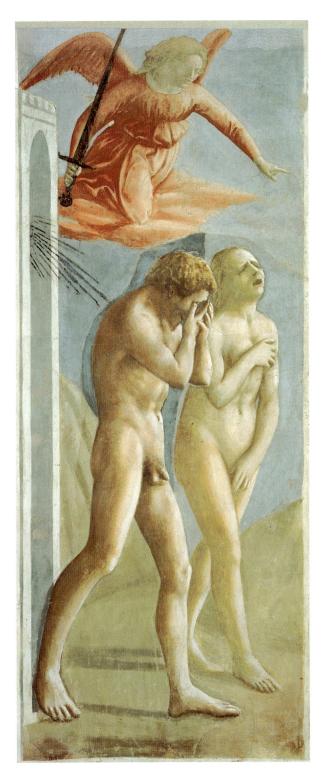

12.4 Masaccio. Expulsion of Adam and Eve from Eden, c. 1425. Fresco, $7'^{1}/_{4}'' \times 2'$ 11" (2.14 \times .90 m). Brancacci Chapel, Santa Maria del Carmine, Florence. The artist manages to convey both a sense of movement and a sense of the deep psychological distress and shame of the expelled couple.

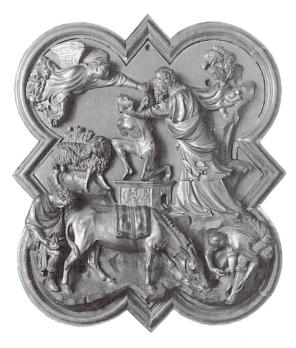

12.5 Filippo Brunelleschi. *The Sacrifice of Isaac*, 1401–1402. Competition panel for the East Doors of the Baptistery of Florence. Gilt bronze relief, $21'' \times 17^{1}/_{2}'''$ (53 × 44 cm). Museo Nazionale del Bargello, Florence. Note the figures spilling over the bottom part of the frame.

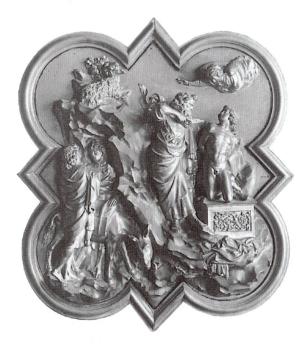

12.6 Lorenzo Ghiberti. *The Sacrifice of Isaac*, 1401–1402. Competition panel for the East Doors of the Baptistery of Florence. Gilt bronze relief, $21'' \times 17^{1}/_{2}''$ (53 × 44 cm). Museo Nazionale del Bargello, Florence. This was the winning panel in the competition.

286

A comparison of the Brunelleschi and Ghiberti panels shows the differences between the two and allows us to infer the criteria used to judge the winner. The assigned subject for the competition was Abraham's sacrifice of Isaac (Genesis 22:1–14). Brunelleschi's version [12.5] has a certain vigor, but it is a busy and crowded composition. The figures of the servants spill out of the four-leaf or quatrefoil frame while the major figures (the ram, the angel, and the two principals) are in flattened two-dimensional profile with little background space.

By contrast, Ghiberti's panel on the same subject [12.6] is divided dramatically by a slashing diagonal line separating the two sets of actors into clearly designated planes of action. The drastically foreshortened angel appears to be flying into the scene from deep space. Furthermore, as a close examination of the cast shows, Ghiberti's panel is a technical tour de force. Except for the figure of Isaac and Abraham's left foot (and part of the

rock it rests on), the entire scene was cast as a single unit. Demonstrating his strong background as a goldsmith, Ghiberti finely modeled and skillfully finished his panel. It is a piece of fierce sentiment, mathematical perspective, and exquisite work.

Ghiberti worked for almost a quarter of a century on the North Doors, completing twenty panels. Just as he was finishing, the cathedral authorities commissioned him (in 1425) to execute another set of panels for the East Doors, those facing the cathedral itself. This commission occupied the next quarter of a century (from roughly 1425 to 1452 or 1453), and the results of these labors were so striking that Michelangelo later in the century said Ghiberti's East Doors were not unworthy to be called the "Gates of Paradise," and they are so-called to this day.

The panels of the East Doors [12.7] differed radically in style and composition from the North Door panels.

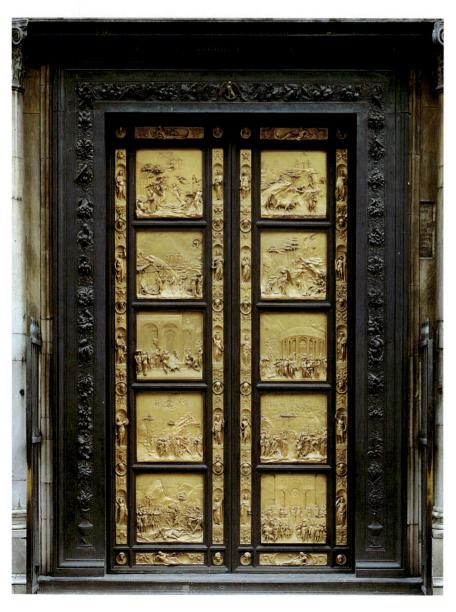

12.7 Lorenzo Ghiberti, 1425–1432. East Doors ("Gates of Paradise") of the Baptistery of the Cathedral of Florence. Gilt bronze relief. Height, 17′ (5.18 m).

The Gothic style quatrefoils were replaced by more classically severe rectangular frames. The complete set of panels was framed, in turn, by a series of portrait busts of prophets and sybils.

Although Brunelleschi lost to Ghiberti in the sculpture competition of 1401, he made a major contribution to this early developmental phase of Renaissance art in another area: architecture. During his stay in Rome, where he had gone with the sculptor Donatello after the competition, he made a study of Roman architectural monuments. In fact, Vasari records that Brunelleschi and Donatello were reputed to be treasure hunters because of their incessant prowlings amid the ruins of the Roman Forum. It was these intensive studies, together with his own intuitive genius, that gave Brunelleschi an idea for solving a problem then thought insoluble: how to construct the dome for the still unfinished Cathedral of Saint Mary of the Flower (Santa Maria del Fiore) in Florence.

The Cathedral of Florence had been built by Arnolfo di Cambio in the previous century over the remains of the older Church of Santa Reparata. In the early fifteenth century, however, the church was still unfinished, although the nave was already complete [12.8]. No one had quite figured out how to span the great area without immense buttresses on the outside and supporting armatures on the inside. Brunelleschi worked on this problem between 1417 and 1420, trying, simultaneously, to solve the technical aspects of doming the building and convincing the skeptical cathedral overseers that it could be done. He won the day eventually, but work on the dome was not completed until 1436.

His solution, briefly, was to combine the buttressing methods of the Gothic cathedral and classical vaulting techniques that he had mastered by his careful study of the Roman Pantheon and other buildings from antiquity. By putting a smaller dome within the larger dome to support the greater weight of the outside dome, he could not only cover the great tambour ("drum") [12.9] but also free the inside of the dome from any need for elaborate armatures or supporting structures. This dome was strong enough to support the lantern that eventually crowned the whole construction. It was a breathtaking technical achievement, as well as an aesthetic success, as any person viewing Florence from the surrounding hills can testify. Years later, writing about his own work on the dome of Saint Peter's in the Vatican, Michelangelo had Brunelleschi's dome in mind when he said "I will create your sister; bigger but no more beautiful."

The technical brilliance of Brunelleschi's dome cannot be overpraised, but his real architectural achievement lies in his building designs that break with older forms of architecture.

His Foundling Hospital [12.10], with its opencolumned loggias and their graceful Corinthian pillars, arches, and entablature, is, despite its seeming simplicity,

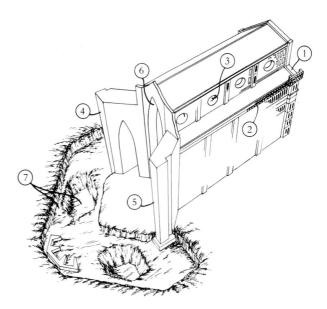

12.8 Cathedral of Florence in 1390. An artist's reconstruction of the cathedral as Brunelleschi would have found it when he began his work. (1) Façade and side wall. (2) Gallery. (3) Circular windows. (4) Armature under construction. (5) Vaulting under construction. (6) Sacristy piers. (7) Excavations for buttresses.

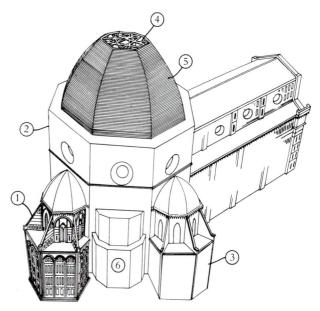

12.9 Cathedral of Florence in 1418. (1) Buttressing. (2) Completed drum (tambour). (3) Side tribunes under construction. (4) Armature under construction. (5) Vaulting under construction. (6) Sacristy piers.

a highly intricate work, its proportions calculated with mathematical rigor. The building is an open departure from the heaviness of the Romanesque so common in the area of Tuscany as well as a rejection of the overly elaborate Gothic exteriors. **12.10** Filippo Brunelleschi. Foundling Hospital, Florence, 1419–1426. The glazed terracotta medallions of the swaddled children are from the della Robbia workshop in Florence.

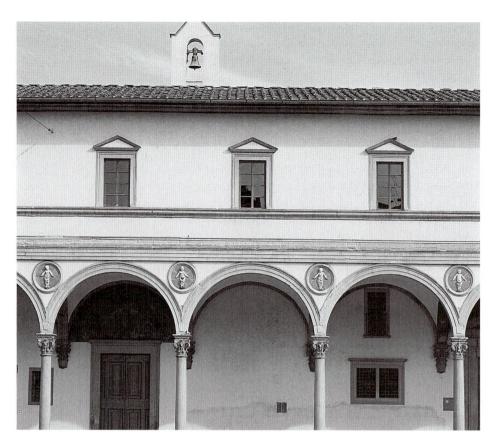

This same concern with Classical order, proportion, and serenity can be seen in Brunelleschi's finest work, the chapel he designed for the Pazzi family next to the Franciscan Church of Santa Croce in Florence [12.11]. Its exterior evokes Roman austerity with its delicate columns, severe façade, and small dome reminiscent of the lines of Rome's Pantheon.

In this very brief look at three different art forms and artists in the early fifteenth century, certain recurring words and themes give a rough descriptive outline of what the Florentine Renaissance style reflects: a concern with, and the technical ability to handle, space and volume in a believable way; a studious approach to models of art from ancient Rome; a departure from the more ethereal mode of medieval otherworldliness to a greater concern for human realism. The Florentine artistic temperament leaped over its medieval heritage (although not completely) in order to reaffirm what it considered the Classical ideal of ancient Rome and Greece.

THE MEDICI ERA

The Florentine Republic was governed by representatives of the major trade guilds. This control by a very select group of people who represented commercial power and wealth inevitably led to domination by the most

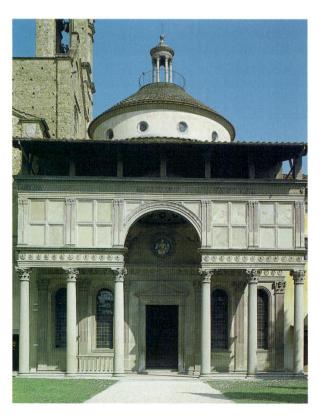

12.11 Filippo Brunelleschi. Pazzi Chapel, Florence, 1430–1433. Part of the Franciscan Church of Santa Croce can be seen in the left background.

wealthy of the group. From 1434 until 1492, Florence was under the control of one family: the Medici.

The Medici family had old, though until then undistinguished, roots in the countryside around Florence. Their prosperity in the fifteenth century rested mainly on their immense banking fortune. By the middle of that century, Medici branch banks existed in London, Naples, Cologne, Geneva, Lyons, Basel, Avignon, Bruges, Antwerp, Lübeck, Bologna, Rome, Pisa, and Venice. The great Flemish painting by Jan van Eyck, Giovanni Arnolfini and His Bride [12.12], in fact, commemorates van Eyck's witnessing of the marriage in 1434 of this Florentine representative of the Medici bank in Bruges. While it is more usual to look at the painting because of its exquisite technique, its rich symbolism, and its almost microscopic concern for detail, it is also profitable to view it sociologically as a testimony to how far the influence of the Medici extended.

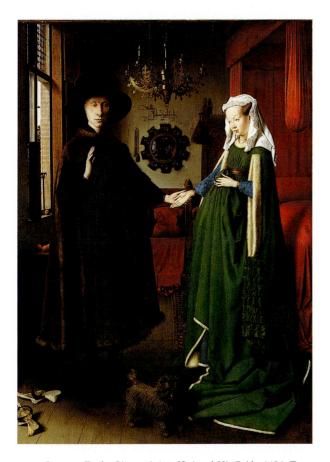

12.12 Jan van Eyck. *Giovanni Arnolfini and His Bride*, 1434. Tempera and oil on wood, approx. $32'' \times 23''$ (81.3×59.7 cm). Reproduced by the courtesy of the Trustees of the National Gallery, London. The artist, reflected in the mirror, stands in the doorway. The Latin words on the wall read "Jan van Eyck was here." The pair of sandals at the lower left symbolizes a sacred event; the dog is a symbol of fidelity and domestic peace.

http://www.artcyclopedia.com/artists/eyck_jan_van.html

Jan van Eyck

Cosimo de' Medici

Cosimo de' Medici (de facto ruler of Florence from 1434 to 1464) was an astute banker and a highly cultivated man of letters. His closest friends were professional humanists, collectors of books, and patrons of the arts. Cosimo himself spent vast sums on the collecting and copying of ancient manuscripts. He had his copyists work in a neat cursive hand that would later be the model for the form of letters we call *italic*. His collection of books (together with those added by later members of his family) formed the core of the great humanist collection housed today in the Laurentian Library in Florence.

Although Cosimo never mastered Greek to any degree, he was intensely interested in Greek philosophy and literature. He financed the chair of Greek at the *Studium* of Florence. When Greek prelates visited Florence during the ecumenical council held in 1439 (the council sought a union between the Greek and Latin churches), Cosimo took the opportunity to seek out scholars from Constantinople in the retinue of the prelates. He was particularly struck with the brilliance of Genisthos Plethon (c. 1355–1452), who lectured on Plato. Cosimo persuaded Plethon to remain in the city to continue his lectures.

Cosimo's most significant contribution to the advancement of Greek studies was the foundation and endowment of an academy for the study of Plato. For years Cosimo and his heirs supported a priest, Marsilio Ficino, in order to allow him to translate and comment on the works of Plato. In the course of his long life (he died in 1499), Ficino translated into Latin all of Plato, Plotinus, and other Platonic thinkers. He wrote his own compendium of Platonism called the *Theologia Platonica*. These translations and commentaries had an immense influence on art and intellectual life in Italy and beyond the Alps.

Cosimo often joined his friends at a suburban villa to discuss Plato under the tutelage of Ficino. This elite group embraced Plato's ideas of striving for the ideal good and persistently searching for truth and beauty. This idealism became an important strain in Florentine culture. Ficino managed to combine his study of Plato with his own understanding of Christianity. It was Ficino who coined the term "Platonic love"—the spiritual bond between two persons who were joined together in the contemplative search for the true, the good, and the beautiful. Cosimo, a pious man in his own right, found great consolation in this Christian Platonism of Ficino. "Come and join me as soon as you possibly can and be

sure to bring with you Plato's treatise *On the Sovereign Good,*" Cosimo once wrote his protégé: "[T]here is no pursuit to which I would devote myself more zealously than the pursuit of truth. Come then and bring with you the lyre of Orpheus."

A fiercely patriotic Florentine known to his contemporaries as *Pater Patriae* ("Father of the Homeland"), Cosimo lavished his funds on art projects to enhance the beauty of the city, at the same time glorifying his family name and atoning for his sins, especially usury, by acts of generous charity. He befriended and supported many artists. He was a very intimate friend and financial supporter of the greatest Florentine sculptor of the first half of the fifteenth century, Donato di Niccolò di Betto Bardi (1386–1466), known as Donatello. Donatello was an eccentric genius who cared for little besides his work; it was said that he left his fees in a basket in his studio for the free use of his apprentices or whoever else might be in need.

http://www.artchive.com/artchive/ftptoc/donatello_ext.html Donatello

Even today a leisurely stroll around the historic center of Florence can, in a short time, give an idea of the tremendous range of Donatello's imaginative and artistic versatility. One need only compare his early Saint George [12.13], fiercely tense and classically severe, to the later bronze David [12.14]. The Saint George is a niche sculpture originally executed for the Church of Or San Michele, whereas the David is meant to be seen from all sides. The David, a near-life-size figure, is the first freestanding statue of a nude figure sculpted since Roman antiquity. It also marks a definite step in Renaissance taste: Despite its subject, it is more clearly "pagan" than biblical in spirit. The sculptor obviously wanted to show the beauty of form of this adolescent male clothed only in carefully fashioned military leg armor and a Tuscan shepherd's hat. The figure was most likely made for a garden. Some scholars have speculated that the commission was from Cosimo himself, although clear documentary proof is lacking.

Donatello's larger-than-life-sized wooden figure of Mary Magdalene [12.15] seems light years away from the spirit of *David*. Carved around 1455, it shows the Magdalene as an ancient penitent, ravaged by time and her own life of penance. The viewer is asked to mentally compare this older woman with the younger woman described in the Bible. The statue, then, is a profound meditation on the vanity of life, a theme lingering in Florentine culture from its medieval past and, at the same time, a hymn to the penitential spirit that made Magdalene a saint in the popular imagination.

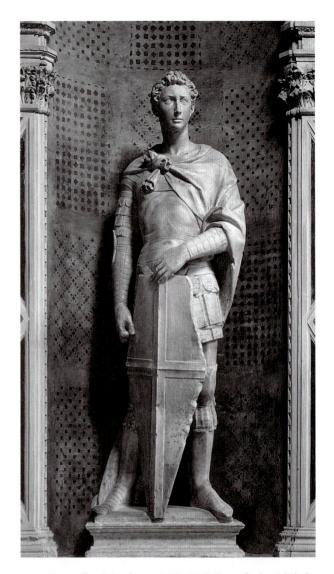

12.13 Donatello. *Saint George*, 1415–1417. From Or San Michele. Marble (has been replaced by a bronze copy). Height approx. 6'10" (2.08 m). Museo Nazionale del Bargello, Florence. Originally, the saint grasped a spear in his right hand.

Cosimo de' Medici had a particular fondness for the Dominican Convent of San Marco in Florence. In 1437 he asked Michelozzo, the architect who designed the Medici palace in Florence, to rebuild the convent for the friars. One of the Dominicans who lived there was a painter of established reputation, Fra Angelico (1387–1455). When Michelozzo's renovations were done, Fra Angelico decorated many of the convent walls and most of the cells of the friars with paintings, executing many of these works under the watchful eye of Cosimo, who stayed regularly at the convent. Fra Angelico's famous *Annunciation* fresco [12.16] shows his indebtedness to the artistic tradition of Masaccio: the use of architecture to frame space, a sense of realism and drama, and a close observation of the actual world.

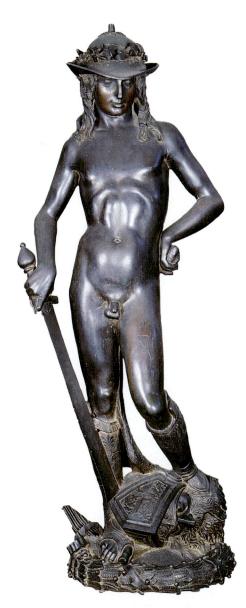

12.14 Donatello. *David*, c. 1428–1432. Bronze. Height $5'2^{1}/2''$ (1.58 m). Museo Nazionale del Bargello, Florence. The killing of Goliath is shown at three stages in this book. Michelangelo's *David* is shown as he sees his foe (Figure 12.28). Bernini's *David* is shown in the exertion of his attack (Figure 15.8). Donatello's *David* reposes after the attack as he leans on the sword of the giant and rests his other foot on Goliath's severed head.

Another painter who enjoyed the Medici largesse was Paolo Uccello (1397–1475), who did a series of three paintings for the Medici palace commemorating the earlier Battle of San Romano (1432) in which the Florentines defeated the Sienese. The paintings (now dispersed to

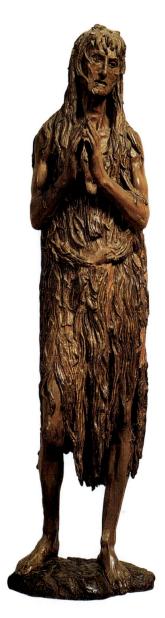

12.15 Donatello. *Saint Mary Magdalene*, c. 1454–1455. Polychromed and guilded wood. Height 6'2" (1.88 m). Museo Dell' Opera del Duomo, Florence. Cleaned and restored after flood damage in 1966, this statue now reveals some traces of the original polychrome. It was originally in the Baptistery of the Florence Cathedral.

museums in London, Florence, and Paris) show Uccello's intense fascination with perspective [12.17]. The scenes are marked by slashing lines, foreshortened animals, receding backgrounds, and seemingly cluttered land-scapes filled with figures of differing proportion. When the three paintings were together as a unit they gave a panoramic sweep of the battle running across 34 feet (10.3 m) of the wall space.

Cosimo's last years were racked with chronic illness and depression brought on by the premature deaths of

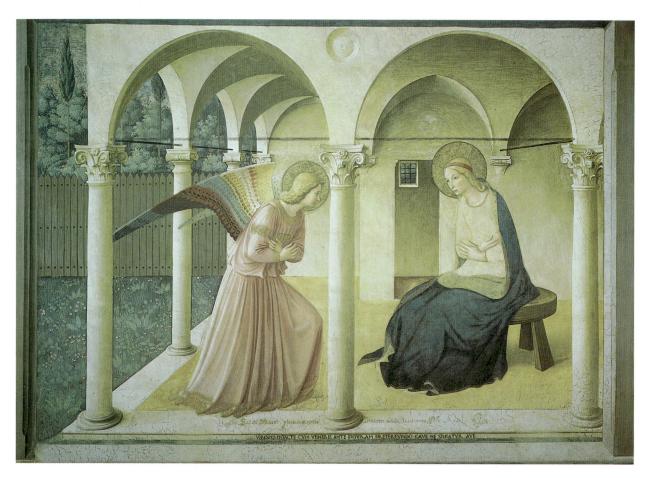

12.16 Fra Angelico. *Annunciation*, 1445–1450. Fresco, $7'6'' \times 10'5''$ (2.29 \times 3.18 m). Monastery of San Marco, Florence. Note how the architecture frames the two principal figures in the scene. Botanists can identify the flowers in the garden to the left.

12.17 Paolo Uccello. *The Battle of San Romano*, 1455. Tempera on wood, $6'10'' \times 10'7''$ (1.83 \times 3.22 m). Galleria degli Uffizi, Florence. The upraised spears and javelins give the picture a sense of frantic complexity.

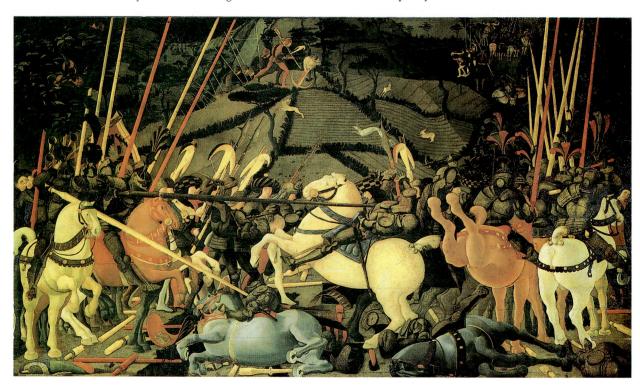

his son Giovanni and a favorite grandson, as well as the physical weakness of his other son, Piero. Toward the end of his life, Cosimo's wife once found him in his study with his eyes closed. She asked him why he sat in that fashion. "To get them accustomed to it," he replied. Cosimo de' Medici died on August 1, 1464. His position as head of the family and as first citizen of the city was assumed by his son Piero, called "the Gouty" in reference to the affiiction of gout from which he suffered all his life.

Piero de' Medici

Piero's control over the city lasted only five years. It was a time beset by much political turmoil as well as continued artistic activity. Piero continued to support his father's old friend Donatello and maintained his patronage of Ficino's Platonic labors and his generous support of both religious and civic art and architecture.

One new painter who came under the care of Piero was Alessandro di Mariano dei Filipepi (1444–1510), known more familiarly as Sandro Botticelli. Botticelli earlier had been an apprentice of the painter Fra Filippo Lippi (c. 1406–1469), but it was Piero and his aristocratic wife Lucrezia Tornabuoni (a highly cultivated woman who was a religious poet) who took Botticelli into their home and treated him as a member of the family. Botticelli stayed closely allied with the Medici for decades.

Bot

One tribute to a Adoration of the Magi the Florentine Church of Sare shown as three generated there are also portraits of Lorenzo of Piero. The painting was paid for Medici family. Many scholars believe it fering to the church in thanksgiving for the family during the political turmoil of 1466.

The theme of the Magi was a favorite of the Magi regularly took part in the pageants in the streets. Florence celebrating the three kings on the Feast of the Epiphany (January 6). It is for that reason, one assumes, that Piero commissioned a fresco of that scene for the chapel of his own palace. The painter was Benozzo Gozzoli (1420–1495), once an apprentice of Fra Angelico. Gozzoli produced an opulent scene filled with personages of Oriental splendor modeled on the Greek scholars who had come to Florence during the ecumenical council and who stayed on to teach Greek. The fresco also included some contemporary portraits, including one of the artist himself [12.19].

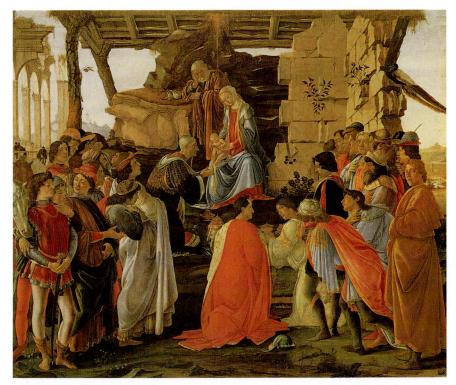

12.18 Sandro Botticelli. *Adoration of the Magi*, 1475. Tempera on wood, $3'7^1/_2'' \times 4'4^3/_4''$ (1.1 \times 1.34 m). Galleria degli Uffizi, Florence. Cosimo de' Medici kneels in front of the Virgin; Lorenzo is in the left foreground; Giuliano is at the right against the wall. The figure in the right foreground looking out is thought to be the artist.

A social leader has made us forget that he _tttp://www.ibiblio.org/wm/paint/auth/botticelli/ tant contributor to the development of vern poetry. He continued the sonnet tradition trarch. One of his most ambitious projectsscious imitation of Dante's Vita Nuova—was k that alternated his own sonnets with exse commentaries; this was the Comento ad tti (A Commentary on Some Sonnets, begun [2.18], a work commissioned for Medici was Botticelli's painting 77). In addition to this very ambitious work, and Giuliano, the sons
by a friend of the
was a votive ofsafety of the unta Maria Novella. The Magi vrote hunting songs, poems for the carnival ligious poetry, and occasional burlesque poems erfully bawdy tone. bem for which Lorenzo is best known is "The The Medici Era Bacchus." Written in 1490, its opening stanzas old Roman dictum of living for the present bee is short and the future is uncertain. 293

12.19 Benozzo Gozzoli. *The Journey of the Magi*, 1459. Detail. Fresco. Length (entire work) 12'4\sqrt{2}" (3.77 m). Chapel, Palazzo Medici-Riccardi, Florence. The horseman, representing one of the Magi, is thought to be an idealized portrait of Byzantine Emperor John VII Paleologus, who visited Florence at the invitation of Cosimo de' Medici for a church council in 1439.

The Song of Bacchus

How beautiful is youth,
That flees so fleetingly by.
Let him be who chases joy
For tomorrow there is no certainty.

Look at Bacchus and Ariadne So beautiful and much in love. Since deceitful time flees They are always happy.

Joyful little satyrs
of the nymphs enamored,
In every cave and glade
Have set traps by the hundred;
Now, by Bacchus intoxicated,
Dance and leap without end.

Let him be who chases joy For tomorrow there is no certainty.

Lorenzo's interests in learning were deep. He had been tutored as a youth by Ficino and as an adult continued the habit of spending evenings with an elite group of friends and Ficino. He often took with him his friend Botticelli and a young sculptor who worked in a Medicisponsored sculpture garden, Michelangelo Buonarroti.

The Laurentian patronage of learning was extensive. Lorenzo contributed the funds necessary to rebuild the University of Pisa and designated it the principal university of Tuscany (Galileo taught there in the next century). He continued to underwrite the study of Greek at the *Studium* of Florence.

The Greek faculty at Florence attracted students from all over Europe. Indeed, this center was a principal means by which Greek learning was exported to the rest of Europe, especially to countries beyond the Alps. English scholars like Thomas Linacre, John Colet, and William Grocyn came to Florence to study Greek and other Classical disciplines. Linacre was later to gain fame as a physician and founder of England's Royal College of Physicians. Grocyn returned to England to found the chair of Greek at Oxford. Colet used his training to become a biblical scholar and a founder of Saint Paul's School in London. The two greatest French humanists of the sixteenth century had, as young men, come under the influence of Greek learning from Italy. Guillaume Budé (died 1540) founded, under the patronage of the French kings, a library at Fontainebleau that was the beginning of the Bibliothèque Nationale of Paris. He also founded the Collège de France, still the most prestigious center of higher learning in France. Jacques Lefèvre d'Étaples had

also studied in Florence and became the greatest intellectual church reformer of sixteenth-century France.

Lorenzo was less interested in painting than either his father Piero or his grandfather Cosimo. Nevertheless, some of the paintings done during his lifetime have come to epitomize the spirit of the age because of their close familial and philosophical links to Lorenzo's family. This is especially true of the work of Botticelli and, more specifically, his paintings *La Primavera* and *The Birth of Venus*.

Botticelli painted *La Primavera* (*Springtime*) [12.20] for a cousin of Lorenzo named Lorenzo di' Pierfrancesco. One of the most popular paintings in Western art, *La Primavera* is an elaborate mythological allegory of the burgeoning fertility of the world. The allegory itself has never been fully explicated, but the main characters are clearly discernible: at the extreme right the wind god Zephyr pursues a nymph who is transformed into the goddess Flora (next figure), who scatters her flowers; at the left are the god Mercury and three dancing Graces. Over the Graces and the central female figure (who represents Spring) is blind Cupid ready to launch an arrow that will bring love to the one he hits. The rich carpeting of springtime flowers and the background of the orange grove provide luxuriant surroundings.

In the sixteenth century, Vasari saw La Primavera in Lorenzo di' Pierfrancesco's villa together with another painting by Botticelli, The Birth of Venus (1480). A gentle, almost fragile work of idealized beauty, The Birth of Venus [12.21] shows the wind gods gently stirring the sea breezes as Venus emerges from the sea and an attendant waits for her with a billowing cape. The Venus figure is inspired by the Venus pudica (the "Modest" Venus) figures of antiquity. The most significant aspect of the painting (and of La Primavera) is the impulse, motivated by Platonism, to idealize the figures. Botticelli is trying to depict not a particular woman but the essential ideal of female beauty. The Venus of this painting reflects a complex synthesis of Platonic idealism, Christian mysticism relating to the Virgin, and the Classical ideal of the female figure of Venus.

Two other artists who lived in Laurentian Florence are of worldwide significance: Leonardo da Vinci (1452–1519) and Michelangelo Buonarroti. Leonardo came from a small Tuscan town near Florence called Vinci. He lived in Florence until the 1480s, when he left for Milan; from there he moved restlessly from place to place until his death in France. Leonardo has been called *the* genius of the Renaissance not so much for what he left in the way of art (although his *Mona Lisa* [Fig. 12.22] and *The Last Supper* [Fig. 12.24]) are surely among the more famous art pieces of all time) as for the things that he dreamed of doing and the problems he set himself to solve, and the phenomena he observed and set down in his *Notebooks*.

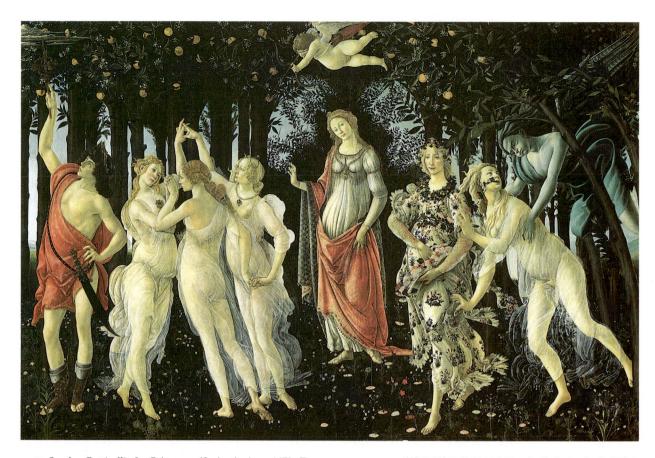

12.20 Sandro Botticelli. La Primavera (Springtime), c. 1478. Tempera on canvas, $6'8'' \times 10'4''$ (2.03 \times 3.14 m). Galleria degli Uffizi, Florence. This work and *The Birth of Venus* (Figure 12.21) are the best examples of Botticelli's fusion of pagan symbolism, Neo-Platonic idealism, and the quest for the ideal female.

http://www.artchive.com/artchive/ftptoc/leonardo_ext.html

If we had nothing but the *Notebooks*, we would still say that Leonardo had one of humanity's most fertile minds. He left sketches for flying machines, submarines, turbines, elevators, ideal cities, and machines of almost every description [12.23]. His knowledge of anatomy was unsurpassed (he came very close to discovering the circulation path of blood), while his interest in the natural worlds of geology and botany was keen. The *Notebooks*, in short, reflect a restlessly searching mind that sought to understand the world and its constituent parts. Its chosen fields of inquiry are dominated by many of the characteristics common to the period: a concern with mathematics, a deep respect for the natural world, and a love for beauty.

Leonardo's *The Last Supper* [12.24] is a good example of these characteristics. Leonardo chooses the moment when Jesus announces that someone at the table will be-

tray him. The apostles are arranged in four distinct groups. The central figure of Christ is highlighted by the apostles who either look at him or gesture toward him. Christ is haloed by the central window space behind him, with the lines of the room all converging toward that point. The painting has great emotional power even though it is mathematically one of the most perfect painting ever executed.

$http://www.repubblicarts.kataweb.it/repubblicarts/leonardo/\\ arte_1pag.html$

Leonardo's The Last Supper

Leonardo's expressive power as a painter is ably illustrated in his striking *Madonna of the Rocks* [12.25], begun shortly after his arrival in Milan in 1483, a decade before he painted *The Last Supper*. The Virgin drapes her right arm over the figure of the infant Saint John the Baptist while her hand hovers in protective blessing over the Christ child. An exquisitely rendered angel points to the scene. The cavernlike space in the background would

VALUES

Intellectual Synthesis

It would be a bit misleading to see the Renaissance as a naive recovery of the Classical past. What actually occurred was a desire for synthesis, which is to say, a recovery of the inherited past of Greece and Rome in order to use that recovery for the needs and aspirations of the time. The first step in this synthesis required a study of the past. It is worthwhile noting how extensive that study was. It ranged from the careful observation and measurement of ancient buildings to the close study of archeological remains from Rome like coins, carved gems, and sculpture to the humanistic work of editing texts, translating them, and providing those aids (like dictionaries, etc.) that would permit this work to go on. The synthesis came when people took what they had recovered from the past (a process called in French ressourcement—"going back to the sources") and transformed what they discovered to meet the needs of their own contemporary situation.

That process of synthesis needs emphasis if one is to understand what happened in, say, fifteenth-century Florence. Brunelleschi did not study Rome's Pantheon to rebuild it but as an exercise in order to better create church architecture. Ficino loved Plato but he thought that in Plato he could explain the Christian faith better than the schoolmen of an earlier period. Machiavelli and Erasmus—radically different types that we have noted in the text—loved the classics for their own sakes but they also saw in them pragmatic clues that would help them understand contemporary problems ranging from how politics ought to be ordered to how church reform might be effected.

If one is to understand the Renaissance, it is crucial to see that the Classical past was not merely "ancient history" but a source for new and innovative ideas and concepts that addressed real and pertinent issues.

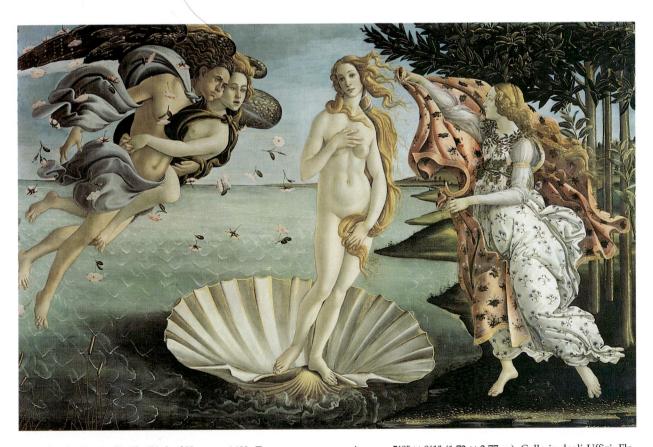

12.21 Sandro Botticelli. *The Birth of Venus*, c. 1482. Tempera on canvas. Approx. $5'8'' \times 9'1''$ (1.72 \times 2.77 m). Galleria degli Uffizi, Florence. Scholars have expended great effort to unlock the full meaning of this work and *La Primavera*. A comparison of the two shows some close similarity in the figures.

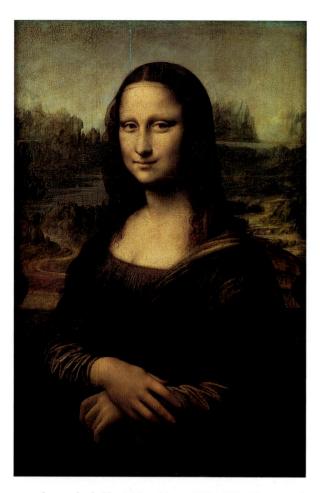

12.22 Leonardo da Vinci. *Mona Lisa,* c. 1503–1505. Oil on wood. Approx. $30'' \times 21''$ (76.2 \times 53.3 cm). Musée du Louvre, Paris.

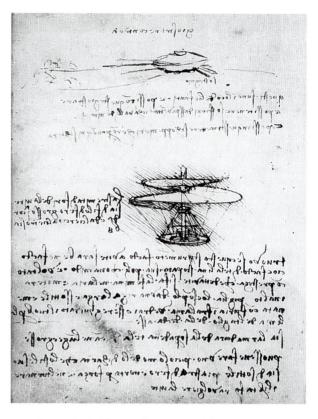

12.23 Leonardo da Vinci. *Helicopter or Aerial Screw*, c. 1485–1490. Bibliothèque de l'Institut de France, Paris. Leonardo's "code writing" is decipherable only when held up to a mirror.

12.24 Leonardo da Vinci. *The Last Supper*, 1495–1498. Fresco, $14'5'' \times 28'^{1}/_{4}''$. Refectory, Santa Maria delle Grazie, Milan. Below the figure of Christ one can still see the doorway cut into the wall during the Napoleonic period by soldiers who used the monastery as a military headquarters.

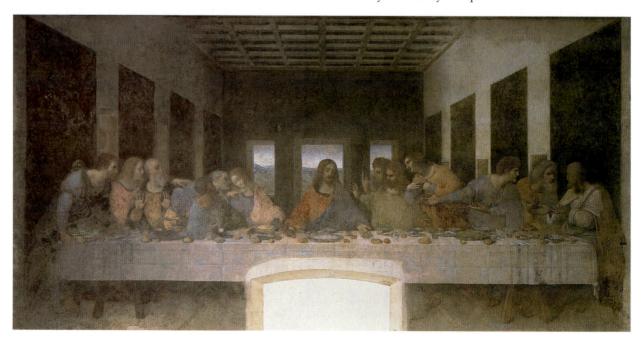

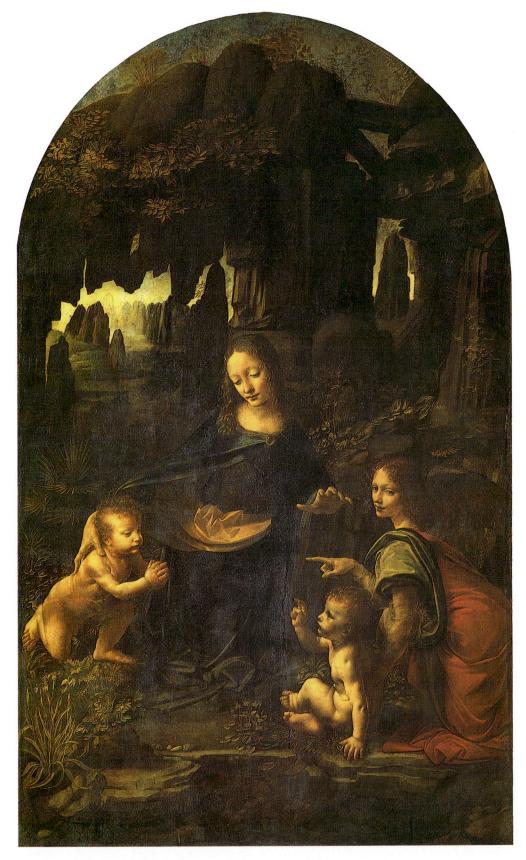

12.25 Leonardo da Vinci. *Madonna of the Rocks*, begun 1483. Panel painting transferred to canvas, $78'' \times 48''$ (198.1 \times 121.9 cm). Louvre, Paris. There is another version of this painting in London's National Gallery, but this one is thought to be completely from the hand of Leonardo. It was to be part of a large altarpiece, never completed, in honor of the Virgin.

remind the perceptive viewer both of the cave at Bethlehem where Christ was born and the cave in which he would be buried. Leonardo's rendering of the jagged rocks stands in sharper relief because of the misty light in the extreme background. The particular beauty of the painting derives at least partially from the juxtaposition of the beautifully rendered persons in all their humanity with the wildly mysterious natural frame in which they are set.

The other great genius of the late fifteenth century is Michelangelo Buonarroti (1476–1564). After his early days in the sculpture garden of Lorenzo, he produced many of his greatest works in Rome (discussed in Chapter 13). However, even a few examples of his early work show both the great promise of Michelangelo's talent and some of the influences he absorbed in Florence under the Medici. The *Madonna of the Stairs* [12.26], an early marble relief, reflects his study of ancient reliefs or cameo carving (which he may well have seen in Lorenzo's collection). By 1498, his style had matured

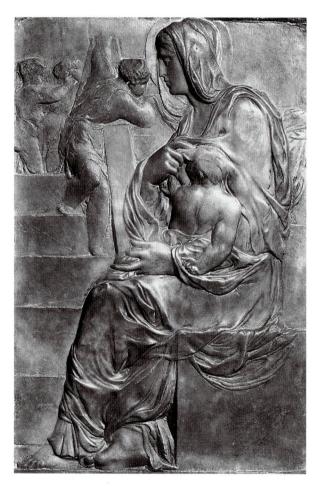

12.26 Michelangelo. *Madonna of the Stairs*, 1489–1492. Marble, $21^3/_4'' \times 15^3/_4'''$ (55 \times 40 cm). Casa Buonarroti, Florence. A fine example of low-relief (bas-relief) carving, with its figures nearly flush to the marble surface.

enough for him to carve, for a French cardinal in Rome, the universally admired *Pietá* [12.27], which combines his deep sensitivity with an idealism in the beauty of the Madonna's face that is reminiscent of Botticelli.

http://www.michelangelo.com/buon/bio-index2.html

Michelangelo

Finally, this early period of Michelangelo's work includes a sculpture that has become almost synonymous with Florence: the *David* [12.28], carved in 1501–1504 from a massive piece of Carrara marble that had lain behind the cathedral in Florence since the middle of the preceding century. The sculpture's great size and its almost photographically realistic musculature combine to make it one of Michelangelo's clearest statements of idealized beauty. The statue was intended to be seen from below with the left arm (the one touching the shoulder) facing the viewer and the right side turned back toward the cathedral. In fact, it was placed outside the Palazzo Vecchio as a symbol of the civic power of the city, where it remained until weathering and damage required its removal to a museum in the nineteenth century.

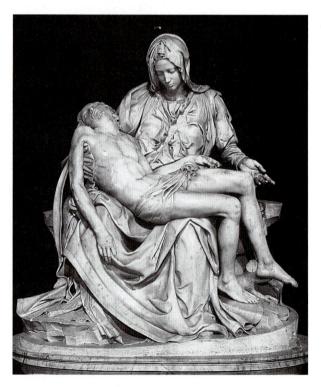

12.27 Michangelo. *Pietá*, 1498–1499. Marble. Height 5'9" (1.75 m). Saint Peter's, Vatican, Rome. One of the most "finished" of Michelangelo's sculptures, its high sheen is the result of intense polishing of the marble.

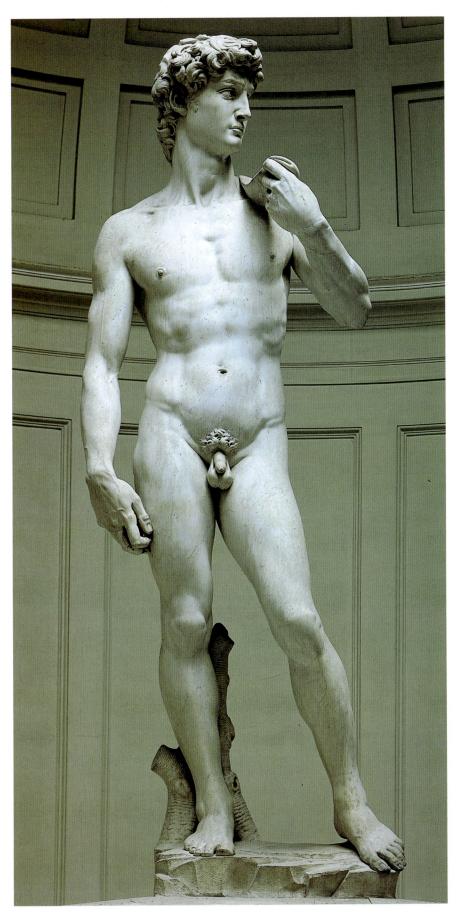

12.28 Michelangelo, *David*, 1501–1504. Marble. Height 18' (5.49 m). Galleria dell' Accademia, Florence. Much of the weight of this figure is borne by David's right leg (with the stylized tree trunk in the rear) in a position called *contraposto* in Italian. It has been said that Botticelli's paintings, the *Davids* of both Donatello and Michelangelo, and the general skepticism of a mind like Leonardo's are all symptoms of the general pagan tone of Laurentian Florence—that Athens and Rome, in short, seemed far more important to fifteenth-century Florence than did Jerusalem. There is no doubt that the Classical revival was central to Florentine culture. Neither is there any doubt that the times had little patience with, or admiration for, medieval culture. However, the notion that the Renaissance spirit marked a clean break with medieval ideals must take into account the life and career of the Dominican preacher and reformer Fra Savonarola (1452–1498).

Savonarola lived at the Convent of San Marco in Florence from 1490 until his execution in 1498. His urgent preaching against the vanities of Florence in general and the degeneracy of its art and culture in particular had an electric effect on the populace. His influence was not limited to the credulous masses or workers in the city. Lorenzo called him to his own deathbed in 1492 to receive the last sacraments even though Savonarola had been a bitter and open enemy of Medici control over the city. Savonarola, in fact, wanted a restored Republic with a strong ethical and theocratic base. Botticelli was so impressed by Savonarola that he burned some of his more worldly paintings, and scholars see in his last works a more profound religiosity derived from the contact with the reforming friar. Michelangelo, when an old man in Rome, told a friend that he could still hear the words of Savonarola ringing in his ears. Pico della Mirandola (1463-1494), one of the most brilliant humanists of the period, turned from his polyglot studies of Greek, Hebrew, Aramaic, and Latin to a devout life under the direction of the friar; only his early death prevented him from joining Savonarola as a friar at San Marco.

http://www.wsu.edu/~dee/REN/PICO.HTM

Pico della Mirandola

Savonarola's hold over the Florentine political order (for a brief time he was the de facto ruler of the city) came to an end in 1498 when he defied papal excommunication and was then strangled and burned in the public square before the Palazzo Vecchio. By that time, Lorenzo had been dead for six years and the Medici family had lost power in Florence. They were to return in the next century, but the Golden Age of Lorenzo had ended with a spasm of medieval piety. The influence of the city and its ideals had, however, already spread far beyond its boundaries.

THE CHARACTER OF RENAISSANCE HUMANISM

http://www.wsu.edu/~dee/REN/HUMANISM.HTM

Humanism

Jules Michelet, a nineteenth-century French historian, first coined the word *Renaissance* specifically to describe the cultural period of fifteenth-century Florence. The broad outline of this rebirth is described by the Swiss historian Jakob Burckhardt in his massive *The Civilization of the Renaissance in Italy*, published in 1860, a book that is the beginning point for any discussion of the topic. Burckhardt's thesis is simple and persuasive. European culture, he argued, was reborn in the fifteenth century after a long dormant period that extended from the fall of the Roman Empire until the beginning of the fourteenth century.

The characteristics of this new birth, Burckhardt said, were first noticeable in Italy and were the foundation blocks of the modern world. It was in late fourteenth- and fifteenth-century Italy that new ideas about the nature of the political order developed, of which the Republican government of Florence is an example, as well as the consciousness of the artist as an individual seeking personal fame. This pursuit of glory and fame was in sharp contrast to the self-effacing and world-denying attitude of the Middle Ages. Burckhardt also saw the thirst for Classical learning, the desire to construct a humanism from that learning, and an emphasis on the good life as an intellectual repudiation of medieval religion and ethics.

Burckhardt's ideas have provoked strong reactions from historians and scholars, many of whom reject his theory as simplistic. Charles Homer Haskins, an American scholar, attacked Burckhardt's ideas in 1927 in a book the title of which gives away his line of argument: *The Renaissance of the Twelfth Century*. Haskins pointed out that everything Burckhardt said about Florentine life in the fifteenth century could be said with equal justification about Paris in the twelfth century. Furthermore (as noted in Chapter 10), scholars have also spoken of a Carolingian Renaissance identified with the court of Emperor Charlemagne.

What is the truth? Was there a genuine Renaissance in fifteenth-century Italy? Many scholars today try to mediate a position between Burckhardt and his detractors. They admit that something new was happening in the intellectual and cultural life of fifteenth-century Italy and that contemporaries were conscious of it. "May every thoughtful spirit thank God that it has been given to him to be born in this new age, so filled with hope and promise, which already enjoys a greater array of gifted

persons than the world has seen in the past thousand years," wrote Matteo Palmieri, a Florentine businessman, in 1436. Yet this "new age" of which Palmieri spoke did not spring up overnight. The roots must be traced to Italy's long tradition of lay learning, the Franciscan movement of the thirteenth century, the relative absence of feudalism in Italy, and the long maintenance of Italian city life. In short, something new was happening precisely because Italy's long historical antecedents permitted it.

The question remains, however: What was new in the Renaissance? The Renaissance was surely more than a change in artistic taste or an advance in technological artistic skill. We need to go deeper. What motivated the shift in artistic taste? What fueled the personal energy that produced artistic innovation? What caused flocks of foreign scholars to cross the Alps to study in Florence and in other centers where they could absorb the "new learning"?

The answer to these questions, briefly, is this: There arose in Italy, as early as the time of Petrarch (1304–1372), but clearly in the fifteenth century, a strong conviction that humanist learning would not only ennoble and perfect the individual but could also serve as a powerful instrument for social and religious reform. Very few Renaissance humanists denied the need for God's grace, but all felt that human intellectual effort should be the first concern of anyone who wished truly to advance the good of self or society. The career of Pico della Mirandola, one of the most brilliant and gifted Florentine humanist scholars, illustrates this humanist belief.

Pico della Mirandola

Pico della Mirandola (1463–1494) was an intimate friend of Lorenzo de' Medici and a companion of the Platonic scholar Marsilio Ficino. Precociously brilliant, Pico once bragged, not totally implausibly, that he had read every book in Italy. He was deeply involved with the intellectual life of his day.

Pico was convinced that all human learning could be synthesized in a way such as to yield basic and elementary truths. To demonstrate this, he set out to master all the systems of knowledge that then existed. He thoroughly mastered the Latin and Greek classics. He studied medieval Aristotelianism at the University of Paris and learned Arabic and the Islamic tradition. He was the first Christian in his day to take an active interest in Hebrew culture; he learned Hebrew and Aramaic and studied the *Talmud* with Jewish scholars.

At the age of twenty, Pico proposed to defend at Rome his nine hundred *theses* ("intellectual propositions"), which he claimed summed up all current learning and speculation. Church leaders attacked some of his propositions as unorthodox; Pico left Rome and the debate was never held.

The preface to these theses, called the *Oration on the Dignity of Man*, has often been cited as the first and most important document of Renaissance humanism. Its central thesis is that humanity stands at the apex of creation in a way such as to create the link between the world of God and that of the creation. Pico brings his wide learning to bear on this fundamental proposition: Humanity is a great miracle. He not only calls on the traditional biblical and Classical sources but also cites, from his immense reading, the opinions of the great writers of the Jewish, Arabic, and Neo-Platonic traditions. The enthusiasm of the youthful Pico for his subject is as apparent as his desire to display his learning.

Scholars disagree on Pico's originality as a thinker. Many argue that his writings are a hodgepodge of knowledge without any genuine synthesis. There is no disagreement, however, about Pico's immense ability as a student of languages and culture to open new fields of study and, in that way, contribute much to the enthusiasm for learning in his own day. His reputation attracted students to him. The most influential of these was a German named Johann Reuchlin (1455-1522), who came to Florence to study Hebrew with him. After mastering that language and Greek as well, Reuchlin went back to Germany to pursue his studies and to apply them to biblical scholarship. In the early sixteenth century he came under the influence of Martin Luther (see Chapter 14) but never joined the Reformation. Reuchlin passionately defended the legitimacy of biblical studies oriented to the original languages. When his approach was attacked in one of those periodic outbursts of anti-Semitism so characteristic of European culture of the time, Reuchlin, true to his humanist impulses, not only defended his studies as a true instrument of religious reform but also made an impassioned plea for toleration that was not characteristic of his time.

Printing Technology and the Spread of Humanism

The export of humanist learning was not restricted to the exchange of scholars between Italy and the countries to the north. Printing had been invented in the early fifteenth century, so books were becoming more accessible to the educated classes. The most famous humanist printer and publisher of the fifteenth century was Aldus Manutius (1449–1515), whose Aldine Press was in Venice, his native city (see map). Aldus was a scholar in his own right; he learned Greek from refugee scholars who settled in Venice after the fall of Constantinople in 1453. Recognizing the need for competent and reliable editions of the Classical authors, he employed professional humanists to collate and correct manuscripts. Erasmus, the greatest of the northern humanists, was, for a time, in his employ.

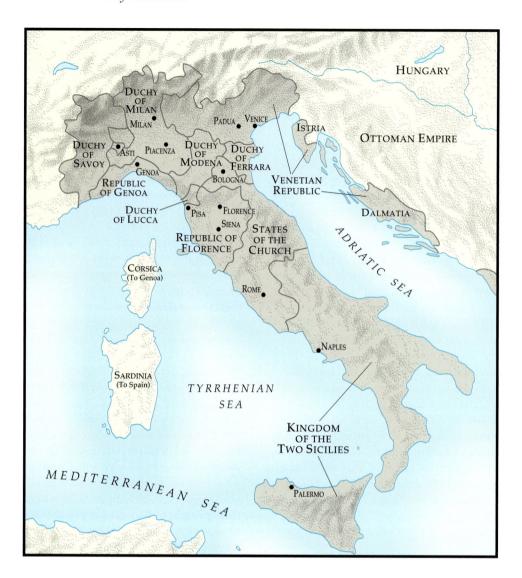

Aldus was also a technical innovator. He designed Greek typefaces, created italic type fonts (modeled after the scribal hand used for copying Florentine manuscripts), developed new inks, and obtained new paper from the nearby town of Fabriano, still a source of fine papers for artists and printmakers. His books were near pocket-size, easily portable, and inexpensive. The scope of the press's activities was huge: After 1494, Aldus (and later his son) published, in about twenty years, the complete works of Aristotle and the works of Plato, Pindar, Herodotus, Sophocles, Aristophanes, Xenophon, and Demosthenes. Aldus reissued the Latin classics in better editions and published vernacular writers like Dante and Petrarch as well as contemporary poets like Poliziano, the Florentine friend of Lorenzo.

The Aldine Press was not an isolated phenomenon. Germany, where Western printing really started, already had an active printing and publishing tradition. Johann Gutenberg (c. 1395–1468) originated the method of printing from movable type that continued to be used with virtually no change until the late nineteenth century. Gutenberg finished printing a Bible at Mainz in 1455. The first book printed in English, *The Recuyell* (collection) of the *Historyes of Troye*, was published by William Caxton in 1475. Historians have estimated that before 1500, European presses produced between six and nine million books in thirteen thousand different editions. Nearly fifty thousand of these books survive in libraries throughout the world.

This conjunction of pride in humanist learning and technology of printing had profound consequences for European culture. It permitted the wide diffusion of ideas to large numbers of people in a relatively short time. There is no doubt that vigorous intellectual movements—one thinks immediately of the Protestant Reformation—benefited immensely from printing. This com-

munications revolution was as important for the Renaissance period as radio, film, television, and the Internet have been for our own.

Women and the Renaissance

It has been asked: Did women have an intellectual/artistic rebirth? It is clear that women, as the idealization of certain images and ideas, were central to the Renaissance conception of beauty (think of Botticelli's *Primavera* or *Venus*) but it is equally true that very little provision was made for women to participate in the new learning that constituted the heart of humanism. A recent generation of scholars, however, have recovered for us voices that have been hitherto silent. When women did receive a humanist education it was either because they came from aristocratic families that allowed them the leisure and means to get an education or they were children of families who prized learning highly and saw nothing amiss to educate women as well as men.

A further element that helped women get an education was the rise of printing. After the popularization of the printed work, books took on a certain "mobility" that permitted women—especially those who came from wealthy or aristocratic families—to possess both books and the leisure to study them. Examples of humanistic writing coming from women in the fifteenth century almost uniformly reflect an upper-class culture.

A recently published anthology of texts (see King & Rabil in Further Reading list) by women humanists in Italy demonstrates that most came from the more illustrious families of the time. Thus Ippolita Sforza (of the Milan Sforzas) actually delivered an oration before the Renaissance humanist and Pope Pius II in 1459. Others, like Isotta Nogarola, had to swim against the tide and choose a life of letters while resisting both marriage and pressure to enter a convent. Others, like Cecilia Gonzaga, entered into convent life for the precise reason of finding the shelter and leisure to advance their studies in the "New Learning."

It is instructive that a determined humanist named Laura Cereta (died 1499) from Brescia constinued her scholarly life throughout her mature years against a tide of criticism from both men who were her peers and from women. Out of those struggles came two letters that were penned to answer both critics: a defense of learning aimed at male humanists, and a defense of her vocation directed toward her female critics. Those two documents testify to the difficulty of her life apart from the roles expected of her in society.

http://www.sas.upenn.edu/~ebbeler/writs/cereta.html

Laura Cereta

TWO STYLES OF HUMANISM

In the generation after the death of Lorenzo de' Medici the new learning made its way north, where it was most often put to use in attempts to reform the religious life of the area; in Italy, however, learning remained tied to more worldly matters. The double usage of humanist learning for secular and spiritual reform can be better appreciated by a brief consideration of the work of the two most important writers of the period after the golden period of the Medicean Renaissance: Niccolò Machiavelli and Desiderius Erasmus.

Machiavelli

http://www.wsu.edu/~dee/REN/MACHIAV.HTM

Machiavelli

Niccolò Machiavelli (1469–1527), trained as a humanist and active as a diplomat in Florence, was exiled from the city when the Medici reassumed power in 1512. In his exile, a few miles from the city which he had served for many years, Machiavelli wrote a political treatise on politics called *The Prince* that was published posthumously.

The Prince is often considered the first purely secular study of political theory in the West. Machiavelli's inspiration is the government of Republican Rome (B.C. 509-31). He sees Christianity's role in politics as a disaster that destroys the power of the state to govern. For that reason, Machiavelli asserts, the state needs to restrict the power of the church, allowing it to exercise its office only in the spiritual realm. The prince, as ruler of the state, must understand that the key to success in governing is in the exercise of power. Power is to be used with wisdom and ruthlessness. The prince, in a favorite illustration of Machiavelli, must be as sly as the fox and as brutal as the lion. Above all, the prince must not be deterred from his tasks by any consideration of morality beyond that of power and its ends. In this sense, cruelty or hypocrisy is permissible; judicious cruelty consolidates power and discourages revolution. Senseless cruelty is, however, counterproductive.

The basic theme of *The Prince* is the pragmatic use of power for state management. Previously the tradition of political theory had always invoked the transcendent authority of God to ensure the stability and legitimacy of the state. For Machiavelli it was power, not the moral law of God, that provided the state with its ultimate sanction. The final test of the successful ruler was the willingness to exercise power judiciously and freedom from the constraints of moral suasion. "A prince must not keep faith when by doing so it would be against his self-interest," Machiavelli says in one of the most famous

passages from his book. His justification is "If all men were good this precept would not be a good one but as they are bad and would not observe their faith with you, so you are not bound to keep faith with them." This bold pragmatism explains why the Catholic Church put *The Prince* on its *Index of Prohibited Books* and why the adjective *Machiavellian* means, in English, "devious or unscrupulous in political dealings." Machiavelli had such a bad reputation that many sixteenth-century English plays had a stock evil character—an Italian called "Old Nick." The English phrase "to be filled with the Old Nick," meaning to be devilish, derives from Machiavelli's reputation as an immoral man. But Machiavelli's realistic pragmatism also explains why Catherine the Great of Russia and Napoleon read him with great care.

In the final analysis, however, it is the figure of the prince that best defines a view of politics that looks to a leader who understands that power is what keeps a political person as a strong ruler. Such a leader uses a simple rule of thumb: How does one exercise power in order to retain power? Such a ruler does not appeal to eternal rules but to simple calculations: Will the exercise of power in this or that particular fashion guarantee the stability of the state? If ruthlessness or violence is needed, let there be ruthlessness or violence (or terror!). Machiavelli did not want to create a monster and he certainly did not want violence for its own sake. He did favor, however, whatever means it took to keep the state intact and powerful by whatever means necessary. That is the deepest meaning of the adjective *Machiavellian*.

Erasmus

http://www.utm.edu/research/iep/e/erasmus.htm

Erasmus

Desiderius Erasmus (1466–1536) has been called the most important Christian humanist in Europe [12.29]. Educated in Holland and at the University of Paris, Erasmus was a monk and priest who soon tired of his official church life. He became aware of humanist learning through his visits to England, where he met men like John Colet and Thomas More. Fired by their enthusiasm for the new learning, Erasmus traveled to Italy in 1506, with lengthy stays in both Rome and Venice. Thereafter he led the life of a wandering scholar, gaining immense fame as both scholar and author.

Erasmus' many books were attempts to combine Classical learning and a simple interiorized approach to Christian living. In the *Enchiridion Militis Christiani* (1502) he attempted to spell out this Christian humanism in practical terms. The title has a typical Erasmian pun; the word *enchiridion* can mean either "handbook" or "short sword"; thus the title can mean the handbook or the short sword of the Christian knight. His *Greek New Testa*-

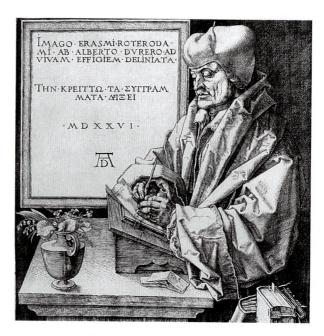

12.29 Albrecht Dürer. *Erasmus of Rotterdam,* 1526. Intaglio print, $9^3/_4$ " \times $7^1/_2$ " (25 \times 19 cm). Detail: Writing stand and monogram. Metropolitan Museum of Art, New York (Fletcher Fund, 1919). The Latin inscription says that Erasmus was drawn from life by the artist; the Greek epigram praises the written word. The stylized letters AD are the signature letters of the artist and appear in all his engravings and prints.

ment (1516) was the first attempt to edit the Greek text of the New Testament by a comparison of extant manuscripts. Because Erasmus used only three manuscripts, his version is not technically perfect, but it was a noteworthy attempt and a clear indication of how a humanist felt he could contribute to ecclesiastical work.

The most famous book written by Erasmus, The Praise of Folly (1509), was dashed off almost as a joke while he was a house guest of Sir Thomas More in England. Again, the title is a pun; Encomium Moriae can mean either "praise of folly" or "praise of More"-Thomas More, his host. The Praise of Folly is a humorous work, but beneath its seemingly lighthearted spoof of the foibles of the day there are strong denunciations of corruption, evil, ignorance, and prejudice in society. Erasmus flailed away at the makers of war (he had a strong pacifist streak), venal lawyers, and fraudulent doctors, but, above all, he bitterly attacked religious corruption: the sterility of religious scholarship and the superstitions in religious practice. Reading The Praise of Folly makes one wonder why Luther never won Erasmus over to the Reformation (Erasmus debated Luther, in fact). Erasmus remained in the old church, but as a bitter critic of its follies and an indefatigable proponent of its reform.

This sweeping social criticism struck an obvious nerve. The book delighted not only the great Sir Thomas More (who was concerned enough about religious convictions to die for them later in the century) but also many sensitive people of the time. *The Praise of Folly* went through twenty-seven editions in the lifetime of Erasmus and outsold every other book except the Bible in the sixteenth century.

Comparing Machiavelli and Erasmus is a bit like comparing apples and potatoes, but a few points of contact can be noted that help us to generalize about the meaning of the Renaissance. Both men were heavily indebted to the new learning coming out of fifteenth-century Italy. Both looked back to the great Classical heritage of the past for their models of inspiration. Both were elegant Latinists who avoided the style and thought patterns of the medieval world. Machiavelli's devotion to the Roman past was total. He saw the historic development of Christianity as a threat and stumbling block to the fine workings of the state. Erasmus, by contrast, felt that learning from the past could be wedded to the Christian tradition to create an instrument for social reform. His ideal was a Christian humanism based on this formula. It was a formula potent enough to influence thinking throughout the sixteenth century.

The tug of war between Classicism and Christianity may be one key to understanding the Renaissance. It may even help us understand something about the character of almost everything we have discussed in this chapter. The culture of the fifteenth century often was, in fact, a dialectical struggle: At times Classical ideals clashed with biblical ideals; at other times, the two managed to live either in harmony or in a temporary marriage of convenience. The strains of Classicism and Christianity interacted in complex and subtle ways. This important fact helps us to understand a culture that produced, in a generation, an elegant scholar like Ficino and a firebrand like Savonarola, a pious artist like Fra Angelico and a titanic genius like Michelangelo—and a Machiavelli and an Erasmus.

Music in the Fifteenth Century

By the early fifteenth century, the force of the Italian ars nova movement in music had spent itself. The principal composers of the early Renaissance were from the North. Strong commercial links between Florence and the North ensured the exchange of ideas, and a new musical idiom that had been developed to please the ear of the prosperous merchant families of the North soon found its way to Italy.

Guillaume Dufay

Guillaume Dufay (c. 1400–1474), the most famous composer of the century, perfectly exemplifies the tendency of music to cross national boundaries. As a young man, Dufay spent several years in Italy studying music and singing in the papal choir at Rome. He later served as

music teacher in the French (Burgundian) court of Charles the Good. The works he composed there included masses and motets; he was one of the first composers after Machaut to write complete settings of the Mass. His secular works include a number of charming *chansons* ("songs") that are free in form and expressive in nature.

Among the changes introduced into music by Dufay and his Burgundian followers (many of whom went to Italy for employment) was the secularization of the motet, a choral work that had previously used a religious text. Motets were now written for special occasions like coronations or noble marriages and the conclusions of peace treaties. Composers who could supply such motets on short notice found welcome in the courts of Renaissance Italian city-states.

Dufay was also one of the first composers to introduce a familiar folk tune into the music of the Mass, the best-known example being his use of the French folk tune *L'homme armé* (*The Man in Armor*) in a mass that is now named for it. Other composers followed suit and the so-called *chanson masses* were composed throughout the fifteenth and sixteenth centuries. The *L'homme armé* alone was used for more than thirty different masses, including ones by such composers as Josquin and Palestrina. The intermingling of secular with religious elements is thoroughly in accordance with Renaissance ideals.

Among Dufay's most prominent pupils was the Flemish composer Johannes Ockeghem (c. 1430–1495), whose music was characterized by a smooth-flowing but complex web of contrapuntal lines generally written in a free style (the lines do not imitate one another). The resulting mood of the music is more serious than Dufay's, partly because of the intellectual complexity of the counterpoint and partly because Ockeghem sought a greater emotional expression. The combination of intellect and feeling is characteristic of the Renaissance striving for Classical balance. Ockeghem's Requiem Mass is the oldest of the genre to survive (Dufay wrote one, but it has not survived).

Music in Medici Florence

The fact that Italian composers were overshadowed by their northern contemporaries did not in any way stifle Italian interest in music. Lorenzo de' Medici founded a school of harmony that attracted musicians from many parts of Europe; he himself had some skill as a lute player. Musical accompaniment enlivened the festivals and public processions of Florence. Popular dance tunes for the *saltarello* and the *pavana* have survived in lute transcriptions.

We know that the Platonist writer Marsilio Ficino played the lyre before admiring audiences, although he had intentions more serious than mere entertainment. Unlike the visual artists who had models from Classical

antiquity for inspiration, students of music had no Classical models to follow: No Greek or Roman music had survived in any significant form. Still, the ideas about music expressed by Plato and other writers fascinated Ficino and others. Greek music had been patterned after the meter of verse and its character carefully controlled by the mode in which it was composed. The Greek doctrine of ethos is still not fully understood today, but Ficino and his friends realized that Plato and Aristotle regarded music as of the highest moral (and hence political) significance. The closest they could come to imitating ancient music was to write settings of Greek and Roman texts in which they tried to follow the meter as closely as possible. Among the most popular works was Vergil's Aeneid: The lament of Dido was set to music by no fewer than fourteen composers in the fifteenth and sixteenth centuries.

A more popular music form was the frottola, probably first developed in Florence although the earliest surviving examples come from the Renaissance court of Mantua. The frottola was a setting of a humorous or amorous poem for three or four parts consisting of a singer and two or three instrumentalists. Written to be performed in aristocratic circles, the frottola often had a simple folk quality. The gradual diffusion of frottole throughout Europe gave Italy a reputation for good simple melody and clear vigorous expression.

The canto carnascialesco ("carnival song") was a specifically Florentine form of the frottola. Written to be sung during the carnival season preceding Lent, such songs were very popular. Even the great Flemish composer Heinrich Issac wrote some during his stay with Lorenzo de' Medici around 1480. With the coming of the Dominican reformer Savonarola, however, the carnivals were abolished because of their alleged licentiousness. The songs also disappeared. After the death of Savonarola the songs were reintroduced but died out again in the sixteenth century.

SUMMARY

The main focus of this chapter is on the city of Florence in the fifteenth century. There are two basic reasons for this attention, one rooted in economics and the other in something far more difficult to define.

Florence was not a feudal city governed by a hereditary prince; it had a species of limited participatory government that was in the hands of its landed and monied individuals. It was the center of European banking in the fifteenth century and the hub of international wool and cloth trade. The vast monies in Florentine hands combined with a great sense of civic pride to give the city unparalleled opportunities for expansion and public works. The results can be seen in the explosion of building, art, sculpture, and learning that stretched throughout the century. The great banking families of Florence built and supported art to enhance their reputations, that of their

cities, and partly as a form of expiation for the sin of taking interest on money-a practice forbidden by the church. We tend to view Florence today from the perspective of their generosity.

Other forces were of course at work. The urban workers were exploited; they had rioted during the end of the fourteenth century and were ready for further protest. An undercurrent of medieval religiosity in the city manifested itself most conspicuously in the rise of Savonarola, who not only appealed to the common people but who also had a reputation for sanctity that could touch the lives of an educated man like Pico della Mirandola and a powerful one like Lorenzo the Magnificent. Every Florentine could visit the Duomo or see the art in the city's churches, but not everyone was equally touched by the great renaissance in ideas and art that bubbled up in Florence.

Most puzzling about Florence in this period is the sheer enormity of artistic talent it produced. Florence was not a huge city; it often portrayed itself as a David in comparison to a Roman or Milanese Goliath. Yet this relatively small city produced a tradition of art that spanned the century: In sculpture Donatello and Michelangelo bridged the generations, as did Masaccio and Botticelli in painting. Part of the explanation, of course, was native talent, but part of it also lies in the character of a city that supported the arts, nurtured artists, and enhanced civic life with beauty and learning.

Pronunciation Guide

Botticelli: Boh-tee-CHEL-ee Brunelleschi: Brew-ne-LESS-ki Cosimo: CAH-ze-mow de' Medici: deh MED-e-chee Donatello: Don-ah-TELL-oh Dufay: Dew-FIE duomo: DWO-mow Ficino: Fee-CHEE-no Ghiberti: Ghee-BAIR-tee Lorenzo: Lo-WREN-zo Machiavelli: Ma-key-ah-VEL-ee Manutius: Mah-KNEW-tee-us Masaccio:

Mah-SA-cho Pico della Mirandola: PEE-ko dell-ah Mee-RAN-

dough-la

Piero: Pea-EH-row Savonarola: Sa-van-ah-ROLL-ah

EXERCISES

1. Choose one of the major paintings of this period and analyze it closely in terms of composition, gradations of color, and use of perspective.

2. List the chief problems of construction involved in raising the dome of the Florence Cathedral in an age that did

not have today's building technologies.

- 3. To what artistic and cultural enterprises would wealthy people most likely contribute today if they had the resources and the power of a Medici family in a contemporary city?
- 4. What does the word *humanism* mean today and how does that meaning differ from its use in the fifteenth century?
- 5. If Erasmus were writing today, what would be his most likely targets of satire? What are the great follies of our age?
- 6. What advice would a contemporary Machiavelli give a contemporary "prince" (powerful political leader)? Why do political philosophers continue to study Machiavelli?
- 7. Many say that computers are changing learning as radically as did printing in its age. How are computer technologies changing learning?

FURTHER READING

- Campbell, L. (1990). *Renaissance portraits*. New Haven: Yale University Press. Survey runs from the fourteenth through the sixteenth centuries.
- Dempsey, C. (1992). The portrayal of love: Botticelli's Primavera and humanist culture at the time of Lorenzo the Magnificent. Princeton, NJ: Princeton University Press. A scholarly study of a fundamental Renaissance theme.
- Hale, J. R. (Ed.). (1982). A concise encyclopedia of the Italian Renaissance. New York: Oxford University Press. Excellent reference work.
- Hale, J. R. (1995). The civilization of Europe in the Renaissance. New York: Simon & Schuster, Touchstone. Excellent and authoritative synthetic work.
- Hartt, F. (1970). *A history of Italian Renaissance art*. London and New York: Thames & Hudson. A standard work.
- Hibbert, C. (1993). *Florence: The biography of a city.* New York: Norton. Readable and interesting.
- Johnson, P. (2000). *The Renaissance*. New York: Modern Library. A short but eminently readable survey.
- King, M. & A. Rabil. (Eds.). (1983). Her immaculate hand: Selected works by and about women humanists of Quattrocento Italy. Binghamton, NY: Medieval and Renaissance Texts. Important anthology.

ONLINE CHAPTER LINKS

These Botticelli sites:

http://www.ibiblio.org/wm/paint/auth/botticelli/ http://www.artchive.com/artchive/B/botticelli.html provide biographical information as well as links to a variety of related sites.

For information about da Vinci's sketches and artwork, and his contributions to science, visit http://library.thinkquest.org/3044/ Some of da Vinci's most famous artwork can be viewed at

http://www.mcs.csuhayward.edu/~malek/Vinci.html

For an interesting account of the theft of Leonardo's *Mona Lisa* early in the twentieth century, visit this Web site:

http://www.pbs.org/treasuresoftheworld/a_nav/mona_nav/main_monafrm.html

For E. H. Gombrich's evaluation of the universal appeal of Leonardo's *Mona Lisa*, visit http://artchive.com/artchive/L/leonardo/monalisa_text.jpg.html

Information concerning the relationship of Pope Julius II and Michelangelo is found at http://www.geocities.com/rr17bb/PatrMich.html

For insights about the Sistine Chapel, visit http://www.kfki.hu/~arthp/tours/sistina/index.html http://www.christusrex.org/wwwl/sistine/

Michelangelo's *Last Judgment* is discussed at http://www.christusrex.org/www1/sistine/40-Judge.html

For E. H. Gombrich's evaluation of Jan van Eyck's *Giovanni Arnolfini and His Bride*, visit

http://artchive.com/artchive/V/van_eyck/arnlfini_text.jpg.html

An extensive examination of the influence of Aldus Manutius is found at

http://www.lib.byu.edu/~aldine/aldus.html

Machiavelli Online at

http://www.sas.upenn.edu/~pgrose/mach/ provides links to a variety of Internet resources related to his life, literary works, and historical background.

Laura Cereta: A Renaissance Feminist

http://www.sas.upenn.edu/~ebbeler/writs/cereta.html examines the life and work of this "determined humanist."

For introductory information about art of the Early Renaissance as well as links to sites related to representative artists, consult *Artcyclopedia*

http://www.artcyclopedia.com/history/early-renaissance.html

For a catalog of useful links to Internet resources, consult Renaissance Music Links

http://classicalmus.hispeed.com/rena.html

Karadar Classical Music at

http://www.karadar.it/Dictionary/Default.htm provides an alphabetical listing of musicians with brief biographies and a list of works (some of which are available on MIDI files).

1400

FLORENTINE RENAISSANCE **1471 – 1484** Reign of Pope Sixtus IV (della Rovere)

1492 Columbus discovers America

1494 Foreign invasions of Italy begin

c. 1494 Aldine Press established in Venice

1471 – 1484 Perugino, Botticelli, and others decorate Sistine Chapel side walls

1493 – 1506 Ancient frescoes and statues uncovered in Rome; *Laocoön* found 1506

c. 1494 Decline of Medici power in Florence causes artists to migrate to Rome

1494–1495 Dürer's first trip to Venice

1503

1503–1513 Reign of Pope Julius II (della Rovere)

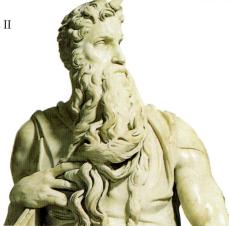

 c. 1510 Decline of Venetian trade as a result of new geographic discoveries

1513–1521 Reign of Pope Leo X (dé Medici)

1517 Reformation begins in Germany with Luther's 95 Theses, challenging the practice of indulgences c. 1500 – 1505 Giorgione, Enthroned Madonna with Saint Liberalis and Saint Francis, altarpiece

I 505 Michelangelo called to Rome by Julius II to begin Pope's tomb; *Moses* (1513–1515), *Captives* (1527–1528)

I505 – I508 Raphael works in Florence; *Madonna of the Meadows* (1505)

1508 Raphael begins frescoes for rooms in Vatican Palace; The School of Athens, Stanza della Segnatura (1509–1511)

1508–1511 Michelangelo, Sistine Chapel ceiling

c. 1510 Giorgione, Fête Champêtre

1511 Raphael, Portrait of Julius II

1515–1547 Francis I lures Leonardo and other Italian artists to France

Painting in Venice emphasizes brilliant color and light; less linear than in Rome and Florence; Titian, *The Assumption of the Virgin* (1518)

1519 Death of Leonardo

1519–1534 Michelangelo works on Medici Chapel sculptures

1523–1534 Reign of Pope Clement VII (dé Medici)

1527 Sack of Rome by Emperor Charles V

1534 Churches of Rome and England separate

1545 Council to reform Catholic Church begins at Trent

c. 1524–1534 Strozzi, poem on Michelangelo's *Night*

1527 Luther translates Bible into German

1528 Castiglione, *The Courtier*, dialogue on ideal courtly life

I550 Vasari, Lives of the Painters

1558–1566 Cellini, Autobiography of Benvenuto Cellini

1561 *The Courtier* translated into English by Sir Thomas Hoby

1520 Death of Raphael

c. 1520 Mannerism emerges as artistic style

c. 1528 Pontormo, Deposition, Capponi Chapel, Santa Felicitá, Florence

c. 1534 Parmigianino, *Madonna of the Long Neck*

1534–1541 Michelangelo, The Last Judgment fresco, Sistine Chapel

1538 Titian, Venus of Urbino

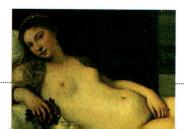

1520

CHAPTER 13 THE HIGH RENAISSANCE IN ITALY

ARCHITECTURE

Music

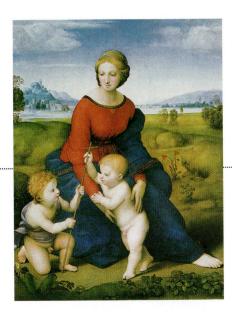

1473 – 1480 Sistine chapel built for Pope Sixtus IV

1473 Sistine Choir established by Sixtus IV

1486-1494 Josquin des Prez intermittently in service of Sistine Choir as composer of masses and motets; Tu Pauperum Refugium

1504 Bramante, Tempietto, San Pietro in Montorio, Rome

1506 Pope Julius II commissions Bramante to rebuild Saint Peter's Basilica

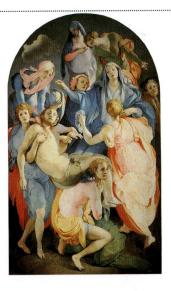

1512 Julian Choir established by Julius II for Saint Peter's Basilica

1527 Adrian Willaert becomes

choirmaster of Saint Mark's,

Venice; multiple choirs and addition of instrumental music are Venetian innovations to liturgical

music

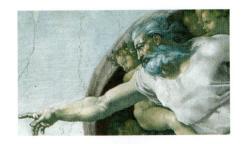

1514 Death of Bramante; Raphael, Sangallo, and others continue work on Saint Peter's

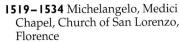

Chapel, Church of San Lorenzo,

1524 Michelangelo, Laurentian Library, Florence, begun; entrance staircase finished 1559

1547 Michelangelo appointed architect of Saint Peter's; apse and dome begun 1547

1571 – 1594 Palestrina, choirmaster of Sistine Choir, in charge of musical reform for Vatican

1567 Palestrina, Missa Papae Marcelli

1603 Victoria, Requiem Mass for the Empress Maria

1554 Cellini casts bronze Perseus in Florence

1564 Death of Michelangelo

1576 Titian dies of plague

1592 Michelangelo's dome for Saint Peter's finished by Giacomo della Porta

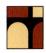

CHAPTER 13

THE HIGH RENAISSANCE IN ITALY

Popes and Patronage

rtists must work where their art is appreciated and their labors rewarded. Florence in the fifteenth century, shaped by the generous and refined patronage of the Medici and others, was an extremely congenial place for the talented artist. But when the political power of the Medici declined in the last decade of that century, many major artists inevitably migrated or were summoned to other centers of wealth and stability. The papal court at the Vatican in Rome was preeminently such a center.

In the fifteenth century (and even earlier) artists found rewarding work at the Vatican. Pope Sixtus IV (reigned 1471–1484) commissioned many artists famous in Florence—among them Ghirlandaio, Botticelli and Perugino—to fresco the side walls of the Sistine Chapel, named for himself, as well as work on other projects that caught his artistic fancy. Not the least of these projects was the enlargement and systematization of the Vatican Library.

The period known as the High Renaissance really began, however, in 1503, when a nephew of Sixtus IV became Pope Julius II (died 1513); both were members of the della Rovere family. Pope Julius was a fiery man who did not hesitate to don full military armor over his vestments and lead his papal troops into battle. Thanks to the influence of his papal uncle, he appreciated the fine arts, indulging his artistic tastes with the same single-mindedness that characterized his military campaigns. It was Pope Julius—called by his contemporaries *il papa terribile* ("the awesome pope")—who summoned both Raphael Sanzio and Michelangelo Buonarroti to Rome.

Raphael

http://www.oir.ucf.edu/wm/paint/auth/raphael/

Raphael

Raphael Sanzio (1483–1520) was born in Urbino, a center of humanist learning east of Florence dominated by the court of the Duke of Urbino. His precocious talent was first nurtured by his father, a painter, whose death in 1494 cut short the youth's education. The young Raphael then went to Perugia as an apprentice to the painter Perugino. Here his talents were quickly recognized. In 1505, at the age of twenty-two, he moved on to Florence, where he worked for three years.

Table 13.1 *Some Renaissance Popes of the Sixteenth Century* Julius II (1503–1513). Of the della Rovere family; Patron of Raphael and Michelangelo.

Leo X (1513–1521). Son of Lorenzo the Magnificent; patronized Michelangelo. Excommunicated Martin Luther.

Hadrian VI (1522–1523). Born in the Netherlands; a ferocious reformer and the last non-Italian pope until the 1970s.

Clement VII (1523–1534). Bastard grandson of Lorenzo dé Medici; commissioned the Medici tombs in Florence. Excommunicated Henry VIII. Commissioned *The Last Judgment* for the Sistine Chapel just before his death.

Paul III (1534–1549). Commissioned Michelangelo to build the Farnese Palace in Rome. Called the reform Council of Trent, which first met in 1545.

Julius III (1550-1555). Patron of the composer Palestrina. Confirmed the constitutions of the Jesuits in 1550. Appointed Michelangelo as chief architect of St. Peter's.

Marcellus II (1555). Reigned as pope twenty-two days. Palestrina composed the *Missa Papae Marcelli* in his honor.

Paul IV (1555–1559). Began the papal reaction against the Renaissance spirit. A fanatical reformer; encouraged the Inquisition and instituted the *Index of Forbidden Books* in 1557.

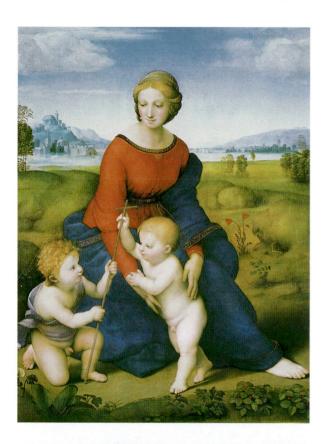

During his stay in Florence, Raphael painted a large number of madonnas in a style that has become almost synonymous with his name. The Madonna of the Meadow [13.1] is typical. In this painting Raphael arranged his figures in a pyramidal configuration to create a believable and balanced space. This geometrical device, which had already been popularized by Leonardo da Vinci, was congenial to the Renaissance preoccupation with rationally ordered composition. More important than the arrangement of shapes, however, is the beautiful modeling of the human forms, especially the figures of the two children, and the genuine sweetness and warmth conveyed by the faces. The head of the Madonna is peaceful and luminous, while the infant Christ and Saint John convey a somewhat more playful mood. The very human quality of the divine figure is Raphael's trademark.

13.1 Raphael. *Madonna of the Meadow*, 1508. Oil on panel, $44^{1}/_{2}^{"} \times 34^{1}/_{4}^{"}$ (113 \times 87 cm). Kunsthistorisches Museum, Vienna. The infant John the Baptist kneels at the left of the picture in homage to the Christ child, who stands before his mother.

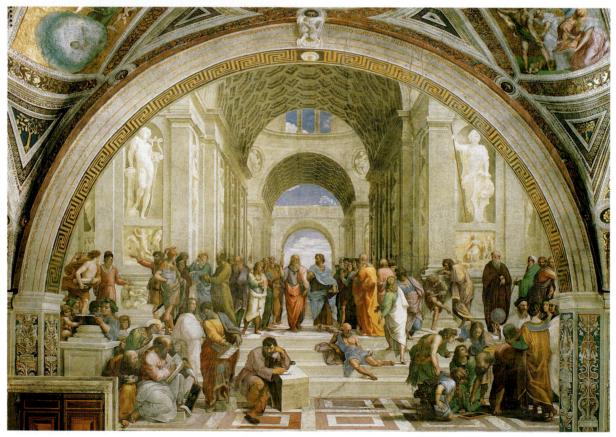

13.2 Raphael. Philosophy (School of Athens), 1509–1511. Fresco, $26' \times 18'$ (7.92 \times 5.48 m). Stanza della Segnatura, Vatican Palace, Rome.

Raphael left Florence for Rome in 1508. By the following year, Pope Julius, whom Raphael later captured in an unforgettably fine portrait, had him working in the Vatican on a variety of projects. The pope, who genuinely loved Raphael, commissioned him to decorate various rooms of his palace. Raphael spent the rest of his brief life working on these projects and filling assorted administrative posts for the papacy, including, at one time, the office of architect of Saint Peter's Basilica and at another time superintendent of the Vatican's collection of antiquities.

One of Raphael's most outstanding works—and certainly one of the most important for defining the meaning of the sixteenth-century Renaissance in Rome—is a large fresco executed in 1509–1511 on the wall of the Stanza della Segnatura, an office in the Vatican Palace where documents requiring the pope's signature were prepared. Called now the *School of Athens* [13.2], the fresco is a highly symbolic homage to philosophy that complements Raphael's similar frescoes in the same room that symbolize poetry, law, and theology.

http://www.christusrex.org/www1/stanzas/S2-Segnatura.html

Raphael's School of Athens

The School of Athens sets the great philosophers of antiquity in an immense illusionistic architectural framework that must have been at least partially inspired by the impressive ruins of Roman baths and basilicas, and perhaps by the new Saint Peter's, then under construction. Raphael's fresco depicts Roman barrel vaulting, coffered ceilings, and broad expanses not unlike the stillexisting baths of ancient Rome. Occupying the center of the fresco, in places of honor framed by the receding lines of the architecture as a device to focus the viewer's eye, are the two greatest ancient Greek philosophers: Plato and Aristotle. Plato holds a copy of the Timaeus in one hand and with the other points to the heavens, the realm of ideal forms. Aristotle holds a copy of his Ethics and points to the earth, where his science of empirical observation must begin. Clustered about the two philosophers in varying poses and at various distances are other great figures of antiquity. Diogenes sprawls in front of the philosophers, while Pythagoras calculates on a slate and Ptolemy holds a globe. At the right, the idealized figure of Euclid with his compass is actually a portrait of Raphael's Roman protector, the architect Bramante. Raphael himself, in a self-portrait, looks out at the viewer at the extreme lower-right corner of the fresco.

Raphael's *School of Athens* reflects a high degree of sensitivity to ordered space, a complete ease with Classical thought, obvious inspiration from the Roman archi-

tectural past, a brilliant sense of color and form, and a love for intellectual clarity—characteristics that could sum up the Renaissance ideal. That such a fresco should adorn a room in the Vatican, the center of Christian authority, is not difficult to explain. The papal court of Julius II shared the humanist conviction that philosophy is the servant of theology and that beauty, even if derived from a pagan civilization, is a gift from God and not to be despised. To underscore this point, Raphael's homage to theology across the room, his fresco called the *Disputà*, shows in a panoramic form similar to the *School of Athens* the efforts of theologians to penetrate Divine mystery.

The Transfiguration was Raphael's last work, left unfinished at his death [13.3]. A great scene, evenly divided between the airy transcendence of the transfigured Christ, flanked by Old Testament figures, and overpoweringly blinded apostles and the rest of the world on the darker level of the earth is still held together with a great sense of balanced activity. This painting is usually considered as one of the great moments of the Roman High Renaissance.

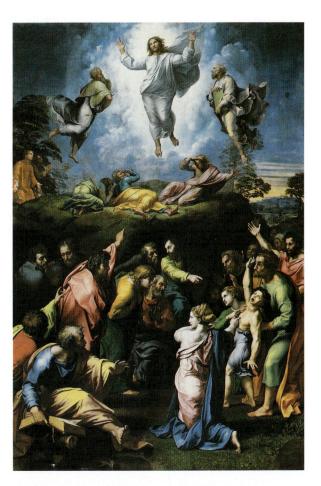

13.3 Raphael. *The Transfiguration*, 1517. Tempera panel, $15'1^{1/2}$ " \times 9' $1^{1/2}$ " (4.6 \times 2.8 m). Vatican Museum, Rome.

Michelangelo

In the lower center of Raphael's *School of Athens* is a lone figure leaning one elbow on a block of marble and scribbling, taking no notice of the exalted scene about him. Strangely isolated in his stonecutter's smock, the figure has recently been identified, at least tentatively, as Michelangelo. If this identification is correct, this is the younger artist's act of homage to the solitary genius who was working just a few yards away from him in the Sistine Chapel.

Michelangelo Buonarroti (1475–1564) was called to Rome in 1505 by Pope Julius II to create for him a monumental tomb. We have no clear sense of what the tomb was to look like, since over the years it went through at least five conceptual revisions. Certain features, however, at least in the initial stages, are definite. It was to have three levels; the bottom level was to have sculpted figures representing Victory and bound slaves. The second level was to have statues of Moses and Saint Paul as well as symbolic figures of the active and contemplative life—representative of the human striving for, and reception of, knowledge. The third level, it is assumed, was to have an effigy of the deceased pope.

The tomb of Pope Julius II was never finished. Michelangelo was interrupted in his long labors by both Pope Julius himself and, after the pope's death, the popes of the Medici family, who were more concerned with projects glorifying their own family. What was completed of the tomb represents a twenty-year span of frustrating delays and revised schemes. Even those finished pieces provide no sense of the whole, but they do represent some of the highest achievements of world art.

One of the finished pieces is the *Moses* [13.4], begun after the death of Julius in 1513. We easily sense both the bulky physicality of Moses and the carefully modeled particulars of musculature, drapery, and hair. The fiercely inspired look on the face of Moses is appropriate for one who has just come down from Mount Sinai after seeing God. The face radiates both divine fury and divine light. It is often said of Michelangelo that his work can overwhelm the viewer with a sense of awesomeness; Italians speak of his *terribilità*. If any single statue has this awesomeness, it is the *Moses*.

The highly finished quality of the *Moses* should be compared to the roughness of the *Boboli Captives* [13.5], the four figures Michelangelo worked on for the tomb of Julius in Florence in 1527–1528. There is no evidence that Michelangelo intended to leave these figures in so crude a state. Nevertheless, these magnificent works give a visual demonstration of the sculptor's methods. Michelangelo sometimes said that a living figure was concealed in a block of marble and that only the excess needed to be carved away to reveal it. The truth of the Neo-Platonic notion that ideal form struggles to be freed from the confines of gross matter can almost be seen in these figures. A

close examination reveals the bite marks of the sculptor's chisel as he worked to reveal each living figure by removing hard marble. Seldom do we have a chance, as we do here, to see the work of a great artist still unfolding.

It is not clear where the *Captives* fit into the overall plan of the tomb of Julius. It is most likely that they were meant to serve as corner supports for the bottom level of the tomb, writhing under the weight of the whole [13.6]. Whatever the ultimate plan was for these figures, they are a stunning testament to the monumentally creative impulse of Michelangelo the sculptor.

Michelangelo had hardly begun work on the pope's tomb when Julius commanded him to fresco the ceiling of the Sistine Chapel to complete the work done in the

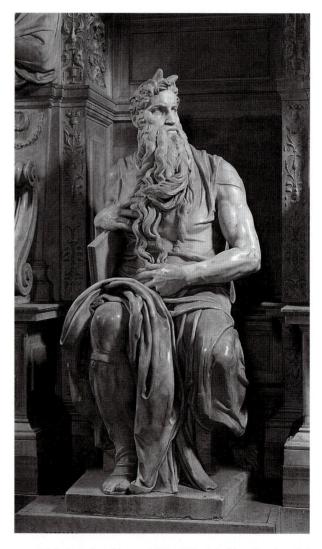

13.4 Michelangelo. *Moses*, 1513–1515. Marble. Height 8'4" (2.54 m). San Pietro in Vincoli, Rome. The horns on the head of Moses represent rays of light; the use of horns instead of rays is based on a mistranslation in the Latin Vulgate Bible.

CONTEMPORARY VOICES

Donna Vittoria and Michelangelo

Donna Vittoria Colonna to Michelangelo:

Most honored Master Michelangelo, your art has brought you such fame that you would perhaps never have believed that this fame could fade with time or through any other cause. But the heavenly light has shone into your heart and shown you that, however long earthly glory may last, it is doomed to suffer the second death.

Michelangelo's poem on this theme:

I know full well that it was a fantasy
That made me think that art could be made into
An idol or a king. Though all men do
This, they do it half-unwillingly.
The loving thoughts, so happy and so vain,
Are finished now. A double death comes near—
The one is sure, the other is a threat.

An exchange between Michelangelo's friend and spiritual adviser (for whom he made some small sculptures and drawings, according to Vasari) and the artist. She was the recipient of a number of his poems.

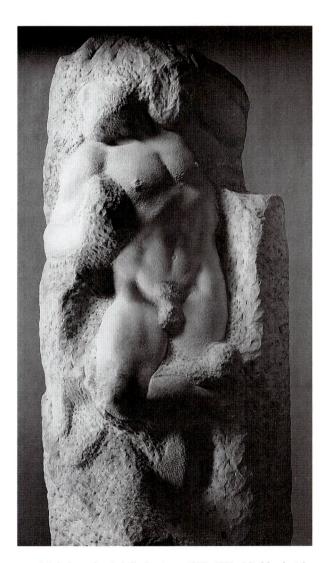

13.5 Michelangelo. *Boboli Captives*, 1527–1528. Marble, height $7'6\frac{1}{2}''$ (2.3 m). Accademia, Florence. These captives once stood in the Boboli Gardens of Florence, hence their name.

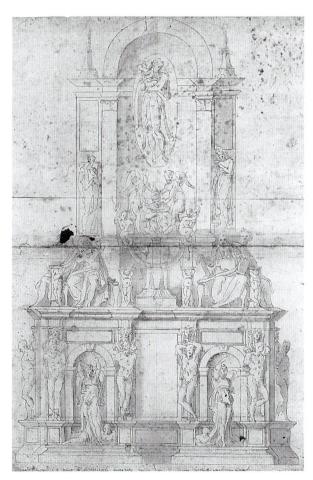

13.6 Drawing of tomb of Julius II. After Michelangelo by his pupil Giacomo Rocchetti. Brown ink, $22^{1/2}$ " \times $15^{1/4}$ " (57 \times 39 cm). Kupferstichkabinett, State Museums, Berlin. This is only one of many projected plans for the tomb of Julius. Note the slaves/captives at the bottom level and Moses on the right at the second level. The semirecumbent figure of the deceased pope is supported by angelic figures with an allegorical figure of Victory overhead in the center.

previous century under Sixtus IV. But Michelangelo resisted the project (he actually fled Rome and had to be ordered back by papal edict). He considered himself a sculptor, and there were technical problems presented by the shape of the ceiling. Nevertheless, he gave in and in three years (1508–1511) finished the ceiling [13.7]. He signed it "Michelangelo, Sculptor" to remind Julius of his reluctance and his own true vocation.

http://www.science.wayne.edu/~mcogan/Humanities/Sistine/index.html

Michelangelo's Sistine Chapel

http://www.kfki.hu/~arthp/tours/sistina/index.html

Tour of Sistine Chapel

The ceiling is as difficult to describe as it is to observe when standing in the Sistine Chapel. The overall organization consists of four large triangles at the corners; a series of eight triangular spaces on the outer border; an intermediate series of figures; and nine central panels (four larger than the other five), all bound together with architectural motifs and nude male figures. The corner triangles depict heroic action in the Old Testament (Judith beheading Holofernes, David slaying Goliath, Haman punished for his crimes, the rod of Moses changing into a serpent), whereas the other eight triangles depict the biblical ancestors of Jesus Christ. The ten major intermediate figures are alternating portraits of pagan sibyls (prophetesses) and Old Testament prophets. The central panels are scenes from the Book of Genesis. The one closest to the altar shows God dividing darkness from light and the one at the other end shows the drunkenness of Noah (Genesis 9:20–27). This bare outline oversimplifies what is actually a complex, intricate design [13.8].

Michelangelo conceived and executed this huge work as a single unit. Its overall meaning is a problem. The issue has engaged historians of art for generations without satisfactory resolution. Any attempt to formulate an authoritative statement must include a number of elements:

 Michelangelo's interest in the Neo-Platonism he had studied as a youth in Florence. Many writers have noted the Neo-Platonic roots of his interest in the manipulation of darkness and light (the progression of darkness to light from the outer borders to the center panels; the panel of God creating light itself), the liberation of spirit from matter (the souls represented by nudes; the drunkenness of Noah, symbolic of humanity trapped by gross matter and thereby degraded),

- and the numerous geometrical allusions done in triads, a triple division being much loved in Neo-Platonic number symbolism.
- The Christian understanding of the Old Testament as a work pointing to the coming of Christ, combined with the notion that even pagan prophets were dimly prophetic figures of Christ.
- 3. The complex tree symbolism in seven of the nine central panels, which refer to the symbolism of the tree in the Bible (the tree of good and evil in the Genesis story, the tree of the Cross, and so forth), as well as being allusions to the pope's family name, which happened to be della Rovere ("of the oak tree").
- 4. The traditional theories of the relationship of the world of human wisdom (represented by the sibyls) and God's revelation (represented by the prophets).

In the panel depicting the Creation of Adam [13.9], to cite one specific example, many of these elements come together. A majestically muscular Adam rises, as if from sleep, from the bare earth as God stretches forth His creative finger to call Adam into being. God's left arm circles a woman and child who represent simultaneously Eve and her children and, by extension, the New Eve, who is the Blessed Virgin. Adam is a prefigurement of Christ. Below Adam a youth holding a cornucopia spilling forth leaves and acorns (symbols of the della Rovere family) stands just above the Persian sibyl. Stylistically, the fresco demonstrates Michelangelo's intense involvement with masculine anatomy seen as muscular monumentality. His ability to combine great physical bulk with linear grace and a powerful display of emotion fairly well defines the adjective Michelangelesque, applied to many later artists who were influenced by his style.

The full force of that Michelangelesque style can be seen in the artist's second contribution to the Sistine Chapel: *The Last Judgment*, which he painted on the wall behind the main altar between the years 1534 and 1541 [13.10]. A huge fresco marking the end of the world when Christ comes back as judge, *The Last Judgment* shows the Divine Judge standing in the upper center of the scene with the world being divided into the Dantean damned at the bottom and those who are called to glory above. Into that great scene Michelangelo poured both his own intense religious vision and a reflection of the troubled days within which he lived. It was, after all, a Rome that had already been sacked in 1527 and a church that had been rived by the Protestant Reformation in the North.

http://www.christusrex.org/www1/sistine/40-Judge.html

Michelangelo's The Last Judgment

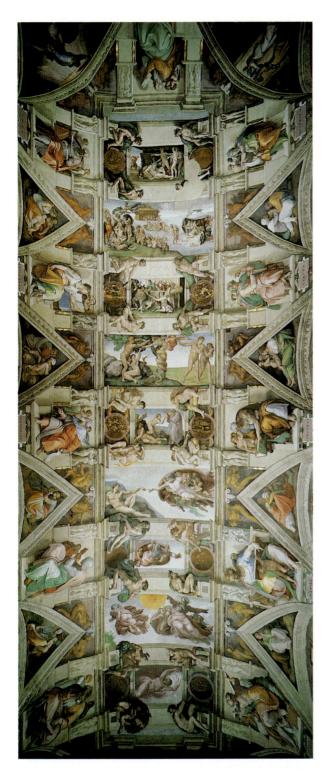

13.7 Michelangelo. Ceiling of the Sistine Chapel, 1508–1511. Fresco, $44' \times 128'$ (13.44 \times 39.01 m). Vatican Palace, Rome.

Under the patronage of popes Leo X and Clement VII—both from the Medici family—Michelangelo worked on another project, the Medici Chapel in the Florentine Church of San Lorenzo. This chapel is particularly inter-

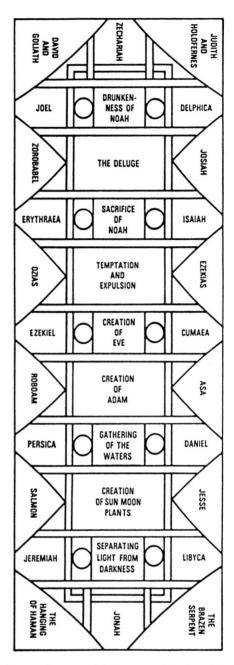

13.8 Schematic drawing of the iconographic plan of the Sistine Ceiling. The corner triangles are called the vele ("sails").

esting because Michelangelo designed and executed both the sculptures and the chapel in which they were to be placed. Although Michelangelo first conceived the project in 1519, he worked on it only in fits and starts from 1521 to 1534. He never completely finished the chapel. In 1545, some of Michelangelo's students set the statues in place.

The interior of the Medici Chapel [13.11] echoes Brunelleschi's Pazzi Chapel with its dome, its use of a light grayish stone called *pietra serena*, its Classical decoration, and its very chaste and severe style. The plan

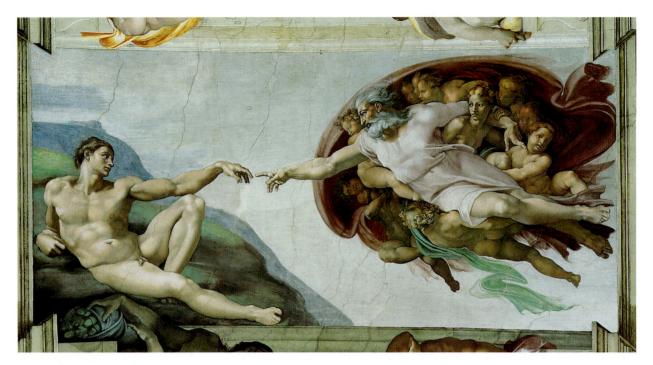

13.9 Michelangelo. *Creation of Adam.* Detail of the Sistine Chapel Ceiling, 1508-1512. Fresco. Approx. $8' \times 9'2''$ (2.44×2.8 m). Vatican Palace, Rome. Compare the figure of Adam to the figure of David (Figure 12.28) to get a sense of Michelangelo's concept of musculature.

envisioned an altar at one end of the chapel and opposite it, at the other end, statues of the Madonna and child with saints Cosmas and Damian. The saints were the patrons of physicians, an allusion to the name *Medici*, which means "the doctor's family." At the base of these statues are buried in utter simplicity the bodies of Lorenzo the Magnificent and his brother Giuliano. On opposite walls are niches with idealized seated figures of relatives of Lorenzo the Magnificent, the dukes Lorenzo and Giuliano de' Medici in Roman armor. Beneath each are two symbolic figures resting on a sarcophagus, *Night* and *Day* and *Dawn* and *Dusk*.

This great complex, unfinished like many of Michelangelo's projects, is a brooding meditation on the shortness of life, the inevitability of death, and the Christian hope for resurrection. Both the stark decoration of the chapel and the positioning of the statues (Duke Lorenzo seems always turned to the dark with his head in shadow while Duke Giuliano seems more readily to accept the light) form a mute testament to the rather pessimistic and brooding nature of their creator. When Michelangelo had finished the figure of *Night* [13.12], a Florentine poet named Strozzi wrote a poem in honor of the statue, with a pun on the name Michelangelo:

The Night you see sleeping in sweet repose Was carved in stone by an angel. Because she sleeps, she has life. If you do not believe this, touch her and She will speak.

Michelangelo, an accomplished poet in his own right, answered Strozzi's lines with a pessimistic rejoinder:

Sleep is precious; more precious to be stone When evil and shame are abroad; It is a blessing not to see, not to hear. Pray, do not disturb me. Speak softly!

The New Saint Peter's

In 1506, Pope Julius II, in a gesture typical of his imperious nature, commissioned the architect Donato Bramante (1444–1514) to rebuild Saint Peter's Basilica in the Vatican. Old Saint Peter's had stood on Vatican Hill since it was first constructed more than a thousand years earlier, during the time of Roman Emperor Constantine. By the early sixteenth century it had suffered repeatedly from roof fires, structural stresses, and the simple ravages of time. In the minds of the Renaissance "moderns" it was a shaky anachronism.

http://www.greatbuildings.com/architects/ Donato_Bramante.html

Bramante

Bramante's design envisioned a central domed church with a floor plan in the shape of a Greek cross with four

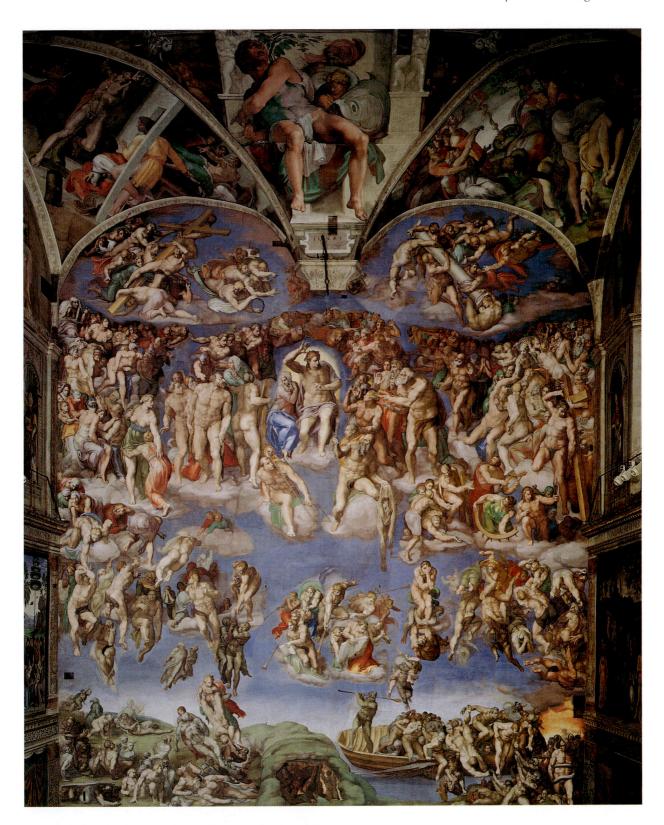

13.10 Michelangelo. *The Last Judgment*. Fresco on the altar wall of the Sistine Chapel (restored), 1534–1541. Vatican Palace, Rome. The loincloths on the figures were added later to appease the puritan sensibilities of post–Reformation Catholicism. The figure in the flayed skin of Saint Bartholomew is a self-portrait of the painter.

equal arms [13.13]. The dome would have been set on a columned arcade with an exterior colonaded arcade, called a *peristyle*, on the outer perimeter of the building. Any of the four main doors was to be directly across from a *portal* ("door") on the opposite side. This central

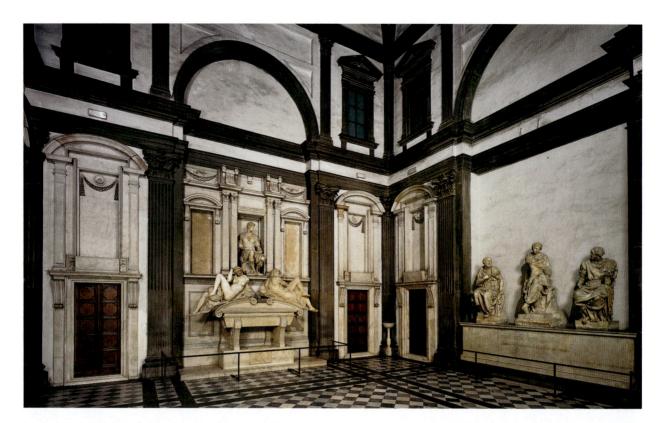

13.11 Michelangelo. Medici Chapel, 1519–1534. Church of San Lorenzo, Florence. It is not clear whether or not the statues of the Madonna and saints were finished by Michelangelo himself.

some thirty years after his death by Giacomo della Porta. The best way to understand what Michelangelo intended is to view Saint Peter's from behind, from the Vatican Gardens, where one can see the great dome looming up over the arms of the Greek cross design [13.14].

plan was not executed in Bramante's lifetime, but a small chapel he built in 1502 next to the Church of San Pietro in Montorio, Rome, may give us a clue to what Bramante had in mind. This *tempietto* ("little temple") is believed to have been done in a style similar to what Bramante wanted later for Saint Peter's.

After Bramante's death, other architects—including Raphael and Sangallo—worked on the massive project. Both these architects added a nave and aisles. In 1546, Michelangelo was appointed architect, since the plans previously drawn up seemed unworkable. Michelangelo returned to Bramante's plan for a central domed Greek cross church but envisioned a ribbed arched dome somewhat after the manner of the cathedral in Florence but on a far larger scale.

The present Saint Peter's seen from the front gives us no clear sense of what Michelangelo had in mind when he drew up his plans. Michelangelo's church had a long nave and a fasade added by Carlo Maderna in the early seventeenth century. The colonnaded piazza was completed under the direction of Gian Lorenzo Bernini in 1663, almost a century after Michelangelo's death. Michelangelo lived to see the completion of the drum that was to support his dome. The dome itself was raised

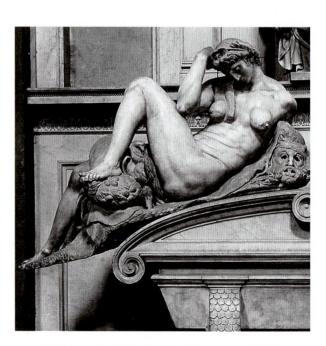

13.12 Michelangelo. *Night*. Detail of the tomb of Giuliano dé Medici, 1519-1534. Marble. Length $6'4^1/2''$ (1.94 m). Church of San Lorenzo, Florence. The owl and the mask under the recumbent figure are emblems of night and dreams.

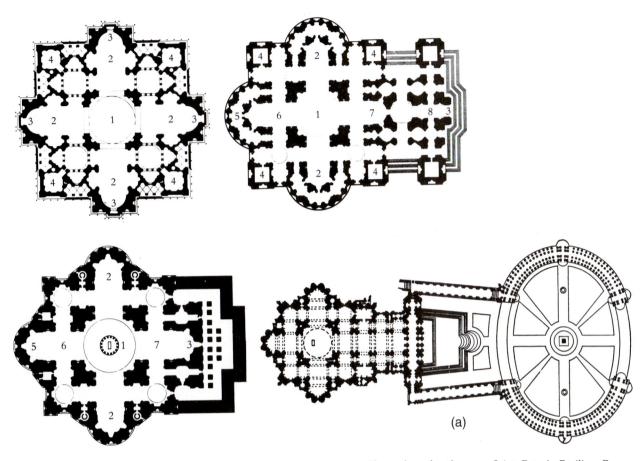

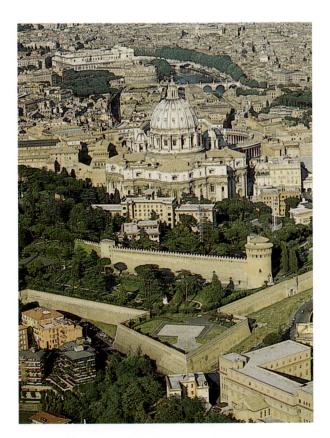

13.13 Floor plans for the new Saint Peter's Basilica, Rome. Maderna's final additions, especially the elongated nave, narthex, and large façade, obscured Michelangelo's original design. (1) Area of papal altar under dome. (2) Transept. (3) Portal. (4) Chapel (not all are identified). (5) Apse. (6) Choir. (7) Nave. (8) Narthex. (a) Bernini's *piazza*, done in 1656.

13.14 Michelangelo. Saint Peter's Basilica. View from the southwest, 1546–1564. Completed 1590 by Giacomo della Porta. The Vatican Gardens are behind the basilica visible at the lower center of this aerial photograph.

The High Renaissance in Venice

The brilliant and dramatic outbreak of artistic activity in sixteenth-century Rome and Florence does not diminish the equally creative art being done in the Republic of Venice to the north. While Rome excelled in fresco, sculpture, and architecture, Venice was famous for its tradition of easel painting. Venice's impressive cosmopolitanism derived from its position as a maritime port and its trading tradition.

Because of the damp atmosphere of their watery city, Venetian painters quickly adopted oil painting, which had first been popularized in the north. Oil painting gave the artist unparalleled opportunities to enrich and deepen color by the application of many layers of paint. Oil painting in general, and Venetian painting in particular, placed great emphasis on the brilliance of its color and the subtlety of its light. The sunny environment of Venice, with light reflecting off the ever-present waterways, further inspired the Venetian feel for color and light. Although the generalization is subject to refinement, there is truth in the observation that Venetian painters emphasized color, whereas painters in the south were preoccupied with line. Venetian painters, like their counterparts in Northern Europe, had an eye for close detail and a love for landscape (an ironic interest, since Venice had so little land).

Giorgione

http://www.artcyclopedia.com/artists/giorgione.html

Giorgione

The most celebrated and enigmatic painter in early sixteenth-century Venice was Giorgio di Castelfranco

13.15 Giorgione. *Enthroned Madonna with Saints Liberalis and Francis of Assisi*, c. 1500-1505. Oil on panel, $6'6^3/4'' \times 5' (1.99 \times 1.52 \text{ m})$. Cathedral, Castelfranco. Saint Francis shows the *stigmata* of Christ that he bore on his body.

(c. 1477–1510), more commonly known as Giorgione. His large altarpiece, *Enthroned Madonna with Saints Liberalis and Francis of Assisi* [13.15], painted for the cathedral of his hometown of Castelfranco, illustrates many of the characteristics of the Venetian Renaissance style. It is a highly geometric work (using the now-conventional form of the triangle with the Madonna at the apex) typical of Renaissance aesthetics of form. At the same time it shows some idiosyncratic characteristics—the luminous quality of the armor of Saint Liberalis and the minutely rendered landscape. This landscape, with its two soldiers in the bend of the road and the receding horizon, echoes painters from the north like Jan van Eyck.

Far more typical of Giorgione's work are his paintings without religious content or recognizable story line or narrative quality. Typical of these is *Le Concert Champêtre* [13.16], done in the final year of the painter's life. The two voluptuous nudes frame two young men who are shadowed but also glowing in their richly rendered costumes. The sky behind threatens a storm, but Giorgione counterposes the storm to a serene pastoral scene that includes a distant farmhouse and shepherds with their flock. What does the painting hope to convey? Why does one woman pour water into the well? Is the lute in the hand of one man or the recorder in the hand of the other woman a clue? We do not know. It may be an elaborate allegory on music or poetry. What is clear is that the painting is a frankly secular homage to the profane joy of life rendered with the richness and lushness of concept and color.

Titian

http://artchive.com/artchive/T/titian.html

Titia

If Giorgione's life was short, that of his onetime apprentice Tiziano Vecelli (c. 1488–1576), known as Titian, was long. Titian brought the Venetian love for striking color to its most beautiful fulfillment. His work had an impact not only on his contemporaries but also on later baroque painters in other countries, such as Peter Paul Rubens in Antwerp and Diego Velázquez in Spain.

13.16 Overleaf: Giorgione, *Le Concert Champêtre*, c. 1510. Oil on canvas, approx. $3'7^{1}/_{4}'' \times 4'6^{1}/_{8}''$ (1.05 × 1.38 m). Louvre, Paris. Giorgione's robust nude figures would be much imitated by later baroque painters like Peter Paul Rubens. Giorgione died before he could finish the painting. It was completed by Titian.

VALUES

Patronage

We have noted in a number of places in these chapters about art *patronage* in the Renaissance period. The question is: To what end did people and/or organizations give lavish funds to sustain the various arts? The answer to that question helps us understand the social value of art.

In the earlier Renaissance, many wealthy laypersons patronized the arts to "pay back" monies earned from interest-taking, which was considered a sinful practice. A more common motive was a combination of a desire to memorialize the family name (a common custom even today), to promote civic pride, and to solidify one's standing in the community. Wealthy cities like Venice underwrote lavish art projects as a projection of civic pride and as a demonstration of power and wealth. The enormous papal expenditures in the fif-

teenth and sixteenth centuries reversed an earlier trend. In the past, laypersons endowed the churches with their monies. The Renaissance popes, by contrast, used church monies to reflect the power of the papacy; to enhance the Roman claim to be the center of the church; to promote a visible form of piety; and, incidentally, to glorify the reign of the pope and his family. Visitors to the Vatican can still see the coats of arms of the families from which the popes came.

The patronage impulses of the past are not all that different from our own (although the church is hardly a central source of artistic patronage today) except that the monies that make art patronage possible come from different sources. This patronage is also the source of much social debate as our contemporaries argue the merits of state and national funding for the arts.

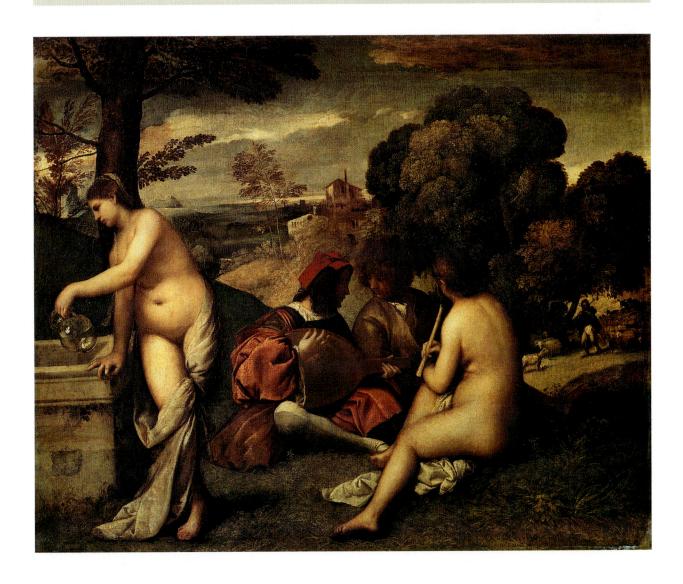

Titian's artistic output during seventy years of activity was huge. His reputation was such that he was lionized by popes and princes. He was a particular favorite of Holy Roman Emperor Charles V, who granted him noble rank after having summoned him on a number of occasions to work at the royal court. From this tremendous body of work two representative paintings, emblematic of the wide range of his abilities, provide a focus.

The huge panel painting in the Venetian Church of the Frari called *Assumption of the Virgin* [13.17] shows Titian at his monumental best. The swirling color in subtly different shadings and the dramatic gestures of the principals, all of which converge on the person of the Madonna, give a feeling of vibrant upward movement;

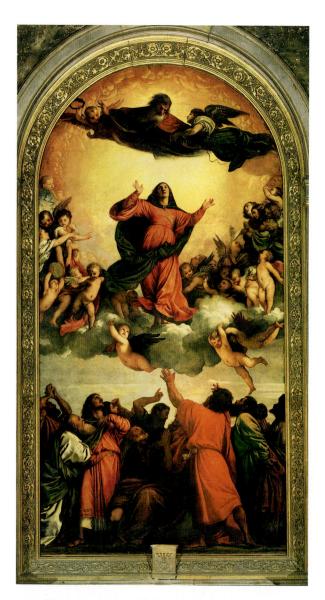

13.17 Titian. Assumption of the Virgin, 1516–1518. Oil on canvas, $22'6'' \times 11'8''$ (6.86 \times 3.56 m). Church of the Frari, Venice. Note the three distinct levels in the composition of the painting.

color and composition define the subject of the assumption of Mary into heaven. The energy in the panel, however, should not distract the viewer from its meticulous spatial relationships. The use of a triangular composition, the subtle shift from dark to light, the lines converging on the Madonna from both above and below are all part of carefully wrought ideas that give the work its final coherence.

Contrast this Assumption with Titian's work of twenty years later, the Venus of Urbino [13.18]. The religious intensity of the Assumption gives way to the sensual delight of the Venus done in homage to feminine beauty from a purely human perspective. The architectural background, evenly divided between light and dark coloration, replaces Giorgione's natural landscapes. The lushness of the nude figure is enhanced by the richness of the brocade, the small bouquet of flowers, the little pet dog, and the circumspect maids at their tasks around a rich clothes chest in the background. The Venus of Urbino reflects a frank love of the human body, which is presented in a lavish artistic vocabulary. It is obvious that Titian painted this work for an aristocratic and wealthy patron.

Tintoretto

http://www.artcyclopedia.com/artists/tintoretto.html

Tintoretto

The last of the Venetian giants was Jacopo Robusti (1518–1594) known more familiarly as Tintoretto ("little Dyer"—named for his father's occupation). After a short apprenticeship with Titian, Tintoretto worked in his own studio in Venice, a city from which he rarely strayed. It was said that over his studio door he wrote the words "The drawing of Michelangelo and the color of Titian." His most famous work was a huge cycle of frescoes done for the Scuola ("Confraternity") of San Rocco in Venice. He began work on the frescoes in 1564 and in 1577 was named the Scuola's official painter. The oil painting depicting The Last Supper [13.19], done for the Church of San Giorgio Maggiore in the final years of his life is a good example of Tintoretto's energetic and dramatic style as well as providing an opportunity for contrasting Tintoretto's work to that of Leonardo. After 1577, Tintoretto was called to decorate the ducal palace in Venice as part of a restoration project following a terrible fire. Besides allegorical work celebrating the grandeur of the city, Tintoretto and his son Domenico worked on the frescoes of the great hall of the palace contributing a huge oil painting of paradise, which is more famous for its size (it covered an eighty-foot wall) than for its beauty.

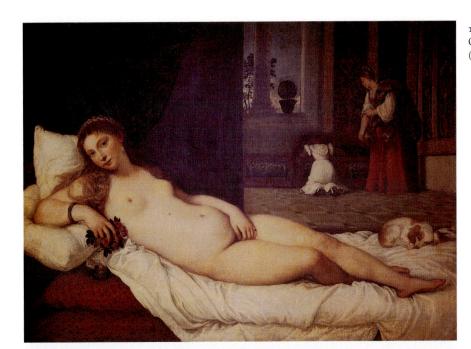

13.18 Titian. *Venus of Urbino*, 1538. Oil on canvas. Approx. $3'11'' \times 5'5''$ (1.19 \times 1.62 m). Uffizi, Florence.

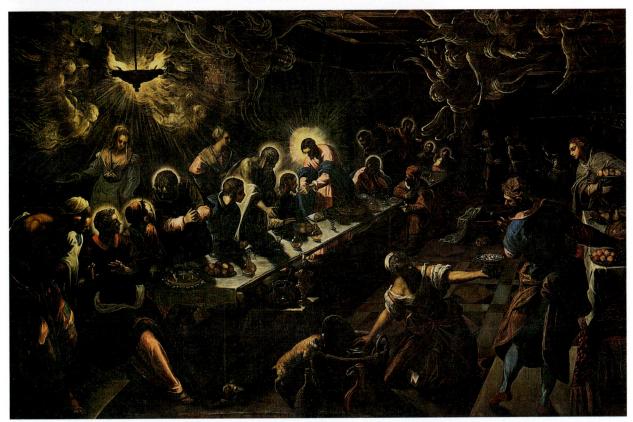

13.19 Tintoretto. The Last Supper, 1592–1594. Oil on canvas, $12' \times 18'8''$ (3.66 \times 5.69 m). Chancel, San Giorgio Maggiore, Venice.

Mannerism

http://www.artcyclopedia.com/history/mannerism.html

Mannerism

There is general agreement that at the end of the second decade of the sixteenth-century, High Renaissance art in Italy—under severe intellectual, psychological, and cultural pressure—gave way to an art style that seemed to be an exaggeration of Renaissance form and a loosening of Renaissance intellectuality. It is not so much that a new

school of artists arose but that a mood touched some artists at some point in their careers and captivated others totally. An earlier generation of art historians saw this tendency, called *Mannerism*, as a sign of decadence and decay. Scholarly opinion is less harsh today, viewing Mannerism as a distinct aesthetic to be judged on its own terms.

Mannerism is difficult to define and the term is often used without any precise sense. The schema proposed by art historian Frederick Hartt might serve in place of a strict definition:

High Renaissance

Content: Normal, supernormal, or ideal; appeals

to universal

Narrative: Direct, compact, comprehensible

Space: Controlled, measured, harmonious, ideal

Composition: Harmonious, integrated, often central-

ized

Proportions: Normative, idealized

Figure: Easily posed, with possibility of motion

to new position

Color: Balanced, controlled, harmonious

Substance: Natural

Mannerism

Content: Abnormal or anormal; exploits strange-

ness of subject uncontrolled emotion, or

withdrawal

Narrative: Elaborate, involved, abstruse

Space: Disjointed, spasmodic, often limited to

foreground plane

Composition: Conflicting, acentral, seeks frame *Proportions:* Uncanonical, usually attenuated

Figure: Tensely posed; confined or overextended

Color: Contrasting, surprising

Substance: Artificial

Using Hartt's schema we can detect Mannerist tendencies in some of Michelangelo's later work. The figures of *Night, Day, Dawn,* and *Dusk* seem to reflect the exaggerations of the Mannerist style Hartt describes. The entrance to the Laurentian Library [13.20] in Florence, begun by Michelangelo in 1524 to rehouse the Medici book collection, shows some of these characteristics. Its windows are not windows, its columns support nothing, its staircases with their rounded steps seem agitated and in motion, its dominant lines break up space in odd and seemingly unresolved ways.

Mannerist characteristics show up in only some of Michelangelo's works (*The Last Judgment* fresco in the Sistine Chapel might also be analyzed in this fashion), but some of his contemporaries quite clearly broke with the intellectual unity of the High Renaissance. Two in particular deserve some attention because they so clearly illustrate the Mannerist imagination.

Jacopo Carucci da Pontormo (1494-1557) was an eccentric and reclusive painter who had studied with Leonardo da Vinci in his youth. Pontormo's greatest

13.20 Michelangelo. Vestibule stairway of the Laurentian Library, San Lorenzo, Florence, begun 1524. Stairway completed 1559. This library today contains many of the books and manuscripts collected by the Medici family.

painting is the *Deposition* [13.21] painted around 1528 for the Church of Santa Felicità in Florence. The most striking feature of this work is its shocking colors: pinks, apple-greens, washed-out blues. It is hard to think of any other Renaissance painting to which this stunningly original and exotic work can be compared.

An even more dramatic example of the Mannerist aesthetic is by Francesco Mazzola (1503–1540), called Parmigianino. He painted the *Madonna of the Long Neck* [13.22] for a church in Bologna. The gigantic proportions in the picture space are made all the more exaggerated by forcing the eye to move from the tiny prophetic figure in the background to the single column and then to the overwhelmingly large Madonna. The infant almost looks dead; in fact, his hanging left arm is reminiscent of the dead Christ in Michelangelo's *Pietà*. The Virgin's figure is rendered in a strangely elongated, almost serpentine, fashion. There is something oddly erotic and exotic about

13.21 Jacopo Carucci da Pontormo. *Deposition*, c. 1528. Oil on wood Approx. $11' \times 6'6''$ (3.5×1.98 m). Capponi Chapel, Church of Santa Felicità, Florence. The twisted figures seem suspended in an airy space of no definite location. Note the odd palette the painter used to emphasize the horror and strangeness of the facial expression.

her due to the shape of her body, the long fingers, and the great curving *S* of her neck. The implied eroticism is reinforced by the partially clad figures clustered at her side.

How and under what circumstances Mannerism grew and matured is the subject of much debate. Some elements of that debate must include the intellectual and social upheavals of the time (everything from wars to the Protestant Reformation) and the human desire and need to innovate once the problems and potential of a given art style have been fully worked out. In a sense, Mannerism is a testament to the inventiveness and restlessness of the human spirit.

Sofonisba Anguissola

http://www.artcyclopedia.com/artists/ anguissola_sofonisba.html

Sofonisba Anguissola

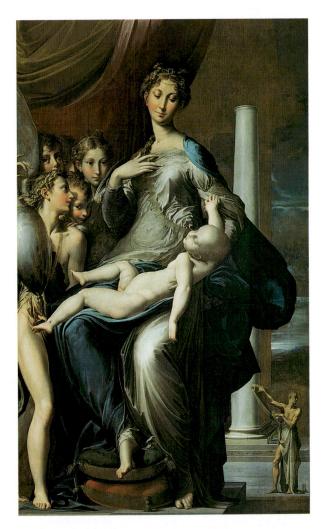

13.22 Parmigianino. *Madonna of the Long Neck*, c. 1535. Oil on wood. Approx. $7'1'' \times 4'4''$ (2.15 \times 1.32 m). Uffizi, Florence. Note the odd prophetic figure and the elongated column in the background.

In 1556, Giorgio Vasari traveled to Cremona to see the "marvels" of six sisters, children of the Anguissola family, who were "excellent in painting, music, and belles artes." The beneficiary of a humanist education at home, the most famous of these sisters was Sofonisba who enjoyed a great degree of fame in her own lifetime. Born in 1532(?), she studied art with a minor master in Cremona. As a young woman she traveled to Rome with her father where she most likely met Michelangelo. Sofonisba also spent time in Milan until, in 1560, she traveled to Spain as a court painter; there she met a Sicilian noble in the service of the Spanish monarch. The couple lived in Sicily but after her husband's death she returned to Cremona. After a remarriage, she moved to Genoa (where she probably met Caravaggio) but finally went back to Palermo, Sicily where she died 1624 after the famous Antony Van Dyck had painted her portrait.

Sofonisba produced an enormous amount of work which is now represented in museums around the world. Her mature work indicates how much she learned not only from the Renaissance masters but from the chiaroscuro techniques of painters like Caravaggio (discussed Chapter 15). A late self-portrait [13.23] amply demonstrates her capacity for both pictorial representa-

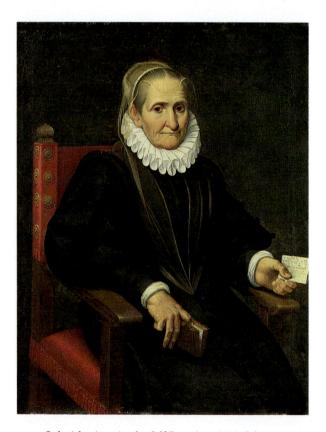

13.23 Sofonisba Anguissola. *Self-Portrait*, c. 1610. Oil on canvas, $37 \times 29^{1}/_{2}$ " (94 × 75 cm). Gottfried Keller Collection, Bern, Switzerland. In her left hand a note reads: "To His Catholic Majesty; I kiss his hand. Anguissola." The portrait was an answer to a request made by Phillip II of Spain.

tion and her capacity for the sharp contrasts of darkness/light, which would become so important in the Baroque period.

Music in the Sixteenth Century

Music at the Papal Court

The emphasis in this chapter on painting, sculpture, and architecture makes it easy to forget that many of these artistic creations were intended for the service of Roman Catholic worship. It should be no surprise that fine music was subsidized and nurtured in Rome at the papal court. In fact, the active patronage of the popes for both the creation and the performance of music dates back to the earliest centuries of the papacy. Gregorian chant, after all, is considered a product of the interest of Pope Gregory and the school of Roman chant. In 1473, Pope Sixtus IV established a permanent choir for his private chapel, which came to be the most important center of Roman music. Sixtus' nephew Julius II endowed the choir for Saint Peter's, the Julian Choir.

The Sistine Choir used only male voices. Preadolescent boys sang the soprano parts, while older men—chosen by competition—sang the alto, tenor, and bass parts. The number of voices varied then from sixteen to twenty-four (the choir eventually became, and still is, much larger). The Sistine Choir sang *a cappella* (without accompaniment), although we know that the popes enjoyed instrumental music outside the confines of the church. Cellini, for example, mentions that he played instrumental motets for Pope Clement VII.

While Botticelli and Perugino were decorating the walls of the Sistine Chapel, the greatest composer of the age, Josquin des Prez (c. 1440–1521), was in the service of the Sistine Choir, composing and directing music for its members from 1486 to 1494. From his music we can get some sense of the quality and style of the music of the time.

http://w3.rz-berlin.mpg.de/cmp/josquin.html

Josquin des Prez

Josquin, who was Flemish, spent only those eight years in Rome, but his influence was widely felt in musical circles. He has been called the bridge figure between the music of the Middle Ages and the Renaissance. Although he wrote madrigals and many masses in his career, it was in the motet for four voices, a form not held to traditional usage in the way masses were, that he

showed his true genius for creative musical composition. Josquin has been most praised for homogeneous musical structure, a sense of balance and order, a feel for the quality of the lyrics. These are all characteristics common to the aspirations of the sixteenth-century Italian humanists. In that sense, Josquin combined the considerable musical tradition of Northern Europe with the new intellectual currents of the Italian south.

The Renaissance motet uses a sacred text sung by four voices in polyphony. Josquin divided his texts into clear divisions but disguised them by using overlapping voices so that one does not sense any break in his music. He also took considerable pains to marry his music to the obvious grammatical sense of the words while still expressing their emotional import by the use of the musical phrase. A portion of the motet Tu Pauperum Refugium (Thou Refuge of the Poor) illustrates both points clearly. The text shows the principle of overlapping (look at the intervals at which the voices enter with, for example, the end of the phrase obdormiat in morte). Likewise, the descending voices underscore the sense of the words ne unquam obdormiat in morte anima mea ("lest my soul sleep in death") in a way that to one musicologist suggests death itself is entering.

The sixteenth-century composer most identified with Rome and the Vatican is Giovanni Pierluigi da Palestrina (1525–1594). He came from the Roman hill town of Palestrina as a youth and spent the rest of his life in the capital city. At various times in his career he was the choirmaster of the choir of Saint Peter's (the *cappella Giulia*), a singer in the Sistine Choir, choirmaster of two other Roman basilicas (Saint John Lateran and Saint Mary Major). Finally, from 1571 until his death, he directed all music for the Vatican.

Palestrina flourished during the rather reactionary period in which the Catholic Church tried to reform itself in response to the Protestant Reformation by returning to the simpler ways of the past. It should not surprise us, then, that the more than one hundred masses he wrote were very conservative. His polyphony, while a model of order, proportion, and clarity, is nonetheless tied very closely to the musical tradition of the ecclesiastical past. Rarely does Palestrina move from the Gregorian roots of church music. For example, amid the polyphony of his Missa Papae Marcelli (Mass in Honor of Pope Marcellus) one can detect the traditional melodies of the Gregorian Kyrie, Agnus Dei, and so on. Despite that conservatism, he was an extremely influential composer whose work is still regularly heard in the Roman basilicas. His music was consciously imitated by the Spanish composer Victoria (or Vittoria—c. 1548-1611), whose motet O Vos Omnes is almost traditional at Holy Week Services in Rome, and by William Byrd (c. 1543-1623), who brought Palestrina's style to England.

For a selection from the Mass in Honor of Pope Marcellus (Missa Papae Marcelli), see the Listening CD.

Venetian Music

The essentially conservative character of Palestrina's music can be contrasted to the far more adventuresome situation in Venice, a city less touched by the ecclesiastical powers of Rome. In 1527, a Dutchman—Adrian Willaert—became choirmaster of the Church of Saint Mark. He in turn trained Andrea Gabrieli and his more famous nephew, Giovanni Gabrieli, who became the most renowned Venetian composer of the sixteenth century.

The Venetians pioneered the use of multiple choirs for their church services. Saint Mark's regularly used two choirs, called split choirs, which permitted greater variation of musical composition in that the choirs could sing to and against each other in increasingly complex patterns. The Venetians were also more inclined to add instrumental music to their liturgical repertoire. They pioneered in the use of the organ for liturgical music. The independent possibilities of the organ gave rise to innovative compositions that highlighted the organ itself. These innovations in time became standard organ pieces: the prelude, the music played before the services began (called in Italy the intonazione), and the virtuoso prelude called the toccata (from the Italian toccare, "to touch"). The toccata was designed to feature the range of the instrument and the dexterity of the performer.

Both Roman and Venetian music were deeply influenced by the musical tradition of the North. Josquin des Prez and Adrian Willaert were, after all, both from the Low Countries. In Italy their music came in contact with the intellectual tradition of Italian humanism. Without

pushing the analogy too far it could be said that Rome gave the musician the same Renaissance sensibility that it gave the painter: a sense of proportion, classicism, and balance. The Venetian composers, much like Venetian painters of the time, were interested in color and emotion.

Contrasting Renaissance Voices

Early-sixteenth-century Renaissance culture was a study in contrasts. The period not only marked a time when some of the most refined artistic accomplishments were achieved, it was also a period of great social upheaval. The lives of both Raphael and Leonardo ended at precisely the time Luther was struggling with the papacy. In 1527, Rome was sacked by Emperor Charles V's soldiers in an orgy of rape and violence the city had not seen since the days of the Vandals in the fifth century. It would be simplistic to reduce the period of the High Renaissance to a contrast between cool intellectual sophistication and intensely violent passion; nevertheless, it is true that two of the most interesting writers of the period in Italy do reflect rather precisely these opposing tendencies.

Castiglione

Baldassare Castiglione (1478–1529) served in the diplomatic corps of Milan, Mantua, and Urbino. He was a versatile man—a person of profound learning, equipped with physical and martial skills, and possessed of a noble and refined demeanor. Raphael's famous portrait of Castiglione [13.24] faithfully reflects both Castiglione's aristocratic and intellectual qualities.

While serving at the court of Urbino from 1504 to 1516, Castiglione decided to write *The Courtier*, a task that occupied him for the next dozen years. It was finally published by the Aldine Press in Venice in 1528, a year before the author's death. In *The Courtier*, cast in the form of an extended dialogue and borrowing heavily from the style and thought of ancient writers from Plato to Cicero, Castiglione has his learned friends discuss a range of topics: the ideals of chivalry, classical virtues, the character of the true courtier, the ideals of Platonic love. Posterity remembers Castiglione's insistent plea that the true courtier should be a person of humanist learning, impecable ethics, refined courtesy, physical and martial skills, and fascinating conversation. He should not possess any of these qualities to the detriment of any other.

The *uomo universale* ("well-rounded person") should do all things with what Castiglione calls *sprezzatura*. *Sprezzatura*, which is almost impossible to translate into a single English word, means something like "effortless mastery." The courtier, unlike the pedant, wears learning lightly, while his mastery of sword and horse has none of the fierce clumsiness of the common soldier in the ranks.

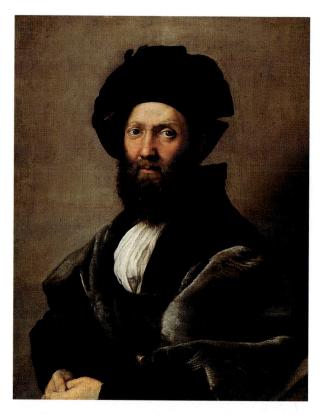

13.24 Raphael. *Baldassare Castiglione*, c. 1514. Oil on panel, transferred to canvas, $29^{1}/_{2}^{"} \times 25^{1}/_{2}^{"}$ (75 × 65 cm). Louvre, Paris. Raphael would have known the famous humanist through family connections in his native Urbino.

The courtier does everything equally well but with an air of unhurried and graceful effortlessness.

Castiglione's work was translated into English by Sir Thomas Hoby in 1561. It exercised an immense influence on what the English upper classes thought the educated gentleman should be. We can detect echoes of Castiglione in some of the plays of Ben Jonson as well as in the drama of William Shakespeare. When in *Hamlet* (III, I), for example, Ophelia cries out in horror at the lunatic behavior of Hamlet (at his loss of *sprezzatura*?) the influence of Castiglione is clear:

Oh, what a noble mind is here o'erthrown! The courtier's, soldier's, scholar's eye, tongue, sword: The expectancy and rose of the fair state, The glass of fashion and the mould of form, The observed of all observers . . .

The most common criticism of Castiglione's courtier is that he reflects a world that is overly refined, too aesthetically sensitive, and excessively preoccupied with the niceties of decorum and decoration. The courtier's world, in short, is the world of the very wealthy, the very aristocratic, and the most select of the elite. If the reader shares that criticism when reading Castiglione, the *Autobiography of Benvenuto Cellini* should prove a bracing antidote to the niceties of Castiglione.

Cellini

http://www.artcyclopedia.com/artists/cellini_benvenuto.html

Cellini

Benvenuto Cellini (1500–1571) was a talented Florentine goldsmith and sculptor whose life, frankly chronicled, was a seemingly never-ending panorama of violence, intrigue, quarrel, sexual excess, egotism, and political machination. His *Autobiography*, much of it dictated to a young apprentice who wrote while Cellini worked, is a vast and rambling narrative of Cellini's life from his birth to the year 1562. We read vignettes about popes and commoners, artists and soldiers, cardinals and prostitutes, assassins and artists, as well as a gallery of other characters from the Renaissance demimonde of Medicean Florence and papal Rome.

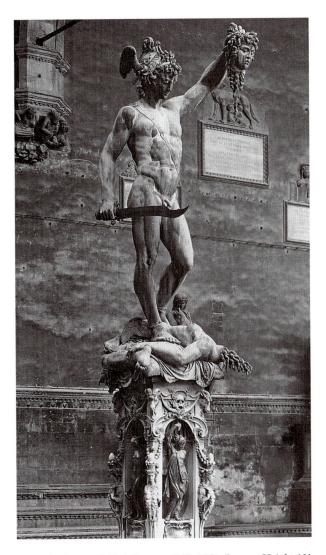

13.25 Benvenuto Cellini. *Perseus*, 1545–1554. Bronze. Height 18' (5.48 m). Loggia dei Lanzi, Florence. Earlier models of this statue, including a first effort in wax, are preserved in the Bargello Museum in Florence.

Above all, we meet Benvenuto Cellini, who makes no bones about his talent, his love of life, or his taste for violence. Cellini is not one of Castiglione's courtiers. Cellini fathered eight legitimate and illegitimate children; he was banished from Florence for sodomy; imprisoned for assault; fled Rome after murdering a man; and fought on the walls of the Castel Sant' Angelo in Rome during the siege of 1527 in defense of the Medici pope Clement VII. Anyone who thinks of the Renaissance artist solely in terms of proportion, love of the Classics, Neo-Platonic philosophy, and genteel humanism is in for a shock when encountering Cellini's *Autobiography*.

One particular part of Cellini's book is interesting not for its characteristic bravado or swagger, but for its insight into the working methods of an artist. In a somewhat melodramatic account, Cellini describes the process of casting the bronze statue of Perseus that actually turned out to be his most famous work [13.25]. It now stands in the Loggia dei Lanzi next to the Palazzo Vecchio in Florence.

Cellini does not belong to the first rank of sculptors, although nobody has denied his skill as a craftsman. The *Perseus*, finished in 1554 for Duke Cosimo I dé Medici, is a highly refined work made more interesting because of Cellini's record of its genesis.

SUMMARY

Art follows patronage, as we have noted. The "high" Renaissance is summed up in the lives and works of three artists: Michelangelo, Raphael, and Leonardo da Vinci. The first two did their most famous work in the Vatican in the sixteenth century whereas Leonardo, true to his restless spirit, sojourned there only for a time before he began his wanderings through the courts of Europe. It is their work that gives full meaning to the summation of Renaissance ideals.

When we look at the work of Raphael and Michelangelo under the patronage of the popes, we should not forget that this explosion of art and culture was taking place while a new and formidable revolution was in the making: the Protestant Reformation. While it would be overly simplistic to believe that the Renaissance caused the Reformation, it must certainly be seen as a contributing factor—as we will see in the next chapter. Even so, there is a marked shift in the atmosphere in which Michelangelo worked in Rome before 1521 and afterward, when the full force of the Protestant revolt in the North was making itself felt in Rome.

The artistic work in Rome can be contrasted profitably with that which took place in Venice during roughly the same period. The Roman Renaissance was under the patronage of the church. Venetian art and music enjoyed the same patronage source as did Florence in the preceding century: commerce and trade. Venice made its

fortune from the sea: The shipping of its busy port looked to both Europe and the Middle East. It was fiercely protective of its independence (including its independence from papal Rome) and proud of its ancient traditions. Even the religious art of Venice possessed a certain freedom from the kind of art being produced in Rome in the same century because Venice had less contact with the seething ideas current in the century.

Renaissance ideas had also penetrated other areas of Italy. Florence still had its artistic life (although somewhat diminished from its great days in the fifteenth century) but provincial cities like Parma and Mantua were not without their notables. Much of this artistic activity rested in the courts of the nobility who supplied the kind of life and leisure that made possible the courtier and the court lifestyle immortalized in the book by Castiglione. The insufficiencies of this court culture would become clear when the religious wars of the sixteenth century broke out and humanism had to confront the new realities coming from the increasingly Protestant North.

Pronunciation Guide

Bramante: Bra-MAHN-tay

Buonarroti: Bwon-ah-ROH-tee Castiglione: KAS-til-YOH-nay

Cellini: Che-LEE-nee

Le Concert Champêtre: Leh Kon-CER Sham-PET-reh

Giorgione: Jor-JOAN-eh
Laurentian: Law-WREN-shen
Palestrina: Pal-es-TRIN-ah

Parmigianino: PAR-me-jan-EE-no
Pontormo: Pon-TOR-mo
sprezzatura: spreh-tza-TOUR-ah

Strozzi:STROH-tzeetempietto:tem-PYET-toeTitian:TEA-shan

EXERCISES

1. If you were to transpose Raphael's School of Athens into a contemporary setting, what kind of architecture would you use to frame the scene and whom would you include among the personages in the picture?

Critics use the adjective Michelangeloesque. Now that you have studied his work, what does that adjective mean to you? Give an all-inclusive definition of the term.

 Michelangelo's Medici Chapel represents the artist's best attempt to express a permanent tribute to the dead. How does it differ in spirit from such monuments today? (You might begin by comparing it to the Vietnam Memorial in Washington, DC, or some other such public monument.)

4. Castiglione's concept of sprezzatura was an attempt to summarize the ideal of the educated courtier. Is there a word or phrase that would best sum up the character of the well-rounded person today? Do we have a similar ideal? If so, how would you characterize it? If not, why not?

- 5. Mannerism as an art style contains an element of exaggeration. Can you think of any art form with which we are familiar that uses exaggeration to make its point?
- 6. Art patronage in the sixteenth century came mainly from the church and from the wealthy. Are they equally sources of patronage today? If not, what has replaced the church as a source of art patronage today? What does that say about our culture? If so, cite examples.

FURTHER READING

Grafton, A. (Ed.). (1994). *Rome reborn: The Vatican Library and Renaissance culture.* New Haven, CT: Yale University Press. Excellent interdisciplinary study.

Kelly, J. N. D. (Ed.). (1986). *The Oxford dictionary of popes*. New York: Oxford University Press. A handy reference work.

Logan, O. (1972). Culture and society in Venice. New York: Scribners. Engaging and readable.

Partner, P. (1976). *Renaissance Rome:* 1550–1559. Berkeley: University of California Press. Cultural history at its best.

Perlingieri, I. (1992). Sofonisba Anguissola: The first great woman artist of the Renaissance. New York: Rizzoli. Excellent text and illustrations.

Stinger, C. (1985). *The Renaissance in Rome*. Bloomington: University of Indiana Press. A readable volume.

Turner, A. R. (1993). *Inventing Leonardo*. New York: Knopf. Valuable on the artist and his times.

ONLINE CHAPTER LINKS

For a biography of Raphael, with links to his paintings and other related sites, visit

http://www.artchive.com/artchive/R/raphael.html

For a collection of several of Raphael's more familiar paintings, visit

http://www.mcs.csuhayward.edu/~malek/Raphael.html

To identify many of the figures in Raphael's School of Athens, consult

http://www.ge-dip.etat-ge.ch/athena/raphael/raf_ath4.html

To view an online collection of Raphael's works at Oxford University's Ashmolean Museum, visit http://www.ashmol.ox.ac.uk/ash/departments/

These multi-purpose Web sites provide extensive biographical information about Michelangelo, with links to works of art and related sites:

http://www.michelangelo.com/buon/bio-index2.html http://hometown.aol.com/dtrofatter/michel.htm http://www.ibiblio.org/wm/paint/auth/michelangelo/ http://artchive.com/artchive/M/michelangelo.html

Information concerning the relationship of Pope Julius II and Michelangelo is found at http://www.geocities.com/rr17bb/PatrMich.html

For insights about the Sistine Chapel, visit http://www.kfki.hu/~arthp/tours/sistina/index.html http://www.science.wayne.edu/~mcogan/Humanities/Sistine/index.html

http://www.christusrex.org/www1/sistine/

Michelangelo's Last Judgment is discussed at http://www.christusrex.org/wwwl/sistine/40-Judge.html

To view an online collection of Michelangelo's works at Oxford University's Ashmolean Museum, visit

http://www.ashmol.ox.ac.uk/ash/departments/

An overview of the far-reaching effects of Christopher Columbus is found at 1492: An Ongoing Voyage: http://lcweb.loc.gov/exhibits/1492/intro.html

For a catalog of useful links to Internet resources, consult *Renaissance Music Links*

http://classicalmus.hispeed.com/rena.html

For introductory information about art of the High Renaissance as well as links to sites related to representative artists, consult *Artcyclopedia* http://www.artcyclopedia.com/history/

high-renaissance.html

Karadar Classical Music at

http://www.karadar.it/Dictionary/Default.htm provides an alphabetical listing of musicians with brief biographies and a list of works (some of which are available on MIDI files).

	GENERAL EVENTS	LITERATURE & PHILOSOPHY	Art
1494			
1500	1498 da Gama lands in India		1494–1495 Dürer visits Italy
	1515–1547 Reign of Francis I in France	I506–I532 Ariosto active in Italy	1500 Dürer, Self-Portrait
THE	1517 Reformation begins in Germany with Luther's 95 Theses,	1509 Erasmus, The Praise of Folly	early 16th cent. Italian Renaissance art and thought spread northward
GENESIS OF THE	challenging the practice of indulgences	1516 More, Utopia	c. 1505–1510 Bosch, Garden of Earthly Delights, triptych
VESTS	1519–1556 Reign of Charles V as Holy Roman Emperor	I521 Luther begins translation of	1508–1511 Dürer, Adoration of the Trinity
GER	1521 Excommunication of Luther by Pope Leo X	Bible into German, published 1534	1513 Dürer, Knight, Death and the
1525	I524–I525 Peasants' War in Germany	I524 Erasmus, De Libero Arbitrio (On Free Will)	Devil, engraving 1515 Grünewald, Isenheim Altarpiece
	1525 Francis I defeated by Charles V at Pavia		1525 Altdorfer, Landscape, early
Protestantism	1527 Sack of Rome by Charles V	1525 Luther, De Servo Arbitrio (On the Bondage of the Will)	example of pure landscape painting 1528 Dürer, Four Books on Human Proportions
STA	1534 Henry VIII founds Anglican Church in England when	1530 Budé persuades Francis I to found Collège de France as center	1529 Altdorfer, Battle of Alexander and Darius
OTE	Parliament passes Act of	for humanism	c. 1530 Clouet, Portrait of Francis I
PR	Supremacy	I6th cent. Humanism spreads, along with interest in scientific inquiry;	c. 1530–1550 Sacred art denounced as idolatry by reforming iconoclasts
ND OF	1539 Society of Jesus (Jesuits) founded by Saint Ignatius of	availability of books increases literacy	c. 1533 – 1540 Decorations by Rosso Fiorentino for Palace at Fontainebleau
SPREAD OF	Loyola 1545 – 1564 Council of Trent initiates	1543 Copernicus, On the Revolution of Celestial Bodies; Vesalius, Seven Books on the	1539–1540 Holbein the Younger, Portrait of Henry VIII in Wedding Dress
1550	Counter-Reformation under Jesuit guidance	SHAKESPEARES Human Body SHAKESPEARES COMEDIES, HISTORIES, & TRAGEDIES	1540–1543 Cellini, The Saltcellar, commissioned by Francis I
COUNTER- REFORMATION	 1550-1555 Wars between Lutheran and Catholic princes in Germany; ended by Peace of Augsburg in 1555 1556 Retirement of Charles V 1556-1598 Reign of Philip II in Spain and Netherlands 1558-1603 Reign of Elizabeth in England 1572 Saint Bartholomew's Day Massacre in France 	I 559 Pope Paul IV publishes first Index of Prohibited Books	c. 1562–1567 Bruegel the Elder, The Triumph of Death, Hunters in the Snow, Peasant Wedding
1575	I581 United Provinces of	I580 Montaigne's first <i>Essays</i>	
RELIGIOUS AND NATIONALISTIC UNREST	Netherlands declare independence from Spain 1585 England sends troops to support Netherlands against Spain 1588 Philip's Spanish Armada defeated by English 1598 Edict of Nantes establishes religious toleration in France 1600 British found East India Tea Company	c. 1587 Marlowe, Tamburlaine, tragedy 1590 Sidney, Arcadia 1590–1596 Spenser, The Faerie Queene, allegorical epic 1590–1610 Drama at height in Elizabethan England 1593 Marlowe, Dr. Faustus, tragedy late 16th–early 17th cent. Cervantes active in Spain, Jonson in England, Tasso in Italy	
NATION 1620	 1602 Duelling banned in France 1607 English found colony of Virginia in New World 1609 Independence of Netherlands recognized by Spain 	c. 1600 Shakespeare, Hamlet c. 1604–1605 Shakespeare, Othello, King Lear, Macbeth 1611 Authorized Version of Bible 1620 Francis Bacon, Novum Organum	c. 1600 Patronage for sacred art wanes in Reformation countries, fluorishes in Counter-Reformation countries

CHAPTER 14 THE RENAISSANCE IN THE NORTH

ARCHITECTURE

Music

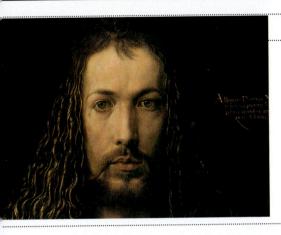

1506 Rebuilding of Saint Peter's Basilica, Rome, begins

Vernacular hymns stressed by Reformers; musical elements in Protestant services simplified by Luther to increase comprehension

- **c. 1510** Isaac and Sendl active in Northern Europe
- **1519** Château de Chambord built by Francis I
- c. 1520 Marot and Janequin compose chansons

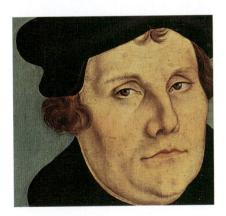

1548–1549 Goujon, Fountain of the Innocents, Louvre, Paris

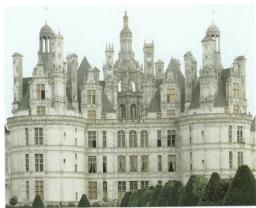

1546 Lescot and Goujon, Square Court of Louvre, begun

c. 1525–1530 Ein' Feste Burg ist Unser' Gott (A Mighty Fortress Is Our God)

1544 Gregorian chant is basis for first Englishlanguage litany in England

1549 Merbecke, The Boke of Common Praier Noted

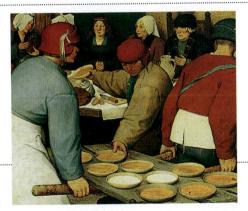

c. 1590 Hilliard, *Portrait of a Youth,* miniature

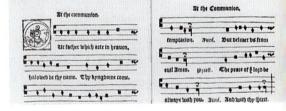

c. 1570 Tallis, English court organist, composes *Lamentations of Jeremiah*

1588 *Musica Transalpina* translated into English

1591 Byrd, My Ladye Nevells Booke

late 16th-early 17th cent. English madrigals by Byrd, Morley, and Weelkes follow Italian models; ayres by Dowland

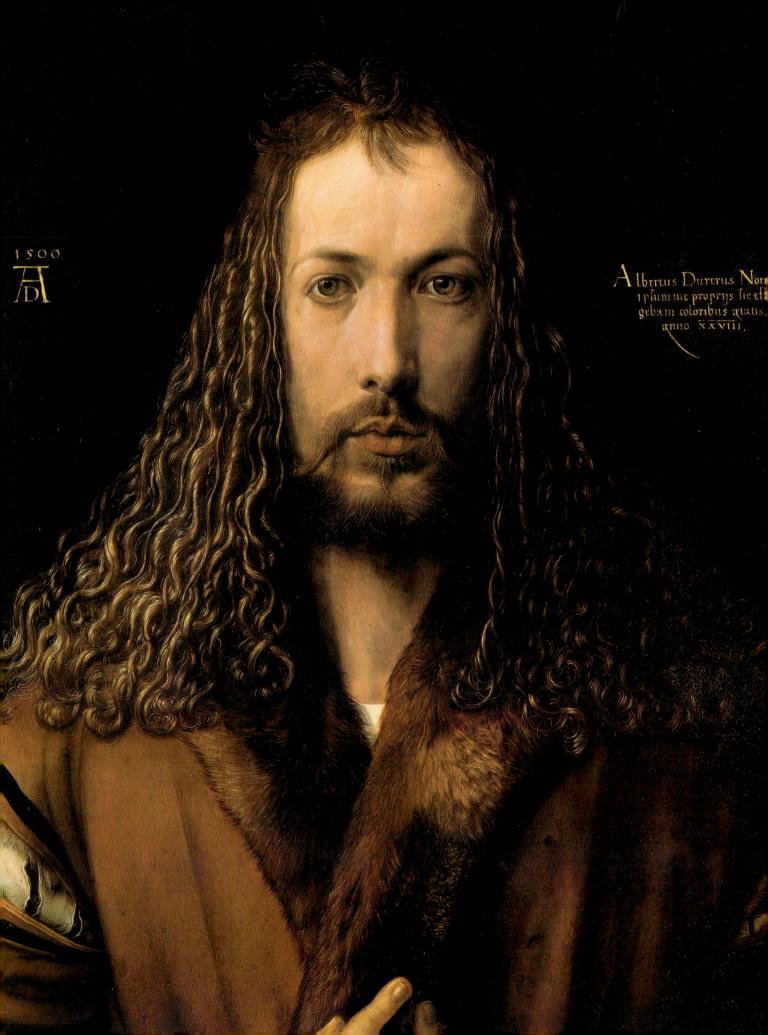

CHAPTER 14

THE RENAISSANCE IN THE NORTH

he ideas and artistic styles that developed in Italy during the fifteenth and sixteenth centuries produced immense changes in the cultural life of England, France, Germany, and the Netherlands. As the Renaissance spread beyond the Alps, the new humanism it carried roused Northern Europe from its conservative intellectual patterns and offered an alternative to traditional religious doctrines. The infusion of Italian ideas produced a new breadth of vision that was responsible for some of the greatest northern painting and for important developments in music. By the end of the sixteenth century, under the influence of humanism, a brilliant cultural life had developed in Elizabethan England, where Renaissance English drama achieved its greatest glory in the work of William Shakespeare.

This was not the first time Northern Europe and Italy had come into contact. During the fourteenth century a style of late-Gothic painting reflecting the grace and elegance of courtly life on both sides of the Alps had developed. Known as the International Style, it was popular in both Italy and Northern Europe. Furthermore, as early as the beginning of that century, German scholars who had traveled to Italy to study returned home with a new enthusiasm for classical antiquity. Nor was the northern Renaissance merely based on Italian ideas, the wholesale adoption by Northern European artists of foreign ways and styles. Northern artists drew upon a rich native past and were able to incorporate exciting new ideas from Italy into their own vision of the world. One of the chief characteristics of northern Renaissance art, in fact, was its emphasis on individualism; painters like Albrecht Dürer and Albrecht Altdorfer are as different from each other as they are from the Italian artists who initially influenced them.

The spread of Italian Renaissance ideas to the north was in many respects political rather than cultural. Throughout most of the sixteenth century the great monarchs of Northern Europe vied with one another for political and military control over the states of Italy and, in the process, were brought into contact with the latest developments in Italian artistic and intellectual life, and often based their own courts on Italian models. Francis I,

who ruled France from 1515 to 1547, made a deliberate attempt to expose French culture to Italian influences by doing everything he could to attract Italian artists to the French court; among those who came were Leonardo da Vinci, Andrea del Sarto (1486–1530), and Benvenuto Cellini [14.1]. Francis and his successors also esteemed literature and scholarship highly. Francis' sister, Marguerite of Navarre, herself a writer of considerable gifts, became the center of an intellectual circle that included many of the finest minds of the age.

The history of Germany is intimately bound up with that of the Hapsburg family. In the first half of the sixteenth century the same Hapsburg king who ruled Germany (under the old name of the Holy Roman Empire) with the title of Charles V ruled Spain under the title of Charles I. Charles was the principal competitor of Francis I for political domination of Italy, and although his interest in the arts was less cultivated than that of his rival, his conquests brought Italian culture to both Spain and the north [14.2]. On his abdication (1556) he divided his vast territories between his brother Ferdinand and his son Philip. The Austrian and Spanish branches of the Hapsburg family remained the principal powers in Europe until the 1650s.

For most of the Renaissance, England remained under the dominion of a single family—the Tudors—whose last representative was Elizabeth I. Like her fellow rulers, in the course of her long reign (1558–1603) Elizabeth established her court as a center of art and learning. Although the influence of Italian models on the visual arts was less marked in England than elsewhere, revived interest in Classical antiquity and the new humanism it inspired is reflected in the works of Shakespeare and other Elizabethan writers.

Although the art of the great northern centers drew heavily on Italy for inspiration, another factor was equally important. The sixteenth century was a period of almost unparalleled intellectual tumult, in which traditional ideas on religion and the nature of the universe were shaken and often permanently changed. Many of the revolutionary movements of the age were in fact northern in origin, and not surprisingly they had a

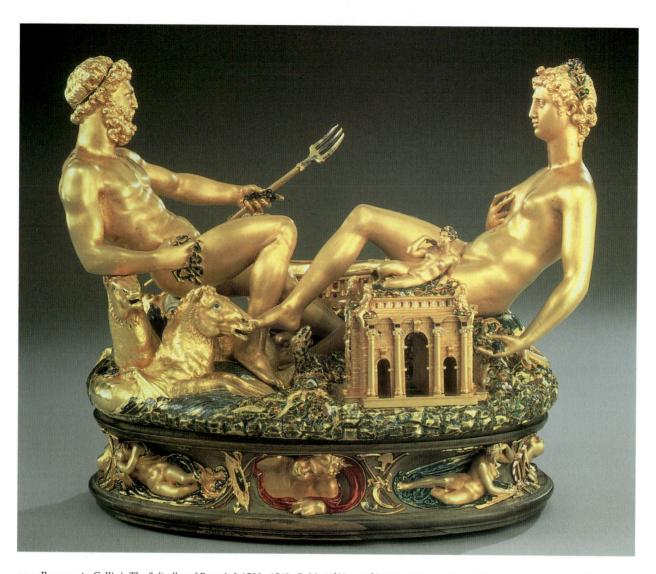

14.1 Benvenuto Cellini. *The Saltcellar of Francis I*, 1539–1543. Gold, $10^{1}/_{4}'' \times 13^{1}/_{8}''$ (26 \times 33 cm). Kunsthistorisches Museum, Vienna. The male figure is Sea; the female is Land. "Both figures were seated with their legs interlaced, just as the arms of the sea run into the land," said Cellini.

profound effect on the art, music, and literature being produced in the same place and time. While northern artists were being influenced by the styles of their fellow artists south of the Alps, their cultural world was being equally shaped by theologians and scientists nearer home. The intellectual developments of this world form a necessary background to its artistic achievements.

THE REFORMATION

On the eve of All Saints' Day in 1517, a German Augustinian friar, Martin Luther (1483–1546), tacked on the door of the collegiate Church of Wittenberg, a parchment containing ninety-five academic propositions (theses) written in Latin—the usual procedure for advertising an

academic debate [14.3]. Luther's theses constituted an attack on the Roman Catholic doctrine of indulgences (forgiveness of punishment for sins, usually obtained either through good works or prayers along with the payment of an appropriate sum of money); a timely topic since an indulgence was currently being preached near Wittenberg to help raise funds for the rebuilding of Saint Peter's in Rome.

Luther's act touched off a controversy that went far beyond academic debate. For the next few years there were arguments among theologians, while Luther received emissaries and directives from the Vatican as well as official warnings from the pope. Luther did not waver in his criticisms. On June 15, 1520, Pope Leo X (Giovanni dé Medici, son of Lorenzo the Magnificent) condemned Luther's teaching as heretical and, on January 3, 1521,

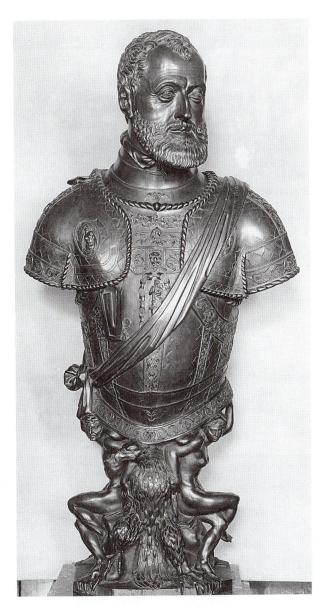

14.2 Leone Leoni. *Bust of Emperor Charles V*, 1533–1555. Bronze. Height 44" (112 cm). Kunsthistorisches Museum, Vienna. The sculptor deliberately portrayed the German ruler as a Roman emperor, thus associating Charles with both Italy and Classical antiquity.

excommunicated him from the Catholic Church. The Protestant Reformation had been born.

Luther's reformation principles began to be applied in churches throughout Germany and a rapid and widespread outbreak of other reforming movements was touched off by Luther's example. By 1523, radical reformers far more iconoclastic than Luther began to agitate for a purer Christianity free from any trace of "popery." These radical reformers are often called *anabaptists* ("baptized again") because of their insistence on adult baptism even if baptism had been performed in infancy. Many of these anabaptist groups had radical social and

political ideas, including pacifism and the refusal to take oaths or participate in civil government, which appealed to the discontent of the lower classes. One outcome was the Peasants' War in Germany, put down with ferocious bloodshed in 1525.

The Reformation was not confined to Germany. In 1523, Zurich, Switzerland, accepted the reformation ideal for its churches. Under the leadership of Ulrich Zwingli (1484–1531) Zurich, and later Berne and Basel, adopted Luther's reforms, including the abolition of statues and images and the right of the clergy to marry (abolishing celibacy). In addition, the list of sacraments was greatly reduced and modified to include only baptism and the Lord's Supper (communion). In Geneva, John Calvin (1509–1564) preached a brand of Protestantism even more extreme than that of either Luther or Zwingli. Calvin's doctrines soon spread north to the British Isles, especially Scotland, under the Calvinist John Knox; and west to the Low Countries, especially Holland. In England, King Henry VIII (born 1491, reigned

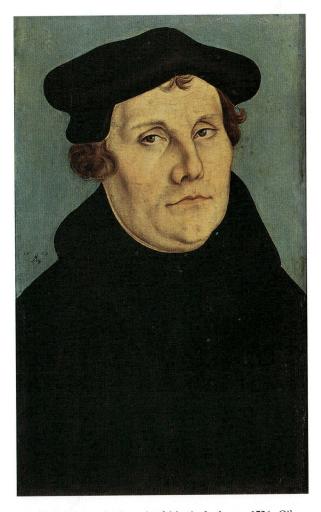

14.3 Lucas Cranach. Portrait of Martin Luther, c. 1526. Oil on panel, $15'' \times 9''$ (38 \times 24 cm). Galleria degli Uffizi, Florence, Italy.

CONTEMPORARY VOICES

Katherine Zell

Many of the Reformation's most active figures were women. Katherine Zell (1497-1562) was the wife of Matthew Zell, one of the first priests to demonstrate his break from the church by marrying. When he died, Katherine continued his teaching and pastoral work. She wrote this letter in 1558 to an old friend who was suffering from leprosy:

My dear Lord Felix, since we have known each other for a full thirty years I am moved to visit you in your long and frightful illness. I have not been able to come as often as I would like, because of the load here for the poor and the sick, but you have been ever in my thoughts. We have often talked of how you have been stricken, cut off from rank, office, from your wife and friends, from all dealings with the world which recoils from your loathsome disease and leaves you in utter loneliness. At first you were bitter and utterly cast down till God gave you strength and patience, and now you are able to thank him that out of love he has taught you to bear the cross. Because I know that your illness weighs upon you daily and may easily cause you again to fall into despair and rebelliousness, I have gathered some passages which may make your voke light in the spirit, though not in the flesh. I have written meditations on the 51st Psalm: "Have mercy upon me, O God, according to thy loving-kindness," and the 130th, "Out of the depths have I cried unto thee, O Lord." And then on the Lord's Prayer and the Creed.

From R. H. Bainton, Women of the Reformation in Germany and Italy (Boston: Beacon, 1974), 69.

1509-1547), formerly a stout opponent of Lutheranism, broke with Rome in 1534 because the pope refused to grant him an annulment from his first wife, Katherine of Aragon [14.4]. In that same year (1534), Henry issued the Act of Supremacy, declaring the English sovereign head of the church in England.

By the middle of the sixteenth century, Europe—for centuries solidly under the authority of the Church of Rome-was therefore divided in a way that has remained essentially unaltered. Spain and Portugal, Italy, most of France, southern Germany, Austria, parts of Eastern Europe (Poland, Hungary, and parts of the Balkans), and Ireland remained Catholic, while most of Switzerland, the British Isles, all of Scandinavia, northern and eastern Germany, and other parts of Eastern Europe gradually switched to Protestantism (see "Religious Divisions in Europe c. 1600").

Causes of the Reformation

What conditions permitted this rapid and revolutionary upheaval in Europe? The standard answer is that the medieval church was so riddled with corruption and incompetence that it was like a house of cards waiting to be toppled. This answer, while containing some truth, is not totally satisfactory since it does not explain why the Reformation did not occur a century earlier, when similar or worse conditions prevailed. Why had the Reformation not taken place during the fourteenth century, when there were such additional factors as plague, schisms, and wars as well as incipient reformers clamoring for change? The exact conditions that permitted the Reformation to happen are difficult to pinpoint, but any explanation must take into account a number of elements that were clearly emerging in the sixteenth century.

First, there was a rising sense of nationalism in Europe combined with increasing resentment at the economic

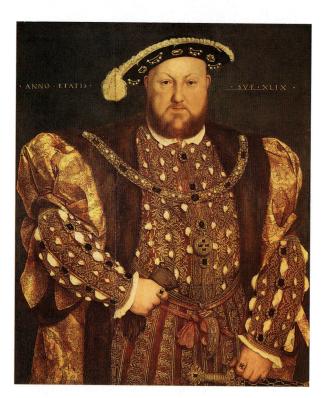

14.4 Hans Holbein the Younger. Henry VIII in Wedding Dress, 1540. Oil on panel, $32\frac{1}{2}$ " \times 29" (83 \times 74 cm). Galleria Barberini, Rome. Weddings were not uncommon events in Henry's life. This wedding, when he was in his 49th year, as the inscription says, was probably the ill-fated one to his fourth wife, Anne of Cleves (see Figure 14.25).

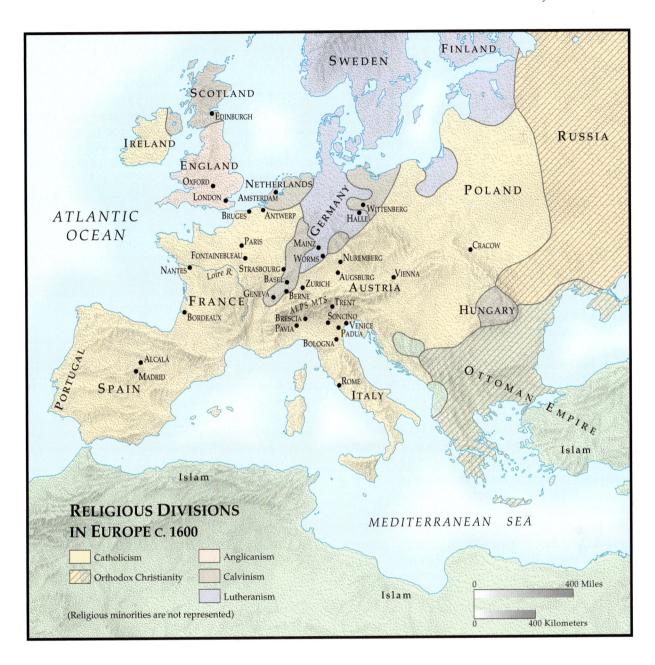

and political demands made by the papacy, many of which ignored the rights of individual countries. Thus Luther's insistence that the German rulers reform the church because the church itself was impotent to do so appealed to both economic and nationalistic self-interests.

Second, the idea of reform in the church had actually been maturing for centuries, with outcries against abuses and pleas for change. Some of the great humanists who were contemporaries of Luther—including Erasmus of Rotterdam, Thomas More in England, and Jacques Lefèvre d'Étaples in France—had also pilloried the excesses of the church. These men, and many of their followers and devoted readers, yearned for a deeper, more interior piety, free from the excessive pomp and cere-

mony that characterized so much of popular medieval religion. Luther's emphasis on personal conversion and his rejection of much of the ecclesiastical superstructure of Catholicism appealed to the sensibilities of many people. That the reformers to the left of Luther demanded even more rejection of Catholic practices shows how widespread was the desire for change.

Third, there were a number of other factors clustered around the two already mentioned. The low moral and intellectual condition of much of the clergy was a scandal; the wealth and lands of the monastic and episcopal lords were envied. In short, a large number of related economic and political factors fed the impulses of the Reformation.

Renaissance Humanism and the Reformation

The relationship between Renaissance humanism and the Protestant Reformation is significant if complex. With the single exception of John Calvin, none of the major church reformers were professional humanists, although all came into contact with the movement. Luther himself had no early contact with the "new learning," even though he utilized its fruits. Nevertheless, humanism as far back as the time of Petrarch shared many intellectual and cultural sentiments with the Reformation. We should note these similarities before treating the wide differences between the two movements.

The reformers and the humanists shared a number of religious aversions. They were both fiercely critical of monasticism, the decadent character of popular devotion to the saints, the low intellectual preparation of the clergy, and the general venality and corruption of the higher clergy, especially the papal *curia*—the body of tribunals and assemblies through which the pope governed the church.

Both the humanists and the reformers felt that the scholastic theology of the universities had degenerated into quibbling arguments, meaningless discussions, and dry academic exercises bereft of any intellectual or spiritual significance. In a common reaction, both rejected the scholastics of the medieval universities in favor of Christian writers of an earlier age. John Calvin's reverence in the sixteenth century for the writings of the early Christian church father and philosopher Augustine (354–430) echoed the equal devotion of Petrarch in the fourteenth century.

Humanists and reformers alike spearheaded a move toward a better understanding of the Bible based not on the authority of theological interpretation but on close, critical scrutiny of the text, preferably in the original Hebrew and Greek. Indeed, the mastery of the three biblical languages (Latin, Greek, and Hebrew) was considered so important in the sixteenth century that schools were founded especially for the specific purpose of instruction in them. Some famous academic institutions, including Corpus Christi College, Oxford; the University of Alcalá, Spain; and the Collège de France in Paris, were founded for that purpose. Luther's own University of Wittenberg had three chairs for the study of biblical languages.

We can see the connection between humanist learning and the Reformation more clearly by noting some aspects of Luther's great translation of the Bible into German. Although there had been many earlier vernacular translations into German, Luther's, which he began in 1521, was the first produced entirely from the original languages, and the texts he used illuminate the contribution of humanist learning. For the New Testament, he used the critical Greek edition prepared by Erasmus. For the Book of Psalms, he used a text published in Hebrew

by the humanist printer Froben at Basel in 1516. The other Hebrew texts were rendered from a Hebrew version published by Italian Jewish scholars who worked in the Italian cities of Soncino and Brescia. His translations of the Apocrypha (books not found in the Hebrew canon) utilized the Greek edition of the Apocrypha printed in 1518 by Aldus Manutius at his press in Venice. As an aid for his labors Luther made abundant use of grammars and glossaries published by the humanist scholar Johann Reuchlin.

In short, Luther's great achievement was possible only because much of the groundwork had already been laid by a generation of humanist philologists. This scholarly tradition endured. In 1611, when the translators of the famous English King James Version wrote their preface to the Bible, they noted that they had consulted commentaries and translations as well as translations or versions in Chaldee, Hebrew, Syriac, Greek, Latin, Spanish, French, Italian, and Dutch.

Although there were similarities and mutual influences between humanists and reformers, there were also vast differences. Two are of particular importance. The first relates to concepts of the nature of humanity. The humanist program was rooted in the notion of human perfectibility. This was as true of the Florentine humanists with their strong Platonic bias as it was of northern humanists like Erasmus. The humanists placed great emphasis on the profoundly Greek (or, more accurately, Socratic) notion that education can produce a moral person. Both humanist learning and humanist education had a strong ethical bias: learning improves and ennobles. The reformers, by contrast, felt that humanity was hopelessly mired in sin and could only be raised from that condition by the freely offered grace of God. For the reformers, the humanists' position that education could perfect a person undercut the notion of a sinful humanity in need of redemption.

The contrast between these two points of view is most clearly evident in a polemical debate between Luther and Erasmus on the nature of the human will. In a 1524 treatise called De Libero Arbitrio (On Free Will), Erasmus defended the notion that human effort cooperates in the process of sanctification and salvation. Luther answered in 1525 with a famous tract titled De Servo Arbitrio (On the Bondage of the Will). The titles of the two pamphlets provide a shorthand description of the severe tension existing between the two viewpoints. A second difference between the humanists and the reformers begins with the humanist notion that behind all religious systems lies a universal truth that can be detected by a careful study of religious texts. Pico della Mirandola, for example, believed that the essential truth of Christianity could be detected in Talmudic, Platonic, Greek, and Latin authors. He felt that a sort of universal religion could be constructed from a close application of humanist scholarship

VALUES

Reform

It is almost too obvious but one would have to say that the predominant value that energized Western Europe in the first half of the sixteenth century was the desire for religious *reform*. This impulse manifested itself in different ways but the acting out of the reform impulse would have great sociopolitical effects in Europe and in the newly discovered lands of the "New World."

This desire for reform was an explicit motivating impulse in the work of the northern humanists who believed that their scholarly labors of biblical translation and the recovery of early Christian classics would be a vehicle by which the Christian life of Europe would be invigorated. The humanists of the North believed in reform by scholarship.

The great Protestant reformers did not set out to start new churches. Their goal was to get back to an earlier, less corrupt, kind of Christianity that would reform Christian life. The close contact between Calvin's reform of Geneva and the city's political life was an attempt not only to reinvigorate religious faith but to provide a different model of governance in civil affairs.

The Catholic response to Protestantism is often called a "counterreformation" but, in fact, it was a genuinely internal reformation clarifying both its own be-

liefs and triggering new religious impulses within. The various reactive strategies of Catholicism to the rise of the Protestant world all derived from a deep sense that the church needed a thorough reformation.

The reforming impulses early in the century eventually solidified into discrete church bodies: the Anglicans in England; Presbyterians in Scotland; Calvinists in parts of Switzerland and Holland; Catholicism in the Mediterranean countries; and Lutheranism in parts of Germany and Scandinavia. Like all reforming movements, that of the sixteenth century eventually formed institutions ready and waiting for a time when new reforming impulses would be required.

Already evident in this period was a new spirit in scientific investigation which would sweep away the older authority-based approach to scientific questions in favor of an empirical, investigative mode which would not only revolutionize science but create the need for new reformations in church life. In the rise of the experimental sciences we can see, in the deepest meaning of the word, a reformation of intellectual life coming alive in the culture of the time, a reformation that would show itself to be, in time, antagonistic to the religious reforms of the first part of the century.

to all areas of religion. The reformers, on the other hand, held to a simple yet unshakable dictum: *Scriptura sola* ("the Bible alone"). While the reformers were quite ready to use humanist methods to investigate the sacred text, they were adamant in their conviction that only the Bible held God's revelation to humanity.

As a result of the translation of the Bible into the vernacular language of millions of Northern Europeans, Reformation theologians were able to lay stress on the Scriptures as the foundation of their teachings. Luther and Calvin further encouraged lay education, urging their followers to read the Bible themselves and find there—and only there—Christian truth. In interpreting what they read, individuals were to be guided by no official religious authority but were to make their own judgment following their own consciences. This doctrine is known as "universal priesthood," since it denies a special authority to the clergy. All these teachings, although primarily theological, were to have profound and longrange cultural impacts.

We can see that there was an intense positive and negative interaction between humanism and the Reformation—a movement energized by books in general and

the Bible in particular. The intensely literary preoccupations of fourteenth- and fifteenth-century humanism provided a background and impetus for the sixteenth-century Reformation. As a philosophical and cultural system, however, humanism was in general too optimistic and ecumenical for the more orthodox reformers. In the latter sixteenth century, humanism as a worldview found a congenial outlook in the Christian humanism of Cervantes and the gentle skepticism of Montaigne, but in Reformation circles it was used only as an intellectual instrument for other ends.

Cultural Significance of the Reformation

Cultural historians have attributed a great deal of significance to the Reformation. Some have argued, for example, that with its strong emphasis on individuals and their religious rights, the Reformation was a harbinger of the modern political world. However, with equal plausibility one could make the case that with its strong emphasis on social discipline and its biblical authoritarianism, the Reformation was the last great spasm of the

medieval world. Likewise, in a famous thesis developed in the early twentieth century by the German sociologist Max Weber, Calvinism was seen as the seedbed and moving force of modern capitalism. Weber's proposition has lingered in our vocabulary in phrases like "work ethic" or "Puritan ethic," although most scholars now see it as more provocative than provable. Regardless of the scholarly debates about these large questions, there are other, more clearly defined ways in which the Protestant Reformation changed the course of Western culture.

First, the Reformation gave a definite impetus to the already growing use of books in Europe. The strong emphasis on the reading and study of the Bible produced inevitable concern for increased literacy. Luther, for example, wanted education to be provided free to children from all classes in Germany.

The central place of the Bible in religious life made an immense impact on the literary culture of the time. Luther's Bible in Germany and the King James Version in England exercised an inestimable influence on the very shape of the language spoken by their readers. In other countries touched by the Reformation the literary influence of the translated Bible in was absolutely fundamental. In the Scandinavian countries, vernacular literature really began with translations of the Bible. In Finland, a more extreme example, Finnish was used as a written language for the first time in translating the Bible.

The Bible was not the only book to see widespread diffusion in this period. Books, pamphlets, and treatises crisscrossed Europe as the often intricate theological battles were waged for one or another theological position. It is not accidental that the Council of Trent (1545–1564), a prime instrument of the Catholic counterreform, stringently legislated the manner in which copies of the Bible were to be translated and distributed. The fact that a list of forbidden books (the infamous *Index*) was instituted by the Catholic Church at this time is evidence that the clerical leadership recognized the immense power of books. The number of books circulating during this period is staggering. Between 1517 and 1520 (even before his break with Rome) Luther's various writings sold about three hundred thousand copies in Europe.

None of this would, of course, have been possible before the Reformation for the simple reason that printing did not exist in Europe. The invention of the printing press and movable type revolutionized Renaissance culture north and south of the Alps in the same way that films, radio, television, and the Internet changed the twentieth century [14.5]. There were two important side effects. The early availability of "book learning" undermined the dominance of universities, which had acted as the traditional guardians and spreaders of knowledge. Also, Latin began to lose its position as the only language for scholarship, since many of the new readers

could not read or write it. Luther grasped the implications of the spread of literacy fully, and his use of it to advance his cause was imitated countless times in the centuries that followed.

A second cultural fact about the Reformation, closely allied to the first, is also noteworthy. The reformers placed great emphasis on the *Word*. Besides reading and listening there was also singing, and the reformers—especially Luther—stressed vernacular hymns. Hymns were seen as both a means of praise and an instrument of instruction. Luther himself was a hymn writer of note. The famous *Ein' Feste Burg Ist Unser' Gott (A Mighty Fortress Is Our God)*, one of the best-loved hymns in Christianity, is generally attributed to him [14.6]. Indeed, the German musical tradition, which ultimately led to Johann Sebastian Bach in the seventeenth century, was very much the product of the Lutheran tradition of hymnody.

http://www.luther.de/e/legenden.html

Martin Luther

Adlin ergo allimilari cis. Scir enim pater velter quid opus lit vodis: an requă perans cum. Sic ergo vos ora biris. Pam notter qui es în clis lan dificeur nome tux. Adveniar regnă tux. Itar volutas tua: licut in clo et în tera. Pane notră luplubităriale da nodis hodie. Et diminte nodis a bira notra: licut et nos dimintimus dediroribus notris. Et ne nos induras în tempranome: led libera nos a malo. Si eum dimilecins pominibis peccata con: diminte et vodis pane velter celetis delicta veltra. Si autem non dimiferius hominibus: nec va

14.5 Portion of a page from the Gutenberg Bible, 1455. Rare Books and Manuscript Division, New York Public Library. The Latin text of the Lord's Prayer (Matthew 6:9–13) begins on the fourth line with *Pater noster*. The first edition of this Bible printed at Mainz probably consisted of no more than 150 copies.

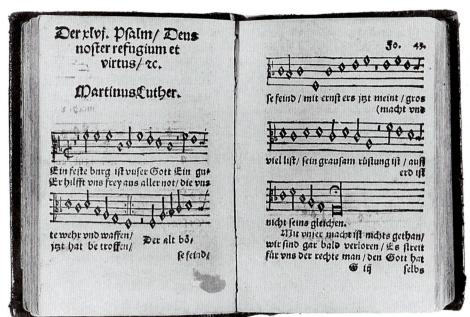

14.6 Luther's German Psalter. Lutherhalle, Wittenberg. The book is open at Luther's hymn Ein' Feste Burg, which is taken from one of the Psalms. The Latin words above Luther's name mean "God: Our refuge and strength." The hymn is printed in German.

On the other hand, the sixteenth-century reformers had little need or sympathy for the painting and sculpture. They were in fact militantly iconoclastic. One of the hallmarks of the first reformers was their denunciation of paintings, statues, and other visual representations as forms of papist idolatry. The net result of this iconoclastic spirit was that, by the beginning of the seventeenth century, patronage for the sacred visual arts had virtually died out in countries where the Reformation was strong.

With the single exception of Rembrandt (and this exception is gigantic) it is difficult to name any first-rate painter or sculptor who worked from a Reformation religious perspective after the sixteenth century, although much secular art was produced.

The attitude of the sixteenth-century reformers toward the older tradition of the visual arts may best be summed up by the Church of Saint Peter in Geneva, Switzerland. Formerly a Romanesque Catholic cathedral of the twelfth century, Saint Peter's became Calvin's own church. The stained glass was removed, the walls whitewashed, the statues and crucifixes taken away, and a pulpit placed where the high altar once stood. The Church of Saint Peter is a thoroughly reformed church, a building whose entire function is for the hearing of the preached and read word. Gone is the older notion (represented, for example, by the Cathedral of Chartres) of the church reflecting the otherworldly vision of heaven in the richness of its art. Reformation culture was in short an *aural*, not a *visual*, culture.

INTELLECTUAL DEVELOPMENTS

Montaigne's Essays

Michel Eyquem de Montaigne (1533–1593) came from a wealthy Bordeaux family. His father, who had been in Italy and was heavily influenced by Renaissance ideas, provided his son with a fine early education. Montaigne spoke nothing but Latin with his tutor when he was a child, so that when he went to school at age six he spoke Latin not only fluently but with a certain elegance. His later education (he studied law for a time) was a keen disappointment to him because of its pedantic narrowness. After a few years of public service, in 1571 Montaigne retired with his family to a rural estate to write and study. There, with the exception of a few years traveling and some further time of public service, he remained until his death.

The times were not happy. France was split over the religious issue, as was Montaigne's own family. He remained a Catholic, but his mother and sisters became Protestants. Only a year after his retirement came the terrible Saint Bartholomew's Day Massacre (August 24, 1572), in which thousands of French Protestants were slaughtered in a bloodbath unequaled in France since the days of the Hundred Years' War. In the face of this violence and religious bigotry, Montaigne returned to a study of the classics and wrote out his ideas for consolation.

Montaigne's method was to write on a widely variegated list of topics gleaned either from his readings or from his own experiences. He called these short meditations essays. Our modern form of the essay is rooted in Montaigne's first use of the genre in Europe. The large numbers of short essays Montaigne wrote share certain qualities characteristic of a mind wearied by the violence and religious bigotry of the time: a sense of stoic calmness (derived from his study of Cicero and Seneca), a tendency to moralize (in the best sense of that abused word) from his experiences, a generous nondogmatism, a vague sense of world-weariness.

The Growth of Science

The sixteenth century was not merely a turning point in the history of religions, it was also a decisive age in the history of science. In earlier times a scientist was likely enough to be an ingenious tinkerer with elaborate inventions who dabbled in alchemy, astrology, and magic [14.7]. The new Renaissance scientist, a person of wide learning with a special interest in mathematics and philosophy, would develop bold and revolutionary ideas but always subject them to the test of practical experience [14.8].

The age produced many advances in science. In England alone William Gilbert (1540–1603) discovered that the earth was a large magnet the pole of which points approximately north; Sir William Harvey (1578–1657) solved the problem of how the blood could "circulate"—get from the arteries to the veins and return to the

heart-by postulating the existence of the thenundiscovered channels we now call "capillaries"; John Napier (1550–1615) discovered the very practical mathematical tool called the *logarithm*, which greatly reduced the time and effort needed to solve difficult equations. Elsewhere in Europe, the German Paracelsus (1493-1541) laid the foundations of modern medicine by his decisive rejection of traditional practices. Although his own theories were soon rejected, his insistence on observation and inquiry had important consequences, one of which can be seen in the work of Andreas Vesalius (1514–1564), who was born in Brussels and studied in Padua. Vesalius' De humani corporis fabrica (Seven Books on the Structure of the Human Body), published in 1543, comprise a complete anatomical treatise, illustrating in minute detail and with impressive accuracy the human form [14.9].

The philosophical representative of the "new science" was Francis Bacon (1561-1626), who combined an active and somewhat disreputable political career with the writing of works intended to demolish traditional scientific views. The chief of these books was the Novum Organum (New Organon, 1620), which aimed to free science from the two-thousand-year-old grasp of Aristotle while at the same time warning against the unrestrained use of untested hypotheses. Science and religion came into direct conflict in the work of the Polish astronomer Nicholaus Copernicus (1473-1543), who studied at the universities of Cracow and Bologna. In 1543, the same year Vesalius' work appeared, Copernicus published De Revolutionibus orbium coelastium (On the Revolutions of Celestial Bodies,) a treatise in which he denied that the sun and the planets revolve around the earth, and reverted

14.7 Giulio Campagnola. The Astrologer, 1509. Engraving, $3^3/4^n \times 6^n$ (9.5 \times 15 cm). British Museum, London (reproduced by courtesy of the Trustees). The old-fashioned astrologer is shown with all the paraphernalia of his craft, immersed in mystical speculation and apparently accompanied by his pet monster.

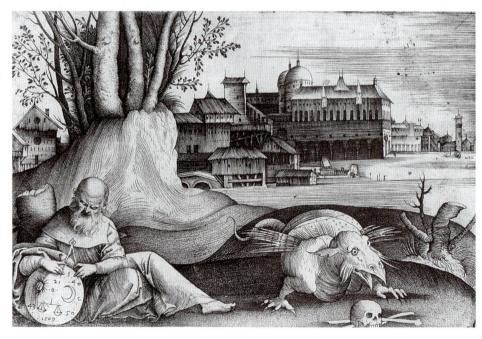

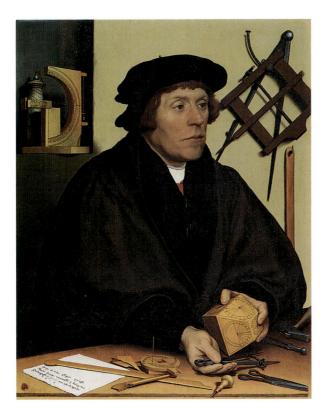

14.8 Hans Holbein the Younger. *Nikolaus Kratzer*, 1528. Tempera on panel, $32'' \times 26''$ (83×67 cm). Louvre, Paris. The new scientists are represented here by Kratzer, official astronomer to the court of Henry VIII and a friend of Dürer. The tools used in the calculation he is making are devised for maximum precision, and the room in which Kratzer is working is equipped as a library.

instead to a long-dead Greek theory that the earth and planets orbit the sun. Catholic and Protestant theologians for once found themselves united in their refusal to accept an explanation of the universe that seemed to contradict the teaching of the Bible, but Copernicus' work, though not a complete break with the past, provided stimulus for Galileo's astronomical discoveries in the following century.

Additionally, the general principle behind Copernicus' method had important repercussions for the entire history of science. Up to his time scientists had taken the position that, with certain exceptions, reality is as it appears to be. If the sun appears to revolve about the earth, that appearance is a "given" in nature, not to be questioned. Copernicus questioned the assumption, claiming that it was equally plausible to take the earth's mobility as a given, since everything that had been explainable in the old way was fully explainable in the new (see Table 14.1). Copernicus' position on scientific matters was thus the equivalent of Luther's stand on the fallibility of the church.

THE VISUAL ARTS IN NORTHERN EUROPE

Painting in Germany: Dürer, Grünewald, Altdorfer

http://artchive.com/artchive/D/durer.html

Albrecht Dürer

The conflict between Italian humanism, with its belief in human perfectibility, and the Reformation, which emphasized sin and the need for prayer, is reflected in the art of the greatest German painters of the early sixteenth

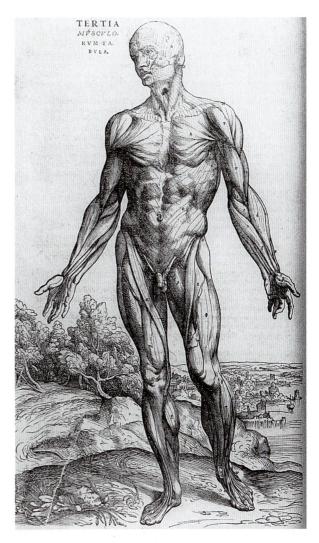

14.9 Andreas Vesalius. "Third Musculature Table" from *De humani corporis fabrica*, Brussels, 1543. National Library of Medicine, Bethesda, Maryland.

TABLE 14.1 Principal Discoveries and Inventions in the Sixteenth Century

1486	Diaz rounds Cape of Good Hope
1492	Columbus discovers America
1493-1541	Paracelsus pioneers the use of chemicals to treat disease
1513	Balboa sights the Pacific Ocean
1516	Portuguese ships reach China
1520 - 1522	First circumnavigation of globe by
	Magellan
1530-1543	Copernicus refutes geocentric view of uni-
1.500	verse
1533	Gemma Frisius invents principle of trian-
	gulation in surveying
1542	Leonhart Fuchs publishes herbal guide to medicine
1543	Vesalius publishes anatomical treatise
1546	Agricola publishes guide to metallurgy
1569	Mercator devises system of mapmaking
1572	Tycho Brahe observes first supernova and produces first modern star catalogue
1582	Pope Gregory XIII reforms the calendar
c. 1600	First refracting telescope constructed in
	Holland
1600	William Gilbert publishes treatise on magnetism

century. It might even be said that the intellectual and religious battles of the times stimulated German art to its highest achievements, for both Albrecht Dürer (1471–1528) and Matthias Grünewald (c. 1470–1528) are, in very different ways, towering figures in the development of European painting. Despite his sympathy with Luther's beliefs, Dürer was strongly influenced by Italian artistic styles and, through Italian models, by Classical ideas. Grünewald, on the other hand, rejected almost all Renaissance innovations and turned instead to traditional northern religious themes, treating them with new passion and emotion. Other artists, meanwhile, chose not to wrestle with the problems of the times. Some, including Albrecht Altdorfer (1480–1538), preferred to stand back and create a worldview of their own.

Dürer was born in Nuremberg, the son of a gold-smith. Even as a child he showed remarkable skill in drawing. His father apprenticed him to a wood engraver, and in 1494–1495—after finishing his training—Dürer made the first of two visits to Italy. There he saw for the first time the new technique of *linear perspective* (where all parallel lines converge at a single vanishing point) and came into contact with the growing interest in human anatomy. Quite as important as these technical discoveries, however, was his perception of a new function for the artist. The traditional German—indeed, medieval—view of the artist was as an artisan

whose task was humbly, if expertly, to reproduce God's creations.

Dürer adopted Renaissance humanism's concept of the artist as an inspired genius, creating a unique personal world. It is not by chance that a first glance at his *Self-Portrait* of 1500 [14.10] suggests a Christlike figure rather than a prosperous German painter of the turn of the century. The effect is intentional. The lofty gaze of the eyes underlines the solemn, almost religious nature of the artist's vision, while the prominent hand draws attention to his use of the pen and the brush to communicate it to us.

In his paintings, Dürer shows a fondness for precise and complex line drawing rather than the softer use of mass and color typical of Italian art. In fact, much of his greatest work appears in the more linear *woodcuts* and *engravings*. In 1498, Dürer published a series of fifteen woodcuts illustrating the Revelation of Saint John, known as the *Apocalypse* series. Woodcut engravings are produced by drawing a design on a block of soft wood, then cutting away the surrounding wood to leave the

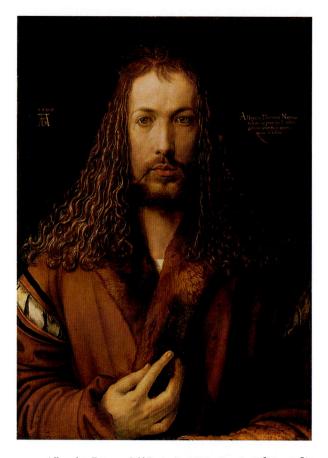

14.10 Albrecht Dürer. *Self-Portrait,* 1500. Panel, $25^5/8'' \times 18^7/8''$ (64 × 48 cm). Alte Pinakothek, Munich. The frontal pose and solemn gaze convey Dürer's belief in the seriousness of his calling.

lines of the drawing standing in relief. The blocks of wood can then be coated with ink and used to print an impression on paper.

In the hands of Dürer this relatively simple technique was raised to new heights of expressiveness, as in his depiction of Saint Michael's fight against the dragon from the *Apocalypse* series [14.11]. In the upper part of the scene, Michael and other angels—all with long hair curiously like Dürer's own—do battle with a gruesome horde of fiends, while the peaceful German landscape below seems untouched by the cosmic fight in progress. Dürer's vision of an apocalyptic struggle between good and evil reflected the spirit of the time and copies of the *Apocalypse* series sold in large quantities. Growing discontent with the church was, as we have seen, one of the causes of Luther's Reformation; the general sense of forthcoming trouble and upheaval gave Dürer's woodcuts a particular aptness.

The medium of *line engraving* was also one to which Dürer brought an unsurpassed subtlety and expressiveness. Unlike a woodblock, where the artist can complete the drawing before cutting away any material, the cop-

per plate from which a line engraving is printed has to be incised directly with the lines of the design by means of a sharp-pointed steel instrument called a burin. The richness of effect Dürer achieved in this extremely difficult medium, as in his engraving of The Fall of Man (Adam and Eve) [14.12], is almost incredible. The engraving further demonstrates not only his technical brilliance but also the source of much of his artistic inspiration. The carefully shaded bodies of Adam and Eve reflect the influence of contemporary Italian ideals of beauty, while the proportions of the figures are derived from Classical literary sources. Dürer made up for the lack of actual Greek and Roman sculpture in Germany by a careful reading of ancient authors, from whom he derived a system of proportion for the human figure.

Dürer returned to Italy in 1505 and spent most of his two-year stay in Venice, discussing theoretical and practical aspects of Renaissance art with Bellini and other Venetian artists. It was inevitable that the rich color characteristic of Venetian painting would make an impression on him, and many of his works of this period (1505–1507) try to outdo even the Venetians in splendor.

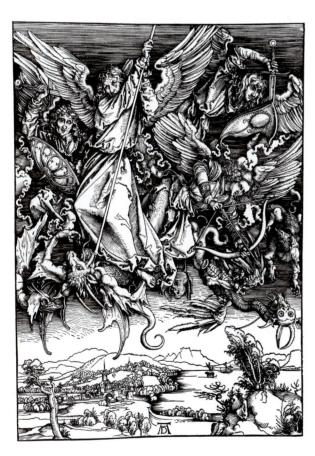

14.11 Albrecht Dürer. "Saint Michael Fighting the Dragon," from the *Apocalypse* series, 1498. Woodcut, $15^{1}/_{2}$ " × $11^{1}/_{8}$ " (39 × 28 cm). British Museum, London (reproduced by courtesy of the Trustees). Note Dürer's characteristic signature at the center bottom.

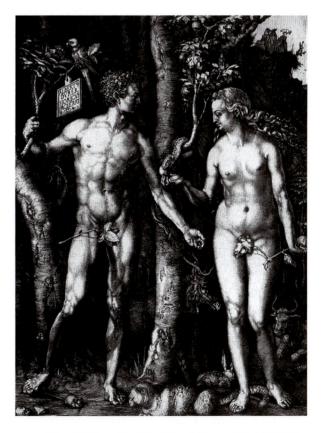

14.12 Albrecht Dürer. *The Fall of Man (Adam and Eve)*, 1504. Engraving, $9^7/8'' \times 7^5/8''$ (25 × 19 cm). Centennial Gift of Landon T. Clay. Courtesy of Museum of Fine Arts, Boston. The animals represent the sins and diseases that resulted from Adam and Eve's eating of the tree of knowledge: the cat, pride and cruelty; the ox, gluttony and sloth; and so on.

His renewed interest in painting was, however, brief. For most the remainder of his life he devoted himself to engraving and to writing theoretical works on art. Between 1513 and 1515, Dürer produced his three greatest engravings. The earliest of these, *Knight, Death, and the Devil* [14.13], again reflects contemporary religious preoccupation with its symbolic use of the Christian knight accompanied by a dog who represents untiring devotion, and beset by the temptations of the devil (in a particularly untempting guise, it must be admitted). Neither this fearsome creature nor the appearance of Death, armed with an hourglass, can shake the knight's steadfast gaze.

By the end of his life Dürer was acknowledged as one of the great figures of his time. Like Luther, he made use of the new possibilities of the printing press to disseminate his ideas. At the time of his death, Dürer was working on Libri IV De Humani Corporis Proportionibus (Four Books on Human Proportions). This work (in Latin), aimed to accomplish for art what Vesalius' did for medicine. It was inspired by two of the great intellectual concerns of the Renaissance: a return to Classical ideals of beauty and proportion, and a new quest for knowledge and scientific precision.

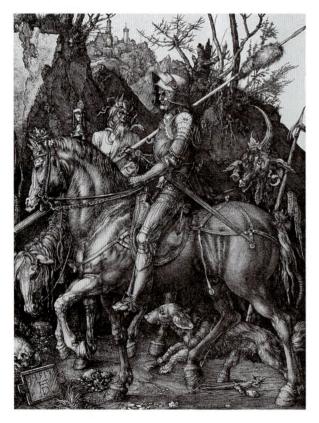

14.13 Albrecht Dürer. Knight, Death, and the Devil, 1513. Engraving, $95\% \times 73\% \times 124 \times 18$ cm). The Metropolitan Museum of Art, Harris Brisbane Dick Fund, 1943. The knight's calm determination reflects Dürer's confidence in the ability of the devout Christian to resist temptation. This engraving may have been inspired by Erasmus' Handbook of the Christian Knight.

Although the work of Grünewald represents the other high point in German Renaissance art, very little is known about his life. Only in the twentieth century did we discover his real name, Mathis Gothart Neithart; the date of his birth and the early years of his career are still a mystery. Grünewald seems to have worked for a while at the court of the Cardinal Archbishop of Mainz, but in the 1525 Peasants' War he sided with the German peasants in their revolt against the injustices of their rulers, after which his enthusiasm for Luther's new ideas kept him from returning to the cardinal's service. He retired to Halle, where he died in 1528.

What we know about his political and religious sympathies—his support for the oppressed and for the ideals of the Reformation—is borne out by the characteristics of his paintings. Unlike Dürer, Grünewald never visited Italy, and showed no interest in the new styles developed there. The Renaissance concept of ideal beauty and the humanist interest in Classical antiquity left him unmoved. Instead, he turned again and again to the traditional religious themes of German medieval art, bringing to them a passionate, almost violent intensity that must at least in part reflect the religious heart-searchings of the times. Yet it would be a mistake to view Grünewald's unforgettable images as merely another product of the spirit of the age, for an artist capable of so unique and personal a vision is in the last analysis inspired by factors that cannot be explained in historical terms. All that can safely be said is that no artist, before or since, has depicted the Crucifixion as a more searing tragedy or Christ's Resurrection as more radiantly triumphant.

Both these scenes occur in Grünewald's greatest work, the Isenheim Altarpiece (completed in 1515), which was commissioned for the church of a hospital run by members of the Order of Saint Anthony. The folding panels are painted with scenes and figures appropriate to its location, including saints associated with the curing of disease and events in the life of Saint Anthony. In particular, the patients who contemplated the altarpiece were expected to meditate on Christ's Crucifixion and Resurrection and derive from them comfort for their own sufferings.

In his painting of Christ in the *Crucifixion* panel [14.14], Grünewald uses numerous details to depict the intensity of Christ's anguish—from his straining hands frozen in the agony of death, to the thorns stuck in his festering body, to the huge iron spike that pins his feet to the cross.

It is difficult to imagine anything further from the Italian Renaissance and its concepts of ideal beauty than this tortured image. Grünewald reveals an equal lack of interest in Renaissance or Classical theories of proportion or perspective. The figure of Christ, for example, is not related in size to the other figures—it dominates the panel—as a glance at the comparative size of the hands will show. Yet the sheer horror of this scene only throws

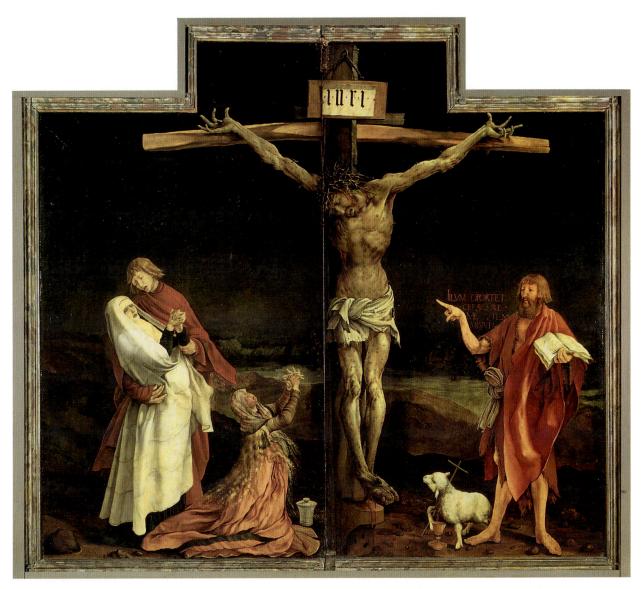

14.14 Matthias Grünewald. Crucifixion from the Isenheim Altarpiece (exterior), completed 1515. Panel (with framing) $9'9^{1}/_{2}'' \times 10'9''$ (2.98 \times 3.28 m). Musée d'Unterlinden, Colmar. Behind Mary Magdalene, who kneels in grief, stand Mary and John; on the other side, John the Baptist points to Christ's sacrifice. Beside him, in Latin, are inscribed the words, "He must increase, but I must decrease." Above Christ are the initial letters of the Latin words meaning "Jesus of Nazareth, King of the Jews."

into greater relief the triumph of the *Resurrection* [14.15]. Christ seems almost to have exploded out of the tomb in a great burst of light that dazzles the viewers as well as the soldiers stumbling below. No greater contrast can be imagined than that between the drooping body on the cross and this soaring, weightless image that suggests a hope of similar resurrection to the sufferers in the hospital.

The drama of Grünewald's spiritual images is in strong contrast to the quiet, poetic calm of the work of

Albrecht Altdorfer. Although closer in style to Grünewald than to Dürer, Altdorfer found his favorite subject not in religious themes but in landscapes. Danube Landscape Near Regensburg [14.16], probably dating from around 1525, is one of the first examples in the Western tradition of a painting without a single human figure. From the time of the Greeks, art had served to tell a story—sacred or secular—or to illustrate some aspect of human behavior. Now for the first time the contemplation of the beauties of nature was in itself deemed a worthy subject for an artist. In this painting, Altdorfer depicts a kind of ideal beauty very different from Dürer's The Fall of Man (see Figure 14.12) but no less moving. Part of his inspiration may have come from the landscapes that can be seen in the background of paintings by Venetian artists like Giorgione, although there is no evidence that Altdorfer ever visited Italy. Even if he had, his sympathy with the forces of nature, its light and scale and sense of life, seems more directly inspired by actual contact.

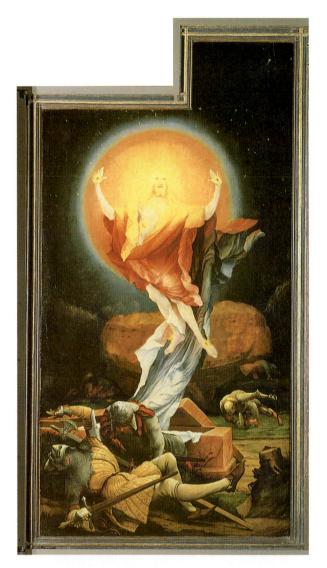

14.15 Matthias Grünewald. *Resurrection* from the Isenheim Altarpiece (first opening). Completed 1515. Panel, $8'2^{1}/_{2}'' \times 3'^{1}/_{2}''$ (2.45 \times .93 m). Musée d'Unterlinden, Colmar. Note the absence of any natural setting and the confused perspective, which give the scene an otherworldly quality.

Painting in the Netherlands: Bosch and Bruegel

http://www.artcyclopedia.com/artists/bosch_hieronymus.html

Bosch

The two greatest Netherlandish painters of the Renaissance, Hieronymus Bosch (c. 1450–1516) and Pieter Bruegel (1525–1569), are linked both by their pessimistic view of human nature and by their use of satire to express it. Bosch furthermore drew upon an apparently in-

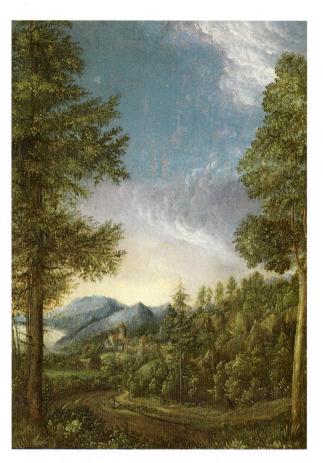

14.16 Albrecht Altdorfer. *Danube Landscape Near Regensburg*, c. 1522–1525. Panel, $11" \times 8^5\/8"$ (28 × 22 cm). Alte Pinakothek, Münich. The only traces of human existence here are the road and the distant castle to which it leads.

exhaustible imagination to create a fantasy world that alternately fascinates and repels as the eye wanders from one bizarre scene to another. Although modern observers have interpreted Bosch's work in a variety of ways, it is generally agreed that, contrary to appearances, he was in fact a deeply religious painter. His chief subject is human folly in its innumerable forms, his theme that the inevitable punishment of sin is Hell. Salvation is possible through Christ, but few, according to Bosch, have the sense to look for it. His paintings show us the consequences.

Almost nothing is known of Bosch's life so his body of work must speak for itself. The most elaborate in its fantasy is a *triptych* (a three-paneled painting) known as the *Garden of Earthly Delights* [14.17, 14.17a], which was probably finished around 1510. Into it are crowded hundreds of nude figures engaged in activities that range from the unimaginable to the indescribable, all in pursuit of erotic pleasure. The movement from the apparently innocent scene of the creation of Eve on the left to the fires of hell on the right illustrates Bosch's belief that the

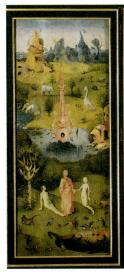

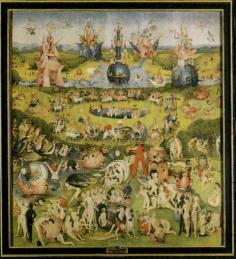

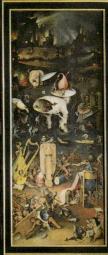

14.17 Hieronymus Bosch. Garden of Earthly Delights, c. 1505-1510. Panel center $7'2^5/8'' \times 6'4^3/4''$ (2.2×1.95 m), each wing $7'2^5/8'' \times 3'2^1/4''$ ($2.2 \times .97$ m). Prado, Madrid. Perhaps surprisingly, this catalog of the sins of the flesh was among the favorite works of the gloomy King Philip II of Spain.

14.17a Hieronymus Bosch. *Garden of Earthly Delights,* c. 1505-1510. Panel detail. Right wing $7'2\frac{5}{8}'' \times 3'2\frac{1}{2}''$ (2.2 × .97 m). Prado, Madrid.

pleasures of the body lead to damnation along a road of increasing depravity. Even in the Garden of Eden we sense what is to come, as Adam sits up with excited enthusiasm on being presented with the naked Eve, while God seems to eye him nervously.

The bright world of the middle panel, in which the pallid, rubbery figures seem to arrange themselves (and one another) in every conceivable position and permutation, gives way on the right to a hallucinatory vision of eternal damnation. Bosch's symbolism is too complex and too private to permit a detailed understanding of the scene, yet his general message is clear enough: Hell is not terrifying so much as it is sordid and pathetic. The frantic scenes of activity are as senseless and futile as those of worldly existence, but in hell their monstrous nature becomes fully apparent.

The sources of Bosch's inspiration in this and his other work are unknown. Many of his demons and fantastic animals seem related to similar manifestations of evil depicted in medieval art, but no medieval artist ever devised a vision such as this or possessed the technique to execute it. To modern eyes some of Bosch's creations, like the human-headed monster on the right-hand panel turning both face and rear toward us, seem to prefigure the surrealist art of the twentieth century. There is a danger, however, in applying labels from the art of later times to that of an earlier period. Bosch must be allowed to stand on his own as one of the great originals in the history of painting.

Pieter Bruegel, often called the Elder to distinguish him from his son of the same name, represents the culmination of Renaissance art in the Netherlands. Like Bosch, his work is often fantastic, and his crowded canvases are frequently filled with scenes of grotesque activity. Some of his paintings suggest that he shared Bosch's view of the apparent futility of human existence and the prevalence of sin. In many of his pictures, however, the scenic

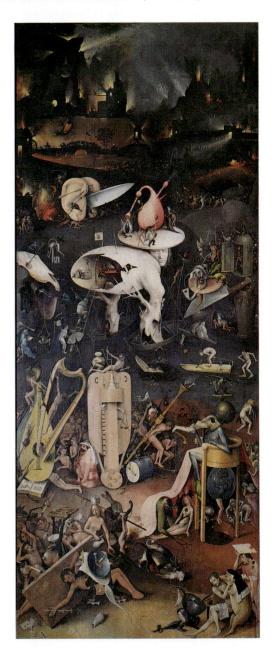

backgrounds reveal a love and understanding of nature very different from Bosch's weird worldview and represent one of the keys to understanding his work. For Bruegel, the full range of human activity formed part of a world in which there existed an underlying order. The beauty of nature forms the background not only to his pictures but actually to the lives of us all, he seems to say; by seeing ourselves as part of the natural cycle of existence we can avoid the folly of sin. If this interpretation of his work is correct, it places Bruegel with the humanists who believed in the possibilities for human good, and there is some evidence to suggest that his friends did include members of a group of humanist philosophers active at Antwerp.

Although Bruegel's best-known paintings are scenes of peasant life, it is a mistake to think of him as unso-phisticated. On the contrary, during the final years of his life, which he spent in Brussels, he was familiar with many of the leading scholars of the day and seems to have been a man of considerable culture. He certainly traveled to Italy, where he was apparently unaffected by the art but deeply impressed by the beauty of the land-

scape. Back home, he may well have supported the move to free the Netherlands from Spanish rule; some of his paintings seem to contain allusions to Spanish cruelties.

Bruegel's vision is so rich and understanding of the range of human experience that it almost rivals that of Shakespeare, who was born in 1564, five years before Bruegel's death. In his great painting The Triumph of Death [14.18], Bruegel looks with uncompromising honesty at the universal phenomenon of death, which comes eventually to all: rich and powerful or poor and hopeless. Unlike Bosch, who reminds us that the righteous (if there are any) will be saved, Bruegel seems to offer no hope. Yet the same artist painted the Peasant Wedding Feast [14.19], a scene of cheerful celebration. True, Bruegel's peasants find pleasure in simple rather than sophisticated delights, in this case chiefly food and drink, but he reminds us that some are luckier than others. The little boy in the foreground, so completely engrossed in licking up every last delicious morsel of food, is counterbalanced by the bagpiper who looks wistfully and wanly over his shoulder at the tray of pies nearby. Nor should we be too hasty to view Bruegel's peasants as unthinking

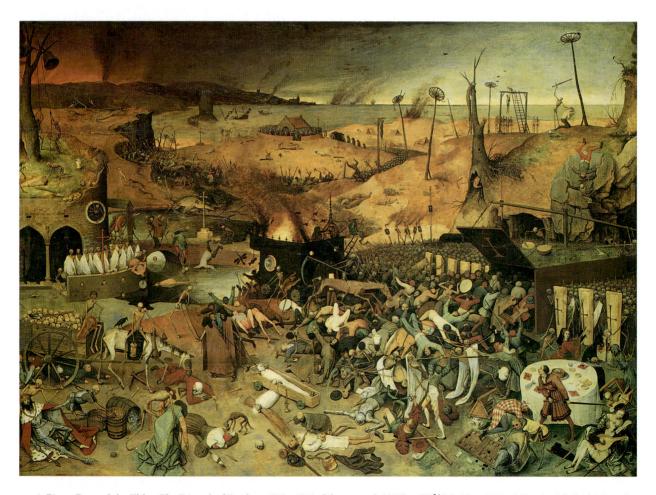

14.18 Pieter Bruegel the Elder. *The Triumph of Death*, c. 1562–1564. Oil on panel, $3'10'' \times 5'3^{3}/4''$ (1.17 × 1.62 m). Prado, Madrid. Note the huge coffin on the right into which the dead are being piled, guarded by rows of skeleton-soldiers.

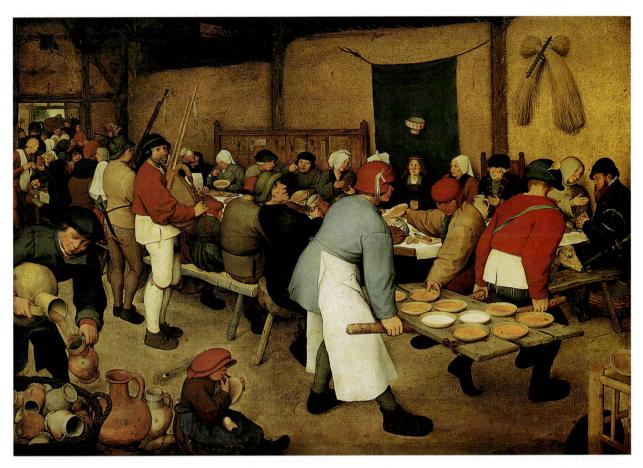

14.19 Pieter Bruegel the Elder. *Peasant Wedding Feast*, 1566–1567. Oil on panel, $3'8'/8'' \times 5'4^{1}/8'''$ (1.14 × 1.63 m). Kunsthistorisches Museum, Vienna. The composition of this painting is based on the diagonal line of the receding table that leads the eye past the bride and the bagpiper to the back of the room.

creatures, content with a brutish existence. The bride certainly does not seem either bright or beautiful, but she radiates happiness, and the general air of merriment is very attractive.

Bruegel's most profound statements are perhaps to be found in a cycle of paintings intended to illustrate the months of the year, rather like the Très Riches Heures of the Limbourg brothers a century earlier (not shown). Bruegel completed only five, including the magnificent Hunters in the Snow (1565) [14.20]. In the background tower lofty peaks representing Bruegel's memory of the Alps, seen on his trip to Italy. From the weary hunters in the foreground a line of barren trees leads the eye to fields of snow where peasants are hard at work. The scene can hardly be called a happy one, but neither is it unhappy. There is an inevitability in the way humans, animals, birds, and nature are all bound together into a unity, expressive of a sense of order and purpose. The lesson of Italian humanism has been translated into a very different language, spoken with a highly individual accent, but Bruegel's northern scene seems in its own way inspired by a similar regard for human dignity.

ART AND ARCHITECTURE IN FRANCE

France of the sixteenth century bears little resemblance to the artistic achievements of Germany and the Netherlands. The influence of Italian art on France was so strong, due in great part to the actual presence at the French court of Italian artists, that French painting was almost completely overwhelmed. The only native artist of note was Jean Clouet (c. 1485–1541), who was retained by Francis I chiefly to serve as his official portrait painter. Among the many portraits of the king attributed to Clouet is one of around 1530 [14.21] that does full justice to the sensual but calculating character of his master.

More interesting than French painting during the sixteenth century is French architecture. The series of luxurious châteaux that Francis I had built along the valley of the river Loire combined the airiness of the earlier French Gothic style with decorative motifs imported from Italian Renaissance architecture. The result was buildings like the beautiful Château de Chambord [14.22].

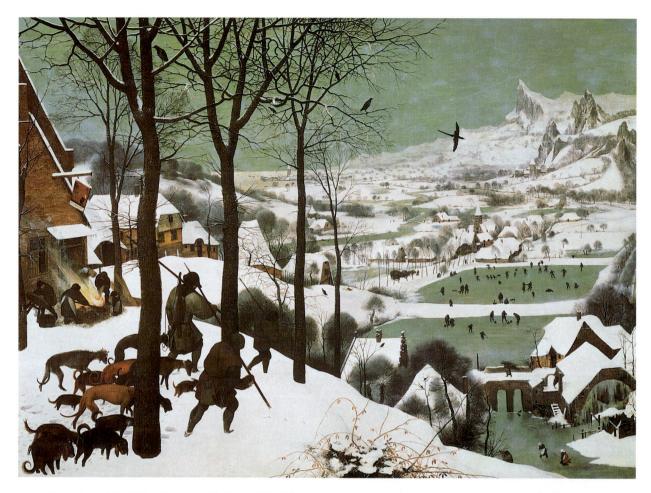

14.20 Pieter Bruegel the Elder. Hunters in the Snow, 1565. Oil on wood. Approx. $46'' \times 64''$ (116.8×162.6 cm). Kunsthistorisches Museum, Vienna. Note Bruegel's careful use of color to suggest a cold, clear, sunless day. From his first crossing of the Alps in the 1530s, Bruegel was inspired by mountain scenery, and it reappeared throughout his work. In this painting, the panoramic sweep from the foreground to the lofty peaks behind makes the scene appear a microcosm of human existence. Thus Bruegel's "world landscapes" or Weltlandsschaften are both literal depictions of scenes from nature and symbolic representations of the relationship between human beings and the world around them.

The love of decoration shown by the builders of Chambord emerges even more strongly as a feature of French architectural style in the design of the Square Court of the Louvre [14.23]. This structure was begun in 1546 by the architect Pierre Lescot (1510–1578) and the sculptor Jean Goujon (c. 1510–1568), working for once without Italian guidance. The façade of the court is a

14.21 Jean Clouet. *Francis I*, c. 1525–1530. Tempera and oil on wood. Approx. $38'' \times 29''$ (96×74 cm). Louvre, Paris. This famous work is now thought to be by an unknown artist rather than by Clouet, but its style is very similar to that of his many official portraits of the king.

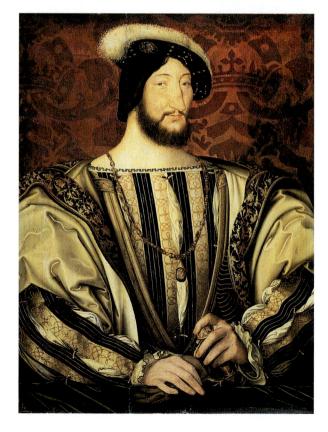

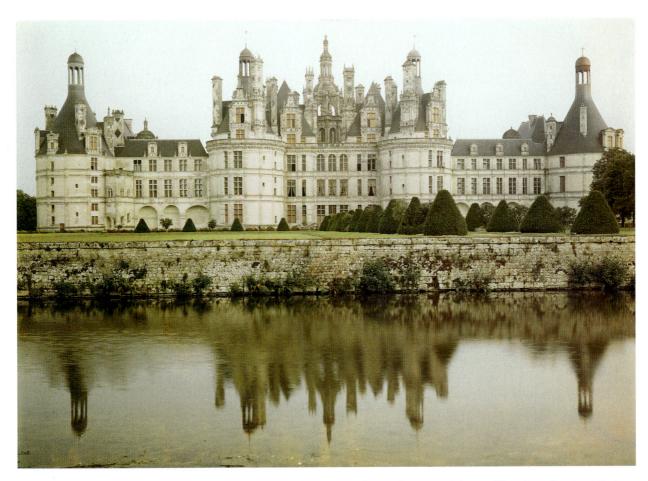

14.22 Château de Chambord, France, begun 1519. Although the turrets and pinnacles are reminiscent of French medieval architecture, the central block and much of the decorative detail suggest Italian Renaissance models.

compendium of Classical forms, from the window moldings to the Corinthian columns to the decorative motifs. The total effect, however, is very different from Italian buildings using the same features. Instead of being grand or awe-inspiring, the building seems graceful and harmonious, perhaps even a little fussy, and the emphasis on decoration became a prominent characteristic of French art in the following two centuries.

ART IN ELIZABETHAN ENGLAND

Throughout the sixteenth century, English political and cultural life followed a path notably different from that of continental Europe, as it did so often in its previous history. The social unrest that had marked the latter Middle Ages in England was finally brought to an end in 1485 by the accession of Henry VII, the first king of the Tudor Dynasty. For the entire sixteenth century, England enjoyed a new stability and commercial prosperity on the basis of which it began to play an increasingly active role in international politics. Henry VIII's final break

with the Catholic Church in 1534 led to the later development of ties between England and the other countries of the Reformation, particularly the Netherlands. When years of tension between the Netherlanders and their Spanish rulers finally broke out into open rebellion, England (then ruled by Queen Elizabeth I) supplied help secretly. Relations between Elizabeth and Spanish King Philip II, were already strained, and English interference in the Spanish Netherlands was unlikely to help. In 1585, a new Spanish campaign of repression in the Netherlands, coupled with the threat of a Spanish invasion of England, drove the queen to resort to more open action—she sent six thousand troops to fight alongside the Netherlanders. Their presence proved decisive.

http://www.tudorhistory.org/elizabeth/

Elizabeth I

Philip's anger at his defeat and at the progress of the campaign for an independent Netherlands was turned in fury against England. The massive Spanish Armada—

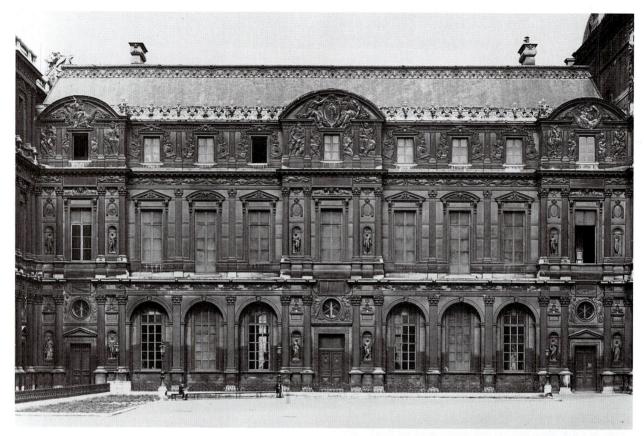

14.23 Pierre Lescot and Jean Goujon. Façade of the Square Court of the Louvre, Paris, begun 1546. The architectural and sculptural decoration is Italian in origin but used here as typically French elaborate ornamentation.

the largest fleet the world had ever seen—was ready early in 1588 and sailed majestically north, only to be met by a fleet of lighter, faster English ships commanded by Sir Francis Drake. The rest is part history, part legend. Even before the expedition sailed, Drake had "singed the beard of the King of Spain" by sailing into Cadiz harbor and setting fire to some of the Spanish galleons anchored there. What was left of the Armada reached the English Channel, where it was destroyed, partly by superior English tactics, partly by a huge storm promptly dubbed (by the victors, at least) the "Protestant Wind." The subsequent tales told of English valor and daring brought a new luster to the closing years of the Elizabethan Age [14.24]. In view of England's self-appointed position as bulwark of Protestantism against the Catholic Church in general and Spain in particular, it is hardly surprising that Renaissance ideas developed south of the Alps took some time to affect English culture. Few Italian artists were tempted to work at the English court or, for that matter, were likely to be invited. Furthermore, England's geographic position inevitably cut it off from intellectual developments in continental Europe and produced a kind of psychological insularity that was bolstered in the

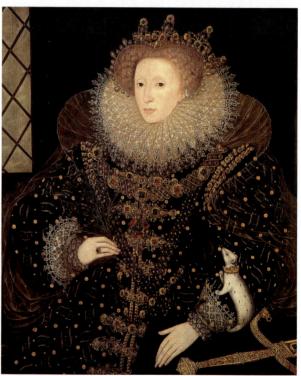

14.24 Nicholas Hilliard (?). *Ermine Portrait of Queen Elizabeth I*, 1585. Oil on canvas, $41^3/_4$ " \times 35" (106 \times 89 cm). Hatfield House, England (collection of the Marquess of Salisbury). The ermine on the queen's sleeve is a symbol of virginity. The portrait as a whole is a symbol of her majesty, not intended to show her actual appearance.

late sixteenth century by a wave of national pride. The finest expression of this is probably to be found in the lines William Shakespeare put into the mouth of John of Gaunt in Act II, scene I of *Richard II*, a play written some six years after the defeat of the Spanish Armada:

This royal throne of kings, this sceptered isle, This earth of majesty, this seat of Mars, This other Eden, demi-Paradise, This fortress built by Nature for herself Against infection and the hand of war, This happy breed of men, this little world, This precious stone set in the silver sea, Which serves it in the office of a wall Or as a moat defensive to a house Against the envy of less happier lands—This blessed plot, this earth, this realm, this England. . . .

On the other hand, the same spirit of nationalism was bound to produce a somewhat narrow-minded rejection of new ideas from outside. English sculpture and painting suffered as a result. The only foreign painter to work in England was himself a northerner, Hans Holbein the

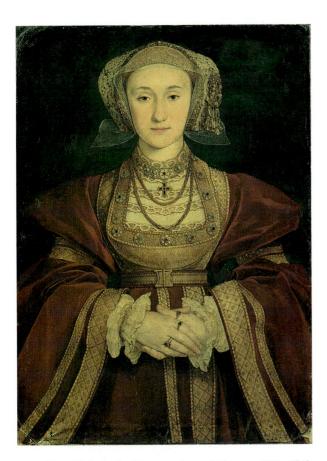

14.25 Hans Holbein the Younger. *Anne of Cleves*, c. 1539–1540. Vellum applied to canvas, $25^5/8'' \times 18^7/8''$ (65 × 48 cm). Louvre, Paris. After viewing this portrait, Henry VIII sent for Anne of Cleves and made her his fourth queen. Note the formal pose and suitably modest downturned gaze.

Younger (1497/98–1543), whose portrait of Henry VIII appears earlier in this chapter (see Figure 14.4). A magnificent portraitist, Holbein was sent by Henry to paint prospective brides so that the king could make his choice with at least some idea of their appearance—an effective if rather tedious method before photography. It must be added that the artist seems to have done his work rather too well, since his picture of *Anne of Cleves* [14.25] inspired Henry to marry the princess only to divorce her within six months, contemptuously dismissing her as his "Flanders Mare."

http://www.ibiblio.org/wm/paint/auth/holbein/

Hans Holbein the Younger

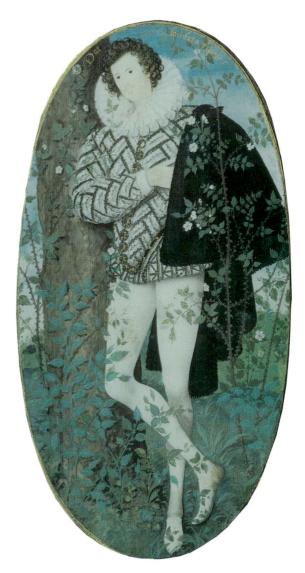

14.26 Nicholas Hilliard. *Portrait of a Youth*, c. 1590. Parchment, $5^3/8^{"} \times 2^3/4^{"}$ (14 × 7 cm). Victoria and Albert Museum, London, Crown copyright. The thorns of the wild rose growing in the foreground may represent friendship in adversity. (The miniature is shown here at almost its actual size.)

Apart from Holbein, English artists were virtually cut off from the new ideas current elsewhere. The only English painter of note during the sixteenth century was Nicholas Hilliard (1547–1619), best known for his miniatures, small portraits often painted in watercolor. The finest is of an unidentified young man who has something of the poetic melancholy of a Shakespearean lover [14.26]. When Hilliard turned to larger works, specifically to portraits of Queen Elizabeth, he was inevitably inhibited by his monarch's demand for a painting that would look regal and imposing rather than realistic. The result, *Ermine Portrait of Queen Elizabeth I*, (see Figure 14.24) is a symbolic representation of majesty rather than a mere portrait.

Music of the Northern Renaissance

As in the visual arts, the Renaissance produced major stylistic changes in the development of music; but, in general, musical development in the Renaissance was marked by a less severe break with medieval custom than was the case with the visual arts. Although sixteenthcentury European composers began to increase the complexity of their style, making frequent use of polyphony, they continued to use forms developed in the High Middle Ages and the early Renaissance. In religious music, the motet remained popular, set to a religious text. Composers also continued to write madrigals (songs for three or more solo voices based generally on secular poems). For the most part these were intended for performance at home, and the skill of the singers was often tested by elaborate, interweaving polyphonic lines. The difficulty of the parts often made it necessary for the singers to be accompanied instrumentally. This increasing complexity produced a significant change in the character of madrigals, which were especially popular in Elizabethan England. Nonetheless, sixteenth-century musicians were recognizably the heirs of their thirteenth- and fourteenthcentury predecessors.

Music in France and Germany

The madrigal form was originally devised in Italy for the entertainment of courtly circles. By the early sixteenth century, French composers, inspired by such lyric poets as Clement Marot (1496–1544), were writing more popular songs known as *chansons*. The best-known composer of chansons was Clement Janequin (c. 1485–c. 1560), who was famous for building his works around a narrative program. In "La Guerre" ("The War") the music imitates the sound of shouting soldiers, fanfares, and rat-

tling guns; other songs feature street cries and birdsong. Frequently repeated notes and the use of nonsense syllables help to give Janequin's music great rhythmic vitality although it lacks the harmonic richness of Italian madrigals.

The same tendency to appeal to a general public characterized German and Flemish songs of the period with texts that were Romantic, military, or sometimes even political in character. Among the great masters of the period was the Flemish composer Heinrich Isaac (c. 1450–1517), who composed songs in Italian and French as well as in German. His style ranges from simple chordlike settings to elaborately interweaving lines that imitate one another. Isaac's pupil, the German Ludwig Sendl (c. 1486–c. 1542), was, if anything, more prolific than his teacher; his music is generally less complex and graceful—almost wistful—in mood.

Elizabethan Music

English music suffered far less than the visual arts from the cultural isolationism of Elizabethan England; the Elizabethan Age, in fact, marks one of the high points in its history. Almost two hundred years earlier, the English musician John Dunstable (c. 1385–1453) had been one of the leading composers in Europe. By bringing English music into the mainstream of continental developments, Dunstable helped prepare the way for his Elizabethan successors. A number of other factors were also responsible for the flourishing state of English music.

To begin with, in England there had always been a greater interest in music than in the visual arts.

Also, the self-imposed ban on the importation of foreign art works and styles did not extend to printed music, with the result that by the early years of the reign of Elizabeth, Italian secular music began to circulate in English musical circles. A volume of Italian songs in translation was published in 1588 under the title *Musica Transalpina* (*Music from Across the Alps*).

As for sacred music, when Henry VIII broke away from the pope he was not at all ready to convert wholeheartedly to Lutheranism or Calvinism and discard those parts of the liturgy that were sung. The services, psalms, and hymns the new Anglican Church had to devise generally (although by no means invariably) used English rather than Latin texts, echoing Luther's use of the vernacular, but continued for the most part to follow Catholic models. Thus, when the first official version of the English Litany was issued in 1544 by Archbishop of Canterbury Thomas Cranmer, it made use of the traditional Gregorian chant, simplified so that only one note was allocated to each syllable of the text. This innovation preserved the flavor of the original music, while making it easier for a listener to follow the meaning of the words and thereby participate more directly in the

14.27 John Merbecke. *The Boke of Common Praier Noted*. British Library, London (reproduced by courtesy of the Trustees). The Lord's Prayer is on the left page and part of the right page. The words are in English, but note the Latin title "Agnus Dei" ("Lamb of God") retained on the right page.

worship. The tendency to simplify is also visible, literally [14.27], in the first published musical setting of the words of *The Boke of Common Praier Noted* (*The Book of Common Prayer Set to Music*), which appeared in 1549. This first musical edition by John Merbecke (c. 1510–c. 1585), again used only one note for each syllable, and his settings followed the normal accentuation of the English words. This work is still used by the Episcopal Church.

In more elaborate music the effects of the Reformation were even less evident. Most of the professional composers of the day had after all been brought up in a Catholic musical tradition, and while the split with Rome affected religious dogma (and of course permitted Henry to marry and divorce at will), it did not alter their freedom to compose religious music as they wished. They continued to write pieces that alternated and combined the two chief styles of the day: blocks of chords in which every voice moved at the same time and the elaborate interweaving of voices known as *counterpoint*.

The musical forms also remained unchanged except in name. Among the most popular compositions throughout Europe were motets, the words of which were often in Latin. English composers continued to write works of this kind but used English texts and called them *anthems*. A piece that used the full choir throughout was called a *full anthem* and one containing passages for solo voice or voices a *verse anthem*. English musicians nevertheless did not entirely abandon the use of Latin. A number of the greatest figures of the period continued to write settings of Latin texts as well as ones in the vernacular.

The dual nature of Elizabethan music is well illustrated by the career of Thomas Tallis (c. 1505–1585), who

spent more than forty years of his life as organist of the Chapel Royal at the English court. Although his official duties required him to compose works for formal Protestant occasions, he also wrote Latin motets and Catholic masses. Tallis was above all a master of counterpoint, bringing the technique of combining and interweaving a number of vocal lines to a new height of complexity in one of his motets, *Spem in Alium (Hope in Another)*, written for no less than forty voices, each moving independently. In his anthems, however, he adopted a simpler style with a greater use of chord passages, so that the listener could follow at least part of the English text. His last works combine both techniques to achieve a highly expressive, even emotional effect, as in his setting of the *Lamentations of Jeremiah*.

Among Tallis' many pupils was William Byrd (c. 1543–1623), the most versatile of Elizabethan composers and one of the greatest in the history of English music. Like Tallis, he produced both Protestant and Catholic church music, writing three Latin masses and four English services, including the so-called Great Service for five voices. Byrd also composed secular vocal and instrumental music, including a particularly beautiful elegy for voice and strings, *Ye Sacred Muses*, inspired by the death of Tallis. The concluding bars, setting the words "Tallis is dead and music dies," demonstrate his ability to achieve considerable emotional pathos with simple means, in this case the rise of an octave in the next-to-last bar:

Much of Byrd's instrumental music was written for the virginal, an early keyboard instrument in the form of an oblong box small enough to be placed on a table or held in the player's lap. It was once believed that the instrument was so-called because of its popularity at the court of Elizabeth, the self-styled Virgin Queen, but references have been found to the name before her time, and its true origin is unknown. Forty-two pieces written for the virginal by Byrd were copied down in 1591 in an album known as *My Ladye Nevells Booke*. They include dances, variations, and fantasias and form a rich compendium of Byrd's range of style.

Byrd also wrote madrigals. The madrigal began in Italy, where the words were as important as the music, and Italian composers often chose poems that reflected the Renaissance interest in Classical antiquity. The English madrigal was less concerned with Renaissance ideas of refinement than with the expression of emotional extremes. Many of the madrigals of Thomas Morley (1557–1602) are lighthearted in tone and fast

moving, making use of refrains like "Fa-la-la." Among the best-known are settings of popular verses rather than literary texts: "Sing We and Chaunt It" and "Now Is the Month of Maying." These were not intended for an elite but for domestic performance by an increasingly prosperous middle class. Other madrigals were more serious, even mournful. Both Morley and his younger contemporary Thomas Weelkes (c. 1575–1623) composed madrigals in memory of Henry Noel, an amateur musician who was a favorite at the court of Queen Elizabeth. Weelkes' piece "Noel, Adieu" is striking for its use of extreme dissonance to express grief. In the following bars, the clash of C against C# seems strikingly modern in its harshness:

For a performance of "Now Is the Month of Maying," see the Listening CD.

The most melancholy works of all Elizabethan music are the *ayres* (simple songs for one voice accompanied by either other voices or instruments) of John Dowland (1562–1626)—the rare example of an Elizabethan musician who traveled widely. Irish by birth, Dowland visited France, Germany, and Italy and even worked for a while at the court of King Christian IV of Denmark; ultimately, he settled in England.

Dowland was the greatest virtuoso of his day on the lute (a plucked string instrument that is a relative of the guitar), and used it to accompany his ayres. Dowland's gloomy temperament was given full expression both in the ayres and in his solo pieces for lute, most of which are as obsessively depressed and woeful as Morley's madrigals are determinedly cheerful. Popular in his own day, in more recent times Dowland's music has undergone something of a revival with the growth of interest in the guitar and other similar instruments.

English Literature: Shakespeare

English literature in the sixteenth century, unlike the visual arts and to a greater extent even than music, was strongly affected by new currents of Renaissance thought. One reason for this is purely practical. Soon after the invention of printing in Germany (see Figure

14.5), William Caxton (c. 1421–1491) introduced the printing press into England and, during the first half of the sixteenth century, books became increasingly plentiful and cheap. With the spread of literature an increased literacy developed, and the new readers were anxious to keep in touch with all the latest ideas of their day. The development of humanism in England undoubtedly influenced Erasmus of Rotterdam, who was brought into contact with humanist ideas during his visits there. In addition to teaching at Cambridge, Erasmus formed a warm personal friendship with the English statesman Sir Thomas More (1478–1535), who became Lord Chancellor in 1529.

More's Utopia, a philosophical romance in Latin describing an ideal world resembling that of Plato's Republic, was written under Erasmus' influence and was firmly based on humanistic ideals. Once introduced, these ideas caught on, and so did the use of Classical or Italian models to express them. Sir Philip Sidney (1554-1586), the dashing youth who has been described as Castiglione's courtier come to life, wrote a series of sonnets in imitation of Petrarch, and a romance, Arcadia, of the kind made popular in Italy by Lodovico Ariosto (1474–1533). Edmund Spenser (1552–1599), the greatest nondramatic poet of Elizabethan England, was also influenced by Ariosto and by Torquato Tasso (1544–1595), Ariosto's Italian successor in the production of massive epic poems. In The Faerie Queene, Spenser combined the romance of Ariosto and the Christian allegory of Tasso to create an immensely complex epic. Its chivalrous hero, the Knight of the Red Cross, represents both Christianity and, through his resemblance to Saint George, England. At the same time, the tests he undergoes make him a Renaissance version of the medieval figure of Everyman. The epic takes place in the imaginary land of Faerie, where the knight's path is frequently blocked by dragons, witches, wizards, and other magical creatures. All this mythological paraphernalia not only advances the plot but also provides a series of allegorical observations on moral and political questions of the day. The result has, in general, been more admired than read.

The greatest of all English achievements in the Renaissance were in drama. The Classical models of English drama were the Latin tragedies of Seneca and the comedies of Plautus and Terence, which, with the introduction of printing, became more frequently read and performed. These ancient Roman plays created a taste for the theater that English dramatists began to satisfy in increasing quantities. At the same time, the increasing prosperity and leisure that created a demand for new madrigals produced a growing audience for drama. To satisfy this audience, traveling groups of actors began to form, often attaching themselves to the household of a noble who acted as their patron. These companies gave

performances in public places, especially the courtyards of inns. When the first permanent theater buildings were constructed, their architects imitated the form of the inn courtyards, with roofs open to the sky and galleries around the sides. The stage generally consisted of a large platform jutting out into the center of the open area known as the *pit* or *ground* [14.28].

The design of these theaters allowed—indeed encouraged—people of all classes to attend performances regularly since the price of admission varied for different parts of the theater. The more prosperous spectators sat in the galleries, where they had a clear view of the stage, while the poorer spectators stood on the ground around the stage. Dramatists and actors soon learned to please these so-called *groundlings* by appealing to their taste for noise and spectacle.

Not all performances were given in public before so democratic an audience. The most successful compa-

14.28 The Globe Playhouse, London, 1599–1613. This conjectural reconstruction by C. Walter Hodges shows the playhouse during the years when *Hamlet, King Lear*, and other Shakespearean plays were first performed there.

nies were invited to entertain Queen Elizabeth and her court. The plays written for these state occasions were generally more sophisticated in both content and style than those written for the general public. The works written for the court of James I, Elizabeth's successor, are among the most elaborate of all. In general, English drama developed from a relatively popular entertainment in the mid-sixteenth century to a more formal artificial one in the early seventeenth century. It is probably no coincidence that the greatest of all Elizabethan dramatists, Shakespeare and Marlowe, wrote their best works at about the midpoint in this development, from about 1590 to 1610. Their plays reflect the increasing appreciation and demand for real poetry and high intellectual content without losing the "common touch" that has given their work its continual appeal.

Christopher Marlowe (1564–1593) was born two months before Shakespeare. Had he not been killed in a fight over a tavern bill at age twenty-nine, he might well have equaled Shakespeare's mighty achievements. It is certainly true that by the same age Shakespeare had written relatively little of importance, whereas Marlowe's works include the monumental two-part *Tamburlaine*, a

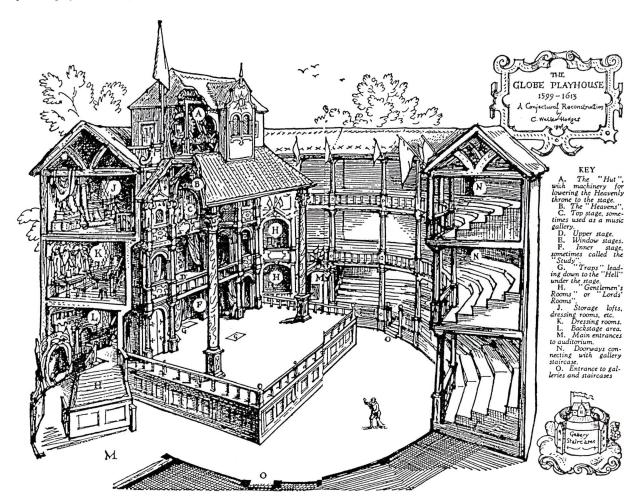

vast tragic drama that explores the limits of human power; exuberant erotic verse like his *Hero and Leander*; and his greatest masterpiece, *Dr. Faustus*. Marlowe's use of blank verse for dramatic expression was imitated by virtually every other Elizabethan playwright, including Shakespeare. It consists of nonrhyming iambic pentameter lines of five metrical feet in which each foot has two syllables, the second foot generally bears the rhythmic stress. In style, Marlowe's work reflects the passion and violence of his own life, their heroes striving to achieve the unachievable by overcoming all limits, only to be defeated by destiny.

Regret at the loss of what Marlowe might have written had he lived longer is balanced by gratitude for the many works William Shakespeare (1564–1616) left us. Shakespeare [14.29] is universally acknowledged as the greatest writer in the English language, and one of the very greatest in any tongue. His position is best summa-

SHAKESPEARES

COMEDIES,
HISTORIES, &
TRAGEDIES.

Published according to the True Original Copies.

Published according to the True Original Copies.

LONDON DON
Printed by Isaac Laggard, and Ed. Blount. 1623.

14.29 Title page of the First Folio. The first collected edition of Shakespeare's works, which was prepared by two of the playwright's fellow actors, London, 1623. Rare books and manuscripts division, New York Public Library.

rized in the words of his leading contemporary and rival playwright Ben Jonson (1572–1637): "He was not of an age, but for all time!"

Surprisingly little is known about Shakespeare's life. He was born at Stratford-upon-Avon; his early years and education seem to have been typical of provincial England, although no details are known. In 1582, he married Anne Hathaway and over the following three years the couple had three children. By 1592, Shakespeare was established in London as an actor and playwright. Exactly how he became involved in the theater and what he did from 1585 to 1592 remains a mystery. From the beginning of his time in London, Shakespeare was associated with the leading theatrical company of the day—the Lord Chamberlain's Men—which changed its name to the King's Men at the accession of James I in 1603.

http://www.shakespeare.org.uk/

Shakespeare

Shakespeare's earliest plays followed the example of Classical models in being carefully constructed, although their plots sometimes seem unnecessarily overcomplicated. In *The Comedy of Errors* (1592–1593), for example, Shakespeare combined two plays by the Roman comic writer Plautus (c. B.C. 254–184) to create a series of situations replete with mistaken identities and general confusion. The careful manipulation of plot in the early plays is achieved at the expense of characterization, and the poetry tends to use artificial literary devices. Even Shakespeare's first great tragedy, *Romeo and Juliet* (1595), is not altogether free from an excessive use of puns and plays on words, although the psychological depiction of the young lovers is convincing and the play contains some magnificent passages.

The comedies of the next few years, including both *The Merchant of Venice* (c. 1596) and *Twelfth Night* (c. 1600), are more lyrical. The brilliant wit of the earlier plays is often replaced by a kind of wistful melancholy. *Twelfth Night* is, in fact, often regarded as Shakespeare's supreme achievement in the field of comedy. Although the plot hinges on a series of well-worn comic devices—mistaken identities, separated twins, and so on—the characters are as vivid and individual as in any of his plays. Furthermore, the work's principal subject, romantic love, is shown from an almost infinite number of viewpoints. Yet at the same time Shakespeare was attracted to historical subjects, generally drawn from English history, as in *Henry IV*, Parts I and II (1597–1598), but also from Roman history, as in *Julius Caesar*.

Julius Caesar (1599) is notable for a number of reasons. It shows that Shakespeare shared the renewed interest of his contemporaries in Classical antiquity. It is, in fact,

based directly on the *Lives* of Caesar, Brutus, and Marc Antony by the Greek historian Plutarch (c. 46–127 A.D.), which had appeared in a new translation by Sir Thomas North in 1579. *Julius Caesar* also illustrates Shakespeare's growing interest in psychological motivation rather than simply sequencing of events.

The playwright tells us not so much what his characters do as why they do it, making use of the soliloquy (a kind of speech in which characters utter their thoughts aloud, without addressing them to anyone else), and thereby revealing to the audience the inner workings of the characters' minds. The use of this device becomes increasingly common in Shakespeare's supreme achievements, the series of tragedies he wrote between 1600 and 1605: Hamlet (c. 1600), Othello (c. 1604), King Lear (c. 1605), and Macbeth (c. 1605). In dramatic truth, poetic beauty, and profundity of meaning these four plays achieve an artistic perfection equaled only by the tragic dramas of Classical Greece. Through his protagonists, Shakespeare explores the great problems of human existence—the many forms of love, the possibilities and consequences of human error, the mystery of death-with a subtlety and yet a directness that remain miraculous through countless readings or performances and continue to provide inspiration to artists and writers. Shakespeare's later plays explore new directions. Antony and Cleopatra (c. 1607-1608) returns to Plutarch and to ancient Rome, but with a new richness and magnificence of language. The conciseness of his great tragedies is replaced by a delight in the sound of words, and the play contains some of the most musical of all Shakespearean verse. His very last works examine the borderline between tragedy and comedy with a sophistication that was perhaps intended to satisfy the new aristocratic audience of the court of King James I. The Tempest (1611), set on an enchanted island, blends high romance and low comedy to create a world of fantasy unlike that of any of his other plays.

In the year he wrote *The Tempest*, Shakespeare left London and retired to Stratford to live out the remaining years of his life in comparative prosperity. Although he continued to write, it is tempting to see in the lines he gave to Prospero toward the end of *The Tempest* (IV, I, 148–158) his own farewell to the theater, and to the world he created for it:

Our revels now are ended. These our actors, As I foretold you, were all spirits, and Are melted into air, into thin air.

And, like the baseless fabric of this vision, The cloud-capped towers, the gorgeous palaces, The solemn temples, the great globe itself—Yea, all which it inherit—shall dissolve And, like this insubstantial pageant faded, Leave not a rack behind. We are such stuff As dreams are made on, and our little life Is rounded with a sleep.

SUMMARY

The Cultural Consequences of the Reformation The political and cultural life of Northern Europe was profoundly changed by the Reformation. After centuries of domination by the Church of Rome, many northern countries gradually switched to one of the various forms of Protestantism, whose ideas and teachings were rapidly spread by the use of the newly invented printing press. The consequences of this division did much to shape modern Europe, while the success of the Reformation movement directly stimulated the counterreformation of the seventeenth century.

Printing and Literature The growth of literacy both north and south of the Alps made possible by the easy availability of books produced a vast new reading public. Among the new literary forms to be introduced was that of the essay, first used by Montaigne. Epic poems were also popular; the works of Lodovico Ariosto and Torquato Tasso circulated widely and were imitated by a number of writers, including Edmund Spenser. The revival of interest in Classical drama produced a new and enthusiastic audience for plays; those written by Elizabethan dramatists like Christopher Marlowe combined high poetic and intellectual quality with popular appeal. The supreme achievement in English literature of the time and perhaps of all time may be found in the works of William Shakespeare. Furthermore, in an age when the importance of education was emphasized, many advances in science were made and important scientific publications appeared. These included Vesalius' work on anatomy and Copernicus' revolutionary astronomical theories.

Painting in Germany: Dürer and Grünewald In the visual arts the sixteenth century saw the spread of Italian Renaissance ideas northward. In some cases they were carried by Italian artists like Benvenuto Cellini, who went to work in France. Some major northern artists, like Albrecht Dürer, actually traveled to Italy. Dürer's art was strongly influenced by Italian theories of perspective, proportion, and color, although he retained a strong interest in line typical of northern art. But not all his contemporaries showed the same interest in Italian styles. Matthias Grünewald's paintings do not show Renaissance concerns for humanism and ideal beauty; instead, they draw on traditional medieval German art to project the artist's own passionate religious beliefs, formed against the background of the bitter conflict of the Peasants' War.

Painting in the Netherlands: Bosch and Bruegel The two leading Netherlandish artists of the century, Hieronymus Bosch and Pieter Bruegel the Elder, were also influenced by contemporary religious ideas. Their work has other characteristics in common: a pessimistic attitude toward human nature and the use of satire—yet the

final effect is very different. Bosch's paintings are complex and bizarre; Bruegel shows a broader range of interest in human activities, together with a love of nature.

Elsewhere in Northern Europe artistic inspiration was more fitful. The only English painter of note was the miniaturist Nicholas Hilliard, while in France the principal achievements were in the field of architecture. Even in Germany and the Netherlands, by the end of the century the Reformation movement's unsympathetic attitude toward the visual arts had produced a virtual end to official patronage for religious art.

Musical Developments in Reformation Europe Music was central to Reformation practice: Luther himself was a hymn writer of note. In England, after Henry VIII broke with Rome to form the Anglican Church, the hymns devised by the new church generally followed Reformation practice by using texts in the vernacular rather than in Latin. The music, however, retained the complexity of the Italian style; as a result, the religious works of musicians like Tallis and Byrd are among the finest of northern Renaissance compositions.

Secular music also had a wide following throughout Northern Europe, particularly as the printing of music became increasingly common. The form of the madrigal, originally devised in Italy, spread to France, Germany, the Netherlands, and England. Many of the works of the leading composers of the day, including the French Clement Janequin and the Flemish Heinrich Isaac, were intended for a popular audience and dealt with Romantic or military themes.

Thus the combination of new Renaissance artistic ideas and new Reformation religious teachings roused Northern Europe from its conservative traditions and stimulated a series of vital cultural developments.

Pronunciation Guide

Altdorfer: ALT-door-fer **Apocalypse:** Ah-POC-a-lip

Apocalypse: Ah-POC-a-lips
Bosch: BOSH
Bruegel: BROY-gull
Byrd: BIRD

Chambord: Sham-BORE shans-ON

Copernicus: Cop-EARN-ik-us

Dürer:DUE-rerGrünewald:GROON-ee-valdGutenberg:GOOT-en-burgHolbein:HOLE-bineIsenheim:IZ-en-himeJanequin:ZHAN-u-canLoire:LWAR

Luther:LOO-therMontaigne:Mont-ANEpolyphonic:pol-i-FON-ic

EXERCISES

- 1. Discuss the career of Albrecht Dürer and compare his work to that of his contemporaries in Germany and Italy.
- 2. What were the principal causes of the Reformation? What was its impact on the development of the arts?
- 3. Describe the effect of the spread of humanism in Northern Europe. What part was played by the invention of printing?
- 4. What are the main features of musical development during the sixteenth century? Discuss the relationship between sacred and secular music.
- Describe Shakespeare's development as a dramatist and analyze the plot of one of his plays.

FURTHER READING

- Cameron, E. (1991). The European Reformation. Oxford: Oxford University Press. A scholarly and up-to-date survey of Reformation history and culture.
- Campbell, L. (1998). *The fifteenth century Netherlandish schools*. London: National Gallery Publications. A fully illustrated description of one of the great collections of early Netherlandish art.
- Campbell, O. J., & E. G. Quinn. (Eds.). (1966). A Shakespeare encyclopedia. New York: Crowell. A valuable source of information on a wide variety of Shakespearean topics.
- Davis, N. (1975). Society and culture in early modern France. Palo Alto, CA: Stanford University Press. A study of popular culture in the sixteenth and seventeenth centuries that includes much fascinating material.
- Eisenstein, E. (1983). The printing revolution in early modern Europe. Cambridge, MA: Cambridge University Press. An important book on an important subject; discusses conventional books and also woodcuts, broadsheets, and printed illustrations.
- Harbison, C. (1995). The mirror of the artist: Northern Renaissance art in its historical context. New York: Harry Abrams.
- Hillerbrand, H. (Ed.). (1996). *The Oxford encyclopedia of the Reformation* (4 vols.). New York: Oxford University Press. An authoritative reference work.
- Hitchcock, H. R. (1981). German Renaissance architecture. Princeton, NJ: Princeton University Press. A well-illustrated study of a surprisingly neglected field; provides a background to contemporary achievements in other artistic fields.
- Newman, J. (1965). Renaissance music. Englewood Cliffs, NJ: Prentice-Hall. A handy and compact account of the main developments in Renaissance music throughout Europe.
- Ozment, S. (1982). *Reformation Europe: A guide to research*. St. Louis, MO: St. Louis University Press. This very useful collection of essays deals with a variety of aspects of Reformation life: art, society and the sexes, and others.
- Panofsky, E. (1971). The life and art of Albrecht Dürer. Princeton, NJ: Princeton University Press. A magisterial account by one of the greatest of all art historians. Difficult at times but immensely rewarding.
- Rose, M. B. (1986). Women in the Middle Ages and the Renaissance. Syracuse, NY: Syracuse University Press. An anthology of readings that brings together a great deal of remarkable material and casts light on a subject that has only recently begun to be studied in its own right.
- Snyder, J. (1985). Northern Renaissance art. Englewood Cliffs, NJ: Prentice-Hall. The most complete general survey of painting, sculpture, and the graphic arts in Northern Europe from 1350 to 1575.

ONLINE CHAPTER LINKS

Project Wittenburg Web site

http://www.iclnet.org/pub/resources/text/wittenberg/wittenberg-home.html

provides an extensive list of links to Internet resources related to Martin Luther.

For biographical information about Martin Luther, insights about the historical context of significant events in his life, an interesting timeline, and links to related sites, visit

http://www.luther.de/e/index.html

The Sir Thomas More Web site

http://www.luminarium.org/renlit/tmore.htm provides a wide range of information about the author, lists of links to his works available on the Internet, links to essays and articles about More, and links to additional resources.

Enjoy a virtual tour of the Louvre Museum in Paris by visiting the *Musée du Louvre* Web site http://www.smartweb.fr/louvre/index.html

Mr. William Shakespeare and the Internet

http://daphne.palomar.edu/shakespeare/ offers an excellent starting point for investigating the myriad of associated Web sites.

Visit the *Shakespeare's Globe Research Database*http://www.rdg.ac.uk/globe/home.htm
which offers information about London's Globe
Theatre, past and present.

An extensive list of Francis Bacon's works is available online at *The Essays of Francis Bacon*http://ourworld.compuserve.com/homepages/
mike_donnelly/bacon_htm

The Galileo Project

http://es.rice.edu/ES/humsoc/Galileo/ provides information about the life and work Galileo, as well as the science of his times.

Enjoy a virtual tour of the Château de Versailles by visiting its Web site

http://www.chateauversailles.fr/en/

For a catalog of useful links to Internet resources, consult *Renaissance Music Links*

http://classicalmus.hispeed.com/rena.html

For introductory information about art of the northern Renaissance as well as links to sites related to representative artists, consult *Artcyclopedia*

http://www.artcyclopedia.com/history/ northern-renaissance.html

For E. H. Gombrich's evaluation of Albrecht Dürer's St. Michael's Fight against the Dragon, visit http://artchive.com/artchive/D/durer/stmichel.jpg.html

Karadar Classical Music at

http://www.karadar.it/Dictionary/Default.htm provides an alphabetical listing of musicians with brief biographies and a list of works (some of which are available on MIDI files).

	GENERAL EVENTS	LITERATURE & PHILOSOPHY	Art
1560			
DECLINE OF SPANISH POWER	 1603 – 1625 Reign of James I in England 1609 Holland and Flanders given virtual independence in truce with Spain 1610 – 1643 Reign of Louis XIII in France; Marie de' Medici is regent during his minority 	 1565 Teresa of Avila, Autobiography 1582–1584 John of the Cross, The Dark Night 1605–1615 Cervantes, Don Quixote 1611 Publication of Authorized Version of Bible, commissioned by King James I 	1595 – 1600 El Greco, The Baptism of Christ 1597 – 1604 Caravaggio and the Carracci at work in Rome c. 1600 – 1602 Caravaggio, The Doubting of Thomas, The Calling of Saint Matthew, The Martyrdom of Saint Matthew 1604 A. Carracci, The Flight into Egypt; decorations for Palazzo Farnese Galleria completed 1616 Hals, Banquet of the Officers of the Saint George Militia Company c. 1618 Rubens, The Rape of the Daughters of Leucippus
THIRTY YEARS' WAR	 1618 Thirty Years' War begins in Germany 1620 English Pilgrims land at Plymouth 1621–1665 Reign of Philip IV in Spain 1643 Five-year-old Louis XIV ascends throne of France under regency of his mother 1648 Peace of Westphalia 	 1621 Donne appointed Dean of Saint Paul's, London 1632 Galileo, founder of modern physics, submits Dialogue Concerning the Two Chief World Systems to Pope Urban VIII; is tried and condemned in 1633 1637 Descartes, "Father of Modern Philosophy," publishes Discourse on Method 1638 Galileo, Dialogues Concerning Two New Sciences c. 1640 French Classical comedy and tragedy at height 1640-1643 Corneille, Horace, Polyeucte, tragedies 1641 Descartes, Meditations 1646 Crashaw, Steps to the Temple 	 c. 1620 Artemisia Gentileschi, Judith and Holofernes 1622–1625 Rubens paints cycle of 24 paintings glorifying Marie de' Medici; Bernini, The Rape of Proserpine 1623 Bernini, David; Velázquez appointed court painter to Philip IV c. 1625 Van Dyck, Portrait of the Marchesa Cataneo 1627 Caravaggio's influence spreads northward when Louis XIII summons Vouet back from Rome to become court artist c. 1630 A. Gentileschi, Self-Portrait as "La Pittura" 1631 Claude Le Lorrain, Mill on a River 1632 Van Dyck court painter to Charles I c. 1639 Ribera, The Martyrdom of Saint Bartholomew 1642 Rembrandt, The Night Watch 1645–1652 Bernini, Saint Teresa in Ecstasy
PURITAN RULE	1649 Execution of Charles I of England; Cromwell rules 1649–1658	 c. 1650 Locke active in England, Pascal in France, Spinoza in Holland 1651 Hobbes, Leviathan c. 1659-1699 Poet and dramatist John Dryden active in England 	c. 1650 Poussin, The Arcadian Shepherds; Georges de La Tour, Saint Sebastian Attended by Saint Irene 1656 Velázquez, Las Meninas
AGE OF LOUIS XIV AND XV	 1660 Restoration of monarchy in England under Charles II 1661 Louis XIV assumes full control of France 1682 Louis XIV moves court to newly remodeled Versailles 1688 Parliamentary enemies of James II invite William of Orange to invade England 1689 Declaration of Rights establishes English constitutional government; William and Mary rule 1715 Louis XIV dies after 72-year 	 1664 Molière, <i>Tartuffe</i>, comedy 1667 Milton, <i>Paradise Lost</i>, epic poem in tradition of Homer and Vergil 1677 Racine, <i>Phèdre</i>, tragedy 1690 Locke, <i>Concerning Human Understanding</i> 1694 Voltaire born in Paris 	1662–1664 Vermeer, Woman Reading a Letter 1669 Death of Rembrandt; last Self-Portrait

1694 Voltaire born in Paris

1774

1715 Louis XIV dies after 72-year reign; Louis XV ascends throne

1701 Rigaud, Louis XIV

CHAPTER 15 THE BAROQUE WORLD

ARCHITECTURE

Music

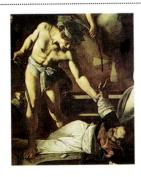

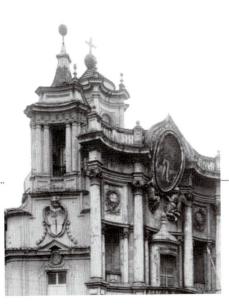

late 16th cent. Birth of opera in Florence, development of *monody*

1594–1595 Peri, *Dafne*, first play set to music, performed in Florence

1600 Peri, Euridice

Opera, concerto grosso, oratorio, cantata, and sonata established as musical forms; virtuoso tradition begins

1607 Monteverdi, L'Orfeo

1619 Schütz, Psalms of David

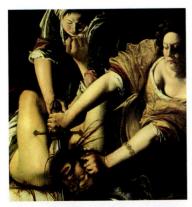

Retention of classical vocabulary of Renaissance but on grandiose scale; civic planning and privatehouse construction also prevalent because of rise of middle classes

1629 Bernini appointed official architect of Saint Peter's, Rome

1631–1687 Longhena, Santa Maria della Salute, Venice

1638–1641 Borromini, Church of San Carlo alle Quattro Fontane, Rome; façade added 1665–1667 1634 Frescobaldi active at Rome

1652 Lully enters service of Louis

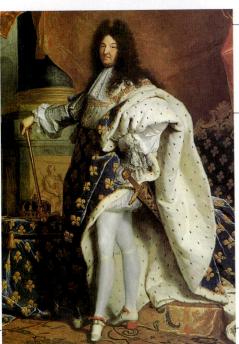

1663 Bernini, piazza and colonnades for Saint Peter's, Rome; church proper completed by Carlo Maderno 1607–1615

1669–1685 Le Vau and Hardouin-Mansart, Garden façade Versailles

1678 Le Brun and Hardouin-Mansart begin Hall of Mirrors, Palace of Versailles 1668 Buxtehude becomes organist at Lübeck

1674 Lully's *Alceste* first performed at Versailles

1685 Births of Bach, Handel, Scarlatti

c. 1720 Vivaldi, *The Four Seasons*, violin concertos

1721 J. S. Bach, Brandenburg Concertos

1723 Bach appointed Kantor of St. Thomas', Leipzig

1729 J. S. Bach, St. Matthew Passion

c. 1735 Rameau, Les Indes Galantes

1742 Handel's *Messiah* first performed

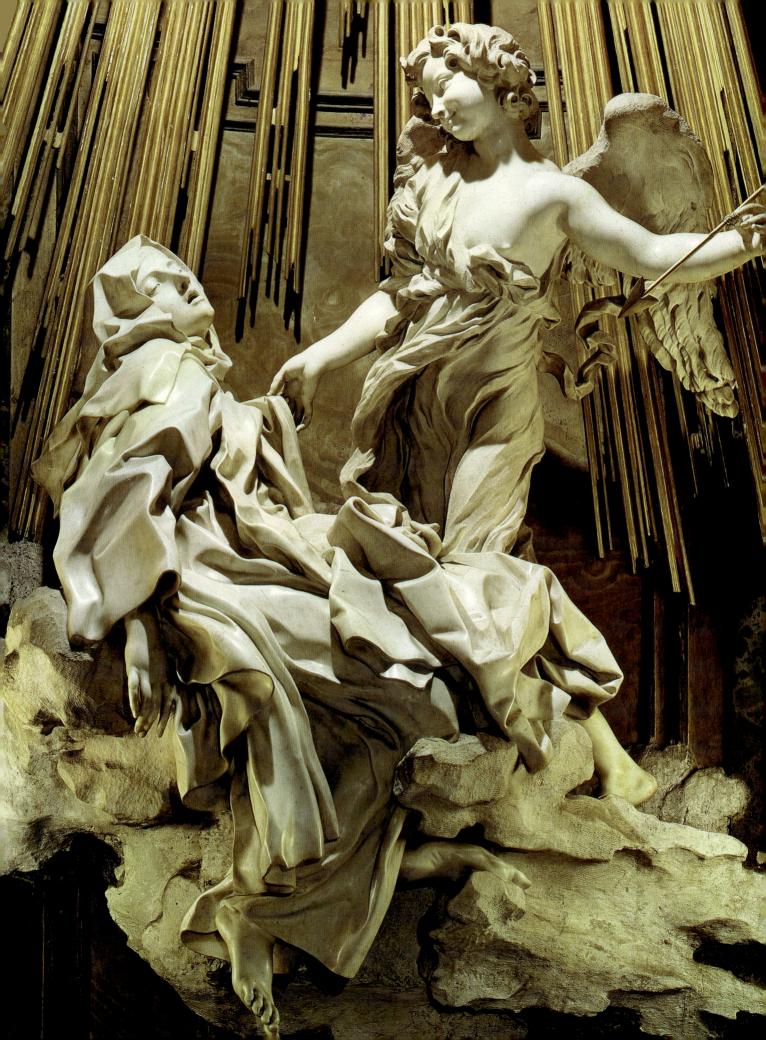

CHAPTER 15 THE BAROQUE WORLD

THE COUNTER-REFORMATION SPIRIT

By about 1600 the intellectual and artistic movements of the Renaissance and Reformation had taken a new turn. Although the cultural activity of the following hundred and fifty years was the natural outgrowth of earlier developments, the difference in spirit—already signaled by the middle of the sixteenth century—was striking.

The chief agent of this new spirit was the Roman Catholic Church. After its initial shock at the success of Protestantism, the Catholic Church decided that the best defense was a well-planned attack. Switching to the offensive, the church relied in great measure on new religious orders like the Jesuits to lead the movement known as the Counter-Reformation. Putting behind them the anxieties of the past, the chief representatives of the Counter-Reformation gave voice to a renewed spirit of confidence in the universality of the church and the authority of its teachings.

The official position of the church was newly stated at the Council of Trent, which met sporadically from 1545 to 1563. Under the leadership of Pope Paul III, the council redefined Catholic doctrines, and reaffirmed those dogmas that Protestantism had challenged. Transubstantiation, the apostolic succession of the priesthood, the belief in purgatory, and the rule of celibacy for the clergy were all confirmed as essential to the Catholic system of faith. The pope remained as monarchical ruler of the church. At the same time, the council tried to eliminate abuses by the clergy, and to tighten discipline. Bishops and priests could no longer hold more than one benefice, and theological seminaries were set up in every diocese to improve the educational level of the priesthood.

One of the key instruments in the campaign to reestablish the authority of the church was the Society of Jesus, an order of priests and brothers dedicated to the defense of the faith. The order was founded in 1534 by Ignatius Loyola (1491–1556), a Spanish nobleman. After spending the first part of his career as a soldier, Loyola

converted to the religious life after suffering a serious wound. His *Spiritual Exercises* (begun 1522–1523) express a mystical, even morbid spirit of introspection, inspired by visions of Satan, Jesus, and the Trinity. A similarly heightened spiritual sense and attempt to describe mystical experiences occurs in the writings of other Spanish Catholics of the Counter-Reformation, most notably Saint Teresa of Avila 1515–1582) and Saint John of the Cross (1542–1591); the latter wrote powerfully of the soul's emergence from the "dark night" to attain union with God.

The order that Loyola founded soon became the most militant of the various religious movements to appear during the sixteenth century. Its members, the Jesuits, fought not with swords or guns, but with eloquence and the power of persuasion. The Jesuits were organized on the model of a military company, led by a general as their chief commander, and required to exercise iron discipline. Their duty was simple: to promote the teachings of the church unquestioningly—Loyola taught that if the church ruled that black was white, its followers were obliged to believe it. They reinforced this position by their vigorous missionary work throughout Europe, the Americas, and the Far East, while improving educational institutions throughout Catholic Europe.

At the same time, the Council of Trent called on artists to remind Catholics of the power and splendor of their religion by commissioning a massive quantity of works of art dedicated to underlining the chief principles of Counter-Reformation teachings. Now it was the task of religious leaders and, under their guidance, of the artists to make this position known to the faithful. New emphasis was placed on clarity and directness. The impression of the church's triumphant resurgence was further reinforced by a new emphasis on material splendor and glory. In Rome, the construction of a number of lavish churches was crowned by the completion at last of Saint Peter's and the addition of Bernini's spectacular piazza ("square") in front of it [15.1], while throughout Catholic Europe there developed a rich and ornate art that could do justice to the new demands for expressive power and spectacle.

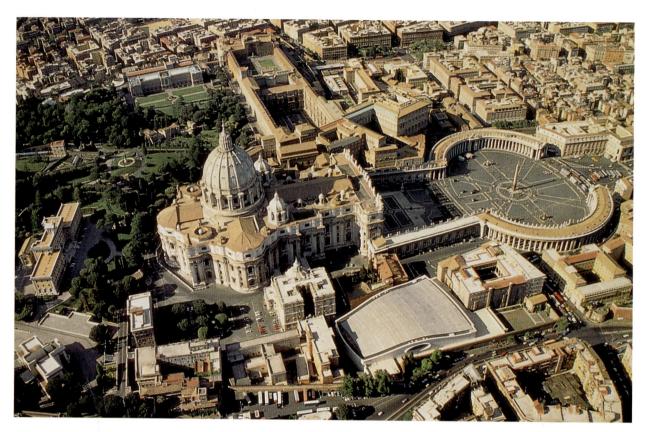

15.1 Aerial view of Saint Peter's, Rome. Height of façade 147' (44.81 m), width 374' (114 m). The nave and façade were finished by Carlo Maderna (1556–1629) between 1606 and 1612, and the colonnades around the square were built between 1656 and 1663 to Bernini's design. The completion of Saint Peter's was one of the first great achievements of baroque architecture.

The term used to describe the new style, at first in derision but since the nineteenth century simply as a convenient label, is *baroque*. The word's origins are obscure. It may be related to the Portuguese *barroco* ("an irregularly shaped pearl"), or perhaps to *baroco* (an Italian term used to describe a complicated problem in medieval logic). In any case, baroque came to be applied in general to anything elaborate and fanciful, in particular to the artistic style of the seventeenth and early eighteenth centuries.

Although strictly speaking baroque is a term applied only to the visual arts, it is frequently used to describe the entire cultural achievement of the age. To extend its use to literature, music, and even intellectual developments of the same period inevitably implies that all the arts of the Baroque period had certain characteristics in common. In fact, a close comparison between the visual arts, music, and literature of the seventeenth and early eighteenth centuries does reveal a number of shared ideas and attitudes. It is important to remember from the outset, however, that this artistic unity is by no means

obvious. A first glance at the cultural range of the period actually reveals a quite astonishing variety of styles, developing individually in widely separated places and subject to very different political and social pressures.

In this respect the Baroque period marks a significant break with the Renaissance, when Italy had been the center of virtually all artistic development. In spite of the impact of the Counter-Reformation, the Reformation itself had begun an irreversible process of decentralization. By the beginning of the seventeenth century, although Rome was still the artistic capital of Europe, important cultural changes were taking place elsewhere. The economic growth of countries like Holland and England, and the increasing power of France, produced a series of artistic styles that developed locally rather than being imported wholesale from south of the Alps. Throughout Northern Europe the rise of the middle class continued to create a new public for the arts, which in turn affected the development of painting, architecture, and music. For the first time European culture began to spread across the Atlantic, carried to the Americas by Counter-Reformation missionaries.

The much greater geographic spread of artistic achievement was accompanied by the creation of new artistic forms in response to new religious and social pressures. In music, for instance, the seventeenth century saw the birth of *opera* and of new kinds of instrumental music, including works for orchestra like the *concerto grosso*. Painters continued to depict scenes from the Bible and from Classical mythology but they turned

increasingly to other subjects including portraits, landscapes, and scenes from everyday life. Architects constructed private townhouses and started to take an interest in civic planning instead of devoting themselves exclusively to churches and palaces.

A similar richness and variety can be found in the philosophical and scientific thought of the period, which managed temporarily to reconcile its own pursuit of scientific truth with traditional theological and political attitudes. By the end of the seventeenth century, however, the practical discoveries of science had begun to undermine long-accepted ideas and to lay the basis for the new skepticism that came to dominate the eighteenth century.

It would be unwise to look for broad general principles operating in an age of such dynamic and varied change. Nonetheless, to understand and appreciate the Baroque spirit as it appears in the individual arts it is helpful to bear in mind the chief assumptions and preoccupations shared by most baroque artists. Whatever the medium in which they worked, baroque artists were united in their commitment to strong emotional statements, psychological exploration, and the invention of new and daring techniques.

Perhaps the most striking of these is the expression of intense emotions. During the Renaissance, artists had generally tried to achieve the calm balance and order they thought of as typically Classical. During the Baroque period, artists were attracted by extremes of feeling—sometimes these strong emotions were personal. Painters and poets alike tried to look into their own souls and reveal by color or word the depths of their own psychic and spiritual experience. More often artists tried to convey intense religious emotions. In each case, far from avoiding painful or extremely emotional states as subjects, their works sought out and explored them.

This concern with emotion produced in its turn an interest in what came to be called *psychology*. Baroque artists attempted to explain how and why their subjects felt as strongly as they did by representing their emotional states as vividly and analytically as possible. This is particularly evident in seventeenth-century opera and drama, where music in the one case and words in the other were used to depict the precise state of mind of the characters.

The desire to express the inexpressible required the invention of new techniques. As a result, baroque art placed great emphasis on virtuosity. Sculptors and painters achieved astonishing realism in the way in which they handled their media. Stone was carved in a way such as to give the effect of thin, flowing drapery, while seventeenth-century painters found ways to reproduce complex effects of light and shade (see Table 15.1). Baroque writers often used elaborate imagery and complicated grammatical structure to express intense emotional states. In music, both composers and performers

TABLE 15.1 Characteristics and Examples of Baroque Art

CHARACTERISTIC	EXAMPLE	
Emotionalism	Caravaggio, The Martyrdom of Saint Matthew [15.3] Rubens, The Rape of the Daughters of Leucippus [15.25]	
Illusionism	Bernini, <i>David</i> [15.8] Rembrandt, <i>The Night Watch</i> [15.30]	
Splendor	Bernini, Saint Peter's Square [15.1] Palace of Versailles [15.18, 15.19] Carracci, The Triumph of Bacchus and Ariadne [15.6]	
Light and Shade	Caravaggio, The Calling of Saint Matthew [15.2] de La Tour, The Lamentation over Saint Sebastian [15.12] Velázquez, Las Meninas [15.23] Vermeer, Woman Reading a Letter [15.29]	
Movement	Borromini, Façade for San Carlo alle Quattro [15.11] El Greco, Burial of Count Orgaz [15.21]	
Religious Fervor	El Greco, Martyrdom of Saint Mau- rice and the Theban Legion [15.20] Ribera, The Martyrdom of Saint Bartholomew [15.22]	
Domestic Intimacy	Caravaggio, Madonna of Loreto [15.4] Rubens, Hélène Fourment and Her Children [15.24] Rembrandt, Jacob Blessing the Sons of Joseph [15.32]	

began to develop new virtuoso skills; composers in their ability to write works of greater and greater complexity, and performers in their ability to sing or play music in the new style. In fact some pieces, like *toccatas* (free-form rhapsodies for keyboard) were principally intended to allow instrumentalists to demonstrate their technique, thus inaugurating the tradition of the virtuoso performer that reached a climax in the nineteenth century.

THE VISUAL ARTS IN THE BAROQUE PERIOD

Painting in Rome: Caravaggio and the Carracci

http://www.artcyclopedia.com/featuredarticle-2000-10.html

Caravaggio

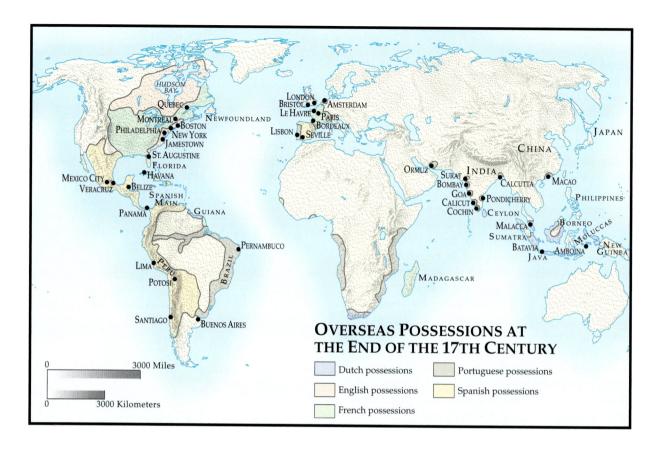

The foundations of baroque style, which was to dominate much of European painting for one hundred and fifty years, were laid in Rome around 1600 by two artists whose works at first glance seem to have little in common. Michelangelo Merisi (1573–1610), better known as Caravaggio, the name of his hometown in northern Italy, explored the darker aspects of life and death in some of the most naturalistic and dramatic pictures ever painted. Annibale Carracci (1560-1609) preferred to paint light and elegant depictions of the loves of gods and goddesses and charming landscapes. That both artists exerted an immense influence on their successors says something for the extreme range of baroque painting. Of the two painters, Caravaggio was certainly the more controversial in his day. His own lifestyle did little to recommend him to the aristocratic and ecclesiastical patrons on whom he depended. From his first arrival in Rome (around 1590), Caravaggio seems to have lived an unconventional and violent life, in continual trouble with the police, and alienating potential friends by his savage temper.

Any chances Caravaggio had for establishing himself successfully in Rome were brought to an abrupt end in 1606 when he quarreled violently with an opponent in a tennis match and stabbed him to death. He avoided pun-

ishment only by fleeing to Naples and then to Malta, where he was thrown into prison for attacking a police officer. Escaping, he made his way to Sicily and then back to Naples, where he yet again got involved in a violent quarrel, this time in a sleazy inn. Seriously wounded, he heard of the possibility of a pardon if he were to return to Rome, but on the journey back he died of a fever (brought on, it was said, by a final attack of rage at some sailors he mistakenly thought had robbed him). The pardon from the pope arrived a few days later. The spirit of rebellion that governed Caravaggio's life can be seen in his art. In his depiction of religious scenes he refused to accept either the traditional idealizing versions of earlier artists or the Counter-Reformation demands for magnificent display. Furthermore, instead of placing his figures in an elaborate setting in accordance with Counter-Reformation principles, Caravaggio surrounded them with shadows, a device that emphasizes the drama of the scene and the poverty of the participants.

Caravaggio's preference for *chiaroscuro* (extreme contrasts between light and dark), was one of the aspects of his style most imitated by later painters. When not handled by a master, the use of heavy shadows surrounding brightly lit figures in the foreground tends to become

artificial and overtheatrical, but in Caravaggio's work it always serves a true dramatic purpose. In his painting *The Calling of Saint Matthew* [15.2], one of three pictures painted between 1597 and 1603 for the Contarelli Chapel in the Church of San Luigi dei Francesi at Rome—Caravaggio's first important Roman commission—the stern hand of Jesus summoning the future apostle is emphasized by the beam of light that reveals the card players at the table; Matthew, awed and fearful, tries to shrink back into the darkness.

In his painting of *The Martyrdom of Saint Matthew* [15.3], Caravaggio used his own experience of suffering to portray it with painful realism; the painting tells us as much about the reactions of the onlookers as about Matthew himself. They range from the sadistic violence of the executioner to the apparent indifference of the figures in shadow on the left; only the angel swooping down with the palm of martyrdom relieves the brutality and pessimism of the scene.

It would be a mistake to think of Caravaggio's work as lacking tenderness. In the *Madonna of Loreto* [15.4] he shows us not the remote grace of a Botticelli Virgin or the sweet, calm beauty of a Raphael Madonna but a simple

Roman mother. As she stands gravely on the doorstep of her backstreet house where the plaster is falling away from the walls, two humble pilgrims fall to their knees in confident prayer. They raise their loving faces to the Virgin and Christ child while turning toward us their muddy, travel-stained feet. It is perhaps not surprising that some of Caravaggio's contemporaries, brought up on the elegant and well-nourished Madonnas and worshipers of the Renaissance and surrounded by the splendor of Counter-Reformation art, should have found pictures like these disrespectful and lacking in devotion. It should be equally unsurprising that once the initial shock wore off, the honesty and truth of Caravaggio's vision made a profound impact on both artists and the public.

Among the painters working in Rome who fell under the spell of Caravaggio's works was Orazio Gentileschi (1563–1639), who was born in Pisa and studied in Florence. Much impressed by Caravaggio's dramatic naturalism and concern for psychological truth, Gentileschi based his own style on that of his younger contemporary. Since he spent the last eighteen years of his life traveling and living in Northern Europe, first in France and then in England, he played an important part in spreading a

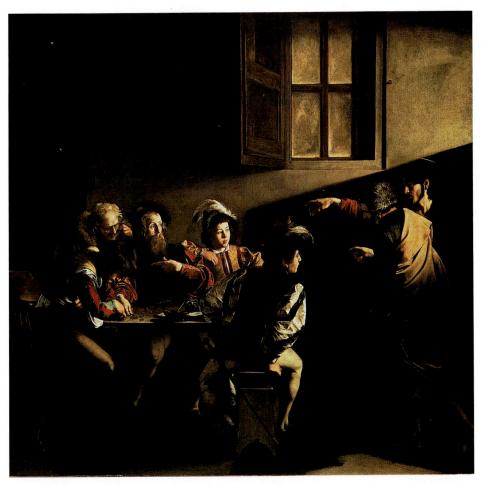

15.2 Caravaggio. The Calling of Saint Matthew, c. 1597-1601. Oil on canvas, $11'1'' \times 11'5''$ (3.38 \times 1.48 m). Contarelli Chapel, San Luigi dei Francesi, Rome. The artist produces a highly dramatic effect by having the bright light emanating from the half-hidden figure of Jesus (to the right) strike the head of Matthew. The future saint draws back from the glare in fear.

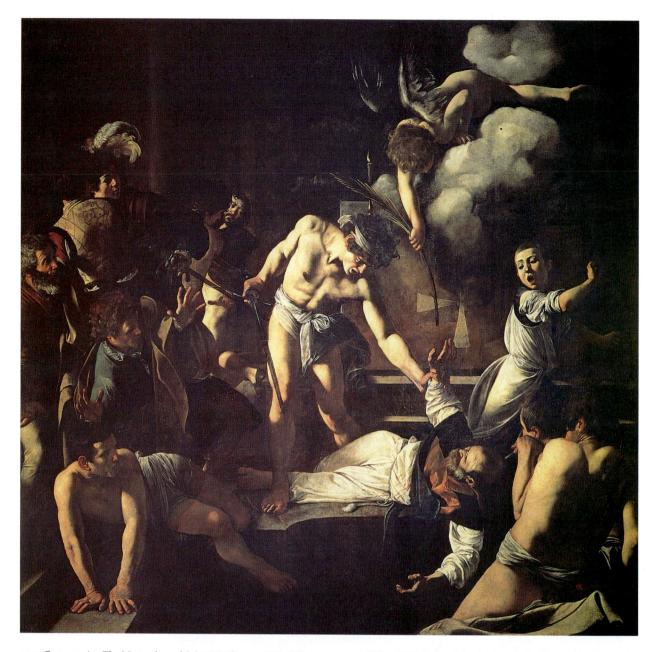

15.3 Caravaggio. *The Martyrdom of Saint Matthew,* c. 1602. Oil on canvas, $10'9'' \times 11'6''$ (3.3 \times 3.5 m). Contarelli Chapel, San Luigi dei Francesi, Rome. The deeply moved onlooker at the very back of the scene is, according to one tradition, a self-portrait of the artist.

knowledge of Caravaggio's style outside Italy. At the same time, moreover, he handed on his enthusiasm to a painter nearer home—his own daughter Artemisia (1592–1652/1653).

Artemisia Gentileschi has been described as the first woman in the history of the Western world to make a significant contribution to the art of her time. The question of why so few women achieved eminence in the visual arts before recent times is a complicated one, and the chief answers are principally social and economic rather than aesthetic. Certainly, Artemisia was typical of the few women painters of the Renaissance and Baroque periods who did become famous in that she was the daughter of a painter and therefore at home in the world of art and artists.

Gentileschi's most famous painting is *Judith and Holofernes* [15.5]. Done in chiaroscuro, the painting conveys a tremendous sense of violence as Judith and her maid loom over the drastically foreshortened body of Holofernes. There is a stark contrast between the realistic

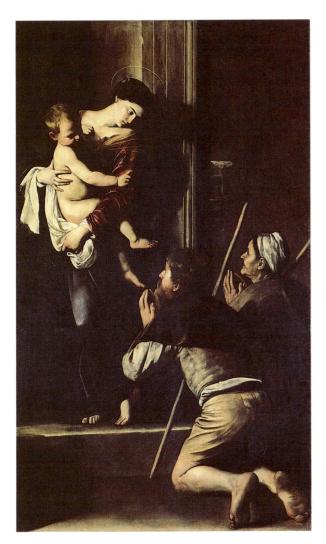

15.4 Caravaggio. *Madonna of Loreto*, 1604. Oil on canvas, $8'6^{1}/_{2}'' \times 4'10^{1}/_{2}''$ (2.6 \times 1.5 m). Cavaletti Chapel, San Agostino, Rome. The shabby clothes show the poverty of the two pilgrims.

violence of the beheading and the sensual richness of the silken bed, jewelry, and cunning drapery. It is not inconceivable that the painter, herself a rape victim in her youth, poured her own passionate protest into this painting of a woman taking retribution against a would-be defiler. This work depicts a scene from the biblical story of the Jewish heroine Judith, who used her charms to save her people from an invading Assyrian army; she won the confidence of its general, Holofernes, and then beheaded him in the privacy of his tent.

It is a far cry from the dark, emotional world of Caravaggio and his followers to the brilliant, idealized world of Annibale Carracci, his brother Agostino, and his cousin Ludovico, all often spoken of collectively as the Carracci. The most gifted member of this Bolognese fam-

ily was Annibale, whose earliest important work in Rome—the decoration of the *galleria* (formal reception hall) of the Palazzo Farnese—was painted between 1597 and 1604, precisely the years when Caravaggio was working on the Contarelli Chapel. The many scenes in the galleria constitute a fresco cycle based on Greek and Roman mythology, depicting the loves of the gods, including *The Triumph of Bacchus and Ariadne* [15.6]. The sense of exuberant life and movement and the mood of unrestrained sensual celebration seem farthest removed from Caravaggio's somber paintings, yet both artists share the baroque love of extreme emotion, and both show the same concern for realism of detail.

The same blend of ideal proportion and realistic detail emerges in Annibale's landscape paintings, of which the best known is probably *The Flight into Egypt* [15.7]. The scene is the countryside around Rome, with the river Tiber in the foreground and the Alban hills in the distance. The tiny human figures are carefully related in proportion to this natural setting, precisely balanced by the distant castle, and located just at the meeting point of the diagonal lines formed by the flock of sheep and the river. As a result, we perceive a sense of idyllic Classical order while being convinced of the reality of the landscape.

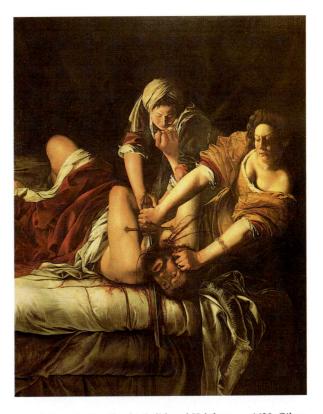

15.5 Artemesia Gentileschi. *Judith and Holofernes*, c. 1620. Oil on canvas, $78^1/_3" \times 64"$ (199 \times 162.5 cm). Galleria degli Uffizi, Florence, Italy.

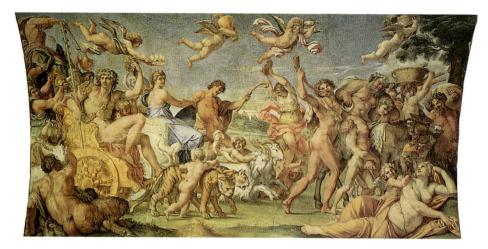

15.6 Annibale Carracci. *The Triumph of Bacchus and Ariadne*, 1597–1600, Fresco. Farnese Palace, Rome. The god's chariot, drawn by tigers, is accompanied by a wild procession of cupids, nymphs, and satyrs.

Roman Baroque Sculpture and Architecture: Bernini and Borromini

http://www.artchive.com/artchive/B/bernini.html
Bernini

The most influential of all Italian baroque artists of the Counter-Reformation was a sculptor and architect, not a

15.7 Annibale Carracci. *The Flight into Egypt*, 1603–1604. Oil on canvas, $4' \times 7'6''$ (.9 \times 2.3 m). Galleria Doria-Pamphili, Rome. In spite of the Holy Family in the center foreground, the painting is not so much religious as it is a depiction of the landscape around Rome.

painter. The sculptural achievement of Gian Lorenzo Bernini (1598–1680), of seemingly unlimited range of expression and unbelievable technical virtuosity, continued to influence sculptors until the nineteenth century; as the chief architect of Counter-Reformation Rome he permanently changed the face of that venerable city.

Born the son of a Florentine sculptor in Naples, Bernini showed signs of his extraordinary abilities at an early age. One of his first important works, a statue of *David* [15.8], seems to have been deliberately intended to evoke comparison with works by his illustrious predecessors. Unlike the *David* of Donatello (see Figure 12.14) or Michelangelo (see Figure 12.28) which show the subject in repose, Bernini's figure is very definitely in the midst of action. From the bitten lips to the muscular

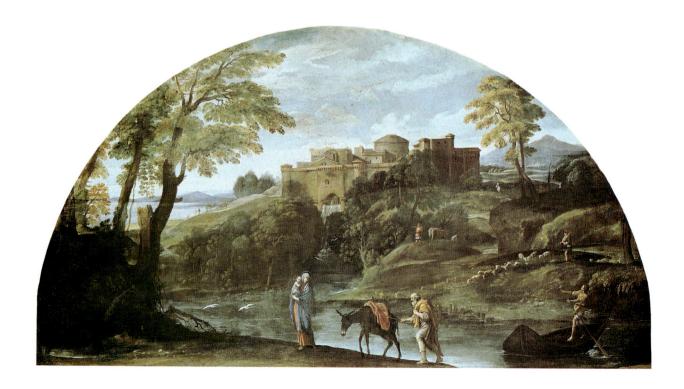

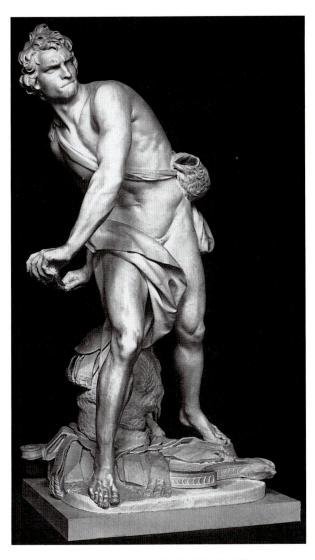

15.8 Gian Lorenzo Bernini. *David*, 1623. Marble. Life size, height $5'6^{1}/_{4}''$ (1.7 m). Galleria Borghese, Rome. It is said that Bernini carved the face while looking at his own in a mirror. The expression reinforces the tension of the pose.

tension of the arms to the final detail of the clenched toes of the right foot, this *David* seems to personify energy, almost exploding through space. Bernini gives the figure additional expressive power by his deep cuts in the stone, producing a strong contrast between light and dark. In its expression of violent emotion, its communication of the psychological state of its subject, and its virtuoso technique, this *David* is a truly baroque figure.

Some of Bernini's sculptures depict his aristocratic patrons with the same mastery he applied to spectacular subjects. The bust of Cardinal Scipione Borghese [15.9], with its quizzical expression and almost uncanny sense of movement, conveys the personality of the sitter with sympathy and subtlety. Most of his finest masterpieces,

however, deal with religious themes, and draw their inspiration from Counter-Reformation teachings.

The most spectacular of these is *Saint Teresa in Ecstasy*, which uses a combination of architecture, sculpture, and natural light to convey the saint's ecstatic vision of an angel [15.10]. Gilded bronze shafts of light are further illuminated by light from a concealed window, as Saint Teresa, torn by violent emotion, awaits the blow of the angel, about to pierce her to the heart.

Works such as these would have been more than sufficient to guarantee Bernini's immortality, but his architectural achievements are equally impressive. The physical appearance of baroque Rome was enriched by numerous Bernini fountains, Bernini palaces, and Bernini churches. Most important of all was his work on Saint Peter's, where he created in front of the basilica a vast piazza with its oval colonnade, central obelisk, and fountains—an ensemble (see Figure 15.1) that rivals in grandeur even the fora of Imperial Rome.

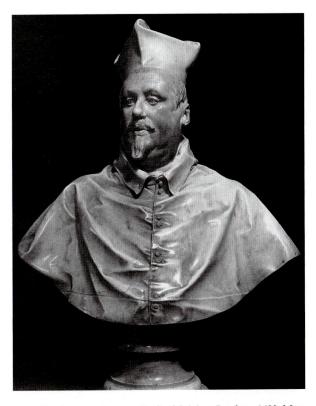

15.9 Gian Lorenzo Bernini. *Cardinal Scipione Borghese*, 1632. Marble. Height 30³/₄" (78 cm). Galleria Borghese, Rome. Breaking with the tradition of Renaissance portraiture, which showed the subject in repose, Bernini portrays the cardinal, his first patron, with a sense of lively movement.

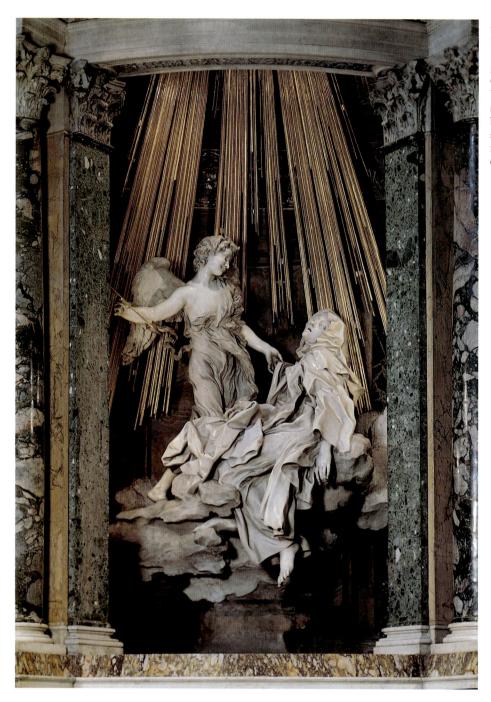

15.10 Gian Lorenzo Bernini. Saint Teresa in Ecstasy, 1645–1652. Marble. Height of group 11'6" (3.5 m). Cornaro Chapel, Santa Maria della Vittoria, Rome. One of the supreme masterpieces of baroque art, this famous work shows Bernini's virtuoso skill in the expression of heightened religious emotion.

Bernini's expansive personality and his success in obtaining important commissions brought him tragically if inevitably into conflict with the other great architect of baroque Rome: Francesco Borromini (1599–1667). Brooding and melancholy much of the time, Borromini spent most of his career in constant competition with his brilliant rival and finally committed suicide (see "Contemporary Voices" box, this chapter). Whereas Bernini was concerned with the broad sweep of a design and

grandiose effects, Borromini concentrated on elaborate details and highly complex structures.

Borromini's greatest and most influential achievement was the church of San Carlo alle Quattro Fontane. The inside, designed between 1638 and 1641, was his first important work; the façade, which he added in 1665–1667, was his last [15.11]. On a relatively small exterior wall space Borromini has placed a wide range of decorative elements—columns, niches, arches, statues—while the

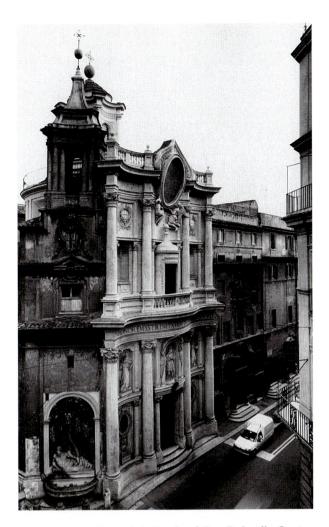

15.11 Francesco Borromini. Façade of San Carlo alle Quattro Fontane, Rome. Begun 1638, façade finished 1667. Length 52′ (15.86 m), width 34′ (10.36 m), width of façade 38′ (11.58 m). The curves and countercurves of the façade, together with the rich, almost cluttered, decoration, mark a deliberate rejection of the Classical style.

façade flows in sinuous curves. The almost obsessive elaboration of design is in strong contrast to the clarity of many of Bernini's buildings, but its ornateness represents another baroque approach to architecture, one that was to have a continual appeal.

BAROQUE ART IN FRANCE AND SPAIN

In general, the more extravagant aspects of Italian baroque art never appealed greatly to French taste, which preferred elegance to display and restraint to emotion. Indeed, the conservative nature of French art found expression before the end of the century in the foundation of the Académie des Beaux-Arts (Academy of the Fine Arts). The first of the special exhibitions organized by the academy took place in 1667, under the patronage of Louis XIV. Both then and through the succeeding centuries academy members saw their function as the defense of traditional standards and values rather than the encouragement of revolutionary new developments. Their innate conservatism affected both the works selected for exhibition and those awarded prizes. The tension between these self-appointed guardians of tradition and those artists who revolted against established ideas lasted well into the nineteenth century.

The closest parallel in French baroque painting to the intensity of Caravaggio is to be found in the strangely moving paintings of Georges de La Tour (1590–1652), whose candlelit scenes and humbly dressed figures are reminiscent of some aspects of the Italian's work. Yet the mood of such paintings as *The Lamentation over Saint Sebastian* [15.12] is far more restrained—the emotions are not stressed.

The greatest French painter of the seventeenth century, Nicolas Poussin (c. 1594–1665), echoed this French

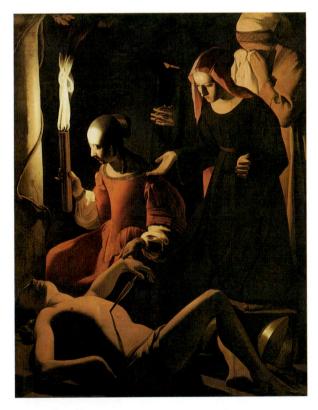

15.12 Georges de La Tour. *The Lamentation over Saint Sebastian*, 1645. Oil on canvas, approx. $5'3'' \times 4'3''$ (1.6 \times 1.3 m). Gemäldegalerie Staatliche Museen. Preussischer Kulturbesitz, Berlin. The influence of Caravaggio is obvious. Nevertheless, the simplification of details and the distaste for violence (there is no blood around the arrow) are typical of the restraint of de La Tour's paintings.

preference for restraint when he decisively rejected the innovations of Caravaggio, whose works he claimed to detest. He saw his own work as a kind of protest against the excesses of the baroque; a strong dislike of his Roman contemporaries did not, however, prevent Poussin from spending most of his life in Rome. It may seem strange that so French an artist should have chosen to live in Italy, but what drew him there was the art of ancient, not baroque, Rome. Poussin's only real and enduring enthusiasm was for the world of Classical antiquity. His friends in Rome included the leading antiquarians of the day, and his paintings often express a nostalgic yearning for a long-vanished past.

Among Poussin's most poignant early works is Et in Arcadia Ego [15.13], in which four country dwellers

gather at a large stone tomb in an idyllic landscape. The inscription they struggle intently to decipher says *Et in Arcadia Ego* ("I am also in Arcadia"), a reminder that death exists even in the midst of such beauty and apparent simple charm. (Arcadia, although an actual region in Greece, was also used to refer to an imaginary land of perfect peace and beauty.) That charm is not altogether so simple, however. Poussin's rustic shepherds and casually dressed shepherdess seem to have stepped directly from some actual antique scene, such as Poussin often incorporated into his paintings, while the rich landscape is reminiscent of Venetian painting. The entire work therefore represents not so much the authentic representation of an actual past as the imaginative creation of a world that never really existed.

15.13 Nicolas Poussin. *Et in Arcadia Ego*, c. 1630. Oil on canvas, approx. $40^{\prime\prime} \times 32^{\prime\prime}$ (102×81 cm). Derbyshire Collection, Chatsworth Settlement. Although influenced by Classical sources, this early version of the subject has a poetical character that owes much to the art of Titian.

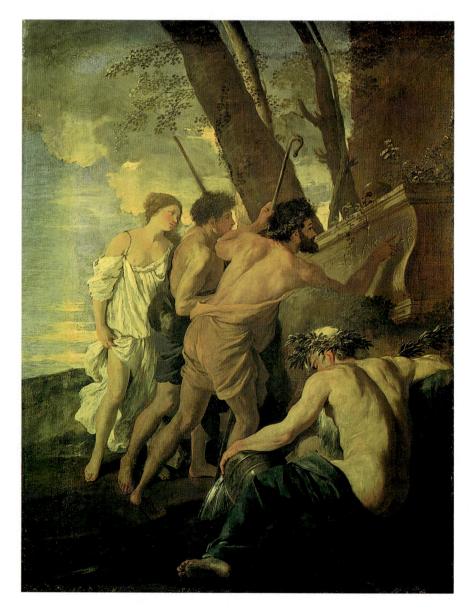

As his career developed, Poussin's style changed. The poetry of his earlier work was replaced by a grandeur that sometimes verges on stiffness. The *Rape of the Sabine Women* [15.14] is conceived on a massive scale and deals with a highly dramatic subject, yet the desperate women and violent Roman soldiers seem almost frozen in motion. Every figure is depicted clearly and precisely, as in Carracci's *The Triumph of Bacchus and Ariadne* (see Figure

15.6), yet with none of the exuberance of the earlier artist. The artificial, contrived air is deliberate.

By the end of his life, Poussin had returned to the simplicity of his earlier style, but it was drained of any trace of emotion. Another version of the subject of *Et in Arcadia Ego* [15.15], painted some ten years later, provides a revealing contrast. The same four figures study the same tomb, but in a mood of deep stillness. Gone is

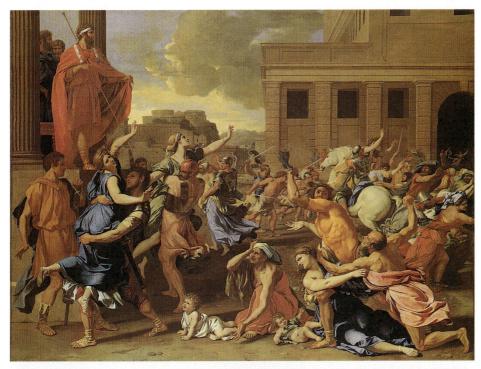

15.14 Nicolas Poussin. Rape of the Sabine Women, c. 1634. Oil on canvas, $60^7/8'' \times 82^5/8''$ (154.6 \times 209.9 cm). Metropolitan Museum of Art, New York, Harris Brisband Dick Fund, 1946. At the time of this painting, Poussin was strongly influenced by the ancient sculptures he had studied in Rome, most notably in the careful depiction of the musculature of his figures.

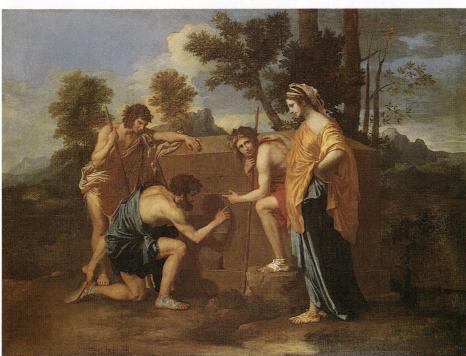

15.15 Nicolas Poussin. *Et in Arcadia Ego*, 1638–1639. Oil on canvas, $33\frac{1}{2}$ " \times 47 $\frac{5}{8}$ " (85 \times 121 cm). Louvre, Paris. When compared to Figure 15.13, an earlier version, this treatment is found to be calmer and less dramatic. The group is seen from the front rather than diagonally, and both faces and poses are deliberately unemotional.

15.16 Claude Gellee (called Le Lorrain). French (worked in Rome), 1600-1682. Mill on a River, 1631. Oil on canvas, $24^1/_4$ " $\times 33^1/_4$ " (61.5×84.5 cm). Museum of Fine Arts, Boston (Seth K. Sweetser Fund). Although this is one of Lorrain's early paintings, it already shows his ability to create a sense of infinite space and depth, in part by calculated contrasts between light and dark.

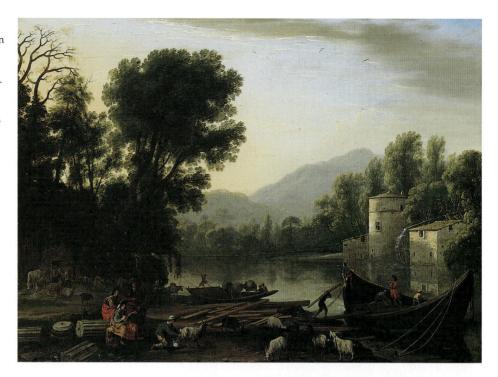

the urgency of the earlier painting and much of the poetry. In its place, Poussin creates a mood of philosophical calm and tries to recapture the lofty spirit of antiquity, most notably in the noble brow and solemn stance of the shepherdess. Compensating for the loss of warmth is the transcendent beauty of the image.

Even had Poussin been prepared to leave Rome and return to the French court, the austere nature of his art would hardly have served to glorify that most autocratic and magnificent of monarchs, Louis XIV (born 1638, reigned 1643–1715). For the most part, the king had only second-rate artists available to him at court. Like Poussin, the other great French painter of the day—Claude Gellee (called Claude Le Lorrain) (1600–1682)—spent most of his life in Rome, and was only interested in painting landscapes [15.16].

Although most official court painters achieved only mediocre respectability, an exception must be made for Hyacinthe Rigaud (1659–1743), whose stunning portrait of Louis XIV [15.17] epitomizes baroque grandeur. It would be difficult to claim the intellectual vigor of Poussin or the emotional honesty of Caravaggio for this frankly flattering image of majesty. The stilted pose and gorgeous robes may even suggest an element of exaggeration, almost of parody; yet a glance at the king's sagging face and stony gaze immediately puts such an idea to rest. Rigaud has captured his patron's outward splendor while not hiding his increasing weakness, due in great part to his decadent lifestyle. The signs of physical collapse are visible—*Et in Versailles Ego*.

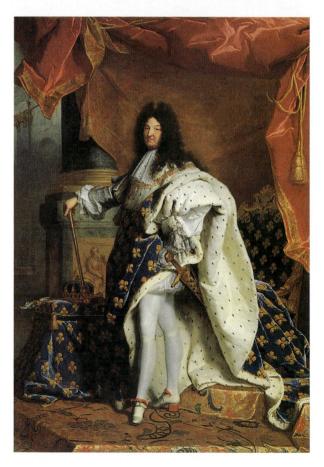

15.17 Hyacinthe Rigaud. *Louis XIV*, 1701. Louvre, Paris, $9^{7}/8^{n} \times 6^{4}$ " (2.77 \times 1.94 m). Louis was sixty-three when this portrait was painted. The swirling ermine-lined robes are a mark of the king's swagger. The ballet pose of his feet is a reminder of the popularity of dancing at the French court.

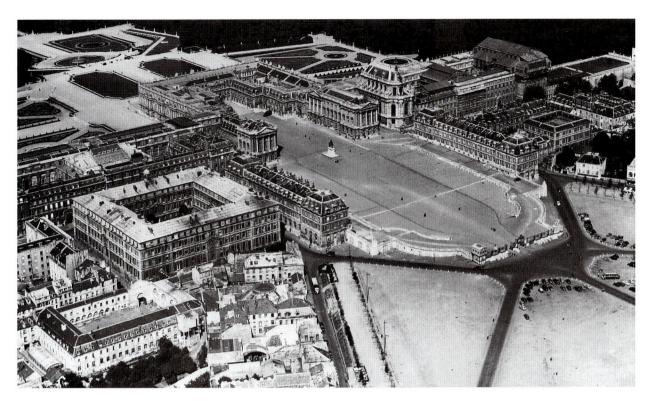

15.18 Aerial view, Palace of Versailles, begun 1669, and a small portion of the surrounding park. Width of palace 1935′ (589.79 m). The chief architects for the last stage of construction at Versailles were Louis le Vau (1612–1670) and Jules Hardouin-Mansart (1646–1708). Although the external decoration of the palace is Classical in style, the massive scale is characteristic of baroque architecture.

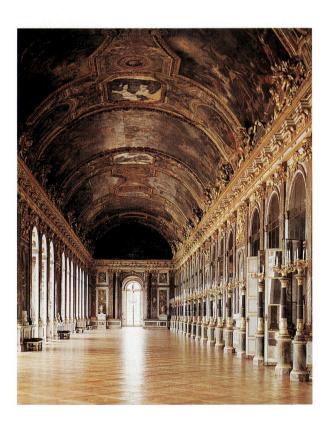

Louis XIV's most lasting artistic achievement was a new center for the court—the Palace of Versailles—built a few miles outside Paris [15.18]. The history of its construction is long and complicated, and the final result betrays some of the uncertainties that went into its planning.

Louis XIV, an acute politician and astute judge of human psychology, was well aware of the fact that the aristocratic courtiers who surrounded him were likely to turn on him if he showed the faintest sign of weakness or hesitation. By constructing an elaborate setting at Versailles in which he could consciously act out the role of Grand Monarch, Louis conveyed the image of himself as supreme ruler and thereby retained his mastery over the aristocracy.

The Palace of Versailles was therefore conceived by the king in political terms. The architects' task, both inside and out, was to create a building that would illustrate Louis XIV's symbolic concept of himself as the Sun King. Thus, each morning the king would rise from his bed, make his way past the assembled court through the Hall of Mirrors [15.19] where the seventeen huge mirrors reflected both the daylight and his own splendor, and enter the gardens along the main wing of the palace—laid

15.19 Jules Hardouin-Mansart and Charles Lebrun. *Galerie des Glaces* (*Hall of Mirrors*), Palace of Versailles. Begun 1676. Length 240′ (73.15 m), width 34′ (10.36 m), height 43′ (13.11 m). The interior decoration was by Charles Lebrun (1619–1690), who borrowed the idea of a ceiling frescoed with mythological scenes from Carracci's painted ceiling in the Farnese Palace (see Figure 15.6).

out in an east—west axis to follow the path of the sun. At the same time both the palace and its gardens, which extend behind it for some two miles, were required to provide an appropriate setting for the balls, feasts, and fireworks displays organized there.

Given the grandiose symbolism of the ground plan and interior decorations, the actual appearance of the outside of the Palace of Versailles, with its rows of Ionic columns, is surprisingly modest. The simplicity of design and decoration is another demonstration of the French ability to combine the extremes of baroque art with a more Classical spirit.

15.20 El Greco. *Martyrdom of Saint Maurice and the Theban Legion*, 1581–1584. Oil on canvas, $14'6'' \times 9'10'' (4.42 \times 3 \text{ m})$. Escorial Palace, Madrid, Spain. The saint is facing the viewer, pointing up toward the heavenly vision he sees.

The Spanish reaction to the baroque was very different. Strong religious emotion had always been a characteristic of Spanish Catholicism, and the new possibilities presented by baroque painting were foreshadowed in the work of the greatest painter active in Spain in the late sixteenth century, El Greco "the Greek" (1541–1614). Domenikos Theotokopoulos (El Greco's birth name) was born on the Greek island of Crete, which at the time was under Venetian rule. He apparently traveled to Venice, where he was influenced by Titian, and to Rome. It is not known why he went to Spain, but El Greco is recorded as having lived in Toledo from 1577 until his death.

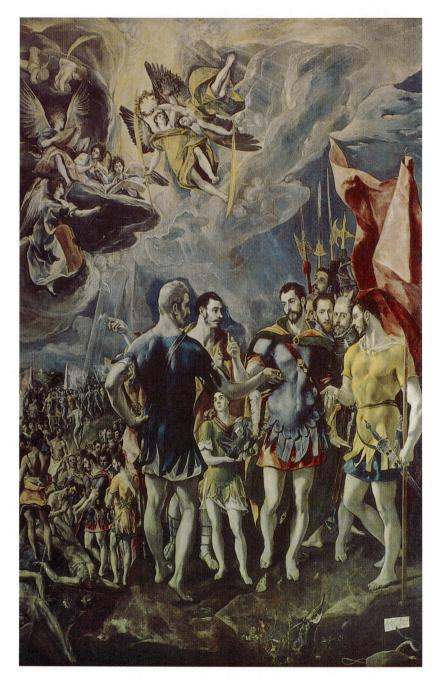

Although he tried to obtain court patronage, the violence of contrasts in his work—clashes of color, scale, and emotion—did not appeal to official taste: his first royal commission, the *Martyrdom of Saint Maurice and the Theban Legion* [15.20], was his last. The painting illustrates the theme of moral responsibility and choice. The Roman soldier Maurice, faced with a conflict between the demands of Roman law and of his Christian faith, chooses the latter, together with his fellow Theban and Christian legionnaires. The hallucinatory brightness of the colors is probably derived from Italian Mannerist painting of earlier in the sixteenth century, as are the elongated proportions; but the effect—underlined by the asymmetrical composition—is incomparably more fierce and disturbing.

In the absence of court patronage, El Greco produced many of his works for Toledo, his city of residence. Among the most spectacular is the *Burial of Court Orgaz* [15.21], a local benefactor who was rewarded for his generosity by the appearance of Saint Augustine and Saint Stephen at his funeral in 1323. They can be seen in the lower center of the painting, burying the count while his soul rises; the small boy dressed in black in the left-hand

corner is the artist's eight-year-old son, identified by an inscription. The rich, heavy robes of the saints are balanced by the swirling drapery of the heavenly figures above, while the material and spiritual worlds are clearly separated by a row of grave, brooding local dignitaries.

The same religious fervor appears in the work of José de Ribera (1591–1652) but is expressed in a far more naturalistic style. Like Caravaggio, Ribera used peasants in his religious scenes, which were painted with strong contrasts of light and dark. In his *The Martyrdom of Saint Bartholomew* [15.22], Ribera spares us nothing in the way of realism as the saint is hauled into position to be flayed. The muscular brutality of his executioners and the sense of impending physical agony are almost masochistic in their vividness. Only in the compassionate faces of some onlookers do we find any relief from the torment of the scene.

Although paintings like Ribera's are representative of much of Spanish baroque art, the work of Diego Velázquez (1599–1660), the greatest Spanish painter of the Baroque period, is very different in spirit. Velázquez used his superlative technique to depict scenes brimming with life, preferring the court of Phillip IV (where he spent much of his career), and the lives of ordinary people to religious or mythological subjects.

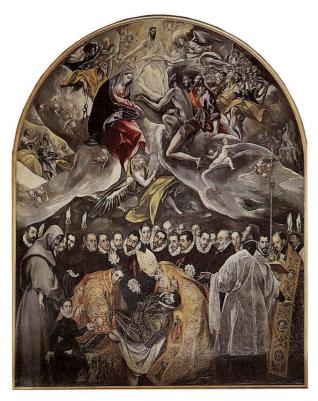

15.21 El Greco. *Burial of Count Orgaz*, 1586. Oil on canvas, $16' \times 11'10''$ (4.88 \times 3.61 m). San Tomé, Toledo, Spain. Note the elongated proportions of the figures in the heavens and the color contrasts between the upper and lower sections of the painting.

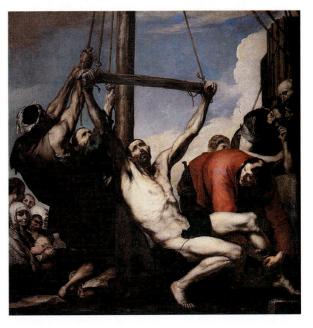

15.22 José de Ribera. *The Martyrdom of Saint Bartholomew*, c. 1639. Oil on canvas, $92'' \times 92''$ (2.34 \times 2.34 m). Museo del Prado, Madrid. Unlike La Tour (see Figure 15.12), Ribera refuses to soften the subject by idealizing his figures.

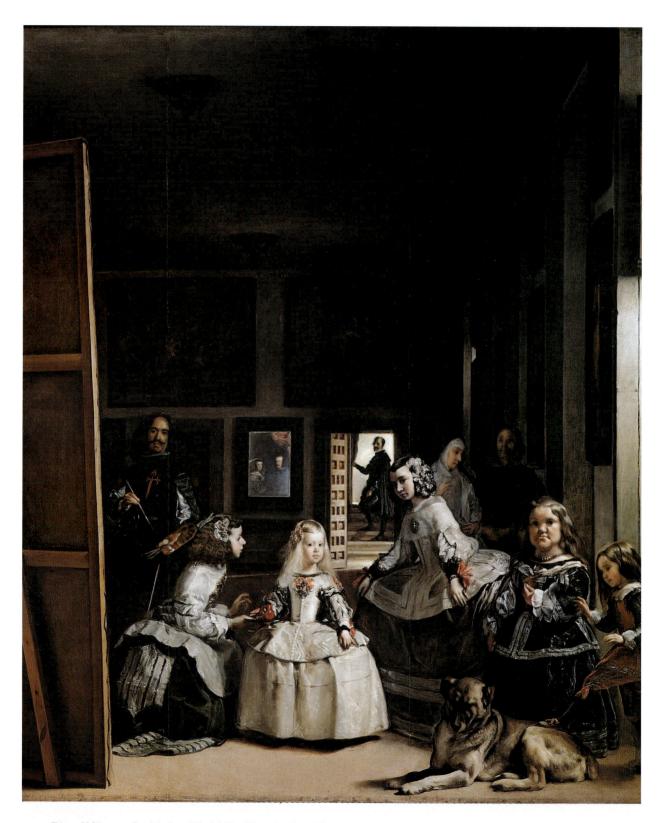

15.23 Diego Velázquez. Las Meninas (The Maids of Honor), 1656. Oil on canvas, $10'5'' \times 9'$ (3.18 \times 2.74 m). Museo del Prado, Madrid. The red cross on the artist's breast, symbol of the noble Order of Santiago, was painted there by the king's command after Velázquez' death. Velázquez regarded his nomination to the order in 1658 as recognition of both his own nobility and that of his art. He thus became one of the first victors in the war that artists had waged ever since the Renaissance for a social status equal to that of their patrons. Throughout the sixteenth and seventeenth centuries, their aristocratic and ecclesiastical employers regarded them as little better than servants; only by the end of the eighteenth century were artists and musicians able to assert their social and political independence.

The finest and most complex work of Velázquez is Las Meninas (The Maids of Honor) [15.23]. Unlike Louis XIV, the Spanish king was fortunate enough to have one of the greatest painters in history to preserve the memory of his court. It is to Philip IV's credit that he treated Velázquez with respect and honor. In return, Velázquez produced a number of superb portraits of the monarch and his family. Las Meninas is an evocation of life in the royal palace. The scene is Velázquez' own studio there; the five-year-old Princess Margarita has come with her two maids to visit the painter at work on a huge painting that must surely be Las Meninas itself. Despite the size of the picture, the mood is quiet, even intimate: two figures in casual conversation, a sleepy dog, a passing court official who raises a curtain at the back to peer into the room. Yet so subtle is Velázquez' use of color that we feel the very presence of the room as a three-dimensional space filled with light—now bright, now shadowy. The reality of details like the little princess' hair or dress never distracts from the overall unity of color and composition. That Velázquez was justifiably proud of his abilities is shown by the two distinguished visitors whose presence is felt rather than seen, reflected as they are in the mirror hanging on the back wall: the king and queen come to honor the artist by visiting him in his own studio.

Baroque Art in Northern Europe

Most baroque art produced in Northern Europe was intended for a middle-class rather than an aristocratic audience, as in Italy, France, and Spain. Before examining the effects of this, however, we must look at two very notable exceptions, Peter Paul Rubens (1577–1640) and his assistant and later rival, Anthony van Dyck (1599–1641), both Flemish by birth.

Rubens is often called the most universal of painters because he produced with apparent ease an almost inexhaustible stream of work of all kinds—religious subjects, portraits, landscapes, mythological scenes—all on the grandest of scales. He must certainly have been among the most active artists in history: in addition to running the workshop used for the production of his commissions, he pursued a career in diplomacy, which involved considerable traveling throughout Europe, and still had time for academic study. He is said to have spoken and written six modern languages and to have read Latin fluently. He was also versed in theology. Further, in contrast to solitary and gloomy figures like Caravaggio and Borromini, Rubens seems to have been contented in his personal life. After the death of his first wife he remarried at

age fifty-three, a girl of sixteen, Hélène Fourment, with whom he spent an ecstatically happy ten years before his death. The paintings of his last decade are among the most intimate and tender of all artistic tributes to married love, as shown in *Hélène Fourment and her Children* [15.24].

http://www.spanisharts.com/prado/rubens.htm

Rubens

For the most part, however, intimacy is not the quality most characteristic of Rubens' art. Generally his pictures convey something of the restless energy of his life. In *The Rape of the Daughters of Leucippus* [15.25] every part of the painting is filled with movement as the mortal women, divine riders, and even the horses are drawn into a single pulsating spiral. The sense of action, so characteristic of Rubens' paintings, is in strong contrast to the frozen movement of Poussin's depiction of a similar episode (see Figure 15.14). Equally typical of the artist is his frank delight in the women's sensuous nudity and ample proportions—the slender grace of other artists' nudes was not at all to Rubens' taste.

Perhaps the most extraordinary achievement of Rubens' remarkable career was his fulfillment of a commission from Marie de' Medici, widow of Henry IV and mother of Louis XIII, to decorate an entire gallery with paintings illustrating her life. In a mere three years, from 1622 to 1625, he created twenty-four enormous paintings commemorating the chief events in which she played a part, with greater flattery than truth. The splendid *Journey of Marie de' Medici* [15.26] shows the magnificently attired queen on horseback at the Battle of Ponts-de-Cé, accompanied by the spirit of Power, while Fame and Glory flutter around her head. It hardly matters that the queen's forces were ignominiously defeated in the battle, so convincingly triumphant does her image appear.

Paintings on this scale required the help of assistants, and there is no doubt that in Rubens' workshop much of the preliminary work was done by his staff. One of the many artists employed for this purpose eventually became as much in demand for portraits of the aristocracy as his former master. Anthony van Dyck spent two years (1618–1620) with Rubens before beginning his career as an independent artist. Although from time to time he painted religious subjects, his fame rests on his formal portraits, many of which were produced during the years he spent in Italy and England.

Van Dyck's refined taste equipped him for satisfying the demands of his noble patrons that they be shown as they thought they looked rather than as they actually

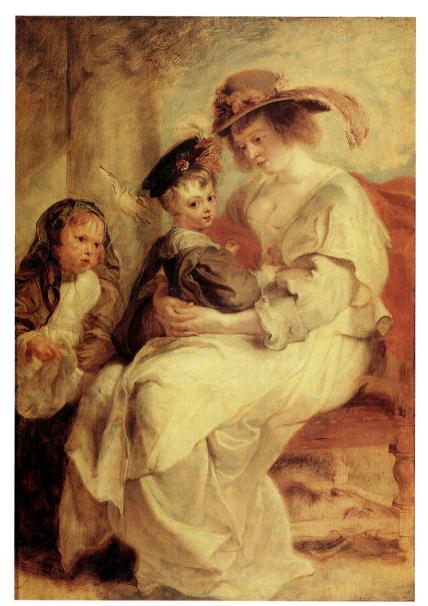

15.24 Peter Paul Rubens. *Hélène Fourment and Her Children*, 1636–1637. Oil on canvas, $44\frac{1}{2}$ " \times $32\frac{1}{4}$ " (118 \times 85 cm). Louvre, Paris. In this affectionate portrait of his young wife and two of their children, Rubens achieves a sense of immediacy and freshness by the lightness of his touch.

were. It is certainly difficult to believe that any reallife figure could have had quite the haughty bearing and lofty dignity of the Marchesa Cataneo [15.27] in van Dyck's portrait of her, although the Genoese nobility of which she was a member was known for its arrogance.

International celebrities like Rubens and van Dyck, at home at the courts of all Europe, were far from typical of northern artists. Indeed, painters in the Netherlands in particular found themselves in a very different situation from their colleagues elsewhere. The two most lucrative sources of commissions—the church and the aristocracy—were unavailable to them because the Dutch Calvinist Church followed the post-Reformation practice of forbidding the use of images in church, and because

Holland had never had its own powerful hereditary nobility. Painters therefore depended on the tastes and demands of the open market.

One highly profitable source of income for Dutch artists in the seventeenth century was the group portrait, in particular that of a militia, or civic guard company. These bands of soldiers had originally served a practical purpose in the defense of their country, but their regular reunions tended to be social gatherings, chiefly for the purpose of eating and drinking. A group of war veterans today would hire a photographer to commemorate their annual reunion; the militia companies engaged the services of a portrait painter. If they were lucky or rich enough they might even get Frans Hals (c. 1580–1666), whose group portraits capture the individuality of each

of the participants while conveying the general convivial spirit of the occasion [15.28]. Hals was certainly not the most imaginative or inventive of artists, but his sheer ability to paint, using broad dynamic brush strokes and cleverly organized compositions, makes his work some of the most attractive of that period.

Very different in spirit was Jan Vermeer (1632–1675), who worked almost unknown in the city of Delft and whose art was virtually forgotten after his death. Rediscovered in the nineteenth century, it is now regarded as second only to Rembrandt's for depth of feeling. At first sight this may seem surprising, since Vermeer's subjects are rather limited in scope. A woman reading a letter [15.29], girls sewing or playing music—through such intimate scenes Vermeer reveals qualities of inner contemplation and repose that are virtually unique in the entire history of art. Unlike Hals, with his loose style, Vermeer built up his forms by applying the paint in the form of tiny dots of color, and then rendering the details with

careful precision. Like Velázquez' *Las Meninas* (see Figure 15.23), his paintings are dominated by light so palpable as to seem to surround the figures with its presence. However, where Velázquez' canvas is suffused with a warm, Mediterranean glow, Vermeer's paintings capture the coolness and clarity of northern light. The perfection of his compositions creates a mood of stillness so complete that mundane activities take on a totally unexpected concentration and become endowed with a heightened sense of importance.

http://sunsite.dk/cgfa/vermeer/index.html

Vermeer

Rembrandt van Rijn (1606–1669) is one of the most deeply loved of all painters. No summary of his achievements can begin to do it justice. Born in Leiden in the

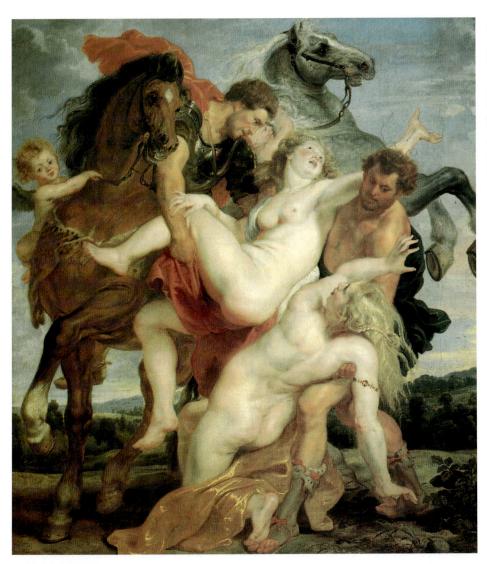

15.25 Peter Paul Rubens. *The Rape of the Daughters of Leucippus*, c. 1618. Oil on canvas, 7'3" × 6'10" (2.21 × 2.08 m). Alte Pinakothek, Munich. According to the Greek legend, Castor and Pollux, twin sons of Zeus, carried off King Leucippus' two daughters, who had been betrothed to their cousins. The myth here becomes symbolic of physical passion.

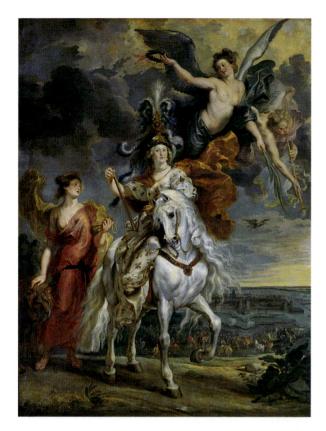

15.26 Peter Paul Rubens. *The Journey of Marie de' Medici*, 1622-1625. Oil on canvas, $14'11'' \times 9'6''$ (3.94×2.95 m). Louvre, Paris. This painting focuses on the triumphant figure of the queen. As in many of his large works, Rubens probably painted the important sections and left other parts to his assistants.

Netherlands, he spent a short time at the university there before beginning his studies as a painter. The early part of his career was spent in Amsterdam, where he moved in 1631 and soon became known as a fashionable portrait painter. His life was that of any successful man of the time, happily married, living in his own fine house.

http://sunsite.dk/cgfa/rembrand/index.html

Rembrandt

Rembrandt's interest in spiritual matters and the eternal problems of existence, however, coupled with his researches into new artistic techniques, seem to have prevented his settling down for long to a bourgeois existence of this kind. The artistic turning point of his career came in 1642, the year of the death of his wife, when he finished the painting known as *The Night Watch* [15.30]. Although ostensibly the same kind of group portrait as Hals' *Banquet of the Officers of the Civic Guard* (see Figure 15.28), it is composed with much greater complexity and subtlety. The arrangement of the figures and the sense of depth show how far Rembrandt was outdistancing his contemporaries.

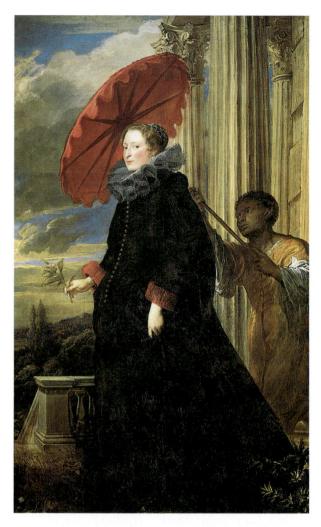

15.27 Anthony van Dyck. Marchesa Elena Grimaldi, Wife of Marchese Nicola Cataneo, c. 1623. Oil on canvas, $97'' \times 68''$ (2.46 \times 1.72 m). National Gallery of Art, Washington (Widener Collection, 1942). Painted fairly early in van Dyck's career during a stay in Genoa, the portrait emphasizes the aristocratic bearing of its subject by somber colors and an artificial setting.

The price Rembrandt paid for his genius was growing neglect, which by 1656 had brought bankruptcy. The less his work appealed to the public of his day, the more Rembrandt retreated into his own spiritual world. About 1645 he set up house with Hendrickje Stoffels, although he never married her, and his unconventional behavior succeeded in alienating him still further from his contemporaries. It was the faithful Hendrickje, however, who together with Titus, Rembrandt's son by his first marriage, helped put his financial affairs in some sort of order. Her death in 1663 left him desolate, and its effect on him is visible in some of his last self-portraits [15.31].

Throughout his life Rembrandt had sought selfunderstanding by painting a series of portraits of himself, charting his inner journey through the increasingly tragic events of his life. Without self-pity or pretense he

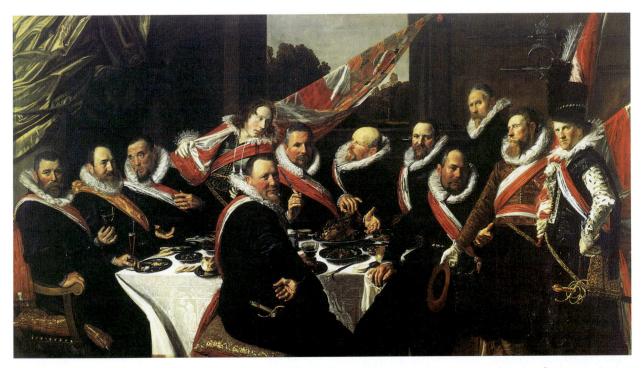

15.28 Frans Hals. Banquet of the Officers of the Civic Guard of Saint George at Haarlem, 1616. Oil on canvas, $5'8^{1}/_{4}'' \times 10'6^{3}/_{8}''$ (1.75 × 3.24 m). Frans Halsmuseum, Haarlem. The diagonal lines of the curtains, banner, and sashes help bind the painting together and make it at the same time both a series of individual portraits and a single unified composition.

analyzed his own feelings and recorded them with a dispassion that might be called merely clinical if its principal achievement were not the revelation of a human soul. By the time of Hendrickje's death, which was followed in 1668 by that of Titus, Rembrandt was producing self-portraits that evoke not so much sympathy for his sufferings as awe at their truth. The inexorable physical decay, the universal fate, is accompanied by a growth in spiritual awareness that must have at least in part come from Rembrandt's lifelong meditation on the Scriptures.

Rembrandt used contrast between light and darkness to achieve dramatic and emotional effect in all his work. Light also served to build composition and to create depth in his paintings and etchings. In the paintings, he often built up layers of paint to create a richness of color and sense of texture unmatched by any of his contemporaries. In his etchings and engravings he developed ways of varying the lines to produce a similarly elaborate surface. A supremely baroque artist, Rembrandt always used his mastery of composition and texture to deepen and enhance the emotional power of the image.

In the final years of his life, Rembrandt turned increasingly to biblical subjects, always using them to explore some aspect of human feelings. In *Jacob Blessing the Sons of Joseph* [15.32] all the tenderness of family affection is expressed in the juxtaposition of the heads of the old man and his son, whose expression of love is surpassed only by that of his wife as she gazes almost unseeingly at

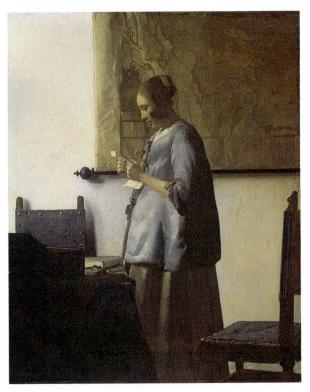

15.29 Jan Vermeer. Woman Reading a Letter, 1662–1664. Oil on canvas, $18^{1}/_{8}'' \times 15^{1}/_{4}''$ (46 × 39 cm). Rijksmuseum, Amsterdam. Much of the sense of balance and repose that Vermeer conveys is achieved by his careful color contrasts between blue and yellow and the repetition of rectangular surfaces such as the table, chairbacks, and the map of the Netherlands on the wall.

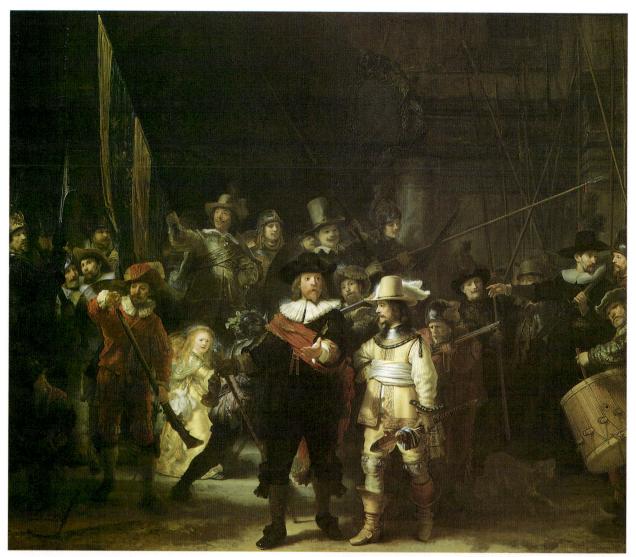

15.30 Rembrandt. The Sortie of Captain Frans Banning Cocq's Company of the Civic Guard (The Night Watch), 1642. Oil on canvas, $11'9^1/_2'' \times 14'2^1/_2''$ (3.63 \times 4.37 m). Rijksmuseum, Amsterdam. Recent cleaning has revealed that the painting's popular name, though conveniently brief, is inaccurate. Far from being submerged in darkness, the principal figures were originally bathed in light and painted in glowing colors.

her sons. The depth of emotion and the dark shadows mark that school of baroque painting initiated by Caravaggio, yet it seems almost an impertinence to categorize so universal a statement. Through this painting Rembrandt seems to offer us a deep spiritual comfort for the tragic nature of human destiny revealed by the self-portraits.

15.31 Rembrandt. *Old Self-Portrait*, 1669. Oil on canvas, $23^{1}/_{4}^{\prime\prime} \times 20^{3}/_{4}^{\prime\prime}$ (59 × 53 cm). Mauritshuis, The Hague. In this, his last self-portrait painted a few months before his death, the artist seems drained of all emotion, his expression resigned, and gaze fixed.

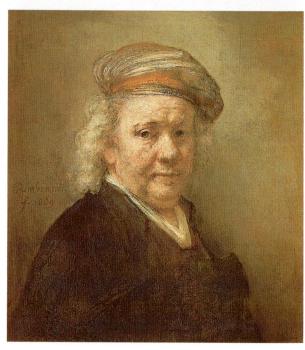

CONTEMPORARY VOICES

Giambattista Passeri

In this passage the seventeenth-century painter and biographer Giambattista Passeri describes the suicide of Francesco Borromini. In the summer of 1667, tormented by Bernini's triumphant successes, Borromini

. . . was assailed again with even greater violence by hypochondria which reduced him within a few days to such a state that nobody recognized him any more for Borromini, so haggard had his body become, and so frightening his face. He twisted his mouth in a thousand horrid ways, rolled his eyes from time to time in a fearful manner, and sometimes would roar and tremble like an irate lion. His nephew [Bernardo] consulted doctors, heard the advice of friends, and had him visited several times by priests. All agreed that he should never be left alone, nor be allowed any occasion for working, and that one should try to make him sleep at all costs, so that his spirit might calm down. This was the precise order which the servants received from his nephew and which they carried out. But instead of improving, his illness grew worse. Finding that he was never obeyed, as all he asked for was refused him; he imagined that this was done in order to annoy him rather than for his good, so that his restlessness increased and as time passed his hypochondria changed into pains in his chest, asthma, and a sort of intermittent frenzy. One evening, during the height of summer, he had at last thrown himself into his bed, but after barely an hour's sleep he woke up again, called the servant on duty, and asked for a light and writing material. Told by the servant that these had been forbidden him by the doctors and his nephew, he went back to bed and tried to sleep. But unable to do so in those hot and sultry hours, he started to toss agitatedly about as usual, until he was heard to exclaim "When will you stop afflicting me, O dismal thoughts? When will my mind cease being agitated? When will all these woes leave me? . . . What am I still doing in this cruel and execrable life?" He rose in a fury and ran to a sword which, unhappily for him and through carelessness of those who served him, had been on a table, and letting himself barbarously fall on the point was pierced from front to back. The servant rushed in at the noise and seeing the terrible spectacle called others for help, and so, half-dead and covered in blood, he was put back to bed. Knowing then that he had really reached the end of his life, he called for the confessor and made his will.

From R. and M. Wittkower, Born Under Saturn (New York: Norton, 1963), p. 141.

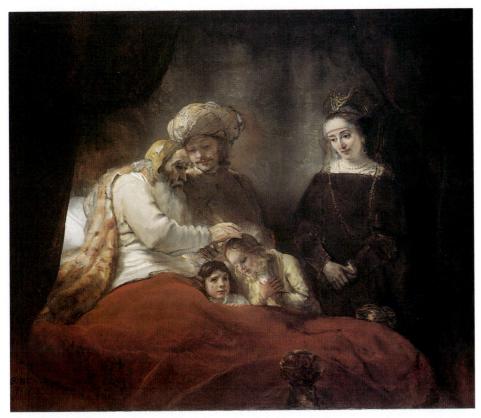

15.32 Rembrandt. Jacob Blessing the Sons of Joseph, 1656. Oil on canvas, $5'8^1/_4'' \times 6'9''$ (1.75 \times 2.1 m). Staatliche Kunstsammlungen Kassel, Galerie Alte Meister, GK 249. In his very personal version of the biblical story, painted the year of his financial collapse, Rembrandt includes Asenath, Joseph's wife. Although she is not mentioned in the text, her presence here emphasizes the family nature of the occasion.

BAROQUE MUSIC

Although the history of music is as long as that of the other arts, the earliest music with which most modern music lovers are on familiar ground is that of the Baroque period. It is safe to say that many thousands of listeners have tapped their feet to the rhythm of a baroque concerto without knowing or caring anything about its historical context, and with good reason: Baroque music, with its strong emphasis on rhythmic vitality and attractive melody, is easy to respond to with pleasure. Furthermore, in the person of Johann Sebastian Bach, the Baroque period produced one of the greatest geniuses in the history of music, one who shared Rembrandt's ability to communicate profound experience on the broadest level.

The qualities that make baroque music popular today were responsible for its original success: Composers of the Baroque period were the first since Classical antiquity to write large quantities of music intended for the pleasure of listeners as well as the glory of God. The polyphonic music of the Middle Ages and the Renaissance, with its interweaving of many musical lines, had enabled composers like Machaut or Palestrina to praise the Lord on the highest level of intellectual achievement, but the result was a musical style far above the heads of most of their contemporary listeners. The Council of

Trent, in accordance with Counter-Reformation principles, had even considered prohibiting polyphony in religious works in order to make church music more accessible to the average congregation before finally deciding that this would be too extreme a measure. For once, the objectives of Reformation and Counter-Reformation coincided, for Luther had already simplified the musical elements in Protestant services for the same reason (see Chapter 14).

The time was therefore ripe for a general move toward sacred music with a wider and more universal appeal. Since at the same time the demand for secular music was growing, it is not surprising that composers soon developed a style sufficiently attractive and flexible not only for the creation of masses and other liturgical works, but also of instrumental and vocal music that could be played and listened to at home [15.33].

The Birth of Opera

Perhaps the major artistic innovation of the seventeenth century was a new form of musical entertainment that had been formulated at the beginning of the Baroque period: *opera*. This consisted of a play in which the text was sung rather than spoken. Throughout the seventeenth century the taste for opera and operatic music swept Europe, attracting aristocratic and middle-class listeners

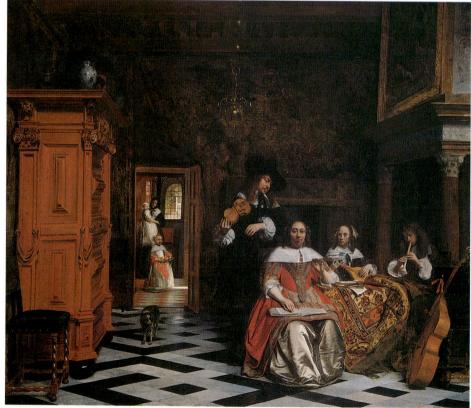

alike. In the process, the public appetite for music with which it could identify grew even greater. Small wonder that twentieth-century listeners have found pleasure and delight in music written to provide our baroque predecessors with precisely these satisfactions.

Like much else of beauty, opera was born in Florence. Ironically enough, an art form that was to become so popular in so short a time was originally conceived of in lofty intellectual terms. Toward the end of the sixteenth century a number of thinkers, poets, and musicians began to meet regularly at the house of a wealthy Florentine noble, Count Giovanni Bardi. This group, known as the Florentine Camerata, objected strongly to the way in which the polyphonic style in vocal music reduced the text to incomprehensible nonsense. They looked back nostalgically to the time of the Greeks, when almost every word of Greek tragedy was both sung and accompanied by instruments, yet remained perfectly understandable to the spectators. Greek music itself was, of course, lost forever; but at least the group could revive what they considered its essence.

The result was the introduction of a musical form known as *monody*, or *recitative*, which consisted of the free declamation of a single vocal line with a simple instrumental accompaniment for support. Thus listeners could follow the text with ease. The addition of music also gave an emotional intensity not present in simple spoken verse, thus satisfying the baroque interest in heightened emotion.

Although in theory monody could be used for either sacred or secular works, its dramatic potential was obvious. In the winter of 1594–1595 the first play set to music, Jacopo Peri's *Dafne*, was performed in Florence. Its subject was drawn from Classical mythology and dealt with Apollo's pursuit of the mortal girl Daphne, who turned into a laurel tree to elude him. In the words of a spectator, "The pleasure and amazement of those present were beyond expression." *Dafne* is now lost, but another work of Peri, *Euridice*, has survived to become the earliest extant opera. It too was based on a Greek myth, that of Orpheus and Eurydice. The first performance took place in 1600, again in Florence, at the wedding of Henry IV of France to the same Marie de' Medici whom Rubens was to portray a generation later (see Figure 15.26).

It is, of course, no coincidence that both of Peri's works as well as many that followed were written on Classical subjects, since the Camerata had taken its initial inspiration from Greek drama. The story of Orpheus and Eurydice, furthermore, had a special appeal for composers, since it told how the musician Orpheus was able to soften the heart of the King of the Underworld by his music and thereby win back his wife Eurydice from the dead. The theme was treated many times in the music of the following four hundred years, yet no subsequent version is more moving or psychologically convincing than

the one by Claudio Monteverdi (1567–1643), the first great genius in the history of opera.

Monteverdi's *L'Orfeo* was first performed in 1607. Its composer brought to the new form not only a complete understanding of the possibilities of monody but in addition an impressive mastery of traditional polyphonic forms such as the madrigal. Equally important for the success of his work was Monteverdi's remarkable dramatic instinct and his ability to transform emotion into musical terms. The contrast between the pastoral gaiety of the first act of *L'Orfeo*, depicting the happy couple's love, and the scene in the second act in which Orpheus is brought the news of his wife's death is achieved with marvelous expressive power.

For a selection from Monteverdi, see the Listening CD.

In L'Orfeo, his first opera, Monteverdi was able to breathe real life into the academic principles of the Florentine Camerata, but the work was written for his noble employer, the Duke of Mantua, and intended for a limited aristocratic public. Monteverdi lived long enough to see the new dramatic form achieve widespread popularity at all levels of society throughout Europe. It did not take long for a taste for Italian opera to spread to Germany and Austria and then to England where, by the end of the century, Italian singers dominated the London stage. The French showed their usual unwillingness to adopt a foreign invention wholesale; nonetheless, the leading composer at the court of Louis XIV was a Florentine who tactfully changed his name from Giovanni Battista Lulli to Jean Baptiste Lully (1632-1687). His stately tragedies, which were performed throughout Europe, incorporated long sections of ballet, a custom continued by his most illustrious successor, Jean Philippe Rameau (1683-1764).

It was in Italy proper that opera won its largest public. In Venice alone, where Monteverdi spent the last thirty years of his life, at least sixteen theaters were built between 1637—when the first public opera house was opened and the end of the century. As in the Elizabethan theater (see Figure 14.28), the design of these opera houses separated the upper ranks of society, who sat in the boxes, from the ordinary citizens—the groundlings.

There is a notable similarity, too, between Elizabethan drama and opera in the way they responded to growing popularity. Just as the groundlings of Shakespeare's day demanded ever more sensational and melodramatic entertainment, so the increasingly demanding and vociferous opera public required new ways of being satisfied. The two chief means by which these desires were met became a feature of most operas written during the following century. The first was the provision of lavish stage

spectacles involving mechanical cloud machines that descended from above and disgorged singers and dancers, complex lighting effects that gave the illusion that the stage was being engulfed by fire, apparently magical transformations, and so on—baroque extravagance at its most extreme. The second was a move away from the declamatory recitative of the earliest operas to selfcontained musical "numbers" known as arias. (In the case of both opera and many other musical forms, we continue to use technical terms like aria in their Italian form-a demonstration of the crucial role played by Italy, and in particular Florence, in the history of music.) The function of music as servant of the drama was beginning to change. Beauty of melody and the technical virtuosity of the singers became the glory of baroque opera, although at the expense of dramatic truth.

Baroque Instrumental and Vocal Music: Johann Sebastian Bach

http://www.jsbach.org/biography.html

Bach

The development of opera permitted the dramatic retelling of mythological or historical tales. Sacred texts as stories derived from the Bible were set to music in a form known as the *oratorio*, which had begun to appear toward the end of the sixteenth century. One of the baroque masters of the oratorio was the Italian Giacomo Carissimi (1605–1674), whose works, based on well-known biblical episodes include *The Judgment of Solomon* and *Job*. By the dramatic use of the chorus, simple textures, and driving rhythms, Carissimi created an effect of strength and power that late-twentieth-century listeners have begun to rediscover.

The concept of the public performance of religious works, rather than secular operas, made a special appeal to Protestant Germans. Heinrich Schütz (1585-1672) wrote a wide variety of oratorios and other sacred works. In his early Psalms of David (1619), Schütz combined the choral technique of Renaissance composers like Gabrieli with the vividness and drama of the madrigal. His setting of The Seven Last Words of Christ (1645-1646) uses soloists, chorus, and instruments to create a complex sequence of narrative sections (recitatives), vocal ensembles, and choruses. Among his last works are three settings of the Passion, the events of the last days of the life of Jesus, in the accounts given by Matthew, Luke, and John. Written in 1666, they revert to the style of a century earlier, with none of the instrumental coloring generally typical of baroque music, both sacred and secular.

Schütz is, in fact, one of the few great baroque composers who, so far as is known, never wrote any purely

instrumental music. The fact is all the more striking because the Baroque period was notable for the emergence of independent instrumental compositions unrelated to texts of any kind. Girolamo Frescobaldi (1583–1643), the greatest organ virtuoso of his day—he was organist at Saint Peter's in Rome—wrote a series of rhapsodic fantasies known as toccatas that combined extreme technical complexity with emotional and dramatic expression. His slightly earlier Dutch contemporary Jan Pieterszoon Sweelinck (1562–1621), organist at Amsterdam, built sets of variations out of different settings of a chorale melody or hymn tune. The writing of *chorale variations*, as this type of piece became known, became popular throughout the Baroque period.

The Danish Dietrich Buxtehude (1637–1707), who spent most of his career in Germany, combined the brilliance of the toccata form with the use of a chorale theme in his chorale fantasies. Starting with a simple hymn melody, he composed free-form rhapsodies that are almost improvisational in style. His suites for *harpsichord* (the keyboard instrument that was a primary forerunner of the modern piano) include movements in variation form, various dances, slow lyric pieces, and other forms; like other composers of his day, Buxtehude used the keyboard suite as a kind of compendium of musical forms.

One of the greatest composers of the late Baroque period was Domenico Scarlatti (1685–1757). The greatest virtuoso of his day on the harpsichord, (the keyboard instrument that was a primary forerunner of the modern piano), Scarlatti wrote hundreds of *sonatas* (short instrumental pieces) for it and laid the foundation for modern keyboard techniques.

Scarlatti's contemporary Georg Frideric Handel (1685–1759) was born in Halle, Germany, christened with the name he later changed to George Frederick Handel when he settled in England and became a naturalized citizen. London was to prove the scene of his greatest successes, among them *Messiah*, first performed in Dublin in 1742. This oratorio is among the most familiar of all baroque musical masterpieces.

For a selection from Handel's *Messiah*, see the Listening CD.

Handel also wrote operas, including a series of masterpieces in Italian that were written for performance in England. Among their greatest glories are the arias, which are permeated by Handel's rich melodic sense; one of the most famous is "Ombra mai fu" from Xerxes, often called the "Largo." His best-known orchestral works are probably The Water Music and The Music for the Royal Fireworks, both originally designed for outdoor performance. Written for a large number of instruments, they were later rearranged for regular concerts.

In the year that saw the births of both Scarlatti and Handel, Johann Sebastian Bach (1685–1750) was born at Eisenach, Germany, into a family that had already been producing musicians for well over a century. With the exception of opera, which, as a devout Lutheran, did not interest him, Bach mastered every musical form of the time, pouring forth some of the most intellectually rigorous and spiritually profound music ever created.

It is among the more remarkable achievements in the history of the arts that most of Bach's music was produced under conditions of grinding toil as organist and choir director in relatively provincial German towns. Even Leipzig—where Bach spent twenty-seven years (from 1723 to his death) as *kantor* ("music director") at the school attached to Saint Thomas' Church—was far removed from the glittering centers of European culture where most artistic developments were taking place. As a result, Bach was little known as a composer during his lifetime and virtually forgotten after his death; only in the nineteenth century did his body of work become known and published. He has since taken his place at the head of the Western musical tradition as the figure who raised the art of polyphony to its highest level.

If the sheer quantity of music Bach wrote is stupefying, so is the complexity of his musical thought. Among the styles he preferred was the fugue (derived from the Latin word for "flight"). In the course of a fugue a single theme is passed from voice to voice or instrument to instrument (generally four in number), each imitating the principal theme in turn. The theme thus becomes combined with itself and, in the process, the composer creates a seamless web of sound in which each musical part is equally important; this technique is called counterpoint (contrapunctum). Bach's ability to endow this highly intellectual technique with emotional power is little short of miraculous. The range of emotions Bach's fugues cover can best be appreciated by sampling his two books of twenty-four preludes and fugues each, known collectively as The Well-Tempered Clavier. Each of the forty-eight preludes and fugues creates its own mood while remaining logically organized according to contrapuntal technique.

Many of Bach's important works are permeated by a single concern: the expression of his deep religious faith. A significant number were written in his capacity as director of music at Saint Thomas' for performance in the church throughout the year. Organ music, masses, oratorios, motets; in all of these he could use music to glorify God and to explore the deeper mysteries of Christianity. His *chorale preludes* consist of variations on chorales and use familiar and well-loved songs as the basis for a kind of musical improvisation. He wrote some two hundred *cantatas* ("short oratorios") made up of sections of declamatory recitative and lyrical arias, which contain an almost inexhaustible range of religious emotions, from joyful celebrations of life to profound meditations on

death. Most overwhelming of all is his setting of the *Saint Matthew Passion*, the story of the trial and Crucifixion of Jesus as recorded in the Gospel of Matthew. In this immense work, Bach asserted his Lutheranism by using the German rather than the Latin translation of the Gospel and by incorporating Lutheran chorales. The use of self-contained arias is Italian, though, and the spirit of deep religious commitment and dramatic fervor can only be described as universal.

It would be a mistake to think of Bach as somehow unworldly and touched only by religious emotions. Certainly his own life had its share of domestic happiness and tragedy. His parents died when he was ten, leaving him to be brought up by an elder brother who treated him with less than complete kindness. At age of fifteen, Bach jumped at the chance to leave home and become a choirboy in the little town of Luneberg. He spent the next few years moving from place to place, perfecting his skills as organist, violinist, and composer.

In 1707 Bach married his cousin, Maria Barbara Bach, who bore him seven children, of whom four died in infancy. Bach was always devoted to his family, and the loss of these children, followed by the death of his wife in 1720, made a deep impression on him. It may have been to provide a mother for his three surviving sons that he remarried in 1721. At any event, his new wife, Anna Magdalena, proved a loving companion, bearing him thirteen more children and helping him with the preparation and copying of his music. One of the shortest but most touching of Bach's works is the little song, "Bist du bei mir," which has survived, copied out in her notebook. The words are: "As long as you are with me I could face my death and eternal rest with joy. How peaceful would my end be if your beautiful hands could close my faithful eyes." (Some scholars now believe that the song may have originally been written by G. H. Stölzel, a contemporary musician whom Bach much admired.)

The move to Leipzig in 1723 was dictated at least in part by the need to provide suitable schooling for his children, although it also offered the stability and security Bach seems to have required. The subsequent years of continual work took their toll, however. Bach's sight had never been good, and the incessant copying of manuscripts produced a continual deterioration. In 1749, Bach was persuaded to undergo two disastrous operations, which left him totally blind. A few months later his sight was suddenly restored, but within ten days he died of apoplexy.

Although the vast majority of Bach's works are on religious themes, the best known of all, the six *Brandenburg Concertos*, were written for the private entertainment of a minor prince, the Margrave of Brandenburg. Their form follows the Italian *concerto grosso*, an orchestral composition in three *movements* (sections): fast-slow-fast. The form had been pioneered by the Venetian composer

Antonio Vivaldi (c. 1676–1741), who delighted in strong contrasts between the orchestra, generally made up of string instruments and a solo instrument, often a violin (as in his well-known set of four concertos *The Four Seasons*) but sometimes a flute, bassoon, or other wind instrument. Four of Bach's six *Brandenburg Concertos* use a group of solo instruments, although the group differs from work to work. The whole set forms a kind of compendium of the possibilities of instrumental color, a true virtuoso achievement requiring equal virtuosity in performance. The musical mood is light, as befits works written primarily for entertainment, but Bach was incapable of writing music without depth, and the slow movements in particular are strikingly beautiful.

For a selection from Vivaldi's *Four Seasons*, see the Listening CD.

The Second Brandenburg Concerto is written for solo trumpet, recorder, oboe, and violin accompanied by a string orchestra. The first movement combines all of these to produce a brilliant rhythmic effect as the solo instruments now emerge from the orchestra, now rejoin it. The melodic line avoids short themes. Instead, as in much baroque music, the melodies are long, elaborate patterns that seem to spread and evolve, having much of the ornateness of baroque art. It does not require the ability to read music to see as well as hear how the opening theme of the Second Brandenburg Concerto forms an unbroken line of sound, rising and falling and doubling back as it luxuriantly spreads itself out.

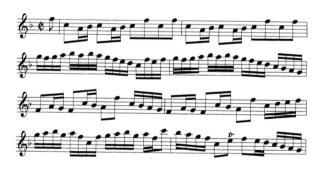

The slow second movement forms a tranquil and meditative interlude. The brilliant tone of the trumpet would be inappropriate here and Bach therefore omits it, leaving the recorder, oboe, and violin quietly to intertwine in a delicate web of sound. After its enforced silence, the trumpet seems to burst out irrepressibly at the beginning of the third movement, claiming the right to set the mood of limitless energy that carries the work to its conclusion.

For a selection from Bach's *Brandenburg Concerto* #2, see the Listening CD.

PHILOSOPHY AND SCIENCE IN THE BAROQUE PERIOD

Throughout the seventeenth century, philosophy—like the visual arts—continued to extend and intensify ideas first developed in the Renaissance by pushing them to new extremes. With the spread of humanism the sixteenth century had seen a growing spirit of philosophical and scientific inquiry. In the Baroque period, that fresh approach to the world and its phenomena was expressed in clear and consistent terms for the first time since the Greeks. It might be said, in fact, that if the Renaissance marked the birth of modern philosophy, the seventeenth century signaled its coming of age.

Briefly stated, the chief difference between the intellectual attitudes of the medieval period and those inaugurated by the Renaissance was a turning away from the contemplation of the absolute and eternal to a study of the particular and the perceivable. Philosophy ceased to be the preserve of the theologians and instead became an independent discipline, no longer prepared to accept a supernatural or divine explanation for the world and human existence.

For better or worse, we are still living with the consequences of this momentous change. The importance of objective truth, objectively demonstrated, lies at the heart of all scientific method, and most modern philosophy. Yet great thinkers before the Renaissance, such as Thomas Aquinas (1225–1274), had also asked questions in an attempt to understand the world and its workings. How did seventeenth-century scientists and philosophers differ from their predecessors in dealing with ageold problems?

The basic difference lay in their approach. When, for example, Aquinas was concerned with the theory of motion, he discussed it in abstract, metaphysical terms. Armed with his copy of Aristotle he claimed that "motion exists because things which are in a state of potentiality seek to actualize themselves." When Galileo wanted to study motion and learn how bodies move in time and space, he climbed to the top of the Leaning Tower of Pisa and dropped weights to watch them fall. It would be difficult to imagine a more dramatic rejection of abstract generalization in favor of objective demonstration (see Table 15.2).

Galileo

http://www-groups.dcs.st-and.ac.uk/~history/ Mathematicians/Galileo.html

Galileo

The life and work of Galileo Galilei (1564–1642) are typical both of the progress made by science in the seventeenth century and of the problems it encountered.

 TABLE 15.2 Principal Scientific Discoveries of the Seventeenth

 Century

	9
1609	Kepler announces his first two laws of planetary
	motion
1614	Napier invents logarithms
1632	Galileo publishes <i>Dialogue Concerning the Two</i>
	Chief World Systems
1643	Torricelli invents the barometer
1660	Boyle formulates his law of gas pressure
1675	Royal Observatory founded at Greenwich,
	England
1697	Isaac Newton publishes his account of the

1687 Isaac Newton publishes his account of the principle of gravity

1710 Leibnitz invents new notations of calculus
 1717 Fahrenheit invents system of measuring temperature

Galileo changed the scientific world in two ways: first, as the stargazer who claimed that his observations through the telescope proved Copernicus right, for which statement he was tried and condemned by the Inquisition; and second, as the founder of modern physics. Although he is probably better known for his work in astronomy, from the scientific point of view his contribution to physics is more important.

Born in Pisa, Galileo inherited from his father Vincenzo, who had been one of the original members of the Florentine *Camerata*, a lively prose style and a fondness for music. As a student at the University of Padua from 1581 to 1592 he began to study medicine but soon changed to mathematics. After a few months back in Pisa, he took a position at the University of Padua as professor of mathematics, remaining there from 1592 to 1600.

In Padua, Galileo designed and built his own telescopes [15.34] and saw for the first time the craters of the moon, sunspots, the phases of Venus, and other phenomena that showed that the universe is in a constant state of change, as Copernicus had claimed. From the time of Aristotle, however, it had been a firm belief that the heavens were unalterable, representing perfection of form and movement. Galileo's discoveries thus disproved what had been a basic philosophical principle for 2000 years and so outraged a professor of philosophy at Padua that he refused to shake his own prejudices by having a look through a telescope for himself.

The more triumphantly Galileo proclaimed his findings, the more he found himself involved in something beyond mere scientific controversy. His real opponent was the church, which had officially adopted the Ptolemaic view of the universe: that the earth formed the center of the universe around which the sun, moon, and planets circled. This theory accorded well with the Bible, which seemed to suggest that the sun moves rather than

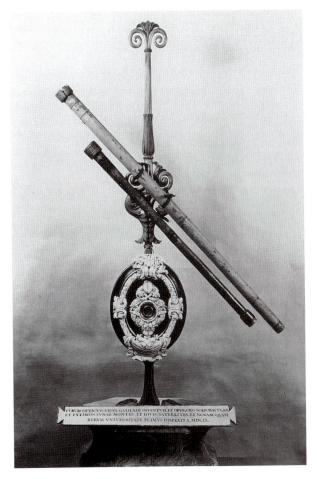

15.34 Galileo Galilei. Telescopes, 1609. Museum of Science, Florence. After his death near Florence in 1642, many of Galileo's instruments, including these telescopes, were collected and preserved. The Museum of Science in Florence, where they can now be seen, was one of the earliest museums to be devoted to scientific rather than artistic works.

the earth; for the church, the Bible naturally took precedence over any reasoning or speculation independent of theology. Galileo, however, considered ecclesiastical officials incompetent to evaluate scientific matters and refused to give way. When he began to claim publicly that his discoveries had proved what Copernicus had theorized but could not validate, the church initiated a case against him on the grounds of heresy.

Galileo had meanwhile returned to his beloved Pisa, where he found himself in considerable danger from the Inquisition. In 1615, he left for Rome to defend his position in the presence of Pope Paul V. He failed and, as a result, was censured and prohibited from spreading the Copernican theory either by teaching or publication.

In 1632, Galileo returned to the attack when a former friend was elected pope. He submitted to Pope Urban VIII a *Dialogue Concerning the Two Chief World Systems*, having carefully chosen the dialogue form so that he could put ideas into the mouths of other characters and

VALUES

Scientific Truth

Many factors contributed to the growth of science in the seventeenth century. Among them were the spread of education, the discovery of the Americas, explorations in Asia and Africa, and the development of urban life. Perhaps the most important of all was a growing skepticism in traditional religious beliefs, induced by the violent wars of religion provoked by the Reformation and Counter-Reformation.

One of the leading figures in the scientific revolution, Francis Bacon (1561–1626), wrote that scientists should follow the example of Columbus, and think all things possible until all things could be tested. This emphasis on the "empirical faculty"—learning based on experience—is a method of drawing general conclusions from particular observations. Medieval thinkers, relying on the examples of Aristotle and Ptolemy, had devised general theories and then looked for specific examples to confirm them. Scientific truth sought to reason in the opposite way: start from the specific and use it to establish a general theory, a process known as *induction*. Above all, the new scientists took nothing for granted, and regarded no opinion as "settled and immovable."

The search for objective, scientific truth required the invention of new instruments. Galileo's telescope allowed him to study the sky and revolutionize astron-

omy. Other researchers used another form of optical instrument—the microscope—to analyze blood and describe bacteria. The invention of the thermometer and barometer made it possible to perform atmospheric experiments.

With the increasing circulation of knowledge, scientists could spread and test their ideas. An international scientific community began to develop, stimulated by the formation of academies and learned societies. The most influential were the Royal Society for Improving Natural Knowledge, founded in London in 1662; and the French Académie des Sciences, founded in 1666. By means of published accounts and private correspondence, scientists were able to see how their own discoveries related to other fields.

Although the study of natural science does not involve questions of theology or philosophy, the growing interest in finding rational explanations for natural phenomena led to a change in views of religion. Most early scientists continued to believe in God, but abandoned the medieval view of the deity as incomprehensible Creator and Judge. Rather, they saw God as the builder of a world-machine which He then put into motion. Humans could come to understand how the machine worked, but only if they used their powers of reason to establish scientific truth.

thereby claim that they were not his own. Once more, under pressure from the Jesuits, Galileo was summoned to Rome. In 1633, he was put on trial after spending several months in prison. His pleas of old age and poor health won no sympathy from the tribunal. He was made to recant and humiliate himself publicly and was sentenced to prison for the rest of his life. (It might well have appealed to Galileo's sense of bitter irony that three hundred forty-seven years later, in 1980, Pope John Paul II, a fellow countryman of the Polish Copernicus, ordered the case to be reopened so that belated justice might be done.)

Influential friends managed to secure Galileo a relatively comfortable house arrest in his villa just outside Florence, and he retired there to work on physics. His last and most important scientific work, *Dialogues Concerning Two New Sciences*, was published in 1638. In it he examined many long-standing problems, including that of motion, always basing his conclusions on practical experiment and observation. In the process he established the outlines of many areas of modern physics.

In all his work Galileo set forth a new way of approaching scientific problems. Instead of trying to understand the final cause or cosmic purpose of natural events and phenomena, he tried to explain their character and the manner in which they came about. He changed the question from *why*? to *what*? and *how*?

Descartes

http://www-groups.dcs.st-and.ac.uk/~history/ Mathematicians/Descartes.html

Descartes

Scientific investigation could not solve every problem of human existence. While it *could* try to explain and interpret objective phenomena, there remained other more subjective areas of experience involving ethical and spiritual questions. The Counter-Reformation on the one

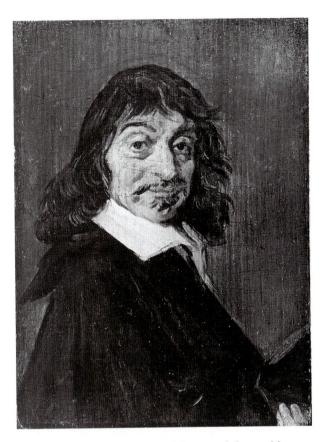

15.35 Frans Hals. *René Descartes*. Oil on panel. Statens Museum for Kunst, (Royal Museum of Fine Arts) Copenhagen. The great French philosopher spent many years in Holland, where his ideas found a receptive audience and where Hals painted this portrait.

hand and the Protestant churches on the other claimed to have discovered the answers. The debates nevertheless continued, most notably in the writings of the French philosopher René Descartes (1596–1650), often called the "Father of Modern Philosophy" [15.35].

In many ways Descartes' philosophical position was symptomatic of his age. He was educated at a Jesuit school but found traditional theological teaching unsatisfactory. Turning to science and mathematics, he began a lifelong search for reliable evidence in his quest to distinguish truth from falsehood. Attacking philosophical problems, his prime concern was to establish criteria for defining reality. His chief published works, the *Discourse on Method* (1637) and the *Meditations* (1641), contain a step-by-step account of how he arrived at his conclusions.

According to Descartes, the first essential in the search for truth was to make a fresh start by refusing to believe anything that could not be decisively proved to be true. This required that he doubt all his previously

held beliefs, including the evidence of his own senses. By stripping away all uncertainties he reached a basis of indubitable certainty on which he could build: that he existed. The very act of doubting proved that he was a thinking being. As he put it in a famous phrase in his second *Meditation*, "Cogito, ergo sum" ("I think, therefore I am").

From this foundation Descartes proceeded to reconstruct the world he had taken to pieces by considering the nature of material objects. He was guided by the principle that whatever is clearly and distinctly perceived must exist. He was aware at the same time that our perceptions of the exact nature of these objects are extremely likely to be incorrect and misleading. When, for example, we look at the sun we see it as a very small disk, although the sun is really an immense globe. We must be careful, therefore, not to assume that our perceptions are bound to be accurate. All that they demonstrate is the simple existence of the object in question.

If the idea of the sun comes from the perception, however inaccurate, of something that actually exists, what of God? Is the idea of a divine being imagined or based on truth? Descartes concluded that the very fact that we who are imperfect and doubting can conceive of a perfect God proves that our conception is based on a reality. In other words, who could ever have imagined God unless God existed? At the center of the Cartesian philosophical system, therefore, lay the belief in a perfect being, not necessarily to be identified with the God of the Old and New Testaments, who had created a world permeated by perfect (that is, mathematical) principles.

At first, this may seem inconsistent with Descartes' position as the founder of modern rational thought. It may seem even stranger that, just at the time when scientific investigators like Galileo were explaining natural phenomena without recourse to divine intervention, Descartes succeeded in proving to his own satisfaction the undeniable existence of a divine being. Yet a more careful look at Descartes' method reveals that both he and Galileo shared the same fundamental confidence in the rational powers of human beings.

Hobbes and Locke

Although Galileo and Descartes represent the major trends in seventeenth-century thought, other important figures made their own individual contributions. Descartes' fellow countryman Blaise Pascal (1623–1662), for example, launched a strong attack on the Jesuits while providing his own somewhat eccentric defense of Christianity. A more mystical approach to religion was that of the Dutch philosopher Baruch Spinoza (1632–

1677), whose concept of the ideal unity of nature later made a strong appeal to nineteenth-century Romantics. The English philosopher Thomas Hobbes (1588–1679), however, had little in common with any of his contemporaries—as he was frequently at pains to make plain. For Hobbes, truth lay only in material things: "All that is real is material, and what is not material is not real."

Hobbes is thus one of the first modern proponents of *materialism* and, like many of his materialist successors, was interested in solving political rather than philosophical problems. Born in the year of the Spanish Armada, Hobbes lived through the turbulent English Civil War, a period marked by constant instability and political confusion. Perhaps in consequence, he developed an enthusiasm for the authority of the law, as represented by the king, that verges on totalitarianism.

Hobbes' political philosophy finds its fullest statement in his book *Leviathan*, first published in 1651. The theory of society that he describes there totally denies the existence in the universe of any divinely established morality. (Hobbes never denied the existence of God, not wishing to outrage public and ecclesiastical opinion unnecessarily, although he might as well have.) According to Hobbes, all laws are created by humans to protect themselves from one another—a necessary precaution in view of human greed and violence. Organized society in consequence is arrived at when individuals give up their personal liberty in order to achieve security. As a result, the ideal state is that in which there is the greatest security, specifically one ruled by an absolute ruler.

From its first appearance Leviathan created a scandal; it has been subjected to continual attack ever since. Hobbes managed to offend both of the chief participants in the intellectual debates of the day: the theologians, by telling them that their doctrines were irrelevant and their terminology "insignificant sound"; and the rationalists, by claiming that human beings, far from being capable of the highest intellectual achievements, are dangerous and aggressive creatures who need to be saved from themselves. Hobbes' pessimism and the extreme nature of his position have won him few wholehearted supporters in the centuries since his death. Yet many modern readers, like others in the time since Leviathan first appeared, must reluctantly admit that there is at least a grain of truth in his picture of society, which can be attested to by personal experience and observation. At the very least, his political philosophy is valuable as a diagnosis and a warning of some aspects of human potential virtually all of his contemporaries and many of his successors have preferred to ignore.

The leading English thinker of the generation following Hobbes was John Locke (1632–1704), whose work helped to pave the way for the European Enlightenment. The son of a country attorney, his education followed tra-

ditional Classical lines, but the young Locke was more interested in medicine and the new experimental sciences. In 1666, he became physician and secretary to the future Earl of Shaftesbury, who encouraged Locke's interest in political philosophy.

In his first works, Locke explored the subjects of property and trade, and the role of the monarch in a modern state. He then turned to more general questions: What is the nature of ideas? How do we get them? and What are the limitations of human knowledge? His most influential work, An Essay Concerning Human Understanding, appeared in 1690. In it he argued against a theory of innate ideas, proposing instead that our ideas derive from our perceptions. Thus, our notions and characters are based on our own individual sense impressions and on our reflections on them, not on inherited values. Rejecting traditional metaphors and metaphysics, Locke advocated an antimonarchical, property-oriented political philosophy, in which ideas served as a kind of personal property.

For his successors in the eighteenth century, Locke seemed to have set human nature free from the control of divine authority. Humans were no longer perceived as the victims of innate original sin or the accidents of birth, but instead derived their ideas and personalities from their experiences. Like many of the spokesmen of the Enlightenment, Voltaire acknowledged the importance of Locke's ideas, while few modern students of education or theory of knowledge have failed to be influenced by him.

LITERATURE IN THE SEVENTEENTH CENTURY

French Baroque Comedy and Tragedy

It is hardly surprising that the Baroque age, which put so high a premium on the expression of dramatic emotion, should have been an important period in the development of the theater. In France in particular, three of the greatest names in the history of drama were active simultaneously, all of them benefiting at one point or another from the patronage of Louis XIV.

Molière was the stage name of Jean Baptiste Poquelin (1622–1673), who was the creator of a new theatrical form, French baroque comedy. Having first made his reputation as an actor, he turned to the writing of drama as a means of deflating pretense and pomposity. In his best works, the deceptions or delusions of the principal characters are revealed for what they are with good humor and considerable understanding of human foibles; but dramatic truth is never sacrificed to mere comic effect. Unlike so many comic creations, Molière's characters

remain believable. Jourdain, the good-natured social climber of *Le Bourgeois Gentilhomme*, and Harpagon, the absurd miser of *L'Avare*, are by no means mere symbols of their respective vices but victims of those vices, albeit willing ones. Even the unpleasant Tartuffe in the play of that name is a living character with his own brand of hypocrisy.

Classical motifs play a strong part in the works of the two greatest tragic dramatists of the age: Pierre Corneille (1606–1684) and Jean Racine (1639–1699). It was Corneille who created, as counterpart to Molière's comedy, French baroque tragedy. Most of his plays take as their theme an event in Classical history or mythology which is often used to express eternal truths about human behavior. The themes of patriotism, as in *Horace*, or martyrdom, as in *Polyeucte*, are certainly as relevant today as they were in seventeenth-century France or in ancient Greece or Rome. However, most people's response to Corneille's treatment of subjects such as these is probably conditioned by the degree to which they enjoy the cut and thrust of rhetorical debate.

Racine may well provide for many modern readers an easier entry into the world of French baroque tragedy. Although for the most part he followed the dramatic form and framework established by Corneille, he used it to explore different areas of human experience. His recurrent theme is self-destruction: the inability to control one's own jealousy, passion, or ambition and the resulting inability, as tragic as it is inevitable, to survive its effects. Furthermore, in plays like *Phèdre* he explored the psychological state of mind of his principal characters, probing for the same kind of understanding of motivation that Monteverdi tried to achieve in music.

The Novel in Spain: Cervantes

By the middle of the sixteenth century, the writing of fiction in Spain had begun to take a characteristic form that was to influence future European fiction. The *picaresque novel* (in Spanish pícaro means "rogue" or "knave") was a Spanish invention; books of this genre tell a story that revolves around a rogue or adventurer. The earliest example is *Lazarillo de Tormes*, which appeared anonymously in 1554. Its hero, Lazarillo, is brought up among beggars and thieves, and many of the episodes serve as an excuse to satirize priests and church officials—so much so, in fact, that the Inquisition ordered parts omitted in later printings. Unlike prose being written elsewhere at the time, the style is colloquial, even racy, and heavy with irony.

Although *Don Quixote*, by general agreement the greatest novel in the Spanish language, has picaresque elements, its style and subject are both far more subtle and complex. Miguel de Cervantes Saavedra (1547–1616), its author, set out to satirize medieval tales of

chivalry and romance by inventing a character—Don Quixote—who is an amiable elderly gentleman looking for the chivalry of storybooks in real life. This apparently simple idea takes on almost infinite levels of meaning, as Don Quixote pursues his ideals, in general without much success, in a world with little time for romance or honor. In his adventures, which bring him into contact with all levels of Spanish society, he is accompanied by his squire Sancho Panza, whose shrewd practicality serves as a foil for his own unworldliness.

The structure of the novel is as leisurely and seemingly as rambling as the Don's wanderings. Yet the various episodes are linked by the constant confrontation between reality and illusion, the real world and that of the imagination. Thus at one level the book becomes a meditation on the relationship between art and life.

By the end of his life, Don Quixote has learned painfully that his noble aspirations cannot be reconciled with the realities of the world, and he dies disillusioned. In the last part of the book, where the humor of the hero's mishaps does not conceal their pathos, Cervantes reaches that rare height of artistry where comedy and tragedy are indistinguishable.

The English Metaphysical Poets

In England, the pinnacle of dramatic expression had been reached by the turn of the century in the works of Shakespeare, and nothing remotely comparable was to follow. The literary form that proved most productive during the seventeenth century was that of lyric poetry, probably because of its ability to express personal emotions, although the single greatest English work of the age was John Milton's epic poem *Paradise Lost*.

It may well be argued that the most important of all literary achievements of the seventeenth century was not an original artistic creation but a translation. It is difficult to know precisely how to categorize the Authorized Version of the Bible, commissioned by King James I and first published in 1611, often called the only great work of literature ever produced by a committee. The fifty-four scholars and translators who worked on the task deliberately tried to create a "biblical" style that would transcend the tone of English as it was then generally used. Their success can be measured by the immense influence the King James Bible has had on speakers and writers of English ever since (see Chapter 14). It remained the Authorized Version for Englishspeaking people until the late nineteenth century, when it was revised in light of the new developments in biblical studies.

Of all seventeenth-century literary figures, the group known as the metaphysical poets, with their concern to give intellectual expression to emotional experience, make a particular appeal to modern readers. As is often pointed out, the label *metaphysical* is highly misleading for two reasons. In the first place, it suggests an organized group of poets consciously following a common style. It is true that the earliest poet to write in the metaphysical style, John Donne (1572–1631), exerted a strong influence on a whole generation of younger poets, but there never existed any unified group or school. (Some scholars would, in fact, classify Donne's style as *Mannerist*.)

Second, *metaphysical* seems to imply that the principal subject of their poetry was philosophical speculation on abstruse questions. It is certainly true that the metaphysical poets were interested in ideas and that they used complex forms of expression and a rich vocabulary to express them. The chief subject of their poems was not philosophy, however, but themselves—particularly their own emotions.

Yet this concern with self-analysis should not suggest a limitation of vision. Indeed, some critics have ranked Donne as second only to the Shakespeare of the Sonnets in range and depth of expression. Donne's intellectual brilliance and his love of paradox and ambiguity make his poetry sometimes difficult to follow. Donne always avoided the conventional, either in word or thought, while the swift changes of mood within a single short poem from light banter to the utmost seriousness can confuse the careless reader. Although it sometimes takes patience to unravel his full meaning, the effort is more than amply rewarded by contact with one of the most daring and honest of poets.

Donne's poems took on widely differing areas of human experience, ranging from some of the most passionate and frank discussions of sexual love ever penned to profound meditations on human mortality and the nature of the soul. Born a Catholic, he traveled widely as a young man and seems to have led a hectic and exciting life. He abandoned Catholicism, perhaps in part to improve his chances of success in Protestant England and, in 1601, on the threshold of a successful career in public life, entered Parliament. The same year, however, he secretly married his patron's sixteen-year-old niece, Anne More. Her father had him dismissed and even imprisoned for a few days, and Donne's career never recovered from the disgrace.

Although Donne's marriage proved a happy one, its early years were clouded by debt, ill health, and frustration. In 1615, at the urging of friends, he finally joined the Anglican Church and entered the ministry. As a preacher he soon became known as among the greatest of his day. By 1621, Donne was appointed to one of the most prestigious positions in London: Dean of Saint Paul's. During his last years he became increasingly obsessed with death. After a serious illness in the spring of 1631 he preached his own funeral sermon and died within a few weeks.

Thus the successful worldliness of the early years gave way to the growing somberness of his later career. We might expect a similar progression from light to darkness in his work, yet throughout his life the two forces of physical passion and religious intensity seem to have been equally dominant, with the result that in much of his poetry each is sometimes used to express the other.

The poems of Donne's younger contemporary, Richard Crashaw (1613–1649), blend extreme emotion and religious fervor in a way that is completely typical of much baroque art. Yet Crashaw serves as a reminder of the danger of combining groups of artists under a single label, since although he shares many points in common with the other metaphysical poets, his work as a whole strikes a unique note.

There can be little doubt that Crashaw's obsessive preoccupation with pain and suffering has more than a touch of masochism, and that his religious fervor is extreme even by baroque standards. Some of the intensity is doubtless due to his violent rejection of his father's Puritanism and his own enthusiastic conversion to Catholicism. Stylistically Crashaw owed much to the influence of the flamboyant Italian baroque poet Giambattista Marino (1569–1625), whose virtuoso literary devices he imitated. Yet the eroticism that so often tinges his spiritual fervor gives to his work a highly individual air.

Milton's Heroic Vision

While the past hundred years have seen a growing appreciation for Donne and his followers, the reputation of John Milton has undergone some notable ups and downs. Revered in the centuries following his death, Milton's work came under fire in the early years of the twentieth century from major poets like T. S. Eliot and Ezra Pound, who claimed that his influence on his successors had been pernicious and led much of subsequent English poetry astray. Now that the dust of these attacks has settled, Milton has resumed his place as one of the greatest of English poets. The power of his spiritual vision, coupled with his heroic attempt to wrestle with the great problems of human existence, seems in fact to speak directly to the uncertainties of our own time.

Milton's life was fraught with controversy. An outstanding student with astonishing facility in languages, he spent his early years traveling widely in Europe and in the composition of relatively lightweight verse—lightweight, that is, when compared to what was to come. Among his most entertaining early works are the companion poems "L'Allegro" and "Il Penseroso," which compare the cheerful and the contemplative character, to appropriate scenery. They were probably written in 1632, following his graduation from Cambridge.

By 1640, however, he had become involved in the tricky issues raised by the English Civil War and the re-

lated problems of church government. He launched into the fray with a series of radical pamphlets that advocated, among other things, divorce on the grounds of incompatibility. (It is presumably no coincidence that his own wife had left him six weeks after their marriage.) His growing support for Oliver Cromwell and the Puritan cause won him an influential position at home but considerable enmity in continental Europe, where he was seen as the defender of those who had ordered the execution of King Charles I in 1649. The strain of his secretarial and diplomatic duties during the following years destroyed his eyesight, but although completely blind, he continued to work with the help of assistants.

When Charles II was restored to power (in 1660), Milton lost his position and was fortunate not to lose his life or liberty. Retired to private life, he spent his remaining years in the composition of three massive works: *Paradise Lost* (1667), *Paradise Regained* (1671), and *Samson Agonistes* (1671).

By almost universal agreement, Milton's most important, if not most accessible, work is *Paradise Lost* composed in the early 1660s and published in 1667. It was intended as an account of the fall of Adam and Eve, and its avowed purpose was to "justify the ways of God to men." The epic is in twelve books (originally ten, but Milton later revised the divisions), written in blank verse.

Milton's language and imagery present an almost inexhaustible combination of biblical and Classical reference. From the very first lines of Book I, where the poet calls on a Classical Muse to help him tell the tale of The Fall, the two great Western cultural traditions are inextricably linked. Indeed, like Bach, Milton represents the summation of these traditions. In his work, Renaissance and Reformation meet and blend to create the most complete statement in English of Christian humanism, the philosophical reconciliation of humanist principles with Christian doctrine. To the Renaissance Milton owed his grounding in the Classics. In composing Paradise Lost an epic poem that touches on the whole range of human experience, he was deliberately inviting comparison to Homer and Vergil. His language is also classical in its inspiration, with its long, grammatically complex sentences and preference for abstract terms. Yet his deeply felt Christianity and his emphasis on human guilt and repentance mark him as a product of the Reformation. Furthermore, although he may have tried to transcend the limitations of his own age, he was as much a child of his time as any of the other artists discussed in this chapter. The dramatic fervor of Bernini, the spiritual certainty of Bach, the psychological insight of Monteverdi, the humanity of Rembrandt—all have their place in Milton's work and mark him, too, as an essentially baroque figure.

SUMMARY

The Counter-Reformation If the history and culture of the sixteenth century were profoundly affected by the Reformation, the prime element to influence those of the seventeenth century was the Counter-Reformation, the Catholic Church's campaign to regain its authority and influence. By clarifying and forcefully asserting their teaching, backed up with a vigorous program of missionary work, church leaders aimed to present a positive and optimistic appearance that would eliminate past discords.

Counter-Reformation Art Among the resources used by Counter-Reformation reformers were the arts. Imposing architectural complexes like Saint Peter's Square in Rome, paintings and sculptures, music and verse could all serve to reinforce the glory of the church. In some cases, works were commissioned officially; in others, artists responded individually to the spirit of the times. Bernini's Saint Teresa in Ecstasy, a statue that reflects the artist's own devout faith, was commissioned for the church in Rome in which it still stands. Richard Crashaw's poetry represents a more personal response to the religious ideas of his day.

The Rise of Science For all the importance of religion, the seventeenth century was also marked by significant developments in philosophy and science. Galileo, the father of modern physics, revolutionized astronomy by proving Copernicus' claims of the previous century correct. Thinkers like Descartes and Hobbes, instead of accepting official church teachings, tried to examine the problems of human existence by their own intellectual approaches. Descartes was the founder of modern rational thought (although a believer in a supreme being); Hobbes was the first modern materialist.

The Arts in the Baroque Period The principal artistic style of the seventeenth century was the baroque, a term originally used for the visual arts but also applied by extension to the other arts of the period. Although the baroque style was created in Italy, it spread quickly throughout Europe and was even carried to the New World by missionaries. Baroque art is marked by a wide range of achievements, but there are a number of common features. Artists in the seventeenth century were concerned with expressing strong emotions, either religious or personal. This in turn led to an interest in exploring human behavior from a psychological point of view. With the new subjects came new techniques, many of which emphasized the virtuosity of the artist. These in turn led to the invention of new forms, for example, in music that of opera; in painting that of landscape scenes.

Baroque Painting The chief characteristics of baroque painting were created in Rome around 1600 by two artists. Caravaggio's work is emotional and dominated

by strong contrasts of light and darkness. Annibale Carracci painted scenes of movement and splendor, many on Classical themes. Both strongly influenced their contemporaries and successors.

Caravaggio's use of light was the forerunner of the work of artists as diverse as the Spaniard Velázquez and the Dutchman Vermeer, while Carracci's choice of classical subjects was followed by the French Poussin. The two greatest painters of Northern Europe,—Rembrandt and Rubens—were also influenced by the ideas of their day. Rembrandt used strong contrasts of light and dark to paint deeply felt religious scenes as well as the self-portraits that explore his own inner emotions. Rubens, one of the most versatile of artists, ranged from mythological subjects to historical paintings like the Marie de' Medici cycle to intimate personal portraits.

Baroque Architecture Although the seventeenth century saw architects increasingly employed in designing private houses, most of the principal building projects were public. At Rome the leading architect was Bernini, also one of the greatest sculptors of the age, whose churches, fountains, and piazzas changed the face of the city. In his sculpture, Bernini drew on virtually all the themes of Counter-Reformation art, including mythological and religious works and vividly characterized portraits. The other great building project of the century was the palace built for Louis XIV at Versailles, where the splendor of the Sun King was reflected in the grandiose decoration scheme.

Music in the Counter-Reformation In music, as in the visual arts, the Baroque period was one of experimentation and high achievement. Counter-Reformation policy required that music for church use should be easily understood and appreciated, as was already the case in the Protestant countries of Northern Europe. At the same time, there was a growing demand for secular music for performance both in public and at home.

The Birth of Opera One of the most important innovations of the seventeenth century was opera. The first opera was performed just before 1600 in Florence, and by the middle of the century opera houses were being built throughout Europe to house the new art form. The first great composer of operas was the Italian Monteverdi, whose L'Orfeo is the earliest opera still performed. Among later musicians of the period to write works for the theater was the German Georg Frideric Handel, many of whose operas were composed to Italian texts for performance in England.

Bach and Handel Handel also wrote oratorios (sacred dramas performed without any staging); indeed, the most famous of all oratorios is his Messiah. The oratorio was a form with a special appeal for Protestant Germans; among its leading exponents was Heinrich Schütz. The greatest of all Lutheran composers, Johann Sebastian Bach, wrote masterpieces in just about every musical form other than opera. Like many of the leading artists of the age, Bach produced works inspired by deep reli-

gious faith as well as pieces like the *Brandenburg Concertos* composed for private entertainment.

Baroque Literature The baroque interest in emotion and drama, exemplified by the invention of opera, led to important developments in writing for the theater as well as in the style of poetic composition and the invention of new literary forms. In France, the comedies of Molière and the tragedies of Corneille and Racine, written in part under the patronage of Louis XIV, illustrate the dramatic range of the period. The religious fervor of the English metaphysical poets is yet another sign of baroque artists' concern with questions of faith and belief. The more practical problems involved in reconciling ideals with the realities of life are described in Don Quixote, one of the first great novels in Western literature. The most monumental of all literary works of the seventeenth century, Milton's Paradise Lost, aimed to combine the principles of Renaissance humanism with Christian teaching. Its drama, spirituality, and psychological insight mark it as a truly baroque masterpiece.

For all the immense range of baroque art and culture, its principal lines were drawn by reactions to the Counter-Reformation. Furthermore, paradoxically enough, by the end of the seventeenth century a movement that had been inspired by opposition to the Reformation had accomplished many of the aims of the earlier reformers. Through art, music, and literature both artists and their audiences were made more familiar with questions of religious faith and more sensitive to aspects of human experience.

Pronunciation Guide

Annibale Carracci: Ann-IB-a-lay Car-AHCH-ee

Baroque: Bar-OAK
Borromini: Bo-roe-MEE-ni
Caravaggio: Ca-ra-VAJ-o
Cervantes: Ser-VAN-teez

concerto grosso: con-CHAIR-towe GRO-sew

Corneille: Cor-NAY
Descartes: Day-CART
Donne: DUN

Don Quixote:Don Ki-HOTE-eeGalileo:Ga-li-LAY-oweGentileschi:Gen-ti-LESS-key

Lorrain: Lor-ANN
Molière: Mo-li-AIR
Monteverdi: Mon-te-VAIR-di
Orfeo: Or-FAY-owe
piazza: pi-AT-sa
Racine: Rah-SEEN
Rameau: Ram-OWE

Rembrandt van Rijn: REM-brant van RHINE

Rubens: RUE-buns
Schütz: SHUETS
Sweelinck: SVAY-link

Theotokopoulos:

They-ot-ok-OP-ou-loss

toccata: Velázquez: to-CA-ta Ve-LASS-kes

Vermeer: Versailles: Vur-MERE Ver-SIGH

EXERCISES

- 1. What characteristics are common to all the arts in the Baroque period? Give examples.
- Compare the paintings of Caravaggio and Rembrandt with regard to subject matter and use of contrasts in light.
- 3. Describe the birth and early development of opera.
- 4. What were the principal scientific and philosophical movements of the seventeenth century? To what extent were they the result of external historical factors?
- 5. Discuss the treatment of religious subjects by baroque artists, writers, and musicians. How does it contrast with that of the Renaissance?

FURTHER READING

- Adams, L. S. (1999). *Key monuments of the baroque*. Denver: Westview Press. A valuable collection both for an overview and for the study of original works.
- Boyd, M. (Ed.). (1999). Oxford composer companions: J. S. Bach. New York: Oxford University Press. A comprehensive guide to practically every aspect of Bach's life and work, including his influence on later composers.
- Brown, J. (1991). *The golden age of painting in Spain.* New Haven, CT: Yale University Press. An authoritative survey of an enormously rich field.
- Cipolla, C. (Ed.). (1974). The Fontana economic history of Europe (vol. II). London: Fontana. A useful survey of the principal developments in a period marked by widespread economic change and overseas expansion.
- Franits, W. (1997). Looking at seventeenth-century Dutch art: Realism reconsidered. Cambridge: Cambridge University Press. A study of Dutch painting that takes a new look at some traditional views.
- Hall, A. R. (1983). The revolution in science: 1500–1750. London: Longman. A detailed examination of the various forms of scientific thought developed in the sixteenth and seventeenth centuries.
- Hanning, B. R. (1980). Of poetry and music's power: Humanism and the creation of opera. Ann Arbor: University of Michigan Press. An interesting study of the world of the Florentine humanists, where opera was born.
- Jacob, M. C. (1988). The cultural meaning of the scientific revolution. New York: Knopf. The effects of scientific developments on society and culture.
- Lavin, I. (1980). Bernini and the unity of the visual arts. New York: Oxford University Press. A magnificent achievement that analyzes in depth Bernini's process of artistic creation.
- McCorquodale, C. (1979). *The baroque painters of Italy.* New York: Phaidon. A handy volume; especially useful for its excellent color illustrations.
- North, M. (1997). Art and commerce in the Dutch golden age. New Haven, CT: Yale University Press. A useful supplement to the Schama book listed below, this emphasizes economic factors rather than cultural ones.

Orrey, L. (1987). *Opera: A concise history.* Rev. by R. Milnes. London: Thames & Hudson. An updated edition of the best brief history of opera, with many interesting photographs.

Schama, S. (1987). *An embarrassment of riches*. New York: Knopf. A social and cultural history of the Dutch Republic.

ONLINE CHAPTER LINKS

The John Locke Bibliography at

http://www.libraries.psu.edu/iasweb/locke/home.htm provides numerous links to a wide range of topics related to John Locke.

Extensive information about Georg Frederic Handel is available at

http://www.classical.net/music/comp.l st/handel.html which features links to biographies, a listing of recommended scores of Handel's works, a CD review, and a list of where to attend a performance of Handel works.

Extensive information about Antonio Vivaldi is available at

http://home.kc.rr.com/vivaldi/

which features a biography, a timeline, a list of other Internet resources, plus reviews of specific recordings of Vivaldi's works (e.g., *The Four Seasons*).

Visit Bach Central Station at

http://www.jsbach.net/bcs/

for the "most extensive directory of J. S. Bach Resources on the Internet."

Site-Molière at

http://www.site-moliere.com/bio/index.html features biographical information about Molière and devotes special attention to several of his dra-

and devotes special attention to several of his dramatic pieces.

A Cervantes' biography, a catalogue of his works, and links to related Internet resources are available at *Cervantes Project* 2001

http://www.csdl.tamu.edu/cervantes/english/index.html

Extensive resources related to John Milton are available at

http://www.luminarium.org/sevenlit/milton/ which provides links to biographies, Milton's works, and essays about Milton and his works.

Karadar Classical Music

http://www.karadar.it/Dictionary/Default.htm provides an alphabetical listing of musicians with brief biographies and a list of works (some of which are available on MIDI files). 1700

ENLIGHTENMENT DAWN OF THE

1710-c. 1795 Rise of Prussia and Russia

1715 Death of Louis XIV

1715-1774 Reign of Louis XV in France

1711 Pope, Essay on Criticism

1712 Pope, The Rape of the Lock, mock-heroic epic

18th cent. Translations of classical authors; Pope's Iliad (1713-1720), Odyssey (1725-1726)

1726 Swift, Gulliver's Travels; Voltaire exiled from France (returns 1729)

1729 Swift, A Modest Proposal

1733-1734 Pope, Essay on Man

1734 Voltaire, *Lettres philosophiques*

1739 Hume, Treatise of Human Nature

c. 1715 Rococo style emerges in France

1717 Watteau, Pilgrimage to Cythera

c. 1730 Carriera, Anna Sofia d'Este, Princess of Modena

1740

AGE OF ENLIGHTENED DESPOTS

1740-1786 Reign of Frederick the Great in Prussia

1774-1792 Reign of Louis XVI and Marie Antoinette in France

Independence

1778-1783 American War of

1773-1814 Jesuits disbanded

1776 American Declaration of

Independence

1788 Collapse of French economy; riots in Paris

1789 French Revolution begins; new American Constitution

1793 Execution of Louis XVI

1793-1795 Reign of Terror in France

1799-1804 Napoleon rules France as consul

1804-1814 Napoleon rules France as emperor

1750-1753 Voltaire at court of Frederick the Great in Potsdam

1751 – 1772 Diderot's Encyclopédie includes writings by Montesquieu and J. J. Rousseau

1758-1778 Voltaire sets up own court in Ferney

1759 Voltaire, Candide

1762 J. J. Rousseau, The Social Contract, Emile

1772 Political writer Thomas Paine meets Benjamin Franklin in London

1776 In Philadelphia, Paine publishes Common Sense, series of pamphlets

1776-1788 Gibbon, History of the Decline and Fall of the Roman Empire

1792 Paine, The Rights of Man

series, Marriage à la Mode 1748 Excavations begin at Pompeii; interest in ancient classical styles increases

1743 – 1745 Hogarth paints satirical

Sculpture more virtuosic than profound; Queirolo, Deception Unmasked (after 1752)

1754 Boucher, Cupid a Captive

c. 1765 Gainsborough, Mary, Countess Howe

1769 Tiepolo, The Immaculate Conception, rococo style applied to religious subject

1771 Houdon, Diderot

1773 Fragonard, Love Letters; Reynolds, Three Ladies Adorning a Term of Hymen, influenced by classical and Renaissance models

c. 1776 Vanvitelli, The Great Cascade, fountains at castle of Caserta near

1784-1785 David, Oath of the Horatii, establishes official style of revolutionary art

c. 1785 Gainsborough, Haymaker and Sleeping Girl

c. 1790 Houdon, George Washington, statue

> 1800 David, Napoleon Crossing the Alps

1808 Canova, Pauline Bonaparte Borghese as Venus Victorious

1789 REVOLUTIONARY AND NAPOLEONIC WARS

CHAPTER 16 THE EIGHTEENTH CENTURY: FROM ROCOCO TO REVOLUTION

ARCHITECTURE

Music

c. 1700 – 1730 Couperin leading composer of *style galant* music at French court

1732 Boffrand begins Hôtel de Soubise, Paris; rococo style applied to room decoration

1743 Henry Hoare begins to lay out classical-inspired park at Stourhead

1743 – 1772 Neumann, Vierzehnheiligen Pilgrim Church near Bamberg

1755 – 1792 Soufflot converts church of Sainte Geneviève into the Pantheon, neoclassical memorial for dead of French Revolution

1785 – 1796 Jefferson's state capitol, Richmond, Virginia, modeled on ancient Roman Maison Carrée at Nimes

1750 Death of J. S. Bachc. 1750 C. P. E. Bach chief representative of emotional empfindsamkeit at court of Frederick the Great

1750–1800 Development of classical style and symphonic form

1752 J. J. Rousseau, Le Devin du Village, opera

1759 Death of Handel

1761 Haydn ("Father of the Symphony") begins 30-year service with Esterhazys

performance of Mozart's The Marriage of Figaro, opera based on Beaumarchais play

1788 Mozart, Symphony No. 40 in g minor

1791 Mozart, Piano Concerto 27 in B flat; opera The Magic Flute

1791 – 1795 Haydn composes 12 symphonies during visits to London, Symphony No. 104 in D Major (1795)

CHAPTER 16

THE EIGHTEENTH CENTURY: FROM ROCOCO TO REVOLUTION

AGE OF DIVERSITY

ven the most determined cultural historians, fully armed with neat labels for successive stages of Western cultural development, acknowledge serious difficulty in categorizing the eighteenth century. Although it has often been called the Age of Enlightenment or the Age of Reason, these labels—which do in fact describe some of its aspects—fail to encompass the full spirit of the age.

From one perspective, the eighteenth century was an age of optimism. It had trust in science and in the power of human reason, belief in a natural order, and an overriding faith in the theory of progress that the world was better than it had ever been and was bound to get better still. Looked at from another perspective, however, the eighteenth century was marked by pervasive resentment and dissatisfaction with established society. By its end, criticism and the press for reform had actually grown into a desire for violent change, producing the American and then the French revolutions. Furthermore, even these two apparently contradictory views—of unqualified optimism and extreme discontent—do not cover all aspects of eighteenth-century culture. For example, one of the most popular artistic styles of the period, the rococo, was characterized by frivolity and lightheartedness. Rococo artists deliberately aimed to create a fantasy world of pleasure into which their patrons could escape from the problems around them.

The eighteenth century, then, presents an immense variety of artistic and intellectual ideas, seemingly contradictory yet in fact coexistent. Each style or idea seems far easier to grasp and categorize by itself than as part of an overall pattern of cultural development. Nevertheless, it is possible to discern at least one characteristic that links together a number of the diverse artistic achievements of the century: a conscious engagement with social issues. An opera such as Wolfgang Amadeus Mozart's *The Marriage of Figaro*, a series of satiric paintings of daily life such as William Hogarth's *Marriage à la*

Mode, a mock epic poem such as Alexander Pope's *The Rape of the Lock*, and evolutionary ideas such as those of Jean-Jacques Rousseau are all examples of ways in which artists and thinkers joined with political leaders to effect social change.

Meanwhile, artists who supported the establishment and were resistant to change were equally engaged in social issues. They too used their art to express and defend their position. François Boucher's portraits of his wealthy aristocratic patrons, for example, often show them in the guises of Greek gods and goddesses, thus imparting a sense of glamour and importance to an aristocracy that was soon to be fighting for its survival.

The contrast between revolutionaries and conservatives lasted right to the eve of the French Revolution. Jacques Louis David's famous painting *Oath of the Horatii* (1784–1785) [16.1], a clarion call to action and resolve, was painted in the same year as Thomas Gainsborough's idealized picture of a *Haymaker and Sleeping Girl* [16.2]. The former, in keeping with the spirit of the times, prefigures the mood of revolution. The latter turns its back on reality, evoking a nostalgic vision of love among the haystacks. In so doing it reinforces the aristocracy's refusal to see the working classes as real people with serious problems of their own. The same contrast occurs in the literature of the age; the conservative stance of Pope or Swift is very different from the views of Enlightenment figures such as Voltaire or Rousseau.

The eighteenth century opened with Louis XIV still strutting down the Hall of Mirrors at the Palace of Versailles, but his death in 1715 marked the beginning of the end of absolute monarchy. Although most of Europe continued to be ruled by hereditary kings, the former emphasis on splendor and privilege was leavened with a new concern for the welfare of the ordinary citizen. Rulers such as Frederick the Great of Prussia (ruled 1740–1786) were no less determined than their predecessors to retain all power in their own hands, but they no longer thought of their kingdoms as private possessions to be manipulated for personal pleasure. Instead, they

16.1 Jacques Louis David, 1748-1785. Oath of the Horatii. Oil on canvas, $10'10''\times 14'$ (3.3 \times 4.25 m). Louvre, Paris. The story of the Horatii, three brothers who swore an oath to defend Rome even at the cost of their lives, is used here to extol patriotism. Painted only five years before the French Revolution, David's work established the official style of revolutionary art.

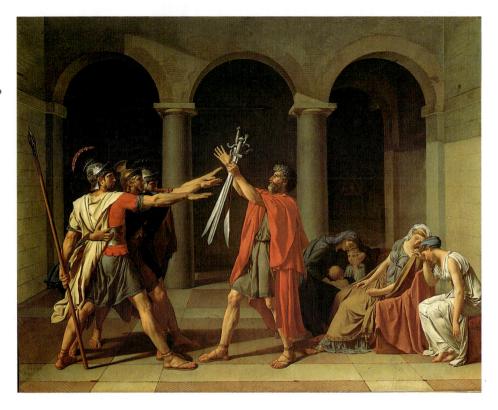

16.2 Thomas Gainsborough. *Haymaker and Sleeping Girl (Mushroom Girl)*, c. 1785. Oil on canvas, $89\frac{1}{2}$ " \times 59" (227.3 \times 149.9 cm). Museum of Fine Arts, Boston (Theresa B. Hopkins and Seth K. Sweetser Fund). These charming and elegant peasants, neither of whom looks exactly ravaged by hard work in the fields, represent the artificial world of rococo art.

regarded them as trusts, which required them to show a sense of duty and responsibility. They built new roads, drained marshes, and reorganized legal and bureaucratic systems along rational lines.

Because of their greater concern for the welfare of their people these new more liberal kings, often known as "enlightened despots," undoubtedly postponed for a while the growing demand for change. Inevitably, however, by drawing attention to the injustices of the past they stimulated an appetite for reform that they themselves were in no position to satisfy. Furthermore, for all their claims—Frederick the Great, for example, described himself as "first servant of the state"—their regimes remained essentially autocratic.

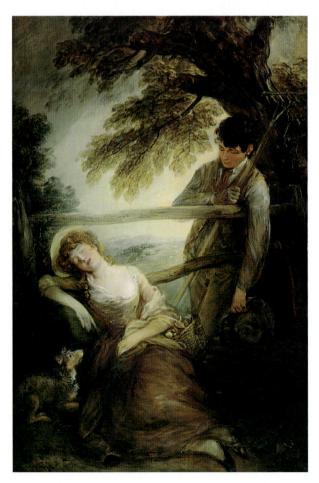

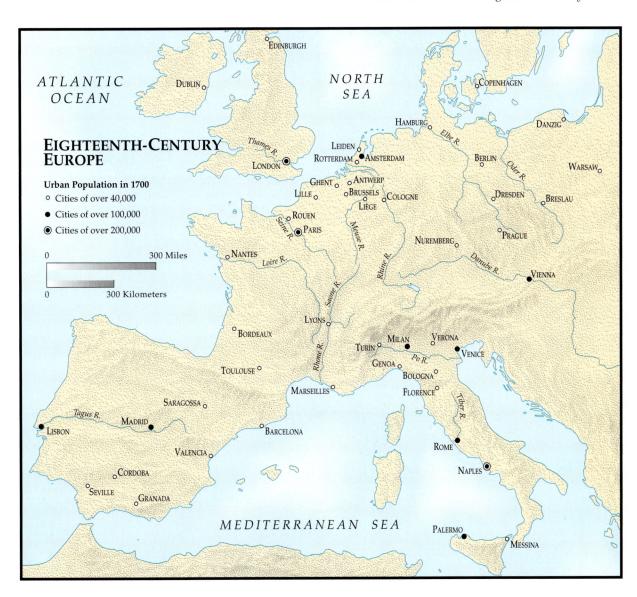

TABLE 16.1 European Rulers in the Eighteenth Century

Enlightened Despots

Entighteneu Despots			
Frederick II of Prussia	1740-1786a		
Catherine the Great of Russia	1762 - 1796		
Gustavus III of Sweden	1771 - 1792		
Charles III of Spain	1759 - 1788		
Joseph II of Austria	1780 - 1790		
Rulers Bound by Parliamentary Government ^b			
George I of England	1714 - 1727		
George II of England	1727 - 1760		

Aristocratic Rulers

George III of England

Louis XV of France	1715 - 1774
Louis XVI of France	1774 - 1792

^a All dates are those of reigns.

1760 - 1820

THE VISUAL ARTS IN THE EIGHTEENTH CENTURY

The Rococo Style

In spite of the changing social climate of the time, the vast majority of eighteenth-century artists still depended on the aristocracy for commissions. The baroque style had partially evolved to satisfy just these patrons, and throughout the early part of the eighteenth century many artists continued to produce works following baroque precedents. Yet, despite the continued fondness for the baroque characteristics of richness and elaboration, there was a significant change of emphasis. The new enlightened despots and their courts had less time for pomposity or excessive grandeur. They wanted not so much to be glorified as entertained. In France, too, the death of Louis XIV served as an excuse to escape the oppressive ceremony of life at the Palace of Versailles; the French court moved back to Paris to live in elegant comfort.

^b English political life was dominated not by the kings but by two powerful prime ministers: Robert Walpole and William Pitt.

The artistic style that developed to meet these new, less grandiose needs first reached its maturity in France. It is generally called *rococo*, a word derived from the French word *rocaille*, which means a kind of elaborate decoration of rocks and shells that often adorned the grottoes of baroque gardens. Rococo art was conceived of as antibaroque, a contrast to the weighty grandeur of seventeenth-century art. It makes plentiful use of shell motifs, along with other decorative elements like scrolls and ribbons, to produce an overall impression of lightness and gaiety. The subject matter is rarely serious, often frivolous, with strong emphasis on romantic dalliance and the pursuit of pleasure.

The style is graceful and harmonious, in contrast to the flamboyant, dramatic effects of much baroque art. It might be said that whereas baroque artists preached or declaimed to their public, rococo art was the equivalent of polite, civilized conversation. Indeed, the eighteenth century was an age of polite society: a time of letter writing, chamber music, dancing. Clearly, such pastimes only represented one aspect of eighteenth-century life, and

the revolutions that shook Europe and the European colonies of North America at the end of the century called on a very different artistic style, the Neo-Classical, discussed below. Neo-Classical artists rejected baroque extravagance and rococo charm in favor of dignity and austerity.

Critics have often said that the only purpose of rococo art was to provide pleasure, but this is a somewhat incomplete view of its social role. The rococo style was for the most part aimed at an aristocratic audience; its grace and charm served the important purpose of shielding this class from the growing problems of the real world. The elegant picnics, the graceful lovers, the Venuses triumphant represent an almost frighteningly unrealistic view of life, and one that met with disapproval from Enlightenment thinkers anxious to promote social change. Yet even the sternest moralist can hardly fail to respond to the enticing fantasy existence that the best of rococo art presents. In a sense, the knowledge that the whole rococo world was to be so completely swept away imparts an added (and, it must be admitted, unintentional)

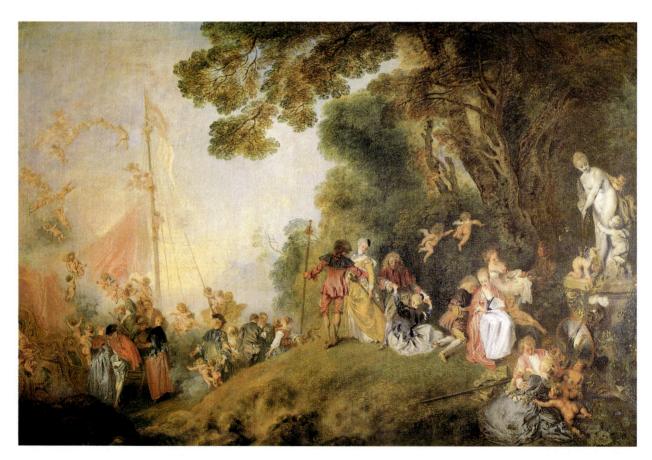

16.3 Jean Antoine Watteau. Pilgrimage to Cythera, 1717. Oil on canvas, $4'3'' \times 6'4^{1}/2''$ (1.3 × 1.94 m). Schloss Charlottenburg, Berlin. One ancient Greek tradition claimed the isle of Cythera as the birthplace of Venus, goddess of love. Thus, the island became symbolic of ideal, tender love. Note that the mood of nostalgia and farewell is conveyed not only by the autumnal colors but also by the late-afternoon light that washes over the scene.

poignancy to its art. The existence of all those fragile ladies and their refined suitors was to be cut short by the guillotine.

The first and probably the greatest French rococo painter, Jean Antoine Watteau (1684-1721), seems to have felt instinctively the transitory and impermanent world he depicted. Watteau is best known for his paintings of fêtes galantes (elegant outdoor festivals attended by courtly figures dressed in the height of fashion). Yet the charming scenes are always touched with a mood of nostalgia that often verges on melancholy. In Pilgrimage to Cythera [16.3], for instance, the handsome young couples are returning home (despite the traditional title of the painting) from a visit to Cythera, the island sacred to Venus and to love. As they leave, a few of them gaze wistfully over their shoulders at the idyllic life they must leave behind, symbolized by the statue of Venus. Watteau thus emphasizes the moment of renunciation, underscoring the sense of departure and farewell by the autumnal colors of the landscape.

François Boucher (1703–1770), the other leading French rococo painter, was also influenced by Rubens. Lacking the restraint or poetry of Watteau, Boucher's paintings carry Rubens' theme of voluptuous beauty to an extreme. His canvases often seem to consist of little beyond mounds of pink flesh, as in *Cupid a Captive* [16.4]. It would certainly be difficult to find profundity of intellectual content in most of his work, the purpose of which is to depict only one aspect of human existence. His visions of erotic delights are frankly intended to arouse other than aesthetic feelings.

Among Boucher's pupils was Jean Honoré Fragonard (1732-1806), the last of the great French rococo painters, who lived long enough to see all demand for rococo art disappear with the coming of the French Revolution. Although his figures are generally more clothed than those of Boucher, they are no less erotic. Even more than his master, Fragonard was able to use landscape to accentuate the mood of romance. In Love Letters [16.5], for example, the couple flirting in the foreground is surrounded by a jungle of trees and bushes that seems to impart a heady, humid air to the apparently innocent confrontation. The end of Fragonard's career is a reminder of how much eighteenthcentury artists were affected by contemporary historical developments. When his aristocratic patrons either died or fled France during the Revolution, he was reduced to complete poverty. It was perhaps because Fragonard supported the ideals of the Revolution, despite its disastrous effect on his personal life, that Jacques-Louis David, one of the Revolution's chief artistic arbiters, found him a job in the Museums Service. The last representative of the rococo tradition died poor and in obscurity as a minor official in the new French Republic.

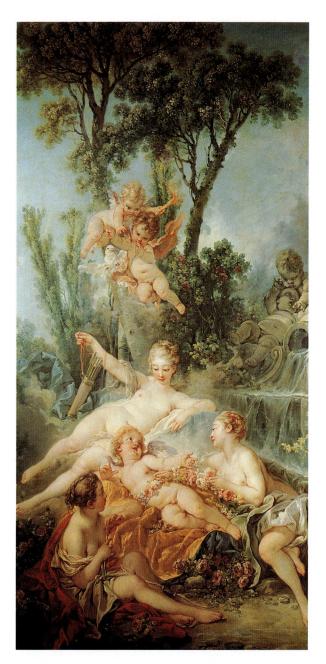

16.4 François Boucher. *Cupid a Captive*, 1754. Oil on canvas, $5'5'' \times 2'9''$ (1.64 \times .83 m). Wallace Collection, London (reproduced by courtesy of the Trustees). Venus is seen in a relaxed and playful mood as she teases her little son by dangling his quiver of arrows above his head. Nonetheless, the presence of her seductive nymphs reminds us that she is not simply the goddess of motherly love.

Taken together, the three leading representatives of rococo painting provide a picture of the fantasy life of eighteenth-century aristocratic society. The work of other rococo artists, however, gives us a clearer impression of what life was really like in that aristocratic world. The

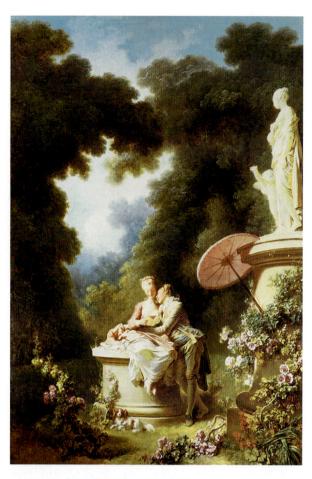

16.5 Jean Honoré Fragonard. *Love Letters*, 1773. Oil on canvas, $10'5'' \times 7'1''$ (3.17 \times 2.17 m). Copyright Frick Collection, New York. Fragonard's style is far more free and less precise than Boucher's. Compare the hazy, atmospheric landscape of this painting to the background of *Cupid a Captive*.

Venetian artist Rosalba Carriera (1675–1757) traveled widely throughout Europe producing large numbers of portraits in the rather unusual medium of *pastel*—dry sticks of color that leave a soft, powdery hue when rubbed on paper. The medium is very delicate, but so, unfortunately, are the works executed in it, since the powder smudges easily and tends to drop off if the paper is shaken. It is unlikely that Carriera was concerned with conveying psychological depths. Her chief aim was to provide her subjects flattering likenesses that reinforced their own favorable visions of themselves. Works like her portrait of *Anna Sofia d'Este, Princess of Modena* [16.6] emphasize the delicacy, charm, and sensuality of eighteenth-century society beauties.

English art in the eighteenth century was also notable for its aristocratic portraits. The more extreme elements of rococo eroticism had little appeal to the English nobility, but the artists who were commissioned to paint their portraits could hardly help being influenced by the style

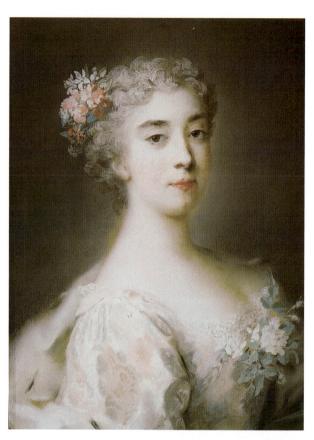

16.6 Rosalba Carriera. *Anna Sofia d'Este, Princess of Modena,* c. 1730. Pastel. Galleria degli Uffizi, Florence. The pale elegance of the subject is typical of most of Carriera's aristocratic sitters, as is the charming untidiness of her dress.

of their day. Thomas Gainsborough (1727-1788), who together with Sir Joshua Reynolds (1723-1792) dominated the English art of the time, even studied for a while with a pupil of Boucher. At a time when rococo art had already fallen into disfavor in France, Gainsborough was still producing paintings like Haymaker and Sleeping Girl (see Figure 16.2), an idealizing rococo vision that recalls the world of Fragonard. Gainsborough's chief reputation, however, was made by his landscapes and portraits. Most of the portraits are set against a landscape background, as in the case of Mary, Countess Howe [16.7]. In this painting, setting and costume are reminiscent of Watteau, but the dignified pose and cool gaze of the subject suggest that she had other than romantic thoughts in mind. There is no lack of poetry in the scene, though, and the resplendent shimmer of the countess' dress is set off perfectly by the more somber tones of the background. Portraits and landscapes lend themselves naturally to rococo treatment, but what of religious art? One of the few painters who tried to apply rococo principles to religious subjects was the Venetian painter Giovanni

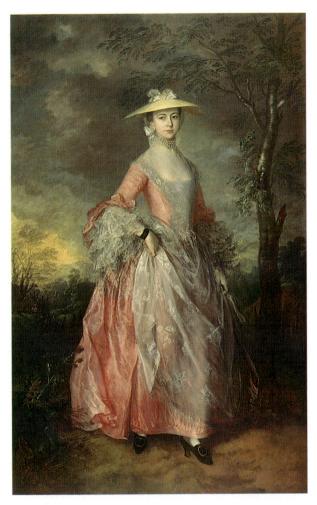

16.7 Thomas Gainsborough. *Mary, Countess Howe,* c. 1765. Oil on canvas, $8' \times 5'$ (2.59 \times 1.52 m). London County Council, Kenwood House (Iveagh Bequest). The wild background and threatening sky set off the subject, but their artificiality is shown by her shoes—hardly appropriate for a walk in the country.

Battista Tiepolo (1696–1770). Many of Tiepolo's most ambitious and best-known works are decorations for the ceilings of churches and palaces, for which projects he was helped by assistants. A more personal work is his painting *The Immaculate Conception* [16.8]. The light colors and chubby cherubs of Boucher and the haughty assurance of Gainsborough's society ladies are here applied to the life of the Virgin Mary.

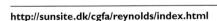

Reynolds

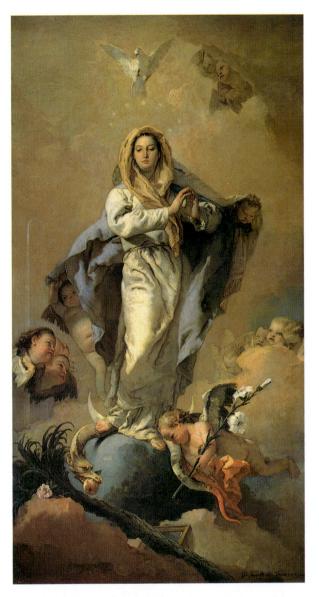

16.8 Giovanni Battista Tiepolo. *The Immaculate Conception*, 1769. Oil on canvas, $9'2'' \times 5'$ (2.79 \times 1.52 m). Museo del Prado, Madrid. The sense of weightlessness and the wonderful cloud effects are both typical of Tiepolo's style.

Rococo sculptors were, for the most part, more concerned with displaying their virtuosity in works aimed at a brilliant effect than with exploring finer shades of meaning. For instance, the figure of *Deception Unmasked* [16.9] by the Genoese sculptor Francesco Queirolo (1704–1762) theoretically has serious religious significance; in practice its principal purpose is to dazzle us with the sculptor's skill at rendering such details as the elaborate net in which Deception hides.

Rococo architecture likewise was principally concerned with delighting the eye rather than inspiring noble sentiments. It is most successful in decorative interiors like those of the Hôtel de Soubise in Paris

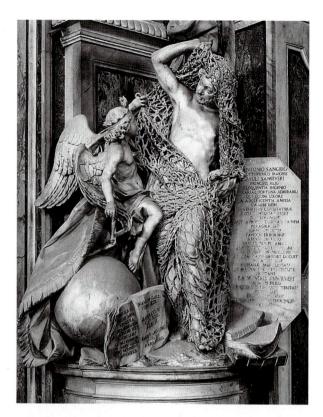

16.9 Francesco Queirolo. *Deception Unmasked*, after 1752. Marble. Height approx. 5'8\sqrt{4}" (1.75 m). Cappella Sansevero, Santa Maria della Pietà di Sangro, Naples. The figure is a Christian sinner freeing himself, with the help of an angel, from the net of deception.

[16.10], where the encrustation of ornament flows from the ceiling down onto the walls, concealing the break between them.

One region of Europe in which the rococo style did exert a powerful influence on religious architecture was southern Germany and Austria. Throughout the seventeenth century, a series of wars in that area had discouraged the construction of new churches or public buildings; with the return of relatively stable conditions in the German states new building again became possible. By one of those fortunate chances in the history of the arts, the fantasy and complexity of the rococo style provided a perfect complement to the new mood of exuberance. The result is a series of churches that is among the happiest of all rococo achievements.

The leading architect of the day was Balthazar Neumann (1687–1753), who had begun his career as an engineer and artillery officer. Among the many palaces and churches he designed, none is more spectacular than the Vierzehnheiligen ("fourteen saints") near Bamberg. The relative simplicity of the exterior deliberately leaves the visitor unprepared for the spaciousness and elaborate decoration of the interior [16.11], with its rows of windows and irregularly placed columns. As in the

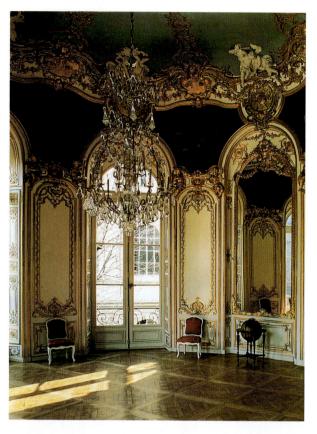

16.10 Germain Boffrand. Salon de la Princesse, Hôtel de Soubise, Paris. c. 1737–1740. Oval $33' \times 26'$ (10.06×7.92 m). Painting by Natoire, sculpture by J. B. Lemoine. The decoration is typical of the rococo style. The shape of the room, the paintings that flow from ceiling to walls, and the reflections in the mirrors all create an impression of light and grace.

Hôtel de Soubise, the joint between the ceiling and walls is hidden by a fresco that, together with its border, spills downward in a series of gracious curves. It is not difficult to imagine what John Calvin would have said of such an interior, but if a church can be allowed to be a place of light and joy, Neumann's design succeeds admirably.

Neo-Classical Art

For all its importance, the rococo style was not the only style to influence eighteenth-century artists. The other principal artistic movement of the age was Neo-Classicism, which increased in popularity as the appeal of the rococo declined.

There were good historical reasons for the rise of Neo-Classicism. The excavation of the buried cities of Herculaneum and Pompeii, beginning in 1711 and 1748 respectively, evoked immense interest in the art of classical antiquity in general and that of Rome in particular. The wall paintings from Pompeian villas of the

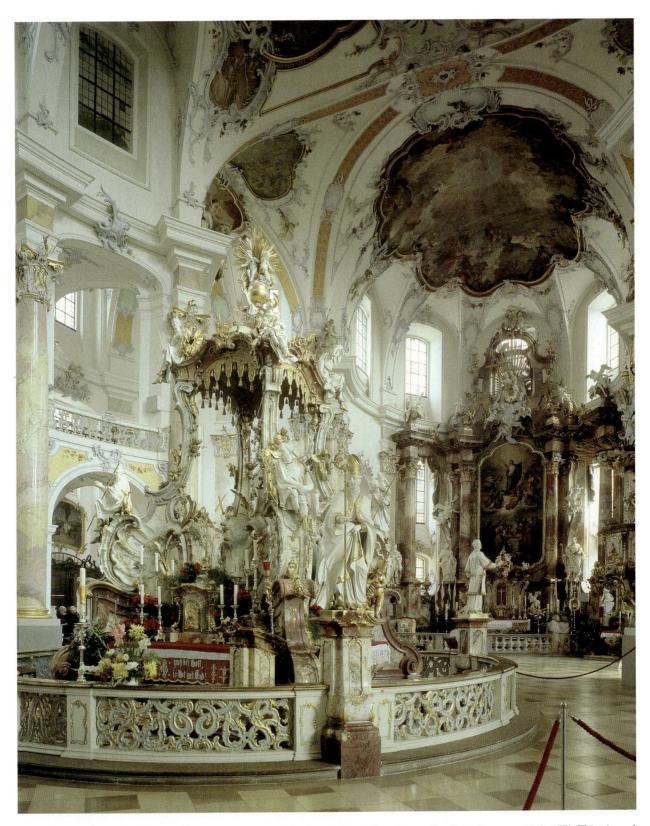

16.11 Balthazar Neumann. Nave and high altar of Vierzehnheiligen Pilgrim Church, near Bamberg, Germany, 1743–1772. This view of the interior shows the high altar at the back of the nave (center) and part of the oval altar in the middle of the church (left). The oval altar, the *Gnadenaltar* ("Mercy Altar"), is a mark of the pilgrimage churches of southern Germany and Austria. Its shape is echoed in the oval ceiling paintings. The architect deliberately rejected the soaring straight lines of Gothic architecture and the balance of symmetry of the Renaissance style in favor of an intricate interweaving of surfaces, solid volumes, and empty spaces.

first century A.D. were copied by countless visitors to the excavations, and reports of the finds were published throughout Europe. The German scholar Johannes Winckelmann (1717–1768), who is sometimes called the Father of Archaeology, played a major part in creating a new awareness of the importance of classical art; in many of his writings he encouraged his contemporaries not only to admire ancient masterpieces but to imitate them.

Further, the aims and ideals of the Roman Republic—freedom, opposition to tyranny, valor—held a special appeal for eighteenth-century republican politicians, and the evocation of Classical models became a characteristic of the art of the French Revolution. The painter who best

represents the official revolutionary style is Jacques Louis David (1748–1825). His *Oath of the Horatii* (see Figure 16.1) draws not only upon a story of ancient Roman civic virtue but also upon a knowledge of ancient dress and armor derived from excavations of Pompeii and elsewhere. The simplicity of its message—the importance of united opposition to tyranny—is expressed by the simple austerity of its style and composition, a far cry from the lush, effete world of Fragonard. David used the

http://www.ibiblio.org/wm/paint/auth/david/

David

16.12 Jacques Louis David. Napoleon Crossing the Alps, 1800. Oil on canvas, 8'10" × 7'7" (2.44 × 2.31 m), National Museum, Versailles. After he took his army across the Alps, Napoleon surprised and defeated an Austrian army. His calm, controlled figure guiding a wildly rearing horse is symbolic of his own vision of himself as bringing order to postrevolutionary France.

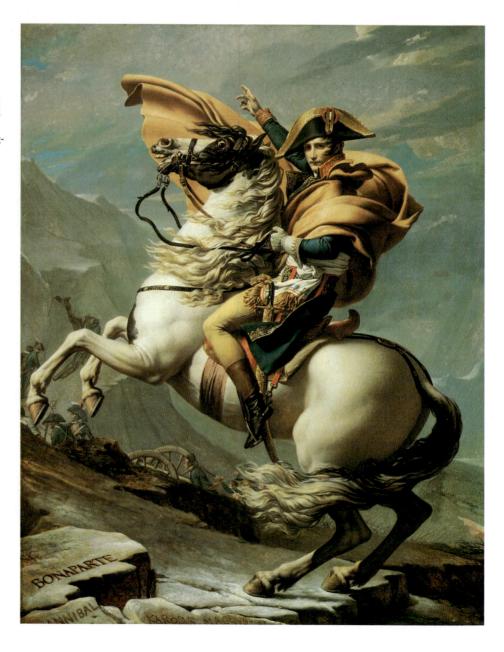

same lofty grandeur to depict Napoleon soon after his accession to power [16.12], although there is considerable if unintentional irony in the use of the revolutionary style to represent the military dictator.

The austere poses and orderly decorations of ancient art came as a refreshing change for those artists who, regardless of politics, were tired of the excesses of the baroque and rococo styles. One of the most notable painters to introduce a Neo-Classical sense of statuesque calmness into his works was Sir Joshua Reynolds, Gainsborough's chief rival in England. *Three Ladies Adorning a Term of Hymen* [16.13] shows three fashionable ladiesabout-town in the guise of figures from Greek mythology. Their static poses seem derived from actual ancient statues. The Classical bust and antique vessel on the right are evidence of a careful attempt to imitate ancient models. Even the stool at center is based on examples found at Pompeii.

Although the rococo and Neo-Classical styles dominated most of eighteenth-century painting, a few important artists avoided both the escapism of the one and the idealism of the other to provide a more truthful picture of the age. The work of William Hogarth, for example, presents its own very individual view of aristocratic society in the eighteenth century.

As a master of line, color, and composition Hogarth was in no way inferior to such contemporaries as Fragonard or Gainsborough, but he used his skills to paint a series of "moral subjects" that satirized the same patrons his colleagues aimed to entertain and to flatter. In his series of paintings called *Marriage à la Mode*, Hogarth illustrated the consequences of a loveless marriage between an impoverished earl and the daughter of a wealthy city merchant who wants to improve his social position. By the second scene in the series, *Shortly After the Marriage* [16.14], matters have already begun to deteriorate.

The principal Neo-Classical sculptors—the Italian Antonio Canova (1757–1822) and the Frenchman Jean Antoine Houdon (1741–1829)—succeeded in using Classical models with real imagination and creativity (see Figure 16.21, and Figure 16.23). Canova's portrait, *Pauline Bonaparte Borghese as Venus Victorious* [16.15], depicts Napoleon's sister with an idealized Classical beauty as she reclines on a couch modeled on one found at Pompeii. The cool worldly elegance of the figure, however, is Canova's own contribution.

For serious projects such as major public buildings, architects tended to follow Classical models, as in the portico of the Pantheon in Paris [16.16], the design of

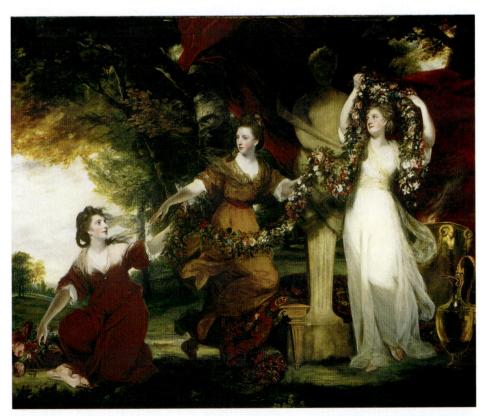

16.13 Sir Joshua Reynolds. Three Ladies Adorning a Term of Hymen, 1773. Oil on canvas, $7'8'' \times 10'4^{1/2}''$ (2.34 × 2.90 m). Tate Gallery, London (reproduced by courtesy of the Trustees). A term is a pillar topped with a bust, in this case of Hymen, god of marriage. Reynolds introduced a marriage theme because the fiancé of one of the ladies, who were daughters of Sir William Montgomery, commissioned the painting. The Neo-Classical composition was deliberately chosen by the artist because it gave him "an opportunity of introducing a variety of graceful historical attitudes.'

which makes use of Classical proportions. As might have been expected, the architects of the American Revolution also turned to classical precedents when they constructed their new public buildings. Thomas Jefferson's State Capitol at Richmond [16.17], for example, shows a conscious rejection of the rococo and all it stood for in favor of the austere world (as it seemed to him) of ancient Rome.

CLASSICAL MUSIC

For the most part, music in the eighteenth century followed the example of literature in retaining a serious purpose, and was relatively untouched by the mood of the rococo style. At the French court, it is true, there was a demand for elegant, lighthearted music to serve as entertainment. The leading composer in this *style galant*

16.14 William Hogarth. Shortly After the Marriage, from Marriage à la Mode, c. 1745. Oil on canvas, 28" × 36" (68 × 89 cm). National Gallery, London (reproduced by courtesy of the Trustees). Although he achieved his effects through laughter, Hogarth had the serious moral purpose of attacking the corruption and hypocrisy of his day.

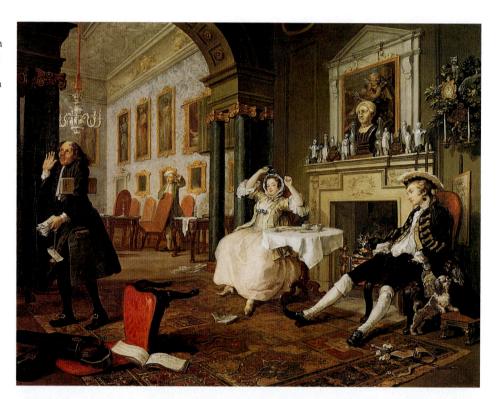

16.15 Antonio Canova. Pauline Bonaparte Borghese as Venus Victorious, 1808. Marble. Life size, length 6'6" (1.98 m). Galleria Borghese, Rome. Canova's blend of simplicity and grace was widely imitated by European and American sculptors throughout the nineteenth century. The apple is the apple of discord, inscribed "to the fairest." According to legend, the goddesses Aphrodite (Venus), Hera, and Athena each offered a tempting bribe to the Trojan Paris, who was to award the apple to one of them. Paris chose Venus, who had promised him the most beautiful of women. The result was the Trojan War, which began when Paris abducted his prize, Helen, wife of a Greek king.

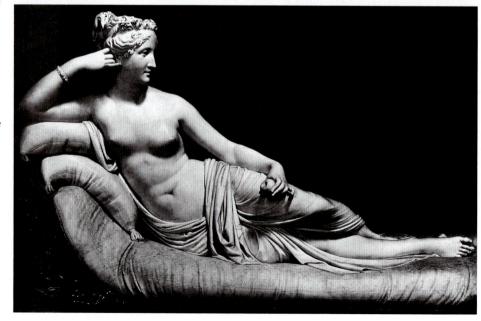

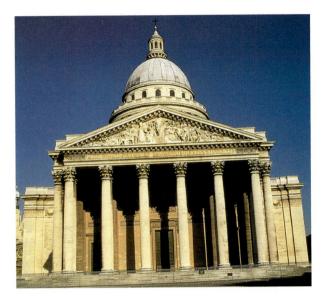

16.16 Germain Soufflot. Pantheon (Sainte Geneviève), Paris, 1755–1792. Originally built as the Church of Sainte Geneviève, the building was converted into a memorial to the illustrious dead at the time of the French Revolution. The architect studied in Rome for a time; the columns and pediment were inspired by ancient Roman temples.

was François Couperin (1668–1733), whose many compositions for keyboard emphasize grace and delicacy at the expense of the rhythmic drive and intellectual rigor of the best of baroque music. Elsewhere in Europe, however, listeners continued to prefer music that expressed emotion. At the court of Frederick the Great (himself an accomplished performer and composer), for example, a musical style known as *empfindsamkeit* ("sensitiveness") developed.

 TABLE 16.2 The Rediscovery of Classical Antiquity in the

 Eighteenth Century

1711 First excavations at Herculaneum

1734 Society of Dilettanti formed in London to encourage exploration

1748 First excavations at Pompeii

1753 Robert Wood and James Dawkins publish *The* Ruins of Palmyra

1757 Wood and Dawkins publish The Ruins of Baalbec

1762 James Stuart and Nicholas Revett publish the first volume of *The Antiquities of Athens*

1764 Robert Adam publishes *The Ruins of the Palace of Diocletian at Spalato;* Johannes Winckelmann publishes *History of Ancient Art*

1769 Richard Chandler and William Pars publish the first volume of *The Antiquities of Ionia*

1772 The Hamilton collection of Greek vases purchased by the British Museum

1785 Richard Colt Hoare explores Etruscan sites in Tuscany

1801 Lord Elgin receives Turkish permission to work on the Parthenon in Athens

The chief exponent of the expressive style was Carl Philipp Emanuel (hereafter referred to as C. P. E.) Bach (1714–1788), a son of Johann Sebastian Bach. His works have considerable emotional range and depth; their rich harmonies and contrasting moods opened up new musical possibilities. Like all his contemporaries, C. P. E. Bach was searching for a formal structure with which to organize them. A single piece or movement from a baroque work had first established a single mood and then

16.17 Thomas Jefferson. State Capitol, Richmond, Virginia, 1785–1796. Like the Pantheon, Jefferson's building was modeled on a Roman temple, the Maison Carrée at Nîmes, but the austere spirit of the American Revolution prompted Jefferson to replace the elaborate Corinthian capitals of the original with simpler Ionic ones.

explored it fully, whether it be joyful, meditative, or tragic. Now composers were developing a musical organization that would allow them to place different emotions side by side, contrast these, and thereby achieve expressive variety.

By the middle of the eighteenth century, a musical style developed that made possible this new range of expression. It is usually called *classical*, although the term is also used in a more general sense, which can be confusing. It would be as well to begin by carefully distinguishing between these two usages.

In its general sense, the term classical is frequently used to distinguish so-called serious music from popular, so that all music likely to be met with in a concert hall or opera house, no matter what its age, is labeled "classical." One reason this distinction is confusing is that for many composers before our own time, there was essentially no difference between serious and popular music. They used the same musical style and techniques for a formal composition to be listened to attentively by an audience of music lovers, as for a religious work to be performed in church, or for dance music or background music for a party or festive occasion. Furthermore, used in this sense, classical tells us nothing significant about the music itself or its period or form. It does not even describe its mood, since many pieces of "classical" or "serious" music were in fact deliberately written to provide light entertainment.

The more precise and technical meaning of "classical" as it relates to music denotes a musical style that was in use from the second half of the eighteenth century and reached its fulfillment in the works of Franz Joseph Haydn (1732–1809) and Wolfgang Amadeus Mozart (1756–1791). It evolved in answer to new musical needs the baroque style could not satisfy and lasted until the early years of the nineteenth century, when it in turn gave way to the romantic style. The figure chiefly responsible for the change from classical to romantic music was Ludwig van Beethoven (1770–1827). Although his musical roots were firmly in the classical style, he is more appropriately seen as a representative of the new romantic age and will be discussed in Chapter 17.

It is no coincidence that the classical style in music developed at much the same time as painters, architects, and poets were turning to Greek and Roman models because the aims of classical music and Neo-Classical art and literature were very similar. After the almost obsessive exuberance and display of the Baroque period, the characteristic qualities of ancient art—balance, clarity, intellectual weight—seemed especially appealing. The eighteenth-century composer, however, faced a problem that differed from that of the artist or writer. Unlike literature or the visual arts, ancient music has disappeared almost without trace. As a result, the classical style in music had to be newly invented to express ancient concepts of balance and order. In addition, it had to combine

these intellectual principles with the no-less-important ability to express a wide range of emotion. Haydn and Mozart were the two supreme masters of the classical style because of their complete command of the possibilities of the new idiom within which they wrote.

The Classical Symphony

The most popular medium in the classical period was instrumental music. In extended orchestral works, *symphonies*, divided into a number of self-contained sections called *movements*, composers were most completely able to express classical principles.

One reason for this was the new standardization of instrumental combinations. In the Baroque period, composers such as Bach had felt free to combine instruments into unusual groups that varied from composition to composition. Each of Bach's Brandenburg Concertos was written for a different set of solo instruments. By about 1750, however, most instrumental music was written for a standard orchestra, the nucleus of which was formed by the string instruments: violins (generally divided into two groups known as first and second), violas, cellos, and double basses. To the strings were added wind instruments, almost always the oboe and bassoon and fairly frequently the flute; the clarinet began to be introduced gradually and, by about 1780, had become a regular member of the orchestra. The only brass instrument commonly included was the French horn. Trumpets, along with the timpani or kettledrums, were reserved for reinforcing volume or rhythm. Trombones were never used in classical symphonies until Beethoven [16.18].

Orchestras made up of these instruments were capable of rich and varied sound combinations ideally suited to the new classical form of the symphony. In general, the classical symphony has four movements (as opposed to the baroque concerto's three): a first, relatively fast one, usually the most complex in form; then a slow, lyrical movement, often songlike; a third movement in the form of a minuet (a stately dance); and a final movement, which brings the entire work to a spirited and usually cheerful conclusion. As time went on, the length and complexity of the movements grew, and many of Haydn's later symphonies last for nearly half an hour. In most cases, however, the most elaborate musical "argument" was always reserved for the first movement, presumably because during it the listeners were freshest and most able to concentrate.

The structure almost invariably chosen for the first movement of a classical symphony was that called *sonata form*. Since sonata form was not only one of the chief features of classical style but also a principle of musical organization that remained popular throughout the nineteenth century, it merits our attention in some detail. The term itself is actually rather confusing, since the word *sonata* is used to describe a work in several movements

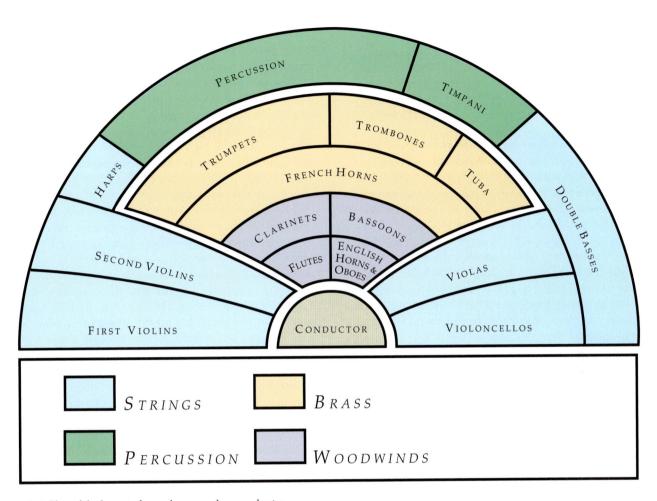

16.18 Plan of the layout of a modern symphony orchestra.

(like a symphony), but written for one or two instruments rather than for an orchestra. Thus, a piano sonata is a piece for solo piano, a violin sonata is a piece for violin and an accompanying instrument, almost always a piano, and so on. A symphony is, in fact, a sonata for orchestra.

The term "sonata form," however, does not, as might be reasonably expected, describe the form of a sonata but a particular kind of musical organization frequently found in the first movement of both symphonies and sonatas as well as other instrumental combinations like string quartets (two violins, viola, and cello). Since first movements are generally played at a fast *tempo* ("speed"), the term *sonata allegro form* is also sometimes used. (The Italian word *allegro* means "fast"; Italian terms are traditionally used in music, as we have seen.)

Unlike baroque music, with its unity based on the use of a single continually expanding theme, sonata form is dominated by the idea of contrasts. The first of the three main sections of a sonata form movement is called the *exposition*, since it sets out, or "exposes," the musical material. This consists of at least two themes, or groups of

themes, that differ from one another in melody, rhythm, and key. They represent, so to speak, the two principal characters in the drama. If the first theme is lively, the second may be thoughtful or melancholy; or a strong marchlike first theme may be followed by a gentle, romantic second one. During the exposition, the first of these *themes* (or "subjects," as they are often called) is stated, followed by a linking passage leading to the second subject and a conclusion that rounds off the exposition.

During the course of the movement it is of the utmost importance that listeners be able to remember these themes and identify them when they reappear. To help make this easier, classical composers replaced the long, flowing lines of baroque melodies with much shorter tunes, often consisting of only a few notes, comparatively easy to recognize when they recur. The difference between baroque and classical melody is clearly visible even on paper. Compare, for example, the continuous pattern of the melodic line in Chapter 15, from Bach's Brandenburg Concerto No. 2, with the following theme from Mozart's Symphony No. 40 in g minor. The tune consists basically of a group of three notes (a) repeated three times to produce a melodic phrase (b). This procedure is then repeated three more times to impress it firmly on one's memory.

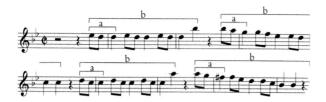

Just in case their listeners were still not perfectly familiar with the basic material of a movement, composers reinforced it by repeating the entire exposition note for note.

In the second section of a sonata form movement, the *development*, the themes stated in the exposition are changed and varied in whatever way the composer's imagination suggests. One part of the first subject is often detached and treated on its own, passing up and down the orchestra, now loud, now soft, as happens in the first movement of Mozart's *Symphony No. 40* to the notes above (a). Sometimes different themes will be combined and played simultaneously. In almost all cases the music passes through a wide variety of keys and moods. In the process the composer sheds new light on what have by now become familiar ideas.

For a selection from Bach's *Brandenburg Concerto* #2 and Mozart's *Symphony No.* 40, see the Listening CD.

At the end of the development, the original themes return to their original form for the third section of the movement, the *recapitulation* ("repeated" theme). The first section is recapitulated with both first and second subjects now in the same key. In this way the conflict implicit in the development section is resolved. A final *coda* (or "tailpiece"; *coda* is the Italian word for "tail") is sometimes added to bring the movement to a suitably firm conclusion.

Sonata form embodies many of the classical principles of balance, order, and control. The recapitulation, which carefully balances the exposition, and the breaking down of the material in the development and its subsequent reassembling both emphasize the sense of structure behind a sonata form movement.

Haydn

The long and immensely productive career of Franz Joseph Haydn spanned a period of great change in both artistic and social terms. Born in Rohrau on the Austro–Hungarian border, he sang as a child in the choir of Saint Stephen's Cathedral in Vienna. After scraping together a living for a few precarious years, in 1761 he entered the service of a wealthy nobleman, Prince Esterhazy.

Haydn began work for the prince on the same terms as any carpenter, cook, or artisan in his master's employ. That he was a creative artist was irrelevant, since social distinctions were made on grounds of wealth or birth, not talent. By the time he left the Esterhazy family almost thirty years later, the aristocracy was competing for the privilege of entertaining him! The world was indeed changing; in the course of two visits to London Haydn found himself feted and honored, and during his last years in Vienna he was among the most famous figures in Europe. Thus Haydn was one of the very first musicians to attain a high social position solely on the strength of his genius. His success signaled the new relationship between the artist and society that was to characterize the nineteenth century.

In personal terms, Haydn seems to have been little affected by his fame. During the long years of service to Prince Esterhazy and his descendants he used the enforced isolation of the palace where he lived to experiment with all the musical forms available to him. In addition to operas, string quartets, piano sonatas, and hundreds of other pieces, Haydn wrote more than one hundred symphonies that exploit almost every conceivable variation on sonata and other classical forms, winning him the nickname "Father of the Symphony." During his visits to London (in 1791-1792 and 1794-1795), he wrote his last twelve symphonies, which are often known as the "London" Symphonies. Although less obviously experimental than his earlier works, they contain perhaps the finest of all his orchestral music; the slow movements in particular manage to express the greatest seriousness and profundity without tragedy or gloom.

Mozart

http://w3.rz-berlin.mpg.de/cmp/mozart.html

Mozart

In 1781, in his fiftieth year and at the height of his powers, Haydn met a young man about whom he was to say a little while later to the young man's father: "Before God and as an honest man, I tell you that your son is the greatest composer known to me either in person or by name." Many of us, for whom the music of Wolfgang Amadeus Mozart represents a continual source of inspiration and joy and a comforting reminder of the heights the human spirit can attain, would see no reason to revise Haydn's judgment [16.19].

Although Mozart's life, in contrast to Haydn's, was to prove one of growing disappointments and setbacks, his early years were comparatively happy. During his child-hood he showed extraordinary musical ability. By age six he could already play the violin and piano and had begun to compose. His father Leopold, himself a professional musician in the service of Archbishop of Salzburg, where the family lived, took Wolfgang on a seemingly never-ending series of trips throughout Europe to exhibit his son's musical prowess. The effect of constant travel on the boy's health and temperament can be imagined,

16.19 Joseph Lange. *Mozart at the Pianoforte*, 1789. Oil on canvas, $13\frac{1}{2}$ " × $11\frac{1}{2}$ " (35 × 30 cm). Mozart Museum, Salzburg. This unfinished portrait shows the composer for once without the wig customary at the time. Mozart must have liked the painting because he had a copy made and sent to his father.

but it was during these trips that he became exposed to the most sophisticated and varied musical ideas of the day; the universality of his own musical style must in part be due to the wide range of influences he was able to assimilate, from the style galant of the rococo to the Renaissance polyphonies he heard in Rome. From time to time father and son would return to Salzburg, where by this time they both held appointments at the court of the archbishop.

In 1772, however, the old archbishop died. His successor, Hieronymus Colloredo, was far less willing to allow his two leading musicians to come and go as they pleased. Artistic independence of the kind Haydn was to achieve was still in the future, and the following ten years were marked by continued quarreling between Mozart and his aristocratic employer. Finally, in 1781, when Mozart could take no more and asked the archbishop for his freedom, he was literally kicked out of the door of the palace. From 1781 to 1791 Mozart spent the last years of his life in Vienna, trying in vain to find a permanent position while writing some of the most sublime masterpieces in the history of music. When he died at age thirty-five, he was buried in a pauper's grave.

The relationship between an artist's life and work is always fascinating. In Mozart's case it raises particular problems. We might expect that continual frustration, poverty, and depression would have left its mark on his music, yet it is a grave mistake to look for autobiographical self-expression in the work of an artist who devoted his life to achieving perfection in his art. In general, Mozart's music reflects only the highest and most noble of human aspirations. Perhaps more than any other artist in any medium, Mozart combines ease and grace with profound learning in his art to come as near to ideal beauty as anything can. Nevertheless, his music remains profoundly human. We are reminded many times not of Mozart's own suffering but of the tragic nature of life itself.

A year before his death, Mozart wrote the last of his great series of concertos for solo piano and orchestra, the *Piano Concerto No.* 27 in *B flat*, K. 595 (Mozart's works are generally listed according to the catalogue first made by Köchel; hence the letter *K* that precedes the catalogue numbers). The wonderful slow movement of this work expresses, with a profundity no less moving for its utter simplicity, the resignation of one for whom the beauty of life is perpetually tinged with sadness. We can only marvel at so direct a statement of so universal a truth.

The need to earn a living, coupled with the inexhaustibility of his inspiration, drew from Mozart works in almost every conceivable category. Symphonies, concertos, masses, sonatas, string quartets are only some of the forms he enriched. It is his operas, however, that many admirers of Mozart would choose if faced with a decision as to what to save if all else were to be lost. Furthermore, his operas provide the clearest picture of his historical position.

Mozart's opera The Marriage of Figaro is based on a play of the same name by the French dramatist Pierre-Augustin Beaumarchais (1732-1799). Although a comedy, the play, which was first performed in 1784, contains serious overtones. The plot is too complicated to permit even a brief summary, but among the characters are a lecherous and deceitful, though charming, Count; his deceived wife, the Countess; her maid Susanna, who puts up a determined resistance against the Count's advances; and Susanna's husband-to-be, Figaro, who finally manages to outwit and embarrass the would-be seducer of his future wife, who is also his own employer [16.20]. In other words, the heroes of the play are the servants and the villain their master. Written as it was on the eve of the French Revolution, Beaumarchais' play was interpreted rightly as an attack on the morals of the ruling classes and a warning that the lower classes would fight back. Beaumarchais was himself firmly associated with the moves toward social and political change; he was an early supporter of the American Revolution and helped organize French support for the insurgent colonists.

Mozart's opera was first performed in 1786. It retains the spirit of protest in the original but adds a sense of humanity and subtlety perhaps only music can bring. No one suffered more than Mozart from the

16.20 *The Marriage of Figaro.* Metropolitan Opera, New York, 1975. In this scene from Act II of Mozart's opera, the Count (on the right) is trying to assert his aristocratic authority against the combined arguments of his wife (left), Susanna (second from right), and Figaro (third from right). The singers are Evelyn Lear as the Countess, Wolfgang Brendel as the Count, Judith Blegen as Susanna, and Justino Diaz as Figaro.

highhandedness of the aristocracy, yet when *The Marriage of Figaro* gives voice to the growing mood of revolution, it does so as a protest against the abuse of human rights rather than in a spirit of personal resentment. In the first act, Figaro's aria "Se vuol' ballare" expresses the pent-up frustration of generations of men and women who had endured injustices and who could take no more. The musical form and expression is still restrained, indeed classical, but Mozart pours into it the feelings of the age.

Mozart's ability to create characters who seem real, with whose feelings we can identify, reaches its height in the Countess. Ignored and duped by her husband, the laughingstock of those around her, she expresses the conflicting emotions of a woman torn between resentment and deep attachment. Her aria in the third act, "Dove sono," begins with a recitative in which she gives vent to her bitterness. Gradually it melts into a slow and meditative section where she asks herself what went wrong: "Where are those happy moments of sweetness and plea-

sure, where did they go, those vows of a deceiving tongue?" The poignant theme to which these words are set returns toward the end of the slow section to provide one of the most affective moments in all opera. Mozart's gift for expressing human behavior at its most noble is conveyed in the aria's final section, where the Countess decides, in spite of everything, to try to win back her husband's love. Thus, in seven or eight minutes, we have been carried from despair to hope, and Mozart has combined his revelation of a human heart with music that by itself is of extraordinary beauty.

The opera as a whole is far richer than discussion of these two arias can suggest. For instance, among the other characters is one of the composer's most memorable creations, the pageboy Cherubino, whose aria "Non so più" epitomizes the breathless, agonizing joy of adolescent love. An accomplishment of another kind is exemplified by the *ensembles* (scenes in which a large number of characters are involved). Here Mozart combines clarity of musical and dramatic action while advancing the plot at a breakneck pace.

The Marriage of Figaro expresses at the same time the spirit of its age and the universality of human nature, a truly classical achievement. Equally impressively, it illuminates the personal emotions of individual people, and through them teaches us about our own reactions to life and its problems. As one distinguished writer has put it, in this work Mozart has added to the world's understanding of people—of human nature.

CONTEMPORARY VOICES

Horace Walpole

A Visit to the Court of Louis XV

The English writer and connoisseur Horace Walpole (1717–1797), has been presented to the king and queen and describes the encounter to a friend.

You perceive that I have been presented. The Queen took great notice of me; none of the rest said a syllable. You are let into the king's bedchamber just as he has put on his shirt; he dresses and talks good-humoredly to a few, glares at strangers, goes to mass, to dinner, and a-hunting. The good old Queen, who is like Lady Primrose in the face, and Queen Caroline in the immensity of her cap, is at her dressing-table, attended by two or three old ladies, who are languishing to be in Abraham's bosom, as the only man's bosom to whom they can hope for admittance. Thence you go to the Dauphin, for all is done in an hour. He scarce stays a

minute; indeed, poor creature; he is a ghost, and cannot possibly last three months. The Dauphiness is in her bedchamber, but dressed and standing; looks cross, is not civil, and has the true Westphalian grace and accents. The four Mesdames, who are clumsy, plump old wenches, with a bad likeness to their father, stand in a bedchamber in a row, with black cloaks and knittingbags, looking good-humored, not knowing what to say, and wriggling as if they wanted to make water. This ceremony too is very short; then you are carried to the Dauphin's three boys, who you may be sure only bow and stare. The Duke of Berry looks weak and weakeyed: the Count de Provence is a fine boy; the Count d'Artois well enough. The whole concludes with seeing the Dauphin's little girl dine, who is as round and as fat as a pudding.

From The Letters of Horace Walpole, P. Cunningham, ed. London, 1892.

LITERATURE IN THE EIGHTEENTH CENTURY

Intellectual Developments

While painters, poets, and musicians were reflecting the changing moods of the eighteenth century in their art, social and political philosophers were examining the problems of contemporary society in a more systematic way. Individual thinkers frequently alternated between optimism and despair, since awareness of the greatness of which human beings were capable was always qualified by the perception of the sorry state of the world. The broad range of diagnosis and/or proposed solutions makes it difficult to generalize on the nature of eighteenthcentury intellectual life, but two contrasting trends can be discerned. A few writers, notably Jonathan Swift, reacted to the problems of the age with deep pessimism, bitterly opposing the view that human nature is basically good. Others, convinced that progress was possible, sought to devise new systems of intellectual, social, or political organization. Rational humanists like Diderot and political philosophers like Rousseau based their arguments on an optimistic view of human nature. However, Voltaire, the best known of all eighteenth-century thinkers, fitted into neither of these two categories-rather, he moved from one to the other. The answer he finally proposed to the problems of existence is as applicable to the world of today as it was to that of the eighteenth century, although perhaps no more welcome.

The renewed interest in Classical culture, visible in the portraits by Sir Joshua Reynolds and buildings like the Pantheon, also made a strong impression on literature. French writers like Racine had already based works on Classical models, and the fables of Jean de La Fontaine (1621–1695) drew freely on Aesop and other Greek and Roman sources. Elsewhere in Europe throughout the eighteenth century, poets continued to produce works on Classical themes, from the plays of Pietro Metastasio (1698–1782) in Italy to the lyric poetry of Friedrich von Schiller (1759–1805) in Germany.

The appeal of Neo-Classical literature was particularly strong in England, where major Greek and Roman works like Homer's *Iliad* and *Odyssey* or Vergil's *Aeneid* had long been widely read and admired. In the seventeenth century, Milton's *Paradise Lost* had represented a deliberate attempt to create an equally monumental epic poem in English. Before the eighteenth century, however, a number of important works, including the tragedies of Aeschylus, had never been translated into English.

The upsurge of enthusiasm for Classical literature that characterized the eighteenth-century English literary scene had two chief effects: Poets and scholars began to translate or retranslate the most important Classical authors; and creative writers began to produce original works in Classical forms, deal with Classical themes, and include Classical references. The general reading public was by now expected to understand and appreciate both the ancient masterpieces themselves and modern works inspired by them.

The principal English writers formed a group calling themselves Augustans. The name reveals the degree to which these writers admired and modeled themselves on the Augustan poets of ancient Rome. In 27 B.C., the victory of the first Roman emperor Augustus ended the chaos of civil war in Rome and brought peace and stability to the Roman world. The principal poets of Rome's Augustan Age, writers like Vergil and Horace, had subsequently commemorated Augustus' achievement in works intended for a sophisticated public. In the same way in England the restoration to power of King Charles II (in 1660) seemed to some of his contemporaries a return to order and civilization after the tumultuous English Civil War. The founders of the English Augustan movement, writers like John Dryden (1631-1700) explored not only the historical parallel by glorifying English achievement under the monarchy but also the literary one by imitating the highly polished style of the Roman Augustan poets in works intended for an aristocratic audience. He also translated into English Vergil, Juvenal, and other Roman poets.

Pope's Rococo Satires

http://www.kirjasto.sci.fi/apope.htm

Pope

Alexander Pope (1688–1744), the greatest English poet of the eighteenth century, was one of the Augustans, yet the lightness and elegance of his wit reflect the rococo spirit of the age.

His genius lay precisely in his awareness that the dry bones of Classical learning needed to have life breathed into them. The spirit that would awaken art in his own time, as it had done for the ancient writers, was that of Nature—not in the sense of the natural world but in the sense of that which is universal and unchanging in human experience. Pope's conception of the vastness and truth of human experience given form and meaning by rules first devised in the ancient past represents eighteenth-century thought at its most constructive.

Like Watteau, Pope suffered throughout his life from ill health. At age twelve, an attack of spinal tuberculosis left him permanently crippled. Perhaps in compensation he soon developed the passion for reading and for the beauty of the world around him that shines through his work. A Catholic in a Protestant country, he was unable establish a career in public life or obtain public patronage for his literary work. As a result he was forced to support himself entirely by writing and translating. Pope's literary reputation was first made by the *Essay on Criticism*, but he won economic independence by producing highly successful translations of Homer's *Iliad* (1713–1720) and *Odyssey* (1721–1726) and an

edition of the works of Shakespeare (1725). With the money he earned from these endeavors, he abandoned commercial publishing and confined himself, for the most part, to his house on the river Thames at Twickenham, where he spent the rest of his life writing, entertaining friends, and indulging his fondness for gardening.

Pope's range as a poet was considerable, but his greatest achievements were in the characteristically rococo medium of satire. Like his fellow countryman Hogarth, his awareness of the heights to which humans can rise was coupled with an acute sense of the frequency of their failure to do so. In the long poem Essay on Man (1733-1734), for example, Pope combines Christian and humanist teaching in a characteristically eighteenth-century manner to express his philosophical position with regard to the preeminent place occupied by human beings in the divine scheme of life. He is at his best, however, when applying his principles to practical situations and uncovering human folly. Pope's reverence for order and reason made him the implacable foe of those who in his eyes were responsible for the declining political morality and artistic standards of the day. It is sometimes said that Pope's satire is tinged with personal hostility. In fact, a series of literary and social squabbles marked his life, suggesting that he was not always motivated by the highest ideals; nonetheless, in his poetry he nearly always based his moral judgments on what he himself described as "the strong antipathy of good to bad," a standard he applied with courage and wit.

Swift's Savage Indignation

Perhaps the darkest of all visions of human nature in the eighteenth century was that of Jonathan Swift (1667–1745). In a letter to Alexander Pope he made it clear that, whatever his affection for individuals, he hated the human race as a whole. According to Swift, human beings were not to be defined automatically as rational animals, as so many eighteenth-century thinkers believed, but as animals *capable* of reason. It was precisely because so many of them failed to live up to their capabilities that Swift turned his "savage indignation" against them into bitter satire, never more so than when the misuse of reason served "to aggravate man's natural corruptions" and provide him with new ones.

Swift was in a position to observe at close quarters the political and social struggles of the times. Born in Dublin, for much of his life he played an active part in supporting Irish resistance to English rule. After studying at Trinity College, Dublin, he went to England and (in 1694) was ordained a priest in the Anglican Church. For the next few years he moved back and forth between England and Ireland, taking a leading role in the political

controversies of the day by publishing articles and pamphlets which, in general, were strongly conservative.

A fervent supporter of the monarchy and of the Anglican Church, Swift had good reason to hope that his advocacy of their cause would win him a position of high rank. In 1713, this hope was partially realized with his appointment as Dean of Saint Patrick's Cathedral in Dublin. Any chances he had of receiving an English bishopric were destroyed in 1714 by the death of Queen Anne and the subsequent dismissal of his political friends from power.

Swift spent the remainder of his life in Ireland, cut off from the mainstream of political and cultural life. Here he increasingly emerged as a publicist for the Irish cause. During his final years his mind began to fail, but not before he had composed the epitaph under which he lies buried in Saint Patrick's Cathedral: *Ubi saeva indignatio ulterius cor lacerare nequit* ("He has gone where savage indignation can tear his heart no more").

During his years in Ireland Swift wrote his bestknown work, Gulliver's Travels, first published in 1726. In a sense Gulliver's Travels has been a victim of its own popularity, since its surprising success as a work for young readers has distracted attention from the author's real purpose: to satirize human behavior. (It says much for the eighteenth century's richness that it could produce two writers working in the same genre-the satirists Swift and Pope-with such differing results.) The first two of Gulliver's four voyages, to the miniature land of Lilliput and to Brobdingnag, the land of giants, are the best known. In these sections the harshness of Swift's satire is to some extent masked by the charm and wit of the narrative. In the voyage to the land of the Houyhnhnms, however, Swift draws a bitter contrast between the Houyhnhnms, a race of horses whose behavior is governed by reason, and their slaves the Yahoos, human in form but bestial in behavior. As expressed by the Yahoos, Swift's vision of the depths to which human beings can sink is profoundly pessimistic. His insistence on their deep moral and intellectual flaws is in strong contrast to the rational humanism of many of his contemporaries who believed in the innate dignity and worth of human beings.

Yet even the Yahoos do not represent Swift's most bitter satire. It took his experience of the direct consequences of "man's inhumanity to man" to draw from his pen a short pamphlet, A Modest Proposal for Preventing the Children of Poor People in Ireland from Being a Burden to Their Parents or Country, and for Making Them Beneficial to the Public, the title of which is generally abbreviated to A Modest Proposal. First published in 1729, this brilliant and shocking work was inspired by the poverty and suffering of a large sector of Ireland's population. Even today the nature of the supposedly benevolent author's "modest proposal" can take the reader's breath away,

both by the calmness with which it is offered and by the devastatingly quiet logic with which its implications are explained. All the irony of which this master satirist was capable is here used to express anger and disgust at injustice and the apparent inevitability of human suffering. Although Swift was writing in response to a particular historical situation, the deep compassion for the poor and oppressed that inspired him transcends its time. Our own world has certainly not lost the need for it.

Rational Humanism: The Encyclopedists

Belief in the essential goodness of human nature and the possibility of progress, which had first been expressed by the humanists of the Renaissance, continued to find supporters throughout the eighteenth century. Indeed, the enormous scientific and technical achievements of the two centuries since the time of Erasmus tended to confirm the opinions of those who took a positive view of human capabilities. It was in order to provide a rational basis for this positive humanism that the French thinker and writer Denis Diderot (1713–1784) [16.21] conceived the project of preparing a vast encyclopedia that would describe the state of contemporary science, technology, and thought and provide a system for the classification of knowledge.

http://www.kirjasto.sci.fi/diderot.htm

Diderot

Work on the *Encyclopédie*, as it is generally called, began in 1747; the last of its seventeen volumes appeared in 1765. By its conclusion, what had begun as a compendium of information had become the statement of a philosophical position: that the extent of human powers and achievements conclusively demonstrates that humans are rational beings. The implication of this position is that any political or religious system seeking to control the minds of individuals is to be condemned. It is hardly surprising, therefore, that some years before the conclusion of the project, the *Encyclopédie* had been banned by decree of Louis XV; the last volumes were published clandestinely.

In religious terms, the *Encyclopédie* took a position of considerable skepticism, advocating freedom of conscience and belief. Politically, however, its position was less extreme and less consistent. One of the most distinguished philosophers to contribute political articles was Charles-Louis Montesquieu (1689–1755), whose own aristocratic origins may have helped mold his relatively conservative views. Both in the *Encyclopédie* and in his own writings, Montesquieu advocated the retention of a

16.21 Jean Antoine Houdon. *Denis Diderot*, 1771. Terra cotta. Height 16" (41 cm). Louvre, Paris. Unlike most official portraiture of the eighteenth century, Houdon's work aims to reveal the character of his sitters. Here he vividly conveys Diderot's humanity and quizzical humor.

monarchy, with powers divided between the king and a series of "intermediate bodies" that included parliament, aristocratic organizations, the middle class, and even the church. By distributing power in this way, Montesquieu hoped to achieve a workable system of "checks and balances," thereby eliminating the possibility of a central dictatorial government. His ideas proved particularly interesting to the authors of the Constitution of the United States.

A very different point of view was espoused by another contributor to the *Encyclopédie*, Jean Jacques Rousseau (1712–1778), whose own quarrelsome and neurotic character played a considerable part in influencing his political philosophy. Diderot had originally com-

missioned Rousseau to produce some articles on music, since the latter was an accomplished composer (his opera *Le Devin du Village* is still performed occasionally). After violently quarreling with Diderot and others, however, Rousseau spent much of an unhappy and restless life writing philosophical treatises and novels that expressed his political convictions. Briefly stated, Rousseau believed that the natural goodness of the human race had been corrupted by the growth of civilization and that the freedom of the individual had been destroyed by the growth of society. For Rousseau, humans were good and society was bad.

Rousseau's praise of the simple virtues like unselfishness and kindness and his high regard for natural human feelings have identified his philosophy with a belief in the "noble savage"; but this is misleading. Far from advocating a return to primitive existence in some nonexistent Garden of Eden, Rousseau passionately strove to create a new social order. In *The Social Contract* (1762) he tried to describe the basis of his ideal state in terms of the General Will of the people, which would delegate authority to individual organs of government, although neither most of his readers nor Rousseau himself seemed very clear on how this General Will should operate.

Although Rousseau's writings express a complex political philosophy, most of his readers were more interested in his emphasis on spontaneous feeling than in his political theories. His contempt for the superficial and the artificial, and his praise for simple and direct relationships between individuals, did a great deal to help demolish the principles of aristocracy and continue to inspire believers in human equality.

Voltaire's Philosophical Cynicism: Candide

It may seem extravagant to claim that the life and work of François Marie-Arouet (1694–1778), best known to us as Voltaire (one of his pen names), can summarize the events of a period as complex as the eighteenth century. That the claim can be not only advanced but also supported is some measure of the breadth of his genius. A writer of poems, plays, novels, and history; a student of science, philosophy, and politics; a man who spent time at the courts of Louis XV and Frederick the Great but also served a prison sentence; a defender of religious and political freedom who at the same time supported enlightened despotism, Voltaire was above all a man engagé—one committed to the concerns of his age [16.22].

After being educated by the Jesuits, he began to publish writings in the satirical style he was to use throughout his life. His belief that the aristocratic society of the times was unjust must have received strong confirmation when his critical position earned him first a year in jail

and then, in 1726, exile from France. Voltaire chose to go to England, where he found a system of government that seemed to him far more liberal and just than that of the French. On his return home in 1729 he discussed the advantages of English political life in his *Lettres philosophiques*, published in 1734, and escaped from the scandal and possibility of arrest his work created by spending the next ten years in the country.

In 1744, Voltaire was finally tempted back to the French court but found little in its formal and artificial life to stimulate him. He discovered a more congenial atmosphere at the court of Frederick the Great at Potsdam, where he spent the years from 1750 to 1753. Frederick's warm welcome and considerable intellectual stature

16.22 Jean Baptiste Pigalle. *Voltaire*, 1770–1776. Marble. Height $4'9^3/8''$ (1.47 m). Louvre, Paris. This most unusual statue of the great philosopher places a powerful head on the torso of an old man. The head was modeled from life when Voltaire was seventy-six; the body is based on that of a Roman statue. The statue seems to represent the triumph of the spirit over the frailty of the body.

must have come as an agreeable change from the sterile ceremony of the French court, and the two men soon established a close friendship. It seems, however, that Potsdam was not big enough to contain two such powerful intellects and temperaments. After a couple of years, Voltaire quarreled with his patron and once again abandoned sophisticated life for that of the country.

In 1758, Voltaire finally settled in the village of Ferney, where he set up his own court. Here the greatest names in Europe—intellectuals, artists, politicians—made the pilgrimage to talk and, above all, listen to the sage of Ferney, while he published work after work, each of which was distributed throughout Europe. Only in 1778, the year of his death, did Voltaire return to Paris, where the excitement brought on by a hero's welcome proved too much for his failing strength.

It is difficult to summarize the philosophy of a man who touched on so many subjects. Nevertheless, one theme recurs continually in Voltaire's writings: the importance of freedom of thought. Voltaire's greatest hatred was reserved for intolerance and bigotry; in letter after letter he ended with the phrase he made famous, Écrasez l'infâme ("Crush the infamous thing"). The "infamous thing" is superstition, which breeds fanaticism and persecution. Those Voltaire judged chiefly responsible for superstition were the Christians—Catholic and Protestant alike.

Voltaire vehemently attacked the traditional view of the Bible as the inspired word of God. He claimed that it contained a mass of anecdotes and contradictions totally irrelevant to the modern world and that the disputes arising from it, which had divided Christians for centuries, were absurd and pointless. Yet Voltaire was far from being an atheist. He was a firm believer in a God who had created the world, but whose worship could not be tied directly to one religion or another: "The only book that needs to be read is the great book of nature." Only natural religion and morality would end prejudice and ignorance.

Voltaire's negative criticisms of human absurdity are more convincing than his positive views on a universal natural morality. It is difficult not to feel at times that even Voltaire himself had only the vaguest ideas of what natural morality really meant. In fact, in Candide (1759), his best-known work, he reaches a much less optimistic conclusion. Candide was written with the avowed purpose of ridiculing the optimism of the German philosopher Gottfried von Leibnitz (1646-1716), who believed that "everything is for the best in the best of all possible worlds." Since both intellect and experience teach that this is far from the case, Voltaire chose to demonstrate the folly of unreasonable optimism, as well as the cruelty and stupidity of the human race, by subjecting his hero Candide to a barrage of disasters and suffering.

THE LATE EIGHTEENTH CENTURY: TIME OF REVOLUTION

Throughout the eighteenth century, Europe continued to prosper economically. The growth of trade and industry, particularly in Britain, France, and Holland, led to a number of significant changes in the lifestyles of increasing numbers of people. Technological improvements in coal mining and iron casting began to lay the foundations for the Industrial Revolution of the nineteenth century. The circulation of more books and newspapers increased general awareness of the issues of the day. As states began to accumulate more revenue, they increased both the size of their armies and the number of those in government employ. The Baroque period had seen the exploitation of imported goods and spices from Asia and gold from Latin America; the eighteenth century was marked by the development of trade with North America and the Caribbean.

Amid such vast changes, it was hardly possible that the very systems of government should remain unaffected. Thinkers like Rousseau and Voltaire began to question the hitherto unquestioned right of the wealthy aristocracy to rule throughout Europe. In Britain, both at home and in the colonies, power was gradually transferred from the king to Parliament. Prussia, Austria, and Russia were ruled by so-called enlightened despots, as we have seen.

In France, however, center of much of the intellectual pressure for change, the despots were not even enlightened. Louis XV, who ruled from 1715 to 1774, showed little interest in the affairs of his subjects or the details of government. The remark often attributed to him, Après moi le déluge ("After me the flood"), suggests that he was fully aware of the consequences of his indifference. Subsequent events fully justified his prediction, yet throughout his long reign he remained either unwilling or unable to follow the example of his fellow European sovereigns and impose some order on government. By the time his grandson Louis XVI succeeded him in 1774, the damage was done. Furthermore, the new king's continued reliance on the traditional aristocratic class, into whose hands he put wealth and political power, offended both the rising middle class and the peasants. When in 1788 the collapse of the French economy was accompanied by a disastrous harvest and consequent steep rise in the cost of food in the first phase of the revolution, riots broke out in Paris and in rural districts. In reaction to the ensuing violence "The Declaration of the Rights of Man and Citizen," which asserted the universal right to "liberty, property, security, and resistance to oppression," was passed on August 26, 1789. Its opening section clearly shows the influence of the American Declaration of Independence.

from The Declaration of the Rights of Man

The representatives of the French people, organized in National Assembly, considering that ignorance, forgetfulness, or contempt of the rights of man are the sole causes of public misfortunes and of the corruption of governments, have resolved to set forth in a solemn declaration the natural, inalienable, and sacred rights of man, in order that such declaration, continually before all members of the social body, may be a perpetual reminder of their rights and duties; in order that the acts of the legislative power and those of the executive power may constantly be compared to the aim of every political institution and may accordingly be more respected; in order that the demands of the citizens, founded henceforth upon simple and incontestable principles, may always be directed toward the maintenance of the Constitution and the welfare of all.

Accordingly, the National Assembly recognizes and proclaims, in the presence and under the auspices of the Supreme Being, the following rights of man and citizen.

- Men are born and remain free and equal in rights; social distinctions may be based only on general usefulness.
- 2. The aim of every political association is the preservation of the natural and inalienable rights of man; these rights are liberty, property, security, and resistance to oppression.
- 3. The source of all sovereignty resides essentially in the nation; no group, no individual may exercise authority not emanating expressly therefrom.
- 4. Liberty consists of the power to do whatever is not injurious to others; thus the enjoyment of the natural rights of every man has for its limits only those that assure other members of society the enjoyment of those same rights; such limits may be determined only by law.
- 5. The law has the right to forbid only actions which are injurious to society. Whatever is not forbidden by law may not be prevented, and no one may be constrained to do what it does not prescribe.
- 6. Law is the expression of the general will; all citizens have the right to concur personally, or through their representatives, in its formation; it must be the same for all, whether it protects or punishes. All citizens, being equal before it, are equally admissible to all public offices, positions, and employments, according to their capacity, and without other distinction than that of virtues and talents.

Declarations alone hardly sufficed, however; after two and a half years of continual political bickering and unrest, the revolution entered its second phase. On September 20, 1792, the National Convention was assembled. One of its first tasks was to try Louis XVI, now deposed and imprisoned for treason. After unanimously finding him guilty, the convention was divided on whether or not to execute him. He was finally condemned to the guillotine by a vote of 361 to 360 and beheaded

VALUES

Revolution

The eighteenth century saw a series of vast upheavals in patterns of European life that had remained constant since late medieval times. The Renaissance and the subsequent Reformation and Counter-Reformation had laid the intellectual bases for the change. The eighteenth century was marked by their consequences. One revolution was in economic affairs. As a result of exploration and colonization, there was an increase in international trade and commerce, which enriched evergrowing numbers of middle-class citizens and their families. On the other hand, the endless wars of the seventeenth century left national governments deeply in debt. In England, the state introduced paper money for the first time in an attempt to restore financial stability. The transfer of wealth from the public sector to private hands encouraged speculation. Spectacular financial collapses of private companies—the most notorious was that of the South Sea Company-produced panic and revolutionary changes in banking systems.

Another revolution, perhaps in the long run the most important of all, was the development of industry. The Industrial Revolution, which reached its climax in the mid-nineteenth century, had its origins a century earlier. The invention of new machines, particularly in the textile industry, led to the establishment of factories, which in turn produced the growth of urban life. New mining techniques of mining turned coal into big business. New technologies revolutionized modes of travel virtually unchanged since Roman times.

At the same time, the complex structure of international diplomatic relations that had existed for centuries began to collapse. Although France remained the leading European power, its economy and internal stability were undermined by the refusal of its ruling class to admit change, and Britain became the richest country in the world. The dominant powers of Renaissance Europe and the Age of Exploration—Spain, Portugal, the city—states of Italy—were in decline, while important new players appeared on the scene: Prussia under the Hohenzollerns, the Russia of Peter the Great.

Impatience with the ways of the Old Regime, together with the desire for revolutionary political and social change, found expression in the writings of Enlightenment figures such as Voltaire. By the end of the eighteenth century, many people throughout Europe were increasingly frustrated by living in continual political and social deprivation. As a result, they took to the streets in direct physical action.

The American Revolution undermined the power of the monarchy in Britain, and speeded up the collapse of the Old Regime in France. The French Revolution petered out in the years of Napoleonic rule, but marked a watershed in Western history and culture: ever since the late eighteenth century, governments have had to reckon with intellectual protest and direct political action by their citizens.

forthwith. The resulting Reign of Terror lasted until 1795. During it, utopian theories of a republic based on liberty, equality, and fraternity were ruthlessly put into practice. The revolutionary leaders cold-bloodedly eliminated all opponents, real or potential, and created massive upheaval throughout all levels of French society.

The principal political group in the convention, the Jacobins, was at first led by Maximilien Robespierre (1758–1794). One of the most controversial figures of the revolution, Robespierre is viewed by some as a demagogue and bloodthirsty fanatic, by others as a fiery idealist and ardent democrat; his vigorous commitment to revolutionary change is disputed by no one. Following Rousseau's belief in the virtues of natural human feelings, Robespierre aimed to establish a "republic of virtue," made up democratically of honest citizens.

In order to implement these goals, revolutionary courts were established, which tried and generally sentenced to death those perceived as the enemies of the revolution. The impression that the Reign of Terror was

aimed principally at the old aristocracy is incorrect. Only nobles suspected of political agitation were arrested, and the vast majority of the guillotine's victims—some 70 percent—were rebellious peasants and workers. Neither were revolutionary leaders immune. Georges-Jacques Danton (1759–1794), one of the earliest spokesmen of the revolution and one of Robespierre's principal political rivals, was executed in March 1794 along with a number of his followers.

Throughout the rest of Europe, events in France were followed with horrified attention. Austria and Prussia were joined by England, Spain, and several smaller states in a war against the revolutionary government. After suffering initial defeat, the French enlarged and reorganized their army and succeeded in driving back the allied troops at the Battle of Fleurus in June 1794. Paradoxically, the military victory, far from reinforcing Robespierre's authority, provided his opponents the strength to eliminate him; he was declared an outlaw on July 27, 1794, and guillotined the next day.

By the spring of the following year, the country was in economic chaos and Paris was torn by street rioting. Many of those who had originally been in favor of revolutionary change, including businessmen and landowning peasants, realized that whatever the virtues of democracy, constitutional government was essential. In reply to these pressures the convention produced a new constitution, known as the Directory. This first formally established French republic lasted only until 1799, when political stability returned to France with the military dictatorship of Napoleon Bonaparte.

Although the French Revolution was an obvious consequence of extreme historical pressures, many of its leaders were additionally inspired by the successful outcome of another revolution: that of the Americans against their British rulers. More specifically, the Americans had rebelled against not the British king but the British parliament. In eighteenth-century England the king was given little chance to be enlightened or otherwise, since supreme power was concentrated in the legislative assembly, which ruled both England itself and, by its appointees, British territories abroad. A series of economic measures enacted by Parliament succeeded in thoroughly rousing American resentment. The story of what followed the Declaration of Independence of July 4, 1776, is too involved to be summarized here. Its result was the signing of a peace treaty in 1783 and the inauguration of the new American Constitution in 1789.

Although the Declaration of Independence was certainly not intended as a work of literature, its author, generally assumed to be Thomas Jefferson, was as successful as any of the literary figures of the eighteenth century in expressing the more optimistic views of the age. The principles enshrined in it assume that human beings are capable of achieving political and social freedom. Positive belief in equality and justice is expressed in universal terms like *man* and *nature*—universal for their day, that is—typical of eighteenth-century enlightened thought [16.23].

from The Declaration of Independence

When in the Course of human events, it becomes necessary for one people to dissolve the political bonds which have connected them with another, and to assume among the Powers of the earth, the separate and equal station to which the Laws of Nature and of Nature's God entitle them, a decent respect to the opinions of mankind requires that they should declare the causes which impel them to the separation.

We hold these truths to be self-evident, that all men are created equal, that they are endowed by their Creator with certain unalienable Rights, that among these are Life, Liberty and the pursuit of Happiness. That to secure these rights, Governments are instituted among Men, de-

16.23 Jean Antoine Houdon. *George Washington*, 1778. Marble. Height 6'8" (2.03 m). Virginia State Capitol, Richmond (courtesy of the Virginia State Library). The sculptor has emphasized the dignity and lofty calm of the first president.

riving their just powers from the consent of the governed. That whenever any Form of Government becomes destructive of these ends, it is the Right of the People to alter or to abolish it, and to institute new Government, laying its foundation on such principles and organizing its powers in such form, as to them shall seem most likely to effect their Safety and Happiness. Prudence, indeed, will dictate that Governments long established should not be changed for light and transient causes; and accordingly all experience hath shown, that mankind are

more disposed to suffer, while evils are sufferable, than to right themselves by abolishing the forms to which they are accustomed. But when a long train of abuses and usurpations, pursuing invariably the same Object, evinces a design to reduce them under absolute Despotism, it is their right, it is their duty, to throw off such Government, and to provide new Guards for their future security. Such has been the patient sufferance of these Colonies; and such is now the necessity which constrains them to alter their former Systems of Government. The history of the present King of Great Britain is a history of repeated injuries and usurpations, all having in direct object the establishment of an absolute Tyranny over these States.

SUMMARY

Monarchy in the Eighteenth Century The eighteenth century marked the passage in European life from the old aristocratic order to the beginnings of modern society. When the age began, Louis XIV was still firmly entrenched; before the century ended, Louis XVI and his wife had been executed by the National Convention of the French Revolution—itself inspired, in theory at least, by the American Revolution of a few years earlier.

Elsewhere in Europe enlightened despots like Frederick the Great of Prussia responded to the growing restlessness of their subjects by reorganizing government and improving living conditions. Frederick's court even became one of the leading cultural and intellectual centers of the time; C. P. E. Bach directed the music there and Voltaire spent two years as Frederick's guest.

Rococo Art In the visual arts the principal style to emerge from the baroque splendors of the previous century was the rococo. Lighter and less grandiose, it was wonderfully suited to the civilized amenities of aristocratic life. The chief rococo painters were French and Italian—appropriately enough, since rulers both in France and in the kingdoms of Italy made few concessions to the growing demands for reform. In architecture, the builders of Parisian private houses such as the Hôtel de Soubise indulged their taste for fanciful decoration, while the rococo churches of southern Germany and Austria represent some of the happiest of all eighteenth-century achievements.

The Neo-Classical Style The other important artistic style of the period was the Neo-Classical. Inspired by the increasing quantities of ancient art being excavated at Pompeii and elsewhere, artists began to turn to the style and subjects of Classical antiquity, which provided a refreshing contrast to the theatricality of baroque and the artificiality of rococo. Furthermore, in the history of the Roman Republic (at least as they perceived it) revolu-

tionary artists of the later eighteenth century found a vehicle for expressing their battle for freedom. In many cases painters incorporated into their works discoveries from the various excavations in progress: the French Jacques Louis David in his paintings for the revolution as well as the English Joshua Reynolds in his portraits of society women.

Ancient sculpture provided a stimulus to some of the leading artists of the day, most notably the Italian Antonio Canova and the French Jean Antoine Houdon. Both of them worked principally during and after the revolutions; Houdon even produced a Neo-Classical statue of George Washington. Washington and the other leaders of the American Revolution turned naturally to classical architecture for their public buildings. Among the finest examples is Thomas Jefferson's State Capitol at Richmond.

Music in the Eighteenth Century: Haydn and Mozart In music the emotional style of baroque composers began to give way to a new way of organizing musical forms. By the mid-eighteenth century, the classical style was beginning to evolve, and the two greatest composers of the age-Franz Joseph Haydn and Wolfgang Amadeus Mozart (both Austrian)-used it to write their symphonies, concertos, and sonatas. Most of these works employed sonata form, a system of musical composition involving contrasts rather than the unity of baroque music. Haydn's hundred or so symphonies show an almost infinitely endless exploration of the possibilities offered by sonata form while also reflecting the evolution of the modern symphony orchestra. His own personal career furthermore illustrates the changing status of the artist: After years of serving in the household of an aristocratic family, he became transformed by his compositions into one of the most famous men in Europe.

Mozart's relations with his noble employers were far less happy. His music, however, transcends the difficulties of his life and achieves the supreme blend of eighteenth-century art's two chief concerns: beauty and learning. Like Haydn, he explored the possibilities of sonata form and also wrote a number of operas that remain among the best-loved of all musical works for the stage. *The Marriage of Figaro* illustrates Mozart's genius for expressing universal human emotions in music, while in its story it reflects the revolutionary mood of the times.

Eighteenth-Century Literature: History and Satire Like music, the literature of the eighteenth century was generally serious. Many writers avoided the lightness of the rococo, preferring to produce works based on Classical models or themes. They included the Italian dramatist Metastasio and the English historian Edward Gibbon. An exception is provided by the satirical writings of Alexander Pope, which poke fun at the pretensions of eighteenth-century society, although many of Pope's

other works are Neo-Classical in style. Other writers used satire, in itself a characteristically rococo medium, as a bitter weapon against human folly. Jonathan Swift's writings present an indictment of his fellow humans that offers little hope for their improvement.

The Encyclopedists The French Encyclopedists of-fered a more optimistic point of view. Denis Diderot and most of his colleagues believed in the essential goodness of human nature and the possibility of progress, and their Encyclopédie was intended to exalt the power of reason. Not all the contributors agreed, however. Jean Jacques Rousseau claimed that society was an evil that corrupted essential human goodness and called for a new social order. Yet all the leading intellectuals of the day, including the greatest of them all, Voltaire, were united in urging the need for radical social change. In novels, pamphlets, plays, and countless other publications Voltaire attacked traditional religion and urged the importance of freedom of thought.

By the end of the century the battle for freedom had plunged France into chaos and demonstrated to the whole of Europe that the old social order had come to an end. The following century was to see the struggle to forge a new society.

Pronunciation Guide

Beaumarchais: Boe

Boe-mar-SHAY

Boucher:

Boo-SHAY

Candide: Cherubino: Can-DEED

Cythera:

Ke-ru-BEEN-owe

David:

SITH-er-a Da-VEED

Diderot:

Di-der-OWE

Fragonard:

Fra-gone-ARE

Haydn:

HI-dn

Montesquieu:

Mont-es-KEW

Mozart:

MOTE-sart

Neumann:

NOY-man

Robespierre:

Robe-spee-AIR

rococo:

ro-co-COWE

Rousseau:

Rue-SEW

timpani:

TIM-pan-ee

Vierzehnheiligen:

Fear-tsayn-HI-li-gen

Voltaire:

Vol-TARE

Watteau:

Wat-OWE

Winckelmann:

VIN-kel-man

EXERCISES

 Compare and contrast the rococo and Neo-Classical styles in the visual arts, illustrating your answer with reference to specific works of art.

- 2. Describe the principles of sonata form and compare it to musical form in the Baroque period.
- 3. What were the main schools of philosophical thought in eighteenth-century France? How are these expressed in the writings of Voltaire?
- 4. Describe the use of satire in the works of Pope and Swift. What are the authors' aims, and how successful are they?
- 5. How were the social and political developments that led to the French Revolution reflected in the arts?

FURTHER READING

- Brookner, A. (1980). *Jacques Louis David*. New York: Harper & Row. A short and readable book by a well-known novelist who is also an art historian; interweaves accounts of David's life and works.
- Chartier, R. (1991). *The cultural origins of the French Revolution*. Durham, NC: Duke University Press. An important study of the intellectual and cultural forces that shaped the eighteenth century in Western Europe.
- Conisbee, P. (1981). Painting in eighteenth-century France. Ithaca, NY: Cornell University Press. A thoroughly organized survey that sets the great names against the background of their lesser contemporaries.
- Garrioch, D. (1986). *Neighborhood and community in Paris,* 1740–1790. Cambridge: Cambridge University Press. This book provides a fascinating study of the daily lives of the residents in various parts of Paris in the years leading to the outbreak of the French Revolution.
- Hampson, N. (1982). *The Enlightenment*. New York: Penguin Books. A good one-volume survey of the background and main stages in the development of the Enlightenment
- Levey, M. (1993). *Painting and sculpture in France, 1700–1789* (new ed.). New Haven, CT: Yale University Press. This well-illustrated book provides an excellent introduction to a rich field; good bibliographies.
- Osborne, C. (1992). *The complete operas of Mozart: A critical guide*. London: Victor Gollancz. A useful guide to all Mozart's stage works.
- Roche, D. (1987). *The people of Paris*. Berkeley: University of California Press. An account of popular culture in eighteenth-century Paris, including material on housing conditions, dress, and leisure activities.
- Roston, M. (1990). *Changing perspectives in literature and the visual arts, 1650–1820.* Princeton, NJ: Princeton University Press. This valuable study takes a comparative look at the arts over a period extending from the later Baroque to the early stages of Romanticism.
- Rowse, A. L. (1975). *Jonathan Swift*. New York: Scribner. An important biography by a leading historian who describes Swift's life against the background of his times; interesting illustrations.
- Sklar, J. (1987). *Montesquieu*. Oxford: Oxford University Press. An excellent study of the life and work of a key eighteenth-century figure.
- Spencer, S. (1984). French women and the Age of Enlightenment. Bloomington: Indiana University Press. A survey of the contribution of women to the cultural and social life of eighteenth-century France.
- Varriano, J. (1986). Italian baroque and rococo architecture. New York: Oxford University Press. A good survey of seventeenth- and eighteenth-century Italian architectural developments.

ONLINE CHAPTER LINKS

Information about Jonathan Swift is available at http://www.jaffebros.com/lee/gulliver/

which also provides specific attention to *Gulliver's Travels*, with a dictionary, a timeline, and a list of quotations.

The Mozart Project

http://www.mozartproject.org/

offers a biography of Mozart, a list of his compositions, selected essays, and links to related Internet resources.

Wolfgang Amadeus Mozart at

http://www.island-of-freedom.com/MOZART.HTM provides an opportunity to listen to numerous selections of Mozart's music, plus links to Mozart biographies, his letters, a catalog of his compositions, and images.

This Haydn site at http://home.wxs.nl/~cmr/haydn/

provides a biography, a catalog of his works, a discography, and a bibliography.

The Voltaire Society of America at http://humanities.uchicago.edu/homes/VSA/ provides links to a variety of Internet resources.

The William Hogarth Archive at http://www.lamp.ac.uk/hogarth/ offers a biography, an extensive image catalog, a bibliography, and links to related Internet resources.

For introductory information about Rococo art as well as links to sites related to representative artists, consult *Artcyclopedia* at http://www.artcyclopedia.com/history/rococo.html

Karadar Classical Music at

http://www.karadar.it/Dictionary/Default.htm provides an alphabetical listing of musicians with brief biographies and a list of works (some of which are available on MIDI files).

		GENERAL EVENTS
	1765	
	1789	1789 French Revolution begins
	S	1793 – 1795 Reign of Terror in France
	Y	1799 – 1804 Napoleon rules France
	IAR C V	consul
	REVOLUTIONARY AND NAPOLEONIC WAR	1804–1814 Napoleon rules France emperor
		1812 Failure of Napoleon's Russian campaign
	AN	1814 Napoleon exiled to Elba; Stephenson's first locomotive
		1814–1815 Congress of Vienna
	1815	1815 Napoleon escapes Elba;
		defeated at Battle of Waterloo
	Z	1815–1850 Industrialization of England
	F TTC	1816 Wreck of French vessel Medus
	H O	1821 Death of Napoleon
	GROWTH OF DUSTRIALIZAT	1821–1829 Greek War of Independence against Turks
	STF	1830–1860 Industrialization of
	INDU	France and Belgium
		1837-1901 Reign of Queen Victoria in England
		1840–1870 Industrialization of
	1848	Germany
	AGE OF NATIONALISM	1848 Revolutionary uprisings throughout Europe
	ION	1040 1070 Haiffastian af Hal
	[AT]	1860–1870 Unification of Italy 1861–1865 American Civil War
	Z	1866–1871 Unified Germany
	E O	1867 Canada granted dominion status; British Factory Act gives
	AG	workers Saturday afternoons off
		1869 First transcontinental railroad completed in America
	1870	1
		1876 Bell patents the telephone

GENERAL EVENTS	LITERATURE & PHILOSOPHY
	1773 Goethe leads Sturm und Drang movement against Neo-Classicism 1774 Goethe, The Sufferings of Young Werther
789 French Revolution begins 793–1795 Reign of Terror in France 799–1804 Napoleon rules France as consul 804–1814 Napoleon rules France as emperor 812 Failure of Napoleon's Russian campaign 814 Napoleon exiled to Elba;	1790 Kant, Critique of Judgment, expounding Transcendental Idealism 1794 Blake, "London" 1798 Wordsworth, "Tintern Abbey" 1807–1830 Philosophy of Hegel published in Germany 1808 Goethe's Faust, Part I
Stephenson's first locomotive 814–1815 Congress of Vienna	
defeated at Battle of Waterloo 315–1850 Industrialization of England 316 Wreck of French vessel Medusa 321 Death of Napoleon 321–1829 Greek War of Independence against Turks 330–1860 Industrialization of France and Belgium 337–1901 Reign of Queen Victoria in England 340–1870 Industrialization of Germany	1819 Schopenhauer, The World as Will and Idea; Keats, Ode to a Nightingale c. 1820 English romantic peak 1820 Shelley, Prometheus Unbound 1821 Byron, Don Juan 1824 Byron dies in Greece 1829–1847 Balzac, The Human Comedy, 90 realistic novels 1832 Goethe, Faust, Part II 1836–1860 Transcendentalist movement in New England 1837–1838 Dickens, Oliver Twist 1840 Poe, Tales of the Grotesque 1846 Sand, Lucrezia Floriani 1847 E. Brontë, Wuthering Heights
348 Revolutionary uprisings throughout Europe 360–1870 Unification of Italy 361–1865 American Civil War 366–1871 Unified Germany	1848 Marx, Communist Manifesto 1851 Melville, Moby Dick 1854 Thoreau, Walden 1855 First edition of Whitman's Leaves of Grass 1856–1857 Flaubert, Madame Bovary 1859 Darwin publishes theory of evolution, On the

1818-1819 Géricault, Raft of the Medusa, first exhibited 1819 1820 – 1822 Goya paints nightmare scenes on walls of his house; Saturn Devouring One of His Sons **1824** Delacroix, Massacre at Chios **1826** Delacroix, The Death of Sardanapalus c. 1830 Social realism follows romanticism; Daumier, The Legislative Belly (1834) 1836 Constable, Stoke-by-Nayland 1844 Turner, Rain, Steam, and Speed c. 1847 Development of national styles. American artists influenced by Transcendentalism; Cole, Genesee Scenery (1847)

ART

in England

faraway lands **1814** Goya, Execution of the Madrileños on May 3, 1808, a retreat from idealism in art

c.1774 Copley leaves Boston to study

1784-1785 David, Oath of the Horatii

1799 David, The Battle of the Romans and the Sabines. Goya becomes court painter to Charles IV of Spain; The Family of Charles IV (1800) 19th cent. Romantic emphasis on emotion, nature, exotic images,

1855 Courbet, The Studio: A Real Allegory of the Last Seven Years of My

> c. 1860 American luminist painting develops; Heade, Lake George (1862)

1866 Homer, Prisoners from the Front, chronicles Civil War

1870 Corot, Ville d'Avray c. 1880 Eakins uses photography and scientific techniques in search for realism; *The* Swimming Hole (1885)

1873-1877 Tolstoy, Anna Karenina

1863-1869 Tolstoy,

War and Peace

1890 Dickinson's poems first published, four years after her death

Origin of Species by Means

of Natural Selection

1862 Hugo, Les Misérables

1888 Pasteur Institute founded in

Paris

1900

CHAPTER 17 THE ROMANTIC ERA

ARCHITECTURE

Music

1808 Girodet-Trioson, *The*Entombment of Atala,
inspired by
Chateaubriand's romantic
novel Atala

1810 Friedrich, *Cloister Graveyard in the Snow*

1811 Ingres, Jupiter and Thetis

1785 – 1796 Jefferson, State Capitol, Richmond, Virginia

1788 Mozart composes last three symphonies

1795 Debut of Beethoven as pianist

Development from classical to romantic music most evident in work of Beethoven; *Pathetique Sonata* (1799)

1804 First performance of Beethoven's *Eroica Symphony*, originally meant to honor Napoleon

19th cent. Sequence of revival styles: neoclassical, neo-Gothic, neo-Renaissance; forms affected by growth of industry and technology

1836 Barry and Pugin begin neo-Gothic Houses of Parliament, London

1814 Beethoven's opera *Fidelio* performed

c. 1815 – 1828 Schubert creates genre of art song (lied), setting to music poetry of Goethe, Schiller, others

1822 Schubert, "Unfinished" Symphony

1824 First performance of Beethoven's *Symphony No.* 9; finale is choral version of Schiller's "Ode to Joy"

1830 Berlioz, Fantastic Symphony

1831 Bellini's bel canto opera Norma performed

1835 Donizetti, Lucia di Lammermoor

c. 1835 – c. 1845 Virtuoso performance at peak; brilliant composer-performers create works of immense technical difficulty: Chopin, *Piano Sonata* in b minor, Op. 35 (1839)

1839 Chopin completes Twenty-Four Preludes, Op. 28

1842 Verdi's *Nabucco* performed; symbolic of Italians' suffering under Austrian rule

1846 Berlioz, The Damnation of Faust

1861 – 1875 Garnier, Opéra, Paris

1865 Reynaud, Gare du Nord, Paris **1851 – 1874** Wagner, *The Ring of the Nibelung;* first staged at new Bayreuth opera house 1876

1853 First performances of Verdi's *Il Trovatore* and *La Traviata*, the latter based on Dumas' novel *The Lady of the Camelias*

1865 Wagner experiments with harmony in *Tristan* and *Isolde*

1874 First production of Moussorgsky's opera *Boris Godunov* in St. Petersburg

1876 Brahms, Symphony No. 1 in c minor

1882 Wagner, Parsifal

1887 Verdi, Otello; Bruckner begins Symphony No. 8 in c minor

CHAPTER 17 THE ROMANTIC ERA

The Concerns of Romanticism

he tide of revolution that swept away much of the old political order in Europe and America in the last quarter of the eighteenth century had momentous consequences for the arts. Both the American and the French revolutions had in fact used art as a means of expressing their spiritual rejection of the aristocratic society against which they were physically rebelling, and both had adopted the Neo-Classical style to do so. Jacques Louis David's images of stern Roman virtue (see Figure 16.1) and Jefferson's evocation of the simple grandeur of Classical architecture (see Figure 16.17) represented, as it were, the revolutionaries' view of themselves and their accomplishments. Neo-Classicism, however, barely survived into the beginning of the nineteenth century. The movement that replaced it, Romanticism, eventually dominated virtually every aspect of nineteenth-century artistic achievement.

The essence of Romanticism is particularly difficult to describe because it is far more concerned with broad general attitudes than with specific stylistic features. Painters, writers, and musicians in the nineteenth century shared a number of concerns in their approach to their art. First was the important emphasis they placed on personal feelings and their expression. Ironically enough, the very revolutionary movements that had encouraged artists to rebel against the conventional styles of the early eighteenth century had themselves proved too restricting and conventional.

Second, emphasis on emotion rather than intellect led to the expression of subjective rather than objective visions; after all, the emotions known best are those we have experienced. The Romantics used art to explore and dissect their own personal hopes and fears (more often the latter) rather than as a means to arrive at some general truth.

This in turn produced a third attitude of Romanticism—its love of the fantastic and the exotic—which made it possible to probe more deeply into an individual's creative imagination. Dreams, for example, were a way of releasing the mind from the constraints of everyday experience and bringing to the surface those dark visions reason had submerged, as the Spanish artist Francisco Goya shows us unforgettably in a famous etching [17.1]. Artists felt free to invent their own dream worlds. Some chose to reconstruct such ages long past as the medieval period, which was particularly popular (Britain's Houses of Parliament [17.2] were begun in 1836 in the Gothic style of six centuries earlier). Others preferred to imagine remote and exotic lands and dreamed of life in the mysterious Orient or on a primitive desert island. Still others simply trusted to the powers of their imagination and invented a fantasy world of their own.

A fourth characteristic of much Romantic art is a mystical attachment to the world of nature that was also the result of the search for new sensations. Painters turned increasingly to landscape, composers sought to evoke the rustling of leaves in a forest or the noise of a storm, and poets tried to express their sense of union with the natural world. Most eighteenth-century artists had turned to nature in search of order and reason. In the nineteenth century, the wild unpredictability of nature would be emphasized, depicted neither objectively nor realistically but as a mirror of the artist's individual emotions. At the same time, the romantic communion with nature expressed a rejection of the Classical notion of a world centered on human activity.

These attitudes, and the new imaginative and creative power they unleashed, had two very different but equally important effects on the relationship between the artist and society. On the one hand, many creative artists became increasingly alienated from their public. Whereas they had once filled a precise role in providing entertainment or satisfying political and religious demands, now their self-expressive works met no particular needs except their own.

On the other hand, an increasing number of artists sought to express the national characteristics of their people via art. Abandoning the common artistic language of earlier periods and instead developing local styles that made use of traditional folk elements, artists were able to stimulate (and in some cases to initiate) the growth of national consciousness and the demand for national independence (see map, "Europe in

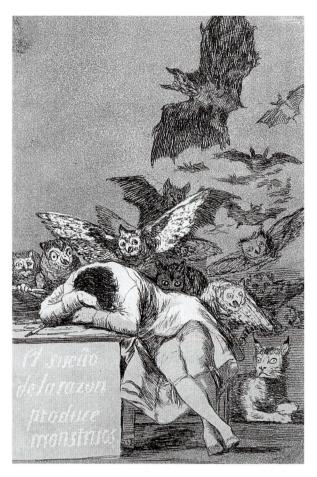

17.1 Francisco Goya. *Los Caprichos*, plate 43: *El sueño de la razón produce monstruos* (*The Sleep of Reason Produces Monsters*), 1797–1798. Etching and aquatint, 8" × 6" (216 × 152 mm). The Metropolitan Museum of Art, gift of M. Knoedler and Co., 1918 [18.64(43)]. The precise meaning of the work is not clear, but it evidently represents the inability of reason to banish monstrous thoughts. Its title is written on the desk below the student, who sleeps with his head on his textbooks.

17.2 Charles Barry and A. W. N. Pugin. Houses of Parliament, London, 1836 – 1860. Length 940' (286.51 m). The relative symmetry of the façade is broken only by the placing of the towers—Gothic in style, as is the decorative detail. 1848"). This was particularly effective in the Russian and Austrian empires (which incorporated many nationalities) and even in America, which had always been only on the fringe of the European cultural tradition, but it also became an increasingly strong tendency in the art of France and Italy, countries that had hitherto shared the same general culture. Thus while some artists were retreating into a private world of their own creation, others were in the forefront of the social and political movements of their own age (Table 17.1).

THE INTELLECTUAL BACKGROUND

It might be expected that a movement like Romanticism, which placed a high value on the feelings of the moment at the expense of conscious reason, would remain relatively unaffected by intellectual principles. Notwithstanding, a number of Romantic artists did in fact draw inspiration from contemporary philosophy. A rapid survey of the chief intellectual developments of the nineteenth century therefore provides a background to the artistic ones.

The ideas that proved most attractive to the Romantic imagination had developed in Germany at the end of the eighteenth century. Their chief spokesman was Immanuel Kant (1724–1804), whose *Critique of Judgment* (1790) defined the pleasure we derive from art as "disinterested satisfaction." Kant conceived of art as uniting opposite principles. It unites the general with the particular, for example, and reason with the imagination. For

TABLE 17.1 Principal Characteristics of the Romantic Movement

The Expression of Personal Feelings

Chopin, *Preludes*Goya, *The Family of Charles IV* [17.11]
Goethe, *The Sufferings of Young Werther*

Self-analysis

Berlioz, Fantastic Symphony Poetry of Keats Whitman, Leaves of Grass

Love of the Fantastic and Exotic

Music and performances of Paganini Girodet-Trioson, *The Entombment of Atala* [17.13] Delacroix, *The Death of Sardanapalus* [17.16]

Interest in Nature

Beethoven, *Pastoral Symphony* Constable, *Hay Wain* [17.23] Poetry of Wordsworth Emerson, *The American Scholar*

Nationalism and Political Commitment

Verdi, *Nabucco* Smetana, *My Fatherland* Goya, *Execution of the Madrileños* [17.10] Byron's support of the Greeks

Erotic Love and the Eternal Feminine

Goethe, Faust, Part II Wagner, Tristan and Isolde

Kant, the only analogy for the way in which art is at the same time useless and yet useful was to be found in the world of nature.

Even more influential than Kant was Georg Wilhelm Friedrich Hegel (1770–1831), whose ideas continued to affect attitudes toward art and artistic criticism into the twentieth century. Like Kant, Hegel stressed art's ability to reconcile and make sense of opposites, and to provide a *synthesis* of the two opposing components of human existence, called *thesis* (pure, infinite being) and *antithesis* (the world of nature). This process, he held, applied to the workings of the mind, and also to the workings of world history, through the development and realization of what he called

the "World Spirit." Hegel's influence on his successors lay less in the details of his philosophical system than in his acceptance of divergences and his attempt to reconcile them. The search for a way to combine differences, to permit the widest variety of experience, is still the basis of much contemporary thinking about the arts.

Both Kant and Hegel developed their ideas in the relatively optimistic intellectual climate of the late eighteenth and early nineteenth centuries, and their approach both to art and to existence is basically positive. A very different position was that of Arthur Schopenhauer (1788-1860), whose major work, The World as Will and Idea (1819), expresses the belief that the dominating will, or power, in the world is evil. At the time of its appearance, Schopenhauer's work made little impression, due in large measure to the popularity of Kant's and Hegel's idealism. Schopenhauer did not help matters by launching a bitter personal attack on Hegel. But the failure of the nationalist uprisings of 1848 in many parts of Europe produced a growing mood of pessimism and gloom, against which background Schopenhauer's vision of a world condemned perpetually to be ravaged by strife and misery seemed more convincing. Thus, his philosophy, if it did not mold the Romantic movement, came to reflect its growing despondency.

It must of course be admitted that many of the major developments in nineteenth-century thought had little direct impact on the contemporary arts. The most influential of all nineteenth-century philosophers was probably Karl Marx (1818–1883), whose belief in the inherent evil of capitalism and in the historical inevitability of a proletarian revolution was powerfully expressed in his *Communist Manifesto* (1848).

http://www.philosophypages.com/ph/marx.htm

Marx

Marx's belief that revolution was both unavoidable and necessary was based at least in part on his own observation of working conditions in industrial England, where his friend and fellow communist Friedrich Engels (1820–1895) had inherited a textile factory. Marx and Engels both believed that the factory workers, although creating wealth for the middle classes, derived no personal benefit. Living in overcrowded, unsanitary conditions, the workers were deprived of any effective political power, and only kept quiet by the drug of religion, which offered them the false hope of rewards in a future life. The plight of the working classes seemed to Marx to transcend all national boundaries and create a universal

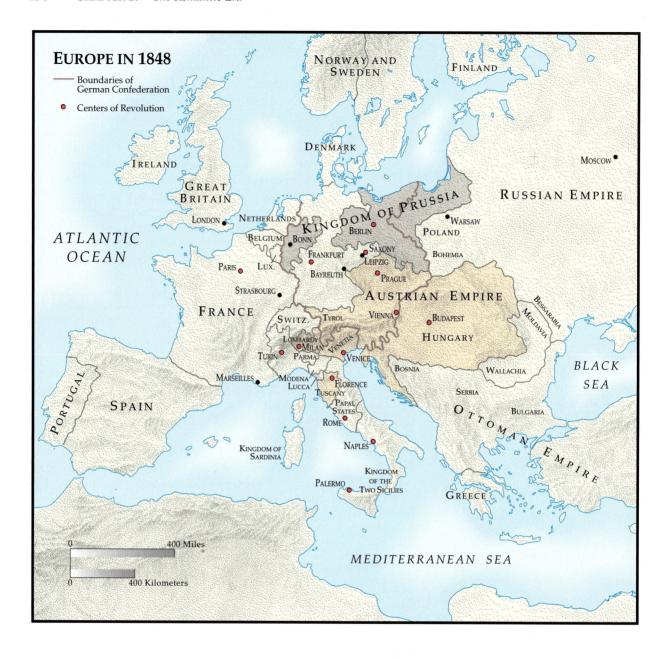

proletariat who could only achieve freedom through revolution: "Workers of the world, unite! You have nothing to lose but your chains!" The drive to political action was underpinned by Marx's economic philosophy, with its emphasis on the value of labor and, more generally, on the supreme importance of economic and social conditions as the true moving forces behind historical events. This so-called materialist concept of history was to have worldwide repercussions in the century that followed Marx's death. More contemporary writers such as Bertolt Brecht (1898-1956) have embraced Marxist principles, and Marxist critics have developed a school of aesthetic criticism that applies standards based on Marxist doctrines. During the nineteenth and early twentieth centuries, however, Marx's influence was exclusively social and political.

Marx clearly laid out his views on the arts. Art has the ability to contribute to important social and political changes, and is thus a determining factor in history. Neither is artistic output limited to the upper or more prosperous social classes; according to the "principle of uneven development"; a higher social order does not necessarily produce a correspondingly high artistic achievement. Capitalism is, in fact, hostile to artistic development because of its obsession with money and profit. As for styles, the only one appropriate for the class struggle and the new state is realism, which would be understood by the widest audience. Lenin inherited and developed this doctrine further when he ordered that art should be a specific "reflection" of reality, and used the party to enforce the official cultural policy.

The nineteenth century saw vast changes in the lives of millions of people, as industrial development and scientific progress overthrew centuries-old ways. The railroad, using engines powered by steam, first appeared in 1825 between Stockton and Darlington in England. By 1850, there were 6000 miles of track in Britain, 3000 in Germany, 2000 in France, and the beginnings of a rail system in Austria, Italy, and Russia. The economic impact was overwhelming. The railroad represented a new industry that fulfilled a universal need; it provided jobs and offered opportunities for capital investment. At the same time, it increased the demand for coal and iron.

Industry soon overtook agriculture as the source of national wealth. With the growth of mass production in factories, the cities connected by rail became vast urban centers, attracting wholesale migration from the countryside. The number of persons living in cities rose dramatically. The population of Turin, in northern Italy, was 86,000 in 1800, 137,000 by 1850, and over 200,000 by 1860. Half of Britain's inhabitants lived in cities by 1850, the first time in history that this was true for any large society. The results were by no means always pleasant; one Londoner described his city in the 1820s as "a wilderness of human beings."

In science, constant research brought a host of new discoveries. Experiments in magnetism and electricity advanced physics. Using new chemical elements, the French chemist Louis Pasteur (1822-1895) explored the process of fermentation and invented "pasteurization" a discovery that helped improve the safety of food. Equally beneficial was Pasteur's demonstration that disease is spread by living but invisible (to the naked eye, at least) germs, that can be combated by vaccination and the sterilization of medical equipment.

No single book affected nineteenth-century readers more powerfully than On the Origin of Species by Means of Natural Selection by Charles Robert Darwin (1809-1882), which appeared in 1859. As a student at Cambridge, in 1831 Darwin was offered the post of naturalist aboard H.M.S. Beagle, a ship ready to embark on a surveying expedition around the world. In the course of the voyage, Darwin studied geological formations, fossils, and the distribution of plant and animal types. On examining his material, Darwin became convinced that species were not fixed categories, as had always been held, but were instead capable of variation. Drawing on the population theories of Malthus, and the geological studies of Sir Charles Lyell, Darwin developed his theory of evolution as an attempt to explain the changes, disappearances, and new appearances of various species.

http://www.blupete.com/Literature/Biographies/Science/

Darwin.htm

According to Darwin, animals and plants evolve by a process of natural selection (he chose the term to contrast it with the "artificial selection" used by animal breeders). Over time, some variations of each species survive while others die out. Those likely to survive are those best suited to prevailing environmental conditions—a process called by one of Darwin's followers "the survival of the fittest." Changes in the environment would lead to adjustments within the species. The first publication of this theory appeared in 1858, in the form of a short scientific paper; On the Origin of Species appeared a year later. In 1871, Darwin published The Descent of Man, in which he claimed that the human race is descended from an animal of the anthropoid group.

The impact of both books was spectacular. Their author quietly continued his research and tried to avoid the popular controversy surrounding his work. Church leaders thundered their denunciations of a theory that utterly contradicted the notion that humans, along with everything else, had been created by God in accordance with a divine plan. Scientists and freethinkers stoutly defended Darwin, often enlarging his claims. Others held that the development of modern capitalism and industrial society represented a clear demonstration of the "survival of the fittest," although Darwin himself never endorsed this "Social Darwinism" (see Table 17.2).

TABLE 17.2 Nineteenth-Century Scientific and Technological **Developments**

1814	Stephenson builds first locomotive
1821	Faraday discovers principle of electric dynamo
1825	Erie Canal opened in the United States
	First railway completed (England)
1839	Daguerre introduces his process of photography
1844	Morse perfects the telegraph
1853	First International Exhibition of Industry (New York)
1858	Transatlantic cable begun (completed 1866)
1859	Darwin publishes On the Origin of Species
	First oil well drilled (in Pennsylvania)
1867	Nobel invents dynamite
1869	Transcontinental railway completed in the United States
	Suez Canal opened
1876	Bell patents the telephone
1879	Edison invents the electric light
1885	First internal combustion engines using gasoline

Achievements in science and technology are reflected to a certain extent in Romantic art, although chiefly from a negative point of view. The growing industrialization of life in the great cities, and the effect of inventions like the railway train on urban architecture served to stimulate a "back-to-nature" movement, as Romanticism provided an escape from the grim realities of urbanization and industrialization. Further, at a time when many people felt themselves submerged and depersonalized in overcrowded cities, the Romantic emphasis on the individual and on self-analysis found an appreciative audience. Many artists contrasted the growing problems of urban life with an idyllic (and highly imaginative) picture of rustic bliss.

Scientific ideas had something of the same negative effect on nineteenth-century artists. The English Victorian writers (so-called after Queen Victoria, who reigned from 1837 to 1901) responded to the growing scientific materialism of the age.

Although few were, strictly speaking, Romantics, much of their resistance to progress in science and industry and their portrayal of its evil effects has its roots in the Romantic tradition.

MUSIC IN THE ROMANTIC ERA

Beethoven

http://w3.rz-berlin.mpg.de/cmp/beethoven.html

Beethoven

For many of the Romantics, music was the supreme art. Free from the intellectual concepts involved in language and the physical limits inherent in the visual arts, it was capable of the most wholehearted and intuitive expression of emotion. Since Ludwig van Beethoven (1770-1827), widely regarded as the pioneer of musical Romanticism, also manifested many characteristically Romantic attitudes—such as love of nature, passionate belief in the freedom of the individual, and fiery temperament—it is not surprising that he has come to be regarded as the prototype of the Romantic artist [17.3]. When Beethoven wrote proudly to one of his most loyal aristocratic supporters, "There will always be thousands of princes, but there is only one Beethoven," he spoke for a new generation of creators. When he used the last movement of his Symphony No. 9 to preach the doctrine of universal brotherhood, he inspired countless ordinary listeners by his fervor. Even today familiarity with Beethoven's music has not dulled its ability to give dramatic expression to the noblest of human sentiments.

Although Beethoven's music served as the springboard for the Romantic movement in music, his own

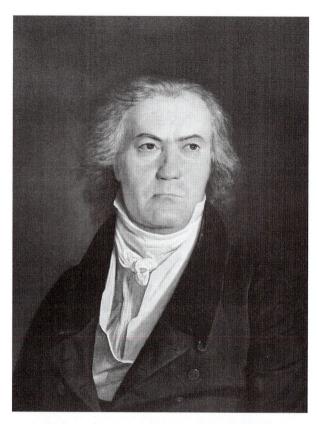

17.3 Ferdinand Georg Waldmuller. *Ludwig van Beethoven*, 1823, 28" × 22³/₄" (72 × 58 cm). Painting now lost. Painted a year before the first performance of Beethoven's *Symphony No. 9 in d minor*, the portrait emphasizes the composer's stubborn independence by both the set of the mouth and the casual, even untidy, dress and hair. Beethoven, who became irascible in his latter years, allowed the artist only one sitting for his portrait commissioned by one of his music publishers.

roots were deep in the classical tradition. He pushed to the limits classicism through use of the sonata allegro form. In spirit, furthermore, his work is representative of the Age of Enlightenment and the revolutionary mood of the turn of the century, as is proved by both the words and music of his opera *Fidelio*. A complex and many-sided genius, Beethoven transcended the achievements of the age in which he was born and set the musical tone for the nineteenth century.

Beethoven was born in Bonn, Germany, where he received his musical training from his father, an alcoholic. Beethoven's father saw the possibility of producing a musical prodigy in his son and forced him to practice hours at the keyboard, often locking him in his room and beating him on his return from drinking bouts. All possibilities of a happy family life were brought to an end in 1787 by the death of Beethoven's mother and his father's subsequent decline into advanced alcoholism. Beethoven sought compensation in the home of the von Breuning family, where he acted as private tutor. It was there that he met other musicians and artists and developed a love

of literature that he kept throughout his life. He also struck up a friendship with a local minor aristocrat, Count Waldstein, who remained his devoted admirer until the composer's death.

In 1792 Waldstein was one of the aristocrats who helped Beethoven go to Vienna to study with Haydn, then regarded as the greatest composer of his day; but although Haydn agreed to give him lessons, the young Beethoven's impatience and suspicion, and Haydn's deficiencies as a teacher, did not make for a happy relationship. Nevertheless, many of the works Beethoven wrote during his first years in Vienna are essentially classical in both form and spirit; only by the end of the century had he begun to extend the emotional range of his music.

One of the first pieces to express the characteristically Beethovenian spirit of rebellion against fate and the determination to struggle on is his Piano Sonata No. 8 in c minor, Op. 13, generally known as the Pathétique. The first movement begins with a slow introduction, but unlike similar introductions in the classical music of Haydn, it sets the emotional tone of the entire piece rather than merely capturing the listener's attention. As is so often the case, the significance of Beethoven's music is as easy to grasp on hearing as it is difficult to express in words. The heavy, foreboding chords seem to try to pull themselves up, only to fall back again and again in defeat, until finally they culminate in a burst of defiant energy that sets the main allegro ("fast") portion of this movement on its stormy way. Just before the very end of the movement the ghost of the slow introduction returns briefly, as if to emphasize the odds against which the struggle has been—and will be—waged.

To hear this work, see the Listening CD.

It is important to understand precisely how Beethoven used music in a new and revolutionary way. Other composers had written music to express emotion long before Beethoven's time, from Bach's outpouring of religious fervor to Mozart's evocation of human joy and sorrow. What is different about Beethoven is that his emotion is autobiographical. His music tells us how he feels, what his succession of moods is, and what conclusion he reaches. It does other things at the same time, and at this early stage in his career for the most part it self-consciously follows classical principles of construction, but the vivid communication of personal emotions is its prime concern. That Beethoven's range was not limited to anger and frustration is immediately demonstrated by the beautiful and consoling middle slow movement of the Pathétique with its lyrical main theme, but the final movement returns to turbulent passion.

Parallels for the turbulent style of the *Pathétique* can be found in other contemporary arts, especially literature, but although to some extent Beethoven was responding to the climate of the times, there can be no doubt that he was also expressing a personal reaction to the terrible tragedy that had begun to afflict him as early as 1796. In that year, the first symptoms of his deafness began to appear; by 1798, his hearing had grown very weak; and by 1802, he was virtually totally deaf.

Nonetheless, although obviously affected by his condition, Beethoven's music was not exclusively concerned with his own fate. The same heroic attitude with which he faced his personal problems was also given universal expression, never more stupendously than in the Symphony No. 3 in E flat, Op. 55, subtitled the Eroica, the "Heroic Symphony." As early as 1799 the French ambassador to Vienna had suggested that Beethoven write a symphony in honor of Napoleon Bonaparte. At the time Napoleon was widely regarded as a popular hero who had triumphed over his humble origins to rise to power as a champion of liberty and democracy. Beethoven's own democratic temperament made him one of Napoleon's many admirers. The symphony was duly begun but, in 1804—the year of its completion—Napoleon had himself crowned emperor. When Beethoven heard the news, he angrily crossed out Napoleon's name on the title page. The first printed edition, which appeared in 1806, bore only the dedication "to celebrate the memory of a great man."

It would be a mistake to view the *Eroica* as merely a portrait of Napoleon. Rather, inspired by what he saw as the heroic stature of the French leader, Beethoven created his own heroic world in sound, in a work of vast dimensions. The first movement alone lasts for almost as long as many a classical symphony. Its complicated structure requires considerable concentration on the part of the listener. The form is basically the old classical sonata allegro form (see Chapter 16), but on a much grander scale and with a wealth of musical ideas. Yet the principal theme of the movement, which the cellos announce at the very beginning, after two hammering, impatient chords demand our attention, is of a rocklike sturdiness and simplicity:

Beethoven's genius emerges as he uses this and other similarly straightforward ideas to build his mighty structure. Throughout the first movement his use of harmony and, in particular, discord, adds to the emotional impact, especially in the middle of the development section, where slashing dissonances seem to tear apart the orchestra. His classical grounding emerges in the recapitulation, where the infinite variety of the development section gives way to a restored sense of unity; the movement ends triumphantly with a long and thrilling coda. The formal structure is recognizably classical, but the intensity of expression, depth of personal commitment, and heroic defiance are all totally Romantic.

The second movement of the *Eroica* is a worthy successor to the first. A funeral march on the same massive scale, it alternates a mood of epic tragedy—which has been compared, in terms of impact with the works of the Greek playwright Aeschylus—with rays of consolation that at times achieve a transcendental exaltation. Although the many subtleties of construction deserve the closest attention, even a first hearing will reveal the grandeur of Beethoven's conception.

The third and fourth movements relax the tension. For the third, Beethoven replaces the stately minuet of the classical symphony with a *scherzo*—the word literally means "joke" and is used to describe a fast-moving, generally lighthearted piece of music. Beethoven's introduction of this kind of music, which in his hands often has something of the crude flavor of a peasant dance, is another illustration of his "democratization" of the symphony. The last movement is a brilliant and energetic series of variations on a theme Beethoven had composed a few years earlier for a ballet he had written on the subject (from Classic mythology) of Prometheus, who defied the ancient gods by giving mortals the gift of fire, for which he was punished by Zeus—a final reference to the heroic mood of the entire work.

Many of the ideas and ideals that permeate the *Eroica* reappear throughout Beethoven's work. His love of liberty and hatred of oppression are expressed in his only opera, *Fidelio*, which describes how a faithful wife rescues her husband who has been unjustly imprisoned for his political views. A good performance of Fidelio is still one of the most uplifting and exalting experiences music has to offer. The concept of triumph over fate recurs in his best-known symphony, *No. 5*, Op. 67, while *Symphony No. 6*, Op. 68, called the *Pastoral*, consists of a Romantic evocation of nature and the emotions it arouses.

To hear a selection from this work, see the Listening CD.

Symphony No. 9, Op. 125, is perhaps the most complete statement of the human striving to conquer all obstacles and win through to universal peace and joy. In it Beethoven introduced a chorus and soloists to give voice to the "Ode to Joy" by his compatriot Friedrich von Schiller (1759–1805). The symphony represents the most complete artistic vindication of Kant's Transcendental Idealism. It is also one of the most influential works of the entire Romantic movement.

Instrumental Music after Beethoven

After Beethoven, music could never again return to its former mood of classical objectivity. Although Beethoven's music may remain unsurpassed for its universalization of individual emotion, his successors tried—

and in large measure succeeded—to find new ways to express their own feelings. Among the first to follow Beethoven was Hector Berlioz (1803–1869), the most distinguished French Romantic composer who produced, among other typically Romantic works, the *Fantastic Symphony*, which describes the hallucinations of an opium-induced dream, and *The Damnation of Faust*, a setting of Part One of Goethe's work. In both of these, Berlioz used the full Romantic apparatus of dreams, witches, demons, and the grotesque to lay bare the artist's innermost feelings although, like Goethe, he never lost an innately Classical streak.

For a selection from this work, see the Listening CD.

A highly intimate and poetic form of Romantic self-revelation is the music of Franz Schubert (1797–1828), who explored in the few years before his premature death the new possibilities opened up by Beethoven in a wide range of musical forms. In general, Schubert was happiest when working on a small scale, as evidenced by his more than six hundred *Lieder* ("songs"), which are an inexhaustible store of musical and emotional expression.

On the whole, the more rhetorical nature of the symphonic form appealed to Schubert less, although the wonderful Symphony No. 8 in b minor, called the Unfinished Symphony because he only completed two movements, combines great poetic feeling with a genuine sense of drama. His finest instrumental music was written for small groups of instruments. The two Trios for Piano, Violin, and Cello, Op. 99 and 100, are rich in the heavenly melodies that seemed to come to him so easily; the second, slow movement of the Trio in E flat, Op. 100, touches profound depths of romantic expression. Like the slow movement of Mozart's Piano Concerto No. 27 in B flat (see Chapter 16), its extreme beauty is tinged with an unutterable sorrow. But whereas Mozart seems to speak for humanity at large, Schubert moves us most deeply by communicating his own personal feelings. Most nineteenth-century composers followed Beethoven in using the symphony as the vehicle for their most serious musical ideas. Robert Schumann (1810-1856) and his student Johannes Brahms (1833-1897) regarded the symphonic form as the most lofty means of musical expression, and each as a result wrote only four symphonies. Brahms did not even dare to write a symphony until he was forty-four, and is said to have felt the presence of Beethoven's works "like the tramp of a giant" behind him. When it finally appeared, Brahms' Symphony No. 1 in c minor, Op. 68, was inevitably compared to Beethoven's symphonies. Although Brahms' strong sense of form and conservative style won him the hostility of the arch-Romantics of the day, other critics hailed him as the true successor to Beethoven.

Both responses were, of course, extreme. Brahms' music certainly is Romantic with its emphasis on warm melody and a passion no less present for being held tightly in rein—but far from echoing the heaven-storming mood of many of the symphonies of his great predecessor, Brahms was really more at home in a relaxed vein. Although the *Symphony No. 1* begins with a gesture of defiant grandeur akin to Beethoven's, the first movement ends by fading dreamily into a glowing tranquility. The lovely slow movement is followed not by a scherzo but by a quiet and graceful *intermezzo* ("interlude"), and only in the last movement are we returned to the mood of the opening.

Closer to the more cosmic mood of the Beethoven symphonies are the nine symphonies of Anton Bruckner (1824-1896). A deeply religious man imbued with a romantic attachment to the beauties of nature, Bruckner combined his devout Catholicism and mystical vision in music of epic grandeur. It has often been remarked that Bruckner's music requires time and patience on the listener's part. His pace is leisurely and he creates huge structures in sound that demand our full concentration if we are to appreciate their "architecture." There is no lack of incidental beauty, however, and the rewards are immense. No other composer has been able to convey quite the tone of mystical exaltation that Bruckner achieves, above all in the slow movements of his last three symphonies. The adagio movement from the Symphony No. 8 in c minor, for instance, moves from the desolate Romanticism of its opening theme to a mighty, blazing climax as thrilling and stirring as anything in nineteenth-century music.

The Age of the Virtuosos

Beethoven's emphasis on the primacy of the artist inspired another series of Romantic composers to move in a very different direction from that of the symphony. Beethoven himself had first made his reputation as a brilliant pianist, and much of his music—both for piano and for other instruments—was of considerable technical difficulty. As composers began to demand greater and greater feats of virtuosity from their performers, performing artists themselves came to attract more attention.

Singers had already, in the eighteenth century, commanded high fees and attracted crowds of fanatical admirers, and continued to do so. Now, however, they were joined by instrumental virtuosos, some of whom were also highly successful composers.

The life of Frédéric Chopin (1810–1849) seems almost too Romantic to be true [17.4]. Both in his piano performances and in the music he composed he united the aristocratic fire of his native Poland with the elegance and sophistication of Paris, where he spent much of his life. His concerts created a sensation throughout Europe, while his piano works exploited (if they did not always

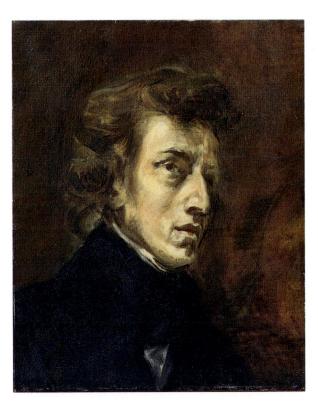

17.4 Eugène Delacroix. *Frederic Chopin*, 1838. Oil on canvas, $18'' \times 15''$ (45×38 cm). Louvre, Paris. Delacroix's portrait of his friend captures Chopin's Romantic introspection. Delacroix was himself a great lover of music, though perhaps surprisingly the great Romantic painter preferred Mozart to Beethoven.

create) new musical forms like the *nocturne*—a short piano piece in which an expressive, if often melancholy, melody floats over a murmuring accompaniment. Chopin is characteristically Romantic in his use of music to express his own personal emotions. The structure of works like the twenty-four *Preludes*, Op. 28, is dictated not by formal considerations but by the feeling of the moment. Thus the first three take us from excited agitation to brooding melancholy to bubbling high spirits in just over three minutes.

In private, Chopin's life was dominated by a much-talked-about liaison with the leading French woman author of the day, George Sand (1804–1876). His early death from tuberculosis put the final Romantic touch to the life of a composer who has been described as the soul of the piano.

Franz Liszt (1811–1886) shared Chopin's brilliant skill at the keyboard and joined to it his own more robust temperament. A natural Romantic, Liszt ran the gamut of Romantic themes and experiences. After beginning his career as a handsome, impetuous young rebel, the idol of the salons of Paris, he conducted a number of well-publicized affairs and ended up by turning to the

consolations of religion. His vast musical output includes some of the most difficult of all piano works (many of them inspired by the beauties of nature), two symphonies on the characteristically Romantic subjects of Faust and Dante (with special emphasis, in the latter case, on the *Inferno*), and a host of pieces that made use of the folk tunes of his native Hungary.

Assessment of Liszt's true musical stature is difficult. He was probably a better composer than his present reputation suggests, although not so great a one as his contemporaries (and he) thought. As a virtuoso performer even *he* takes second place to Nicolò Paganini (1782–1840), the greatest violinist of the age, if not of all time.

Like Chopin and Liszt, Paganini also composed, but it was his public performances that won him his amazing reputation. So apparently impossible were the technical feats he so casually executed that rumor spread that, like Faust, he had sold his soul to the devil. This typically Romantic exaggeration was, of course, assiduously encouraged by Paganini himself, who cultivated a suitably ghoulish appearance to enhance his public image. Nothing more clearly illustrates the nineteenth century's obsession with music as emotional expression (in this case, diabolical) than the fact that Paganini's concerts earned him both honors throughout Europe and a considerable fortune.

Musical Nationalism

Both Chopin and Liszt introduced the music of their native lands into their works, Chopin in his *mazurkas* and *polonaises* (traditional Polish dances) and Liszt in his *Hungarian Rhapsodies*. For the most part, however, they adapted their musical styles to the prevailing international fashions of the day.

Other composers placed greater emphasis on their native musical traditions. In Russia, a group of five composers (Moussorgsky, Balakirev, Borodin, Cui, and Rimsky-Korsakov) consciously set out to exploit their rich musical heritage. The greatest of the five was Modest Moussorgsky (1839-1881), whose opera Boris Godunov (1874) is based on an episode in Russian history. It makes full use of Russian folksongs and religious music in telling the story of Tsar Boris Godunov, who rises to power by killing the true heir to the throne. Although Boris is the opera's single most important character, the work is really dominated by the chorus, which represents the Russian people. Moussorgsky powerfully depicts their changing emotions, from bewilderment to awe, to fear, to rage, and in so doing gives voice to the feelings of his nation.

Elsewhere in Eastern Europe composers were finding similar inspiration in national themes and folk music. The Czech composer Bedřich Smetana (1824–1884), who aligned himself with his native Bohemia in the uprising against Austrian rule in 1848, composed a set of seven pieces for orchestra under the collective title of *Má Vlast (My Fatherland)*. The best known, *Vltava (The Moldau)*, depicts the course of the river Vltava as it flows from its source through the countryside to the capital city of Prague. His fellow countryman Antonin Dvořák (1841–1904) also drew on the rich tradition of folk music in works like his *Slavonic Dances*, colorful settings of Czech folktunes.

Opera in Italy: Verdi

Throughout the nineteenth century, opera achieved new heights of popularity in Europe and "operamania" began to spread to America, where opera houses opened in New York (1854) and Chicago (1865). On both sides of the Atlantic opera house stages are still dominated by the works of the two nineteenth-century giants: the Italian Giuseppe Verdi and the German Richard Wagner.

When Giuseppe Verdi (1813-1901) began his career, the Italian opera-going public was interested in beautiful and brilliant singing rather than realism of plot or action. This love of what is often called bel canto ("beautiful singing") should not be misunderstood. Composers like Gaetano Donizetti (1797-1848) and Vincenzo Bellini (1801-1835) used their music to express sincere and deep emotions and even drama, but the emotional expression was achieved primarily by means of song and not by a convincing dramatic situation. The plots of their operas serve only as an excuse for the music; thus characters in bel canto operas are frequently given to fits of madness in order to give musical expression to deep emotion. Within the necessary framework provided by the plot, a great singer, inspired by great music, could use the magic of the human voice to communicate a dramatic emotion that transcended the time and place of the action. Under the inspiration of Verdi and Wagner, however, opera began to move in a different direction. The subjects composers chose remained larger than life, but dramatic credibility became increasingly important.

Beginning in the 1950s, however, many music lovers began to discover a rich source of musical beauty and even drama in a work like Bellini's *Norma*, first performed in 1831. The revival and subsequent popularity of much early-nineteenth-century opera is due in large measure to the performances and recordings of Maria Callas [17.5], whose enormous talent showed how a superb interpreter could bring such works to life. Following her example, other singers turned to *bel canto* opera, with the result that performances of *Norma* and of Donizetti's best-known opera, *Lucia di Lammermoor*

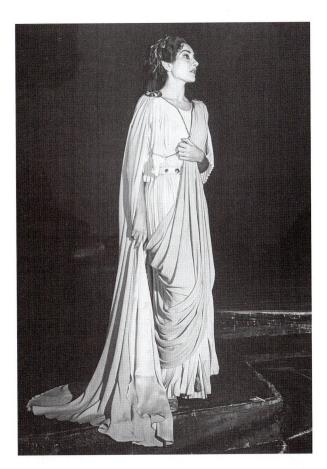

17.5 Maria Callas as Norma in Bellini's opera of the same title, Covent Garden, London, 1957. The Greek–American Maria Callas (1923–1977), one of the great sopranos of the twentieth century, made her professional debut in Verona in 1947. Her first appearances at La Scala, Milan; Covent Garden, London; and the Metropolitan Opera, New York followed in 1950, 1952, and 1956.

(1835), have become a regular feature of modern operatic life, while lesser-known works are revived in increasing numbers.

The revival of *bel canto* works has certainly not been at the expense of Verdi, perhaps the best-loved of all opera composers. His works showed a new concern for dramatic and psychological truth. Even in his early operas like *Nabucco* (1842) or *Luisa Miller* (1849) Verdi was able to give convincing expression to human relationships. At the same time, his music became associated with the growing nationalist movement in Italy. *Nabucco*, for example, deals ostensibly with the captivity of the Jews in Babylon and their oppression by Nebuchadnezzar, but the plight of the Jews became symbolic of the Italians' suffering under Austrian rule. The chorus the captives sing as they think of hap-

pier days, "Va, pensiero . . ." ("Fly, thought, on golden wings, go settle on the slopes and hills where the soft breezes of our native land smell gentle and mild"), became a kind of theme song for the Italian nationalist movement, the Risorgimento, in large measure because of the inspiring yet nostalgic quality of Verdi's tune.

Verdi's musical and dramatic powers reached their first great climax in three major masterpieces—Rigoletto (1851), Il Trovatore (1853), and La Traviata (1853)—which remain among the most popular of all operas. They are very different in subject and atmosphere. Il Trovatore is perhaps the most traditional in approach, with its gory and involved plot centering around the troubadour Manrico and its abundance of superb melodies. In Rigoletto, Verdi achieved one of his most convincing character portrayals in the hunchback court jester Rigoletto, who is forced to suppress his human feelings and play the fool to his vicious and lecherous master, the Duke of Mantua. With La Traviata based on Dumas' play La dame aux camélias (The Lady of the Camelias), Verdi broke new ground in the history of opera by dealing with contemporary life rather than a historical or mythological subject.

The principal character of La Traviata is Violetta, a popular courtesan in Paris, who falls in love with Alfredo Germont, a young man from the provinces, and decides to give up her sophisticated life in the capital for country bliss. Her reputation follows her there, however, in the form of Alfredo's father. In a long and emotional encounter he persuades her to abandon his son and put an end to the disgrace she is bringing on his family [17.6]. Violetta, who is aware that she is suffering from a fatal illness, returns alone to the cruel glitter of her life in Paris. By the end of the opera, her money gone, she lies dving in poverty and solitude. At this tragic moment Verdi gives her one of his most moving arias, "Addio del passato" ("Goodbye bright dreams of the past"), as she thinks back over her earlier life. Alfredo, who has finally learned of the sacrifice she has made for his sake, rushes to find her, only to arrive for a final farewell-Violetta dies in his arms.

Throughout the latter part of his career, Verdi's powers continued to develop and enrich, until in 1887 he produced in *Otello*, a version of Shakespeare's tragedy of the same name, perhaps the supreme work in the entire Italian operatic tradition. From the first shattering chord that opens the first act to Otello's heartbreaking death at the end of the last, Verdi rose to the Shakespearean challenge with music of unsurpassed eloquence. In a work that is so consistently inspired it seems invidious to pick out highlights, but the ecstatic love duet of Act I between Otello and Desdemona deserves mention as one of the noblest and most moving of all depictions of romantic passion.

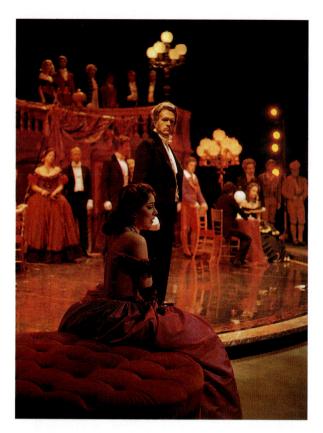

17.6 La Traviata. Metropolitan Opera, New York, 1981. La Traviata was first produced in New York in 1856. Many noted sopranos have sung the role of Violetta, including Maria Callas (Figure 17.5).

To hear a selection from one of Verdi's contemporaries, see Puccini on the Listening CD.

Opera in Germany: Wagner

http://www.hup.harvard.edu/HBDM/hbdm.wagner.html

Wagner

The impact of Richard Wagner (1813–1883) on his times went far beyond the opera house. Not only did his works change the course of the history of music, but many of his ideas also had a profound effect on writers and painters [17.7]. This truly revolutionary figure even became actively involved with the revolutionary uprisings of 1848 and spent a number of years in exile in Switzerland.

It is difficult to summarize the variety of Wagner's ideas, which ranged from art to politics to vegetarianism and are not noted for their tolerance. Behind many of his writings on opera and drama lay the concept that the most powerful form of artistic expression was one that

united all the arts—music, painting, poetry, movement—in a single work of art, the *Gesamtkunstwerk* ("complete artwork"). To illustrate this theory, Wagner wrote both the words and music of what he called "music dramas" and even designed and built a special theater for their performance at Bayreuth, where they are still performed every year at the Bayreuth Festival.

A number of characteristics link all Wagner's mature works. First, he abolished the old separation between recitatives (in which the action was advanced) and arias, duets, or other individual musical numbers (which held up the action). Wagner's music flowed continuously from the beginning to the end of each act with no pauses. Second, he eliminated the vocal display and virtuosity that had been traditional in opera. Wagner roles are certainly not easy to sing, but their difficulties are always for dramatic reasons and not to show off a singer's skill. Third, he put a new emphasis on the orchestra, which not only accompanied the singers but also provided a rich musical argument of its own. This was enhanced by his fourth contribution, the famous device of the leitmotiv ("leading motif"), which consisted of giving each of the principal characters, ideas, and even objects an individual theme of his, her, or its own. By recalling these themes and by combining them or changing them Wagner achieved highly complex dramatic and psychological effects.

Wagner generally drew his subjects from German mythology. By peopling his stage with heroes, gods, giants, magic swans, and the like, he aimed to create universal dramas that would express universal emotions. In his most monumental achievement, The Ring of the Nibelung, written between 1851 and 1874, he even represented the end of the world. The Ring consists of four separate music dramas, The Rhinegold, The Valkyrie, Siegfried, and The Twilight of the Gods, the plot of which defies summary. In music of incredible richness, Wagner depicted not only the actions and reactions of his characters but also the wonders of nature. In Siegfried, for example, we hear the rustling of the forest and the songs of woodbirds, while throughout The Ring and especially in the well-known "Rhine Journey" from The Twilight of the Gods the mighty river Rhine sounds throughout the score. At the same time, The Ring has a number of philosophical and political messages, many of which are derived from Schopenhauer. One of its main themes is that power corrupts, while Wagner also adopted Goethe's idea of redemption by a woman in the final resolution of the drama.

To hear Wagner's leitmotiv for the *Ride of the Valkyries,* see the Listening CD.

No brief discussion can begin to do justice to so stupendous a work. It is probably easier to see Wagner's genius in operation by looking at a work on small scale, a

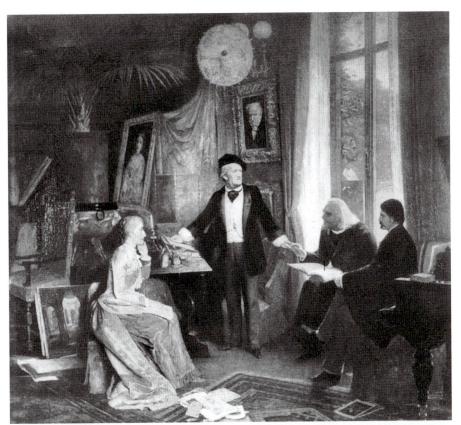

17.7 Wilhelm Beckmann. Richard Wagner at His Home in Bayreuth, 1880. Oil on canvas, $4'^3/_4'' \times 5'^15/_8''$ (1.25 \times 1.58 m). Richard Wagner Museum, Triebschen-Luzern, Switzerland. Characteristically, Wagner is holding forth to his wife and friends, in this case Liszt in his garb as Abbot and the author Hans von Wolzogen. At lower left are some stage designs for Wagner's final work: Parsifal.

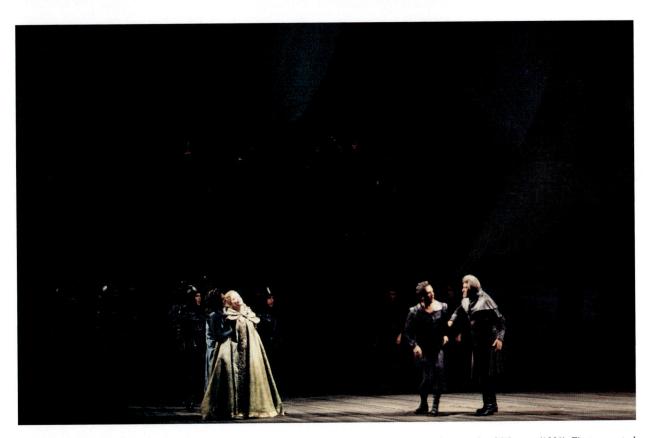

17.8 Scene from *Tristan and Isolde*, Act II, the Bayreuth staging designed by Wagner's grandson, Wieland Wagner (1981). First mounted in 1962, the production starred Wolfgang Windgassen and Birgit Nilsson as the lovers. The abstract sets and complex lighting have influenced much stage design since then.

single self-contained music drama—albeit one of some four hours' duration. *Tristan and Isolde* was first performed in 1865, and its very first notes opened a new musical era. Its subject is the overwhelming love of the English knight Tristan and the Irish princess Isolde, so great that the pair betray his dearest friend and lord and her husband, King Mark of Cornwall, and so overpowering that it can achieve its complete fulfillment only in death.

Wagner's typically Romantic preoccupation with love and death may seem morbid and farfetched, but under the sway of his intoxicating music it is difficult to resist. The sense of passion awakened but unfulfilled is expressed in the famous opening bars of the Prelude, with their theme that yearns upward and the discords that dissolve into one another only to hang unresolved in the air:

The music imparts no sense of settled harmony or clear direction. This lack of *tonality*, used here for dramatic purpose, was to have a considerable influence on modern music.

The core of *Tristan and Isolde* is the long love scene at the heart of the second act, where the music reaches heights of erotic ecstasy too potent for some listeners. Whereas Verdi's love duet in *Otello* presents two noble spirits responding to one another with deep feeling but with dignity, Wagner's characters are racked by passions they cannot begin to control. If ever music expressed what neither words nor images could depict, it is in the overwhelming physical emotion of this scene [17.8].

The pulsating orchestra and surging voices of the lovers build up an almost unbearable tension that Wagner suddenly breaks with the arrival of King Mark. Once again, as in the Prelude, fulfillment is denied both to the lovers and to us.

That fulfillment is reached only at the very end of the work in Isolde's "Liebestod" ("Love Death"). Tristan has died, and over his body Isolde begins to sing a kind of incantation. She imagines she sees the spirit of her beloved, and in obscure, broken words describes the bliss of union in death before sinking lifeless upon him. Although the "Liebestod" does make its full effect when heard at the end of the entire work, even out of context the emotional power of the music as it rises to its climax can hardly fail to affect the sensitive listener.

ROMANTIC ART

Painting at the Turn of the Century: Goya

Just as Beethoven and his Romantic successors rejected the idealizing and universal qualities of classical music to achieve a more intense and personal communication, painters also began to abandon the lofty, remote world of Neo-Classical art for more vivid images. In the case of

painting, however, the question of style was far more related to political developments. We have already seen in Chapter 16 that Neo-Classicism had become, as it were, the official artistic dress of the French Revolution, so it was not easy for a painter working in France, still the center of artistic life, suddenly to abandon the revolutionary style. The problem is particularly visible in the works of Jacques Louis David (1748-1825), whose Oath of the Horatii (see Figure 16.1) had been inspired by the prerevolutionary longing for austere Republican virtue. By the end of the revolution, David had come to appreciate the advantages of peace; his painting The Battle of the Romans and the Sabines of 1799 [17.9] expresses his desire for an end to violence and bloodshed. The subject is drawn from Roman mythology and focuses on that moment when Hersilia, wife of the Roman leader Romulus, interrupts the battle between Romans and Sabines and begs for an end to war. Its significance is precisely the reverse of the Oath of the Horatii. In place of a masculine call to arms and sacrifice, David shows his heroine making an impassioned plea for peace. The style, however, remains firmly Neo-Classical, not only in the choice of subject but also in its execution. For all the weapons and armor, there is no sign of actual physical violence. The two opponents, with their heroic figures and noble brows, are idealized along typical Neo-Classical lines. The emotional gestures of Hersilia and others are also stylized and frozen. The painting is powerful, but it depicts a concept rather than individual human feelings.

The contrast between the Neo-Classical representation of the horrors of war and a Romantic treatment of the same theme can be seen by comparing David's painting to *Execution of the Madrileños on May 3, 1808* [17.10] by Francisco Goya (1746–1828). In Goya's painting, nothing is idealized. The horror and the terror of the victims, their faceless executioners, the blood streaming in the dust all combine to create an almost unbearable image of protest against human cruelty. Goya's painting is Romantic because it conveys to us his own personal emotions at the thought of the executions and because, great artist that he was, his emotions become our own.

As Beethoven convinces us of the necessity to struggle against the injustices of human beings and of fate by his own passionate commitment, so Goya by his intensity urges us to condemn the atrocities of war. Furthermore, both Beethoven and Goya shared a common sympathy with the oppressed and a hatred of tyranny. The soldiers firing their bayoneted guns in Goya's painting were serving in the army of Napoleon; the event shown took place some four years after Beethoven had seen the danger Napoleon presented to the cause of liberty and had erased his name from the *Eroica*.

It was, of course, easier for an artist outside France to abandon the artistic language of Neo-Classicism for more direct ways of communication. Although from 1824 to his death Goya lived in France, he was born in Spain

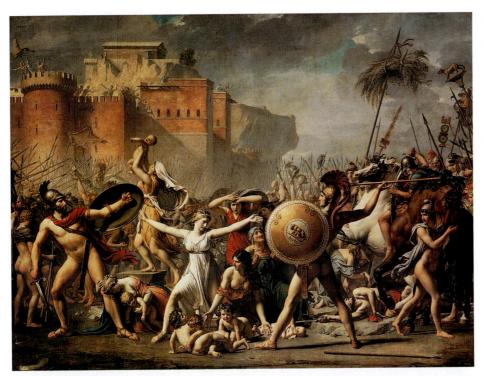

17.9 Jacques Louis David. The Battle of the Romans and the Sabines, 1799. Oil on canvas, $12'5'' \times 16'9'' (3.8 \times 5.1 \text{ m})$. Louvre, Paris. David may have intended his depiction of feminine virtue as a tribute to his wife, who left him when he voted for the execution of Louis XVI but returned to him when he was imprisoned for a time.

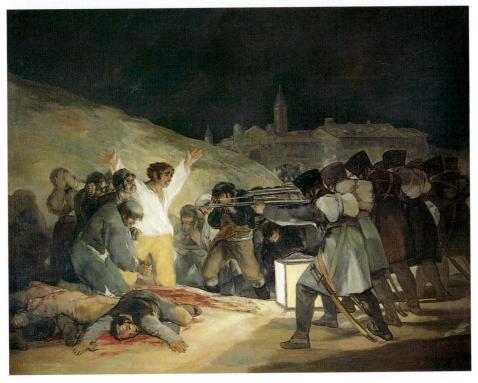

17.10 Francisco Goya. Execution of the Madrileños on May 3, 1808, 1814. Oil on canvas, 8'8\[^3/_4\]" \times 11'3\[^3/_4\]" (2.66 \times 3.45 m). Museo del Prado, Madrid. The painting shows the execution of a group of citizens of Madrid who had demonstrated against the French occupation by Napoleon's troops. The Spanish government commissioned the painting after the expulsion of the French army.

and spent most of his working life there. Removed from the mainstream of artistic life, he seems never to have been attracted by the Neo-Classical style. Some of his first paintings were influenced by the rococo style of Tiepolo (see Figure 16.8), who was in Spain from 1762 until 1770, but his own introspective nature and the strength of his feelings seem to have driven Goya to find

more direct means of expression. Personal suffering may have played a part also, since Goya, like Beethoven, became totally deaf.

In 1799, Goya became official painter to King Charles IV of Spain, and was commissioned to produce a series of formal court portraits. The most famous of these, *The Family of Charles IV* [17.11], was deliberately modeled

17.11 Francisco Goya.

The Family of Charles IV, 1800.
Oil on canvas, 9'2" × 11'
(2.79 × 3.35 m). Museo del
Prado, Madrid. In this
scathing portrayal of the
Spanish royal family, the
artist depicts himself working
quietly at the far left. The
French writer Alphonse
Daudet said the painting
showed "the grocer and his
family who have just won
top prize in the lottery."

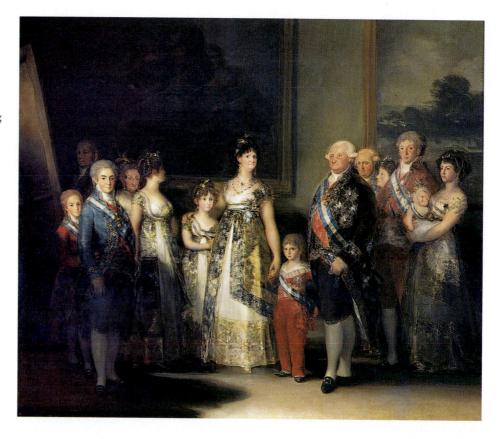

on Velázquez' Las Meninas (see Figure 15.23). Goya shows us the royal family—king, queen, children, and grandchildren—in the artist's studio, where they have come to visit. The comparison he intends us to make between his own painting and that of his distinguished predecessor is devastating. At first glance, Goya's painting may seem just another official portrait, but it does not take a viewer very long to realize that something is very wrong at the court of Spain. Instead of grace and elegance, Goya's patrons radiate arrogance, vanity, and stupidity. The king and queen, in particular, are especially unappealing.

The effect of Goya's painting is not so much one of realism as of personal comment, although there is every reason to believe that the queen was in fact quite as ugly as she appears here. The artist is communicating his own feelings of disgust at the emptiness, indeed the evil, of court life. That he does so through the medium of an official court portrait that is itself a parody of one of the most famous of all court portraits is of course an intentional irony.

Even at the time of his official court paintings Goya was obsessed by the darker side of life. His engraving *The Sleep of Reason Produces Monsters* (see Figure 17.1) foreshadowed the work of his last years. Between 1820 and 1822 Goya covered the walls of his own house with paintings that depict a nightmare world of horror and despair. *Saturn Devouring One of His Sons* [17.12] makes

use of a Classical myth to portray the god of time in the act of destroying humanity, but the treatment owes nothing to Neo-Classicism. Indeed, no simple stylistic label seems adequate to describe so personal a vision. The intensity of expression, the fantastic nature of the subject, and the mood of introspection are all typically Romantic, yet the totality transcends its components. No one but Goya has ever expressed a vision of human existence in quite these terms.

Painting and Architecture in France: Romantics and Realists

Although the events of the French Revolution and Napoleon's subsequent dictatorship had an immediate impact on artists, writers, and musicians outside France, their effect on French artists was more complex. As we have seen earlier in this chapter, David was never able to throw off the influence of Neo-Classicism, and his immediate successors had a hard time finding a style that could do justice to romantic themes while remaining within Neo-Classical limits. One solution was offered by Anne Louis Girodet-Trioson (1767–1824), whose painting *The Entombment of Atala* [17.13] depicts a highly Romantic subject acted out, as it were, by Classical figures.

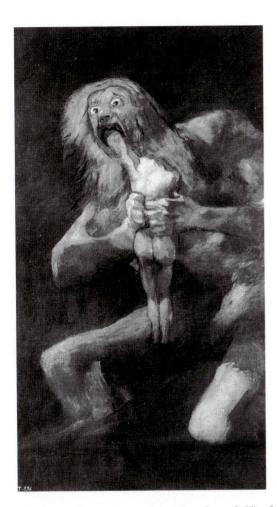

17.12 Francisco Goya. Saturn Devouring One of His Sons, 1819-1823. Detail of a detached fresco on canvas. Full size approx. $57'' \times 32''$ (144.8×81.3 cm). Museo del Prado, Madrid. The painting originally decorated a wall in Goya's country house, La Quinta del Sordo ("Deaf Man's Villa").

The subject is from a popular novel by the French Romantic novelist René de Chateaubriand (1768-1848) and depicts the burial of its heroine, Atala, in the American wilderness where the book is set. The other figures are her Indian lover, Choctas, and a priest from a nearby mission in the Florida swamps. The story of the painting therefore contains just about every conceivable element of Romanticism: an exotic location, emphasis on personal emotion, the theme of unfulfilled love. Girodet provides for his characters a Romantic setting, with its dramatic light and mysterious jungle background, but the figures themselves are idealized in a thoroughly Classical way. Atala's wan beauty and elegant drapery and the muscular nudity of her lover are obviously reminiscent of Classical models. Only the mysterious figure of the old priest provides a hint of Romantic gloom.

It took a real-life disaster and a major national scandal to inspire the first genuinely romantic French painting. In 1816, a French government vessel, the *Medusa*, bound for Africa with an incompetent political appointee as cap-

tain, was wrecked in a storm. The one hundred fortynine passengers and crew members were crowded onto a hastily improvised raft that drifted for days under the equatorial sun. Hunger, thirst, madness, and even, it was rumored, cannibalism had reduced the survivors to fifteen by the time the raft was finally sighted.

The young French painter Jean Louis André Théodore Géricault (1791-1824), whose original enthusiasm for Napoleon had been replaced by adherence to the liberal cause, depicted the moment of the sighting of the raft in his painting Raft of the Medusa [17.14]. Horror at the suffering of the victims and anger at the corruption and incompetence of the ship's officers (and their political supporters) inspired a work that, from its first exhibition in 1819, created a sensation in artistic circles. Even the general public flocked to see a painting that illustrated contemporary events so dramatically. In the process they became exposed to the principles of Romantic painting. Géricault's work deliberately rejects the ideal beauty of Classical models. The agonizing torment of the survivors is powerfully rendered, and the dramatic use of lighting underlines the intense emotions of the scene.

When Géricault died following a fall from a horse, the cause of Romanticism was taken up by his young friend and admirer, Ferdinand Victor Eugène Delacroix (1798–1863), whose name has become synonymous with Romantic painting. Although the subjects of many of his paintings involve violent emotions, Delacroix himself seems to have been aloof and reserved. He never married, or for that matter formed any lasting relationship. His *Journal* reveals him as a man constantly stimulated by ideas and experience but he preferred to live his life through his art—a true Romantic. Among his few close friends was Chopin; his portrait of the composer (see Figure 17.4) seems to symbolize the introspective creative vision of the romantic artist.

http://www.ibiblio.org/wm/paint/auth/delacroix/

Delacroix

Like his mentor Géricault, Delacroix supported the liberal movements of the day. His painting *Massacre at Chios* [17.15] depicted a particularly brutal event in the Greek War of Independence. In 1824, the year in which Lord Byron died while supporting the Greek cause, the Turks massacred some 90 percent of the population of the Greek island of Chios, and Delacroix' painting on the subject was intended to rouse popular indignation. It certainly roused the indignation of the traditional artists of the day, one of whom dubbed it "the massacre of painting," principally because of its revolutionary use of color. Whereas David and other Neo-Classical painters had drawn their forms and then filled them in with color, Delacroix used color itself to create form. The result is a much more fluid use of paint.

17.13 Anne Louis Girodet-Trioson. *The Entombment of Atala*, 1808. Oil on canvas, $6'11^3/4'' \times 8'9''$ (2.13 \times 2.67 m). Louvre, Paris. The anti-Classical nature of the subject is emphasized by the Christian symbolism of the two crosses, one on Atala's breast and the other rather improbably placed high in the jungle outside the cave.

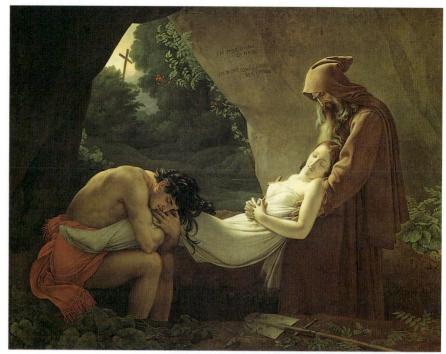

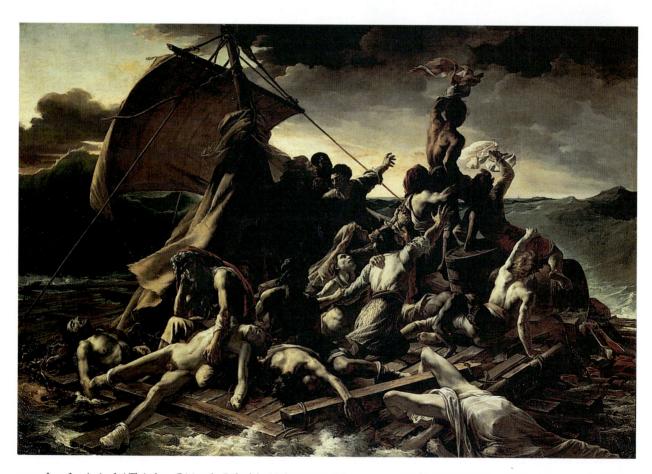

17.14 Jean Louis André Théodore Géricault. *Raft of the Medusa*, 1818. Oil on canvas, $16'1^1/4'' \times 23'6''$ (4.91 \times 7.16 m). Louvre, Paris. Note the careful composition of this huge work, built around a line that leads from the bottom-left corner to the top right, where a survivor desperately waves his shirt.

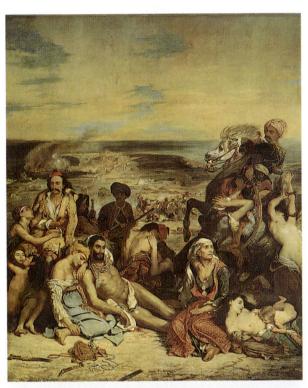

17.15 Eugène Delacroix. Massacre at Chios, 1824. Oil on canvas, $13'7'' \times 11'10''$ (4.19 \times 3.64 m). Louvre, Paris. Rather than depict a single scene, the painter chose to combine several episodes, contrasting the static misery of the figures on the left with a swirl of activity on the right.

17.16 Eugène Delacroix. The Death of Sardanapalus, 1826. Oil on canvas, $12'1'' \times 16'3''$ (3.68×4.95 m). Louvre, Paris. This painting makes no attempt to achieve archaeological accuracy but instead concentrates on exploiting the violence and cruelty of the story. Delacroix called this work Massacre No. 2, a reference to his earlier painting, the Massacre at Chios (Figure 17.15). Although this suggests a certain detachment on the artist's part, there is no lack of energy or commitment in the free, almost violent, brush strokes.

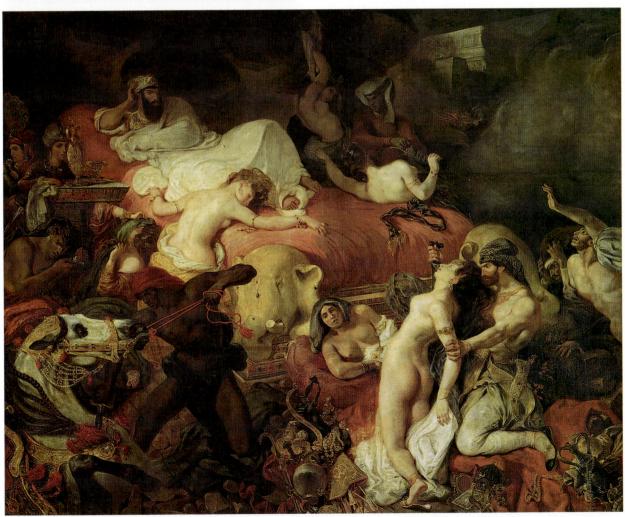

Lord Byron figures again in another of Delacroix' best-known paintings, since it was on one of the poet's works that the artist based The Death of Sardanapalus [17.16]. The Assyrian king, faced with the destruction of his palace by the Medes, decided to prevent his enemies from enjoying his possessions after his death by ordering that his wives, horses, and dogs be killed and their bodies piled up, together with his treasures, at the foot of the funeral pyre he intended for himself. The opulent, violent theme is treated with appropriate drama; the savage brutality of the foreground contrasts with the lonely, brooding figure of the king reclining on his couch above. Over the entire scene, however, hovers an air of unreality, even of fantasy, as if Delacroix is trying to convey not so much the sufferings of the victims as the intensity of his own imagination.

Although with Delacroix' advocacy Romanticism acquired a vast popular following, not all French artists joined the Romantic cause. A fierce and bitter rear-guard action was fought by the leading Neo-Classical proponents, headed by Jean Auguste Dominique Ingres (1780–1867), who was, in his own very different way, as great a painter as Delacroix. The self-appointed defender of Classicism, Ingres once said of Delacroix that "his art is the complete expression of an incomplete intelligence." Characteristically, his war against Romantic painting was waged vindictively and on the most personal terms.

Now that the dust has settled, however, it becomes clear that Ingres, far from religiously adhering to Classical doctrines, was himself unable to suppress a Romantic streak. His extraordinary painting Jupiter and Thetis [17.17] deals with an event from Homer's Iliad and shows Thetis, the mother of Achilles, begging the father of gods and mortals to avenge an insult by the Greek commander Agamemnon to her son by allowing the Trojans to be victorious. The subject may be Classical, but Ingres' treatment of it is strikingly personal, even bizarre. Sensuality blends with an almost hallucinatory sharpness of detail to create a memorable if curiously disturbing image. Even in his more conventional portraits [17.18], Ingres' stupendous technique endows subject and setting with an effect that is the very reverse of academic. The style that in the end succeeded in replacing the full-blown romanticism of Delacroix and his followers was not that of the Neo-Classical school, with its emphasis on idealism, but a style that stressed precisely the reverse qualities. The greatest French painters of the second half of the nineteenth century were Realists who used the everyday events of the world around them to express their views of life. One of the first Realist artists was Honoré Daumier (1808-1879), who followed the example of Goya in using his work to criticize the evils of society in general and government in particular. In Le Ventre Legislatif (The Legislative Belly), [17.19] Daumier produced a powerful image of the greed and corruption

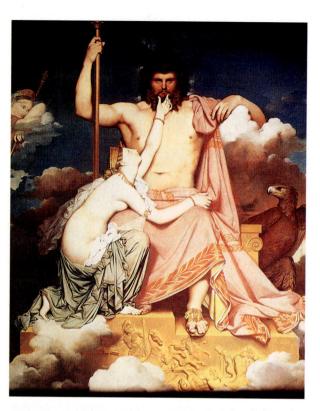

17.17 Jean Auguste Dominique Ingres. Jupiter and Thetis, 1811. Oil on canvas, $10'10'' \times 8'5''$ (3.3 \times 2.57 m). Musée Granet, Aixen-Provence. The figure of Jupiter, with his youthful face surrounded by a vast wreath of beard and hair, is highly unconventional. Thetis' arms and throat are purposely distorted to emphasize her supplication.

of political opportunists that has lost neither its bitterness nor, unfortunately, its relevance.

Equally political was the realism of Gustave Courbet (1819-1877), a fervent champion of the working class, whose ability to identify with ordinary people won him the label of Socialist. Courbet tried to correct this political impression of his artistic and philosophical position in a vast and not entirely successful allegorical work, The Studio: A Real Allegory of the Last Seven Years of My Life [17.20]. Like Goya's royal portrait (see Figure 17.11), the painting deliberately evokes memories of Velázquez' Las Meninas (see Figure 15.23), although the artist is now placed firmly in the center of the picture, hard at work on a landscape, inspired by a nude model who may represent Realism or Truth. The various other figures symbolize the forces that made up Courbet's world. There is some doubt as to the precise identification of many of them, and it is not even clear that Courbet himself had any single allegory in mind. The total effect of the confusion, unintentional though it may be, is to underline the essentially Romantic origins of Courbet's egocentric vision.

Neither Romanticism nor its realistic vision made much impression on architectural styles in nineteenth-

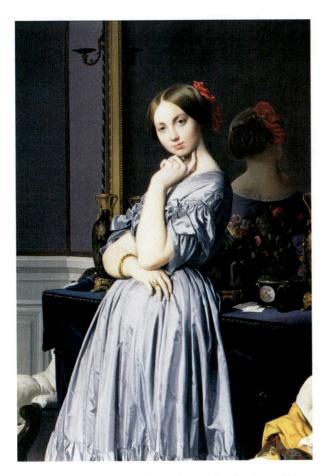

17.18 Jean Auguste Dominique Ingres. *La Comtesse d'Haussonville*, 1845. Oil on canvas, $4'5^{1}/_{2}'' \times 3'^{1}/_{4}''$ (1.36 × .92 m). Frick Collection, New York. The artist seems to have been more interested in his subject's dress, which is marvelously painted, than in her personality. The reflection in the mirror reinforces the highly polished air of the painting.

century France. French architects retained a fondness for classical forms and abandoned them only to revive the styles of the Renaissance. In some of the public buildings designed to meet the needs of the age, however, the elaborate decoration makes use of Classical elements to achieve an ornateness of effect that is not very far from the opulent splendor of Delacroix' *Death of Sardanapalus* (see Figure 17.16).

The most ornate of all nineteenth-century French buildings was the Paris Opera [17.21] of Charles Garnier (1824–1898). The new opera house had to be sufficiently large to accommodate the growing public for opera and sufficiently ostentatious to satisfy its taste. Garnier's building, designed in 1861 and finally opened in 1875, makes use of Classical ornamentation like Corinthian columns and huge winged Victories, but the total effect is highly un-Classical, a riot of confusion that would surely have appalled Classical and Renaissance architects alike.

Painting in Germany and England

Unlike their French counterparts, Romantic artists in both Germany and England were particularly attracted by the possibilities offered by landscape painting. The emotional range of their work illustrates once again the versatility of the Romantic style. The German painter Caspar David Friedrich (1774–1840) seems to have drawn some of his Gothic gloom from a tradition that had been strong in Germany since the Middle Ages, although he uses it to Romantic effect. His *Cloister Graveyard in the Snow* [17.22], in fact, illustrates a number of Romantic preoccupations, with its ruined medieval architecture and melancholy dreamlike atmosphere.

17.19 Honoré Daumier. Le Ventre Legislatif (The Legislative Belly), 1834. Lithograph, $11^1/_{16}" \times 17^1/_{16}"$ (28.1 \times 43.3 cm). Philadelphia Museum of Art (gift of Carl Zigrosser). Although obviously caricatures, the politicians arranged in tiers are recognizable as individual members of the legislative assembly of the time.

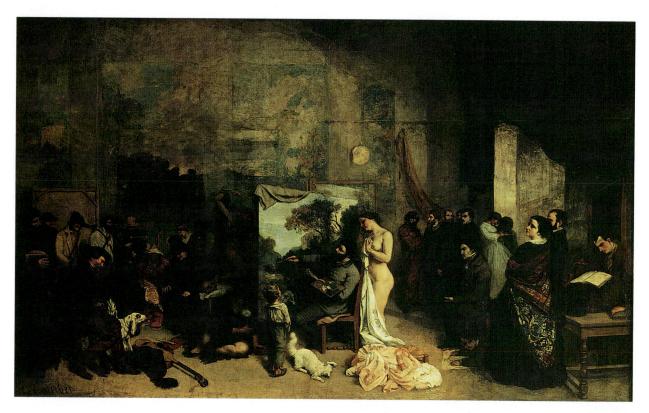

17.20 Gustave Courbet. The Studio: A Real Allegory of the Last Seven Years of My Life, 1855. Oil on canvas, $11'9^3/_4'' \times 19'6^5/_8''$ (3.6 \times 5.96 m). Louvre, Paris. Although most of the figures can be convincingly identified as symbols or real people, no one has ever satisfactorily explained the small boy admiring Courbet's work or the cat at his feet.

The English painter John Constable (1776–1837), on the other hand, shared the deep and warm love of nature expressed by Wordsworth. His paintings convey not only the physical beauties of the landscape but also a

sense of the less tangible aspects of the natural world. In *Hay Wain* [17.23], for example, we not only see the peaceful rustic scene, with its squat, comforting house on the left, we also can even sense that light and quality of

17.21 Charles Garnier. Opéra, Paris, 1861–1875, at dusk. The incredibly rich and complex ornamentation has earned this style of architecture the label Neo-Baroque.

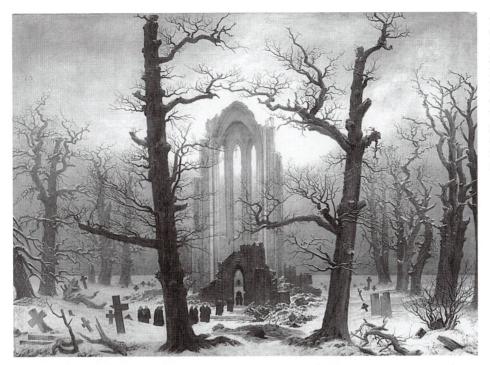

17.22 Caspar David Friedrich. Cloister Graveyard in the Snow, 1810. Oil on canvas, $3'11^5/8'' \times 5'10''$ (1.21 \times 1.78 m). Formerly Nationalgalerie Berlin. (Painting destroyed during World War II.) The vast bare trees in the foreground and the ruined Gothic abbey behind emphasize the insignificance of the human figures.

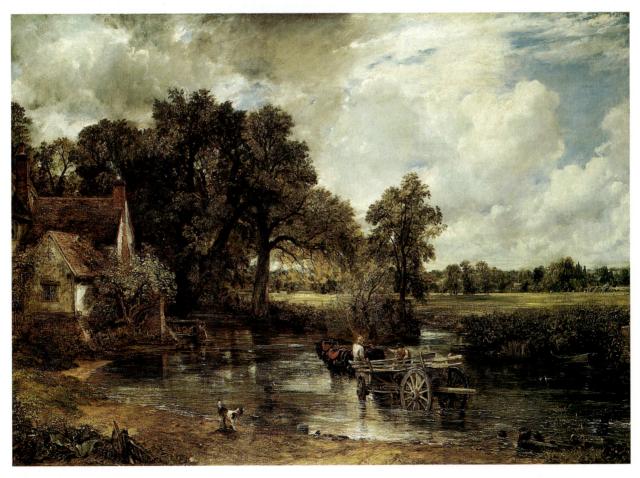

17.23 John Constable. Hay Wain, 1821. Oil on canvas, $4'3'' \times 6'1''$ (1.28 \times 1.85 m). The National Gallery, London (reproduced by courtesy of the Trustees). Note Constable's bold use of color, which impressed Delacroix.

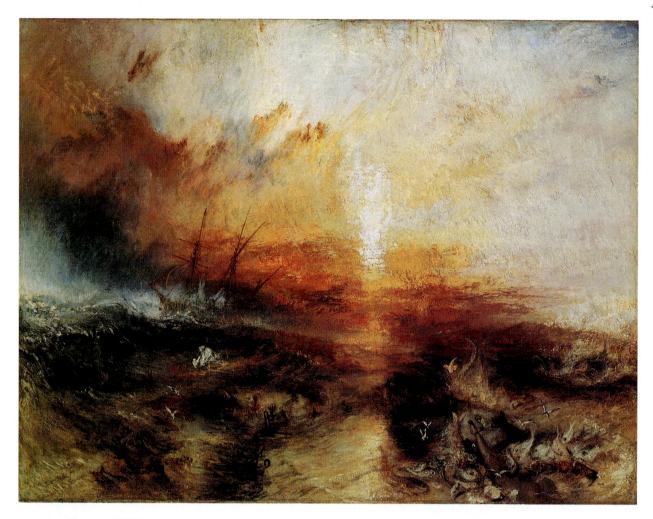

17.24 Joseph Mallord William Turner. The Slave Ship, 1840. Oil on canvas, $35^3_4'' \times 48^3_4''$ (90.8 × 122.6 cm). Museum of Fine Arts, Boston (Henry Lillie Pierce Fund). The title of this painting is an abbreviation of a longer one: Slavers Throwing Overboard the Dead and Dying; Typhoon Coming On. Turner includes a horrifying detail at lower center: the chains still binding the slaves whose desperate hands show above the water. Note the extreme contrast between Turner's interpretation of color and light and that of the American luminists as shown in Heade's painting (Figure 17.31).

atmosphere, prompted by the billowing clouds that, responsible for the fertility of the countryside, seem about to release their moisture.

Constable's use of color pales besides that of his contemporary, Joseph Mallord William Turner (1775–1851). In a sense, the precise subjects of Turner's paintings are irrelevant. All his mature works use light, color, and movement to represent a cosmic union of the elements in which earth, sky, fire, and water dissolve into one another and every trace of the material world disappears. His technique is seen at its most characteristic in *The Slave Ship* [17.24].

Like Géricault's *Raft of the Medusa* (see Figure 17.14), Turner's *Slave Ship* deals with a social disgrace of the time; in this case, to jettison their entire human cargo—a horrifyingly common habit of the captains of slave ships if an epidemic broke out. Turner only incidentally illustrates his specific subject—the detail of drowning figures

in the lower-right corner seems to have been added as an afterthought—and concentrates instead on conveying his vision of the grandeur and mystery of the universe.

LITERATURE IN THE NINETEENTH CENTURY

Goethe

http://worldroots.com/brigitte/goethel.htm

Goethe

The towering figure of Johann Wolfgang von Goethe (1749–1832) spans the transition from Neo-Classicism to

Romanticism in literature like a colossus. So great was the range of his genius that in the course of a long and immensely productive life he wrote in a bewildering variety of disciplines. One of the first writers to rebel against the principles of Neo-Classicism, Goethe used both poetry and prose to express the most turbulent emotions; yet he continued to produce work written according to Neo-Classical principles of clarity and balance until his final years, when he expressed in his writing a profound if abstruse symbolism.

Although the vein of Romanticism is only one of many that runs through Goethe's work, it is an important one. As a young man Goethe studied law, first at Leipzig and then at Strassburg, where by 1770 he was already writing lyric poetry of astonishing directness and spontaneity. By 1773, he was acknowledged as the leader of the literary movement known as Sturm und Drang ("Storm and Stress"). This German manifestation of Romanticism rebelled against the formal structure and order of Neo-Classicism, replacing it with an emphasis on originality, imagination, and feelings. Its chief subjects were nature, primitive emotions, and protest against established authority. Although the Sturm und Drang movement was originally confined to literature, its precepts were felt elsewhere. For instance, it was partly under the inspiration of this movement that Beethoven developed his fiery style.

The climax of this period in Goethe's life is represented by his novel The Sufferings of Young Werther (1774), which describes how an idealistic young man comes to feel increasingly disillusioned and frustrated by life, develops a hopeless passion for a happily married woman, and ends his agony by putting a bullet through his head. All of these events but the last were autobiographical. Instead of committing suicide, Goethe left town and turned his life experiences into the novel that won him international fame. Not surprisingly it became a key work of the Romantic movement. Young men began to dress in the blue jacket and yellow trousers Werther is described as wearing, and some, disappointed in love, even committed suicide with copies of the book in their pockets—a dramatic if regrettable illustration of Goethe's ability to communicate his own emotions to others [17.25].

The years around the turn of the century found Goethe extending the range of his output. Along with such plays as the Classical drama *Iphigenia in Tauris*, which expressed his belief in purity and sincere humanity, were stormy works like *Egmont*, inspired by the idea that human life is controlled by demonic forces. The work for which Goethe is probably best known, *Faust*, was begun at about the turn of the century, although its composition took many years. Part One was published in 1808, and Part Two was only finished in 1832, shortly before his death.

17.25 Tony Johannot. Illustration for a later edition of *The Sufferings of Young Werther*, 1852. By permission of the Houghton Library, Harvard University. The hero has just declared his hopeless passion for Charlotte.

The subject of Dr. Faustus and his pact with the devil had been treated before in literature, notably in the play by Christopher Marlowe. The theme was guaranteed to appeal to Romantic sensibilities with its elements of the mysterious and fantastic and, in Part One, Goethe put additional stress on the human emotions involved. The chief victim of Faust's lust for experience and power is the pure and innocent Gretchen, whom he callously seduces and then abandons. She becomes deranged as a result. At the end of Part One of *Faust*, Gretchen is accused of the murder of her illegitimate child, condemned to death, and executed. Moving from irony to wit to profound compassion, the rich tapestry of Part One shows Goethe, like Beethoven and Goya, on the side of suffering humanity.

Part Two of *Faust* is very different. Its theme, expressed symbolically through Faust's pact with the devil, is nothing less than the destiny of Western culture. Our civilization's unceasing activity and thirst for new

experiences inevitably produces error and suffering; at the same time, it is the result of the divine spark within us and will, in the end, guarantee our salvation. In his choice of the agent of this salvation Goethe established one of the other great themes of Romanticism, the Eternal Feminine. Faust is finally redeemed by the divine love of Gretchen, who leads him upward to salvation.

Romantic Poetry

English Romantic poetry of the first half of the nineteenth century represents a peak in the history of English literature. Its chief writers, generally known as the Romantic poets, touched on a number of themes characteristic of the age. William Wordsworth's deep love of the country led him to explore the relationship between human beings and the world of nature; Percy Bysshe Shelley and George Gordon, Lord Byron (hereafter called Lord Byron), probed the more passionate, even demonic aspects of existence; and John Keats expressed his own sensitive responses to the eternal problems of art, life, and death. William Wordsworth (1770-1850), often called the founder of the Romantic movement in English poetry, clearly described his aims and ideals in his critical writings. For Wordsworth, the poet was a person with special gifts, "endowed with more lively sensibility, more enthusiasm and tenderness, who has a greater knowledge of human nature, and a more comprehensive soul" than ordinary people.

Rejecting artificiality and stylization, Wordsworth aimed to make his poetry communicate directly in easily comprehensible terms. His principal theme was the relation between human beings and nature, which he explored by thinking back calmly on experiences that had earlier produced a violent emotional reaction: his famous "emotion recollected in tranquility."

Wordsworth's emotion recollected in tranquility is in strong contrast to the poetry of Lord Byron (1788-1824), who filled both his life and work with the same moody, passionate frenzy of activity [17.26]. Much of his time was spent wandering throughout Europe, where he became a living symbol of the unconventional, homeless, tormented Romantic hero who has come to be called Byronic after him. Much of his flamboyant behavior was no doubt calculated to produce the effect it did, but his personality must have indeed been striking for no less a figure than Goethe to describe him as "a personality of such eminence as has never been before and is not likely to come again." Byron's sincere commitment to struggles for liberty like the Greek war of independence against the Turks can be judged by the fact that he died while on military duty in Greece.

17.26 Thomas Phillips. Lord Byron in Albanian Costume, 1814. Oil on canvas, $29^{1}/_{2}^{"} \times 24^{1}/_{2}^{"}$ (75 \times 62 cm). National Portrait Gallery, London. Byron is shown during his first visit to Greece, dressed for the role of Romantic sympathizer with exotic lands and peoples.

Percy Bysshe Shelley (1792–1822), who like Byron spent many of his most creative years in Italy, lived a life of continual turmoil. After being expelled from Oxford for publishing his atheistic views, he espoused the cause of anarchy and eloped with the daughter of one of its chief philosophical advocates. The consequent public scandal, coupled with ill health and critical hostility toward his work, gave him a sense of bitterness and pessimism that lasted until his death by drowning.

Shelley's brilliant mind and restless temperament produced poetry that united extremes of feeling, veering from the highest pitch of exultant joy to the most extreme despondency. His belief in the possibility of human perfection is expressed in his greatest work, *Prometheus Unbound* (1820), where the means of salvation is love—the love of human beings for one another expressed in the last movement of Beethoven's *Ninth Symphony*—rather than the redeeming female love of Goethe and Wagner. His most accessible works, however, are probably the short lyrics in which he seized a fleeting moment of human emotion and captured it by his poetic imagination.

Even Shelley's sensitivity to the poetic beauty of language was surpassed by that of John Keats (1795–1821), whose life, clouded by unhappy love and the tuberculosis that killed him so tragically young, inspired poetry of rare poignance and sensitivity. In his *Odes* (lyric poems of strong feeling), in particular, Keats conveys both the glory and the tragedy of human existence and dwells almost longingly on the peace of death. In the wonderful "Ode to a Nightingale," the song of a bird comes to represent a permanent beauty beyond human grasp. The sensuous images, the intensity of emotion, and the flowing rhythm join to produce a magical effect.

http://www.englishhistory.net/keats/life.html

Keats

The Novel

Although great novels have been written in our own time, the nineteenth century probably marked the high point in the creation of fiction. Increase in literacy and a rise in the general level of education resulted in a public eager for entertainment and instruction, and the success of such writers as Charles Dickens and Leo Tolstoy was due in large measure to their ability to combine the two. The best of nineteenth-century novels were those rare phenomena: great works of art that achieved popularity in their own day. Many of these are still able to enthrall the modern reader with their humanity and insight.

Most of the leading novelists of the mid-nineteenth century wrote within a tradition of Realism that came gradually to replace the more self-centered vision of Romanticism. Instead of describing an imaginary world of their own creation, they looked outward to find inspiration in the day-to-day events of real life. The increasing social problems produced by industrial and urban development produced not merely a lament for the spirit of the times but also a passionate desire for the power to change them as well. In some cases, writers were able to combine the Romantic style with a social conscience, as in the case of the French novelist Victor Hugo (1802-1885), whose Les Misérables (1862) describes the plight of the miserable victims of society's injustices. The hero of the novel, Jean Valjean, is an ex-convict who is rehabilitated through the agency of human sympathy and pity. Hugo provides graphic descriptions of the squalor and suffering of the poor, but his high-flown rhetorical style is essentially Romantic.

Increasingly, however, writers found that they could best do justice to the problems of existence by adopting a more naturalistic style and describing their characters' lives in realistic terms. One of the most subtle attacks on contemporary values is *Madame Bovary* (1856–1857) by Gustave Flaubert (1821–1880). Flaubert's contempt for bourgeois society finds expression in his portrait of Emma Bovary, who tries to discover in her own provincial life the romantic love she reads about in novels. Her shoddy affairs and increasing debts lead to an inevitably dramatic conclusion. Flaubert is at his best when portraying the banality of Emma's everyday existence.

Honoré de Balzac (1779–1850) was the most versatile of all French novelists. He created a series of some ninety novels and stories, under the general title of *The Human Comedy*, in which many of the same characters appear more than once. Above all a Realist, Balzac depicted the social and political currents of his time while imposing on them a sense of artistic unity. His novels are immensely addictive. The reader who finds in one of them a reference to characters or events described in another novel hastens there to be led on to a third, and so on. Balzac thus succeeds in creating a fictional world that seems, by a characteristically Romantic paradox, more real than historical reality.

Among the leading literary figures of Balzac's Paris, and a personal friend of Balzac himself, was the remarkable Aurore Dupin (1804–1876), better known by her pseudonym George Sand. This redoubtable defender of women's rights and attacker of male privilege used her novels to wage war on many of the accepted conventions of society. In her first novel, *Lélia* (1833) she attacked, among other institutions, the church, marriage, the laws of property, and the double standard of morality whereby women were condemned for doing what was condoned for men.

Unconventional in her own life, Sand became the lover of Chopin, with whom she lived from 1838 to 1847. Her autobiographical novel *Lucrezia Floriani* (1846) chronicles as thinly disguised fiction the remarkable course of this relationship, albeit very much from its author's point of view.

If France was one of the great centers of nineteenth-century fiction, another was Russia, where Leo Tolstoy (1828–1910) produced, among other works, two huge novels of international stature: War and Peace (1863–1869) and Anna Karenina (1873–1877). The first is mainly set against the background of Napoleon's invasion of Russia in 1812. Among the vast array of characters is the Rostov family, aristocratic but far from wealthy, who, together with their acquaintances, have their lives permanently altered by the great historical events through which they live. Tolstoy even emphasizes the way in which the course of the war affects his characters by

CONTEMPORARY VOICES

Isabella Bird Meets a Mountain Man

Isabella Bird (1831–1904), the English travel writer, meets Rocky Mountain Jim in Colorado in 1873 "a man who any woman might love, but who no sane woman would marry." A tireless traveler throughout America, Asia, and Australia, Isabella finally did settle down for a while and marry; her husband observed that he "had only one formidable rival in Isabella's heart, and that is the high Table Land of Central Asia."

Roused by the growling of the dog, his owner came out, a broad, thickset man, about the middle height, with an old cap on his head, and wearing a gray hunting-suit much the worse for wear (almost falling to pieces, in fact), a digger's scarf knotted round his waist, a knife in his belt, and a bosom friend, a revolver, sticking out of the breast pocket of his coat; his feet, which were very small, were bare, except for some dilapidated moccasins made of horse hide. The marvel was how his clothes hung together, and on him. The scarf round his waist must have had something to do with it. His face was remarkable. He is a man about 45, and must have been strikingly handsome. He has large gray-blue eyes, deeply set, with well-marked eyebrows, a handsome aquiline nose, and a very handsome mouth. His face was smooth shaven except for a dense moustache and imperial [a pointed beard]. Tawny hair, in thin uncaredfor curls, fell from under his hunter's cap and over his collar. One eye was entirely gone, and the loss made one side of the face repulsive, while the other might have been modeled in marble. "Desperado" was written in large letters all over him. I almost repented of having sought his acquaintance.

His first impulse was to swear at the dog, but on seeing a lady he contented himself with kicking him, and coming up to me he raised his cap, showing as he did so a magnificently formed brow and head, and in a cultured tone of voice asked if there were anything he could do for me? I asked for some water, and he brought some in a battered tin, gracefully apologizing for not having anything more presentable. We entered into conversation, and as he spoke I forgot both his reputation and appearance, for his manner was that of a chivalrous gentleman, his accent refined, and his language easy and elegant. I inquired about some beavers' paws which were drying, and in a moment they hung on the horn of my saddle. Apropos of the wild animals of the region, he told me that the loss of his eye was owing to a recent encounter with a grizzly bear, which after giving him a death hug, tearing him all over, breaking his arm and scratching out his eye, had left him for dead.

From A Lady's Life in the Rocky Mountains (London, 1879); reprinted by Virago Press (London, 1982).

combining figures he created for the novel with real historical personages, including Napoleon, and allowing them to meet.

http://www.kirjasto.sci.fi/ltolstoi.htm

Tolstoy

At the heart of the novel is the young and impressionable Natasha Rostov, whose own confused love life seems to reflect the confusion of the times. Yet its philosophy is profoundly optimistic, in spite of the tragedies of Natasha's own life and the horrors of war that surround her. Her final survival and triumph represent the glorification of the irrational forces of life, which she symbolizes as the "natural person," over sophisticated and rational civilization. Tolstoy's high regard for irrationality and contempt for reason link him with other nineteenth-century Romantics, and his ability to analyze character

through the presentation of emotionally significant detail and to sweep the reader up in the panorama of historical events make *War and Peace* the most important work of Russian Realistic fiction.

Toward the end of his life, Tolstoy gave up his successful career and happy family life to undertake a mystical search for the secret of universal love. Renouncing his property, he began to wear peasant dress and went to work in the fields, although at the time of his death he was still searching in vain for peace. Russia's other great novelist, Fyodor Dostoyevsky (1821–1881), although he died before Tolstoy, had far more in common with the late nineteenth century than with the Romantic movement, and he is accordingly discussed in Chapter 18.

The riches of the English nineteenth-century novel are almost unlimited. They range from the profoundly intellectual and absorbing works of George Eliot, the pen name of Mary Ann Evans (1819–1880), to *Wuthering Heights* (1847), the only novel by Emily Brontë (1818–1848) and one of the most dramatic and passionate

pieces of fiction ever written. The book's brilliant evocation of atmosphere and violent emotion produces a shattering effect. Like the two already mentioned, many of the leading novelists of the time were women, and the variety of their works soon puts to flight any facile notions about the feminine approach to literature. Elizabeth Gaskell (1810–1865), for example, was one of the leading social critics of the day; her novels study the effects of industrialization on the poor.

If one figure stands out in the field of the English novel, it is Charles Dickens (1812-1870), immensely popular during his lifetime and widely read ever since. It is regrettable that one of Dickens' best-known novels, A Tale of Two Cities (1859), is one of his least characteristic, since its melodramatic and not totally successful historical reconstruction of the French Revolution may have deterred potential readers from exploring the wealth of humor, emotion, and imagination in his more successful books. Each of Dickens' novels and short stories creates its own world, peopled by an incredible array of characters individualized by their tics and quirks of personality. Dickens' ability to move us from laughter to tears and back again gives his work a continual human appeal, although it has won him the censure of some of the more severe critics.

Throughout his life, Dickens was an active campaigner against social injustices and used his books to focus on individual institutions and their evil effects. *Oliver Twist* (1837–1838) attacked the treatment of the poor in workhouses and revealed Dickens' view of crime as the manifestation of a general failing in society [17.27]. In *Hard Times* (1854) he turned, like Gaskell, to the evils of industrialization and pointed out some of the harm that misguided attempts at education can do.

THE ROMANTIC ERA IN AMERICA

The early history of the arts in America was intimately linked to developments in Europe. England, in particular, by virtue of its common tongue and political connections, exerted an influence on literature and painting that even the War of Independence did not end. American writers sought publishers and readers there, and modeled their style on that of English writers. American painters went to London to study, sometimes with less than happy results. John Singleton Copley (1738–1815), for example, produced a series of portraits in a simple, direct style of his own [17.28] before leaving Boston for England, where he fell victim to Sir Joshua Reynolds' grand manner (see Figure 16.13). Of American music we cannot say much, since the earliest American composers confined their attention to settings of hymns and patri-

17.27 George Cruikshank. "Please sir, I want some more," from *Oliver Twist*, 1838. Print Collection. Miriam and Ira D. Wallach Division of Art, Prints and Photographs. The New York Public Library. Astor, Lenox and Tilden Foundations. In the workhouse, young Oliver Twist dares to ask for a second bowl of gruel. Cruikshank (1792–1878), a famed illustrator and caricaturist of the nineteenth century, illustrated more than 850 books; probably his best-known work is that for *Oliver Twist*.

otic songs. A recognizably American musical tradition of composition did not develop before the very end of the nineteenth century, although much earlier European performers found a vast and enthusiastic musical public in the course of their American tours [17.29].

In the case of literature and the visual arts, the French Revolution provided a change of direction, for revolutionary ties inevitably resulted in the importation of Neo-Classicism into America. With the dawning of the Romantic era, however, American artists began to develop for the first time an authentic voice of their own. In many cases they still owed much to European examples. Indeed, the tradition of the expatriate American artist who left home to study in Europe and remained there had been firmly established by the eighteenth century. Throughout the nineteenth century, writers like Washington Irving (1783-1859) and painters like Thomas Eakins (1844-1916) continued to bring back to America themes and styles they had acquired during their European travels. Something about the very nature of Romanticism, however, with its emphasis on the

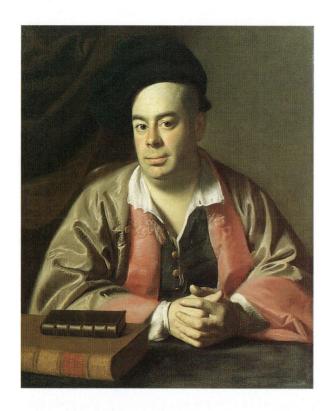

individual, seemed to fire the American imagination. The Romantic love of the remote and mysterious reached a peak in the macabre stories of Edgar Allan Poe (1809–1849). For the first time, in the Romantic era American artists began to produce work that was both a genuine product of their native land and at the same time of international stature.

American Literature

In a land where daily existence was lived so close to the wildness and beauty of nature, the Romantic attachment to the natural world was bound to make a special appeal.

17.28 John Singleton Copley. *Nathaniel Hurd*, 1765. Oil on canvas, $30'' \times 25^{1/2}''$ (76 × 65 cm). Cleveland Museum of Art (Gift of the John Huntington Art and Polytechnic Trust). In this portrait of a friend, Copley avoids technical tricks. The result is an attractive simplicity of style that still allows him to reveal something of the subject's personality.

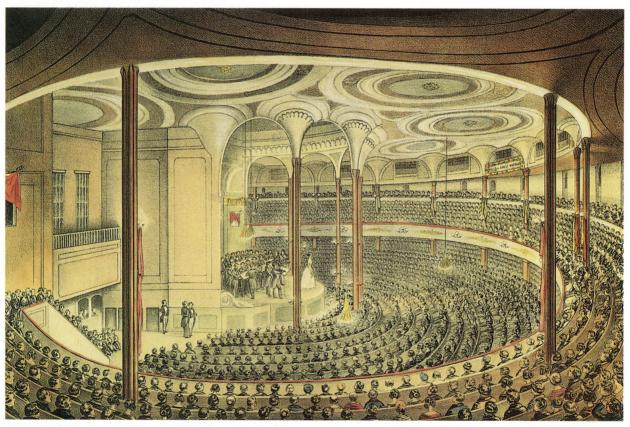

17.29 Nathaniel Currier. First Appearance of Jenny Lind in America: At Castle Garden, Sept. 11, 1850. Lithograph detail. J. Clarence Davies Collection, Museum of the City of New York. The great soprano, inevitably known as the Swedish Nightingale, made a highly successful tour of America under the management of P. T. Barnum in 1850–1851, during which she earned the staggering sum of \$120,000 (multiply by ten for present value). At this first appearance in New York, the total receipts were \$26,238. Nathaniel Currier (1813–1888) and James Merritt Ives (1824–1895), who became his partner in 1857, were lithographers who sold thousands of hand-colored prints that show many aspects of nineteenth-century American life.

The Romantic concept of the transcendental unity of humans and nature was quickly taken up in the early nineteenth century by a group of American writers who even called themselves the Transcendentalists. Borrowing ideas from Kant and from his English followers such as Coleridge and Wordsworth, they developed notions of an order of truth that transcends what we can perceive by our physical senses and which unites the entire world. One of their leading representatives, Ralph Waldo Emerson (1803-1882), underlined the particular importance of the natural world for American writers in his essay "The American Scholar," first published in 1837. In calling for the development of a national literature, Emerson laid down as a necessary condition for its success that his compatriots should draw their inspiration from the wonders of their own country. A few years later he was to write: "America is a poem in our eyes; its ample geography dazzles the imagination, and it will not wait long for metres."

Emerson always tried to make his own work "smell of pines and resound with the hum of insects," but although his ideas have exerted a profound effect on the development of American culture, Emerson was a better thinker than creative artist. Far more successful as a literary practitioner of Transcendentalist principles was Henry David Thoreau (1817–1862), whose masterpiece Walden (1854) uses his day-to-day experiences as he lived in solitude on the shore of Walden Pond to draw general conclusions about the nature of existence. Thoreau's passionate support of the freedom of the individual led him to be active in the antislavery movement and, by the end of his life, he had moved from belief in passive resistance to open advocacy of violence against slavery.

Ideas of freedom, tolerance, and spiritual unity reached their most complete poetic expression in the works of America's first great poet, Walt Whitman (1819–1892). His first important collection of poems was published in 1855 under the title Leaves of Grass. From then until his death he produced edition after edition, retaining the same title but gradually adding many new poems and revising the old ones. Whitman was defiantly, even aggressively, an American poet, yet the central theme of most of his work was the importance of the individual. The contradiction this involves serves as a reminder of the essentially Romantic character of Whitman's mission since, by describing the details of his own feelings and reactions, he hoped to communicate a sense of the essential oneness of the human condition. Much of the time the sheer vitality and flow of his language helps to make his experiences our own, although many of his earlier readers were horrified at the explicit sexual descriptions in some of his poems. Above all, Whitman was a fiery defender of freedom and democracy. His vision of the human race united with itself and with the universe had a special significance for the late twentieth century that continues.

Emily Dickinson (1830-1881) was as private in her life and work as Whitman was public in his. Only seven of her poems appeared in print during her lifetime, and the first complete edition was published as late as 1958. Yet, today, few American poets are better known or better loved. Her work tries to create a balance between passion and the prompting of reason, while her interest in psychological experience appeals to modern readers. Many, too, are attracted by her desire for a secure religious faith, equaled only by her stubborn skepticism. The essential optimism of the Transcendentalists, especially as interpreted by Whitman, is absent from the work of the two great American novelists of the nineteenth century: Nathaniel Hawthorne (1804-1864) and Herman Melville (1819 - 1891).

Hawthorne in particular was deeply concerned with the apparently ineradicable evil in a society dedicated to progress. In *The Scarlet Letter* (1850), his first major success, and in many of his short stories he explored the conflicts between traditional values and the drive for change.

Melville imitated Hawthorne's example in combining realism with allegory and in dealing with profound moral issues. His subjects and style are both very different, however. *Moby Dick* (1851), his masterpiece, is often hailed as the greatest of all American works of fiction. It shares with Goethe's *Faust* the theme of the search for truth and self-discovery, which Melville works out by using the metaphor of the New England whaling industry. Both Melville and Hawthorne were at their greatest when using uniquely American settings and characters to shed light on universal human experience.

American Painting

Under the influence of the Transcendentalists, landscape painting in America took on a new significance. Emerson reminded the artist who set out to paint a natural scene that "landscape has a beauty for his eye because it expresses a thought which to him is good, and this because the same power which sees through his eyes is seen in that spectacle." Natural beauty, in other words, is moral beauty, and both demonstrate the Transcendental unity of the universe.

The earliest painters of landscapes intended to glorify the wonders of nature are known collectively as the Hudson River School. The foundations of their style

VALUES

Nationalism

One of the consequences of the rise of the cities and growing political consciousness was the development of nationalism: the identification of individuals with a nation—state, with its own culture and history. In the past, the units of which people felt a part were either smaller—a local region—or larger—a religious organization or a social class. In many cases, the nations with which people began to identify were either broken up into separate small states, as in the case of the future Germany and Italy, or formed part of a larger state: Hungary, Austria, and Serbia were all under the rule of the Hapsburg Empire, with Austria dominating the rest.

The period from 1848 to 1914 was one in which the struggle for national independence marked political and social life and left a strong impact on European culture. The arts, in fact, became one of the chief ways in which nationalists sought to stimulate a sense of peoples' awareness of their national roots. One of the basic factors that distinguished the Hungarians or the Czechs from their Austrian rulers was their language, and patriotic leaders fought for the right to use their own language in schools, government, and legal proceedings. In Hungary, the result was the creation by Austria of the Dual Monarchy in 1867, which allowed Hungarian speakers to have their own systems of education and public life. A year later, the Hapsburgs granted a similar independence to minorities living there: Poles, Czechs, Slovaks, Romanians, and others.

In Germany and Italy, the reverse process operated. Although most Italians spoke a dialect of the same language, they had been ruled for centuries by a bewildering array of outside powers. In Sicily alone, Arabs, French, Spaniards, and English were only some of the occupiers who had succeeded one another. The architects of Italian unity used the existence of a common language, which went back to the poet Dante, to forge a sense of national identity.

The arts also played their part. Nationalist composers used folktunes, sometimes real and sometimes invented, to underscore a sense of national consciousness. In the visual arts, painters illustrated historical events and sculptors portrayed patriotic leaders. While the newly formed nations aimed to create an independent national culture, the great powers reinforced their own identities. Russian composers turned away from Western models to underline their Slavic roots, while in Britain the artists and writers of the Victorian Age depicted the glories (and, in some cases, the horrors) of their nation.

The consequences of the rise of national consciousness dominated the twentieth century, and are still with us today. The age of world war was inaugurated by competition between nation—states, and the last half of the twentieth century saw the collapse and regrouping of many of the countries created in the first half. Among the casualties are the former Czechoslovakia and Yugoslavia. The struggle of minorities to win their own nationhood remains a cause of bloodshed. The Basques of northern Spain and the Corsican separatists are just two examples. In both cases, language and the arts continue to serve as weapons in the struggle.

were laid by Thomas Cole (1801–1848), born in England, whose later paintings combine grandeur of effect with accurate observation of details. His *Genesee Scenery* [17.30] is particularly successful in capturing a sense of atmosphere and presence.

By mid-century, a new approach to landscape painting had developed. Generally called *luminism*, it aimed to provide the sense of artistic anonymity Emerson and other Transcendentalists demanded. In a way this is the exact antithesis of Romanticism. Instead of sharing with the viewer their own reactions, the luminists tried by realism to eliminate their own presence and let nothing stand between the viewer and the scenes. Yet the results, far from achieving only a photographic realism, have an utterly characteristic and haunting beauty that has no real parallel in European art of the time. The painting

Lake George [17.31] by Martin J. Heade (1819–1904), one of the leading luminists, seems almost to foreshadow the Surrealist art of the twentieth century.

The two great American painters of the latter nineteenth century—Winslow Homer (1836–1910) and Thomas Eakins (1844–1916)—both used the luminist approach to realism as a basis for their own very individual styles. In the case of Homer, the realism of his early paintings was in large measure the result of his work as a documentary artist, recording the events of the Civil War. His style underwent a notable change as he became exposed to contemporary French Impressionist painting (discussed in Chapter 18). His mysterious *Eagle Head* [17.32] is certainly far more than a naturalistic depiction of three women and a dog on a beach. By the way in which he has positioned the figures, Homer suggests

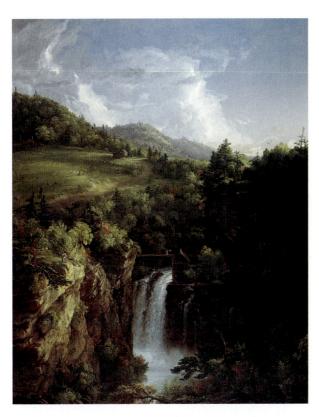

17.30 Thomas Cole. Genesee Scenery (Landscape with Waterfall), 1847. Oil on canvas, $51'' \times 39^{1}/2''$ (1.2 \times 1 m). Museum of Art, Rhode Island School of Design, Providence (Jesse Metcalf Fund). One of Cole's last works, this shows a meticulous care for detail that is never allowed to detract from the broad sweep of the view.

rather than spells out greater emotional depths than initially meet the eye. The sense of restrained drama occurs elsewhere in his work, while the sea became a growing obsession with him and provided virtually the only subject of his last works.

Thomas Eakins used Realism as a means of achieving objective truth. His pursuit of scientific accuracy led him to make a particular study of the possibilities of photography. Animals and, more particularly, humans in motion continually fascinated him. This trait can be observed in *The Swimming Hole* [17.33], where the variety of poses and actions produces a series of individual anatomical studies rather than a unified picture.

In his own day Eakins' blunt insistence on accuracy of perception did not endear him to a public that demanded more glamorous art. Yet if many of his works seem essentially anti-Romantic in spirit, foreshadowing as they do the age of mechanical precision, in his portraits he returns to the Romantic tradition of expressing emotions by depicting them. The sitter in *Miss Van Buren* [17.34], as in most of his portraits, turns her eyes away from us, rapt in profound inner contemplation. The artist's own emotional response to the mood of his subject is made visible in his painting.

Painters such as Homer and Eakins, like Whitman and other writers discussed here, are important in the history of American culture not only for the value of

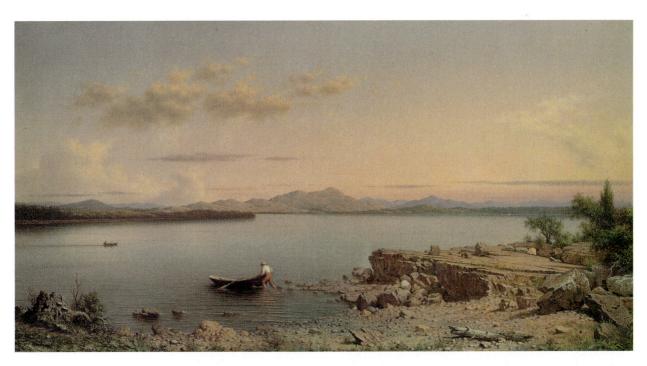

17.31 Martin Johnson Heade. *Lake George*, 1862. Oil on canvas, $26'' \times 49^3/4''$ (68 × 126.3 cm). Museum of Fine Arts, Boston (bequest of Maxim Karolik). Note the smooth surface of the painting, which reveals no trace of the artist's brush strokes, and the extreme precision of the rendering of the rocks at right.

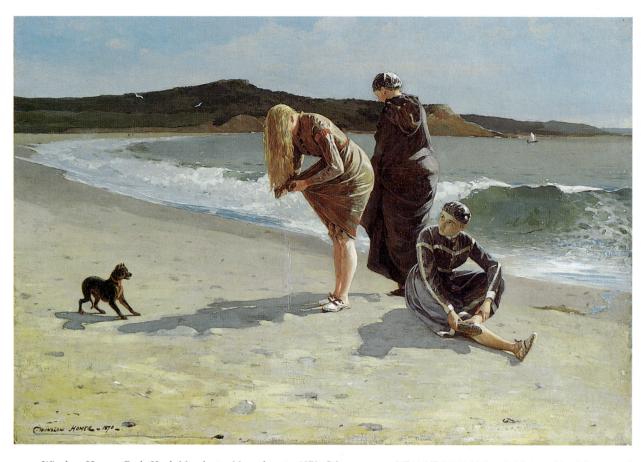

17.32 Winslow Homer. Eagle Head, Manchester, Massachusetts, 1870. Oil on canvas, $26'' \times 38''$ (66×96.5 cm). Metropolitan Museum of Art, New York (gift of Mrs. William F. Milton, 1923). This painting, produced after Homer's visit to France, shows a new, more Impressionistic approach to light and sea.

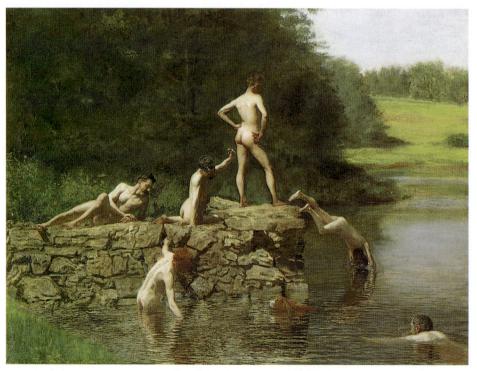

17.33 Thomas Eakins. The Swimming Hole, 1885. Oil on canvas, $27^3/8'' \times 36^3/8''$ $(69.5 \times 92.4 \text{ cm})$. Amon Carter Museum, Fort Worth, Texas, acquired by the Friends of Art, Fort Worth Art Association, 1925. Presented to the Amon Carter Museum, 1990, by the Modern Art Museum of Fort Worth through grants and donations from the Amon G. Carter Foundation, the Sid W. Richardson Foundation, the Anne Burnett and Charles Tandy Foundation, Capital Cities/ABC Foundation, Fort Worth Star-Telegram, The R. D. and Joan Dale Hubbard Foundation, and the people of Fort Worth. Eakins painted figures directly from models placed in poses from Greek sculpture in order to try to see nature as the Greeks saw it, but without the Greeks' idealization. The figure swimming in the bottom-righthand corner is Eakins.

17.34 Thomas Eakins. *Miss Van Buren*, c. 1889–1891. Oil on canvas, $45'' \times 32''$ (114×81 cm). Phillips Collection, Washington, D.C. Note how, in contrast to the portraits by Ingres (Figure 17.18) and Copley (Figure 17.28), Eakins achieves deep feeling and sensitivity by the angle of his subject's head and her position in the chair.

their individual works. Their achievements demonstrated that American society could at last produce creative figures capable of absorbing the European cultural experience without losing their individuality.

SUMMARY

The Rise of Nationalism The revolutionary changes that ushered in the nineteenth century, and that were to continue throughout it, profoundly affected society and culture. The industrialization of Europe produced vast changes in the lifestyles of millions of people. The Greek struggle for independence, the unification of Italy and of

Germany, and the nationalist revolutionary uprisings of 1848 in many parts of Europe all radically changed the balance of power and the nature of society. The same period further saw the gradual assertion of the United States, tested and tried by its own civil war, as one of the leading Western nations. By the end of the nineteenth century, America had not only established itself as a world power, it had also produced artists, writers, and musicians who created works with an authentically American spirit.

Intellectual Ferment: Darwin and Marx A period of such widespread change was naturally also one of major intellectual ferment. The political philosophy of Karl Marx and the scientific speculations of Charles Darwin, influential in their day, remain powerful and controversial in the present. The optimism of Immanuel Kant and Friedrich Hegel and the pessimism of Arthur Schopenhauer were reflected in numerous works of art.

Romanticism in the Arts The artistic movement that developed alongside these ideas was Romanticism. The Romantics, for all their divergences, shared a number of common concerns. They sought to express their personal feelings in their works rather than search for some kind of abstract philosophical or religious "truth." They were attracted by the fantastic and the exotic, and by worlds remote in time—the Middle Ages, or in place—the mysterious Orient. Many of them felt a special regard for nature, in the context of which human achievement seemed so reduced. For some, on the other hand, the new age of industry and technology was itself exotic and exciting. Many Romantic artists identified with the nationalist movements of the times and either supported their own country's fight for freedom (as in the case of Verdi) or championed the cause of others (as did Lord Byron).

Beethoven and His Successors In music the transition from the Classical to the Romantic style can be heard in the works of Ludwig van Beethoven. With roots deep in the Classical tradition, Beethoven used music to express emotion in a revolutionary way, pushing traditional forms like the sonata to their limits. Typical of the age is his concern with freedom, which appears in Fidelio (his only opera), and human unity, as expressed in the last movement of the Ninth Symphony.

Many of Beethoven's successors in the field of instrumental music continued to use symphonic forms for their major works. Among the leading symphonists of the century were Hector Berlioz, Johannes Brahms, and Anton Bruckner. Other composers, although they wrote symphonies, were more at home in the intimate world of songs and chamber music: Franz Schubert and Robert Schumann. The Romantic emphasis on personal feelings and the display of emotion encouraged the development of another characteristic of nineteenth-century music: the virtuoso composer—performer.

Frédéric Chopin, Franz Liszt, and Niccolò Paganini all won international fame performing their own works. The nationalist spirit of the times was especially appealing to musicians who could draw on a rich tradition of folk music. The Russian Modest Moussorgsky and the Czech Bedrich Smetana both wrote works using national themes and folktunes.

Wagner and Verdi The world of opera was dominated by two giants: Giuseppe Verdi and Richard Wagner. The former took the forms of early-nineteenth-century opera and used them to create powerful and dramatic masterpieces. An enthusiastic supporter of Italy's nationalist movement, Verdi never abandoned the basic elements of the Italian operatic tradition—expressive melody and vital rhythm—but he infused these with new dramatic truth. Wagner's quest for "mu-

sic drama" led him in a very different direction. His work breaks with the operatic tradition of individual musical numbers; the music, in which the orchestra plays an important part, runs continuously from the beginning to the end of each act. In addition, the use of leading motifs to represent characters or ideas makes possible complex dramatic effects. Wagner's works revolutionized the development of both operatic and nonoperatic music, and his theoretical writings on music and much else made him one of the nineteenth century's leading cultural figures.

Romanticism and Realism in Nineteenth-Century Painting Just as Beethoven spanned the transition from Classical to Romantic in music, so Francisco Goya, some of whose early works were painted in the rococo style, produced some of the most powerful of Romantic paintings. His concern with justice and liberty, as illustrated in Execution of the Madrileños on May 3, 1808 and with the world of dreams, as in The Sleep of Reason Produces Monsters, was prototypical of much Romantic art.

In France, painters were divided into two camps. The fully committed Romantics included Théodore Géricault, also concerned to point out injustice, and Eugène Delacroix, whose work touched on virtually every aspect of romanticism: nationalism, exoticism, eroticism. The other school was that of the Realists. Honoré Daumier's way of combating the corruption of his day was to portray it as graphically as possible. In the meantime, Ingres waged his campaign against both progressive movements by continuing to paint in the academic Neo-Classical style of the preceding century or at least his version of it.

The World of Nature Painters in England and Germany were particularly attracted by the Romantic love of nature. Caspar David Friedrich used the grandeur of the natural world to underline the transitoriness of human achievement, while in John Constable's landscapes there is greater harmony between people and their surroundings. Joseph M. W. Turner, Constable's contemporary, falls into a category by himself. Although many of his subjects were Romantic, his use of form and color make light and movement the real themes of his paintings.

From Neo-Classicism to Romanticism in Literature: Goethe In literature no figure dominated his time more than Johann Wolfgang von Goethe, the German poet, dramatist, and novelist. One of the first writers to break the fetters of Neo-Classicism, he nonetheless continued to produce Neo-Classical works as well as more Romantic ones. The scale of his writings runs from the most intimate love lyrics to the monumental two parts of his Faust drama.

The Romantic Poets and the Novel The work of the English Romantic poets William Wordsworth, Percy Bysshe Shelley, John Keats, and Lord Byron touched on all the principal Romantic themes. Other English writers

used the novel as a means of expressing their concern with social issues, as in the case of Charles Dickens, or their absorption with strong emotion, as did Emily Brontë. Indeed, the nineteenth century was the great age of the novel, with Honoré de Balzac and Gustave Flaubert writing in France and above all Leo Tolstoy in Russia.

The Nineteenth Century in America The Romantic Era was the first period in which American artists created their own original styles rather than borrow them from Europe. Love of nature inspired writers like Henry David Thoreau and painters like Thomas Cole. The description of strong emotions, often personal ones, characterizes the poetry of Walt Whitman and many of the paintings of Winslow Homer. Thomas Eakins, with his interest in Realism, made use of a nineteenth-century invention that had an enormous impact on the visual arts: photography.

By the end of the century the audience for art of all kinds had expanded immeasurably. No longer commissioned by the church or the aristocracy, artworks expressed the hopes and fears of individual artists and of humanity at large. Furthermore, as the revolutionaries of the eighteenth century had dreamed, they had helped bring about social change.

Pronunciation Guide

Bal-ZAK Balzac: Berlioz: **BARE-li-owes** Bruckner: **BROOK-ner** Chios: KEY-08 Chopin: Show-PAN Coor-BAY Courbet: Daumier: Doe-MYAY Delacroix: De-la-KRWA **ACHE-ins** Eakins; Fidelio: Fi-DAY-li-owe Géricault: Jay-rick-OWE Goethe: **GUR-te** Ingres: **ANG** Kant: **CANT**

leitmotiv: LITE-mow-teef Liebestod: LEE-bis-tote

Liszt: LIST

Moussorgsky:Mus-ORG-skiNabucco:Na-BOO-koSardanapalus:Sar-dan-AP-al-usscherzo:SCARE-tsowSchopenhauer:SHOWP-en-how-er

Thoreau: Thoh-ROW
Traviata: Tra-vi-AH-ta
Wagner: VAHG-ner
Waldstein: VALD-stine

EXERCISES

- 1. Analyze the elements of the Romantic style and compare its effect on the various arts.
- Discuss the career of Beethoven and assess his influence on the development of music in the nineteenth century.
- 3. What were the principal schools of French Romantic painting? Who were their leaders? What kinds of subjects did they choose? Explain why.
- 4. Which factors—historical, cultural, social—favored the popularity of the novel in the nineteenth century? How do they compare to present conditions? What is the current status of the novel?
- 5. Discuss the American contribution to the Romantic movement.

FURTHER READING

- Ackroyd, P. (1991). *Dickens*. London: Minerva Press. A magnificently realized rounded portrait of the great novelist by an author who is himself one of the leading novelists of our times.
- Cairns, D. (1989). *Berlioz: The making of an artist.* London: Sphere Books. See comments below.
- Cairns, D. (1999). Berlioz: Servitude and greatness. New York: Penguin. In this book and its predecessor (see above), Cairns provides an astonishingly vivid picture of nineteenth-century cultural life. We meet several figures including Delacroix and Ingres, Flaubert and George Sand, and musicians Rossini, Verdi, and Wagner.
- Chissell, J. (1983). Clara Schumann: A dedicated spirit. London: Hamish Hamilton. An absorbing biography of a woman whose life was divided between her composer-husband and her own career as performer (pianist) and composer.
- Clark, K. (1986). The Romantic rebellion. New York: Harper & Row. The latest edition of a magisterial survey of the Romantic movement, plentifully illustrated.
- Cooper, M. (1985). Beethoven: The last decade. New York: Oxford University Press. An unusually detailed study of the events and compositions of Beethoven's final years, with an interesting appendix on his medical history.
- Davidoff, L., & C. Hall. (1991). Family fortunes: Men and women of the English middle class, 1780–1850. Chicago: University of Chicago Press. An important study of social developments during a crucial period in the evolution of the modern world.
- Eisenmann, S. E. (1994). *Nineteenth-century art: A critical history*. New York: Thames & Hudson. A good general survey; excellent illustrations.
- Gage, J. (Ed. and Trans.). (1980). Goethe on art. Berkeley: University of California Press. This book contains many of Goethe's observations on art and throws considerable light on the poet's own work.
- Kemp, T. (1985). *Industrialization in nineteenth-century Europe*. London: Longman. A survey of the effects of the Industrial Revolution on the chief European powers.
- Kerman, J., & A. Tyson. (1983). Beethoven. London: Macmillan. Based on the entry in the New Grove Dictionary of Music, this provides a great deal of information, including a complete catalogue of Beethoven's works.
- Miller, A. L. (1993). *The empire of the eye: Landscape representation and American colonial politics*. Ithaca, NY: Cornell University Press.

Paulson, R. (1982). *Literary landscape: Turner and Constable*. New Haven, CT: Yale University Press. A cross-discipline study, this difficult but rewarding work attempts to "read" the landscape paintings of Turner and Constable by finding literary meanings for them.

Tanner, M. (1996). Wagner. New York: HarperCollins. Perhaps the best short introduction to the man and his

music.

ONLINE CHAPTER LINKS

Extensive Internet resources are listed at Kant on the Web

http://www.hkbu.edu.hk/~ppp/Kant.html

The Karl Marx and Fredrick Engels Internet Archive http://csf.colorado.edu/mirrors/marxists.org/archive/marx/

provides links to biography, works, letters, and images available on the Internet.

The Classical Music Pages entry for Ludwig von Beethoven

http://w3.rz-berlin.mpg.de/cmp/beethoven.html provides a biography and picture gallery, plus an extensive listing of the composer's works.

The Berlioz Society Home Page at

http://www.standrews.u-net.com/BerliozSociety.html provides a wide range of information, with numerous links to additional Internet resources.

Two valuable Chopin Web sites are found at http://www.geocities.com/Vienna/4279/ which includes a brief biography, photographs, and a MIDI collection and

http://www.prs.net/chopin.html which features an extensive MIDI collection.

For further information about Verdi, consult http://www.classical.net/music/comp.lst/verdi.html which provides links to biographies, lists of compositions, and critical opinions of his works.

The Richard Wagner Archive at http://users.utu.fi/hansalmi/wagner.spml and Wagner Resources on the Internet at http://home.no.net/wagner/links.html examine a wide range of topics, including biography, his operas and letters, and art inspired by his compositions.

A virtual tour of Goya's works in Washington's National Portrait Gallery is available at http://www.nga.gov/collection/gallery/gg52/gg52-main1.html

Among the Internet sites devoted to Emily Dickinson is *The Emily Dickinson International Society* at http://www.cwru.edu/affil/edis/edisindex.html

The Dickinson Homestead at

http://www.dickinsonhomestead.org

includes a history of where Dickinson lived all but fifteen years of her life.

Mary Wollstonecraft and Mary Shelley: Writing Lives at

http://www.ucalgary.ca/UofC/Others/CIH/ WritingLives/WLMSlinks.html

offers links to a variety of biographies, primary and secondary sources, and filmographies related to *Frankenstein*.

Valuable resources related to Lord Byron are available at *The Lord Byron Home Page* at

http://www.lordbyron.ds4a.com

and Lord Byron: A Comprehensive Study of His Life and Works at

http://englishhistory.net/byron.html

The Wordsworth Trust at

http://www.wordsworth.org.uk/

provides offers a variety of information, focusing on the poet and his circle, their lives and their works, and also includes preservation efforts related to Dove Cottage.

Among the Internet resources related to Charles Dickens are *The Dickens Project* at

http://humwww.ucsc.edu/dickens/index.html
Charles Dickens at

http://www.helsinki.fi/kasv/nokol/dickens.html and Gad's Hill Place at

http://www.perryweb.com/Dickens/

A virtual tour of London's Dickens House Museum is available at

http://www.rmplc.co.uk/orgs/dickens/DHM/DHM2/index.html

A wide range of information about Transcendentalism—the movement, its members, and their successors—is available at

http://www.transcendentalists.com

Valuable Internet resources related to Henry David Thoreau are available at *The Thoreau Home Page*

http://www.walden.org/thoreau/Default.asp and The Thoreau Reader

http://www.eserver.org/thoreau/

A thorough examination of Walt Whitman and his works is available at

http://jefferson.village.virginia.edu/whitman/

The Life and Works of Herman Melville at http://www.melville.org/ offers a wide variety of links to Internet resources related to Herman Melville.

Wm. Blake's Life at

http://www.vu.union.edu/~blake/life.html offers a biography and then addresses Blake as an artisan, writer, and thinker.

For a catalog of useful links to Internet resources, consult *Romantic Music Links* at http://classicalmus.hispeed.com/romantic.html

For introductory information about Neoclassic art as well as links to sites related to representative artists, consult *Artcyclopedia* at

http://www.artcyclopedia.com/history/ neoclassicism.html

Karadar Classical Music at

http://www.karadar.it/Dictionary/Default.htm provides an alphabetical listing of musicians with brief biographies and a list of works (some of which are available on MIDI files). 1860

GROWTH OF BIG BUSINESS

1876 Speech first transmitted through telephone by Alexander Graham Bell

1880-1914 Height of European colonialism

1886 Dedication of Statue of Liberty, presented by France to America

1889 International League of Socialist Parties founded

1866 Dostoyevsky, Crime and Punishment

1870-1914 New areas explored in writing: impact of subconscious on human behavior, the role of women

1879 First performance of Ibsen's realistic drama, A Doll's House

1881 Death of Dostoyevsky

1883 - 1892 Nietzsche, Thus Spoke Zarathustra

1863 Manet exhibits Le Déjeuner sur l'Herbe to public outrage

1869-1872 Degas, Degas' Father Listening to Lorenzo Pagans Singing

1874 Impressionism emerges when Monet and others exhibit at Café Guerbois, Paris; Impression: Sunrise (1872)

1875 Monet, Red Boats at Argenteuil 1876 Renoir, Le Moulin de la Galette

c. 1880 Postimpressionists reject impressionism

1882 Manet, A Bar at the Folies-Bergère

1884-1886 Seurat, A Sunday on La Grande Jatte

c. 1885 Protocubist experiments of Cézanne; Still Life with Commode

1886 Rodin, The Kiss; Degas, The Tub 1888 van Gogh, The Night Café

1889 van Gogh, The Starry Night; Cassatt, Mother and Child

1890

COLONIALISM EUROPEAN

1900

HEIGHT OF

1890-1914 Industrialization of Russia

1891 Shaw, drama critic for Saturday Review, champions Ibsen

1893 Wilde, Salome

1894 Kate Chopin, The Story of an Hour

1899 Kate Chopin, The Awakening

1900 Freud,

of Dreams

1891 Gauguin, Ia Orana Maria; Mary Cassatt's first solo exhibition in

1893 Munch, The Scream; Rodin begins Monument to Balzac

1894–1898 Kollwitz, March of the Weavers, etching based on Hauptmann play

1899-1902 Boer War

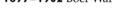

1901 Death of Queen Victoria of England; reign of Edward VII begins; first message sent over Marconi's transatlantic wireless telegraph

1903 Wright brothers make first airplane flight

1904 Russo-Japanese War

1905 First Revolution breaks out in Russia; Einstein formulates theory of relativity; first motion-picture theater opens in Pittsburgh

Chekov

1904 Death of

1911 Revolution in China establishes republic

1914 World War I begins

c. 1904-1906 Cézanne paints last series of landscapes depicting Mont Sainte-Victoire

1903 – 1913 German expressionist movement Die Brücke

1905 First Fauve exhibition in Paris; Matisse, The Joy of Life (1905–1906)

1907-1914 Picasso and Braque develop cubism in Paris

1911 Matisse, The Red Studio; German expressionist group Der Blaue Reiter formed

1914

RISE OF GERMAN MILITARY POWER

CHAPTER 18 TOWARD THE MODERN ERA: 1870-1914

ARCHITECTURE

Music

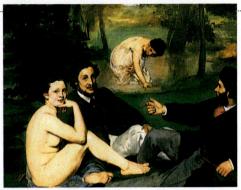

1883 Birth of Gropius

mid-19th cent. Liszt's symphonic poems precursors of program music

1893 Tchaikovsky, Pathetique

in D marks transition from

romantic to modern music 1894 Debussy, musical impressionist, composes Prélude à l'après-midi d'un

1895 R. Strauss, Till Eulenspiegel 1896 Puccini champions verismo in Italian opera; La Bohème 1899 R. Strauss, A Hero's Life

Symphony, precedes composer's suicide. Mahler's Symphony No. 1

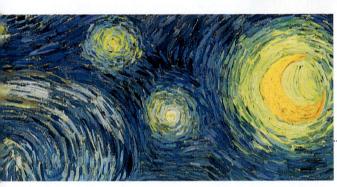

1890-1891 Sullivan, St. Louis, first

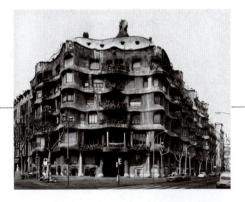

Wainwright Building, skyscraper

> 1900-1904 Puccini, Tosca; Madama Butterfly

1905 First performance of R. Strauss' opera Salome, based on Wilde's play; Debussy, La Mer

1908 Schönberg, Three Piano Pieces, Op. 11, first major atonal work

1909-1910 Mahler, Symphony No. 9

1910-1913 Stravinsky composes The Firebird, Petrouchka, Rite of Spring for Diaghilev's Ballet Russe in Paris

1911-1915 R. Strauss, Alpine Symphony

1912 Schönberg, Pierrot Lunaire

1913 Ravel composes Daphnis and Chloe for Diaghilev

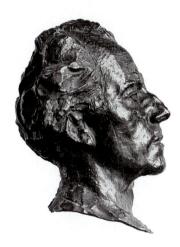

1909 Nolde, Pentecost; Rodin, Portrait of Mahler

1912 Heckel, Two Men at a Table (To Dostoyevsky)

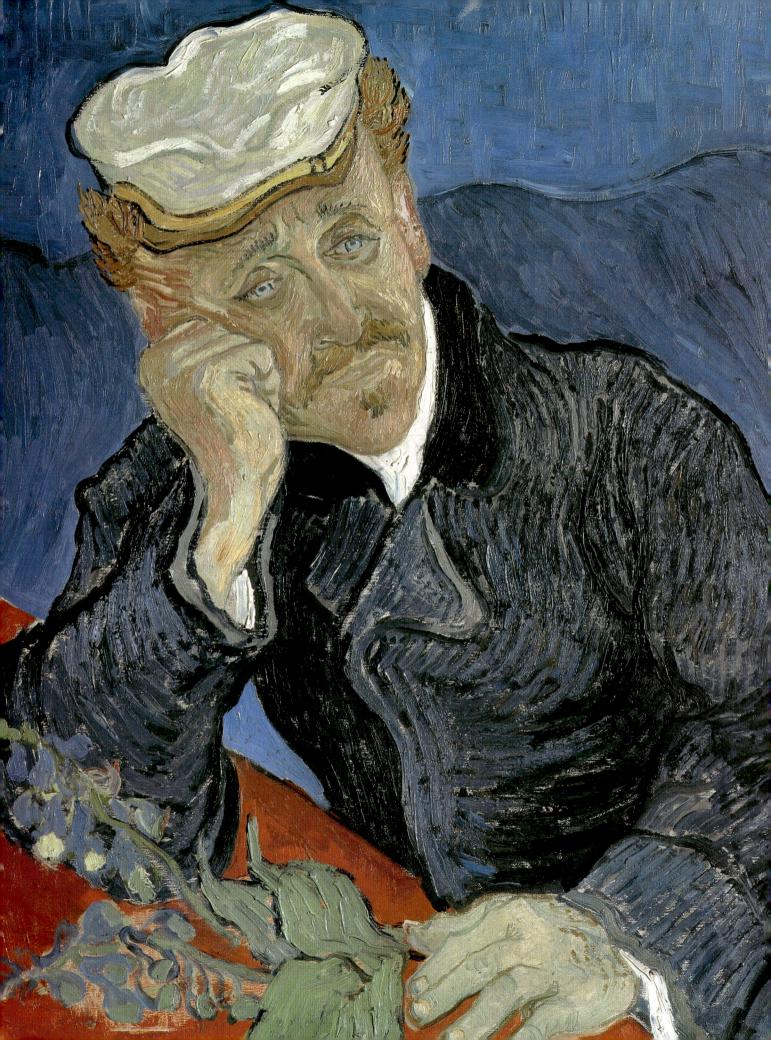

CHAPTER 18

TOWARD THE MODERN Era: 1870-1914

The more intimately we are affected by events, the more difficult it is to evaluate them objectively. Looking back, we can see that the world in which we live—with its great hopes and even greater fears—began to take its present shape in the early years of the twentieth century. World War I (1914–1918) marked an end to almost three thousand years of European political and cultural supremacy as well as the beginning of a world in which events in any corner of the globe could—and still do—have immense consequences for good or ill for the entire human race. The effects on the humanities of so vast a change in direction are the subject of Chapters 21 and 22. Here we will consider some of the causes and early symptoms of the change.

Although the period in which the modern world was formed is the historical era that directly affects our daily lives, our cultural traditions go back to ancient Greece and Rome. Yet even if the cataclysmic events of the twentieth century did not destroy the value of centuries of accumulated experience, we naturally feel more intimately linked to the generation of our parents and grandparents than to the more distant generations of ancestors of which we are also the product. Nevertheless, our parents and grandparents are the very people whose nearness to us in time and emotional impact makes them and their world more difficult to understand objectively.

Our own responses to the increasing complexity of historical forces during the formative stages of modern culture are still so confused that it is helpful to turn to the reactions of individual artists and thinkers who themselves lived through the times and can to some extent interpret them to us. Further, within the relatively limited sphere of artistic creativity we can observe at work forces that also operated on a much larger scale. As so often in the history of Western civilization, the arts provide a direct and powerful, if incomplete, expression of the spirit of an age. It may even be that the enduring importance of the humanities as a reflection of the human condition is one of the few aspects of Western civi-

lization to survive a century of global turmoil, and help us now in the twenty-first century.

THE GROWING UNREST

By the last quarter of the nineteenth century there was a widespread if unfocused feeling in Europe that life could not continue as before. Social and political revolutions had replaced the old monarchies with more nearly equitable forms of government. Scientific and technological developments had affected millions of ordinary people, bringing them improved standards of living and a more congenial existence. As a result, a new mood of cheerfulness began to make itself felt in the great cities of Europe; in Paris, for example, the period became known as the belle époque ("beautiful age").

But the apparent gaiety was only superficial. The price of the immense changes that made it possible had been unrest and violence, and the forces that had been built to achieve them remained in existence. Thus, in a period of nominal peace, most of the leading countries in Europe were maintaining huge armies and introducing compulsory military service. Long before 1914, a growing mood of frustration led many people to assume that sooner or later war would break out—a belief that certainly did not help to avert it [18.1].

The many historical causes of this mood are beyond the scope of this book, but some of the more important underlying factors are easy enough to perceive. First, the growth of democratic systems of government had taught increasing numbers of people that they had a right to share in the material benefits made possible by the Industrial Revolution. Discontent grew on all sides. In the richest countries in Europe—France, England, and Germany—the poor compared their lot to that of the more affluent. Simultaneously, in the poorer European countries, including Ireland, Spain, Portugal, and all of Eastern Europe, everyone looked with envy toward their wealthier neighbors. Even more significantly, those vast continents that the empire-building European powers

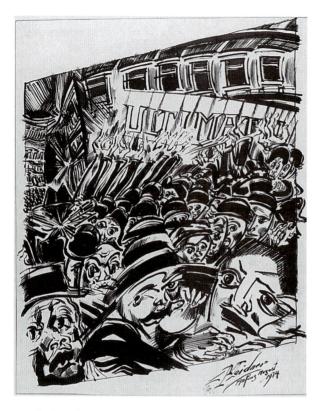

18.1 Ludwig Meidner. *The Eve of War,* 1914. Stadtische Kunsthalle, Recklinghausen. The distorted faces and violent, heaving composition reflect the spirit of a world on the point of collapse.

were introducing to European civilization for the first time, including parts of Africa, Asia, and South America, began increasingly to resent European domination.

Second, the scientific progress that made possible improvements in people's lives created problems of its own. New medical advances reduced the rate of infant mortality, cured hitherto fatal diseases, and prolonged life expectancy. As a result, populations in most of Europe soared to record levels, creating food and housing shortages. New forms of transport and industrial processes brought vast numbers of workers to the cities. Consequently, the lives of many people were uprooted and their daily existence became anonymous and impersonal.

Third, the growth of a world financial market, primarily dependent upon the value of gold, gave new power to the forces of big business. In turn, the rise of capitalism, fiercely opposed by the growing forces of socialism [18.2], provoked the development of trade unions to protect the interests of the workers.

Finally, at a time when so many political and social forces were pitted against one another there seemed to be no certainty on which to fall back. Religion had lost its hold over intellectual circles by the eighteenth century and, by the end of the nineteenth century, strong religious faith and its manifestation in church attendance began to fall drastically at all levels of society. The newly developing fields of anthropology and psychology, far from replacing religion, provided fresh controversy with their radically different explanations of human life and behavior.

18.2 Käthe Kollwitz. March of the Weavers, from The Weavers Cycle, 1897. Etching, $8^3/8'' \times$ $11^{5/8}$ " (21 × 29 cm). University of Michigan Museum of Art, Ann Arbor, 1956/1.21. This print is based on a play, The Weavers, by the German playwright Gerhart Hauptmann (1862-1946) dealing with the misery and helplessness of both workers and owners in the industrial age. The axes and mattocks in the workers' hands point to the coming violence.

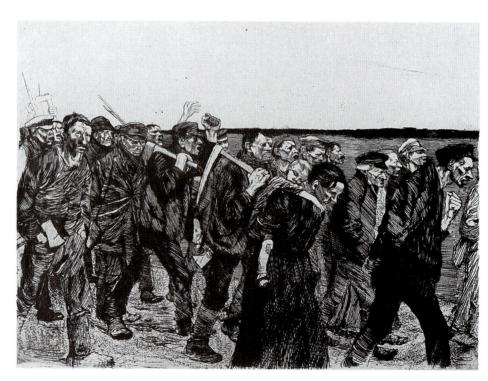

In a state of such potential explosiveness it is hardly surprising that a major collapse of the fabric of European civilization seemed inevitable. Only in America, where hundreds of thousands of Europeans emigrated in the hope of making a new start, did optimism seem possible [18.3]. Events were moving at so fast a pace that few thinkers were able to detach themselves from their times

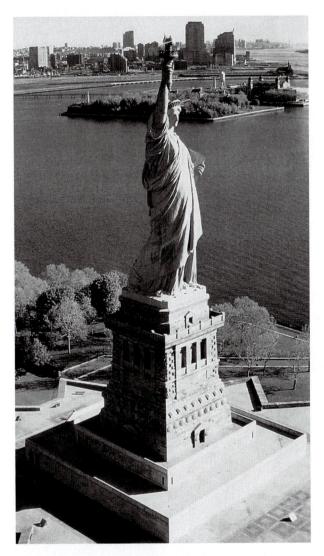

18.3 Frédéric-Auguste Bartholdi. Statue of Liberty (Liberty Enlightening the World). Constructed and erected in Paris, 1876–1884; disassembled, shipped to New York, re-erected, dedicated 1886. Hammered copper sheets over iron trusswork and armature; height of figure 151' (46 m), total height, including pedestal, above sea level 306' (93 m). This famous monument, which still dominates New York's harbor, became the symbol to European immigrants in the late nineteenth century of the welcome they would find in the New World. The colossal statue (the head alone is 13'6", or 4.4 m, high) was a gift from France to the United States. It was designed by the French sculptor Frédéric-Auguste Bartholdi (1834–1904); its supporting framework was designed by the French engineer Gustave Eiffel (1832–1923), known mainly for his Eiffel Tower in Paris, France's national monument, completed in 1889.

and develop a philosophical basis for dealing with them. One of the few who did was Friedrich Wilhelm Nietzsche (1844–1900), whose ominous diagnosis of the state of Western civilization in *Thus Spoke Zarathustra* (1883–1892) and other works led him to propose drastic remedies.

http://www.dartmouth.edu/%7Efnchron/

Nietzsche

For Nietzsche, Christianity was a slave religion, extolling feeble virtues such as compassion and selfsacrifice, the greatest curse of Western civilization. He viewed democracy as little better, calling it the rule of the mediocre masses. The only valid life force, according to Nietzsche, is the "will to power"; that energy that casts off all moral restraints in its pursuit of independence. Anything that contributes to power is good. Society can only improve if strong and bold individuals who can survive the loss of illusions, by the free assertion of the will, establish new values of nobility and goodness. Nietzsche called this superior individual an Übermensch (literally "overperson"). Like Schopenhauer in the early nineteenth century (see Chapter 17), Nietzsche is valuable principally for the way in which he anticipated future ideas rather than because he was the leader of a movement. Unfortunately, his concepts were later taken up and distorted by many would-be world rulers of the twentieth century, most notoriously the leaders of Nazi Germany.

Cut adrift from the security of religion or philosophy, the arts responded to the restless mood of the times by searching for new subjects and styles. Often these subjects and styles challenged principles that had been accepted for centuries. In music, traditional concepts of harmony and rhythm were first radically extended and then, by some composers at least, completely discarded. In literature, new areas of experience were explored, including the impact of the subconscious on human behavior, and traditional attitudes like the role of women were examined afresh. In the visual arts, the Impressionists found a totally new way of looking at the world, which in turn opened up other exciting new fields of artistic expression. Whatever their defects, the formative years of the modern world were certainly not dull with respect to the arts.

New Movements in the Visual Arts

Something of the feverish activity in the visual arts during this period can be gauged by the sheer number of

movements and styles that followed one another in rapid succession: Impressionism, post-Impressionism, Fauvism, Expressionism, culminating in the birth of Cubism around the time of World War I. Cubism is discussed in Chapter 21 because of its effects on the whole of

twentieth-century art, but all the other movements form important stages in the transition from traditional artistic styles to present-day art, much of which rejects any attempt at Realism in favor of abstract values of line, shape, and color. An understanding of their significance is thus a

18.4 Édouard Manet. *Le Déjeuner sur l'Herbe*, 1863. Oil on canvas, $7'^3/_4'' \times 8'10^3/_8''$ (2.15 \times 2.7 m). Musée d'Orsay, Paris. Manet probably based the landscape on sketches made outdoors but painted the figures from models in his studio, something a careful look at the painting seems to confirm.

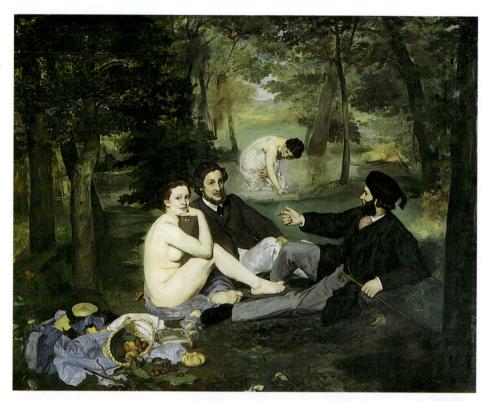

18.5 Édouard Manet. *A Bar at the Folies-Bergère*, 1882. Oil on canvas, approx. $37" \times 51"$ (.95 \times 1.3 m). The Courtauld Institute Galleries, London (Courtauld Collection). Note the very Impressionistic way in which Manet painted the girl's top-hatted customer, reflected in the mirror at right.

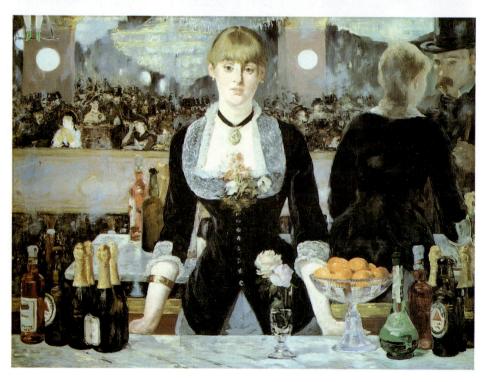

necessary prerequisite for a full appreciation of modern abstract art. Quite apart from their historical interest, however, the artistic movements of the late nineteenth and twentieth centuries have much visual pleasure to offer.

As so often in the past, the center of artistic activity was Paris, where Édouard Manet (1832-1883) created a sensation in 1863 with his painting Le Déjeuner sur l'Herbe (Luncheon on the Grass) [18.4]. Public outcry was directed against the subject of the painting: a female nude among two fully clothed young men and another clothed female figure. Other artists had combined nude females and clothed males before in a single picture, but Manet's scene has a particular air of reality; the way the unclad young woman stares out from the canvas and the two smartly dressed young men appear nonchalantly indifferent to her condition can still take the spectator by surprise. The true break with tradition, however, lay not in the picture's subject but its style. The artist is much less interested in telling us what his characters are doing than in showing us how he sees them and their surroundings. Instead of representing them as rounded, threedimensional forms, he has painted them as a series of broad, flat areas in which the brilliance of color is unmuted. In creating this style, Manet laid the philosophical foundations that made Impressionism possible.

The massive, almost monumental human form reappears in one of Manet's last paintings, *A Bar at the Folies-Bergère* of 1882 [18.5], where the barmaid amid her bot-

tles and dishes presents the same solid appearance as the nude in *Déjeuner*. If we glance over her shoulder, however, and look into the mirror as it reflects her back and the crowded scene of which we have temporarily become a part, the style changes. The sharp outlines and fully defined forms of the foreground are replaced by a blur of shapes and colors that conveys the general impression of a crowded theater without reproducing specific details. A comparison between the background of the two pictures makes it clear that between 1863 and 1881 something drastic had occurred in the way painters looked at scenes and then reproduced them.

Impressionism

http://www.ibiblio.org/wm/paint/glo/impressionism/

Impressionism

In 1874, a group of young artists organized an exhibition of their work during conversations at the Café Guerbois in Paris. Their unconventional approach to art and their contempt for traditional methods meant that normal avenues of publicity were closed to them; they hoped that the exhibition would succeed in bringing their work to public attention. It certainly did! One of the paintings, *Impression: Sunrise* [18.6] by Claude Monet (1840–1926),

18.6 Claude Monet. *Impression:* Sunrise, 1872. Oil on canvas, $19^1/2^n \times 14^1/2^n$ (50×62 cm). Musée Marmottan, Paris. Although this was the painting after which the Impressionist movement was named, its use of Impressionistic techniques is relatively undeveloped compared to Figure 18.7 and Figure 18.8.

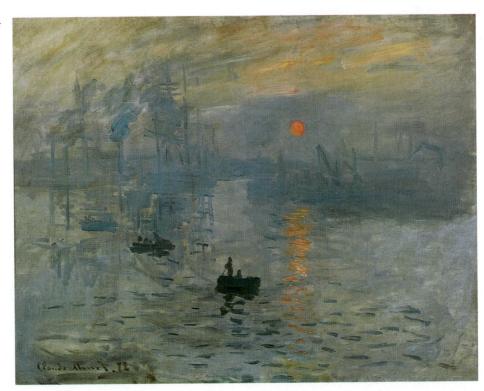

particularly scandalized the more conventional critics, some of whom derisively borrowed its title and nick-named the whole group "Impressionists." Within a few years the Impressionists had revolutionized European painting.

Although Impressionism seemed at the time to represent a radical break with the past, it first developed out of yet another attempt to achieve greater realism, a tradition that had begun at the dawn of the Renaissance with Giotto. The Impressionists concentrated, however, on realism of light and color rather than realism of form and sought to reproduce—with utmost fidelity—the literal impression an object made on their eyes. If, for example, we look at a house or a human face from a distance, we automatically interpret it on the basis of our mental knowledge, and "see" details that are not truly visible. Impressionist painters tried to banish all such interpretations from their art and to paint with an

"innocent eye." In *Red Boats at Argenteuil* [18.7] Monet recorded all the colors he saw in the water and the reflections of the boats without trying to blend them together conventionally (or intellectually). The result is not a painting of boats at anchor but a representation of the instantaneous impact on the eye of the lights and colors of those boats; that is, what the artist saw rather than what he knew.

Throughout his long career, Monet retained a total fidelity to visual perception. His fellow painter Paul Cézanne (1839–1906) is said to have called him "only an eye, but my God what an eye!" Monet's preoccupation with the effects of light and color reached its most complete expression in his numerous paintings of water lilies in his garden. In version after version he tried to capture in paint the effect of the shimmering, ever-changing appearance of water, leaves, and blossoms. The result, as in the *Water Lilies* of 1920–1921 [18.8], reproduces not so

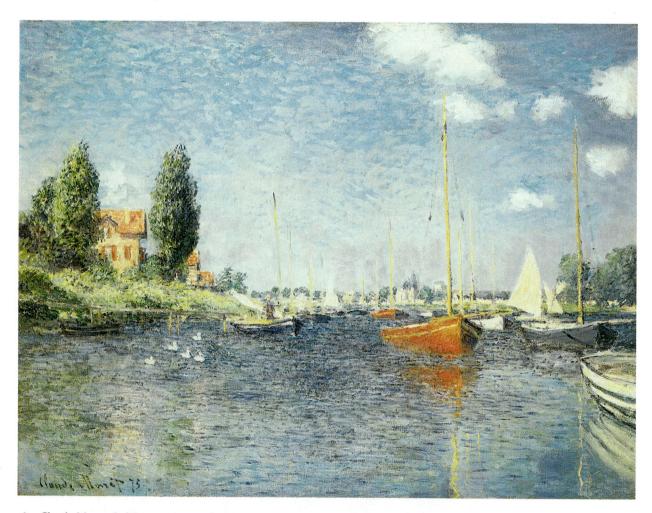

18.7 Claude Monet. Red Boats at Argenteuil, 1875. Oil on canvas, $24'' \times 32^3/8''$ (61.9 × 82.4 cm). Courtesy of the Harvard University Art Museum. Fogg Art Museum (bequest—Collection of Maurice Wertheim, Class of 1906). Painted the year after the first Impressionist exhibition in Paris, this shows Monet's characteristic way of combining separate colors to reproduce the effect of light.

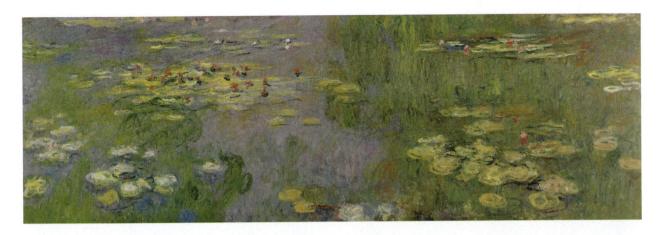

18.8 Claude Monet. Nymphéas (Water Lilies), 1920–1921. Oil on canvas, 6'6" × 19'7" (1.98 × 5.97 m). The Carnegie Museum of Art, Pittsburgh (acquired through the generosity of Mrs. Alan M. Scaife, 1962). This is one of a number of huge paintings (in this case almost 20' long) that Monet produced in the garden of his house in Giverny. Note the contrast with his Red Boats at Argenteuil of forty-five years earlier (Figure 18.7); in Water Lilies there is a very different attitude to realism of form. The greatly enlarged detail at right gives an idea of Monet's technique—one that looks simple at first glance but actually results from many separate, complex decisions. In every case, the artist was guided by purely visual factors rather than formal or intellectual ones.

much the actual appearance of Monet's lily pond as an abstract symphony of glowing colors and reflecting lights. Paradoxically, the most complete devotion to naturalism was to pave the way for abstraction and for what we know as "modern art."

Monet's art represents Impressionism in its purest form. Other painters, while preserving its general principles, devised variants on it. Pierre Auguste Renoir (1841-1919) shared Monet's interest in reproducing the effects of light in patches of color, but he brought to his subjects a human interest that derived from his own joy in life. It is a refreshing change, in fact, to find an artist whose work consistently explored the beauty of the world around him rather than the great problems of human existence. Neither was Renoir's interest limited, as was Monet's, to the wonders of nature. His most enduring love was for women as symbols of life itself; in his paintings, they radiate an immense warmth and charm. His painting of Le Moulin de la Galette [18.9], a popular Parisian restaurant and dance hall, captures the spirit of the crowd by means of the same fragmentary patches of color Manet used in the background of A Bar at the Folies-Bergère (see Figure 18.5), but Renoir adds his own sense of happy activity. The group in the foreground is particularly touching, with its sympathetic depiction of adolescent love. The boy leans impetuously forward, while the girl who has attracted his attention leans back and looks gravely yet seductively into his face, restrained by the protective arm of an older companion. Although the encounter may be commonplace, Renoir endows it with a significance and a humanity far different from Monet's more austere, if more literal, vision of the world by setting it against the warmth and movement of the background.

Unlike many other Impressionists, Renoir traveled widely throughout Europe in order to see the paintings of the great Renaissance and Baroque masters. The influence of artists like Raphael, Velázquez, and Rubens is visible in his work. This combination of an Impressionistic approach to color with a more traditional attitude to form and composition emerges in *Two Girls at the Piano* [18.10], where the girls' arms have a genuine sense of roundness and weight. This painting is no mere visual exercise—Renoir endows his figures with a sense of self-assurance that only emphasizes their vulnerability.

The artist Edgar Hilaire Germain Degas (1834–1917) shared Renoir's interest in people, but unlike Renoir (who emphasized the positive side of life) he simply reported what he saw, stressing neither the good nor the bad. By showing us intimate moments in other people's

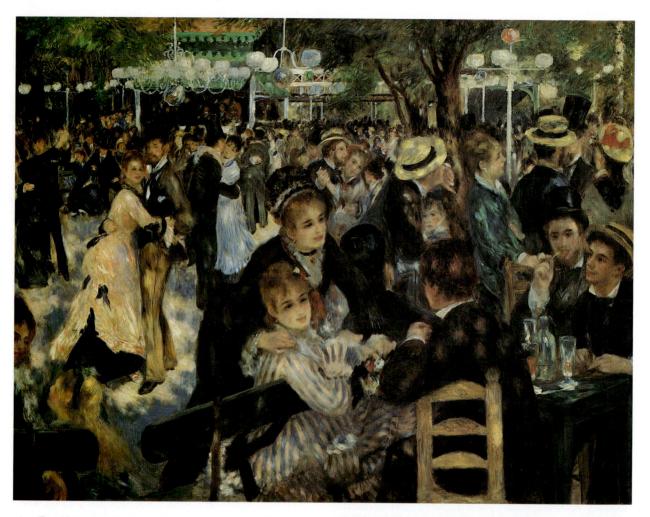

18.9 (Pierre) Auguste Renoir. *Le Moulin de la Galette,* 1876. Oil on canvas, approx. $51'' \times 68''$ (129. 5×172 . 7 cm). Louvre, Paris. By using small patches of color, Renoir achieves the impression of dappled sunlight filtering through the trees.

lives, revealed by a momentary gesture or expression, his frankness, far from being heartless, as some of his critics have claimed, conveys the universality of human experience. Although Degas exhibited with the Impressionists and, like them, chose to paint scenes from the everyday events of life, his psychological penetration distinguishes his art from their more literal approach to painting. Even the Impressionist principle of capturing a scene spontaneously, in action, becomes in Degas' hands a powerful means of expression. One of the themes he turned to again and again was ballet, perhaps because of the

18.10 (Pierre) Auguste Renoir. *Two Girls at the Piano*, 1892. Oil on canvas, $45^{1}/_{2}^{"} \times 34^{1}/_{2}^{"}$ (116×90 cm). Musée d'Orsay, Paris. The position of the two girls, one leaning forward and resting her arm on the shoulder of the other, is almost exactly the same as that of the woman and the girl in the center of Figure 18.9; this position seems to have appealed to Renoir as a gesture of affection.

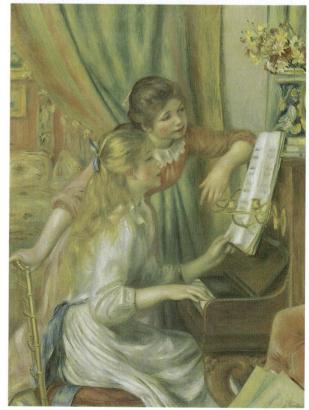

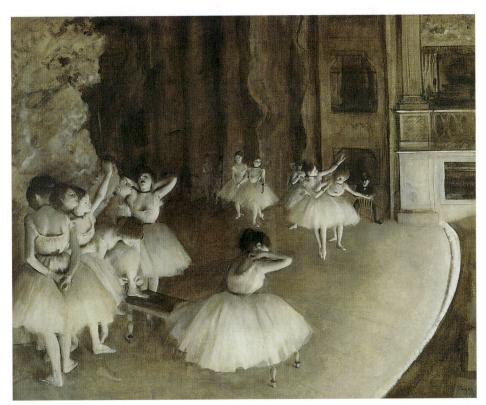

18.11 Edgar Degas. *The Rehearsal*, 1874. Oil on canvas, $26'' \times 32^{1}/4''$ (66 × 82 cm). Musée d'Orsay, Paris. Degas' careful observation extends even to the director of the ballet troupe at the right-hand edge of the stage, hat almost over his eyes, holding the back of his chair.

range of movement it involved, although he also often underlined the gulf between the Romantic façade of ballet and its down-to-earth reality. In *The Rehearsal* [18.11]

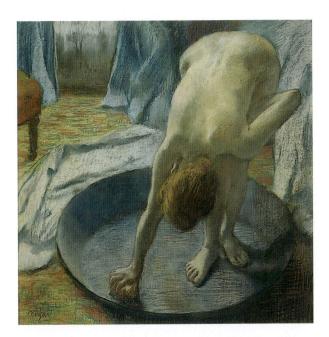

18.12 Edgar Degas. *The Tub*, c. 1886. Pastel, $27^5/8$ " (70 cm) square. Hill-Stead Museum, Farmington, Connecticut. The beautiful simplicity of Degas' drawing gives an impression of action glimpsed momentarily, as if by one passing by.

we are left in no doubt that neither ballet nor ballet dancers are entirely glamorous. Degas' point of view is emphasized by the unusual vantage point from which the stage is shown: close to and from a position high up on the side. Far from coldly observing and reproducing the scene, Degas creates an instant bond between us and the hard-worked dancers, based on our perception of them as human beings.

Degas' honesty won him the reputation of being a mysogynist because many of his representations of female nudes lack the idealizing qualities of Renoir's and other painters' works. In a series of pastels he shows women caught unawares in simple, natural poses. *The Tub* [18.12], with its unusual angle of vision, shows why these were sometimes called "key-hole visions." Far from posing, his subjects seem to be spied on while they are engrossed in the most intimate and natural activities.

One of Degas' closest friends was the American artist Mary Cassatt (1844–1926), who, after overcoming strong opposition from her father, settled in Europe to pursue an artistic career. Like Degas, Cassatt painted spontaneous scenes from daily life, particularly situations involving mothers and children. *Mother and Child* [18.13] shows the mother turned away from us and a child who is saved from sentimentality by his complete unawareness of our presence. Cassatt never married, but there is no reason to think that her paintings of children were created out of frustration. She seems to have had a rich

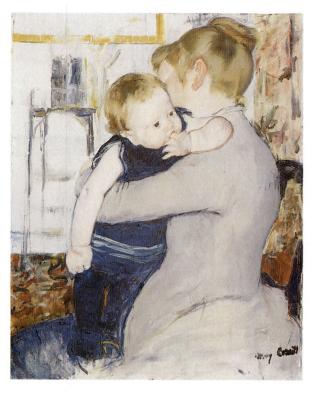

18.13 Mary Cassatt. *Mother and Child,* c. 1889. Oil on canvas, $29'' \times 23^{1}/2''$ (74 × 60 cm). Cincinnati Art Museum (John J. Emery Endowment, 1928). By turning the mother's face away the artist concentrates attention on the child, an effect enhanced by the vague background.

and happy life, and her championship of the Impressionist cause among her American friends led to many of them buying and taking home Impressionist works. Cassatt's artist friends had much to thank her for, and so do the curators of many American museums and galleries, which have inherited collections of Impressionist paintings.

Another member of the same circle was Berthe Morisot (1841–1895) whose early painting career was encouraged by Corot. In 1868, Morisot met Manet and they became warm friends; a few years later she married his younger brother. An active member of the Impressionist group, she exhibited works in almost all their shows.

Morisot's work has often been labeled "feminine," both by her contemporaries and by more recent critics. Like Cassatt, a close friend, she often painted women and children. Yet she also produced works of considerable breadth. View of Paris from the Trocadero [18.14] presents a panoramic view of the city. The sense of light and atmosphere is conveyed by loose, fluid brushstrokes. The figures in the foreground do not seem part of any story or incident but help focus the scale of the view, which is seen as if from a height.

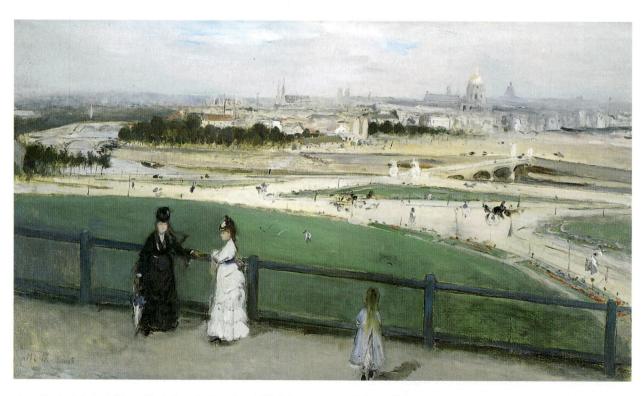

18.14 Berthe Morisot. *View of Paris from the Trocadero*, 1872. Oil on canvas, $18\frac{1}{8}$ " × $32\frac{1}{16}$ " (46.3 × 81.3 cm). Santa Barbara Museum of Art (gift of Mrs. Hugh N. Kirkland). The separation between the various planes of the view produces an effect of breadth and tranquility.

The impact of Impressionism on sculptors was inevitably limited, since many of its principles were dependent on color and light and could only be applied in paint. Nevertheless, the greatest sculptor of the age (according to many, the greatest since Bernini), Auguste François René Rodin (1840–1917), reproduced in bronze something of the Impressionist love of shifting forms and light and shadow. His remarkable figure of Balzac [18.15] demonstrates the irregularity of surface by which Rodin converted two-dimensional Impressionist effects to a three-dimensional format. It also reveals one of the ways in which he differed from his Impressionist contemporaries, since his themes are generally massive and dramatic rather than drawn from everyday life. The statue of Balzac shows the great novelist possessed by creative inspiration, rather than his actual physical appearance. The subject of this sculpture is really the violent force of genius (a concept also illustrated in Rodin's portrayal of the composer Gustav Mahler (see Figure 18.31) and Rodin conveys it with almost elemental power.

It should perhaps not be surprising that critics of the day were unprepared for such burning intensity. One of them dubbed the statue a "toad in a sack." But in retrospect, Rodin breathed new life into sculpture. The "primitive" grandeur of his images formed a powerful attraction for future sculptors.

In general, Rodin's works in marble are less Impressionistic than those in bronze, but his famous *The Kiss* [18.16] achieves something of Renoir's blurred sensuality by the soft texture of the stone and the smooth transitions between the forms of the figures. Yet even though Rodin at times seems to strive for an Impressionistic surface effect, the drama and full-blooded

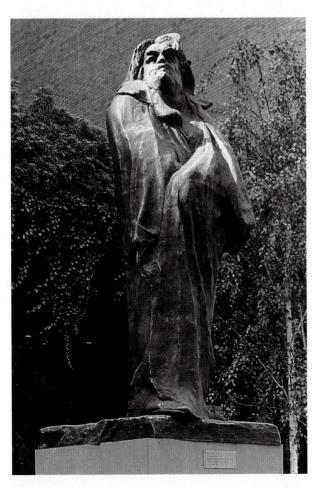

18.15 Auguste Rodin. *Monument to Balzac,* 1897–1898. Bronze (cast 1954), $9'3'' \times 48^1/4'' \times 41''$ (282 \times 122.5 \times 104.2 cm). The Museum of Modern Art, New York. Presented in memory of Curt Valentin by his friends. Unlike most sculptors who worked in bronze, Rodin avoided a smooth surface by roughening and gouging the metal.

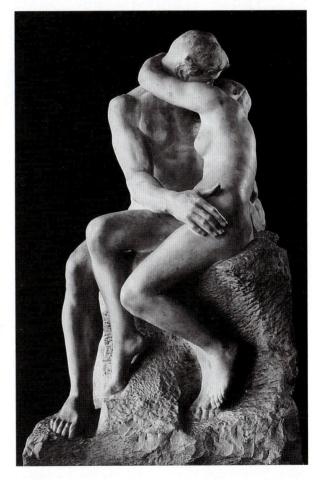

18.16 Auguste Rodin. *The Kiss*, 1886. Marble. Height 6'2" (1.9 m). Musée Rodin, Paris. As in his Balzac statue, the artist uses the texture of the material to enhance the appearance of his work. But the smooth, slightly blurred surface of the marble here, in contrast to the rough surface of the portrait, produces a glowing effect.

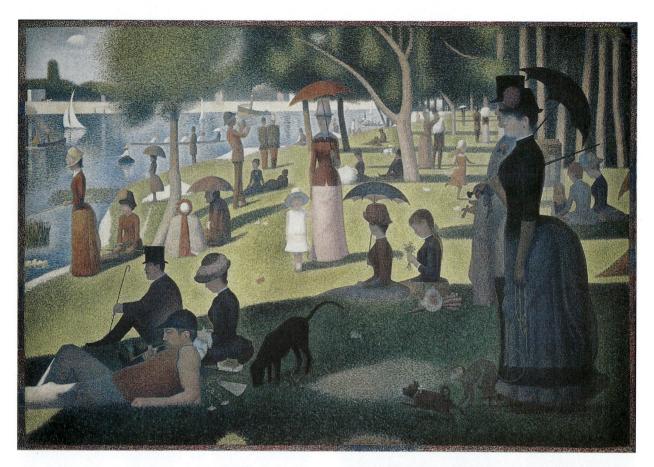

18.17 Georges Seurat. A Sunday on La Grande Jatte, 1884–1886. Oil on canvas, $6'9'' \times 10'^{3}/8''$ (207.5 × 308 cm). The Art Institute of Chicago (Helen Birch Bartlett Memorial Collection), 1926.224. For all the casual activity in this scene of strollers in a park on an island in the river Seine, Seurat's remarkable sense of form endows it with an air of formality. Both shape and color (applied in minute dots) are rigorously ordered.

commitment of many of his works show the inadequacy of stylistic labels. We can only describe Rodin as a sculptor who used the Impressionist style in works that foreshadow modern developments; that is, as a great original.

18.18 Paul Gauguin. *Ia Orana Maria*, 1891. Oil on canvas, $44^3/_4'' \times 34^1/_2''$ (113.7 × 87.7 cm). Metropolitan Museum of Art, New York. (Bequest of Samuel A. Lewisohn, 1951). The title means "We hail thee, Mary"; the painting shows a Tahitian Madonna and child being worshiped by two women with an angel standing between them. The whole scene presents a fusion of Western spiritual values and the simple beauty of primitive Polynesian life.

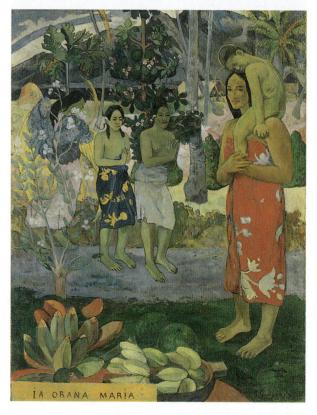

Post-Impressionism

http://www.nga.gov/collection/gallery/gg84/gg84-main

Post-Impressionism

As a stylistic category, post-Impressionism is one of the least helpful or descriptive terms in art history. The artists who are generally grouped together under it have as their only real common characteristic a rejection of Impressionism for new approaches to painting. All of them arrived at their own individual styles. Their grouping together is therefore more a matter of historical convenience than critical judgment. The scientific precision of Georges Pierre Seurat (1859-1891), for example whose paintings, based on the geometric relationship of forms in space, are made up of thousands of tiny dots of paint applied according to strict theories of color [18.17] has little in common with the flamboyant and exotic art of (Eugéne Henri) Paul Gauguin (1848-1903). Particularly in his last paintings, based on his experiences in Tahiti, Gauguin attacked primitive subjects in a highly sophisticated manner, producing results like Ia Orana Maria [18.18], which may attract or repel viewers but rarely leave them indifferent.

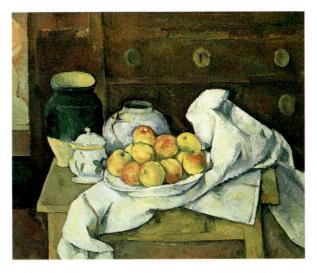

18.19 Paul Cézanne. Still Life with Commode, c. 1887–1888. Oil on canvas, $25^{1}/_{2}^{"} \times 31^{3}/_{4}^{"}$ (65.1 \times 80.8 cm). Harvard Museum of Art. Fogg Art Museum (bequest—Collection of Maurice Wertheim, Class of 1906). So painstakingly did the artist work on the precise arrangement of the objects in his still life and on their depiction that the fruit usually rotted long before a painting was complete.

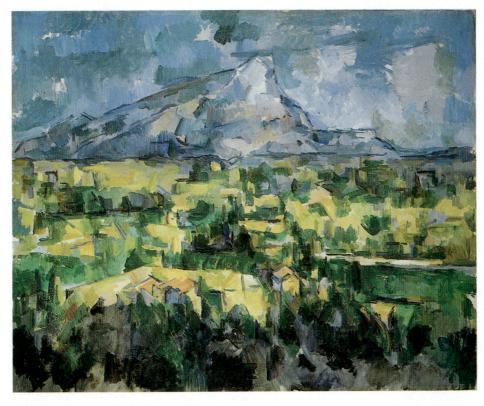

18.20 Paul Cézanne. Mont Sainte-Victoire, 1904–1906. Oil on canvas, $28^7/8^n \times 36^1/4^n$ (73 × 92 cm). Philadelphia Museum of Art (George W. Elkins Collection). The reduction of the elements in the landscape to flat planes and the avoidance of the effect of perspective give the painting a sense of concentrated intensity.

The greatest post-Impressionist painter was Paul Cézanne. It would be difficult to overestimate the revolutionary quality of Cézanne's art, which has been compared to that of the proto-Renaissance Florentine painter Giotto as an influence on Western art. Cézanne's innovations brought to an end the sixhundred-year attempt since Giotto's time to reproduce nature in painting. In place of nature Cézanne looked for order; or rather he tried to impose order on nature, without worrying if the results were realistic. It is not easy to comprehend or express in intellectual terms the character of Cézanne's vision, although, as so often in the arts, the works speak for themselves. He claimed that he wanted to "make of Impressionism something solid and durable," and many of his paintings have a monumental air; they convey the mass and

weight, in terms of both shape and color of his subject matter, rather than its literal physical appearance. His Still Life with Commode [18.19] does not try to show how the fruit, vase, and cloth really look or reproduce their actual relationship to one another. On the contrary, the painter has deliberately distorted the surface of the table and oversimplified the shapes of the objects to achieve a totally satisfying composition. Abstract considerations, in other words, take precedence over fidelity to nature. Cézanne believed that all forms in nature are based on the cone, the sphere, and the cylinder, and he shapes and balances the forms to make them conform to this using vigorous, rhythmical brush strokes. In the process, a simple plate of fruit takes on a quality that can only be called massive.

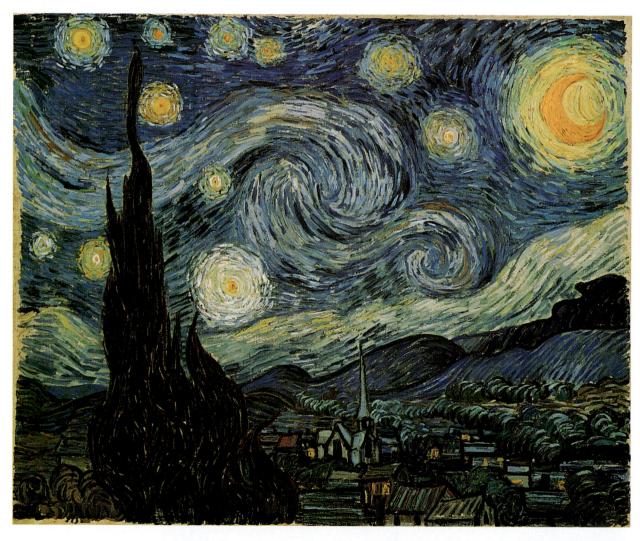

18.21 Vincent van Gogh. The Starry Night, 1889. Oil on canvas, $29'' \times 36^{1}/_{4}''$ (73.7 × 92.1 cm). Collection, The Museum of Modern Art, New York (acquired through the Lillie P. Bliss Bequest). The impression of irresistible movement is the result of the artist's careful use of line and shape. The scene is dominated by vertical spirals formed by the cypress trees and horizontal ones in the sky, which create a sense of rushing speed.

The miracle of Cézanne's paintings is that for all their concern with ideal order they are still vibrantly alive. Mont Sainte-Victoire [18.20] is one of a number of versions Cézanne painted of the same scene, visible from his studio window. Perhaps the contrast between the peaceful countryside and the grandeur of the mountain beyond partially explains the scene's appeal to him. He produced the transition from foreground to background and up to the sky by the wonderful manipulation of planes of pure color. It illustrates his claim that he tried to give the style of Impressionism a more solid appearance by giving his shapes a more continuous surface, an effect produced by broad brushstrokes. Yet equally the painting conveys the vivid colors of a Mediterranean landscape, with particular details refined away so as to leave behind the pure essence of all its beauty.

Nothing could be in greater contrast to Cézanne's ordered world than the tormented vision of Vincent van Gogh (1853–1890), the tragedy of whose life found its expression in his work. The autobiographical nature of van Gogh's painting, together with its passionate feelings, has a special appeal to modern sensibilities. In fairness to van Gogh, however, we should remember that by giving expression to his desperate emotions the artist was, however briefly, triumphing over them. Further, in a way that only the arts make possible, the suffering of a grim, even bizarre life became transformed into a profound if admittedly partial statement on the human

condition. Desperate ecstasy and passionate frenzy are not emotions common to most people, yet *The Starry Night* [18.21] communicates them immediately and unforgettably.

http://artchive.com/artchive.V/vangogh.html

Van Gogh

The momentum of swirling, flickering forms in *The Starry Night* is intoxicating, but for the most part van Gogh's vision of the world was profoundly pessimistic. *The Night Café* [18.22] was described by the artist himself as "one of the ugliest I have done," but the ugliness was deliberate. Van Gogh's subject was "the terrible passions of humanity," expressed by the harsh contrasts between red, green, and yellow, which were intended to convey the idea that "the café is a place where one can ruin one-self, go mad, or commit a crime."

Much of van Gogh's pessimism was undoubtedly the result of the unhappy circumstances of his own life, but it is tempting to place it in the wider context of his times and see it also as a terrifying manifestation of the growing social and spiritual alienation of society in the late nineteenth century. That van Gogh was actually aware of this is shown by a remark he made about his *Portrait of*

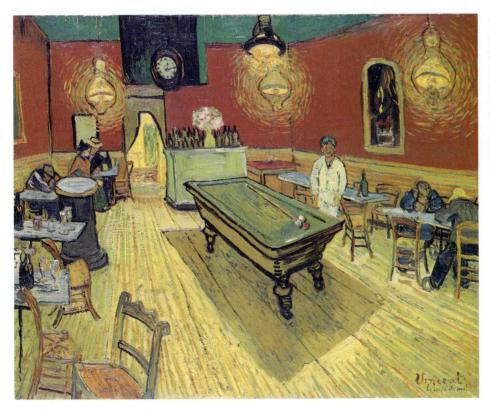

18.22 Vincent van Gogh. *The Night Café*, 1888. Oil on canvas, $28\frac{1}{2}$ " \times $36\frac{1}{4}$ " (72×92 cm). Yale University Art Gallery, New Haven (bequest of Stephen C. Clark). Compare the lack of perspective in Cézanne's *Mont Sainte-Victoire* (Figure 18.20) to the highly exaggerated perspective used by van Gogh here to achieve a sense of violent intensity.

Dr. Gachet [18.23], the physician who treated him in his last illness. He had painted the doctor, he said, with the "heartbroken expression of our times."

Fauvism and Expressionism

http://www.ibiblio.org/wm/paint/glo/expressionism/

Expressionism

By the early years of the twentieth century, the violent mood of the times had intensified still further, and artists continued to express this in their art. The impact of post-Impressionists like van Gogh inspired several new movements—the most important of which was *Fauvism*. This developed in France, and *Expressionism*, which reached its high point developed in Germany.

The origin of the term "Fauvism" reveals much of its character. In 1905, a group of artists exhibited paintings that broke so violently with tradition in their use of color and form that a critic described the painters as *les fauves*

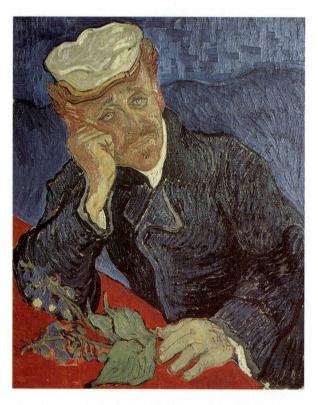

18.23 Vincent van Gogh. *Portrait of Dr. Gachet*, 1890. Oil on canvas, $26^{1}/_{4}^{"} \times 22^{1}/_{2}^{"}$ (67×57 cm). Private collection, Japan. Gachet was an amateur artist and friend of van Gogh who often provided medical treatment for his painter acquaintances without taking any fee. Mentally ill and in despair, van Gogh committed suicide while staying with Gachet.

("the wild beasts"). These painters had little in common apart from their desire to discard all traditional values; not surprisingly, the group broke up after a short while. But one of their number, Henri Matisse (1869–1954), became a major force in twentieth-century art.

Henri Matisse was the leading spirit of the Fauves. His works are filled with the bold accents and brilliant color typical of Fauvist art. Yet the flowing images of Matisse's paintings strike an individual note, expressing a mood of optimism and festivity curiously at odds with the times. One of his first important paintings, *The Joy of Life* [18.24], shows fields and trees in bright sunlight, where men and women are sleeping, dancing, and making music and love. It is difficult to think of any work of art further removed from the anguish of the years immediately preceding World War I than this image of innocent joy painted between 1905 and 1906.

TABLE 18.1 Principal Characteristics of Fauvism and Expressionism

FAUVISM	
TAUVISM	

Violent, startling color contrasts

Paintings reflect the effect of visual contact on the psyche

Nature interpreted and subjected to the spirit of the artists

Composition a decorative arrangement of elements to express the artist's feelings

Technique deliberately crude to disturb the form of objects

No effect of light or depth

Art for art's sake

EXPRESSIONISM

Brilliant, clashing colors

Paintings reflect mysticism, selfexamination, speculation on the infinite

Nature used to interpret the universe

Composition: distorted forms in a controlled space, derived from late Gothic woodcut tradition

Technique influenced by medieval art and the primitivistic art of Africa and Oceania

No use of traditional perspective

Art to convey emotional or psychological truth

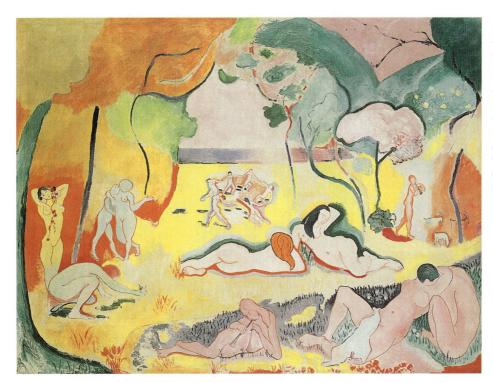

18.24 Henri Matisse. *The Joy of Life*, 1905–1906. Oil on canvas, $5'8'' \times 7'9^3/_4''$ (1.74 \times 2.38 cm). Barnes Foundation, BF No. 719, Merion Station, Pennsylvania. By varying the sizes of the figures without regard to the relationship of one group to another the artist accentuates the sense of dreamlike unreality. Note Matisse's characteristically simple, flowing lines.

http://www.ibiblio.org/wm/paint/auth/matisse/

Matisse

Matisse was saved from the gloom of his contemporaries by his sheer pleasure in seeing and painting; his work communicates the delight of visual sensation eloquently. His still-life paintings, like those of Cézanne, sacrifice Realism in effective and satisfying design, but his use of color and the distortion of the natural relationships of the objects he paints are even greater than Cézanne's. In *The Red Studio* [18.25], every form is clearly recognizable but touched by the painter's unique vision. It is as if Matisse compels us to look through his eyes and see familiar objects suddenly take on new, vibrant life.

Matisse's sunny view of the world was very unusual, however. In northern Europe, particularly, increasing social and political tensions inspired a group of artists generally known as Expressionists to produce works that are at best gloomy and foreboding, sometimes chilling.

The forerunner of Expressionist art was the Norwegian painter Edvard Munch (1863–1944), whose influence on German painting was comparable to that of Cézanne's on French. The morbid insecurity that characterized Munch's own temperament emerges with horrifying force in his best-known work, *The Scream*

[18.26], from which the lonely figure's cry seems to reverberate visibly through space. This painting is more than autobiographical, however, since it reflects a tendency on the part of Norwegian and other Scandinavian artists and writers to explore social and psychological problems. Elsewhere in Europe the Spanish architect Antonio Gaudí (1852–1926) applied the same artistic principles to his buildings, with often startling results. His Casa Milá [18.27], an apartment house in Barcelona, like *The Scream*, makes use of restless, waving lines that seem to undulate as we look. The sense of disturbance is continued by the spiraling chimneys although Gaudí's intention was neither to upset nor necessarily to protest.

By 1905, Expressionist artists in Germany were using the bold, undisguised brushstrokes and vivid colors of Fauvism to paint subjects with more than a touch of Munch's torment. The German Expressionists, many of them grouped in "schools" with such names as *Die Brücke* ("The Bridge") and *Der Blaue Reiter* ("The Blue Rider"), were relatively untouched by the intellectual and technical explorations of their contemporaries elsewhere. Instead, they were concerned with the emotional impact that a work could produce on the viewer. They were fascinated by the power of color to express mood, ideas, and emotion. They wanted their art to affect not only the eye but the viewer's inner sense. When they succeeded, as they often did, their works aroused strong emotions.

18.25 Henri Matisse. The Red Studio, Issy-les-Molineaux, 1911. Oil on canvas, $71^{1}/_{4}" \times 7'2^{1}/_{4}" (1.81 \times 2.19 \text{ m})$. Collection, The Museum of Modern Art, New York (Mrs. Simon Guggenheim Fund). The paintings and small sculptures in the studio are actual works by Matisse himself; they show the brilliant colors typical of Fauve art.

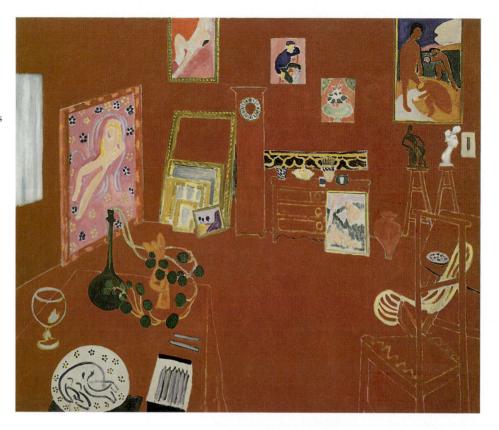

One of their principal themes was alienation and loneliness, so it is not surprising that they often turned to the writings of Dostoyevsky for inspiration. *Two Men at a Table*, [18.28], by Erich Heckel (1883–1970), is in fact subtitled *To Dostoyevsky*.

Emil Nolde (1867–1956), who identified himself with Die Brücke after 1906, was one of the few Expressionists to paint biblical scenes. To these he brought his own ecstatic, barbaric intensity. *Pentecost* [18.29] shows the apostles seated around the table literally burning with inspiration; the tongues of flame of the biblical account are visible above their heads. Their faces have a masklike simplicity, but the huge eyes and heavy eyebrows convey frighteningly intense emotion. The image is far more disturbing than inspiring. Even in a religious context, Expressionist art touches chords of alarm, and hysteria, unhappily appropriate to the times.

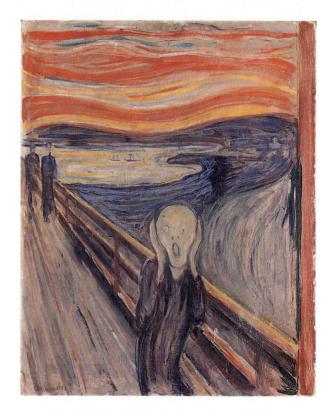

18.26 Edvard Munch. *The Scream*, 1893. Oil on cardboard, $35\frac{1}{2}$ " × $28\frac{3}{4}$ " (91 × 74 cm). Nasjonalgalleriet, Oslo. Munch once said, "I hear the scream in nature," and in this painting the anguish of the human figure seems to be echoed by the entire world around.

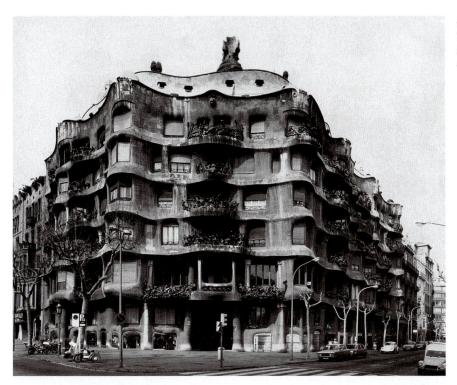

18.27 Antonio Gaudí. Casa Milá, Barcelona, 1907. Note the rough surface of the stone and the absence of any straight lines.

NEW STYLES IN MUSIC

Impressionism had forced both artists and public to think afresh about painting and seeing; by the early years of the twentieth century, musicians and music lovers were also to have many of their preconceptions challenged. Not only were traditional forms like the symphony either discarded or handled in a radical new way, but even the basic ingredients of musical expression, *melody, harmony*, and *rhythm*, were subject to star-

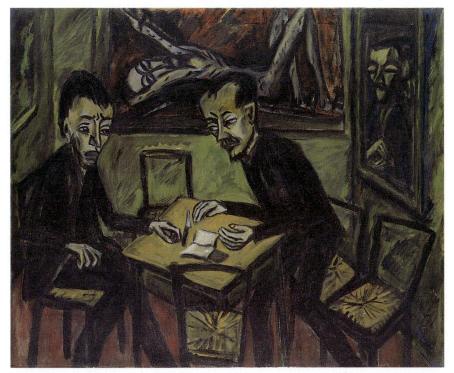

18.28 Erich Heckel. *Two Men at a Table (To Dostoyevsky),* 1912. Kunsthalle, Hamburg. The two figures seem separated from one another by doubt and distrust, each wrapped up in his own isolation. Behind them is a distorted image of the crucified Christ.

18.29 Emil Nolde. *Pentecost*, 1909. Oil on canvas, $2'8'' \times 3'6''$ (87×107 cm). Staatliche Musseen Preussischer Kulturbesitz, National-galerie, Berlin. The broad, simplified faces and the powerful gestures of Christ in the center and of the two apostles clasping hands impart to the scene a concentration of emotional intensity.

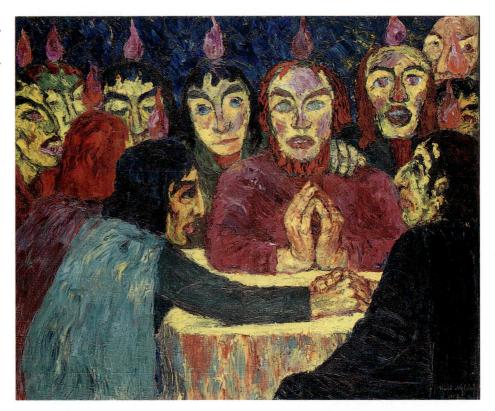

tling new developments. Few periods in the history of music are in fact more packed with change than those between 1870 and 1914, which saw a fresh approach to symphonic form, the rise of a musical version of Impressionism, and the revolutionary innovations of the two giants of modern music: Schönberg and Stravinsky.

Orchestral Music at the Turn of the Nineteenth Century

Although many extended orchestral works written in the last years of the nineteenth and the early twentieth centuries were called symphonies by their composers, they would hardly have been recognizable as such to Haydn or Beethoven. The custom of varying the traditional number and content of symphonic movements had already begun during the Romantic period; Berlioz had written his *Fantastic Symphony* as early as 1829 (see Chapter 17). Nonetheless, by the turn of the century, so-called symphonies were being written that had little in common with one another, much less the Classic symphonic tradition.

The driving force behind many of these works was the urge to communicate something beyond purely musical values. From the time of the ancient Greeks, many composers attempted to write instrumental music that told a story or described some event, including Vivaldi and his *Four Seasons* and Beethoven in his curious work known as the *Battle Symphony*. By the mid-nineteenth century, however, composers had begun to devise elabo-

rate *programs* (plots), which their music would then describe. Music of this kind is generally known as *program music*, the first great exponent of which was Liszt (see Chapter 17), who wrote works with titles like *Hamlet*, *Orpheus*, and *The Battle of the Huns*, for which he invented the generic description *symphonic poem*.

The principle behind program music is no better or worse than many another. The success of any individual piece depends naturally on the degree to which narrative and musical interest can be combined. There are, to be sure, some cases where a composer has been carried away by eagerness for realism. Ottorino Respighi (1879–1936), for example, incorporated the sound of a nightingale by including a record player and a recording of live birdsong in his *Pines of Rome* (1924).

No one was more successful at writing convincing program symphonies and symphonic poems (tone poems, as he called them) than the German composer Richard Strauss (1864–1949). One of his first successful tone poems, Don Juan, begun in 1886, deals with the familiar story of the compulsive Spanish lover from a characteristically late-nineteenth-century point of view. Instead of the unrepentant Don Giovanni of Mozart or Byron's amused (and amusing) Don Juan, Strauss presents a man striving to overcome the bonds of human nature, only to be driven by failure and despair to suicide. The music, gorgeously orchestrated for a vast array of instruments, moves in bursts of passion, from the surging splendor of its opening to a bleak and shuddering conclusion.

VALUES

Colonialism

The transition, beginning around 1500, from the world of the late Middle Ages to the dawn of the modern era was due, in large measure, to European expansion overseas, with the vast economic developments that it brought. From the mid-nineteenth century, this search for new territories abroad became transformed into the drive to win Imperial possessions, and the history of the past two centuries has seen the rise and subsequent collapse of European colonial empires. In the process, European dominance has given way to a global culture in which the destinies of all parts of the world are linked. Technological changes, weapons of mass destruction, and, in the past few years, rapid progress in electronic communication, have all in different ways helped to build the "global village."

In the course of the twentieth century, struggles for independence in many parts of the world led to the notion of Imperialism, one of the chief motivating forces in nineteenth-century politics and culture, acquiring strongly negative associations. Its original impetus came from economic, political, and psychological considerations. In the first place, conquest of overseas territories and peoples provided a source of raw material and abundant cheap labor. At the same time, the colonies became centers for investment and thereby absorbed surplus capital, which accumulated as the capitalist system began to grow—a point made by one of the fiercest opponents of both capitalism and imperialism: Lenin.

Politically, Imperialism provided a means whereby the leading European powers could continue their rivalries outside Europe. At the beginning of the nineteenth century, at the Congress of Vienna of 1815, the delegates had created a political "balance of power," whereby no state was able to dominate. Each country had its own national sovereignty and could maintain independence of action, which meant that none could achieve superiority in Europe. Now, by conquering more and richer territory in Africa and Asia, Western European colonizers could try to surpass one another.

No less important was the psychological factor. With the rise of nationalism national pride became a powerful factor in determining political and military decisions. Furthermore, with the growth of anonymous cities, some form of heroic achievement abroad could bring personal glory, as well as give those less advantaged a chance to improve their lot.

A further factor, as European possessions abroad began to accumulate, was that of strategy. By taking a well-located port or island its conquerors could open up new territories, or hold on to what they had—or even block a rival.

At least some of the drive for empire also involved fewer self-interest factors. Many conquerors claimed, and some surely believed, that their motives were to "spread civilization"—in its European form, at least. Missionaries accompanied most colonial expeditions, and colonial governments tried to outlaw those local customs that appalled their administrators: cannibalism, child marriage, nakedness. The physical conditions and education of the local populations often improved, although rulers resisted most calls for self-government.

The eventual result was that the colonized peoples slowly began to fight for their own independence. In the process, the zeal of nineteenth-century colonizers began to be regarded as arrogant and self-serving, rather than heroic and altruistic. Like many other values in history, however, colonialism should be seen in its historical context to be fairly judged.

Strauss was not limited to grand and tragic subjects. *Till Eulenspiegel* is one of the most successful examples of humor in music. It tells the story of a notorious practical joker and swindler. Even when Till goes too far in his pranks and ends up on the gallows (vividly depicted by Strauss' orchestration), the music returns to a cheerful conclusion.

One of Strauss' most remarkable works, and one that clearly demonstrates the new attitude toward symphonic form, is his *Alpine Symphony*, written between 1911 and 1915. In one huge movement lasting some fifty minutes it describes a mountain-climbing expedition, detailing the adventures on the way (with waterfalls, cowbells, glaciers all in the music) and, at its climax, the arrival on the summit. The final section depicts the descent, during

which a violent storm breaks out, and the music finally sinks to rest in the peace with which it opened. All this may sound more like a movie's soundtrack than a serious piece of music, but skeptical listeners should try the *Alpine Symphony* for themselves. It is as far from conventional notions of a symphony as Cézanne's painting of *Mont Sainte-Victoire* (see Figure 18.20) is from a conventional landscape, but genius makes its own rules. Strauss' work should be taken on its own terms.

Not surprisingly, a composer capable of such exuberant imagination was also fully at home in the opera house. Several of Strauss' operas are among the greatest of all twentieth-century contributions to the repertoire. In some, he was clearly influenced by the prevailingly gloomy and morbid mood of German Expressionist art.

CONTEMPORARY VOICES

Gustav Mahler

A letter from Mahler to his wife Alma reporting on a meeting with Richard Strauss. Mahler had heard *Salome*, and was impressed. The *she* in the second sentence is Pauline, Strauss' wife.

Berlin, January 190

My dear, good Almschili;

Yesterday afternoon I went to see Strauss. She met me at the door with pst! pst! Richard is sleeping, pulled me into her (very slovenly) boudoir, where her old mama was sitting over some mess (not coffee) and filled me full of nonsensical chatter about various financial and sexual occurrences of the last two years, in the meantime asking hastily about a thousand and one things without waiting for a reply, would not let me go under any circumstances, told me that yesterday morning Richard had had a very exhausting rehearsal in Leipzig, then returned to Berlin and conducted *Götterdämmerung* in the evening, and this afternoon, worn to a frazzle, he had gone to sleep, and she was carefully guarding his sleep. I was dumbfounded.

Suddenly she burst out: "Now we have to wake up the rascal!" Without my being able to prevent it, she pulled me with both her fists into his room and yelled at him in a very loud voice: "Get up, Gustav is here!" (For an hour I was Gustav—then suddenly Herr Direk-

tor again.) Strauss got up, smiled patiently, and then we went back to a very animated discussion of all that sheer bilge. Later we had tea and they brought me back to my hotel in their automobile, after arranging for me to take lunch with them at noon Saturday.

There I found two tickets for parquet seats in the first row for *Salome* and I took Berliner along. The performance was excellent in every respect—orchestrally, vocally, and scenically it was pure Kitsch and Stoll, and again it made an extraordinary impression on me. It is an extremely clever, very powerful piece, which certainly belongs among the most significant of our time! Beneath a heap of rubbish an infernal fire lives and burns in it—not just fireworks.

That's the way it is with Strauss's whole personality and it's difficult to separate the wheat from the chaff. But I had felt tremendous respect for the whole manifestation and this was confirmed again. I was tremendously pleased. I go the whole hog on that. Yesterday Blech conducted—excellently. Saturday Strauss is conducting and I am going again. Destinn was magnificent; the Jochanaan [Berger] very fine. The others, so-so. The orchestra really superb.

From G. Norman and M. L. Shrifte: Letters of Composers (New York: Grosset & Dunlap, 1946), p. 301.

His first big success, for example, was a setting of the English writer Oscar Wilde's play *Salome*, based on the biblical story, first performed to a horrified audience in 1905. After one performance (in 1907) at the Metropolitan Opera House in New York, it was banned in the United States for almost thirty years. The final scene provides a frightening yet curiously moving depiction of erotic depravity, as Salome kisses the lips of the severed head of John the Baptist. This subject had been gruesomely represented by the German Expressionist painter Lovis Corinth (1858–1925) in 1899 [18.30].

Works like *Don Juan* and the *Alpine Symphony* deal with stories we know or describe events with which we are familiar. In other cases, however, Strauss took as his subject his own life, and a number of his pieces, including the *Domestic Symphony* and the somewhat immodestly titled *Ein Heldenleben (Hero's Life)*, are frankly autobiographical. In this he was following a custom that had become increasingly popular in the late nineteenth century—the composition of music concerned with the detailed revelation of its composer's inner emotional life.

One of the first musicians to make his personal emotions the basis for a symphony was the late-Romantic composer Peter Ilych Tchaikovsky (1840-1893), whose Symphony No. 6 in b minor, known as the Pathétique, was written in the year of his death. An early draft outline of its "story" was found among his papers, describing its "impulsive passion, confidence, eagerness for activity," followed by love and disappointments, and finally collapse and death. It is now believed that the Russian composer's death from cholera was not, as used to be thought, accidental, but deliberate suicide. The reasons are still not clear, but they perhaps related to a potentially scandalous love affair in high places with which Tchaikovsky had become involved. In the light of this information, the Pathétique takes on new poignancy. Its last movement sinks mournfully into silence after a series of climaxes that seem to protest bitterly if vainly against the injustices of life.

http://w3.rz-berlin.mpg.de/cmp/tchaikovsky.html

Tchaikovsky

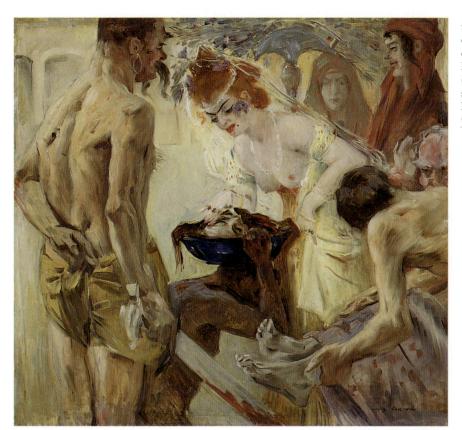

18.30 Lovis Corinth. Salome, 1899. Oil on canvas, $29^{1}/_{2}$ " \times 33" (76.2 \times 83.3 cm). Courtesy of Busch-Reisinger Museum, Harvard University (gift of Hans H. A. Meyn). Note the strikingly modern look of Salome, here representing the degeneracy of the artist's own times.

The revelation of a composer's life and emotions through his music reached its most complete expression in the works of Gustav Mahler (1860–1911). Until around 1960, the centenary of his birth in Bohemia, Mahler's music was almost unknown and he was generally derided as unoriginal and overambitious. Now that he has become one of the most frequently performed and recorded of composers, we can begin to appreciate his true worth and learn the danger of hasty judgments.

The world of Mahler's symphonies is filled with his own anxieties, triumphs, hopes, and fears, but it also illuminates our own problem-ridden age. It may well be that Mahler speaks so convincingly and so movingly to a growing number of ordinary music lovers because his music touches on areas of human experience unexplored before his time and increasingly significant to ours. In purely musical terms, however, Mahler can now be seen as a profoundly original genius. Like Rodin, who produced a marvelous portrait of him [18.31], he stands as both the last major figure of the nineteenth century in his field and a pioneer in the modern world. Indeed, it was precisely Mahler's innovations that won him the scorn of earlier listeners: his deliberate use of popular, banal tunes, for example, and the abrupt changes of mood in his music. A symphony, he once said, should be like the world; it should contain everything. His own nine completed symphonies (he left a tenth unfinished), and *Das Lied von der Erde* (*The Song of the Earth*), a symphony for two singers and orchestra, certainly contain just about every human emotion.

As early as the *Symphony No. 1 in D*, we can hear the highly individual characteristics of Mahler's music. The third movement of the symphony is a funeral march, but its wry, ironic tone is totally unlike any other in the history of music. The movement opens with the mournful sound of a solo double bass playing the old round "Frère Jacques," which is then taken up by the rest of the orchestra. There are sudden bursts of trite nostalgia and violent aggression until the mood gradually changes to one of genuine tenderness. After a gentle middle section, the movement returns to the bizarre and unsettling spirit of the opening.

By the end of his life Mahler was writing far less optimistic music than his *Symphony No. 1*, which—despite its third-movement funeral march—concludes with a long finale ending in a blaze of triumphant glory. Mahler's last completed works, *The Song of the Earth* and *Symphony No. 9*, composed under the shadow of fatal heart disease and impending death, express all the beauty of the world together with the sorrow and ultimate resignation of one who has to leave it. The final movement of the *Symphony No. 9*, in particular, is a

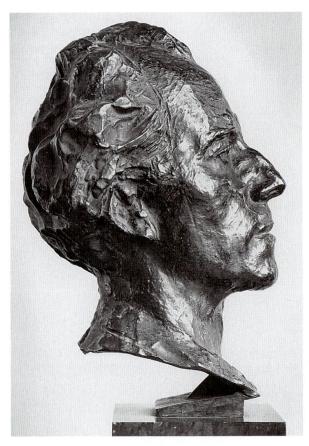

18.31 (Pierre) Auguste Rodin. *Gustav Mahler*, 1909. Bronze. Height 13" (34 cm). Musée Rodin, Paris. As in his *Monument to Balzac* (Figure 18.15), Rodin deliberately roughened the surface of the bronze for dramatic effect. In this case Mahler's hollow cheeks and intense gaze are powerfully suggested.

uniquely eloquent statement of courage in the face of human dissolution. Opening with a long, slow theme of great passion and nobility, the movement gradually fades away as the music dissolves into fragments and finally sinks into silence. Like all Mahler's music, and like the paintings of van Gogh or Munch, the *Symphony No. 9* does not turn its back on the ugliness and tragedy of life; but Mahler, unlike many of his contemporaries, was able to see beyond these and express something of the painful joy of human existence. Perhaps this is why his music has become so revered today.

Impressionism in Music

At about the same time painters in France were developing the style we call Impressionist, Claude Debussy (1862–1918), a young French composer, began to break new musical ground. Abandoning the concept of the development of themes in a systematic musical argument,

which lies behind classical sonata form and Romantic symphonic structure, he aimed for a constantly changing flow of sound. Instead of dealing with human emotions, Debussy's music evoked the atmosphere of nature: the wind and rain and the sea. The emphasis on shifting tone colors led inevitably to comparisons to Impressionist painting. Like Monet or Renoir, he avoided grand, dramatic subjects in favor of ephemeral, intangible sensations and replaced Romantic opulence with refinement.

These comparisons should nevertheless not be exaggerated. Debussy and the Impressionists shared a strong reaction against tradition in general and the Romantic tradition in particular, in response to which they created a radically new approach to their respective arts, but Impressionism permanently changed the history of painting, while the only really successful Impressionist composer was Debussy. Later musicians borrowed some of Debussy's musical devices, including his highly fluid harmony and frequent dissonances, but Debussy never really founded a school. The chief developments in twentieth-century music after Debussy took a very different direction, summed up rather unsympathetically by the French poet Jean Cocteau (1891-1963): "After music with the silk brush, music with the axe." These developments represent a more determined break with tradition than the refined style of Debussy. Indeed, with the passing of time Debussy's musical style appears increasingly to represent the last gasp of Romanticism rather than the dawn of a new era.

Whatever his historical position, Debussy was without doubt one of the great creative musical figures of his time. He is at his best and most Impressionist in orchestral works like La Mer (The Sea), which Debussy himself called symphonic sketches—a rather curious term that shows the composer for once willing to accept a traditional label. This marine counterpart of Strauss' Alpine Symphony is in three movements, the titles of which ("From Dawn to Noon on the Sea," "Play of the Waves," and "Dialogue of the Wind and the Sea") describe the general atmosphere that concerned Debussy rather than literal sounds. There are no birdcalls or thunderclaps in the music; instead the continual ebb and flow of the music suggest the mood of a seascape. The second movement, for example, depicts the sparkling sunlight on the waves by means of delicate, flashing violin scales punctuated by bright flecks of sound color from the wind instruments. It is scarcely possible to resist a comparison with the shimmering colors of Monet's Water Lilies (see Figure 18.8).

Elsewhere, Debussy's music is less explicitly descriptive. His piano music, among his finest compositions, shows an incredible sensitivity to the range of sound effects that instrument can achieve. Many of his pieces have descriptive titles—"Footsteps in the Snow," "The Girl with the Flaxen Hair," and so on—but these were

often added after their composition as the obligatory touch of musical Impressionism. Sometimes they were even suggested by Debussy's friends as their own personal reactions to his music.

For a selection from Debussy, see the Listening CD.

The only composer to make wholehearted use of Debussy's Impressionistic style was his fellow countryman Maurice Joseph Ravel (1875–1937), who, however, added a highly individual quality of his own. Ravel was far more concerned with classical form and balance than Debussy. His musical god was Mozart, and something of the limpid clarity of Mozart's music can be heard in many of his pieces—although certainly not in the all-too-familiar *Bolero*. His lovely *Piano Concerto in G* alternates a Mozartian delicacy and grace with an exuberance born of Ravel's encounters with jazz. Even in his most overtly Impressionistic moments, like the scene in his ballet *Daphnis and Chloe* that describes dawn rising, he retains an elegance and verve that differs distinctly from the veiled and muted tones of Debussy.

The Search for a New Musical Language

In 1908, the Austrian composer Arnold Schönberg (1874–1951) wrote his *Three Piano Pieces*, Op. 11, in which he was "conscious of having broken all restrictions" of past musical traditions. After their first performance one critic described them as "pointless ugliness" and "perversion." In 1913, the first performance of *The Rite of Spring*, a ballet by the Russian-born composer Igor Fyodorovich Stravinsky (1882–1971), was given in Paris, where he was then living. It was greeted with hissing, stamping, and yelling, and Stravinsky was accused of the "destruction of music as an art." Stravinsky and Schönberg are today justly hailed as the founders of modern music, but we can agree with their opponents in at least one respect: their revolutionary innovations permanently changed the course of musical development.

http://www.karadar.it/Dictionary/stravinskj.html

Stravinsky

For a selection from Stravinsky's *Rite of Spring*, see the Listening CD.

It is a measure of their achievement that today listeners find *The Rite of Spring* exciting, even explosive, but perfectly approachable. If Stravinsky's ballet score has lost its power to shock and horrify, it is principally be-

cause we have become accustomed to music written in its shadow. The Rite of Spring has created its own musical tradition, one without which present-day music at all levels of popularity would be unthinkable. Schönberg's effect has been less widespread and more subtle; nonetheless, no serious composer writing since his time has been able to ignore his music. It is significant that Stravinsky himself, who originally seemed to be taking music down a radically different "path to destruction," eventually adopted principles of composition based on Schönberg's methods.

As is true of all apparently revolutionary breaks with the past, Stravinsky and Schönberg were really only pushing to extreme conclusions developments that had been under way for some time. Traditional harmony had been collapsing since the time of Wagner, and Schönberg only dealt it a death blow by his innovations. Wagner's Tristan and Isolde had opened with a series of chords that were not firmly rooted in any key and had no particular sense of direction (see Chapter 17), a device Wagner used to express the poetic concept of restless yearning. Other composers followed him in rejecting the concept of a fixed harmonic center from which the music might stray so long as it returned there, replacing it with a much more fluid use of harmony. (Debussy, in his attempts to go beyond the bounds of conventional harmony, often combined chords and constructed themes in a way such as to avoid the sense of a tonal center; the result can be heard in the wandering, unsettled quality of much of his music.)

Schönberg believed that the time had come to abandon a harmonic (or tonal) system that had served music well for over three hundred years but had simply become worn out. He therefore began to write atonal music-music that deliberately avoided traditional chords and harmonies. Thus Schönberg's atonality was a natural consequence of earlier musical developments. At the same time, it was fully in accordance with the spirit of the times. The sense of a growing rejection of traditional values, culminating in a decisive and violent break with the past, can be felt not only in the arts but also in the political and social life of Europe; Schönberg's drastic abandonment of centuries of musical tradition prefigured by only a few years the far more drastic abandonment of centuries of tradition brought about by World War I.

There is another sense in which Schönberg's innovations correspond to contemporary developments. One of the principal effects of atonality is a mood of instability—even disturbance—which lends itself to the same kind of morbid themes that attracted Expressionist painters. In fact, many of Schönberg's early atonal works deal with such themes. Schönberg was himself a painter of some ability and generally worked in an Expressionist style.

514

One of Schönberg's most extraordinary pieces is Pierrot Lunaire, finished in 1912, a setting of twenty-one poems for woman's voice and small instrumental group. The poems describe the bizarre experiences of their hero, Pierrot, who is an Expressionist version of the eternal clown, and their mood is grotesque and at times demonic. The eighth poem, for example, describes a crowd of gigantic black moths flying down to block out the sunlight, while in the eleventh, titled "Red Mass," Pierrot holds his own heart in his bloodstained fingers to use as a "horrible red sacrificial wafer." Schönberg's music clothes these verses in appropriately fantastic and macabre music. The effect is enhanced by the fact that the singer is instructed to speak the words at specific pitches. This device of Sprechstimme ("voiced speech"), invented by Schönberg for Pierrot Lunaire, is difficult to execute, but when it is done properly by a skilled performer, it imparts a wistfully dreamlike quality to the music.

To hear Pierrot Lunaire, see the Listening CD.

The freedom atonality permitted the composer became something of a liability and, by the 1920s, Schönberg replaced it with a system of composition as rigid as any earlier method in the history of music. His famous twelve-tone technique makes use of the twelve notes of the chromatic scale (on the piano, all the black and white notes in a single octave), which are carefully arranged in a row or series, the latter term having given rise to the name serialism to describe the technique. The basic row, together with variant forms, then serves as the basis for a movement or even an entire work, with the order of the notes remaining always the same. The following example presents the row used in the first movement of Schönberg's Piano Suite, Op. 25, together with three of its variant forms. No. 1 is the row itself, No. 2 its inversion (that is, the notes are separated by the same distance but in the opposite direction, down instead of up, and up instead of down); No. 3 is the row retrograde or backward, and No. 4 the inversion of this backward form, known as retrograde inversion.

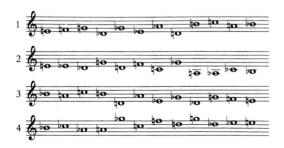

Just as with program music, the only fair way to judge the twelve-tone technique is by its results. Not all works written using it are masterpieces, but we can hardly expect them to be. It is not a system that appeals to all composers or brings out the best in them, but few systems ever have universal application. A number of Schönberg's own twelve-tone works, including his unfinished opera *Moses and Aaron* and the *Violin Concerto* of 1934, demonstrate that serial music can be both beautiful and moving. The twenty-first century will decide whether the system has permanent and enduring value.

Like Pierrot Lunaire, Stravinsky's The Rite of Spring deals with a violent theme. It is subtitled Pictures from Pagan Russia and describes a springtime ritual culminating in the sacrifice of a chosen human victim. Whereas Schönberg jettisoned traditional harmony, Stravinsky used a new approach to rhythm as the basis of his piece. Constantly changing, immensely complex, and frequently violent, his rhythmic patterns convey a sense of barbaric frenzy that is enhanced by the weight of sound obtained from the use of a vast orchestra. There are some more peaceful moments, notably the nostalgic opening section, but in general the impression is of intense exhilaration. Something of the rhythmic vitality of The Rite of Spring can be seen in this brief extract from the final orgiastic dance. The same melodic fragment is repeated over and over again, but in a constantly fluctuating rhythm that changes almost from bar to bar.

The Rite of Spring was the last of three ballets (the others were The Firebird and Petrouchka) that Stravinsky based on Russian folk subjects [18.32]. In the years following World War I he wrote music in a wide variety of styles, absorbing influences as varied as Bach, Tchaikovsky, and jazz. Yet a characteristically Stravinskian flavor pervades all his best works, with the result that his music is almost always instantly recognizable. Short, expressive melodies and unceasing rhythmic vitality, both evident in The Rite of Spring, recur in works like the Symphony in Three Movements in 1945. Even when, in the 1950s, he finally adopted the technique of serialism he retained his own unique musical personality. Indeed, Stravinsky is a peculiarly twentieth-century cultural phenomenon, an artist uprooted from his homeland, cut off (by choice) from his cultural heritage, and exposed to a barrage of influences and counterinfluences. That he never lost his sense of personal identity or his belief in the enduring value of art made him a twentiethcentury hero.

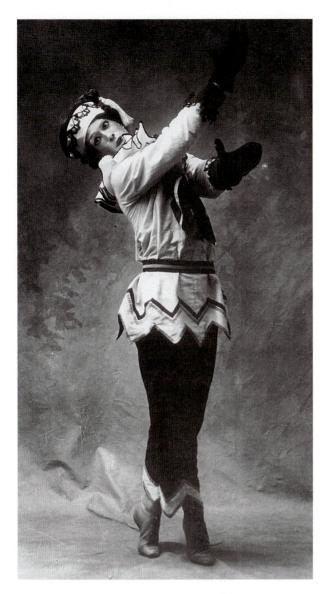

18.32 Vaslav Nijinsky as the puppet Petrouchka in Igor Stravinsky's ballet of that name, as choreographed by Michel Fokine and performed by the Ballet Russe. Paris, 1911. New York Public Library at Lincoln Center (Roger Pryor Dodge Collection). Nijinsky (1890–1950), a Russian, was one of the greatest dancers of all time. Fokine (1880–1942), also a Russian, was a choreographer who broke new ground in the ballet just as the Impressionists did in art and music.

New Subjects for Literature

Psychological Insights in the Novel

At the end of the nineteenth century, many writers were still as concerned with exploring the nature of their own individual existences as they had been when the century began. In fact, the first years of the twentieth century saw an increasing interest in the effect of the subconscious on human behavior, a result in large measure of the work of the Austrian psychoanalyst Sigmund Freud (1856–1939);

the general conclusions Freud reached are discussed in Chapter 21. In many ways his interest in the part played by individual frustrations, repressions, and neuroses (particularly sexual) in creating personality was prefigured in the writing of two of the greatest novelists of the late nineteenth century: Fyodor Dostoyevsky (1821–1881) and Marcel Proust (1871–1922).

Self-knowledge played a major part in Dostoyevsky's work, and his concern for psychological truth led him into a profound study of his characters' subconscious motives. His empathy for human suffering derived in part from his identification with Russian Orthodox Christianity, with its emphasis on suffering as a means to salvation. Although well aware of social injustices, he was more concerned with their effect on the individual soul than on society as a whole. His books present, to be sure, a vivid picture of the Russia of his day, with characters at all levels of society brought brilliantly to life. Nevertheless, he was able to combine realism of perception with a deep psychological understanding of the workings of the human heart. Few artists have presented so convincing a picture of individuals struggling between good and evil.

The temptation to evil forms a principal theme of one of his most powerful works, *Crime and Punishment*. In it Dostoyevsky tells the story of a poor student, Raskolnikov, whose growing feeling of alienation from his fellow human beings leads to a belief that he is superior to society and above conventional morality. To prove this to himself, Raskolnikov decides to commit an act of defiance: the murder of a defenseless old woman, not for gain but as a demonstration of his own power.

He murders the old woman and also her younger sister, who catches him in the act. Crime is followed immediately, however, not by the punishment of the law but by the punishment of his own conscience. Guilt and remorse cut him off even farther from human contact until finally, in utter despair and on the verge of madness, he goes to the police and confesses to the murder. Here and in his other works, Dostoyevsky underlines the terrible dangers of intellectual arrogance. The world he portrays is essentially cruel, one in which simplicity and self-awareness are the only weapons against human evil, and suffering is a necessary price paid for victory.

If Dostoyevsky used violence to depict his worldview, his contemporary and fellow Russian Anton Pavlovich Chekhov (1860–1904) used irony and satire to show the passivity and emptiness of his characters. In plays and short stories, Chekhov paints a provincial world whose residents dream of escape, filled with a frustrated longing for action. The three sisters who are the chief characters in the play of that name never manage to achieve their ambition to go "To Moscow, to Moscow!" In stories such as "The Lady with the Dog," Chekhov uses apparent triviality to express profound understanding, whereas in "The Bet" he ironically challenges most of our basic values.

One of the most influential of all modern writers was the French novelist Marcel Proust. Proust's youth was spent in the fashionable world of Parisian high society, where he entertained lavishly and mixed with the leading figures of the day while writing elegant if superficial poems and stories. The death of his father in 1903 and of his mother in 1905 brought about a complete change. He retired to his house in Paris and rarely left his sound-proofed bedroom, where he wrote the vast work for which he is famous, *Remembrance of Things Past*. The first volume appeared in 1913; the eighth and last volume was not published until 1927, five years after his death.

It is difficult to do justice to this amazing work. The lengthy story is told in the first person by a narrator who, though never named, obviously has much in common with Proust himself. Its entire concern is to recall the narrator's past life—from earliest childhood to middle age—by bringing to mind the people, places, things, and events that have affected him. In the course of the narrator's journey back into his past he realizes that all of it lies hidden inside him and that the tiniest circumstance—a scent, a taste, the appearance of someone's hair—can trigger a whole chain of memory associations. By the end of the final volume the narrator has decided to preserve the recollection of his past life by making it permanent in the form of a book—the book the reader has just finished.

Proust's awareness of the importance of the subconscious and his illustration of the way in which it can be unlocked have had a great appeal to modern writers, as has his *stream of consciousness* style, which appears to reproduce his thought processes as they actually occur rather than as edited by a writer for logical connections and development. Further, as we follow Proust's (or the narrator's) careful and painstaking resurrection of his past, it is important to remember that his purpose is far more than a mere intellectual exercise. By recalling the past we bring it back to life in a literal sense. Memory is our most powerful weapon against death.

Responses to a Changing Society: The Role of Women

Not all writers in the late nineteenth and early twentieth centuries devoted themselves to the kind of psychological investigation found in the works of Dostoyevsky and Proust. The larger question of the nature of society continued to attract the attention of more socially conscious writers who explored the widening range of problems created by industrial life as well as a whole new series of social issues (see Table 18.2).

One of the most significant aspects of the development of the modern world has been the changing role of women in family life and in society at large. The issue of women's right to vote was bitterly fought in the early years of the twentieth century, and not until 1918 in Great Britain and 1920 in the United States were women permitted to participate in the electoral process. On a more personal basis, the growing availability and frequency of divorce began to cause many women (and men) to rethink the nature of the marriage tie. The pace of women's emancipation from the stock role assigned to them over centuries was, of course, extremely slow, and the process is far from complete. A beginning had to be made somewhere, however, and it is only fitting that a period characterized by cultural and political change should also be marked by social change in this most fundamental of areas.

In the same way Dickens had led the drive against industrial oppression and exploitation in the midnineteenth century, writers of the late nineteenth and

TABLE 18.2 Social and Intellectual Developments: 1870–1914

TABLE 18.2	Social and Intellectual Developments: 18/0–1914
1875	German Social Democratic party founded
1879	Edison invents electric light bulb
1881	Pasteur and Koch prove "germ theory" of disease
1883	Social insurance initiated by Bismarck in Germany
1888	Brazil abolishes slavery, the last nation to do so
1889	International league of socialist parties founded, the so-called Second International
1894-1906	Dreyfus affair in France reveals widespread anti-Semitism and leads to separation of church and state
1895	Roentgen discovers x-rays Marconi invents wireless telegraphy
1900	Freud publishes The Interpretation of Dreams
1903	Wright brothers make first flight with power-driven plane
1905	Einstein formulates theory of relativity Revolution in Russia fails to produce significant social change
1906-1911	Social insurance and parliamentary reform enacted in Britain
1909	Ford produces assembly-line made automobiles
1911	Revolution in China establishes republic Rutherford formulates theory of positively charged atomic nucleus

early twentieth centuries not only reflected feminist concerns but actively promoted them as well. They tackled a range of problems so vast that we can do no more than look at just one area, marriage, through the eyes of two writers of the late nineteenth century. One of them, Henrik Ibsen (1828–1906), was the most famous playwright of his day and a figure of international renown. The other, Kate Chopin (1851–1904), was ignored in her own lifetime even in her native America.

Ibsen was born in Norway, although he spent much of his time in Italy. Most of his mature plays deal with the conventions of society and their consequences, generally tragic. Although many are technically set in Norway, their significance was intended to be universal. The problems Ibsen explored were frequently ones regarded as taboo, including venereal disease, incest, and insanity. The realistic format of the plays brought issues like these home to his audience with shocking force. At first derided, Ibsen eventually became a key figure in the development of drama, particularly in the English-speaking world, where his work was championed by George Bernard Shaw (1856–1950), who later inherited Ibsen's mantle as a progressive social critic.

In one of his first important plays, A Doll's House (1879), Ibsen dealt with the issue of women's rights. The principal characters, Torvald Helmer and his wife Nora, have been married for eight years, apparently happily enough. Early in their marriage, however, before Helmer had become a prosperous lawyer, Nora had secretly borrowed some money from Krogstad, a friend, to pay for her husband's medical treatment; she had told Torvald that the money came from her father because Helmer was too proud to borrow. As the play opens, Krogstad, to whom Nora is still in debt, threatens to blackmail her if she does not persuade Helmer to find him a job. When she refuses to do so, Krogstad duly writes a letter to Helmer revealing the truth. Helmer recoils in horror at his wife's deception. The matter of the money is eventually settled by other means and Helmer eventually forgives Nora, but not before the experience has given her a new and unforgettable insight into her relationship with her husband. In the final scene, she walks out the door, slams it, and leaves him forever.

Nora decides to abandon her husband on two grounds. In the first place, she realizes how small a part she plays in her husband's real life. As she says, "Ever since the first day we met, we have never exchanged so much as one serious word about serious things." The superficiality of their relationship horrifies her. In the second place, Helmer's inability to rise to the challenge presented by the discovery of his wife's deception and prove his love for her by claiming that it was he who had borrowed and failed to repay the debt diminishes him in Nora's eyes. Ibsen tries to express what he sees as an essential difference between men and women when, in re-

ply to Helmer's statement "One doesn't sacrifice one's honor for love's sake," Nora replies, "Millions of women have done so." Nora's decision not to be her husband's childish plaything—to leave the doll's house in which she was the doll—was so contrary to accepted social behavior that one noted critic remarked: "That slammed door reverberated across the roof of the world."

In comparison to the towering figure of Ibsen, the American writer Kate Chopin found few readers in her own lifetime; even today she is not widely known. Only recently have critics begun to do justice to the fine construction and rich psychological insight of her novel *The Awakening*, denounced as immoral and banned when first published in 1899. Its principal theme is the oppressive role women are forced to play in family life. Edna, its heroine, like Nora in *A Doll's House*, resents the meaninglessness of her relationship with her husband and the tedium of her daily existence. Her only escape is to yield to her sexual drives and find freedom not in slamming the door behind her but by throwing herself into a passionate if unloving affair.

In her short stories, Chopin dealt with the same kind of problem, but with greater delicacy and often with a wry humor. Frequently on the smallest of scales, these stories examine the prison that marriage seems so often to represent. In the course of a couple of pages Chopin exposes an all-too-common area of human experience and, like Ibsen, touches a chord that rings as true now as it did at the turn of the century.

SUMMARY

The Coming of World War The last years of the nineteenth century saw the threat of war gathering with increasing speed over Europe. The gap between the prosperous and the poor, the growth of the forces of big business, overcrowding and food shortages in the cities all tended to create a climate of unease that the rivalries of the major European powers exacerbated. Many emigrated to America in search of a new start. For the philosopher Friedrich Nietzsche only drastic remedies could prevent the collapse of Western civilization.

Impressionist Painting In each of the arts the years leading up to World War I were marked by far-reaching changes. In the case of painting, the Impressionist school developed in Paris. Foreshadowed in the work of Édouard Manet, Impressionist art represented a new way of looking at the world. Painters like Claude Monet, Auguste Renoir, and Berthe Morisot reproduced what they saw rather than visually interpret their subjects. The depiction of light and atmosphere became increasingly important. The figure studies of Edgar Degas and Mary Cassatt avoided the careful poses of earlier times in favor of natural, intimate scenes.

The Post-Impressionists The various schools that developed out of Impressionism are collectively known as post-Impressionist although they have little in common with one another. Among the leading artists were Paul Gauguin, with his love of exotic subjects, and Vincent van Gogh, whose deeply moving images have made him perhaps the best known of all nineteenth-century painters. In historical terms, the most important figure was probably Paul Cézanne: His works are the first since the dawn of the Renaissance to eliminate perspective and impose order on nature rather than try to reproduce it.

Expressionism and the Fauves In the early years of the twentieth century two movements began to emerge: Fauvism and Expressionism—the former in France and the latter in Germany and Scandinavia. Both emphasized bright colors and violent emotions, and the works of Edvard Munch and other Expressionists are generally tormented in spirit. Henri Matisse, the leading Fauve artist, however, produced works that are joyous and optimistic; he was to become a major force in twentieth-century painting.

Orchestral Music at the Turn of the Nineteenth Century Composers of orchestral music in the late nineteenth and early twentieth centuries turned increasingly to the rich language of post-Wagnerian harmony and instrumentation to express either extramusical "programs" or to compose "autobiographical" works. The leading figures of the period included Richard Strauss and Gustav Mahler. Many of Strauss' operas have held the stage since their first performances, while his tone poems use a vast orchestra either to tell a story (as in Don Juan) or to describe his own life (Domestic Symphony). Mahler's symphonies, neglected in the composer's lifetime, have come to represent some of the highest achievements of the symphonic tradition. Openly autobiographical, they reflect at the same time the universal human problems of loss and anxiety.

In France, the music of Claude Debussy and, to a lesser extent, Maurice Ravel, set out to achieve the musical equivalent of Impressionism. In works like *La Mer* Debussy used new harmonic combinations to render the atmosphere of a seascape.

New Approaches to Music: Schönberg and Stravinsky The experiments of composers like Mahler and Debussy at least retained many of the traditional musical forms and modes of expression, although they vastly extended them. In the early years of the twentieth century, Arnold Schönberg and Igor Stravinsky wrote works that represented a significant break with the past. Schönberg's atonal and, later, serial music sought to replace the traditional harmonic structure of Western musical style with a new freedom, albeit one limited by the serial system. In The Rite of Spring and other works Stravinsky revealed a new approach to rhythm. Both composers profoundly influenced the development of twentieth-century music.

Literature and the Subconscious Like other arts, literature also underwent revolutionary change in the latter decades of the nineteenth century. In the hands of Fyodor Dostoyevsky and Marcel Proust, the novel became a vehicle to reveal the effects of the subconscious on human behavior. In Dostoyevsky's books self-knowledge and psychological truth are combined to explore the nature of human suffering. Proust's massive exploration of the past not only seeks to uncover his own memories, it also deals with the very nature of time itself. Both writers, along with many of their contemporaries, joined painters and musicians in pushing their art to its limits in order to extend its range of expression.

Writers and the Changing Role of Women A more traditional aim of literature was to effect social change. At a time when society was becoming aware of the changing role of women in the modern world, writers aimed to explore the implications for marriage and the family of the gradual emancipation of women and the increasing availability of divorce. The plays of Henrik Ibsen not only described the issues of his day, including feminist ones, they were also intended to open up discussion of topics—venereal disease, incest—that his middle-class audience would have preferred to ignore.

With the outbreak of war in 1914, the arts were wrenched from their traditional lines of development to express the anxieties of the age. Nothing—in art, culture, politics, or society—was ever to return to its former state.

Pronunciation Guide

belle époque:bell ep-OCKCézanne:Say-ZANDegas:De-GA

Dostoyevsky: Doh-stoy-EV-ski

Gauguin: Go-GAN Ibsen: IB-sun Manet: Ma-NAY Monet: Mo-NAY **Morisot:** Mo-ri-SEW Munch: **MOONK** Nietzsche: NEE-che **Proust: PROOST** Renoir: Ren-WAAR Rodin: Roe-DAN Schönberg: SHURN-burg

Till Eulenspiegel: Til OY-lin-shpee-gull

van Gogh: van GO

EXERCISES

 Assess the impact of political and philosophical developments on the arts in the late nineteenth century.

- 2. Describe the goals and achievements of the Impressionist movement in painting. How do you account for the enormous popularity of Impressionist art ever since?
- 3. How did Arnold Schönberg's music break with the past? How does his serial system function? What is its purpose?
- 4. In what ways is the changing role of women reflected in art and literature at the turn of the century?
- Compare the fiction of Dostoyevsky and Proust. How does it differ from earlier nineteenth-century novels discussed in Chapter 17?

FURTHER READING

Broude, N. (1991). Impressionism: A feminist reading. New York: Rizzoli. A refreshing look at some familiar works, with very good illustrations.

Clark, T. J. (1984). The painting of modern life: Paris in the art of Manet and his followers. New York: Knopf. A Marxist analysis of Impressionist art and the society in which it was created, with much valuable information about the development of urban life. Controversial but stimulating.

Franklin, P. (1997). *The life of Mahler*. New York: Cambridge University Press. A fine biography that places Mahler's life and music in the context of the cultural conflicts of his era.

Fried, M. (1996). *Manet's modernism, or, the face of painting in the 1860s*. Chicago: University of Chicago Press. An important book that analyzes the artistic conditions leading to the birth of Impressionism.

Hamilton, G. H. (1986). Manet and his critics. New Haven, CT: Yale University Press. The latest edition of an important study of the origins of Impressionism.

Hobsbawm, E. (1987). *The age of empire,* 1875–1914. New York: Pantheon. A study of the late nineteenth century that pulls together social, political, and cultural developments.

Jensen, R. (1994). Marketing Modernism in fin-de-siècle Europe. Princeton, NJ: Princeton University Press. A fascinating and unusual perspective on European art at the end of the nineteenth century.

Kennedy, M. (1999). Richard Strauss: Man, musician, enigma. New York: Cambridge University Press. One of the latest studies of Strauss and his music. Kennedy deals relatively sympathetically with Strauss' controversial relationship with the Nazis.

Kent, S. K. (1987). Sex and suffrage in Britain, 1860–1914.
Princeton, NJ: Princeton University Press. A good introduction to the impact of the women's movement on pre-World War I society and culture.

 Lipton, E. (1986). Looking into Degas: Uneasy images of women and modern life. Berkeley: University of California Press.
 A feminist analysis of Degas' art, cogently argued and profusely illustrated.

Rewald, J. (1986). Cézanne: A biography. New York: Abrams. A lavish biography of one of the founding fathers of modern art. Excellent illustrations, a high proportion of which are in color.

Sked, A. (1989). *The decline and fall of the Hapsburg Empire,* 1815–1918. London: Longman. An excellent introduction to the historical background of the period.

Smith, P. (1995). *Impressionism: Beneath the surface.* New York: Harry N. Abrams. An interesting and beautifully illustrated study of Impressionist art.

Tadier, J-Y. (2000). Marcel Proust: A Life, Trans. Euan Cameron. New York: Viking. An authoritative study of Proust's life and works from the leading French Proust scholar.

ONLINE CHAPTER LINKS

Extensive Internet resources—including biography and works—are available at *The Vincent van Gogh Gallery* at

http://www.vangoghgallery.com/

For information about Édouard Manet's life, his works, his friends, and his associates, visit http://www.mystudios.com/manet/manet.html

The Rodin Museum at

http://www.rodinmuseum.org/

provides an account of the conservation of the Philadephia version of Rodin's *The Thinker*, which suffered from the effects of pollution after having been displayed outside for more than sixty years. Also visit the Musée Rodin in Paris at http://www.musee-rodin.fr/welcome.htm

Two sites devoted to Richard Strauss http://www.richard-strauss.com/http://people.unt.edu/~dmeek/rstrauss.html feature biographical information, lists of compositions, performance aspects, and links to a wide variety of Internet resources.

Two sites devoted to Sigmund Freud http://www.freudpage.com/en-us/freud/index.html http://www.freud.org.uk/

feature extensive information—biographic accounts, selected works, a virtual tour of his home, photographs of the original analytic couch, as well as numerous links to additional Internet resources.

The Kolb-Proust Archive for Research at http://www.library.uiuc.edu/kolbp/

is a scholarly site devoted to the study of Marcel Proust and his times and features links to related Internet resources.

Internet resources related to Kate Chopin are available at

http://www.womenwriters.net/domesticgoddess/chopin I.htm

Karadar Classical Music at

http://www.karadar.it/Dictionary/Default.htm provides an alphabetical listing of musicians with brief biographies and a list of works (some of which are available on MIDI files).

	GENERAL EVENTS	LITERATURE & PHILOSOPHY	ART & ARCHITECTURE
		India	
1100	II92 Sultanate of Delhi establishes first major seat of Muslim power in India		
1200			
1300			
1400			
1500	I500 – I700 The Mughal Empire in India I526 Afghanistan chieftan Babur (1483–1530) wins control of northern India Babur's grandson Akbar (1542–1605) extends Muslim rule to most of India	Akbar commissions a new language, Urdu, to establish a common language for the empire	Under the Mughal emperors, secular art forms develop depicting realistic portraits and historical events
1600	Aurangzeb (1618–1707), last significant Mughal emperor, orders systematic destruction of Hindu works	Hindu poet Tulsi Das (1532?–1623) writes the Sanskrit epic "The Holy Lake of the Acts of Rama"	Taj Mahal built by Shah Jehan (1632–1649)
1700	1764 India falls under the virtual control of the British East India		
	1800 British control of India made official1885 Founding of India's National Congress party	Prem Cand (1880–1936) India novelist and short-story writer	
1900	1914–1917 World War I 1917 Mohandas Gandhi (1869–1948) leads postwar campaign for Indian independence, espousing "Satyagraha" or nonviolent civil disobedience 1939–1945 World War II 1948 Gandhi assassinated by Hindu extremist	In <i>The Apu Trilogy,</i> and other works, Indian filmmaker Satyajit Ray (1921–1992) tells about the lives of ordinary people, using the details of everyday life to give a general impression of their culture	

1950 End of British rule

2000

CHAPTER 19

India, China, and Japan: From the Medieval to the Modern World

GENERAL EVENTS

LITERATURE & PHILOSOPHY

ART & ARCHITECTURE

CHINA

1279 Mongols invade China, seizing Beijing

1368-1644 Ming Dynasty Confucianism with its emphasis on obedience and loyalty to authorities develops under the Ming Dynasty

Confucianism results in both a rigid conservatism in existing forms and an explosion of experimentation in new artistic forms

1200s Construction of imperial capital Beijing, including the Forbidden City, follows conservative plan

Ming Dynasty produces vases of exceptional quality

1400 Landscape provides a new subject for painters

1500 First collections of "Hua-Pen," works based on the oral traditions of traveling storytellers appear Chin P'ing Mei, one of the first novels to focus on daily life rather than the fantastic or epic stories of tradition

Monkey, by Wu Ch'eng-en (c. 1501 – 1580), relates the legends and tales of the travels of Tripitaka, an actual **Buddhist** priest

> Painter Shitao introduces a more vigorous

line in landscape painting

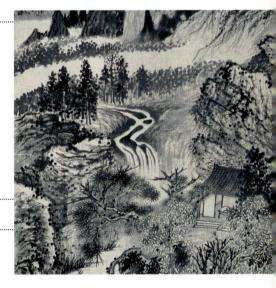

1644-1911 Qing Dynasty Kang (1654–1722) establishes the Grand Council to solidify his power with local bureaucratic structures

1669 Ferdinand Verbiest (1623-1688), a westerner, becomes head of the Beijing Astronomical Bureau

1689 Treaty with Peter the Great limits Russian expansion into China; British East India Company arrives in China

1800 Chinese independence threatened by traders importing opium

1839 - 1842 Opium War results when China resists western efforts to import opium

Conditions in China result in widespread unrest and rebellion 1851 – 1864 Tai Ping Rebellion

1900-1901 Boxer Rebellion results in full western control of China

1911 Sun Yat-sen (1866-1925) and the Republican army defeats the monarchy

Chiang Kai-shek (1887–1975) leads the Kuomintang, authoritarian regime initially intended to result in democratic rule

1949 Mao Tse-tung (1893–1976) Chinese communist party leader assumes power

After World War II virtually all art either glorifies communism or vilifies previous regimes

Like the other arts, Chinese film was rigidly controlled by the Communist Party; recent filmakers like Zhang Yimou (b. 1951) have been able to present stories of a more personal nature; his films Raise the Red Lantern (1951) and The Story of Qiu Ju, (1992) for example, highlight the social system in China with special attention on hardships faced by women

JAPAN

200

THE HEIAN PERIOD 082

Agricultural communities based on tribal chiefs develop in Japan

780 Heian, present-day Kyoto, becomes new capital and stable center of government

Fujiwara Michinaga (966–1027) serves as regent to the royal family

Japanese develop their own system of writing

No plays, which combine ritual and slapstick elements to tell traditional stories, develop

Lady Murasaki Shikibu (c. 980–1030) writes *The Tale of Genji*, based on her experiences at the Heian court; it becomes the most famous literary work of its day

The "pillow-book" or diaries of Sei Shonagon (c. 1000) also survive from this era

The Tale of Genji

1185

1450

1603

THE EDO PERIOD

I185 The Period of Feudal Rule
The city of Kakamura becomes a
more aggressive rival to the capital
at Kyoto, marking the beginning of
feudal rule under a new warrior
class of samurai serving under the
military command of the shogūn
1274, 1281 Successive waves of

Mongol invasion

1467–1568 Age of the Warring States1590 Hideyoshi (1537–1598) reunitesJapan

Tokugawa (1543–1616) creates a new capital at Edo, the modern Tokyo

1853 Commodore Matthew Perry arrives, intent on opening Japan to American trade

Basho (1644–1694), a great poet of the age, develops the *haiku*

Ihara Saikaku (1642–1693) becomes famous for his novels, including "Life of an Amorous Woman"

In "The Love Suicide at Amijima" and other works, Chikamatsu Monzaemon (1653–1725) contributes to the new dramatic form *kabuki*, which draws on real life for material

Japanese artists continue to develop traditional Chinese models for landscape painting

Hokusai Katsushika (1760–1849) explores the popular new medium of

woodblock

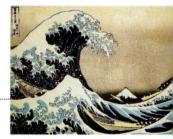

1868

1900

1950

1868 The Meiji

Japan begins a vast program of modernization under the Meji emperors

By 1905 Japan has industrialized successfully enough to defeat the Russians in the Russo-Japanese War

War 1914–1917 World War I 1939–1945 World War II

1952 End of American occupation of Japan

1950s, acclaimed Japanese film director Akira Kurosawa (1910–1998) directs *Rashomon* and *Seven Samurai*; his career continues well into the 80s with *Kagemusha* and *Ran*, reflecting the influence of such classic American filmakers as John Ford

2000

CHAPTER 19

India, China, and Japan: From the Medieval to the Modern World

t the time the medieval era in Western Europe was nearing its end, two principal regions in southeast Asia—India and China—underwent lasting changes as a result of outside invaders. The third, Japan, maintained its cultural isolation from the rest of the world until the nineteenth century. All three regions eventually came into contact with Western culture.

India: From Mughal Conquest to British Rule

With the decline of Buddhism and the fall of the Gupta Empire, India separated into a series of kingdoms, many of which were ruled by *rajputs*. For the most part, these local rulers were descendants of warriors from Central Asia, who had converted to Hinduism and claimed membership in the warrior caste. Their constant feuding prevented the formation of a thriving economy or stable government, and left India vulnerable to conquest by an outside force—that of the Muslims.

The first major seat of Muslim power was at Delhi, where Turkish forces established a sultanate (a Muslim kingdom ruled by a sultan) in 1192. Although it fell to successive waves of invaders, the Sultanate of Delhi established Islam as a new force in the subcontinent; it was strongest in the northwest—the Indus Valley—a region that centuries later broke away from India to become the Islamic Republic of Pakistan after World War II.

THE MUGHAL EMPIRE

http://ourworld.compuserve.com/homepages/asimz/dmughal.htm

Mughal Empire

In 1526, Babur (1483–1530), an Afghanistan chieftain, led his troops into India, and in a short time won control over most of northern India. His grandson, Akbar (1542–1605), further extended Muslim rule to cover most of India and Afghanistan. Akbar's kingdom was called the *Mughal* (the Persian word for "Mongol") Empire, and lasted until the British took control of India in the eighteenth century.

http://www.itihaas.com/medieval/baburl.html

Babur

Unlike earlier raiders bent on plunder, both Akbar and his grandfather intended from the outset that the land they conquered should become a center for civilization. Akbar was famous not only for his courage and military prowess, but also as a book collector and patron of the arts. Unlike Muslim rulers elsewhere, Akbar made no attempt to impose the Islamic faith on his subjects. He married a Hindu princess, and allowed Hindu women at his court to practice their religion openly. In order to provide a common language for all his subjects, Akbar commissioned scholars to create a blend of Hindi (hitherto the most widely spoken language in India) with Arabic and Persian. The new language, called *Urdu*, is, together with Hindi and English, one of India's three official languages today.

Under Akbar's successors, the Mughal Empire expanded further to include all of the subcontinent except for the extreme southern tip. During the first half of the seventeenth century, patronage of the arts reached new heights, as Mughal architects and painters devised a new style which, like the Urdu language, combined aspects of the Hindu tradition with Persian and other Muslim elements.

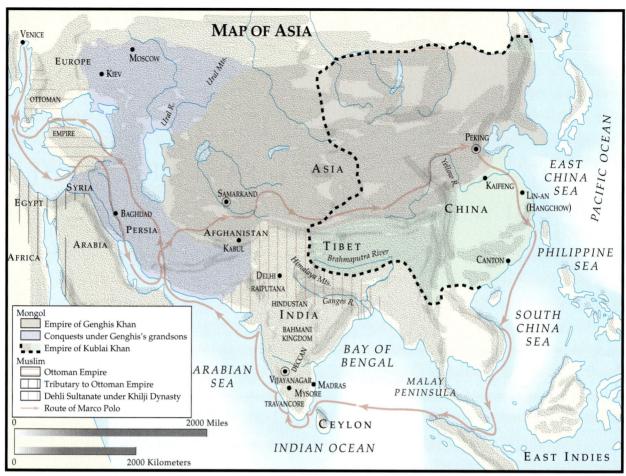

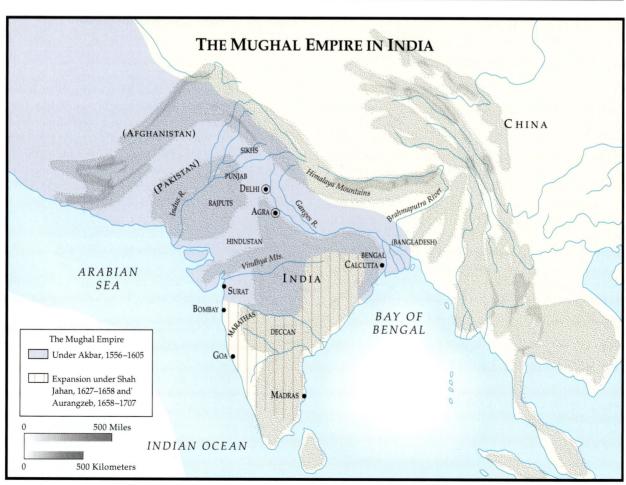

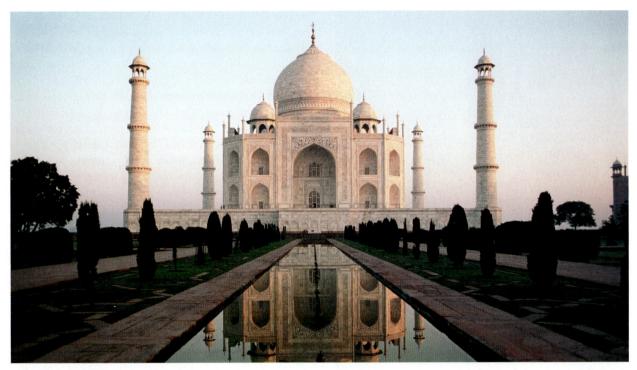

19.1 The Taj Mahal at Agra. Built 1632–1649, at the command of Shah Jehan, as the tomb for his favorite wife (it eventually served as the Shah's own tomb).

Mughal Art

The most visible remains of Mughal rule in India were left by Mughal architects. Mosques, palaces, walled cities, and forts all show traditional Indian techniques combined with new innovations from Arabic architecture. Among the most important of these innovations are the dome, pointed arch, and minaret ("tower"); this last feature formed a vital element in the construction of mosques, Islam's most important religious architectural form. The most famous of Mughal buildings-and one of the best known anywhere in the world—is the Taj Mahal at Agra, built by order of Shah Jehan (1592–1666) during the years 1632-1649 [19.1]. The shah commissioned the Taj Mahal as a tomb and monument for his beloved wife Banu Begam, the mother of fourteen of his children; a woman as renowned for her charity as for her beauty. The dome, towers, and landscaping—in particular the use of water—are all typical Mughal features. Together with the elaborate decorations, or arabesques, they make the Taj Mahal seem an eternal symbol of the queen, "radiant in her youthful beauty, who still lingers on the riverbanks, at early morn, in the glowing midday sun, or in the silver moonlight."

Virtually all Mughal painting is in the form of book illustrations or miniature paintings that were collected in portfolios. Unlike earlier Hindu and Buddhist art, Mughal painting is secular. It shows scenes of courtly life, including—for the first time in Indian art—realistic portraits [19.2] and often depicts historical events [19.3].

As in the case of Mughal architecture, the overwhelming influence comes from Persian art of the period. A new art form in India also drew inspiration from Persian models, that of calligraphy which was often combined with miniature paintings. Very few earlier Sanskrit or Hindu

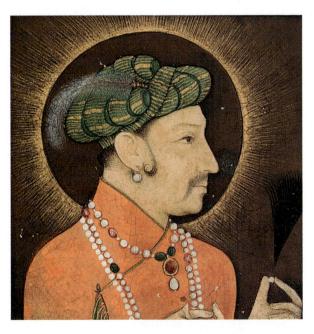

19.2 Portrait of Jahangir (1569–1627), who ruled as Mughal emperor from 1605–1627. Painting on paper, $1^9/_{12}" \times 1^7/_{16}"$ (17 × 17 cm). Museum of Fine Arts, Boston.

19.3 Dhanasri Ragini from a Ragamala manuscript. Watercolor and gold paint on paper. $12.37'' \times 9.13''$ (31.42 cm \times 23.19 cm). Indian, Deccani, Asifya Period (1726–1950).

texts contained illustrations. By contrast, Mughal artists made full use of the decorative possibilities of Arabic or Persian script [19.4].

Literature and the production of fine books was highly esteemed by Mughal aristocrats. Babur, the founder of Mughal rule, wrote his autobiography, the *Babur-nama*, in Eastern Turkish. It is still regarded as one of the finest examples of Turkish prose literature. His

19.4 Worship of Fire as a divine gift by Hushang (Feast of Sadeh): Persian Safavid miniature, c. 1525.

successor, Homayun (ruled 1530–1540; 1555–1556) was so devoted to books that when he rode into battle he took with him part of his library, carried on camelback. Homayun also wrote poetry, using the Persian, rather than Turkish language. Mughal tolerance allowed Hindu writers to continue to write works in their own language and on traditional themes. The poet Tulsi Das (1532?–1623), drawing on the Sanskrit epic, the *Ramayana*, produced *Ramcaritmanas* (*The Holy Lake of the Acts of Rama*), a work that combines monotheism with traditional Hindu polytheism and is still widely read.

The End of Mughal Rule and the Arrival of the British

The religious tolerance of the early Mughal rulers eroded over time. The last significant Mughal emperor, Aurangzeb (1618–1707) destroyed Hindu temples and increased his Hindu subjects' taxes. For the first time, Hindus serving in the imperial bureaucracy had to convert to Islam. Another factor contributing to the collapse of Mughal power was the rise of a new religion, related to Hinduism, but with no caste system: Sikhism. The Sikhs combined Hindu rituals with a highly activistic approach, forming a military brotherhood that succeeded in setting up an independent state of their own, which lasted until 1849. In that same year British forces had won control over the rest of India.

Throughout the eighteenth century, the British and French had fought their battle for colonial supremacy on Indian soil. The British East India Trading Company began its operations as early as 1600, and the superiority of British naval forces assured them victory over other European rivals—first Portugal, then France. By 1764, although India was theoretically made up of separate kingdoms, including a Sikh state and a much-reduced Mughal Empire, in practice government was in British hands, first under the East India Company and then, by 1800, directly under the British government. For the next century and a half, India was the "Jewel in the Crown" of the British Empire.

THE RISE OF NATIONALISM

Throughout the early years of the twentieth century, many of those colonized by the chief European powers began to strive for self-rule. In India, the battle began in 1885 with the founding of India's National Congress party. During World War I, three million Indian soldiers fought in British armies. This brought about further impetus, and a postwar campaign for India's independence was led by Mohandas Gandhi (1869–1948). First in South Africa, and then—after 1915 in India—Gandhi developed the principle of *Satyagraha* ("nonviolent civil

disobedience"). Born a Brahmin (the highest Hindu caste), Gandhi opposed the caste system, to the delight of the poor and India's Muslims, while maintaining Hindu backing by praising religious tradition. Pressure for independence grew during the 1930s and, by the end of World War II, Britain had no choice but to withdraw. Despite Gandhi's efforts to unite Hindus and Muslims—a policy that led to his assassination in 1948 by a Hindu extremist—Britain had played its own part in encouraging Hindu—Muslim tension, and the subcontinent split into the Republic of India (predominantly Hindu) and the Republic of Pakistan (mostly Muslim).

http://theory.tifr.res.in/bombay/persons/mk-gandhi.html

Mohandas Gandhi

One of the effects of the struggle for self-rule was to create a generation of Indian authors who, writing in both their own languages and in English, sought to draw attention to their country's plight. They include the novelist and short-story writer Prem Cand (1880-1936) and, most famously, Rabindranath Tagore (1861-1941). In 1913, Tagore won the Nobel Prize for literature; he also painted and composed music, including India's first national anthem. He also founded a school and a university. Tagore's writing and teaching stressed that national freedom was meaningless without personal freedom, and that true authority comes only from basic humanity. The tradition of Indian writers using English for their works continued throughout the twentieth century, and at the beginning of the twenty-first century many of the leading novelists of the day who write in English-Salman Rushdie, Vikram Seth, and many others—are Indian.

CHINESE CULTURE UNDER IMPERIAL RULE

China retained a central government for most of its history. Indeed, for the period from 1368 to the Republican Revolution of 1911, two dynasties controlled Chinese political and cultural life: the Ming (1368–1644) and the Qing (1644–1911). As in India, European traders established operations in China—the British East India Company arrived in 1689. Portuguese Jesuit missionaries had been established in the preceding century, using Macao (leased by the emperor to Portugal) as their base [19.5]. Unlike the Indian experience, however, where the European colonial powers fought out their wars on Indian soil, China remained virtually untouched by the West, and Macao remained the only port of entry for non-

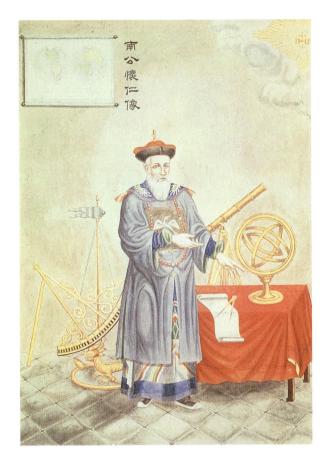

19.5 Painting of a Belgian Jesuit missionary, dressed in traditional Chinese costume. China, seventeenth century.

Chinese until the nineteenth century. Thus the central government was able to maintain tight control over the arrival of both people and ideas. This encouraged the stability of the state bureaucracy and the social structure, but did little to encourage trade or manufacturing. As a result, the rapid increase in population between 1600 and 1800—from around one hundred fifty million to some three hundred million—led inevitably to widespread poverty and political unrest, conditions that Western colonial powers were quick to exploit during the nineteenth century, culminating in the Republican Revolution of 1911.

The Arts under the Ming Dynasty

In 1279, the urban society created in China under the T'ang and Sung dynasties fell under the control of Mongol invaders from Central Asia. It took almost a century for resentment of foreign occupation, coupled with a series of disastrous floods, to provoke a widespread peasants' revolt. One of the rebels' leaders seized the Mongol capital, Beijing, and in 1368 declared himself the first emperor of the Ming Dynasty.

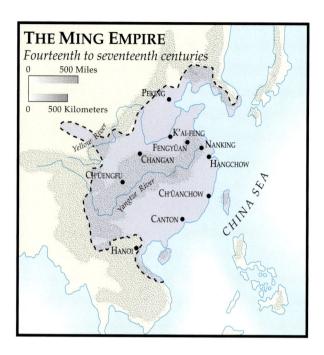

Under the Ming emperors, China enjoyed an extended period of political and economic stability and cultural enrichment. The basis for all aspects of life was Confucianism in its most traditional form. The importance of obedience and loyalty to the authorities became paramount, both within the individual family, headed by the father; and in the state as a whole, headed by the emperor, the Son of Heaven, who ruled as the "father" of his country. The effect of this conservatism on the arts was twofold. Those fields that had been cultivated in the past remained little changed; one Ming writer observed that since the early writers on Confucius had discovered everything worth knowing, it was unnecessary to write any more scholarly works. Further, writers and painters tackling traditional themes tended to imitate past models. As a result, the Ming period saw the invention of new artistic forms, in which creative artists felt themselves free to experiment.

The most popular new literary genres were the novel and the short story. The latter, known as *Hua-Pen*, were often based on the oral tales of professional traveling storytellers, or at any rate aimed to give that impression. They included verses inserted into the prose narrative, audience reaction, and the use of the speech of the streets. Traditional Buddhist subjects were combined with scenes from everyday life. The earliest collections of Hua-Pen date to the sixteenth century, although many of these had probably circulated for more than a century.

One of the first novels to focus on daily life rather than extraordinary events is the anonymous Chin P'ing Mei. This story chronicles the lurid career of the licentious Hsi-men. The society it describes is driven mainly by lust, greed, and vanity, although its author makes no attempt to moralize. The book owed its immediate and continuing popularity to its openly erotic episodes. Another novel to achieve a large readership, particularly among children, is Monkey, written by Wu Ch'eng-en (c. 1501-1580). Describing the journey to India of a Buddhist priest, Tripitaka, it makes use of centuries-old tales and legends. Tripitaka is an historical figure who actually made a pilgrimage to India in the seventh century. By the tenth century, his travels had already inspired an entire cycle of fantastic tales which, by the beginning of the Ming Dynasty, were the subject of stage plays. Wu Ch'eng-en thus had a mass of material to draw on for his long fairy tale.

The real hero of the story is not Tripitaka but his assistant, Monkey, whose magical powers and craftiness enable the two travelers to overcome all obstaclesboth natural and supernatural—and complete their journey. The story combines fantasy, folklore, and history, together with strong elements of satire. The absurd bureaucratic behavior of the gods is clearly intended to poke fun at the complexity of the Chinese state bureaucracy. Tripitaka represents a kind of Chinese "Everyman," blundering along through the various problems he has to face, whereas Monkey represents the ingenuity of human intelligence. One of Tripitaka's other fellow pilgrims, Pigsy, personifies human physical desires and brute strength. None of these layers of meaning are allowed to interfere with the narrative drive and the richness of the various adventures encountered by the pilgrims.

In the visual arts, landscape provided a new subject for painters. Early Ming Dynasty works take traditional human subjects—a scholar and his companion, together with a crane, for example—and place them in a natural setting [19.6]. A century later, in a painting by Shen Zhou, the human subject is barely visible, overwhelmed by the grandeur of the mountain scenery [19.7]. Like many other individuals of the period, Shen Zhou was a gentleman-scholar rather than a professional artist. One of the differences between art in China and in the West was that the Chinese paid no particular respect to professional artists, who mainly worked on decorative projects. Ideas such as the Renaissance notion of the inspired genius who produces a masterpiece did not form part of the Chinese aesthetic. Amateurs, who considered themselves above "mere" technique, were the most admired of painters.

Another way in which the arts in China differed from those in the West was that the Chinese did not distinguish between the major art forms—painting,

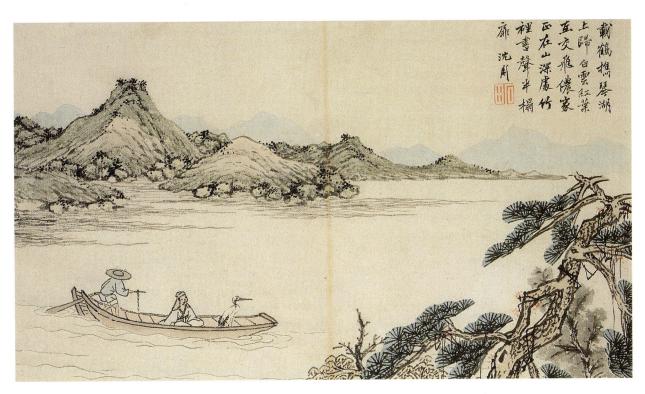

19.6 Ming Dynasty painting showing scholar and crane sailing home, fifteenth century. Nelson Atkins Museum, Kansas City, Missouri. Landscape Album: Five leaves by Shen Chou, One Leaf by Wen.

sculpture, architecture—and the so-called decorative arts: painted pottery and calligraphy for example. The same gentleman—scholar who could produce a land-scape would also pride himself on his elegant handwriting. Both the paintings illustrated here (see Figure 19.6 and Figure 19.7) include examples of calligraphy, a practice unimaginable in Western art of the same period. Chinese connoisseurs had always prized and collected

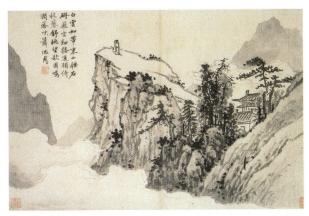

19.7 Shen Zhou. *Poet on a Mountaintop.* Ming Dynasty, c. 1500. Painting mounted as a handscroll. Ink and color on paper, $15\frac{1}{4}$ " \times $23\frac{3}{4}$ " (38.1 \times 60.2 cm). Nelson Atkins Museum, Kansas City, Missouri.

painted ceramicware, and potters of the Ming Dynasty produced vases of exceptional quality [19.8]. Pieces of decorated porcelain began increasingly to circulate in the West, taken there by traders and missionaries. These transported pieces added a new word to the English language for high-quality pottery: *china*.

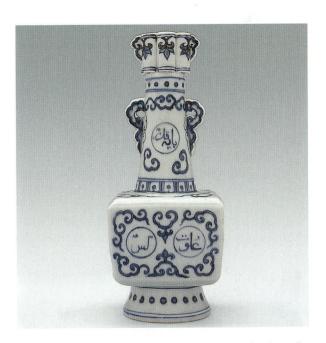

19.8 Arrow vase with Persian inscriptions and floral scrolls. China, Ming Dynasty (1368–1644). Porcelain with underglaze blue decoration, width $^{3}\!/_{4}^{\prime\prime}$ (10.7 cm). Severance and Greta Millikin Collection, 1964. 170. The Cleveland Museum of Art.

While artists working in the fields of literature and painting could experiment and invent new forms, architects were tied far more closely to the traditions of Confucianism, particularly if they were working on official projects. Nowhere is this more clearly visible than in the construction of Beijing as Imperial capital. It was originally laid out in a rectangular plan during the thirteenth century, by order of the Mongol King Kublai Khan (c. 1216-1294). We have a description of how it then looked from perhaps the most famous travel writer of all time, Marco Polo (c. 1254-1324), who arrived in China in 1275 and spent time there as an envoy of Kublai Khan. When the Chinese succeeded in driving out the Mongols, they retained Beijing as Imperial capital; the city was reconstructed early in the Ming Dynasty, at the beginning of the fifteenth century.

http://www.nationalgeographic.com/genghis/timeline/index.html

Kublai Khan

http://www.mrdowling.com/613-marcopolo.html

Marco Polo

The chief buildings, including the emperor's residence-known as the Forbidden City-and the main government offices, or Imperial City, were laid out on a grid plan with a north-south axis, to the north of the rest of the city. All these buildings faced south, with their backs to the direction that symbolized evil: the Mongol invasion. This was just one more example to the Chinese of the fact that north represented misfortune. The Forbidden City stood to the extreme north of the complex, so that the emperor, like the northerly Pole star, could overlook his subjects [19.9]. A series of gateways and courtyards led from the main entrance, the southern Gate of Heavenly Peace (which now gives its name to the vast square in front of the buildings, "Tiananmen") to the heart of the palace, the Hall of Supreme Harmony, where the emperor held audiences and performed special rituals. Thus the entire complex represented traditional symbolic values.

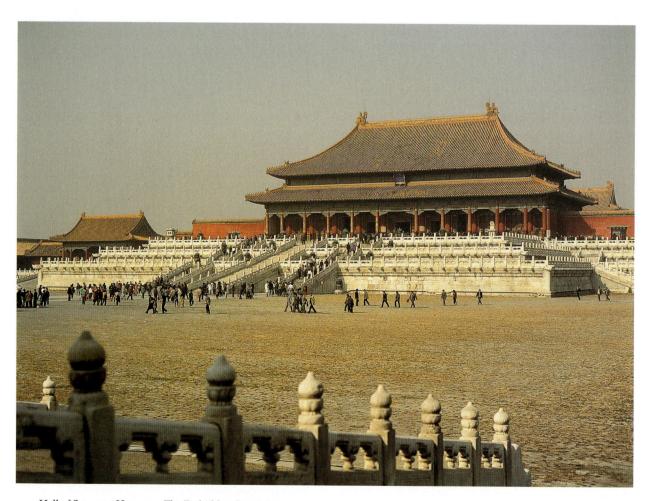

19.9 Hall of Supreme Harmony. The Forbidden City, Beijing.

The general attitude toward cultural development during the Ming Dynasty can be summed up in a phrase frequently used by Ming-period scholars: "change within tradition." The result was to produce a culture—and also a society—that was stable but which lacked dynamic development. The preeminence of gentleman—scholars, artists and bureaucrats, rather than professionals, inevitably led to economic decline. By the early seventeenth century, as the bureaucracy became increasingly corrupt and the emperors began to lose control, rebellions and banditry became rampant and, in 1628, a popular uprising drove the last Ming emperor to hang himself. The resulting confusion attracted invaders from the south, who soon established a new dynasty, the Qing, the last royal house to rule China.

THE QING DYNASTY: CHINA AND THE WESTERN POWERS

http://www.yutopian.com/history/qing.html

Qing Dynasty

The new Qing rulers, who came from Manchuria, were foreigners in the eyes of most Chinese. Although they maintained their own army they had to rely on the established bureaucracy for the day-to-day running of the empire. One of the early Qing emperors, Kang Hsi (1654-1722) set up a grand council to supervise the bureaucrats, and succeeded in interweaving local and central administration. These measures strengthened the power of the emperor. Simultaneously, Kang Hsi began to make tentative contacts abroad. In 1689, he signed a treaty with Peter the Great of Russia, to set limits to the expanding Russian Empire, and encouraged the introduction—carefully controlled—of Western arts and education. The Jesuit missionary Matteo Ricci (1552-1610) had already studied Chinese in order to familiarize some of those at court with Western mathematics, geography, and astronomy. Kang Hsi employed other Jesuits as mapmakers, and took Jesuit physicians with him on his travels. Some Westerners even received appointments at court. The Flemish missionary and astronomer Ferdinand Verbiest (1623–1688) became head of Beijing's Astronomical Bureau in 1669, and played a part in helping to determine the Chinese-Russian border. When, however, the pope sent an ambassador to ask if a permanent papal legation could be set up in Beijing (in part, probably, to keep an eye on the Jesuits), the emperor refused permission, and required all resident Jesuits to sign a declaration stating that they understood and accepted the definition of Confucianism and ancestral rituals as formulated by Kang Hsi himself.

In cultural terms, however, China remained stagnant. Technological methods remained basic [19.10]. Artistic works followed old formulas, often on a more lavish scale, with the studied elegance of earlier Ming ware replaced by the use of multicolored techniques [19.11]. A few painters tried to reestablish the vigor of former days. The painter Shitao stressed the vitality of line, as can be seen in his landscape scene showing a hut in the mountains [19.12], far more vigorous than the landscapes of the Ming period.

By 1800, Chinese independence was beginning to come under threat. As Western traders established themselves in India and other parts of Asia, they recognized the potential for profit at home as demand rose for Chinese tea, fine vases, silks, and exotic works of art. Trade, however, depended on exchange, and foreign merchants could find little in the way of Western products to interest the Chinese. Silver and gold would have been acceptable, but the British, who were the chief traders, had no intention of damaging their balance of trade by incurring trade deficits. British merchants therefore began importing large quantities of opium from India into China. The Chinese, well aware of the harmful effects of the drug, made little use of it. The Chinese government, therefore, attempted to prevent its importation; the emperor even addressed a personal appeal to Queen Victoria, which she ignored.

19.10 A Chinese papermaker dipping a bamboo frame into pulp, which is then spread thinly across the frame to dry.

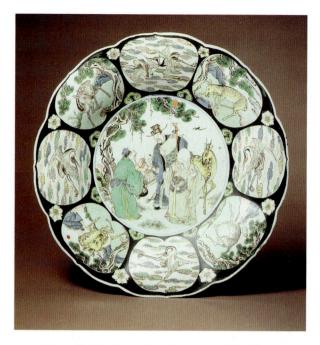

19.11 Dish with lobed rim. Qing Dynasty, c.1700. White porcelain with overglaze, 1'2" in diameter (40 cm). The Percival David Foundation of Chinese Art, London.

When (in 1839) the Chinese tried to block the introduction of opium, the result was outright war. The Opium War of 1839-1842, in which the British used their vastly superior naval power to blockade the entire coast, forced the Chinese to open up a string of ports along their coast, including Canton and Shanghai, thereby ending their isolation. Quite apart from their bitter resentment at the introduction of a drug that soon became widely used (importation rose from six thousand cases in 1820 to one hundred thousand in 1880), the Chinese also had to face the arrival of other Westerners—France and the United States, among others. One of the results of all this turmoil was a series of internal rebellions, which the Chinese authorities could only put down by humiliatingly having to ask the invading foreigners for help. During the Tai Ping Rebellion (1851-1864), a Franco-British force occupied Beijing, drove out the emperor, and burned down the Summer Palace.

When the central government grew increasingly ineffectual, the foreign trading powers benefited from a weak central authority that was dependent upon them

19.12 Shitao. *Landscape.* Qing Dynasty, late seventeenth century. Album leaf, ink and colors on paper, $9 \times 11''$ (30×33 cm). C. C. Wang Collection, New York.

CONTEMPORARY VOICES

The Emperor of China Studies Western Mathematics

Chinese Emperor Kang Hsi Muses on His Contacts with Western Ideas

I realized, too, that Western Mathematics has its uses. I first grew interested in this subject shortly after I came to the throne, during the confrontations between the Jesuit Adam Schall and his Chinese critic, Yang Kuang-hsien, when the two men argued the merits of their respective techniques by the Wumen gate, and none of the great officials there knew what was going on. Schall died in prison, but after I had learned something about astronomy I pardoned his friend Verbiest in 1669 and gave him an official position, promoting him in 1682. In 1687, I let the newly arrived Jesuit Fontaney and the others come to Beijing, although they had come to China illegally on a Chinese merchant vessel and the Board of Rites had recommended their deportation; and through-

out the 1680s I discussed Western skills in Manchu with Verbiest, and I made Grimaldi and Pereira learn the language as well, so they could converse with me.

After the treaty of Nerchinsk had been signed with the Russians, I ordered the Jesuits Thomas, Gerbillon, and Bouvet to study Manchu also, and to compose treatises in that language on Western arithmetic and the geometry of Euclid. In the early 1690s, I often worked several hours a day with them. With Verbiest I had examined each stage of the forging of cannons, and made him build a water fountain that operated in conjunction with an organ, and erect a windmill in the court.

From Emperor of China: Self-portrait of K'ang-hsi, Jonathan D. Spence (New York: Vintage Books/Random House, 1988), p. 72.

for the little influence it possessed. The utter unconcern of these foreign traders and settlers for the culture they were invading is evidenced by the design of an English church built in Shanghai in the late nineteenth century [19.13]. With the suppression of the bloody Boxer Rebel-

19.13 Photograph of an English church built in Shanghai in the late nineteenth century.

lion of 1900–1901, the Western powers took virtual control, constructing railways and opening up river traffic to all parts of the interior.

In 1911, republicans led by Sun Yat-sen (1866–1925) finally brought down the monarchy, but the collapse of centuries-old institutions created decades of chaos, complicated by two world wars. Two chief movements struggled for power in China. The Kuomintang, led by Chiang Kai-shek (1887–1975) offered authoritarian rule, which was supposed to evolve into a form of democracy. The other, the Chinese Communist Party, aimed to follow the example of Russia's Bolshevik movement, was led by Mao Tse-tung (1893–1976). The communists came to power in 1949. Virtually all the art produced under communist rule either exhorts the party (under Mao especially) [19.14], or reminds its viewers of the horrors of earlier times [19.15].

The Art and Culture of Japan

Early Japanese History and Culture

Archaeological evidence suggests that although early settlers in Japan had developed agricultural communities by A.D. 200, these were based on tribal chiefs; each tribal group had its own god, thought of as an ancestor. Around 400, one of these communities was sufficiently sophisticated to bring in scribes from Korea to keep

19.14 A vast statue of Chairman Mao, the center of celebrations of National Day in China, October 2, 1966. c. 36' (12 m). The statue is being carried by some of the paraders.

records—no system of writing as yet existed in Japan. The original chief city had been Nara, laid out in 706 in imitation of Chinese urban design. Less than a century later, however, the various settlements, now much expanded, came together in a new capital, Kyoto (then known as Heian), which remained a center of stable government and economic growth until 1185.

Although early Japanese religious thought owed much to the influences of Buddhism and Confucianism, the native Japanese religion was Shintoism. This involved not only worship of the spirits of nature—including the all-important rice god—and a complex series of rituals, but also the imperial cult; that is, the ruling emperor and his ancestors were worshiped as divine. The tension between Shintoism and the influence of Chinese Buddhism always remained an important factor in Japanese religious life. Indeed, the move from Nara to Kyoto was in part to escape from the domination of Nara's Buddhist priests.

http://www.shinto.org/

Shintoism

During this period, the Japanese developed their own writing system, partly based on the Chinese system. Poetry was popular, and as urban centers grew, various forms of theater became common. Perhaps the best known is the *no* play, in which dancers enact dramatic stories combined with ritual and slapstick [19.16]. The most famous literary work of the age was *The Tale of Genji*, written by Lady Murasaki Shikibu (c. 980–1030). Murasaki lived during the so-called Fujiwara period, one dominated by members of that family; the most important, Fujiwara Michinaga, ruled as regent from 966 to 1027.

Murasaki's father held a minor position at court. She married and had children, but when her husband died and her father was transferred to the provinces, Murasaki took a position in the service of Empress Akiko. The diary she wrote during her years at court gives precious insight into life there. Basically seriousminded, Murasaki had little time for the frivolity of many of her contemporaries. By a remarkable chance, another diary of the same period has also survived, kept by Sei Shonagon (active c. 1000). Sei Shonagun's work takes the form of a "pillow-book"—a collection of her notes and observations on the day's events that are often

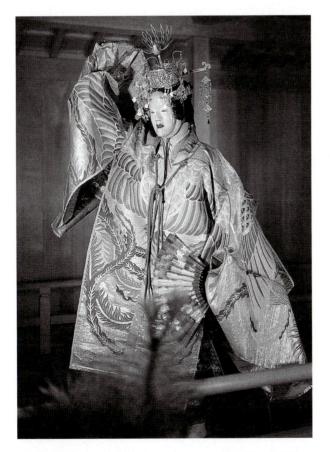

19.16 Portrait of an actor in a *no* play. The pinned hairstyle suggests the male actor is playing a female role.

19.15 Sculptured scene of rent collection in pre-Communist days, with the peasants kneeling before their masters. Clayplaster, life-size, 1965. Dayi, Sichuan Province, China.

malicious and sometimes indelicate, forming an interesting contrast with the more straitlaced Murasaki.

Murasaki's enduring fame is based on her novel, The Tale of Genji. One of the great achievements of Japanese literature, the book describes the amorous adventures of Prince Genji, set against a court background very similar to that in which Murasaki herself moved. She writes with great delicacy and an underlying melancholy, often underlined by descriptions of nature. The autumnal winds, swift-flowing rivers, snow in winter—all serve as background to the book's more poignant scenes. One of the unintentional effects of Murasaki's psychological subtlety is to reveal the gulf between the aesthetic sensibilities of the aristocratic elite at court and the lives of the peasants, the overwhelming majority of the population. It seems that life at court consisted of music and love affairs, poetry recitations, and apt quotations from the classics. The art of the same period shares this otherworldly quality. A scene illustrating an episode from The Tale of Genji shows the hero with his beloved shortly before her death. To the left, in the garden, a weeping tree adds to the autumnal gloom [19.17].

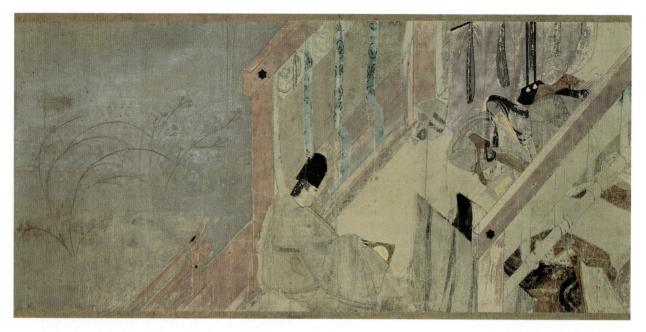

19.17 Scene from *The Tale of Genji*. Late Heian period, first half of twelfth century. Handscroll. Ink and color on paper, 8⁵/₈" high (28 cm). Goto Art Museum, Tokyo.

The Period of Feudal Rule

As the increasingly remote court life of Kyoto led to internal rivalry, in 1185 a new, more aggressive center developed at Kakamura. The emperor now combined legal and administrative duties with military command, creating a new office—samurai-dokoro—which gave him control of all Japan's warriors (samurai is the Japanese name for a professional warrior). His title was Seiitaishogun ("barbarian-suppressing commander-in-chief"), later shortened to shogūn. This newly enhanced warrior class dominated Japanese culture sufficiently enough to defeat two waves of Mongol invaders (in 1274 and 1281). Bands of warriors followed their aristocratic leader who was in turn bound to the emperor—a system not unlike the feudal system developing independently in Western Europe around the same period.

Over time, the local *daimyo* ("warlords") began to assert their own authority against that of the shogun, and the years 1467 to 1568 are known as the Age of the Warring States. With the introduction of firearms first obtained from Portuguese traders, and then manufactured in Japan, individual daimyo began to build their own fortified centers, and the authority of the central government grew ever weaker. The Portuguese guns may have increased the influence of individual warriors, but they undercut the traditional samurai fighting style, and raised the problem of outside influence in a society that had been virtually closed to the outside world for centuries. Fighting between the various warlords was finally ended under two powerful leaders, Hideyoshi (1537–

1598), who once more united Japan by 1590, and Tokugawa (1543–1616). The latter created a new capital in 1603 at Edo (present-day Tokyo). Members of the Tokugawa family ruled there until 1868.

The Edo Period

Artists in the Edo period produced a wide variety of work, catering to the needs of an increasingly urban and sophisticated population. The landscape scenes of Chinese gentleman-scholars (see Figure 19.6 and Figure 19.7) proved a popular influence, but the Japanese versions used gentler colors. Both vegetation and background mountains are more abstract, giving a dreamlike quality to the view [19.18]. Other artists aimed to combine the richness of color of traditional Japanese art with the precision in description of Western artists, as in the gorgeous silk painting Peacocks and Peonies [19.19]. Woodblock, a popular new medium, made possible the making of multiple copies for a growing number of collectors. The most famous artist in this field was Hokusai Katsushika (1760–1849), whose image of a wave crashing in the foreground, while a diminutive but enduring Mount Fuji appears at the center of the background is one of the most familiar of all Japanese works of art [19.20].

Japanese writers of the Edo period made major contributions in poetry, fiction, and dramatic writing. The greatest poet of the age was Basho (1644–1694), who developed one of the most important Japanese verse forms, the *haiku* (originally called *hokku*). This consists of three

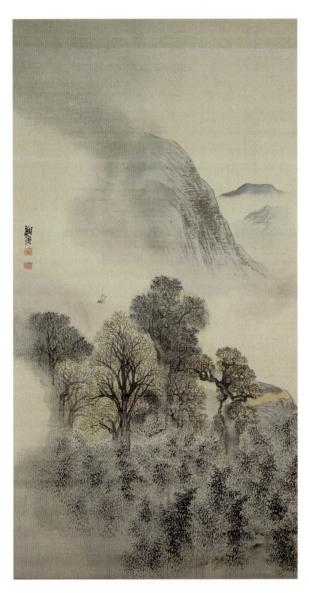

19.18 Yosa Buson. *Cuckoo Flying over New Verdure.* Edo period, late eighteenth century. Hanging scroll. Ink and color on silk, $5^{\prime 1}/_{2}^{\prime \prime} \times 2^{\prime} 7^{1}/_{4}^{\prime \prime}$ (1.33 m \times 89 cm). Hiraki Ukiyoe Museum, Yokahama, Japan.

lines of five, seven, and five syllables. Haiku typically uses an image, often drawn from nature, to evoke or suggest a feeling or mood. Basho spent most of his life either in retreat or on solitary journeys, writing poems that evoke entire landscapes by the telling selection of the crucial details. In this way, he aimed to provide a poetic equivalent of the flash of enlightenment that a meditating Buddhist hoped to achieve. Basho was himself a devout Buddhist, with a special interest in Zen Buddhism. (Zen, which avoided images, rituals, and sacred texts, and stressed contemplation and meditation, had a great influence on Japanese culture.)

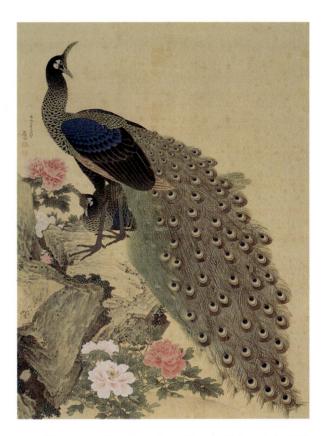

19.19 Maruyama Okyo. *Peacocks and Peonies*. Edo period, 1776. Hanging scroll. Color on silk, $4'3'_{3}'' \times 2'2^{7}_{8}''$ (1.25 m \times 68 cm). Imperial Household Collection, Tokyo.

http://www.big.or.jp/~loupe/links/ehisto/ebasho.shtml

Basho's contemporary, Ihara Saikaku (1642-1693) also wrote poetry, but was chiefly famous for his novels. Many of these follow the various adventures of their heroes and heroines rather in the manner of The Tale of Genji to which they form a middle-class equivalent. Life of an Amorous Woman, for example, is narrated by an old woman as she looks back over her life from the Buddhist retreat to which she has retired. Beginning as a high-class prostitute, she gradually declined to a mere streetwalker, and eventually scraped a living from the few occupations open to women. The overt eroticism is in strong contrast with Lady Murasaki's delicacy, and emerges in Saikaku's other writings, which include a collection of tales about male homosexual love. Similar themes of love among the bourgeois merchant classes inspire the plays of Chikamatsu Monzaemon (1653-1725). One of the most famous is The Love Suicide at Amijima, which describes the life and eventual death of a paper merchant,

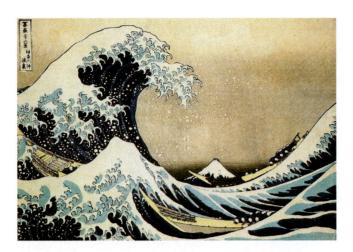

19.20 Hokusai Katsushika. *The Great Wall off Kanagawa*. Togukawa period, c. 1831. Polychrome woodblock print, $9^7/8^{"} \times 14^5/8^{"}$ (25.5 × 37.1 cm).

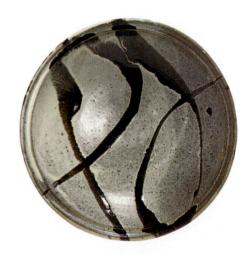

19.21. Hamada Shoji. Large bowl, 1962. Black trails on translucent glaze, $5\frac{7}{8}$ " \times 1'10 $\frac{1}{2}$ " (14 \times 74 cm). National Museum of Modern Art, Kyoto.

ruined by his hopeless love for a prostitute. The earlier *no* dramas had enacted traditional stories, passed down from generation to generation. This new form of drama, based on real-life incidents, is called *kabuki*, and grew increasingly popular despite government opposition.

At the very end of the Edo period, Japan was thrust into contact with the Western powers. In 1853, the famous American naval expedition of Commodore Matthew Calbraith Perry arrived in Edo Bay and insisted, under threat of bombardment, that Americans be allowed to trade. Britain, Russia, and Holland soon followed. The ensuing contest between conservatives and reformers was soon won by the latter, when a new emperor ascended to the throne in 1867.

MODERN JAPAN: THE MEIJI

The new Emperor Mitsuhito's reign (1817-1912), known as the Meiji ("enlightened government") introduced a radical program of reform, abolished feudalism, and quickly built a strong central government. A new army, modeled on the German system, was formed. A parliament consisting of an upper and a lower house, served under the emperor. Banks, railways, and a merchant marine all permitted Japan to industrialize at a speed that far outstripped India or China and, by 1905, Japan could claim military victory over a European opponent in the Russo-Japanese War. Yet although the tumultuous events of the twentieth century brought ever-increasing globalization of culture and economies, Japanese artists have continued to work in ways inherited from the past. As in China, high-quality ceramic manufacture has always been a feature of artistic production, and the tradition continues, with contemporary artists adapting new styles and techniques to old art forms [19.21].

SUMMARY

The Mughal Empire Muslim forces had arrived in northwest India in the thirteenth century, but with the conquest of large parts of the subcontinent by the Mughal general Babur in 1526, most of India came under the rule of the Mughals for the following two and a half centuries. The Mughal Empire, both under Babur and his grandson Akbar, established an organized system of administration, which devoted considerable effort to cultural achievement and aimed to promote unity. The emperors did not impose the Islamic religion on their Hindu subjects, and introduced a new language, Urdu, which combined elements of Arabic and Persian with the Hindi language spoken most commonly in India before their arrival.

Mughal Art The art of the Mughal period similarly aimed to combine elements of preexisting Indian styles with Arabic and, above all, Persian characteristics. Buildings such as the Taj Mahal introduced forms of dome, arch, and tower that were commonly used in Islamic architecture. Mughal painters depicted scenes from real life and portraits, rather than restricting themselves to religious subjects, as earlier Hindu and Buddhist artists had done. The emperors themselves highly valued literature, both collecting books and writing their own works. At the same time, Hindu writers continued to produce religious texts in their own language.

The End of Mughal Rule and the Arrival of the British Toward the end of the Mughal period, later emperors proved less tolerant, and local resistance led to the collapse of the empire. At the same time, European traders began to assert ever greater influence. The leaders in this were the British, who defeated European rivals, and during the eighteenth century won virtual political and economic control over the separate states into which India had once again fallen.

The Rise of Nationalism With the formation of the Indian National Congress Party toward the end of the nineteenth century, India was one of the first colonized nations to begin the struggle for independence. Throughout the 1920s and 1930s, Mohandas Gandhi played a major role in leading this cause, with his policy of nonviolent civil disobedience. Many leading Indian writers of the day used English to introduce India's problems to a wider audience. Finally, following World War II, British rule ended, although one of the consequences was the partition of the subcontinent into mainly Hindu India, and the new Muslim state of Pakistan. The mass population transfers which accompanied partition involved millions of deaths on both sides.

Chinese Culture under Imperial Rule Following the centuries of confusion caused by the Mongol invasions, China once again came under central rule. The two dynasties to govern China from the fourteenth century to modern times were the Ming (1368–1644) and the Qing (1644–1911).

The Arts under Ming Rule With the restoration of imperial rule came a return to traditional Confucian values and familiar artistic forms. One of the effects was to encourage artists in search of new ideas to invent or develop new artistic forms. Writers turned to the short story, based on everyday life, or to the novel. In some cases, as in the novel Monkey, the author could use what seemed pure fantasy to satirize aspects of contemporary political life. Painters, many of whom were gentleman—scholars rather than professionals, depicted landscapes in which individual humans were dwarfed by the grandeur of nature. The major building project of the age was the construction of the Imperial palace—the Forbidden City—at Beijing; the Mongols had made Beijing their capital, and the Ming emperors retained it as such.

The Qing Dynasty: China and the West When the Ming Dynasty finally collapsed, invaders from northeast China, Manchuria, set up the Qing Dynasty, the last to rule China before modern times. Early Qing rulers succeeded in limiting contacts with Western traders, although Jesuit missionaries succeeded in establishing limited contacts, not the least of which was at the Imperial court, where they managed to introduce some Western technology and culture. In general, however, the Qing period saw growing stagnation, with artists continuing to repeat familiar subjects.

By the nineteenth century, China was under growing pressure to allow trade with outside powers. The Opium War of 1839–1842, in which the British compelled the Chinese to accept increasing quantities of a drug whose harmful effects were well known to both sides, led to the opening of Chinese markets to other Western nations, including France and the United States. As internal revolutionaries fought against the collapse of traditional ways in China—first in the Taiping Rebellion of 1851–1864, then in the Boxer Rebellion of 1900–1901—the last Qing

rulers were forced to turn to the outside powers who were the cause of the revolts to help crush them. By 1911, mass dissatisfaction led to the end of millennia of Imperial rule. The republic that followed saw its own share of bloody conflict before the establishment of the Communist Chinese Peoples' Republic in 1949.

The Arts and Culture of Japan: Early Japanese History and Culture The early history of Japan seems to have been mainly agricultural, but over time settlements grew in size, and the first Japanese capital was founded at Nara (c. 700). Although Buddhism played an important role in influencing Japanese culture throughout its history, the religion native to Japan was Shintoism, essentially a form of nature worship. Shintoism differs from other Asian religions, however, in its belief in the divine nature of the emperor, descended from the sun goddess. In the early ninth century, Japan's capital moved to Kyoto, where a rich and elaborate court life developed, with much emphasis on elegance and formal ritual. One of the most revealing sources of information about the artificiality and ceremony of the court is the novel by Lady Murasaki, The Tale of Genji.

The Period of Feudal Rule In an attempt to counteract what was seen as the weakness of Imperial rule at Kyoto, a new administrative center was set up (in 1185) at Kakamura. Japanese soldiers were formed into a new warrior class of *samurai*, under the military command of the *shogun*. Individual warrior bands owed their loyalty to their own warlords, who in turn were subject to the emperor. Over time, this system degenerated into fighting between rival groups—a period of violence exacerbated by the importation of firearms from the Portuguese.

The Edo Period Peace was only restored by a strong leadership that transferred the capital once again, this time to Tokyo (Edo). With renewed central government, Japan began to develop an increasingly sophisticated urban culture, and the Edo period was one in which the arts flourished. Painters produced works inspired by a host of outside styles, from traditional Chinese landscape scenes to Western realistic depictions of people and animals. Novelists and storytellers drew on contemporary everyday life, rather than the artificial world of the Imperial court. Poets, of whom the most popular was Basho, invented a new form of short poem, the haiku, derived in part from the inspiration of Zen Buddhism, which aimed to provide the enlightenment of sudden insight derived from the world of nature.

Modern Japan: The Meiji Beginning in 1868, under the Meiji emperors, Japan began a hasty program of modernization. Catapulted into the modern world by the arrival of Commodore Matthew Perry's American fleet in 1853, Japan soon began to acquire the infrastructure of an industrial economy. These changes, together with reforms in education, politics, and communications allowed Japan, in its first hostile encounter with a European power in the Russo–Japanese War of 1905–1906, to

540

prove victorious. By the end of the twentieth century, of all the cultures of Asia, Japan was the one best capable of competing with the West on equal terms.

Postscript: A Note on Asian Film One of the most direct and enjoyable means of access to an unknown culture is by way of its films. In the case of the cultures of Southeast Asia, movies made since World War II provide an especially rich source. In China, government censorship meant that for much of the postwar period, filmmakers had little choice but to echo the official party line. But in recent years, independent directors have been able to create works that reflect their own vision. Perhaps the best known of Chinese directors is Zhang Yimou, whose films include Raise the Red Lantern and The Story of Qiu Ju, both of which give a vivid impression of the social system existing in China, with special attention to the hardships of women.

In the case of India and Japan, two directors in particular—the Indian Satyajit Ray (b. 1921) and the Japanese Akira Kurosawa (1910–1998)—have made films that many movie critics consider as among the greatest ever produced, and are already classics of the medium.

Ray was born into a prosperous Bengali family, and studied art as a young man. His films aim to show the lives of ordinary people, and use the details of their everyday existence to give a more general impression of the culture of which they form a part. His best-known work is probably The Apu Trilogy, three films that tell the story of a young Bengali boy growing to maturity: The Song of the Road (Pather Panchali) of 1955, The Unvanquished (Aparajito) of 1957, and The World of Apu of 1958. Taken together, the three movies, with specially composed background music played by Ravi Shankar, provide an unforgettably moving impression of coming of age in both rural and urban India, and point out the similarities between a culture that at first seems so remote from life in the West in the twenty-first century. A later Ray film, The Home and the World (1984), sets a romantic love triangle against the background of the early years of the twentieth century, with its scheming and treacherous British rulers.

The greatest Japanese filmmaker—Kurosawa—is, if anything, even more highly esteemed. Influenced by American movies, in particular those of John Ford, Kurosawa brought his own insights to bear on a wide range of human situations and historical periods. The first of his films to catch international attention was *Rashomon* (1950), is a study in human perception and memory. This was followed by *Seven Samurai* (1954), which brilliantly recreates the lives—and deaths—of Japanese feudal warriors, and has been listed as one of the ten greatest films of all time. This film was later remade as an American film, *The Magnificent Seven*. A later historical epic, set in the sixteenth century, is *Kagemusha* (1980), which explores the notion of identity: a petty thief, who resembles

the dying warlord of a powerful clan, takes over as leader, and gradually assumes the character of the man he is pretending to be. One critic writing of Kurosawa, referred to the "Shakespearean cast of his genius"; two of his most dramatic films are based on works by Shakespeare: *Throne of Blood* (1957), based on *Macbeth*, and *Ran* (1985), Kurosawa's version of *King Lear*. The latter is a movie of immense power, profoundly pessimistic in tone.

Pronunciation Guide

Aurangzeb:Our-ANG-zebBasho:BAH-SHOWBeijing:Bay-JINGdaimyo:DIME-yoGenji:GHEN-jiHeian:HAY-an

Hokusai:HOE-COO-SIGHKublai Khan:KOO-bli KONKurosawa:KOO-ro-SAH-wa

Macao: Ma-COW

Matteo Ricci: Mat-A-owe RICH-ee

Meiji: MAY-ji

Mohandas Gandhi: Moe-HAN-das GAN-di

Mughal:MOO-galMurasaki:MOOR-a-SAR-ki

Qing: CHING

Rabindranath Tagore: Ra-BIN-dra-nath Ta-GORE

Ramayana: RA-MA-YA-NA
Saikaku: SIGH-KAY-KOO
samurai: SAM-oo-rye
shogun: SHOW-GUN

Sikh: SEEK

Tokugawa: TOH-KOO-GAH-WAH

Tripitaka: Tri-pi-TAH-ka
Urdu: OOR-do
Verbiest: Ver-BEAST

EXERCISES

- What effect did contact with Western civilization have on the cultures of India, China, and Japan? How did it differ in each case?
- 2. What were the lasting results of the Mughal conquest of India for the history of the subcontinent?
- 3. Urdu is just one of many attempts to construct a new language. What others have been tried? Why did Urdu succeed? Why did others fail?
- 4. What are the outstanding features of Marco Polo's account of his travels? Which other travelers left descriptions of their travels in Asia before modern times?
- 5. Why has Zen Buddhism become popular in the West in modern times? What are its chief characteristics?

6. Lady Murasaki is a rare example of a woman artist before the nineteenth century, either in Western or Asian culture. Why have there been so few? Why did such a high proportion of those few write rather than paint or compose

FURTHER READING

Barnhart, R. M. (1993). Painters of the great Ming: The Imperial Court and the Zen school. Dallas, TX: Dallas Museum of Art. This well-illustrated account provides a cultural context for Ming painting.

Beach, M. C. (1992). Mughal and Rajput painting. Cambridge: Cambridge University Press. An excellent survey, with

superb illustrations.

Clunas, C. (1997). Art in China. Oxford: Oxford University Press. A useful survey of an immense field, with handy bibliographies to help find more specialized works.

Elisseeff, D., & Vadim Elisseeff. (1985). Art of Japan (Trans. I Mark Paris). New York: Harry Abrams. Comprehensive and well illustrated.

Gascoigne, B. (1971). The great Moghuls. New York: Harper & Row. This historical account is beginning to show its age, but still provides a very readable introduction.

Girard-Gestan, M. et al. (1998). Art of Southeast Asia (Trans. J. A. Underwood). New York: Harry N. Abrams. An upto-date overview of all the cultures discussed in this chapter, with separate essays by experts.

Sickman, L., & A. C. Soper. (1992). The art and architecture of China. New Haven, CT: Yale University Press. Especially

valuable for the material on architecture.

Spence, J. D. (1988). Emperor of China: Self-portrait of K'anghsi. New York: Vintage Press. The author has selected and combined extracts from both public and private documents to provide an astonishing picture of the life of a Ching emperor. Not to be missed.

Sullivan, M. (1984). The arts of China (3rd ed.). Berkeley: University of California Press. The most recent edition of perhaps the best single-volume introduction to its subject.

Welch, S. C. (1985). India: Art and culture: 1300-1900. New York: The Metropolitan Museum of Art. This provides an inevitably concentrated account of a vast amount of material, but the selection is judicious, and the illustrations are well chosen.

ONLINE CHAPTER LINKS

Among the sites providing valuable information related to the Taj Mahal are http://www.taj-mahal.net/topEng/index.htm http://www.liveindia.com/tajmahal/index.html http://users.erols.com/zenithco/tajmahal.html http://www.angelfire.com/in/myindia/tajmahal.html

Mohandas K. Gandhi: Man of Millenium

http://www.mkgandhi.org

provides an extensive list of educational resources and links to Internet sites in several categories including biographies, teachings, and articles.

A collection of poetry written by Rabindranath Tagore, the 1913 Nobel Laureate in Literature, is available at

http://www.indolink.com/Poetry/tgorIndx.html

For a virtual tour of China's Forbidden City, visit http://www.chinavista.com/beijing/gugong/!start.html

For an informative Web site about Kublai Khan and sponsored by the National Geographic Society, visit

http://www.nationalgeographic.com/genghis/trail.html

Extensive information about Mao Tse-tung and the Chinese Communist Revolution is found at http://www.maoism.org/

Kabuki for Everyone at

http://www.fix.co.jp/kabuki/kabuki.html

provides an online theater (featuring illustrations and videos of performances) and information about Kabuki sounds and make-up, plus summaries and explanations of major plays.

Among the sites providing valuable information related to Buddhism are

http://www.fundamentalbuddhism.com/ http://www.easternreligions.com/bframe.html http://www.internets.com/buddha.htm

Hindu Resources Online at

http://www.hindu.org/

http://www.hinduism.co.za/

http://www.hindunet.org

provide numerous links to a wide variety of information—including art, music, and culture; dharma and philosophy; travel and pilgrimage; and ancient sciences (e.g., yoga).

Links to Hindu art are available at http://www.hindunet.org/hindu_pictures/

Among the sites providing valuable information related to Confucius are

http://www.confucius.org/main01.htm#e

http://www.easternreligions.com/cframe.html which offer links to biographies, translations in several languages, and graphics representing sev-

Information about extensive studies related to the Silk Road is available at

http://www.silk-road.com/toc/index.html

eral writings in their original characters.

	GENERAL EVENTS	LITERATURE & PHILOSOPHY	ART
E		*.	
	First occupation of site of Great		
Ħ.	Zimbabwe		
ď	300 A.D. – 1075 Kingdom of Ghana		
	Ghana emerges as a trading center between Africa and the Mediterranean,		
)	exporting gold and other goods		
	Height of Ghana's success; at this time it is the world's largest gold producer		More sophisticated metal working tools make larger communities possible
	Introduction of new food crops in Nigeria		make larger conditionines possible
4	1075 Defeat of Ghana by Muslim Berbers		A STATE OF THE PARTY OF THE PAR
)	1300–1500 Kingdom of Benin		人為學生
	Benin Kingdom flourishes under the hereditary rule of the Oba, trading in		Bronze plaques adorn the
	pepper and ivory		Oba's central
	Great Zimbabwe serves as base for a trading empire extending from the		palace
0 -	Near East, Persia, and China		
	Beginning of European colonization and the slave trade	Before the 20th century, most African story telling was done by word of mouth	
		1500 Religious verse brought by Muslim	
		traders is paraphrased in Swahili; over time, the Swahili-Arabic script becomes	
0		a new poetic tradition	
	1787? – 1828 Life of the legendary Zulu King Shaka, who organized weak Zulu	Oral poet Somali Raage Ugaas, becomes popular for his wisdom and piety	
	warriors into a formidable fighting force	Saiyid Abdallah (c. 1720–1810) writes,	
	loice	"Self-Examination," a long poem using the decline of great Arab trading cities	
		on the East African coast as a symbol of the inevitability of death	
0	Mass deportation of male Benin	c. 1805 Qamaan Bulhan becomes well-	
	population by Arab and European slave-traders	known for his philosophical and reflective verses, which in some cases	
	1895 Ghana falls under French rule	have now become proverbial	
0		expressions	A-A6:
	Shona people now occupy site of Great Zimbabwe	1907 Lesotho native Thomas Mofolo (1875? – 1948) writes <i>Traveler of the East</i>	As African art works begin to circulate among Western collectors, African
	Zimodowe	in his native language, Sesotho, becoming the first African novelist	artistic styles begin to influence the work of Western artists like Pablo
		1912 Mofolo writes Chaka, his most	Picasso
		celebrated book, but the missionary- run press that published his previous	
		works refuse to publish it	
		1925 Chaka becomes an instant best-seller and is widely translated	
		1929 Senegalese poet writing in French,	
		Leopold Senghor (1906–1989) creates a literary movement known as	
		"negritude," which celebrates the	
		unique traditions of African art 1930 Africa's most acclaimed 20th	7,6
5		century writer, Chinua Achebe, is born	
	1960 Nigeria receives independence from the British	1958 Chinua Achebe writes his first novel, <i>Things Fall Apart</i> , in English	Contemporary African art
	1967 Igbo people of eastern Nigeria	1960 Nigerian writer, Wole Soyinka	continues to
	secede to form the Republic of Biafra; Chinua Achebe becomes Minister of	becomes president of Senegal, retiring voluntarily in 1980	examine the conflict
	Information in the new state	Achebe publishes <i>No Longer at Ease</i>	between Western and
			traditional
			culture
TO NT	1970 Igbo breakaway is crushed by the	1986 Wole Soyinka becomes the first	Culture

CHAPTER 20 THE PEOPLES AND CULTURES OF AFRICA

ARCHITECTURE

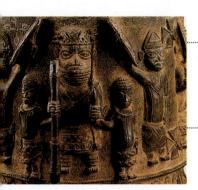

Benin artists also created ancestral altars representing the power of Oba

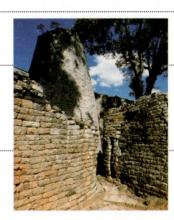

1300 Rulers of Great Zimbabwe erect huge stone buildings surrounded by massive walls

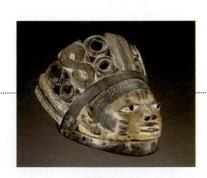

1990 Traditional artforms and rituals involving masks and head dresses continue to play a crucial role in African communities

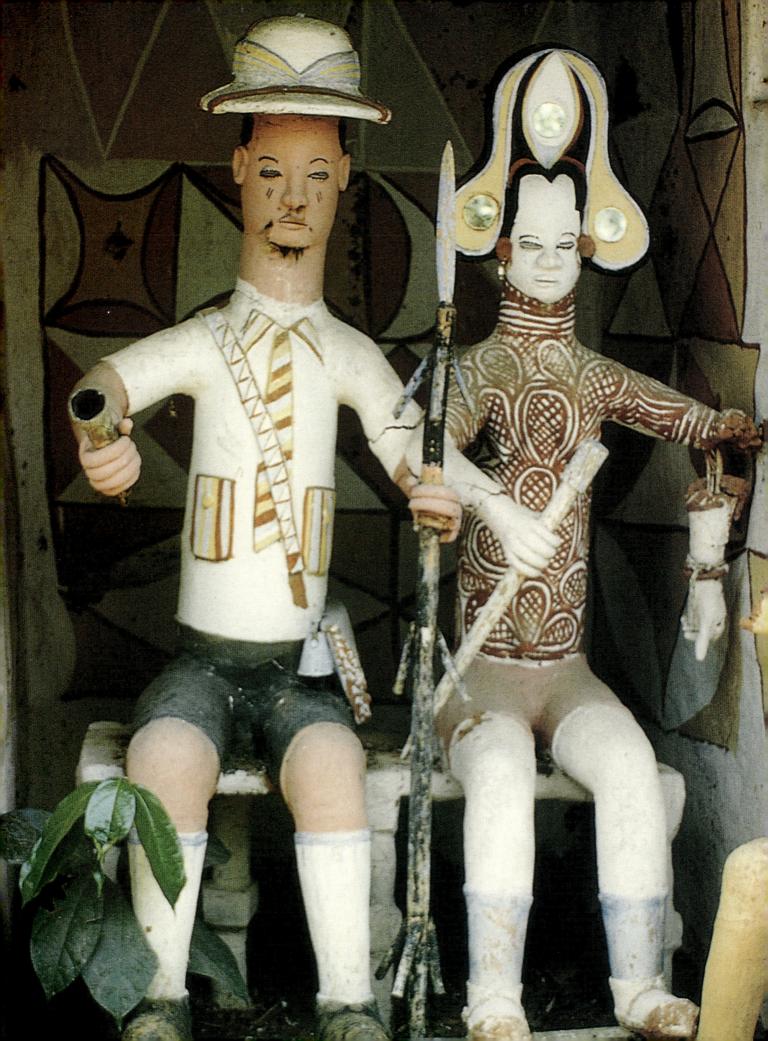

CHAPTER 20

THE PEOPLES AND CULTURES OF AFRICA

study of the humanities as they developed in Africa requires a special approach. In the first place, the sheer size of Africa—three times as big as the continental United States and Alaska—and the variety of climates and landforms prevented the formation of a single unified culture. Unlike India or China, Africa was never united under a central government; it is therefore impossible to generalize about developments there. Like the Americas, technology and the ability to write did not develop at the same speed as in Europe and Asia, and we have no consistent written records before the nineteenth century. Further confusion was created by the arrival of Muslim and European traders in the sixteenth century and the subsequent centuries of generally brutal colonization. To reconstruct the earliest civilizations on African soil, we must rely on archaeological remains and written accounts by the first outsiders to visit the early African kingdoms. The general picture is that of a series of powerful and highly developed states.

Religion and Society in Early Africa

At first sight, African life seems to have been divided by its size into a wide variety of differing peoples and cultures. It is often observed that today over one thousand languages are spoken in sub-Saharan Africa. Yet the majority of these are related to four or five basic tongues, suggesting that beneath the apparent diversity there lies a common cultural inheritance. Other factors bear this out. One important characteristic many Africans share is their attitude toward their environment and living creatures. Although a single common African religion never existed, most African peoples developed a variety of animist beliefs. These took forms specific to individual regions, but all basically aimed to understand the world and human life through the workings of nature, using rituals and ceremonies to deal with illness, death, and natural disasters. For many groups, the focus of their specific cult was a particular animal-which became sacred—and could not therefore be killed by members of the group. Because, in the absence of written texts, the accumulation of religious practices and beliefs had to be memorized and passed on by word of mouth, the elderly became revered, and a tradition of ancestor worship developed. This in turn laid emphasis on the family and, more broadly, the village community. Within the community certain extended families, or kinship groups, served specific functions: hunters, farmers, traders, and so on. Thus, religion and social structure reinforced one another, and allowed for the slow evolution of increasingly powerful kingdoms.

THREE EARLY AFRICAN KINGDOMS: GHANA, BENIN, AND ZIMBABWE

http://www.wsu.edu/~dee/CIVAFRCA/FOREST.HTM

Early African Kingdoms/Benin

One of the earliest states to develop was Ghana, in West Africa. Caravan routes crossing the Sahara linked the region to Mediterranean cities, first by horse and oxen and then, after A.D. 300, by camel. Shortly after, the city of Ghana, on the upper river Niger, began to export gold, animal hides, pepper, ivory, and slaves in exchange for salt, cloth, pottery, and other manufactured goods. Ghana grew increasingly wealthy and, at the height of its success (around 1000), was probably the world's largest gold producer. According to an Arab traveler who visited Ghana in 1065, the army numbered two hundred thousand, of whom forty thousand were armed with bows and arrows. This formidable fighting force was defeated a decade later by a nomadic army of Muslim Berbers. The Berbers moved north after a few years to attack Morocco, but Ghana never fully recovered (in part

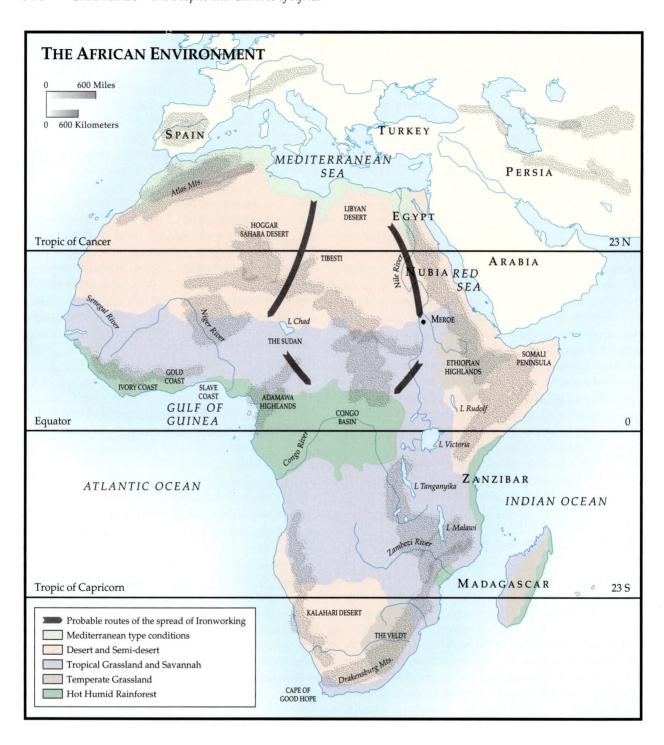

because the gold mines were beginning to peter out), and by 1300, the great kingdom was only a memory.

During the time of Ghana's slow decline, the kingdom of Benin was beginning to grow in what is now modern-day Nigeria (ancient Benin should *not* be confused with the modern African state of Benin). The period around 1000 saw the introduction of new food crops from East Asia, and more sophisticated methods of metalworking, making larger communities possible. The kingdom of Benin flourished between the fourteenth and

sixteenth centuries, trading widely in pepper and ivory. Its eventual decline was due to the massive deportation of its male population in the nineteenth century by Arab and European slave traders. The kingdom was ruled by a hereditary male absolute monarch with the title of *Oba*, who had at his disposal a powerful army and an effective central government.

The Oba's central palace was adorned with a series of bronze plaques, showing the life of the court and military exploits. On one of these, we see an Oba flanked by the royal bodyguard. The Oba wears a high crown and a ceremonial cape, and is brandishing a spear. The soldiers, smaller in stature to indicate their lesser importance, stand quietly by [20.1]. Among the sculptures discovered in the palace is a small portrait of a royal woman with necklace and braided hair, which offers insight into the lavish life at the Benin court. At the same time, the beauty of line and balance between decoration and naturalism give some idea of how much we have lost with the disappearance of so much African art [20.2].

Another bronze from Benin throws light on religious practices at court. It comes from one of the Oba's ancestral altars, at which he would have offered up sacrifices, either for favors received from the gods, or in the hope of receiving future ones. The Oba appears both on the side and on the lid, again dominating the accompanying attendants. On the lid, two meek leopards crouch humbly at his feet. Even the creatures of the wild acknowledge the supreme power of their master while other animals range around the base [20.3].

The greatest ancient kingdom in South Africa was Zimbabwe. Bushmen paintings and tools show that the earliest people to occupy the site settled there in the Stone Age. Around 1300, its rulers ordered the erection of huge stone

20.1 Bronze Frieze from Benin, Nigeria, showing an Oba (ruler) with his warriors, fifteenth–sixteenth century. $18^{1}/_{2}'' \times 14^{1}/_{2}''$. Peabody Museum, Harvard University.

buildings surrounded by massive walls; the complex is now known as Great Zimbabwe [20.4]. Finds in the ruins include beads and pottery from the Near East, Persia, and even China, suggesting that it served as the base for a trading empire that must have been active well before the arrival of the Europeans, some two centuries later.

http://www.usd.edu/anth/zimb.html

Great Zimbabwe

Attempts to understand the function of Great Zimbabwe's constructions are largely based on accounts of Portuguese traders who visited the site after its original inhabitants had abandoned it. The main building seems to have been a royal residence, with other structures perhaps for nobles, and a great open ceremonial court. It has been calculated that at the height of its power, the complex may have served as the center for a population of some eighteen thousand persons, with the ruling class living inside, and the remainder in less permanent structures on the surrounding land.

Portuguese documents describe Great Zimbabwe as "the capital of the god-kings called Monomotapa." In the

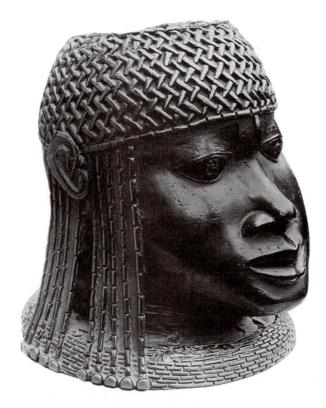

20.2 Portrait of a royal woman, from the palace at Benin, Nigeria. Bronze, sixteenth century, height $7^1/8$ ". Fogg Art Museum, Harvard University.

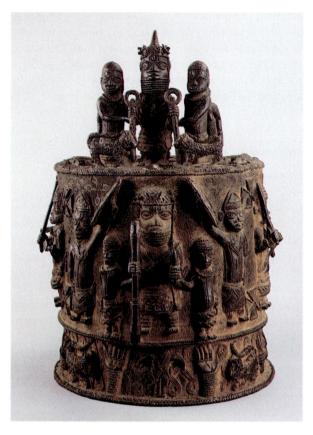

20.3 Altar of the hand, from Benin, Nigeria, c. seventeenth–eighteenth century. Bronze, $1'5^{1}/_{2}''$ (19 cm) high. British Museum, London.

sixteenth century, Europeans used this name for two Shona rulers: Mutota and Matope. The original inhabitants may well have been ancestors of the Shona people, who are now among the groups living in modern Zimbabwe. Part of Shona beliefs is the idea that ancestral spirits take the form of birds, often eagles. In one of the enclosed structures, perhaps an ancestral shrine, archaeologists discovered a large soapstone block crowned by a bird, with a crocodile carved on to the stone's lower surface. Below the bird is a row of circles which, in later Shona art, are called "eyes of the crocodile" [20.5].

All three kingdoms flourished long before the Europeans entered Africa's interior. From the sixteenth century, with the beginning of the age of European colonization and the slave trade that accompanied it, Europeans began to settle in coastal regions, which served as bases for exploring and exploiting Africa's extraordinary natural resources. Islamic missionaries had carried their religion southward across the Sahara desert centuries earlier. Now the arrival of the Europeans brought Christianity and, under the influence of both religions, traditional patterns of ritual and ancestor worship began to die out.

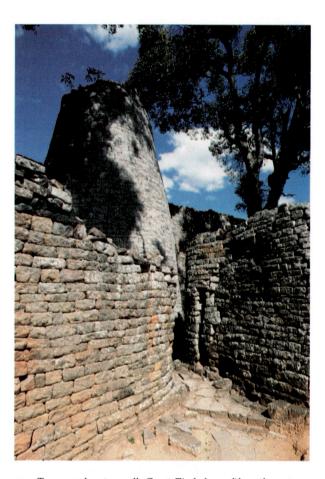

20.4 Tower and outer wall, Great Zimbabwe, fifteenth century. Granite.

AFRICAN LITERATURE

Although very little written African literature existed before the twentieth century, there was a rich tradition of storytelling, often in verse. Much of this was passed down by word of mouth, in the same way as the earliest works of Western literature—Homer's *Iliad* and *Odyssey*—and a little has been preserved, written down by later generations using either the Arabic or Western alphabet. Somalia had a rich poetic tradition. Raage Ugaas (eighteenth century), of the Somali Ogaden clan, was popular for his wisdom and piety, whereas another Somali oral poet, Qamaan Bulhan (probably midnineteenth century) was well-known for his philosophical and reflective verses, some of which have become proverbial expressions.

One area that did develop an earlier written tradition was the coastal region of East Africa where *Swahili* (an African language strongly influenced by Arabic) was and still is spoken. Beginning in the sixteenth century, Muslim traders brought with them to the coastal trading centers didactic and religious verse that was paraphrased in

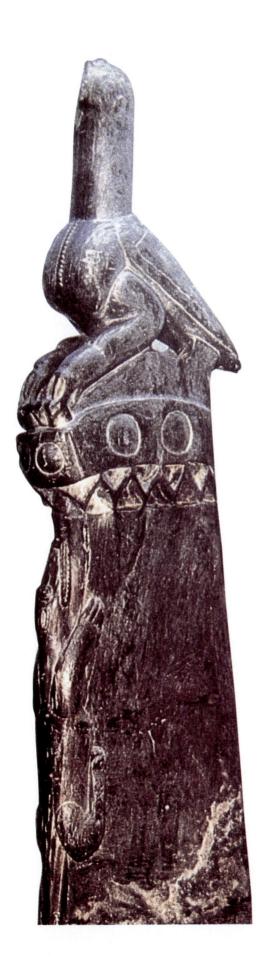

Swahili, with the Swahili version written between the lines of the Arabic text. Over time, poets used this Swahili–Arabic script to compose their own works, either recording traditional songs or creating new ones. Saiyid Abdallah (c. 1720–1810) was born on the island of Lamu, now part of present-day Kenya. In his long poem *Self-examination* he uses the decline of the great Arab trading cities on the East African coast, increasingly overshadowed during Abdallah's time by the new European colonial centers, as a symbol of the inevitability of death.

Over time, as African writers began to use the Western alphabet, they also adopted Western languages, normally the one spoken by their colonial occupiers. The modern state of Senegal, which once formed part of the eleventh-century kingdom of Ghana, fell under French rule in 1895. As a young boy, Leopold Senghor (1906-1989) was sent to a Catholic mission school where he learned French and Latin. In due course he won a scholarship to study in Paris, where Senghor became part of a group of talented black writers, some African, some West Indian, and some, including Langston Hughes, American. Overwhelmed by the squalor of the city of Paris and the arrogance of its people—the conquerors of his country-Senghor found strength in his "blackness." He later talked of discovering Africa in France, and feeling his "pagan sap which prances and dances."

Together with his fellow black African exiles, he created a literary movement known as negritude. Senghor defined negritude as "the sum total of the civilization of the African world. It is not racialism, it is culture." Negritude's contribution to universal civilization, he believed, lay in Africa's uniqueness: the song styles and rhythms of its oral literature and poetry, but also its social values of traditionalism, earthiness, and the importance of community. In his own poems, Senghor often used woman as a symbol for Mother Africa, his version of Mother Earth. Not all African writers were convinced by Senghor's philosophy. One Senegalese contemporary described it as "mystification" that ignored the class struggle, elitist, and out of touch with the masses. Many younger African critics have attacked negritude as a compromise with Neo-Colonialism, a refusal to complete the decolonization of the African mind. The Nigerian writer Wole Soyinka (who in 1986 was the first African to receive the Nobel Prize for literature) has dismissed negritude by observing that "tigers do not contemplate their 'tigritude' but just act naturally by pouncing." Senghor went on to a career in politics, building on negritude to form a variety of African socialism, neither capitalist nor

20.5 Bird with crocodile image on stone monolith, from Great Zimbabwe, fifteenth century. Soapstone. Bird image 1'2\frac{1}{2}" (14 cm) high. Great Zimbabwe Site Museum, Zimbabwe.

Marxist. Becoming president of Senegal in 1960, he retired in 1980, the first African president to do so by his own choice. Whatever the lasting value of his aesthetic theories, his influence on twentieth-century African history is undeniable. One of his fellow countrymen called him "the myth that is endlessly discussed."

Other important African writers used their own language, rather than that of the colonizers. The first African novelist, Thomas Mofolo (1875?-1948), was born in Lesotho, a landlocked kingdom in the middle of South Africa, upon which it has always been economically dependent. While he was teaching in South Africa and Lesotho, Mofolo's passion for storytelling encouraged friends to urge him to begin writing. In 1906, he published Traveler of the East, writing in the Sesotho language. The book is generally considered both the first novel by an African and the first written in an African language. In his early work, Mofolo sought to combine Christian elements with traditional tales and poems. By the time he came to write his most important and successful novel, Chaka (1912) he used African religion as the overriding influence in his characters' lives. The book describes the career of Zulu King Shaka (1787?-1828), an actual historical figure who organized the hitherto weak Zulu warriors into a formidable fighting force. The real king was notorious for his cruelty and paranoia. In Mofolo's story, however, Chaka begins as genuinely heroic and courageous. The tragic hero then declines into tyranny and eventual insanity when, in an African version of Faust's pact with the devil, he sells his soul into sorcery. The missionary press, which had published his earlier books, refused to publish it, and it did not appear in print until 1925. Chaka became an instant best-seller, and has been widely translated.

http://campus.northpark.edu/history//WebChron/Africa/ShakaZulu.html

Shaka

The most widely read and acclaimed African novelist of the twentieth century is probably Chinua Achebe, born in Nigeria in 1930; his family belonged to the Igbo people of eastern Nigeria. When Nigeria became independent in 1960, the country (an artificial creation of the British) began to divide. In 1967, the Igbo seceded to form the Republic of Biafra, and Achebe, a passionate supporter of the Igbo, became Minister of Information in the new state. The Igbo breakaway was crushed in 1970, and the central Nigerian government seized control again. Achebe, overwhelmed by the death of many of his closest friends and the defeat of his people, chose to remain in Nigeria under the terms of the general amnesty for the rebels, and the war became a constantly recurring subject in much of his poetry.

http://www.kirjasto.sci.fi/achebe.htm

Chinua Achebe

http://www.siu.edu/~anthro/mccall/jones/index.html

Igbo people

The central theme of Achebe's work is the conflict between two worlds: Western technology and values, and traditional African society. In most of his novels, the chief character is torn by these opposing forces, and is often destroyed in the process. His first book, *Things Fall Apart* (1958), forewarns us by its title (a quotation from W. B. Yeats' poem, "The Second Coming") that its story is tragic. When the British arrive in a traditional Igbo society, they undermine the values that have sustained it, and one of the community's most respected leaders is driven to suicide, as "things fall apart." Although the disaster is implicit from the beginning, Achebe's cool, laconic prose style distances the storyteller from his tale.

In his next novel, *No Longer at Ease* (1960), conflict becomes internalized. Its chief character, Obi Okonkwo, has been sent by his community to England for his education, and on his return takes an uneasy position among the corrupt minor British bureaucrats governing local affairs. As the story unfolds, Achebe paints a bitter, if ironic, picture of the colonial ruling classes, the bewilderment of the Africans, and of the disastrous effect of both forces on the innocent young man in the middle. Obi's plight is made even more poignant by the impact on him of two powerful aspects of Western culture: Christianity and Romantic love.

Achebe wrote his novels in English and, as in the case of Senghor, many of his fellow African writers have reproached him for writing in a colonial language. Achebe has always argued, however, that only Western languages can carry the message to those who most need to hear it. Furthermore, by using European languages, Africans can prove that their work can stand alongside Western literature with honor. Above all, throughout his long career, Achebe has always believed that the retelling of the African experience is crucial. In one of his novels, an elder says: "It is the story that saves our progeny from blundering like blind beggars into the spikes of the cactus fence. The story is our escort; without it, we are blind."

Traditional African Art in the Modern Period

In order to appreciate traditional African art, it is necessary to bear in mind its cultural context. Unlike most modern Western artists, African artists generally have

CONTEMPORARY VOICES

An Arab and a European Visit Africa

This account of the Ghanaian capital (probably Kumbi Saleh) comes from the travel account of al-Bakri, an Arab geographer.

Ghana consists of two towns lying in a plain. One of these towns is inhabited by Muslims. It is large and possesses twelve mosques. . . . The town in which the king lives is six miles from the Muslim one and bears the name Al Gaba. The land between the two towns is covered with houses. The houses of the inhabitants are made of stone and acacia wood. The king has a palace and a number of dome-shaped dwellings, the whole surrounded by an enclosure like the defensive wall of a city. . . . The king adorns himself like a woman, wearing necklaces and bracelets, and when he sits before the people he puts on a high cap decorated with gold and wrapped in turbans of fine cotton.

Cited in E. Jefferson Murphy, History of African Civilization (New York: Crowell, 1972), p. 110.

The following description of the capital of Benin was written by a Dutch trader in the late seventeenth century, long after the city's heyday.

The town is enclosed on one side by a wall ten-feet high, made of a double palisade of trees, with stakes in between interlaced in the form of a cross, thickly lined with earth. On the other side a marsh, fringed with bushes, which stretches from one end of the wall to the other, serves as a natural rampart to the town. There are several gates, eight- or nine-feet high, and five-feet wide. . . . The king's palace. . . . is a collection of buildings which occupy as much space as the town of Haarlem, and which is enclosed within walls. There are numerous apartments for the king's ministers and fine galleries most of which are as big as those on the Exchange at Amsterdam.

Cited in Murphy, op. cit., p. 172.

not produced works as aesthetic objects to be looked at, but rather to fulfill a precise function in society and religion. Until the commercialization of recent times, the notion of a museum or gallery was alien to African art. Also, far from following Western ideas of "inspiration" or progress, African art is firmly rooted in tradition. The identity of the individual creator is far less important that the authenticity of the object and, as a result, we know very few names of African artists. Whether it exalts the secular power of rulers, or the spiritual force of the spirit world—and often, of course, the two overlap—the sculpture or mask must evoke age-old memories and associations. At the same time, African artists are as open to the influences of changing times and the world around them as are Western or Asian artists

The conflict between Achebe's Igbo tradition and the newly arrived Western forces, which leads to tragedy in his novels, is made visible in a pair of clay figures produced by an Igbo artist [20.6]. Seated in a shrine made of adobe (sundried mud brick), they represent the thunder god, Amadioha, and his wife. The god, symbol of worldly power wears the clothing of the forces of Western colonialism, including sunhat, gun, and even necktie. His wife, as if representing Senghor's "Mother Africa," has a traditional hairstyle and body paint. To further enrich the visual impact of the pair, the "Western-style" thunder god is also carrying a traditional spear and has tattoo markings on his face, and both figures have "white" skin. The same complexity of influences can be seen on many of the houses constructed by the Dogon people of the modern state of Mali—the geographical and political states of modern Africa are the result, for the most part, of Western colonization, and their borders do not conform to original settlement patterns. In the example illustrated [20.7], the central unpainted post dates probably to the nineteenth century. It bears the figure of a woman, probably a female ancestor. The other posts, added over time to replace earlier ones, show the growing exposure to external—mainly Western—influences, including a Western-style realistic sun, moon, star, and writing.

Many traditional African works of art celebrate the renewal of life and, simultaneously, its fragility. When women of the Luluwa people of what is now the Democratic Republic of the Congo, want a child but are unable to conceive one, they traditionally seek help from their ancestors by turning to a "healer." The healer initiates them into a fertility cult, which aims to prevent miscarriage and safeguard newborn infants by reincarnating a female ancestor in the form of a wooden image [20.8]. The statuettes have two short pegs, one attached to each foot, which are inserted into a vessel containing medicine; a hole is drilled into the top of the head in which the healer inserts special herbs to cure infertility since, according to Luluwa beliefs, the natural cavities of the skull are associated with divine insight into past and future experience.

The statue illustrated here is unusually large and elaborately carved, suggesting that it was made for a woman

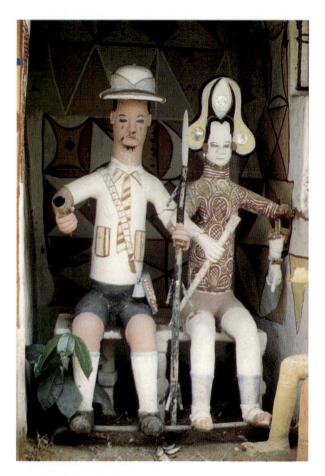

20.6 Mbari thunder god (Amadioha) in modern dress with wife, Igbo. Umgote Orishaeze, Nigeria. Clay. Height $15\frac{1}{2}$ ". Photographed 1966.

of high rank. The inward contemplation of the expression, accentuated by the large eyelids and downward gaze, conveys the Luluwa view of women as mediators between nature and the world of the spirit. As is often the case in African culture, the same basic idea emerges elsewhere with a different artistic style. The Yoruba people, whose culture developed in the region now made up of western Nigeria and the Republic of Benin, also revered the spiritual role of the mother, and often symbolized it by using the moon as an emblem of the eternal feminine.

http://www.africapolicy.org/bp/ethyor.htm

Yoruba people

A painted wooden Yoruba mask takes the form of a woman's face. It was used in a special ritual dedicated to "the mothers," whose power is at its greatest at night [20.9]. Masks play a crucial role in the rituals of many different African peoples, providing a means of transforming humans into animals or spirits, blurring age and gender distinctions, and invoking supernatural forces. In most cases, the mask represents an ideal type, such as a young woman capable of bearing many children [20.10], seen here as used in a ritual dance of the Baga Sitemu in modern Guinea. On rare occasions, a mask is carved to capture the appearance of an individual. A photograph (taken in 1971) shows Moya Yanso together with her stepson, holding a mask carved around 1913 to represent her in her youthful beauty [20.11].

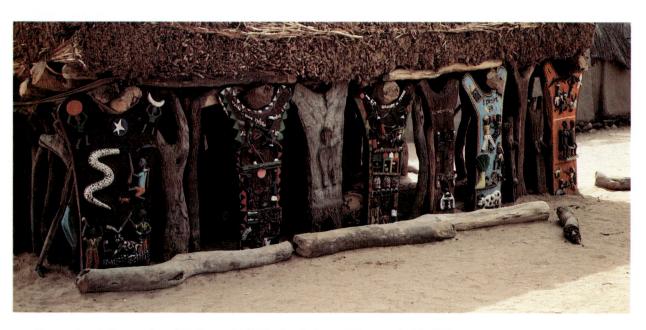

20.7 Togu na (men's "house of words"). Dogon, Mali. Wood and pigment. Photographed in 1989.

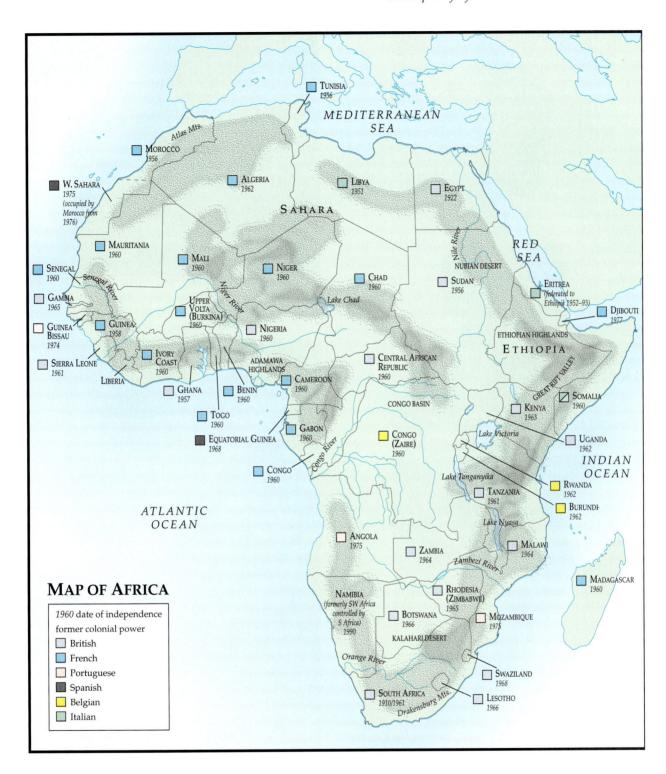

THE IMPACT OF AFRICAN CULTURE ON THE WEST

Throughout the nineteenth century, as Western nations continued to colonize Africa, a growing number of African art works began to circulate among Western collectors. One result was to create increasing interest in the study of anthropology, as scholars began to try to understand and

distinguish between the various cultures. By the turn of the century, however, African artistic styles were directly influencing Western art. Pablo Picasso, one of the towering figures of twentieth-century art, returned throughout his long career to the African masks he had seen at a Paris exhibition, and which he began to collect himself. One of the first of his works to show their effect on his painting is illustrated at the beginning of the next chapter

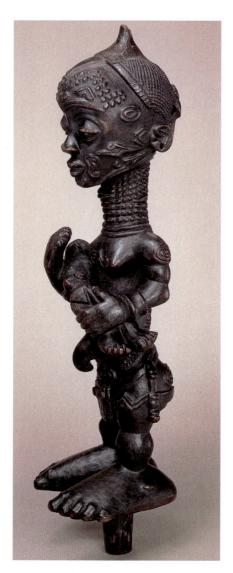

20.8 Maternity figure from Luluwa, Democratic Republic of the Congo. Mid- to late nineteenth century. Wood, $11^3/8^{"} \times 3^3/8^{"} \times 3^{1}/2^{"}$ (28.9 \times 8.6 \times 8.2 cm). The Art Institute of Chicago, Wirt D. Walker Endowment fund.

(see Figure 21.1), the painting known as *Les Demoiselles d'Avignon*. Sixty years later, commissioned to design a monumental sculpture for the city of Chicago, Picasso produced a work inspired by the same source [20.12].

Perhaps an even more direct link between African culture and modern Western culture is in music. As Chapter 21 describes in detail, jazz derives ultimately from the music of the African ancestors of African Americans. Yet jazz only partially represents Africa's musical legacy, as the growing interest in world music continues to show.

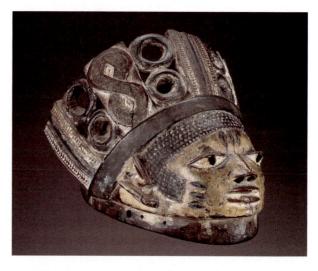

20.9 Mask, Yoruba, from Republic of Benin. Paint on wood. Height $14^{1/2}$ " (37 cm).

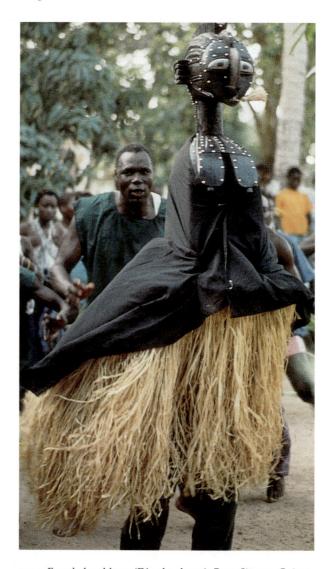

20.10 Female headdress (D'amba dance), Baga Sitemu, Guinea. Photographed in 1990.

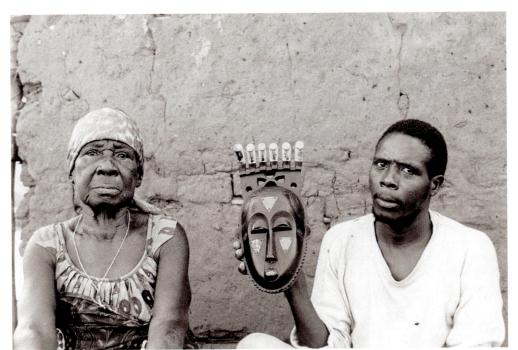

20.11 Ghagba portrait mask of Moya Yanso and stepson, Kouame Ndri. Kami village, Baule, Ivory Coast. Mask carved around 1913, photographed in 1971.

SUMMARY

The development of culture in Africa was, in large measure, conditioned by climate and the different varieties of environment. The absence before modern times of a consistent written record means that our picture of early societies there is based largely on archaeological evidence and the historical accounts of the first Muslim and Western travelers.

Religion and Society in Early Africa Although African culture was never unified, certain characteristics were shared by many early African societies. Religious beliefs were generally animist, using the world of nature to explain to individuals their own lives. Successive generations passed on traditional beliefs by word of mouth, and the elders in a family or group therefore acquired a special status. Within each society, particular families or kin-groups undertook specific tasks.

Three Early Kingdoms: Ghana, Benin, Zimbabwe Of the many powerful and sophisticated kingdoms that developed in Africa before the age of colonization, Ghana was outstanding for its wealth, and exported large quantities of gold. Its period of greatest richness occurred around 1000. Both Benin (in West Africa) and Zimbabwe (in South Africa) began to grow around 1300. We can document life in Benin by means of the bronze plaques used to decorate the royal buildings. They reveal a society ruled by a hereditary king, and a religion that placed emphasis on the cult of ancestor worship. Zimbabwe was chiefly notable for its massive stone buildings and

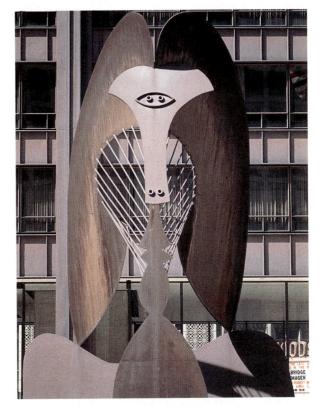

20.12 Pablo Picasso. *Chicago Picasso*. Steel. Height 50' (15.25 m), 1967. Civic Center Plaza, Chicago.

for its trade with Asia long before the Europeans established trade links there.

African Literature The earliest literary tradition in Africa was oral, although some of the Muslim traders in East Africa introduced Arabic script. One of the results was the development of Swahili, an African language influenced by Arabic. In the early twentieth century, African writers were faced with the choice of whether to write in their own language or that of their colonizers. Leopold Senghor (of Senegal) wrote in French, but was a leading influence in the literary movement known as "negritude," which emphasized the specifically African contribution to world culture. The first African novelist, Thomas Mofolo, wrote in the language of his birthplace: Lesotho. The Nigerian Chinua Achebe writes in English; his books explore the impact of Western colonialism on African culture and lifestyles.

Traditional African Arts in the Modern Period The same contrast between Western culture and traditional African artistic styles recurs in the visual arts. Most African artists created works for secular rulers or ritual purposes. Recurrent symbols included animals and natural phenomena such as the moon. Masks played an important role as a means of transforming or concealing identity.

The Impact of African Culture on the West The discovery of African art by Western artists in the late nineteenth century, and the development of jazz in the early twentieth century are two important illustrations of African influence on Western culture.

Pronunciation Guide

Achebe:

a-CHAY-BAY

Biafra:

Be-AF-ra

Lesotho:

Less-OWO-thow

Lulawa:

Mofolo:

Loo-LAR-wa

Oba:

Mo-FOE-low

OWE-ba

Senghor:

Sun-GORE

Shona:

SHOW-na

Swahili:

Swa-HEE-li

Yoruba:

Yo-ROO-ba

Zimbabwe:

Zim-BAB-wi

EXERCISES

- 1. Which aspects of their culture did African slaves bring with them to the United States? How have these transplanted forms been changed or modified?
- 2. Compare the effects of Islam and Christianity on African art and religion.
- 3. The question of which language to write in has been a major issue for twentieth-century African writers. What

- are the arguments for and against the use of Western languages?
- 4. Masks play an important role in African art and ritual. How does their use compare to that in Western culture? How have other cultures used masks?
- 5. For most of their history, African poets and storytellers depended on transmission of their compositions by word of mouth. What other cultures have used similar methods?

FURTHER READING

- Ajayi, J. F., & M. Crowder. (1985). Historical atlas of Africa. Cambridge: Cambridge University Press. A highly useful survey that covers a broad field.
- Blier, S. P. (1998). The royal arts of Africa. New York: Abrams. Lavishly illustrated; an excellent recent survey.
- Brockman, N. C. (1994). An African biographical dictionary. Santa Barbara, CA: ABC Clio. An extremely useful reference work that provides a brief introduction to more than five hundred prominent sub-Saharan Africans from all periods of history.
- Davidson, B. (1971). African kingdoms. New York: Time-Life Books. Fine illustrations and a very readable text make this a reliable introduction to African history.
- LaGamma, A. (2000). Art and oracle: African art and divination. New York: Metropolitan Museum of Art. An introduction to the relationship between traditional African religion and art, with a valuable introductory essay by John Pemberton III.
- Lamb, D. (1983). The Africans. New York: Random House. A journalist's view of many aspects of African life and culture.
- Oliver, R., & M. Crowder (Eds.). (1981). The Cambridge encyclopedia of Africa. Cambridge: Cambridge University Press. Perhaps the most complete single-volume refer-
- Phillips, T. (Ed.). (1995). Africa. The art of a continent. New York: Prestel. A series of essays that range widely over the diversity of African art.
- Sieber, R., & R. A. Walker. (1987). African art in the cycle of life. Washington, DC: Smithsonian Institution. This account illuminates the context in which African artists worked.
- Ungar, S. J. (1985). Africa: The people and politics of an emerging continent. New York: Simon & Schuster. Useful background for a study of African culture.

ONLINE CHAPTER LINKS

Internet links to information about the ancient kingdom of Ghana are available at

http://www.sas.upenn.edu/African_Studies/

Country_Specific/Ghana.html

with a history, a map, and links to other Internet resources.

Visit the Smithsonian's *National Museum of African Art* to view a wide variety of artwork from throughout Africa.

Africa South of the Sahara Chronology at http://campus.northpark.edu/history//WebChron/Africa/Africa.html

provides an overview of historical events, with links to several additional Internet resources.

The Yale University's Kamusi Project at http://www.yale.edu/swahili/ offers links to a wide variety of Internet resources,

including dictionaries, a pronunciation guide, grammar notes, and a slide show of images from East Africa.

A collection of Negritude Internet resources is available at

http://www.wlu.edu/~hblackme/negritude/

Learn more about Zimbabwe by visiting http://www.wsu.edu:8080/~dee/CIVAFRCA/MWEN.HTM;

be sure to follow the links for other Internet sites about Africa.

GENERAL EVENTS	LITERATURE & PHILOSOPHY	Art
1900–1905 Einstein researches the theory of relativity	 1900–1905 Freud formulates basic ideas of psychoanalysis; The Interpretation of Dreams (1900) 1908–1915 Marinetti publishes futurist manifestos 	1907 African sculpture fascinates artists in Paris: Picasso, Les Demoiselles d'Avignon; Retrospective of Cézanne's work in Paris; Picasso and Braque begin cubist experiments: Braque, Violin and Palette (1909–1910); Picasso, Daniel-Henry Kahnweiler (1910) 1909–1915 Italian futurists glorify technological progress
1910 Death of Edward VII of England	1910 Death of Tolstoy 1910–1941 British Bloomsbury Group around Virginia and Leonard Woolf rejects Edwardian mentality	I910 Roger Fry's First Post- Impressionist Exhibition scandalizes London; Kandinsky, Concerning the Spiritual in Art c. I911 German expressionism flourishes
1914 World War I begins; European colonialism wanes	1913 Carl Jung breaks with Freud 1915–1916 Dada movement founded Café Voltaire in Zurich; Dada manifesto by Tristan Tzara (1918)	 1912–1914 Mondrian in Paris influenced by cubists; Color Planes in Oval (1913–1914) 1913 New York Armory Show brings avant-garde art to attention of American public 1915 End of futurist movement;

1917 Bolshevik Revolution ends tsarist rule in Russia

1917 Cocteau, scenario for ballet Parade; Wilfred Owen, "Dulce et Decorum Est;" Leonard Woolf begins Hogarth Press

1919 Yeats, "The Second Coming" 1922 Alienation and cultural despair themes in postwar literature: T. S. Eliot, The Waste Land; Joyce, Ulysses. Sinclair Lewis satirizes American middle class in Babbitt

1924 Freudian theory and dadaism foster surrealism; Breton, First Surrealist Manifesto; Freudian themes appear in American drama; O'Neill, Desire Under the Elms (1924)

c. 1925 Black cultural regeneration, "Harlem Renaissance," in Northern U.S. cities

1925 Eliot, The Hollow Men: Kafka. The Trial

1926 Kafka, The Castle

1929 V. Woolf, A Room of One's Own

1930 Freud, Civilization and Its Discontents

1939 Death of Freud; Auden, In

Memory of Sigmund Freud

1932 Huxley warns against unrestrained growth of technology in Brave New World

5 End of futurist movement; Severini, Armored Train in Action

1915-1916 Dada artists begin assault on traditional concepts of art; Duchamp L.H.O.O.Q. (1919)

1916 Arp, Fleur Marteau

1917 Picasso designs Parade set

1921 Picasso, Three Musicians 1921-1931 Klee teaches at Bauhaus; Kandinsky appointed professor in

1922 1923 - 1924 Chagall, The Green Violinist 1924 Surrealism begins; Buñuel and

Dalí collaborate on films Un Chien

Andalou (1929), L'Âge d'Or (1930) 1925 Eisenstein completes influential film Potemkin

1926 Gris, Guitar and Music Paper; Kandinsky, Several Circles, No. 323; Klee, Around the Fish

1927 Rouault, This will be the last time, *little Father! (Miserere* series)

1928 Magritte, Man with a Newspaper

1930 Cocteau film, Blood of a Poet 1931 Dalí, The Persistence of Memory

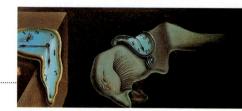

1942-1943 Mondrian, Broadway Boogie-Woogie 1944-1946 Eisenstein, Ivan the Terrible, Parts I and II

1918 World War I ends; women granted right to vote in Great Britain

1920 Women granted right to vote in **United States**

1922 Fascists come to power in **Italy** after Mussolini's march on Rome

1927 Lindbergh's solo flight across Atlantic

1928 First sound movie produced

1929 Great Depression begins in Europe and America

1933 Nazis come to power in Germany under Hitler; first refugees leave country

1936-1939 Spanish Civil War; Guernica bombed (1937)

1939 WORLD WAR II

1945

BETWEEN THE WORLD WARS

1901

EDWARDIAN AGE IN ENGLAND

1910

THE CALM AND THE

1918

1939 Germany invades Poland; World War II begins

1939 First commercial TV

1941 United States enters war

1945 World War II ends

1945 Orwell, Animal Farm 1949 Orwell, 1984

CHAPTER 21 BETWEEN THE WORLD WARS

ARCHITECTURE

Music

c. 1900 Jazz originates among Black musicians of New Orleans

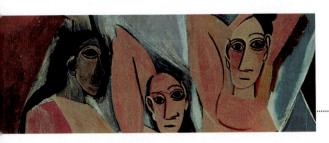

1909 Wright, Robie House, Chicago

- c. 1910 Peak and decline of ragtime music; jazz becomes fully developed
- **1911** Piano rag composer Scott Joplin completes opera *Treemonisha*
- **1913** Stravinsky's *The Rite of Spring* first performed in Paris

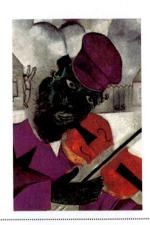

1916 Death of futurist architect Antonio Sant'Elia in World War I **1917** Satie composes score for ballet *Parade*

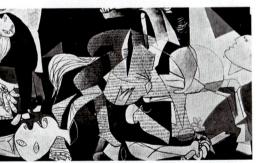

1935 – 1940 WPA photographers

1936 Riefenstahl, Triumph of the Will, film glorifying Nazis

1937 Picasso paints Guernica in protest against war; Dalí uses Freudian symbolism in Inventions of the Monsters

1938 Eisenstein film *Alexander Nevsky*, score by Prokofiev; Riefenstahl, *Olympia* 1919 Bauhaus design school founded at Weimar; Bauhaus ideas find wide acclaim in architecture and many industrial fields

1919–1920 Russian constructivist sculptor and visionary architect Tatlin builds model for Monument to the Third International Avant-garde composers come under influence of jazz and ragtime: Stravinsky, L'Histoire du Soldat (1918), Hindemith, Klaviersuite (1922)

c. 1920 Chicago becomes jazz center; in New York's Harlem, Cotton Club provides showcase for jazz performers

1920s Josephine Baker and other American performers bring jazz and blues to Paris

1923 Schoenberg perfects twelvetone technique (serialism)

1924 Gershwin, Rhapsody in Blue

1926 Gershwin, *Concerto in F Major* for piano

1930 Weill, *The Threepenny Opera*, text
by Bertolt Brecht

1935 Gershwin's Porgy and Bess, first widely successful American opera

1943 Duke Ellington's symphonic suite Black, Brown, and Beige premieres at Carnegie Hall

late 1930s Bauhaus architects Gropius and van der Rohe flee Nazi Germany for United States

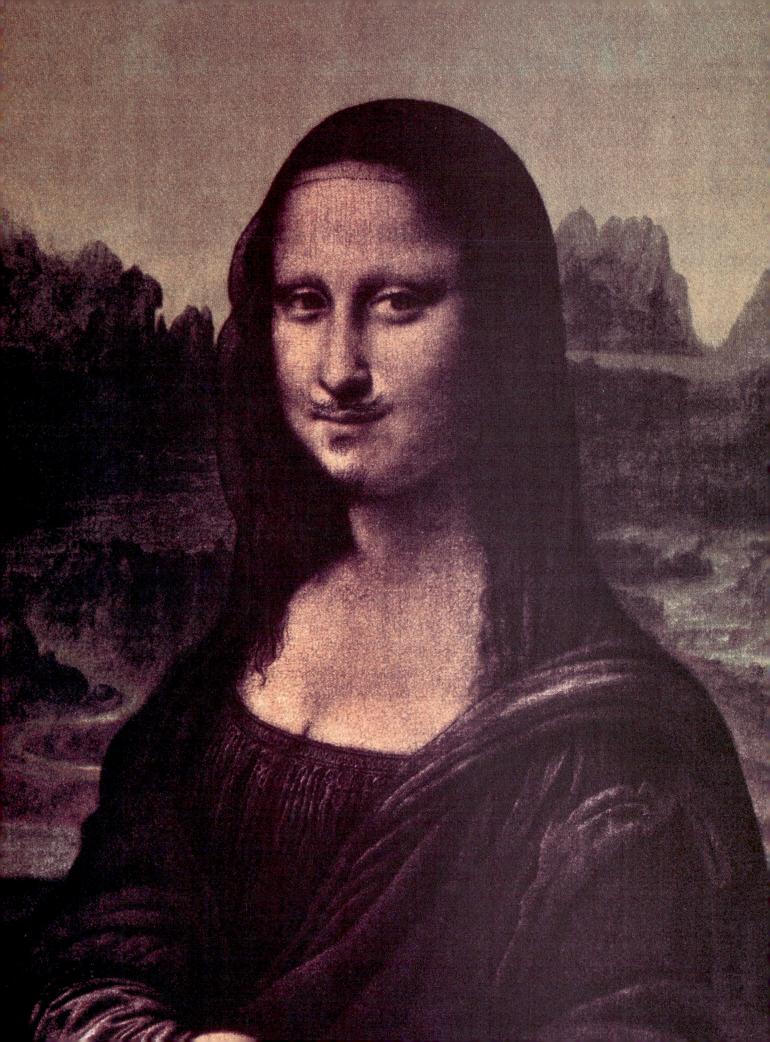

CHAPTER 21

BETWEEN THE WORLD WARS

THE GREAT WAR (WORLD WAR I) AND ITS SIGNIFICANCE

he armed conflict that raged throughout Europe from 1914 until 1918 put to rest forever the notion that war was a heroic rite of passage conferring nobility and glory. The use of technology—especially poison gas, tanks, and planes—made possible slaughter on a scale hitherto only imagined by storytellers. The sheer numbers of soldiers killed in the major battles of World War I continue to stagger the imagination. By the end of the war the Germans had lost three and a half million men and the Allies five million.

The sociopolitical consequences of the Great War were monumental. The geopolitical face of Europe was considerably altered. The October Revolution of 1917 led by V. I. Lenin toppled the tsarist regime and produced a communist government in Russia; it was a direct result of Russia's humiliation in the war. The punitive attitude of the Allies and the stricken state of Germany's postwar economy provided the seedbed from which Hitler's National Socialist movement (Nazism) sprang. Postwar turmoil led to Mussolini's ascendancy in Italy. England had lost many of its best young men in the war; those who survived leaned toward either frivolity or pacifism.

Culturally, World War I sounded the death knell for the world of settled values. The battle carnage and the senseless destruction—in no small part the result of callous and incompetent military leadership—made a mockery of patriotic slogans, appeals to class, and the metaphysical unity of nations. One result of this disillusionment was a spirit of frivolity but another was bitterness and cynicism about anything connected with military glory. A whole school of poets, many of whom did not survive the war, gave vent to their hatred and disgust with this first modern war. English poets like Rupert Brooke (1887–1915) and Wilfred Owen (1893–1918) both died in the war, but not before penning powerful poems about the stupidity, the carnage, and the waste of the battles.

The political upheavals and cultural tremors of the immediate postwar period coincided with a technological revolution in transportation and communications. After World War I, radio came into its own. It is difficult to comprehend what this information linkup meant for people previously isolated by lack of access to the larger world of information and culture. Similarly, the mass production of the automobile, made possible by the assembly-line techniques of Henry Ford in the United States, provided mobility to many who a generation before were confined to an urban neighborhood or a rural village. The widespread popularity of the cinema gave new forms of entertainment and instruction to those who were already accustomed to the voices of the radio coming into their homes each evening.

LITERARY MODERNISM

At the end of World War I, the Irish poet William Butler Yeats (1865–1939), profoundly moved by unrest in his own country (particularly the Easter Rebellion of 1916) and the rising militarism on the Continent, wrote one of the most extraordinarily beautiful and prophetic poems of modern times, "The Second Coming." The title of the poem is deeply ironic because it refers not to the glorious promised return of the Savior but an event the poet only hints at in an ominous manner. A line from that poem with its prescient look into the future is as strikingly relevant for our times as it was for Yeats:

http://www.kirjasto.sci.fi/wbyeats.htm

Yeats

Things fall apart; the centre cannot hold; Mere anarchy is loosed upon the world, The blood-dimmed tide is loosed, and everywhere The ceremony of innocence is drowned; The best lack all conviction, while the worst Are full of passionate intensity.

T. S. Eliot and James Joyce

The year 1922 was a turning point for literary modernism. In that year T. S. Eliot (1888-1965), an expatriate American living in England, published his poem The Waste Land and James Joyce (1882–1941), an expatriate Irish writer living on the Continent, published his novel Ulysses. In their respective works Eliot and Joyce reflect some of the primary characteristics of what is called the *modernist temper* in literature. There is fragmentation of line and image, the abandonment of traditional forms, an overwhelming sense of alienation and human homelessness (both authors were selfimposed exiles), an ambivalence about the traditional culture, an intense desire to find some anchor in a past that seems to be escaping, a blurring of the distinction between reality "out there" and the world of subjective experience, and, finally, a straining and pushing of language to provide new meanings for a world they see as exhausted.

Both Eliot and Joyce reflect the conviction that, in Yeats' phrase, "the centre cannot hold." For Joyce, only art would give people a new worldview that would provide meaning. Eliot felt that if culture was to survive, one had to recover a sense of cultural continuity through a linkage of the artistic and religious tradition of the past. That perceived need for past cultural links helps explain why Eliot's poems are filled with allusions to works of art and literature as well as fragments from Christian rituals.

The gradual shift from cultural despair in *The Waste Land* can be traced in Eliot's later poems beginning with "The Hollow Men" (1925) and "Ash Wednesday" (1930) and culminating in *Four Quartets*, which were completed in the early forties. The *Quartets* were Eliot's mature affirmation of his Christian faith as a bulwark against the ravages of modernist culture. To read *The Waste Land* and the *Four Quartets* in tandem is to see one way in which a sensitive mind moved from chaos to stability in the period between the wars.

Before World War I, Joyce had already published his collection of short stories under the title *Dubliners* (1912) and his *Portrait of the Artist as a Young Man* (1916). The former was a series of linked short stories in which persons come to some spiritual insight (which Joyce called an "epiphany"), while the latter was a thinly disguised autobiographical memoir of his own youth before he left for the Continent in self-imposed exile after his graduation from college. With the 1922 publication of *Ulysses*, Joyce was recognized as a powerful innovator in literature. In 1939, two years before his death, Joyce published the dauntingly difficult *Finnegans Wake*. Joyce once said that *Ulysses* was a book of the day (it takes place in one day) while *Finnegans Wake* was a haunting dream book of the night.

Joyce's blend of myth and personal story, his manylayered puns and linguistic allusions, his fascination with stream of consciousness, his sense of the artist alienated from his roots, and his credo of the artist as maker of the world have all made him one of the watershed influences on literature in the twentieth century.

Franz Kafka

Perhaps the quintessential modernist in literature is the Czech writer Franz Kafka (1883–1924). A Germanspeaking Jew born and raised in Prague, Kafka was by heritage alienated from both the majority language of his city and its predominant religion. An obscure clerk for a major insurance company in Prague, he published virtually nothing during his lifetime. He ordered that his works be destroyed after his death, but a friend did not accede to his wish. What we have from Kafka's pen is so unique that it has contributed the adjective *Kafkaesque* to our language. A Kafkaesque experience is one in which a person feels trapped by forces that seem simultaneously ridiculous, threatening, incomprehensible, and dangerous.

This is precisely the tone of Kafka's fiction. In Kafka's *The Trial* (1925) Joseph K. (note the near-anonymity of the name) is arrested for a crime that is never named by a court authority that is not part of the usual system of justice. At the end of the novel the hero (if he can be called that) is executed in a vacant lot by two seedy functionaries of the court. In *The Castle* (1926) a land surveyor known merely as K., hired by the lord of a castle overlooking a remote village, attempts in vain to approach the castle, to communicate with its lord, to learn of his duties. In time, he would be satisfied just to know if there actually is a lord who has hired him.

No critic has successfully uncovered the meaning of these novels—if in fact they should be called novels. Kafka's work might better be called extended parables that suggest, but do not explicate, a terrible sense of human guilt, a feeling of loss, and an air of oppression and muted violence.

Virginia Woolf

http://www.kirjasto.sci.fi/vwoolf.htm

Woolf

Virginia Woolf (1882–1941) is one of the most important writers in the period of literary modernism. Novels like

Mrs. Dalloway (1925), To the Lighthouse (1927), and The Waves (1931) have been justly praised for their keen sense of narrative, sophisticated awareness of time shifts, and profound feeling for the textures of modern life.

Woolf's reputation would be secure if she had only been known for her novels but she was also an accomplished critic, a founder (with her husband Leonard Woolf) of the esteemed Hogarth Press, and a member of an intellectual circle in London known as the Bloomsbury Group. That informal circle of friends was at the cutting edge of some of the most important cultural activities of the period. Lytton Strachey, the biographer, was a member, as was John Maynard Keynes, the influential economist. The group also included the art critics Roger Fry and Clive Bell, who championed the new art coming from France. The Bloomsbury Group also had close contacts with mathematician—philosopher Bertrand Russell and poet T. S. Eliot.

Two small books, written by Woolf as polemical pieces, are of special contemporary interest. A Room of One's Own (1929) and Three Guineas (1938) were passionate but keenly argued polemics against the discrimination of women in public intellectual life. Woolf argued that English letters had failed to provide the world with a tradition of great women writers not because women lacked talent but because social structures never provided them with a room of their own; that is, the social and economic aid to be free to write and think or the encouragement to find outlets for their work. Woolf, a brilliant and intellectually restless woman, passionately resented the kind of society that had barred her from full access to English university life and entry to the professions. Her books were early salvos in the coming battle for women's rights. Woolf is rightly seen as one of the keenest thinkers of the modern feminist movement whose authority was enhanced by the position she held as a world-class writer and critic.

THE REVOLUTION IN ART: CUBISM

Between 1908 and 1914, two young artists—Frenchman Georges Braque (1882–1963) and expatriate Spaniard Pablo Ruiz Picasso (1881–1973)—began a series of artistic experiments in Paris that revolutionized the direction of Western painting. For nearly five hundred years, painting in the West had attempted a reconstruction on canvas of a real or ideal world "out there" by the use of three-dimensional perspective and the rules of geometry. This artistic tradition, rooted in the ideas of the Italian Renaissance, created the expectation that when one looked at a painting one would see the immediate figures more clearly and proportionally larger while the

background figures and the background in general would be smaller and less clearly defined. After all, it was reasoned, that is how the eye sees the real world. Braque and Picasso challenged that view as radically as Einstein, a decade before, had challenged all the Classical assumptions we had made about the physical world around us.

To Braque and Picasso, paint on an essentially twodimensional and flat canvas represented a challenge: How could one be faithful to a medium that by its very nature was not three-dimensional while still portraying objects that by their very nature are three-dimensional? Part of their answer came from a study of Paul Cézanne's many paintings of Mont Sainte-Victoire executed the century before. Cézanne saw and emphasized the geometric characteristics of nature; his representations of the mountain broke it down into a series of geometrical planes. With the example of Cézanne and their own native genius, Braque and Picasso began a series of paintings to put this new way of "seeing" into practice. These experiments in painting began an era called analytical Cubism because the artists were most concerned with exploring the geometric qualities of objects seen without reference to linear perspective.

http://www.ibiblio.org/wm/paint/glo/cubism/

Cubism

Picasso's Les Demoiselles d'Avignon [21.1], painted in 1907, is regarded as a landmark of twentieth-century painting. Using the traditional motif of a group of bathers (the title of the painting is a sly joke; it alludes to a brothel on Avignon Street in Barcelona), Picasso moves from poses that echo Classical sculpture on the left to increasingly fragmented and distorted figures on the right. His acquaintance with African art prompted him to repaint the faces that same year to reflect his delight with the highly angular and "primitive" African masks he had seen at a Paris exhibition. The importance of this work rests in its violently defiant move away from both the Classical perspective of Renaissance art and the experiments of Cézanne in the preceding century. It heralds the Cubism with which both Picasso and Braque became identified the following year.

A look at representative paintings by Braque and Picasso will help clarify the aim of the Cubists. In *Violin and Palette* [21.2] Braque depicts a violin so that the viewer sees at once the front, the sides, and the bottom of the instrument while they appear simultaneously on a single flat plane. The ordinary depth of the violin has disappeared. The violin is recognizable but the older notion of the violin as appearing "real" has been replaced by the artist's vision of the violin as a problem to be solved according to his vision and through his analysis.

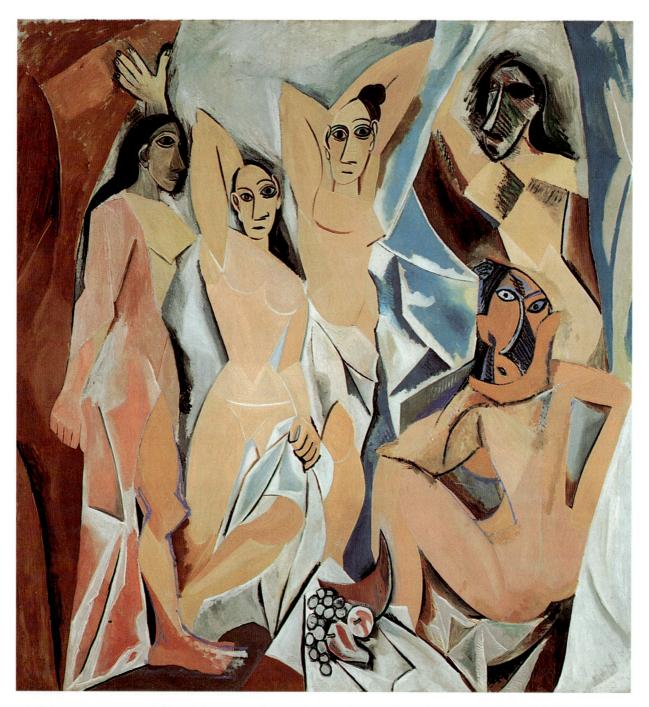

21.1 Pablo Picasso. Les Demoiselles d'Avignon, Paris (begun May, reworked July 1907). Oil on canvas, $8' \times 7'8''$ (243.9 \times 233.7 cm). Collection, The Museum of Modern Art, New York (acquired through the Lillie P. Bliss Bequest). Note the increasing distortion of the faces as one's eyes move from left to right.

In Picasso's portrait of Daniel-Henry Kahnweiler [21.3] the entire picture plane has become a geometric grid in which the traditional portrait form has been broken into separate cubelike shapes and scattered without reference to traditional proportion. The viewer must reconstruct the portrait from the various positions on the cubist grid. Within the picture one detects here a

face, there a clasped hand, and a table with a bottle on it. The intense preoccupation with line and form in this work can be noted by a close examination of the tiled surface facets that provide the painting with its artistic unity.

In the postwar period, the impact of Cubism on the artistic imagination was profound and widespread.

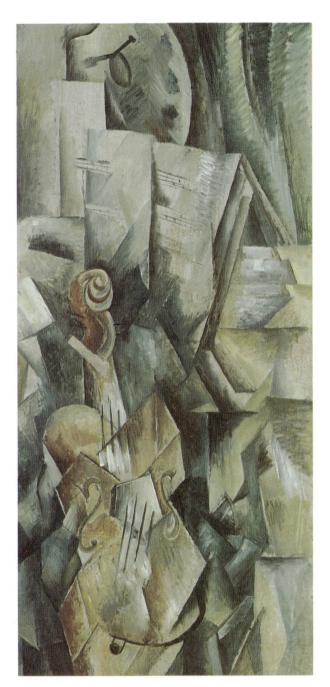

21.2 Georges Braque. *Violin and Palette*, 1909–1910. Oil on canvas, $36^{1}/8^{"} \times 16^{1}/8^{"}$ (92 × 43 cm). Guggenheim Museum, The Solomon R. Guggenheim Foundation, New York (PN 54.1412). The Cubist strategy of breaking up planes can be seen clearly by visually attempting to reconstruct the normal shape of the violin.

Picasso himself moved away from the technically refined yet somewhat abstractly intellectual style of analytic Cubism to what has been called *synthetic Cubism*. In *Three Musicians* [21.4] he still employs the flat planes and two-dimensional linearity of Cubism, as the geometric masks of the three figures and the way they are lined up clearly

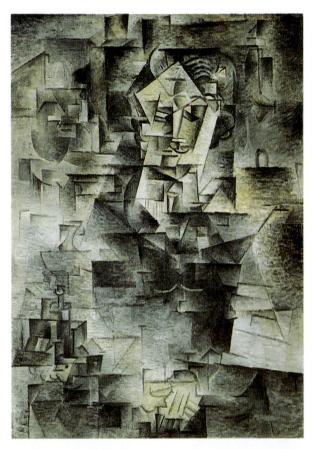

21.3 Pablo Picasso. *Daniel-Henry Kahnweiler*, 1910. Oil on canvas, $39^3/8'' \times 28^5/8''$ (100.6 \times 72.8 cm). Art Institute of Chicago (Gift of Mrs. Gilbert W. Chapman in memory of Charles B. Goodspeed, 1948.561). Note the intensely two-dimensional plane of the painting.

show, but their color, vivacity, playfulness, and expressiveness somehow make us forget that they are worked out in terms of geometry. These postwar paintings seem more humane, alive, and less intellectually abstract.

The visual revolution of Cubism stimulated other artists to use the Cubist insight in a variety of ways. Only a close historical analysis could chart the many ways in which Cubism made its mark on subsequent art, but a sampling shows both the richness and diversity of art in the West after the Great War.

Some painters, like Juan Gris (1887–1927), continued to experiment rather faithfully with the problems Picasso and Braque explored before the war. His *Guitar and Music Paper* [21.5] demonstrates that such experimentation was no mere exercise in copying. Other artists followed along the lines of Gris. The Dutch painter Piet Mondrian (1872–1944), after visits to Paris where he saw Cubist work, abandoned his earlier naturalistic works for paintings like *Color Planes in Oval* [21.6], a work whose main focus is on line and square highlighted by color.

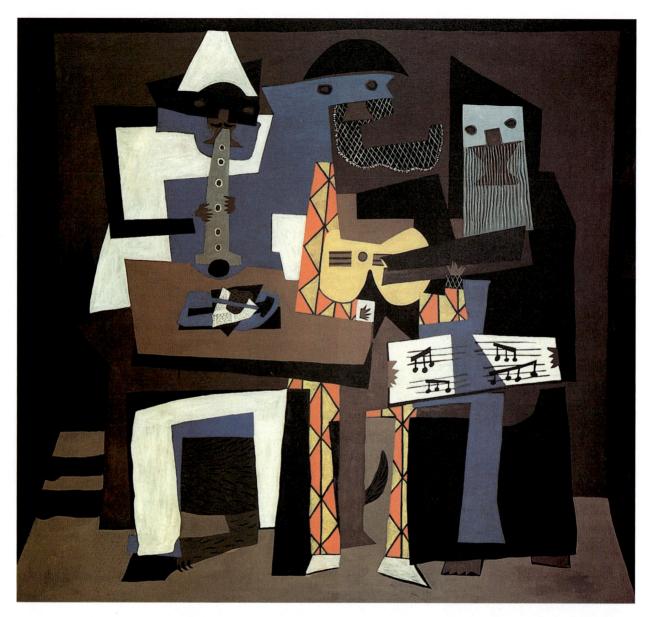

21.4 Pablo Picasso. *Three Musicians*. Fontainebleau, summer 1921. Oil on canvas, $6'7'' \times 7'3^3/4''$ (2.7 × 2.23 m). Collection, The Museum of Modern Art, New York (Gift of Mrs. Simon Guggenheim Fund). Another, more severe, version of this painting done in the same year now hangs in New York's Museum of Modern Art.

The influence of Cubism was not confined to a desire for simplified line and color even though such a trend has continued to the present in *Minimalist* and Hardedge art. The *Green Violinist* [21.7] by Marc Chagall (1889–1985) combines Cubist touches (in the figure of the violinist) with the artist's penchant for dreamy scenes evoking memories of Jewish village life in Eastern Europe.

Although Cubism was the most radical departure in modern art, it was not the only major art trend that overarched the period of the Great War. German painters continued to paint works in the Expressionist style of the early years of the century. Perhaps the most accomplished exponent of Expressionism was Wassily Kandinsky (1866–1944), who was also one of the few painters of his time who attempted to state his theories of art in writing. Kandinsky's *Concerning the Spiritual in Art* (1910) argued his conviction that the inner, mystical core of a human being is the truest source of great art. That attitude, together with Kandinsky's conviction that the physical sciences were undermining confidence in the solidity of the world as we see it, led him closer to color

VALUES

Disillusionment

The period between the two world wars has often been characterized as a time of disillusionment. The horrendous slaughter of World War I, the brief spasm of economic prosperity followed by the worldwide Depression, the lack of trust in governments, and the questioning of traditional culture created a culture seeking ways to fill the moral vacancy of the times. Responses ranged from a new hedonism reflected in the excesses of the Jazz Age to a renewed search for some kind of a center for culture in the works of the modernist writers.

The most dangerous reaction to this disillusioned spirit was the rise of the total state. From Lenin's Russia, Hitler's Germany, and Mussolini's Italy arose a totalitarianism that saw the state as the total center of power which would guide everything from economics and social policy to the arena of culture, arts, and propaganda. The distinction between public and private life was erased by the total state.

One great lesson that can be learned from the rise of modern totalitarianism is the vigor with which the total state repressed all cultural alternatives to its own vision of reality. The suppression of free speech, independent media, toleration for the arts, the space for independent social groups or churches or civic organizations was total in the Soviet Union, Germany, and Italy. The vigorous antifascist novelist Ignazio Silone once wrote that what the state feared more than anything else was one person scrawling "NO" on a wall in the public square.

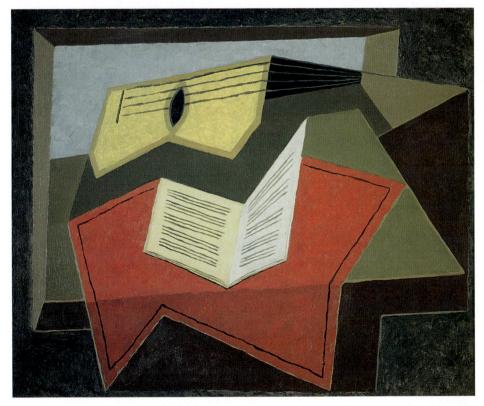

21.5 Juan Gris. *Guitar and Music Paper*, 1926. Oil on canvas, $25^5/8^{"} \times 31^7/8^{"}$ (65×81 cm). Private collection. It is instructive to compare this work to Braque's painting of a similar subject (Figure 21.2) to see how a similar theme was handled differently by another Cubist painter.

abstraction and further away from any form of representation. By 1926, Kandinsky was attempting to express the infinity and formlessness of the world (indeed, the cosmos) in paintings like *Several Circles* [21.8] without appeal to any representative figures or sense of narration (nonobjective art).

Freud, the Unconscious, and Surrealism

In 1900, on the very threshold of the century, a Viennese physician Sigmund Freud (1856–1939) published *The Interpretation of Dreams*—one of the most influential works

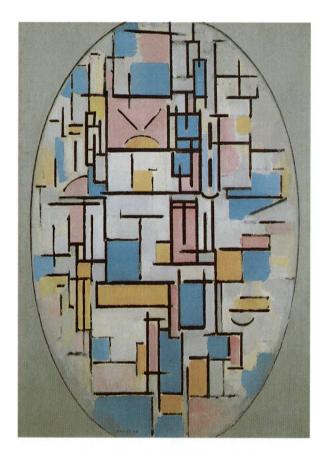

21.6 Piet Mondrian. *Color Planes in Oval*, 1913–1914. Oil on canvas, $42^3/8$ " \times 31" (108 \times 79 cm). Collection, The Museum of Modern Art, New York (purchase). Color experiments of this kind would exert an enormous influence on clothing design and the graphic arts in subsequent decades.

of modern times. In it, Freud argued that deep in the unconscious, which Freud called the id, were chaotic emotional forces of life and love (called libido or Eros) and death and violence (called *Thanatos*). These unconscious forces, often at war with each other, are kept in check by the ego, which is the more conscious self, and the superego, which is the formally received training of parental control and social reinforcements. Human life is shaped largely by the struggle between the ego and superego to prevent the deeply submerged drives of the unconscious from emerging. One way to penetrate the murky realm of the human unconscious, according to Freud, was via dreams. In the life of sleep and dreams the ego and superego are more vulnerable in their repressive activities. "The dream," Freud wrote, "is the royal road to the unconscious." To put it simply, Freud turned the modern mind inward to explore those hidden depths of the human personality where the most primitive and dynamic forces of life dwell. Freudian psychoanalysis is not only a therapeutic technique to help anxious patients but also a descriptive philosophy that proposes to account for both human behavior and culture in general.

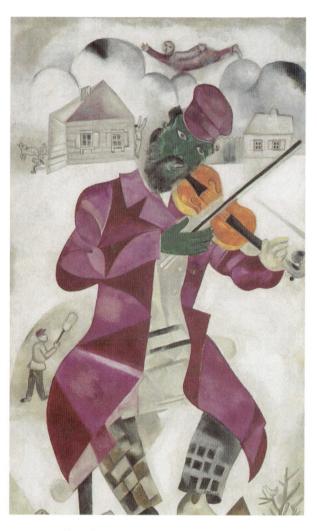

21.7 Marc Chagall. *Green Violinist*, 1923–1924. Oil on canvas, $6'8'' \times 3'6^{1/4}''$ (1.98 \times 1.09 m). Guggenheim Museum, The Solomon R. Guggenheim Foundation, New York. This highly complex work blends Cubist, primitive, and dreamlike characteristics. Chagall's work blends memories of his Russian past and Jewish mysticism in a highly formal manner.

After the Great War, Freud's ideas were readily accessible to large numbers of European intellectuals. His emphasis on nonrational elements in human behavior exercised a wide influence on those who had been horrified by the carnage of the war. One group was particularly anxious to use Freud's theories about the dream world of the unconscious as a basis for a new aesthetics. The result was the movement known as *Surrealism*.

Surrealism was both a literary and an artistic movement, gathered around the journal *Littérature*, edited in Paris by the French critic André Breton. In 1924, Breton published his first *Manifesto of Surrealism*, which paid explicit homage to Freud's ideas on the subjective world of the dream and the unconscious. "Surrealism," Breton declared, "is based on the belief in the superior reality of certain forms of association hitherto neglected, in the

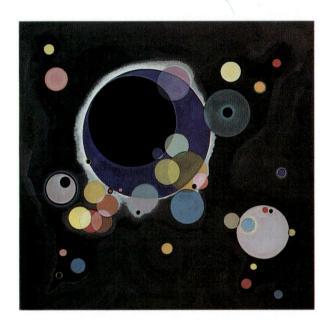

21.8 Wassily Kandinsky. *Several Circles*, 1926. Oil on canvas, $4'7^1/8''$ (1.4 m) square. Guggenheim Museum, The Solomon R. Guggenheim Foundation, New York.

omnipotence of the dream, and in the disinterested play of thought."

The painters first associated with Surrealism are familiar to every museum goer: Jean Arp, Giorgio de Chirico, Max Ernst, Paul Klee, Joan Miró, Pablo Picasso. The Spanish artist Salvador Dalí (1904–1989), who joined the movement in its latter period, however, was to become almost synonymous with Surrealism. His *The Persistence of Memory* [21.9] is perhaps the most famous Surrealist painting. Its dreamlike quality comes from the juxtaposition of almost photographic realism with a sense of infinite quiet space and objects that seem unwilling to obey the laws of physics. The soft watches seem to melt in their plasticity. It is the very juxtaposition

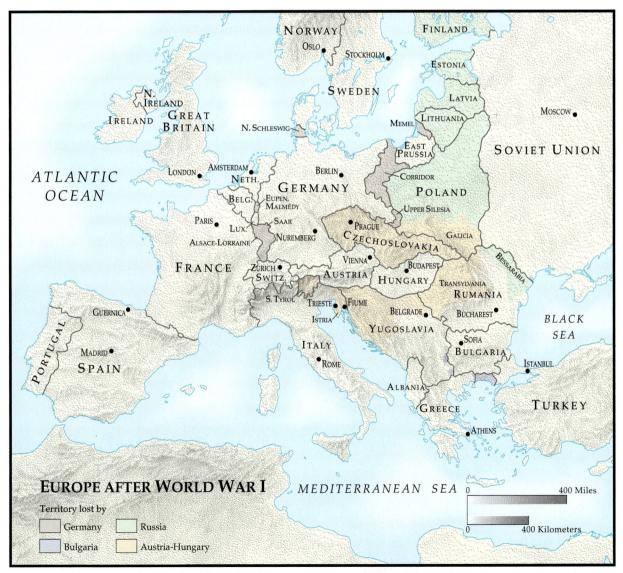

Contemporary Voices

Virginia Woolf

Then Joyce is dead: Joyce about a fortnight younger than I am. I remember Miss Weaver, in wool gloves, bringing *Ulysses* in typescript to our teatable at Hogarth House . . . One day Catherine [sic] Mansfield came, and I had it out. She began to read, ridiculing: then suddenly said: But there's something in this: a scene that should figure I suppose in the history of literature . . . Then I remember Tom [T. S. Eliot] saying: how could anyone write again after the immense prodigy of that last chapter?

We were in London on Monday. I went to London Bridge. I looked at the river; very misty; some tufts of smoke, perhaps from burning houses. There was another fire on Saturday. Then I saw a cliff of wall, eaten out, at one corner; a great corner all smashed: a bank; the monument erect; tried to get a bus; but such a block I dismounted; and the second bus advised me to walk. A complete jam of traffic; for streets were being blown up. So by Tube to the Temple; and there wandered in the desolate ruins of my old squares: gashed, dismantled; the old red bricks all white powder, something like a builder's yard. Grey dirt and broken windows. Sightseers; all that completeness ravished and demolished.

An abridged entry in Virginia Woolf's diary for January 15, 1941, describing the results of the German bombing of London. Shortly after writing this entry Virginia Woolf committed suicide.

of solidity and lack of solidity that contributes to the "surreal" tone of the painting. In other paintings, like *Inventions of the Monsters* [21.10], Dalí's surreal world has more apparent allusions to the Freudian unconscious.

There are open references to terror, violence, and sexuality. The double portrait is an allusion to the androgenous characteristics that make up each person, and Dalí frequently alludes to this bisexual dynamic in his work.

21.9 Salvador Dalí. The Persistence of Memory, 1931. Oil on canvas, $9^{1}/_{2}^{"} \times 13^{"}$ (24.1 \times 33 cm). Collection, The Museum of Modern Art, New York (Given anonymously).

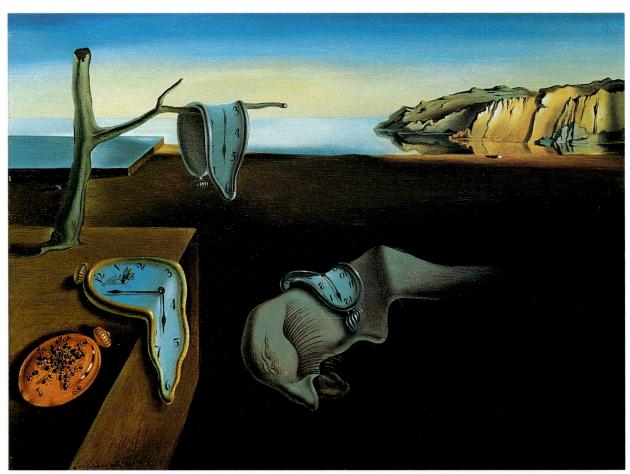

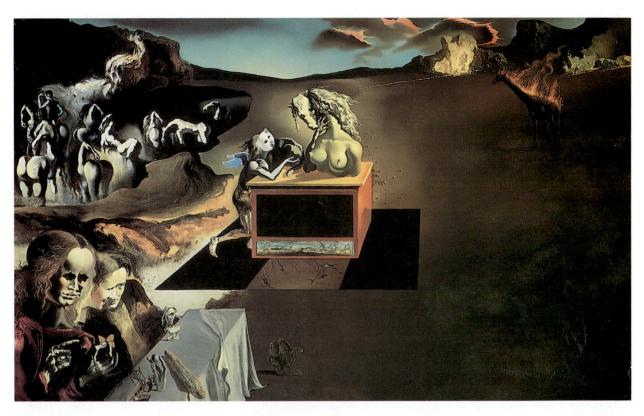

21.10 Salvador Dalí. *Inventions of the Monsters*, 1937. Oil on canvas, $20^{1}/8^{"} \times 30^{7}/8^{"}$ (51.2 × 78.4 cm). The Art Institute of Chicago (Joseph Winterbotham Collection, 1943.798). Note the highly charged erotic character of the painting.

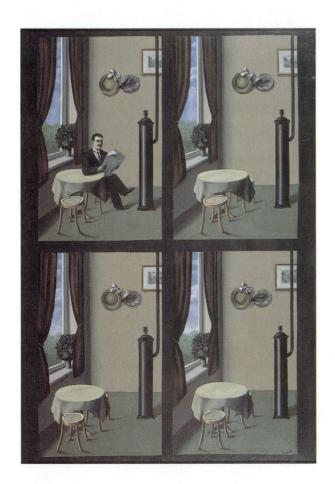

21.11 René Magritte. *Man with a Newspaper*, 1928. Oil on canvas, $45\frac{1}{2}$ " \times 32" (116 \times 81 cm). Tate Gallery, London (reproduced by courtesy of the Trustees). Magritte's power to invoke solitude is evident in this picture.

Dalí utilized strong realist draftmanship to set out his dreamworld. The iconography of his work, at least in the 1930s, was orthodox in its Freudianism.

Another surrealist, René Magritte (1898–1967), was no less a draftsman but was less concerned with the dark side of the unconscious. His work, done with scrupulous attention to realistic detail, calls into question our assumptions about the reality of our world. In his *Man with a Newspaper* [21.11], even the title of the painting misleads because the man, like a figure in a single frame of a motion picture, disappears quickly.

Film was a major influence on Magritte's development—as it was on other Surrealists. The motion picture camera could be used to make images that corresponded closely with surreal intentions. Figures could dissolve, blend into other figures, be elongated, or slowly disappear. Some of the first artists associated with Surrealism—like the American Man Ray—experimented with both still photography and moving pictures. Dalí collaborated with his compatriot film director Luis Buñuel to produce two famous Surrealistic films: *Un Chien Andalou*

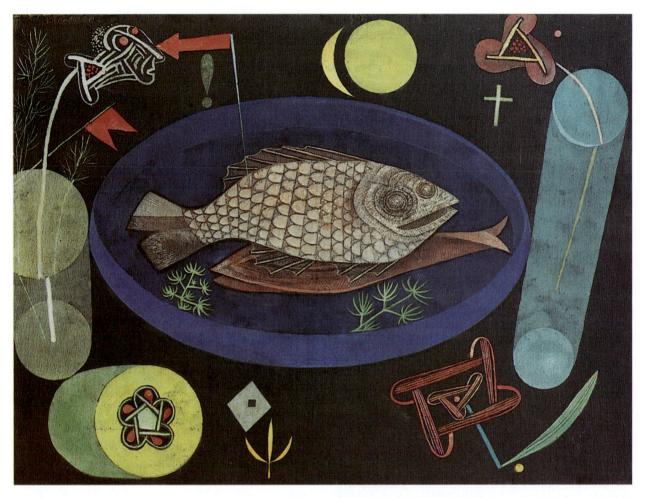

21.12 Paul Klee. Around the Fish, 1926. Oil on canvas, $18^3/8'' \times 25^1/8''$ (47 × 64 cm). Collection, The Museum of Modern Art, New York (Abby Aldrich Rockefeller Fund). The figures in the painting seem to float freely in an indeterminate space.

(1929) and *L'Âge d'Or* (1930). The French poet Jean Cocteau also produced a famous Surrealistic film in 1931: *Blood of a Poet.*

One artist deserves a separate mention; although his association with the surrealist movement was important, it does not adequately define his originality. The Swiss painter Paul Klee (1879-1940) had been influenced by most of the major art movements of his day. He knew the work of Picasso in Paris; he exhibited for a time with Der Blaue Reiter in Germany; after the war he taught at the famous design school in Germany called the Bauhaus. Finally, Klee showed his work at the first Surrealist exhibition of art in Paris. It was characteristic of Klee's talent that he could absorb elements of Cubist formalism, Expressionist colorism, and the fantasy of the Surrealists without being merely a derivative painter. He was, in fact, one of the most original and imaginative artists of the first half of the twentieth century. A painting like his 1926 Around the Fish [21.12] is typical. The cylindrical forms hint at Cubism but the floating shapes, some enigmatic, and the brilliant coloring evoke the dreamlike world of the surreal.

We have already noted that Freud's pioneering researches into the nature of the unconscious profoundly impressed those writers associated with André Breton. Other writers more fully explored the implications of Freud and his followers throughout the twentieth century in fiction, poetry, drama, and criticism. The great American dramatist Eugene O'Neill (1888-1953) restated basic Freudian themes of love and hate between children and parents (the *Oedipus* and *Electra* complexes) in plays like Desire under the Elms and Mourning Becomes Electra. Other writers of world repute like Franz Kafka and the American novelist William Harrison Faulkner (1897-1962) may not have been directly dependent upon Freud's writings but their works are more accessible when we understand that they are dealing with similar issues and problems.

THE AGE OF JAZZ

Jazz is a peculiarly American contribution to Western culture, born out of the unique experience of Americans of African heritage (hereafter referred to as "blacks"). The matrix out of which jazz was born is an imperfectly documented history of a process that includes, among other elements: (1) certain intonations, rhythmic patterns (such as love of repetition), and melodic lines that come ultimately from the African ancestors of American Blacks; (2) the tradition of the spirituals, Christian hymns sung both in the slave culture of the South and in the free churches of Blacks after the Civil War; (3) the ineffable music of the blues, developed in the Deep South with its characteristic blue note (the lowering by a half-step of a note in the melodic line), which produces a sound hard to describe but instantly recognized; and (4) adaptations of certain European songs, especially French quadrilles and polkas, into a slightly different style of music that became known as ragtime.

For an example of ragtime, see Scott Joplin's *Maple Leaf Rag* on the Listening CD.

The blues existed mainly as an oral tradition in the Deep South in the nineteenth century with one singer passing down songs to another. It became a popular public art form in city life from the 1920s onward. Musicians like W. C. Handy (the "grandfather of the blues") and singers like Mamie Smith, Ethel Waters, and Ma Rainey were immensely popular in the 1920s. Their very popularity brought the blues style to the larger, mainly Anglo audiences in the period between the wars even though, as scholars generally agree, the blues were a quintessentially African American contribution to art.

Jazz made its first organized appearance in New Orleans around the turn of the century. The musicians, who were all African Americans, performed without written music and were self-taught. They formed bands and played in the streets and in the cabarets of the city. By the end of World War I, many of these musicians had migrated north to Chicago—which, in the early 1920s, was the center of jazz music. From there, jazz spread to Harlem in New York City and to other urban centers on both coasts.

The influence of Black jazz (and its Anglo counterpart) on American culture is difficult to overestimate. In fact, the period directly after World War I has been called "The Jazz Age," borrowing from an F. Scott Fitzgerald title. Some of the musicians of that era have permanent niches in American culture: the great blues singer Bessie Smith (1895–1937) and the trumpeter Louis ("Satchmo") Armstrong (1900–1971), along with such rediscovered masters as Eubie Blake (1883–1983) and Alberta Hunter

who made hit records in the 1920s and was still an active singer and recording artist into the 1980s. Jazz figures who reach down into contemporary culture would include such classic masters as Duke Ellington (1899–1974), Count Basie (1904–1984), and Lionel Hampton (1913–1994).

http://mathriscl.lunet.edu/blues/Bessie_Smith.html

Bessie Smith

http://www.npg.si.edu/exh/armstrong/

Louis Armstrong

The popularity of jazz, a peculiarly Black musical idiom, was soon appropriated by the predominantly Anglo culture in America so that often Anglo jazz bands and the mass media (the first talking motion picture in this country starred a white actor, Al Jolson, singing in blackface in *The Jazz Singer*) overshadowed the unheralded Black musicians of the time. Only more recently have serious and systematic attempts been made to recover early jazz recordings (since written music is by and large nonexistent) and to bring out of retirement or obscurity the now-old blues singers who are the most authentic exponents of this art form.

Jazz as a musical and cultural phenomenon was not limited to the United States in the period after World War I. Jazz had a tremendous following in Paris in the 1920s, where one of the genuine celebrities was the Black American singer Josephine Baker [21.13].

Just as Pablo Picasso had assimilated African sculptural styles in his painting, so serious musicians on the Continent began to understand the possibilities of this African American music for their own explorations in modern music. As early as 1913, Igor Stravinsky (1882-1971) utilized the syncopated rhythms of jazz in his path-breaking ballet The Rite of Spring. His L'Histoire du soldat (1918) incorporates a "ragtime" piece Stravinsky composed based only on sheet music copies he had seen of such music. Other avant-garde composers in Europe also came under the influence of jazz. Paul Hindemith's (1895-1963) Klaviersuite (1922) shows the clear influence of jazz. Kurt Weill's (1900-1950) Dreigroschenoper (Threepenny Opera) (1928), with a libretto by Bertolt Brecht, shows a deep acquaintance with jazz—demonstrated notably in the song "Mack the Knife."

By the 1930s, the influence of jazz in the United States had moved into the cultural consciousness of the country at large. Jazz was now commonly referred to as *swing*, and swing bands toured the country and were featured in films. The bands of Duke Ellington and Count Basie

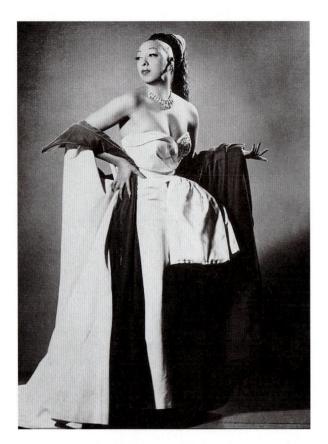

21.13 Josephine Baker.

were well-known even though their members, on tour, had to put up with the indignities of racial segregation: They often played in hotels and clubs which they themselves would have been unable to patronize. By the late 1930s, there was even a renewed interest in the older roots of jazz. In 1938, for example, Carnegie Hall in New York City was the site of the "Spirituals to Swing" concert, which presented a range of musicians from old-time New Orleans-style jazz performers to such avant-garde performers as Lester Young.

Many of the musicians of the swing era were extremely talented and quite able to cross musical boundaries. The great clarinetist Benny Goodman recorded Mozart's *Clarinet Quintet* with the Budapest String Quartet in 1939, the year he commissioned a composition from classical composer Béla Bartók (1881–1945). The African American jazz musician Fats Waller, in that same year, wrote his *London Suite*, his impressionistic tribute to that city.

Such crossovers were the exception rather than the rule, but they do underscore the rich musical tradition of the jazz movement. In post—World War II, a new experiment in avant-garde music—new wave—and cool jazz that would give performers the opportunity to extend the definition and range of jazz to where it would intersect with other forms of avant-garde music. This is evidenced by the musical careers of the late Charlie ("Bird") Parker (1920–1955) and the late Miles Davis.

George Gershwin

The most persistent effort to transpose jazz into the idiom of symphonic and operatic music was that made by the American composer George Gershwin (1898–1937). In large symphonic works like *Rhapsody in Blue* (1924) and *Concerto in F* (1926) for piano and orchestra Gershwin utilized such jazz characteristics as blue notes, syncopation, and *riffs* (seemingly improvised variations) on a basic theme along with the more classically disciplined form for large orchestral music.

It is certainly appropriate, perhaps inevitable, that the first widely successful American opera should have a jazz background. George Gershwin's Porgy and Bess (1935) incorporated jazz and other African American musical material such as the "shouting" spirituals of the Carolina coastal black churches to a libretto written by the Southern novelist DuBose Heyward and Gershwin's brother, Ira. Porgy and Bess was not an immediate success in New York, but later revivals in the 1940s and after World War II established its reputation. In 1952, it had a full week's run at the La Scala opera house in Milan; in 1976, the Houston Opera mounted a full production, with earlier deletions restored, that was seen subsequently at the Metropolitan Opera in New York. It now ranks as a classic. Some of its most famous songs (such as "Summertime" and "It Ain't Necessarily So") have become standards.

For a selection from *Porgy and Bess*, see the Listening CD.

Being Anglo, Gershwin had easier access to the world stage than did many of the African Americans in the first half of the twentieth century. It has only been in the past few decades that a fine composer like Scott Joplin (1868–1917), for example, has achieved any wide recognition in this country. The great blues singer Bessie Smith died after an automobile accident in the South because of delays in finding a hospital that would treat blacks. Many other singers and instrumentalists have remained in obscurity all their lives, although some—artists like the late Louis Armstrong—were so extraordinarily gifted that not even the hostile and segregated culture of the times could repress their talent.

http://www.hup.harvard.edu/HBDM/hbdm.joplin.html

Joplin

Duke Ellington

One African American who managed to emerge decisively from the confines of black nightclubs into international fame was Edward Kennedy ("Duke") Ellington (1899–1974). Ellington gained fame at the Cotton Club in

Harlem in the 1920s both for his virtuoso orchestral skills and for his prolific output as a composer. He was not only a successful writer of such popular musical pieces as "Take the A Train" and "Mood Indigo," but also a true original in his attempt to extend the musical idiom of jazz into a larger arena. After World War II, Ellington produced many works for symphonic settings. His symphonic suite *Black, Brown, and Beige* had its first hearing at Carnegie Hall in 1943. This work was followed by others—the titles of which alone indicate the ambition of his musical interests: *Shakespearean Suite* (1957), *Nutcracker Suite* (1960), *Peer Gynt Suite* (1962), and his ballet *The River* (1970), which he wrote for the dance company of Alvin Ailey, a notable African American choreographer.

To hear Duke Ellington's *Take the A Train*, see the Listening CD.

THE HARLEM RENAISSANCE

http://www.pbs.org/newshour/forum/february98/harlem_2-20.html

Harlem Renaissance

Jazz is an American or, more specifically, a distinctively African American contribution to world culture. It was not the only cultural movement among African Americans in the period between the wars. In the section of New York City known as Harlem there was a concentration of African American writers, artists, intellectuals, and musicians who produced such a conspicuous body of specifically African American work that they are known collectively as the *Harlem Renaissance*. There were

explorers of African American culture like Zora Neale Hurston, James Weldon Johnson, and Alain Locke; poets like Countee Cullen, Helene Johnson, Langston Hughes, and Claude McKay; artists like Hale Woodruff, Sargent Johnson, Augusta Savage, Romare Bearden, and the famous muralist and painter, Aaron Douglas [21.14].

When one reads the poetry and fiction produced during the 1920s and 1930s by the Harlem Renaissance writers it is easy to detect abiding themes of the African American experience: the ancestral roots of Africa; the quest for dignity in a culture of racism; a debate over the degree to which African American values should be part of—as opposed to distinct from—the majority culture; and the role of the church in life.

Behind most of these questions was the one posed at the very beginning of the century by the African American intellectual W. E. B. DuBois (1868–1963): What self-identity does an African American affirm who must hold in balance his identity as being African, his place in American life, and the racism he endures? Those issues burn at the heart of what the Harlem Renaissance debated.

BALLET: COLLABORATION IN ART

In the period between the world wars one form of culture where the genius of the various arts most easily fused was the ballet. The most creative experiments took place in Paris through the collaboration of a cosmopolitan and talented group of artists.

The driving force behind ballet in this period in Paris was Serge Diaghilev (1872–1929), a Russian-born impresario who founded a dance company called the Ballet

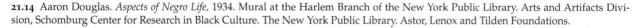

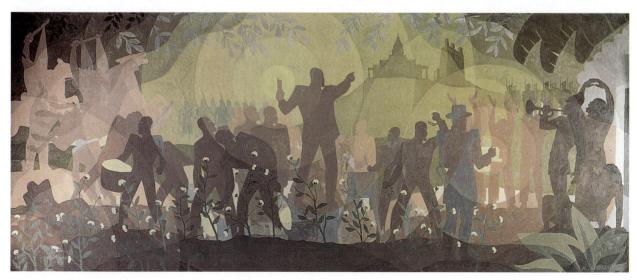

Russe, which opened its first artistic season in 1909. Diaghilev brought from Russia two of the most famous dancers of the first half of the century: Vaslav Nijinsky (1890–1950) and Anna Pavlova (1881–1931).

Diaghilev had a particular genius for recruiting artists to produce works for his ballet. Over the years, the Ballet Russe danced to the commissioned music of Igor Stravinsky, Maurice Ravel, Serge Prokofiev, Claude Debussy, Erik Satie, and Darius Milhaud. In that same period, sets, costumes, and stage curtains were commissioned from such artists as Pablo Picasso, Georges Rouault, Naum Gabo, Giorgio de Chirico, and Jean Cocteau.

Diaghilev produced a one-act dance called *Parade* (1917) in Paris. This short piece (revived in 1981 at the Metropolitan Opera with sets by the English painter David Hockney) is an excellent example of the level of artistic collaboration Diaghilev could obtain. The story of the interaction of street performers and men going off to war was by the poet Jean Cocteau (1891–1963); the avant-garde composer Erik Satie (1866–1925) contributed a score replete with street sounds, whistles,

horns, and other accoutrements of urban life. Pablo Picasso designed the curtain drop, the sets, and the costumes [21.15]. *Parade* had much to say about musicians, players, and street performers, so the production was ready-made for Picasso's well-known interest in these kinds of people.

The collaborative effort of these important figures was a fertile source of artistic inspiration. Picasso had a great love for such work and returned to it on a number of other occasions. He designed the sets for *Pulcinella* (1920), which had music by Igor Stravinsky. He designed sets for a balletic interpretation of Euripides' tragedy *Antigone* done from a translation of the play from the Greek into French by Jean Cocteau. In 1924, he also executed designs for a ballet that had original music written by Erik Satie, called *Mercury*.

Ballet, like opera, is an art form that lends itself to artistic integration. To enjoy ballet, one must see the disciplined dancers in an appropriate setting, hear the musical score that at once interprets and guides the movements of the dancers, and follow the narrative or "book"

21.15 Pablo Picasso. Curtain for the ballet *Parade*. Paris, 1917. Tempera on cloth, $34'9'' \times 56'^{3}/4''$ (10.6 × 17.3 m). Musée National d'Art Moderne, Centre Georges Pompidou, Paris. Many critics agree that both the music and the choreography of the ballet were overwhelmed by Picasso's brilliant sets.

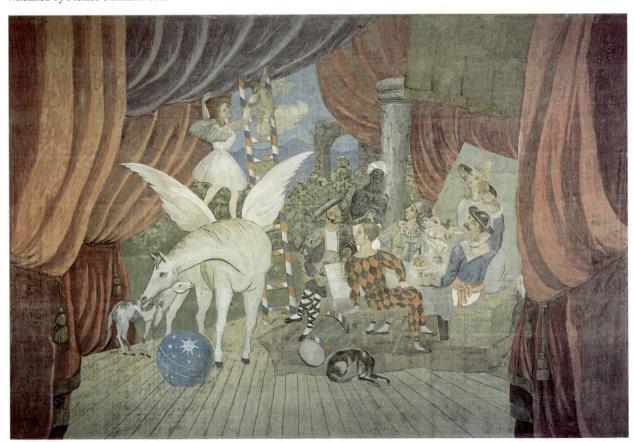

of the action. It is no wonder that an organizational genius like Diaghilev would seek out and nurture the efforts of the most creative artists of his era.

Art as Escape: Dada

http://www.peak.org/~dadaist/English/Graphics/

Dada

A group of artists, writers, and musicians who gathered around the tables of the Café Voltaire in Zurich in 1915 founded a movement to protest what they considered the madness of the war and its senseless slaughter. They decided to fight the "scientific" and "rational" warmakers and politicians with nonsense language, ugly dissonant music, and a totally irreverent and iconoclastic attitude toward the great masterpieces of past culture. It was called Dada, a nonsense word of disputed origin that could be a diminutive of father or the word for yes or a child's word for hobbyhorse. One of its poets, Tristan Tzara, wrote a Dada manifesto in 1918 that called for, among other things, a destruction of good manners, the abolition of logic, the destruction of memory, forgetfulness with respect to the future, and the elevation of the spontaneous to the highest good.

One of the most representative and creative of the Dada artists was Marcel Duchamp (1887-1968), who after 1915 was associated with an avant-garde art gallery in New York founded by the American photographers Alfred Stieglitz (1864–1946) and Edward Steichen (1879– 1973). Duchamp was a restless innovator who originated two ideas in sculpture that became part of the common vocabulary of modern art: mobiles (sculptures with moving parts) and ready-mades (sculptures constructed from preexisting fabricated material originally intended for other purposes). Besides these important innovations, Duchamp has also gained notoriety for his whimsically irreverent attitude toward art, illustrated by his gesture of exhibiting a urinal at an art show as well as his humorous but lacerating spoofs of high culture, the most "Dada" of which is L.H.O.O.Q.—his famous defacement of the Mona Lisa [21.16].

The Dadaists could not maintain the constant energy of their anarchy, so it was inevitable that they would move individually in other directions. Dada was a movement symptomatic of the crisis of the times, a reaction to chaos but no adequate answer to it. It is no small irony that while the Dada theater group performed in Zurich's Voltaire cabaret in 1916, there lived across the street an obscure Russian political activist in exile from his native land. He would also respond to the chaos of the time but in a far different way. His name was V. I. Lenin.

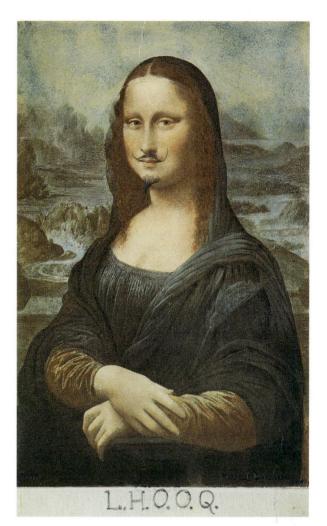

21.16 Marcel Duchamp. *L.H.O.O.Q.*, 1919. Rectified readymade. Pencil on colored reproduction of Leonardo da Vinci's *Mona Lisa*, $7^3/_4$ " $\times 4^7/_8$ " (20 \times 12 cm). Private Collection. The French pronunciation of the letters under the picture sound like an off-color expression.

Art as Protest: Guernica

The late Protestant theologian Paul Tillich once called Picasso's *Guernica* [21.17] the great Protestant painting. He said this not because Picasso was religious (which he was not) but because of the quality and depth of Picasso's protest against inhumanity. The title of the painting comes from the name of a small Basque town that was saturation-bombed by Germany's Condor Legion in the service of Franco's fascist rebel forces during the Spanish Civil War. Picasso completed the huge canvas in two months—May and June 1937—so that he could exhibit it at the Paris World's Fair that year.

There have been intense studies of the genesis and development of *Guernica* in order to "unlock" its symbolism, but it would be safe to begin with Picasso's particular images. Many of these images recur over and over

again in his work to convey Picasso's sense of horror at the destruction of war together with his muted affirmation of hope in the face of the horror. His iconography is reinforced by its somber palette: gradations of black, brown, and white.

The very complexity of images in *Guernica* at first glance seems chaotic, but prolonged viewing reveals a dense and ordered rhythm. Starting at the left with the bull—Picasso's symbol of brute force, of Spain, and at times of the artist himself—we see beneath the animal a woman with the broken body of a child. The echo of the Pietà theme is obvious. In the lower center and to the right is a dismembered figure, in the Cubist style, over whom rears up a "screaming" horse. At the top right of the work are Picasso's only hints of hope in the face of such evil: a small open window above a supplicant figure and an emerging figure holding a lamp. Over the center is an *oculus* ("eye") in which a lamp burns and casts off light.

As a social document the importance of *Guernica* cannot be overestimated. The German bombing of the little town was an experiment in a new style of warfare, a style that would be refined into a deadly technique in World War II. In *Guernica*, Picasso innovatively combines various stylistic techniques that were employed on the eve of World War I—Expressionistic distortion and Cubist abstraction—to protest a technological development that became commonplace in the next war. In this sense, *Guernica* is a pivotal document—it straddles two cata-

clysmic struggles in the century. *Guernica*'s cry of outrage provides an important observation about human culture. The painting reminds us that at its best the human imagination calls up the most primordial symbols of our collective experience (the woman and child, the horse and bull, the symbol of light) and invests them with new power and expressiveness fit for the demands of the age.

Art as Propaganda: Film

The first motion pictures are attributed to the French Lumière Brothers (1895) and the American Panopticon and Vitascope developed in New York the year after. By the time of World War I, there was already a vast movie industry turning out short silent films for an eager audience. Sound technology was added to films in 1927. But already longer films with lavish productions were being produced. It was during the period of World War I that people began to understand the power of film to educate, persuade, and shape public opinion. This development came at a time when there was a rise in totalitarian government with its insatiable desire to propagandize.

Propaganda is the diffusion of a point of view with the intention to persuade and convince. We usually think of it in political terms. Throughout history, propagandists have used books, art, and music to spread their ideas. Inventions in the early part of the twentieth century, however, added immeasurably to the propagandist's weapons.

21.17 Pablo Picasso. *Guernica*, 1937. Oil on canvas, $11'5^{1}/_{2}'' \times 25'5^{1}/_{4}''$ (3.49 × 7.77 m). Centro de Arte Reina Sofia, Madrid, Spain. This monumental painting was on extended loan in New York until after the death of General Francisco Franco, when Picasso agreed to its return to his native Spain.

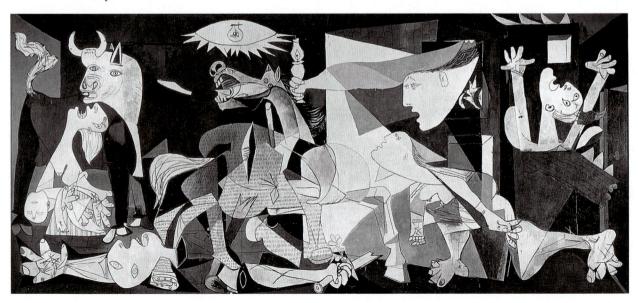

Besides radio, the other medium that most successfully blended propaganda with attempts at some artistic vision in the first half of the twentieth century was film. Two acknowledged masters of the use of film for propaganda need to be singled out because they set such a standard of excellence that, at least through their finest work, propaganda became high art.

Sergei Eisenstein (1898–1948) remains not only the greatest filmmaker the Soviet Union has produced but one of the most influential artists in the history of the cinema as well.

A dedicated supporter of the Russian Revolution, Eisenstein fully appreciated Lenin's observation that the cinema would become the foremost cultural weapon in winning over the proletariat to the Revolution. From his early film Strike! (1925) to his last work, Ivan the Terrible, Part I (1944) and Part II (1946), Eisenstein was conscious of the class struggle, the needs of the working class, and the inevitable advance of socialism in history—themes dear to the official line of Stalin's USSR. Despite this orthodox line, Eisenstein was never an ideological hack. His films were meticulously thought out and he brought to bear his own considerable culture and learning to make films of high art. His Alexander Nevsky (1938) had an impressive musical score by Serge Prokofiev, and the two men worked closely to integrate musical and visual concepts. His vast Ivan the Terrible was deeply indebted to a study of El Greco's paintings; Eisenstein was struck by the cinematic possibilities in that artist's striking canvases.

http://www.abamedia.com/rao/gallery/old/eisen.html

Sergei Eisenstein

Eisenstein's most influential film, *Potemkin* (finished at the close of 1925), is the story of the 1905 naval mutiny on the battleship *Potemkin* and the subsequent riot in Odessa that was crushed by the tsarist police. The communists saw in that historical incident a major foreshadowing of the October Revolution of 1917, which brought the Bolsheviks to power.

The scene in *Potemkin* of the crowd cheering the mutineers on a broad flight of stairs in Odessa and the subsequent charge of the police is a classic sequence in film history. In that sequence, Eisenstein uses the device of *montage* (the sharp juxtaposition of shots by film cutting and editing) with such power that the scene became a benchmark for subsequent filmmakers. His close-ups were meant to convey a whole scene quickly: A shot of a wounded woman cuts to a close-up of a clenched hand that slowly opens, telling the story of death in a moment. A crazily moving baby carriage is a macabre metaphor for the entire crowd in panic and flight. Shattered eyeglasses and blood pouring from an eye [21.18] become a terrible shorthand statement of police violence.

For sheer explicit propaganda one must turn to two documentary films made in Nazi Germany in the 1930s by the popular film actress and director Leni Riefenstahl (1902–). Her first great film was a documentary of the 1934 Nazi Congress in Nuremberg called *Triumph of*

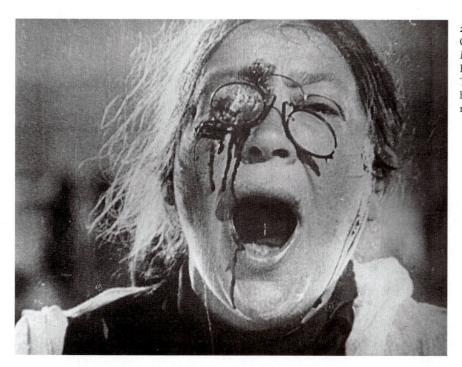

21.18 Sergei Eisenstein. Still from the Odessa steps sequence of the film *Potemkin*. Museum of Modern Art, Film Stills Archives, New York. This close-up is a classic shot in the history of film. The single image represents the horror of the entire scene.

the Will (1936). Designed to glorify the Nazi Party and to impress the rest of the world, the film made ample use of the great masses of party stalwarts who gathered for their rally. That documentary allowed the young film-maker to show the party congress as a highly stylized and ritualistic celebration of the Nazi virtues of discipline, order, congregated might, and the racial superiority of the Teutonic elite of the party members.

Riefenstahl's other great film, and arguably her masterwork, was a long documentary made at the Berlin Olympics of 1936 and issued in 1938 under the title *Olympia*. Riefenstahl used five camera technicians and thirty-eight assistants as well as footage shot by news agency photographers to make her film. The completed documentary, divided into two parts, pays tribute to the Olympic spirit of ancient Greece, develops a long section on the carrying of the Olympic torch to Berlin, records the homage to Hitler and the Nazi Party, and shows most of the major athletic competitions.

As a film, *Olympia* is matchless in its imaginative use of the camera to catch the beauty of sport [21.19]. The vexing question is to what degree the film is political beyond the obvious homage paid to the German Third Reich, which sponsored the Olympics in 1936. Many critics note its elitist attitude to justify their contention that it is propaganda, albeit of a very high and subtle quality. Athletes are depicted as superior beings who act beyond the range of ordinary mortals. They give all and seem almost demigods. The film praises the heroic, the conquest, the struggle. It praises the ritualized discipline of the crowds and lovingly seeks out examples of the adoring Berlin masses surrounding the party leaders.

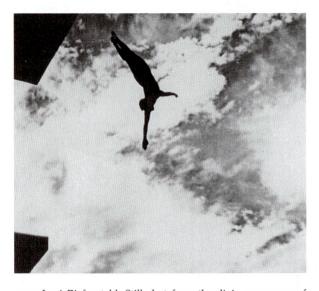

21.19 Leni Riefenstahl. Still shot from the diving sequence of *Olympia*, 1938. This still shows the uniquely original camera angles Riefenstahl used. Such angles became a model for documentary filmmakers.

PHOTOGRAPHY

Photography is a nineteenth-century invention, as we have seen. During the nineteenth century, photography had a complex technological evolution as photographers sought ways to make cameras and photographic equipment more mobile. As this mobility increased, photography developed a number of specialties: portraiture, landscapes, documentation, and reportage. Most important and more basic, photography gave to the world what no other visual medium could: immediacy. Before the advent of photography it was the job of the field artist to transcribe an event in sketches and then transfer those drawings onto etching plates for reproduction in newspapers and magazines. With the photograph people could "see" events as they were actually happening. The idea that "a picture is worth a thousand words" has become a tired cliché, but it is difficult for us today to comprehend the impact the first photographs of war must have made when traveling photographers sent back to England pictures of dying soldiers in the Crimean War of the 1850s or when the American public first saw the pictures of death and devastation made by Mathew Brady (1823-1896) and his assistants during the Civil War in the 1860s.

Further technical advances, like the small portable Kodak camera invented by the American George Eastman in the late nineteenth century and 35mm cameras (including the famous Leica) invented in the early twentieth century in Germany, contributed to the advance of photography in the twentieth century. In the period after World War I, there was an intense interest in photography as a new instrument for art. Man Ray (1890–1976), an American artist living in Paris, experimented with darkroom manipulations to produce what he called rayograms. László Moholy-Nagy (1895-1946) taught a wide range of techniques in photography while he was an instructor at the influential Bauhaus school of design in Germany. When the school was closed by the Nazis, Moholy-Nagy came to the United States in 1933, where he continued to be a great influence on the development of American photography. A group of American photographers loosely connected with what was called the "f/64 Group" included pioneer photographers who are now recognized as authentic geniuses of the medium: Edward Weston (1886-1958), Ansel Adams (1902-1984), and Imogen Cunningham (1883–1975). We have already noted the influence of Alfred Stieglitz on the avant-garde art of New York. These photographers, and others like them, emphasized direct, crisp, and nonmanipulative pictures that set the standard for much of modern photography.

In the United States, the most powerful pictures between the world wars that were produced for social purposes were those photographs made to show the terrible economic deprivations of the Great Depression of the 1930s. In the mid-1930s, the Farm Security Administration of the United States Department of Agriculture commissioned a number of photographers to record the life of America's rural poor. The resulting portfolios of these pictures taken by such photographers as Dorothea Lange, Arthur Rothstein, and Walker Evans have become classics of their kind. In 1941, the Pulitzer Prize-winning writer James Agee wrote a prose commentary on some of the photographs of Walker Evans. The photos of Evans and the text of James Agee were published together under the title Let Us Now Praise Famous Men [21.20]. Along with John Steinbeck's novel The Grapes of Wrath (itself turned into an Academy Award-winning film), Agee's book is one of the most moving documents of the Great Depression, as well as a model of how word and picture can be brought together into an artistic whole for both social and aesthetic purposes.

ART AS PROPHECY: FROM FUTURISM TO BRAVE NEW WORLD

Great art always has a thrust to the future. This chapter began with the observation of William Butler Yeats that "the center cannot hold"—a prescient observation, as the aftermath of World War I was to show.

Not all artists were either so pessimistic or so prophetic as Yeats. A small group of painters, sculptors, architects, and intellectuals in Italy looked to the future with hope and to the past with contempt. Known as the *Futurists*, they exalted the values of industrial civilization, the power of urban accomplishment, and (with equal intensity) despised the artistic culture of the past. The theorist of the movement was a Milanese poet and writer, Filippo Tommaso Marinetti (1876–1944), who issued a long series of Futurist manifestos between 1908 and 1915.

21.20 Walker Evans. *Share Cropper's Family*, Alabama, 1935. Black and white. Photograph. The Museum of Modern Art, New York. Gift of the Farm Security Administration. Evans and James Agee often visited this family. Agee wrote about the family in *Let Us Now Praise Famous Men*. With Bud Fields, a one-mule tenant farmer, age fifty-nine, are his second wife, Ivy (mid-twenties), their daughter (twenty months), Ivy's daughter by an earlier common-law marriage (eight), Bud's and Ivy's son (three), and Ivy's mother (early fifties).

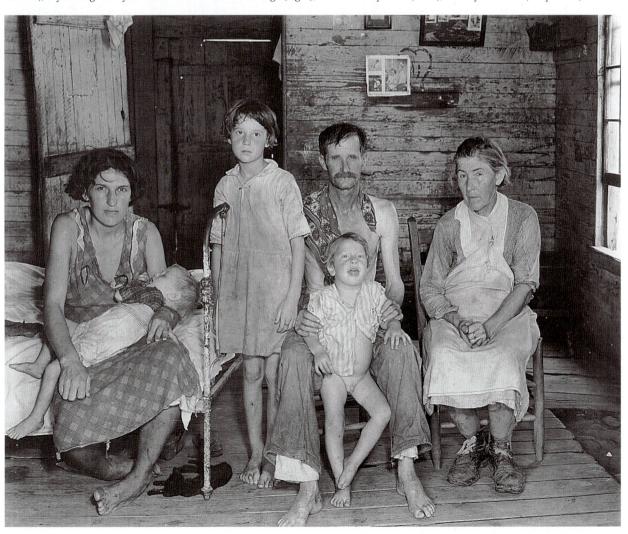

21.21 Gino Severini. *Armored Train in Action*, 1915. Oil on canvas, $45^3/8^{"} \times 34^7/8^{"}$ (115.8 \times 88.5 cm). The Museum of Modern Art, New York (gift of Richard S. Zeisler). The influence of Cubism in the composition is obvious.

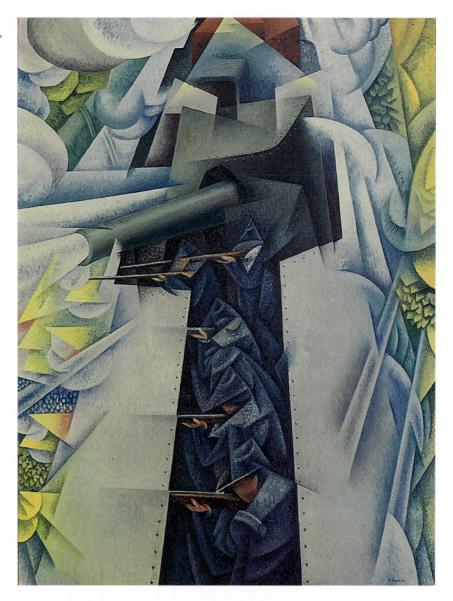

In the few years during which Futurism flourished, its followers produced significant paintings, sculptures, and ideas about city planning and urban architecture. World War I was to end their posturing; the sculptor Umberto Boccioni and the futurist architect Antonio Sant'Elia were both to die in 1916, victims of the war. Some of the futurists, including Marinetti, true to their fascination with power, war, destruction, and the exaltation of might, would be increasingly used as apologists for the emerging fascist movement in Italy. Thus a painting like Gino Severini's *Armored Train in Action* [21.21] proved prophetic in ways not quite appreciated in 1915.

The Futurist romance with industrial culture and the idea of technological "progress" was not shared by all artists of the twentieth century. We have already noted that T. S. Eliot pronounced his world a wasteland. The American novelist Sinclair Lewis (1885–1951) viciously

satirized American complacency in the postwar period. His novel *Babbitt* (1922) was a scathing indictment of the middle-class love for the concept of "a chicken in every pot and two cars in every garage." His philistine hero, George Babbitt, became synonymous with a mindless materialism in love with gadgets, comfort, and simplistic midwestern values.

By contrast, the English novelist Aldous Leonard Huxley (1894–1963) saw the unrestrained growth of technology as an inevitable tool of totalitarian control over individuals and society. His 1932 novel *Brave New World* was a harbinger of a whole literature of prophetic warning about future dangers. The two most famous prophetic works of the post–World War II era are *Animal Farm* (1945) and *1984* (1949), both by the English writer George Orwell, the pen name used by Eric Arthur Blair (1903–1950).

Huxley's *Brave New World* is set in the far distant future—600 A.F. (After [Henry] Ford, who had been deified as the founder of industrial society because he developed the assembly line.) In this society, babies are born and raised in state hatcheries according to the needs of the state. They are produced in five classes (from Alpha to Epsilon) so that the exact numbers of needed intellectuals (Alphas) and menials (Epsilons) are produced. The goal of society is expressed in three words: Community/Identity/Stability. All sensory experience is supplied either by machines or a pleasure-drug called *soma*. Individuality, family relationships, creativity, and a host of other "unmanageable" human qualities have been eradicated from society either by coercion or programming.

Toward the end of the novel there is a climactic conversation between John Savage, a boy from the wilds of New Mexico raised outside the control of society, and Mustapha Mond, one of the controllers of the "brave new world" of the future. Patiently, Mustapha Mond explains to the uncivilized young man the reasons why certain repressions are inevitable and necessary in the society of the future. The reader sees rather clearly how aware Huxley is that the great humanistic achievements of the past—literature, art, religion—are threatening forces to any totalitarian society and as such are logical targets for a "scientifically" constructed society. His explanations now have a prescient and somber reality to us in the light of what we know about the real totalitarian societies of our own time.

SUMMARY

What made World War I so catastrophic was the advanced technologies used in the service of death. The old military charge against an enemy became obsolete with the invention of the machine gun just as the use of poison gas (not outlawed until after the war) made a mockery of military exercises of strategy. The result was an appalling slaughter of youth on a scale unparalleled in human history.

In the period between the wars the memory of that slaughter shook intellectuals to the core. Their response was predictable enough: protest or pacifism or a total distrust of the powers of rationality to cope with human evil. The reaction to the Great War ranged, in short, from T. S. Eliot's combination of pessimism and faith to the playful nonsense of the Dada artists and the inner retreat of the Surrealists.

The technological advances that had made the war so terrible also gave promise of new forms of communication that would advance the arts radically into new and different fields. The widespread development of radio networks, the transition of the film from the silent screen to the "talkies," the increased mobility brought about by the automobile, and the advances in photography would not only produce new art forms but also provide their availability to larger audiences.

Coupled with these advances were some profound shifts in social status. People were leaving rural areas in great numbers for the factories of the cities of America and Europe. The old social stratification of the classes was beginning to break down in Europe. The economic dislocations brought on by the war created urban poverty in Europe and, after a giddy decade of prosperity in the 1920s, the Depression years in the United States. In response to these social and economic dislocations, new political movements seemed attractive and compelling. Hitler's National Socialist party rose against the background of Germany's defeat, as did Mussolini's fascists. The period between the wars also saw the consolidation of communist power in Russia and the rise of the totalitarian state under Stalin.

Finally, we should note other fundamental (and radical) ideas that were beginning to gain notice. Einsteinian physics were changing the picture of the world in which we lived because it contained the seeds of the atomic era. Sigmund Freud's ideas were also radically reshaping our notions of the interior landscape of the human soul.

All of these forces—political, technological, scientific, social, and artistic—gave a shape to a culture that in its richness (and sadness) we call the Western world between the two great wars.

Pronunciation Guide

BRAK Braque: **Breton: Bre-TAN Buñuel:** Boon-WELL Chagall: Sha-GAL DIAG-i-leff Diaghilev: Duchamp: **Dew-SHAWM** Guernica: GHER-nee-ka Kafka: KAF-ka

Mustapha Mond: MUS-taw-fa MOND

Nijinsky: Nidge-IN-ski Riefenstahl: REEF-in-stall Stravinsky: Stra-VIN-ski

EXERCISES

- 1. Look carefully at a Cubist painting. Can you analyze the precise manner in which a Picasso or a Braque tries to get us to see in a new and unaccustomed way?
- 2. Some people have called Kafka a Surrealist writer. Is that an apt description of his writing? Why or why not? Is "dreamlike" ("nightmarish") an apt way to think of his writing?
- Jazz is still a much-respected art form today. Give a description of what you understand as jazz and distinguish it from rock music.
- 4. Discuss ways in which photography and film are used for propaganda currently.

FURTHER READING

Anderson, H., & Bearden, R. (1993). A history of African American artists from 1792 to the present. New York: Pantheon. Especially good on the Harlem Renaissance.

Bell, Q. (1972). *Virginia Woolf: A biography*. New York: Harcourt, 1972. A standard biography, written by Woolf's nephew; very readable.

Douglas, A. (1995). *Terrible honesty: Mongrel Manhattan in the* 1920s. New York: Farrar, Straus & Giroux. A brilliant intellectual and cultural history.

Fussell, P. (1976). The Great War and modern memory. New York: Oxford University Press. A classic study of the cultural impact of World War I.

Gay, P. (1988). Freud: A life for our time. New York: Norton. Quite good on the spread of Freudian ideas in the twentieth century.

Hughes, R. (1981). The shock of the new. New York: Knopf. Lavishly illustrated history of modern art derived from the television series of the same name.

Richardson, J. (1991). *Pablo Picasso* (Vol. 1). New York: Knopf. See commentary below.

Richardson, J. (1996). *Pablo Picasso* (Vol. 2). New York: Knopf. A definitive biography; brilliant for the cultural background of the period leading up to the *Demoiselles*.

ONLINE CHAPTER LINKS

Constructing Kafka at

http://info.pitt.edu/~kafka/intro.html

provides an biography, a bibliography, and links to other Internet resources.

Two sites devoted to Sigmund Freud

http://www.freudpage.com/en-us/freud/index.html http://www.freud.org.uk/

feature extensive information—biographic accounts, selected works, a virtual tour of his home, photographs of the original analytic couch, as well as numerous links to additional Internet resources.

A detailed examination of Picasso's career is available at the *On-Line Picasso Project* at

http://www.tamu.edu/mocl/picasso/

An exhibit of many Dalí works plus biographical information are available at *Salvador Dalí Museum* at

http://www.salvadordalimuseum.org/

and Salvador Dalí Gallery at

http://daligallery.com/

The Magritte Site at

http://www.magritte.com/

offers biographical information and a virtual museum that includes over 300 of his works.

Surrealomania at

http://www.surrealomania.co.uk/

offers a wide range of information about this movement and its artists.

What Is Jazz at

http://www.bigeastern.com/dr_t/index.htm

presents a lecture series by Dr. Billy Taylor, noted Jazz pianist.

Information about the Origins of Jazz is available at

http://www.redhotjazz.com/originsarticle.html

which includes extensive links to related Internet resources.

Derived from the Louis Armstrong Jazz Oral History Project, a collection of streaming video interviews with several great Jazz musicians is available from

http://www.nypl.org/research/sc/scl/MULTIMED/ JAZZHIST/jazzhist.html

Blues Online at

http://mathriscl.lunet.edu/blues/blues.html

provides a wide range of links to additional Internet resources, including Blues styles, Blues bands, and Blues sound bytes.

W. C. Handy, "Father of the Blues"

http://www2.una.edu/library/handy/

features a biography, photographs, a chronological listing of the musician's works, and links to several related Internet resources.

Three Duke Ellington sites at

http://www.geocities.com/BourbonStreet/Delta/8601/http://www.dukeellington.com/

http://www.redhotjazz.com/duke.html

feature extensive information about the musician's life and works.

Louis Armstrong Online at

http://independentmusician.com/louis/

associated with Queens College (New York), features information about the musician's life and works, a discography, and an online exhibit.

Louis "Satchmo" Armstrong at

http://www.redhotjazz.com/louie.html

provides an informative biography of the musician, with extensive links to other musicians and events as they relate to Armstrong's life.

Aldous Huxley at http://somaweb.org provides biographical information about

provides biographical information about the author, a comprehensive bibliography, and links to Internet resources related to the *Brave New World*.

Several Marcel Duchamp sites, providing biographical as well as annotated lists of links to other Internet resources, are available online at http://www.marcelduchamp.net/ http://www.marcelduchamp.org/ http://www.franceweb.fr/zumba/Duchamp/index.html

1939

WORLD WAR II AND AFTERMATH

1950

THE BEAT GENERATION

bomb

USSR

Supreme Court

1960

THE ATOMIC ERA

THE YOUTH MOVEMENT

1975

Revolution in Communist China 1966 Founding of National Organization for Women in U.S.

assassinated

1968 Assassination of Martin Luther King Jr. and Robert F. Kennedy; youth movement at apex

1969 First walk on moon

Vietnam

1989 Berlin Wall breached

1991 Soviet Union dissolved at the

1939 World War II begins; start of commercial television

1941 Japanese attack Pearl Harbor

1945 First atomic bombs used in warfare against Japan; World War II ends; Nazi extermination of Jews becomes widely known

1946 First meeting of UN General Assembly in London

1948 Israel becomes independent state; Berlin airlift marks beginning of "cold war"

1949 China becomes communist under leadership of Mao Zedong

1950 Korean War begins; FCC

approves first commercial

1952 U.S. explodes first hydrogen

1955 Civil Rights Movement starts in

1957 First earth satellite launched by

1961 East Germans erect Berlin Wall;

Soviets put first person in space

1962 First American orbits earth in

1963 President John F. Kennedy

1964 Massive buildup of American troops in Vietnam; Cultural

space; transatlantic transmission of

television signal via earth satellite

transmission of color TV

1946 Orwell, 1984; Sartre, Existentialism as a Humanism

Existentialist philosophy influences writers and dramatists: Camus, The Stranger (1942); Beckett, Waiting for Godot (1953)

1949 Miller's Death of a Salesman given Pulitzer Prize for Drama; Faulkner awarded Nobel Prize for Literature

1950 Sociologist Riesman writes The Lonely Crowd

1951 Langston Hughes, "Harlem," 'Theme for English B"

1950s Alienation and anxiety become major themes of "Beat" writers Kerouac and Ginsberg

1960 Wiesel, Night, memoir of Nazi concentration camps

1961 Heller, Catch-22, satire on absurdity of war

1963 Flannery O'Connor, "Revelation"

1964 Stoppard, Rosencrantz and Guildenstern Are Dead

1970 Solzhenitsvn awarded Nobel Prize for Literature; Toffler, Future Shock; Nikki Giovanni, "Ego Tripping'

1971 Plath, The Bell Jar, published posthumously

1973 Pynchon, Gravity's Rainbow

late 1930s Refugee artists Hoffman, Albers, Grosz bring ideas to North America

1942 Cornell, Medici Slot Machine; Peggy Guggenheim exhibits European art at New York Gallery

1943 Pollock's first exhibition

c. 1945 New York becomes international art center; New York School includes abstract expressionism, color-field painting

1948 Pollock, Number 1

1949 Shahn, Death of a Miner

1951 Frankenthaler begins stained canvases: The Bay (1963); Moore, Reclining Figure

1950s Rauschenberg experiments with "combine" paintings and, with Cage, "happenings"

1953 – 1954 Motherwell, *Elegy to the* Spanish Republic #34

c. 1955 Reaction to abstract expressionism results in "Pop" art; Johns, Flag (1954–1955); Warhol, Soupcans

1956 Bergman film *Wild Strawberries* 1957-1960 Nevelson, Sky Cathedral-Moon Garden + One

1959 Rauschenberg, Monogram; Gottlieb, Thrust; Calder, Big Red

1960 Johns, beer cans Painted Bronze 1960s Rothko panels for Houston

Chapel, opened 1971 1962 Chamberlain, Velvet White, sculpture of crushed auto parts

1963 Smith, Cubi I: Manzù, Doors of Saint Peter's

1964 Kubrick, film Dr. Strangelove

1964-1966 Segal, The Diner; Kienholz, The State Hospital 1964 Bearden, The Prevalence of

Ritual: Baptism

1966 Oldenburg, Soft Toilet

1970s Resurgence of realism; incorporation of technology in art: videotapes, computers, lasers

1974 Kelly, Grey Panels 2; Pearlstein, Two Female Models on Regency Sofa

1976-1978 Leslie, 7 A.M. News

1976-1982 Abakanowicz, Backs

1976 Cabin Fever by Susan Rothenberg

1981 Picasso's Guernica "returned" to

1981 Anselm Kiefer's Innerraum

1987 Lacy's Little Egypt Condo, New York City

1975 American withdrawal from

1977 New Chinese government allows art previously banned

1981 First space shuttle flight

end of 1991

1993

CHAPTER 22 THE CONTEMPORARY CONTOUR

ARCHITECTURE

Music

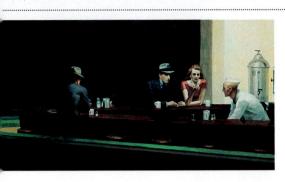

- late 1930s Bauhaus architects Gropius and van der Rohe flee Nazi Germany for United States
- 1943 Wright designs Guggenheim Museum, New York
- c. 1947 Buckminster Fuller develops geodesic dome

and Vitellozzi,

(1956 - 1957)

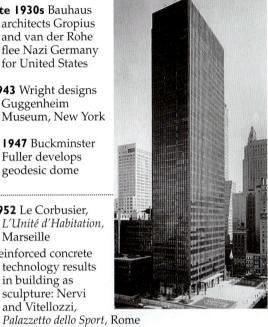

- 1945 Britten composes opera Peter Grimes
- 1948 Structuralist Boulez composes Second Piano Sonata; LP recordings become commercially available

1952 Boulez, Structures; Cage experiments with aleatoric music: 4'3"

- 1958 van der Rohe and Johnson, Seagram Building, New York
- 1959 Guggenheim Museum completed
- 1959-1972 Utzon, Opera House, Sydney
- 1955-1956 Stockhausen, Song of the
- 1958 Cage, Concert for Piano and Orchestra

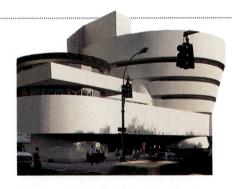

- 1960 Niemeyer completes government buildings at Brasilia
- 1962 Saarinen, TWA Flight Center, New York
- 1960 Penderecki, Threnody for the Victims of Hiroshima
- 1962 Britten, War Requiem; Shostakovich, Symphony No. 13, text from poems by Yevtushenko
- 1965 Stockhausen, Mixtur
- c. 1965 Baez, Seeger, Dylan entertain with protest songs; height of rock music and Beatles; Lennon, Yesterday; eclectic music of Zappa and Mothers of Invention
- 1971 Shostakovich, Symphony No. 15
- 1973 Stockhausen, Stop; Britten, opera Death in Venice

- 1977 Piano and Rogers, Pompidou Center, Paris
- 1978 Pei, East Wing of National Gallery of Art, Washington, DC
- 1991 Venturi and Brown, Seattle Art Museum

- 1978 Penderecki, opera Paradise Lost
- 1983 Reich's The Desert Music

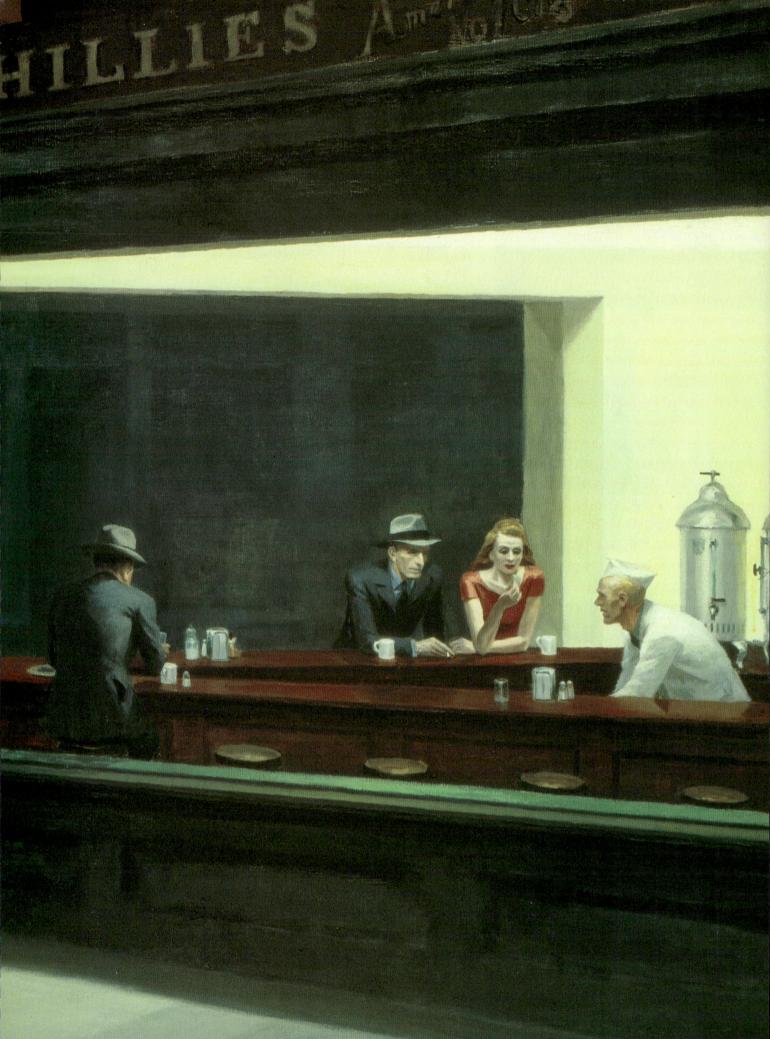

CHAPTER 22

THE CONTEMPORARY CONTOUR

TOWARD A GLOBAL CULTURE

ow that we have entered the twenty-first century and the new millennium has begun, the events that happened after 1945 seem to recede into distant history. It is difficult to remember what has happened to our culture in the three generations since the end of World War II. Events that occurred in the past more than four decades ago are still perhaps too close to know whether or not they have permanently changed us as a people. Was the moon landing of 1969 really a watershed in our consciousness as humans? Did the "American Century," so proudly forecast by commentators at the end of World War II, end? Has the revolution in communications already radically changed the way we learn things? Is the age of microtechnology, new forms of communication, and the computer age going to bring in a new, wonderful era or an anti-utopia?

The decades following World War II were rightly called *The Atomic Age*. Developed largely by refugee scientists during that war, atomic weaponry loomed like an ominous shadow over all international tensions and potentially belligerent situations. It is not merely a question of nuclear bombs being bigger or more deadly weapons, although they are surely that. Nuclear weapons can have long-term and little-understood consequences for both nature and the individuals who might survive the first blast. Today, with a precariously balanced peace between superpowers, the real fear of nuclear weapons is their possible use by rogue nations or terrorist groups.

First, because modern warfare was so far beyond the power of the postwar human intellect to imagine, artists turned to satire as a way of expressing their fear and hatred of it. Novels like Joseph Heller's *Catch-22* (1961) and Thomas Pynchon's *Gravity's Rainbow* (1973) sketched out war in terms of insanity, irrationality, and the blackest of humor; while Stanley Kubrick's brilliant movie *Dr. Strangelove* (1964) mounted a scathing attack on those who speak coolly about "megadeaths" and "mutual assured destruction" (MAD in military jargon). Any attempt at mere realism, these artists seemed to say, pales into triviality.

Second, at the end of World War II, the United States emerged both as a leading economic power in the world and as the leader of the "Free World" in its struggle against communism. This preeminence explains both the high standard of living in the West and the resentment of those who did not share it. Only recently have we understood that economic supremacy does not permit a nation to live free from outside forces. The energy crises, the need for raw materials, the quest for labor, and the search for new markets today bind many nations together in a delicate economic and social network of political relationships. The United States depends on other countries; the shifting patterns of economic relationships between North America, Europe, the Third World, Japan, and the oil producers are all reminders of how fragile that network really is. That is why we can speak of a "global economy." With the collapse of communism in Eastern Europe, new patterns of culture slowly began to emerge as the vigor of the Pacific Rim nations attest. We do not know exactly how the "New World Order" will operate. What we do know is that our lives are not insulated: Our stereos are assembled in Malaysia; our vegetables may come from Mexico; our blue jeans are sewn in Bangladesh; and our sneakers manufactured in Romania.

The material satisfactions of Western life also spawned other kinds of dissatisfaction. While we may be the best-fed, best-housed, and best-clothed citizens in history, the hunger for individual and social meaning remains a constant in our lives. For instance, many movements in this country—for civil rights, the rights of women, for minority recognition—are signs of that human restlessness that will not be satisfied by bread alone. These movements are not peculiar to North America as democratic movements in other parts of the world so readily attest.

The incredible achievements of modern society have exacted their price. Sigmund Freud shrewdly pointed out in *Civilization and Its Discontents* (1929) that the price of advanced culture is a certain repression of the individual together with the need of that individual to conform to the larger will of the community. North Americans

have always been sensitive to the constraints of the state, since their history began as a revolt against statist domination.

The Western world tends to view repression in terms more social than political. The very complexity of the technological management of modern life has led many to complain that we are becoming mere numbers or ciphers under the indifferent control of databanks and computers. Such warnings began as early as George Orwell's political novel 1984 (1946), written right after World War II; progressed through David Riesman's sociological tract of the 1950s, *The Lonely Crowd*; to the futurist predictions of Alvin Toffler's *Future Shock* in the 1970s. Now, in the new millennium, many more such analyses are sure to appear.

Art, of course, reflects not only the materials of its age but also its hopes and anxieties. The art, literature, and music of contemporary times attempt to diagnose our ills, protest our injustices, and offer alternative visions of what life might become. On very exceptional occasions, the voice of the artist can sum up a cultural condition in a way such that change can come. Who would have believed that an obscure convict, buried in the vast prison complex of the Siberian wasteland, would raise his voice against injustice and repression to change radically the way a whole society is understood? But that is exactly what Alexsandr Solzhenitsyn did with respect to the ominous character of a now collapsed Soviet communism. The same may be said of Nelson Mandela who went from being a political prisoner to becoming the first African president of South Africa.

The true artist can finally articulate a vision of what humanity can trust. In the midst of alienation, the artist can bring community and in the midst of ugliness, beauty. The artist, in short, acts not only as a voice of protest but also as a voice of hope. The American novelist William Harrison Faulkner (1897-1962) spent a lifetime chronicling the violence, decay, injustice, poverty, and lost dreams of the American South. His novels are difficult to read, for they reflect the modernist sense of dislocated place and fragmented time. His most famous novel, The Sound and the Fury (1929), was notorious for its depiction of defective children, incestuous relationships, loutish drunkenness, and violence. In that sense it reflects the bleak landscape of the modern literary imagination. Yet Faulkner insisted that beneath the horror of modern life was a strong residue of human hope and goodness. Faulkner reaffirmed it resoundingly in his acceptance speech when awarded the Nobel Prize for Literature in 1949: "I believe that man will not merely endure; he will prevail."

Two generations later, in 1993, the African American woman of letters and novelist, Toni Morrison, would accept that same prize with a ringing act of faith in the power of language to aid our common humanity as well

as a powerful description of how much the evil powers of the world fear the depths of true language.

In the rapidly shifting contours of our contemporary world we might reflect on the ways in which artists have participated in the restructuring of societies. Many of those who struggled for human rights in the former Soviet Union and the Eastern bloc were poets, novelists, filmmakers, musicians, and playwrights. The redefinition of the status of women or others who suffer minority status in our own country expresses their plight in everything from films to poetry. The "subversive" quality of popular music is not only a part of our culture but has become a worldwide phenomenon. The role of artists in the changing of society is very much a part of the fabric of this chapter; history teaches that this will also be true now in the new millennium.

EXISTENTIALISM

The philosophy that most persistently gripped the intellectual imagination of the Western world in the immediate postwar period was existentialism. Existentialism is more an attitude than a single philosophical system. Its direct ancestry can be traced to the nineteenth-century Danish theologian and religious thinker Søren Aabye Kierkegaard (1813-1855), who set out its main emphases. Kierkegaard strongly reacted against the great abstract philosophical systems developed by such philosophers as Georg Wilhelm Hegel (1770-1831) in favor of an intense study of the individual person in his or her actual existing situation in the world. Kierkegaard emphasized the single individual ("the crowd is untruth") who exists in a specific set of circumstances at a particular time in history with a specific consciousness. Philosophers like Hegel, Kierkegaard once noted ironically, answer every question about the universe except

 TABLE 22.1
 Some Writers in the Existentialist Tradition

Fyodor Dostoyevsky (1821–1881)—Russian Søren Kierkegaard (1813–1855)—Danish Friedrich Nietzsche (1844–1900)—German Miguel de Unamuno (1864–1936)—Spanish Nicholas Berdyaev (1874–1948)—Russian Rainer Maria Rilke (1875–1926)—Czech/German Martin Buber (1878–1965)—Austrian/Israeli Jacques Maritain (1882–1973)—French Karl Jaspers (1883–1969)—German Franz Kafka (1883–1924)—Czech/German José Ortega y Gasset (1883–1955)—Spanish Martin Heidegger (1889–1976)—German Jean-Paul Sartre (1905–1980)—French Albert Camus (1913–1960)—French

"Who am I?," "What am I doing here?," and "Where am I going?"

http://www.tameri.com/csw/exist/kierk.html

Kierkegaard

This radically subjective self-examination was carried on throughout the twentieth century by philosophers like Friedrich Nietzsche and novelists like Fyodor Dostoyevsky, who are regarded as forerunners of modern existentialist philosophy. In the twentieth century, writers like Franz Kafka, the German poet Rainer Maria Rilke, the Spanish critic Miguel de Unamuno, and, above all, the German philosopher Martin Heidegger gave sharper focus to the existentialist creed. The postwar writer who best articulated existentialism both as a philosophy and a lifestyle, however, was the French writer and philosopher Jean-Paul Sartre (1905–1980).

Sartre believed it the task of the modern thinker to take seriously the implications of atheism. If there is no God, Sartre insisted, then there is no blueprint for what a person should be and no ultimate significance to the universe. People are thrown into life and their very aloneness forces them to make decisions about who they are and what they shall become. "People are condemned to be free," Sartre wrote. Existentialism was an attempt to help people understand their place in an absurd world, their obligation to face up to their freedom, and the kinds of ethics available to individuals in a world bereft of absolutes.

Sartre began his mature career just as Germany was beginning its hostilities in the late 1930s. After being a prisoner of war in Germany, Sartre lived in occupied France, where he was active in the French Resistance, especially as a writer for the newspaper *Combat*. Along with novelist Albert Camus (1913–1960) and feminist writer Simone de Beauvoir (1908–1986) they were the major voices demanding integrity in the face of the absurdities and horrors of war-torn Europe. Such an attitude might be considered a posture if it were not for the circumstances in which these existentialist writers worked.

The appeal of existentialism was its marriage of thought and action, its analysis of modern anxiety, and its willingness to express its ideas through the media of plays, novels, films, and newspaper polemics. After the close of the war in 1945, there was a veritable explosion of existentialist theater (Samuel Beckett, Harold Pinter, Jean Gênet, Eugène Ionesco) and existentialist fiction (Camus, Sartre, Beauvoir) in Europe. In the United States, existentialist themes were taken up eagerly by intellectuals and writers who were attracted to its emphasis on anxiety and alienation.

The so-called Beat writers of the 1950s embraced a rather vulgarized style of existentialism filtered through

the mesh of jazz and the black experience. Such Beat writers as the late Jack Kerouac, Gregory Corso, and Allan Ginsberg embraced the existentialist idea of alienation even though they rejected the austere tone of their European counterparts. Their sense of alienation was united with the idea of experience heightened by ecstasy either of a musical, sexual, or chemical origin. The Beats, at least in that sense, were the progenitors of the 1960s hippies.

The existentialist ethic remained alive mainly through the novels of Albert Camus. In works like *The Stranger* (1942), *The Plague* (1947), and *The Fall* (1956), Camus, who disliked being called an existentialist, continued to impress his readers with heroes who fought the ultimate absurdity of the world with lucidity and dedication and without illusion.

Today, existentialism is mainly an historical moment in the postwar culture of Europe and America. Its importance, however, resides in its capacity to formulate some of the most important ideas of modernity: the absence of religious faith, the continuous search for meaning, the dignity of the individual, the concern for human subjectivity.

Painting Since 1945

Art critic Barbara Rose wrote that the history of world art in the second half of the twentieth century bore an unmistakable American stamp. It is hard to quarrel with that historical judgment since in the 1940s the United States, and more specifically New York, became the center of new impulses in art, much the way Paris had been in the first half of the twentieth century. At the end of that century, however, it was also clear that American supremacy may well have been diluted as art took on an international and transnational character.

Part of this geographical shift from Paris to New York can be explained by the pressures of World War II. Numerous artists and intellectuals fled the totalitarian regimes of Europe to settle in America. Refugee artist-teachers like Hans Hofmann (1880-1966), Josef Albers (1888–1976), and George Grosz (1893–1959) brought European ideas to a new generation of American painters. The American patron and art collector Peggy Guggenheim, then married to the Surrealist painter Max Ernst, fled her European home when war broke out to return to New York City, where at her Art of This Century gallery she exhibited such European painters as Braque, Léger, Arp, Brancusi, Picasso, Severini, and Miró. She quickly became a patron of the American painters who eventually led the American avant-garde movement. Peggy Guggenheim's support of this group in New York was crucial to the "Americanization" of modern art.

History nevertheless rarely records total and immediate shifts in artistic styles. Thus, while a revolution was taking place in American art and, for that matter, in world art, some excellent artists continued to work in an older tradition relatively untouched by this revolution. Edward Hopper (1882–1967), for instance, continued to produce paintings that explored his interest in light and his sensitivity to the problems of human isolation and loneliness. His *Nighthawks* [22.1] is an example of Hopper's twin concerns. Ben Shahn (1898–1969) never lost the social passion that had motivated his work all through the 1930s. His *Death of a Miner* [22.2] is both a tribute to and an outcry against the death of a workingman in a senseless accident.

Another painter who remained untouched by the postwar American revolution in painting was Georgia O'Keeffe (1887–1986), who had her first show in New York in 1916 at the galleries of Alfred Stieglitz, the photographer she married in 1924. Her early paintings, like *Calla Lily with Red Roses* [22.3], show both a masterful sense of color and a precise sense of line. She belonged to the early strain of American modernism but continued in her own style. O'Keeffe has been not only recognized as a major artist in her own right but also as the focus for serious discussion about a feminist aesthetic in art contemporaneously.

Abstract Expressionism

The artists discussed in the last section have a secure reputation in the history of art, but it was the abstract Expressionists who gave art in the period after 1945 its "unmistakable American stamp." The term abstract Expressionism is useful because it alludes to two characteristics fundamental to the work of these artists: It was devoid of recognizable content (and thus abstract) and it used color, line, and shape to express interior states of subjective aesthetic experience. Action painting and New York School are two other terms used to classify these painters.

The acknowledged leader of the abstract Expressionists was the Wyoming-born painter Jackson Pollock (1912–1956), who had his first one-man show at Peggy Guggenheim's gallery in 1943.

Pollock's early work was characterized by an interest in primitive symbolism, deriving from the artist's long encounter with the psychology of Carl Jung. By the early 1940s, under the influence of the Surrealists and their technique of automatic creation—in which the artist allows the unconscious rather than the conscious will to stimulate the act of creation—Pollock began to depart radically from traditional ways of painting.

22.1 Edward Hopper. *Nighthawks*, 1942. Oil on canvas, $2'6'' \times 4'8^{11}/_{16}''$. The Art Institute of Chicago, Chicago (Friends of American Art Collection).

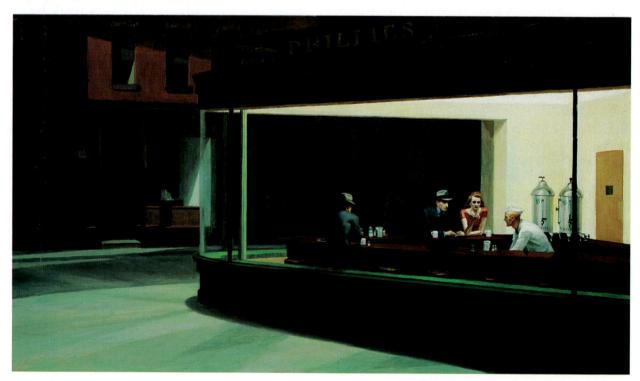

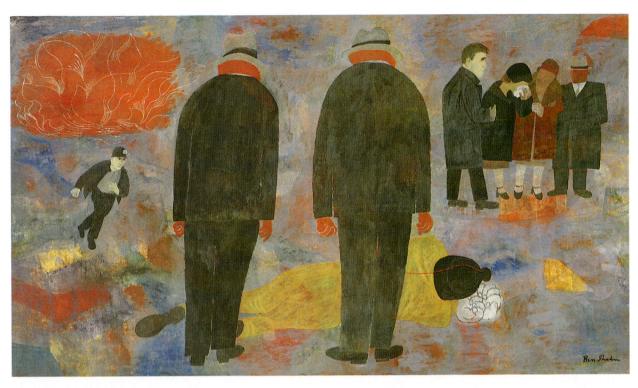

22.2 Ben Shahn. *Death of a Miner*, 1949. Tempera on muslin treated with gesso on panel, $27'' \times 48''$ (68.5 × 1.22 cm). Metropolitan Museum of Art, New York (Arthur Hoppock Hearn Fund, 1950). Copyright © 1997 Estate of Ben Shahn/Licensed by VAGA, New York, NY.

At first Pollock discarded brush and palette for sticks, small mops, and sponges to apply paint in coarse, heavy gestures. Then he set aside instruments altogether and poured, dripped, and spattered paint directly on the canvas in nervous gestural lines rather than enclosed shapes. For his colors he mixed the expensive oils of the

artists with the utilitarian enamels used by house painters. Perhaps most radically, instead of using an easel he rolled out on the floor of his studio large expanses of canvas and applied paint in his unusual manner as he walked around and on them. The dimensions of the finished painting were fixed when Pollock decided

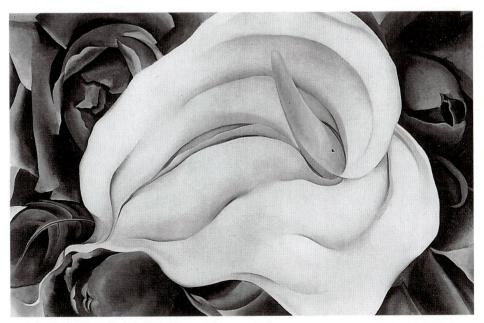

22.3 Georgia O'Keeffe. *Calla Lily with Red Roses*, 1927. Oil on canvas, 30" × 48" (76 × 122 cm). Private Collection. The artist took the common subject of flowers and, through her profound line and strong sense of color, turned them into mysterious, nearly abstract, shapes of feminine power.

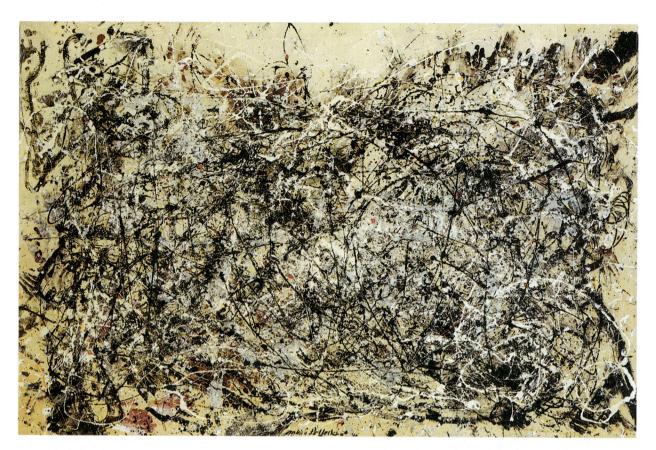

22.4 Jackson Pollock. *Number 1*, 1948. Oil and enamel on unprimed canvas, $5'8'' \times 8'8''$ (1.7×2.6 m). Collection, Museum of Modern Art, New York (purchase). The theoretical basis for such random painting can be traced to the Freudian idea of free association and the Surrealist adaptation of that technique for art called *psychic automatism*.

to cut out from this canvas a particular area and then attach it to the traditional wooden support or stretcher. The result of these unorthodox procedures was huge paintings composed of intricate patterns of dribbles, drops, and lines—webs of color vibrant in their complexity [22.4]. The energy-filled nets of paint extended to the limits of the stretched canvas and by implication beyond, seeming to have no beginning or end and hence attracting the stylistic label "overall" painting. Neither did these colors and lines suggest the illusion of space receding in planes behind the surface of the picture, although they did create a sense of continuous rhythmic movement.

Other painters of the New York School in the 1940s and 1950s were more interested in the potentialities of large fields of color and abstract symbol systems, often with obvious psychological meanings. Adolph Gottlieb (1903–1974) painted a series of "bursts" in the 1950s in which a luminous sunlike color field hung over a primordial exploding mass [22.5]. Robert Motherwell (1915–1991) executed hundreds of paintings in which huge primitive black shapes are in the foreground of subtle, broken color fields [22.6]. Mark Rothko (1903–1970) experimented restlessly with floating color forms

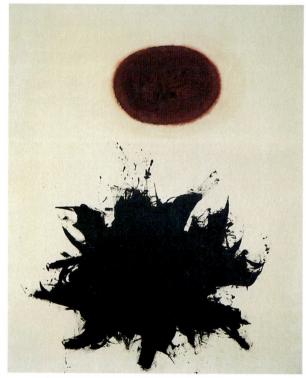

22.5 Adolph Gottlieb. *Thrust*, 1959. Oil on canvas, $9' \times 7'6''$ (2.74 \times 2.29 m). Metropolitan Museum of Art, New York (George A. Hearn Fund, 1959). Copyright © 1997 Adolph and Esther Gottlieb Foundation/Licensed by VAGA, New York, NY. Gottlieb's art is partly inspired by a year he spent in Arizona studying the Native American tradition of pictographs. The paintings also have a strong sexual undercurrent.

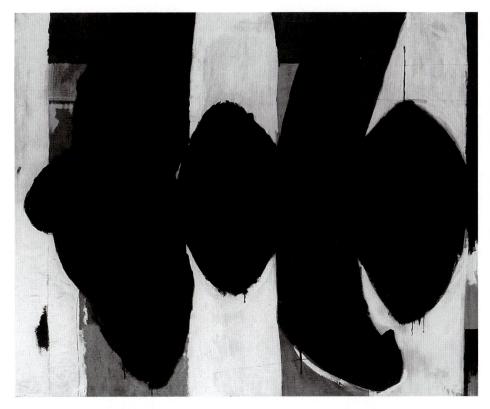

22.6 Robert Motherwell. Elegy to the Spanish Republic #34, 1953-1954. Oil on canvas, $80'' \times 100''$ (203.2 \times 254 cm). Albright-Knox Art Gallery, Buffalo, NY (gift of Seymour H. Knox, 1957). Copyright © 1997 Dedalus Foundation/ Licensed by VAGA, New York, NY. The title of the painting was inspired by the poetry of Federico García Lorca, but no direct literary reference should be seen in the painting. Motherwell insists that the "painter communes with himself."

of the most subtle variation and hue. In the 1960s, Rothko painted a series of panels for a chapel in Houston [22.7] in which he attempted with some success to use color variations alone to evoke a sensibility of mystical awareness of transcendence.

What did these artists have in common? Their energy and originality make it difficult to be categorical although some generalizations are possible. They all continued the modernist tendency to break with the older conventions of art. As the Cubists turned away from traditional perspective so the abstract Expressionists turned away from recognizable content to focus on the implications of color and line. Second, they were expressionists, which is to say that they were concerned with the ability

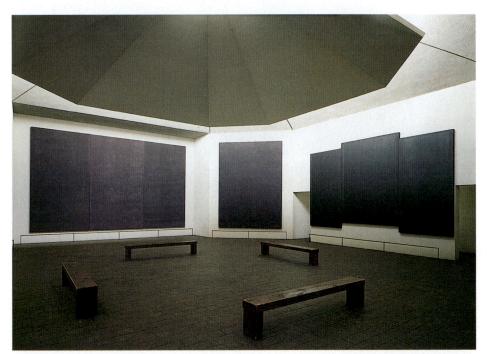

22.7 The Rothko Chapel, consecrated 1971, Houston, Texas. North, northeast, and east wall paintings. Oil on canvas (1965-1966). Chapel design by Philip Johnson. Murals by Mark Rothko. This ecumenical chapel contains fourteen panels finished several years before the artist's death. Rothko desired that the panels' brooding simplicity be a focus for the personal meditations of each viewer. He said he sought to create, between the chapel's entrance and its apse, the tension between doom and promise.

CONTEMPORARY VOICES

Georgia O'Keeffe

I have picked bones where I have found them—Have picked up sea shells and rocks and pieces of wood where there were sea shells and rocks and pieces of wood that I liked.

When I found beautiful white bones in the desert I picked them up and took them home too.

I have used these things to say what is to me the wideness and the wonder of the world as I live in it.

A pelvis bone has always been useful in any animal that has it—quite as useful as a head I suppose. For years in the country the pelvis bones lay about the house indoors and out—always underfoot—seen and not seen as such things can be—seen in many different ways. . . .

I was the sort of child that ate around the raisin on the cookie and ate around the hole in the doughnut saving either the raisin or the hole for the last and best.

So probably—not having changed much—when I started painting the pelvis bones I was most interested in the holes in the bones—what I saw through them—particularly the blue from holding them up to the sun against the sky as one is apt to do when one seems to have more sky than earth in one's world—

They were most wonderful against the Blue—the Blue that will be there as it is now after all men's destruction is finished.

I have tried to paint the Bones and the Blue.

A catalogue statement of Georgia O'Keeffe about her desert paintings, 1944.

of their paintings to express not what they saw but what they felt and what they hoped to communicate to others. As one critic has put it, in an age when organized religion could no longer compel people with the notion of revelation, these artists wished to express their sense of ultimate meaning and their thirst for the infinite. "Instead of making cathedrals out of Christ, Man, or 'Life,'" painter Barnett Newman wrote, "we are making them out of ourselves, out of our own feeling."

The desire to expand the possibilities of pure color detached from any recognizable imagery has been carried on and extended by a second generation of color-field

22.8 Helen Frankenthaler. *The Bay,* 1963. Acrylic resin on canvas, $6'8^1/_4'' \times 6'9^1/_4''$ (2.02 × 2.08 m). Detroit Institute of Arts (gift of Dr. Hilbert and Mrs. H. Delawter). Frankenthaler's work gains its almost watercolor luminosity by her practice of thinning her paints to the consistency of washes.

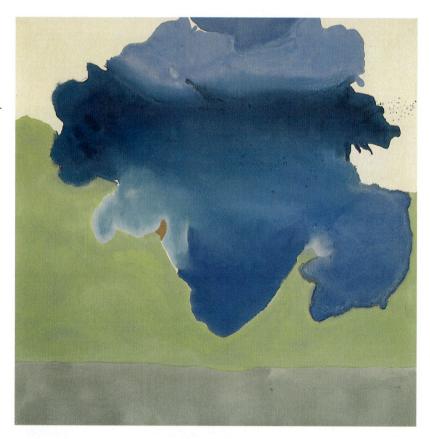

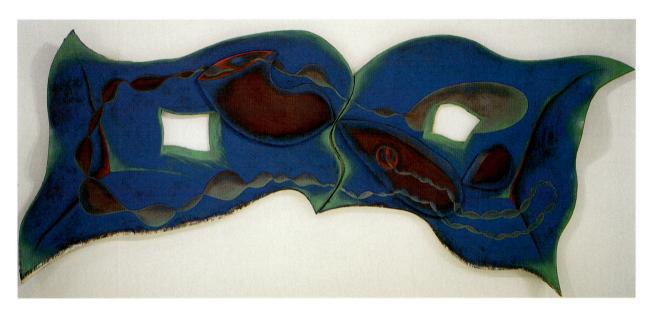

22.9 Elizabeth Murray. *Open Book.* Whitney Museum of American Art, New York.

painters, the most notable of whom is Helen Frankenthaler (b. 1928). Around 1951, Frankenthaler began to saturate unprimed canvases with poured paint so that the figure (the paint) merged into the ground (the canvas) of the work. By staining the canvas she carried Pollock's action painting one step farther, emphasizing the pure liquidity of paint and the color that derives from it. Frankenthaler uses the thinnest of paints to take advantage of the light contrast between the paint and the unstained canvas (unlike Pollock she does not paint all over her ground). The result has been paintings with the subtlety of watercolors but distinctively and inescapably different [22.8]. Her

younger contemporary, Elizabeth Murray (b. 1940) still finds energy in abstract art. She paints large abstract canvases but experiments with more than one canvas and uses a firmer control over her paint as is apparent in her work *Open Book* [22.9].

The Return to Representation

It was inevitable that some artists would break with abstract Expressionism and return to a consideration of the object. This reaction began in the mid-1950s with painters like Jasper Johns (b. 1930), whose *Flag* series [22.10] heralded a new appreciation of objects. Further, Johns' art focused on objects taken from the mundane world. Johns went on to paint and sculpt targets, toothbrushes, beer

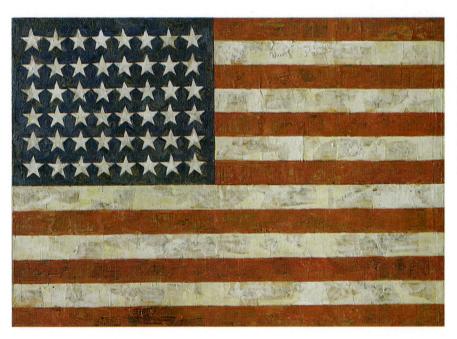

22.10 Jasper Johns. *Flag*, 1954. Encaustic, oil, and collage on fabric mounted on plywood, $3'6^{1}/_{4}'' \times 5'^{5}/_{8}''$ (1.07 \times 1.54 m). Museum of Modern Art, New York (gift of Philip Johnson in honor of Alfred Barr Jr.). Copyright © 1997 Jasper Johns/Licensed by VAGA, New York, NY. The rather banal subject should not detract from Johns' phenomenal technique. Encaustic is painting done with molten colored wax.

22.11 Robert Rauschenberg.

Monogram, 1955–1959. Freestanding combine, 5'4\frac{1}{2}" \times 3'6" \times 5'3\frac{1}{4}" (1.64 \times 1.07 \times 1.61 m). Moderna

Museet, Stockholm. Copyright

© 1997 Robert Rauschenberg/Licensed by VAGA, New York, NY.

Although Rauschenberg's work was once considered a spoof of abstract art—a sort of contemporary Dada—he is now regarded as one of the most inventive of American

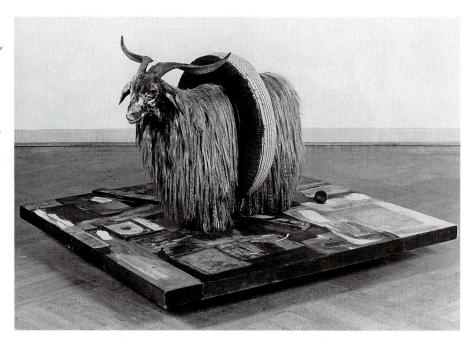

cans, and even his own artist's brushes. This shift signaled a whimsical and ironic rejection of highly emotive, content-free, and intellectualized abstract art.

Robert Rauschenberg (b. 1925) was another artist who helped define the sensibility emerging as a counterforce

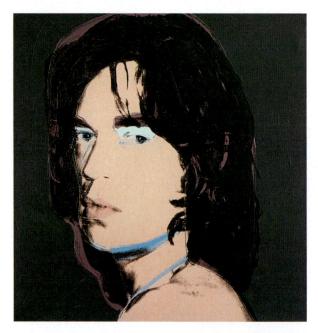

22.12 Andy Warhol. *Mick Jagger*, 1975. Synthetic polymer paint and silkscreen ink on canvas, 40" (102 cm) square. The Andy Warhol Foundation for the Visual Arts. Warhol incorporated into high art the world of the media, money, and fashion. Until his death in 1987, he incarnated the notion of the artist as celebrity figure with his explorations in video, film, photography, magazine publishing, graphics, and painting.

to abstract Expressionism in the 1950s. Rauschenberg studied at Black Mountain College, an experimental school in North Carolina, under the tutelage of the refugee Bauhaus painter Josef Albers. A more important influence from his Black Mountain days was the avantgarde musician and composer John Cage (1912-1992), who encouraged experiments combining music, drama, dance, art, and other media into coherent artistic wholes which were called Happenings. Rauschenberg began to experiment with what he called "combine" paintings that utilized painting combined with any number of assembled objects in a manner that had deep roots in the avant-garde. By 1959, he was doing large-scale works like his Monogram [22.11], which combined an assortment of elements (including a stuffed goat!) in an outrageous yet delightful collage.

The third artist who emerged in the late 1950s—Andy Warhol (1930–1987)—became notorious for his paintings of soup cans, soap boxes, cola bottles, and the other throwaway detritus of our society. This made his name synonymous with *Pop art*, a term first used in England to describe the art of popular culture. The long-range judgment on Warhol as a serious artist may be harsh, but he understood one thing quite well: Taste today is largely shaped by the incessant pressure of advertising, mass media, pulp writing, and the transient culture of fads. Warhol, who began his career as a commercial illustrator, exploited that fact relentlessly.

Over the years, Warhol increasingly turned his attention away from painting and toward printmaking, videotapes, movies, and Polaroid® photography. His subjects tended to be the celebrities of film and the social world. Whether his art is a prophetic judgment on our culture or

a subtle manipulation of it is difficult to answer since Warhol could be bafflingly indirect. His lightly retouched silkscreen prints of entertainment celebrities [22.12] seem banal and of little permanent value, but that may be exactly what he wished to express.

Painting from the 1970s is difficult to categorize. Some artists continued to explore color-field painting with great verve. Others, such as Ellsworth Kelly, Kenneth Noland, and Frank Stella, explored more formal elements with carefully drawn "hard edges," primary colors, and geometrically precise compositions. They were almost ascetic in their use of line and color, as "minimalist" works of an artist like Ellsworth Kelly show [22.13].

Another group of painters went back totally to the recognizable object painted in a manner so realistic that critics called them *Photorealists*. Less glossy than the Photorealists but almost Classical in their fine draftsmanship are the erotically charged nudes of Philip Pearlstein, who takes a position somewhere between the fragmented world of Cubism and the slick glossiness of popular magazines. His *Two Female Models on Regency Sofa* [22.14] is a serious and unsentimental study of the female figure.

For Alfred Leslie (b. 1927), the past can still be a teacher for the modern painter. In a work like 7 A.M. News [22.15] Leslie combines an eye for contemporary reality and the use of *chiaroscuro*, a technique he consciously borrows directly from the seventeenth-

22.13 Ellsworth Kelly. *Grey Panels* 2, 1974. Oil on canvas (two panels), $92'' \times 102''$ (233.6 \times 304.8 cm). Leo Castelli Gallery, New York. By comparing this work to Frankenthaler's (Figure 22.8), one can see the different approaches to color in the post-abstract Expressionist period.

century painter Caravaggio. With Leslie we have come, as it were, full circle from the abstract Expressionist break with tradition to a contemporary painter who

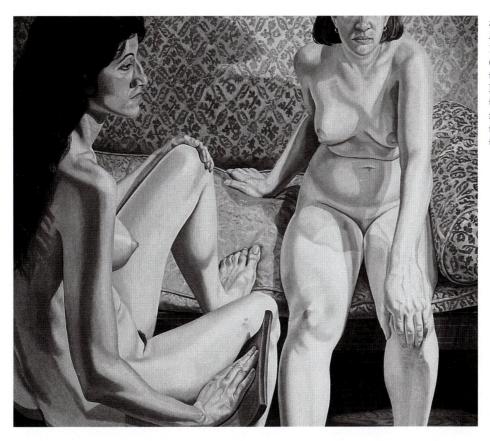

22.14 Philip Pearlstein. *Two Female Models on Regency Sofa,* 1974. Oil on canvas, $5' \times 5'10''$ (1.52 \times 1.78 m). Private Collection, New York. Compare Pearlstein's nudes to those of the Renaissance tradition represented by an artist like Titian to get a feeling for the modern temper.

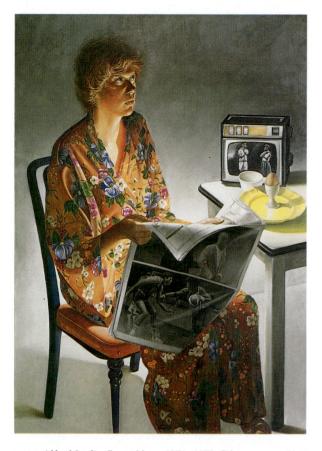

22.15 Alfred Leslie. 7 *A.M. News*, 1976–1978. Oil on canvas, $7' \times 5'$ (2.13 \times 1.52 m). Oil and Steel Gallery, Long Island. Copyright © Alfred Leslie. Leslie uses the technique of *chiaroscuro* in conscious homage to baroque masters like Caravaggio and Rembrandt.

consciously looks back to seventeenth-century masters for formal inspiration.

One can say that two intellectual trends seem to have emerged in American painting in this period. One strain, abstract Expressionism and its various offspring, is heavily indebted to the modernist intellectual tradition, with its many roots in psychological theories of Jung and Freud and the existentialist vocabulary of anxiety and alienation. By contrast, the work of painters like Johns, Warhol, Rauschenberg, and others is far more closely linked to the vast world of popular culture in postindustrial America. Its material, its symbols, and its intentions reflect the values of consumer culture more than the 1940s work of the New York School. Pop art, largely free from the brooding metaphysics of the abstract Expressionists, can be seen—perhaps simultaneously—as a celebration and a challenge to middle-class values.

One sees that same blend of "isms" and references to popular culture in the work of African American artists. A painter like Romare Bearden (1914–1988) produced a body of work that absorbed collage, Cubism, and tendencies to abstraction in order to make a body of art that was distinctively his own. A painting like *The Prevalence of Ritual: Baptism* [22.16] celebrates a traditional religious ritual with references to Africa done in a Cubist style. By contrast, the painter Jean Lacy (b. 1932) utilizes mixed media in a work like *Little Egypt Condo, New York City* to celebrate her racial heritage and, at the same time, celebrate the energy of city life [22.17].

22.16 Romare Bearden. *The Prevalence of Ritual: Baptism,* 1964. Collage on board, 9" × 12" (23 × 30 cm). The Hirshhorn Museum and Sculpture Garden, Smithsonian Institution. Washington, DC. (Gift of Joseph H. Hirshhorn, 1966). Copyright © 1997 Romare Bearden Foundation/Licensed by VAGA, New York, NY.

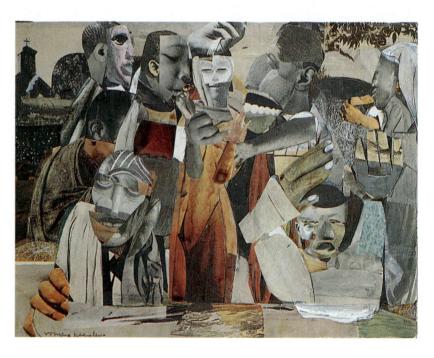

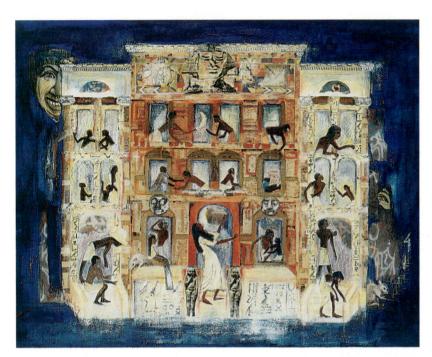

22.17 Jean Lacy. Little Egypt Condo, New York City, 1987. Mixed media on museum board, $10^{1}/_{2}'' \times 13^{1}/_{2}''$ (26.6 \times 33.5 cm). Dallas Museum of Arts, gift of the Dallas Chapter of LINKS, Inc.

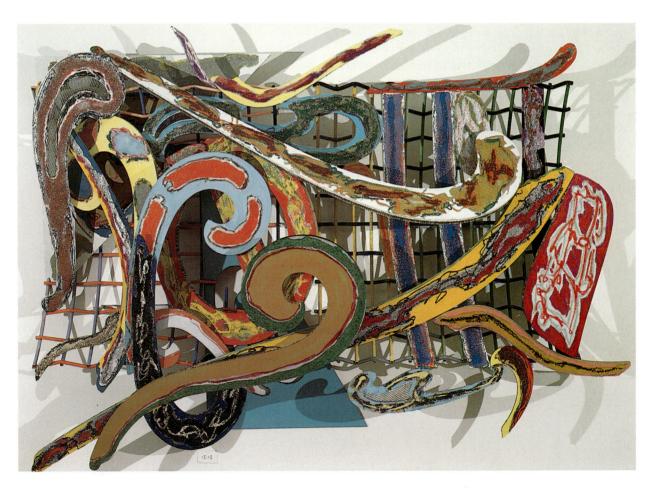

22.18 Frank Stella. *Shoubeegi (Indian Birds)*, 1978. Mixed media on metal relief, $94'' \times 120'' \times 32^{1}/_{2}''$ (238.8 \times 304.8 \times 82.6 cm). Private Collection (courtesy of Leo Castelli Gallery, New York). Stella has been the foremost and most persistent defender of abstract art on the American scene today.

Painting in the late 1970s and 1980s went in many directions. Critics are agreed on one point: There is no predominant "ism" that defines contemporary art. The profusion of styles apparent on that day's art scene testifies to either a vigorous eclecticism or a sense of confusion. Older painters like Frank Stella still pushed the limits of abstract art [22.18], while Susan Rothenberg's canvases reflected a concern with the very texture of painting, in which recognizable figures emerged like risen ghosts [22.19]. The same polarity of styles can be seen by contrasting the sunny optimism of the English-born David Hockney (now living in California) [22.20] with the brooding work of the German Expressionist painter, Anselm Kiefer [22.21]. These artists worked in a time when "older masters" like Johns, Rauschenberg, and others still pushed the limits of their original insights and flights of imagination.

CONTEMPORARY SCULPTURE

Sculpture since 1945 shows both continuities and radical experimentation. The Italian sculptor Giacomo Manzù (1908–1990) still worked with traditional forms of bronze-casting to produce works like the doors of Saint Peter's [22.22] commissioned by the Vatican in the 1950s and cast in the 1960s. While his style is modern, the overall concept and nature of the commission hark back to the Italian Renaissance and earlier.

Much of contemporary sculpture has utilized newer metals (stainless steel or rolled steel, for instance) and welding techniques to allow some freedom from the inherent density of cast bronze, the traditional metal of the sculptor. David Smith (1906–1965) used his skills as a one-time auto-body assembler to produce simple and elegant metal sculptures that reflected his not inconsiderable technical skills with metal as well as his refined sense of aesthetic balance. In works like *Cubi I* [22.23], Smith used stainless steel to produce a geometrically balanced work of solidity that conveys a sense of airy lightness.

Alexander Calder (1898–1976) used his early training as a mechanical engineer to combine the weightiness of metal with the grace of movement. Mobiles like *Big Red* [22.24] are constructed of painted sheet metal and wire; these constructions move because they are so delicately balanced that they respond to even the slightest currents of air. Calder once said that people think monuments "come out of the ground, never out of the ceiling"; his mobiles were meant to demonstrate just the opposite.

http://www.rogallery.com/calder-biography.htm

Alexander Calder

Other contemporary sculptors expanded the notion of assembling disparate materials into a coherent artistic whole. Employing far from traditional materials, these artists utilized a variety of found and manufactured articles of the most amazing variety to create organic artistic wholes. Louise Nevelson (1900–1988), for example, used

22.19 Susan Rothenberg. *Cabin Fever*, 1976. Acrylic and tempera on canvas, $67'' \times 84''$ (170.2 \times 213.4 cm) Collection of the Modern Art Museum of Fort Worth, Museum Purchase, Sid W. Richardson Foundation Endowment Fund and an Anonymous Donor.

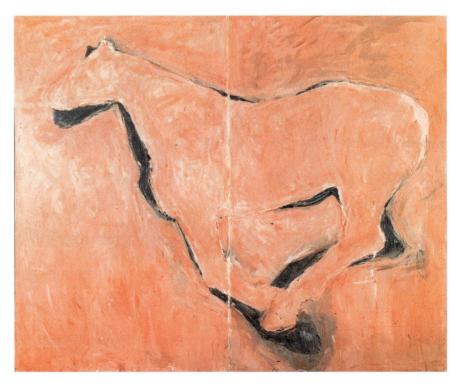

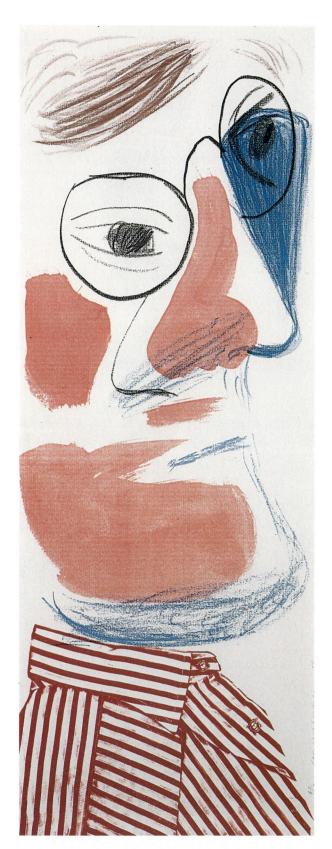

22.20 David Hockney. *Self-Portrait, July 1986*, 1986. Homemade print executed on color office copy machine, two panels, $22'' \times 8^{1}/_{2}''$ (55.9 \times 21.6 cm). Collection of the artist. This work was done by running the page through commercial copying machines to get the various colors of the finished portrait.

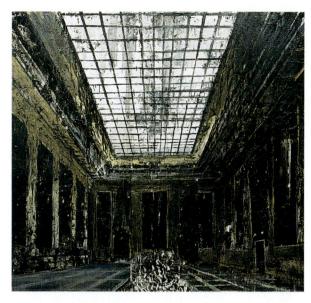

22.21 Anselm Kiefer. *Innenraum*, 1981. Oil, paper, and canvas, $111' \times 122'$ (34.45×37.2 m). Stedelijk Museum, Amsterdam. Kiefer's monumental paintings have echoes of past masters combined with a brooding sense of Germany's own past, mythic and historical.

pieces of wood, many of which had been lathed or turned for commercial uses, to assemble large-scale structures that seemed at the same time to function as walls closing off space and as containers to hold the items that made up her compositions [22.26]. Joseph Cornell (1903–1972), early influenced by both Surrealism and Dada, constructed small boxes that he filled with inexpensive trinkets, maps, bottles, tops, stones, and other trivia. In contrast to the larger brooding, almost totemic spirit of Nevelson, Cornell's painstakingly organized boxes [22.25] allude to a private world of fantasy.

The sculptural interest in Assemblage has been carried a step farther by such artists as George Segal (1924-2000) and Edward Kienholz (1927-1994). Their works re-create entire tableaux into which realistically sculptured figures are placed. Segal, once a painting student of Hans Hofmann in New York, liked to cast human figures in plaster of Paris and then set them in particular but familiar settings [22.27]. The starkness of the lone white figures evokes a mood of isolation and loneliness not unlike that of the paintings of Edward Hopper. Kienholz was far better prepared to invest his works with strong social comment. His State Hospital [22.28] is a strong, critical indictment of the institutional neglect of the mentally ill. The chained figure at the bottom of the tableau "dreams" of his own self-image (note the cartoonlike bubble) on the top bunk. In the original version of this powerful piece, goldfish were swimming in the plastic-enclosed faces of the two figures.

Both Segal and Kienholz have certain ties to Pop art but neither works within its whimsical or humorous vein.

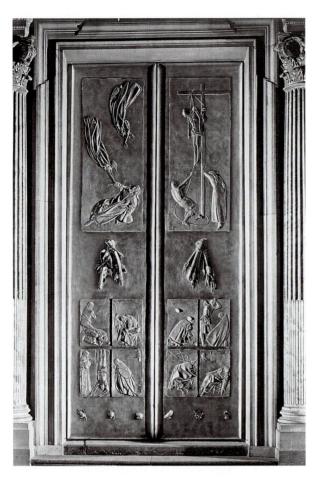

22.22 Giacomo Manzù. Doors of Saint Peter's, 1963. Cast bronze, $24'3'' \times 11'9''$ (7.4×3.6 m). Vatican City, Rome. These doors are on the extreme left of the portico of the basilica. (Opposite is the entrance opened only for Holy Year celebrations, every quarter-century.)

Claes Oldenburg (b. 1929), however, is one of the more humorously outrageous and inventively intelligent artists working today. He has proposed (and, in many cases, executed) monumental outdoor sculptures depicting teddy bears, ice-cream bars, lipsticks, and baseball bats. From the 1960s on, Oldenburg experimented with sculptures that turn normally rigid objects into "soft" or "collapsing" versions made from vinyl or canvas and stuffed with kapok. A piece like his *Soft Toilet* [22.29] is simultaneously humorous and mocking. It echoes Pop art and recalls the oozing edges so characteristic of Surrealism.

Overarching these decades of sculptural development is the work of the British sculptor Henry Moore (1898–1986). Moore's work, which extends back into the 1920s, is a powerful amalgam of the monumental tradition of Western sculpture deriving from Renaissance masters like Michelangelo and his love for the forms coming from the early cultures of Africa, Mexico, and

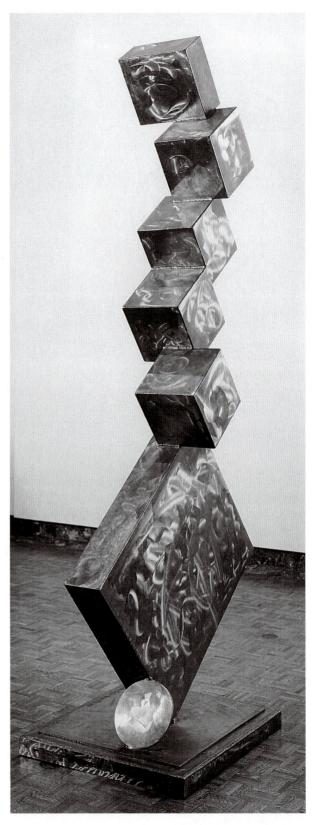

22.23 David Smith. *Cubi I*, 1963. Stainless steel, height 10'4'' (3.15 m). Detroit Institute of Arts (Founders Society Purchase Fund). Copyright © 1997 Estate of David Smith/Licensed by VAGA, New York, NY. Critics recognize Smith as one of the most important sculptors of the twentieth century. Smith took this photograph at his studio in Bolton Landing, New York.

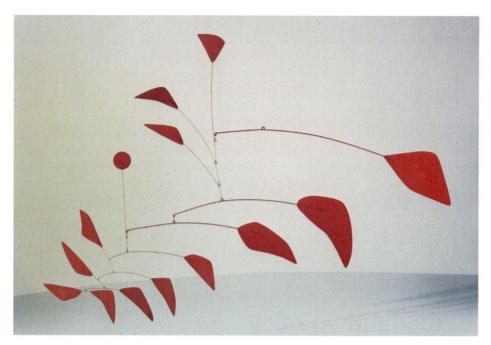

22.24 Alexander Calder. *Big Red*, 1959. Painted sheet metal and steel wire, $6'2'' \times 9'6''$ (1.9 × 2.9 m). Whitney Museum of American Art, New York (purchased with funds from the Friends of the Whitney Museum of American Art).

pre-Colombian Latin America. From these two sources Moore worked out hauntingly beautiful works—some on a massive scale—that speak of the most primordial realities of art.

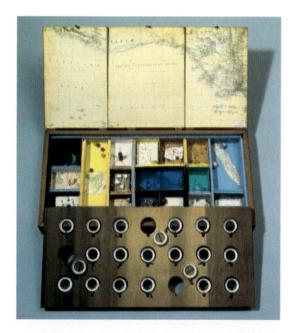

22.25 Joseph Cornell. *Object Roses des Vents*, 1942–1953. Wooden box with twenty-one compasses set in a wooden tray resting on Plexiglas-topped-and-partitioned section, divided into seventeen compartments containing small miscellaneous objects and three-part hinged lid covered inside with parts of maps of New Guinea and Australia, $2^5/8^{"} \times 21^{1}/4^{"} \times 10^{3}/8^{"}$ (6.7 \times 53.9 \times 26.4 cm). Museum of Modern Art, New York (Mr. and Mrs. Gerald Murphy Fund).

Moore's *Reclining Figure* [22.30] is a complex work that illustrates many of the sculptor's mature interests. The outline is obviously that of a woman in a rather abstract form. There is also the hint of bonelike structure, a favorite motif in Moore's abstract sculpture, and holes pierce the figure. The holes, Moore once said, reminded him of caves and openings in hillsides with their hint of mystery, and critics have also noted their obvious sexual

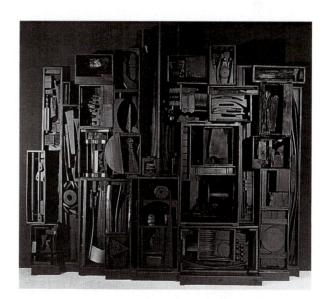

22.26 Louise Nevelson. *Sky Cathedral—Moon Garden + One,* 1957–1960. Painted wood, $9'1'' \times 10'10'' \times 19''$ (2.77 \times 3.3 \times .48 m). Pace Gallery, Milly and Arnold Glimcher Collection. This detail shows the intricate and complex nature of Nevelson's work. At her death in 1988, she was considered one of the most accomplished sculptors in the world.

VALUES

Liberation

If we understand *liberation* in the deep social sense as freedom *to* realize one's full human potential as well as freedom *from* oppressive structures, we would then have to say that the desire for, and realization of, liberating freedom is one of the hallmarks of modern world culture. This was especially true in the second half of the twentieth century.

Liberation has come both for millions from the totalitarian regimes of fascism, Nazism, and Marxism as well as freedom from the colonial powers in areas as diverse as India and Africa. These liberation movements have their mirror image in the struggle for civil rights for people of color, for women, for exploited social minorities, as well as struggles to end poverty, hunger, and the exploitation of children.

What energizes these quite different movements for freedom and liberation? A partial answer is to be found

in the power of mass communication to let people know that they are victims of oppression. There is also the power of certain fundamental ideas derived, in the West, from Greek philosophical thought and biblical prophetism which crystallized in the Enlightenment that held forth the promise of the right to "life, liberty, and the pursuit of happiness."

The struggle for social and political liberation has involved many communities with some spokespersons standing out both because of their personal bravery and the power of their convictions. We think immediately of Mohandas Gandhi in India; Martin Luther King Jr. in the United States; Desmond Tutu and Nelson Mandela in Africa; Lech Walesa and Vaclav Havel in Eastern Europe as well as the many unnamed persons who put their lives on the line to live free.

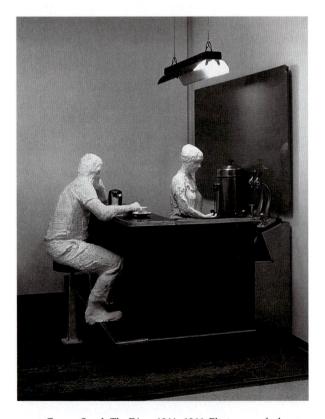

22.27 George Segal. *The Diner*, 1964–1966. Plaster, wood, chrome, formica, masonite, fluorescent lights, $8'6'' \times 9' \times 7'3''$ (2.59 \times 2.75 \times 2.14 m). Walker Art Center, Minneapolis (gift of the T. B. Walker Foundation, 1966). Copyright © 1997 George Segal/Licensed by VAGA, New York, NY. More recently, Segal experimented with colored plasters and large bronze cast outdoor pieces.

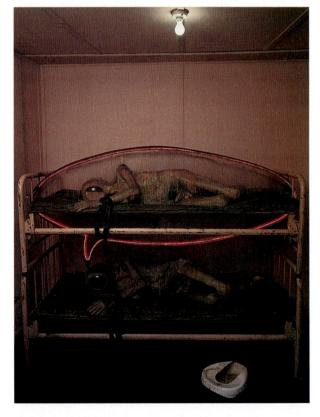

22.28 Edward Kienholz. *The State Hospital.* Detail, 1966. Mixed media, $8' \times 12' \times 10'$ (2.44 \times 3.66 \times 3.05 m). Moderna Museet, Stockholm. Kienholz's work provokes such violent reactions that in 1966 some works were threatened with removal from a one-person show he had in Los Angeles.

connotations. The figure reclines after the fashion of Etruscan and Mexican burial figures. In a single work Moore hints at three primordial forces in the universal human experience: life (the female figure), death (the bonelike configurations), and sexuality (the holes). It is a sculpture contemporary in style but timeless in its message.

Most of the sculpture just discussed was made for a gallery or a collector. Thanks to increased government

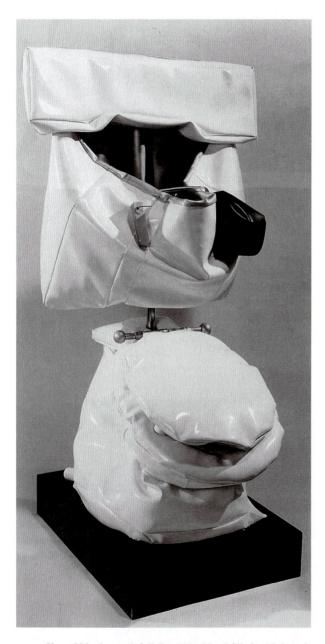

22.29 Claes Oldenburg. *Soft Toilet*, 1966. Vinyl filled with kapok painted with liquitex, and wood. Height 4'4" (1.27 m). Whitney Museum of Modern Art, New York (50th Anniversary Gift of Mr. and Mrs. Victor M. Ganzi). Oldenburg's humor derives from the well-known device of taking the expected and rendering it in an unexpected self-parodying form.

and corporate patronage in recent decades it is possible for an average citizen to view outdoor sculpture as part of the urban environment. A walk in the downtown area of Chicago, for example, provides a chance to see monumental works of Picasso, Chagall, Bertoia, Calder, and Oldenburg. The fact that the federal government had set aside a certain percentage of its building budget for works of art to enhance public buildings has been an impetus for wider diffusion of modern art and sculpture. In one sense, the government, the large foundations, and the corporations have supplanted the church and the aristocracy as patrons for monumental art in our time.

One of the most moving public outdoor works is the Vietnam Veterans Memorial [22.31] in Washington, DC. The work's designer was a young student at Yale, Maya Ying Lin. Two polished black granite walls, each over two hundred feet in length, converge in a vee-shape. Fifty-five thousand names of dead service personnel killed in Vietnam are inscribed on the walls; the polished surface acts as a mirror for those who visit what has become one of the most popular pilgrimage spots in the nation's capital.

In the 1980s, sculpture demonstrated a variety not unlike that of contemporary painting. The Bulgarian-born Christo and his wife, Jeanne-Claude, sought out large natural sites to drape with various fabrics for temporary alteration of our perception of familiar places [22.32]. Part of Christo's strategy was to mobilize large numbers of volunteers to actually create the work he had so carefully planned. By contrast, the haunting work of Magdalena Abakanowicz uses basic fibers to make pieces that have fearful references to twentieth-century human disasters [22.33]. The American sculptor Duane Hanson (d. 1996) took advantage of new materials like polyvinyl to create hyper-realistic visions of ordinary people in ordinary experiences [22.34]. All these sculptors have drawn on the most advanced contributions of material science and technology while meditating on problems of the human condition as old as art itself. The American painter Jennifer Bartlett (b. 1941) has more recently moved into sculpture, taking some of the iconic symbols from her painting and turning them into arresting threedimensional figures like her House [22.35] and Two Boats [22.36], done as part of a commission for the Volvo Corporation in Sweden. By contrast, Mary Frank (b. 1932) has stepped into the world of ceramics to use terra-cotta to create large-scale sculptures of women that reflect a haunting beauty and an almost primitive power [22.37]. Finally, one sculptor (if that is the word!) who has fully explored the potentialities of our media culture is the Korean-born Nam June Paik whose assemblage titled Electronic Superhighway pays homage to what is surely one of the most revolutionary elements of contemporary culture [22.38].

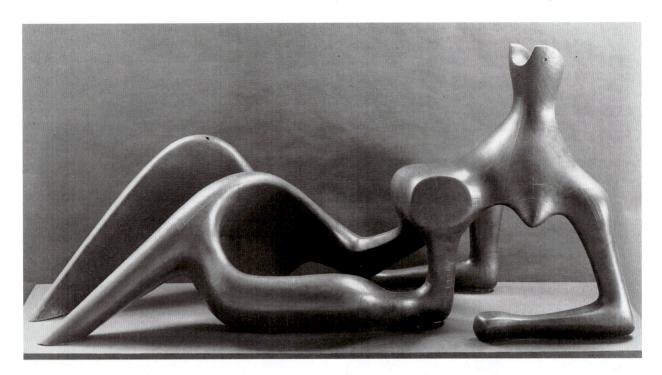

22.30 Henry Moore. *Reclining Figure*, 1951. Bronze. Length 7'5" (2.25 m). Musée National d'Art Moderne, Centre Georges Pompidou, Paris. Note the allusions to bones in the figure, allusions that serve as a counterpoint to the curved character of the figure.

ARCHITECTURE

The most influential American architect of the twentieth century was Frank Lloyd Wright (1869–1959), who was a

disciple of Louis Sullivan (1856–1924). Sullivan had built the first skyscrapers in the United States in the last decade of the nineteenth century. Like Sullivan, Wright championed an architecture that produced buildings designed for their specific function with an eye focused on the natural environment in which the building was to be placed and with a sensitivity to what the building should "say." "Form follows function" was Sullivan's famous aphorism for this belief. For Wright and his disciples there was something ludicrous about designing a post

22.31 Maya Ying Lin. *Vietnam Veterans Memorial,* 1982. Black granite. The Mall, Washington, DC.

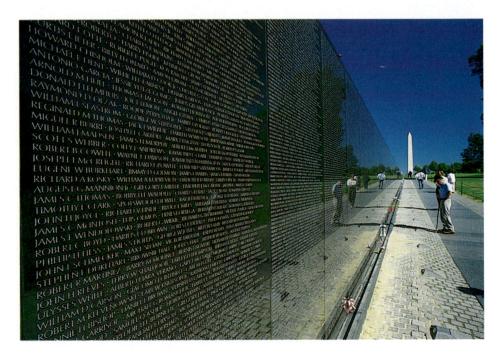

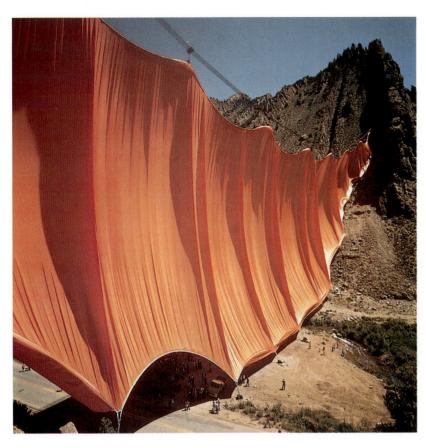

22.32 Christo and Jeanne-Claude. *Valley Curtain*. Rifle, Colorado, 1970–1972. One hundred forty-two thousand square feet of woven nylon fabric; 110,000 pounds of steel cables. Spans 1250' (381 m), height 365' to 182' (111 to 56 m). Project direction: Jan van der Marck. Since that project, Christo and Jeanne-Claude realized projects include a 24-mile *Running Fence* in California, 11 *Surrounding Islands* in Florida, *The Pont Neuf Wrapped* in Paris, and *The Umbrellas*, Japan–USA, 1984–1992.

office to look like a Greek temple and then building it in the center of a Midwestern American city. Wright wanted an *organic* architecture—an architecture that grows out of its location rather than being superimposed on it.

http://www.cypgrp.com/flw/

Frank Lloyd Wright

22.33 Magdalena Abakanowicz. *Backs*, 1976–1982. (80 pieces) burlap and resin, each approx. $27^{1}/4^{"} \times 22^{"} \times 26"$ (69 × 56 × 66 cm). Each unique. Courtesy, Marlborough Gallery, New York. Copyright © 1996 Magdalena Abakanowicz, *Backs*, 1976–1980/ Licensed by VAGA, New York, NY. These figures speak of human degradation, the horrors of war and servitude, and inhumanity. Abakanowicz has pushed fiber arts to new and profound directions beyond the mere designation of "craft art."

22.34 Duane Hanson. *The Dockman*, 1979. Polyvinyl, polychromed in oil, life-size. Collection Belger Cartage Service, Inc. Compare this work to George Segal's casts in Figure 22.27.

For decades Wright designed private homes, college campuses, industrial buildings, and churches that reflected this basic philosophy. In the postwar period

22.35 Jennifer Bartlett. *House,* 1984. White painted wood with copper roof. Volvo Corporation, Göteborg, Sweden.

22.36 Jennifer Bartlett. *Two Boats*, 1984. Cor-ten steel. Volvo Corporate Headquarters, Göteborg, Sweden.

Wright finished his celebrated Solomon R. Guggenheim Museum [22.39] in New York City from plans he had made in 1943. This building, one of Wright's true masterpieces, is a capsule summary of his architectural ideals. Wright was interested in the flow of space rather than its obstruction ("Democracy needs something basically better than a box"), so the Guggenheim Museum's interior is designed to eliminate as many corners and angles as possible. The interior is essentially one very large room with an immensely airy central space. Rising from the floor in a continuous flow for six stories is a long simple spiraling ramp cantilevered off the supporting walls. A museum-goer can walk down the ramp and view an exhibition without ever encountering a wall or partition. The viewing of the art is a continuous unwinding experience. Thus the function of the museum (to show art) is accomplished by the *form* of the building.

The exterior of the Guggenheim Museum vividly demonstrates the possibilities inherent in the new building materials that became available in that century. By the use of reinforced or ferroconcrete, one could model or sculpt a building easily. The Guggenheim Museum, with its soft curves and cylindrical forms, seems to rise up from its base. The undulating lines stand in sharp contrast to the boxy angles and corners of most of the

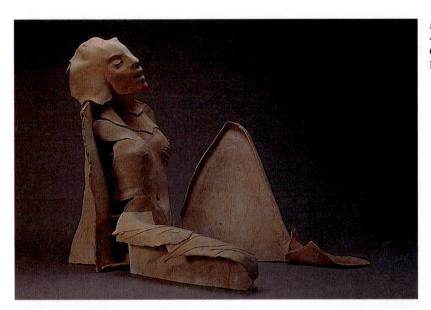

22.37 Mary Frank. *Chant*, 1984. Ceramic, $40'' \times 60'' \times 38''$ ($102 \times 152.4 \times 96.5$ cm). Collection of Virginia Museum of Fine Arts, Richmond, Virginia.

buildings found in New York City. By using such a design, made to fit a rather restricted urban space, the Guggenheim almost takes on the quality of sculpture.

The sculptural possibilities of reinforced and prestressed concrete gave other architects the means to "model" buildings in dramatically attractive ways. The Italian engineer and architect Pier Luigi Nervi (1891–1979) demonstrated the creative use of concrete in a series of buildings he designed with Annibale Vitellozi for the 1960 Olympic Games in Rome [22.40]. Eero Saarinen

(1910–1961) showed in the TWA Flight Center at Kennedy International Airport in New York City [22.41] that a building can become almost pure sculpture; Saarinen's wing motif is peculiarly appropriate for an airport terminal. That architects have not exhausted the potentialities of this modeled architecture seems clear from the Opera House complex in Sydney, Australia [22.42]. Here the Danish architect Jörn Utzon utilized Saarinen's wing motif, but it is no slavish copy since Utzon gives it a new and dramatic emphasis.

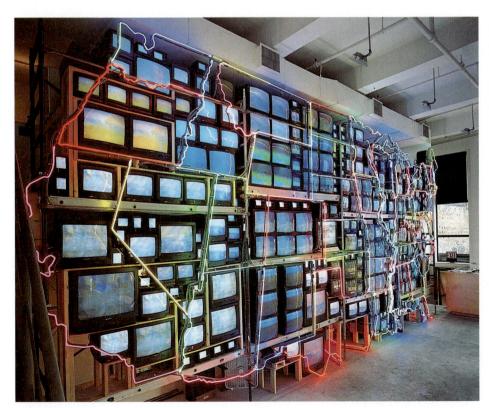

22.38 Nam June Paik. Electronic Superhighway, 1995. Multiple television monitors (313 TVs—US/24 TVs—Alaska/1 TV—Hawaii). Laser disk images, neon, and audio, $15' \times 32' \times 4'$ ($4.6 \times 9.8 \times 1.2$ m). Holly Solomon Gallery, New York.

22.39 Frank Lloyd Wright. Solomon R. Guggenheim Museum, 1957-1959. Reinforced concrete, diameter at ground level approx. 100' (30.48 m), at roof level 128' (39 m), height of dome 92' (28 m). The Solomon R. Guggenheim Foundation, New York. One of the most discussed American buildings of the twentieth century, it is hard to realize that it sits in the midst of New York's Fifth Avenue buildings. A new rectangular addition now stands behind the museum.

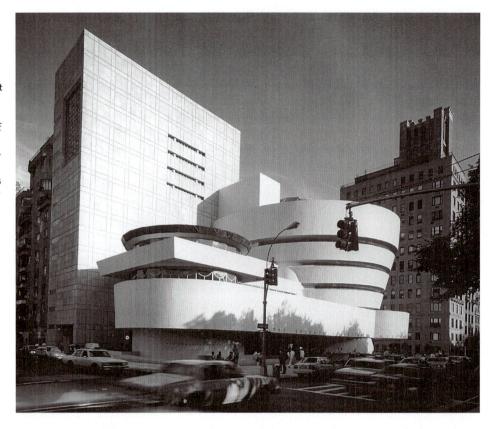

The influential French architect Le Corbusier (1887–1965; born Charles Édouard Jeanneret-Gris) did not share Wright's enthusiasm for "organic" architecture. Le Corbusier saw architecture as a human achievement that should stand in counterpoint to the world of nature. During his long career, Le Corbusier designed and oversaw the construction of both individual buildings and

22.40 Pier Luigi Nervi and Annibale Vitellozi. Palazzetto dello Sport, Rome, 1956–1957. The walls beneath the dome are of glass. The Y-shaped ferroconcrete columns are reminiscent of caryatids; their outstretched "arms" support the dome.

more ambitious habitations ranging from apartment complexes to an entire city. One of his most important contributions to architecture is his series of Unités d'Habitation in Marseille (1952) and Nantes [22.43]. These complexes were attempts to make large housing units into livable modules that would not only provide living space but would also be sufficiently self-contained to incorporate shopping, recreation, and walking areas. Le Corbusier used basic forms (simple squares, rectangles) for the complexes and set them on pylons to both give more space beneath the buildings and break up their rather blocky look. Many of these buildings would be set in green park areas situated to capture something

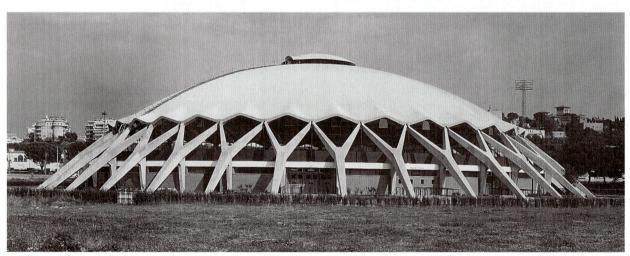

22.41 Eero Saarinen. Trans World Flight Center, Kennedy International Airport, New York, 1962. The building brilliantly shows the sculptural possibilities of concrete. There is a hint of a bird in flight in the general configuration of the roof as it flares out on both sides.

of the natural world and the sun. The basic building material is concrete and steel (often the concrete was not finished or polished since Le Corbusier liked the rough texture of the material). Less-inspired architects have utilized these same concepts for public housing with indifferent success—as visits to the peripheries of most urban centers will attest. Indeed, time has been a harsh

judge of Le Corbusier's vision of human living space which is now judged to be soulless and deadening.

Le Corbusier's influence in North America has been mainly derivative. Two other European architects, however, have had an immense impact on American architecture. Walter Gropius (1883–1969) and Ludwig Miës van der Rohe (1896–1969) came to this country in the late 1930s, refugees from Nazi Germany. Both men had long been associated with the German school of design, the Bauhaus.

Van der Rohe's Seagram Building [22.44] in New York City, designed with Philip Johnson (1906–1991), beautifully illustrates the intent of Bauhaus design. It is a

22.42 Jörn Utzon. Opera House, Sydney, Australia, 1959-1972. Reinforced concrete. Height of highest shell 200' (60.96 m). The building juts dramatically into Sydney's harbor. Structural technology was pushed to the limit by the construction of the shells, which are both roof and walls. The openings between the shells are closed with two layers of amber-tinted glass to reduce outside noise and to open up views to people in the lobbies of the buildings.

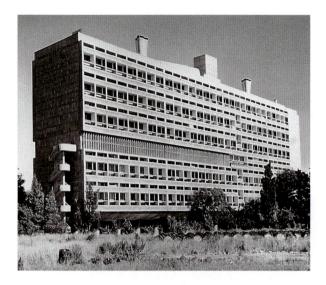

22.43 Le Corbusier. L'Unité d'Habitation, Marseille, France, 1947–1952. Length 550′ (167.64 m), height 184′ (56.08 m), width 79′ (24.08 m). The individual balconies have colored panels to break up the stark rough concrete exterior. Imitation of this style resulted in much soulless public housing in the large cities of the world.

22.44 Ludwig Miës van der Rohe and Philip Johnson. Seagram Building, New York. Height 512′ (156.2 m). Compare the cleanly severe lines of this building to those of the more ornate buildings in the background.

The Seagram Building now seems rather ordinary to us, given the unending procession of glass-and-steel buildings found in most large city centers. That many of these buildings are derivative cannot be denied; that they may result in sterile jungles of glass and metal is likewise a fact. Imitation does not always flatter the vision of the artist but excesses do not invalidate the original goal of the Bauhaus designers. They were committed to crispness of design and the imaginative use of material. In the hands of a master architect that idea is still valid, as the stunning East Wing addition to the National Gallery of Art in Washington, DC, clearly demonstrates [22.45]. This building, designed by I. M. Pei (b. 1917), utilizes pink granite and glass within the limits of a rather rigid geometric design to create a building monumental

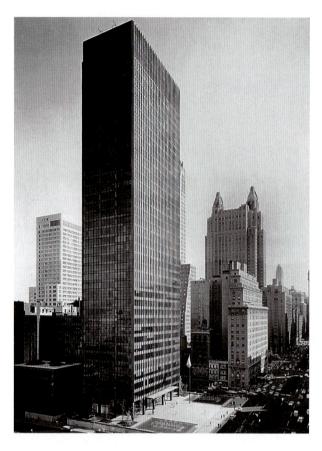

in scale without loss of lightness or crispness of design.

One can profitably contrast the chaste exterior East Wing of Washington's National Gallery with the Georges Pompidou National Center for Arts and Culture in Paris [22.46], designed by Renzo Piano and Richard Rogers. The Pompidou Center was opened in 1977 as a complex of art, musical research, industrial design, and public archives. The architects eschewed the clean lines of Classical sculpture, covering the exterior with brightly colored heating ducts, elevators, escalators, and building supports. It has been a highly controversial building since its inception but Parisians (and visitors) have found it a beautiful and intriguing place. Whether its industrial style will endure is, of course, open to question, but for now its garishness and nervous energy have made it a cultural mecca for visitors to Paris. It may in time even rival that other monument once despised by Parisians and now practically a symbol for the city: the Eiffel Tower.

Since the 1970s, a number of architects, including Philip Johnson and Robert Venturi, have moved beyond the standard modern design of large buildings to reshape them with decorative elements and more broken lines; this break from the severe lines of modernist taste has come to be called *postmodernism* in architecture. The country now has many such buildings but one, a

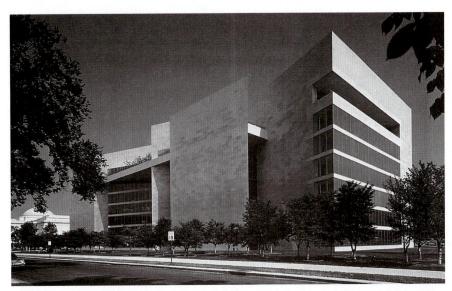

22.45 I. M. Pei. East Wing of the National Gallery of Art, c. 1992, Washington, DC, opened 1978. Pei combined a "modernist" look with a "classical" one that prevents the edifice from clashing with the older buildings on the mall leading to the Capitol.

skyscraper in Seattle, Washington, well illustrates the postmodern sensibility [22.47]. The designer, William Pederson, retains the severe lines and the ample use of glass characteristic of most modern business buildings, but he breaks up those lines with a bowed center of the

22.46 Renzo Piano and Richard Rogers. Georges Pompidou National Center for Arts and Culture, Paris, 1977. In the recent past this center has taken on a lively bohemian air; nearby streets are lined with galleries and adjoining squares are dotted with street performers and musicians.

building that stands in contrast to the classical sides. The higher floors break up the design of the lower floors and, in an almost postmodern signature, he caps the building with a half-arch students will remember seeing on the façades of Renaissance and baroque buildings but whose ultimate inspiration is the Roman half-arch. One architectural critic has said that this building sums up what is best in innovative skyscraper design today. Its sense of color (the stone is a pinkish granite); its homage to Classical decorative motifs; its advance upon Bauhaus severity (without a firm rejection of it)—all summarize what is known as the postmodern in architecture.

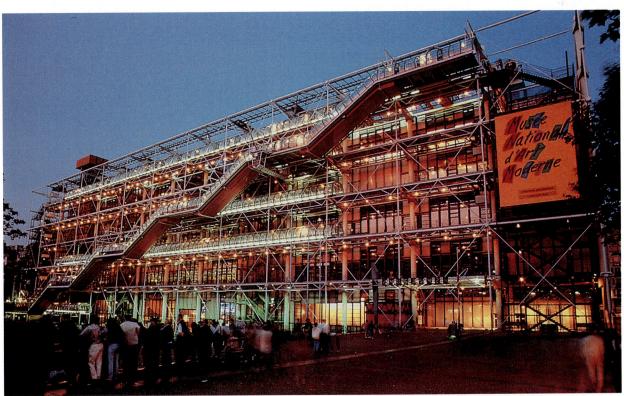

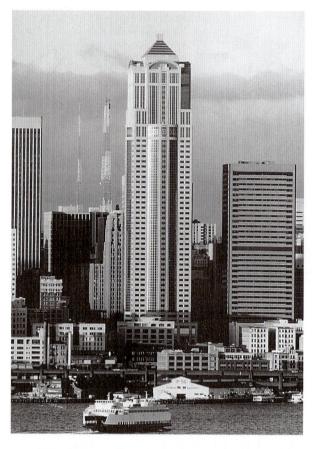

22.47 Kohn, Pederson, Fox. 1201 Third Avenue in Seattle, Washington, 1988. The postmodern character of the building may be seen clearly by contrasting this building with the two office towers to the right and left in the photograph.

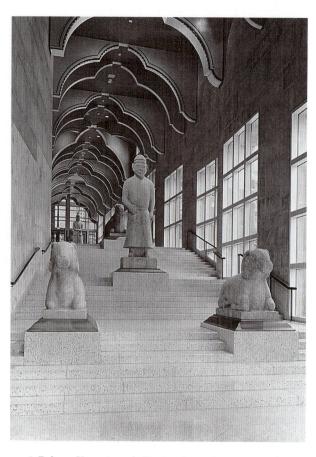

22.48 Robert Venturi and Denise Scott Brown. Seattle Art Museum (interior corridor), 1991. Note the almost orientallooking arches and the perspectival view enhanced by the hidden lighting.

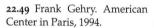

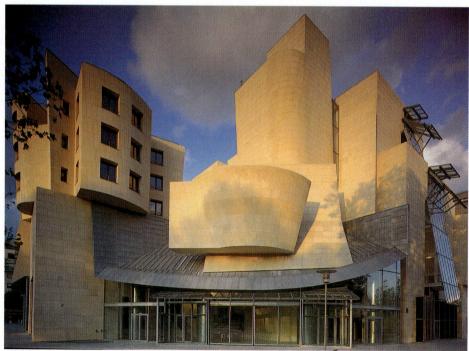

The Seattle Art Museum (1991), designed by the husband and wife team of Robert Venturi and Denise Scott Brown, has many of the same postmodern characteristics with its bold use of color and modification of traditional architectural motifs to provide a startling new vision, which is an advance beyond the modernist ideal [22.48].

A far more radical and "destabilizing" example of postmodern architecture is the innovative work of the Los Angeles-based architect, Frank Gehry (b. 1929) whose recently opened (1994) American Center in Paris [22.49], done in Parisian limestone, is an energetically eccentric work of angles and sweeping lines.

Finally, we should take note of two other museums opened in the 1990s as examples of creative architectural thinking. The New Tate, across the river Thames from Saint Paul's Cathedral in London, is a fine example of how to engage in urban renewal creatively. The museum is housed in what was once a power station. Designed by two Swiss architects—Jacques Herzog and Pierre de Meuron—who turned a massive industrial plant into a severe museum with spacious galleries including the stunning room where once the main dynamo was housed [22.50]. By contrast, the Getty Center (opened in 1997) in the Santa Monica Mountains outside Los Ange-

les is a stunning complex of six buildings faced with sixteen thousand tons of travertine stone quarried in Italy. The architect, Richard Meier, joined forces with the noted environmental artist Robert Irwin to create a multileveled building complex with Irwin's central garden as a unifying centerpiece [22.51].

SOME TRENDS IN CONTEMPORARY LITERATURE

By the end of World War II, literary figures who had defined the modernist temper—like T. S. Eliot, James Joyce, Thomas Mann, Ezra Pound—were either dead or had already published their best work. Their passionate search for meaning in an alienated world, however, still inspired the work of others. The great modernist themes received attention by other voices in other media. The Swedish filmmaker Ingmar Bergman (b. 1918) began a series of classic films starting with his black and white Wild Strawberries in 1956, which explored the loss of religious faith and the demands of modern despair. The enigmatic Irish playwright (who lived in France and wrote in French and English) Samuel Beckett

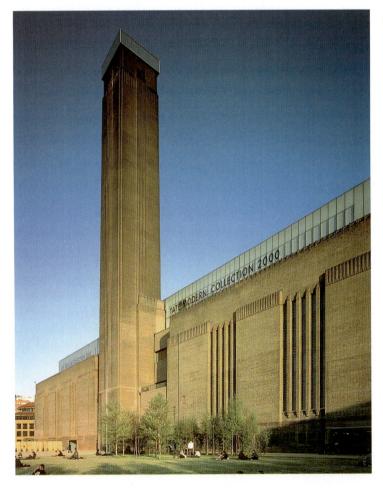

22.50 The new Tate.

22.51 Richard Meier, Getty Center, Los Angeles, 1997.

(1906–1989) produced plays like *Waiting for Godot* (1952), absurdist literature that explores a world beyond logic, decency, and the certainty of language itself.

http://www.kirjasto.sci.fi/beckett.htm

Beckett

Waiting for Godot, for all its apparent simplicity, is maddeningly difficult to interpret. Two characters, Vladimir and Estragon, wait at an unnamed and barren crossroads for Godot. Their patient wait is interrupted by antic encounters with two other characters. In the two acts, each representing one day, a young boy announces that Godot will arrive the next day. At the end of the play Vladimir and Estragon decide to wait for Godot although they toy momentarily with the idea of splitting up or committing suicide if Godot does not come to save them.

The language of *Godot* is laced with biblical allusions and religious puns. Is Godot God and does the play illuminate the nature of an absurd world without final significance? Beckett does not say and critics do not agree, although they are in accord with the judgment that *Waiting for Godot* is a classic—if cryptic—statement about language, human relations, and the ultimate significance of the world.

Gradually, as the war receded in time, other voices relating the horrors of the war experience began to be heard. The most compelling atrocity of the war period, the extermination of six million Jews and countless other dissidents or enemies in the Nazi concentration camps, has resulted in many attempts to tell the world that story. The most significant voice of the survivors of the event is the European-born Elie Wiesel (b. 1928), a survivor of the camps. Wiesel describes himself as a "teller of tales." He feels a duty, beyond the normal duty of art, to keep alive the memory of the near-extermination of his people. Wiesel's autobiographical memoir and arguably his greatest work *Night* (1960) recounts his own years in the camps. It is a terribly moving book with its juxtaposition of a young boy's fervent faith with the demonic powers of the camp.

In the United States, an entirely new generation of writers defined the nature of the American experience. Arthur Miller's play Death of a Salesman (1949) explored the failure of the American Dream in the person of its tragic hero, Willie Loman, an ordinary man defeated by life. J. D. Salinger's The Catcher in the Rye (1951) documented the bewildering coming of age of an American adolescent in so compelling a manner that it was, for a time, a cult book for the young. Southern writers like Eudora Welty, William Styron, Walker Percy, and Flannery O'Connor continued the meditations of William Faulkner about an area of the United States that has tasted defeat in a way no other region has. Poets like Wallace Stevens, Theodore Roethke, William Carlos Williams, and Marianne Moore continued to celebrate the beauties and terrors of both nature and people.

We have already noted that existentialism was well suited to the postwar mood. One aspect of existentialism's ethos was its insistence on protest and human dissatisfaction. That element of existential protest has been very much a part of the postwar scene. The civil rights movement of the late 1950s and early 1960s became a paradigm for other protests such as those against the Vietnam War; in favor of the rights of women; for the rights of the dispossessed, underprivileged, or the victims of discrimination. The literature of protest has been very much a part of this cry for human rights.

First and foremost, one can trace the African Americans' struggle for dignity and full equality through the literature they produced, especially in the period after World War I. The great pioneers were those writers who are grouped loosely under the name "Harlem Renaissance" (discussed in Chapter 21). By refusing the stereotype of "Negro" they crafted an eloquent literature demanding humanity and unqualified justice. The work of these writers presaged the powerful torrent of African American fiction chronicling racial injustice in America. Two novels in particular, Richard Wright's Native Son (1940) and Ralph Ellison's Invisible Man (1952), have taken on the character of American classics. Younger writers followed, most notably James Baldwin, whose Go Tell It on the Mountain (1953) fused vivid memories of black Harlem, jazz, and the intense religion of the black church into a searing portrait of growing up black in America. Alice Walker explored her Southern roots in the explosively powerful The Color Purple (1982).

http://www.kirjasto.sci.fi/jbaldwin.htm

James Baldwin

For many of the younger black writers in America the theme of black pride has been linked with the consciousness of being a woman. Nikki Giovanni (b. 1936) produced a body of poetry celebrating both her sense of "blackness" and her pride in her femininity. Her poetry has been a poetic blend of black history and female consciousness done in an American mode. Similarly, Maya Angelou has become an enormously important voice for the African American community as has Gwendolyn Brooks, whose ties go back to the writers of the Harlem Renaissance.

The rightful claims of women have been advanced currently by an activist spirit that seeks equality of women and men, free from any sexual discrimination. The battle for women's rights began in the nineteenth century. It was fought again in the drive for women's suffrage in the first part of the twentieth century and continues today in the feminist movement. The cultural

oppression of women has been a major concern of the great women writers of our time. Writers like Doris Lessing, Margaret Atwood, Adrienne Rich, Maxine Kumin, and others continue to explore feminine consciousness in great depth and from differing angles of vision.

Two twentieth-century poets deserve particular mention, since both of them dealt so clearly with the dissatisfaction of women. Sylvia Plath (1932–1963) and Anne Sexton (1928–1974) used the imagery of traditional sexual roles to complain about the restraints of their position. Ironically enough, the precociously talented Sylvia Plath and Anne Sexton knew each other briefly when they studied poetry together. Sylvia Plath not only produced an important body of poetry but also a largely autobiographical novel, *The Bell Jar* (1962), describing most of her short and unhappy life. Anne Sexton, by contrast, wrote only poetry. Both, alas, died by their own hand after tortured lives of emotional upheavals.

A Note on the Postmodern

In the past generation some literary critics have been insisting, with varying degrees of acceptance, that much of contemporary literature has moved beyond the modernist preoccupation with alienation, myth, fragmentation of time, and the interior states of the self. The most debated questions now are: What exactly has followed modernism (by definition it is postmodern)? Does it have a shaping spirit? Who are its most significant practitioners? The latter question seems to be the easiest to answer. Many critics would mention the following among those who are setting and defining the postmodernist literary agenda: Italo Calvino in Italy; Jorge Luis Borges in Argentina; Gabriel García Márquez in Colombia; and a strong group of American writers that includes Donald Barthelme, Robert Coover, John Barth, Stanley Elkin, Thomas Pynchon, Renata Adler, Susan Sontag, and Kurt Vonnegut Jr. Borges is perhaps the writer most influential in shaping the postmodern sensibility.

This list of writers represents far-ranging and diverse sensibilities. What do they hold in common that permits them to be considered representative postmodernists? Some critics see the postmodernists as those who push the modernist worldview to its extreme limit. Postmodernist writing, these critics say, is less concerned with traditional plot lines, more antirational, more private in its vision, more concerned in making the work a private world of meanings and significations. This is hardly a satisfactory definition since it merely defines the postmodern as more of the same. It does *not* define, it merely extends the definition. Postmodernism is a form of literary art in the process of birth. It must build on what modernism has accomplished but it must also find its own voice.

It is impossible to create art today as if Cubism or abstract Expressionism had never existed, just as it is impossible to compose music as if Stravinsky had never lived. Further, we cannot live life (or even look at it) as if relativity, atomic weapons, and Freudian explorations of the unconscious were not part of our intellectual and social climate. If art is to become part of the human enterprise, it must surely reflect its past without being a prisoner of it. In fact, most of the great achievements in the arts have done precisely that; they have mastered the tradition and then extended it. The terrain of modernism has been fairly well mapped; it is time to move on. But in which direction?

Music Since 1945

Avant-Garde Developments

Since World War II, many avant-garde composers have been moving toward greater and greater complexity of musical organization, coupled with an increasing use of new kinds of sound. At the same time, other musicians, disturbed by their colleagues' obsessive concern for order, have tried to introduce an element of chance—even chaos—into the creation of a work of music. Both the "structuralists" and the advocates of random music have attracted followers, and only time will tell which approach will prove more fruitful.

Before considering the nature of these two schools in detail, some general observations are in order. It must be admitted that advanced contemporary music presents a tough challenge to the patience, sympathy, and ears of many sincere music lovers. Unlike the visual arts and literature, modern music seems, at least superficially, to have made virtually a complete break with past traditions. Further, much of it seems remote from our actual experience. Developments in painting or architecture are visible around us in one form or another on a daily basis, and modern writers deal with problems that affect us in our own lives. Many creative musicians, however, have withdrawn to the scientific laboratory, where they construct their pieces with the aid of machines and in accordance with mathematical principles. It is hardly surprising that the results may at first seem sterile.

Yet it is well worth making an effort to understand and enjoy the latest developments in music. Concentration and an open mind will remove many of the barriers. So will persistence. Music lovers who listen twenty times to a recording of a Chopin waltz or a Mahler symphony for every one time they listen to a work by Boulez or Stockhausen can hardly expect to make much progress in understanding a new and admittedly difficult idiom. Much of today's music may well not survive the test of time, but it is equally probable that some pieces will become classics in this twenty-first century. By discrimina-

tive listening we can play our own part in judging which music is worthless and which will be of permanent value.

The principle of precise musical organization had already become important in twentieth-century music with the serialism of Arnold Schönberg. Schönberg's ordering of pitch (the melodic and harmonic element of music) in rigidly maintained twelve-tone rows has been extended by recent composers to other elements. Pierre Boulez (b. 1925), for example, constructed rows of twelve-note durations (the length of time each note sounds), twelve levels of volume, and twelve ways of striking the keys for works like his Second Piano Sonata (1948) and Structures for two pianos (1952). In this music, every element (pitch, length of notes, volume, and attack) is totally ordered and controlled by the composer in accordance with his predetermined rows, since none of the twelve components of each row can be repeated until after the other eleven.

The effect of this "total control" is to eliminate any sense of traditional melody, harmony, or counterpoint along with the emotions they evoke. Instead the composer aims to create a pure and abstract "structure" that deliberately avoids any kind of subjective emotional expression.

There remains, however, one element in these piano works that even Boulez cannot totally control: the human element. All the composer's instructions, however precise, have to be interpreted and executed by a performer, and as long as composers are dependent on performers to interpret their works they cannot avoid a measure of subjectivity. Different pianists will inevitably produce different results, and even the same pianist will not produce an identical performance on every occasion.

It was to solve this problem that in the 1950s some composers began to turn to *electronic music*, the sounds of which are produced not by conventional musical instruments but by an electronic oscillator, a machine that produces pure sound waves. A composer can order the sounds by means of a computer and then transfer these to recording tape for playback. In the past few years the process of manipulating electronic sound has been simplified by the invention of the *synthesizer* (an electronic instrument that can produce just about any kind of sound effect). In combination with a computer, machines like the Moog synthesizer can be used for either original electronic works or creating electronic versions of traditional music, as in the popular "Switched-on Bach" recordings of the 1960s.

From its earliest days, electronic music has alarmed many listeners by its apparent lack of humanity. The whistles, clicks, and hisses that characterize it may be eerily appropriate to the mysteries of the Space Age, but have little to do with *traditional* musical expression. Indeed, composers of electronic music have had considerable difficulty in inventing formal structures for organizing the vast range of sounds available to them. In

addition, there still exists no universally agreed-on system of writing down electronic compositions, most of which exist only on tape. It is probably significant that even Karlheinz Stockhausen (b. 1928), one of the leading figures in electronic music, has tended to combine electronic sounds with conventional musical instruments [22.52]. His *Mixtur* (1965), for example, is written for five orchestras, electronic equipment, and loudspeakers. During performance the sounds produced by the orchestral instruments are electronically altered and simultaneously mixed with the instrumental sound and prerecorded tape. In this way an element of live participation has been reintroduced.

For all its radical innovations, however, *Mixtur* at least maintains the basic premise of music in the Western tradition: that composers can communicate with their listeners by predetermining ("composing") their works according to an intellectual set of rules. The laws of baroque counterpoint, classical sonata form, or Stockhausen's ordering and altering of sound patterns all represent systems that have enabled composers to plan and create musical works. One of the most revolutionary of all recent developments, however, has been the invention of *aleatoric* music. The name is derived from the Latin

22.52 From Karlheinz Stockhausen. *nr.* 11 Refrain, 1961. Universal Editions, Ltd., London. Used by permission. This portion of the score was reproduced in the composer's own work, *Test on Electronic and Instrumental Music*. The system of musical notation that Stockhausen devised for this piece is as revolutionary as the music itself; it is explained in a preface to the score.

word *alea* (a dice game) and is applied to music in which an important role is played by the element of chance.

One of the leading exponents of this genre of music is the American composer John Cage (1912-1992), who had been much influenced by Zen philosophy. Adopting the Zen attitude that one must go beyond logic in life, Cage argued that music should reflect the random chaos of the world around us and so does not seek to impose order on it. His Concert for Piano and Orchestra (1958) has a piano part consisting of eighty-four different "sound events," some, all, or none of which are to be played in any random order. The orchestral accompaniment consists of separate pages of music, some, all, or none of which can be played by any (or no) instrument, in any order and combination. Clearly, every performance of the Concert is going to be a unique event, largely dependent upon pure chance for its actual sound. In other pieces, Cage instructed the performers to determine the sequence of events by even more random methods, including the tossing of coins.

Works like these are, of course, more interesting for the questions they ask about the nature of music than for any intrinsic value of their own. Cage partly reacted against what he regarded as the excessive organization and rigidity of composers like Boulez and Stockhausen, but at the same time he also raised some important considerations. What is the function of the artist in the modern world? What is the relationship between creator and performer? And what part, if any, should the listeners themselves play in the creation of a piece of music? Need it always be a passive part? If Cage's own answers to questions like these may not satisfy everyone, he had at least posed the problems in an intriguing form.

The New Minimalists

A very different solution to the search for a musical style has been proposed by a younger generation of American composers. Steve Reich (b. 1936) is one of the first musicians to build lengthy pieces out of the multiple repetition of simple chords and rhythms. Critics sometimes assume that the purpose of these repetitions is to achieve a hypnotic effect by inducing a kind of state of trance. Reich himself stated that his aim is, in fact, the reverse: a state of heightened concentration.

In *The Desert Music*, a composition for chorus and instruments completed in 1983, Reich's choice of texts is helpful to an understanding of his music. The work's central section consists of a setting of words by the American poet William Carlos Williams (1883–1963):

It is a principle of music to repeat the theme. Repeat and repeat again, as the pace mounts. The theme is difficult but no more difficult than the facts to be resolved.

622

The piece begins with the pulsing of a series of broken chords, which is sustained in a variety of ways, chiefly by tuned mallets. This pulsation, together with a wordless choral vocalization, gives the work a rhythmical complexity and richness of sound that is at times reminiscent of some African or Balinese music.

The works of Philip Glass (b. 1937) are even more openly influenced by non-Western music. Glass studied the Indian tabla drums for a time; he is also interested in West African music, and has worked with Ravi Shankar, the great Indian sitar virtuoso. Many of Glass' compositions are based on combinations of rhythmical structures derived from classical Indian music. They are built up into repeating modules, the effect of which has been likened by unsympathetic listeners to a needle stuck in a record groove.

Length plays an important part in Glass' operas, for which he has collaborated with the American dramatist Robert Wilson. Wilson, like Glass, is interested in "apparent motionlessness and endless durations during which dreams are dreamed and significant matters are understood." Together they have produced three massive stage works in the years between 1975 and 1985: Einstein on the Beach, Satyagraha, and Akhnaten. The performances involve a team of collaborators that includes directors, designers, and choreographers; the results have the quality of a theatrical "happening." Although a description of the works makes them sound remote and difficult, performances of them have been extremely successful. Even New York's Metropolitan Opera House, not famous for an adventurous nature in selecting repertory, was sold out for two performances of Einstein on the Beach. Clearly, whatever its theoretical origins, the music of Glass reaches a wide public.

Traditional Approaches to Modern Music

Not all composers have abandoned the traditional means of musical expression. Musicians like Benjamin Britten (1913–1976) and Dmitri Shostakovich (1906–1975) demonstrated that an innovative approach to the traditional elements of melody, harmony, and rhythm can still produce exciting and moving results. And neither can be accused of losing touch with the modern world. Britten's *War Requiem* (1962) is an eloquent plea for an end to the violence of contemporary life, whereas Shostakovich's entire musical output reflects his uneasy relationship with Soviet authority. His *Symphony No. 13* (1962) includes settings of poems by the Russian poet Yevtushenko on anti–Semitism in Russia and earned him unpopularity in Soviet artistic and political circles.

http://www.siue.edu/~aho/musov/dmitri.html

Dmitri Shostakovich

Both Britten and Shostakovich did not hesitate to write recognizable "tunes" in their music. In his last

symphony, *No.* 15 (1971), Shostakovich even quoted themes from Rossini's *William Tell Overture* (the familiar "Lone Ranger" theme) and from Wagner. The work is at the same time easy to listen to and deeply serious. Like much of Shostakovich's music, it is concerned with the nature of death (a subject also explored in his *Symphony No.* 14). Throughout its four movements, Shostakovich's sense of rhythm is much in evidence, as is his feeling for orchestral color, in which he demonstrates that the resources of a traditional symphony orchestra are far from exhausted. The final mysterious dying close of *Symphony No.* 15 is especially striking in its use of familiar ingredients—repeating rhythmic patterns, simple melodic phrases—to achieve an unusual effect.

If Shostakovich demonstrated that a musical form as old-fashioned as the symphony can still be used to create masterpieces, Britten did the same for opera. His first great success, Peter Grimes (1945), employed traditional operatic devices like arias, trios, and choruses to depict the tragic fate of its hero, a man whose alienation from society leads to his persecution at the hands of his fellow citizens. In other works, Britten followed the example of many of his illustrious predecessors in turning to earlier literary masterpieces for inspiration. A Midsummer Night's Dream (1960) is a setting of Shakespeare's play, while Death in Venice (1973) is based on the story by Thomas Mann. In all of his operas Britten writes music that is easy to listen to (and, equally important, not impossible to sing), but he never condescends to his audience. Each work deals with a recognizable area of human experience and presents it in a valid musical and dramatic form. It is always dangerous to make predictions about the verdict of posterity, but from today's vantage point the music of Britten seems to have as good a chance as any of surviving in this new century.

Popular (Pop) Music

No discussion of music since 1945 would be complete without mentioning pop music, the worldwide appeal of which is a social fact of our times. Much of pop music is American in origin, although its ancestry is deeply rooted in the larger Western musical tradition. Its development both in this country and abroad is so complex as to be outside the scope of this book. One cannot adequately describe in a few pages the character of folk music, rhythm and blues, country and western, and the various shades of rock, much less sketch out their tangled interrelationships.

A single example demonstrates this complexity. During the 1960s, protest singers like Joan Baez, Pete Seeger, and Bob Dylan had in their standard repertoire a song called "This Land Is Your Land." The song had been written by Woody Guthrie as an American leftist reaction to the sentiments expressed in Irving Berlin's "God Bless America." Guthrie had adapted an old mountain ballad sung by the Carter Family—a formative part of country

and western music at the Grand Ole Opry since the late 1920s. The Carters played and sang mountain music that was a complex blending of old English balladry, Scottish drills, some black music, and the hymn tradition of the mountain churches.

The worldwide appeal of pop music must be recognized. The numbers in themselves are staggering. Between 1965 and 1973, nearly twelve hundred different recorded versions of the Beatles' song "Yesterday" (written by Paul McCartney and John Lennon) were available. By 1977, the Beatles had sold over one hundred million record albums and the same number of singles. Elvis Presley had sold more than eighty million singles at the time of his death in 1977; today, some years after his death, all his major albums remain in stock in record stores. Bootleg tapes and cassettes are prized in those places of the world where political and social oppression are facts of life.

The very best of popular music, both folk and rock, is sophisticated and elegant. Classic rock albums of the Beatles like Revolver reflect influences from the blues, ballads, the music of India, jazz harmonies, and some baroque orchestrations. The talented (and outrageous) Frank Zappa and the Mothers of Invention dedicated their 1960s album Freak Out to "Charles Mingus, Pierre Boulez, Anton Webern, Igor Stravinsky, Willie Dixon, Guitar Slim, Edgar Varèse, and Muddy Waters." Zappa's experiments with mixing rock and classical music were deemed serious enough for the celebrated conductor Zubin Mehta and the Los Angeles Philharmonic to have attempted some joint concerts. The popular folksinger Judy Collins' most successful album of the 1960s-Wildflowers—was orchestrated and arranged by Joshua Rifkin, a classical composer once on the music faculty of Princeton University. The crossbreeding of folk, rock, and classical modes of music continues with increasing interest in the use of electronics and advanced amplification systems.

The folk and rock music of the 1960s saw itself in the vanguard of social change and turmoil. Rock music was inextricably entwined with the youth culture. In fact, popular music provided one of the most patent examples of the so-called Generation Gap. If the Beatles upset the older generation with their sunny irreverence, their coded language about drugs, and their open sexuality, groups like the Rolling Stones were regarded by many as a clear menace to society. With their hard-driving music, their aggressive style of life, their sensuality, and their barely concealed flirtation with violence and nihilism, the Stones were seen by many as a living metaphor for the anarchy of the turbulent 1960s. It was hardly reassuring for parents to see their young bring home a Stones album titled Their Satanic Majesties Request inside the cover of which is an apocalyptic collage of Hieronymus Bosch, Ingres, Mughal Indian miniatures, and pop photography. Neither were many consoled when the violence of the music was translated into actual violence as rock stars like Jimi Hendrix, Janis Joplin, Phil Ochs, and Jim Morrison destroyed themselves with alcohol or drugs. Contemporary concerns with the social consequences of everything from heavy metal to rap music must be seen against the background of criticism of popular music that goes far back into our past.

Whatever the long-range judgment of history may be, pop music in its variegated forms is as much an indicator of our present culture as the novels of Dickens were of the nineteenth century. It partakes of both brash commercial hype and genuine social statement. The record album of a major rock group today represents the complex interaction of advanced technology, big business, and high-powered marketing techniques as well as the music itself. Likewise, a rock concert is no mere live presentation of music to an audience; it is a multimedia "happening" in which the plastic arts, dramatic staging, sophisticated lighting and amplification, and a medley of other visual and aural aids are blended to create an artistic whole with the music. Beyond (or under) this glitter, notoriety, and hype, however, is a music arising from real issues and expressing real feelings. New wave punk rock and heavy metal music, for instance, reflected the alienation of the working-class youth of Great Britain in the 1970s and 1980s. The rise of rap music, born in the African American experience, has grown into a cultural phenomenon that crosses racial and ethnic boundaries.

Finally, pop music is not a phenomenon of the moment alone. Its roots are in the tribulations of urban African Americans, the traditionalism of rural Anglos, the protest of activists, and the hopes and aspirations of the common people, causes with a lengthy history in the United States yet still alive today. Pop music, then, is both a social document of our era and a record of our past.

The very best pop music hymns the joy of love, the anxiety of modern life, the yearning for ecstasy, and the damnation of institutionalized corruption. Rock music in particular creates and offers the possibility of ecstasy. For those who dwell in the urban wastelands of post-technological America or the stultifying structures of post-Stalinist Eastern Europe the vibrant beat and incessant sound of rock music must be a welcome, if temporary, refuge from the bleakness of life.

Now in the twenty-first century, the popular music scene shows two new trends that coincide with some of the themes we have noted in this chapter.

First, advances in communication technology have not only spawned the music video (in which the visual arts, drama, and music can be joined in a single art experience) but—with the easy access of cable television linkups—it is now also possible to air transcontinental performances (like the famous Live Aid show of 1985) in which rock concerts take on a simultaneous character and showcase the international idiom of rock music. This communication revolution has taken a further step with the easy access of the Internet.

Second, and closely allied to the first trend, there has been a powerful crossfertilization of music brought about through easy communication. Rock music, with its old roots in American forms of music, has now expanded to absorb everything from Caribbean and Latin American music to the music of West Africa and Eastern Europe. If there is any truth in the thesis of the global culture it is most easily seen, in its infant stages, in the world of popular music.

SUMMARY

This chapter deals with Western culture after the time of World War II. In the postwar period, with Europe in shambles and the Far East still asleep, we confidently felt that the twentieth was the American century; many people, not always admiringly, spoke of the "Coca-Colazation" of the world. From the vantage point of the beginning of the twenty-first century we see that, however powerful the United States may be, there now exist other countervailing powers, as the economic power of Japan readily demonstrates.

This postwar period also saw some dramatic shifts in the arts. The modernist temper that prevailed both in literature and in the arts had its inevitable reaction. The power of the New York School of painting (abstract expressionism/color-field painting/minimalism) has been challenged by new art forces, mainly from Europe, that emphasize once again the picture plane and the expressive power of emotion. In literature, the modernist temper exemplified in writers like Eliot, Woolf, and others gave way to a postmodern sensibility represented in writers who are from Latin America, Japan, and Europe. Increasing attention is being paid to the writers from both Eastern Europe and Africa.

Out of the human rights movement of the past decades has arisen a determined effort to affirm the place of women in the world of the arts both by retrieving their overlooked work from the past and by careful attention to those at work today. Similarly, individuals of color—both male and female—have come to the attention of large audiences as the arts democratize. Contemporary debates over the core humanities requirements in universities (Should they restrict themselves to the old "classics" or should they represent many voices and many cultures?) simply reflect the pressures of the culture, which is no longer sure of its older assumptions.

No consensus exists on a humanistic worldview. The postwar power of existentialism sprang both from its philosophical ideas and from its adaptability to the arts, especially the literary arts. Although the writings of Albert Camus are still read and the plays of Beckett and Ionesco are still performed, these now reflect a settled place in the literary canon with no new single idea providing the power to energize the arts as a whole.

It may well be that the key word to describe the contemporary situation is *pluralism*: a diversity of influences, ideas, and movements spawned by an age of instant communication and ever-growing technology. The notion of a global culture argues for a common culture growing out of mutual links. There is some evidence of commonality, but it must be said that in other areas there are regional differences and even antagonisms. What we seem to be seeing in an age when more people than ever before buy books, see films, watch television, listen to tapes and CDs, go to plays and concerts, and use the Internet is a situation the Greek philosophers wrote about millennia ago—the curious puzzle about the relationship of unity and diversity in the observable world: We are one, but we are also many.

Pronunciation Guide

Borges: BOR-hays
Boulez: Boo-lez
Camus: Cam-OO

existentialism: eggs-es-TEN-shall-ism

Godot: go-DOUGH

Le Corbusier: Luh Cor-BOO-see-ay
Miës van der Rohe: MEESE van der ROW-eh

Rauschenberg:RAU-shen-bergSøren Kierkegaard:SORE-en Keer-ke-garShostakovich:Shah-stah-KO-vich

Wiesel: Vee-ZELL

EXERCISES

- 1. When we look at abstract Expressionist art it is tempting to believe that "anyone could do that." But *can* "anyone" do it? How does one go about describing in writing the character of abstract art?
- 2. Look closely at a work by Alexander Calder. Would a Classical sculptor (Rodin, Michelangelo) have recognized Calder's work as "sculpture"? What makes it different? Why is it called sculpture?
- 3. After reading Sartre's essay on existentialism, ask your-self: Is this a philosophy that could serve as a guide to my life? Give the reasons for your answer.
- 4. Look carefully at your campus buildings. Does "form follow function"? Is "less more"? Can you detect the styles that influenced the campus architect?
- 5. A classic is said to have a "surplus of meaning"—it is so good that one can always go back and learn more from it. Are there compositions in popular music that are now "classics" in that sense? List five songs that still inspire musicians today.
- 6. Have the new forms of communication (especially television) made you less of a reader? How does reading differ from watching television? How does looking at art differ from looking at television? listening to music? Has the Internet changed your life? Explain.

FURTHER READING

Armstong, T., et al. (1976). 200 years of American sculpture. New York: Whitney Museum. This well-illustrated catalogue has abundant bibliographies. A good first look at sculpture in this country from a historical perspective.

Broude, N., & M. Garrard. (Eds.). (1990). *The power of feminist art*. New York: Abrams. A good survey of the 1960s and

Cage, J. (1969). *Silence*. Cambridge: MIT Press. A manifesto from one of the leaders of the artistic avant-garde.

Cantor, N. F. (1988). Twentieth-century culture: Modernism to deconstruction. New York: Peter Lang. A survey of critical theory in this century that includes developments after structuralism.

Docker, J. (1994). *Postmodernism and popular culture: A cultural history*. New York: Cambridge University Press. An excellent but difficult interdisciplinary study.

Glass, P., & R. T. Jones. (1987). *Music by Philip Glass*. New York: Harper & Row. A good introduction to the minimalist spirit in music, with a discography.

Goldberger, P. (1983). On the rise: Architecture and design in the post modern age. New York: Penguin. An excellent survey of contemporary trends by the New York Times' architecture critic.

Hilberg, R. (1967). The destruction of the European Jews. Chicago, IL: Quadrangle. The standard history of the subject; essential background for reading Wiesel and other Holocaust authors.

Hughes, R. (1990). Nothing if not critical: Selected essays. New York: Knopf. Readable cultural criticism by the author of The Shock of the New.

Kaufmann, W. (Ed.). (1975). Existentialism from Dostoevsky to Sartre. New York: New American Library. A standard anthology, although not everyone agrees that "revolt" is the prime category for understanding the movement.

Rose, B. (1986). American painting in the twentieth century. New York: Rizzoli. Especially good on the New York School of art.

Rubin, W. (1980). *Pablo Picasso: A retrospective*. New York: Museum of Modern Art. This profusely illustrated catalogue sums up a good deal of the twentieth century with its scholarly concentration on the century's major figure in art.

Sandler, I. (1970). The triumph of American painting. New York: Praeger. Sandler is the best chronicler of the New York School of painting.

Yates, G. G. (1975). What women want: The idea of the movement. Cambridge, MA: Harvard University Press. A good introduction to the feminist movement considered historically.

ONLINE CHAPTER LINKS

A wide range of information related to Existentialism is available at

http://www.tameri.com/csw/exist/exist.html

For information about Georgia O'Keeffe, visit the Georgia O'Keeffe Museum at

http://www.okeeffemuseum.org/indexflash.html

or The Georgia O'Keeffe Online Gallery at http://www.happyshadows.com/okeeffe/

For information about Andy Warhol, visit the *Andy Warhol Museum*

http://www.warhol.org/ and The Andy Warhol Homepage http://www.warhol.dk/

All-Wright Site: An Internet Guide to Frank Lloyd Wright at

http://www.geocities.com/SoHo/1469/flw.html offers a complete guide to the architect's built work, along with pages concerning his life and quotations, as well as links to other relevant Internet sites.

Elie Wiesel: Teacher Resource File at http://www.kirjasto.sci.fi/wiesel.htm provides links to a wide variety of Internet resources.

Information about Richard Wright is available at http://www.itvs.org/RichardWright/http://www.olemiss.edu/depts/english/ms-writers/dir/wright_richard/http://www.pbs.org/rwbb/rwtoc.html

The Ralph Ellison Webliography at

http://www.centerx.gseis.ucla.edu/weblio/ellison.html provides extensive information about the author of *Invisible Man*, including a biography, book reviews, photographs, and links to additional Internet resources.

Nikki Giovanni's own Web site is available at http://athena.english.vt.edu/Giovanni/cv/biog.html

Shostakovich.com at

http://www.shostakovich.org/

dedicated to the music of Dmitri Shostakovich, features a catalogue of his works, a recording guide, and a list of related Internet resources.

Extensive information about Bob Dylan is available at

http://rollingstone.com/sections/artists/text/ artistgen.asp?afl=googl&LookUpString=184 which features a biography, discography, photograph gallery, and article archive.

For information about Leonard Bernstein, visit http://www.leonardbernstein.com/ http://www.users.globalnet.co.uk/~mcgoni/

Karadar Classical Music at

http://www.karadar.it/Dictionary/Default.htm provides an alphabetical listing of musicians with brief biographies and a list of works (some of which are available on MIDI files).

For a catalog of useful links to Internet resources, consult *Twentieth Century Music Links* at http://classicalmus.hispeed.com/twentieth.html

Terms italicized within the definitions are themselves defined within the Glossary.

a capella Music sung without instrumental accompaniment.

abacus (1) The slab that forms the upper part of a capital. (2) A computing device using movable counters.

academy Derived from Akademeia, the name of the garden where Plato taught his students; the term came to be applied to official (generally conservative) teaching establish-

accompaniment The musical background to a melody.

acoustics The science of the nature and character of sound.

acropolis Literally, the high point of a Greek city, frequently serving as refuge in time of war. The best known is the Acropolis of Athens.

acrylic A clear plastic used to make paints and as a casting material in sculpture.

adagio Italian for "slow"; used as an instruction to musical performers.

adobe Sun-dried mud brick.

aesthetic Describes the pleasure derived from a work of art, as opposed to any practical or informative value it might have. In philosophy, aesthetics is the study of the nature of art and its relation to human experience.

agora In ancient Greek cities, the open marketplace, often used for public meetings.

aisle In church architecture, the long open spaces parallel to the nave.

aleatory music Music made in a random way after the composer sets out the elements of the musical piece.

allegory A dramatic or artistic device in which the superficial sense is accompanied by a deeper or more profound meaning.

allegro Italian for "merry" or "lively"; a musical direction.

altar In ancient religion, a table at which offerings were made or victims sacrificed. In Christian churches, a raised structure at which the sacrament of the Eucharist is consecrated, forming the center of the ritual.

altarpiece A painted or sculptured panel placed above and behind an altar to inspire religious devotion.

alto The lowest range of the female voice, also called contralto.

ambulatory Covered walkway around the apse of a church.

amphora Greek wine jar.

anthropomorphism The endowing of nonhuman objects or forces with human characteristics.

antiphony Music in which two or more voices alternate with one another.

apse Eastern end of a church, generally semicircular, in which the altar is housed

architecture The art and science of designing and constructing buildings for human use.

architrave The lowest division of an entablature.

archivault The molding that frames an

aria Song for a solo voice in an opera, an oratorio, or a cantata.

Ars Nova Latin for "the New Art." Describes the more complex new music of the fourteenth century, marked by richer harmonies and elaborate rhythmic devices.

assemblage The making of a sculpture or other three-dimensional art piece from a variety of materials. Compare collage, montage.

atelier A workshop.

atonality The absence of a key or tonal center in a musical composition.

atrium An open court in a Roman house or in front of a church.

augmentation In music, the process of slowing down a melody or musical phrase by increasing (generally doubling) the length of its notes.

aulos Greek wind instrument, similar to an oboe but consisting of two pipes.

autocracy Political rule by one person of unlimited power.

avant-garde French for advance-guard. Term used to describe artists using innovative or experimental techniques.

axis An imaginary line around which the elements of a painting, sculpture or building are organized; the direction and focus of these elements establishes the axis.

ballad A narrative poem or song with simple stanzas and a refrain which is usually repeated at the end of each stanza.

ballet A dance performance, often involving a narrative or plot sequence, usually accompanied by music.

band A musical performance group made up of woodwind, brass, and percussion, but no strings.

baritone The male singing voice of medium register, between bass and tenor.

barrel vault A semicircular vault unbroken by ribs or groins.

basilica Originally a large hall used in Roman times for public meetings, law courts, etc.; later applied to a specific type of early Christian church.

bas-relief Low relief; see relief.

bass The lowest range of the male voice. beat The unit for measuring time and meter in music.

Berber Muslim peoples of North Africa. binary form A two-part musical form in which the second part is different from the first, and both parts are usually repeated.

bitonality A musical technique involving the simultaneous performance of two melodies in different tonalities.

black figure A technique used in Greek vase painting which involved painting figures in black paint in silhouette and incising details with a sharp point. It was used throughout the Archaic period. Compare red figure.

blank verse Unrhymed verse often used in English epic and dramatic poetry. Its meter is iambic pentameter.

Compare heroic couplet.

blue note A flattened third or seventh note in a chord, characteristic of jazz and blues.

brass instruments The French horn, trumpet, trombone, and tuba, all of which have metal mouthpieces and

Bronze Age The period during which bronze (an alloy of copper and tin) was the chief material for tools and weapons. It began in Europe around 3000 B.C. and ended around 1000 B.C. with the introduction of iron.

Buddha Literally "The Enlightened One." Title of Siddartha Gautama.

burin Steel tool used to make copper en-

buttress An exterior architectural support.

cadenza In music, a free or improvised passage, usually inserted toward the end of a movement or aria, intended to display the performer's technical skill.

caliph An Arabic term for leader or ruler.

calligraphy The art of penmanship and lettering—literally "beautiful writ-

campanile In Italy the bell tower of a church, often standing next to but separate from the church building.

- canon From the Greek meaning a "rule" or "standard." In architecture it is a standard of proportion. In literature it is the authentic list of an author's works. In music it is the melodic line sung by overlapping voices in strict imitation. In religious terms it represents the authentic books in the Bible or the authoritative prayer of the Eucharist in the Mass or the authoritative law of the church promulgated by ecclesiastical authority.
- cantata Italian for a piece of music that is sung rather than played; an instrumental piece is known as a *sonata*.
- cantus firmus Latin for "fixed song," a system of structuring a polyphonic composition around a preselected melody by adding new melodies above and/or below. The technique was used by medieval and Renaissance composers.
- **canzoniere** The Italian word for a songbook.
- capital The head, or crowning part, of a column, taking the weight of the entablature.
- **capitulary** A collection of rules or regulations sent out by a legislative body.
- cartoon (1) A full-scale preparatory drawing for a picture, generally a large one such as a wall painting. (2) A humorous drawing.
- caryatid A sculptured female figure taking the place of a column.
- cast A molded replica made by a process whereby plaster, wax, clay, or metal is poured in liquid form into a mold. When the material has hardened the mold is removed, leaving a replica of the original from which the mold was taken.
- catharsis Literally, "purgation." Technical term used by Aristotle to describe the emotional effect of a tragic drama upon the spectator.
- cathedra The bishop's throne. From that word comes the word cathedral, i.e., a church where a bishop officiates.
- **cella** Inner shrine of a Greek or Roman temple.
- ceramics Objects made of baked clay, such as vases and other forms of pottery, tiles, and small sculptures.
- **chamber music** Music written for small groups.
- chancel The part of a church that is east of the nave and includes choir and sanctuary.
- chant A single line of melody in free rhythm and unaccompanied. The term is most frequently used for liturgical music such as Gregorian or Ambrosian chant.
- **chapel** A small space within a church or a secular building such as a palace or

- castle, containing an *altar* consecrated for ritual use.
- **chevet** The eastern (altar) end of a church.
- chiaroscuro In painting, the use of strong contrasts between light and dark.
- choir The part of a church chancel between nave and sanctuary where the monks sing the Office; a group of singers.
- **chorale** A simple hymn tune sung either in unison or harmonized.
- **chord** Any combination of three or more notes sounded together.
- chorus In ancient Greek drama, a group of performers who comment collectively on the main action. The term came to be used, like *choir*, for a group of singers.
- **cithara** An elaborate seven-string *lyre* used in Greek and Roman music.
- classical Generally applied to the civilizations of Greece and Rome; more specifically to Greek art and culture in the fifth and fourth centuries B.C. Later imitations of classical styles are called neoclassical. Classical is also often used as a broad definition of excellence: a "classic" can date to any period.
- clavecin French for "harpsichord." clef French for "key." In written music the term denotes the sign placed at the beginning of the staff to indicate the range of notes it contains.
- **clerestory** A row of windows in a wall above an adjoining roof.
- cloister The enclosed garden of a monastery, surrounded by a covered walkway; by extension the monastery itself. Also, a covered walkway alone.
- coda Italian for "tail." Final section of a musical movement in sonata form, summing up the previous material.
- codex A manuscript volume.
- **coffer** In *architecture*, a recessed panel in a ceiling.
- **collage** A composition produced by pasting together disparate objects such as train tickets, newspaper clippings, or textiles. Compare *assemblage*, *montage*.
- colonnade A row of columns.
- comedy An amusing and lighthearted play or narrative intended to provoke laughter on the part of the spectator; or a work with a happy ending.
- **composer** The writer of a piece of music.
- composition Generally, the arrangement or organization of the elements that make up a work of art. More specifically, a piece of music.
- **concerto** A piece of music for one or more solo instruments and *orchestra*,

- usually with three contrasting move-
- **concerto grosso** A piece of music similar to a *concerto* but designed to display the *orchestra* as a whole.
- concetto Italian for "concept." In Renaissance and Baroque art, the idea that undergirds an artistic ensemble.
- **consul** One of two Roman officials elected annually to serve as the highest state magistrates in the Republic. **contralto** See *alto*.
- contrapposto In sculpture, placing a human figure so that one part (e.g., the shoulder) is turned in a direction opposite to another part (e.g., the hip
- and leg).cori spezzati Italian for "split choirs."The use of two or more choirs for a musical performance.
- Corinthian An order of architecture that was popular in Rome, marked by elaborately decorated capitals bearing acanthus leaves. Compare Doric, Ionic.
- cornice The upper part of an *entablature*.
 counterpoint Two or more distinct melodic lines sung or played simultaneously in a single unified composition.
- **crescendo** In music, a gradual increase in volume.
- **cruciform** Arranged or shaped like a cross.
- crypt A vaulted chamber, completely or partially underground, which usually contains a chapel. It is found in a church under the choir.
- cult A system of religious belief and its followers.
- cuneiform A system of writing, common in the ancient Near East, using characters made up of wedge shapes. Compare hieroglyphics.
- da capo Italian for "from the beginning." In a musical performance, return to and repetition of the beginning section.
- **daguerreotype** Early system of photography in which the image is produced on a silver-coated plate.
- **decrescendo** In music, a gradual decrease in volume.
- design The overall conception or scheme of a work of art. In the visual arts, the organization of a work's composition based on the arrangement of lines or contrast between light and dark.
- **development** Central section of a *sonata-form* movement, in which the themes of the exposition are developed.
- **dialectics** A logical process of arriving at the truth by putting in juxtaposi-

- tion contrary propositions; a term often used in medieval philosophy and theology, and also in the writings of Hegel and Marx.
- **diatonic** The seven notes of a major or minor *scale*, corresponding to the piano's white *keys* in an *octave*.
- **diminuendo** In music, a gradual decrease in volume.
- Daiymo A Japanese war lord.
- diminution The speeding up of a musical phrase by decreasing (usually halving) the length of the notes.
- dithyramb Choral hymn to the Greek god Dionysus, often wild and violent in character. Later, any violent song, speech, or writing. Compare paean.
- dome A hemispherical vault.
- **dominant** The fifth note of a *diatonic* scale.
- **Doric** One of the Greek orders of *architecture*, simple and austere in style. Compare *Corinthian*, *Ionic*.
- **dramatis personae** Latin for characters in a play.
- **dynamics** In music, the various levels of loudness and softness of sound, together with their increase and decrease.
- echinus The lower part of the *capital*. elevation In *architecture*, a drawing of the side of a building which does not show perspective.
- **encaustic** A painting technique using molten wax colored by pigments.
- engraving (1) The art of producing a depressed design on a wood or metal block by cutting it in with a tool. (2) The impression or image made from such a wood or metal block by ink that fills the design. Compare burin, etching, woodcut.
- entablature The part of a Greek or Roman temple above the columns, normally consisting of architrave, frieze, and cornice.
- entasis The characteristic swelling of a Greek column at a point about a third above its base.
- **epic** A long narrative poem celebrating the exploits of a heroic character.
- **Epicurean** A follower of the Greek philosopher Epicurus, who held that pleasure was the chief aim in life.
- epithet Adjective used to describe the special characteristics of a person or object.
- **essay** A short literary composition, usually in prose, dealing with a specific topic.
- etching (1) The art of producing a depressed design on a metal plate by cutting lines through a wax coating and then applying corrosive acid that removes the metal under the lines.

- (2) The impression or image made from such a plate by ink that fills the design. Compare *engraving*, *woodcut*.
- ethos Greek word meaning "character."

 In general, that which distinguishes a particular work of art and gives it character. More specifically, a term used by the Greeks to describe the moral and ethical character that they ascribed to music.
- evangelist One of the authors of the four *Gospels* in the Bible: Matthew, Mark, Luke, and John.
- **exposition** In music, the statement of the themes or musical ideas in the first section of a *sonata-form movement*.
- façade The front of a building.
 ferroconcrete A modern building material consisting of concrete and steel reinforcing rods or mesh.
- finale In music, the final section of a large instrumental composition or of the act of an *opera*.
- flagellants Persons who whip themselves out of religious devotion.
- flat A symbol () used in music to signify that the note it precedes should be lowered by one half-step.
- **flute** Architectural term for the vertical grooves on Greek (and later) columns generally.
- **foot** In poetry, the unit for measuring *meter*.
- **foreshortening** The artistic technique whereby a sense of depth and three-dimensionality is obtained by the use of receding lines.
- **form** The arrangement of the general structure of a work of art.
- forte Italian for "loud."
- **fresco** A painting technique that employs the use of pigments on wet plaster.
- friar A member of one of the religious orders of begging brothers founded in the Middle Ages.
- frieze The middle section of an entablature. A band of painted or carved decoration, often found running around the outside of a Greek or Roman temple.
- fugue A polyphonic composition, generally for two to four voices (vocal or instrumental), in which the same themes are passed from voice to voice and combined in counterpoint.
- **gallery** A long, narrow room or corridor, such as the spaces above the *aisles* of a church.
- **genre** A type or category of art. In the visual arts, the depiction of scenes from everyday life.

- Gesamtkunstwerk German for "complete work of art." The term, coined by Wagner, refers to an artistic ensemble in which elements from literature, music, art, and the dance are combined into a single artistic totality.
- **glaze** In oil painting a transparent layer of paint laid over a dried painted canvas. In *ceramics* a thin coating of clay fused to the piece by firing in a kiln
- gospels The four biblical accounts of the life of Jesus, ascribed to Matthew, Mark, Luke, and John. Compare evangelist.
- **gouache** An opaque watercolor medium.
- **graphic** Description and demonstration by visual means.
- **Greek cross** A cross with arms of equal length.
- **Gregorian chant** *Monophonic* religious music usually sung without accompaniment. Called *plainsong*. Compare *melisma*, *neum*, *trope*.
- **ground** A coating applied to a surface to prepare it for painting.
- **guilloche** A decorative band made up of interlocking lines of design.
- **hadith** Islamic law/traditions outside of the Qu'ran.
- haj The Islamic pilgrimage to Mecca.
 Haiku Short three-lined Japanese poem made up of five, seven, and five syllables
- hamartia Literally Greek for "missing the mark," "failure," or "error." Term used by Aristotle to describe the character flaw that would cause the tragic end of an otherwise noble hero.
- happening In art, a multimedia event performed with audience participation so as to create a single artistic expression.
- harmony The *chords* or vertical structure of a piece of music; the relationships existing between simultaneously sounding notes and chord progressions
- **hedonism** The philosophical theory that material pleasure is the principal good in life.
- hegira Muhammad's flight from Mecca to Medina; marks the beginning of the Islamic religion.
- heroic couplet The *meter* generally employed in *epic* poetry, consisting of pairs of rhyming *iambic pentameter* lines. Compare *blank verse*.
- **hierarchy** A system of ordering people or things which places them in higher and lower ranks.
- **hieroglyphics** A system of writing in which the characters consist of

realistic or stylized pictures of actual objects, animals, or human beings (whole or part). The Egyptian hieroglyphic script is the best known, but by no means the only one. Compare *cuneiform*.

high relief See relief.

hippodrome A race course for horses and chariots. Compare *spina*.

homophony Music in which a single melody is supported by a harmonious accompaniment. Compare *monophonic*.

hubris The Greek word for "insolence" or "excessive pride."

humanist In the Renaissance, someone trained in the humane letters of the ancient classics and employed to use those skills. More generally, one who studies the humanities as opposed to the sciences.

hymn A religious song intended to give praise and adoration.

- iambic pentameter Describes the *meter* of poetry written in lines consisting of five groups (pentameter) of two syllables each, the second syllable stressed more than the first (iambic *foot*).
- icon Greek word for "image." Panel paintings used in the Orthodox church as representations of divine realities.
- **iconography** The set of symbols and allusions that gives meaning to a complex work of art.
- ideal The depiction of people, objects, and scenes according to an idealized, preconceived model.
- **idol** An image of a deity that serves as the object of worship.
- **image** The representation of a human or nonhuman subject, or of an event.
- **imitation** In music, the restatement of a melodic idea in different voice parts of a *contrapuntal* composition.
- impasto Paint laid on in thick textures.improvisation In musical performance,the spontaneous invention of musicfor voice or instrument.
- **incising** Cutting into a surface with a sharp instrument.
- intercolumniation The horizontal distance between the central points of adjacent columns in a Greek or Roman temple.
- interval Musical term for the difference in pitch between two musical notes.
- **Ionic** One of the Greek orders of *architecture*, elaborate and graceful in style. Compare *Doric*, *Corinthian*.
- Iron Age The period beginning in Europe around 1000 B.C. during which iron was the chief material used for tools and weapons.

- **isorhythmic** *Polyphonic* music in which the various sections are unified by repeated rhythmic patterns, but the melodies are varied.
- italic The type face *like this* designed during the Renaissance that was based on a form of handwriting often used in manuscript copying.
- jamb Upright piece of a window or a door frame, often decorated in medieval churches.
- jazz Form of American music first developed in the Black community in the early twentieth century, consisting of improvisation on a melodic theme.
- jongleur In French, a wandering minstrel. A professional musician, actor, or mime who went from place to place, offering entertainment.
- **Kabuki** A kind of Japanese drama based on real life characters.
- key (1) The tonal center around which a composer bases a musical work. (2) The mechanism by which a keyboard instrument (piano, organ, etc.) or wind instrument (clarinet, bassoon, etc.) is made to sound.
- **keystone** Central stone of an arch. **kore** Type of standing female statue produced in Greece in the Archaic period.
- **kouros** Type of standing male statue, generally nude, produced in Greece in the Archaic period.
- **lancet** A pointed window frame of a medieval Gothic cathedral.
- **landscape** In the visual arts, the depiction of scenery in nature.
- **Latin cross** A cross with the vertical arm longer than the horizontal arm.
- **legato** Italian for "tied." In music, the performance of notes in a smooth line. The opposite, with notes detached, is called *staccato*.
- Leitmotif German for "leading motif." A system devised by Wagner whereby a melodic idea represents a character, an object, or an idea.
- **lekythos** Small Greek vase for oil or perfume, often used during funeral ceremonies.
- **libretto** Italian for "little book." In music, the text or words of an *opera*, *oratorio*, or other musical work involving text.
- lied German for "song."
- **line engraving** A type of *engraving* in which the image is made by scored lines of varying width.

- **lintel** The piece that spans two upright posts.
- **lithography** A method of producing a print from a slab of stone on which an image has been drawn with a grease crayon or waxy liquid.
- **liturgy** The rites used in public and official religious worship.
- **loggia** A gallery open on one or more sides, often with arches.

low relief See relief.

- **lunette** Semicircular space in wall for window or decoration.
- lyre Small stringed instrument used in Greek and Roman music. Compare cithara.
- lyric (1) Words or verses written to be set to music. (2) Description of a work of art that is poetic, personal, even ecstatic in spirit.
- Madonna Italian for "My Lady." Used for the Virgin Mary.
- madrigal Polyphonic song for three or more voices, with verses set to the same music and a refrain set to different music.
- mandorla Almond-shaped light area surrounding a sacred personage in a work of art.
- **Mass** The most sacred rite of the Catholic *liturgy*.
- matroneum Gallery for women in churches, especially churches in the Byzantine tradition.
- mausoleum Burial chapel or shrine. meander Decorative pattern in the form of a maze, commonly found in Greek geometric art.
- **melisma** In *Gregorian chant*, an intricate chain of notes sung on one syllable. Compare *trope*.
- meter A systematically arranged and measured rhythm in poetry or music.
- **metopes** Square slabs often decorated with sculpture which alternated with *triglyphs* to form the *frieze* of a *Doric* temple.
- michrab A recessed space or wall design in a mosque to indicate direction of Mecca for Islamic worshippers.
- Minbar A pulpit in an Islamic mosque. minnesingers German medieval musicians of the aristocratic class who composed songs of love and chivalry. Compare *troubadors*.
- minuet A French seventeenth-century dance, the form of which was eventually incorporated into the *sonata* and *symphony* as the third *movement*.
- **mobile** A sculpture so constructed that its parts move either by mechanical or natural means.
- **mode** (1) In ancient and medieval music an arrangement of notes forming a scale which, by the character of inter-

- vals, determines the nature of the composition. Compare *tetrachord*. (2) In modern music one of the two classes, major or minor, into which musical scales are divided.
- **modulation** In music, movement from one *key* to another.
- monastery A place where monks live in communal style for spiritual purposes.
- **monochrome** A single color, or variations on a single color.
- **monody** A *monophonic* vocal piece of music.
- **monophonic** From the Greek meaning "one voice." Describes music consisting of a single melodic line. Compare *polyphonic*.
- montage (1) In the cinema, the art of conveying an idea and/or mood by the rapid juxtaposition of different images and camera angles. (2) In art, the kind of work made from pictures or parts of pictures already produced and now forming a new composition. Compare assemblage, collage.
- mosaic Floor or wall decoration consisting of small pieces of stone, ceramic, shell, or glass set into plaster or cement.
- mosque Islamic house of worship. motet (1) Musical composition, developed in the 13th century, in which words (French "mots") were added to fragments of *Gregorian chant*. (2) sixteenth-century composition: fouror five-voiced sacred work, generally based on a Latin text.
- **movement** In music, an individual section of a *symphony*, *concerto*, or other extended composition.
- **mullions** The lines dividing windows into separate units.
- mural Wall painting or mosaics attached to a wall.
- myth Story or legend whose origin is unknown; myths often help to explain a cultural tradition or cast light on a historical event.
- **narthex** The porch or vestibule of a church.
- natural In music, the sign (\$) which cancels any previously indicated sharp (\$) or flat (\$).
- **nave** From the Latin meaning "ship." The central space of a church.
- Neanderthal Early stage in the development of the human species, lasting from before 100,000 B.C. to around 35,000 B.C.
- Negritude A literary movement in twentieth century Black Africa based on African culture.
- **Neolithic** Last part of the Stone Age, when agricultural skills had been

- developed but stone was still the principal material for tools and weapons. It began in the Near East around 8000 B.C. and in Europe around 6000 B.C.
- **neum** The basic symbol used in the notation of *Gregorian chant*.
- **niche** A hollow recess or indentation in a wall to hold a statue or other object.
- **notation** The system of writing out music in symbols that can be reproduced in performance.
- **obelisk** A rectangular shaft of stone that tapers to a pyramidal point.
- Obi Title of ruler of the medieval African kingdom of Benin (modern Nigeria).
- **octave** The *interval* from one note to the next with the same pitch; e.g., from C to the C above or below.
- **oculus** A circular eye-like window or opening.
- **ode** A lyric poem, usually exalted and emotional in character.
- oil painting Painting in a medium made up of powdered colors bound together with oil, generally linseed.
- opera Theatrical performance involving a drama, the text of which is sung to the accompaniment of an orchestra.
- **opus** Latin for "work." Used for chronological lists of composers' works.
- Opus Dei Latin for "work of God."
 Used to describe the choral offices of
 monks, which are sung during the
 hours of the day.
- oral composition The composition and transmission of works of literature by word of mouth, as in the case of the Homeric epics.
- **oratorio** An extended musical *composition* for solo singers, *chorus*, and *orchestra* on a religious subject. Unlike *opera*, the oratorio is not staged.
- orchestra (1) In Greek theaters, the circular space in front of the stage in which the *chorus* moves. (2) A group of instrumentalists who come together to perform musical *compositions*.
- order (1) In classical architecture a specific form of column and entablature; see Doric, Ionic, and Corinthian. (2) More generally, the arrangement imposed on the various elements in a work of art.
- organum An early form of polyphonic music in which one or more melody lines were sung along with the song line of plainsong. Compare Gregorian chant.
- orientalizing Term used to describe Greek art of the seventh century B.C. that was influenced by Eastern artistic styles.

- **overture** An instrumental *composition* played as an introduction to a *ballet*, *opera*, or *oratorio*.
- paean A Greek hymn to Apollo and other gods, either praying for help or giving thanks for help already received. Later generally applied to any song of praise or triumph. Compare dithyramb.
- Paleolithic The Old Stone Age, during which human beings appeared and manufactured tools for the first time. It began around two and a half million years ago.
- palette (1) The tray on which a painter mixes colors. (2) The range and combination of colors typical of a particular painter.
- panel A rigid, flat support, generally square or rectangular, for a painting; the most common material is wood.
- pantheon The collected gods. By extension, a temple to them. In modern usage a public building containing the tombs or memorials of famous people.
- pantocrator From the Greek meaning "one who rules or dominates all." Used for those figures of God and/or Christ found in the apses of Byzantine churches.
- **parable** A story told to point up a philosophical or religious truth.
- parallelism A literary device, common in the psalms, of either repeating or imaging one line of poetry with another that uses different words but expresses the same thought.
- pastel A drawing made by rubbing colored chalks on paper.
- **pathos** That aspect of a work of art that evokes sympathy or pity.
- **pediment** The triangular space formed by the roof *cornices* on a Greek or Roman temple.
- pendentives Triangular architectural devices used to support a dome of a structure; the dome may rest directly on the pendentives. Compare squinches.
- percussion instruments Musical instruments that are struck or shaken to produce a sound, e.g., drums, tambourine, cymbals.
- peripatetic Greek for "walking around." Specifically applied to followers of the philosopher Aristotle.
- peristyle An arcade (usually of columns) around the outside of a building. The term is often used of temple architecture.
- **perspective** A technique in the visual arts for producing on a flat or shallow surface the effect of three dimensions and deep space.

- piano Italian for "soft."
- piazza Italian term for a large, open public square.
- pietà An image of the Virgin with the dead Christ.
- pietra serena Italian for "serene stone." A characteristic building stone often used in Italy.
- pilaster In architecture a pillar in relief.
- Pillow book Japanese literary work in the form of a daily diary.
- pitch In music the relative highness or lowness of a note as established by the frequency of vibrations occurring per second within it.
- pizzicato Italian for "plucked." An instruction to performers on string instruments to pluck instead of bow their strings.
- plainsong See Gregorian chant.
- plan An architectural drawing showing in two dimensions the arrangement of space in a building.
- podium A base, platform, or pedestal for a building, statue, or monu-
- polis The Greek word for "city," used to designate the independent city-states of ancient Greece.
- polychrome Several colors. Compare monochrome.
- polyphonic From the Greek meaning 'many voices." Describes a musical composition built from the simultaneous interweaving of different melodic lines into a single whole. Compare monophonic.
- portal A door, usually of a church or cathedral.
- portico A porch with a roof supported by columns.
- prelude In music, a short piece that precedes a large-scale composition.
- pre-socratic Collective term for all Greek philosophers before the time of Socrates.
- presto Italian for "fast."
- program music Instrumental compositions that imitate sound effects, describe events, or narrate a dramatic sequence of events.
- prophet From the Greek meaning "one who speaks for another." In the Hebrew and Christian tradition it is one who speaks with the authority of God. In a secondary meaning, it is one who speaks about the future with authority.
- **proportion** The relation of one part to another, and each part to the whole, in respect of size, whether of height, width, length, or depth.
- prosody The art of setting words to music.

- which later works are based.
- psalter Another name for the Book of Psalms from the Bible.
- Qur'an The sacred scriptures of Islam.
- Raiput Medieval Indian ruler generally of central Asian descent.
- realism A nineteenth-century style in the visual arts in which people, objects, and events were depicted in a manner that aimed to be true to life. In film, the style of Neorealism developed in the post–World War II period according to similar principles.
- recapitulation The third section of a sonata-form movement in which the ideas set out in the exposition are repeated.
- recitative A style of musical declamation that is halfway between singing and ordinary speech.
- red figure A technique used in Greek vase painting which involved painting red figures on a black background and adding details with a brush. Compare black figure.
- register In music, the range of notes within the capacity of a human voice or an instrument.
- relief Sculptural technique whereby figures are carved out of a block of stone, part of which is left to form a background. Depending on the degree to which the figures project, the relief is described as either high or
- reliquary A small casket or shrine in which sacred relics are kept.
- **requiem** A Mass for the dead. revelation Divine self-disclosure to humans.
- rondo A musical form in which one main theme recurs in alternation with various other themes. The form was often used in the last movement of a sonata or symphony.
- Samurai A Japanese warrior.
- Sangha A Buddhist monastery or the Buddhist monastic life in general.
- **sanctuary** In religion, a sacred place. The part of a church where the altar is placed.
- sarcophagus From the Greek meaning "flesh eater." A stone (usually limestone) coffin.
- satire An amusing exposure of folly and vice, which aims to produce moral reform.

- prototype An original model or form on Satyagraha Nonviolence; a sociopolitical strategy devised by Mohandas Gandhi.
 - satyr Greek mythological figure usually shown with an animal's ears and tail.
 - scale (1) In music, a succession of notes arranged in ascending or descending order. (2) More generally, the relative or proportional size of an object or
 - scherzo Italian for "joke." A lighthearted and fast-moving piece of mu-
 - score The written form of a piece of music in which all the parts are
 - scriptorium That room in a medieval monastery in which manuscripts were copied and illuminated.
 - section An architectural drawing showing the side of a building.
 - secular Not sacred; relating to the
 - sequence In music, the repetition of a melodic phrase at different pitches.
 - serenade A type of instrumental composition originally performed in the eighteenth century as background music for public occasions.
 - serial music A type of twentiethcentury musical composition in which various components (notes, rhythms, dynamics, etc.) are organized into a fixed series.
 - sharp In music, a sign (#) which raises the note it precedes by one half-step.
 - silhouette The definition of a form by its outline.
 - skolion Greek drinking song, generally sung at banquets.
 - soliloquy A speech delivered by an actor either while alone on stage or unheard by the other characters, generally so constructed as to indicate the inner feelings of a character.
 - sonata An extended instrumental composition, generally in three or four movements.
 - sonata form A structural form for instrumental music that employs exposition, development, and recapitulation as its major divisions.
 - sonnet A fourteen-line poem, either eight lines (octave) and six lines (sextet) or three quatrains of four lines and an ending couplet. Often attributed to Petrarch, the form—keeping the basic fourteen lines—was modified by such poets as Spenser, Shakespeare, and Milton.
 - soprano The highest register of the female voice.
 - spandrel A triangular space above a window in a barrel vault ceiling, or the space between two arches in an arcade.

- **spina** A monument at the center of a stadium or *hippodrome*, usually in the form of a triangular *obelisk*.
- squinches Either columns or *lintels* used in corners of a room to carry the weight of a superimposed mass.

 Their use resembles that of *pendentives*.
- staccato See legato.
- **staff** The five horizontal lines, with four spaces between, on which musical notation is written.
- **stele** Upright stone slab decorated with relief carvings, frequently used as a grave marker.
- still life A painting of objects such as fruit, flowers, dishes, etc., arranged to form a pleasing composition.
- stoa A roofed colonnade, generally found in ancient Greek open markets, to provide space for shops and shelter.
- stoic School of Greek philosophy, later popular at Rome, which taught that the universe is governed by Reason and that Virtue is the only good in life.
- **stretcher** A wooden or metal frame on which a painter's canvas is stretched.
- **string quartet** A performing group consisting of two violins, viola, and cello; a *composition* in *sonata form* written for such a group.
- string instruments The violin, viola, violoncello (or cello), and double bass.
 All of these have strings that produce sound when stroked with a bow or plucked.
- Stupa A sacred tower in Buddhism. stylobate The upper step on which the columns of a Greek temple stand.
- suite In music, a collection of various movements performed as a whole, sometimes with a linkage in key or theme between the movements.
- summa The summation of a body of learning, particularly in the fields of philosophy and theology.
- **sura** A chapter division in the *Qur'an*, the scripture of Islam.
- syllogism A form of argumentation in which a conclusion is drawn from a major premise by the use of a minor premise: All men are mortal/Socrates is a man/ Therefore Socrates is mortal.
- **symmetry** An arrangement in which various elements are so arranged as to parallel one another on either side of an *axis*.
- **symphonic poem** A one-movement orchestral work meant to illustrate a nonmusical object like a poem, painting, or view of nature. Also called a tone poem.

- **symphony** An extended orchestral *composition*, generally in three or four movements, in *sonata form*.
- **syncopation** In music, the accentuation of a beat that is normally weak or unaccented.
- **synthesizer** An electronic instrument for the production and control of sound that can be used for the making of music.
- tabernacle A container for a sacred object; a receptacle on the altar of a Catholic church to contain the Eucharist
- **tambour** The drum that supports the cupola of a church.
- **tempera** A painting technique using coloring mixed with egg yolk, glue, or casein.
- **tempo** In music, the speed at which the notes are performed.
- **tenor** The highest range of the male voice. In medieval *organum*, it is the voice that holds the melody of the *plainsong*.
- ternary form A musical form composed of three separate sections, with the second in contrast to the first and third, and the third a modified repeat of the first.
- terra cotta Italian meaning "baked earth." Baked clay used for *ceramics*. Also sometimes refers to the reddishbrown color of baked clay.
- **tesserae** The small pieces of colored stone used for the creation of a *mosaic*.
- **tetrachord** Musical term for a series of four notes. Two tetrachords formed a *mode*.
- **theme** In music, a short melody or a self-contained musical phrase.
- **tholos** Term in Greek *architecture* for a round building.
- **timbre** The particular quality of sound produced by a voice or instrument.
- **toccata** In music, a *virtuoso composition* for a keyboard instrument characterized by a free style with long, technically difficult passages.
- **toga** Flowing woolen garment worn by Roman citizens.
- **tonality** In music, the organization of all tones and chords of a piece in relation to the first tone of a *key*.
- tonic The first and principal note of a key, serving as a point of departure and return.
- tragedy A serious drama in which the principal character is often brought to disaster by his/her hamartia, or tragic flaw.

- **transept** In a cruciform church, the entire part set at right angles to the *nave*.
- **treble** In music, the higher voices, whose music is written on a *staff* marked by a treble *clef*.
- triglyphs Rectangular slabs divided by two vertical grooves into three vertical bands; these alternated with *metopes* to form the *frieze* of a *Doric* temple.
- **triptych** A painting consisting of three panels. A painting with two panels is called a diptych; one with several panels is a polyptych.
- trompe l'oeil From the French meaning "to fool the eye." A painting technique by which the viewer seems to see real subjects or objects instead of their artistic representation.
- **trope** In *Gregorian chant*, words added to a long *melisma*.
- **troubadors** Aristocratic southern French musicians of the Middle Ages who composed *secular* songs with themes of love and chivalry; called trouvères in northern France. Compare *minnesingers*.
- **trumeau** A supporting pillar for a church *portal*, common in medieval churches.
- twelve-tone technique A serial method of composition devised by Schönberg in the early twentieth century. Works in this style are based on a tone row consisting of an arbitrary arrangement of the twelve notes of the octave.
- **tympanum** The space, usually decorated, above a *portal*, between a *lintel* and an *arch*.
- unison The sound that occurs when two or more voices or instruments simultaneously produce the same note or melody at the same pitch.
- value (1) In music, the length of a note.(2) In painting, the property of a color that makes it seem light or dark.
- vanishing point In perspective, the point at which receding lines seem to converge and vanish.
- **vault** A roof composed of arches of masonry or cement construction.
- virginal A stringed keyboard instrument, sometimes called a spinet, which was a predecessor of the harpsichord.
- virtuoso A person who exhibits great technical ability, especially in music. As an adjective, it describes a musical performance that exhibits, or a music composition that demands, great technical ability.

- vivace Italian for "lively" or "vivacious."
- **volutes** Spirals that form an *Ionic capital*.
- votive An offering made to a deity either in support of a request or in gratitude for the fulfillment of an earlier prayer.
- **voussoirs** Wedge-shaped blocks in an arch.
- waltz A dance in triple rhythm.
- woodcut (1) A wood block with a raised design produced by gouging out unwanted areas. (2) The impression or image made from such a block by inking the raised surfaces. Compare engraving, etching, lithograph.
- woodwind instruments The flute, oboe, English horn, clarinet, bass clarinet, bassoon, contrabassoon, and saxo-
- phone. All of these are pipes perforated by holes in their sides which produce musical sound when the columns of air within them are vibrated by blowing on a mouthpiece.

ziggurat An Assyrian or Babylonian stepped pyramid.

Page numbers in italics indicate photo illustrations.

A cappella chant, 207, 330 Aachen, 172, 201-204, 210, 213-220, 215, 217-220 Abacus, 46, 47, 203 Abakanowicz, Magdalena, 607 Backs, 607, 609 Abbasid Dynasty, 194 Abbey of Saint Denis, 210, 225-229, 226-228, 231, 236 Abdallah, Saiyid, 549 Self-examination, 549 Abelard, Peter, 225, 238 Sic et Non, 238 Abraham (Hebrew patriarch), 143, 147, 186, 189 Abstract expressionism, 592-597, 594-597, 600 Abu Simbel, Temple at, 16, 20 Académie des Beaux-Arts, 383 Académie des Sciences, 404 Academy, of Plato, 66, 164 Achebe, Chinua, 550 No Longer at Ease, 550 Things Fall Apart, 550 Achilles, 36-37, 39, 47, 49 Acropolis, 42, 44, 58, 58-59, 64, 70-73, 72, 73Action painting, 592 Actium, Battle of, 99 Acts, Book of, 147 Adam and Eve (Fall of Man) (Dürer), 351, 351, 353 Adams, Ansel, 580 Adams, Henry, 235 Mont-Saint-Michel and Chartres, 235 Adler, Renata, 619 Adobe, 551 Adoptive emperors of Rome, 99 Adoration of the Magi (Botticelli), 293, 293 Adoration of the Magi (Gentile da Fabriano), 282, 283 The Adventures of Don Quixote (Cervantes), 407 Aegean culture in the Bronze Age, 18-27 Cycladic art, 20-21, 21 influence of, 18-19 Minoan culture, 19, 21-22, 23-26, 24, 123 Mycenaean culture, 19, 24-27, 27, 33timeline, 1 Aegisthus, 62, 62 Aeneas, 102, 103, 103 Aeneid (Vergil), 100-102, 245, 256, 308, 433 Aeschylus, 60, 61, 62-63, 69, 433, 454 Agamemnon, 62, 62

The Eumenides, 61, 62 The Libation Bearers, 62 Oresteia trilogy, 62-63 Suppliants, 61 Aesop, 433 Aesthetics in philosophy, 50 Afghanistan, 126 Africa and African culture art, 550-552, 563 cultural impact on West, 553-554, 563 early Kingdoms, 545-548 literature, 548-550 maps, 546, 553 music, 554, 573 religion and society in, 545 timeline, 542-543 Africa (Petrarch), 256 African Americans abstract expressionism, 600 Harlem Renaissance, 575, 619 jazz, 573-575 opera, 574 pop music, 623 slavery, 147, 546 Afterlife. See also Religion in ancient Egyptian religion, 10-12, 13, 14in Dante's Divine Comedy, 196, 238, 245-247, 247, 256 Agamemnon, 25, 36, 47, 49, 62, Agamemnon (Aeschylus), 62, 62 Age of Colonization, Greece, 33,39-40Age of Enlightenment, 415 Age of Reason, 415 Age of Warring States, Japan, Agee, James, 581 Let Us Now Praise Famous Men, 581 Agesander, 82 Agincourt, Battle of, 254 Agnus Dei in Ordinary of the Mass, 275 Agra, 192, 193, 524, 524 Agricultural words, 196 Agriculture, United States Department of, 581 Ailey, Alvin, 575 Aix-la-Chapelle. See Aachen Akbar, Mughal emperor, 523, 525, 525 Akhenaton, Nefertiti and Three of Their Children, 14-15, 17 Akhenaton, pharaoh of Egypt, 14-15, 17Akhnaten (Glass and Wilson), Akkad, 8

Akkadians, 6, 8-9

Al-Ghazali, 196

The Incoherence of the Philosophers, 196 Al-Hakam, 190-191 Al-Hazen, 195 Al-Khwarizmi, 195 Al Malik, Abd, 189 Al-Mamun, 194 Al-Rashid, Harun, 201, 202 Al-Uqlidisi, 195 Al Walid, Abd, 189 Albers, Josef, 591, 598 Albert the Great, 242 Alcaeus, 50, 90 Alcalá, University of, Spain, 344 Alcuin of York, 203, 204, 205, On the Cultivation of Learning, 204 Aldine Press, 179, 303-304, 332 Aldus Manutius, 303-304, 344 Aleatoric music, 621 Alemanni, 114 Alexander Nevsky (Eisenstein), Alexander of Hales, 242 Alexander Severus, emperor of Rome, 99 Alexander the Great, 10, 17-18, 57, 65, 66, 78, 79, 81 Alexandria, 79, 100 Alexandria, Temple of the Muses at, 79 Algebra, 130 Algorithm, 195 Alhambra, 191-193, 192 Alighieri, Dante. See Dante Alighieri Allahah, 188, 195 The Allegory of the Cave (Plato), 238 Allegro form, sonata, 429, 453 "L'Allegro" (Milton), 408 Alpine Symphony (Strauss), 509, 510, 512 Altamira cave paintings, 4 Altar of Peace, 103-104, 103 - 104Altar of the hand, 548 Altar to Zeus, 81, 82, 83 Altdorfer, Albrecht, 339, 350, 353 Danube Landscape Near Regensburg, 353, 354 Amadioha, 551, 552 Amarna art, ancient Egypt, 15, 17 Ambrose, Saint, 207 Ambrosian music, 207 Ambulatory, 226, 226 Amenhotep IV, pharaoh of Egypt, 14

art, 590, 591-592, 592-593

Civil War, 479, 580 Declaration of Independence, 438, 440-441 Great Depression, 581 Harlem Renaissance, 575, 619 immigration to, 490-491, 491 jazz, 573-575 novel in literature, 478 opera, 574 painting, 477-479, 479-481, photography, 580-582, 581 post-World War II, 589 Revolutionary War, 440-441, Romantic era, 475-479, 479-481, 480, 481 Rome's influence on, 101 American Center in Paris (Gehry), 616, 617 Amiens Cathedral, 227-228, Amphion, 47 Amsterdam, 394 Anabaptists, 341 Ananke, 37 Anavysos Kouros, 42, 43 Anaxagoras of Clazomenae, 50 Anchise, 102 Ancient civilizations Aegean culture in the Bronze Age, 5, 18-27, 33 Minoan culture, 19, 21-22, 23-26, 24, 123 Mycenaean culture, 19, 24-27, 27, 33 China (See China and Chinese culture) Egypt (See Egypt and Egyptian culture) Greece (See Greece) India (See India and Indian culture) map, 5 Mesopotamia, 6-10 Akkadian culture, 6, 8-9 Assyrians, 6, 9, 11, 27, 143 Babylonian culture, 6, 9, 11, Cycladic art, 20-21, 21 Sumer, 6-8 Neolithic period, 3-5, 18 Paleolithic period, 3, 4, 27 Rome (See Rome) timeline, xxxii-1 Andrew, Apostle, 172 Fra Angelico, 290, 293, 307 The Annunciation, 290, 291 Angelou, Maya, 619 Anglicanism, 345, 362, 435 Anguissola, Sofonisba, 329-330

Self-Portrait, 330, 330

Animal Farm (Orwell), 582	Aristotle's influence on,	rococo style, 421–422, 422,	Boethius' translation of, 163
Animist beliefs, Africa, 546, 553	66-67, 195, 247	423	Charlemagne, influence on,
Anna Karenina (Tolstoy), 473	Augustine's influence on,	Greece	203
Anna Sofia d'Este, Princess of	161-162	Classical, 69-74, 75, 77-78,	on dialectics, 237
Modena (Carriera), 420, 420	Boethius' influence on, 162	78	Lyceum founding, 66
Annals (Ennius), 95	estrangement from God, 246	early period, 44–46, 47, 69,	on music, xxvi, 47, 48, 49, 67
Anne of Cleves (Holbein the	scholasticism, 225, 242-245,	71	and music of fifteenth
Younger), 361, 361	244	Hellenistic, 79–83, 81, 82	century, 308
Annunciation and Nativity	science and motion, 402	Pergamum, 81, 81	paradoxes discussed by, 51
(Pisano, N.), 260, 261	Summa Theologica, 242, 243,	India, 524–525, 524–525	Pico della Mirandola's study
The Annunciation (Fra	245	Islam, 188–193	of, 303
Angelico), 290, 292 The Annunciation (Martini), 266,	<i>Ara Pacis</i> , 103–104, 103–104 Arabic, 522, 525, 549	Middle Ages and Fourteenth	as Plato's pupil, 66
267	Arabic, 322, 323, 349 Arabic language, 6, 186–187,	century Gothic style, 225–237,	on polis, 60
The Annunciation of the Death of	194–195	226–228, 231–236, 239,	in Raphael's <i>School of Athens</i> , 314, 315
the Virgin (Duccio), 263	Arabic numerals, 130, 195	270–272, 272–275	recovery of, 225, 238
Anoninius Pius, emperor of	Arcadia (Sidnev), 364	light, mysticism of,	significance of, 57, 66, 67
Rome, 99	Arch, 109, 109–111, 110, 112	229-230, 231, 232, 233	on tragedy, 63–64, 66
Anthemius of Tralles, 164, 165	Arch of Constantine, 116	Romanesque style, 216,	translations of, 163, 179, 195,
Anthems, 363	Arch of Titus, 109, 144	218, 218, 219, 220, 228	203
Anti-semitism, 303	Archaeology	modern era, 505, 507	works
Antigone, 63	Dura-Europos, 151–152, 153	as permanent, spatial art,	Ethics, 245
Antigone (ballet), 577	Eighteenth century	xxiii	Metaphysics, 66, 241
Antigone (Euripides), 577	excavations, 422, 424	Renaissance	Physics, 66
Antigone (Sophocles), 14, 61, 63	Etruscans, 91	early in Florence, 284, 285,	Poetics, 63-64, 66
Antioch, 79, 80, 100	Minoan culture and Knossos	286-288, 288	Rhetoric, 66
Antiphonal singing, 155	excavation, 16, 21–23,	High Italian, 320–322, 322,	Armored Train in Action
Antithesis, 449	23-27	323	(Severini), 581, 582
Antonines emperors of Rome, 99	Mycenae and Schliemann's excavations, 21, 24–27, 27	Northern Europe, 357–359, 359, 360	Armstrong, Louis, 573, 574
Antony, Mark, 99	Pompeii, 16, 105–106,	Romantic era, 466–467, 468	Arouet, Francois Marie. <i>See</i> Voltaire
Antony and Cleopatra	105–109, 108	Rome	Around the Fish (Klee), 572, 572
(Shakespeare), 367	Troy, 25, 26	Etruscan, 109–110	Arp, Jean, 569, 591
Anubis, 13	Tutankhamen's tomb, 15-16,	Imperial, 105–107, 108,	Ars Nova, 272–275, 274, 275
Anurangzeb, Mughal emperor,	19	109, 109 – 112, 110, 111, 112,	Ars Nova Musicae (The New Art
525	Archaic smile, 43, 43	164	of Music) (Vitry), 273
Aparajito (The Unvanquished)	Archbishop of Salzburg,	late, 114, 115, 115–116, 116	Art. See also Architecture;
(Ray, S.), 540	430-431	Republican, 98, 98-99	Painting; Pottery and
Aphlad, 151	Architecture	Twentieth century	ceramics; Sculpture; specific
Aphrodite, 34, 35, 77, 97	Africa, 547–548, 548	contemporary contour, 590,	artists and artworks
Aphrodite at Cyrene (Venus	ancient civilizations	608-617, 612-618	Africa, 547–548, 547–549,
Anadyomene) (Praxiteles),	Aegean, 16, 23, 24, 24–25,	modern era, 505, 507	550-552
77, 77 Apocalypse series (Dürer),	26, 33 Branzo A co. 5	World Wars, period	ancient periods and cultures
350–351, 351	Bronze Age, 5 Egypt, 10–13, <i>15</i> , <i>20</i> ,	between, 582 World Wars, period between,	Aegean cultures, 18–26, 20–22, 21, 23–27
Apocrypha, Luther's	45-46	582	China, 133, 134–136, 137
translation of, 344	Indian, 127	Architrave, 46, 47	Egypt, 7, 10–18, 12, 15–20,
Apollo	Mesopotamia, 8-9, 10	Archivolts, 218, 220, 230	41
Delos as sacred to, 58	Baroque period	Arena Chapel, Padua, 264	Indian Buddhism and
in Laocoön Group, 83	France, 387, 387-380	Ares, 34, 35, 97	Hinduism, 127-129,
in literature, 34–35, 62	Rome, 373–375, 374,	Arezzo, Guido de, 237	128-130
in music, 47, 49	380-383, 381-383	Argos, 62, 65, 68	Mesopotamia, $6-10$, $7-11$
Roman equivalency, 97	Byzantium	Ariadne, 21	Neolithic period, $3, 4-5$
sculpture of, Temple of Zeus,	ascendancy of, 164–166,	Arian Baptistery, 167, 169–170	Paleolithic period, 3, 4, 4,
69, 72	165, 175–178, 177	Arian Christians, 167, 169–170	27
Temple of, 46, 63, 106	Ravenna, 166–178,	Arian Saints, 171	Ashoka, Emperor of India,
Apollo of Veii, 92, 92 Apologists, Christian, 150	166–178 Charlemagne and Medieval	Arias, 400 Ariosto, Lodovico, 364	126-127
Apology (Plato), 65	Charlemagne and Medieval culture, 172, 203–204, 210,	Aristion, Stele of, 43, 45	Baroque period France, <i>383–387</i> , 383–388
Apology (Xenophon), 65	213–220, 215–220	Aristophanes, 64–65, 304	Northern Europe, 391–397,
Apostles of Jesus, 169–170	China, 529, 529	The Birds, 64	392–397
Apoxyomenos (The Scraper)	Christian period, early,	Lysistrata, 64	Rome, 375–383, 377–383
(Lysippus), 78	152–154, 154	Aristotle	Spain, 388–390, 388–391,
Apse, 167	contemporary contour, 590,	Aldine Press, publication by,	407
The Apu Trilogy (Ray, S.), 540	608-617, 612-618	304	Byzantium, 166–178,
Aqueducts, 112, 112	Eighteenth century	Aquinas, influence on, 66-67,	166-178, 179, 281 (See also
Aquinas, Saint Thomas	neo-classical, 425-426, 427	161, 195, 244, 247, 402	Mosaics)

China, 527 – 528, 528, 530	Romantic era, 447, 460–463,	Athenodorus, 82	Avignon, 253, 256-257
Christian period, early,	461-470, 466-468, 470	Athens	The Awakening (Chopin, K.), 517
150-151, 151, 152, 153	Rome	Acropolis in, 42, 44, 58,	Ayres, 364
contemporary contour	Etruscan, 91, 91-92	58-59, 64, 70-73, 72, 73	•
abstract expressionism,	Imperial, 107, 108,	art, 40-41	В
592-597, 594-597, 600	115–116, 116	Christianity, Paul's sermon	B. C. E. (before the common era),
American supremacy in,	Republican, 93, 98, 98–99	on, 147	123
590-592, 592-593	Twentieth century	Classical Ideal in, 57–60	Babbitt (Lewis, S.), 582
	contemporary contour,	drama in, 60–65	Babur, Mughal ruler, 525
representation, 597–602, 597–603	590-602, 592-603	Golden Age of, 59, 103	Babur-nama, 524
	modern era, 492–506,	Heroic Age, 33	Babur-nama (Babur), 525
Eighteenth century		0	Babylonian Captivity of
neo-classical, 422, 424–426,	493-506, 566-567	as Mycenaean city, 25, 33 Peloponnesian War, 57–60,	Hebrews, 143
424-426	World Wars, period		
Rococo style, 415, 417–422,	between, 563–582,	64–65, 66, 70, 71	Babylonian culture, 6, 9, 11, 143
418-422	564-567, 570-572,	Pericles' leadership of, 59,	Bacchae (Euripides), 64
film, 571–572, 578–580,	576-578, 581	59-60, 70-71	Bacchus, 97
579-580, 618	World Wars, period between	Persians, defeat of, 51	Bach, Anna Magdalena, 401
Greece	ballet, 575–577, 576	Plato in, 66	Bach, Carl Philipp Emanuel (C.
Archaic period, 41-42	cubism, 563–567, 564–567	Socrates in, 65–66	P. E.), 427–428
Classical period, 68–76,	dada, 577, 577	Atman, 125	Bach, Johann Sebastian, 275,
75	futurism in, 581, 581–582	Atomic era, 589	398, 400–402, 428, 429, 453
early period, 35 , $37-44$,	photography, 580–582, <i>581</i>	Atomic Theory, 51	Bist du bei mir, 401
<i>38–40,</i> 515	as protest, 577 – 578, 578	Atomism, 51	Brandenburg Concertos (Bach),
Hellenistic period, 79-83,	surrealism, 568-572,	Aton, 14	401 – 402, 428, 429
81, 82	570-572	Aton-Ra, 12, 13	Saint Matthew Passion, 401
how to view, xxiv-xxv	Artabanus, 52	Atonal music, 513-514	The Well-Tempered Clavier, 401
India, 524–525, 524–525	Artemis, 22, 27, 35, 49, 97	Atrium, 152, 154	Bach, Maria Barbara, 401
Islam, 38, 187-188, 194,	Artemis, Temple of, 78	Atropos, 37	Backs (Abakanowicz), 607, 609
195-196	Arti, trade guilds in Florence,	Attalids, 80	Bacon, Francis, 348, 404
Japan, 535-537, 537	281	Attalus I, king of Pergamum, 81	Baez, Joan, 622
Middle Ages and Fourteenth	Aryans of Indus Valley,	Attic Red Figured Calyx Krater,	Baga Sitemu, 553, 554
century	123-127	62	Baghavad-Gita, 128, 129
Charlemagne and	Aryballos, Corinthian vase, 40	Attica, 33	Baghdad, 194-196
Medieval culture, 211–213,	Asceticism, 125, 126	Attick Black-figure crater,	Bainton, R. H., 342
212-213, 212-214, 213, 214	"Ash Wednesday" (Eliot), 562	Corinthian vase, 40, 41	Bait al-hikma (House of
illuminated books, 204,	Ashoka, Emperor of India,	Atticus, 95–96	Wisdom), 194-195
206, 211–213, 213, 214, 239,	126–127, 128	Atwood, Margaret, 619	Baker, Josephine, 573, 574
275	Asia. See China and Chinese	Au départir de vous (Machaut),	Balakirev, Miliy Alexeyevich,
Italy, 259–266, 260–266	culture; India and Indian	275	456
Northern Europe, 266–270,	culture; Japan and	Augustans, 434	Baldassare Castiglione (Raphael),
269–271	Japanese culture	Augustine of Hippo, Saint,	332, 333
stained-glass windows,	Aspects of Negro Life (Douglas),	161–162, 256, 344	Baldwin, James, 619
226, 229 – 230, 231	575	The City of God, 161–162, 214,	Ball, John, 259
modern era	Assemblage, 603	259	Ballades, 275
		Confessions, 162, 207, 256	Ballet, 514, 515, 574, 575–577,
expressionism, 492,	Assisi, Saint Francis ot, 241–242, 242, 243, 264, 266,	Augustus, emperor of Rome,	576
505-506, 506, 566-567	281	98, 99, 99–105, 101, 104,	Ballet Russe, 576
fauvism in, 504–505, 505,	Asso, 100	434	Balzac, Honoré de, 473
506			Banking, 281, 289, 439
impressionism, 493–498,	Assumption of the Virgin (Titian),	Augustus of Prima Porta, 103,	0
493-500	326, 326	112	Banquet of the Officers of the Civic
post-impressionism, 492,	Assurbanipal, king of	Aulos, 48, 48, 67	Guard of Saint George at
500-506, 501-506	Assyrians, 9, 11	Austria, rococo style in, 422	Haarlem (Hals), 394, 395
as permanent, xxiii	Assurnasirpal II, king of	Authorized Version of the Bible,	Banu Begam, 524
Renaissance	Assyrians, 9	407	Baptisteries of Ravenna, 167,
early, 281–282, 282–287,	Assyrian Empire, 6, 9, 11, 27,	Autobiography of Benvenuto	168–169, 169
289-294, 296-301	143	Cellini (Cellini), 333	Baptistery of the Cathedral of
Elizabethan England,	The Astrologer (Campagnola),	Autocracy, 169	Florence, 284, 285, 286
359-362, 360-361	348	Automatic creation, 593	A Bar at the Folies-Bergère
France, 357–359, 358	Astronomy, 203, 348–349	Avant-garde developments,	(Manet), 492, 493, 495
High Italian, 313–330,	Athena	musical, 573, 620–621	Barbarossa, Frederick, emperor,
314-317, 319-323,	Acropolis, honored on, 58,	L'Avare (Molière), 407	210
325-330	70, 72–73, 74	Avatar, 128, 129	Bardi, Count Giovanni, 281, 399
Netherlands, 354-357,	in literature, 34, 35, 62	Averröes of Córdova, 195, 196,	Baroque period, 373–411
355-358	in music, 47	244	architecture, 373 – 375, 374,
Northern Europe, 339–342,	Roman equivalency, 97	The Incoherence of Incoherence,	387, 387–388
340-342, 347, 349-361,	Temple of (See Parthenon)	196	art
349-362	Athena Slaying the Giant, 82, 83	Avicenna, 195, 244	France, 383-387, 383-388

Berry, Duc de, 259, 267, 270 Beaumarchais, Pierre-Augustin, Blank verse, 366 Northern Europe, 391-397, Bertoia, Harry, 607 The Blind Harper of Leiden, 154, 392 - 397Bes, 12 Rome, 375-380, 377-380 Marriage of Figaro, 431 155 Beauvais Cathedral, 227-228, Bessarion, Cardinal, 179 Blood circulation, 348 Spain, 388-390, 388-391, "The Bet" (Chekhov), 515 Blood of a Poet (Cocteau), 571 Between World Wars. See World Beckett, Samuel, 591, 617 Bloomsbury Group, 563 baroque as term, 374 Wars, period between Blue note, 573 Counter-Reformation spirit Beckmann, Wilhelm, 459 in, 373-375 Bede, Venerable, 203 Bhakti, 125 The Blue Rider (Der Blaue Biafra, Republic of, 550 Reiter) school, 505 drama, 406-407 Beethoven, Ludwig van, 428, English metaphysical poets, 452, 452-455, 460, 461 Bible. See also Christianity; Blues (music), 573 Religion; Religion 407-408 Battle Sumphony, 508 Boboli Captives (Michelangelo), Fidelio, 452, 454 Biblical traditions and the Hellenistic Greece and, 80 literature, 406-409 "Ode to Joy" from Symphony West, 143 Boccaccio, Giovanni, 179, 245, book list of Old and New map, 373 No. 9, 454 255, 256, 281, 389 De Claris Mulieribus, 259 music, 374-375, 398-402 Testament, 148 Piano Sonata No. 8 in C minor Erasmus's Greek New Decameron, 253, 255, 257, 258 (Pathétique), 453 philosophy, 375, 402, 404-406 Symphony No. 5, 454 Testament, 306 Boccioni, Umberto, 582 Symphony No. 6, Op. 68 ethics in, 146 Bodhisattvas, 128, 129, 130 rococo style as anti-baroque, (Pastoral), 454 Greek codex of New Boeotia, 33, 49 418 science, 375, 402-404 Symphony No. 9, Op.125, 452, Testament, 176 Boethius, Anicius Manlius Gutenberg Bible, 304, 346 454, 472 Severinus, 161, 162-163, timeline, 370-371 as Hebrew history, 143-144 Symphony No. 3 in E flat, Op. Barrel vault, 110, 110, 216, 218 Barry, Charles, 448 55 (Eroica), 453 King James Version of, 344, The Consolation of Philosophy, 346, 407 Barth, John, 619 Before the common era 162 - 163, 257Barthelme, Donald, 619 (B. C. E.), 123 message of the Hebrew Bible, Boffrand, Germain, 422 Bartholdi, Frédéric-Auguste, Begam, Banu, 524 144 - 147Bolero (Ravel), 513 monotheism in, 145-146 Bologna, University of, 348 Beijing, 526 Reformation and, 344-345, Bolshevik party, Russia, 532 Bel canto operas, 456-457 Statue of Liberty, 491 Bonaventure, Saint, 242, 264, Bartlett, Jennifer, 607 Belisarius, 174 346 Bell, Clive, 563 revelation in, 146 266 Bartók, Béla, 574 Boniface VIII, Pope, 253 Basho, 353-536 The Bell Jar (Plath), 619 stories as models and types, Basie, Count, 573, 574 Belle époque, in Paris, 489 The Book of Common Prayer Bellini, Vincenzo, 351, 456-457 Noted, 362-363, 363 stories in stained glass, 230, Basilica of Constantine, 109, The Book of Peace (de Pisan), 259 Norma, 456, 457 114, 115 231 The Book of the City of Ladies (de Basilica style, 109, 114, 115, 152, Benares, 126 study of, during Charlemagne's rule, Pisan), 259 Benedict of Nursia, Saint, 204 154, 164, 189. See also Saint 203 - 204Book of the Dead, 12 Benedictine monasticism, Peter's Basilica Basques, 210 204-206, 216, 218. See also translations of, 203, 306, Books. See also Bible; specific The Battle of San Romano Abbey of Saint Denis 344-345, 346, 362, 407 titles and authors (Uccello), 291, 292 Benedictus in Ordinary of the Voltaire on, 437 education in Charlemagne's The Battle of the Huns (Liszt), Mass, 275 Bibliothèque Nationale, Paris, time, 203 234-235, 295 illuminated, 204, 206, Benefices, 241 Benin, Kingdom of, 546-547, Big Red (Calder), 602, 605 211-213, 213, 214, 239, 274, The Battle of the Romans and the Bird, Isabella, 474 Sabines (David), 460, 461 551 Benin, Republic of, 552 Bird with crocodile on stone India, 524-525, 525 Battle Symphony (Beethoven), monolith, 548, 549 printing, 303-305, 346, 364 Berbers, 545 The Birds (Aristophanes), 64 Battle(s) Berdyaev, Nicholas, 590 Borges, Jorge Luis, 619 The Birth of Venus (Botticelli), Boris Godunov (Moussorgsky), Bergman, Ingmar, 617 Actium, 99 295, 297, 305 456 Wild Strawberries, 617 Agincourt, 254 Chaeronea, 65 Berlin, Irving, 622 Bishop Ecclesius, 171, 173, 173 Born, Ernest, 217 "God Bless America," 622 Bishop Maximian, 171, 174, 174, Born Under Saturn (Wittkower, Crécy, 255 Berlioz, Hector, 454, 508 R. and M.), 397 Fleurus, 439 Hastings, 210 The Damnation of Faust, 454 Bishop of Hippo. See Augustine Borodin, Alexander Marathon, 51, 62 Fantastic Symphony, 454, of Hippo, Saint Porfirievich, 456 Bishop's throne, 174, 176 Borromini, Francesco, 382-383, 508 Pharsalus, 95 Poitiers, 201, 255 Bernadone, Giovanni, 241. See Bist du bei mir (Bach), 401 383, 397 also Francis of Assisi Bithynia, 161 Bosch, Hieronymus, 354-355, Ponts-de-Cé, 391, 394 Black, Brown, and Beige Roncesvalles, 201, 210 Bernard of Clairvaux, 220 Bauhaus, 595, 613-614, 615 Bernini, Gian Lorenzo, (Ellington), 575 Garden of Earthly Delights, Black Death, 253, 254, 266, 281 The Bay (Frankenthaler), 596 380 - 381, 397354-355, 355 Black-figure style, 44, 46 Cardinal Scipione Borghese, Bosporus, 161 Bearden, Romare, 575, 600 Blacks, of ancient Egypt, 10. See 381, 381 Botticelli, Sandro, 293, 302, 313, The Prevalence of Ritual: David, 380-381, 381 also Africa and African Baptism (Bearden), 600, 600 Adoration of the Magi, 293, 293 Saint Peter's Basilica, 381 culture; African Americans Beatitudes, 147 Beatles, 623 Saint Peter's Square, 373, 374 Blair, Eric Arthur. See Orwell, The Birth of Venus, 295, 297, Saint Teresa in Ecstasy, 381, George 305 Revolver, 623

Blake, Eubie, 573

Dante, 245

Beatrice, 245

382

La Primavera (The Springtime), 295, 296, 305 Boucher, François, 415, 419 Cupid a Captive, 419, 419 Boulé, 58 Boulez, Pierre, 620 Second Piano Sonata, 620 Structures, 620 Le Bourgeois Gentilhomme (Molière), 407 Boxer Rebellion, 532 Brady, Mathew, 580 Brahman, 125, 126 Brahms, Johannes, 454–455 Symphony No. I in C minor, Op. 68, 454-455 Bramante, Donato, 320, 321-322 Brancacci Chapel, 284, 284, 285 Brancusi, Constantin, 591 Brandenburg, Margrave of, 401 Brandenburg Concertos (Bach), 401-402, 428, 429 Braque, Georges, 563-564, 591 Violin and Palette (Braque), 563, 565 Brass instruments in symphony orchestra, 428, 429 Brave New World (Huxley), 582 - 583Brecht, Bertolt, 450, 573 "Mack the Knife," 573 Breton, André, 568, 572 The Bridge (Die Brücke) school, Brigid of Ireland, 206 Britain. See England British East India Trading Company, 525, 526 British Museum, 73, 74, 75 British rule, India, 522, 525 Britten, Benjamin, 622 Death in Venice, 622 A Midsummer Night's Dream, 622 Peter Grimes, 622 War Requiem, 622 Broederlam, Melchior, 267 Brontë, Emily, 474-475 Wuthering Heights, 474-475 Bronze Age, 5, 18-27, 33 Brooke, Rupert, 561 Brooks, Gwendolyn, 619 Brown, Denise Scott, 616, 617 Bruckner, Anton, 455 Symphony No. 8 in C minor, Bruegel, Pieter the Elder, 354, 355 - 357Hunters in the Snow, 357, 358 Peasant Wedding Feast, 356, The Triumph of Death, 356, 356 Brunelleschi, Filippo Florence Cathedral, 270, 287, 287 Foundling Hospital, 287, 288

Pazzi Chapel, 287, 288, 319 The Sacrifice of Isaac, 285, 286 sculpture competition for Florence Baptistery doors, 284, 285, 286 synthesis and, 297 Buber, Martin, 590 Bubonic plague, 59-60, 253, 254, 266 Bucolics (Vergil), 100 Buddha, 125-126 Buddhism art, 127-128, 130 Basho and, 537 Buddha's life, 125-126 in China, 135, 534 Hellenistic Greece and, 79 in India, 126-129, 523, 524 map, 127 Budé, Guillaume, 295 The Buildings (Procopius of Caesarea), 163 Bulham, Qamaan, 548 Bull, figure of, 123 Minotaur, 21, 22, 49 Buñuel, Luis, 571 Un Chien Andalou, 571-572 L'Âge d'Or, 572 Buonaiuto, Andrea di, 244 The Triumph of Saint Thomas Aquinas, 244 Burckhardt, Jakob, 301-303 The Civilization of the Renaissance, 301 Burgundy, Duke of, 267 Burial of Count Orgaz (El Greco), 389, 389 Burial rituals and funeral practices Byzantine, 170, 170-171 Chinese, 134, 134 Christian, early, 150 Egyptian, 12, 12-13 Etruscan, 91, 92, 93 Greek, 14, 68, 70 Mesopotamian, 14 Neanderthal people, 14 tomb(s) Hunting and Fishing at Tarquinia, 92, 93 Julius II, 316, 317, 318 Lorenzo de'Medici, 320 Theodoric, 170, 170-171 Tutankhamen's, 15-16, 19 Burin, 351 Bust of Emperor Charles V (Leoni), 341 Butes, 74 Buttresses, 227, 228, 228 Buxtehude, Dietrich, 400, 401 Byblos, 144 Byrd, William, 331, 363 My Ladye Nevells Booke, 363 Ye Sacred Muses, 363 Byron, George Gordon, Lord, 466, 472, 472

Byzantium, 161-181

Al-Khwarizmi in, 195 art, 166-179, 166-525 (See also Mosaics) ascendancy, 163-166 Charlemagne's coronation as rebellion to, 201 Constantine, emperor of, 101 Fourteenth century art, Italo-Byzantine influence in, 179, 260-262, 260-263 Hagia Sophia, Church of, 164-166, 165, 178 Islam, influence on, 189, 190 literature, 161-163 maps, 168, 176 persistence of Byzantine culture, 178-180 Ravenna, 166-178 Rome, decline of, 161–163 Saint Catherine's Monastery at Mount Sinai, 175-178, 177, 178, 179 timeline, 158-159

Cabin Fever (Rothenberg), 602, 602 Caedmon, 206 Caesar, Julius. See Julius Caesar Caesar Augustus, emperor of Rome, 98, 99, 99-105, 101, Café Voltaire, Zurich, 577 Cage, John, 598, 621 Concert for Piano and Orchestra, 621 Calder, Alexander, 602, 607 Big Red, 602, 605 Calendar, Julian, 89 Calf-Bearer, 42, 43 Caligula, emperor of Rome, 99, Calla Lily with Red Roses (O'Keeffe), 592, 593 Callas, Maria, 457, 457 Calligraphy, 135, 137, 187-188, 213, 524, 525, 528 The Calling of Saint Matthew (Caravaggio), 377, 377 Calvin, John, 161, 341-342, 344, 345, 347 Calvinism, 345, 346 Calvinist Church, Dutch, 392 Calvino, Italo, 619 Di Cambio, Arnolfo, 287 Cambridge University, 237 Camento ad alcuni sonetti (A Commentary on Some

Sonnets) (Lorenzo de'

Medici), 294

Campagnola, Giulio, 348

The Astrologer, 348

Camus, Albert, 590, 591

Camerata, 399, 403

The Fall, 591

The Plague, 591

The Stranger, 591

Canaan, 143 Candide (Voltaire), 436-437 Canon of the Bible, 145 The Canon (Polykleitos), 68 Canova, Antonio, 109, 425 Pauline Bonaparte Borghese as Venus Victorious, 425, 426 Cantatas, 401 The Canterbury Tales (Chaucer), 240,257 - 258Canto carnascialesco (carnival song), 308 Cantor, 155 Cantus, 203 Cantus firmus, 237 Cantus planus, 207 Canzoni, 256 Canzoniere (Songbook) (Petrarch), 256-257 Cape, Saint Martin of Tours', Capital (architecture), 46, 47 Capitalism, 346, 450-451, 490, Capitoline hills, Rome, 93 Capitoline She-Wolf, 91 Cappella Giulia, 331 Los Caprichos (Goya), 447, 448 Captives (Michelangelo), 316, 317, 318 Caravaggio, 330, 375-379, 386, The Calling of Saint Matthew, 377, 377 Madonna of Loreto, 377, 379 The Marturdom of Saint Matthew, 377, 378 Cardinal Scipione Borghese (Bernini), 381, 381 Carissimi, Giacomo, 401 The Judgment of Solomon and Job. 400 Carmina Burana (Orff), 241 Carnival song (canto carnascialesco), 308 Carolingian Empire, map of, 202. See also Charlemagne and Medieval culture Carolingian monastery, 216, 217 Carolingian Renaissance, 201, 211 Carracci, Agostino, 379 Carracci, Annibale, 376, 379 The Flight into Egypt, 379, 380 The Triumph of Bacchus and Ariadne, 379, 380, 385 Carracci, Ludovico, 379 Carriera, Rosalba, 420 Anna Sofia d'Este, Princess of Modena, 420, 420 Carter, Howard, 15, 19

Carter Family, 622–623

Casa Milá (Gaudí), 505, 507

Cassatt, Mary, 497-498

Carthage, 94, 102, 149

Caryatids, 74, 75

Caste system, India, 124, 525-526 Castiglione, Baldassare, 332, 333, 364 The Courtier (Castiglione), 332, 364 The Castle (Kafka), 562 Castrati, xxvi Catacombs, 150 Cataneo, Marchesa, 392, 394 Catch-22 (Heller), 589 Catcher in the Rye (Salinger), 618 Catharsis, 66 Cathedra, 174, 176 Cathedral(s). See also Church(es); Saint Peter's Basilica at Amiens, 227-228 at Beauvais, 227-228 cathedral defined, 174 Charlemagne's at Aachen, 172, 210 at Chartres, 227-230, 231, 232, 233-235, 234, 235 in early Christian period, 152-154, 154, 164-166, 165 Florence, 284, 285, 286, 287, at Florence, 247, 270, 272 at Gloucester, 272, 274 Gothic architecture high middle ages, 225-237, 226, 227, 228, 231-236 late middle ages, 270-272, Hagia Sophia, Church of, 164-166, 165, 178 Holy Sepulchre, Church of the, 153-154, 154, 164, 189, illuminated books, 204, 206, 211-213, 213, 214, 239, 274, light, mysticism of, 229-230, 231, 232, 233 at Milan, 247, 270, 271, 272 at Notre Dame, 226-227, 227, 233, 238 at Noyons, 226, 227 Ravenna, 161, 162, 166-178, 166-178 Saint Patrick's, Dublin, 434 at Senlis, 226, 227 stained-glass windows, 226, 229-230, 231 at Strasbourg, 260, 260 town center, cathedral as, 229 - 236Catherine, Saint, Monastery at Mount Sinai, 175-178, 177, 178, 179 Catherine of Siena, Saint, 254 Catherine the Great, empress of Russia, 306, 417 Catholic church. See also Christianity; Monasteries; Chansons de geste, 210 Saint(s)

Aristotalian philosophy and, 66 - 67canonical Books of the Bible, 145 Charlemagne, canonization of, 210, 210-211 vs. Copernican theories, 349 Counter-Reformation and, 345, 346, 373-375 Great Schism, 289-255 Index of Prohibited Books, 306, 346 Machiavelli and, 306 music in Sixteenth century, 330, 331 Reformation, 331, 341-343, 345, 347-348, 359-360 Vatican, 152, 154, 179, 201 Cattle, as Aryan currency, 124 Catullus, 90-91, 95 Causae et Curae (Causes and Cures) (Hildegard of Bingen), 206 Cave paintings, Paleolithic period, 4, 4 Caxton, William, 304, 364 Cecrops, king of Athens, 74 Cefalù, 178 Ceiling, Sistine Chapel ceiling (Michelangelo), 318-319, 319, 320 Ceiling mosaic in Orthodox Baptistery, 169 Cellini, Benvenuto, 330, 333, Autobiography of Benvenuto Cellini, 333 Perseus, 333, 333 The Saltcellar of Francis I, 340 Cemetery at Ur, Royal, 14 Cemetery of Vergina, Royal, 76, 76 Ceramics. See Pottery Ceres, 97 Cereta, Laura, 305 Cervantes Saavedra, Miguel de, 345, 407 The Adventures of Don Quixote, 407 Cerveteri, 91 Ceylon, 127 Cézanne, Paul, 494, 502-503 Mont Sainte-Victoire, 501, 503, 509, 563 Still Life with Commode, 501, 502 Chaeronea, Battle of, 65 Chagall, Marc, 566, 607 Green Violinist, 566, 568 Chaka (Mofolo), 550 Chambord, Château of, 357, 359 Champs Elysées, arch on, 110 Chand, Prem, 526 Chandra Gupta I, 128-129 Chandra Gupta II, 128-129, 130 Chansons, 307, 362

Chansons d'histoire, 210 Chant (Frank), 611 Chanting and religious observance, 154, 203, 206-208, 237 Chapel of Charlemagne, 214-215, 215 Chapter, 232 Charity in Islam, 186 Charlemagne and Medieval culture, 201-221. See also Middle Ages architecture, 172, 203-204, 210, 213-220, 215-220 art, 211-213, 212-214 Charlemagne idealization and canonization of, 210, 210 - 211rule of, 201-204, 205, 210 drama, 209-210 education, 203-204, 205 literature, 203-204, 209, 210-211 map, 202 monasticism, 204-208 music, 206-209 Saint Denis Abbey, 225-226 sculpture, 218, 219-220 timeline, 198-199 Charles I, king of England, 409 Charles I, king of Spain, 339 Charles II, king of England, 409, 434 Charles III, king of Spain, 417 Charles IV, emperor of Holy Roman empire, 267 Charles IV, king of Spain, 461 Charles the Bald, 233 Charles the Good, 307 Charles the Great, 201. See also Charlemagne Charles V, emperor of Holy Roman Empire, 326, 332, 339, 341 Charles V, king of France, 258 Charles VII, king of France, 258 Chartres Cathedral, 227-230, 231, 232, 233-235, 234, 235 Château of Chambord, 357, 359 Chateaubriand, René de, 463 Chaucer, Geoffrey, 162-163, 254, 256, 257-258, 276, 281 The Canterbury Tales, 240, 257-258 Chefren, pharaoh of Egypt, 13, 13, 15, 16 Chekhov, Anton Pavlovich, 515 "The Bet," 515 "The Lady with the Dog," "To Moscow, to Moscow," 515

Chensu, 13

Chevet, 234

Chi, 173, 174

Cheops, pharaoh of Egypt, 13

Chi-Rho Monogram, 150, 153 Chiang Kai-shek, 532 Chiaroscuro, 330, 376-377, 599 Chicago sculpture, 607 Un Chien Andalou (Buñuel and Dali), 571-572 Chikamatsu Monzaemon, 536-537 The Love Suicide at Amijima, 536-537 Children of Israel, 143, 147 Ch'in Dynasty, 133-134 Chin P'ing Mei, 527 China, as term, 528 China and Chinese culture architecture, 529, 529 art, 133, 134-136, 137, 527-528, 528, 530 Communist party, 532, 533 Confucianism, 132, 133 **Dynasties** Ch'in, 133-134 Chou, 131-132, 133, 134, 135, 135 Han, 133, 134 Ming, 526-530, 527 Qing, 530-532 Sung, 526 T'ang, 133, 134, 526 film, 540 Golden Age of, 134 Imperial rule, 526-530 literature, 527, 529 maps, 131, 523, 527 painting, 391, 527-528, 528 Silk industry, 163 Taoism, 132-133 timeline, 120-121, 521 trade and commerce, 530-532 unification of China, 132-136 Chirico, Giorgio de, 569, 576 Choir. See Vocal music Chopin, Frédéric, 455, 455-456, 473 Preludes, Op. 28, 455 Chopin, Kate, 517 The Awakening (Chopin, K.), Chorale fantasies, 401 Chorale preludes, 401 Chorale variations, 400 Chorus in Greek drama, 61 Chou Dynasty, 131-132, 133, 134, 135, 135 Chou Fang, 136 Christ, defined, 147 Christ as Good Shepherd, 150, 152 Christ as the Good Shepherd mosaic, 167, 167 Christ Pantocrater, 178, 178 Christ Teaching the Apostles, 150, 151 Christ the Pantocrater, 171, 173, 173, 178, 178 Christian IV, king of Denmark, 364

Church; Mosque(s);

Cistercians, 225

Temple(s)

Colloguy, Church of the, 176 Christianity. See also Bible; Cithara, 48, 48 Colonization Dutch Calvinist Church, 392 Catholic Church; The City of God (Augustine), in Africa, 553 Monasteries; Reformation Greek Orthodox Church, 178, 161-162, 214, 259 Age of, and Greece, 33, Byzantium City-states 39 - 40architecture, 164-178, Hagia Sophia, Church of, China, 131 values and, 509 164-166, 165, 178 165 - 178civic pride in, 60 Colonna, Donna Vittoria, 318 Holy Sepulchre, Church of Greece, 10, 33, 39-40, 58-59, ascendancy of, 163-166 Color, in music, xxviii the, 153-154, 154, 164, 189, literature, 161-163 60,64-65Color Planes in Oval (Mondrian), Italy, 60 painted icons, 178, 565, 568 light in Byzantine structures, Mesopotamia, 10 178 - 179The Color Purple (Walker), 619 philosophy, 161-163 164 - 165, 165Civil wars Colosseum, Rome, 109 Roman decline, 161-163 Old Saint Peter's, 320 American, 479, 580 Columbus, Christopher, 404 China's Qing Dynasty, 530 Or San Michele, 290 England, 409, 434 Columns Christian humanism and, Russian Orthodox church, Spanish, 577-578 corinthian order, 46, 111, 111 306-307 178 Civilization, characteristics of, 3 doric order, 44-46, 47, 69, 71, Saint Catherine's Monastery Civilization and Its Discontents early at Mount Sinai, 175-178, (Freud), 589-590 architecture, 152-154, 154 ionic order, 44-46, 47, 71, 72, art, 150-151, 151, 152, 153 177, 178, 179 The Civilization of the 73 - 74,75Saint Denis Abbey, 210, beginnings of, 147-152 Renaissance (Burckhardt), Minoan vs. Egyptian and 225-229, 226, 227, 228, 231, Dura-Europos Greek, 22 archeological site, 151-152, Clarinet Quintet (Mozart), 574 Combat, 591 Saint Mark's, Venice, 331 De Claris Mulieribus (Boccaccio), 153 Comedy, 64-65, 95, 406-407 Judaism and, 143-155 Saint Peter's, Geneva, 346 The Comedy of Errors Saint Peter's Basilica, 152, Class. See Social class (Shakespeare), 366 map of communities, 148 music, 154-155 154, 201 Classe, 171, 173 Commentaries (Julius Caesar), persecutions of Christians, Saint Thomas', Leipzig, 401 The Classic of the Way and Its 95 148 - 150San Carlo alle Quattro Power (Tao te ching) (Lao-A Commentary on Some Sonnets Fontane, 382-383, 383 renewed covenant, 145 tzu), 132 (Camento ad alcuni sonetti) Roman Empire, official San Domenico, 262, 262 Classical Greece. See Greece, (Lorenzo de' Medici), 294 religion of, 89, 97, 116 San Giorgio Maggiore, Classical and Hellenistic Commerce. See Trade and spread of, 147-150 Venice, 326, 327 Classical Ideal, Greco-Roman, commerce timeline, 140-141 San Lorenzo, Florence, 319, 57-60, 116 Commodus, emperor of Rome, liturgy, 165-166, 169, 177, Classical music, symphony, 203, 206-207 San Luigi dei Francesi, Rome, 428-432 Communism, 449, 532, 533, Middle Ages Classics of Songs, 134 561 San Vitale, 171, 172-175, 173, architecture, Gothic style, Claudius, emperor of Rome, 99, Communist Manifesto (Marx and 225-237, 226-228, 174, 214 104, 149 Engels), 449 Sant' Apollinare Nuovo, 231-236, 239, 270-272, Clement VII, Pope, 313, 319, Compline, 205 170-171, 170-173 272 - 275330, 333 Composers. See Music; specific Great Schism, 253-255 Santa Croce, Rome, 288 Cleopatra, queen of Egypt, 99, composers and compositions Santa Maria del Carmine, impact on, 225 102 Composition, viewing of art, Clerestory, 152 Reconquista in Spain, 191 Florence, 284, 284, 285, 286 XXV Nietzsche on, 491 Santa Maria Novella, Cloister Graveyard in the Snow Conceptual art, ancient Egypt, Orthodox Christians Florence, 283, 283, 293 (Friedrich), 467, 469 icons, 177, 178, 179 Santa Reparata, Florence, 287 Cloisters, 214, 216, 217, 241 Concerning the Spiritual in Art Santa Trinitá, Florence, 283 (Kandinsky), 566 Neonian Baptistry, 167, Clotho, 37 Shanghai, China, 532, 532 168, 169 Clouet, Jean, 357 Concert for Piano and Orchestra social significance of, Francis I, 357, 358 Theodoric's palace, 171 (Cage), 621 Pico della Mirandola on, 303, 230 - 236Cluny Abbey, 228 Concerto grosso, 374, 401 Vierzehnheiligen Pilgrim Clytemnestra, 62, 62 Concerto in F Major (Gershwin, Church, 422, 423 pilgrimages, 210, 216, 218, Cnidus, 77 G.), 574 233, 235-236 Wittenberg, Church of, 340 Cocteau, Jean, 512, 572, 576 Confessions (Augustine), 162, Christine de Pisan, 258-259 Cicero, Marcus Tullius Blood of a Poet, 571 207, 256 The Book of Peace, 259 Aristotle, influence by, 66 Coda, in sonata form, 430 Confucianism, 132, 133, 529, The Book of the City of Ladies, bust of, 98 Codex Sinaiticus, 176 533 Charlemagne, influence on, Coffeehouse, 196 Confucius, 132, 132, 133, 134 A Letter to the God of Love, 259 203, 204 Cole, Thomas, 478 Congo, Democratic Republic of Julius Caesar and, 95-96, 98, The Treasure of the City of Genesee Scenery, 479, 479 the, 408, 551 Ladies, 259 98-99 Coleridge, Samuel Taylor, 66 Congress of Vienna (1815), 509 Christo, 607 Montaigne, influence on, 348 Colet, John, 295, 306 Conquest, period in Hebrew Chronicles (Froissart), 255, 259 Petrarch, influence on, 256 Collège de France, Paris, 295, history, 143 Chrysippus, 68 as stoic, 163 344 The Consolation of Philosophy Chrysostom, Saint John, 165 Cifra, 195 Collins, Judy, 623 (Boethius), 162-163, 257 Church(es). See also Cimabue, 179, 262, 262, 263, 281 Wildflowers, 623 Constable, John, 468, 470 Cathedral(s); Catholic Crucifixion, 262, 262 Colloquy, Church of the, 176 Hay Wain, 468, 469 Madonna Enthroned, 262, 262

Colloredo, Hieronymus, 431

Cologne, 203

Constantine, Arch of, 116

Constantine, emperor of Rome

capital moved from Rome,	Vibia Perpetua, 126	Crécy, Battle of, 255	Inventions of the Monsters, 570,
101, 113 Christian toleration decree,	women in the Reformation, 342	Credo in Ordinary of the Mass,	571
149	Woolf, Virginia, 570	275 Creon, king of Thebes, 14, 63	L'Âge d'Or (film), 572 The Persistence of Memory,
early Christian Period,	Context, viewing of art,	Crete, 19, 20, 25	569–570, <i>570</i>
152-154, 154, 161, 164	xxiii–xxiv	Crime and Punishment	Dalton, John, 51
as last principal Roman	Contrapunctum, 401	(Dostoyevsky), 515	Damascus, 147, 189, 190
emperor, 99	Convent of San Marco, 290, 301	Critique of Judgment (Kant), 448	Damascus, Mosque of, 189, 190
marble head of, 114 Old Saint Peter's church,	The Conversion of the Harlot	Crito and Timarista, Stele of, 71	La Dame aux camélias (The Lady
320	Thaïs (Hroswitha), 209 Convivio (Dante), 245	Crito (Plato), 65 Cromwell, Oliver, 409	of the Camelias) (Dumas), 457
Receiving Homage from the	Coover, Robert, 619	The Crossing of the Red Sea, 151,	The Damnation of Faust
Senate, 116	Copernicus, Nicholas, 348–349,	153	(Berlioz), 454
Roman architecture, 115	403	Crucifixion (Cimabue), 262, 262	Dance
Constantinople	Copley, John Singleton, 475	Crucifixion from Isenheim	of Baga Sitemu, 553, 554
capital moved to, 113, 161 Charlemagne's rule, 201–202	Le Corbusier, 612–613 Unités d'Habitation,	Altarpiece (Grünewald), 352, 353	ballet, 514, 515, 574, 575–577, 576
Hagia Sophia, Church of,	Marseille, 612, 614	Crucifixion ivory carving, 212,	in early Greece, 47–49, 49
164–166, 165	Córdoba, 190, 201	213	Daniel-Henry Kahnweiler
influence of, 178–180	Córdoba, Mosque of, 190, 191,	Crusades, 178, 216, 225, 226	(Picasso), 564, 565
Justinian's rule, 163–164	192	Cubi I (Smith), 602, 604	Dante Alighieri
Mosque of Córdoba, materials for, 190, 191	Corinth, 40–41, 46, 58, 65 Corinth, Lovis, 510	Cubism, 492, 563–567, 564–567	Aldine Press, published by, 304
Muslim attack on, 186	Salome, 510, 511	Cubism, synthetic, 565 Cui, Cesar Antonovich, 456	vs. Boccaccio, 253
Turk conquest of, 178, 180	Corinthian order, 46, 111, 111	Cullen, Countee, 575	Boethius, quoting of, 162
Contarelli Chapel, 377	Corinthians, Paul's letters to,	Culture, defined, xxiii	on da Vinci, Leonardo, 67
Contemporary contour,	148	Cuneiform system of writing, 6,	on dialectics, 238
589–625 architecture, 505, 507, 590,	Corneille, Pierre, 407 Horace, 407	7, 19	in Fourteenth century, 256 on Great Schism, 254
608-617, 612-618	Polyeucte, 407	Cunningham, Imogen, 580 Cunningham, P., 433	Tuscan dialect of Italian, 281
art, 590, 590, 591–608,	Cornell, Joseph, 603	Cupid a Captive (Boucher), 419,	on Vergil, 100
592-611, 619-620	Object Roses des Vents, 605	419	works
drama, 617–618	Cornice, 46, 47	Currier, Nathaniel, 476	Convivio, 245
global culture, 589–591 literature, 590–591, 617–620	Corpus Christi College at	First Appearance of Jenny Lind	The Divine Comedy, 196,
music, 620–624	Oxford University, 344 Corpus Iuris Civilis, 97	in America, 476 Curtain for ballet Parade	238, 245–247, 247, 456 Inferno from The Divine
opera, 622	Corso, Gregory, 591	(Picasso), 576, 576–577	Comedy, 456
philosophy, 590-591	Cosimo de' Medici, 289-290,	Cush, 10, 27	De Monarchia, 245
sculpture, 602–607, 604–611	293, 293, 295, 333	Cybele, 116	Vita Nuova, 245, 294
timeline, 586–587 Contemporary voices	Cosmeterium ad catacumbas,	Cyclades islands, 20–21	De Vulgari Eloquentia, 245
Africa, Arab and European	150 Cotton Club, Harlem, 574	Cycladic art, 20–21, 21 Cyprus, 26	Dante and His Poem (Michelino), 247
visit to, 551	Cotton cultivation, 123	Cyrus the Great, 10	Dante (Botticelli), 245
Ashoka's Rock Edict, 126	Council of Trent, 346, 373, 398	-,	Danton, Georges-Jacques, 439
Ball, John, 259	Counter-Reformation, 373 – 375,	D	Danube Landscape Near
Fra Savonarola, 282	398, 404	Da Vinci, Leonardo	Regensburg (Altdorfer), 353,
in Charlemagne's time, 205 Homer's world, daily life in,	Counterpoint, music, xxviii, 237, 363, 401	Carucci da Pontormo and, 328	354 Daphnis and Chloe (Ravel), 513
39	Couperin, François, 427	creativity and Aquinas, 67	Darius, king of Persia, 51
Kang Hsi, Chinese Emperor,	Courbet, Gustaye, 466	at French court, 339	Dark Ages, 201, 210. See also
531	The Studio: A Real Allegory of	genius of, 295-296, 300	Middle Ages
Kerdo the Cobbler on, 80	the Last Seven Years of My	Raphael's use of geometric	Darwin, Charles, 451
Louis XV of France, court of, 433	Life, 466, 468	configuration, 314 works	The Descent of Man, 451
to Alma Mahler, 510	Court of the Lions, Alhambra, 191–192, 192	The Last Supper, 295, 296,	On the Origin of Species, 451 Das, Tulsi, 525
Medieval parent and student,	The Courtier (Castiglione), 332,	298, 326	Ramcaritmanas (The Holy Lake
240	364	Madonna of the Rocks, 296,	of the Acts of Rama), 525
Michelangelo and Donna	Covenant, 145	299, 300	Das Lied von der Erde (The Song
Vittoria, 317 Middle Ages, scholarship in,	Craft viewing of art year	Mona Lisa, 295, 298	of the Earth) (Mahler), 511
205	Craft, viewing of art, xxv Cranach, Lucas, 341	Notebooks, 295–296, 298 Dada, 577, 577	Daudet, Alphonse, 462 Daumier, Honoré
O'Keeffe, Georgia, 596	Portrait of Martin Luther,	Dafne (Peri), 399	The Legislative Belly (Le Ventre
Procopius of Caesarea, 126	341	Dagulf Psalter, 212-213, 213, 214	Legislatif), 466, 467
Rome, Imperial, dinner party	Cranmer, Thomas, 362	Daimyo, 535	David, Jacques Louis, 419,
in, 80	Crashaw, Richard, 408	Dalí, Salvador, 569–571	424 – 425, 447, 462
Sufi path, Al Ghazzali on, 196	Creation of Adam (Michelangelo), 318, 320	<i>Un Chien Andalou</i> (film), 571–572	The Battle of the Romans and the Sabines, 460, 461
00,000,000,000,000	(, 100, 101

Babylonian, 9 Napoleon Crossing the Alps, 424, 424-425 Oath of the Horatii, 415, 416, 424, 461 62 - 65,97David, king of Hebrews, 143 David (artist), 109 Minoan, 24, 26 David (Bernini), 380-381, 381 David (Donatello), 290, 291 David (Michelangelo), 300, 301, 21, 22, 27 149 - 150Davis, Miles, 574 Dawn (Michelangelo), 320, 328 Sumerian, 8 Day (Michelangelo), 320, 328 De Beauvoir, Simone, 591 De Claris Mulieribus (Boccaccio), 259 De Hooch, Pieter, 398 De humani corporis fabrica (Vesalius), 349 465, 466, 467 De la Tour, Georges, 383 The Lamentation over Saint Sebastian, 383, 383 De Libero Arbitrio (On Free Will) Delos, 58 (Erasmus), 344 Delphi, 39, 47, 63, 77 De Meun, Jean, 259 Demeter, 27, 35, 97 De Monarchia (Dante), 245 De Musica, 275 De Pizzano, Thomas, 258 De Rerum Natura (On the Nature of Things) (Lucretius), 96 De Revolutionibus orbium coelastium (On the Revolutions of Celestial Denier, 202 Bodies) (Copernicus), 348 De Servo Arbitrio (On the Bondage of the Will) 436 (Luther), 344 De Viris Illustris (Petrarch), 256 De Vita Solitaria (Petrarch), 256 De Vulgari Eloquentia (Dante), 245 Death in Venice (Britten), 622 Death in Venice (Mann), 622 Death of a Miner (Shahn), 593 Death of a Salesman (Miller), 618 The Death of Sardanapalus (Delacroix), 465, 466, 467 Death of the Virgin, 260, 260, 269, Debussy, Claude, 512-513, 576 La Mer (The Sea), 512 Decameron (Boccaccio), 253, 255, Egypt, 14 257, 258 Deception Unmasked (Queirolo), 621-622 421, 422 Decimals, 130, 195 Decius, emperor of Rome, 99, 572 149 Declaration of Independence, Destiny, 37 American, 438, 440-441 Declaration of the Rights of Man, 438 Degas, Edgar, 495-497 Devotion, in Hinduism, 125 The Rehearsal, 497, 497 Dheli Sultanate, 522, 523 The Tub, 497, 497 Deities. See also God, Dhouda, 204

monotheistic

Diaghilev, Serge, 575-577 Christian denial of, 149-150 Dialectics, 237 Dialogue Concerning the Two Egyptian, 10-12, 14 Chief World Systems Greek, 27, 34-37, 38, 47, 49, (Galileo), 403 Dialogues Concerning Two New Hindu, 38, 125, 127-128 Sciences (Galileo), 404 Diana, 97 Mother Goddess, 4, 5, 6, 20, Dickens, Charles, 473, 475, 516 Roman, 96-98, 97, 116, Hard Times, 475 Oliver Twist, 475, 475 A Tale of Two Cities, 475 Le Déjenner sur l'Herbe Dickinson, Emily, 477 Diderot, Denis, 433, 435, 436, (Luncheon on the Grass) (Manet), 492, 493 Del Santo, Andrea, 339 Dido, queen of Carthage, 102 Delacroix, Ferdinand Victor Die Brücke (The Bridge) school, Eugène, 463, 466 The Death of Sardanapalus, Dijon, 267 Dilogues of Plato, 65 Frederic Chopin, 455 The Diner (Segal), 603, 606 Massacre at Chios, 463, 465 Diocletian, emperor of Rome, Delian League, 58, 59, 71 99, 115, 149 Diogenes, 314, 315 Dionysius II, king of Sicily, 66 Dionysius the Areopagite, 229 Dionysus, 21, 34, 35, 49, 60-61, Demetrios, Father, 179 Democratic Republic of the Dipylon Amphora, 38, 39, 39 Congo, 408, 551 Discobolos (Discus Thrower) Les Demoiselles d'Avignon (Picasso), 554, 563, 564 (Myron), 68, 68 Demon of Luxury, 219 Discourse on Method (Descartes), 405 Demosthenes, 65, 304 Disillusionment, 567 Denis Diderot (Houdon), 435, A Distant Mirror (Tuchman), 255 Department of Agriculture, Dithyramb, 49 United States, 581 Divided Kingdom, period in Deposition (Pontormo), 327, 328 Hebrew history, 143 The Divine Comedy (Dante), 196, Der Blaue Reiter (The Blue Rider) school, 505 238, 245-247, 247, 256 Dervishes, dancing, 194 Divine Liturgy of John Des Prez, Josquin, 307, 330-331 Chrysostom, 165 Divine Office, 205, 207 Tu Pauperum Refugium (Thou Refuge of the Poor), 330 Divorce, 9, 18 Descartes, René, 405, 405 The Dockman (Hanson), 607, 610 Discourse on Method Doctor, as academic title, 239 (Descartes), 405 Doge's Palace, Venice, 271, 273 Meditations (Descartes), 405 Dogon people, 551, 552 The Descent of Man (Darwin), A Doll's House (Ibsen), 517 Dome, architectural, 110, Descriptive style of art, ancient Dome of the Rock, Jerusalem, The Desert Music (Reich), 189, 190 Desire (Pothos) (Scopas), 77, 77 Domestic Symphony (Strauss), Desire under the Elms (O'Neill), 510 Dominic, Saint, 242 Dominican Convent of San Marco, 290, 301 Development, in sonata form, Dominicans, 242, 290, 301 Le Devin du Village (Rousseau), Domitian, emperor of Rome, 99, 113

Di Cambio, Arnolfo, 287

Donatello, 287, 290, 293 David, 290, 291 Saint George, 290, 290 Saint Mary Magdalene, 290, Donizetti, Gaetano, 456 Lucia di Lammermoor, 456-457, 457 Donne, John, 408 Doors of Saint Peter's (Manzù), Doors of the Baptistery of Florence (Brunelleschi), 285, 286 Doors of the Baptistery of Florence (Ghiberti), 284, 285, 286, Dorian mode of music, 48, 67 Doric order, 44-46, 47, 69, 71, Doryphoros (Spearbearer) (Polykleitos), 68, 70 Dostovevsky, Fyodor, 474, 506, 515, 590, 591 Crime and Punishment, 515 Douglas, Aaron, 575 Aspects of Negro Life (Douglas), 575 Dowland, John, 364 Dr. Faustus (Marlowe), 366 Dragon, Chinese bronze, 135, 135 Drake, Sir Francis, 360 Drama. See also Literature; Tragedy; specific plays and playwrights Charlemagne and Medieval culture, 209-210 comedy, 64-65, 95, 406-407 Elizabethan, 364-367, 399 Florence, classical revival in, 61 Greece, 51, 60–65 Japan, 533, 536, 537 Middle Ages, 209 Rome, 95, 364-365 Twentieth century, 517, 572, 618-619 Dramatic literature, xxviii-xxix Dreams, 447 Dreigroschenoper (Threepenny Opera) (Weill), 573 Dr. Strangelove (film), 589 110-111, 164, 164, 287, 287, Dryden, John, 434 Dualists, 51 Dubliners (Joyce), 562 DuBois, W. E. B., 575 Duccio di Buoninsegna, 262, The Annunciation of the Death of the Virgin, 263 Madonna Enthroned, 262, 263 Maestà, 262, 263 Duchamp, Marcel, 577 L. H. O. O. Q. (Mona Lisa), Don Juan (Strauss), 508, 510 Don Quixote, The Adventures of 577 Dufay, Guillaume, 307 (Cervantes), 407 Dumas, Alexandre, 457 Don Quixote (Strauss), 49

Dunstable, John, 362 Middle Ages, impact on, 225 Ivan the Terrible, part I and II, Encomium Moriae (Erasmus), Duomo (Florence), 270, 272 Plato's Academy, 66 Duomo (Milan), 270-271, 272 scholasticism, 237-245 Potemkin, 579, 579 Encyclopédie, 435-436 Dupin, Aurore, 473. See also science, 405 Strike!, 579 Encyclopedists, 435-436 Sand, George social class, 204 El Greco, 388-389, 579 Engels, Friednich, 449-450 Duplum, 237 studia in Italy, 179 Burial of Count Orgaz, 388, 389 Communist Manifesto, 449 Dura-Europos, 151–152, 153 of women, 209, 241, 258-259, Martyrdom of Saint Maurice England Dürer, Albrecht, 339, 350-352, and the Theban Legion, 388, American Revolutionary 353 Edward III, king of England, War, 440-441, 447 Apocalypse series, 350-351, 255, 257 Electra, 62 art, 359-362, 360-361, 425, 351 Egmont (Goethe), 471 Electra complex, 572 426, 427 Erasmus of Rotterdam, 306 Ego, 568 Electronic music, 620-621 Baroque period, 399 Fall of Man (Adam and Eve), Egypt and Egyptian culture, Electronic Superhighway (Paik), Chinese trade, 526 351, 351, 353 607,610 civil war, 409 Knight, Death, and the Devil, Alexander's conquest of, Elegy to the Spanish Republic #34 drama, 364-367, 399 352, 352 17 - 18(Motherwell), 594, 595 Houses of Parliament in, 448, Libri IV De Humani Corpons ancient Egypt, 10-18 Elephant ceremonial vessel, 132 449 Proportionibus (Four Books art, 7, 10-18, 12, 15-20, 41 Elgin, Lord, 73 Hundred Years' War, 255 on Human Proportions), 352 Buddhist missionaries in, Elgin Marbles, 73, 74, 75 India, British rule of, 525 Saint Michael Fighting the Eliot, George, 474 late Gothic architecture in, Dragon, 351, 351 Cleopatra, queen of, 99, 102 Eliot, T. S., 100, 247, 408, 562, 272, 274 Self-Portrait, 350, 350 Hebrew exodus, 143, 146 563, 570, 582, 617 literature, 257-258, 364-367, Dusk (Michelangelo), 320, 328 hieroglyphics, 7 "Ash Wednesday," 562 407-408, 434-435, Dusyanta, 130 influence of, 27 Four Quartets, 562 561 - 563Dutch Calvinist Church, 392 love, marriage and divorce in "The Hollow Men," 562 music, 331, 362-364, 399 Dvorák, Antonin, 456 ancient, 18 The Waste Land, 562, 582 opera's popularity in, 399 Slavonic Dances, 456 opium, 530-531 vs. Mesopotamia, 5 Elizabeth I, queen of England, Dylan, Bob, 622 New Kingdom, 10, 14-18 339, 359 – 360, 360, 362, 363, painting, 420-421, 420-421, Old and Middle Kingdoms, 467-468, 469, 470 12 - 14Elizabethan England. See also Peasant Revolt, 255, 259 Eagle Head, Manchester, overview of ancient, 5, 10 England poetry, 407-408, 472-473 Massachusetts (Homer), Ptolemies kingdom in, 79 art, 359-362, 360-361 in Renaissance, 339 478, 480 religion and deities, 10-12, literature, 364-367 science, 348-349 Eakins, Thomas, 475, 478-479, 14 music, 362-364 Engraving, 350 480 - 481timeline, 1 Elkin, Stanley, 619 Enkidu, 6 Miss Van Buren, 480, 481 Eiffel, Gustave, 491 Ellington, Edward Kennedy Enlightened One (Buddha), 125 The Swimming Hole, 480, 480 Eiffel Tower, 491, 614 'Duke," 573-575 Enlightenment, Age of, 415 Black, Brown, and Beige, 575 Early Renaissance. See Eighteenth century, 415-443 Ennius, 95 Renaissance, Early as age of diversity, 415-416 "Mood Indigo," 575 Annals, 95 East Doors of the Baptistery of architecture, 421-422, 422, Nutcracker Suite, 575 Ensembles, 432 Florence (Brunelleschi), 285, 423 Peer Gynt Suite, 575 Entablature, 46, 47 art The River, 575 Entasis, 71 East Doors of the Baptistery of Shakespearean Suite, 575 neo-classical, 424-426, Enthroned Madonna with Saints Florence (Ghiberti), 284, 424 - 426, 460"Take the A Train," 575 Liberalis and Francis of 285, 286, 286 rococo style, 415, 417-422, Ellison, Ralph, 619 Assisi (Giorgione), 324, 324 East Wing, National Gallery of Invisible Man, 619 The Entombment of Atala Art (Pei), 614, 615 encyclopedists in, 435-436 Emerson, Ralph Waldo, 477 (Girodet-Tnioson), 462, 464 Eastman, George, 580 literature, 433-437 Emotion Ephesus, 46, 78 Ecclesia, 58 map, 417 Baroque study of, 375, 377, Epic literature, xxix Ecclesius, Bishop, 171, 173, 173 music, 426-432 380, 381, 388, 389, 393-395, Epic of Gilgamesh, 6-8 Echinus, 46 rediscovery of classical Epictetus, 96-97 Eclogues (Vergil), 100 antiquity in, 422-423, 427 emotional context, viewing Enchiridion, 96 Edict of Diocletian, 115 revolutions (social), 438-441 of art, xxiv Handbook, 96 Edo (later Tokyo), 535 sculpture, 421, 422 love, 18, 95 Epicureanism, 51, 96, 97, 116 Edo period, Japan, 535-537 timeline, 412-413 modern era, 505-506 Epicurus, 96 Education. See also Universities Eightfold Noble Path of Romantic era, 447 Epistemology in philosophy, 50 Aristotle's Lyceum, 66 Buddhism, 126 Empedocles of Acragas, 50 Erasmus, Desiderius (Erasmus Bait al-hikma (House of Emperor of China: Self-Portrait of Ein' Feste Burg Ist Unser' Gott (A of Rotterdam) Wisdom), 194-195 Mighty Fortress Is Our God) K'ang Hsi (Spence), 532 as Christian humanist. in Biblical languages, 344 (Luther), 346, 347 Emperors of Rome, 99, 113 28-29, 297, 303, 306, 435 cathedrals and, 232-233 Ein Heldenleben (Hero's Life) Empfindsamkeit, 427 Reformation and, 343, 344 in Charlemagne's time, (Strauss), 510 Empire, values of, 101 203-204, 205 Einhard, 205, 207 Encaustic method of painting, De Libero Arbitrio (On Free Greek studies, 179-180, 289, Einstein on the Beach (Glass and 178, 178 Will), 344 295, 297 Enchiridion (Epictetus), 96 Wilson), 622 **Enchiridion Militis** literacy and Reformation, 346 Eisenstein, Sergei, 579 Enchiridion Militis Christiani Christiani, 306 Luther on, 346 Alexander Nevsky, 579 (Erasmus), 306 Encomium Moriae, 306

English humanism and, Greek New Testament, 306 The Praise of Folly, 306-307 Erasmus of Rotterdam (Dürer), 306 Erechtheum temple, 70, 73-74, Erechtheus, king of Athens, 74 Ermine Portrait of Queen Elizabeth I (Hilliard), 360, Ernst, Max, 569, 591 Eroica Symphony (Beethoven), 453 Eros, 568 "An Essay Concerning Human Understanding" (Locke), Essay on Criticism (Pope), 434 Essay on Man (Pope), 434 Essays (Montaigne), 347-348 Esterhazy, prince of Austria, Et in Arcadia Ego (Poussin), 384, 384, 385 Etheria, 175-176 Peregrinatio, 175-176 Ethics, in Bible, 145, 146 Ethics (Aristotle), 245 Ethos, 48, 67, 155, 308 Etruscans, 91-92, 109-110 Euclid, 203, 314, 315, 532 Eumenes II, king of Pergamum, Eumenides, 62 The Eumenides (Aeschylus), 61, Euphrates River, 5, 5, 6 Euphronios Vase, 44, 46 Euridice (Peri), 399 Euripides, 60, 61, 64, 576 Antigone, 576 Bacchae, 64 Helen, 64 Iphigenia in Taurus, 64 The Suppliant Women, 64 Europe. See Renaissance, Northern Europe; specific countries Evans, Arthur, 21-22 Knossos excavation and Minoan culture, 21-23, 23 - 27Evans, Mary Ann, 474. See also Eliot, George Evans, Walker, 581 The Eve of War (Meidner), 489, Everyman (morality play), 209, 364, 527 Evolution, 3, 451 Execution of the Madrileños on May 3, 1808 (Goya), 461, 461 Exekias, 44, 46

Exemplum, 230, 253, 258

Exile, period in Hebrew history, 143–144
Existentialism, 591–592, 600, 619
Exodos, period in Hebrew history, 143
Exodus, Book of, 147
Exposition, in sonata form, 429
Expressionism, 492, 505–506, 506, 566–567, 592–597, 594–597, 599
The Expulsion of Adam and Eve from Eden (Masaccio), 284, 285

F F/64 Group, 580 Fables of Aesop, 433 Fabliaux, 253, 258 The Faerie Queene (Spenser), 364 Fairs. See Trade and commerce The Fall (Camus), 591 Fall of Man (Adam and Eve) (Dürer), 351, 351, 353 The Family of Charles IV (Goya), 461, 462 Fantastic Symphony (Berlioz), 454,508 Fasting Buddha, 128, 130 Fate, 37, 63-64 Fatima, daughter of Muhammad's, 185 Faulkner, William, 572, 590, 618 Faust (Goethe), 471-472 Fauvism, 492, 504-505, 505, 506 Female head from Uruk, 6, 8 Feminism, 563, 619 Ferdinand, king of Austria, 339 Fertile Crescent, 7. See also Mesopotamia Fêtes galantes, rococo period, 419 Feudal Japan, 535 Feudalism, 201, 217 Ficino, Marsilio, 179, 289, 293, 295, 297, 303, 307, 308 Fideism, 242 Fidelio (Beethoven), 452, 454 Fifteenth century, 283. See also Renaissance Fifth Century B. C., Greek sculpture and vase painting, 68-76, 68-76. See also Greece, Classical and Hellenistic Filipepi, Alessandro di Maniano dei, 293. See also Botticelli, Sandro Fra Filippo Lippi, 293

Film, 540, 571-572, 578-580,

Finnegans Wake (Joyce), 562

The Firebird (Stravinsky), 514

First Appearance of Jenny Lind in

America (Currier), 476

579-580, 618

Finnish language, 346

Fish and Chalice, 153

Fish as Christian symbol, 150, 153 Fitzgerald, F. Scott, 573 Five Classics, 134 Flag series (Johnson), 597, 597 Flagellants, 255 Flaubert, Gustave, 473 Flavian emperors of Rome, 99 Fleurus, Battle of, 439 The Flight into Egypt (Carracci), 379, 380 Flood, in *Epic of Gilgamesh*, 7 Florence. See Italy; Renaissance, early, in Florence Florence, Cathedral of, 247, 270, 272, 284, 285, 286, 287, 287 Fontainebleau, library at, 295 Forbidden City, Beijing, 529, Ford, Henry, 561, 583 Form, in music, xxviii Form and function in architecture, 608, 610 Formal elements, viewing of art, xxv Fortuna, 37 Forum, Roman, 93, 94 Foundling Hospital, Florence, 287, 288 Four Books on Human Proportions (Libri IV De Humani Corpons Proportionibus) (Dürer), 352 Four Noble Truths of Buddhism, 127 Four Quartets (Eliot), 562 The Four Seasons (Vivaldi), 402, 508 Fourfold Noble Path of Buddhism, 126 Fourteenth century. See Middle Ages, Fourteenth century Fourth Century B. C., visual arts in, 76-78, 76-78. See also Greece, Classical and Hellenistic Fourth interval in music, 67 Fra Angelico, 290, 293, 307 The Annunciation, 290, 291 Fra Filippo Lippi, 293 Fra Savonarola, 282, 302, 307, Fragonard, Jean Honoré, 419 Love Letters, 419, 420 France. See also Paris architecture, 466-467, 468 art, 339, 357-358, 358, 492-506, 492-506 encyclopedists, 435-436 French Revolution, 415, 419, 424, 438-439 Ghana, colonialism in, 549

Hundred Years' War, 255

India, colonialism in, 525

literature, 258-259, 473-474

231

Île-de-France, 227, 229, 230,

music, 272-275, 274, 275, 362 painting Baroque period, 171–175. 383-388, 406-407 cave paintings, Paleolithic period, 4, 4 rococo, 418-420, 418-420 Romantic era, 462–463, 464 - 466, 466Saint Bartholomew's Day Massacre in, 347 Francis I, king of France, 339, 357, 358 Francis I (Clouet), 357, 358 Francis of Assisi, Saint, 241-242, 242, 243, 264, 266, Franciscans, 241-242, 264, 288 François Vase, 40 Frank, Mary, 607 Chant, 611 Frankenthaler, Helen, 596-597 The Bay, 596 Frankish kingdom, 203, 204, 207, 210. See also Charlemagne and Medieval culture Franklin, Benjamin, 147 Freak Out (Zappa), 623 Frederic Chopin (Delacroix), 455 Frederick Barbarossa, emperor of Roman Empire, 210 Frederick II, emperor of Prussia, "the Great," 415-416, 417, 427, 437 French Republic, 419 Frescobaldi, Girolamo, 400, 401 Frescoes, 108, 150, 151, 151, 153 Freud, Sigmund, 63, 514, 567-568, 570-572, 600 Civilization and Its Discontents, 589-590 The Interpretation of Dreams, 567-568 Friedrich, Caspar David, 467 Cloister Graveyard in the Snow, 467, 469 Frieze, 46, 47, 71, 72, 73, 103, 128 Froben, printer at Basel, 344 Froissart, Jean, 255, 259 Chronicles, 255, 259 Frottola, 308 Fry, Roger, 563 Fugue, 401 Fujiwara Michinaga, 533 Full anthem, 363 Funeral practices. See Burial rituals and funeral practices The Furies, 62 Future Shock (Toffler), 590 Futurism, 581-582 G

G Gabo, Naum, 576 Gabriel, Angel, 185 Gabrieli, Andrea, 331

Goodman, Benny, 574

Gabrieli, Giovanni, 331
Gainsborough, Thomas, 420
Haymaker and Sleeping Girl,
415, 416, 420
Mary, Countess Howe, 419, 420
Gaius, 103
Gaius Caligula, emperor of
Rome, 99, 100
Galatians, Paul's letters to,
148
Galen, 195
Galileo Galilei, 295, 349,
402-403, 403
Dialogue Concerning the Two
Chief World Systems, 403
Dialogues Concerning Two New
Sciences, 404
Galilei, Vincenzo, 403
Galla Placidia, regent of
Ravenna, 166, 166-167,
167, 168
Galleria, 379
Gandersheim, 209
Gandhara, Buddhist sculpture
at, 79
Gandharan, 79
Gandhi, Mohandas, 525-526,
606
Ganges River Valley, 128
García Máquez, Gabriel, 619
Garden of Earthly Delights
(Bosch), 354–355, 355
Gargoyles, 230, 233
Garnier, Charles, 467
Paris Opera House, 468
Gaskell, Elizabeth, 475
Gates of Paradise (Ghiberti), 286,
286
Gaudí, Antonio, 505
Casa Milá, 505, 507
Gauguin, Paul, 501
Ia Orana Maria, 500, 501
Gaul, 81, 94
Gautama, Siddhartha, 125–126
Gehry, Frank, 617
American Center in Paris,
616, 617
Gellee, Claude, 386
Mill on a River, 386, 386
Generation Gap, 623
Genesee Scenery (Cole), 479, 479
Genesis, Book of, 7, 145-214
Gênet, Jean, 591
Geneva, 345, 346
Genghis Khan, ruler of
Mongols, 523
Gentile da Fabriano, 283
Adoration of the Magi, 282, 283
Gentileschi, Artemisia, 378–379
Judith and Holofernes,
378-379, 379
Gentileschi, Orazio, 377-378
Geometric art, Greek pottery,
37–38, 38, 39, 40
Geometric period, 38
George I, king of England, 417

George II, king of England, 417

George III, king of England, 417 Giovanni, Nikki, 619 George Washington (Houdon), 440 Georges Pompidou National Center for Arts and Culture (Piano and 462 Rogers), 614, 615 Georgics (Vergil), 100-101 Geranos, 49 Géricault, Jean Louis André 320, 322 Théodore Giza, pyramids at, 13, 15 Gladiatorial contests, 89, 90 Raft of the Medusa, 463, 464. 470 Germany architecture, 422 art, 339, 349-353, 350-354 expressionism, 505-506, 506, 229-230, 231 566-567 Glass, Philip, 622 Hroswitha's dramas, 209 Akhnaten, 622 minnesingers in, 237 music, 362 Satyagraha, 622 Nazism, 561, 580, 606 Global culture, 589-591 opera, 458, 459, 460 painting, 467, 469 365 Peasant Revolt, 255, 259, 341, 275 Reformation, 341 Gershwin, George, 574-575 Go Tell It On the Mountain Concerto in F Major, 574 (Baldwin), 619 Porgy and Bess, 574 Rhapsody in Blue, 574 also Religion Gershwin, Ira, 574 Aguinas on, 243-244 Gesamtkunstwerk, 61, 458 Aristotle on, 66-67 Getty Center (Irwin and Meier), 618 161 - 162Ghagba portrait mask, African, Boethius on, 162-163 553, 555 Ghana, 545-547, 551 Al-Ghazali, 196 in Islam, 185, 186, 187 The Incoherence of the Philosophers, 196 231, 232, 233 Ghiberti, Lorenzo, 281, 284, 286 - 287622 Gates of Paradise doors, 286, 286 Deities The Sacrifice of Isaac, 285, 286 Ghinlandaio, Domenico, 313 62 - 65,97Gilbert, William, 348 Rome, 96-98, 97, 116, Gilgamesh, ruler of Sumeria, 149 - 1506 - 8Ginsberg, Allan, 591 Giorgione di Castelfranco, 324, Egmont, 471 324, 353 Faust, 471-472, 477 Enthroned Madonna with Iphigeneia in Tauris, 471 Saints Liberalis and Francis The Sufferings of Young of Assisi, 324, 324 Werther, 471, 471 Le Concert Champêtre, 324, Golden Ages 324 - 325of Athens, 59, 103 Giotto da Bondone, 179, 256, of Augustus, New, 103 259-266, 281 of China, 134 The Lamentation over the Dead of Greece, 57, 70 Christ, 264, 265 of Latin Literature, 104 Madonna Enthroned, 264, 264 of Rome, 99 The Meeting of Joachim and Goliadic verse, 241 Anna, 264, 265 Golias, Saint, 241 Saint Francis Renounces His

Worldly Goods, 264, 266, 266

Giovanni Arnolfini and His Bride Gospel Book of Charlemagne, 211, (van Eyck), 289, 289 Giovanni de' Medici, 293, 340 Gospels, 147, 152, 171. See also Girodet-Trioson, Anne-Louis, Bible Gothic, as a term, 227 The Entombment of Atala, 462, Gothic style, architecture high middle ages, 225-237, Giuliano de' Medici, 293, 293, 226-228, 231-236 late middle ages, 270-272, 272, 273 Goths, 114, 161, 162, 169-170, 214 art in early Christian period, Gottlieb, Adolph, 594-595 Thrust, 594, 594 stained-glass windows, 226, Goujon, Jean, 358, 360 Government and political theory autocracy, 169 Einstein on the Beach, 622 Confucius, 132 democracy, 58, 92-93 Florence, republican Globe Playhouse, London, 365, government of, 281 gothic cathedral and, Gloria in Ordinary of the Mass, 230 - 234Greek tyrants, 42, 65 Gloucester Cathedral, 272, 274 of Plato, 66 Roman, 97 Goya, Francisco, 460-462 God, monotheistic, 303, 404. See Execution of the Madrileños on May 3, 1808, 460, 461 The Family of Charles IV, 461, Augustine of Hippo on, Los Caprichos (The Sleep of Reason Produces Monsters), 447, 448, 462 Saturn Devouring One of His Dante's view on, 245-247 Sons, 462, 463 in Hebrew Bible, 145-147 Gozzoli, Benozzo, 293-294, 294 The Journey of the Magi, 294 light, mysticism of, 229-230, Grabar, André, 178 "God Bless America" (Berlin), Graeco-Roman culture and the West, 143 Gods and Goddesses. See also Granada, 191-192, 192 Grand Ole Opry, 623 Greece, 27, 34-37, 38, 47, 49, The Grapes of Wrath (Steinbeck), 581 Grave Stele of Crito and Timarista, 71 Gravity's Rainbow (Pynchon), Goethe, Johann Wolfgang von, 109, 454, 458, 470-472, 477 589 Great Depression, 581 Great Panathenaic Festival, 72, Great Schism, 253-255 Great Wall of China, 133, 133 - 134The Great Wall of Kanagawa (Hokusai Katsusika), 537 Great War (World War I), 489, 525, 561, 567, 580 Great Zimbabwe, 547-548, 548 Greece. See also Athens Classical and Hellenistic, 57 - 85architecture, 69-74, 75, Gonzaga, Cecilia, 305 Good Shepherd, 150, 152 77-78, 78, 79-83, 81, 82

646

art, 79-80, 82 Greek New Testament (Erasmus), Hall of Mirrors, Versailles, 387, Hegel, Georg Wilhelm city-states of, 58-59, 64-65 387-388, 415 Friedrich, 449, 590 Hals, Frans, 392-393 Classical Ideal, 57–60 Greek Orthodox Church, 178, Hegira, 185 Banquet of the Officers of the Heidegger, Martin, 590, 591 drama, 51, 60-65 179 Civic Guard of Saint George Green Violinist (Chagall), 566, Heisenberg, Werner, 51 Hebrew conquest, 143 at Haarlem, 394, 395 Helen (Euripides), 64 Knossos, 20-21 Gregorian chant, 203, 206-208, map, 34, 79 René Descartes, 404 Hélène Fourment and Her music, xxvi, 67, 89 237, 330, 331, 362-363 Hamada Shoji, 537 Children (Rubens), 391, 392 Mycenaean culture, 19, Gregory, Pope, 330 Hamartia, 64 Hell, in Dante's Divine Comedy, Gregory the Great, Pope, 203, Hamlet (Liszt), 508 245-247, 248 24-27, 27, 33painting, 44, 46, 68, 70, 76 207 Hamlet (Shakespeare), 332, 367 Hellenistic Greece. See Greece, Grey Panels 2 (Kelly), 599 Hammurabi, king of Babylonia, Classical and Hellenistic Peloponnesian War, 57–60, Gris, Juan, 565 9, 10, 11 Heller, Joseph, 589 64-66, 68, 70, 71Persian Wars, 58-59, 65 Guitar and Music Paper, 565, Hammurabi, Stele of, 7, 9, 11 Catch-22, 589 philosophy, 65-67 Hampton, Lionel, 573 Heloise and Abelard, 241 Grocyn, William, 295 Han Dynasty, 133, 134, 135, 135, poetry, 49-50, 64 Hemlock, Socrates' poison, 65 Gropius, Walter, 613 136, 137 Hendrix, Jimi, 623 Roman conquest of, 94, Grosz, George, 591 Handbook (Epictetus), 96 Henotheism, 145 Henry IV, king of France, 391, Ground, of theater, 365 Handel, Georg Frideric, 400 sculpture, 68, 68-71, 76-78, 76-78 Groundlings, 365, 399 Messiah, 400 399 Grünewald, Matthias, 350, The Music for Royal Fireworks, Henry IV, parts I and II sphinx as motif, 13, 15 Thirty Tyrants rule in, 66 352 - 353(Shakespeare), 366 timeline, 54-55 Crucifixion from Isenheim The Water Music, 400 Henry VII, king of England, 359 Altarpiece, 352, 353 Xerxes, 400 Henry VIII, king of England, cultural influence of Buddhist missionaries in, Isenheim Altarpiece, Handwriting. See Writing 341-342, 342, 349, 362, 363 127 352-353, 353, 354 Handy, W. C., 573 Henry VIII in Wedding Dress Byzantine influences on, Resurrection from Isenheim Hanson, Duane, 607, 610 (Holbein the Younger), 179 - 180Altarpiece, 353, 354 The Dockman, 607, 610 342 Greek studies, 289, 295, Gudea, 9, 9 Haphaistos, 74 Hephaestus, 35, 97 Guernica (Picasso), 577-578, Hapi, 13 Hera, 27, 34, 35, 46, 47, 97 297, 304 578 Happenings, 598 Hera, Temple of, 46, 47 impact on Middle Ages, "La Guerre" ("The War") 225 Hapsburg family, 339, 478 Heraclitus of Ephesus, 51 (Janequin), 362 Harappa, 123 Herculaneum excavation, 422, language, 179, 201 Guggenheim, Peggy, 591, 592 on opera, 399 Hard Times (Dickens), 475 424 Hermes, 35, 47, 97 on Reformation education, Guggenheim Museum Hardedge art, 565 Hermes with Infant Dionysus (Wright), 610-611, 612 Harlem Renaissance, 563, 575, Guide for the Perplexed (Praxiteles), 76, 76 scholarship, 179-180 619 early period, 33-53 (Maimonides), 244 Harmony, xxvi, 51, 67, 507 Hero and Leander (Marlowe), 366 Guido, Tommaso, 283. See also Harp, 154, 155 Herodotus, 51-52, 304 Aegean culture in the Bronze Age, 18-27 Masaccio Harpsichord, 400 History of the Persian Wars, 51 Age of Colonization, 33, Guilds, 234-235, 281 Harrer, Gustave Adolphus, 80 Heroic Age in early Greece, 33-37 Guitar and Music Paper (Gris), 39 - 40Hartt, Frederick, 328 Herondas, 80 565, 567 Harvey, Sir William, 348 architecture, 44-46, 47 art, 35, 37-44, 38-40, 515 Gulliver's Travels (Swift), 435 Haskins, Charles Homer, 301 Hero's Life (Ein Heldenleben) Gupta Empire, 128-131, 525 city-states of, 10, 33, 34, The Renaissance of the Twelfth (Strauss), 510 Gustav Mahler (Rodin), 499, 511, Century, 301 Herzog, Jacques, 617 defeat of Persians by, 27, 42 512 Hastings, Battle of, 210 Tate Museum, 617 Gustavus III, king of Sweden, Hathaway, Anne, 366 Hesiod, 49, 50 Heroic Age in, 33-37 Theogony, 49 Iron Age in, 26, 27, 33 417 Hathor, 13 literature, 35-37, 49-52 Gutenberg, Johannes, 304 Havel, Vaclav, 606 Works and Days, 49 Gutenberg Bible, 306, 346 map, 34 Hawthorne, Nathaniel, 477 Heyward, DuBose, 574 Guthrie, Woody, 622-623 The Scarlet Letter, 477 Hideyoshi, 535 music and dance in, 47-49, "This Land Is Your Land," Hay Wain (Constable), 468, 469 Hierarchical, Middle Ages as, Olympic Games in, 39 622 Haydn, Franz Joseph, 428, 430, painting, 44, 46 Gutians, 8 Hieroglyphics, 7, 22 philosophy, 50-51 Haymaker and Sleeping Girl High Italian Renaissance. See poetry, 49-50 (Gainsborough), 415, 416, Renaissance, High Italian religion and deities, 27, H. M. S Beagle, 451 420 period 34 - 37, 47, 49Hadith, 187 Al-Hazen, 195 High Middle Ages. See Middle Hadrian, emperor of Rome, 98, sculpture, 41-44, 41-45 Heade, Martin J. Ages, High period Lake George, 478-479, 479 timeline, 30-31 99, 111, 164 High relief, 42 Hadrian VI, Pope, 313 Gods and Goddesses, 27, Hebrew language, 6, 344 Hilda, abbess of Whitby, 206 34-37, 38, 47, 49, 62-65, 97 Hagia Sophia, Church of, Hebrews, history of, 143-144. Hildegard of Bingen, 206, 206 164-166, 165, 178 Golden Age of, 57, 70 See also Judaism Causae et Curae (Causes and Greek literature in translation Haiku, 353-536 Heckel, Erich, 506 Cures), 206 (Herondas, Howe, and Haj, 185 Two Men at a Table, 506, 507 Ordo Virtutum, 206

Al-Hakam, 190-191

Hector, 36

Harrer), 80

Physica, 206

Scivias, 206, 206	Trojan War, 25	Hungarian Rhapsodies (Liszt),	Gupta Empire, 128–131
Symphonia, 206	works	456	Hindu art, 127–128
Hilliard, Nicholas, 362	Iliad, 25, 33, 35-37, 39, 47,	Huns, 114, 130	Indian nationalism, 525
Ermine Portrait of Queen	101	Hunter, Alberta, 573	Indus Valley civilization,
Elizabeth I, 360, 362	Odyssey, 21, 25, 33, 35-37,	Hunters in the Snow (Bruegel the	123-124
Portrait of a Youth, 361, 362	101	Elder), 357, 358	Islam and Muslims in,
Hinayana, 135	Homer, Winslow, 478, 480-481	Hurston, Zora Neale, 575	525-526
Hindemith, Paul, 573	Eagle Head, Manchester,	Huxley, Aldous, 582	Al-Khwarizmi in, 195
Klaviersuite, 574	Massachusetts, 478, 480	Brave New World, 582-583	literature, 124–125, 129–130,
Hinduism, 525–526	Honorius, emperor of Rome,	Hymnody, 346	525, 525-526
art, 127–128	161	Hymns. See Vocal music	map, 523
gods, 38	De Hooch, Pieter, 398	•	Mughal Empire, 522, 523,
literature, 124–125 number notation, 195	Hope in Another (Spem in Alium)	I Ia Orana Maria (Gauguin), 500,	524–525 nationalism, 525–526
origins, 125, 129	(Tallis), 363 Hopper, Edward, 592	501	painting, 524–525, 525
Hippo, Augustine of. See	Nighthawks, 592	Ibsen, Henrik, 517	poetry, 524–525
Augustine of Hippo, Saint	Office in a Small City, 592	A Doll's House, 517	Taj Mahal, 192, 193
L'Histoire du soldat (Stravinsky),	Horace, 100, 104, 434	Icons, 177, 179	timeline, 120-121, 520
573-574	Horace (Corneille), 407	Id, 568	Induction, 404
Historians, 51–52, 59	Horarium Monasticum,	Igbo people, 550, 551	Indulgences, 340
History, viewing of art, xxiv	205-206	Ignatius Loyola, 373	Indus River Valley, 18–19,
History of African Civilization	Horn, Walter, 217	Spiritual Exercises, 373	123–124, 128, 525
(Murphy, E. J.), 551	Horses, Aryan civilization, 124	Ihara Saikaku, 536–537	Industrial Revolution, 439
History of Ancient Art	Hortensian Law, 94	"Il Penseroso" (Milton), 408	Industrialization, 451–452
(Winckelmann), 109	Horus, 12, 13	Il Trovatore (Verdi), 457	Inferno, in Dante's The Divine Comedy, 245–247, 246, 248
History of Egypt (Manetho), 10 History of the Peloponnesian War	Hôtel de Soubise, Paris, 421–422, 422	Ile-de-France, 226, 229, 230, 231 <i>Iliad</i> (Homer), 25, 33, 35–37, 39,	Ingres, Jean Auguste
(Thucydides), 59	Houdon, Jean Antoine, 425,	47, 101, 433, 434, 466, 548	Dominique, 109, 466, 623
History of the Persian Wars	435	Ilium, 25	<i>Jupiter and Thetis</i> , 466, 466
(Herodotus), 51	Denis Diderot, 435, 436	Illuminated manuscripts, 204,	La Comtesse d'Haussonville,
Hitler, Adolf, 561, 567, 580	George Washington, 440	206, 211 – 213, 213, 214, 239,	466, 467
Hittites, 6	House (Bartlett), 607, 610	274, 275	Inneraum (Kiefer), 603
Hobbes, Thomas, 405-406	House of the Silver Wedding,	Imam, 185	Inquisition, 403, 407
Leviathan, 405–406	Pompeii, 108	Imhotep, 13, 45	Inscriptions, early Christian art,
Hockney, David, 527, 576	House of Wisdom (Bait al-	The Immaculate Conception	150, 153
Self-Portrait, 602, 603	hikma), 194–195	(Tiepolo), 421, 421	Institutes, Justinian's, 164
Hofmann, Hans, 591, 603	Houses of Parliament, London,	Immigration to America, 491	Institutio Oratoria (Quintilian),
Hogarth, William, 425 Marriage à la Mode, 415, 425,	448, 449 Houston Grand Opera, 574	Imperial fora, Rome, 111, 111–112	203 Intellectual context, viewing of
426	Howe, George, 80	Imperial Rome. See Rome,	art, xxiv
Hogarth Press, 563	Hroswitha, 209	Imperial	Intellectual synthesis, 297
Hohenzollern family, 439	The Conversion of the Harlot	Imperial rule, China, 526–530	Intermezzo, 455
Hokusai Katsusika, 535	Thaïs, 209	Imperialism, 509	International Gothic style, 283
The Great Wall of Kanagawa,	Theophilus, 209	Impression: Sunrise (Monet), 493,	International Style of art, 266,
537	Hua-Pen, 527	493-494	267, 399
Holbein, Hans the Younger, 361	Hubris, 52, 58	Impressionism	The Interpretation of Dreams
Anne of Cleves, 361, 361	Hudson River School, 477–479	art and painting, 492–500,	(Freud), 567–568
Henry VIII in Wedding Dress, 342	Hughes, Langston, 575	493–498 music, 512–513	Interval, fourth, in music, 67 Intonazione, 331
Nikolaus Kratzer, 349	Hugo, Victor, 473 Les Misérables, 473	The Incoherence of Incoherence	Introit, 208
Holland. See Netherlands	The Human Comedy (Balzac),	(Averröes of Córdova), 196	Inventions in Renaissance, 349,
"The Hollow Men" (Eliot), 562	473	The Incoherence of the	350
The Holy Lake of the Acts of Rama	Human form in Greek art, 38	Philosophers (Al-Ghazali),	Inventions of the Monsters (Dalí),
(Ramcaritmanas) (Das), 525	De humani corporis fabrica	196	570, 571
Holy Sepulchre, church of,	(Vesalius), 349	Index of Prohibited Books by	Invisible Man (Ellison), 619
Jerusalem, 153–154, 154,	Humanism	Catholic Church, 306, 346	Ionesco, Eugène, 591
164, 189, 202	artist and, 350	India and Indian culture	Ionic order, 44–46, 47, 71, 72,
The Holy Trinity (Masaccio), 283,	Christian humanism,	architecture, 524–525,	73–74, 75
283	306–307 Engage 206, 206, 207	524-525	Iphigeneia in Tauris (Goethe),
The Home and the World (Ray, S.), 540	Erasmus, 306, 306–307	art, 127–128, 128–130, 524–525, 524–525	471 Iphigenia, 62
Homer	Machiavelli, 305–306 Pico della Mirandola, 303	Aryans, 123–127	Iphigenia in Taurus (Euripides),
identity of, and stories,	printing technology and	Ashoka's reign, 126–127	64
35–37, 65	spread of, 303–305	British rule, 522, 525	Iran, 8
Iliad, 433, 434, 466, 548	Reformation and, 344–345	Buddhism, 125-128	Ireland, 204
Odyssey, 433, 434, 548	Renaissance, early, 301-307	film, 540	Irene, empress of Byzantium,
vs. rational philosophy, 50	Hundred Years' War, 255	Greek influences on, 78	201

330 - 331Christianity (Gentileschi), 378-379, 379 Iron Age, 26, 27, 33 Irving, Washington, 475 *Jesus calls the apostles Peter and* Julian Choir, 330 opera Baroque period, 374, Andrew, 172 Julio-Claudian emperors of Irwin, Robert, 618 398-400 Getty Center, 618 Jewelry, 22, 24, 40 Rome, 99 Romantic era, 456-457, 458 Jews. See Judaism Isaac, Charlemagne's envoy to **Julius Caesar** Renaissance city-states of, 60 Joan of Arc, 259 architecture of, 98-99 Al-Rashid, 202 rococo style, 420, 420 Job. 147 assassination of, 93-94, 95, Isaac, Heinrich, 308, 362 Roman control of, 94 Job. Book of, 162 Isadore of Seville, 203 Ius Civile of Rome, 97 Johannot, Tony, 471 Isenheim Altarpiece calendar by, 89 (Grünewald), 352-353, Ivan the Terrible, part I and II John, Duc de Berry, 268 as dictator of Rome, 94, (Eisenstein), 579 95-96,97 353, 354 John, Gospel of, 147 Ivory carving, 212-213, 213, Ishafan Mosque, 189 John Chrysostom, Saint, 165 law and, 97 John of the Cross, Saint, 373 Ishmael, 189 214 siege of Alexandria by, 79 John Paul II, Pope, 404 Isidore of Miletus, 164, 165 works Isis, 12, 116 John the Baptist, 169, 174, 176 Commentaries, 95 Jacob Blessing the Sons of Joseph Islam and Muslims Johns, Jasper, 597-598, 602 Ius Civile, 97 Africa, 545-546, 548 (Rembrandt), 395-396, 397 Flag series, 597, 597 Julius Caesar (Shakespeare), 95, Jacobins, 439 Johnson, Helene, 575 Aquinas' use of scholarship, 366 - 367Jade, carved, 135 Johnson, James Weldon, 575 Julius II, Pope, 313, 315, 316, 244 architecture, 188-193 Jahan, Shah, 192 Johnson, Philip, 613-614 317, 318, 320, 330 art, 38, 187-188, 194, James, Shine of Saint, 210 Rothko Chapel, 595 Julius II, Tomb of, 316, 317, 318 James I, king of England, 365, Seagram Building, 613, 614 195-196 Julius III, Pope, 313 birth of, 185-187 366, 367, 407 Johnson, Sargent, 575 Jumna River, India, 192 Janequin, Clement, 362 Charlemagne and, 201-202, Jolson, Al, 573 Jung, Carl, 592, 600 "La Guerre" ("The War"), 362 Jonah Sarcophagus, 150, 152 Juno, 97 Japan and Japanese culture, Jongleurs, 211 Crusades against, 178, 216, Jupiter, 97, 151 533-538 Jonson, Ben, 332, 366 Jupiter and Thetis (Ingres), 466, 225, 226 art, 535-537, 537 culture of, 194-196 Joplin, Janis, 623 drama, 533, 536, 537 Joplin, Scott, 574 Jupiter of the Capitoline, dialectics and, 237 Hagia Sophia, conversion of, early period, 532-534 Jordan river, 169 Temple of, 101 Edo period, 535-537 Joseph, Hebrew patriarch, 143, Jurisprudence. See Legal issues 166 India, 131, 525-526 feudal, 535 Justin II, emperor of film, 540 Byzantium, 165-166 literature, 195, 201, 202 Joseph II, king of Austria, 417 literature, 536-537 map, 187 Joshua, Book of, 143 Justin Martyr, 150 medicine and science of, modern era, 537 Josquin des Prez, 307, 330-331 Justinian, emperor of 195-196 painting, 535-536, 537 Tu Pauperum Refugium (Thou Byzantium poetry, 533, 536 Refuge of the Poor), 330 ascendancy of, 163-164 Muslim Spain, 190, 201 timeline, 522 Journey of Marie de' Medici churches built by, 166 pilgrimages, 185 Jaspers, Karl, 590 (Rubens), 391, 394 Qur'an, 166, 186-188, 188, Corpus Iuris Civilis, 97 189, 193-196 Jazz, 563, 573-575 The Journey of the Magi Hagia Sophia, Church of, 164 revelation and, 146 The Jazz Singer (film), 573 (Gozzoli), 294 as icon of Christ, 178, 178 in Song of Roland, 211 Jeanne-Claude, wife of Christo, The Joy of Life (Matisse), 504, Justinian's Code, 97, 98, 164, Sufism, 193-194 607 505 179 timeline, 182-183 Jeanneret-Gris, Charles Joyce, James, 562, 570, 617 map, 176 Édouard, 612. See also Le Portrait of the Artist as a Young Ravenna, 162, 171, 173, 174 Islamic Republic of Pakistan, 522, 526 Corbusier Man, 562 represented as Christ, Isorhythm, 274 Iefferson, Thomas, 426, 440, 447 Ulusses, 562 173-174, 174 Israel, 143-144, 147, 148. See Virginia State Capital at **Judaism** Saint Catherine's Monastery also Jerusalem Richmond, 426, 427 Black Death and, 255 at Mount Sinai, 175-178, Istanbul. See Constantinople Jehan, Shah, 524 Christianity, early, and, 177, 178, 179 Italo-Byzantine art, 260, 261 Jerome, Saint, 203 143 - 155Juvenal, 113, 434 Jerusalem dialectics and, 237 Italy. See also Florence; Renaissance; Rome; Venice Christian martyrs, 149 early history of, 6, 143 K Church of the Holy Hebrew Bible, 144-147 Ka'ba, 186 architecture, 270-272, 272, Sepulchre, 153-154, 154, history of Hebrews, 143-144 Kabuki, 537 art, 179, 256, 259-266, 164, 189, 202 immigration, Charlemagne's Kafka, Franz, 563, 572, 590, 591 Hebrew history, 143-144 welcome of, 202-203 The Trial, 562 260 - 266Byzantine influence in, Islam, 186, 189-190, 190 Middle Ages, impact on, 225 Kagemusha (Kurosawa), 540 178 - 179Jesus, 147 music, 154-155 Kahnweiler, Daniel-Henry, 564, Etruscan period, 91 pilgrimages to, 216 Pico della Mirandola, study Greek colonization of, timeline, 140-141 Kakamura, Japan, 535 39 - 40scholars during Middle Ages, Kalidosa, 129-130 in China, 526, 526, 530, 532 literature of Petrarch, 162, 196 Sakuntala, 130 179, 256-257, 266 Descartes' education, 405 Judges, Book of, 143 Kandinsky, Wassily, 566-567 founding of order, 373 The Judgment of Solomon and Job map, 304 Concerning the Spiritual in Art, monasticism in, 204 Voltaire's education, 436 (Carissimi), 400

Jesus, 147, 150, 150, 169. See also

music, 272-275, 274, 275,

Judith and Holofernes

Several Circles, 567, 569

Rashomon, 540 Kang Hsi, emperor of China, The Last Judgment in Hebrew Bible, 144-145 530, 532 Seven Samurai, 540 (Michelangelo), 318, 321, Hortensian Law, 94 Kant, Immanuel, 448-449, 454 Throne of Blood, 540 328 Islamic Shari'a, 187 Kvoto, 533 The Last Supper (Leonardo da Critique of Judgment, 448 Ius Civile, 97 Kantor, 401 Kyrie Eleison in Ordinary of Vinci), 295, 296 Justinian's Code, 97, 98, 164, Last Supper motif, 150, 151 Kao-tsu, 134 the Mass, 275 Karma, 125 The Last Supper (Tintoretto), Law of the Twelve Tables, 97 Karnak, Temple at, 16 L 326, 327 Rome, Republican, 96-98, L. H. O. O. Q. (Mona Lisa) Kassites, 9 Late Gothic architecture, 164, 179 Katholikon, 177, 177 (Duchamp), 577 270-272, 272, 273 Socrates, trial of, 65-66 Keats, John, 473 La Comtesse d'Haussonville Late period, ancient Egypt, 10, Ten Commandments, 145 "Ode to a Nightingale," 473 (Ingres), 466, 467 17 - 18university establishment, Kelly, Ellsworth, 599, 599 La Dame aux camélias (The Lady of Late Stone Age, 3-5 Kennedy Airport, Trans World the Camelias) (Dumas), 457 Latin classics published by vendetta, primitive law of, 62 Flight Center at (Saarinen), La Fontaine, Jean de, 433 Aldine Press, 304 Legends, 206 "La Guerre" ("The War") 611, 613 Latin language, 91, 123-124, Léger, Fernand, 591 Kerdo the Cobbler, 80 (Janequin), 362 179, 344 The Legislative Belly (Le Ventre La Mer (The Sea) (Debussy), Kerouac, Jack, 591 Latin Quarter, Paris, 239 Legislatif) (Daumier), 466, Keynes, John Maynard, 563 Latins, 91 467 Khan, Genghis, ruler of La Primavera (The Springtime) Lauds, 205 Leica, 580 (Botticelli), 295, 296, 305 Mongols, 523 Laurencius de Voltolina, 239 Leipzig, 401 Khan, Kublai, ruler of Mongols, La Sainte Chapelle, 228 Lélia (Sand), 473 Laurentian era, 293 529 La Scala opera house, 574 Laurentian Library, 289, 328, Lendit, 226 Labyrinth, 20, 49 Al-Khwarizmi, 195 328 Lenin, V. I., 449, 509, 561, 567, Lachesis, 37 577, 579 Kiefer, Anselm, 602 Law. See Legal issues Kienholz, Edward, 603-604 Laconia, 33 The Law Code of Hammurabi, Lennon, John, 623 The State Hospital, 603-604, Lacy, Jean, 600 9, 10, 11 "Yesterday," 623 The Lady of the Camelias (La Law of the Twelve Tables, 97 Lenses and optics, 195 606 Kierkegaard, Søren Aabye, Dame aux camélias) Lawrence, Saint, 166, 167, 168 Leo III, Pope, 201 Lazarillo de Tormes, 407 Leo X, Pope, 313, 319, 340 591 - 592(Dumas), 457 King, Martin Luther, Jr., 146, Lady of Warka, 6, 8 Le Bourgeois Gentilhomme Leonardo da Vinci. See Da Lady Philosophy by Boethius, (Molière), 407 Vinci, Leonardo King James Version of Bible, 162-163 Le Concert Champêtre Leoni, Leone, 341 "The Lady with the Dog" (Giorgione), 324, 324-325 344, 346, 407 Bust of Emperor Charles V, 341 King Lear (Shakespeare), 367 (Chekhov), 515 Le Corbusier, 612-613 Léonin, 237 King's Peace, Greece, 65 Laertes, 37 Unités d'Habitation, Magnus Liber Organi, 237 The Kiss (Rodin), 499, 499-500 Lagash, 9 Marseille, 612, 614 Les Demoiselles d'Avignon L'Âge d'Or (Buñuel and Dali), Klaviersuite (Hindemith), 573 Le Déjenner sur l'Herbe (Picasso), 544, 563, 564 Klee, Paul, 569, 572 572 (Luncheon on the Grass) Les Misérables (Hugo), 473 Lake George (Heade), 478-479, Around the Fish, 572, 572 (Manet), 492, 492 Lesbia, 94 Knight, Death, and the Devil 479 Le Devin du Village (Rousseau), Lesbos, 48, 49 "L'Allegro" (Milton), 408 (Dürer), 352, 352 Lescot, Pierre, 358, 360 436 Knossos excavation and The Lamentation over Saint Leslie, Alfred, 599-600 Le Lorrain, Claude, 386 Minoan culture, 16, 21-23, Sebastian (De La Tour), 383, Le Moulin de la Colette (Renoir), Lessing, Doris, 619 23 - 27495, 496 Let Us Now Praise Famous Men Knox, John, 341 The Lamentation over the Dead Le Ventre Legislatif (The (Agee), 581, 581 Köchel, Ludwig von, 431 Christ (Giotto), 264, 265 Legislative Belly) (Daumier), Letter to Posterity (Petrarch), Lamentations of Jeremiah (Tallis), 466, 467 Kodak camera, 580 162, 256 A Letter to the God of Love (de Koine, 149 363 League of Corinth, 65 Kollwitz, Käthe, 490 Lancet window, 233 Leaning Tower of Pisa, 402 Pisan), 259 March of the Weavers, 490 Landini, Francesco, 275 Learning. See Education Letters of Composers (Norman Koran. See Qur'an Landscape painting, 477-479, Leaves of Grass (Whitman), and Shrifte), 510 Kore (korai), 41, 41, 42, 44 479 477 The Letters of Horace Walpole Landscape (Shitao), 531 Kouros (kouroi), 41, 42, 42, 43 Lectio divina, 207 (Cunningham), 433 Lange, Dorothea, 582 Krishna, 128, 129 Lettres philosophiques Lecture of Henricus de Alemania, Krishna and the Maiden in a Lange, Joseph, 431 239 (Voltaire), 437 Garden, 128, 129 Mozart at the Pianoforte, 431 Lefèvre d'Étaples, Jacques, 295, Leucippus, 51 Kritios Boy, 43-44, 45, 72 Lao-tzu, 132 Leuctra, 65 Kublai Khan, ruler of Mongols, Tao te ching, 132 Left Bank of the Seine, Leviathan (Hobbes), 405-406 Laocoön Group, 82, 83 University of Paris, 238 Lewis, Sinclair, 582 Laodicea, 155 Kubrick, Stanley, 589 Legal issues Babbitt, 582 Athen's democratic form of Kufic calligraphy, 187, 188 Laon, 204, 231 L'Histoire du soldat (Stravinsky), Lapith and Centaur, 69, 72, 73 Kumin, Maxine, 619 government, 58 573-574 Kuomintang, 532 Las Meninas (The Maids of Charlemagne's legal decrees, Li Po, 135 Kurosawa, Akira, 540 Honor) (Velázquez), 390, The Libation Bearers (Aeschylus), 391, 462, 466 Kagemusha, 540 Greece, Solon in, 42

Lascaux cave paintings, 4, 4

Hammurabi's code, 9, 10, 11

Liberation, 606

Ran, 540

Libido, 568	Charlemagne and	Medici Chapel, buried in,	portrait of, 341
Libraries, 79, 179, 234-235,	Medieval culture, 203-204,	319-320	Reformation and, 332,
295	209, 210–211	Michelangelo and, 300, 302	340–341, 341
Libri IV De Humani Corpons Proportionibus (Four Books	in Fourteenth century, 255–259	music and, 307 Pope Leo X, son of, 340	Reuchlin, influence on, 303 works
on Human Proportions)	High period, 241–247, 248	"the magnificent," 294–296	De Servo Arbitrio (On the
(Dürer), 352	novel, 473-475, 478, 515-517	works	Bondage of the Will), 344
Liebnitz, Gottfried von, 437	as permanent art, xxiii	Camento ad alcuni sonetti (A	Lutheranism, 345
Lieder (Schubert), 454	Renaissance	Commentary on Some	Lux nova, 229
Lietmotiv, 458 Life of an Amourous Woman	Early, and humanism, 281, 301–307	Sonnets), 294 "The Song of Bacchus," 295	Luxor, Temple at, 16 Lyceum, 66
(Ihara Saikaku), 536–537	High Italian, 332–333	L'Orfeo (Monteverdi), 399	Lydia, 91
Life of Giotto (Vasari), 259–260	Northern Europe, 339,	Le Lorrain, Claude, 386	Lydian mode of music, 48, 67
Light	364-367	Los Angeles Philharmonic, 623	Lyell, Sir Charles, 451
churches of Byzantium,	Romantic era, 470–475, 476–478	Los Caprichos (Goya), 447, 448	Lyons, 204
164–165, 165 France and Spain, 376–377,	Rome	Lost Tribes of Israel, 143 Louis XIII, king of France, 391	Lyre, 47, 48, 154 Lyric poetry, 49–50, 64, 90, 95
379, 381, 383, 387–388	Imperial, 100–102, 104,	Louis XIV, king of France,	Lysippus, 76, 77, 77, 78
mysticism of, 229-230, 231,	112-113	386-387, 391, 399, 406, 415	Apoxyomenos, 78
232, 233	Republican, 95–96	Louis XIV (Rigaud), 386, 386	Lysistrata (Aristophanes), 64
Northern Europe, 393–396	Twentieth century contour,	Louis XV, king of France, 417, 433, 435, 436, 438	M
symbolism of, 165 Lighthouse of Alexandria, 79,	590–591, 617–620	Louis XVI, king of France, 417,	Má Vlast (My Fatherland)
80, 81	modern era, 515–517,	438	(Smetana), 456
Limbourg Brothers, 269, 357	561-563, 582	Louvre, Square Count of, 358,	Macao, 526
Très Riches Heures du Duc de	World Wars, period	360	Macbeth (Shakespeare), 367
Berry, 269, 270, 271, 272, 357	between, 561–419, 575–576, 582	Love, 18, 95 Love Letters (Fragonard), 419,	Macedon, 60, 65, 66 Macedonian Empire, 57, 65,
Lin, Maya Ying, 607	Littérature, 568	420	78–79, 80
Vietnam Veterans Memorial,	The Little Clay Cart (Sudraka),	The Love Suicide at Amijima	Machaut, Guillaume de,
Washington, D. C., 607, 608	130	(Chikamatsu Monzaemon),	274–276, 307
Linacre, Thomas, 295	Little Egypt Condo, New York	536-537	Au départir de vous, 275
Line, in music, xxvii	City (Lacy), 600, 601 Liturgical music, organ used	Low Countries. <i>See</i> Netherlands	<i>Messe de Notre Dame,</i> 274–275 Machiavelli, Niccolò, 297,
Line engraving, 351 Linear perspective, 350	for, 331–332, 400	Low relief, 42	305–306
Lion capital, 127, 128	Liturgical trope, 208-209	Lower Egypt, 10	The Prince, 305-306
Liszt, Franz, 455–456, 508	Liturgy, 165–166, 169, 177, 203,	Loyang, 137	"Mack the Knife" (Brecht), 573
The Battle of the Huns, 508	206–207 Live Aid music show, 623	Lucan, 204 Lucia di Lammermoor	Madame Bovary (Flaubert), 473 Maderna, Carlo, 323, 374
Hamlet, 508 Hungarian Rhapsodies, 456	Lives of the Artists (Vasari), 259,	(Donizetti), 456–457	Madonna Enthroned (Cimabue),
Orpheus, 508	284	Lucifer, 246	262, 262
Literacy. See Education	Lives (Plutarch), 367	Lucretius, 96	Madonna Enthroned (Duccio),
Literature. See also Drama;	Livia, empress of Rome, 101	De Rerum Natura (On the	262, 263
Novel; Poetry; specific authors and literary works	Livy, 104 Locke, Alain, 575	Nature of Things), 96 Lucrezia Floriani (Sand), 473	Madonna Enthroned (Giotto), 264, 264
Africa, 548–550	Locke, John, 405–406	Ludwig van Beethoven	Madonna of Loreto (Caravaggio),
ancient periods and cultures	"An Essay Concerning	(Waldmuller), 452	377, 379
China, 132, 134-135	Human Understanding,"	Luisa Miller (Verdi), 457	Madonna of the Long Neck
Egyptian library at	406	Luke, Gospel of, 147	(Parmigianino), 329, 329
Alexandria, 79 Indian/Aryan, 124–125,	Logarithm, 348 Loggia dei Lanzi, 333	Lulli, Giovanni Batista, 399 Lully, Jean Baptiste, 399	Madonna of the Meadow (Raphael), 314, 314
129–130	Logic in philosophy, 50	Luluwa people, 550–552, 554	Madonna of the Rocks (da Vinci),
Mesopotamia, 6-8	Lombard, Peter, 238	Luminism, 478	296, 299, 300
Sumer, 6	Lombards, 178	Luncheon on the Grass (Le	Madonna of the Stairs
Baroque period, 406–409	London Suite (Waller), 574	Déjeuner sur l'Herbe)	(Michelangelo), 300, 300 Madrigals, 275, 330, 362, 364
Byzantium, 161–163 China, 527, 529	London Symphonies (Haydn), 430	(Manet), 492, 493 Lunette, 167	Madrigals, 275, 330, 362–364 Maestà (Duccio), 262, 263
Christianity, early, 144–150,	The Lonely Crowd (Riesman), 590	Lung-men Caves, 135, 137	Magi, 171, 172, 174
161-163	Lorenzetti, Ambrogio, 266, 268,	L'Unités d'Habitation,	Magi Bearing Gifts, 171, 172
Eighteenth century, 433–437	281	Marseille (Le Corbusier),	Magister, 242
Greece, 35–37, 49–52, 80 Hinduism, 124–125	Peaceful City, 266, 268 Peaceful Country, 266, 268	612, 614 Luther, Martin	Magistri, 239 Magnificent Seven (film), 540
Hinduism, 124–125 how to read, xxviii–xxix	Lorenzetti, Pietro, 266, 281	Augustine of Hippo, as	Magnus Liber Organi (Léonin),
India, 525, 525–526	Lorenzo de' Medici	influence on, 161	237
Islam, 195, 201, 202	Adoration of Magi (Botticelli),	Erasmus and, 306–307	Magritte, René, 571
Japan, 536–537	depicted in, 293, 293	humanism and, 344–345	Man with a Newspaper, 571,
Middle Ages	humanism following, 305	as hymn writer, 346–347, 347	571

Ming Dynasty, 527 Masaccio, 281, 283, 283, 284, Meditations (Descartes), 405 Mahabharata, 124, 128, 129 Mughal Empire, 523 284, 285 The Meditations (Marcus Mahal, Muntaz, 192 Aurelius Antoninus), 97 Mahayana, 135 Renaissance Europe, Masada, 144 religious divisions in, 343 Masjid, 188 Medium, in music, xxviii Mahler, Alma, 510 Roman world, 90 Massacre at Chios (Delacroix), Medusa, 44, 45 Mahler, Gustav, 499, 511, 512 The Meeting of Joachim and Anna The Song of the Earth (Das Lied Romantic era (1848) Europe, 463, 465 von der Erde), 511 450 Massacre No. 2 (Delacroix), 465 (Giotto), 264, 265 Marathon, Battle of, 51, 62 Masterpieces, defined, xxiii Mehta, Zubin, 623 Symphony No. 9, 511-512 Meidner, Ludwig, 489 Symphony No. 1 in D, 511 Marcellus II, Pope, 313 Materialism, 50, 406 The Eve of War, 489, 490 March of the Weavers (Kollwitz), Maternity figure from Luluwa, The Maids of Honor (Las 490 551,554 Meier, Richard, 618 Meninas) (Velázquez), 390, Marchesa Elena Grimaldi (van Mathematics. See also Science Getty Center, 618 391, 462, 466 in Charlemagne's time, 203 Meiji era, 537, 537 Dyck), 392, 394 Maimonides, Moses, 195-196, Marco Polo, 523, 529 decimals, 130, 195 Melisma, 208, 237 Melody, xxviii, 237, 363, 401, Guide for the Perplexed, 244 Marcus Aurelius Antoninus, geometry in Renaissance emperor of Rome, 96-97, 99 painting, 283 507 Mainz, 204 Gupta Indian, 130 Melville, Herman, 477-478 The Meditations, 97 Majuscule, 213 Islamic influence, 195-196 Moby Dick, 477 Mali, 551 Margrave of Brandenburg, 401 Marguerite of Navarre, 339 Memento mori motif, 209 Al-Malik, Abd, 189 Kang Hsi, emperor of China, Marie-Arouet, François, 436. See studied by, 530, 532 Memorabilia (Xenophon of Mallia, 22, 24 Malthus, Thomas, 451 also Voltaire logarithm, discovery of, Colophon), 65 Menandros, ruler of Greece, 79 Marie de' Medici, 187, 391, 394 348 - 349Al-Mamun, 194 Marinetti, Fiippo Tommaso, Polykleitos' system, 68 Mendicant brotherhood, 241 Man with a Newspaper 581-582 Pythagoras and, 51 Las Meninas (The Maids of (Magritte), 571, 571 Honor) (Velázquez), 390, Marino, Giambattista, 408 Matins, 205 Mandela, Nelson, 606 Mandorla, 218, 220 Maritain, Jacques, 590 Matisse, Henri, 504-505 391, 462, 466 Marius, 94 The Joy of Life, 504, 505 Menorah, 144 Manet, Édouard, 493 Merbecke, John, 363 Mark, Gospel of, 147 The Red Studio, 505, 506 A Bar at the Folies-Bergère, 492, Merchant class, 202-203 493, 495 Mark, Saint, 178, 179 Matope, 548 The Merchant of Venice Matthew, Gospel of, 147 Le Déjeuner sur l'Herbe Marlowe, Christopher, 365-366, 471 Mausoleum of Galla Placidia, (Shakespeare), 366 (Luncheon on the Grass), Dr. Faustus, 366 166, 166-167, 167, 168 Mercury, 97 492, 493 Maximian, Bishop, 171, 174, Hero and Leander, 366 Mercury (Satie), 576 Manetho, 10 Tamburlaine, 365-366 174, 176 Merisi, Michelangelo, 376 History of Egypt, 10 Maro, Publius Vergilius. See Mesopotamia, 6-10 Manifesto of Surrealism (Breton), Mazurkas, 456 Abraham from, 143 Vergil Mazzola, Francesco, 329. See also Parmigianino Akkadia culture, 8-9 Marot, Clement, 362 Mann, Thomas, 617, 622 Marriage, in Egypt, 18 McCartney, Paul, 623 Assyrian culture, 6, 10, 11, 27, Mannerism, Renaissance, Marriage à la Mode (Hogarth), "Yesterday," 623 143 327-330, 328-330, 389 415, 425, 426 McKay, Claude, 575 Babylonian culture, 6, 9, 11, Mansfield, Katherine, 570 Marriage of Figaro Meander pattern, 38 143 Mantua, Duke of, 399 burial rituals, 14 Manutius, Aldus, 303-304, 344 (Beaumarchais), 431 Mecca, 185, 186, 186 Mechanics, Gupta Indian, 130 vs. Egypt, 5 The Marriage of Figaro (Mozart), Manzù, Giacomo, 602 415, 431-432, 432 influence of, 27 Medea, 64 Mao Tse-tung, 532, 533 Sumerian culture, 6-8 Medes, 9 Mars, 97 Maps Martel, Charles "Charles the Medici, Cosimo de', 101, 179, timeline, xxxii Africa, 546, 553 Hammer," 201 289-290, 293, 293, 295, 333 Messe de Notre Dame (Machaut), Ancient World, 5 274 - 275Asia, 523 Martini, Simone, 256, 266-267, Medici, Giovanni de', 293, 340 Messiah, 146, 147 267, 268, 281 Medici, Giuliano de', 293, 293, Baroque period, 373 The Annunciation, 266, 267 320, 322 Messiah (Handel), 400 Black Death, 254 Medici, Lorenzo de', 293, Metaphysical poetry, 407-408 The Martyrdom of Saint Buddhism, 127 Bartholomew (Ribera), 389, Metaphysics (Aristotle), 66, 241 Byzantium, 168, 176 293-296, 300, 301, 305, 307, Carolingian Empire, 202 320, 340 Metaphysics in philosophy, 50 The Martyrdom of Saint Camento ad alcuni sonetti (A Metastasio, Pietro, 433 Charlemagne and Medieval Metopes, 46, 47, 69, 73 culture, 202 Lawrence, 167, 168 Commentary on Some The Martyrdom of Saint Matthew Sonnets), 294 Metropolitan Opera, New York, China, 131, 527 574,622 (Caravaggio), 377, 378 "The Song of Bacchus," 295 Christian communities, 148 Metz, 204, 207 Martyrdom of Saint Maurice and Medici, Marie de', 391, 394, 399 Eighteenth century Europe, the Theban Legion (El Medici, Piero de', 293-294, 295 Meun, Jean de, 259 Greco), 388, 389 Medici Chapel, 319-320, 322 De Meuron, Pierre, 617 Europe, 254, 343, 417, 450 Tate Museum, 617 Martyrs, Christian, 148-149 Medici era, 281, 288-300, Greece, 34, 79 289-294, 296-301, 302 Michelangelo Buonarroti Île-de-France, 229 Maruyama Okyo, 535 Medicine, 130, 195-196, 349 Brunelleschi's dome, 287, 323 India, 127, 523 Peacocks and Peonies, 535, 536 genius of, 300, 301 Marx, Karl, 449-450 Medieval culture. See Islamic world, 187 Communist Manifesto, 449 Charlemagne and Laurentian Library, 328, 328 Israel, 148 patronage for, 295, 316-322 Italy, Renaissance, 304 Mary, Countess Howe Medieval culture

(Gainsborough), 419, 420

Medina, 186, 187

poetry of, 317

Justinian's Empire, 176

Great Schism in, 253-255 Miró, Joan, 569, 591 Gregorian chant and, 203, significance of, 307 Hundred Years' War, 37 Misogyny, 258, 259 206-208, 237 works Captives, 316, 317, 318 literature, 255-259 Miss Van Buren (Eakins), 480, music, 272-275, 274, 275, 481 Creation of Adam, 318, 320 Missa Papae Marcelli (Mass in David, 300, 301, 302 painting, 266, 267, 268, 269 Honor of Pope Marcellus) Dawn, 320, 328 Paris during, 225 (Palestrina), 331 Day, 320, 328 Petrarch in, 162, 179, Mithra, 116, 151 Dusk, 320, 328 164 256-257, 266 Mitsushito, emperor of Japan, The Last Judgment, 318, 321, timeline, 250-251 Madonna of the Stairs, 300, High period of, 225-249 Mixolydian mode of music, 67 Aquinas during, 242-245, Mixtur (Stockhausen), 621 Mobiles, 577, 602, 605 Medici Chapel, 319-320, 244 architecture, 225-237, 322 Moby Dick (Melville), 477 226-228, 231-236, 239, 275 Moses, 316, 316 Modern era, 489-519 226, 227 Night, 320, 322, 328 art, 226, 229-230, 231 architecture, 505, 507 literature, 241-247, 248 Pietá, 300, 300 music at the school of expressionism, 505-506, Saint Peter's Basilica, 287 Notre Dame, 236-237 506, 566-567 Sistine Chapel ceiling, painting, 242, 243, 244, 245, 318-319, 319, 320 fauvism in, 504-505, 505, tomb for Pope Julius II, 317, 318 scholasticism, 204, 225, impressionism, 493-498, 237 - 245493-500 Michelet, Jules, 301 sculpture, 230, 232, 233, Michelino, Domenico di, 247 post-impressionism, 492, 500-506, 501-506 493-494 Mick Jagger (Warhol), 598 timeline, 222-223 drama, 517 Microscope, 404 universities during, growing unrest, 489-491 Middle Ages early Medieval period, 237 - 241, 239Japan, 537 literature, 515-517, 561-563, 199-339 Middle Kingdom, ancient architecture, 172, 203-204, Egypt, 10, 13-14 582 Middle Way of Buddhism, 126 music, 507-514 210, 213-220, 215-220 A Midsummer Night's Dream Aristotle's influence on, science, 490 (Britten), 622 sculpture, 491, 499, 499-500, art, 204, 206, 211-213, 213, A Midsummer Night's Dream 512 Mongols, 178 214, 239, 274, 275 (Shakespeare), 622 timeline, 486-487 Charlemagne and, A Mighty Fortress Is Our God women in, 516-517 Monody, 399 201-204, 205, 210-211 (Ein' Feste Burg Ist Unser' Modernism, literary, 561-563 Gott) (Luther), 346, 347 598 drama, 209 A Modest Proposal (Swift), 435 Mihrab, 188 Mofolo, Thomas, 550 Islam, 190, 195-196, 201 literature, 203-204, 209, Milan, 60, 161, 271, 272 Chaka, 550 Milan, Cathedral (duomo) of, 210-211 Traveler of the East, 550 Mohenjo-daro, 123, 124 liturgical trope, 208-209 Monreal, 178 medicine and science, Milhaud, Darius, 576 Moholy-Nagy, László, 580 Mill on a River (Gellee), 386, 386 195 - 196Moirai, 37 Miller, Arthur, 618 monasteries, Benedictine The Moldau (Vltava) (Smetana), and Carolingian, 204-206, Death of a Salesman, 618 456 Milton, John, 100, 246, 407-408 Molière, 406-407 Montage, 580 216, 217 music, 203, 206-208, 237 "L'Allegro," 408 L'Avare, 407 Roman influence on, 95, Paradise Lost, 246 Le Bourgeois Gentilhomme, Paradise Lost (Milton), 407, 407 Tartuffe, 407 Romanesque style during, 409, 433 Paradise Regained, 408 Mona Lisa, L. H. O. O. Q. 204, 206 216, 218, 218, 219, 220 (Duchamp), 577 "Il Penseroso," 408 scholasticism in, 195-196 sculpture, 218, 219-220 Samson Agonistes, 409 Mona Lisa (da Vinci), 289, 295 435 - 436timeline, 198-199 Minarets, 188-189, 192, 524 De Monarchia (Dante), 245 Fourteenth century, 251-439 Minerva, 97 Monarchy. See specific monarchs L'Orfeo, 399 Ming Dynasty, 526-530, 527 Monarchy, United, in Hebrew (See also Renaissance, early, Minimalism, contemporary history, 143, 146 499, 499 in Florence) architecture, Gothic style, music, 621 Monasteries. See also Jesuits 270-272, 272-275 Minimalist art, 565 Benedictine, 204-206, 216, art, 259-272, 260-266, 272, Minnesingers, 237 218 Minoan culture, 19, 21-22, Buddhist, 126-127, 128, 135 Black Death, 253, 255, 266 23-26, 24, 123Carolingian monastery, 216, Minos, king of Knossos, 20 605, 607 Dante's Divine Comedy, 217 Dominicans, 242, 290, 301 Minotaur, 20, 22, 49 196, 238, 245-247, 247 Minuet, 428 education and, 237-238 Francis of Assisi, 241-242, 242, 243 Minuscule, 213 Franciscan, 241-242, 264

humanist and reformer criticism of, 344 major parts of, 216 monasticism defined, 204 monks in Constantinople, Mount Sinai, 174-175 Russian, 178 Saint Catherine's Monastery at Mount Sinai, 175-178, 177, 178, 179 Saint Denis Abbey, 225-227, Saint Gall Monastery, 216, Sainte Geneviève, 238 women and monastic life, 204, 205, 206 Mondrian, Piet, 565 Color Planes in Oval, 565, 568 Monet, Claude, 493-495, 512 Impression: Sunrise, 493, Nymphéas (Water Lilies), 494-495, 495, 512 Red Boats at Argenteuil, 494, Monetary system in early Renaissance, 281 Mongol Empire, India, 522, 523, 524-525, 535 Monkey (Wu Ch'eng-en), 527 Monogram (Rauschenbeng), 598, Monophonic singing, xxvi, 207 Monotheism, 145-146, 149, 185. See also God, monotheistic Mont-Saint-Michel and Chartres (Adams), 235 Mont Sainte-Victoire (Cézanne), 501, 503, 509 Montaigne, Michel Eyquem de, 345,347-349Essays, 347-348 Monte Cassino monastery, Italy, Montesquieu, Charles-Louis, Monteverdi, Claudio, 399 Monument to Balzac (Rodin), "Mood Indigo" (Ellington), 575 Moog synthesizer, 620 Moore, Henry, 563, 604-605, Reclining Figure (Moore), 605, Moore, Marianne, 618 Morality play, 209 Everyman, 209

M Cir. Tl 20(207	Maussangalay Madast 456		Nationa Con (IAI-i-l-1) (10
More, Sir Thomas, 306–307, 343, 364	Moussorgsky, Modest, 456 Boris Godunov, 456	modern era, 507–514 Reformation, 346–347, 347	Native Son (Wright), 619 Nativity and Annunciation to the
Utopia, 364	Movements (musical), 401, 428	Renaissance, 307–308, 340,	Shepherds (G. Pisano), 261
Morisot, Berthe, 498	Movies (film), 571–572,	362–364	Natural History (Pliny the
View of Paris from the	578-580, 579-580, 618	rhythm, 507	Elder), 105
Trocadero, 498, 498	Mozarabic chant, 207	Romantic era, 452–460	Nave, 152
Morley, Thomas, 363–364	Mozart, Leopold, 430	Rome, 89	Naxos, 21
Morrison, Jim, 623	Mozart, Wolfgang Amadeus,	Sixteenth century, 330-333	Nazism, 561, 579, 606
Morrison, Toni, 590	428, 430–432, 453	as temporaral art, xxiii	Ndri, Kuoame, 555
Mortality and (cultural) values,	Clarinet Quintet, 574	Twentieth century	Neanderthal people, 4, 14
14	The Marriage of Figaro, 415,	contemporary contour,	Near Eastern art, Greek
Mosaics. See also Architecture;	431–432, 432	620-624 modern era 507 514	influence on, 40
Art Byzantine	Piano Concerto No. 27 in B flat, 431, 454	modern era, 507–514 World Wars, period	Nefertiti, queen of Egypt, 10, 17 Negritude, 549
in early Christian period,	Symphony No. 40 in G minor,	between, 573–575	Neithart, Mathi Gothart, 352.
153	429, 430	World Wars, period between,	See also Grünewald,
Hagia Sophia, 164, 165	Mozart at the Pianoforte (Lange),	573-575	Matthias
influence of, 178	379, 431, 530	The Music for Royal Fireworks	Neo-classical art, 422, 424-426,
at Ravenna, 167, 167–175,	Mrs. Dalloway (Woolf), 563	(Handel), 400	424-426, 460
169-171, 172-173	Muezzin, 188	Music from Across the Alps	Neo-Colonialism, 549
Rome, 90	Mughal Empire, India, 522, 523,	(Musica Transalpina), 362	Neo-Platonism, 230
San Vitale church, 171, 172,	524–525, 535 Muchala 192	Music videos, 623	Neolithic period, 3–5, 18
173, 173, 174, 175 Islamic, 189, 190, 191	Mughals, 192 Muhammad, 146, 185, 195, 196	Musica ficta, 275 Musica Transalpina (Music from	Neonian Baptistry, 167, 168, 169
Italo-Byzantine, 260, 261	Mummification in ancient	Across the Alps), 362	Neoplatonism, 318
Middle Ages, 248	Egypt, 13	Muslims. See Islam and	Neptune, 97
vs. stained-glass windows,	Munch, Edvard, 505–506, 506,	Muslims	Neptune, Temple of, 47
230	512	Mussolini, Benito, 561	Nero, emperor of Rome, 89, 96,
Moses, 143, 146, 147, 174, 175,	Murasaki Shikibu, 533-534, 536	Mutota, 548	99, 100, 148-149
195	The Tale of Genji, 353,	My Fatherland (Má Vlast)	Nerva, emperor of Rome, 99
Moses and Aaron (Schönberg),	533-534, 536	(Smetana), 456	Nervi, Pier Luigi, 611
514	The Murder of Agamemnon by	My Ladye Nevells Booke (Byrd),	Palazetto Della Sport, Rome,
Moses (Michelangelo), 316,	Aegisthus, 62	363 Mu Sacrat (Sacratum) (Potrorch)	611, 612 Notherlands
316 Mosque(s)	Murphy, E. Jefferson, 551 History of African Civilization,	My Secret (Secretum) (Petrarch), 256–257	Netherlands Baroque art in, 392–396,
Córdoba, 190, 191, 192	551	Mycale, 51	394–397
Damascus, 189, 190	Murray, Elizabeth, 597	Mycenae, 16, 19, 24–27, 27, 33	English alliance with, 359
Hagia Sophia as, 166	Muses at Alexandria, Temple of	Mycerinus, pharaoh of Egypt,	musical influence from, 331
India during the Mughal	the, 79	13	Reformation in, 341
Empire, 524, 524-525	Museum at Alexandria, 79	Myron, 68	Renaissance painting in,
Ishafan, 189	Music. See also Vocal music;	Discus Thrower, 68, 68	354–357, 355–358
Islamic architecture and,	specific composers,	Mysteries, Villa of the, 107,	Neumann, Balthazar, 422, 423
188-190, 189-192 Mototo 227, 207, 220, 262, 262	compositions and performers Aristotle and Plato on, 308	108 Mysticism of light, 229–230,	Neums, 207 Nevelson, Louise, 602–603
Motets, 237, 307, 330, 362, 363 Mother and Child (Cassatt), 497,	Baroque period, 374–375,	231, 232, 233	Sky Cathedral, 605
498	398-402	201, 202, 200	New Golden Age of Augustus,
Mother Earth, 549–550	Christian and Jewish, early,	N	103
Mother Goddess, 4, 5, 6, 20, 21,	154-155	Nabi, 146	New Kingdom, ancient Egypt,
22, 27	concepts in, xxvii–xxviii	Nabucco (Verdi), 457	16-18
Mothers of Invention, 623	contemporary contour,	Nalanda, 130	New Testament, Bible, 145, 147,
Motherwell, Robert, 594	620-624	Napier, John, 348	148, 165, 176
Elegy to the Spanish Republic	Eighteenth century, 426–432	Napoleon Bonaparte, 306, 424,	New wave, 574
#34, 594, 595 Motion pictures (film),	Greece, 47–49, 49, 51, 67, 89, 155	440, 453, 474 Napoleon Crossing the Alps	New York, 591–592 New York, Washington Square,
571–572, 578–580,	harmony, xxvi, 51, 67, 507	(David), 424, 424–425	arch on, 110
579–580, 618	how to listen to, xxv–xxviii	Nara, Japan, 533	New York School, 592, 594, 600
Le Moulin de la Colette (Renoir),	liturgical music, organ used	Naram-Sin, Stele of, 8, 9	Newman, Barnett, 596
495, 496	for, 331–332, 400	Narthex, 226, 226	Di Niccolò di Betto Bardi,
Mount Athos, 178, 179	melody, xxviii, 237, 363, 401	Nathaniel Hurd (Copley), 476	Donato, 290. See also
Mount Fuji, 535	Middle Ages	National Congress party, India,	Donatello
Mount Sinai, 174	Charlemagne and	525	Nietzsche, Friedrich Wilhelm,
Saint Catherine's Monastery	Medieval culture, 203, 206–209	National Gallery of Art, East Wing (Pei), 614, 615	491, 590, 591 Nigeria 546, 550, 552
at, 175–178, 177, 178, 179 Mount Vesuvius, eruption of,	in Fourteenth Century,	Wing (Pei), 614, 615 Nationalism, 342–343, 456, 478,	Nigeria, 546, 550, 552 The Night Café (van Gogh), 503,
105–107	272–275, 274, 275	509, 525–526	503
Mourning Becomes Electra	High period of, 236–237,	Nationes, University of Paris,	Night (Michelangelo), 320, 322,
(O'Neill), 572	241	239	328

TT 27 1 1 17 1 (D 1 1 1)	0)	_
The Night Watch (Rembrandt),	0	Mourning Becomes Electra, 572	P
394, 396	O Vos Omnes (Victoria), 331	Open Book (Murray), 597, 597	Padua, 264
Night (Wiesel), 618	Oath of the Horatii (David), 415,	Opera. See also Vocal music	Padua, University of, 348, 403
Nighthawks (Hopper), 592	416, 424, 460	Baroque period, 374,	Paean, 49
Nijinsky, Vaslav, 515	Oba, 546 – 547, 547	398-400	Paestum, 46
Nikolaus Kratzer (Holbein the	Object Roses des Vents (Cornell),	Eighteenth century, 431–432	Pafnutius, 209
Younger), 349	605	invention of, 61	Paganini, Nicolò, 456
Nile River, 5, 5, 10, 13	Ochs, Phil, 623	Romantic era	Paganism, 162, 179
Nîmes, 112, 113	Ockeghem, Johannes, 307	Beethoven, 452	Paik, Nam June, 607, 610
Nimrud, 9	Requiem Mass, 307	Germany, 458, 459, 460	Electronic Superhighway, 607,
1984 (Orwell), 582, 590	O'Connor, Flannery, 618	Italy, 456–457, 457, 458	610
Nineteenth century. See Modern	Octave, 51, 67	Twentieth century, 510, 574,	Painting. See also Art
era; Romantic era	Octavian, emperor of Rome, 99.	622	ancient periods and cultures
Ninety-five theses of Martin	See also Augustus, emperor	Opera House, Sydney,	Aegean cultures, 23, 24, 25
Luther, 340	of Rome	Australia (Utzon), 611, 613	in caves, 4, 4
Nineveh, 8, 9, 11	Octavius, 99	Opium, 530–531	Egypt, 6
Nirvana, 126	Oculus, 578	Opium War, 531	Baroque period
No Longer at Ease (Achebe), 550	Oculus, dome, 111	Oplontis, 109	France, 383–386, 383–387
No play, 533, 534	"Ode to a Nightingale" (Keats),	Optics, 195	Northern Europe, 391–397,
Noah, 6	473	Opus Dei, 206	392-397
Nobatae, 10	"Ode to Joy" from Symphony	Or San Michele, Church of, 290	in Rome, 375–380, 377–380
Nocturne, 455	No. 9 (Beethoven), 454	Oration on the Dignity of Man	Spain, 388–390, 388–391
Nocturns, 205	"Ode to Joy" (Schiller), 454	(Pico della Mirandola), 303	Byzantium, encaustic, 178, 178
"Noel, Adieu" (Weelkes), 363	Odes (Keats), 473	Oratorio, 400	China, 527–529, 528, 530
Nogarola, Isotta, 305	Odysseus, 36, 37	Orchestra, classical symphony,	Christian, early, 150–151,
Noland, Kenneth, 599	Odyssey (Homer), 21, 25, 33,	428, 429	151, 153
Nolde, Emil, 506	35–37, 101, 433, 434, 548	Orchestral music, 508–512	contemporary contour, 590,
Pentecost (Nolde), 506, 508 Norma (Bellini), 456, 457	Oedipus, 13, 64	Order of Saint Anthony, 352	591–608, 592–611
	Oedipus complex, 572	Ordinary of the Mass, 274–275	Eighteenth century
Norman, G., 510	Oedipus the King (Sophocles), 61, 63–64	Ordo Virtutum (Hildegard of	neo-classical, 422, 424–426,
Normans, 178, 210 North, Sir Thomas, 367	Office in a Small City (Hopper),	Bingen), 206	424–426, 460
Northern Europe. See also	592	Oresteia trilogy (Aeschylus), 62–63	rococo style, 415, 417–422, 418–422
Renaissance, Northern	O'Keeffe, Georgia, 592, 596	Orestes, 62	Greece
Europe	Calla Lily with Red Roses, 592,	Orff, Carl, 241	
art, Middle Ages, 266–270,	593	Carmina Burana, 241	Archaic period, 41–42, 44, 46
269, 270, 271	Old Kingdom, ancient Egypt,	Organ, for liturgical music,	early period, 48
Baroque period, 391–397,	10, 12–14	331–332, 400	Hellenistic, 68, 70
392–397	Old Saint Peter's Basilica, 152,	Organic architecture, 609, 612	India, 524–525, 525
Notebooks (da Vinci), 289,	154, 201	Organum, 237	Japan, 535–536, 537
295–296	Old Saint Peter's church, 320	Orientalizing, 40	Middle Ages
Notre Dame Cathedral,	Old Self-Portrait (Rembrandt),	Orlando. See Song of Roland	Fourteenth Century,
226-227, 227, 233, 238	394, 396	Orleans, 204	259–270, 262–271
Notre Dame de Belle Verrière, 230,	Old Stone Age, 3	Orpheus, 47	High period of, 242, 243,
231	Old Testament, Bible, 145, 146,	Orpheus in Monteverdi's	244, 245, 247
Notre Dame school of music,	148	L'Orfeo, 399	illuminated manuscripts,
236-237	Oldenburg, Claes, 603-604, 607	Orpheus (Liszt), 508	204, 206, 211–213, 213, 214,
Novel. See also Literature	Soft Toilet, 604, 607	Ortega Y Gasset, José, 590	239, 274, 275
America in 19th century, 478	Oliver Twist (Dickens), 475, 475	Orthodox Christians	modern era
modern era, psychological	Olympia, 39, 41, 69, 71, 71, 72,	icons, 177, 178, 179	expressionism, 505-506,
insights in, 515-517	77	Neonian Baptistery, 167, 168,	506, 566 – 567
Romantic era, 473-475	Olympia (Riefenstahl), 580, 580	169	fauvism, 504-505, 505, 506
women's role depicted in,	Olympic Games, 39, 580, 611	Theodoric's palace, 171	Impressionism, 493–498,
516-517	Olympus, 48	Orwell, George, 582, 590	493-500
Novitiate, 216, 217	On the Cultivation of Learning	Animal Farm, 582	post-impressionism, 492,
Novum Organum (New	(Alcuin of York), 204	1984, 582, 590	500-506, 501-506
Oregonian) (Bacon), 348	On the Nature of Things (De	Osiris, 12, 12, 13, 60	Renaissance
Noyons Cathedral, 226, 227	Rerum Natura) (Lucretius),	Ostia, 112, 113	early, 282-284, 283-296,
Nubians, 10	96	Otello (Verdi), 457, 460	289, 292-294, 296-299
Number 1 (Pollock), 593-594,	On the Origin of Species by	Othello (Shakespeare), 367, 457	Elizabethan England,
594	Means of Natural Selection	Outcasts, Aryan caste, 124	359-362, 360-361
Numerical systems, 195	(Darwin), 451	"Overall" painting, 594	France, 357–359, 358
Nutcracker Suite (Ellington),	On the Sovereign Good (Plato),	Ovid, 104, 204, 256	High Italian, 313–315,
575	290	Owen, Wilfred, 561	314-315, 317, 318-320,
Nymphéas (Water Lilies)	O'Neill, Eugene, 572	Oxford University, 237, 241,	319-321, 322-330,
(Monet), 494-495, 495, 512	Desire under the Elms, 572	295, 344	324-330

Northern Europe, 347,	Parade (ballet), 576	Pavlova, Anna, 576	Rome and, 115
349-361, 349-362	Paradise Lost (Milton), 246, 407,	Pazzi Chapel, 287, 288, 320	The Persistence of Memory (Dalí),
	409, 433	Pazzi family, 281	569 – 570, 570
Romantic era	Paradise (Paradiso) in Dante's	Peace, Altar of, 103–104,	Perspective. See Painting,
America, 477–479, 479–481, 481	Divine Comedy, 238,	103-104	Renaissance
	245 – 247	Peaceful City (Lorenzetti, A.),	Perugino, 313, 330
Europe, 447, 460 – 463,	Paradise Regained (Milton), 409	266, 268	Peter, Apostle, 169, 172
461–470, 466–468, 470		Peaceful Country (Lorenzetti,	Peter Grimes (Britten), 622
Rome, 92, 93, 95, 101, 107,	Parcae, 37	A.), 266, 268	Peter of Pisa, 203
108	Parchment, 211		Peter the Deacon, 203, 205
Twentieth century	Paris	Peacocks and Peonies (Maruyama	Peter the Great of Russia, 439,
contemporary contour, 590,	art in modern era, 492–506,	Okyo), 535, 536	530
591–608, 592–611	492-506	Pearlstein, Philip, 599	
modern era, 493–506,	ballet in, 575	Two Female Models on Regency	Petrarch, Francesco
493-506	belle époque, 489	Sofa, 599, 599	Adine Press, published by,
World Wars, period	as center of art world, 592	Peasant Revolt, Germany, 255,	304
between, 563–578,	Champs Elysées, arch on,	259, 341, 352	Augustine, devotion to, 344
564–572, 577, 578	110	Peasant Wedding Feast (Bruegel	as Dante's successors, 281
World Wars, period between	in High Middle Ages, 225,	the Elder), 356, 357	Greek language learning, 179
cubism, 563-567, 564-567	239	Pederson, William, 615, 616	life of, 256–257
dada, 577, 577	jazz, 573	Seattle Art Museum, 615, 616,	Martini, Simone, friend of, 266
as protest, 577 – 578, <i>578</i>	University of, 225, 237, 238,	616	Sidney's imitation of, 364
surrealism, 568-572,	239-240, 260, 306	1201 Third Avenue, Seattle,	works
570-572	Paris Opera House (Garnier),	618	Africa, 256
Pakistan, 123, 126, 522, 526	467, 468	Pediment, 46, 47	Canzoniere (Songbook),
Palace(s)	Parker, Charlie ("Bird"), 574	Peer Gynt Suite (Ellington), 575	256-257
Alhambra, 191, 192, 192	Parmenides of Elea, 51	Pei, I. M., 614	De Viris Illustris, 256
Assyrian, 9, 11	Parmigianino, 329	National Gallery of Art, East	De Vita Solitaria, 256
Charlemagne's at Aachen,	Madonna of the Long Neck, 329	Wing, 614, 615	Letter to Posterity, 162, 256
203-204, 213-220, 215,	Parthenon, 58, 58, 59, 70–73, 72,	Pélerinage de Charlemagne, 225	Secretum (My Secret),
217, 218, 219, 220	73, 103	Peloponnesian War, 57-60,	256-257
Diocletian, 115, 115	Parthians, 103	64-66, 68, 70, 71	Petronius, 97
Doge's Palace, Venice,	Pascal, Blaise, 405	Peloponnesus, 24	The Satyricon, 97
271 – 272, 273	Pasiphae, 21	Pendentives, 164	Petrouchka (Stravinsky), 514
of the Lions, Alhambra, 191,	Passeri, Giambattista, 397	Penelope, 37	Phaedo (Plato), 65
192, 192	Pastel, 420	"Il Penseroso" (Milton), 408	Phaedra, 64
Minoan, 22, 23, 24, 24, 26, 27	Pasteur, Louis, 451	Pentecost (Nolde), 506, 508	Phaistos, 22
Mycenaean, 26–27, 27	Pasteurization, 449	Peplos Kore, 42, 44	Pharaohs of ancient Egypt, 12,
of the Myrtles, Alhambra, 191	Pastoral (Symphony No. 6, Op.	Percussion instruments in	13–18, 17, 27
Theodoric's palace, 171, 172	68) (Beethoven), 454	symphony orchestra, 428,	Pharsalus, Battle of, 95
Versailles, 387, 387–388, 415	Paten, 174, 174	429	Phèdre (Racine), 407
Palatine Hill, Rome, 93, 109	Pater Patriae, 101	Percy, Walker, 618	Phidias, 71
Palazzetto dello Sport (Nervi	Pater Patriae, Cosimo Medici as,	Peregrinatio (Etheria), 175–176	Philip II, king of Spain, 339,
and Vitellozi), 611, 612	290	Pergamum, 79, 80–81, 81, 83, 99	355, 359 – 360
Palazzo Farnese, 379, 380	Pather Panchali (The Song of the	Peri, Jacopo, 399	Philip IV, king of Spain, 389
Palazzo Pubblico, Siena, 266,	Road) (Ray, S.), 540	Dafne, 399	Philip of Macedon, 60, 65, 66
268, 271, 273	Pathétique (Piano Sonata No. 8 in	Euridice, 399	Philip the Bold, Duke, 267–268
Palazzo Vecchio, 271, 281, 301,	C minor) (Beethoven), 453	Pericles, ruler of Athens, 59,	Philistines, 143
333	Pathétique (Symphony No. 6 in B	59-60, 63, 70-71	Philosophy. See also specific
Paleolithic period, 3, 4, 27	minor) (Tchaikovsky), 510	Period of Warring States, 131	philosophers and works
	Patriarchs, period in Hebrew	Peripatetic, 66	Baroque period, 375, 402,
Palermo, 178	history, 143	Peristyle, 321	404-406
Palestine, 202	Patricians, 93, 94	Pérotin, 237	Biblical influence on,
Palestrina, 98, 99	Patroclus, 36, 37	Perpendicular architecture, 272,	145-146
Palestrina, Giovanni Pierluigi		274	China, 132–133, 134
da, 307, 331	Patronage, 325	Perry, Matthew Calbraith, 537	Christianity, early, 161–163,
Missa Papae Marcelli (Mass in	Paul, Apostle, 169		167
Honor of Pope Marcellus),	Paul, early Christian zealot,	Persepolis, 127	
331	147–148	Perseus (Cellini), 333	contemporary contour, 590–591
Palmieni, Matteo, 303	Paul III, Pope, 313, 373	Persian, 522, 525, 525	
Pan-Hellenic League, 71	Paul IV, Pope, 313	Persian Empire	defined, 50
Pandects, Justinian's, 164	Paul the Deacon, 203	Alexander the Great, 65	Eighteenth century,
Pantheon, 110, 111, 164,	Paul V, Pope, 403	Assyria and, 9–10, 27	intellectual developments,
425-426, 427, 433	Pauline Bonaparte Borghese as	Egypt and, 10, 17–18, 27	433-437
Pantocrater, Christ the, 171,	Venus Victorious (Canova),	Greece and, 27, 40, 42, 101	Greece, 49, 50–51, 65–67, 96
173, 173	425, 426	influence on India, 127	Middle Ages, 238–245
Paper making, 195, 211	Pavana, 308	Persian Wars, 57, 58–59, 65,	Renaissance, 301–307,
Paracelsus, 348	Pavia, 202	69	332-333, 347-348

Pines of Rome (Respighi), 508

Africa, 548-549

Julius III, 313

Romantic era, 448-452, 454,	Pinten, Harold, 591	Chinese, 134-135	Leo III, 201
476-477	Pisa, Leaning Tower of, 402	contemporary contour, 619	Leo X, 313, 319, 341
Rome, 96-98	Pisano, Giovanni, 260–261, 261	England, 407-409	Marcellus II, 313
Philosophy (School of Athens)	Nativity and Annunciation to	Fourteenth century, 256-257	Paul III, 313, 373
(Raphael), 314, 315	the Shepherds, 261	Goliadic verse, 241	Paul IV, 313
Phoenicians, 6, 40, 94	Pisano, Nicola, 260, 261	Harlem Renaissance, 575	Paul V, 403
Photography, 580–582, 581	Annunciation and Nativity,	how to read, xxix	Renaissance, High Italian,
Photorealists, 599	260, 261	India, 124-125, 129, 524-525	patronage during,
Phrygians, 48, 67, 116	Pisistratus, 42	Islamic, 194	313–323
Physica (Hildegard of Bingen),	Pit, of theater, 365	Japan, 533, 535–536	Sixtus IV, 313, 318, 330
206	Pius II, Pope, 305	lyric, 49–50, 64, 90, 95	Urban II, 210
Physics (Aristotle), 66	De Pizzano, Thomas, 258	of Middle Ages, 210–211,	Urban VIII, 403
Piano, Renzo, 614	Plague, 59–60, 253, 254, 266	240-241, 245-247	Popular "pop" music, 622–624
Georges Pompidou National	The Plague, 281	Renaissance, High Italian,	Poquelin, Jean Baptiste, 406. See
Center for Arts and	The Plague (Camus), 591	294–295, 317	also Molière
Culture, 614, 615	Plataea, 51	Roman, 95, 100–102	Porch of the Maidens, 74, 75
Piano Concerto in G (Ravel), 513	Plath, Sylvia, 619	Romantic era, 472–475	Porgy and Bess (Gershwin, G.),
Piano Concerto No. 27 in B flat	The Bell Jar, 619	Poitiers, Battle of, 201, 255	574
(Mozart), 431, 454	Plato	Polis, Greek, 33, 39–40, 60	Porta, Giacomo della, 322, 323
Piano Sonata No. 8 in C minor	Academy of, 66, 164	Political philosophy, 50	Portal, 218, 321
(Pathétique) (Beethoven),	Aldine Press, publication by,	Political theory. See	Portonaccio Temple, 92
453	304	Government and political	Portrait busts, 98, 98–99
	Arabic translations, 195	theory	Portrait mask, African, 553, 555
Piano Suite, Op. 25 (Schönberg),	Augustine of Hippo,	Poliziano, 304	
514 Diagram Saint Batan's 272	influence on, 161	Pollock, Jackson, 592–594	Portrait of a Family Making
Piazza, Saint Peter's, 373			Music (Hooch), 398
Picaresque novel, 407	Boethius and, 163	Number 1, 593–594, 594	Portrait of a Youth (Hilliard),
Picasso, Pablo Ruiz	Cosimo de' Medici,	Polonaises, 456	361, 362
African art influence, 553	discussion by, 289–290	Polydrus of Rhodes, 82	Portrait of Confucius, 132
in Chicago, 607	dialectics, 237	Polyeucte (Corneille), 407	Portrait of Dr. Gachet (van
cubism, 563–565	Ficino, Marsilio, influenced	Polykleitos, 68, 70	Gogh), 503–504, 504
Guggenheim exhibition of,	by, 297	The Canon, 68	Portrait of Martin Luther
591	ideal society and political	Doryphoros, 68, 70	(Cranach), 341
as protest, 577 – 578	theory of, 66	Polynices, 63	Portrait of royal (Benin)
surrealism, 569	on light, 165	Polyphony, xxvi, 237, 274, 331,	woman, 547
works	and More's Utopia, 364	362, 399, 401	Portrait of the Artist as a Young
curtain for ballet Parade,	on music, xxvi, 48, 49, 67, 308	Polytheism, 145	Man (Joyce), 562
576, 576–577	paradoxes discussed by, 51	Pompeii, 16, 105–106, 105–109,	Portugal, 535
Daniel-Henry Kahnweiler,	in School of Athens (Raphael),	108, 422, 424	Poseidon, 35, 73, 74, 97
564, 565	315	Pompey, senator of Rome, 94,	Post-impressionism, 492,
Guernica, 577 – 578, 578	significance of, 50, 57	95	500-506, 501-506
Les Demoiselles d'Avignon,	Socrates and, 65–66	Georges Pompidou National	Postmodernism, 614–615,
554, 563, 564	on the soul, 76	Center for Arts and	619-620
Pulcinella (ballet), 576	study of, 179	Culture (Paiano and	Potemkin (Eisenstein), 579, 579
Three Musicians, 565, 566	Theory of Forms, 66	Rogers), 614, 615	Pothos (Desire) (Scopas), 77, 77
Pico della Mirandola, 302, 303,	Three Fates and, 37	Pont du Gard, Nîmes, 112, 113	Pottery and ceramics
344	works	The Pont Neuf Wrapped	Aegean culture, 20, 21, 22
Oration on the Dignity of Man,	Apology, 65	(Christo), 609	China, 134, 135, 136, 528, 528,
303	Crito, 65	Pontormo, Jacopo Canucci da,	530, 531
Pictographs, cuneiform, 6, 7, 19	Phaedo, 65	328-329	Greece
Pierfrancesco, Lorenzo di', 295	The Republic, 238	Deposition, 329, 329	classical, 62, 68, 70
Piero de' Medici, 293–294	Platonic love, 289, 332	Ponts-de-Cé, Battle of, 391, 394	early, $37-38$, $38-40$, $40-41$,
Pierrot Lunaire (Schönberg),	Plautus, 95, 364	Pop art, 598, 603–604	44, 46, 49
513-514	Plebeians, 93, 94	Pope, Alexander, 434	India, 123
Pietá (Michelangelo), 300, 300	Plethon, Genistos, 179, 289	Essay on Criticism, 434	invention of, 5
Pietas, 149–150	Pliny the Elder, 105, 203	Essay on Man, 434	Japan, 537, 537
Pietra serena, 319	Natural History, 105	The Rape of the Lock, 415	vase painting, 44, 46, 68, 70
Pigalle, Jean Baptiste, 437	Pliny the Younger, 105–107	Pope(s)	Pound, Ezra, 408, 617
Voltaire, 437	Plotinus, 289	Boniface VIII, 253	Poussin, Nicolas, 383–386,
Pilgrimage to Cythera (Watteau),	Plutarch, 367	Clement VII, 313, 319, 330,	384-385
418, 419	Pluto Seizing Persephone, 76, 76	333	Et in Arcadia Ego, 384, 384,
Pilgrimages	Poe, Edgar Allan, 476	Gregory, 330	385
Christian, 210, 216, 218, 233,	Poet on a Mountaintop (Shen	Gregory the Great, 203, 207	The Rape of the Sabine Women,
235-236	Zhou), 528	Hadrian VI, 313	385, 385
Islamic, 185	Poetics (Aristotle), 63-64, 66	John Paul II, 404	Praeneste, 99
Pillow book, 533–534	Poetry. See also Literature;	Julius II, 313, 315, 316, 317,	Prague, 267
Pindar, 304	specific poets	318, 320, 330	The Praise of Folly (Erasmus),

306-307

Old Self-Portrait, 394, 396

Praxiteles, 76-77 Psalms of David (Schütz), 400 Rajputs, 522 Reformation. See also Aphrodite of Cyrene, 77 Psalters, 211-213, 213, 214 Ramadan, 185 Christianity Augustine of Hippo, Hermes with Infant Dionysus, Psammetichos I, pharaoh of Ramapithecus, 3 Ramayana, 124 influence on, 161 Egypt, 41 Pseudo-Dionysius, doctrine of, Ramcaritmanas (The Holy Lake of causes of, 342-343 Prayer the Acts of Rama) (Das), 525 Counter-Reformation, in Islam, 185, 186, 188-189 monastic life, 204-206 Pseudo-Turpin, 211, 225 Rameau, Jean Philippe, 399 373-375, 398, 404 Ramses II, pharaoh of Egypt, cultural significance of, Opus Dei, 206 Psychic automatism, 594 16, 20 345 - 347Preaching Friars of Saint Psychology humanism and, 344-345 abstract expressionism, Ran (Kurosawa), 540 Dominic, 242 592-594 The Rape of the Daughters of Luther, 332, 340-341, 341 Predynastic Egypt, 10 Leucippus (Rubens), 391, music, 331, 362-363, 398 Prehistory, timeline of, xxxii Baroque origins, 375 Preludes, Op. 28 (Chopin), 455 contemporary contour, printing, 304 589-590 The Rape of the Lock (Pope), 415 The Rehearsal (Degas), 497, 497 Prem Chand, 526 The Rape of the Sabine Women Reheims, 274 Presbyterianism, 345 modern era insights in the novel, 515-516 (Poussin), 385, 385 Reich, Steve, 621 Presley, Elvis, 623 Raphael Sanzio, 314-315, 322 The Desert Music, 621-622 Presocratics, 50-51 Ptah, 13 The Prevalence of Ritual: Baptism Ptolemies, kingdom of, 78, 79 Baldassare Castiglione, 332, Reign of Terror, French (Rearden), 600, 600 Ptolemy, 315, 403, 404 Revolution, 439 Ptolemy, king, 79 Madonna of the Meadow, 314, Relics, 225, 233 Des Prez, Josquin, 307, Relief carving. See Sculpture 330 - 331Publius Vergilius Maro. See School of Athens (Philosophy), Religion. See also Buddhism; Tu Pauperum Refugium (Thou Vergil Refuge of the Poor), 330 Pugin, A. W. N., 448 314.315 Christianity; Deities; God, The Transfiguration, 315, 315 monotheistic; Humanism; Priene, 77 Puja, 125 Pulcinella (ballet), 576 Al-Rashid, Harun, 201, 202 Islam and Muslims; Judaism; Reformation; ancient Egypt, 12, 13 Punic Wars, 94 Rashomon (Kurosawa), 540 specific theologians Christian (See Catholic Purgation of the soul, 66 Rational humanism, 435-436 African animist beliefs, 546, Purgatory, in Dante's Divine Rationalism, 242 church) Indian caste, 124, 130-132 Comedy, 245-247 Rauschenbeng, Robert, 598 Purgatory (Purgatorio) in Monogram, 598, 598 afterlife Sumer, 6 La Primavera (The Springtime) Dante's Divine Comedy, Ravel, Maurice, 513, 576 ancient Egyptian religion, (Botticelli), 295, 296, 305 245 - 247Bolero, 513 10-12, 13, 14"Puritan ethic," 346 Piano Concerto in G, 513 in Dante's Divine Comedy, Prime, horarium monasticum, 196, 238, 245-247, 247, 256 Pynchon, Thomas, 589, 619 Ravenna, 161, 162, 166-178, 205 "Primitive" arts, 563 Gravity's Rainbow, 589 166 - 178ancient periods and cultures The Prince (Machiavelli), Pyramids, Egyptian, 12-13, 15, Ray, Man, 571, 580 Aegean culture, 8-9, 24 Ray, Satyajit, 540 China, 132-133 305-306 Printing, 303-305, 346, 364 Pyrenees, 210 The Apu Trilogy, 540 Egypt, 11-15 The Home and the World, 540 India/Aryan, 123-125 Pythagoras of Samos, xxvi, Priscian, 203 Sumer, 6 50-51, 67, 315 The Song of the Road (Pather Priscilla catacombs, 150, 151 Procopius of Caesarea, 163 Pythagoreanism, 50 Panchali), 540 Baroque period, 392, 406-407 The Unvanquished (Aparajito), Black Death, 254-255 The Buildings, 163 Pythian Games, 49 Greece, 33-37, 50, 51, 58 Secret History, 163 Program music, 508 The World of Apu, 540 Hinduism, 125, 127-128, Rayograms, 580 525-526 Programs (plots) in music, 508 Qá aba, Mecca, 185 light, mysticism of, 229-230, Qing Dynasty, 526, 530-532 Readymades, 577 Prokofiev, Serge, 576, 579 Quadrivium, 203 231, 232, 233 Alexander Nevsky, score for Realism, Nineteenth century Quadruplum, 237 novels, 473-475 Nietzsche on Christianity, film, 579 Queirolo, Francesco, 421 painting, American, 477-479, Prometheus Unbound (Shelley), Deception Unmasked, 421, 422 479-481, 481 Pico della Mirandola on, 303, Quem Quæritis trope, 208 Reason, Age of, 415 Propaganda, 577-580 prayer, 185, 186, 188-189, The Questions of King Milinda, Reason, Aquinas' view on, 243 Propertius, 104 204-206 The Prophet Jeremiah, 219 Recapitulation, in sonata form, Protestantism, 331, 341-343, The Prophets, Hebrew Bible, Quintilian, 203 345, 347-348, 359-360 Institutio Oratoria, 203 Recitative, 399 144 - 145, 146Propylaea, Parthenon, 73, 75 Qur'an, 166, 186-187, 188, Reclining Figure (Moore), 605, religious divisions in Renaissance Europe, 343 193-195, 197-287 605, 607 Prose, xxix of Rome, 96-97 Rabia, Saint, 193, 287-289 Reconquista, 191 Protagoras, 51 Taoism, 132-133 Protestantism, 162, 254, 345, Racine, Jean, 407, 433 The Recuyell of the Historyes of Voltaire on, 437 359-360. See also Phèdre, 407 Troye, 304 Reliquary of Charlemagne, 210 Radio, 561, 579 Red Boats at Argenteuil (Monet), Reformation Rembrandt van Rijn, 347, Protogeometric period, 38 Raft of the Medusa (Géricault), 494, 494 393-396 Red-figure style, 44, 46 Proust, Marcel, 516 463, 464, 470 Jacob Blessing the Sons of Remembrance of Things Past, Ragtime, 573 The Red Studio (Matisse), 505, Joseph, 395-396, 397 Rainey, Ma, 573 506 516 The Night Watch, 394, 396 Raise the Red Lantern (Zhang Refectory, 216, 217 Providence, 163

Reform, 345

Yimou), 540

Psalms, 154, 155

Remembrance of Things Past (Proust), 516 Remus, 91, 103 Renaissance Augustine, writers devotion to, 162 city-states of Italy, 60 classics, appreciation of, 179 early, in Florence, 281-308 architecture, 287-288, 287-288 art, 281-282, 282-287, 289-294, 296-301 banking and commerce in, as city state, 60 Dante in, 245 education, 289, 295, 297 Fifteenth century major social events, 283 first use of term "Renaissance," 301 humanism during, 301 - 307Laurentian Library in, 289, 328, 328 map, 304 Medici era, 281, 288-300, 289-294, 296-301, 302 music, 307-308, 399 as opera's birthplace, 399 painting, 281-296, 282-284, 289, 292-294, 296 - 299palazzos in, 271 philosophy, 301-307 printing technology, 303 - 305Republican government of, 281 sculpture, 284-286, 284-287, 300, 301, 301 timeline, 278-279 women during, 305 High Italian period, 313-334 architecture, 320-322, 322, art, 313-330, 314-317, 319-323, 325-330 intellectual synthesis of, painting, 313-315, 314-315, 317, 318-321, 319-321, 324-327, 324-330, 329-330 philosophy, 332-333 poetry, 294-295, 317 popes and patronage during, 313-323 sculpture, 316, 317, 318, 322, 322 Sixteenth century, 330-333 timeline, 310-311 Venice, 324-326, 325-327 Northern Europe, 339-108 architecture, 357-359, 359, 360

art, 339-342, 340-342, 347, 349-361, 349-362 drama, 364-367 literature, 364-367 map, 342 music, 362-364 painting, 349-361, 349-362 philosophy, 347-348 Reformation, 340-347 science, 348-349 timeline, 336-337 Rome's influence on, 101 The Renaissance of the Twelfth century (Haskins), 301 René Descartes (Hals), 404 Renoir, (Pierre) Auguste, 495, Le Moulin de la Colette, 495, Two Girls at the Piano, 495, 496 Representation, in Twentieth century art, 597-602, 597-603 Republic of Benin, 552 Republic of Biafra, 550 The Republic (Plato), 238, 364 Republican Rome. See Rome, Republican Requiem Mass (Ockeghem), 307 De Rerum Natura (On the Nature of Things) (Lucretius), 96 Respighi, Ottorino, 508 Pines of Rome, 508 Responsorial singing, 155 Restoration. See Reformation Resurrection from Isenheim Altarpiece (Grünewald), 353, 354 Return from exile, period in Hebrew history, 143-144 Reuchlin, Johannes, 303, 344 Revelation, 146 Revelation, Book of, 171 De Revolutionibus orbium coelastium (On the Revolutions of Celestial Bodies) (Copernicus), 348 Revolutions American, 440-441, 447 in Eighteenth century, 438 - 441French, 415, 419, 424, 438 - 439Industrial, 439 Russian, 561, 577 values and, 439 On the Revolutions of Celestial Bodies (De Revolutionibus orbium coelastium) (Copernicus), 348 Revolver (Beatles), 623 Reynolds, Sir Joshua, 420, 425,

433, 475

Three Ladies Adorning a Term

of Hymen, 425, 425

Rhapsody in Blue (Gershwin, G.), 574 Rhazes, 195 Rhetoric (Aristotle), 66 The Rhinegold (Wagner), 458 Rho, 150, 153, 173, 174 Rhodes, 26, 77 Rhythm, 507 Riace Bronzes, 68, 69 Ribera, José de, 389, 389 The Martyrdom of Saint Bartholomew, 389, 389 Ricci, Matteo, 530 Rich, Adrienne, 619 Richard II, king of England, 267 Richard II Presented to the Virgin and Child by His Patron Saints (Wilton Diptych), 267, 269 Richard II (Shakespeare), 361 Richard Wagner at His Home in Bayreuth (Beckmann), 459 Richmond, VA, State Capital at (Jefferson), 426, 427 Riefenstahl, Leni, 579-580 Olympia, 580, 580 Triumph of the Will, 579-580 Riesman, David, 590 The Lonely Crowd, 590 Riffs, 574 Rifkin, Joshua, 623 The Rig Veda, 125-126 Rigaud, Hyacinthe, 386, 386 Rigoletto (Verdi), 457 Rilke, Rainer Maria, 590, 591 Rimsky-Korsakov, Nikolai Andreivitch, 456 The Ring of the Nibelung (Wagner), 458 The Rite of Spring (Stravinsky), 513, 514, 573 The River (Ellington), 575 Robert of Anjou, king of France, Robespierre, Maximilien, 439 Robin Hood, 255 Robusti, Domenico, 326 Robusti, Jacopo, 326. See also **Tintoretto** Rocchetti, Giacomo, 317 Rock Edict XII, 126 Rock music, 623-624 Rococo style, 415, 417-422, 418-422 Rodin, August François René, 499 - 500Gustav Mahler, 499, 511, 512 The Kiss, 499, 499-500 Monument to Balzac, 499, 499 Roethke, Theodore, 618 Rogers, Richard, 614 Georges Pompidou National Center for Arts and Culture, 614, 615 Roland, Song of, 201, 210-211 Rolling Stones, 623

Their Satanic Majesties Request, 623 Roman Catholic Church. See Catholic Church Roman chant, 203 Romance of the Rose, 257, 259 Romanesque style, 216, 218, 218, 219, 220, 228 Romanization, 97 Romantic era, 447-485 in America, 475-478 architecture, 466-467, 468 art, 447, 460-463, 461-470, 466-468, 470 concerns of, 447-448 intellectual background of, 448-452 literature, 470-475 map, 450 music, 452-460 opera in Italy, 456-457, 458 science, 451-452 timeline, 444-445 Rome, See also Vatican Baroque period, architecture. 373-375, 374, 380-383, 381 - 383cultural importance of, 89-91, 225 Eighteenth century, influence on, 433-434 Etruscans, 91-92 Gods and Goddesses, 96-98, 97, 116, 149-150 Imperial, 99-171 architecture, 105-107, 108-116, 109-112, 115-116, 164 art, 107, 108, 115-116, 116 Charlemagne as ruler of, 201, 202 Christianity in, 147, 148 - 150decline of, 91, 113-116, 130, 161-163 dinner party in, 97 emperors of, 99, 113 Hebrews, conquest of, 143 - 144length of period, 91 literature, 100-102, 104, 112 - 113model of, 109 as multiethnic, 101 as object of satire, 112-113 Paul's letters to, 148 sculpture, 102-105, 103, urban life in, 112 values of, 101 map, 90 Renaissance (See also Renaissance, High Italian period) Charles V, Emperor, destruction by army of, 332

empire of, 306, 417, 439 Saint Teresa in Ecstasy (Bernini), Sanctus in Ordinary of the drama, 364-365 influence on, 101 literature, 473-474, 515 381, 382 music at papal count, Revolution in, 561, 577 Saint Thomas Aquinas. See Aquinas, Saint Thomas Russo-Japanese War, 537 330-331 tsar of, 169, 176 Saint Thomas' Church, Leipzig, Republican, 92-99, 116-171 architecture, 98, 98-99 Russian Orthodox church, 178 Saint Victor, church of, 238 art, 98-99 conquest of Greece by, 57 Sainte Geneviève Monastery, historic periods of, 91 Saarinen, Eero, 611, 613 524 law of, 96-98, 164, 179 Sacadas of Argos, 49 Sainte Madeleine, church of, literature, 95–96 Sacramentary, 203 218, 219, 220 overview, 92-95 The Sacrifice of Isaac Saint(s) (Brunelleschi), 285, 286 Ambrose, 207 philosophy, 96-98 timeline, 86-87 The Sacrifice of Isaac (Ghiberti), Augustine (See Augustine of 288 Romeo and Juliet (Shakespeare), 285, 286 Hippo, Saint) Benedict of Nursia, 204 Saint Anthony, Order of, 352 366 Saint Bartholomew's Day Bonaventure, 242, 264, 266 Romulus, 91, 103 Catherine of Siena, 254 Massacre, 347 Romulus Augustulus, 113 Roncesvalles, Battle of, 201, 210 Saint Catherine's Monastery at Charlemagne, 210 Mount Sinai, 175-178, 177, Dominic, 242 A Room of One's Own (Woolf), 178, 179 Francis of Assisi, 241-242, 242, 243, 264, 266, 281 Saint Denis Abbey, 210, Rose, Barbara, 591-592 225-229, 226, 227, 228, 231, Golias, 241 Rose window, 233 Jerome, 203 Rossini, Gioacchino Antonio, 236 Saint Francis Preaching to the John Chrysostom, 165 622 William Tell Overture, 622 Birds, 243 John of the Cross, 373 Roswitha. See Hroswitha Saint Francis Renounces His Lawrence, 166, 167, 168 Mark, 178, 179 Rothenberg, Susan, 602 Worldly Goods (Giotto), 264, Cabin Fever, 602, 602 266, 266 Martin of Tours, 214 Rothko, Mark, 594-595 Saint Gall monastery, Mary of the Flower, 287 Rabia, 193, 287-289 Rothko Chapel murals, 595, 595 Switzerland, 204, 208, 216, 8,8 Rothko Chapel (Johnson, P.), Teresa of Avila, 373 595, 595-596 Saint George (Donatello), 290, Victor, 238 Rothstein, Arthur, 582 Vitalis, 171, 173 Saint James, Shine of, 210 Sakuntala (Kalidosa), 130 Rouault, Georges, 576 Saint John Lateran basilica, Saladin, 196 Rousseau, Jean-Jacques, 415, Salerno, 238 Satire 433, 435-436, 439 331 Saint Mark's Church, Venice, Salinger, J. D., 618 Le Devin du Village, 436 Catcher in the Rye, 618 The Social Contract, 436 331 Saint Mary Magdalene Salome (Corinth), 510, 511 Row, twelve-tone technique, (Donatello), 290, 291 Salome (Strauss), 510 Saint Mary Major basilica, 331 Salome (Wilde), 510 Royal Cemetery at Ur, 14 Saint Matthew Passion (Bach), Salonica, 178 Royal Cemetery of Vergina, 76, Saltarello, 308 Royal College of Physicians, Saint Michael Fighting the The Saltcellar of Francis I 622 Dragon (Dürer), 351, 351 (Cellini), 340 Salzburg, Archbishop of, Royal Grave Circle, Troy, 25, Saint Patrick's Cathedral, 430 - 431Dublin, 434 Royal Society for Improving Saint Paul's School, 295 Samos, 46 Saint Peter's Basilica. See also Samson Agonistes (Milton), 409 Natural Knowledge, 404 Rubens, Peter Paul, 324, Vatican Samurai-dokoro, 535 in Baroque period, 373-374, San Carlo alle Quattro Fontane 391-392 Hélène Fourment and Her 374, 381 church, 382-383, 383 San Domenico, Church of, 262, Children, 391, 392 Charlemagne's coronation, 152, 154, 201 Journey of Marie de' Medici, 391, 394 choir, 331 San Giorgio Maggiore church, Constantine and, 152, 154 Venice, 326, 327 The Rape of the Daughters of San Lorenzo church, Florence, Leucippus, 391, 393 Manzù's doors at, 602, 604 Rule of Saint Benedict, 204-Michelangelo's dome, 287, 319, 322 San Luigi dei Francesi Church, Pope Julius II rebuilding of, Rome, 377 Running Fence (Christo), 609 320, 322, 323 San Marco, Convent of, 290, 301 Rushdie, Salman, 526 Russell, Bertrand, 563 Saint Peter's Church, Geneva, San Rocco, Scuola at, 326 San Vitale, Church of, 171, Russia Saint Peter's Square, 373, 374 172-175, 173, 174, 214 Bolshevik party, 532 Byzantine influence on, 178, Saint Sernin Church, 216, 218, Sanctuary of Fortuna

Primigenia, 98, 99

179, 180

218

Mass, 275 Sand, George, 455, 473 Lélia, 473 Lucrezia Floriani, 473 Sangallo, Giuliano da, 322 Sanghas, 127 Sanskrit, 123-124, 125, 129, 195, Sant' Apollinare Nuovo church, 170, 170-171, 171, 172, 173 Santa Costanza, 164 Santa Croce, 270 Santa Croce church, Florence, Santa Maria del Carmine church, Florence, 284, 284, 285, 286 Santa Maria del Fiore, 287 Santa Maria Novella church, Florence, 283, 283, 293 Santa Reparata church, Florence, 287 Santa Trinitá church, 283 Sant'Elia, Antonio, 582 Santiago de Compostela shrine, 210, 216, 228 Del Santo, Andrea, 339 Sappho, 49-50, 90 Sargon, king of Akkadians, Sarnath, 125 Sartre, Jean-Paul, 590, 591 Satan, 35, 246, 248 Satie, Erik, 576 Mercury, 576 of Pope, 434 Rome as object of, 112-113 of Swift, 434-435 Satires (Juvenal), 113 Saturn Devouring One of His Sons (Goya), 462, 463 Satvagraha, 525-526 Satyagraha (Glass and Wilson), Satyr play, 60-61 The Satyricon (Petronius), 97 Saul, king of Hebrews, 143 Saul of Tarsus, 147 Savage, Augusta, 576 Fra Savonarola, 282, 302, 307, 308 Scarlatti, Domenico, 400-401 The Scarlet Letter (Hawthorne), Scene of Hunting and Threshing, 135, 136 Schall, Adam, 532 Scherzo, 454 Schiller, Friedrich von, 454 "Ode to Joy," 454 Schliemann, Heinrich, 21, 24 - 27, 27Scholar and Crane painting, Ming Dynasty, 527, 528 Scholastica, sister of Saint Benedict, 206

150, 152, 153

394, 396

Hamlet, 332, 367

Scholasticism, 204, 225, 237–245, 281	contemporary contour, 602-607, 604-611	Self-Portrait (Anguissola), 330, 330	Hen: 366
Schönberg, Arnold, 508,	Eighteenth century, 421, 422	Self-Portrait (Dürer), 350, 350	Juliu
513-514, 620	Greece	Self-Portrait (Hockney), 602, 603	King
Moses and Aaron, 514	Archaic period, 41–43, 41–44	Selinus, 42, 44	Mac
Piano Suite, Op. 25, 514		Semitic period, Mesopotamia, 6	The .
Pierrot Lunaire, 513–514	Classical, 68, 68–71, 76–78,	Senate	AM
Three Piano Pieces, 513	76-78	Republican Rome, 93, 94	Drea
Violin Concerto, 514	early period, 35, 41–44, 41–45	United States, 101	Othe
School of Athens (Philosophy)		Seneca, 96, 348, 364	Rich
(Raphael), 314, 315	Helenistic, 81, 81–82, 83	Senegal, 549, 550	Rom
Schopenhauer, Arthur, 449, 458, 491	Middle Ages	Senfl, Ludwig, 362	The '
	Charlemagne and	Senghor, Leopold, 549–550	Twel
Schubert, Franz, 454 Lieder, 454	Medieval culture, 218, 219–220	Senlis Cathedral, 226, 227	Shakespea
Symphony No. 8 in B minor	Fourteenth Century Italy,	Septimius Severus, emperor of Rome, 99	574
(Unfinished Symphony), 454	260–261, 260–261,		Shamash
Trio in E flat, 454	267–268, 270	Septuagint version of Bible, 145	Shang D
Trios for Piano, Violin and	High period of, 230, 232,	Serialism, 514	Shangha
Cello, Op. 99 and 100, 454	233, 236	Series, twelve-tone technique,	532 Shankar
Schumann, Robert, 454	modern era, 491, 499,	514	Shankar,
Schütz, Heinrich, 400	499-500, 512	Sermon on the Mount, 147	Share Cro
Science. See also Mathematics	neo-classical, 425–426, 426		581 Shallow I
astronomy, 203, 348–349	Renaissance	Sesostris III, pharaoh of Egypt, 14, 17	Shelley, I Promet
Baroque period, 375, 402–404	early in Florence, 284–286,	Set, 13	Shem, 6
education and scientific	284–287, 300, 301, 301	Seth, Vikram, 526	Shen Zho
truth, 405	High Italian, 316, 317, 318,	Sethos, 12	Poet on
Gupta Indian, 129, 130	322, 322	Setting, viewing of art, xxiv	Sheyks, 1
Islamic, 195–196	Rome	Seurat, Georges, 501	Shi'a trac
medicine, 130, 195–196, 349	Etruscan, 91–92, 91–93	A Sunday on La Grande Jatte,	Shih Hua
microscope, 404	Imperial, 98, 98–99,	500	Shiites, 1
modern era, 489–490	102–105, 103, 104, 116, 116,	7 A. M. News (Leslie), 599–600,	Shintoisn
no Hebrew word for, 143	144	600	Shitao, 53
psychology, 375, 515–516,	Republican, 95	Seven Books on the Structure of	Landsci
589-590, 592-594	Twentieth century	the Human Body (Vesalius),	Shiva, 38
Reformation, 345	contemporary contour,	348	Shogún,
Renaissance, 348-349, 349	602-607, 604-611	The Seven Last Words of Christ	Shona pe
Romantic era, 451-452	modern era, 491, 499,	(Schütz), 400	Shortly A
telescopes, 403, 403, 404	499-500, 512	Seven Samurai (Kurosawa), 540	Mari
Scivias (The Way to Knowledge)	The Sea (La Mer) (Debussy), 512	Seven Wonders of the World,	(Hog
(Hildegard of Bingen), 206,	Seagram Building (van der	79	Shostako
206	Rohe and Johnson),	Seventeenth century. See	Sympho
Scopas, 76, 77, 77	613-614, 614	Baroque period	Sympho
Pothos, 77, 77	Seal of Charlemagne, 202	Several Circles (Kandinsky),	Sympho
Scotland, Reformation in, 341	Seal stones, 22, 123	566-567, 569	Shoubeegi
The Scraper (Apoxyomenos)	Seattle Art Museum (Venturi	Severini, Gino, 582, 591	601
(Lysippus), 78	and Brown), 615, 616	Armored Train in Action, 581,	Shrifte, N
The Scream (Munch), 505, 506	Seattle skyline, 614–615, 616	582	Shrine of
Scriptorium, 216, 217	"The Second Coming" (Yeats),	Sexton, Anne, 619	210
Scriptura sola, 344–345	404, 550, 561	Sexual union and Hinduism,	Sic et Non
Sculpture. See also Art	Second Piano Sonata (Boulez),	127	Sicily, 39,
Africa, 548, 549	620	Sfonza, Ippolita, 305	Siddharth
ancient periods and cultures	Secret History (Procopius of	Shah Jahan, 192, 524	Sidney, Si
Aegean, 23, 24, 24–25, 26	Caesarea), 163	Shahn, Ben, 592	Arcadia
Assyria, 9, 11	Secretum (My Secret) (Petrarch),	Death of a Miner, 593	Siegfried (
China, 131, 132, 135, 135,	256-257	Shakespeare, William	Siena, 60,
137	Seeger, Pete, 622	vs. Chaucer, 257, 258	268,
Egypt, 14–15, 16, 17, 17, 20	Segal, George, 603	English Renaissance, 339,	Siena, Sai
India, 123, 124, 127, 128	The Diner, 603, 606	364-367, 366	Sikhism,
Mesopotamia, $6-10$, $8-10$	Sei Shonagon, 533-534	Kurosawa, as inspiration to,	Silk indus
Neolithic and Paleolithic,	Seiitaishogun, 536	540	Sinai, Mo
4, 5	Seker, 13	Pope, Alexander, as	Mon
Baroque period, 380–383,	Seleucids, kingdom of, 78, 79,	inspiration to, 434	177,
381-383	79	works	Singing. S
Buddhist, 79	Self-examination (Abdallah), 549	Antony and Cleopatra, 367	Sistine Ch
Christian period, early, 144,	Self-Portrait, Old (Rembrandt),	The Comedy of Errors, 366	319.

ry IV, parts I and II, us Caesar, 95, 366-367 g Lear, 107, 367, 540 cbeth, 107, 367, 540 Merchant of Venice, 366 lidsummer Night's ım, 622 ello, 367, 457 ard II, 361 ieo and Juliet, 366 Tempest, 367 lfth Night, 366 arean Suite (Ellington), 1, 9, 11 ynasty, 131 i church, China, 532, Ravi, 540, 622 opper's Family (Evans), Percy Bysshe, 472–473 theus Unbound, 472 ou, 527 a Mountaintop, 528 dition, Islam, 193 ang-ti, 133-134 .85 m, 533 30, 531 аре, 531 535 eople, 547–548 fter the Marriage from riage à la Mode garth), 425, 426 vich, Dmitri, 622 ony No. 13, 622 ony No. 14, 622 ony No. 15, 622 (Indian Birds) (Stella), И. L., 510 Saint James, Spain, 1 (Abelard), 238 60, 66, 91, 178 ha Gautama, 125-126 ir Philip, 257, 364 , 364 (Wagner), 458 262, 263, 266, 267, 269 int Catherine of, 254 stry, 163, 196 ount, Saint Catherine's astery at, 175-178, *178,* **1**79 See Vocal music hapel, 313, 318-319, 320, 330 Sistine Choir, 330, 331

Sixtoonth contury See
Sixteenth century. See
Renaissance, Northern
Europe
Sixtus IV, Pope, 313, 318, 330
Sketes, 178
Sky Cathedral (Nevelson), 605
Skyscrapers, 612-617, 612-617
The Slave Ship (Turner), 470, 470
Slavery, 13, 22, 147, 546
Slavonic Dances (Dvorák), 456
The Sleep of Reason Produces
Monsters (Los Caprichos)
(Goya), 447, 448, 462
Sluter, Claus, 268, 270
Smetana, Bedrich, 456
Má Vlast (My Fatherland),
456
Vltava (The Moldau), 456
Smile, archaic, Greek sculpture,
43, 43
Smith, Bessie, 573, 574–575
Smith, David, 602
Cubi I, 602, 604
Smith, Mamie, 573
Snake Goddess, 22, 26
Social class
Baroque music for the
masses, 398-399
during Charlemagne's rule,
202-203, 204
Christianity, early, 149
Indian/Aryan, 124, 130-131
Renaissance, early, 281
Rome, 93, 100
The Social Contract (Rousseau),
436
Social elements, viewing of art,
XXV
Social War, Roman, 94
Socialism, 490
Society of Jesus. See Jesuits
Socrates, 50, 65–66
Soft Toilet (Oldenburg), 604, 607
Solar year calculation, 195
Soliloquy, 367
Solomon, king of Hebrews, 143,
147
Solomon, Temple of, 143, 144,
145
Solomon R. Guggenheim
Manager (Alvinte)
Museum (Wright),
610-611, 612
Solon, 42
Solzhenitsyn, Alexandr, 590
Sonata allegro form, 429, 453
Sonata form, 400, 428-429
Song of Aspremont, 211
"The Song of Bacchus"
(Lorenzo de' Medici), 295
Song of Roland, 201, 210-211
The Song of the Earth (Das Lied
von der Erde) Mahler, 511
The Song of the Road (Pather
Panchali) (Ray, S.), 540
Songs. See Vocal music
Sonnets. See Poetry
Sontag, Susan, 619

Sophists, 65 Sophocles, 60, 63, 304 Antigone, 14, 61, 63 Oedipus the King, 61, 63-64 Sorbon, Robert de, 239 Sorbonne, 239 The Sortie of Captain Frans Banning Cocq's Company of the Civic Guard (The Night Watch) (Rembrandt), 394, 396 Soufflot, Germain, 427 The Sound and the Fury (Faulkner), 590 South Sea Company, 439 Sovinka, Wole, 549 Spain Armada of, 359-360, 361 art, 388-390, 388-391, 407, 577-579 Civil War, 578 literature, 407 as Muslim, 190, 201 pilgrimage to shrines in, 210, Reconquista in, 191 Sparta, 33, 51, 58-59, 64-65 Spearbearer (Doryphoros) (Polykleitos), 68, 70 Spem in Alium (Hope in Another) (Tallis), 363 Spence, Jonathan D., 532 Spenser, Edmund, 257, 364 Sphinx, 13, 15 Spinoza, Baruch, 405-406 Spiritual Exercises (Loyola), 373 Spirituality. See Religion Split, 115, 115 The Spoils of Jerusalem, 144 Sports and game Chinese, 135, 136 Etruscan, 92 Olympic Games, 39 Pythian Games, 49 Sprechstimme, 514 Sprezzatura, 332 Spring Fresco, 25 Square Court of the Louvre, 358, 360 Squinches, 171 Sri Lanka, 127 Stadium, Florence, 289, 295 Stained-glass windows, 226, 229-230, 231 Stalin, Joseph, 579 The Starry Night (van Gogh), 502, 503 State Capital at Richmond, VA (Jefferson), 426, 427 The State Hospital (Kienholz), 603-604,606 Statius, 204 Statue of Liberty (Bartholdi), 491 Statues. See Sculpture Steichen, Edward, 577 Steinbeck, John, 581 The Grapes of Wrath, 581

Stele, 7, 8, 8, 9, 9, 11, 43, 45, 71 Stele of Aristion, 43, 45 Stele of Crito and Timarista, 71 Stele of Hammurabi, 7, 9, 11 Stele of Naram-Sin, 8, 9 Stella, Frank, 599, 602 Shoubeegi (Indian Birds), 601 Stephanos (architect), 177 Stevens, Wallace, 618 Stevenson, Robert Louis, 42 Stieglitz, Alfred, 577, 580, 592 Stigmata, 241 Still Life with Commode (Cézanne), 501, 502 Stockhausen, Karlheinz, 621 Mixtur, 621 Stoffels, Hendrickje, 394-395 Stoicism, 96-97, 116, 162, 163 Stölzel, G. H., 401 Stone Age, 3-5 The Story of Qui Ju (Zhang Yimou), 540 Strachey, Lytton, 563 The Stranger (Camus), 591 Strasbourg Cathedral, 260, 260 Strauss, Pauline, 510 Strauss, Richard, 49, 509 Alpine Symphony, 509, 510, 512 Domestic Symphony, 510 Don Juan, 508, 510 Don Quixote, 49 Hero's Life (Ein Heldenleben), 510 Salome, 510 Till Eulenspiegel, 49, 509 Stravinsky, Igor Fyodorovich, 508, 514, 514, 573, 576 The Firebird, 514 L'Histoire du soldat, 573-574 Petrouchka, 514 Pulcinella (ballet), 576 The Rite of Spring, 513, 514, 573 Symphony in Three Movements, 514 Stream of consciousness style, Strike! (Eisenstein), 579 Stringed instruments in symphony orchestra, 428, 429 Strozzi, Palla, 281, 283, 320 Structures (Boulez), 620 Studia, 179 The Studio: A Real Allegory of the Last Seven Years of My Life (Courbet), 466, 468 Stupas, 127 Sturm and Drang (Storm and Stress), 471

Style galant, 426

Sudraka, 130

Suetonius, 105

Styron, William, 618

Subjects, of sonata form, 429

The Little Clay Cart, 130

The Sufferings of Young Werther (Goethe), 471, 471 Sufi tradition in Islam, 193-194 Suger, Abbot, 225-227, 226, 229, 236, 246 The Suicide of Ajax (Exekias), 44, Sulla, 94, 98, 99 Sullivan, Louis, 608 Sultanate, 522, 523 Sumer, 6-8 Summa Theologica (Aquinas), 242, 243, 245 Sun Yat-sen, 532 A Sunday on La Grande Jatte, (Seurat), 500 Sung Dynasty, 526 Sunni tradition, Islam, 193 Sunya, Hindu number notations, 195 Super ego, 567-568 The Suppliant Women (Euripides), 64 Suppliants (Aeschylus), 61 Sûrah, Qur'an, 186 Surplus of meaning, art, xxiii Surrealism, 568-572, 570-572 Surrounding Islands (Christo), 609 Swahili, 549 Sweelinck, Jan Pietenszoon, 400 Swift, Jonathan, 113, 433, 434 - 435Gulliver's Travels, 435 A Modest Proposal, 435 The Swimming Hole (Eakins), 480, 480 Swing era, 575 "Switched-on Bach," 620 Swordmaking, 196, 203 Sybaris, 39 Symbolic elements, viewing of art, xxv Symphonia (Hildegard of Bingen), 206 Symphonic poem, 508 Symphonic sketches, 512 Symphony, classical, 428-432 Symphony in Three Movements (Stravinsky), 514 Symphony No. 6, Op. 68 (Pastoral) (Beethoven), 454 Symphony No. 5 (Beethoven), 454 Symphony No. 9 (Beethoven), 452, 454, 472 Symphony No. 6 in B minor (Pathétique) (Tchaikovsky), Symphony No. 8 in B minor (Unfinished Symphony) (Schubert), 454 Symphony No. 8 in C minor (Bruckner), 455 Symphony No. 3 in E flat, Op. 55

(Eroica) (Beethoven), 453

Symphony No. 40 in G minor

Temple Mount, Jerusalem, 189

Thera, 22

China, 120-121, 522

(Mozart), 429, 430 Temple(s). See also Church(es) Thermopylae, 51 Christianity, early, and Abu Simbel, 16, 20 Symphony No. 9 (Mahler), Theses of Apollo, 46, 63, 106 511-512 by Martin Luther, 340 Ara Pacis, 103-104, 103-104 Symphony No. 13 by Pico della Mirandola, 303 (Shostakovich), 622 of Artemis, 78 Theseus, ruler of Athens, 21, 49, Sumphony No. 14 of Athena (See Parthenon) (Shostakovich), 622 Dura-Europos, 151-152, 153 Thesis-antithesis, 449 Egyptian, 16, 19, 20 Symphony No. 15 Things Fall Apart (Achebe), Etruscan, 92 (Shostakovich), 622 Greek, 44-46, 47, 69, 71, 71, Symphony No. I in C minor, Op. 1201 Third Avenue, Seattle 68 (Brahms), 454-455 72, 78, 78, 110 (Pederson), 618 Symphony No. I in D (Mahler), of Hera, 46, 47 Third Musculature Table Jerusalem, 143, 144, 144 (Vesalius), 349 Symposium (Xenophon), 65 of Jupiter of the Capitoline, "This Land Is Your Land" Synthesis, 245, 297, 449. See also 101 (Guthrie), 622 Middle Ages, High period of the Muses at Alexandria, Tholos, 78, 78 79 Thomas Aquinas. See Aquinas, Synthesizer, 620-621 of Neptune, 47 Saint Thomas Synthetic Cubism, 565 Parthenon, 58, 58, 59, 70-73, Thoreau, Henry David, 477 Syracuse, 39, 66 72, 73 Walden, 477 Syria, 6, 78, 79, 127, 143, 147, Portonaccio, 92 Thoth, 12, 12, 13 Roman, 95, 103-104, 110 A Thousand and One Nights, 202 of Solomon, 143, 144, 145 Thrace, 161 T Sumerian, 6 Three Fates, 37 Tablature in music, 67 of Zeus, 69, 71, 72 Three Goddesses, 73, 74 Tacitus, 105-106, 148-149 Tempo, 429 Three Guineas (Woolf), 563 Tagore, Rabindranath, 526 Ten Commandments, 145 Three Ladies Adorning a Term of Tai Ping Rebellion, 531 Tenor, 237 Hymen (Reynolds), 425, 425 Taj Mahal, 192, 193, 524, 524 Terence, 95, 209, 364 Three Musicians (Picasso), 565, "Take the A Train" (Ellington), Teresa of Avila, Saint, 373 566 Terpander, 48 Three Piano Pieces (Schönberg), The Tale of Genji (Murasaki Tertullian, 150 513 Shikibu), 533-534, 535, Terza rims, 245 Threepenny Opera Tesserae, 167 (Dreigroschenoper) (Weill), Test on Electronic and A Tale of Two Cities (Dickens), 475 Instrumental Music Throne of Blood (Kurosawa), 540 Tallis, Thomas, 363 (Stockhausen), 621 Thrones Lamentations of Jeremiah, 363 Testament, 145 Bishop Maximian, 174, 176 176 Spem in Alium (Hope in Tetrachord, 67 of Charlemagne, 214-215 Texture, in music, xxvii-xxviii Another), 363 from Tutankhamen's tomb, Talmud, 303 Thales of Miletus, 50 19 Tambour, 287 Thanatos, 568 Thrust (Gottlieb), 594, 594 Tamburlaine (Marlowe), "The War" ("La Guerre") Thucydides, 59 365-366 (Janequin), 362 History of the Peloponnesian Tammuz, 6 Theater. See Drama War, 59 T'ang Court Ladies Playing Board Thebes, 13, 14, 19, 25, 33, 58, 65 Thus Spoke Zarathustra Game, 135, 136 Their Satanic Majesties Request (Nietzsche), 497 T'ang Dynasty, 133, 134, 135, (Rolling Stones), 623 Tiananmen, Forbidden City, 137, 526 Themes, exposition of, 429 529, 529 Tao, 132 Themis, 37 Tiber River, 91 Tao te ching (Lao-tzu), 132 Theodora, empress of Tiberius, emperor of Rome, 99, Taoism, 132-133, 135 Byzantium, 163-164, 174, Tariqas, 193 175, 176 Tiepolo, Giovanni Battista, Tarquinia, 91, 92, 93 Theodoric, king of Goths, 162, 420-421, 461 Tartuffe (Molière), 407 170, 170-171, 172, 214 The Immaculate Conception, Tasso, Tonquato, 364 Theodoric's palace, 171, 172 421, 421 Toga, 92 Tate Museum (Herzog and Theodulf of Orleans, 203 Tigris River, 5, 5, 6 Meuron), 617 Theogony (Hesiod), 49 Till Eulenspiegel (Strauss), 49, Tchaikovsky, Peter llych, 510 Theologia Platonica (Plethon), 508 Symphony No. 6 in B minor Tillich, Paul, 577 (Pathétique), 510 Theology. See Religion; specific Timbre, in music, xxviii Tel el-Amarna, 14, 15 theologians **Timelines** Theophilus (Hrosvitha), 209 Telemachus, 37 Africa, 542-543 Telescopes, 403, 403, 404 Theory of Forms, 66 ancient civilizations, xxxii-1 The Tempest (Shakespeare), 367 Theotokopoulos, Domenikos, Baroque period, 370-371 Tempietto, 322 388. See also El Greco Byzantium, 158-159

Jerusalem, 140-141 contemporary contour, 586 - 587Eighteenth century, 412-413 Greece classical and Hellenistic, early, 30-31 India, 120-121, 520 Islam, 182-183 Japan, 521 Middle Ages Charlemagne and Medieval culture, 198-199 Fourteenth century, 250 - 251High period, 222-223 modern era, 486-487 Renaissance early, 278-279 High Italian, 310-311 Northern Europe, 336-337 Romantic era, 444-445 Rome, 86-87 Twentieth century contemporary contour, 586 - 587modern era, 486-487 World Wars, period between, 558-559 World Wars, period between, 558-559 Tintoretto, 326 The Last Supper, 326, 327 Scuola of San Rocco, 326 Tischendorf, Konstantin von, Titian, 326, 388 Assumption of the Virgin, 326, Le Concert Champêtre, 324 - 325Venus of Urbino, 326, 327 Titus, Arch of, 109, 144 Titus, emperor of Rome, 99 Tizianio Vecelli, 324. See also To Dostoyevsky (Heckel), 506, 507 "To Moscow, to Moscow" (Chekhov), 515 To the Lighthouse (Woolf), 563 Toccatas, 331, 375, 400 Toffler, Alvin, 590 Future Shock, 590 Togu na, 552 Tokugawa, 535 Tokyo, 535 Toledo, 388, 389 Tolstoy, Leo, 473-474 Anna Karenina, 473 War and Peace, 473-474 Tomb(s). See also Burial rituals and funeral practices Hunting and Fishing at Tarquinia, 92, 93

Julius II, 316, 317, 318	Trios for Piano, Violin and Cello,	timeline, 586-587	Universitas, 239
Lorenzo de'Medici, 320	Op. 99 and 100 (Schubert),	modern era, 489-485	Universities
Theodoric, 170, 170-171	454	architecture, 505, 507	Alcalá, Spain, 344
Tutankhamen's, 15-16, 19	Triplum, 237	art, 491–506, 492–508,	Bologna, 237, 238, 241, 348
Tonalty, 460	Triptych, 354	493-506, 500-506, 511	Cambridge, 237
Tone poems, 508	Tristan and Isolde (Wagner), 459,	drama, 517	Cracow, 348
Torah, 144	460, 513	growing unrest, 489-491	Oxford, 237, 241
Torcello, 179	The Triumph of Bacchus and	Japan, 537	Padua, 348, 403
Tornabuoni, Lucrezia, 281, 293	Ariadne (Carracci), 379, 380,	literature, 515–517,	Paris, 225, 237, 238, 239-240,
Torso of a Man, 123, 124	385	561-563, 582	260, 306
Totalitarianism, 567	The Triumph of Death (Bruegel	music, 507-514	Pisa, 295
Tours, 204	the Elder), 356, 356	science, 490	rise of, during Middle Ages,
Tower of Winds at Athens, 80	The Triumph of Saint Thomas	timeline, 486–487	237-241, 239
Town center, cathedral as,	Aquinas (Buonaiuto), 244	women in, 516-517	Wittenberg, 344
229-236	Triumph of the Will (Riefenstahl),	World Wars, period between,	The Unvanquished (Aparajito)
Trade and commerce	579-580	561-585	(Ray, S.), 540
banking, 281, 289	Trivium, 203	art, 570–572, 563–572,	Uomo universale, 332
Byzantine routes, 178	Trojan War, 25, 36–37, 62	564-567, 576-582,	Upanishads, 125
cathedral as town center,	Trompe l'oeil, 167	576-582	Upper Egypt, 10
229-236	Trope, 208	literature, 561–419,	Al-Uqlidisi, 195
Charlemagne and, 202–203	Troubadours, 237	561–563, 575–576, 582	Ur, 8, 10
China, 530–532	Trouvères, 237	map, 569	Ur, Royal Cemetery at, 14
Etruscan, 91–92	Troy, 25–26, 26, 62, 83, 102	music, 563, 573–575, 622	Urban II, Pope, 210
fairs (lendit), 233, 244, 334	Trumeau, 218, 219	painting, 563–567,	Urban VIII, Pope, 403
Fifteenth century in Florence,	Tsar of Russia, 169, 176	564–567, 576–582, 576–582	Urbino, 60
281	Tu Pauperum Refugium (Thou	timeline, 558–559	Urdu, 525
Ghana, 545–546	Refuge of the Poor)	The Twilight of the Gods	Uruk, 6, 8
Greece, 39–40, 42	(Josquin), 330	(Wagner), 458	Usury in Islam, 185 Utnapishtim, 7
guilds and, 234–235, 281	The Tub (Degas), 497, 497	Two Boats (Bartlett), 607, 610 Two Female Models on Regency	Utopia (More), 364
Indian / Aryan, 123	Tuba, 89	Sofa (Pearlstein), 599, 599	Utzon, Jörn, 611
Islamic, 196	Tuchman, Barbara, 255 A Distant Mirror, 255	Two Girls at the Piano (Renoir),	Sydney Opera House, 611,
Japan, 535, 537	Tudor Family, 339, 359	495, 496	613
Tragedy. See also Drama			015
A mistatle on 66	lista 150	True Men at a Table (Heckel) 506	
Aristotle on, 66	Tufa, 150 Tuppel yault 110, 110, 216, 218	Two Men at a Table (Heckel), 506,	V
French, 406-407	Tunnel vault, 110, 110, 216, 218	507	V Valerian, emperor of Rome,
French, 406–407 Greek drama, 60–64	Tunnel vault, 110, 110, 216, 218 Turks, conquest of	507 Tyche, 37	V Valerian, emperor of Rome, 149
French, 406–407 Greek drama, 60–64 opera, Greek influence on,	Tunnel vault, 110, 110, 216, 218 Turks, conquest of Constantinople, 166, 178,	507 Tyche, 37 Tympanum, 218, 220	Valerian, emperor of Rome, 149
French, 406–407 Greek drama, 60–64 opera, Greek influence on, 399	Tunnel vault, 110, 110, 216, 218 Turks, conquest of Constantinople, 166, 178, 179	507 Tyche, 37 Tympanum, 218, 220 Tyrants, 42, 65, 281	Valerian, emperor of Rome,
French, 406–407 Greek drama, 60–64 opera, Greek influence on, 399 Roman drama, 95	Tunnel vault, 110, 110, 216, 218 Turks, conquest of Constantinople, 166, 178, 179 Turner, Joseph Mallond, 470	507 Tyche, 37 Tympanum, 218, 220	Valerian, emperor of Rome, 149 The Valkyrie (Wagner), 458
French, 406–407 Greek drama, 60–64 opera, Greek influence on, 399 Roman drama, 95 Tragic flaw, of Aristotle, 66	Tunnel vault, 110, 110, 216, 218 Turks, conquest of Constantinople, 166, 178, 179	507 Tyche, 37 Tympanum, 218, 220 Tyrants, 42, 65, 281	Valerian, emperor of Rome, 149 The Valkyrie (Wagner), 458 Valley Curtain (Christo), 609
French, 406–407 Greek drama, 60–64 opera, Greek influence on, 399 Roman drama, 95 Tragic flaw, of Aristotle, 66 Trajan, emperor of Rome, 99	Tunnel vault, 110, 110, 216, 218 Turks, conquest of Constantinople, 166, 178, 179 Turner, Joseph Mallond, 470 The Slave Ship, 470, 470	507 Tyche, 37 Tympanum, 218, 220 Tyrants, 42, 65, 281 Tzara, Tristan, 577	Valerian, emperor of Rome, 149 The Valkyrie (Wagner), 458 Valley Curtain (Christo), 609 Values
French, 406–407 Greek drama, 60–64 opera, Greek influence on, 399 Roman drama, 95 Tragic flaw, of Aristotle, 66 Trajan, emperor of Rome, 99 Trans World Flight Center,	Tunnel vault, 110, 110, 216, 218 Turks, conquest of Constantinople, 166, 178, 179 Turner, Joseph Mallond, 470 The Slave Ship, 470, 470 Tuscan dialect, 281	507 Tyche, 37 Tympanum, 218, 220 Tyrants, 42, 65, 281 Tzara, Tristan, 577	Valerian, emperor of Rome, 149 The Valkyrie (Wagner), 458 Valley Curtain (Christo), 609 Values autocracy, 169
French, 406–407 Greek drama, 60–64 opera, Greek influence on, 399 Roman drama, 95 Tragic flaw, of Aristotle, 66 Trajan, emperor of Rome, 99 Trans World Flight Center, Kennedy Airport	Tunnel vault, 110, 110, 216, 218 Turks, conquest of Constantinople, 166, 178, 179 Turner, Joseph Mallond, 470 The Slave Ship, 470, 470 Tuscan dialect, 281 Tuscany, 91 Tutankhamen, pharaoh of	507 Tyche, 37 Tympanum, 218, 220 Tyrants, 42, 65, 281 Tzara, Tristan, 577 U Übermensch, 491	Valerian, emperor of Rome, 149 The Valkyrie (Wagner), 458 Valley Curtain (Christo), 609 Values autocracy, 169 Black Death, 255 civic pride in city-states, 60 colonialism, 509
French, 406–407 Greek drama, 60–64 opera, Greek influence on, 399 Roman drama, 95 Tragic flaw, of Aristotle, 66 Trajan, emperor of Rome, 99 Trans World Flight Center,	Tunnel vault, 110, 110, 216, 218 Turks, conquest of Constantinople, 166, 178, 179 Turner, Joseph Mallond, 470 The Slave Ship, 470, 470 Tuscan dialect, 281 Tuscany, 91	507 Tyche, 37 Tympanum, 218, 220 Tyrants, 42, 65, 281 Tzara, Tristan, 577 U Übermensch, 491 Uccello, Paolo, 291, 292	Valerian, emperor of Rome, 149 The Valkyrie (Wagner), 458 Valley Curtain (Christo), 609 Values autocracy, 169 Black Death, 255 civic pride in city-states, 60 colonialism, 509 destiny, 37
French, 406–407 Greek drama, 60–64 opera, Greek influence on, 399 Roman drama, 95 Tragic flaw, of Aristotle, 66 Trajan, emperor of Rome, 99 Trans World Flight Center, Kennedy Airport (Saarinen), 611, 613	Tunnel vault, 110, 110, 216, 218 Turks, conquest of Constantinople, 166, 178, 179 Turner, Joseph Mallond, 470 The Slave Ship, 470, 470 Tuscan dialect, 281 Tuscany, 91 Tutankhamen, pharaoh of Egypt, 15–16, 19, 27 Tutu, Desmond, 606 Twelfth Night (Shakespeare), 366	Tyche, 37 Tympanum, 218, 220 Tyrants, 42, 65, 281 Tzara, Tristan, 577 U Übermensch, 491 Uccello, Paolo, 291, 292 The Battle of San Romano, 291,	Valerian, emperor of Rome, 149 The Valkyrie (Wagner), 458 Valley Curtain (Christo), 609 Values autocracy, 169 Black Death, 255 civic pride in city-states, 60 colonialism, 509 destiny, 37 dialectics, 238
French, 406–407 Greek drama, 60–64 opera, Greek influence on, 399 Roman drama, 95 Tragic flaw, of Aristotle, 66 Trajan, emperor of Rome, 99 Trans World Flight Center, Kennedy Airport (Saarinen), 611, 613 Transcendentalism, 454, 476–477 Transept, 152	Tunnel vault, 110, 110, 216, 218 Turks, conquest of Constantinople, 166, 178, 179 Turner, Joseph Mallond, 470 The Slave Ship, 470, 470 Tuscan dialect, 281 Tuscany, 91 Tutankhamen, pharaoh of Egypt, 15–16, 19, 27 Tutu, Desmond, 606	Tyche, 37 Tyche, 37 Tympanum, 218, 220 Tyrants, 42, 65, 281 Tzara, Tristan, 577 U Übermensch, 491 Uccello, Paolo, 291, 292 The Battle of San Romano, 291, 292 Ugaas, Raage, 548 Ulpian, 98	Valerian, emperor of Rome, 149 The Valkyrie (Wagner), 458 Valley Curtain (Christo), 609 Values autocracy, 169 Black Death, 255 civic pride in city-states, 60 colonialism, 509 destiny, 37 dialectics, 238 disillusionment, 567
French, 406–407 Greek drama, 60–64 opera, Greek influence on, 399 Roman drama, 95 Tragic flaw, of Aristotle, 66 Trajan, emperor of Rome, 99 Trans World Flight Center, Kennedy Airport (Saarinen), 611, 613 Transcendentalism, 454, 476–477	Tunnel vault, 110, 110, 216, 218 Turks, conquest of Constantinople, 166, 178, 179 Turner, Joseph Mallond, 470 The Slave Ship, 470, 470 Tuscan dialect, 281 Tuscany, 91 Tutankhamen, pharaoh of Egypt, 15–16, 19, 27 Tutu, Desmond, 606 Twelfth Night (Shakespeare), 366 Twelve Apostles of Jesus, 169–170	Tyche, 37 Tyche, 37 Tympanum, 218, 220 Tyrants, 42, 65, 281 Tzara, Tristan, 577 U Übermensch, 491 Uccello, Paolo, 291, 292 The Battle of San Romano, 291, 292 Ugaas, Raage, 548 Ulpian, 98 Ultrecht Psalter, 211–212, 212	Valerian, emperor of Rome, 149 The Valkyrie (Wagner), 458 Valley Curtain (Christo), 609 Values autocracy, 169 Black Death, 255 civic pride in city-states, 60 colonialism, 509 destiny, 37 dialectics, 238 disillusionment, 567 empire, of Rome, 101
French, 406–407 Greek drama, 60–64 opera, Greek influence on, 399 Roman drama, 95 Tragic flaw, of Aristotle, 66 Trajan, emperor of Rome, 99 Trans World Flight Center, Kennedy Airport (Saarinen), 611, 613 Transcendentalism, 454, 476–477 Transept, 152 The Transfiguration (Raphael), 315, 315	Tunnel vault, 110, 110, 216, 218 Turks, conquest of Constantinople, 166, 178, 179 Turner, Joseph Mallond, 470 The Slave Ship, 470, 470 Tuscan dialect, 281 Tuscany, 91 Tutankhamen, pharaoh of Egypt, 15–16, 19, 27 Tutu, Desmond, 606 Twelfth Night (Shakespeare), 366 Twelve Apostles of Jesus, 169–170 Twelve-tone technique, 514	Tyche, 37 Tyche, 37 Tympanum, 218, 220 Tyrants, 42, 65, 281 Tzara, Tristan, 577 U Übermensch, 491 Uccello, Paolo, 291, 292 The Battle of San Romano, 291, 292 Ugaas, Raage, 548 Ulpian, 98 Ultrecht Psalter, 211–212, 212 Ulysses (Joyce), 562	Valerian, emperor of Rome, 149 The Valkyrie (Wagner), 458 Valley Curtain (Christo), 609 Values autocracy, 169 Black Death, 255 civic pride in city-states, 60 colonialism, 509 destiny, 37 dialectics, 238 disillusionment, 567 empire, of Rome, 101 feudalism, 217
French, 406–407 Greek drama, 60–64 opera, Greek influence on, 399 Roman drama, 95 Tragic flaw, of Aristotle, 66 Trajan, emperor of Rome, 99 Trans World Flight Center, Kennedy Airport (Saarinen), 611, 613 Transcendentalism, 454, 476–477 Transept, 152 The Transfiguration (Raphael), 315, 315 Traveler of the East (Mofolo), 550	Tunnel vault, 110, 110, 216, 218 Turks, conquest of Constantinople, 166, 178, 179 Turner, Joseph Mallond, 470 The Slave Ship, 470, 470 Tuscan dialect, 281 Tuscany, 91 Tutankhamen, pharaoh of Egypt, 15–16, 19, 27 Tutu, Desmond, 606 Twelfth Night (Shakespeare), 366 Twelve Apostles of Jesus, 169–170 Twelve-tone technique, 514 Twelve Tribes of Israel, 143	Tyche, 37 Tyche, 37 Tympanum, 218, 220 Tyrants, 42, 65, 281 Tzara, Tristan, 577 U Übermensch, 491 Uccello, Paolo, 291, 292 The Battle of San Romano, 291, 292 Ugaas, Raage, 548 Ulpian, 98 Ultrecht Psalter, 211–212, 212 Ulysses (Joyce), 562 The Umbrellas (Christo), 609	Valerian, emperor of Rome, 149 The Valkyrie (Wagner), 458 Valley Curtain (Christo), 609 Values autocracy, 169 Black Death, 255 civic pride in city-states, 60 colonialism, 509 destiny, 37 dialectics, 238 disillusionment, 567 empire, of Rome, 101 feudalism, 217 intellectual synthesis, 297
French, 406–407 Greek drama, 60–64 opera, Greek influence on, 399 Roman drama, 95 Tragic flaw, of Aristotle, 66 Trajan, emperor of Rome, 99 Trans World Flight Center, Kennedy Airport (Saarinen), 611, 613 Transcendentalism, 454, 476–477 Transept, 152 The Transfiguration (Raphael), 315, 315	Tunnel vault, 110, 110, 216, 218 Turks, conquest of Constantinople, 166, 178, 179 Turner, Joseph Mallond, 470 The Slave Ship, 470, 470 Tuscan dialect, 281 Tuscany, 91 Tutankhamen, pharaoh of Egypt, 15–16, 19, 27 Tutu, Desmond, 606 Twelfth Night (Shakespeare), 366 Twelve Apostles of Jesus, 169–170 Twelve-tone technique, 514 Twelve Tribes of Israel, 143 Twentieth century	Tyche, 37 Tyche, 37 Tympanum, 218, 220 Tyrants, 42, 65, 281 Tzara, Tristan, 577 U Übermensch, 491 Uccello, Paolo, 291, 292 The Battle of San Romano, 291, 292 Ugaas, Raage, 548 Ulpian, 98 Ultrecht Psalter, 211–212, 212 Ulysses (Joyce), 562 The Umbrellas (Christo), 609 Un Chien Andalou (Buñuel and	Valerian, emperor of Rome, 149 The Valkyrie (Wagner), 458 Valley Curtain (Christo), 609 Values autocracy, 169 Black Death, 255 civic pride in city-states, 60 colonialism, 509 destiny, 37 dialectics, 238 disillusionment, 567 empire, of Rome, 101 feudalism, 217 intellectual synthesis, 297 Islamic values, 195
French, 406–407 Greek drama, 60–64 opera, Greek influence on, 399 Roman drama, 95 Tragic flaw, of Aristotle, 66 Trajan, emperor of Rome, 99 Trans World Flight Center, Kennedy Airport (Saarinen), 611, 613 Transcendentalism, 454, 476–477 Transept, 152 The Transfiguration (Raphael), 315, 315 Traveler of the East (Mofolo), 550 The Treasure of the City of Ladies (de Pisan), 259	Tunnel vault, 110, 110, 216, 218 Turks, conquest of Constantinople, 166, 178, 179 Turner, Joseph Mallond, 470 The Slave Ship, 470, 470 Tuscan dialect, 281 Tuscany, 91 Tutankhamen, pharaoh of Egypt, 15–16, 19, 27 Tutu, Desmond, 606 Twelfth Night (Shakespeare), 366 Twelve Apostles of Jesus, 169–170 Twelve-tone technique, 514 Twelve Tribes of Israel, 143 Twentieth century contemporary contour,	Tyche, 37 Tyche, 37 Tympanum, 218, 220 Tyrants, 42, 65, 281 Tzara, Tristan, 577 U Übermensch, 491 Uccello, Paolo, 291, 292 The Battle of San Romano, 291, 292 Ugaas, Raage, 548 Ulpian, 98 Ultrecht Psalter, 211–212, 212 Ulysses (Joyce), 562 The Umbrellas (Christo), 609 Un Chien Andalou (Buñuel and Dali), 571–572	Valerian, emperor of Rome, 149 The Valkyrie (Wagner), 458 Valley Curtain (Christo), 609 Values autocracy, 169 Black Death, 255 civic pride in city-states, 60 colonialism, 509 destiny, 37 dialectics, 238 disillusionment, 567 empire, of Rome, 101 feudalism, 217 intellectual synthesis, 297 Islamic values, 195 liberation, 606
French, 406–407 Greek drama, 60–64 opera, Greek influence on, 399 Roman drama, 95 Tragic flaw, of Aristotle, 66 Trajan, emperor of Rome, 99 Trans World Flight Center, Kennedy Airport (Saarinen), 611, 613 Transcendentalism, 454, 476–477 Transept, 152 The Transfiguration (Raphael), 315, 315 Traveler of the East (Mofolo), 550 The Treasure of the City of Ladies (de Pisan), 259 Trecento, 253, 271	Tunnel vault, 110, 110, 216, 218 Turks, conquest of Constantinople, 166, 178, 179 Turner, Joseph Mallond, 470 The Slave Ship, 470, 470 Tuscan dialect, 281 Tuscany, 91 Tutankhamen, pharaoh of Egypt, 15–16, 19, 27 Tutu, Desmond, 606 Twelfth Night (Shakespeare), 366 Twelve Apostles of Jesus, 169–170 Twelve-tone technique, 514 Twelve Tribes of Israel, 143 Twentieth century contemporary contour, 589–625	Tyche, 37 Tyche, 37 Tympanum, 218, 220 Tyrants, 42, 65, 281 Tzara, Tristan, 577 U Übermensch, 491 Uccello, Paolo, 291, 292 The Battle of San Romano, 291, 292 Ugaas, Raage, 548 Ulpian, 98 Ultrecht Psalter, 211–212, 212 Ulysses (Joyce), 562 The Umbrellas (Christo), 609 Un Chien Andalou (Buñuel and Dali), 571–572 Unamuno, Miguel de, 590, 591	Valerian, emperor of Rome, 149 The Valkyrie (Wagner), 458 Valley Curtain (Christo), 609 Values autocracy, 169 Black Death, 255 civic pride in city-states, 60 colonialism, 509 destiny, 37 dialectics, 238 disillusionment, 567 empire, of Rome, 101 feudalism, 217 intellectual synthesis, 297 Islamic values, 195 liberation, 606 love, marriage, and divorce
French, 406–407 Greek drama, 60–64 opera, Greek influence on, 399 Roman drama, 95 Tragic flaw, of Aristotle, 66 Trajan, emperor of Rome, 99 Trans World Flight Center, Kennedy Airport (Saarinen), 611, 613 Transcendentalism, 454, 476–477 Transept, 152 The Transfiguration (Raphael), 315, 315 Traveler of the East (Mofolo), 550 The Treasure of the City of Ladies (de Pisan), 259 Trecento, 253, 271 Très Riches Heures du Duc de	Tunnel vault, 110, 110, 216, 218 Turks, conquest of Constantinople, 166, 178, 179 Turner, Joseph Mallond, 470 The Slave Ship, 470, 470 Tuscan dialect, 281 Tuscany, 91 Tutankhamen, pharaoh of Egypt, 15–16, 19, 27 Tutu, Desmond, 606 Twelfth Night (Shakespeare), 366 Twelve Apostles of Jesus, 169–170 Twelve-tone technique, 514 Twelve Tribes of Israel, 143 Twentieth century contemporary contour, 589–625 architecture, 505, 507, 590,	Tyche, 37 Tyche, 37 Tympanum, 218, 220 Tyrants, 42, 65, 281 Tzara, Tristan, 577 U Übermensch, 491 Uccello, Paolo, 291, 292 The Battle of San Romano, 291, 292 Ugaas, Raage, 548 Ulpian, 98 Ultrecht Psalter, 211–212, 212 Ulysses (Joyce), 562 The Umbrellas (Christo), 609 Un Chien Andalou (Buñuel and Dali), 571–572 Unamuno, Miguel de, 590, 591 Unconscious, 568, 571, 592	Valerian, emperor of Rome, 149 The Valkyrie (Wagner), 458 Valley Curtain (Christo), 609 Values autocracy, 169 Black Death, 255 civic pride in city-states, 60 colonialism, 509 destiny, 37 dialectics, 238 disillusionment, 567 empire, of Rome, 101 feudalism, 217 intellectual synthesis, 297 Islamic values, 195 liberation, 606 love, marriage, and divorce in Egypt, 18
French, 406–407 Greek drama, 60–64 opera, Greek influence on, 399 Roman drama, 95 Tragic flaw, of Aristotle, 66 Trajan, emperor of Rome, 99 Trans World Flight Center, Kennedy Airport (Saarinen), 611, 613 Transcendentalism, 454, 476–477 Transept, 152 The Transfiguration (Raphael), 315, 315 Traveler of the East (Mofolo), 550 The Treasure of the City of Ladies (de Pisan), 259 Trecento, 253, 271 Très Riches Heures du Duc de Berry (Limbourg Brothers),	Tunnel vault, 110, 110, 216, 218 Turks, conquest of Constantinople, 166, 178, 179 Turner, Joseph Mallond, 470 The Slave Ship, 470, 470 Tuscan dialect, 281 Tuscany, 91 Tutankhamen, pharaoh of Egypt, 15–16, 19, 27 Tutu, Desmond, 606 Twelfth Night (Shakespeare), 366 Twelve Apostles of Jesus, 169–170 Twelve-tone technique, 514 Twelve Tribes of Israel, 143 Twentieth century contemporary contour, 589–625 architecture, 505, 507, 590, 608–617, 612–618	Tyche, 37 Tyche, 37 Tympanum, 218, 220 Tyrants, 42, 65, 281 Tzara, Tristan, 577 U Übermensch, 491 Uccello, Paolo, 291, 292 The Battle of San Romano, 291, 292 Ugaas, Raage, 548 Ulpian, 98 Ultrecht Psalter, 211–212, 212 Ulysses (Joyce), 562 The Umbrellas (Christo), 609 Un Chien Andalou (Buñuel and Dali), 571–572 Unamuno, Miguel de, 590, 591 Unconscious, 568, 571, 592 Unfinished Symphony (Symphony	Valerian, emperor of Rome, 149 The Valkyrie (Wagner), 458 Valley Curtain (Christo), 609 Values autocracy, 169 Black Death, 255 civic pride in city-states, 60 colonialism, 509 destiny, 37 dialectics, 238 disillusionment, 567 empire, of Rome, 101 feudalism, 217 intellectual synthesis, 297 Islamic values, 195 liberation, 606 love, marriage, and divorce in Egypt, 18 mortality, 14
French, 406–407 Greek drama, 60–64 opera, Greek influence on, 399 Roman drama, 95 Tragic flaw, of Aristotle, 66 Trajan, emperor of Rome, 99 Trans World Flight Center, Kennedy Airport (Saarinen), 611, 613 Transcendentalism, 454, 476–477 Transept, 152 The Transfiguration (Raphael), 315, 315 Traveler of the East (Mofolo), 550 The Treasure of the City of Ladies (de Pisan), 259 Trecento, 253, 271 Très Riches Heures du Duc de Berry (Limbourg Brothers), 269, 270–271, 272, 357	Tunnel vault, 110, 110, 216, 218 Turks, conquest of Constantinople, 166, 178, 179 Turner, Joseph Mallond, 470 The Slave Ship, 470, 470 Tuscan dialect, 281 Tuscany, 91 Tutankhamen, pharaoh of Egypt, 15–16, 19, 27 Tutu, Desmond, 606 Twelfth Night (Shakespeare), 366 Twelve Apostles of Jesus, 169–170 Twelve-tone technique, 514 Twelve Tribes of Israel, 143 Twentieth century contemporary contour, 589–625 architecture, 505, 507, 590, 608–617, 612–618 art, 590, 591–608, 592–611,	Tyche, 37 Tyche, 37 Tympanum, 218, 220 Tyrants, 42, 65, 281 Tzara, Tristan, 577 U Übermensch, 491 Uccello, Paolo, 291, 292 The Battle of San Romano, 291, 292 Ugaas, Raage, 548 Ulpian, 98 Ultrecht Psalter, 211–212, 212 Ulysses (Joyce), 562 The Umbrellas (Christo), 609 Un Chien Andalou (Buñuel and Dali), 571–572 Unamuno, Miguel de, 590, 591 Unconscious, 568, 571, 592 Unfinished Symphony (Symphony No. 8 in B minor)	Valerian, emperor of Rome, 149 The Valkyrie (Wagner), 458 Valley Curtain (Christo), 609 Values autocracy, 169 Black Death, 255 civic pride in city-states, 60 colonialism, 509 destiny, 37 dialectics, 238 disillusionment, 567 empire, of Rome, 101 feudalism, 217 intellectual synthesis, 297 Islamic values, 195 liberation, 606 love, marriage, and divorce in Egypt, 18 mortality, 14 nationalism, 478
French, 406–407 Greek drama, 60–64 opera, Greek influence on, 399 Roman drama, 95 Tragic flaw, of Aristotle, 66 Trajan, emperor of Rome, 99 Trans World Flight Center, Kennedy Airport (Saarinen), 611, 613 Transcendentalism, 454, 476–477 Transept, 152 The Transfiguration (Raphael), 315, 315 Traveler of the East (Mofolo), 550 The Treasure of the City of Ladies (de Pisan), 259 Trecento, 253, 271 Très Riches Heures du Duc de Berry (Limbourg Brothers), 269, 270–271, 272, 357 The Trial (Kafka), 562	Tunnel vault, 110, 110, 216, 218 Turks, conquest of Constantinople, 166, 178, 179 Turner, Joseph Mallond, 470 The Slave Ship, 470, 470 Tuscan dialect, 281 Tuscany, 91 Tutankhamen, pharaoh of Egypt, 15–16, 19, 27 Tutu, Desmond, 606 Twelfth Night (Shakespeare), 366 Twelve Apostles of Jesus, 169–170 Twelve-tone technique, 514 Twelve Tribes of Israel, 143 Twentieth century contemporary contour, 589–625 architecture, 505, 507, 590, 608–617, 612–618 art, 590, 591–608, 592–611, 619–620	Tyche, 37 Tyche, 37 Tympanum, 218, 220 Tyrants, 42, 65, 281 Tzara, Tristan, 577 U Übermensch, 491 Uccello, Paolo, 291, 292 The Battle of San Romano, 291, 292 Ugaas, Raage, 548 Ulpian, 98 Ultrecht Psalter, 211–212, 212 Ulysses (Joyce), 562 The Umbrellas (Christo), 609 Un Chien Andalou (Buñuel and Dali), 571–572 Unamuno, Miguel de, 590, 591 Unconscious, 568, 571, 592 Unfinished Symphony (Symphony No. 8 in B minor) (Schubert), 454	Valerian, emperor of Rome, 149 The Valkyrie (Wagner), 458 Valley Curtain (Christo), 609 Values autocracy, 169 Black Death, 255 civic pride in city-states, 60 colonialism, 509 destiny, 37 dialectics, 238 disillusionment, 567 empire, of Rome, 101 feudalism, 217 intellectual synthesis, 297 Islamic values, 195 liberation, 606 love, marriage, and divorce in Egypt, 18 mortality, 14 nationalism, 478 natural disaster and human
French, 406–407 Greek drama, 60–64 opera, Greek influence on, 399 Roman drama, 95 Tragic flaw, of Aristotle, 66 Trajan, emperor of Rome, 99 Trans World Flight Center, Kennedy Airport (Saarinen), 611, 613 Transcendentalism, 454, 476–477 Transept, 152 The Transfiguration (Raphael), 315, 315 Traveler of the East (Mofolo), 550 The Treasure of the City of Ladies (de Pisan), 259 Trecento, 253, 271 Très Riches Heures du Duc de Berry (Limbourg Brothers), 269, 270–271, 272, 357 The Trial (Kafka), 562 Tribonian, 164	Tunnel vault, 110, 110, 216, 218 Turks, conquest of Constantinople, 166, 178, 179 Turner, Joseph Mallond, 470 The Slave Ship, 470, 470 Tuscan dialect, 281 Tuscany, 91 Tutankhamen, pharaoh of Egypt, 15–16, 19, 27 Tutu, Desmond, 606 Twelfth Night (Shakespeare), 366 Twelve Apostles of Jesus, 169–170 Twelve-tone technique, 514 Twelve Tribes of Israel, 143 Twentieth century contemporary contour, 589–625 architecture, 505, 507, 590, 608–617, 612–618 art, 590, 591–608, 592–611, 619–620 drama, 617–618	Tyche, 37 Tyche, 37 Tympanum, 218, 220 Tyrants, 42, 65, 281 Tzara, Tristan, 577 U Übermensch, 491 Uccello, Paolo, 291, 292 The Battle of San Romano, 291, 292 Ugaas, Raage, 548 Ulpian, 98 Ultrecht Psalter, 211–212, 212 Ulysses (Joyce), 562 The Umbrellas (Christo), 609 Un Chien Andalou (Buñuel and Dali), 571–572 Unamuno, Miguel de, 590, 591 Unconscious, 568, 571, 592 Unfinished Symphony (Symphony No. 8 in B minor) (Schubert), 454 Unification of China, 132–136	Valerian, emperor of Rome, 149 The Valkyrie (Wagner), 458 Valley Curtain (Christo), 609 Values autocracy, 169 Black Death, 255 civic pride in city-states, 60 colonialism, 509 destiny, 37 dialectics, 238 disillusionment, 567 empire, of Rome, 101 feudalism, 217 intellectual synthesis, 297 Islamic values, 195 liberation, 606 love, marriage, and divorce in Egypt, 18 mortality, 14 nationalism, 478 natural disaster and human response, 255
French, 406–407 Greek drama, 60–64 opera, Greek influence on, 399 Roman drama, 95 Tragic flaw, of Aristotle, 66 Trajan, emperor of Rome, 99 Trans World Flight Center, Kennedy Airport (Saarinen), 611, 613 Transcendentalism, 454, 476–477 Transept, 152 The Transfiguration (Raphael), 315, 315 Traveler of the East (Mofolo), 550 The Treasure of the City of Ladies (de Pisan), 259 Trecento, 253, 271 Très Riches Heures du Duc de Berry (Limbourg Brothers), 269, 270–271, 272, 357 The Trial (Kafka), 562 Tribonian, 164 Tribunes, 93	Tunnel vault, 110, 110, 216, 218 Turks, conquest of Constantinople, 166, 178, 179 Turner, Joseph Mallond, 470 The Slave Ship, 470, 470 Tuscan dialect, 281 Tuscany, 91 Tutankhamen, pharaoh of Egypt, 15–16, 19, 27 Tutu, Desmond, 606 Twelfth Night (Shakespeare), 366 Twelve Apostles of Jesus, 169–170 Twelve-tone technique, 514 Twelve Tribes of Israel, 143 Twentieth century contemporary contour, 589–625 architecture, 505, 507, 590, 608–617, 612–618 art, 590, 591–608, 592–611, 619–620 drama, 617–618 global culture, 589–591	Tyche, 37 Tyche, 37 Tympanum, 218, 220 Tyrants, 42, 65, 281 Tzara, Tristan, 577 U Übermensch, 491 Uccello, Paolo, 291, 292 The Battle of San Romano, 291, 292 Ugaas, Raage, 548 Ulpian, 98 Ultrecht Psalter, 211–212, 212 Ulysses (Joyce), 562 The Umbrellas (Christo), 609 Un Chien Andalou (Buñuel and Dali), 571–572 Unamuno, Miguel de, 590, 591 Unconscious, 568, 571, 592 Unfinished Symphony (Symphony No. 8 in B minor) (Schubert), 454 Unification of China, 132–136 United Monarchy, Hebrew, 143	Valerian, emperor of Rome, 149 The Valkyrie (Wagner), 458 Valley Curtain (Christo), 609 Values autocracy, 169 Black Death, 255 civic pride in city-states, 60 colonialism, 509 destiny, 37 dialectics, 238 disillusionment, 567 empire, of Rome, 101 feudalism, 217 intellectual synthesis, 297 Islamic values, 195 liberation, 606 love, marriage, and divorce in Egypt, 18 mortality, 14 nationalism, 478 natural disaster and human response, 255 patronage, 325
French, 406–407 Greek drama, 60–64 opera, Greek influence on, 399 Roman drama, 95 Tragic flaw, of Aristotle, 66 Trajan, emperor of Rome, 99 Trans World Flight Center, Kennedy Airport (Saarinen), 611, 613 Transcendentalism, 454, 476–477 Transept, 152 The Transfiguration (Raphael), 315, 315 Traveler of the East (Mofolo), 550 The Treasure of the City of Ladies (de Pisan), 259 Trecento, 253, 271 Très Riches Heures du Duc de Berry (Limbourg Brothers), 269, 270–271, 272, 357 The Trial (Kafka), 562 Tribonian, 164 Tribunes, 93 The Tribute Money (Masaccio),	Tunnel vault, 110, 110, 216, 218 Turks, conquest of Constantinople, 166, 178, 179 Turner, Joseph Mallond, 470 The Slave Ship, 470, 470 Tuscan dialect, 281 Tuscany, 91 Tutankhamen, pharaoh of Egypt, 15–16, 19, 27 Tutu, Desmond, 606 Twelfth Night (Shakespeare), 366 Twelve Apostles of Jesus, 169–170 Twelve-tone technique, 514 Twelve Tribes of Israel, 143 Twentieth century contemporary contour, 589–625 architecture, 505, 507, 590, 608–617, 612–618 art, 590, 591–608, 592–611, 619–620 drama, 617–618 global culture, 589–591 literature, 590–591,	Tyche, 37 Tyche, 37 Tympanum, 218, 220 Tyrants, 42, 65, 281 Tzara, Tristan, 577 U Übermensch, 491 Uccello, Paolo, 291, 292 The Battle of San Romano, 291, 292 Ugaas, Raage, 548 Ulpian, 98 Ultrecht Psalter, 211–212, 212 Ulysses (Joyce), 562 The Umbrellas (Christo), 609 Un Chien Andalou (Buñuel and Dali), 571–572 Unamuno, Miguel de, 590, 591 Unconscious, 568, 571, 592 Unfinished Symphony (Symphony No. 8 in B minor) (Schubert), 454 Unification of China, 132–136 United Monarchy, Hebrew, 143 United States. See America	Valerian, emperor of Rome, 149 The Valkyrie (Wagner), 458 Valley Curtain (Christo), 609 Values autocracy, 169 Black Death, 255 civic pride in city-states, 60 colonialism, 509 destiny, 37 dialectics, 238 disillusionment, 567 empire, of Rome, 101 feudalism, 217 intellectual synthesis, 297 Islamic values, 195 liberation, 606 love, marriage, and divorce in Egypt, 18 mortality, 14 nationalism, 478 natural disaster and human response, 255 patronage, 325 reform, religious, 345
French, 406–407 Greek drama, 60–64 opera, Greek influence on, 399 Roman drama, 95 Tragic flaw, of Aristotle, 66 Trajan, emperor of Rome, 99 Trans World Flight Center, Kennedy Airport (Saarinen), 611, 613 Transcendentalism, 454, 476–477 Transept, 152 The Transfiguration (Raphael), 315, 315 Traveler of the East (Mofolo), 550 The Treasure of the City of Ladies (de Pisan), 259 Trecento, 253, 271 Très Riches Heures du Duc de Berry (Limbourg Brothers), 269, 270–271, 272, 357 The Trial (Kafka), 562 Tribonian, 164 Tribunes, 93 The Tribute Money (Masaccio), 284, 284	Tunnel vault, 110, 110, 216, 218 Turks, conquest of Constantinople, 166, 178, 179 Turner, Joseph Mallond, 470 The Slave Ship, 470, 470 Tuscan dialect, 281 Tuscany, 91 Tutankhamen, pharaoh of Egypt, 15–16, 19, 27 Tutu, Desmond, 606 Twelfth Night (Shakespeare), 366 Twelve Apostles of Jesus, 169–170 Twelve-tone technique, 514 Twelve Tribes of Israel, 143 Twentieth century contemporary contour, 589–625 architecture, 505, 507, 590, 608–617, 612–618 art, 590, 591–608, 592–611, 619–620 drama, 617–618 global culture, 589–591 literature, 590–591, 617–620	Tyche, 37 Tyche, 37 Tympanum, 218, 220 Tyrants, 42, 65, 281 Tzara, Tristan, 577 U Übermensch, 491 Uccello, Paolo, 291, 292 The Battle of San Romano, 291, 292 Ugaas, Raage, 548 Ulpian, 98 Ultrecht Psalter, 211–212, 212 Ulysses (Joyce), 562 The Umbrellas (Christo), 609 Un Chien Andalou (Buñuel and Dali), 571–572 Unamuno, Miguel de, 590, 591 Unconscious, 568, 571, 592 Unfinished Symphony (Symphony No. 8 in B minor) (Schubert), 454 Unification of China, 132–136 United Monarchy, Hebrew, 143 United States. See America United States Department of	Valerian, emperor of Rome, 149 The Valkyrie (Wagner), 458 Valley Curtain (Christo), 609 Values autocracy, 169 Black Death, 255 civic pride in city-states, 60 colonialism, 509 destiny, 37 dialectics, 238 disillusionment, 567 empire, of Rome, 101 feudalism, 217 intellectual synthesis, 297 Islamic values, 195 liberation, 606 love, marriage, and divorce in Egypt, 18 mortality, 14 nationalism, 478 natural disaster and human response, 255 patronage, 325 reform, religious, 345 revelation, 146
French, 406–407 Greek drama, 60–64 opera, Greek influence on, 399 Roman drama, 95 Tragic flaw, of Aristotle, 66 Trajan, emperor of Rome, 99 Trans World Flight Center, Kennedy Airport (Saarinen), 611, 613 Transcendentalism, 454, 476–477 Transept, 152 The Transfiguration (Raphael), 315, 315 Traveler of the East (Mofolo), 550 The Treasure of the City of Ladies (de Pisan), 259 Trecento, 253, 271 Très Riches Heures du Duc de Berry (Limbourg Brothers), 269, 270–271, 272, 357 The Trial (Kafka), 562 Tribonian, 164 Tribunes, 93 The Tribute Money (Masaccio), 284, 284 Trier, 207	Tunnel vault, 110, 110, 216, 218 Turks, conquest of Constantinople, 166, 178, 179 Turner, Joseph Mallond, 470 The Slave Ship, 470, 470 Tuscan dialect, 281 Tuscany, 91 Tutankhamen, pharaoh of Egypt, 15–16, 19, 27 Tutu, Desmond, 606 Twelfth Night (Shakespeare), 366 Twelve Apostles of Jesus, 169–170 Twelve-tone technique, 514 Twelve Tribes of Israel, 143 Twentieth century contemporary contour, 589–625 architecture, 505, 507, 590, 608–617, 612–618 art, 590, 591–608, 592–611, 619–620 drama, 617–618 global culture, 589–591 literature, 590–591, 617–620 music, 620–624	Tyche, 37 Tyche, 37 Tympanum, 218, 220 Tyrants, 42, 65, 281 Tzara, Tristan, 577 U Übermensch, 491 Uccello, Paolo, 291, 292 The Battle of San Romano, 291, 292 Ugaas, Raage, 548 Ulpian, 98 Ultrecht Psalter, 211–212, 212 Ulysses (Joyce), 562 The Umbrellas (Christo), 609 Un Chien Andalou (Buñuel and Dali), 571–572 Unamuno, Miguel de, 590, 591 Unconscious, 568, 571, 592 Unfinished Symphony (Symphony No. 8 in B minor) (Schubert), 454 Unification of China, 132–136 United Monarchy, Hebrew, 143 United States. See America United States Department of Agriculture, 581	Valerian, emperor of Rome, 149 The Valkyrie (Wagner), 458 Valley Curtain (Christo), 609 Values autocracy, 169 Black Death, 255 civic pride in city-states, 60 colonialism, 509 destiny, 37 dialectics, 238 disillusionment, 567 empire, of Rome, 101 feudalism, 217 intellectual synthesis, 297 Islamic values, 195 liberation, 606 love, marriage, and divorce in Egypt, 18 mortality, 14 nationalism, 478 natural disaster and human response, 255 patronage, 325 reform, religious, 345 revelation, 146 revolution, 439
French, 406–407 Greek drama, 60–64 opera, Greek influence on, 399 Roman drama, 95 Tragic flaw, of Aristotle, 66 Trajan, emperor of Rome, 99 Trans World Flight Center, Kennedy Airport (Saarinen), 611, 613 Transcendentalism, 454, 476–477 Transept, 152 The Transfiguration (Raphael), 315, 315 Traveler of the East (Mofolo), 550 The Treasure of the City of Ladies (de Pisan), 259 Trecento, 253, 271 Très Riches Heures du Duc de Berry (Limbourg Brothers), 269, 270–271, 272, 357 The Trial (Kafka), 562 Tribonian, 164 Tribunes, 93 The Tribute Money (Masaccio), 284, 284 Trier, 207 Triforium, 164	Tunnel vault, 110, 110, 216, 218 Turks, conquest of Constantinople, 166, 178, 179 Turner, Joseph Mallond, 470 The Slave Ship, 470, 470 Tuscan dialect, 281 Tuscany, 91 Tutankhamen, pharaoh of Egypt, 15–16, 19, 27 Tutu, Desmond, 606 Twelfth Night (Shakespeare), 366 Twelve Apostles of Jesus, 169–170 Twelve-tone technique, 514 Twelve Tribes of Israel, 143 Twentieth century contemporary contour, 589–625 architecture, 505, 507, 590, 608–617, 612–618 art, 590, 591–608, 592–611, 619–620 drama, 617–618 global culture, 589–591 literature, 590–591, 617–620 music, 620–624 opera, 622	Tyche, 37 Tyche, 37 Tympanum, 218, 220 Tyrants, 42, 65, 281 Tzara, Tristan, 577 U Übermensch, 491 Uccello, Paolo, 291, 292 The Battle of San Romano, 291, 292 Ugaas, Raage, 548 Ulpian, 98 Ultrecht Psalter, 211–212, 212 Ulysses (Joyce), 562 The Umbrellas (Christo), 609 Un Chien Andalou (Buñuel and Dali), 571–572 Unamuno, Miguel de, 590, 591 Unconscious, 568, 571, 592 Unfinished Symphony (Symphony No. 8 in B minor) (Schubert), 454 Unification of China, 132–136 United Monarchy, Hebrew, 143 United States. See America United States Department of Agriculture, 581 L'Unités d'Habitation,	Valerian, emperor of Rome, 149 The Valkyrie (Wagner), 458 Valley Curtain (Christo), 609 Values autocracy, 169 Black Death, 255 civic pride in city-states, 60 colonialism, 509 destiny, 37 dialectics, 238 disillusionment, 567 empire, of Rome, 101 feudalism, 217 intellectual synthesis, 297 Islamic values, 195 liberation, 606 love, marriage, and divorce in Egypt, 18 mortality, 14 nationalism, 478 natural disaster and human response, 255 patronage, 325 reform, religious, 345 revelation, 146 revolution, 439 scientific truth, 404
French, 406–407 Greek drama, 60–64 opera, Greek influence on, 399 Roman drama, 95 Tragic flaw, of Aristotle, 66 Trajan, emperor of Rome, 99 Trans World Flight Center, Kennedy Airport (Saarinen), 611, 613 Transcendentalism, 454, 476–477 Transept, 152 The Transfiguration (Raphael), 315, 315 Traveler of the East (Mofolo), 550 The Treasure of the City of Ladies (de Pisan), 259 Trecento, 253, 271 Très Riches Heures du Duc de Berry (Limbourg Brothers), 269, 270–271, 272, 357 The Trial (Kafka), 562 Tribonian, 164 Tribunes, 93 The Tribute Money (Masaccio), 284, 284 Trier, 207 Triforium, 164 Triglyphs, 46, 47, 69	Tunnel vault, 110, 110, 216, 218 Turks, conquest of Constantinople, 166, 178, 179 Turner, Joseph Mallond, 470 The Slave Ship, 470, 470 Tuscan dialect, 281 Tuscany, 91 Tutankhamen, pharaoh of Egypt, 15–16, 19, 27 Tutu, Desmond, 606 Twelfth Night (Shakespeare), 366 Twelve Apostles of Jesus, 169–170 Twelve-tone technique, 514 Twelve Tribes of Israel, 143 Twentieth century contemporary contour, 589–625 architecture, 505, 507, 590, 608–617, 612–618 art, 590, 591–608, 592–611, 619–620 drama, 617–618 global culture, 589–591 literature, 590–591, 617–620 music, 620–624 opera, 622 philosophy, existentialism,	Tyche, 37 Tyche, 37 Tympanum, 218, 220 Tyrants, 42, 65, 281 Tzara, Tristan, 577 U Übermensch, 491 Uccello, Paolo, 291, 292 The Battle of San Romano, 291, 292 Ugaas, Raage, 548 Ulpian, 98 Ultrecht Psalter, 211–212, 212 Ullysses (Joyce), 562 The Umbrellas (Christo), 609 Un Chien Andalou (Buñuel and Dali), 571–572 Unamuno, Miguel de, 590, 591 Unconscious, 568, 571, 592 Unfinished Symphony (Symphony No. 8 in B minor) (Schubert), 454 Unification of China, 132–136 United Monarchy, Hebrew, 143 United States Department of Agriculture, 581 L'Unités d'Habitation, Marseille (Le Corbusier),	Valerian, emperor of Rome, 149 The Valkyrie (Wagner), 458 Valley Curtain (Christo), 609 Values autocracy, 169 Black Death, 255 civic pride in city-states, 60 colonialism, 509 destiny, 37 dialectics, 238 disillusionment, 567 empire, of Rome, 101 feudalism, 217 intellectual synthesis, 297 Islamic values, 195 liberation, 606 love, marriage, and divorce in Egypt, 18 mortality, 14 nationalism, 478 natural disaster and human response, 255 patronage, 325 reform, religious, 345 revelation, 146 revolution, 439
French, 406–407 Greek drama, 60–64 opera, Greek influence on, 399 Roman drama, 95 Tragic flaw, of Aristotle, 66 Trajan, emperor of Rome, 99 Trans World Flight Center, Kennedy Airport (Saarinen), 611, 613 Transcendentalism, 454, 476–477 Transept, 152 The Transfiguration (Raphael), 315, 315 Traveler of the East (Mofolo), 550 The Treasure of the City of Ladies (de Pisan), 259 Trecento, 253, 271 Très Riches Heures du Duc de Berry (Limbourg Brothers), 269, 270–271, 272, 357 The Trial (Kafka), 562 Tribonian, 164 Tribunes, 93 The Tribute Money (Masaccio), 284, 284 Trier, 207 Triforium, 164 Triglyphs, 46, 47, 69 Trilogy, Greek tragedy, 61	Tunnel vault, 110, 110, 216, 218 Turks, conquest of Constantinople, 166, 178, 179 Turner, Joseph Mallond, 470 The Slave Ship, 470, 470 Tuscan dialect, 281 Tuscany, 91 Tutankhamen, pharaoh of Egypt, 15–16, 19, 27 Tutu, Desmond, 606 Twelfth Night (Shakespeare), 366 Twelve Apostles of Jesus, 169–170 Twelve-tone technique, 514 Twelve Tribes of Israel, 143 Twentieth century contemporary contour, 589–625 architecture, 505, 507, 590, 608–617, 612–618 art, 590, 591–608, 592–611, 619–620 drama, 617–618 global culture, 589–591 literature, 590–591, 617–620 music, 620–624 opera, 622 philosophy, existentialism, 590–591	Tyche, 37 Tyche, 37 Tympanum, 218, 220 Tyrants, 42, 65, 281 Tzara, Tristan, 577 U Übermensch, 491 Uccello, Paolo, 291, 292 The Battle of San Romano, 291, 292 Ugaas, Raage, 548 Ulpian, 98 Ultrecht Psalter, 211–212, 212 Ulysses (Joyce), 562 The Umbrellas (Christo), 609 Un Chien Andalou (Buñuel and Dali), 571–572 Unamuno, Miguel de, 590, 591 Unconscious, 568, 571, 592 Unfinished Symphony (Symphony No. 8 in B minor) (Schubert), 454 Unification of China, 132–136 United Monarchy, Hebrew, 143 United States. See America United States Department of Agriculture, 581 L'Unités d'Habitation, Marseille (Le Corbusier), 612, 614	Valerian, emperor of Rome, 149 The Valkyrie (Wagner), 458 Valley Curtain (Christo), 609 Values autocracy, 169 Black Death, 255 civic pride in city-states, 60 colonialism, 509 destiny, 37 dialectics, 238 disillusionment, 567 empire, of Rome, 101 feudalism, 217 intellectual synthesis, 297 Islamic values, 195 liberation, 606 love, marriage, and divorce in Egypt, 18 mortality, 14 nationalism, 478 natural disaster and human response, 255 patronage, 325 reform, religious, 345 revelation, 146 revolution, 439 scientific truth, 404 Van den Rohe, Ludwig Miës,
French, 406–407 Greek drama, 60–64 opera, Greek influence on, 399 Roman drama, 95 Tragic flaw, of Aristotle, 66 Trajan, emperor of Rome, 99 Trans World Flight Center, Kennedy Airport (Saarinen), 611, 613 Transcendentalism, 454, 476–477 Transept, 152 The Transfiguration (Raphael), 315, 315 Traveler of the East (Mofolo), 550 The Treasure of the City of Ladies (de Pisan), 259 Trecento, 253, 271 Très Riches Heures du Duc de Berry (Limbourg Brothers), 269, 270–271, 272, 357 The Trial (Kafka), 562 Tribonian, 164 Tribunes, 93 The Tribute Money (Masaccio), 284, 284 Trier, 207 Triforium, 164 Triglyphs, 46, 47, 69	Tunnel vault, 110, 110, 216, 218 Turks, conquest of Constantinople, 166, 178, 179 Turner, Joseph Mallond, 470 The Slave Ship, 470, 470 Tuscan dialect, 281 Tuscany, 91 Tutankhamen, pharaoh of Egypt, 15–16, 19, 27 Tutu, Desmond, 606 Twelfth Night (Shakespeare), 366 Twelve Apostles of Jesus, 169–170 Twelve-tone technique, 514 Twelve Tribes of Israel, 143 Twentieth century contemporary contour, 589–625 architecture, 505, 507, 590, 608–617, 612–618 art, 590, 591–608, 592–611, 619–620 drama, 617–618 global culture, 589–591 literature, 590–591, 617–620 music, 620–624 opera, 622 philosophy, existentialism,	Tyche, 37 Tyche, 37 Tympanum, 218, 220 Tyrants, 42, 65, 281 Tzara, Tristan, 577 U Übermensch, 491 Uccello, Paolo, 291, 292 The Battle of San Romano, 291, 292 Ugaas, Raage, 548 Ulpian, 98 Ultrecht Psalter, 211–212, 212 Ullysses (Joyce), 562 The Umbrellas (Christo), 609 Un Chien Andalou (Buñuel and Dali), 571–572 Unamuno, Miguel de, 590, 591 Unconscious, 568, 571, 592 Unfinished Symphony (Symphony No. 8 in B minor) (Schubert), 454 Unification of China, 132–136 United Monarchy, Hebrew, 143 United States Department of Agriculture, 581 L'Unités d'Habitation, Marseille (Le Corbusier),	Valerian, emperor of Rome, 149 The Valkyrie (Wagner), 458 Valley Curtain (Christo), 609 Values autocracy, 169 Black Death, 255 civic pride in city-states, 60 colonialism, 509 destiny, 37 dialectics, 238 disillusionment, 567 empire, of Rome, 101 feudalism, 217 intellectual synthesis, 297 Islamic values, 195 liberation, 606 love, marriage, and divorce in Egypt, 18 mortality, 14 nationalism, 478 natural disaster and human response, 255 patronage, 325 reform, religious, 345 revelation, 146 revolution, 439 scientific truth, 404 Van den Rohe, Ludwig Miës, 613

La Traviata, 457

Luisa Miller, 457

Van Dyck, Anthony, 330,	Nabucco, 457	Visigoths, 161	Al Walid, Abd, 189
391-392	Otello, 457, 460	Visual arts, as permanent	Walker, Alice, 619
Marchesa Elena Grimaldi, 392,	Rigoletto, 457	spatial art, xxiii. See also	The Color Purple, 619
394	Vergil, 308, 390, 434	Art	Waller, Fats, 574
Van Eyck, Jan, 289, 289, 324	Aeneid, 308, 433	Vita Nuova (Dante), 245, 294	London Suite, 574
Van Gogh, Vincent, 503-504,	Augustus, emperor of Rome,	De Vita Solitaria (Petrarch), 256	Walpole, Horace, 433
512	and, 100–102	Vitalis, Saint, 171, 173	War and Peace (Tolstoy),
The Night Café, 503, 503	in Dante's Divine Comedy, 245	Vitellozi, Annibale, 611	473-474
Portrait of Dr. Gachet,	Golden Age of Latin	Palazetto Della Sport, Rome,	War Requiem (Britten), 622
503-504, 504	literature, 104	611, 612	Warhol, Andy, 598-599
The Starry Night, 502, 503	Petrarch and, 256	Vitry, Philippe de, 273	Mick Jagger, 598
Van Rijn, Titus, 394	scholasticism, 204	Ars Nova Musicae (The New	Warring States, Age of, Japan,
Varaha, 128, 129	works	Art of Music), 273	535
Varanasi, 126	Aeneid, 100-102, 245, 256	Vittoria (composer), 331	Warrior Seated at His Tomb, 68,
Vasari, Giorgio, 259-260, 284,	Bucolics, 100	Vivaldi, Antonio, 402	70
287, 295, 330	Eclogues, 100	The Four Seasons, 402, 508	Washington, George, 440
Life of Giotto, 259–260	<i>Georgics</i> , 100–101	Vladimir, prince of Russia, 178	Washington Square, NY, arch
Lives of the Artists, 259	Vergina, Royal Cemetery of, 76,	Vltava (The Moldau) (Smetana),	on, 110
Vases, Greek painting of, 44, 46,	76	456	Wasp Pendant, 22, 24
68, 70. See also Pottery and	Vermeer, Jan, 393	Vocal music. See also Music;	The Waste Land (Eliot), 562, 582
ceramics	Woman Reading a Letter, 393,	Opera	Water Lilies (Nymphéas)
Vatican. See also Saint Peter's	395	antiphonal singing, 155	(Monet), 494-495, 495, 512
Basilica	Vernacular translation of Bible,	Baroque period, 400-402	The Water Music (Handel), 400
library, 179	346, 362	chanting and religious	Waters, Ethel, 573
Michelangelo's art in, 313,	Verona, 60	observance, 154, 203,	Watteau, Jean Antoine, 419, 434
318-319, 319, 320	Versailles Palace, 387, 387–388,	206-208, 237	Pilgrimage to Cythera, 418,
music at papal court in	415	choir, 226, 226	419
Sixteenth century, 330–331	Verse anthem, 363	early Greece, 48	The Waves (Woolf), 563
Palestrina's compositions for,	Vesalius, Andreas, 348	hymns of Reformation,	The Way to Knowledge (Scivias)
331	Third Musculature Table	346-347, 347	(Hildegard of Bingen), 206,
Raphael's art in, 314, 315	from De humani corporis	jazz and blues, 573	206
Saint Peter's Basilica, 152,	fabrica, 349	monophonic singing, xxvi,	Weber, Max, 346
154, 201	Vespasian, emperor of Rome, 99	207	Weelkes, Thomas, 364
Sistine Chapel, 313, 318–319,	Vespers, 205	opera, invention of, 61	"Noel, Adieu," 364
319, 320	Vesuvius, eruption of, 105–107	polyphony, xxvi, 237, 274,	Weill, Kurt, 573
Vedas, 125-126, 129	Vézelay, 218, 219, 220	331, 362, 399, 401	Dreigroschenoper (Threepenny
Velázquez, Diego, 324, 389, 393,	Vibia Perpetua, 149	Sixteenth century, 330-333	Opera), 573
466	Vico, Giambattista, 3	Voltaire, 406, 433, 436-437, 439	The Well of Moses (Sluter),
Las Meninas (The Maids of	Victor, Saint, 238	Candide, 436-437	267-268, 270
Honor), 390, 391, 462	Victoria, queen of England, 101,	Lettres philosophiques, 437	The Well-Tempered Clavier
Vendetta, primitive law of, 62	452, 530	Voltaire (Pigalle), 437	(Bach), 401
Venice	Victoria (composer), 331	Volterra, 92, 93, 98	Welty, Eudora, 618
as city-state, 60	Victorian Age, 101	Volutes, 46, 47	The West, 143
Crusades and trade, 179	Victory Stele of Naram-Sin, 8, 9	Von Breuning family, 452	Weston, Edward, 580
Doge's Palace in, 271-272,	Videos, music, 623	Vonnegut, Kurt, Jr., 619	White Huns, 130–131
273	Vierzehnheiligen Pilgrim	Vulcan, 97	Whitman, Walt, 477, 480-481
Dürer in, 351	Church, 422, 423	De Vulgari Eloquentia (Dante),	Leaves of Grass, 477
Monteverdi in, 399	Vietnam Veterans Memorial,	245	Wiesel, Elie, 618
music in sixteenth century,	Washington, D. C. (Lin),	Vulgate Bible, 203	Night, 618
331-332	607, 608	-	Wild Strawberries (Bergman),
Renaissance, High Italian,	View of Paris from the Trocadero	W	617
323-326, 324-327	(Morisot), 498, 498	Wagner, Richard, xxvii, 61, 456,	Wilde, Oscar, 510
Le Ventre Legislatif (The	Vikings, 203	458, 460, 472, 513, 622	Salome, 510
Legislative Belly) (Daumier),	Villa of the Mysteries, 107, 108	The Rhinegold, 458	Wildflowers (Collins), 623
466, 467	Villard de Honnecourt,	The Ring of the Nibelung, 458	Willaert, Adrian, 331
Venturi, Robert, 615	234-235, 236	Siegfried, 458	Willendorf, Venus of, 4, 5
Venus, 97, 103	Vintner's window, 235	Tristan and Isolde, 459, 460,	William of Champeaux, 238
Venus Anadyomene (Aphrodite at	Violin and Palette (Braque), 563,	513	William of Moerbeke, 244
Cyrene) (Praxiteles), 77, 77	565	The Twilight of the Gods, 458	William Tell Overture (Rossini),
Venus of Urbino (Titian), 326, 327	Violin Concerto (Schönberg), 514	The Valkyrie, 458	622
Venus of Willendorf, 4, 5	Virgil. See Vergil	Waiting for Godot (Beckett),	Williams, William Carlos, 618,
Verbiest, Ferdinand, 530, 532	Virgin and Child, 150, 151	617-618	621
Verdi, Giuseppe, 456-457, 458,	Virginia State Capital at	Walden (Thoreau), 477	Wilson, Robert, 622
460	Richmond (Jefferson), 426,	Waldmuller, Ferdinand Georg,	Akhnaten, 622
Il Trovatore, 457	427	452	Einstein on the Beach, 622

De Viris Illustris (Petrarch), 256

Vishnu, 128, 129

Waldstein, Count, 453

Walesa, Lech, 606

Satyagraha, 622

Wilton Diptych, 267, 269, 272

Winckelmann, Johann, 109 History of Ancient Art, 109 Winckelmann, Johannes, 424 Wittenberg, Church of, 340 Wittenberg, University of, 344 Wittkower, R. and M., 397 Born Under Saturn, 397 Woman Reading a Letter (Vermeer), 393, 395 Women. See also specific women contemporary era, rights of, education of, 209, 241. 258-259, 305 feminism, 563, 619 Greek sculpture of, 77 literature by, 619 modern era, 516-517 monastic life, 204, 205, 206 Mother Goddesses, 4, 5, 6, 20, 21, 22, 27 reformation, 342 Renaissance, 305, 329-330, 330 Women of the Reformation (Bainton), 342 Woodblock print, Japanese, 535-536, 537 Woodcuts, 350 Woodruff, Hale, 575 Woodwind instruments in symphony orchestra, 428, Wool trade in 15th-century Florence, 281 Woolf, Leonard, 563 Woolf, Virginia, 241, 562-563, To the Lighthouse, 563

Mrs. Dalloway, 563 A Room of One's Own, 563 Three Guineas, 563 The Waves, 563 The Word, Reformation emphasis on, 346 Words from Islamic culture, 196 Wordsworth, William, 472, 473 "Work ethic, "Protestant, 346 Works and Days (Hesiod), 49 The World as Will and Idea (Schopenhauer), 449 The World of Apu (Ray, S.), 540 World War I, 489, 525, 561, 567, World War II, 580, 591 World Wars, period between, 561-585 art ballet, 575-577, 576 cubism, 563-566, 563-567, 564-567 dada, 577, 577 film as propaganda, 571-572, 578-580, 579-580, 618 futurism in, 581, 581-582, 582 photography, 580-582, 581 as protest, 577-578, 578, 578 surrealism, 568-572, 570 - 572literature, 561-563, 575-576, 582 map, 569 music, 563, 573-575, 622 painting, 563-567, 564-567,

576-582, 576-582

timeline, 558-559 Wright, Frank Lloyd, 608-610 Solomon R. Guggenheim Museum, 610-611, 612 Wright, Richard, 619 Native Son (Wright), 619 Writing calligraphy, 135, 137, 187-188, 213, 524, 525, 528 in Charlemagne's time, 203 cuneiform, 6, 7, 19 illuminated manuscripts, 204, 206, 211–213, 213, 214, 239, 274, 275 Indian / Aryan, 123-124 invention of, 6 Islamic, 186-188 The Writings, Hebrew Bible, 144 - 145Wu Ch'eng-en, 527 Monkey, 527 Wuthering Heights (Brontë), 474 - 475Wyatt, Sir Thomas, 257 Wyclif, John, 254

X
Xenophanes of Colophon, 50
Memorabilia, 65
Xenophon, 65, 304
Apology, 65
Memorabilia, 65
Symposium, 65
Xerxes, king of Persia, 51, 52, 58
Xerxes (Handel), 400

Y Yang Kuang-hsien, 532 Yanso, Moya, 553, 555 Ye Sacred Muses (Byrd), 363
Yeats, William Butler, 550, 561, 562, 582
"The Second Coming," 550, 561
"Yesterday" (McCartney and Lennon), 623
Yevtushenko, 622
Yoruba mask, 554
Yoruba people, 552, 554, 554
Young, Lester, 574

Zakro, 22 Zappa, Frank, 623 Zell, Katherine, 342 Zell, Matthew, 342 Zen Buddhism, 536 Zeno, 51 Zero, 130, 195 Zeus Altar to, 81, 82, 83 destiny, 37 Dura-Eurpoas ruins, 151 Greek and Roman deities, 97 impact of, 27 in literature, 34, 35, 35, 52, Temple of, 69, 71, 72 Zhang Yimou, 540 Raise the Red Lantern, 540 The Story of Qui Ju, 540 Ziggurats, 8, 18 Zoser, 97 Zoser, pharaoh of Egypt, 13

Zwingli, Ulrich, 341-342

CHAPTER 1—Photo 1.1: Colorphoto Hans Hinz, Allscheil/Basel, pp. 2, 4; Photo 1.2: Naturhistorisches Museum, Vienna, p. 5; Photo 1.3: Hirmer Fotoarchiv, Munich, p. 7; Photo 1.4: Hirmer Fotoarchiv, Munich, p. 8 (L); Photo 1.5: Scala/Art Resource, New York, p. 8 (R); Photo 1.6: Saskia Ltd. Cultural Documentation, p. 9; Photo 1.7: © Dean Conger/CORBIS, p. 10 (Top); Photo 1.8: The Metropolitan Museum of Art, New York, Harris Brisbane Dick Fund, 1959. (59.2) Photograph copyright © 1982 Metropolitan Museum of Art, p. 10 (Bot); Photo 1.9: © Réunion des Musées Nationaux, Paris, p. 11 (Top); Photo 1.10: Courtesy of the Trustees of the British Museum, London, p. 11 (Bot); Photo 1.11: Hirmer Fotoarchiv, Munich, p. 12; Photo 1.12: Robert Harding Picture Library, London, p. 15; Photo 1.13: Hirmer Fotoarchiv, Munich, p. 16; Photo 1.14: Hirmer Fotoarchiv, Munich, p. 17 (L); Photo 1.15: © Ägyptishes Museum, Staatliche Museen, Bildarchiv Preussischer Kulturbesitz, Berlin, p. 17 (UR); Photo 1.16: © Margarete Büsing/Bildarchiv Preussischer Kulturbesitz, Berlin, p. 17 (LR); Photo 1.17: Katherine Young, NYC/AP/ Wide World Photos, p. 19 (Top); Photo 1.18: © Charles & Josette Lenars/ CORBIS, p. 19 (Bot); Photo 1.19: John P. Stevens, Ancient Art and Architecture Collection, London, p. 20; Photo 1.20: Eric Lessing/Art Resource, New York, p. 21 (L); Photo 1.21: Courtesy of the Trustees of the British Museum, London, p. 21 (R); Photo 1.22: © Gail Mooney/CORBIS, p. 23; Photo 1.24: Robert Harding Picture Library, London, p. 24 (Top); Photo 1.25: Ancient Art and Architecture Collection, Harrow-on-the-Hill, England, p. 24 (Bot); Photo 1.26: Hirmer Fotoarchiv, Munich, p. 25; Photo 1.27: Leonard Von Matt, p. 26 (L); Photo 1.28: Hirmer Fotoarchiv, Munich, p. 26 (R); Photo 1.29: Alton S. Tobey, Larchmont, NY, p. 27

CHAPTER 2—Photo 2.1: Nimatallah/ Art Resource, New York, p. 35; Photo 2.2: Deutsches Archaeologisches Institut, Athens, p. 38; Photo 2. 3: Copyright © Colorphoto Hans Hinz, Allschwil/Basel, p. 39; Photo 2.4: Staatliches Museen zu Berlin— Preussischer Kulturbesitz Antikensammiung/BPK, p. 40 (Top); Photo 2.5: Scala/Art Resource, New York, p. 40 (Bot); Photo 2.6: Deutsches

Archaeologisches Institut, Athens, p. 41; Photo 2.7: Metropolitan Museum of Art, New York, Fletcher Fund, 1932 (32.11.1). Photo copyright © 1993 The Metropolitan Museum of Art, p. 42; Photo 2.8: Saskia Ltd. Cultural Documentation, p. 43 (L); Photo 2.9: Nimatallah/Art Resource, NY, pp. 30, 43 (R); Photo 2.10: Studio Kontos, p. 44 (L); Photo 2.11: Alinari/Art Resource, New York, p. 44 (R); Photo 2.12: Ancient Art and Architecture Collection, Harrow-on-the-Hill, England, p. 45 (L); Photo 2.13: Nimatallah/Art Resource, NY, p. 45 (R); Photo 2.14: Photo from Laboratories Photographique, Devos, p. 46 (Top); Photo 2.15: Metropolitan Museum of Art, bequest of Joseph H. Durkee, gift of Darlus Ogden Mills and gift of C. Ruxton Love, by exchange, 1972. (1972.11.10). Copyright © 1999 by the Metropolitan Museum of Art, p. 46 (Bot); Photo 2.16: © Tony Gervis/F.R.P.S./Robert Harding Picture Library, p. 47; Photo 2.18: Metropolitan Museum of Art, New York (Fletcher Fund, 1956). Copyright © 1989 by the Metropolitan Museum of Art, p. 48 (L); Photo 2.19: Hirmer Fotoarchiv, Munich, p. 48 (R); Photo 2.20: Deutsches Archaologisches Institut, Athens, p. 49

CHAPTER 3—Photo 3.1: © Paul Warhol Photography, pp. 56, 58; Photo 3.2: Photo Vatican Museums, p. 59; Photo 3.3: Rhoda Sidney, PhotoEdit, Long Beach, CA, p. 61; Photo 3.4: William Francis Warden Fund. Courtesy of the Museum of Fine Arts, Boston, p. 62; Photo 3.5: Eric Lessing/PhotoEdit, Long Beach, CA, p. 63; Photo 3.6: Alinari/Art Resource, New York, p. 68; Photo 3.7: Scala/Art Resource, New York, p. 69; Photo 3.8: Scala/Art Resource, New York, p. 70 (L); Photo 3.9: Hirmer Fotoarchiv, Munich, p. 70 (R); Photo 3.10: Hirmer Fotoarchiv, Munich, p. 71; Photo 3.12: Scala/Art Resource, New York, p. 72 (Top); Photo 3.13: Royal Ontario Museum, Toronto, p. 72 (Bot); Photo 3.14: William Katz/Photo Researchers, Inc., p. 73; Photo 3.15: Hirmer Fotoarchiv, Munich, p. 74 (Top); Photo 3.16: Reproduced by courtesy of the Trustees of the British Museum, London. Hirmer Fotoarchiv, Munich, p. 74 (Bot); Photo 3.17: Reproduced by courtesy of the Trustees of the British Museum, London. Hirmer Fotoarchiv, Munich, p. 75

New York, p. 75 (Bot); Photo 3.19: D. Lada/H. Armstrong Roberts, p. 75 (UR); Photo 3.20: Courtesy of the Hellenic Ministry of Culture, p. 76 (L); Photo 3.21: Scala/Art Resource, New York, p. 76 (R); Photo 3.22: Alinari/Art Resource, New York, p. 77 (L); Photo 3.23: Barbara Malter, Capitoline Museums, Rome, p. 77 (R); Photo 3.24: Vatican Museums, Rome, p. 78 (L); Photo 3.25: M. Thonig/H. Armstrong Roberts, p. 78 (R); Photo 3.26: Hirmer Fotoarchiv, Munich, p. 81 (UL); Photo 3.28: Staatliche Musseen zu Berlin-Preussischer Kulturbesitz Antikensannlung, Berlin, p. 81 (Bot); Photo 3.29: Eric Lessing/Art Resource, p. 82 (Top); Photo 3.30: Scala/Art Resource, New York, p. 82 (Bot)

CHAPTER 4—Photo 4.2: Photo Henri Stierlin, p. 91; Photo 4.3: Canali Photobank, Italy, p. 92; Photo 4.4: Hirmer Fotorarchiv, Munich, p. 93 (Top); Photo 4.5: Alinari/Art Resource, New York, p. 93 (Bot); Photo 4.6: 1994 Richard T. Nowitz/Photo Researchers, Inc., p. 94; Photo 4.7: Alinari/Art Resource, New York, p. 98; Photo 4.9: Scala/Art Resource, New York, p. 101; Photo 4.10: Alinari/Art Resource, New York, p. 103; Photo 4.11: Scala/Art Resource, New York, p. 104 (Top); Photo 4.12: Scala/Art Resource, New York, p. 104 (Bot); Photo 4.13: Superstock, p. 105; Photo 4.14A: Superstock, p. 106 (UL); Photo 4.14B: Leonard Van Matt/Photo Researchers, Inc., p. 106 (UR); Photo 4.15: Alinari/Art Resource, New York, p. 106 (Bot); Photo 4.16: Scala/Art Resource, New York, pp. 88, 108 (Top); Photo 4.17: Scala/Art Resource, New York, p. 108 (Bot); Photo 4.18: Scala/Art Resource, New York, p. 109 (Top); Photo 4.21: Alinari/Art Resource, New York, p. 110; Photo 4.24: © M. Thonig/H. Armstrong Roberts, p. 112; Photo 4.25: Fototeca Unione, p. 113; Photo 4.26: Scala/Art Resource, New York, p. 114 (Top); Photo 4.27: Scala/Art Resource, New York, p. 114 (Bot); Photo 4.28: Alinari/Art Resource, New York, p. 115; Photo 4.29: Alinari/Art Resource, New York, p. 116

the British Museum, London. Hirmer Fotoarchiv, Munich, p. 74 (Bot); Photo 3.17: Reproduced by courtesy of the Trustees of the British Museum, London. Hirmer Fotoarchiv, Munich, p. 75 (UL); Photo 3.18: Scala/Art Resource,

CHAPTER 5—Photo 5.1: Borromeo/Art Resource, New York, p. 124; Photo 5.2: Archeological Survey of India, Janpath, New Delhi, p. 128 (L); Photo 5.3: © Adam Wolfitt/CORBIS, p. 128 (R); (UL); Photo 3.18: Scala/Art Resource,

(Top); Photo 5.5: © B. D. Rupani/Dinodia, p. 129 (Bot); Photo 5.6: Courtesy of the Freer Gallery of Art, Smithsonian Institution, Washington, DC. Accession #F1949.9, p. 130 (Top); Photo 5.7: Scala/Art Resource, NY, p. 130 (Bot); Photo 5.8: Courtesy of the Freer Gallery of Art, Smithsonian Institution, Washington, DC. Accession #F1936.6, p. 132 (Top); Photo 5.9: © Mary Evans Picture Library, p. 132 (Bot); Photo 5.10: © Superstock, p. 133; Photo 5.11: © Superstock, p. 134; Photo 5.12: Réunion des Musées Nationaux/Art Resource, NY, p. 135 (Bot); Photo 5.13: © Peoples Republic of China/Lauros-Giraudon, Paris/Superstock, p. 135 (Top); Photo 5.14: Richard Rudolph Collection, Los Angeles, p. 136 (Top); Photo 5.15: Courtesy of the Freer Gallery of Art, Smithsonian Institution, Washington, DC. Accession #F1939.37, pp. 122, 136 (Bot); Photo 5.16: © Werner Foreman/CORBIS, p. 137 (Top)

CHAPTER 6—Photo 6.2: Alinari/Art Resource, New York, p. 144 (Bot); Photo 6.3: Andre Held, Ecublens, Switzerland, p. 151 (Top); Photo 6.4: Scala/Art Resource, New York, p. 151 (Bot); Photo 6.5: Scala/Art Resource, New York, p. 152 (Top); Photo 6.6: Alinari/Art Resource, New York. 1875, Roma, Sarcofago Cristiano—Museo Laterano, p. 152 (Bot); Photo 6.7: Alinari/Art Resource, New York, p. 153 (UL); Photo 6.8: Robert Harding Picture Library, London, p. 153 (UR); Photo 6.9: Zev Radovan, Jerusalem, p. 153 (Bot); Photo 6.13: Rijksmuseum van Oudheden, Leiden, Netherlands, p. 155

CHAPTER 7—Photo 7.2: Alan Oddie/ PhotoEdit, Long Beach, CA, p. 165 (Top); Photo 7.3: Zefa/H. Armstrong Roberts, p. 165 (Bot); Photo 7.4: Hirmer Fotoarchiv, Munich, p. 166; Photo 7.5: Scala/Art Resource, New York, p. 167; Photo 7.6: Scala/Art Resource, New York, p. 168; Photo 7.7: Scala/Art Resource, New York, p. 169; Photo 7.8: Alinari/Art Resource, New York, p. 179 (Top); Photo 7.9: Estate of Leonard von Matt, Stansstad, Switzerland, p. 170 (Bot); Photo 7.10: Estate of Leonard von Matt, Stansstad, Switzerland, p. 171; Photo 7.11: Ancient Art and Architecture Collection, Harrowon-the-Hill, England, p. 172 (Top); Photo 7.12: Scala/Art Resource, New York, p. 172 (Mid); Photo 7.13: Scala/Art Resource, New York, p. 172 (LL); Photo 7.14: Fotocielo, Rome, p. 172 (LR); Photo 7.15: Hirmer Fo7.16: Scala/Art Resource, New York, p. 173 (Bot); Photo 7.17: Canali Photobank, Italy, p. 174; Photo 7.18: Canali Photobank, Italy, p. 175 (Top); Photo 7.19: Estate of Leonard von Matt, Stansstad, Switzerland, pp. 160, 175 (Bot); Photo 7.20: Hirmer Fotoarchiv, Munich, p. 176; Photo 7.21: 1991 Laura Zito/Photo Researchers, Inc., p. 177; Photo 7.22: Ancient Art and Architecture Collection, Harrow-on-the-Hill, England, p. 178

CHAPTER 8—Photo 8.1: Mehmet Biber/Photo Researchers, Inc., p. 186; Photo 8.2: Bildarchiv Preussischer Kulturbesitz, Berlin, p. 188; Photo 8.3: Christopher Rennie/Robert Harding Picture Library, p. 189; Photo 8.4: Yoram Lehmann, Jerusalem, p. 190 (Top); Photo 8.5: © Ronald Sheridan/Ancient Art & Architecture, p. 190 (Bot); Photo 8.6: © Ronald Sheridan/Ancient Art & Architecture, p. 191 (L); Photo 8.7: © Ronald Sheridan/Ancient Art & Architecture, p. 191 (R); Photo 8.8: © M. Thonig/H. Armstrong Roberts, p. 192 (Top); Photo 8.9: Institute Anatler d'Art Hispanic, p. 192 (Bot); Photo 8.10: © Ronald Sheridan/Ancient Art & Architecture, pp. 184, 193; Photo 8.11: © K.M. Westermann/CORBIS, p. 194

CHAPTER 9—Photo 9.1: Archives Nationales de France, p. 202; Photo 9.2: Tafel 19, Scivias, courtesy of Sr. Scholastica, Abtei St., p. 206; Photo 9.3: D.Y./Art Resource, New York, p. 210; Photo 9.4: © Ann Munchow, Dom-Kapitel-Aachen, p. 212 (Top); Photo 9.5: Rare Books and Manuscript Division, New York Public Library, p. 212 (Bot); Photo 9.7: Austrian National Library (Österreichische Nationalbibliothek), Vienna, pp. 200, 213 (R); Photo 9.8: Giraudon/Art Resource, New York, p. 214; Photo 9.9: Romisch-Germanisches Zentral Museum, Mainz, p. 215 (Top); Photo 9.10: Dr. Harold Busch, p. 215 (Bot); Photo 9.13: Bildarchiv Foto Marburg/Art Resource, New York, p. 218; Photo 9.14: Marburg/Art Resource, p. 219 (UL); Photo Photographiques, 9.15: Archives Paris/SPADEM, p. 219 (LL); Photo 9.16: Emeric Feher © CNMHS/SPA-DEM, p. 219 (R); Photo 9.17: J. E. Bulloz Editions, Paris, p. 220

on-the-Hill, England, p. 172 (Top); CHAPTER 10—Photo 10.1b: Scala/Art Photo 7.12: Scala/Art Resource, New York, p. 172 (Mid); Photo 7.13: Scala/Art Resource, New York, p. 172 (Mid); Photo 7.13: Scala/Art Resource, New York, p. 172 (Sonia Halliday and Laura Lushington, ULL); Photo 7.14: Fotocielo, Rome, p. 172 (LR); Photo 7.15: Hirmer Fotoarchiv, Munich, p. 173 (Top); Photo New York, pp. 224, 231; Photo 10.6:

Giraudon/Art Resource, New York, p. 232; Photo 10.7: Alinari/Art Resource, p. 233; Photo 10.8: © Marc Garanger/CORBIS, p. 234; Photo 10.9: Giraudon/Art Resource, New York, p. 235; Photo 10.10: Bibliotheque Nationale, Paris, p. 236 (L); Photo 10.11: Getty Research Institute, Research Library, Wim Swaan Photograph Collection, 96.P.21, p. 236(R); Photo 10.12: Bildarchiv Preussischer Kulturbesitz, Berlin, p. 239; Photo 10.13: Scala/Art Resource, New York, p. 242; Photo 10.14: Scala/Art Resource, New York, p. 243; Photo 10.15: Scala/Art Resource, New York, p. 244; Photo 10.16: Colorphoto Hans Hinz, Artothek, p. 245; Photo 10.17: Scala/Art Resource, New York, p. 247; Photo 10.18: Scala/Art Resource, New York, p. 248

CHAPTER 11—Photo 11.1: Archives Photographiques, Paris/SPADEM, p. 260; Photo 11.2: Alinari/Art Resource, New York, p. 261 (Top); Photo 11.3: Alinari/Art Resource, New York, p. 261 (Bot); Photo 11.4: Scala/Art Resource, New York, p. 262 (L); Photo 11.5: Scala/Art Resource, New York, p. 262 (R); Photo 11.6: Alinari/Art Resource, New York, p. 263 (Top); Photo 11.7: Scala/Art Resource, New York, p. 263 (Bot); Photo 11.8: Studio Pizzi/Summerfield, p. 264; Photo 11.9: Alinari/Art Resource, New York, p. 265 (Top); Photo 11.10: Scala/Art Resource, New York, p. 265 (Bot); Photo 11.11: Scala/Art Resource, New York, p. 266; Photo 11.12: Canali Photobank, Italy, p. 267; Photo 11.13: Scala/Art Resource, New York, p. 268 (Top); Photo 11.14: Scala/Art Resource, New York, p. 268 (Bot); Photo 11.15: William Francis Warden Fund; Seth K. Sweetser Fund, The Henry C. and Martha B. Angell Collection, Juliana Chenev Edwards Collection, Gift of Martin Brimmer, and Gift of Reverend and Mrs. Frederick Frottingham, by exchange. Courtesy of the Museum of Fine Arts, Boston, p. 269 (Top); Photo 11.16: Eric Lessing/Art Resource/Reproduced by courtesy of the Trustees of the National Gallery, London, p. 269 (Bot); Photo 11.17: Giraudon, Paris, p. 270 (Top); Photo 11.18: Giraudon/Art Resource, New York, p. 270 (Bot); Photo 11.19: Giraudon, p. 271; Photo 11.20: Scala/Art Resource, New York, p. 272 (Top); Photo 11.21: R. Krubner/H. Armstrong Roberts, p. 272 (Bot); Photo 11.22: Scala/Art Resource, New York, p. 273 (Top); Photo 11.23: G. Barone/Superstock, Inc., p. 273 (Bot); Photo 11.24: Woodmansterne, London, p. 274 (L); Photo 11.25: Courtesy of the

Trustees of the British Library, London, pp. 252, 274 (R); Photo 11.26: Scala/Art Resource, New York, p. 275

CHAPTER 12—Photo 12.1: Eric Lessing, Art Resource, NY, p. 282; Photo 12.2: Canali Photobank, Italy, p. 283; Photo 12.3: Canali Photobank, Italy, p. 284; Photo 12.4: Canali Photobank, Italy, p. 285 (L); Photo 12.5: Harcourt Collection, p. 285 (UR); Photo 12.6: Harcourt Collection, p. 285 (LR); Photo 12.7: Canali Photobank, Italy, p. 286; Photo 12.10: Scala/Art Resource, New York, p. 288 (Top); Photo 12.11: Nicholas Sapieha/Art Resource, New York, p. 288 (Bot); Photo 12.12: By courtesy of the Trustees of the National Gallery, London, p. 289; Photo 12.13: Summerfield Press Limited, p. 290; Photo 12.14: Ralph Lieberman, p. 291 (L); Photo 12.15: Canali Photobank, Italy, p. 291 (R); Photo 12.16: Scala/Art Resource, New York, p. 292 (Top); Photo 12.17: Eric Lessing/Art Resource, New York, p. 292 (Bot); Photo 12.18: Scala/Art Resource, New York, p. 293; Photo 12.19: Canali Photobank, Italy, p. 294; Photo 12.20: Scala/Art Resource, New York, p. 296; Photo 12.21: Summerfield Press Limited, p. 297; Photo 12.22: R.M.N./Duplicata, p. 298 (UL); Photo 12.23: Artothek, p. 298 (UR); Photo 12.24: Artothek, p. 298 (Bot); Photo 12.25: Eric Lessing/Art Resource, New York, pp. 280, 299; Photo 12.26: Alinari/Art Resource, New York, p. 300 (L); Photo 12.27: Alinari/Art Resource, New York, p. 300 (R); Photo 12.28: Eric Lessing/Art Resource, New York, p. 301; Photo 12.29: Metropolitan Museum of Art, Fletcher Fund, 1919 (19.73.120) All rights reserved. The Metropolitan Museum of Art, New York, p. 306

CHAPTER 13—Photo 13.1: Kunsthistorisches Museum, Vienna, p. 314 (Top); Photo 13.2: Eric Lessing/Art Resource, New York, p. 314 (Bot); Photo 13.3: Scala/Art Resource, New York, p. 315; Photo 13.4: Summerfield Press Limited, p. 316; Photo 13.5: Summerfield Press Limited, p. 317 (L); Photo 13.6: Jorg P. Anders/Kupferstichkabinett Staatliche Museen zu Kulturbesitz/ Berlin—Preussischer BPK, Berlin, p. 317 (R); Photo 13.7: Photo Vatican Museums, p. 319; Photo 13.9: Scala/Art Resource, New York, p. 320; Photo 13.10: Nippon Television Network Corporation, 1994, p. 321; Photo 13.11: Summerfield Press Limited, p. 322 (Top); Photo 13.12: Alinari/Art Resource, New York, p. 322 (Bot); Photo 13.14: Alinari/Art Resource, New York, p. 323; Photo 13.15:

Scala/Art Resource, New York, p. 324; Photo 13.16: © Réunion des Musées Nationaux, Paris, p. 325; Photo 13.17: Eric Lessing/Art Resource, New York, p. 326; Photo 13.18: Canali Photobank, Îtaly, p. 327 (Top); Photo 13.19: Scala/Art Resource, New York, p. 327 (Bot); Photo 13.20: Alinari/Art Resource, New York, p. 328; Photo 13.21: Canali Photobank, Italy, p. 329 (L); Photo 13.22: Summerfield Press Limited, p. 329 (R); Photo 13.23: Kunsthaus Zurich (Switzerland), on loan from the Gottfried Keller Foundation. Copyright © 1997 by Kunsthaus Zurich. All rights reserved, p. 330; Photo 13.24: © Réunion des Musées Nationaux, Paris, p. 332; Photo 13.25: Alinari/Art Resource, New York, p. 333

CHAPTER 14—Photo 14.1: Kunsthistorisches Museum, Vienna, p. 340; Photo 14.2: Kunsthistorisches Museum, Vienna, p. 341 (L); Photo 14.3: Scala/Art Resource, New York, p. 341 (R); Photo 14.4: Scala/Art Resource, New York, p. 342; Photo 14.5: Rare Books and Manuscript Division, New York Public Library, p. 346; Photo 14.6: Lutherhalle (History of the Reformation Museum), Wittenberg, Germany, p. 347; Photo 14.7: Courtesy of the Trustees of The British Museum, London, p. 348; Photo 14.8: © Réunion des Musées Nationaux, Paris, p. 349 (Top); Photo 14.9: National Library of Medicine, Bethesda, Maryland, p. 349 (Bot); Photo 14.10: Blauel/Gnamm-Artothek, pp. 338, 350; Photo 14.11: Reproduced by courtesy of the Trustees of The British Museum, London, p. 351 (L); Photo 14.12: Courtesy Museum of Fine Arts, Boston, centennial gift of Landon T. Clay, p. 351(R); Photo 14.13: Copyright © 1985 Metropolitan Museum of Art, New York, p. 352; Photo 14.14: Giraudon/Art Resource, New York, p. 353; Photo 14.15: J. Blauel/Gnamm-Artothek, p. 354 (L); Photo 14.16: Giraudon/Art Resource, New York, p. 354 (R); Photo 14.17: Museo del Prado, Madrid, p. 355 (Top); Photo 14.17a: Museo del Prado, Madrid, p. 355 (Bot); Photo 14.18: Museo del Prado, Madrid, p. 356; Photo 14.19: Kunsthistorisches Museum, Vienna, p. 357; Photo 14.20: Kunsthistorisches Museum, Vienna, p. 358 (Top); Photo 14.21: © Réunion des Musées Nationaux, Paris, p. 358 (Bot); Photo 14.22: Scala/Art Resource, New York, p. 359; Photo 14.23: Giraudon, p. 360 (Top); Photo 14.24: Copyright © the Marquess of Salisbury, p. 360 (Bot); Photo 14.25: © Réunion des Musées Nationaux, Paris, p. 361 (L); Photo 14.26: Victoria and Albert Museum, London, p. 361 (R); Photo 14.27: Reproduced by courtesy of the Trustees of the British Library, London, p. 363; Photo 14.29: New York Public Library, p. 366

CHAPTER 15—Photo 15.1: © Jean Pragen/Tony Stone Worldwide, p. 374; Photo 15.2: Scala/Art Resource, New York, p. 377; Photo 15.3: Scala/Art Resource, New York, p. 378; Photo 15.4: Scala/Art Resource, New York, p. 379 (Top); Photo 15.5: Scala/Art Resource, New York, p. 379 (Bot); Photo 15.6: Scala/Art Resource, New York, p. 380 (Top); Photo 15.7: Scala/Art Resource, New York, p. 380 (Bot); Photo 15.8: Alinari/Art Resource, New York, p. 381 (Top); Photo 15.9: Alinari/Art Resource, New York, p. 381 (Bot); Photo 15.10: Scala/Art Resource, New York, p. 382; Photo 15.11: Summerfield Press Limited, p. 383 (Top); Photo 15.12: Jörg P. Anders/Staatliche Museen zu Berlin. Preussischer Kulturbesitz Gemäldegalerie, Berlin/BPK, p. 383 (Bot); Photo 15.13: Reproduced by permission of the Chatsworth Settlement Trustees, p. 384; Photo 15.14: Metropolitan Museum of Art, New York, Harris Brisband Dick Fund, p. 385 (Top); Photo 15.15: © Réunion des Musées Nationaux, Paris-Hervé Lewandowski, p. 385 (Bot); Photo 15.16: Seth K. Sweetser Fund. Courtesy of the Museum of Fine Arts, Boston, p. 386 (Top); Photo 15.17: © Réunion des Musées Nationaux, Paris, p. 386 (Bot); Photo 15.18: Hunting Aerofilms Limited, p. 387 (Top); Photo 15.19: Eric Lessing/Art Resource, New York, p. 387 (Bot); Photo 15.20: Scala/Art Resource, New York, p. 388; Photo 15.21: Ampliaciones y Reproducciones, MAS, Barcelona, p. 389 (L); Photo 15.22: Museo del Prado, Madrid, p. 389 (R); Photo 15.23: Museo del Prado, Madrid, p. 390; Photo 15.24: © Réunion des Musées Nationaux, Paris, p. 392; Photo 15.25: J. Blauel/Artothek, p. 393; Photo 15.26: Giraudon/Art Resource, New York, p. 394 (L); Photo 15.27: National Gallery of Art, Washington (Widener Collection, 1942), p. 394 (R); Photo 15.28: Foto Tom Haartsen, p. 395 (Top); Photo 15.29: Rijksmuseum, Amsterdam, p. 395 (Bot); Photo 15.30: Rijksmuseum, Amsterdam, p. 396 (Top); Photo 15.31: Scala/Art Resource, New York, p. 396 (Bot); Photo 15.32: Staatliche Kunstsammlungen Kassel, Galerie Alte Meister, GK 249, p. 397; Photo 15.33: © Cleveland Museum of Art, Gift of Hanna Fund, 51, 355, p. 398; Photo 15.34: Scala/Art Resource, New York, p. 403; Photo 15.35: Hans Peterson, Copenhagen, p. 405

CHAPTER 16—Photo 16.1: © Réunion des Musées Nationaux, Paris-G. Blot/C. Jean, p. 416 (Top); Photo 16.2: Copyright 1997 Museum of Fine Arts. All rights reserved, p. 416 (Bot); Photo 16.3: © Eric Lessing/Art Resource, NY, p. 418; Photo 16.4: Reproduced by permission of the Trustees of the Wallace Collection, London, p. 419; Photo 16.5: Copyright © Frick Collection, New York, pp. 414, 420 (L); Photo 16.6: Summerfield Press Limited, p. 420 (R); Photo 16.7: English Heritage Photographic Library, p. 421 (L); Photo 16.8: Museo del Prado, Madrid, p. 421 (R); Photo 16.9: Alinari/Art Resource, New York, p. 422 (L); Photo 16.10: Scala/Art Resource, New York, p. 422 (R); Photo 16.11: A. F. Kersting, London, p. 423; Photo 16.12: Lauros/Giraudon, p. 424; Photo 16.13: Tate Gallery, London/Art Resource, New York, p. 425; Photo 16.14: Reproduced by courtesy of the Trustees of the National Gallery, London, p. 426 (Top); Photo 16.15: Alinari/Art Resource, New York, p. 426 (Bot); Photo 16.16: Sylvain Grandadam/Pantheon, Paris/ Photo Researchers, Inc., p. 427 (Top); Photo 16.17: Virginia Tourism Group, p. 427 (Bot); Photo 16.19: © Internationale Stiftung Mozarteum (Mozart Museum), Salzburg, p. 431; Photo 16.20: © 1993 Beth Bergman, p. 432; Photo 16.21: © Réunion des Musées Nationaux, Paris-Hervé, p. 436; Photo 16.22: Giraudon/Art Resource, New York, p. 437; Photo 16.23: Dementi-Foster, Richmond, Virginia, p. 440

CHAPTER 17—Photo 17.1: The Metropolitan Museum of Art, gift of M. Knoedler and Co., 1918 [18.64(43)]. All rights reserved, The Metropolitan Museum of Art, New York, p. 448 (Top); Photo 17.2: Browlie/Photo Researchers, Inc., p. 448 (Bot); Photo 17.3: Archiv fur Kunst und Geschichte, Berlin, p. 452; Photo 17.4: © Réunion des Musées Nationaux, Paris, p. 455; Photo 17.5: Henry Wisneski, Bricktown, NJ, p. 457; Photo 17.6: © 1993 Beth Bergman, New York, p. 458; Photo 17.7: Richard Wagner Museum, Triebschen-Luzern, p. 459 (Top); Photo 17.8: Jack Vartoogian, New York, p. 459 (Bot); Photo 17.9: © Réunion des Musées Nationaux, Paris, p. 461 (Top); Photo 17.10: Museo del Prado, Madrid, p. 461 (Bot); Photo 17.11: Museo del Prado, Madrid, p. 462; Photo 17.12: Museo del Prado, Madrid, p. 463; Photo 17.13: © R. G. Ojeda/Réunion des Musées Nationaux, Paris, p. 464 (Top); Photo 17.14: © Réunion des Musées Nationaux, Paris, p. 464 (Bot); Photo 17.15: © Hervé Lewandowski/Réunion des Musées Nationaux, Paris, p. 465 (Top); Photo 17.16: Giraudon/ Art Resource, Inc. New York, p. 465 (Bot); Photo 17.17: Eric Lessing/Art Resource, New York, p. 466; Photo 17.18: Copyright © Frick Collection, New York, pp. 446, 467 (Top); Photo 17.19: Philadelphia Museum of Art: Gift of Carl Zigrosser, p. 467 (Bot); Photo 17.20: Scala/Art Resource, New York, p. 468 (Top); Photo 17.21: © Hubert Camille/Tony Stone Worldwide, p. 468 (Bot); Photo 17.22: Staatlich Museen zu Berlin, p. 469 (Top); Photo 17.23: By courtesy of the Trustees of the National Gallery, London, p. 469 (Bot); Photo 17.24: Museum of Fine Arts, Boston (Henry Lillie Peirce Fund), p. 470; Photo 17.25: By permission of the Houghton Library, Harvard University, p. 471; Photo 17.26: National Portrait Gallery, London, p. 472; Photo 17.27: Print Collection. Miriam and Ira D. Wallach Division of Art, Prints and Photographs. The New York Public Library. Astor, Lenox and Tilden Foundations, p. 475; Photo 17.28: © Cleveland Museum of Art, Gift of the John Huntington Art and Polytechnic Trust, 1915.534, p. 476 (Top); Photo 17.29: Museum of the City of New York, p. 476 (Bot); Photo 17.30: Museum of Art, Rhode Island School of Design, Providence, Rhode Island, p. 479 (Top); Photo 17.31: Bequest of Maxim Karolik. Courtesy of the Museum of Fine Arts, Boston, p. 479 (Bot); Photo 17.32: Metropolitan Museum, New York, gift of Mrs. William F. Milton, 1923. (23.77.2) Copyright © 1992 by the Metropolitan Museum of Art, p. 480 (Top); Photo 17.33: Swimming Hole by Thomas Eakins, oil on canvas, 1885. Amon Carter Museum, Fort Worth, Texas, acquired by the Friends of Art, Fort Worth Art Association, 1925. Presented to the Amon Carter Museum, 1990, from the Modern Art Museum of Fort Worth through grants and donations from the Amon G. Carter Foundation, the Sid W. Richardson Foundation, the Anne Burnett and Charles Tandy Foundation, Capital Cities/ ABC Foundation, Fort Worth Star-Telegram, the R. D. and Joan Dale Hubbard Foundation, and the people of Fort Worth, p. 480 (Bot); Photo 17.34: Phillips Collection, Washington, DC, p. 481

CHAPTER 18—Photo 18.1: Stadtische Kunsthalle, Recklinghausen, p. 490

(Top); Photo 18.2: University of Michigan Museum of Art, Ann Arbor, 1956/1.21, p. 490 (Bot); Photo 18.3: A & L Sinibaldi/Tony Stone Images, p. 491; Photo 18.4: Giraudon/Art Resource, New York, p. 492 (Top); Photo 18.5: Courtesy of the Coutauld Institute Galleries, London (Coutauld Collection), p. 492 (Bot); Photo 18.6: © Giraudon/Art Resource, NY, p. 493; Photo 18.7: Courtesy of the Fogg Art Museum, Harvard University Art Museums. Bequest from the collection of Maurice Wertheim, Class of 1906. Copyright © President and Fellows Harvard College, Harvard University Art Museums, p. 494; Photo 18.8: The Carnegie Museum of Art, Pittsburgh (acquired through the generosity of Mrs. Alan M. Scaife, 1962), p. 495 (Top); Photo 18.8a: The Carnegie Museum of Art, Pittsburgh (acquired through the generosity of Mrs. Alan M. Scaife, 1962), p. 495 (Bot); Photo 18.9: © Réunion des Musées Nationaux, Paris, p. 496 (Top); Photo 18.10: © Jean/Réunion des Musées Nationaux, Paris, p. 496 (Bot); Photo 18.11: © Hervé Lewandowski/Réunion des Musées Nationaux, Paris, p. 497 (Top); Photo 18.12: Hill-Stead Museum. Farmington, Connecticut, p. 497 (Bot); Photo 18.13: Cincinnati Art Museum (John J. Emery Endowment, 1928), p. 498 (Top); Photo 18.14: Santa Barbara Museum of Art (gift of Mrs. Hugh N. Kirkland). Photo by Scott McClaine, Dec. 1994, p. 498 (Bot); Photo 18.15: Copyright © 1997 The Museum of Modern Art, New York, presented in memory of Curt Valentin by his friends, p. 499 (L); Photo 18.16: Copyright © 1998 Bruno Jarret/Artists Rights Society (ARS), New York/ ADAGP, Paris, p. 499 (R); Photo 18.17: © 1996 The Art Institute of Chicago. (Helen Birch Bartlett Memorial Collection, 1926.224). All rights reserved, p. 500 (Top); Photo 18.18: Metropolitan Museum of Art, New York. Bequest of Sam A. Lewisohn, 1951. (51.112.2). Copyright © 1997 by the Metropolitan Museum of Art, p. 500 (Bot); Photo 18.19: Courtesy of the Fogg Art Museum, Harvard University Art Museums. Bequest from the collection of Maurice Wertheim, Class of 1906. Copyright © President and Fellows Harvard College, Harvard University Art Museums, p. 501 (Top); Photo 18.20: Philadelphia Museum of Art: The George W. Elkins Collection. Photo by Graydon Wood, 1994, p. 501 (Bot); Photo 18.21: Museum of Modern Art, New York (acquired through the Lillie P. Bliss bequest). Copyright © 1998 The Museum of Modern Art,

New York, p. 502; Photo 18.22: Yale University Art Gallery, New Haven (beguest of Stephen C. Clark), p. 503; Photo 18.23: Réunion des Musées Nationaux/Art Resource, New York, pp. 488, 504; Photo 18.24: Copyright © 1998 Artists Rights Society (ARS), New York. Photo copyright © 1993 by The Barnes Foundation, BF No. 719, Merion Station, Pennsylvania, p. 505; Photo 18.25: Copyright © 1998 Artists Rights Society (ARS), New York. Museum of Modern Art, New York. (Mrs. Simon Guggenheim Fund). Photograph © 1998 The Museum of Modern Art, New York, p. 506 (Top); Photo 18.26: Copyright © 1992 Munch Museum, Oslo, p. 506 (Bot); Photo 18.27: Ralph Lieberman, p. 507 (Top); Photo 18.28: Copyright © Elke Walford, p. 507 (Bot); Photo 18.29: Staatliche Musseen zu Berlin-Preussischer Kulturbesitz, Nationalgalerie, Berlin, p. 508; Photo 18.30: Courtesy of Busch-Reisinger Museum, Harvard University (gift of Hans H. A. Meyn). Copyright © President and Fellows Harvard College, Harvard University Art Museums, p. 511; Photo 18.31: Copyright © 1998 Bruno Jarret/Artists Rights Society (ARS), New York/ ADAGP, Paris, p. 512; Photo 18.32: Public Library for the Performing Arts. Dance Collection, The New York Public Library for the Performing Arts. Astor, Lenox, and Tilden Foundations, p. 515

CHAPTER 19—Photo 19.1: © Brian Vikander/CORBIS, p. 525 (Top); Photo 19.2: Ross Coomaraswamy Collection, 17.3105. Courtesy of the Museum of Fine Arts, Boston, p. 525 (Bot); Photo 19.3: The Nelson-Atkins Museum of Art, Kansas City, Missouri (Purchase: Nelson Trust) 31-131/7. Photograph by Mel McLean, p. 526 (Top); Photo 19.4: The Granger Collection, p. 526 (Bot); Photo 19.5: Giraudon/Art Resource, NY, p. 527; Photo 19.6: © 1991 The Nelson Gallery-Foundation. THE NELSON-ATKINS MUSEUM OF ART, KANSAS CITY, MISSOURI (Purchase Nelson Trust) 46-51/3 photography by Robert Newcombe. All reproduction rights reserved, p. 529 (Top); Photo 19.7: © 1991 The Nelson Gallery-Foundation. THE NELSON-ATKINS MU-SEUM OF ART, KANSAS CITY, MIS-SOURI (Purchase Nelson Trust) 46-51/2 photography by Robert Newcombe. All reproduction rights reserved, p. 529 (LL); Photo 19.8: Cleveland Museum of Art, Severance and Greta Millikin Collection, 1964.170, p. 529 (LR); Photo 19.9: R. Richardson/H. Armstrong Roberts, p. 530;

Photo 19.10: The Granger Collection, p. 531; Photo 19.11: Courtesy of The Percival David Foundation of Chinese Art, p. 532 (Top); Photo 19.12: Réunion des Musées Nationaux/Art Resource, New York, p. 532 (Bot); Photo 19.13: Peabody Essex Museums, East India Square, Salem, MA 01970, USA, p. 533; Photo 19.14: New China Pictures/ Eastfoto/Sovfoto, p. 534; Photo 19.15: Audrey R. Topping, p. 535 (Top); Photo 19.16: Scala/Art Resource, NY, p. 535 (Bot); Photo 19.19: Photo courtesv of the International Society for Education Information, Inc., Tokyo, p. 537 (R); Photo 19.20: Reproduced by permission. Copyright © 2001 Museum of Fine Arts, Boston. 11.17652. All rights reserved, p. 538 (L)

CHAPTER 20—Photo 20.1: Copyright President & Fellows of Harvard College Peabody Museum, Harvard University. Photographer: Hillel Burger, p. 547 (L); Photo 20.2: Courtesy of the Fog Art Museum, Harvard University Art Museums. Gift of Mrs. John D. Rockefeller, Jr., (Abby Aldrich Rockefeller). Copyright © President and Fellows Harvard College, p. 547 (R); Photo 20.3: Reproduced by courtesy of the Trustees of The British Museum, London, p. 548 (L); Photo 20.4: © David Reed/CORBIS, p. 548 (R); Photo 20.5: Photo Great Zimbabwe Site Museum, p. 549; Photo 20.6: Photo from Herbert Cole, pp. 544, 552 (Top); Photo 20.8: © 2001 The Art Institute of Chicago. All rights reserved, p. 554 (L); Photo 20.9: Copyright 2002 National Museum of African Art, Smithsonian Institution. Photograph by Frank Khoury, p. 554 (UR); Photo 20.10: Photo Frederick Lamp, 1990, p. 554 (LR); Photo 20.11: Susan Vogel, p. 555 (Top); Photo 20.12: Copyright © 1998 by the Estate of Pablo Picasso/Artists Rights Society (ARS), New York. Art Resource, NY, p. 555 (Bot)

CHAPTER 21—Photo 21.1: Copyright © 1998 by the Estate of Pablo Picasso/Artists Rights Society (ARS), New York. Photo copyright © 1998 The Museum of Modern Art, New York, p. 564; Photo 21.2: Copyright © 1998 Artists Rights Society (ARS), New York/ADAGP, Paris. Photo by David Heald/© The Solomon R. Guggenheirm Foundation, New York (PN 54.1412), p. 565 (L); Photo 21.3: Copyright © 1998 by the Estate of Pablo Picasso/Artists Rights Society (ARS), New York. Photo copyright © 1992 Art Institute of Chicago. All rights reserved, p. 565 (R); Photo 21.4:

Copyright © 1998 by the Estate of Pablo Picasso/Artists Rights Society (ARS), New York. Photo copyright © 2001 The Museum of Modern Art, p. 566; Photo 21.5: Saidenberg Gallery, Private Collection, p. 567; Photo 21.6: The Museum of Modern Art, New York. Photo copyright © 1998 The Museum of Modern Art, New York, p. 568 (L); Photo 21.7: Copyright © 1998 Artists Rights Society (ARS), New York/ADAGP, Paris. Photo by David Heald/© The Solomon R. Guggenheirm Foundation, New York, p. 568 (R); Photo 21.8: David Heald/© The Solomon R. Guggenheim Foundation, New York, p. 569; Photo 21.9: Copyright © 1998 Artists Rights Society (ARS), New York/Demart Pro Arte, Paris. Photo copyright © 1998 The Museum of Modern Art, New York, p. 570; Photo 21.10: Copyright © 1998 Artists Rights Society (ARS), New York/Demart Pro Arte, Paris. Photograph copyright © 1992 The Art Institute of Chicago. All rights reserved, p. 571 (Top); Photo 21.11: Tate Gallery, London/Art Resource, p. 571 (Bot); Photo 21.12: Copyright © 1998 Artists Rights Society (ARS), New York/VG Bild-Kunst, Bonn. The Museum of Modern Art, New York (Abby Aldrich Rockefeller Fund). Photo copyright © 1998 The Museum of Modern Art, New York, p. 572; Photo 21.13: Archive Photos, p. 574; Photo 21.14: Arts and Artifacts Division, Schomburg Center for Research in Black Culture, The New York Public Library. Astor, Lenox and Tilden Foundations, p. 575; Photo 21.15: Copyright © 1998 by the Estate of Pablo Picasso/Artists Rights Society (ARS), New York. Photo courtesy of Musée National d'Art Moderne, Centre Georges Pompidou, Paris, p. 576; Photo 21.16: Copyright © 1998 Artists Rights Society (ARS), New York/ADAGP, Paris/Estate of Marcel Duchamp. Photo copyright © Cameraphoto-Arte, Venezia/Art Resource, NY. pp. 560, 577; Photo 21.17: Copyright © 1998 by the Estate of Pablo Picasso/Artists Rights Society (ARS), New York. Photo copyright @ ARS, NY. Centro de Arte Reina Sofia, Madrid, Spain. Art Resource, New York, p. 578; Photo 21.18: Museum of Modern Art, Film Stills Archives, NY, p. 579; Photo 21.19: Phoenix Films, Richard Sabol/Promotions, p. 580; Photo 21.20: The Museum of Modern Art, New York. Gift of the Farm Security Administration. Copy Print, copyright © 1998 The Museum of Modern Art, New York, p. 581; Photo 21.21: Copyright © 1998 Artists Rights

Society (ARS), New York/ADAGP, Paris. The Museum of Modern Art, New York (gift of Richard S. Zeisier). Photo copyright © 1998 The Museum of Modern Art, New York, p. 582

CHAPTER 22—Photo 22.1: © 2001 The Art Institute of Chicago. All rights reserved, pp. 588, 592; Photo 22.2: Copyright © 1998 Estate of Ben Shahn/Licensed by VAGA, New York, NY. Metropolitan Museum of Art, New York, Arthur Hoppock Hearn Fund, 1950. (50.77). Copyright © 1991 by the Metropolitan Museum of Art, p. 593 (Top); Photo 22.3: Copyright © 1998 The Georgia O'Keeffe Foundation/ Artists Rights Society (ARS), New York. Photo courtesy of Hirschl and Adler Galleries, Inc., New York. Painting in Private Collection, p. 593 (Bot); Photo 22.4: Copyright © 1998 Pollock-Krasner Foundation/Artists Rights Society (ARS), New York. Museum of Modern Art, New York. Photo copyright © 1998 The Museum of Modern Art, New York, p. 594 (Top); Photo 22.5: Copyright © 1998 Adolph and Esther Gottlieb Foundation/Licensed by VAGA, New York, NY. Metropolitan Museum of Art, New York, George A. Hearn Fund, 1959. (59.164) Photo by Malcom Varon. Copyright © 1990 by the Metropolitan Museum of Art, p. 594 (Bot); Photo 22.6: Copyright © 1998 Dedalus Foundation/Licensed by VAGA, New York, NY. Albright-Know Art Gallery, Buffalo, NY (gift of Seymor H. Knox, 1957), p. 595 (Top); Photo 22.7: Copyright © 1998 Kate Rothko-Prizel & Christopher Rothko/ Artists Rights Society (ARS), New York. Photo courtesy of The Rothko Chapel, p. 595 (Bot); Photo 22.8: Detroit Institute of Arts. Gift of Dr. Hilbert and Mrs. H. Delawter. Copyright © Helen Frankenthaler, p. 596; Photo 22.9: Photography by Ellen Page Wilson, courtesy of Pace Wildenstein Gallery, New York, p. 597 (Top); Photo 22.10: Copyright © 1998 Jasper Johns/Licensed by VAGA, New York, NY. Photo copyright © 1998 The Museum of Modern Art, New York, p. 597

(Bot); Photo 22.11: Copyright © 1998 Robert Rauschenberg/Licensed by VAGA, New York, NY. Moderna Museet, Statens Kunstmuseer, Stockholm, Sweden, p. 598 (Top); Photo 22.12: Copyright © 1998 The Andy Warhol Foundation for the Visual Arts/Artists Rights Society (ARS), New York. Photo copyright © Art Resource, New York, p. 598 (Bot); Photo 22.13: Photo by Eric Pollitzer/Leo Castelli Gallery, NY, p. 599 (Top); Photo 22.14: Courtesy of Phillip Pealstein, p. 599 (Bot); Photo 22.15: Copyright © Alfred Leslie, p. 600 (Top); Photo 22.16: Copyright © 1998 Romare Bearden, p. 600 (Bot); Photo 22.17: Dallas Museum of Arts, gift of the Dallas Chapter of LINKS, Inc., p. 601 (Top); Photo 22.18: Copyright © 1998 by Frank Stella/Artists Rights Society (ARS), New York. Photo by Bevan Davies/Courtesy of Leo Castelli Gallery, New York, p. 602 (Bot); Photo 22.19: © 1986 David Hockney, p. 602; Photo 22.20: © 1986 David Hockney, p. 603 (L); Photo 22.21: Stedelijk Museum, Amsterdam, p. 603 (Top); Photo 22.22: Fabbrica di San Pietro, p. 604 (L); Photo 22.23: Copyright © 1998 Estate of David Smith/Licensed by VAGA, New York, Detroit Institute of Arts. (Founders Society Purchase Fund), p. 604 (R); Photo 22.24: Copyright © 1998 Artists Rights Society (ARS), New York/ADAGP, Paris. Photo Copyright © 1997 Whitney Museum, New York. Photography by Sandak, Inc./G. K. Hall & Company, p. 605 (Top); Photo 22.25: Museum of Modern Art, New York, (Mr. and Mrs. Gerald Murphy Fund.) Photograph © 1998 The Museum of Modern Art, New York. Photo copyright © 1998 The Museum of Modern Art, New York, p. 605 (LL); Photo 22.26: Pace Gallery, Milly and Arnold Glimcher Collection, p. 605 (LR); Photo 22.27: Copyright © 1998 George Segal/Licensed by VAGA, New York, NY. Walker Art Center, Minneapolis (gift of the T. B. Walker Foundation, 1966), p. 606 (L); Photo 22.28: Moderna

Museet, Stockholm, p. 606 (R); Photo 22.29: Whitney Museum of American Art, NY (50th Anniversary Gift of Mr. and Mrs. Victor M. Ganzi), p. 607; Photo 22.30: Musée National d'Art Moderne, Centre Georges Pompidou, Paris, p. 608 (Top); Photo 22.31: Richard Pasley/Stock Boston, p. 608 (Bot); Photo 22.32: Harry Shunk/ © Christo and Jeanne-Claude 1972, p. 609 (Top); Photo 22.33: Copyright 1998 Magdalena Abakanowicz, Backs, 1976-1980 /Licensed by VAGA, New York, NY, courtesy, Marlborough Gallery, New York, p. 609 (Bot); Photo 22.34: Courtesy of Belger Cartage Service, Inc., Kansas City, MO. Copyright © 1990 Duane Hanson, p. 610 (UL); Photo 22.35: Photo by Tommy Näzell/BLR Fotografernia AB. Courtesy of the Volvo Corporation, Göteborg, Sweden, p. 610 (UR); Photo 22.36: Photo by Tommy Näzell/BLR Fotografernia AB. Courtesy of the Volvo Corporation, Göteborg, Sweden, p. 610 (LR); Photo 22.37: Collection of Virginia Museum of Fine Arts, Richmond, VA, p. 611 (Top); Photo 22.38: Courtesy of the artist and Holly Solomon Gallery, NY, p. 611 (Bot); Photo 22.39: David Heald/The Solomon R. Guggenheim Foundation, New York, p. 612 (Top); Photo 22.40: Alinari/Art Resource, New York, p. 612 (Bot); Photo 22.41: Ezra Stoller © ESTO. All rights reserved, p. 613 (Top); Photo 22.42: 0 Austen/Tony Stone Worldwide, Ltd., p. 613 (Bot); Photo 22.44: Ezra Stoller © ESTO. All rights reserved, p. 614 (R); Photo 22.45: Ezra Stoller © ESTO. All rights reserved, p. 615 (Top); Photo 22.46: Patrick Ingrad/Tony Stone Images, p. 615 (Bot); Photo 22.47: James F. House/Kohn Peterson Fox Associates, p. 616 (UL); Photo 22.48: Susan Dirk, p. 616 (UR); Photo 22.49: © Scott Frances/ESTO. All rights reserved, p. 616 (Bot); Photo 22.50: Tate Gallery, London/Art Resource, NY, p. 617; Photo 22.51: David Young-Wolfe/PhotoEdit, p. 618

LITERARY ACKNOWLEDGMENTS

CHAPTER 1—page 9: From the LAW CODE OF HAMMURABI. Copyright University of Chicago Press. Reprinted by permission; page 18: From LIFE UNDER THE PHARAOHS by Leonard Cottrell, pp. 84, 94. Copyright © 1960 by Leonard Cottrell. Reprinted by permission of Henry Holt and Company, LLC; page 18: From TEMPLES, TOMBS AND HIEROGLYPHICS by Barbara Mertz, 1964. Copyright © 1964, 1978 by Barbara Mertz. All rights reserved.

CHAPTER 2—page 39: From BOOK XVII of THE ILIAD by Homer, translated by E. V. Rieu. Published by Penguin Books, Ltd.

CHAPTER 3—page 80: "Kerdo the Cobbler" by Herondas from GREEK LITERATURE IN TRANSLATION, translated by George Howe and Gustave Adolphus Harrer (New York: Harper, 1924). Reprinted by permission of Marcella Harrer.

CHAPTER 4—page 96: "Letter by Cicero" translated by John Reich; page 97: From THE SATYRICON by Petronius, translation formerly attributed to Oscar Wilde. Privately printed.

CHAPTER 7—page 163: Reprinted by permission of the publishers and the

Trustees of the Loeb Classical Library from PROCOPIUS: VOLUME I, Loeb Classical Library Volume L048, translated by H. B. Dewing, Cambridge, MA: Harvard University Press, 1914. The Loeb Classical Library® is a registered trademark of the President and Fellows of Harvard College.

CHAPTER 9—page 208: "Quem Quæritis" trope from SAINT GAIL MANUSCRIPTS in CHIEF PRE-SHAKE-SPEAREAN DRAMAS by John Quincey Adams, editor, 1924.

CHAPTER 10—page 240: From "General Prologue" of THE CANTERBURY TALES by Geoffrey Chaucer, translated by David Wright. Copyright © 1985 by David Wright. Reprinted by permission of PFD on behalf of the Estate of David Wright.

CHAPTER 14—page 342: Letter by Katherine Zell reprinted from WOMEN OF THE REFORMATION IN GERMANY AND ITALY by Roland H. Bainton, © 1971 by Augsburg Fortress Press.

CHAPTER 15—page 397: From BORN UNDER SATURN by Giambattista Passeri, translated by Rudolf and Margot Wittkower, © 1963 by Rudolf and Margot Wittkower, renewed 1991 by

Margot Wittkower. Used by permission of Random House, Inc.

CHAPTER 18—page 510: Letter of Gustav Mahler to his wife from LETTERS OF COMPOSERS by G. Norman and M. L. Shrifte.

CHAPTER 19—page 533: From EMPEROR OF CHINA by Jonathan D. Spence, copyright © 1984 by Jonathan D. Spence. Used by permission of Alfred A. Knopf, a division of Random House, Inc.

CHAPTER 21—page 561: Reprinted with the permission of Scribner, a division of Simon & Schuster from THE COLLECTED POEMS OF W. B. YEATS, Revised Second Edition, edited by Richard J. Finneran. Copyright 1924 by Macmillan Publishing Company, renewed 1952 by Bertha Georgia Yeats.

CHAPTER 22—page 596: Statement by Georgia O'Keeffe, 1944. Published by permission of the Georgia O'Keeffe Foundation; page 621: By William Carlos Williams from COLLECTED POEMS 1939–1962, VOLUME II, copyright 1953 by William Carlos Williams. Reprinted by permission of New Directions Publishing Corp.